2005 Artist's & Graphic Designer's Market®

Mary Cox, Editor
Lauren Mosko, Assistant Editor

WRITER'S DIGEST BOOKS
CINCINNATI, OH

If you are an editor, art director, creative director, art publisher or gallery director and would like to be considered for a listing in the next edition of *Artist's & Graphic Designer's Market*, send your request for a questionnaire to *Artist's & Graphic Designer's Market*—QR, 4700 East Galbraith Road, Cincinnati OH 45236, or e-mail artdesign@fwpubs.com.

Editorial Director, Writer's Digest Books: Barbara Kuroff
Managing Editor, Writer's Digest Annual Books: Alice Pope
Writer's Market website: www.writersmarket.com
Writer's Digest Books website: www.writersdigest.com

International Standard Serial Number 1075-0894
International Standard Book Number 1-58297-278-8

Cover design by Nick and Diane Gliebe, Design Matters
Interior design by Clare Finney

Attention Booksellers: This is an annual directory of F+W Publications. Return deadline for this edition is December 31, 2005.

Contents

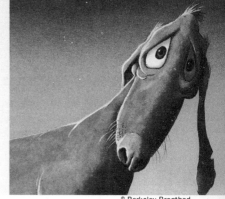

© Berkeley Breathed

© Black Olive

THE MARKETS

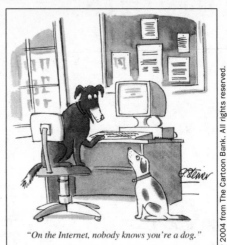

"On the Internet, nobody knows you're a dog."

© Judy Kaufman

RESOURCES

INDEXES

© Joan Ritchie

From the Editor

The year was 1975. Gerald Ford was in the White House, gas was 44 cents a gallon, *Jaws* terrified movie-goers, Bruce Springsteen released *Born to Run*, *Saturday Night Live* aired for the first time, Cincinnati won the World Series—and the publication you hold in your hands made its debut.

Thirty years ago it seemed pretty risky to publish a book about marketing artwork. The stereotype of the starving artist was very much alive—as was the stubborn cliché that art isn't valued until its creator's demise.

Somebody at F+W Publications thought differently. With the success of *Writer's Market*, the well-known and respected annual directory for writers, one of our editors asked "Why not a similar resource for artists?" There *were* markets for artists—lots of them. Publishers, advertising agencies, galleries and businesses all needed talented artists, illustrators, graphic designers and cartoonists on a regular basis. And so *Artist's Market* was born.

Through the 1980s the book continued to evolve, adding more pages, markets and insightful interviews. With the growth of technology, career opportunities in design and illustration came to the forefront. *Artist's Market* morphed into *Artist's & Graphic Designer's Market*, expanding its focus. Technology continues to influence how artists interact with galleries and clients. Through e-mail and the Internet, images can be instantly transported anywhere in the world. Who knows what's in store?

If you've used *AGDM* in the past, you may notice this edition's more user-friendly design. It's part of our philosophy of continually improving our format so it's easier to use. It's a safe bet the next 30 years will bring more innovations and changes, but one thing's clear: We'll never veer from our goal of guiding you toward a successful career in art and motivating you to be the best you can be.

Mary Cox

Mary Cox
artdesign@fwpubs.com

P.S. Please return the feedback form on page 583. I'd love to hear from you and find out how you use *AGDM* to market your work—and you just might win a free copy of the next edition!

How to Use This Book

To Find Markets for Your Work

J ust launching your freelance art career? Don't know quite where to begin? You've come to the right place! Your first step will be finding out about your potential clients and customers—who they are and how you can reach them. That's what this book is all about. We provide the names and addresses of art buyers along with plenty of marketing tips. You provide the hard work, creativity and patience necessary to hang in there until work starts coming your way.

If you are picking up this book for the first time, you might not know quite how to start using it. Your first impulse might be to flip through and quickly make a mailing list, submitting to everyone with hopes that someone might like your work. Resist that urge. As Louis Pasteur once said, "Luck favors the prepared mind." Read on and find out what you'll need to know before you jump in.

What you'll find in this book

In focus groups, artists have told us *Artist's & Graphic Designer's Market* can be overwhelming at first. Don't worry, it's really not that difficult to navigate. Here's how.

The book is divided into five parts:

1. Business articles and interviews
2. Section introductions
3. Listings of companies and galleries
4. Insider Reports
5. Indexes

Listings: the heart of this book

Beyond this section, the book is further divided into market sections, from Greeting Card companies to Record Labels. (See Table of Contents for complete list.) Each section begins with an introduction containing information and advice to help you break into the specific market.

Listings are the life's blood of this book. In a nutshell listings are names, addresses and contact information for places that buy or commission artwork, along with a description of the type of art they need and their submission preferences.

Interviews and Insider Reports

Throughout this book you will find interviews with working artists and experts from the art world. These articles give you a richer understanding of the marketplace by sharing the featured artists' personal experiences and insights. Their stories, and the lessons you can

learn from other artists' feats and follies, give you an important edge over artists who skip the articles. Insider Reports are listed in the Table of Contents under "Markets."

HOW *AGDM* "WORKS"

Following the instructions in the listings, we suggest you send samples of your work (not originals) to a dozen (or more) targeted listings. The more listings you send to, the greater your chances. Establish a tracking system to keep track of who you submit your work to and send follow-up mailings to your target markets at least twice a year.

How to read listings

Each listing contains a description of the artwork and/or services it prefers. The information often reveals how much freelance artwork they use, whether computer skills are needed and which software programs are preferred.

In some sections, additional subheads help you identify potential markets. Magazine listings specify needs for cartoons and illustrations. Galleries specify media and style.

Editorial comments, denoted by bullets (•), give you extra information about markets, such as company awards, mergers and insight into a listing's staff or procedures.

It takes a while to get accustomed to the layout and language in the listings. In the beginning, you will encounter some terms and symbols that might be unfamiliar to you. Refer to the Glossary on page 579 to help you with terms you don't understand.

Listings are often preceded by symbols, which help lead the way to new listings **N**, mailing address or contact name changes **☑** and other information. When you encounter these symbols, refer to the inside back cover of this book for a complete list of their meanings.

Working with listings

1. Read the entire listing to decide whether to submit your samples. Do NOT use this book simply as a mailing list of names and addresses. Reading listings helps you narrow your mailing list and submit appropriate material.

2. Read the description of the company or gallery in the first paragraph of the listing. Then jump to the **Needs** heading to find out what type of artwork the listing prefers. Is it the type of artwork you create? This is the first step to narrowing your target market. You should only send your samples to listings that need the kind of work you create.

3. Send appropriate submissions. It seems like common sense to research what kind of samples a listing wants before sending off just any artwork you have on hand. But believe it or not, some artists skip this step. Many art directors have pulled their listings from *AGDM* because they've received too many inappropriate submissions. Look under the **First Contact & Terms** heading to find out how to contact the listing. Some companies and publishers are very picky about what kind of samples they like to see; others are more flexible.

What's an inappropriate submission? I'll give you an example. Suppose you want to be a children's book illustrator. Don't send your sample of puppies and kittens to *Business Law Today* magazine—they would rather see law-related subjects. Instead use the Niche Marketing Index to find listings that take children's illustrations. You'd be surprised how many illustrators waste their postage sending the wrong samples. And boy, does that alienate art directors. Make sure all your mailings are *appropriate* ones.

4. Consider your competition. Under the **Needs** heading, compare the number of freelancers who contact the listing with the number they actually work with. You'll have a better chance with listings that use a lot of artwork or work with many artists.

5. Look for what they pay. In most sections, you can find this information under **First Contact & Terms**. Book publishers list pay rates under headings pertaining to the type of work you do, such as **Text Illustration** or **Book Design**.

At first, try not to be too picky about how much a listing pays. After you have a couple of assignments under your belt, you might decide to only send samples to medium- or high-paying markets.

6. Be sure to read the "tips"! Artists say the information within the **Tips** helps them get a feel for what a company might be like to work for.

These steps are just the beginning. As you become accustomed to reading listings, you will think of more ways to mine this book for your potential clients. Some of our readers tell us they peruse listings to find the speed at which a magazine pays its freelancers. In publishing, it's often a long wait until an edition or book is actually published, but if you are paid "on acceptance" you'll get a check soon after you complete the assignment and it is approved by the Art Director.

When looking for galleries, savvy artists often check to see how many square feet of space is available and what hours the gallery is open. These details all factor in when narrowing down your search for target markets.

Pay attention to copyright information

It's also important to consider what **rights** listings buy. It is preferable to work with listings that buy first or one-time rights. If you see a listing that buys "all rights," be aware you may be giving up the right to sell that particular artwork in the future.

Look for specialties and niche markets

In the Advertising, Design & Related Markets section, we tell what kind of clients an ad agency has within the first paragraph of the listing. If you hope to design restaurant menus, for example, target agencies that have restaurants for clients. But if you don't like to draw food-related illustration and prefer illustrating people, you might target ad agencies whose clients are hospitals or financial institutions. If you like to draw cars, look for agencies with clients in the automotive industry, and so on. Many book publishers specialize, too. Look for a publisher who specializes in children's books if that's the type of work you'd like to do. **The Niche Marketing Index** on page 585 lists possible opportunities for specialization.

Read listings for ideas

You'd be surprised how many artists found new niches they hadn't thought of by browsing the listings. One greeting card artist read about a company that produces mugs. Inspiration struck. Now this artist has added mugs to her repertoire, along with paper plates, figurines and rubber stamps—all because she browsed the listings for ideas!

Sending out samples

Once you narrow down some target markets, the next step is sending them samples of your work. As you create your samples and submission packets, be aware your package or postcard has to look professional. It must be up to the standards art directors and gallery dealers expect. See Promotional Mailings: A Great Way to Launch Your Career, on pages 19 for a look at some great samples sent out by other artists. Make sure your samples rise to that standard of professionalism.

New year, new listings

Use this book for one year. Highlight listings, make notes in the margins, fill it full of Post-it notes. In November of the year 2005, our next edition—the 2006 *Artist's & Graphic Designer's Market*—starts arriving in bookstores. By then, we'll have collected hundreds of new listings and changes in contact information. It is a career investment to buy the new edition every year. (And it's deductible! See Freelancing For Fun and Profit on page 6.)

Getting Started

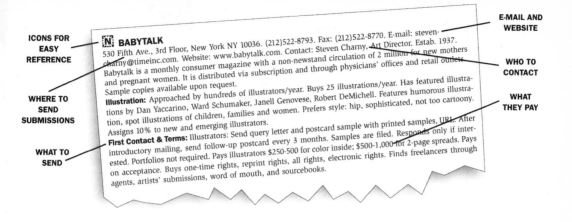

ICONS FOR
EASY
REFERENCE

WHERE TO
SEND
SUBMISSIONS

WHAT TO
SEND

E-MAIL AND
WEBSITE

WHO TO
CONTACT

WHAT
THEY PAY

[N] BABYTALK
530 Fifth Ave., 3rd Floor, New York NY 10036. (212)522-8793. Fax: (212)522-8770. E-mail: steven-charny@timeinc.com. Website: www.babytalk.com. Contact: Steven Charny, Art Director. Estab. 1937. Babytalk is a monthly consumer magazine with a non-newsstand circulation of 2 million for new mothers and pregnant women. It is distributed via subscription and through physicians' offices and retail outlets. Sample copies available upon request.
Illustration: Approached by hundreds of illustrators/year. Buys 25 illustrations/year. Has featured illustrations by Dan Yaccarino, Ward Schumaker, Janell Genovese, Robert DeMichell. Features humorous illustration, spot illustrations of children, families and women. Prefers style: hip, sophisticated, not too cartoony. Assigns 10% to new and emerging illustrators.
First Contact & Terms: Illustrators: Send query letter and postcard sample with printed samples, URL. After introductory mailing, send follow-up postcard every 3 months. Samples are filed. Responds only if interested. Portfolios not required. Pays illustrators $250-500 for color inside; $500-1,000 for 2-page spreads. Pays on acceptance. Buys one-time rights, reprint rights, all rights, electronic rights. Finds freelancers through agents, artists' submissions, word of mouth, and sourcebooks.

Join a professional organization

Artists who have the most success using this book are those who take the time to read the articles to learn about the bigger picture. In our interviews and Insider Reports, you'll learn what has worked for other artists and what kind of work impresses art directors and gallery dealers.

You'll find out how joining professional organizations such as the **Graphic Artists Guild** (www.gag.org) or the **American Institute of Graphic Arts** (www.aiga.org) can jump start your career. You'll find out the importance of reading trade magazines such as *HOW* (www.howdesign.com), *Print* and *Greetings etc.* to learn more about the industries you hope to approach. You'll learn about trade shows, portfolio days, websites, art reps, shipping, billing, working with vendors, networking, self-promotion and hundreds of other details it would take years to find out about on your own. Perhaps most importantly, you'll read about how successful artists overcame rejection through persistence.

Hang in there!

Being professional doesn't happen overnight. It's a gradual process. I would venture to say that only after two or three years of using each successive year's edition of this book will you have garnered enough information and experience to be a true professional in your field. So if you really want to be a professional artist, hang in there. Before long, you'll feel that heady feeling that comes from selling your work or seeing your illustrations on a greeting card or in a magazine. If you really want it and you're willing to work for it, it *will* happen.

Freelancing for Fun and Profit

How to Stay on Track and Get Paid

A career as an artist or illustrator involves much more than just painting or drawing. Successful artists must also become small business owners who know their way around an invoice or a contract. Though business seems the antithesis of art, never fear. If you bring your creativity to the business aspects of your work, you will come up with some pretty nifty ideas for keeping your business on track. The most important rule of all is to find a system that works for you and stick with it!

YOUR DAILY RECORD-KEEPING SYSTEM

Every artist needs to keep a daily record of art-making and marketing activities. Before you do anything else, visit an office supply store and pick out the following items (or your own variations of these items). Keep it simple so you can remember your system and use it on "automatic pilot" whenever you make a business transaction.

What you'll need:

- A packet of colorful file folders.
- A notebook to serve as a log or journal to keep track of your daily art-making and art marketing activities.
- A small pocket notebook to keep in your car to track mileage and gas expenses.

How to start your system

- Designate a permanent location in your studio or home office for two file folders and your notebook.
- Label one red file folder "Expenses."
- Label one green file folder "Income."
- Write in your daily log book: Today's date _____ "Started business system."

Every time you purchase anything for your business, such as envelopes or art supplies, place the receipt in your red "Expenses" folder. When you receive payment for an assignment or painting, photocopy the check or place the receipt in your green "Income" folder.

That's all there is to it. By the way, if you purchase any of the suggested supplies at the store, place your receipt in the "Expenses" folder. Congratulations! You've already begun to use your record-keeping system!

"Job jackets" keep assignments on track

Whether you are an illustrator or fine artist, you should devise a system for keeping track of assignments and artworks. Most illustrators assign job numbers to each assignment they

receive and create a "job jacket" or file folders for each job. Some file these folders by client name; others keep folders in numerical order. The important thing is to keep all correspondence for each assignment in a spot where you can easily find it.

Pricing illustration and design

One of the hardest things to master is what to charge for your work. It's difficult to make blanket statements on this topic. Every slice of the market is somewhat different. Neverthe-

Pricing your fine art

Tips

There are no hard and fast rules for pricing your fine artwork. Most artists and galleries base prices on market value—what the buying public is currently paying for similar work. Learn the market value by visiting galleries and checking prices of works similar to yours. When you are starting out, don't compare your prices to established artists but to emerging talent in your region. Consider these when determining price:

- **Medium.** Oils and acrylics cost more than watercolors by the same artist. Price paintings higher than drawings.

- **Expense of materials.** Charge more for work done on expensive paper than for work of a similar size on a lesser grade paper.

- **Size.** Though a large work isn't necessarily better than a small one, as a rule of thumb you can charge more for the larger work.

- **Scarcity.** Charge more for one-of-a-kind works like paintings and drawings, than for limited editions such as lithographs and woodcuts.

- **Status of artist.** Established artists can charge more than lesser-known artists.

- **Status of gallery.** Prestigious galleries can charge higher prices.

- **Region.** Works usually sell for more in larger cities like New York and Chicago.

- **Gallery commission.** The gallery will charge from 30 to 50 percent commission. Your cut must cover the cost of materials, studio space, taxes and perhaps shipping and insurance, and enough extra to make a profit. If materials for a painting cost $25, matting and framing cost $37 and you spent five hours working on it, make sure you get at least the cost of material and labor back before the gallery takes their share. Once you set your price, stick to the same price structure wherever you show your work. A $500 painting by you should cost $500 whether it is bought in a gallery or directly from you. To do otherwise is not fair to the gallery and devalues your work.

As you establish a reputation, begin to raise your prices—but do so cautiously. Each time you "graduate" to a new price level, it becomes more difficult to come back down.

The Art of Business

less, there is one recurring pattern: Hourly rates are generally only paid to designers working in house on a client's equipment. Freelance illustrators working out of their own studios are almost always paid a flat fee or an advance against royalties.

If you don't know what to charge, begin by devising an hourly rate, taking into consideration the cost of materials and overhead and what you think your time is worth. If you are a designer, determine what the average salary would be for a full-time employee doing the same job. Then estimate how many hours the job will take and quote a flat fee based on these calculations.

There is a distinct difference between giving the client a job estimate and a job quote. An estimate is a ballpark figure of what the job will cost but is subject to change. A quote is a set fee which, once agreed upon, is pretty much carved in stone. Make sure the client understands which you are negotiating. Estimates are often used as a preliminary step in itemizing costs for a combination of design services such as concepting, typesetting and printing. Flat quotes are usually used by illustrators, as there are fewer factors involved in arriving at fees.

For recommended fees for different services, refer to *Graphic Designer's Guide to Pricing, Estimating & Budgeting* by Theo Stephan Williams and the *Graphic Artist's Guild's Handbook of Pricing & Ethical Guidelines*, 11th edition. Many artists' organizations have hotlines you can call to find out standard payment for the job you're doing.

As you set fees, certain stipulations call for higher rates. Consider these bargaining points:

- **Usage (rights).** The more rights purchased, the more you can charge. For example, if the client asks for a "buyout" (to buy all rights), you can charge more, because by relinquishing all rights to future use of your work, you will be losing out on resale potential.
- **Turnaround time.** If you are asked to turn the job around quickly, charge more.
- **Budget.** Don't be afraid to ask a project's budget before offering a quote. You won't want to charge $500 for a print ad illustration if the ad agency has a budget of $40,000 for that ad. If the budget is that big, ask for higher payment.
- **Reputation.** The more well known you are, the more you can charge. As you become established, periodically raise your rates (in small steps) and see what happens.

What goes in a contract?

Contracts are simply business tools to make sure everyone is in agreement. Ask for one any time you enter into a business agreement. Be sure to arrange for the specifics in writing or provide your own. A letter stating the terms of agreement signed by both parties can serve as an informal contract. Several excellent books, such as *Legal Guide for the Visual Artist* (Fourth Edition) and *Business and Legal Forms for Illustrators*, both by Tad Crawford (Allworth Press), contain negotiation checklists and tear-out forms and provide sample contracts you can copy. The sample contracts in these books cover practically any situation you might run into.

The items specified in your contract will vary according to the market you are dealing with and the complexity of the project. Nevertheless, here are some basic points you'll want to cover:

Commercial contracts
- **A description of the service you are providing.**
- **Deadlines for finished work.**
- **Rights sold.**
- **Your fee.** Hourly rate, flat fee or royalty.
- **Kill fee.** Compensatory payment received by you if the project is cancelled.
- **Changes fees.** Penalty fees to be paid by the client for last-minute changes.

- **Advances.** Any funds paid to you before you begin working on the project.
- **Payment schedule.** When and how often you will be paid for the assignment.
- **Statement regarding return of original art.** Unless you are doing work for hire, your artwork should always be returned to you.

Gallery contracts

- **Terms of acquisition or representation.** Will the work be handled on consignment? What is the gallery's commission?
- **Nature of the show(s).** Will the work be exhibited in group or solo shows or both?
- **Time frames.** At what point will the gallery return unsold works to you? When will the contract cease to be in effect? If a work is sold, when will you be paid?
- **Promotion.** Who will coordinate and pay for promotion? What does promotion entail? Who pays for printing and mailing of invitations? If costs are shared, what is the breakdown?
- **Insurance.** Will the gallery insure the work while it is being exhibited?
- **Shipping.** Who will pay for shipping costs to and from the gallery?
- **Geographic restrictions.** If you sign with this gallery, will you relinquish the rights to show your work elsewhere in a specified area? If so, what are the boundaries of this area?

How to send invoices

If you are a designer or illustrator, you will be responsible for sending invoices for your services. Clients generally will not issue checks without them, so mail or fax an invoice as soon as you've completed the assignment. Illustrators are generally paid in full either upon receipt of illustration or on publication. Most graphic designers arrange to be paid in thirds, billing the first third before starting the project, the second after the client approves the initial roughs and the third upon completion of the project.

Standard invoice forms allow you to itemize your services. The more you spell out the charges, the easier it will be for your clients to understand what they are paying for. Most freelancers charge extra for changes made after approval of the initial layout. Keep a separate form for change orders and attach it to your invoice.

If you are an illustrator, your invoice can be much simpler, as you'll generally be charging a flat fee. It's helpful, in determining your quoted fee, to itemize charges according to time, materials and expenses. (The client need not see this itemization; it is for your own purposes.)

Most businesses require your social security number or tax ID number before they can cut a check, so include this information in your bill. Be sure to put a due date on each invoice; include the phrase "payable within 30 days" (or other preferred time frame) directly on your invoice. Most freelancers ask for payment within 10-30 days.

Sample invoices are featured in *Business and Legal Forms for Illustrators* and *Business and Legal Forms for Graphic Designers*, by Tad Crawford (Allworth Press).

If you are working with a gallery, you will not need to send invoices. The gallery should send you a check each time one of your pieces is sold (generally within 30 days). To ensure that you are paid promptly, call the gallery periodically to touch base. Let the director or business manager know that you are keeping an eye on your work. When selling work independently of a gallery, give receipts to buyers and keep copies for your records.

Take advantage of tax deductions

You have the right to deduct legitimate business expenses from your taxable income. Art supplies, studio rent, printing costs and other business expenses are deductible against your gross art-related income. It is imperative to seek the help of an accountant or tax preparation

Can I deduct my home studio?

Important

If you freelance full time from your home and devote a separate area to your business, you may qualify for a home office deduction. If eligible, you can deduct a percentage of your rent or mortgage and utilities and expenses like office supplies and business-related telephone calls.

The IRS does not allow deductions if the space is used for reasons other than business. A studio or office in your home must meet three criteria:

- The space must be used exclusively for your business.

- The space must be used regularly as a place of business.

- The space must be your principle place of business.

The IRS might question a home office deduction if you are employed full time elsewhere and freelance from home. If you do claim a home office, the area must be clearly divided from your living area. A desk in your bedroom will not qualify. To figure out the percentage of your home used for business, divide the total square footage of your home by the total square footage of your office. This will give you a percentage to work with when figuring deductions. If the home office is 10% of the square footage of your home, deduct 10% of expenses such as rent, heat and air conditioning.

The total home office deduction cannot exceed the gross income you derive from its business use. You cannot take a net business loss resulting from a home office deduction. Your business must be profitable three out of five years. Otherwise, you will be classified as a hobbyist and will not be entitled to this deduction.

Consult a tax advisor before attempting to take this deduction, since its interpretations frequently change.

For additional information, refer to IRS Publication 587, Business Use of Your Home, which can be downloaded at www.irs.gov or ordered by calling (800)829-3676.

service in filing your return. In the event your deductions exceed profits, the loss will lower your taxable income from other sources.

To guard against taxpayers fraudulently claiming hobby expenses as business losses, the IRS requires taxpayers demonstrate a "profit motive." As a general rule, you must show a profit three out of five years to retain a business status. If you are audited, the burden of proof will be on you to demonstrate your work is a business and not a hobby.

The nine criteria the IRS uses to distinguish a business from a hobby are:

- the manner in which you conduct your business
- expertise
- amount of time and effort put into your work
- expectation of future profits
- success in similar ventures

- history of profit and losses
- amount of occasional profits
- financial status
- element of personal pleasure or recreation

If the IRS rules that you paint for pure enjoyment rather than profit, they will consider you a hobbyist. Complete and accurate records will demonstrate to the IRS that you take your business seriously.

Even if you are a ''hobbyist,'' you can deduct expenses such as supplies on a Schedule A, but you can only take art-related deductions equal to art-related income. If you sold two $500 paintings, you can deduct expenses such as art supplies, art books and seminars only up to $1,000. Itemize deductions only if your total itemized deductions exceed your standard deduction. You will not be allowed to deduct a loss from other sources of income.

How to fill out a Schedule C

To deduct business expenses, you or your accountant will fill out a 1040 tax form (not 1040EZ) and prepare a Schedule C. Schedule C is a separate form used to calculate profit or loss from your business. The income (or loss) from Schedule C is then reported on the 1040 form. In regard to business expenses, the standard deduction does not come into play as it would for a hobbyist. The total of your business expenses need not exceed the standard deduction.

There is a shorter form called Schedule C-EZ for self-employed people in service industries. It can be applicable to illustrators and designers who have receipts of $25,000 or less and deductible expenses of $2,000 or less. Check with your accountant to see if you qualify.

Deductible expenses include advertising costs, brochures, business cards, professional group dues, subscriptions to trade journals and arts magazines, legal and professional services, leased office equipment, office supplies, business travel expenses, etc. Your accountant can give you a list of all 100 percent and 50 percent deductible expenses (such as entertainment). And don't forget to deduct the cost of this book.

As a self-employed ''sole proprieter,'' there is no employer regularly taking tax out of your paycheck. Your accountant will help you put money away to meet your tax obligations and may advise you to estimate your tax and file quarterly returns.

Your accountant also will be knowledgeable about another annual tax called the Social Security Self-Employment tax. You must pay this tax if your net freelance income is $400 or more.

The fees of tax professionals are relatively low, and they are deductible. To find a good accountant, ask colleagues for recommendations, look for advertisements in trade publications or ask your local Small Business Association.

Whenever possible, retain your independent contractor status

Some clients automatically classify freelancers as employees and require them to file Form W-4. If you are placed on employee status, you may be entitled to certain benefits but a portion of your earnings will be withheld by the client until the end of the tax year and you could forfeit certain deductions. In short, you may end up taking home less than you would if you were classified as an independent contractor.

The IRS uses a list of 20 factors to determine whether a person should be classified as an independent contractor or an employee. This list can be found in the IRS Publication 937. Note, however, that your client will be the first to decide how you will be classified.

The Art of Business

The Art of Business

Report all income to Uncle Sam

Don't be tempted to sell artwork without reporting it on your income tax. You may think this saves money, but it can do real damage to your career and credibility—even if you are never audited by the IRS. Unless you report your income, the IRS will not categorize you as a professional, and you won't be able to deduct expenses. And don't think you won't get caught if you neglect to report income. If you bill any client in excess of $600, the IRS requires the client to provide you with a form 1099 at the end of the year. Your client must send one copy to the IRS and a copy to you to attach to your income tax return. Likewise, if you pay a freelancer over $600, you must issue a 1099 form. This procedure is one way the IRS cuts down on unreported income.

Register with the state sales tax department

Most states require a two to seven percent sales tax on artwork you sell directly from your studio or at art fairs or on work created for a client. You must register with the state sales tax department, which will issue you a sales permit or a resale number and send you appropriate forms and instructions for collecting the tax. Getting a sales permit usually involves filling out a form and paying a small fee. Reporting sales tax is a relatively simple procedure. Record all sales taxes on invoices and in your sales journal. Every three months, total the taxes collected and send it to the state sales tax department.

In most states, if you sell to a customer outside of your sales tax area, you do not have to collect sales tax. However, this may not hold true for your state. You may also need a business license or permit. Call your state tax office to find out what is required.

Save money on art supply sales tax

As long as you have the above sales permit number, you can buy art supplies without paying sales tax. You will probably have to fill out a tax-exempt form with your permit number at the sales desk where you buy materials. The reason you do not have to pay sales tax on art supplies is that sales tax is only charged on the final product. However, you must then add the cost of materials into the cost of your finished painting or the final artwork for your client. Keep all receipts in case of a tax audit. If the state discovers that you have not collected sales tax, you will be liable for tax and penalties.

If you sell all your work through galleries, they will charge sales tax, but you still need a tax exempt number to get a tax exemption on supplies.

Some states claim "creativity" is a non-taxable service, while others view it as a product and therefore taxable. Be certain you understand the sales tax laws to avoid being held liable for uncollected money at tax time. Write to your state auditor for sales tax information.

Save money on postage

When you send out postcard samples or invitations to openings, you can save big bucks by mailing bulk. Fine artists should send submissions via first class mail for quicker service and better handling. Package flat work between heavy cardboard or foam core, or roll it in a cardboard tube. Include your business card or a label with your name and address on the outside of the packaging material in case the outer wrapper becomes separated from the inner packing in transit.

Protect larger works—particularly those that are matted or framed—with a strong outer surface, such as laminated cardboard, masonite or light plywood. Wrap the work in polyfoam, heavy cloth or bubble wrap and cushion it against the outer container with spacers to keep from moving. Whenever possible, ship work before it is glassed. If the glass breaks en route, it may destroy your original image. If you are shipping large framed work, contact a museum in your area for more suggestions on packaging.

Helpful resources

For More Info

Most IRS offices have walk-in centers open year-round and offer over 90 free IRS publications to help taxpayers. Some helpful booklets include Publication 334—Tax Guide for Small Business; Publication 505—Tax Withholding and Estimated Tax; and Publication 533—Self Employment Tax. Order by phone at (800)829-3676.

There's plenty of great advice on the Internet, too. Check out the official IRS website: www.irs.gov. Fun graphics lead you to information, and you can even download tax forms.

If you don't have access to the Web, the booklet that comes with your tax return forms contains addresses of regional Forms Distribution Centers you can write to for information.

The U.S. Small Business Administration offers seminars and publications to help you launch your business. Check out their extensive website at www.sba.gov.

Arts organizations hold many workshops covering business management, often including detailed tax information. Inquire at your local arts council, arts organization or university to see if a workshop is scheduled.

The Service Corp of Retired Executives (SCORE) offers free business counseling via e-mail at their website at www.score.org.

The U.S. Postal Service will not automatically insure your work, but you can purchase up to $600 worth of coverage. Artworks exceeding this value should be sent by registered mail. Certified packages travel a little slower but are easier to track.

Consider special services offered by the post office, such as Priority Mail, Express Mail Next Day Service and Special Delivery. For overnight delivery, check to see which air freight services are available in your area. Federal Express automatically insures packages for $100 and will ship art valued up to $500. Their 24-hour computer tracking system enables you to locate your package at any time.

UPS automatically insures work for $100, but you can purchase additional insurance for work valued as high as $25,000 for items shipped by air (there is no limit for items sent on the ground). UPS cannot guarantee arrival dates but will track lost packages. It also offers Two-Day Blue Label Air Service within the U.S. and Next Day Service in specific zip code zones.

Before sending any original work, make sure you have a copy (photocopy, slide or transparency) in your files. Always make a quick address check by phone before putting your package in the mail.

Send us your business tips!

If you've discovered a business strategy we've missed, please write to *Artist's & Graphic Designer's Market*, 4700 East Galbraith Road, Cincinnati OH 45236 or e-mail us at artdesign@f wpubs.com. A free copy of the 2006 edition goes to the best five suggestions.

The Art of Business

Know Your Rights

Taking the Mystery Out of Copyright

Are you confused about copyright? Most artists are, but the idea is really based on one simple premise: As creator of your artwork, you have certain inherent rights over your work and can control how each one of your artworks is used, until you sell your rights to someone else.

The legal term for these rights is called **copyright**. Technically, any original artwork you produce is automatically copyrighted as soon as you put it in tangible form.

To be automatically copyrighted, your artwork must fall within these guidelines:

- **It must be your *original* creation.** It cannot be a *copy* of somebody else's work.
- **It must be "pictorial, graphic, or sculptural."** Utilitarian objects, such as lamps or toasters, are not covered, although you can copyright an illustration featured on a lamp or toaster.
- **It must be fixed in "any tangible medium, now known or later developed."** Your work, or at least a representation of a planned work, must be created in or on a medium you can see or touch, such as paper, canvas, clay, a sketch pad or even a website. It can't just be an idea in your head. An idea cannot be copyrighted.

Copyright lasts for your lifetime plus seventy years

Copyright is *exclusive*. When you create a work, the rights automatically belong to you and nobody else but you until you sell those rights to someone else.

In October 1998, Congress passed the Sonny Bono Copyright Term Extension Act, which extended the term of U.S. copyright protection. Works of art created on or after January 1978 are protected for your lifetime plus 70 years.

The artist's bundle of rights

One of the most important things you need to know about copyright is that it is not just a *singular* right. It is a *bundle* of rights you enjoy as creator of your artwork. Let's take a look at the five major categories in your bundle of rights and examine them individually:

- **Reproduction right.** You have the right to make copies of the original work.
- **Modification right.** You have the right to create derivative works based on the original work.
- **Distribution rights.** You have the right to sell, rent or lease copies of your work.
- **Public performance right.** The right to play, recite or otherwise perform a work. (This right is more applicable to written or musical art forms than visual art.)
- **Public display right.** You have the right to display your work in a public place.

This bundle of rights can be divided up in a number of ways, so that you can sell all or part of any of those exclusive rights to one or more parties. The system of selling parts of your copyright bundle is sometimes referred to as **"divisible" copyright**. Just as a land owner could divide up his property and sell it to many different people, the artist can divide up his rights to an artwork and sell portions of those rights to different buyers.

Divisible copyright: Divide and conquer

Why is this so important? Because dividing up your bundle and selling parts of it to different buyers will help you get the most payment from each of your artworks. For any one of your artworks, you can sell your entire bundle of rights at one time (not advisable!) or divide and sell each bundle pertaining to that work into smaller portions and make more money as a result. You can grant one party the right to use your work on a greeting card and sell another party the right to print that same work on T-shirts.

Clients tend to use legal jargon to specify the rights they want to buy. The terms below are commonly used in contracts to specify portions of your bundle of rights. Some terms are vague or general, such as "all rights"; others are more specific, such as "first North American rights." Make sure you know what each term means.

Divisible copyright terms

- **One-time rights.** Your client buys the right to use or publish your artwork or illustration on a one-time basis. One fee is paid for one use. Most magazine and bookcover assignments fall under this category.
- **First rights.** This is almost the same as purchase of one-time rights, except that the buyer is also paying for the privilege of being the first to use your image. He may use it only once unless the other rights are negotiated.

 Sometimes first rights can be further broken down geographically when a contract is drawn up. The buyer might ask to buy **first North American rights,** meaning he would have the right to be the first to publish the work in North America.
- **Exclusive rights.** This guarantees the buyer's exclusive right to use the artwork in his particular market or for a particular product. Exclusive rights are frequently negotiated by greeting card and gift companies. One company might purchase the exclusive right to use your work as a greeting card, leaving you free to sell the exclusive rights to produce the image on a mug to another company.
- **Promotion rights.** These rights allow a publisher to use an artwork for promotion of a publication in which the artwork appeared. For example, if *The New Yorker* bought promotional rights to your cartoon, they could also use it in a direct mail promotion.
- **Electronic rights.** These rights allow a buyer to place your work on electronic media such as websites. Often these rights are requested with print rights.
- **Work for hire.** Under the Copyright Act of 1976, section 101, a "work for hire" is defined as "(1) a work prepared by an employee within the scope of his or her employment; or (2) a work . . . specially ordered or commissioned for use as a contribution to a collective, as part of a motion picture or audiovisual work or as a supplementary work . . . if the parties expressly agree in a written instrument signed by them that the work shall be considered a work made for hire." When the agreement is "work for hire," you surrender all rights to the image and can never resell that particular image again. If you agree to the terms, make sure the money you receive makes it well worth the arrangement.
- **All rights.** Again, be very aware that this phrase means you will relinquish your right to a specific artwork. Before agreeing to the terms, make sure this is an arrangement

you can live with. At the very least, arrange for the contract to expire after a specified date. Terms for all rights—including time period for usage and compensation—should be confirmed in a written agreement with the client.

Since legally your artwork is your property, when you create an illustration for a magazine you are, in effect, temporarily "leasing" your work to the client for publication. Chances are you'll never hear an art director ask to lease or license your illustration, and he may not even realize he is leasing, not buying, your work. But most art directors know that once the magazine is published, the art director has no further claims to your work and the rights revert back to you. If the art director wants to use your work a second or third time, he must ask permission and negotiate with you to determine any additional fees you want to charge. You are free to take that same artwork and sell it to another buyer.

However, had the art director bought "all rights," you could not legally offer that same image to another client. If you agreed to create the artwork as "work for hire," you relinquished your rights entirely.

What licensing agents know

The practice of leasing parts or groups of an artist's bundle of rights is often referred to as **"licensing,"** because (legally) the artist is granting someone a "license" to use his work for a limited time for a specific reason. As licensing agents have come to realize, it is the exclusivity of the rights and the ability to divide and sell them that make them valuable. Knowing exactly what rights you own, which you can sell, and in what combinations will help you negotiate with your clients.

Don't sell conflicting rights to different clients

You also have to make sure the rights you sell to one client don't conflict with any of the rights sold to other clients. For example, you can't sell the exclusive right to use your image on greeting cards to two separate greeting card companies. You *can* sell the exclusive greeting card rights to one card company and the exclusive rights to use your artwork on mugs to a separate gift company. It's always good to get such agreements in writing and to let both companies know your work will appear on other products.

When to use the Copyright © and credit lines

A copyright notice consists of the word "Copyright" or its symbol ©, the year the work was created or first published and the full name of the copyright owner. It should be placed where it can easily be seen, on the front or back of an illustration or artwork. It's also common to print your copyright notice on slide mounts or onto labels on the back of photographs.

Under today's laws, placing the copyright symbol on your work isn't absolutely necessary to claim copyright infringement and take a plagiarist to court if he steals your work. If you browse through magazines, you will often see the illustrator's name in small print near the illustration, *without* the Copyright ©. This is common practice in the magazine industry. Even though the © is not printed, the illustrator still owns the copyright unless the magazine purchased all rights to the work. Just make sure the art director gives you a credit line near the illustration.

Usually you will not see the artist's name or credit line alongside advertisements for products. Advertising agencies often purchase all rights to the work for a specified time. They usually pay the artist generously for this privilege and spell out the terms clearly in the artist's contract.

How to register a copyright

To register your work with the U.S. Copyright Office, call the Copyright Form Hotline at (202) 707-9100 and ask for package 115 and circulars 40 and 40A. Cartoonists should ask for package 111 and circular 44. You can also write to the Copyright Office, Library of Congress, 101 Independence Ave. SE, Washington DC 20559, Attn: Information Publications, Section LM0455.

You can also download forms from the Copyright Office website at www.copyright.gov. Whether you call or write, they will send you a package containing Form VA (for visual artists). Registering your work costs $30.

After you fill out the form, return it to the Copyright Office with a check or money order for $30, a deposit copy or copies of the work and a cover letter explaining your request. For almost all artistic work, deposits consist of transparencies (35mm or $2\frac{1}{4} \times 2\frac{1}{4}$) or photographic prints (preferably $8\frac{1}{2} \times 10$). Send one copy for unpublished works; two copies for published works.

You can register an entire collection of your work rather than one work at a time. That way you will only have to pay one $30 fee for an unlimited number of works. For example if you have created a hundred works between 2003 and 2004, you can send a copyright form VA to register "the collected work of Jane Smith, 2003-2004." But you will have to send either slides or photocopies of each of those works.

Why register?

It seems like a lot of time and trouble to send in the paperwork to register copyrights for all your artworks. It may not be necessary or worth it to you to register every artwork you create. After all, a work is copyrighted the moment it's created anyway, right?

The benefits of registering are basically to give you additional clout in case an infringement occurs and you decide to take the offender to court. Without a copyright registration, it probably wouldn't be economically feasible to file suit, because you'd be only entitled to your damages and the infringer's profits, which might not equal the cost of litigating the case. Had the works been registered with the U.S. Copyright office, it would be easier to prove your case and get reimbursed for your court costs.

Likewise, the big advantage of using the copyright © also comes when and if you ever have to take an infringer to court. Since the copyright © is the most clear warning to potential plagiarizers, it is easier to collect damages if the © is in plain sight.

Register with the U.S. Copyright Office those works you fear are likely to be plagiarized before or shortly after they have been exhibited or published. That way, if anyone uses your work without permission, you can take action.

Deal swiftly with plagiarists

If you suspect your work has been plagiarized and you have not already registered it with the Copyright Office, register it immediately. You have to wait until it is registered before you can take legal action against the infringer.

Before taking the matter to court, however, your first course of action might be a well-phrased letter from your lawyer telling the offender to "cease and desist" using your work, because you have a registered copyright. Such a warning (especially if printed on your lawyer's letterhead) is often enough to get the offender to stop using your work.

Don't sell your rights too cheaply

Recently a controversy has been raging about whether or not artists should sell the rights to their work to stock illustration agencies. Many illustrators strongly believe selling rights to stock agencies hurts the illustration profession. They say artists who deal with stock agencies,

The Art of Business

Copyright resources

For More Info

The U.S. Copyright Website (www.copyright.gov), the official site of the U.S. Copyright Office, is very helpful and will answer just about any question you can think of. Information is also available by phone at (202)707-3000. Another great site, called The Copyright Website, is located at http://benedict.com.

A few great books on the subject are *Legal Guide for the Visual Artist*, by Tad Crawford (Allworth Press); *The Rights of Authors, Artists, and other Creative People*, by Kenneth P. Norwick and Jerry Simon Chasen (Southern Illinois University Press); *Electronic Highway Robbery: An Artist's Guide to Copyrights in the Digital Era*, by Mary E. Carter (Peachpit Press). *The Business of Being an Artist*, by Daniel Grant (Allworth Press), contains a section on obtaining copyright/trademark protection on the Internet.

especially those who sell royalty-free art, are giving up the rights to their work too cheaply.

Another pressing copyright concern is the issue of electronic rights. As technology makes it easier to download images, it is more important than ever for artists to protect their work against infringement.

Log on to www.theispot.com and discuss copyright issues with your fellow artists. Join organizations that crusade for artists' rights, such as the Graphic Artist's Guild (www.gag.org) or The American Institute of Graphic Arts (www.aiga.org). Volunteer Lawyers for the Arts (www.vlany.org) is a national network of lawyers who volunteer free legal services to artists who can't afford legal advice. A quick search of the Web will help you locate a branch in your state. Most branches offer workshops and consultations.

Promotional Mailings

A Great Way to Launch Your Career

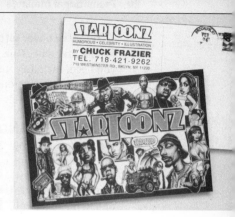

So you're ready to launch your freelance art or gallery career. How do you let people know about your talent? One way is by introducing yourself to them by sending promotional samples. Samples are your most important sales tool so put a lot of thought into what you send. Your ultimate success depends largely on the impression they make.

We divided this article into three sections, so whether you are a fine artist, illustrator or designer, check the appropriate heading for guidelines. Read individual listings and section introductions thoroughly for more specific instructions.

As you read the listings, you'll see the term SASE, short for self-addressed, stamped envelope. Enclose a SASE with your submissions if you want your material returned. If you send postcards or tearsheets, no return envelope is necessary. Many art directors only want nonreturnable samples. More and more, busy art directors do not have time to return samples, even with SASEs. So read listings carefully and save stamps!

ILLUSTRATORS AND CARTOONISTS

You will have several choices when submitting to magazines, book publishers and other illustration and cartoon markets. Many freelancers send a cover letter and one or two samples in initial mailings. Others prefer a simple postcard showing their illustrations. Here are a few of your options:

Postcard. Choose one (or more) of your illustrations or cartoons that is representative of your style, then have the image printed on postcards. Have your name, address and phone number printed on the front of the postcard or in the return address corner. Somewhere on the card should be printed the word "Illustrator" or "Cartoonist." If you use one or two colors, you can keep the cost below $200. Art directors like postcards because they are easy to file or tack on a bulletin board. If the art director likes what she sees, she can always call you for more samples.

Promotional sheet. If you want to show more of your work, you can opt for an 8½×11 color or black and white photocopy of your work. No matter what size sample you send, never fold the page. It is more professional to send them flat, in a 9×12 envelope, along with a typed query letter, preferably on your own professional stationery.

Tearsheets. After you complete assignments, acquire copies of any printed pages on which your illustrations appear. Tearsheets impress art directors because they are proof that you are experienced and have met deadlines on previous projects.

Photographs. Some illustrators have been successful sending photographs, but printed or photocopied samples are preferred by most art directors. It is probably not practical or effective to send slides.

Query or cover letter. A query letter is a nice way to introduce yourself to an art director for the first time. One or two paragraphs stating you are available for freelance work is all you need. Include your phone number, samples or tearsheets.

E-mail submissions. E-mail is another great way to introduce your work to potential clients. When sending e-mails, provide a link to your website or JPEGs of your best work.

DESIGNERS AND COMPUTER ARTISTS

Plan and create your submission package as if it were a paying assignment from a client. Your submission piece should show your skill as a designer. Include one or both of the following:

Cover letter. This is your opportunity to show you can design a beautiful, simple logo or letterhead for your own business card, stationery and envelopes. Have these all-important pieces printed on excellent quality bond paper. Then write a simple cover letter stating your experience and skills.

Sample. Your sample can be a copy of an assignment you have done for another client or a clever self-promotional piece. Design a great piece to show off your capabilities. For ideas and inspiration, browse through *Designers' Self-Promotion: How Designers and Design Companies Attract Attention to Themselves*, by Roger Walton (HBI).

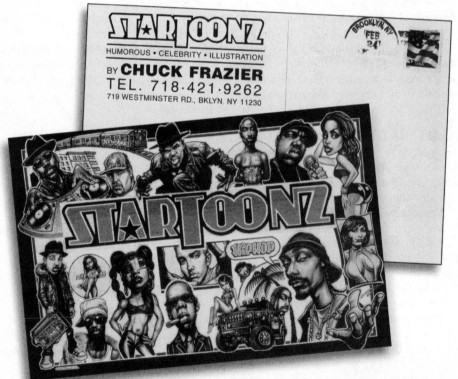

© Chuck Frazier

Caricatures have become more popular for magazine assignments. Chuck Frazier leverages this trend by sending samples of today's celebrities. In this sample, Frazier presents a constellation of rap and hip hop stars such as P.Diddy, Mya, Eminem, Jay-Z and Snoop Dogg. By adding his own "Startoonz" logo and appropriate details, Frazier stands out from the competition and wins assignments. Frazier prominently displays his name and contact information on the back of the postcard.

STAND OUT FROM THE CROWD

You may only have a few seconds to grab art directors' attention as they make their way through the "slush" pile (an industry term for unsolicited submissions). Make yourself stand out in simple, effective ways:

Tie in your cover letter with your sample. When sending an initial mailing to a potential client, include a cover letter of introduction with your sample. Type it on a great-looking letterhead of your own design. Make your sample tie in with your cover letter by repeating a design element from your sample onto your letterhead. List some of your past clients within your letter.

Send artful invoices. After you complete assignments, a well-designed invoice (with one of your illustrations or designs strategically placed on it, of course) will make you look professional and help art directors remember you—and hopefully, think of you for another assignment!

Follow up with seasonal promotions. Many illustrators regularly send out holiday-

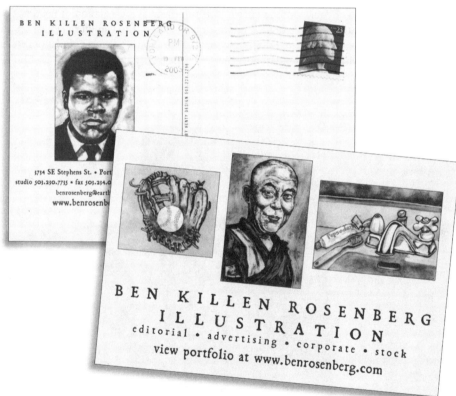

The Art of Business

Ben Killen Rosenberg's postcard sample shows three unrelated artworks. Why does this work as a sample? The baseball mitt and kitchen sink show everyday objects. The Dalai Lama stares out at the viewer with a mysterious glance. All are rendered in a simple, direct, realistic style, with a similar color palette. Any art director receiving this sample can tell at a glace that Rosenberg has a distinct, illustrative style that brings a quiet dignity and an almost Zen-like quality to ordinary objects. This style could be the perfect solution for an art director who is trying to portray a similar mood in an article. Rosenberg found one more opportunity to show his distinct style on the back of the card with a portrait of Muhammad Ali. Rosenberg also includes his name, address and website in a simple font that complements his illustrations. The layout of this card was designed by Molly Henty, who also helped Rosenberg with font choices.

themed promo cards. Holiday promotions build relationships while reminding past and potential clients of your services. It's a good idea to get out your calendar at the beginning of each year and plan some special promos for the year's holidays.

ARE PORTFOLIOS NECESSARY?

You do not need to send a portfolio when you first contact a market. But after buyers see your samples they may want to see more, so have a portfolio ready to show.

Many successful illustrators started their careers by making appointments to show their portfolios. But it is often enough for art directors to see your samples.

Some markets in this book have drop-off policies, accepting portfolios one or two days a week. You will not be present for the review and can pick up the work a few days later, after they've had a chance to look at it. Since things can get lost, include only duplicates that can be insured at a reasonable cost. Only show originals when you can be present for the review. Label your portfolio with your name, address and phone number.

PORTFOLIO POINTERS

The overall appearance of your portfolio affects your professional presentation. It need not be made of high-grade leather to leave a good impression. Neatness and careful organization are essential whether you are using a three-ring binder or a leather case. The most popular portfolios are simulated leather with puncture-proof sides that allow the inclusion of loose samples. Choose

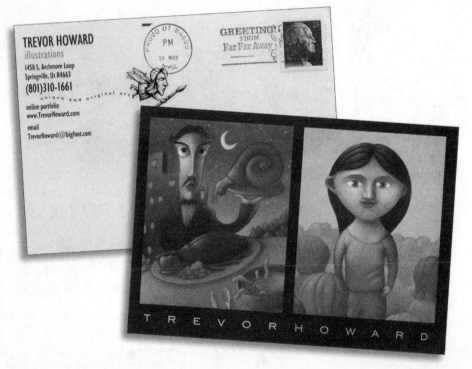

© Trevor Howard

This sample by Trevor Howard shows how effective it can be to show more than one illustration. The waiter carrying a tray of what looks like a sleepy escargot creates interest and shows art directors that Howard can tell a story with his art. Catch Howard's online portfolio at *www.TrevorHoward.com.*

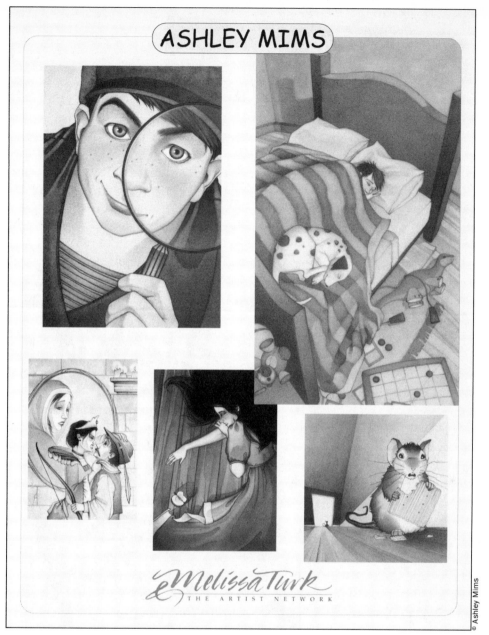

This promotional sheet for illustrator Ashley Mims is a perfect showcase for her award-winning style. The same layout was also used very effectively as a page in *Picturebook*, a sourcebook many art directors reference to find children's illustrators. Ashley Mims is represented by Melissa Turk and The Artist Network, and also maintains an online portfolio at www.ashley-mims.com where these and other illustrations can be viewed in glorious color. Check out *Picturebook* at www.picture-book.com for self-promotion ideas and strategies—and lots of great art.

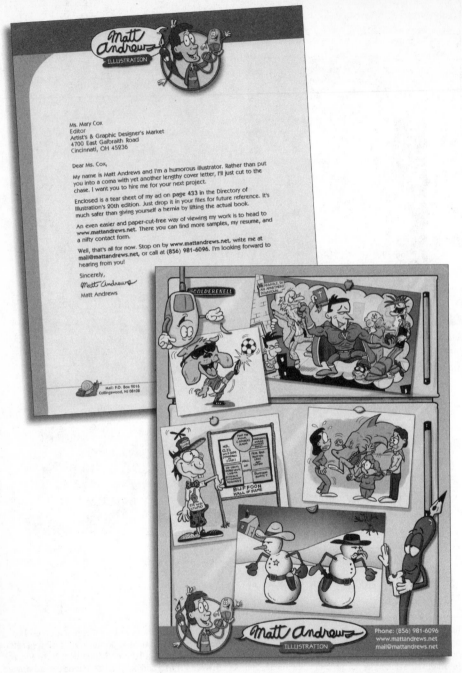

As an illustrator, you only have a few seconds to catch art directors' attention as they flip through their daily stack of mail. To break out of the crowd, you have to convey both your talent and your professionalism in one quick glance. Matt Andrews has taken the time to coordinate all his promotional material, from the letterhead he designed personally to his sample, labels and business card. This promo sheet is a tear sheet from the page Andrews took out in the *Directory of Illustration*. Having a "total look" for his illustration samples, which even offers a caricature of himself as logo, shows art directors that while his work is very creative and funny, Andrews is a professional who has his act together and will follow through on deadlines.

a size that can be handled easily. Avoid the large, "student" size books which are too big to fit easily on an art director's desk. Most artists choose 11×14 or 18×24. If you are a fine artist and your work is too large for a portfolio, bring your slides and a few small samples.

- **Don't include everything you've done in your portfolio.** Select only your best work and choose pieces germane to the company or gallery you are approaching. If you're showing your book to an ad agency, for example, don't include greeting card illustrations.
- **Show progressives.** In reviewing portfolios, art directors look for consistency of style and skill. They sometimes like to see work in different stages (roughs, comps and finished pieces) to see the progression of ideas and how you handle certain problems.
- **Allow your work to speak for itself when presenting your portfolio.** It's best to keep explanations to a minimum and be available for questions if asked. Prepare for the review by taking along notes on each piece. If the buyer asks a question, take the opportunity to talk a little bit about the piece in question. Mention the budget, time frame and any problems you faced and solved. If you are a fine artist, talk about how the piece fits into the evolution of a concept and how it relates to other pieces you've shown.
- **Leave a business card.** Don't ever walk out of a portfolio review without leaving the buyer a sample to remember you by. A few weeks after your review, follow up by sending a small promo postcard or other sample as a reminder.

GUIDELINES FOR FINE ARTISTS

Send a 9×12 envelope containing material galleries request in their listings. Usually that means a query letter, slides and résumé, but check each listing. Some galleries like to see more. Here's an overview of the various components you can include:

- **Slides.** Send 8-12 slides of similar work in a plastic slide sleeve (available at art supply stores). To protect slides from being damaged, insert slide sheets between two pieces of cardboard. Ideally, slides should be taken by a professional photographer, but if you must take your own slides, refer to *The Quick & Easy Guide to Photographing Your Artwork*, by Roger Saddington (North Light Books), or *Photographing Your Artwork*, by Russell Hart and Nan Star (Amherst Media). Label each slide with your name, the title of the work, media and dimensions of the work and an arrow indicating the top of the slide. Include a list of titles and suggested prices they can refer to as they review slides. Make sure the list is in the same order as the slides. Type your name, address and phone number at the top of the list. Don't send a variety of unrelated work. Send work that shows one style or direction.
- **Query letter or cover letter.** Type one or two paragraphs expressing your interest in showing at the gallery, and include a date and time when you will follow up.
- **Résumé or bio.** Your résumé should concentrate on your art-related experience. List any shows your work has been included in and the dates. A bio is a paragraph describing where you were born, your education, the work you do and where you have shown in the past.
- **Artist's statement.** Some galleries require a short statement about your work and the themes you are exploring. Your statement should show you have a sense of vision. It should also explain what you hope to convey in your work.
- **Portfolios.** Gallery directors sometimes ask to see your portfolio, but they can usually judge from your slides whether your work would be appropriate for their galleries. Never visit a gallery to show your portfolio without first setting up an appointment.
- **SASE.** If you need material back, don't forget to include a SASE.

The Art of Business

Berkeley Breathed

Beyond "Bloom County"

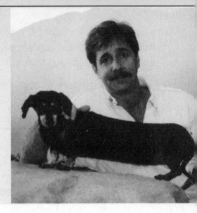

by Anne Bowling

During the 1980s, the characters of Milo, Binkley, Steve Dallas, Bill the Cat, Lola, and a winsome, flightless waterfowl named Opus were the darlings of newspaper comics. They inhabited the rolling hills of "Bloom County," which earned strip cartoonist Berkeley Breathed a Pulitzer Prize in 1987, and have since blossomed into a cottage industry for their creator.

Had he been asked, coming out of college, whether cartooning would pay the rent for the rest of his professional life, Breathed may have laughed. Until "Bloom County," he had inked only one strip, a college newspaper comic called "Academia Waltz" (mostly unprintable now, he says). A chance connection with a mailroom clerk got his work into the Washington Post Writers Group syndicate, and the rest was serendipitous history, culminating with publication of the 2004 title *Opus: 25 Years of His Sunday Best* (Little, Brown).

"If you want to see artistic evolution, fan those pages. It's almost embarrassing," Breathed says of the most recent release featuring his trademark penguin. "But then, my changes are pretty damned embarrassing as well."

For the few uninitiated, "Bloom County" joined the leftist voice of Garry Trudeau's "Doonesbury" in social commentary, pulling politicians and celebrities alike into the act. And in spite of the strip's leftist leanings, Breathed drew fans from across the political spectrum, including former president Ronald Reagan (who extended an invitation to dinner) and then-secretary of defense Caspar Weinberger, who was included in this whimsical poem Opus recited to Milo in the strip:

How I love to watch the morn with golden sun
That shines, up above to nicely warm those
Frosty toes of mine

The wind doth taste of bittersweet,
Like jasper wine and sugar.
I bet it's blown through others' feet,
Like those of

(he pauses to find a rhyme)

Caspar Weinberger.

ANNE BOWLING is the former editor of *Novel & Short Story Writer's Market* and a columnist on children's literature for *Pages* magazine.

Breathed discontinued "Bloom County" in 1989—while it was running in 1,300 papers—saying in an interview that cartoonists "die and go to hell for working beyond that magic intersection of art and fun." But he found his voice again with the Sunday-only strip "Outland," and in it brought back many "Bloom County" characters and developed some new (among them Milquetoast the cockroach) for some good, clean, libertarian fun.

After retiring "Outland" in 1995, Breathed seemed finished with comic strips, at one point referring to them as "the buggy whips of this millennium: quaint and eclipsed." During this hiatus, he holed up in his studio to refine his craft and concentrate on picture books, eventually having six published (see sidebar). It was during this period that the self-taught artist's work took on a more painterly quality, using light for a heightened dramatic effect. He stepped out of the world of "Bloom County" for four titles, one of which was the acclaimed 2003 title *Flawed Dogs*, a celebration of the "bent and plain" shelter dogs and an appeal to readers to adopt homeless animals.

The whimsy and occasional tenderness of Breathed's work belies the curmudgeon in him: He is bluntly critical of the changes cartooning has undergone in the last quarter-century,

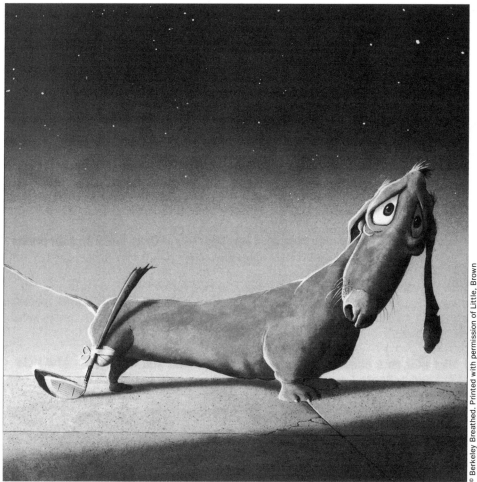

© Berkeley Breathed. Printed with permission of Little, Brown

One of the strange and wonderful characters in *Flawed Dogs*, a recent book by Berkeley Breathed, is Sam the Lion, a slightly flawed wiener dog with expressive eyes.

deriding bland humor, shrinking space, and strips penned by staffers. In a 2003 *Salon* interview, Breathed remarked sarcastically: "I'd hate to see readers force editors to eliminate the comic strips marketed by corporations, widows and distant relatives long after their deceased creators pass on. What would happen to all the hacks hired by Jim Davis to write and draw 'Garfield' if we were to put it out of business?" Critics have speculated that Breathed's Bill the Cat, a Ralph Steadman-esque, hairball-hacking character who closely resembles road kill, was created as the cartoonist's anti-Garfield.

But happily for his fans, the temptation to return to Opus and company proved too strong for Breathed to resist, and in 2003 he brought the strip back for a Sunday-only encore in 160 newspapers nationwide. In an industry where space is limited, strips are shrinking and some of the competition is actually no longer alive, Breathed's deal was a cartoonist's dream. Opus commanded half-page placement in each paper running the strip—a feat last achieved by Bill Watterson with "Calvin & Hobbes."

Here Breathed talks about the return of Opus, his route to publication and prospects for strip artists starting out.

How has reception been to the return of "Opus"?

Graciously warm but qualified. For those fans dogged in their efforts to look for "Bloom County" in whatever I'm drawing, it is a disappointment . . . and shall remain so. It's not 1985, we're all 20 years older and I'm drawing only four panels a month, not 30—a mere glimpse into my character's lives, not the daily narrative that a normal comic strip can maintain. You cannot, indeed, go home again on such a limited schedule. Or on any schedule, actually.

I draw now strictly because it is great fun to do so, now more than ever. Many are happy for the limited Opus. Others remain bored. Once a week is truly a flawed plan for a comic strip. But for me, it was a necessary compromise.

The character Opus has evolved quite a bit since his introduction. Will he continue to do so in this new strip?

He will as long as I do. The process hasn't stopped for me, thankfully. When it does, Opus will become Garfield.

Does having a Sunday-only strip give you time to continue work on your books?

. . . On anything. Seven days a week stripping without a staff is for the young and foolish.

How do you divide your time between the two forms?

If it were just books, it would be simple. A Sunday panel takes two days to execute. Developing movies for Hollywood takes . . . well, nothing ever actually gets made, so it's an infinite process. Complicating to a stripper and new father.

I read that as a child you didn't read comics, that you watched "*Wild Wild West* and collected snakes." So how did you come to comics?

By default. I was literally run out of the other positions in the University of Texas *Daily Texan* newspaper. Cartoons were the safest place to stick a congenital liar.

Were you a formally trained artist or self-taught? What are your thoughts on advantages/disadvantages to both?

I copied everyone to learn. A common technique. Taking art lessons in college might have helped if I had wanted to build sculpture from rubbish. My advice for a cartoonist: Skip the art classes. Study history. It's the historical context, stupid.

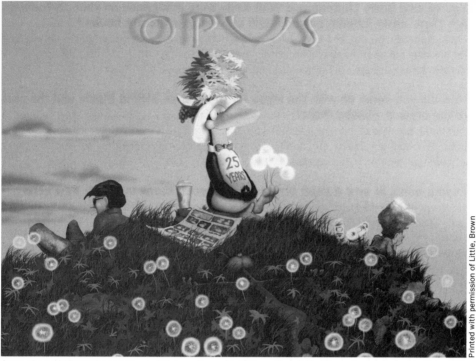

Opus, the maladjusted penguin—and the most popular "Bloom County" citizen—is celebrated in *Opus: 25 Years of His Sunday Best* (Little, Brown) 2004.

Were there a lot of experiments you went through, stylistically and in terms of approach, before you had "Bloom County" publication-ready?

I snorted some mocha through my nose at this question. Conscientiousness is quite simply out of my résumé. In a moral universe, there is no explanation for any success I might have enjoyed.

How did you go about eventually getting syndicated? How long did it take?

The son of a mailroom employee at the *Washington Post* gave his mother some of my college strips from Texas. They found their way to the syndicate. They offered me a contract. This is called "not paying dues" folks.

What would you call your period of greatest artistic development?

Raising my children. After that, learning a *little bit* about painting as I painted my picture books for the last 10 years. I surprised myself occasionally—which, for a person who forced himself to learn to draw to put funny pictures to his writing—is a singular joy: "Wow. That mailbox really looks like it's . . . metal. I can paint!"

Your picture books are fabulous, rich and atmospheric. And light always plays a big role in them. Did you take particular care to develop your technique of using light?

I stole from the best: Chris Van Allsburg and Frank Frazetta. Now there's a combination from hell.

You've said Garry Trudeau and Walt Kelly were influences on your *cartooning*. Are there other influences you could cite on your picture books?

Chris. Honestly, he was all I knew of children's books outside of Seuss, who was too sketchy for my taste but appropriately whimsical. On the other hand, Chris's writing I found way too obtuse. As usual, I split the difference and found my style.

How did you come up with the ideas for the stories behind Bipsie and the rest of the crew in *Flawed Dogs*?

Our home has a large sign outside that says "the J & B Dog Ranch." Dogs are simply on my brain as paintable subjects. Oh, don't ask me where the ideas come from. We carefully don't explore that too much in case we lose it by looking.

In your mind, is now a good time for an artist to break in with a new strip?

1955 would have been better. It's very . . . crowded out there. The good news is that it's wide open for another star. We're all gone, for the most part.

How would you recommend an unknown go about this?

Send their stuff to the *Washington Post* mailroom. I honestly have no idea. Sleep with someone, maybe? Persistence, as usual, helps enormously. Not that I ever had a single dollop of it.

You have said newspaper comics are in their twilight years—do you think the explosion of the graphic novel form is helping provide an outlet for those who like to tell stories illustrated in panels (and for those who like to read them)?

Absolutely. And that's where movies are coming from.

Any advice for those considering getting into the field today?

Get a teeny tiny pen and learn to print even teenier. And, yes, keep that frigging day job.

Books by Berkeley Breathed

CARTOON COLLECTIONS

- *Opus: 25 Years of His Sunday Best*, 2004
- *One Last Little Peek, 1980-1995: The Final Strips, The Special Hits, The Inside Tips*, 1995
- *His Kisses Are Dreamy . . . but Those Hairballs Down My Cleavage . . .!!!*, 1994
- *Politically, Fashionably and Aerodynamically Incorrect*, 1992
- *Classics of Western Literature: Bloom County 1986-1989*, 1990
- *Happy Trails*, 1990
- *Night of the Mary Kay Commandos*, 1989
- *Tales Too Ticklish to Tell*, 1988
- *Billy and the Boingers Bootleg*, 1987
- *Bloom County Babylon: Five Years of Basic Naughtiness*, 1986
- *Penguin Dreams and Stranger Things*, 1985
- *Toons for Our Times: A Bloom County Book of Heavy Metal Rump 'n Roll*, 1984

PICTURE BOOKS

- *Flawed Dogs, The Year End Leftovers at the Piddleton "Last Chance" Dog Pound*, 2003
- *The Last Basselope, One Ferocious Story*, 2001
- *Edward Fudwupper Fibbed Big*, 2000
- *Goodnight Opus*, 1996
- *A Wish For Wings That Work: An Opus Christmas Story*, 1995
- *Red Ranger Came Calling, A Guaranteed True Christmas Story*, 1994

All of Breathed's books published by Little, Brown. For more information on Berkeley Breathed and his work, visit www.berkeleybreathed.com.

Interviews

Bob Mankoff

The New Yorker's *Cartoon Editor* *Reveals the Naked Truth*

by Lauren Mosko

Each week, approximately 1,000 cartoons cross the desk of Bob Mankoff, the cartoon editor at *The New Yorker*. Of those, Mankoff selects about 40 to take to the art meeting with the magazine's editor, David Remnick. Together, the two whittle the stack down to the 20 or so that actually make it into the magazine. The hierarch of humor takes the selection process very seriously because he hasn't always launched his paper airplanes from the editorial side of the desk. In his book, *The Naked Cartoonist* (Black Dog & Leventhal, 2002), Mankoff recalls that he submitted 10 cartoons every week for two straight years before one finally found its way into *The New Yorker*'s hallowed pages. He has proclaimed that event the "greatest professional day of my life."

To those of you who placed a cartoon in *The New Yorker* this week: Congratulations! And for the creators of the other 980 rejected submissions—especially those dedicated cartoonists who try (like the young Mankoff) *week* after *week* after *week* and can't seem to figure out where you're going wrong—here's a little help and encouragement, straight from the editor himself.

In an interview with the National Cartoonists Society (NCS), you said that if someone calls to say they "have a great idea for a cartoon" it's a sign of an amateur and is "almost a kiss of death." Are there other submission missteps that are so vile they warrant an immediate trip to the garbage can?

If someone sends in a single cartoon for submission, it's clear they think this idea is so great that it simply *must* get in. When people ask me how many cartoons they should send, I say, "Do ten." They say, "Why ten?" You know, nine out of ten things don't work out.

Another sign of an amateur is when someone is absolutely sure, among the five they submit, that they know the one that's going to be picked—that they know somebody else's mind or what someone else is going to think is funny. Having an idea, even when you're a professional—and professionals have many, many ideas—is a distortion in itself. When you have the idea, you're very happy you had the idea just because right before that you *didn't* have the idea. So you have what I call "idea rapture," which distorts the way you think other people might feel about your idea. It's very hard to judge at that point because you're a biased viewer. So you should create a lot of cartoons and submit them. And they should generally be . . . you know . . . It makes sense if they're all on the same sized paper. (*laughs*)

LAUREN MOSKO is assistant editor of *Artist's & Graphic Designer's Market* and *Children's Writer's & Illustrator's Market*.

I can tell when someone's been at it awhile, and you should be at it awhile before you send cartoons to *The New Yorker*. You shouldn't get up in the morning and say, "I'd like to be a cartoonist. You know, I'd like to be a *New Yorker* cartoonist. I think I'll draw a few and send one to them." I can tell when submissions are coming from that sector.

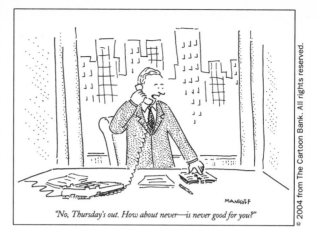

"No, Thursday's out. How about never—is never good for you?"

Similarly, are there any elements of a submitted cartoon itself that are automatic turn-offs?

Nothing is automatic, although generally if I see cartoons drawn in a great variety of styles, it's clear the artist doesn't have any particular style. Also some cartoons are clearly imitations of somebody *else*'s style. Like a cartoonist really likes Roz Chast; they like Roz Chast so much they think they *are* Roz Chast. That type of stuff.

And sometimes people who can't draw at all write little things on their cartoons clarifying what's actually in the drawing. Like "this is a toaster" or "this is *supposed* to be a toaster." I would say these are things that aren't going to work for us.

Is breaking into *The New Yorker* more of an "if at first you don't succeed . . ." process or a "you either have it or you don't" gift? Has an oft-rejected cartoonist ever surprised you by submitting a piece that's finally a good fit for the magazine?

I'd say it's really very rare for a cartoonist to break into *The New Yorker* on the first try. I don't know if that's ever occurred. But trying over and over again just by itself won't work either.

I'd say, to some extent, you either have it or you don't, but the "it" that you have takes time to develop. The "it" that you have takes work. I often see a cartoonist's work and I can see there's something there—but it's not there yet. It might take a year, it might take two or three years before that person has coalesced all the elements of their style and their humor so that it really works.

When you find a new cartoonist who you think has potential to be a regular contributor, how do you groom them for the job?

I try to give them feedback, which is different than it used to be, really. There used to be many more magazines to which people could submit cartoons . . . sort of like the minor leagues, where they could work it out for themselves.

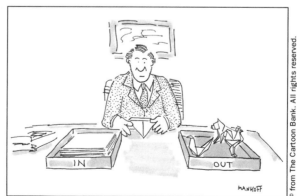

But I do try to give people a lot of feedback so they understand what we're really looking for in a *New Yorker* cartoon versus just a cartoon in general.

To be a *New Yorker* cartoonist—which is somewhat different even from having *a* cartoon published in *The New Yorker*—is something pretty difficult to achieve. I don't know exactly what it is from an individual person that I or *The New Yorker* or the editor, David Remnick, is looking for—that's part of the surprise, how somebody will develop. But cartoonists must have the dedication and the confidence to find something that seems original within themselves and to bring that out. And that usually takes a lot of work. So I will keep giving them feedback as their work comes in.

We have all the cartoon scrapbooks at *The New Yorker* office and digitally at The Cartoon Bank (www.cartoonbank.com) so I tell them to look at these different types of cartoons that have been done—from Peter Arno to Helen Hokinson to Roz Chast—and see the different ways people have looked at problems, either from a gag point of view, or a slice of life point

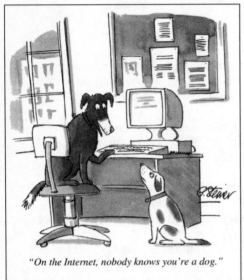

"On the Internet, nobody knows you're a dog."

"All right, have it your way—you heard a seal bark!"

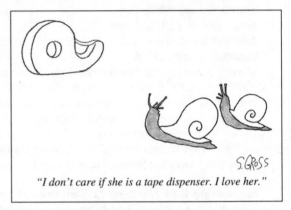

"I don't care if she is a tape dispenser. I love her."

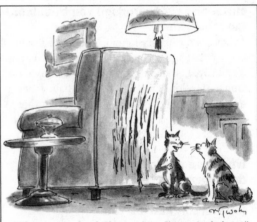

"I have a couple of other projects I'm excited about."

What makes a *New Yorker* cartoon? What do lovesick snails, internet-surfing dogs, multi-tasking cats and wayward seals have in common? It's hard to quantify. But in the hands of classic *New Yorker* cartoonists such as Sam Gross, Mike Twohy, James Thurber and Peter Steiner, these unlikely characters and situations communicate unique styles of thinking that hit the funny bone and the brain simultaneously.

of view, or a fantasy point of view. Get a little background in any style. Look at other cartoons—not to copy them but to realize what's been done.

I'll also talk to them about the drawings. Different people have different problems in drawing. Problems can come from incompetence and from *too much* competence. From the point of view of someone who's an illustrator, they're drawing too carefully, they're drawing too well, they're killing the joke. They're doing an illustration in which they're trying to show off too much. People are being distracted by all the stuff in the drawing rather than the drawing being transparent. And in terms of a person who can't draw or can draw somewhat, they haven't developed their particular doodle, their particular expression, in a Thurberesque way, which can get their idea across but still looks consistent, still has charm.

Most people can't draw anymore in the classical sense, and that can be okay. Just like most singers we listen to can't sing in the classical sense. But Bob Dylan is singing his songs and the voice seems appropriate to what he's doing. And it still is consistent. I like to say to the people who can't draw: There's bad-bad drawing and bad-*good* drawing. Now when you look at Thurber, you see bad-good drawing. You see something that's easy, and consistent, and confident. I don't have a formula, but in drawing that's simple, you want some sort of charm and personality to come through, almost like your signature work.

How long does this grooming process take?
It depends. For a guy like Matt Diffee, who is published quite often now, I think he started cartooning in 1998, but I don't think it was really until 2001 or 2002 that he hit his stride.

There was an article on the young cartoonists in *The New York Times* Style section a while ago. These are all people I'm trying to bring along. Some are struggling more than others and some are having more or less success. I don't really know where the road will end or if they'll be completely successful or not. It's a difficult thing.

How often do you take on a new cartoonist?
Every year there are new cartoonists in the magazine. It's not closed. It's definitely not closed. I want new cartoonists, but they still have to meet what we need.

You mean trying to get them to go from just placing a cartoon to actually being . . .?
Yes, to actually being someone you can depend on regularly who is confident in themselves and we have confidence in them.

In the NCS interview, you also said (cryptically), "We try to encourage people who have a particular point of view, a particular voice." So how would you define this "particular voice"? What's the point of view that *The New Yorker* is looking for? More simply: Just what makes a *New Yorker* cartoon?
It's many different voices. Our cartoonists genuinely want to do these cartoons. They're not doing it for us, they're doing it for themselves first. I want you to do what *you* like, and then we publish what *we* like, and we hope the reader likes it. But it's not a focus-group thing. It's not slanted for *The New Yorker*. But what you see in *The New Yorker*, whether it's Jack Ziegler or Roz Chast or Danny Shanahan or the greats of the past like Peter Arno or Charles Addams . . . When you see their cartoons, you know who it is. And not just by the style but by the style of *thinking*. It's hard to have a unique style of thinking. You can't make it up. You can have it within you, and it can be discovered by the process of cartooning.

One of the unique characteristics about many *New Yorker* cartoons is that they are using the medium of cartooning, the medium of humor, to communicate ideas. Not *funny* ideas, but ideas about things that are funny because they're communicated through this medium.

They're thinking through the medium of cartooning about a very wide range of things that interest them, with the dual purpose of both entertaining and communicating an idea.

Humor does not just exist within "cartoonland." Or within three or four different themes: men and women fight, bosses are overbearing, employees are incompetent . . . In many other publications, you'll see there's not very much range being discussed, but *The New Yorker* discusses a very wide range of topics without making our cartoons editorial cartoons. And that's one thing that distinguishes a *New Yorker* cartoon from most other cartoons that appear elsewhere. There's no hard-and-fast rule. We can have any joke really on any subject, whereas if a cartoon's in *Playboy*, it's a sex cartoon; if it's in *The Wall Street Journal*, it's a business cartoon.

There's a whole business at The Cartoon Bank of reprinting our cartoons—because other people find the thoughts they express valuable, whether it's in a Power Point presentation or in a textbook or in a print or in a notecard. They think the cartoon is funny, but usually they think that the idea it illustrates is being expressed perfectly. That's the common thread. You get to see the individuals—Charlie Barsotti, Peter Steiner, Bob Weber, Lee Lorenz. You see they work in a particular way, not just their style but their style of thinking through this medium, that is unique to each one of them.

How has the humor of "The New Yorker Cartoon"—as a body of work—changed from the time when James Geraghty and Lee Lorenz were the editors to now?

There has been an evolution. The *New Yorker* cartoon was invented in the '20s and '30s—in the Geraghty Era—when you had the classic gag cartoon with an unusual or incongruent picture. Like a plane going down and officials are watching it and the designer is looking at it and he's walking away and saying, "Oh well. Back to the drawing board." That's a Peter Arno cartoon. Those had sort of an ordinary caption that deflated the very incongruous picture. Or the gag was in the caption but there was an ordinary picture, like the William Hamilton cartoon where a father is saying to his young son, "New money is just old money that got away." The joke is verbal, but the picture is ordinary. Most of the cartoons during the Geraghty era were working out these classic gag formats or what you think of as a "joke." You see it, you put the caption together with the picture, there's a slight delay . . . AH! You get it.

As Thurber comes in, in the '30s and '40s, he sort of introduces a more literary, idiosyncratic and whimsical strain to the genre. Like the couple in bed saying . . . "Have it your way, you heard a seal bark!" It's strange, it's sort of funny, and it has the individual personality of James Thurber.

What you find in humor is sort of like the plates of the earth. Tectonic plates move and the continents move over time. (*laughs*) In the same way, humor sort of shifts. In the '30s and '40s, coming out of radio and Vaudeville, it was wackier stuff, with more props, set-ups, and things. With Lee Lorenz and the editor then, William Shawn, we got into more personal styles. They stopped using gag writers, and the artist did everything, which made cartooning very different—much more personal. You saw a much more personal style, which was very free in terms of the ideas it could entertain. During this era especially, more people were saying, "I don't get it" or "Some of the *New Yorker* cartoons I don't understand." That's because they were very personal or almost a type of conceptual art. Rather than trying to go for a joke, they were using cartoons as an artistic medium, not only in the drawing but also in the thinking. There's no gag there and yet it's almost like looking at someone's sketchbook. I think that was interesting.

Then Tina Brown came in and as editor she said, "You know what, I don't want cartoons that people don't understand." So I think it swung back a little bit with Tina. Maybe now

also with David Remnick. Most of the cartoons in *The New Yorker* you understand, although every once in a while we like to throw one in that is just someone exploring his own mind, the twists and turns of his own sort of consciousness. I think that's where we are now.

I'm sort of a gag guy myself, but I like to think that when you open the magazine it's a little bit like you're in an exhibit of cartoons. You might see something that looks very strange but it's in *The New Yorker* so you pay attention to it. Just like you would in a museum. You say, "Oh, that's interesting." And you understand that not everything has to be ha-ha funny. You want a sort of pace when you look in the magazine—almost like a little symphony of humor. Some people create a little slice of life. Something a little wry. An observation of what really is. If you think that's a gag, you won't think it's funny, but if you appreciate it for what it is, you'll like it. We're not trying to fool around with

Roz Chast's distinct comic style is a *New Yorker* favorite.

your mind. We're not trying to frustrate you. We are trying to present something that you find interesting because *we respect your intelligence*. That's the overall ethos of the magazine.

We really believe in this. We believe in cartooning as a valid way of exploring the world. We believe in humor, and cartooning in general, as a valuable way of thinking about the world. As an *authentic* way—not the children's table.

Is *The New Yorker*'s audience changing?
Yes, the demographic of *The New Yorker* is getting younger. That's why I want new cartoonists. I want people in their 20s and 30s. As much as I want to tell people what's gone before and what's current and the eternal verities of cartooning, I want them to lead me to new forms of making cartoons. Maybe it's a mixture of images from the Internet and drawing and collage. There could be a million different things.

The audience will change and the people who do the cartoons will change.

Has working as cartoon editor for *The New Yorker* influenced your own work? The way you view your own work?
It just makes me much more selective. I'm going to spend time on the cartoons that I think actually have ideas I want to communicate about the world. I'm not going to try to say, "Hmmm. Can I do another desert island cartoon?" Often when you're a freelancer you've sort of got to keep working. But I have a day job and a night job. I'm kept busy.

How has your own style influenced the *New Yorker* cartoon? What do you consider to be your "legacy"?
I want to continue. There's nothing wrong at all with what Lee Lorenz and my predecessors did. My legacy is that I want to keep it going for a whole new generation of people. Not only

by opening up *The New Yorker*, by telling people as much, by trying to inspire them and mentor them and groom them but also through the ancillary institution of The Cartoon Bank, where we provide income for them. I'm trying to save (*laughs*) magazine cartooning from extinction. I know the ambition is grandiose, but I'd rather put it out there. I don't really think I'm going to *save* it, but I think I can be an important part of *The New Yorker* as an institution and an even more important part of making sure this unique American form— that we are, frankly, the steward of now—survives.

Any last words?

The New Yorker is open. You can call, you can get an appointment, you can come and visit me. It's going to be very tough to get into the magazine but it's not going to be tough to get in to see me.

David Mack

Kabuki *Creator Still Evolving*

by Cindy Duesing

Fans of comic book artist David Mack might want to send a thank-you note to his orthodontist. After all, it was the braces on Mack's teeth that excluded him from military basic training at age 16, an option Mack considered in order to fund his way through college. Because of the rejection, the creator of cult classic *Kabuki*, who also writes and illustrates Marvel's *Daredevil*, was forced to try a different path. So he applied for an art scholarship with the help of his high school teacher. During the application process, he discovered what he was meant to do in life.

Mack's *Kabuki* series features a mysterious agent/operative.

"Growing up, I'd always had a passion, a compulsion for making things," explains Mack. "I'd build airplanes and people out of paper or whatever was handy, then draw in the details and make up a story to go with what I'd created.

"For the scholarship, I had to show examples of my work in different categories. I did some photography, charcoal, oil, watercolor and three-dimensional pieces. My teacher couldn't think of a final category, so I decided to make my own comic book—I wrote it, inked it, lettered it. Suddenly, I found a medium that allowed me to integrate everything I love, and I could do it in my own style. I couldn't wait to wake up every day and work on the next page. There was this great energy, this momentum. And the more I did, the more exciting it was."

Mack won the scholarship to Northern Kentucky University and never looked back. "I guess it was naïve of me, but I just decided to become a comic book writer and artist," he says. "I told people that's what I was, because I believed it."

But Mack didn't stop at lip service. He put his work out there for others in the industry to see.

CINDY DUESING is the former editor of WritersMarket.com. Her work has appeared in *Writer's Digest*, *Photographer's Market*, *Novel & Short Story Writer's Market* and *Poet's Market*.

"When I was still in high school, a college recruiter came to talk to my class," he remembers. "He mentioned that Mike Parobeck (an artist who drew classics like Batman, Superman and Wonder Woman) had attended this school. I had always admired Mike's work, so I contacted him through the recruiter. I started sending him my stuff, and he would critique it."

Indeed, throughout his college years, Mack was attending conventions and showing his work. His first job was for an independent comic book publisher who paid him $10 a page. Each page took 12 hours to complete. "I did seven issues for that publisher," he says, "so I had a lot of work invested. Often I was drawing in class, trying to meet my deadline."

When he was just 20, Mack first penned *Kabuki*, the story of a scarred young woman—haunted by her mother's death—who becomes an operative for a Japanese government agency. It was his senior Honors thesis. Though the book was unusual in style and substance, a publisher for whom he'd already done a bestseller agreed to publish it. It has been on bookstore shelves consistently since 1994 in periodical form, as well as in hardcover and paperback collections. Currently, there are close to 2 million copies in print in the U.S. alone. It's also licensed to foreign publishers and has been translated into seven languages.

Mack has been nominated for five Eisner awards (the "Oscar" of the industry) and is one of the only creators to be listed in both the Top Ten Writers List and the Top Ten Artists List in *Wizard* magazine. His work on Marvel's *Daredevil* was included in the 2003 Fox film of the same name, starring Ben Affleck and Jennifer Garner. He has also illustrated and designed jazz and rock album covers for American and Japanese labels, including work for Paul McCartney and Tori Amos.

Mack and fellow comic creator Brian Bendis recently formed a new imprint at Marvel, called ICON, specifically for their two creator-owned books, *Kabuki* and *Powers*. New *Kabuki* titles, including "The Alchemy" series, will now be published through Marvel, though Mack will still retain complete creative independence.

Though his talent is apparent, Mack attributes much of his success to his unwavering drive to get his work in front of the right people. "When I first started in this business, I met lots of artists who were more talented than I," says Mack. "But they didn't work at it all the time. They didn't

Kabuki has received international acclaim for its innovative painting techniques.

submit things and do the footwork. It's like they needed some kind of validation before they would follow through."

A common mistake newcomers make, says Mack, is to interpret the editor's rejection as the publisher's rejection. "Show your stuff to all the editors, particularly the ones who do your kind of projects. Editors come and go—keep submitting."

Alternately, Mack urges artists to develop a relationship with editors. "What you're proposing might not be right for a specific publisher, but that editor may move on to another company and call you. The more you show your work, you'll see this amazing ripple effect."

When writers and illustrators ask how to break into the business, Mack counters with his own questions, "What are your goals? Do you want to do your own project? If so, do that first—don't wait to be validated by a publisher. Companies ask you to do work based on

what you've already done. I had more freedom by having a finished product in hand than if I had just approached a publisher and said, 'I want to be a penciler.' "

Shortly after *Kabuki* came out, Mack found himself in the enviable position of dealing with Hollywood studios. "Studios always have people scouting for new properties," he says. "I got a lot of offers from companies wanting to buy the film rights for *Kabuki*, but you get a sense whether a company is just trying to buy up rights or whether they're really going to do something with it. It's also important to discern if they have the same vision for the movie as you do."

Mack eventually settled on a deal with Fox and is working on the film as writer, co-producer, consultant, and visual designer.

By anyone's standards, Mack has achieved outstanding success at an early age. But he maintains an unassuming lifestyle living and working in what was his mother's house in Bromley, Kentucky.

"Success has been a steady process for me," he says. "There's never been a point where I finally said, 'Wow, I'm earning "x" amount of dollars. I've finally made it.' The success is getting to wake up and do whatever I want. Every time I finish a page, it's a success. Every little step has felt like a success. I'm still evolving. If you do what you need to be doing, the details work themselves out. The universe fits the pieces around you."

Interviews

Graphic Novels

*Four Publishing Insiders Take
You Beyond Bam! and Pow!*

by Lauren Mosko

If you've been keeping tabs on the publishing industry, you already know comic books—and their format spin-off, graphic novels—are attracting more attention from publishers, librarians, booksellers and readers alike. With comics tie-ins (like Spider-Man, The Hulk, X-Men and Hellboy) and graphic-novel-based movies (like *Ghost World*, *From Hell* and *Road to Perdition*) enjoying much success at the box office, both comics aficionados and those who stare blankly when you mention Stan Lee or Will Eisner are rediscovering the art of illustration and its power as a medium for storytelling. It's prime time for graphic artists, but before you grab your pens, you need a basic understanding of the format and how this segment of the industry is different from the rest of the comics-publishing world.

Although many, even within the trade, use the terms interchangeably, there are a few key differences between a comic book and a graphic novel. First, graphic novels are book-sized volumes of material not previously published in traditional "comic book" periodical form. Also, comics periodicals are generally part of a lengthy, on-going series, so someone new to a title might have to read six or eight back issues just to understand the story. On the other hand, graphic novels are usually self-contained. Of course, there are always exceptions, such as Neil Gaiman's 10-part *Sandman* series (DC Comics), but even those installments are easily digestible on their own.

It's also important to understand that "graphic novel" is a format (i.e. telling a story using sequential art), *not* a genre, that encompasses works of nonfiction, as well. Joe Sacco's *The Fixer* (Drawn & Quarterly) addresses issues of western journalism while reporting from Bosnia; Chester Brown presents a comic-strip biography of the Canadian politician *Louis Riel* (Drawn & Quarterly); Pulitzer Prize winner Art Spiegelman's *MAUS* (Pantheon) is his father's Holocaust memoir.

So don't think that just because you've never drawn a superhero, warlock or robot that you've ruled out a career in comics. It doesn't matter whether your characters are historical or contemporary, romantic or gruesome, fantastic or realistic, comedic or mysterious; there's a place in the world of graphic novels for your work, as long as your art has a story to tell.

To help you get started and to give you some insight on breaking into the panels and navigating the gutters, we've assembled four industry insiders—**Jamie S. Rich**, freelance writer and former editor-in-chief of Oni Press; **Jeff Mason**, publisher of Alternative Comics

LAUREN MOSKO is assistant editor of *Artist's & Graphic Designer's Market* and *Children's Writer's & Illustrator's Market*.

Say what?

- **Graphic Novel:** Book-length story told using sequential art, usually self-contained and previously unpublished in pamphlet form.

- **Manga:** Literally meaning "entertaining visual"; licensed editions of Japanese (or Japanese-inspired) comics re-released in English or in split-language, often read right-to-left.

- **Pamphlet:** Saddle-stitched publications with paper covers; what you think of when you hear the term "comic book."

- **Trade Paperback:** A reprint collection of a comic series bound together as one volume.

- **Will Eisner:** Often credited with the invention of the graphic novel after publishing *A Contract with God* in 1978 (Titan Books).

and *Indy Magazine*; **Jennifer de Guzman**, editor-in-chief of SLG (Slave Labor Graphics) Publishing; and **Lee Dawson**, publicist for Dark Horse Comics, Inc.

What's the best way for someone with roughs for a graphic novel to approach a publisher?

Jamie Rich: However they can. The big conventions are often the best starting point, something face to face. Printed preview books and online displays are also good showcases.

Jeff Mason: First, find out whether or not that publisher has submission guidelines. Check that publisher's website. Read the guidelines, and follow them exactly. Don't submit your rough draft, your first draft, or your second draft.

Jennifer de Guzman: The best thing to do is to find out what each publisher prefers. Here at SLG Publishing, for example, we don't look at art or writing on its own—we only consider projects that have both an artist and a writer attached to it. Other publishers might not take unsolicited submissions or they might have specific procedures for making proposals. As with any other writing market, you should know the submission guidelines before you send something in or approach a publisher.

Lee Dawson: Well, it is tough to break in. Many comic companies don't accept writing submissions—not only because of the amount of time it takes to wade through them but also because of potential legal problems (e.g. someone sends in a writing submission, and then claims at a later date that the company stole their idea). I would suggest checking the company's website for submission information. At Dark Horse, that's where we keep ours. Ideally, the best bet for both writers and illustrators is to try to self-publish and get noticed that way. We have discovered numerous writers and artists through their self-published work.

What's the biggest mistake you see new or potential writer/illustrators making?

Rich: They spend too much time worrying about what a publisher may want or too much time trying to recapture comics from their youth. We need more passion in our potential creators; we need people who have a burning desire to tell stories. You don't see novelists rehashing characters that are over a half-century old because it gives them the tingly feeling

of being a little kid. We need less people who think to themselves, "Gee, wouldn't it be cool to be in comics," and more that have an inner flame that says, "I must relate this story to the world."

Mason: The biggest mistake I see is writers and illustrators not attempting to familiarize themselves with my company, my policies, and my attitudes before attempting to submit work to me. It is essential that you know who you are trying to interact with!

de Guzman: Not knowing the submission guidelines is a big mistake. Submitting projects that don't fit the publisher is another. Writers often make the mistake of e-mailing me ideas and asking if we'd be interested in a project like they describe, but we can't tell just based on an idea. The *execution* of the idea is more important.

Dawson: Lack of originality is probably the number one writing taboo. Illustrators need to be sure they can draw hands and faces conveying emotion, as opposed to just a static battle scene. Most importantly, writers need to be able to tell a story in sequence.

© Jamie Rich

"We need more passion in our potential creators; we need people who have a burning desire to tell stories."

—Jamie Rich

Would you encourage people who are interested in the format to attend comic conventions? If so, what can they hope to take away from the experience?

Rich: Yeah, I would encourage them to. I think they need to network with artists and editors and generally get known, schmooze their way into maybe getting people to look at their work.

As far as what to expect, expect to hear some good pointers. That's honestly it. You should check any belief that you will get a job then and there at the door, particularly if you're looking at freelance work for a big company. I'm not saying it won't happen, as I have begun the steps to work with people based on a convention portfolio review. It's just that if you enter into the review anticipating the editor saying, "You're hired," you will probably be disappointed and maybe miss the forest for the trees when it comes to actually hearing their feedback. And you do need to listen. Whatever the reviewer tells you as far as the next steps to take in keeping in touch with them, you need to do. I got pretty sick of telling guys to send me a package and never hearing from them again. Having no follow-through makes you your own worst enemy.

Mason: I would say that this is almost essential. Go to comic book conventions to meet people, to learn about the career you are hoping to pursue, and learn to be more at ease with yourself and the notion of being a professional.

de Guzman: People who want to get into the business could learn a good deal from attending comic conventions. Comic-Con International in San Diego is *the* convention to attend. It might be overwhelming to someone who is not familiar with the industry, however. The convention hall is always packed, and the sheer number of booths makes it impossible to know what to do without a game plan. Check the programs and see when publishers are holding submissions workshops; as far as I know, writers and artists must attend these workshops to even have their work considered by DC. Independent publishers often hold panels on what kind of books they're looking for and how to approach submissions, as well.

The other thing to do is to look at the books. Check out what is out there, what kind of books each publisher puts out, and become familiar with the market.

Dawson: Yes definitely! Comic conventions are the best way to network with other creators and a chance to talk with publishers. A lot can be gleaned from a conversation with the right folks.

What should an illustrator bring to a convention?

Rich: Well, the first thing I'd say is don't bring anything you might be embarrassed by, where you have to explain why the quality is lower than the rest of your work. I've seen plenty of portfolios padded out with older material that isn't up to par, and the person usually admits it's just to have more in his or her book. My advice is to bring the best material you've worked on that year. If you're a repeat customer, bring the previous year's best, too, and mark it off as such. Then, if you talk to the same editor, you can say, "This is what you saw before, and I thought you might like to see my progress."

Having a complete comic roughed out is a pretty good sign to an indie publisher that you're ready to go. The gamble a publisher takes is that you have the ability to finish something, so showing that it's possible never hurts. Just be prepared to be malleable. If you feel the work is set in stone, you might lose out on putting valuable advice to use.

de Guzman: Illustrators should tailor what they bring to whom they're showing their work. At conventions, we will give portfolio reviews to anyone who asks for one, but if they're looking to possibly work with us, they should know that traditional superhero drawings aren't going to get our attention. If an artist shows us quality work that is in line with the kind of thing we publish, we might ask him or her to send us a proposal.

Artists should have character drawings, a few sequential pages and cover designs in their portfolio. And if there's something they don't feel is their best work, they should not include it in their portfolio and then say, "This isn't my best work" when the portfolio reviewer looks at it. Leave out what you don't think is your best work!

Show publishers your very best, and also be prepared for honest assessments of your work. You're asking people to do their job when you ask them for a review, and their job is to tell you what they think you're doing well and what they think you could improve. If they do their job well, they're going to be point out weaknesses in your work that you might not have been aware of. Comments like that can be tough to hear, but if you take them in the right spirit, you can learn a lot.

Dawson: Artists can check out our "Portfolio Prep 101" tutorial on the Dark Horse website. (www.darkhorse.com/company/submissions.php#prep)

In your experience, does the industry regard creative-team jobs (i.e. when the writing and illustrating are not done by the same person) with any less respect? And what advice would you give a writer or illustrator who's looking for a partner for a graphic-novel project?

Rich: I think there is a certain snobbery that exists amongst members of the indie community. I personally think it's bunk. It's like saying an actor has to also write and direct. This is classically a collaborative medium, and so there is no shame in being realistic and choosing to write the books, but realizing you can't draw and vice versa.

I would tell any writer looking for an artist to be very selective, though. Your artist is going to be the first thing a potential publisher sees about your package. That's your first foot forward, and if the artist is terrible, you may never recover. Ask yourself if you'd pay money to buy a book this guy drew. Ask yourself, "Is he as good as half the people working in comics today?" If the answer isn't, "No, he's better," move on. Same goes for artists

Interviews

Conventions

- Comic-Con International, WonderCon, and Alternative Press Expo (APE) (www.comic-con.org).
- MoCCA (Museum of Comic and Cartoon Art) Art Festival (www.moccany.org).
- BookExpo America (BEA) (www.bookexpoamerica.com).

looking for writers, though I think it's much easier for an artist to show off, since you can look good without having the words read.

Mason: No, the industry does not give less respect to writers and illustrators than to individuals who both write and illustrate. In addition, creative teams can create comics quicker than a single cartoonist. My best advice would be for individuals to attend comic book conventions, talk to people, and use the Internet to try to connect with a creative partner.

de Guzman: Creative teams are the standard in the big two—Marvel and DC—so there's nothing disrespectable about them in the industry. They're less common in independent publishing, but in my experience, they're not looked down upon. Writers or illustrators who are looking for partners should try to get involved in online comics communities. There are often illustrators looking for writers and writers looking for illustrators there. Comic book writers and illustrators are very active in the online world. The comic book industry still is very insular, and anyone interested in becoming part of it probably would do well to make some contacts and get his or her name out there.

Dawson: Creative teams are held in the same regard as the single writer/artist. The bulk of the industry is made up of creative teams, and some of the most esteemed and popular titles in the medium's history were co-created. It sounds obvious, but I would suggest the writer look for an illustrator who will truly compliment the tone of the work—even more than choosing the "best" artist. If the illustrator is able to capture the emotion of the writing, it will really enhance the story beyond simply being technically proficient.

What is your opinion on graphic novel contests? Do you find that they're being used as serious tools to find new talent, or are they more of a sales/publicity gimmick?

Rich: I honestly can't say. I know I am personally very cynical about such things, but I can't speak for the intentions of others.

Mason: I think that they are useful to both the publishers and the new talents. They are both serious tools to find new talent as well as a sales/publicity gimmick. The best of both worlds.

de Guzman: I haven't heard much buzz about graphic novel contests. I know that Dark Horse had a contest to get new comics published on their website, but I haven't heard anything about writing contests specifically.

Dawson: We are running a sort of graphic novel contest right now. It's actually a talent search but for finished projects. We are indeed using it to find talent, as opposed to getting more sales or publicity. These types of things are too much work to be used only as promotional tools!

Are graphic-novel anthologies more of a stepping stone for those seeking independent publication, or are they considered an end in themselves?

Rich: I am not sure exactly what purpose they serve. I think the short story in comics is a terribly misunderstood form. I think most people in comics don't get the short story and end up giving us not very much of a story at all. They often rely on a bad twist ending, or go nowhere, or just seem to exist, as you say, as an end unto themselves. I personally rarely read them, and honestly, have lost any taste for editing them. So, at risk of sounding like a an old grump—which I very much am—I will settle on them serving their own purpose for the most part, with the occasional gem shining through. Which, in the end, has me going from caustic to wishy-washy. Ha-ha!

Mason: Certainly both, with most anthologies leaning toward one end of the balance or the other, depending on the anthology.

de Guzman: It's certainly an accomplishment to be published in an anthology. Sometimes, as with the *Bizarro Comics* anthology that DC recently published, it's a sign that an artist or writer has "arrived" in the industry. However, it seems that the goal is usually to get a title all to oneself, whether it be writing a superhero comic for one of the big two or having one's own work published by an indie publisher.

© Black Olive

> "People who want to get into the business could learn a good deal from attending comic conventions."
> —Jennifer deGuzman

Dawson: I think they can be an end in themselves, as getting published in any format is a great goal. It really depends on the individual and if he or she wants to take the story beyond the anthology.

How has digital technology impacted graphic novel illustration? Submission?

Rich: It's impacted everything. You can now deliver all of your material digitally, and just about anyone can have the same production abilities as a big company for not too much money. Unfortunately, though, there is a lot of margin for error. I've seen a lot of poorly printed books that show there are people who don't understand the technology they are using. I'm not just talking small companies, either. I've seen books from Marvel and Image Comics that I could see where the settings were wrong or they ran the art through a bad process. In other words, don't think that just because you have a computer and a scanner you automatically have the whole thing sussed out.

It's made submissions really easy, though. With the most basic of HTML skills, any artist can throw up an online portfolio and send the link around or post it on message boards. It's a quick and effective way to get your work in front of a lot of people. I will say, though, it's one thing to send links to an editor and another to send huge files via e-mail. If you don't have permission to send attachments, don't. You will clog up the person's e-mail, almost assuring that they won't be very happy with you by the time your art gets through. Additionally, since they don't know you, how can they trust your attachments to be safe? I personally would delete any e-mail with attached art without even looking at it.

I am not on the bandwagon, though, that thinks online or digital comics are the way of the future. I still don't think there has been a very good interface between reader and screen created, and it's certainly bad for the eyes.

deGuzman: One of our new artists, Christopher, actually does all of the inking of his comic *The Ghouly Boys* digitally. Tyson Smith did the art for *Emily and the Intergalactic Lemonade Stand* entirely on the computer, too. Neither of the comics looks stiff or lifeless, though. Digital technology is such that artists can use it to create work that looks very natural and dynamic.

Most of the artists do their coloring digitally, which means that it's much easier on the production side. How something looks on screen is pretty much how it looks when it's printed. There are none of the potential changes in color and texture that you get when you photograph or scan art. Lettering is something that's usually done on the computer, too.

Most of the artists I work with still use the old analog tools—paper, pencils, pen, brush, ink. But whatever the artists use to draw, the principles of sequential art storytelling remain the same.

We still don't take electronic submissions. It may seem wasteful, but we want to see things on paper, since that's how they will eventually appear.

Dawson: One of our senior editors, Chris Warner, really feels that computer coloring has been the most important advent, opening up tremendous visual possibilities we couldn't have dreamed of 20 years ago. This has developed to the degree that more and more books are going straight from pencils to color, skipping the inking stage entirely. To that end, tight penciling has become an even more marketable skill.

As far as submissions, the ability to send samples electronically or to post them on personal websites has made it a lot easier, faster and less expensive for creators to showcase their work.

Similarly, do you think the industry is moving toward computer-generated illustration (vs. traditional pencil & ink)? Any particularly good and/or bad creative software out there?

Rich: I haven't really encountered much. I know a couple of artists who like to use their Wacom tablets to do roughs or a quick strip for a website. But outside of coloring, and the occasional attempt to beat deadlines by not actually inking, just scanning pencils, I haven't seen much influx of digital art at all.

de Guzman: I think on the drawing side, pencil and inking still rule the school. Coloring is mostly digital now—and I must say, I'm not very pleased with the coloring in comics these days. I call it "bling-bling" coloring. Colorists seem to make everything gleam just because they can.

Adobe Illustrator is probably the must-use product for artists who want to do their drawing on the computer. Adobe Photoshop is more for coloring. I'm not the most knowledgeable person out there about these things, though.

Dawson: The pencil is still a far more expressive and versatile tool for the nuts and bolts of illustration and storytelling, so I don't expect that to go away any time soon. However, as more artists become more comfortable working digitally and as the tools continue to improve, illustrators will move more and more into digital imaging. Still, talent will still be the most important asset, regardless of whether an artist uses paint or Painter.

What's the inside story on strictly Web-based graphic novels? Do you see all print titles eventually heading in that direction?

Rich: I don't know about heading in that direction. I think in general, right now, most people aren't as well trained to read on screen, and the interface still has issues. Perhaps a new generation will be more equipped for it, and we'll see more of it. I don't see Web comics as less viable, at all, though. Whatever gets your work out there is good. As long as you

aren't using the digital element for trickery to hide problems with the work (which you can also do in print), then I think it's fine.

Mason: I don't think many print titles are soon to head to the Internet. Once truly easy-to-use, cheap, beautiful handheld electronic books are ubiquitous, I don't think we'll see that much of a migration to the Web.

de Guzman: I know that Artbomb.net and Dark Horse have done some interesting things with online comics, and there are some interesting independently produced Web comics out there, but I don't see comics moving in that direction any time soon. For them to do so would mean that the comic book industry would have to move much farther away from the collector mentality. The collector attitude is—happily, in my opinion—on the wane, especially when it comes to independent comics, but there are still collectors out there, and online comics don't lend themselves well to being collected. But, more generally, I think there is still an aesthetic aversion to reading things that aren't on paper, as well as logistical problems with transforming the publishing industry in that way. Some people were sure the e-book would take the traditional book industry by storm, but that hasn't really happened. People have been reading books on paper for centuries, and it's going to take some time to alter people's preferences. It's a gradual process.

Dawson: Well, for a while there it was the talk of the industry that Web comics might take over, but it really hasn't turned out that way. There are some great online comics, but it seems that the people have spoken, and they still love the printed versions over Web-based stuff. I think this is true in the book world, as well. There's just no substitute for having that comic in your hand.

Read more about it

For More Info

For more information about drawing graphic novels, see our interview with David Mack, author of the *Kabuki* and *Daredevil* graphic novel series, on page 39. Also, check out these titles from IMPACT books: *Comics Crash Course*, by Vincent Giarrano; *Superhero Madness* and *Manga Madness*, by David Okum; and *Manga Secrets*, by Lea Hernandez, available in major bookstores or by calling (800)448-0915.

Interviews

Success Stories

It Could Happen to You

by Donya Dickerson

Everywhere you look, there is art. It might be on a greeting card you are buying for a close friend or in a magazine you are reading or on a poster advertising a local concert. Take a few minutes to observe the world around you, and you'll see that you are surrounded by masterpieces. Pretty wonderful, huh?

And behind each piece, there is a story. That's right. A *success* story. And that's what this article is all about: the accomplishments of all the artists who are responsible for creating the art that enlightens and enriches our everyday lives. Since you are reading this book, it's likely that you are one of these artists, too. Maybe you are just getting ready to submit your work for the first time, or maybe you are a seasoned artist looking for new markets. Either way, this book is full of opportunities.

The three artists in this article—Alejandra Vernon, Julie Stinchcomb and Wendy C. Thompson—have lots to share about attracting the attention of markets and launching careers as artists. Follow their advice as you approach the markets listed in this book. Before you know it, you'll be well on your way to a success story of your own.

Alejandra Vernon

When Alejandra Vernon started sending her work to markets she found in *Artist's & Graphic Designer's Market*, she targeted her submissions very carefully. "I picked out categories I thought might use my work and then checked out their needs," she explains, "so I wouldn't waste any time on companies that were looking for cartoons, for instance."

Alejandra Vernon

Her careful research paid off and she soon received a response from Cape Shore, Inc., who wanted her to design a Christmas card. According to Vernon, "It was a wonderful, challenging experience because the company was very specific in what it wanted. When the art director sent me a template with the theme required, I remember wondering, 'How will I ever illustrate two seagulls with Santa caps giving each other gifts in front of a lighthouse?' but the finished card was adorable." This card helped her build a relationship with Cape Shore, Inc., and

DONYA DICKERSON is an editor at McGraw-Hill Trade, specializing in business books. She previously worked as an editor for Writer's Digest Books and edited three editions of *Guide to Literary Agents*.

Vernon continues to do assignments for the company. (For samples of her work, visit www.avernon.com.)

Previously Vernon had only sold her art through galleries, so it was a switch to start working in the greeting card market. She knew some artists found it frustrating to do commissioned work based on someone else's vision, but she instead viewed it as "an enlargement of my viewpoint, as well as technique." She explains, "Many artists feel that 'commercializing' art is diminishing it, but I disagree. I must confess that the biggest thrill I've had is not seeing my work hanging in an upscale gallery, but seeing a coaster set I designed for Cape Shore at the local drug store."

To reach other markets, Vernon started doing quarterly postcard mailings with photos of her work, which she describes as "an intricate collage mixed media that has a folk art innocence to it." Through *Artist's & Graphic Designer's Market*, she has had her work published in several markets, including *The Other Side*, a magazine for new artists, and *Presbyterians Today*, which recently used one of her illustrations for the cover.

Vernon believes artists must have faith

Alejandra Vernon's intricate collages portray everyday moments in a magical way. This interior, entitled *Esau*, can be seen on www.avernon.com, along with many other colorful works. Vernon's website is a friendly place to visit, view art and enjoy frequent chatty updates about her upcoming projects and exhibitions.

in their work. "This has nothing to do with 'ego,'" she says. "In fact, it's best if you get your ego out of it and look at your work objectively and rationally. You'll get tons of rejections, some of them quite rude. If you're the sensitive type, you need to toughen up and not take every word personally."

Patience is another key personality trait of successful artists. She says, "The average time I've waited for a response from a market is a year, sometimes two. I remember the art director from *Utne Reader* telling me, 'I have this postcard you sent us, and I think you might be the one we need.' I had sent them that postcard two years earlier . . . another job gained through patience!"

Finally, Vernon advises artists to "always say yes to a challenging project, and don't let the pay influence you, as you never know where the job will lead. A small job I did for Augsberg Fortress Publishers, a little church bulletin cover, has five years later led to my first book cover with Crowley Publications for Penelope Duckworth's *Mary: The Imagination of Her Heart*. Who knows where the book cover will lead!"

Julie Stinchcomb

Julie Stinchcomb's best piece of advice for artists submitting their work to new markets is to "spend the money to put together a strong sample packet or brochure." Instead of sending out numerous samples, she recommends only including, "something simple that showcases your work quickly. Presentation is a huge part of getting a positive response. Art directors are very busy and receive tons of portfolios each year. They can tell within the first couple of samples whether your work is suitable for their needs. Make it brief but give them your best up front."

Interviews

Julie Stinchcomb

Stinchcomb, who operates Pinecombe Studios, knows a lot about the art industry through her past work as a hand-lettering artist, designer and art director for 21 years employed by Gibson Greetings, and through her work for advertising agencies designing logos, lettering and business stationery. It is through this experience that she found her niche in the Social Expressions industry, which includes greeting cards.

She also learned the importance of having a wide range of skills to reach as many paying markets as possible. "As a lettering artist alone, the market is tough," Stinchcomb explains. "What has helped me is the ability to design the art in addition to doing lettering. I am also proficient in software programs on my MacIntosh computer and have the capability of sending all of my artwork digitally, quickly and ready for pre-press."

When submitting her work to markets she found in *AGDM*, Stinchcomb's first step was to "go through the book with a highlighter to find the companies that matched my interests and strengths." Next, she created "mini-portfolios of my work along with a cover letter and followed the directions from each company as to how and whom to direct my samples."

According to Stinchcomb, "Some companies responded within a couple of weeks and some within a couple of months." Some loved her samples and gave her paying assignments. Others wrote back positive comments but "either did not need my services at the time or my design style and techniques did not quite match their product line. Regardless, hearing back from the companies was important." Some, however, never responded. "You may only receive work from 10% of the companies you send letters and samples to," she says. Because of this, Stinchcomb recommends sending out samples to as many markets as possible. Using this strategy, she's found work with a lot of excellent greeting card companies, including The Paper Magic Group, Current, Paramount Cards and Renaissance Greetings.

Even though some companies don't respond, Stinchcomb advises artists not to get frustrated. Instead, she says, "If you don't hear from a company within six months, follow up with a postcard. Unless they send a letter telling you that your style does not match their needs, don't hesitate to send another packet or contact

Julie Stinchcomb is a lettering artist/graphic designer who has had success sending out self-promotional samples to greeting card companies in *Artist's & Graphic Designer's Market*. Stinchomb chose a name for her business—Pinecombe Studios—which sets her apart and adds a professional note.

them again within the year. I've had instances where I called back to the right place at the right time and received an assignment on the spot." Through this perseverance, she has gotten many assignments and made many key contacts.

Interviews

Wendy C. Thompson

Wendy Thompson took careful notes before she started submitting her work to markets she found in *AGDM*. "I would thumb through and re-read the sections, getting familiar with what companies were looking for, making notes in the margins, highlighting websites and e-mail addresses. I focused on greeting cards, posters and prints, magazines and a few children's book publishers."

Wendy C. Thompson

Thompson also made sure she knew as much as possible about each market she submitted to by downloading guidelines from company websites. This research told her everything she needed to know, such as "Do they need a bio; what size image do they need; do they return originals; do they buy all rights? Are they looking for someone with specific design and computer training? Do they want humor or Florida seascapes? This criteria eliminated some of the choices. I only queried companies looking for what I had to offer." For companies who don't have websites, Thompson recommends sending "a letter with SASE requesting their guidelines."

After Thompson had her list of targeted markets, she sent out a mailing that included four photocopied images, a brief bio and a query letter. She received a phone call from one company, but nothing came of it. She also got some positive notes, which kept her from feeling discouraged.

Four months after her first mailing, she received a phone call from Brush Dance, which publishes books, greeting cards, catalogs and other gift products. According to Thompson, "They needed four pieces right away for a deadline, and the graphic designer remembered

When creating a new line of products featuring the poetry of Rumi, Brush Dance decided that Wendy Thompson's nature images were a perfect match for the poet's calm, meditative words.

my samples on file. I was able to get the digital images to them on time, and we signed a contract within a few weeks." Since that first assignment, Brush Dance has used almost every image Thompson has sent to them. Now they approach her for assignments, and she knows it's crucial to act professionally to maintain their strong working relationship. "When they have a request, such as holiday images, I comply right away."

Brush Dance recently chose Thompson to illustrate the work of popular poet Jelaluddin Rumi (translated by renowned poet, Coleman Barks). As their Rumi artist, Thompson has done illustrations for 12 cards, 2 calendars, magnets, pocket journals, a date book and bath and body products. Thompson describes her work as "nature oriented, with lots of detail and at times a touch of whimsy." Her colored pencil images of herons, lotus, Koi and dragonflies were the perfect match for the calm, meditative poetry of Rumi. (View her work at www.w thompsonart.com.)

Thompson's success has garnered her more than just exposure. "My contract with Brush Dance has also helped my self-confidence," she explains. "Because of Brush Dance and my work being out there for more to see, I have been able to sell more of my own work and show at local galleries, and I am also teaching colored pencil lessons." She's also learned a lot about the business of art, such as "licensing and contracts, and that I can still do other things with my artwork as long as I respect my contract with Brush Dance."

For artists trying to break into new markets, Thompson says, "Be persistent and patient, and it *will* pay off. The markets in *AGDM* offer you the opportunity to make contacts. However, if you don't do the footwork, no one will know what you have to offer. I have always dreaded the idea of 'selling myself,' but things did not start happening until I put myself out there."

Interviews

Greeting Cards, Gifts & Products

© Gary Patterson

The companies listed here contain some great potential clients for you. Although greeting card publishers make up the bulk of the listings, you'll also find hundreds of other opportunities. The businesses in this section need images for all kinds of other products: paper plates, napkins, banners, shopping bags, T-shirts, school supplies, personal checks, calendars—you name it. We've included manufacturers of everyday items, like mugs, as well as companies looking for fine art for limited edition collectibles.

THE BEST WAY TO ENTER THE MARKET

1. Read the listings carefully to learn exactly what products each company makes and the specific styles and subject matter they use.

2. Visit stores. Browse store shelves to see what's out there. Take a notebook and jot down the types of cards and products you see. If you want to illustrate greeting cards, familiarize yourself with the various categories of cards and note which images tend to appear again and again in each category.

3. Track down trends. Pay attention to the larger trends in society. Society's move toward diversity, openness and acceptance is reflected in the cards we buy. There has also been a return to patriotism. Fads such as reality TV, as well as popular celebrities, often show up in images on cards and gifts. Trends can also be spotted in movies, national magazines and on websites.

WHAT TO SUBMIT

- Do NOT send originals. Companies want to see photographs, photocopies, printed samples, computer printouts, slides or tearsheets.
- Before you make copies of your sample, render the original artwork in watercolor or gouache in the standard industry size, $4^{5}/_{8} \times 7^{1}/_{2}$ inches.
- Artwork should be upbeat, brightly colored and appropriate to one of the major categories or niches popular in the industry.
- When creating greeting card art, leave some space at the top or bottom of the artwork, because cards often feature lettering there. Check stores to see how much space to leave. It is not necessary to add lettering, because companies often prefer to use staff artists to create lettering.
- Have color photocopies or slides made of your completed artwork. (See listings for specific instructions.)
- Make sure each sample is labeled with your name, address and phone number.
- Send three to five appropriate samples of your work to the contact person named in the

Insider tips you can use

Tips

Linda King Davey spent 10 years at Paramount Cards as a creative planner, humor manager and creative director and served as creative vice president at Marian Heath for five years. Now she's working as a freelance illustrator, editor and art director. Here, she gives her observations on how to increase your salability in a changing market.

1. Due to increased belt tightening, greeting card companies have fewer in-house artists, or else they've eliminated them entirely. This is good news for freelancers. More companies are buying freelance versus internally generated art.

2. Art directors want to identify an artist with one specific look. The ability to do various styles of illustration was once thought to increase an artist's marketability, but having multiple styles in your portfolio is not as highly regarded these days and can possibly be a drawback.

3. In recent years, consumer acceptance of contemporary looks has grown. The demand for creative, unique and innovative techniques is great.

4. Art directors typically have difficulty finding designs for specific categories, such as Wedding Congratulations, First Communion, Graduation and so on. You may want to consider doing speculative designs in these areas.

5. Create designs that utilize popular greeting card finishes like foil, emboss, glitter and virko (raised, plastic coating). Art directors will appreciate having these processes considered as an integral part of the design.

6. When sending a portfolio, make it clear what you want returned and what the art director can keep on file. Always include samples or photocopies that can be kept on file with your name, phone and e-mail address on each piece.

—Cindy Duesing

listing. Include a brief (one to two paragraph) cover letter with your initial mailing.

- Enclose a self-addressed stamped envelope if you need your samples back.
- Within six months, follow up with another mailing to the same listings and additional companies you have researched.

Submitting to gift & product companies

Send samples similar to those you would send to greeting card companies, only don't be concerned with leaving room at the top of the artwork for a greeting. Some companies prefer you send postcard samples or color photocopies. Check the listings for specifics.

Greeting card basics

Important

- **Approximately 7 billion** greeting cards are purchased annually, generating more than $7.5 billion in retail sales.

- **Women** buy 85 to 90 percent of all cards.

- **The average person** receives eight birthday cards a year.

- **Seasonal cards** express greetings for more than 20 different holidays, including Christmas, Easter and Valentine's Day.

- **Everyday cards** express non-holiday sentiments. The "everyday" category includes get well cards, thank you cards, sympathy cards, and a growing number of person-to-person greetings. There are cards of encouragement that say "Hang in there!" and cards to congratulate couples on staying together, or even getting divorced! There are cards from "the gang at the office" and cards to beloved pets. Check the rows and rows of cards in store racks to note the many "everyday" occasions.

- **Birthday cards** are the most popular everyday cards, accounting for 60% of sales of everyday cards.

- **Categories** are further broken down into the following areas: **traditional, humorous** and "**alternative**" cards. "Alternative" cards feature quirky, sophisticated or offbeat humor.

- **The most popular card-sending holidays,** according to the Greeting Card Association, are (in order):

 1. Christmas
 2. Valentine's Day
 3. Mother's Day
 4. Easter
 5. Father's Day
 6. Thanksgiving
 7. Halloween
 8. St. Patrick's Day
 9. Jewish New Year
 10. Hannukkah
 11. Grandparent's Day
 12. Sweetest Day
 13. Passover
 14. Secretary's Day
 15. National Boss's Day
 16. April Fool's Day
 17. Nurses' Day

Payment and royalties

Most card and product companies pay set fees or royalty rates for design and illustration. Card companies almost always purchase full rights to work, but some are willing to negotiate for other arrangements, such as greeting card rights only. If the company has ancillary plans in mind for your work (calendars, stationery, party supplies or toys), they will probably want to buy all rights. In such cases, you may be able to bargain for higher payment. For more tips, see Know Your Rights: Taking The Mystery Out of Copyright on page 14.

Don't overlook the collectibles market

Limited edition collectibles—everything from Dale Earnhardt collector plates to *Wizard of Oz* ornaments—appeal to a wide audience and are a lucrative niche for artists. To do well in this field, you have to be flexible enough to take suggestions. Companies test market to find

out which images will sell the best, so they will guide you in the creative process. For a collectible plate, for example, your work must fit into a circular format or you'll be asked to extend the painting out to the edge of the plate.

Popular themes for collectibles include patriotic images, Native American, wildlife, animals (especially kittens and puppies), children, religious (including madonnas and angels), stuffed animals, dolls, TV nostalgia, gardening, culinary and sports images.

E-cards

If you are at all familiar with the Internet, you know that electronic greeting cards are everywhere. Many can be sent for free, but they drive people to websites so they are a big bonus for websites to offer visitors. The most popular e-cards are animated, and there is an increasing need for artists who can animate their own designs for the Web, using Flash animation. To look at the range in electronic greeting cards, visit a few sites, such as www.amazon.com; www.bluemountain.com; www.barnesandnoble.com, and do a few Web searches. Companies often post their design needs on their websites.

Helpful resources

For More Info

Greetings etc. (www.greetingsmagazine.com) is the official publication of the Greeting Card Association (www.greetingcard.org). Subscriptions are reasonably priced. To subscribe call (973)252-0100.

Party & Paper is a trade magazine focusing on the party niche. Visit their website at www.partypaper.com for industry news and subscription information.

The National Stationery Show, the "main event" of the greeting card industry, is held each May at New York City's Jacob K. Javits Center. Visit www.nationalstationeryshow.com to learn more about that important event. Other industry events are held across the country each year. For upcoming trade show dates, check *Greetings Etc.* or *Party & Paper.*

ACME GRAPHICS, INC.

201 Third Ave. SW, Box 1348, Cedar Rapids IA 52406. (319)364-0233. Fax: (319)363-6437. E-mail: jeffs@acmegr aphicsinc.com. **President:** Jeff Scherrman. Estab. 1913. Produces printed merchandise used by funeral directors, such as acknowledgments, register books and prayer cards. Art guidelines free for SASE.

- Acme Graphics manufactures a line of merchandise for funeral directors. Floral subjects, religious subjects and scenes are their most popular products.

Needs Approached by 30 freelancers/year. Considers pen & ink, watercolor and acrylic. "We will send a copy of our catalog to show type of work we do." Art guidelines available for SASE with first-class postage. Looking for religious, church window, floral and nature art. Also uses freelancers for calligraphy and lettering.

First Contact & Terms Designers should send query letter with résumé, photocopies, photographs, slides and transparencies. Illustrators send postcard sample or query letter with brochure, photocopies, photographs, slides and tearsheets. Accepts submissions on disk. Samples are not filed and are returned by SASE. Responds in 10 days. Call or write for appointment to show portfolio of roughs. Originals are returned. Requests work on spec before assigning a job. Pays by the project, $50 minimum or flat fee. Buys all rights.

Tips "Send samples or prints of work from other companies. No modern art. Some designs are too expensive to print. Learn all you can about printing production."

ALASKA MOMMA, INC.

303 Fifth Ave., New York NY 10016. (212)679-4404. Fax: (212)696-1340. E-mail: licensing@alaskamomma.com. **President, licensing:** Shirley Henschel. "We are a licensing company representing artists, illustrators, designers and established characters. We ourselves do not buy artwork. We act as a licensing agent for the artist. We license artwork and design concepts such as wildlife, florals, art deco and tropical to toy, clothing, giftware, textiles, stationery and housewares manufacturers and publishers."

Needs "We are looking for people whose work can be developed into dimensional products. An artist must have a distinctive and unique style that a manufacturer can't get from his own art department. We need art that can be applied to products such as posters, cards, puzzles, albums, bath accessories, figurines, calendars, etc. No cartoon art, no abstract art, no b&w art."

First Contact & Terms "Artists may submit work in any form as long as it is a fair representation of their style." Prefers to see several multiple color samples in a mailable size. No originals. "We are interested in artists whose work is suitable for a licensing program. We do not want to see b&w art drawings. What we need to see are transparencies or color photographs or color photocopies of finished art. We need to see a consistent style in a fairly extensive package of art. Otherwise, we don't really have a feeling for what the artist can do. The artist should think about products and determine if the submitted material is suitable for licensed products. Please send SASE so the samples can be returned. We work on royalties that run from 5-10% from our licensees. We require an advance against royalties from all customers. Earned royalties depend on whether the products sell."

Tips "Publishers of greeting cards and paper products have become interested in more traditional and conservative styles. There is less of a market for novelty and cartoon art. We need artists more than ever as we especially need fresh talent in a difficult market. Look at product! Know what companies are willing to license."

ALLPORT EDITIONS

2337 NW York, Portland OR 97210-2112. (503)223-7268. Fax: (503)223-9182. E-mail: info@allport.com. Website: www.allport.com. **Contact:** Creative Director. Estab. 1983. Produces greeting cards and stationery. Specializes in greeting cards: fine art, humor, contemporary illustration, florals, animals and collage.

Needs Approached by 100 freelancers/year. Works with 10 freelancers/year. Buys 60 freelance designs and illustrations/year. Art guidelines available on website. Uses freelancers mainly for art for cards. Also for final art. Prefers art scaleable to card size. Produces material for all holidays and seasons, birthdays and everyday. Submit seasonal material 1 year in advance.

First Contact & Terms Illustrators and artists send query letter with photocopies or photographs and SASE. Accepts submissions on disk compatible with PC-formatted TIFF or JPEG files with Illustrator, Photoshop or Quark document. Samples are filed or returned by SASE. Responds in 3 months. Portfolio review not required. Rights purchased vary according to project. Pays for illustration by the project. Finds freelancers through artists' submissions and stationery show in New York.

Tips "Submit enough samples for us to get a feel for your style/collection. Two is probably too few, forty is too many."

AMBERLEY GREETING CARD CO.

11510 Goldcoast Dr., Cincinnati OH 45249-1695. (513)489-2775. Fax: (513)489-2857. E-mail: dcronstein@amber leygreeting.com. Website: www.amberleygreeting.com. **Contact:** Dan Cronstein. Estab. 1966. Produces greeting

cards. "We are a multi-line company directed toward all ages. We publish conventional as well as humorous cards."

Needs Approached by 20 freelancers/year. Works with 10 freelancers/year. Buys 250 illustrations/year. Works on assignment only. Considers any media.

First Contact & Terms Send query letter with nonreturnable sample or color photocopies. Calligraphers send photocopies of lettering styles. Samples are filed. Responds only if interested. Pays illustration flat fee $75-125; pays calligraphy flat fee $20-30. Buys all rights.

Tips "Send appropriate materials. Go to a card store or supermarket and study the greeting cards. Look at what makes card art different than a lot of other illustration. Caption room, cliché scenes, "cute" animals, colors, etc. Research publishers and send appropriate art! I wish artists would not send a greeting card publisher art that looks unlike any card they've ever seen on display anywhere."

AMERICAN GREETINGS CORPORATION

One American Rd., Cleveland OH 44144. (216)252-7300. E-mail: jim.hicks@amgreetings.com. Website: www.amgreetings.com. **Director of Creative Recruitment:** James E. Hicks. Estab. 1906. Produces greeting cards, stationery, calendars, paper tableware products, giftwrap and ornaments—"a complete line of social expressions products."

Needs Prefers artists with experience in illustration, decorative design and calligraphy. Usually works from a list of 100 active freelancers. Guidelines available for SASE.

First Contact & Terms Send query letter with résumé. "Do not send samples." Pays $200 and up based on complexity of design. Does not offer royalties.

Tips "Get a BFA in Graphic Design with a strong emphasis on typography."

AMSCAN INC.

80 Grasslands Rd., Elmsford NY 10523. (914)345-2020. Fax: (914)345-8431. **Contact:** Connie Pozzuto. Estab. 1954. Designs and manufactures paper party goods. Extensive line includes paper tableware, invitations, giftwrap and bags, decorations. Complete range of party themes for all ages, all seasons and all holidays. Features a gift line which includes baby hard and soft goods, wedding giftware, and home decorative and tabletop products. Seasonal giftware also included.

Needs "Ever-expanding department with incredible appetite for fresh design and illustration. Subject matter varies from baby, juvenile, floral, type-driven and graphics. Designing is accomplished both in the traditional way by hand (i.e., painting) or on the computer using a variety of programs like FreeHand, Illustrator, Painter and Photoshop."

First Contact & Terms "Send samples or copies of artwork to show us range of illustration styles. If artwork is appropriate, we will pursue." Pays by the project $300-3,500 for illustration and design.

AR-EN PARTY PRINTERS, INC.

8225 N. Christiana Ave., Skokie IL 60076. (847)673-7390. Fax: (847)673-7379. E-mail: info@ar-en.net. Website: ar-en.net. **Owner:** Gary Morrison. Estab. 1978. Produces stationery and paper tableware products. Makes personalized party accessories for weddings and all other affairs and special events.

Needs Works with 2 freelancers/year. Buys 10 freelance designs and illustrations/year. Art guidelines not available. Works on assignment only. Uses freelancers mainly for new designs. Also for calligraphy. Looking for contemporary and stylish designs, especially b&w line art, no gray scale, to use for hot stamping dyes. Prefers small (2×2) format.

First Contact & Terms Send query letter with brochure, résumé and SASE. Samples are filed or returned by SASE if requested by artist. Responds in 2 weeks. Company will contact artist for portfolio review if interested. Rights purchased vary according to project. Pays by the hour, $60 minimum; by the project, $1,000 minimum.

Tips "My best new ideas always evolve from something I see that turns me on. Do you have an idea/style that you love? Market it. Someone out there needs it."

☑ ART LICENSING INTERNATIONAL

7350 So. Tamiami Trail #227, Sarasota FL 34231. (941)966-8912. Fax: (941)966-8914. E-mail: artlicensing@comcast.net. Website: www.artlicensinginc.com. **Contact:** Michael Woodward, president. Produces calendars, decorative housewares, gifts, greeting cards, jigsaw puzzles, party supplies, stationery and textiles.
- Please see listing in Artists' Reps section.

ARTFUL GREETINGS

P.O. Box 52428, Durham NC 27717. (919)598-7599. Fax: (919)598-8909. E-mail: myw@artfulgreetings.com. Website: www.artfulgreetings.com. **Vice President of Operations:** Marian Whittedalderman. Estab. 1990. Produces bookmarks, greeting cards, T-shirts and prints. Specializes in multicultural subject matter, all ages.

Needs Approached by 200 freelancers/year. Works with 10 freelancers/year. Buys 20 freelance designs and illustrations/year. No b&w art. Pastel chalk media does not reproduce as bright enough color for us. Uses freelancers mainly for cards. Considers bright color art, no photographs. Looking for art depicting people of all races. Prefers a multiple of 2 sizes: 5×7 and $5\frac{1}{2} \times 8$. Produces material for Christmas, Mother's Day, Father's Day, graduation, Kwanzaa, Valentine's Day, birthdays, everyday, sympathy, get well, romantic, thank you, woman-to-woman and multicultural. Submit seasonal material 1 year in advance.
First Contact & Terms Designers send photocopies, SASE, slides, transparencies (call first). Illustrators send photocopies (call first). Samples are filed. Artist should follow up with call or letter after initial query. Will contact for portfolio review of color slides and transparencies if interested. Negotiates rights purchased. Pays for illustration by the project $50-100. Finds freelancers through word of mouth, NY Stationery Show.
Tips "Don't sell your one, recognizable style to all the multicultural card companies."

ARTVISIONS

12117 SE 26th St., Bellevue WA 98005-4118. (425)746-2201. E-mail: art@artvisions.com. Website: www.artvisions.com. **Owner:** Neil Miller. Estab. 1993. Markets include publishers, publishers of limited edition prints, calendars, home decor, stationary, note cards and greeting cards, posters, and manufacturers of giftware, home furnishings, textiles, puzzles and games.
Handles Fine art licensing for listed markets. See extensive listing in Artists' Reps section.

N THE ASHTON-DRAKE GALLERIES

9200 N. Maryland Ave., Niles IL 60714. Website: www.collectiblestoday.com. Estab. 1985. Direct response marketer of collectible dolls, ornaments and figurines. Clients: consumers, mostly women of all age groups.
Needs Approached by 300 freelance artists/year. Works with 250 freelance doll artists, sculptors, costume designers and illustrators/year. Works on assignment only. Uses freelancers for illustration, wigmaking, porcelain decorating, shoemaking, costuming and prop making. Prior experience in giftware design and doll design a plus. Subject matter includes babies, toddlers, children, brides and fashion. Prefers "cute, realistic and natural human features."
First Contact & Terms Send or e-mail query letter with résumé and copies of samples to be kept on file. Prefers photographs, tearsheets or photostats as samples. Samples not filed are returned. Responds in 1 month. Compensation by project varies. Concept illustrations are done "on spec." Sculptors receive contract for length of series on royalty basis with guaranteed advances.
Tips "Please make sure we're appropriate for you. Visit our website before sending samples!"

BERGQUIST IMPORTS, INC.

1412 Hwy. 33 S., Cloquet MN 55720. (218)879-3343. Fax: (218)879-0010. E-mail: bbergqu106@aol.com. Website: www.bergquistimports.com. **President:** Barry Bergquist. Estab. 1948. Produces paper napkins, mugs and tile. Wholesaler of mugs, decorator tile, plates and dinnerware.
Needs Approached by 25 freelancers/year. Works with 5 freelancers/year. Buys 50 designs and illustrations/year. Prefers freelancers with experience in Scandinavian designs. Works on assignment only. Also uses freelancers for calligraphy. Produces material for Christmas, Valentine's Day and everyday. Submit seasonal material 6-8 months in advance.
First Contact & Terms Send query letter with brochure, tearsheets and photographs. Samples are not filed and are returned. Responds in 2 months. Request portfolio review in original query. Artist should follow up with a letter after initial query. Portfolio should include roughs, color tearsheets and photographs. Rights purchased vary according to project. Originals are returned at job's completion. Requests work on spec before assigning a job. Pays by the project, $50-300; average flat fee of $100 for illustration/design; or royalties of 5%. Finds artists through word of mouth, submissions/self-promotions and art fairs.

✓ BLOOMIN' FLOWER CARDS

4734 Pearl St., Boulder CO 80301. (800)894-9185. Fax: (303)545-5273. E-mail: don@bloomin.com. Website: http://bloomin.com. **President:** Don Martin. Estab. 1995. Produces greeting cards, stationery and gift tags—all embedded with seeds.
Needs Approached by 100 freelancers/year. Works with 5-8 freelancers/year. Buys 5-8 freelance designs and illustrations/year. Art guidelines available. Uses freelancers mainly for card images. Considers all media. Looking for florals, garden scenes, holiday florals, birds, and butterflies—bright colors, no photography. Produces material for Christmas, Easter, Mother's Day, Father's Day, Valentine's Day, Earth Day, birthdays, everyday, get well, romantic and thank you. Submit seasonal material 8 months in advance.
First Contact & Terms Designers send query letter with color photocopies and SASE or electronic files. Illustrators send postcard sample of work, color photocopies or e-mail. Samples are filed or returned with letter if not interested. Responds if interested. Portfolio review not required. Rights purchased vary according to project.

Pays royalties for design. Pays by the project or royalties for illustration. Finds freelancers through word of mouth, submissions, and local artists' guild.

Tips "All submissions MUST be relevant to flowers and gardening."

☑ BLUE MOUNTAIN ARTS

P.O. Box 1007, Boulder CO 80306. (303)417-6513. Fax: (303)447-0939. E-mail: jkauflin@sps.com. Website: www.sps.com. **Contact:** Jody Kauflin, art director. Estab. 1970. Produces books, bookmarks, calendars, greeting cards, mugs and prints. Specializes in handmade looking greeting cards, calendars and books with inspirational or whimsical messages accompanied by colorful hand-painted illustrations.

Needs Art guidelines free with SASE and first-class postage or on website. Uses freelancers mainly for hand-painted illustrations. Considers all media. Product categories include alternative cards, alternative/humor, conventional, cute, inspirational and teen. Submit seasonal material 10 months in advance. Art size should be 5 × 7 vertical format for greeting cards.

First Contact & Terms Send query letter with photocopies, photographs, SASE and tearsheets. Send no more than 5 illustrations initially. No phone calls, faxes or e-mails. Samples are filed or are returned by SASE. Responds in 1 month. Portfolio not required. Buys all rights. Pays freelancers flat rate; $150-250/illustration if chosen. Finds freelancers through artists' submissions and word of mouth.

Tips "We are an innovative company, always looking for fresh and unique art styles to accompany our sensitive or whimsical messages. We strive for a hand-made look. We love color! We don't want photography! We don't want slick computer art! Do in-store research to get a feel for the look and content of our products. We want illustrations for printed cards, NOT E-CARDS! We want to see illustrations that fit with our existing looks and we also want fresh, new and exciting styles. Remember that people buy cards for what they say. The illustration is a beautiful backdrop for the message."

☑ ☒ ☒ BLUE MOUNTAIN WALLCOVERINGS

(formerly Imperial Home Decor Group), 15 Akron Rd., Toronto ON M8W 1T3 Canada. (416)251-1678. Fax: (416)251-8968. Website: www.blmtn.com. **Contact:** Dan Scott. Produces wallpaper.

Needs Works with 20-50 freelancers/year. Prefers local designers/illustrators with experience in wallpaper. Art guidelines available. Product categories include conventional, country, juvenile and teen. 5% of freelance work demands knowledge of Photoshop.

- Blue Mountain Wallcoverings acquired Imperial Home Decor Group, Inc. (IHDG) in February 2004, creating one of the largest manufacturers and distributors of wallcoverings in the world.

First Contact & Terms Send brochure, photocopies and photographs. Samples are filed. Responds only if interested. Company will contact artist for portfolio review of color, finished art, original art, photographs, transparencies if interested. Buys rights for wallpaper and/or all rights. Pays freelancers by the project. Finds freelancers through agents, artists' submissions and word of mouth.

BLUE SKY PUBLISHING

6595 Odell Place, Suite C, Boulder CO 80301. (303)530-4654. E-mail: bspinfo@blueskypublishing.net. Website: www.blueskypublishing.net. **Contact:** Helen McRae. Estab. 1989. Produces greeting cards. "At Blue Sky Publishing, we are committed to producing contemporary fine art greeting cards that communicate reverence for nature and all creatures of the earth, that express the powerful life-affirming themes of love, nurturing and healing, and that share different cultural perspectives and traditions, while maintaining the integrity of our artists' work."

Needs Approached by 500 freelancers/year. Works with 3 freelancers/year. Licenses 80 fine art pieces/year. Works with freelancers from all over US. Prefers freelancers with experience in fine art media: oils, oil pastels, acrylics, calligraphy, vibrant watercolor and fine art photography. Art guidelines available for SASE. "We primarily license existing pieces of art or photography. We rarely commission work." Looking for colorful, contemporary images with strong emotional impact. Art guidelines for SASE with first-class postage. Produces cards for all occasions. Submit seasonal material 1 year in advance.

First Contact & Terms Send query letter with SASE, slides or transparencies. Samples are filed or returned if SASE is provided. Responds in 4 months if interested. Transparencies are returned at job's completion. Pays royalties of 3% with a $150 advance against royalties. Buys greeting-card rights for 5 years (standard contract; sometimes negotiated).

Tips "We're interested in seeing artwork with strong emotional impact. Holiday cards are what we produce in biggest volume. We are looking for joyful images, cards dealing with relationships, especially between men and women, with pets, with Mother Nature and folk art. Vibrant colors are important."

☑ THE BRADFORD EXCHANGE

9333 Milwaukee Ave., Niles IL 60714. (847)581-8217. Fax: (847)581-8220. E-mail: squigley@bradfordexchange. com. **Artist Relations:** Suzanne Quigley. Estab. 1973. Produces and markets collectible products, including collector plates, ornaments, music boxes, cottages and figurines.

Needs Approached by thousands of freelancers/year. "We're seeking talented freelance designers, illustrators and artists to work with our product development teams." Prefers artists with experience in rendering painterly, realistic, "finished" scenes; best mediums are oil and acrylic. Uses freelancers for all work including border designs, sculpture. Traditional representational style is best, depicting children, pets, wildlife, homes, religious subjects, fantasy art, animation, celebrities, florals or songbirds in idealized settings.

First Contact & Terms Designers send color references or samples of work you have done or a CD, along with a résumé and additional information. Please do not send original work or items that are one of a kind. Samples are filed in our Artist Resource file and are reviewed by product development team members as concepts are created that would be appropriate for your work. Art Director will contact artist only if interested. "We offer competitive compensation."

ⓝ BRILLIANT ENTERPRISES

117 W. Valerio St., Santa Barbara CA 93101. **Art Director:** Ashleigh Brilliant. Publishes postcards.

Needs Buys up to 300 designs/year. Freelancers may submit designs for word-and-picture postcards, illustrated with line drawings.

First Contact & Terms Submit $5\frac{1}{2} \times 3\frac{1}{2}$ horizontal b&w line drawings and SASE. Responds in 2 weeks. Buys all rights. "Since our approach is very offbeat, it is essential that freelancers first study our line. Ashleigh Brilliant's books include *I May Not Be Totally Perfect, But Parts of Me Are Excellent*; *Appreciate Me Now and Avoid the Rush*; and *I Want to Reach Your Mind, Where Is It Currently Located?* "We supply a catalog and sample set of cards for $2 plus SASE." Pays $60 minimum, depending on "the going rate" for camera-ready word-and-picture design.

Tips "Since our product is highly unusual, familiarize yourself with it by sending for our catalog. Otherwise, you will just be wasting our time and yours."

ⓝ BRUSH DANCE INC.

1 Simms St., San Rafael CA 94901. (800)531-7445. Fax: (415)259-0905. E-mail: lkalloch@brushdance.com. Website: www.brushdance.com. **Contact:** Liz Kalloch, art director. Estab. 1989. Produces greeting cards, calendars, blank journals, illustrated journals, giftbooks, boxed notes and magnets. "The line of Brush Dance products is inspired by the interplay of art and words. We develop products that combine powerful and playful words and images that act as daily reminders that inspire, connect, challenge and support."

Needs Approached by 200 freelancers/year. Works with 5 freelancers/year. Art guidelines for 9×11 SASE with $1.50 postage. Uses freelancers mainly for illustration and calligraphy. Looking for non-traditional work conveying emotion or message. Prefers 5×7 or 7×5 originals or designs that can easily be reduced or enlarged to these proportions. Produces material for all occasions.

First Contact & Terms Check our website for artist guidelines. Send query letter and hard copy samples of your work, 35mm slides, transparencies or color copies. *Never send originals.* Samples are filed or returned by SASE. Responds only if interested. Buys all rights. Originals are returned at job's completion. Pays royalty of 5-7.5% depending on product. Finds artists through word of mouth, submissions, art shows.

Tips "Be sure to include self-addressed returned mailer with appropriate postage securely attached, and look at our website to be sure your work will fit into our line of products."

ⓝ CAMPAGNA FURNITURE

7500 E. Pinnacle Peak Rd. H221, Scottsdale AZ 85255. (480)563-2577. Fax: (480)563-7459. E-mail: laurajmorse @hotmail.com. Website: campagnafurniture.com. Vice President: Laura Morse. Estab. 1994. Produces furniture. Specializes in powder room vanities and entertainment units.

Needs Approached by 80 freelancers/year. Works with 12 freelancers/year. Buys 100 freelance designs and/ or illustrations/year. Uses freelancers mainly for decoupage. Considers all media. Product categories include floral, Trompe L'Oeil, landscape.

First Contact & Terms Send query letter with tearsheets, photocopies and photographs. Accepts e-mail submissions with link to website and submissions with image file. Prefers Windows-compatible, JPEG files. Samples are not filed and returned by SASE. Responds only if interested. Portfolio not required but should include finished art. Buys rights for furniture. Pays freelancers by the project $100 minimum-$200 maximum. Finds freelancers through word of mouth and artists' submissions.

Tips "We will consider new themes which individual artists might think appropriate for our cabinetry."

CAN CREATIONS, INC.

Box 8576, Pembroke Pines FL 33084. (954)581-3312. **President:** Judy Rappoport. Estab. 1984. Manufacturer of Cello wrap.

Needs Approached by 8-10 freelance artists/year. Works with 2-3 freelance designers/year. Assigns 5 freelance jobs/year. Prefers local artists only. Works on assignment only. Uses freelance artists mainly for "design work for cello wrap." Also uses artists for advertising design, illustration and layout; brochure design; posters; signage; magazine illustration and layout. "We are not looking for illustrators at the present time. Most designs we need are graphic and we also need designs which are geared toward trends in the gift industry."

First Contact & Terms Send query letter with tearsheets and photostats. Samples are not filed and are returned by SASE only if requested by artist. Responds in 2 weeks. Call or write to schedule an appointment to show a portfolio, which should include roughs and b&w tearsheets and photostats. Pays for design by the project, $75 minimum. Pays for illustration by the project, $150 minimum. Considers client's budget and how work will be used when establishing payment. Negotiates rights purchased.

Tips "We are looking for simple designs geared to a high-end market."

ꈤ CAPE SHORE, INC.

division of Downeast Concepts, 86 Downeast Dr., Yarmouth ME 04096. (207)846-3726. E-mail: capeshore@dow neastconcepts.com. Website: www.downeastconcepts.com. **Contact:** Freelance Submissions. Estab. 1947. "Cape Shore is concerned with seeking, manufacturing and distributing a quality line of gifts and stationery for the souvenir and gift market." Licenses art by noted illustrators with a track record for paper products and giftware. Guidelines available on website.

Needs Approached by 100 freelancers/year. Works with 50 freelancers/year. Buys 400 freelance designs and illustrations/year. Prefers artists and product designers with experience in gift product, hanging ornament and stationery markets. Art guidelines available free for SASE. Uses freelance illustration for boxed note cards, Christmas cards, ornaments, ceramics and other paper products. Considers all media. Looking for skilled wood carvers with a warm, endearing folk art style for holiday gift products.

First Contact & Terms "Do not telephone; no exceptions." Send query letter with color copies. Samples are filed or are returned by SASE. Art director will contact artist for portfolio review if interested. Portfolio should include finished samples, printed samples. Pays for design by the project, advance on royalties or negotiable flat fee. Buys varying rights according to project.

Tips "Cape Shore is looking for realistic detail, good technique, and traditional themes or very high quality contemporary looks for coastal as well as inland markets. We will sometimes buy art for a full line of products, or we may buy art for a single note or gift item. Proven success in the giftware field a plus, but will consider new talent and exceptional unpublished illustrators."

CARDMAKERS

Box 236, High Bridge Rd., Lyme NH 03768. Phone/fax: (603)795-4422. Fax: (603)795-4222. Website: www.card makers.com. **Principal:** Peter Diebold. Estab. 1978. Produces greeting cards. "We produce special cards for special interests and greeting cards for businesses—primarily Christmas. We have now expanded our Christmas line to include 'photo mount' designs, added designs to our everyday line for stockbrokers and have recently launched a new everyday line for boaters."

Needs Approached by more than 300 freelancers/year. Works with 5-10 freelancers/year. Buys 20-40 designs and illustrations/year. Prefers professional-caliber artists. Art guidelines available on website or for SASE with first-class postage. Please do not e-mail us for same. Works on assignment only. Uses freelancers mainly for greeting card design, calligraphy and mechanicals. Also for paste-up. Considers all media. "We market 5×7 cards designed to appeal to individual's specific interest—boating, building, cycling, stocks and bonds, etc." Prefers an upscale look. Submit seasonal ideas 6-9 months in advance.

First Contact & Terms Designers send query letter with SASE and brief sample of work. Illustrators send postcard sample or query letter with brief sample of work. "One good sample of work is enough for us. A return postcard with boxes to check off is wonderful. Phone calls are out; fax is a bad idea." Samples are filed or are returned by SASE. Responds only if interested unless with SASE. Portfolio review not required. Pays flat fee of $100-300 depending on many variables. Rights purchased vary according to project. Interested in buying second rights (reprint rights) to previously published work, if not previously used for greeting cards. Finds artists through word of mouth, exhibitions and *Artist's & Graphic Designer's Market* submissions.

Tips "We like to see new work in the early part of the year. It's important that you show us samples *before* requesting submission requirements. Getting published and gaining experience should be the main objective of freelancers entering the field. We favor fresh talent (but do also feature seasoned talent). PLEASE be patient waiting to hear from us! Make sure your work is equal to or better than that which is commonly found in use presently. Go to a large greeting card store. If you think you're as good or better than the artists there, continue!"

CAROLE JOY CREATIONS, INC.

6 Production Dr., #1, Brookfield CT 06804. Fax: (203)740-4495. Website: www.carolejoy.com. **President:** Carole Gellineau. Estab. 1986. Produces greeting cards. Specializes in cards, notes and invitations for people who share an African heritage.

Needs Approached by 200 freelancers/year. Works with 5-10 freelancers/year. Buys 100 freelance designs, illustrations and calligraphy/year. Prefers artists "who are thoroughly familiar with, educated in and sensitive to the African-American culture." Works on assignment only. Uses freelancers mainly for greeting card art. Also for calligraphy. Considers full color only. Looking for realistic, traditional, Afrocentric, colorful and upbeat style. Prefers 11×14. 20% freelance design work demands knowledge of Illustrator, Photoshop and QuarkXPress. Also produces material for Christmas, Easter, Mother's Day, Father's Day, graduation, Kwanzaa, Valentine's Day, birthdays and everyday. Also for sympathy, get well, romantic, thank you, serious illness and multicultural cards. Submit seasonal material 1 year in advance.

First Contact & Terms Send query letter with brochure, photocopies, photographs and SASE. No phone calls or slides. No e-mail addresses. Responds to street address only. Calligraphers send samples and compensation requirements. Samples are not filed and are returned with SASE only within 6 months. Responds only if interested. Portfolio review not required. Buys all rights. Pays for illustration by the project.

Tips "Excellent illustration skills are necessary and designs should be appropriate for African-American social expression. Writers should send verse that is appropriate for greeting cards and avoid lengthy, personal experiences. Verse and art should be uplifting."

CASPARI, INC.

(formerly H. George Caspari, Inc.), 116 E. 27th St., New York NY 10016. (212)685-9798. **Contact:** Lucille Andriola. Publishes greeting cards, Christmas cards, invitations, giftwrap and paper napkins. "The line maintains a very traditional theme."

Needs Buys 80-100 illustrations/year. Prefers watercolor, gouache, acrylics and other color media. Produces seasonal material for Christmas, Mother's Day, Father's Day, Easter and Valentine's Day. Also for life events such as moving, new house, wedding, birthday, graduation, baby, get well, sympathy.

First Contact & Terms Send samples to Lucille Andriola to review. Prefers unpublished original illustrations, slides or transparencies. Art director will contact artist for portfolio review if interested. **Pays on acceptance**; negotiable. Pays flat fee of $400 for design. Finds artists through word of mouth, magazines, submissions/self-promotions, sourcebooks, agents, visiting artist's exhibitions, art fairs and artists' reps.

Tips "Caspari and many other small companies rely on freelance artists to give the line a fresh, overall style rather than relying on one artist. We feel this is a strong point of our company. Please do not send verses."

CATCH PUBLISHING, INC.

456 Penn St., Yeadon PA 19050. (484)521-0132. Fax: (610)626-2778. **Contact:** Michael Markowicz. Produces greeting cards, stationery, giftwrap, blank books, posters and calendars.

Needs Approached by 200 freelancers/year. Works with 5-10 freelancers/year. Buys 25-50 freelance designs and illustrations/year. Art guidelines for SASE with first-class postage. Uses freelancers mainly for design. Considers all media. Produces material for Christmas, New Year and everyday. Submit seasonal material 1 year in advance.

First Contact & Terms Send query letter with brochure, tearsheets, résumé, slides, computer disks and SASE. Samples are not filed and are returned by SASE if requested by artist. Responds in 6 months. Company will contact artist for portfolio review if interested. Portfolio should include final art, slides or large format transparencies. Rights purchased vary according to project. Originals are returned at job's completion. Pays royalties of 10-12% (may vary according to job).

CEDCO PUBLISHING CO.

100 Pelican Way, San Rafael CA 94901. E-mail: licensingadministrator@cedco.com. Website: www.cedco.com. **Contact:** Licensing Department. Estab. 1982. Produces 200 upscale calendars and books.

Needs Approached by 500 freelancers/year. Art guidelines on website. "We never give assignment work." Uses freelancers mainly for stock material and ideas. "We use either 35mm slides or 4×5s of the work."

First Contact & Terms "No phone calls accepted." Send query letter with nonreturnable photocopies and tearsheets. Samples are filed. Also send list of places where your work has been published. Responds only if interested. To show portfolio, mail thumbnails and b&w photostats, tearsheets and photographs or e-mail JPEG file. Original artwork is returned at the job's completion. Pays by the project. Buys one-time rights. Interested in buying second rights (reprint rights) to previously published work. Finds artists through art fairs and licensing agents.

Tips "Full calendar ideas encouraged!"

Kathy Davis

The Business Side of Creativity

I am a Woman. I am Invincible. I am Tired," is the message on one of Kathy Davis' most popular greeting cards and a very fitting sentiment coming from such a successful artist, businesswoman, and mother. Although probably overworked and no doubt tired, Davis affirms that she never really gets burnt out because she can never run out of ideas: "The beauty is that my well really never runs dry. The more work I do, the more ideas I seem to have."

To manage the constant flow, and ensure that not a moment of inspiration is wasted, Davis keeps a journal documenting all the bits and pieces of creativity to use at a later date. She began her career as a creator of greeting cards after attending the National Stationery Show in New York where she met with companies and received encouraging feedback on her samples. However, her interest in the creative field started long before that as a child whose favorite class was art. Davis went on to earn a Masters in Art Education and taught for more than a decade before venturing out into the consumer market. This career move led to both the creation of her own business in 1990 and a successful partnership with Recycled Paper Greetings, a business relationship she describes as "a match made in heaven!"

When the business side of the industry overwhelms her, Davis tries to recenter herself by taking a long walk or hike, frequenting museums and bookshops, or trying to find a quiet place to sketch and write. "Pay attention to yourself and your needs," she advises. "We need to do that as artists and as individuals. The important thing is to fill your cup again."

Have you noticed any changes in the greeting card industry?

The biggest change I've noticed is the length of time card designs stay active. In the past, cards could have years of success. But, today, retailers are mimicking the fashion industry in their search for something new and fresh every season because newer cards sell better. As a result, the demand has increased and artists must keep up and always be willing and able to create new and fresh designs on a regular basis.

The development of e-mail and e-cards has surprisingly helped rather than hurt the greeting card industry. Handmade or handwritten personal communication in a tangible form seems to have more value now. Greeting card companies are more willing to invest in special processes such as die-cuts, foils, and special papers to enhance the value of a card and make it a kind of personal gift.

What are your career needs and how do you prioritize them?

It is almost impossible to figure out all of your needs in advance. When I first got started, I tried to research resources I needed not only to do my art but also to create structure

for my own business. I knew I would need legal advice on occasion, so I located a lawyer who specialized in copyright issues. As well, I had to address the bookkeeping and financial components of my business. I did most of the bookkeeping myself and found an accountant who assisted me with the end-of-year financials. I joined the Graphic Artists Guild and local business groups in order to get health insurance. Being a member of these groups helped to lower the cost of my healthcare expense. I wanted to communicate with other artists and exchange ideas, so I started small creative group sessions with local artists in my area. We met once a month to discuss ideas and give each other feedback.

Did you send out mailings when you first started out?

I completed some designs in my portfolio that I felt would work in this industry and went to the National Stationery Show to visit with potential companies face to face. I then followed-up in writing and sent additional samples of my work. I found the *Artist's & Graphic Designer's Market* very useful in this stage as a guide to locate additional companies to contact. In my experience, mailings alone did not create as much impact as meeting face to face.

I've found that it is essential to attend shows, such as the National Stationery Show, especially early in your career. It allows you to get a feel for various companies and where your artwork may fit. You don't want to go to a company where they already have a look similar to your own. Instead, go where your work could add a new dimension and not conflict with the existing lines. It can be overwhelming to see all the work at the trade shows, but it is also inspiring to recognize the current trends and to make contacts. I want to caution artists, however, that the primary reason companies attend these shows is to sell products to retailers. You need to be respectful and inquire as to whether the company has a creative director in attendance or if they can provide contact information. Try to set up meetings either at the show or after the show.

What is your experience with rejection? Even after all your successes, do you still ever occasionally receive negative feedback?

I receive plenty of negative feedback and it never ends, no matter how successful you become. Not everything you do is a home run. You need to keep in mind that you fail more than you succeed and perseverance is key. You need to respect and weigh constructive criticism. This type of feedback is so valuable, helping you respond to the needs of the market and find the right avenues for your work. It takes a thick skin sometimes. Your work may not appeal to everyone, but if you believe in it and enjoy it, then it's worth the effort in the end.

How did you decide what work to send out and what still needed revision?

I worked to create things in a series of looks, sending out multiple groupings of work to show a variety. My tendency was to put my ideas out there, even if they were not completed perfectly the way I had envisioned. I was open to feedback and wanted to get a good feeling about what potential companies were looking for. Rather than overwork the designs, I waited and hoped to get responses back from companies and then I reworked and re-sponded according to the feedback.

How did you approach the creative process of forming your own look and "line" of greeting cards?

I attempted not to pressure myself too much. I have always struggled with trying to define "my look," but I decided to work from my gut and my heart to see what came out. I've

Kathy Davis's love of nature shows in her work. Her signature style is known for featuring sunshine, flowers and animals in a light, lovely and fun way. Davis's work can be seen on greeting cards, stationery, stickers, wrapping paper and a myriad of other products. Visit her website, *www.kathydavis.com*, for more art and words of wisdom.

found that I like to work in a variety of ways with just as many mediums. Even though my watercolor looks became popular initially, I still enjoy working with different styles. Sometimes I worry that I have too much "variety" and may lose the recognizable component of my style. But I have heard from people on the outside that, when they see my art as a body of work, it holds together with a common thread. Whether it is the color palette or the overall look, there seems to be a quality that emerges as a "signature Kathy Davis look."

I encourage artists to work as freely as they can and not to worry too much about forming their own look. It works well to create designs in a series of four that have some similar themes in layout or style, like similar border treatments. It will give some unity for a presentation and allow companies to get a feel for an artist's capabilities. Have fun and give yourself permission to play. Out of that play will come art that is original to you, and that freshness is so important in this industry.

Can you speak about the business side of freelancing?

If you decide to work for yourself, be prepared to spend a lot of time on the business side of things. It's not for everyone, as it can take as much, or even more, than the time you spend on your artwork. A president of a greeting card company once advised me to keep a clear focus on how I spend my time. This is especially critical as your company grows and you find the need to hire help. You need to be the one to set boundaries and delegate to others. You have to be motivated, organized, able to meet deadlines, and willing to learn about contract negotiations. It is absolutely critical to follow through with your assignments. Once your work is published, it's important to keep track of things like being paid on time, maintaining accurate records, and handling taxes. It is also essential to create a system for organizing your workflow.

How important is licensing to a beginning artist?

I believe licensing to a number of different product categories can be detrimental if started too early in your career. A better approach is to gain depth and experience in one or two categories. You want to be sure to get accurate sales records and thoroughly understand the product you are designing before you diversify. Develop a name for yourself and a reputation for success in a specialized area. Then it will be easier for you to springboard into other categories. I'm sure some beginning artists have licensed their work successfully, but I think it's best to experience success in one or two areas to provide the momentum and foundation you will need to expand.

—*Rebecca Chrysler*

◼ 🖼 CENTRIC CORP.

6712 Melrose Ave., Los Angeles CA 90038. (323)936-2100. Fax: (323)936-2101. E-mail: centric@juno.com. Website: www.centriccorp.com. **President:** Sammy Okdot. Estab. 1986. Produces fashion watches, clocks, mugs, frames, pens and T-shirts for ages 13-60.

Needs Approached by 40 freelancers/year. Works with 6-7 freelancers/year. Buys approximately 100 designs and illustrations/year. Prefers local freelancers only. Works on assignment only. Uses freelancers mainly for watch and clock dials, frames and mug designs, T-shirts, pens and packaging. Also for mechanicals and Web design. Considers mainly graphics, computer graphics, cartoons, pen & ink, photography. 95% of freelance work demands knowledge of QuarkXPress, Illustrator, Photoshop.

First Contact & Terms Send postcard sample or query letter with appropriate samples. Accepts submissions on disk. Samples are filed if interested. Responds only if interested. Originals are returned at job's completion. Also needs package/product designers, pay rate negotiable. Requests work on spec before assigning a job. Pays by the project. Pays royalties of 1-10% for design. Rights purchased vary according to project. Finds artists through submissions/self-promotions, sourcebooks, agents and artists' reps.

Tips "Show your range on a postcard addressed personally to the target person. Be flexible, easy to work with. The World Wide Web is making it easier to work with artists in other locations."

☑ CHARTPAK/FRANCES MEYER, INC.

(formerly Frances Meyer, Inc.), 1 River Road, Leeds MA 01053. (800)628-1910. Fax: (800)762-7918. E-mail: creative@francesmeyer.com. Website: www.francesmeyer.com. **Contact:** Tom Richards, creative director. Estab. 1979. Produces scrapbooking products, stickers and stationery.

- Frances Meyer was acquired by Chartpak in 2003. Product lines will retain the Frances Meyer look, but company moved from Savannah, Georgia to Leeds, Massachusetts.

Needs Works with 5-6 freelance artists/year. Art guidelines available free for SASE. Commissions 100 freelance illustrations and designs/year. Works on assignment only. "Most of our artists work in either watercolor or acrylic. We are open, however, to artists who work in other media." Looking for "everything from upscale and sophisticated adult theme-oriented paper items, to fun, youthful designs for birth announcements, baby and youth products. Diversity of style, originality of work, as well as technical skills are a few of our basic needs." Produces material for Christmas, graduation, Thanksgiving (fall), New Year's, Halloween, birthdays, everyday, weddings, showers, new baby, etc. Submit seasonal material 6-12 months in advance.

First Contact & Terms Send query letter with tearsheets, SASE, photocopies, transparencies (no originals) and "as much information as is necessary to show diversity of style and creativity." "No response or return of samples by Frances Meyer, Inc. *without SASE*!"Responds in 2-3 months. Company will contact artist for portfolio review if interested. Originals are returned at job's completion. Pays royalty (varies).

Tips "Generally, we are looking to work with a few talented and committed artists for an extended period of time. We do not 'clean out' our line on an annual basis just to introduce new product. If an item sells, it will remain in the line. Punctuality concerning deadlines is a necessity."

CLEO, INC.

4025 Viscount Ave., Memphis TN 38118. (901)369-6657 or (800)289-2536. Fax: (901)369-6376. E-mail: cpatat@cleowrap.com. Website: www.cleowrap.com. **Senior Director of Creative Resources:** Claude Patat. Estab. 1953. Produces giftwrap and gift bags. "Cleo is the world's largest Christmas giftwrap manufacturer. Other product categories include some seasonal product. Mass market for all age groups."

Needs Approached by 25 freelancers/year. Works with 40-50 freelancers/year. Buys more than 200 freelance designs and illustrations/year. Uses freelancers mainly for giftwrap and gift bags (designs). Also for calligraphy. Considers most any media. Looking for fresh, imaginative as well as classic quality designs for Christmas. 30″ repeat for giftwrap. Art guidelines available. Submit seasonal material at least a year in advance.

First Contact & Terms Send query letter with slides, SASE, photocopies, transparencies and speculative art. Accepts submissions on disk. Samples are filed if interested or returned by SASE if requested by artist. Responds only if interested. Rights purchased vary according to project; usually buys all rights. Pays flat fee. Also needs package/product designers, pay rate negotiable. Finds artists through agents, sourcebooks, magazines, word of mouth and submissions.

Tips "Understand the needs of the particular market to which you submit your work."

☑ COURAGE CENTER

P.O. Box 1563, St. Cloud MN 56302-1563. (888)413-3323. Fax: (888)873-1771. E-mail: artsearch@courage.org. Website: www.couragecards.org. **Art and Production Manager:** Laura Brooks. Estab. 1970. "Courage Cards are holiday cards that are produced to support the programs of Courage Center, a nonprofit provider of rehabilitation services that helps people with disabilities live more independently."

Needs In search of holiday art themes including: traditional, winter, nostalgic, religious, ethnic and world peace designs. Features artists with disabilities, but all artists are encouraged to enter the annual Courage Card Art Search. Art guidelines available on company's website.

First Contact & Terms Call or e-mail name and address to receive Art Search guidelines, which are mailed January for the March 31 entry deadline. Artist retains ownership of the art. Pays $350 licensing fee in addition to nationwide recognition through distribution of more than 500,000 catalogs and promotional pieces, Internet, TV, radio and print advertising.

Tips "Do not send originals. We prefer that entries arrive as a result of the Art Search. The Selection Committee chooses art that will reproduce well as a card—colorful contemporary and traditional images for holiday greetings. Participation in the Courage Cards Art Search is a wonderful way to share your talents and help people live more independently."

CREATIF LICENSING

31 Old Town Crossing, Mount Kisco NY 10549. (914)241-6211. E-mail: info@creatifusa.com. Website: www.creatifusa.com. **President and Licensing Manager:** Paul Cohen. Estab. 1975. "Creatif is a licensing agency that represents artists and concept people." Licenses art for commercial applications for consumer products in gift stationery and home furnishings industry.

Needs Looking for unique art styles and/or concepts that are applicable to multiple products and categories.

First Contact & Terms Send query letter with brochure, photocopies, photographs, SASE and tearsheets. Does not accept e-mail attachments but will review website links. Responds in 2 months. Samples are returned with SASE. Creatif will obtain licensing agreements on behalf of the artists, negotiate and manage the licensing programs and pay royalties. Artists are responsible for filing all copyright and trademark. Requires exclusive representation of artists.

Tips "We are looking to license talented and committed artists. Be aware of current trends and design with specific products in mind."

SUZANNE CRUISE CREATIVE SERVICES, INC.

7199 W. 98th Terrace, #110, Overland Park KS 66212. (913)648-2190. Fax: (913)648-2110. E-mail: artagent@crui secreative.com. Website: www.cruisecreative.com. **President:** Suzanne Cruise. Estab. 1990. "Sells and licenses art for calendars, craft papers, decorative housewares, fabric giftbags, gifts, giftwrap, greeting cards, home decor, keychains, mugs, ornaments, prints, rubber stamps, stickers, tabletop, and textiles. "We are a full-service licensing agency, as well as a full-service creative agency representing licensed artists and freelance artists. Our services include, but are not limited to, screening manufacturers for quality and distribution, negotiating rights, overseeing contracts and payments, sending artists' samples to manufacturers for review, and exhibiting artists' work at major trade shows annually." Art guidelines on website.

Needs Seeks established and emerging artists with distinctive styles suitable for the ever-changing consumer market. Looking for artists that manufacturers cannot find in their own art staff or in the freelance market, or who have a style that has the potential to become a classic license. "We represent a wide variety of freelance artists, and a few select licensed artists, offering their work to manufacturers of goods such as gifts, textiles, home furnishings, bedding, book publishing, social expression, puzzles, rubber stamps, etc. We look for art that has popular appeal. It can be traditional, whimsical, cute, humorous, seasonal or everyday, as long as it is not 'dated'."

First Contact & Terms Send query letter with color photocopies, tearsheets or samples. No originals. Samples are returned only if accompanied by SASE. Responds only if interested. Portfolio required. Request portfolio review in original query.

Tips "Walk a few trade shows and familiarize yourself with the industries you want your work to be in. Attend a few of the panel discussions that are put on during the shows to get to know the business a little better."

CURRENT, INC.

1005 E. Woodmen Rd., Colorado Springs CO 80920. (719)594-4100. Fax: (719)531-2564. Website: www.currentc atalog.com. **Creative Business Manager:** Dana Grignano. Estab. 1950. Produces bookmarks, calendars, collectible plates, decorative housewares, decorations, giftbags, gifts, giftwrap, greeting cards, mugs, ornaments, school supplies, stationery, T-shirts. Specializes in seasonal and everyday social expressions products.

Needs Works with hundreds of freelancers/year. Buys 700 freelance designs and illustrations/year. Prefers freelancers with experience in greeting cards and textile industries. Uses freelancers mainly for cards, wraps, calendars, gifts, calligraphy. Considers all media. Product categories include business, conventional, cute, cute/religious, juvenile, religious, teen. Freelancers should be familiar with Photoshop, Illustrator and FreeHand. Produces material for all holidays and seasons and everyday. Submit seasonal material year-round.

First Contact & Terms Send query letter with photocopies, tearsheets, brochure and photographs. Samples are filed. Responds only if interested. Will contact artist for portfolio review if interested. Buys all rights. Pays by the project; $50-500. Finds freelancers through agents, artists' submissions, sourcebooks.

Tips "Review website or catalog prior to sending work."

▣ CUSTOM STUDIOS INC.

6118 N. Broadway St., Chicago IL 60660-2502. (773)761-1150. E-mail: wing@custom-studios.com. Website: www.custom-studios.com. **President:** Gary Wing. Estab. 1966. "We specialize in designing and screen printing custom T-shirts for schools, business promotions, fundraising and for our own line of stock." Also manufacture coffee mugs, bumper stickers, balloons and over 100 other products.

Needs Works with 10 freelance illustrators/year. Assigns 12 freelance jobs/year. Needs b&w illustrations (some original and some from customer's sketch). Uses artists for direct mail and brochures/fliers, but mostly for custom and stock T-shirt designs.

First Contact & Terms Send query letter with résumé, photostats, photocopies or tearsheets. "We will not return originals or samples." Responds in 1 month. Mail b&w tearsheets or photostats to be kept on file. Pays for design and illustration by the hour, $28-35; by the project, $50-150. Considers turnaround time and rights purchased when establishing payment. For designs submitted to be used as stock T-shirt designs, pays 5-10% royalty. Rights purchased vary according to project.

Tips "Send 5-10 good copies of your best work. We would like to see more black & white, camera-ready illustrations—copies, not originals. Do not get discouraged if your first designs sent are not accepted."

DESIGN DESIGN, INC.

P.O. Box 2266, Grand Rapids MI 49501. (616)774-2448. Fax: (616)774-4020. **Creative Director:** Tom Vituj. Produces humorous and traditional fine art greeting cards, stationery, magnets, sticky notes, giftwrap/tissue and paper plates/napkins.

Needs Uses freelancers for all of the above products. Considers most media. Produces cards for everyday and all holidays. Submit seasonal material 1 year in advance.

First Contact & Terms Send query letter with appropriate samples and SASE. Samples are not filed and are returned by SASE if requested by artist. To show portfolio, send color copies, photographs or slides. Do not send originals. Pays various royalties per product development.

DIMENSIONS, INC.

1801 N 12th St., Reading PA 19604. (610)939-9900. Fax: (610)939-9666. E-mail: pam.keller@dimensions-crafts.com. Website: www.dimensions-crafts.com. **Designer Relations Coordinator:** Pamela Keller. Produces craft kits and leaflets, including but not limited to needlework, stained glass, paint-by-number, and memory crafts. "We are a craft manufacturer with emphasis on sophisticated artwork and talented designers. Products include needlecraft kits and leaflets, paint-by-number, wearable art crafts, baby products. Primary market is adult women but children's crafts also included."

Needs Approached by 50-100 freelancers/year. Works with 200 freelancers/year. Develops more than 400 freelance designs and illustrations/year. Uses freelancers mainly for the original artwork for each product. Art guidelines for SASE with first-class postage. In-house art staff adapts for needlecraft. Considers all media. Looking for fine art, realistic representation, good composition, more complex designs than some greeting card art; fairly tight illustration with good definition; also whimsical, fun characters. Produces material for Christmas; Halloween; everyday; birth, wedding and anniversary records. Majority of products are everyday decorative designs for the home.

First Contact & Terms Send cover letter with color brochure, tearsheets, photographs or photocopies. Samples are filed "if artwork has potential for our market." Samples are returned by SASE only if requested by artist. Responds in 1 month. Portfolio review not required. Originals are returned at job's completion. Pays by project, royalties of 2-5%; sometimes purchases outright. Finds artists through magazines, trade shows, word of mouth, licensors/reps.

Tips "Current popular subjects in our industry: florals, wildlife, garden themes, ocean themes, celestial, cats, birds, Southwest/Native American, Victorian, juvenile/baby and whimsical."

EDITIONS LIMITED/FREDERICK BECK

51 Bartlett Ave., Pittsfield MA 01201. (413)443-0973. Fax: (413)445-5014. E-mail: mark@chatsworthcollection.com. Website: www.chatsworthcollection.com. **Art Director:** Mark Brown. Estab. 1958. Produces holiday greeting cards, personalized and box stock and stationery.

- Editions Limited joined forces with Frederick Beck Originals. The company also runs Gene Bliley Stationery. See editorial comment under Frederick Beck Originals for further information. Mark Brown is the art director for all three divisions.

Needs Approached by 100 freelancers/year. Works with 20 freelancers/year. Buys 50-100 freelance designs and illustrations/year. Prefers freelancers with experience in silkscreen. Art guidelines available. Uses freelancers mainly for silkscreen greeting cards. Also for separations and design. Considers offset, silkscreen, thermography, foil stamp. Looking for traditional holiday, a little whimsy, contemporary designs. Size varies. Produces material for Christmas, graduation, Hannukkah, New Year, Rosh Hashanah and Valentine's Day. Submit seasonal material 15 months in advance.

First Contact & Terms Designers send query letter with brochure, photocopies, photographs, résumé, tearsheets. Samples are filed. Responds in 1 month. Will contact artist for portfolio review of b&w, color, final art, photographs, photostats, roughs if interested. Buys all rights. Pays $150-300/design. Finds freelancers through word of mouth, past history.

EISENHART WALLCOVERINGS CO.

400 Pine St., Hanover PA 17331. (717)632-8024. Fax: (717)632-0288. Website: www.eisenwalls.com. **Design Center Administrator:** Gina Shaw. Licensing: JoAnn Berwager. Estab. 1940. Produces custom and residential wallpaper, borders, murals and coordinating fabrics. Licenses various types of artwork for wall coverings. Manufactures and imports residential and architectural wallcovering under the Ashford House®, Eisenhart® and Color Tree® collections.

Needs Works with 10-20 freelancers/year. Buys 50-100 freelance designs and illustrations/year. Prefers freelancers with experience in wallcovering design, experience with Photoshop helpful. Uses freelancers mainly for wallpaper design/color. Also for P-O-P. Looking for traditional as well as novelty designs.

First Contact & Terms Designers should contact by e-mail. Illustrators send query letter with color copies.

Samples are filed. Samples are returned by SASE if requested. Responds in 2 weeks. Artist should contact after 2 weeks. Will contact for portfolio review if interested. Buys all rights. Pays by design, varies. Finds freelancers through artists' submissions.

☑ KRISTIN ELLIOTT, INC.

6 Opportunity Way, Newburyport MA 01950. (978)526-7126. Fax: (978)465-6522. E-mail: kedesignstudio@verizon.net. Website: www.kristinelliott.com. **Creative Director:** Barbara Elliott. Publishes greeting cards and stationery products.

Needs Works with 25 freelance artists/year. Uses illustrations and graphic design. Prefers watercolor and gouache. Produces Christmas and everyday stationery products, including boxed notes, imprintables and photo cards.

First Contact & Terms Send published samples, color copies, slides, tearsheets or photos. Include SASE for return of materials. Payment negotiable.

Tips Crisp, clean colors preferred. "Show prospective clients a full range of art styles in a professional presentation."

ENESCO GROUP INC.

225 Windsor Dr., Itasca IL 60143-1225. (630)875-5300. Fax: (630)875-5350. Website: www.enesco.com. **Contact:** New Submissions/Licensing. Producer and importer of fine gifts and collectibles, such as resin, porcelain bisque and earthenware figurines, plates, hanging ornaments, bells, picture frames, decorative housewares. Clients: gift stores, card shops and department stores.

Needs Works with multiple freelance artists/year. Prefers artists with experience in gift product and packaging development. Uses freelancers for rendering, illustration and sculpture. 50% of freelance work demands knowledge of Photoshop, QuarkXPress or Illustrator.

First Contact & Terms Send query letter with résumé, tearsheets and/or photographs. Samples are filed or are returned. Responds in 2 weeks. Pays by the project.

Tips "Contact by mail only. It is better to send samples and/or photocopies of work instead of original art. All will be reviewed by Senior Creative Director, Executive Vice President and Licensing Director. If your talent is a good match to Enesco's product development, we will contact you to discuss further arrangements. Please do not send slides. Have a well-thought-out concept that relates to gift products before mailing your submissions."

☒ EPIC PRODUCTS INC.

17370 Mt. Herrmann, Fountain Valley CA 92708. (714)641-8194. Fax: (714)641-8217. E-mail: adubow@epicproductsinc.com. Website: www.epicproductsinc.com. **Presidents:** Ardeen and Steve DuBow. Estab. 1978. Produces paper tableware products and wine and spirits accessories. "Epic Products manufactures products for the gourmet/housewares market; specifically products that are wine-related. Many have a design printed on them."

Needs Approached by 50-75 freelance artists/year. Works with 10-15 freelancers/year. Buys 25-50 designs and illustrations/year. Prefers artists with experience in gourmet/housewares, wine and spirits, gift and stationery.

First Contact & Terms Send query letter with résumé and photocopies. Samples are filed. Write for appointment to show portfolio. Portfolio should include thumbnails, roughs, final art, b&w and color. Buys all rights. Originals are not returned. Pays by the project.

☒ EVERYTHING METAL IMAGINABLE, INC. (E.M.I.)

401 E. Cypress, Visalia CA 93277. (559)732-8126 or (800)777-8126. Fax: (559)732-5961. Website: www.artbronze.com. **Artists' Liaison:** Reneé Robbins. Estab. 1967. Wholesale manufacturer. "We manufacture lost wax bronze sculpture." Clients: wholesalers, premium incentive consumers, retailers, auctioneers, corporations.

Needs Approached by 10 freelance artists/year. Works with 20 freelance designers/year. Assigns 5-10 jobs to freelance artists/year. Prefers artists that understand centrifugal casting, bronze casting and the principles of mold-making. Uses artists for figurine sculpture and model-making.

First Contact & Terms Send query letter with brochure or résumé, tearsheets, photostats, photocopies and slides. Samples not filed are returned only if requested. Responds only if interested. Call for appointment to show portfolio of original/final art and photographs "or any samples." Pays for design by the project, $500-20,000. Buys all rights.

Tips "Artists must be conscious of detail in their work, be able to work expediently and under time pressure and be able to accept criticism of work from client. Price of program must include completing work to satisfaction of customers. Trends include children at play."

☑ FAIRCHILD ART/FAIRCHILD PHOENIX

1601 Archdale Dr., Charlotte NC 28210. (704)556-7117. **Owner/President:** Marilynn Fairchild. Estab. 1985. Produces fine art greeting cards, stationery, posters and art prints.

Needs Approached by 10-15 artists/year. Works with 1 or 2 artists/year. Buys 10-20 designs and illustrations/year. Prefers "quality fine artists." Uses freelancers mainly "when artwork is needed to complement our present product line." Considers all media. Prefers "work which is proportionate to 25×38 or 23×35 printing sheets; also sizes useful for printing 2-up, 4-up or 10-up on these size sheets." Produces material for birthdays and everyday. Submit 1 year before holiday. 10-25% of freelance works demands knowledge of FreeHand, Illustrator or CorelArt. Prefers quality fine art.

First Contact & Terms Send query letter with brochure, résumé, tearsheets, photographs or photocopies. Samples are filed or are not returned. Responds only if interested. Write for appointment to show portfolio, or mail finished art samples, b&w and color photostats, tearsheets and photographs. Pays flat fee for illustration/design, $100-300; or by the hour, $15 minimum. Rights purchased vary according to project.

Tips This company looks for professionalism in its freelancers. "Now producing a public fine art television show titled 'Fairchild Art Insight' featuring professional, experienced fine artists using different media and styles (i.e., glass, sculpture, metalworking, fabric art, etc.)."

FIDDLER'S ELBOW

(formerly The Toy Works, Inc.), Fiddler's Elbow Rd., Middle Falls NY 12848. (518)692-9665. Fax: (518)692-9186. E-mail: info@thetoyworks.com. Website: www.fiddlerselbow.com. **Art and Licensing Coordinator:** John Gunther. Estab. 1974. Produces decorative housewares, gifts, pillows, totes, soft sculpture, flags and doormats.

Needs Works with 5 freelancers/year. Art guidelines available free for SASE. Buys 50 freelance designs and illustrations/year. Uses freelancers mainly for design and illustration. Looking for traditional, floral, adult contemporary. 50% of freelance design demands knowledge of Photoshop, Illustrator and QuarkXPress, however computer knowledge is not a must. Produces material for everyday home decor.

First Contact & Terms Designers and illustrators send query letter with photostats, résumé, photocopies, photographs. Accepts disk submissions compatible with Postscript. Samples are filed or returned. Responds in 4 months. No phone calls! Portfolio review not required. Rights purchased vary according to project.

Tips When approaching a manufacturer, send color comps or prototypes with the type of art you create. It is much easier for manufacturers to understand your art if they see it on their product.

FISHER-PRICE

636 Girard Ave., E. Aurora NY 14052. (716)687-3983. Fax: (716)687-5281. Website: www.fisherprice.com. **Manager, Product Art:** Henry Schmidt. Estab. 1931. Manufacturer of toys and other children's products.

Needs Approached by 10-15 freelance artists/year. Works with 25-30 freelance illustrators and sculptors and 15-20 freelance graphic designers/year. Assigns 100-150 jobs to freelancers/year. Prefers artists with experience in children's style illustration and graphics. Works on assignment only. Uses freelancers mainly for product decoration (label art). Prefers all media and styles except loose watercolor. Also uses sculptors. 25% of work demands knowledge of FreeHand, Illustrator, Photoshop.

- This company has two separate art departments: Advertising and Packaging, which does catalogs and promotional materials, and Product Art, which designs decorations for actual toys. Be sure to specify your intent when submitting material for consideration. Art director told *AGDM* he has been receiving more e-mail and disk samples. He says it's a convenient way for him or his staff to look at work.

First Contact & Terms Send query letter with nonreturnable samples showing art style or photographs. Samples are filed. Responds only if interested. Call to schedule an appointment to show a portfolio. Portfolio should include original, final art and color photographs and transparencies. Pays for design and illustration by the hour, $25-50. Buys all rights.

☑ GAGNÉ WALLCOVERING, INC.

1771 N. Hercules Ave., Clearwater FL 33765. (727)461-1812. Fax: (727)447-6277. **Contact:** Linda Vierk, studio director. Estab. 1977. Produces wall murals and wallpaper. Specializes in residential and commercial wallcoverings, borders and murals encompassing a broad range of styles and themes for all age groups.

Needs Approached by 12-20 freelancers/year. Works with 20 freelancers/year. Buys 150 freelance designs and/or illustrations/year. Considers oils, watercolors, pastels, colored pencil, gouache, acrylic—just about anything two dimensional. Artists should check current wallcovering collections to see the most common techniques and media used.

First Contact & Terms Send brochure, color photocopies, photographs, slides, tearsheets, actual painted or printed sample of artist's hand if possible. Samples are filed. Responds only if interested. Portfolio not required. "We usually buy all rights to a design, but occasionally consider other arrangements." Pays freelancers by the project $500-1,200. Finds freelancers through magazines, licensing agencies, trade shows and word of mouth.

Tips "We are usually looking for traditional florals, country/folkart, juvenile and novelty designs. We do many borders and are always interested in fine representational art. Panoramic borders and murals are also a special

interest. Be aware of interior design trends, both in style and color. Visit a wallcovering store and see what is currently being sold. Send us a few samples of your best quality, well-painted, detailed work.

GALISON BOOKS/MUDPUPPY PRESS
28 W. 44th St., New York NY 10036. (212)354-8840. Fax: (212)391-4037. E-mail: Lorena@galison.com. Website: www.galison.com. **Creative Director:** Lorena Siminovich. Estab. 1978. Produces boxed greeting cards, puzzles, address books and specialty journals. Many projects are done in collaboration with museums around the world.
Needs Works with 10-15 freelancers/year. Buys 20 designs and illustrations/year. Works on assignment only. Uses freelancers mainly for illustration. Considers all media. Also produces material for Christmas and New Year. Submit seasonal material 1 year in advance. 100% of design and 5% of illustration demand knowledge of QuarkXPress.
First Contact & Terms Send postcard sample, photocopies, résumé and tearsheets (no unsolicited original artwork) and SASE. Accepts submissions on disk compatible with Photoshop, Illustrator or QuarkXPress (but not preferred). Samples are filed. Responds only if interested. Request portfolio review in original query. Creative Director will contact artist for portfolio review if interested. Portfolio should include color photostats, slides, tearsheets and dummies. Originals are returned at job's completion. Pays by project. Rights purchased vary according to project. Finds artists through word of mouth, magazines and artists' reps.
Tips "Looking for great presentation and artwork we think will sell and be competitive within the gift market."

GALLANT GREETINGS CORP.
P.O. Box 308, Franklin Park IL 60131. (847)671-6500. Fax: (847)233-2499. E-mail: joanlackouitz@gallantgreetings.com. Website: www.gallantgreetings.com. **Vice President Product Development:** Joan Lackouitz. Estab. 1966. Creator and publisher of seasonal and everyday greeting cards.
First Contact & Terms Samples are not filed or returned. Responds only if interested.

☑ GALLERY GRAPHICS, INC.
P.O. Box 502, Noel MO 64854. (417)475-6191. Fax: (417)475-6494. E-mail: info@gallerygraphics. Website: gallerygraphics.com. **Art Director:** Olivia Jacob. Estab. 1979. Produces calendars, gifts, greeting cards, stationery, prints, notepads, notecards. Gift company specializing primarily in nostalgic, country and other traditional designs.
Needs Approached by 100 freelancers/year. Works with 10 freelancers/year. Buys 100 freelance illustrations/year. Art guidelines free for SASE with first-class postage. Uses freelancers mainly for illustration. Considers any 2-dimensional media. Looking for country, teddy bears, florals, traditional. Prefers 16×20 maximum. Produces material for Christmas, Valentine's Day, birthdays, sympathy, get well, thank you. Submit seasonal material 8 months in advance.
First Contact & Terms Accepts printed samples or Photoshop files. Send TIFF or EPS files. Samples are filed or returned by SASE. Will contact artist for portfolio review of color photographs, photostats, slides, tearsheets, transparencies if interested. Payment negotiable. Finds freelancers through submissions and word of mouth.
Tips "Be flexible and open to suggestions."

C.R. GIBSON, CREATIVE PAPERS
404 BNA Drive, Building 200, Suite 600, Nashville TN 37217. (615)724-2900. Fax: (615)391-3166. Website: www.crgibson.com. **Vice President of Creative:** Ann Cummings. Producer of stationery and gift products, baby, kitchen and wedding collections. Specializes in baby, children, feminine, floral, wedding and kitchen-related subjects, as well as holiday designs. 80% require freelance illustration; 15% require freelance design. Gift catalog free by request.
Needs Approached by 200-300 freelance artists/year. Works with 30-50 illustrators and 10-30 designers/year. Assigns 30-50 design and 30-50 illustration jobs/year. Uses freelancers mainly for covers, borders and cards. 50% of freelance work demands knowledge of QuarkXPress, FreeHand and Illustrator. Works on assignment only.
First Contact & Terms Send query letter with brochure, résumé, tearsheets and photocopies. Samples are filed or are returned. Responds only if interested. Request portfolio review in original query. Portfolio should include thumbnails, finished art samples, color tearsheets and photographs. Return of original artwork contingent on contract. Sometimes requests work on spec before assigning a job. Interested in buying second rights (reprint rights) to previously published work. "Payment varies due to complexity and deadlines." Finds artists through word of mouth, magazines, artists' submissions/self-promotion, sourcebooks, agents, visiting artist's exhibitions, art fairs and artists' reps.
Tips "The majority of our mechanical art is executed on the computer with discs and laser runouts given to the engraver. Please give a professional presentation of your work."

ⓃGLOBAL GRAPHICS & GIFTS LLC.

16781 Chagrin Blvd. #333, Shaker Heights OH 44120. E-mail: fredw@globalgraphics ~ gifts.com. Website: www. globalgraphics ~ gifts.com. President: Fred Willingham. Estab. 1995. Produces calendars, e-cards, giftbags, gift-wrap/wrapping paper, greeting cards, party supplies and stationery. Specializes in all types of cards including traditional, humorous, inspirational, juvenile and whimsical.

Needs Works with 5-10 freelancers/year. Buys 50-100 freelance designs and/or illustrations/year. Uses freelancers mainly for illustration and photography. Product categories include African-American, alternative/humor, conventional, cute, cute/religious, Hispanic, inspirational, juvenile, religious and teen. Produces material for baby congrats, birthday, Christmas, congratulations, Easter, everyday, Father's Day, First Communion/Confirmation, get-well/sympathy, graduation, Mother's Day, Valentine's Day and wedding/anniversary. Submit seasonal material 1 year in advance. Art size should be 12×18 or less. 5% of freelance digital art and design work demands knowledge of FreeHand, Illustrator, InDesign, Photoshop.

First Contact & Terms Send postcard sample with brochure, photocopies and tearsheets. Send follow-up postcard every 3 months. Samples are filed. Responds only if interested. Portfolio not required. Buys all rights. Pays freelancers by the project $150 minimum-$400 maximum. Finds freelancers through agents, artists' submissions and word of mouth.

Tips "Make sure artwork is clean. Our standards for art are very high. Only send upbeat themes, nothing depressing. Only interested in wholesome images."

GRAHAM & BROWN

3 Corporate Dr., Cranbury NJ 08512. (609)395-9200. Fax: (609)395-9676. E-mail: atopper@grahambrownusa.c om. Website: www.grahambrown.com. **President:** Bill Woods. Estab. 1946. Produces residential wall coverings and home decor products.

Needs Prefers freelancers for designs. Also for artwork. Produces material for everyday.

First Contact & Terms Designers send query letter with photographs. Illustrators send postcard sample of work only to the attention of Andrea Topper. Samples are filed or returned. Responds only if interested. Buys all rights. For illustration pays a variable flat fee. Finds freelancers through shows (Surtex, etc.).

ⓃGREAT AMERICAN PUZZLE FACTORY INC.

16 S. Main St., S. Norwalk CT 06854. Fax: (203)838-2065. E-mail: Ashevlin@greatamericanpuzzle.com. Website: www.greatamericanpuzzle.com. **President:** Pat Duncan. Art Director: Frank DeStefano. Licensing: Patricia Duncan. Estab. 1975. Produces jigsaw puzzles and games for adults and children. Licenses wildlife, Americana and cats for puzzles (children's and adults').

Needs Approached by 150 freelancers/year. Works with 80 freelancers/year. Buys 50 designs and illustrations/ year. Uses freelancers mainly for puzzle material. Art guidelines for SASE with first-class postage. Looking for "fun, busy and colorful" work. 100% of graphic design requires knowledge of QuarkXPress, Illustrator or Photoshop.

First Contact & Terms Send postcard sample or query letter with brochure, tearsheets and photocopies. Also accepts e-mail submissions. Do not send originals or transparencies. Samples are filed or are returned. Art director will contact artist for portfolio review if interested. Original artwork is returned at job's completion. Pays flat fee of $600-1,000, work for hire. Royalties of 5-6% for licensed art (existing art only). Interested in buying second rights (reprint rights) to previously published work.

Tips "All artwork should be *bright*, cheerful and eye-catching. 'Subtle' is not an appropriate look for our market. Go to a toy store and look at what is out there. Do your homework! Send a professional-looking package to appropriate potential clients. Presentation means a lot. We get a lot of totally inappropriate submissions."

HALLMARK CARDS, INC.

P.O. Box 419580, Drop 216, Kansas City MO 64141-6580. Website: www.hallmark.com. Estab. 1931.
 ● Because of Hallmark's large creative staff of full-time employees and their established base of freelance talent capable of fulfilling their product needs, they do not accept unsolicited freelance submissions.

MARIAN HEATH GREETING CARDS, LCC

9 Kendrick Rd., Wareham MA 02571. (508)291-0766. Fax: (508)295-5992. E-mail: marianheath@marianheath.c om. Website: www.marianheath.com. **Creative Director:** Molly DelMastro. Estab. 1950. Produces giftbags, giftwrap, greeting cards, stationery and ancillary products. Greeting card company supporting independent card and gift shop retailers.

Needs Approached by 100 freelancers/year. Works with 35-45 freelancers/year. Buys 1,200 freelance designs and illustrations/year. Prefers freelancers with experience in social expression. Art guidelines free for SASE with first-class postage or e-mail requesting guidelines. Uses freelancers mainly for greeting cards. Considers all media and styles. Generally $5^{1}/_{4} \times 7^{1}/_{4}$ unless otherwise directed. Will accept various sizes due to digital

production, manipulation. 30% of freelance design and illustration work demands knowledge of Photoshop, Illustrator, QuarkXPress. Produces material for all holidays and seasons and everyday. Submit seasonal material 1 year in advance.

First Contact & Terms Designers send query letter with photocopies, résumé and SASE. OK to send slides, tearsheets and transparencies if necessary. Illustrators send query letter with photocopies, résumé, tearsheets and SASE. Accepts Mac-formatted JPEG disk submissions. Samples are filed or returned by SASE. Responds within 1 month. Will contact artist for portfolio review of color, final art, slides, tearsheets and transparencies. Pays for illustration by the project; flat fee; varies per project. Finds freelancers through agents, artists' rep, artist's submission, licensing and design houses.

HOFFMASTER SOLO CUP COMPANY

2920 N. Main St., Oshkosh WI 54903. (920)235-9330. Fax:(920)235-1642. **Art and Marketing Services Manager:** Paul Zuehlke. Produces decorative paper tableware, placemats, plates, tablecloths and napkins for institutional and consumer markets. Printing includes up to 6-color flexographic napkin printing.

Needs Approached by 20-30 freelancers/year. Works with 5-10 freelancers/year. Prefers freelancers with experience in paper tableware products. Art guidelines and specific design needs based on current market are available from Creative Managers. Looking for trends and traditional styles. Prefers 9" round artwork with coodinating 6.5" square image. Produces material for all holidays and seasons and everyday. Special need for seasonal material.

First Contact & Terms Send query letter with photocopies, résumé, appropriate samples by mail or fax only. Ideas may be sent in a color rough sketch. Accepts disk submissions compatible with Illustrator and FreeHand. Samples are filed or returned by SASE if requested by artist. Responds in 90 days only if interested. "Will provide feedback to artists whose designs could be adapted but are not currently acceptable for use without additional work and a resubmission." Creative Manager will contact artist for portfolio review if interested. Portfolio should include thumbnails, roughs, finished art samples, color photostats, tearsheets, photographs and dummies. Prefers to buy artwork outright. Rights purchased vary according to project. Pays by the project $350-1,500. Amounts vary according to project. May work on a royalty arrangement for recognized properties. Finds freelancers through art fairs and artists' reps.

Tips Looking for new trends and designs appropriate for plates and napkins.

IGPC

460 W. 34th St., 10th Floor, New York NY 10001. (212)629-7979. Fax: (212)629-3350. E-mail: mfriedman@igpc. net. Website: www.igpc.net. **Art Director:** Mordechai Friedman. Agent to foreign governments. "We produce postage stamps and related items on behalf of 40 different foreign governments."

Needs Approached by 50 freelance artists/year. Works with 75-100 freelance illustrators and designers/year. Assigns several hundred jobs to freelancers/year. Prefers artists within metropolitan New York or tri-state area. Must have excellent design and composition skills and a working knowledge of graphic design (mechanicals). Artwork must be focused and alive (4-color) and reproducible to stamp size (usually 4 times up). Works on assignment only. Uses artists for postage stamp art. Prefers airbrush, acrylic and gouache (some watercolor and oil OK). Must have reasonable knowledge of Photoshop and Quark.

First Contact & Terms Send samples showing illustrative skills. Doesn't need to be precious high quality. Color copies are fine. Responds in 5 weeks. Art Director will contact artist for portfolio review if interested. Portfolio should contain "4-color illustrations of realistic, tight flora, fauna, technical subjects, autos or ships. Also include reduced samples of original artwork." Sometimes requests work on spec before assigning a job. Pays by the project, $1,000-4,000. Consider government allowance per project when establishing payment.

Tips "Artists considering working with IGPC must have excellent drawing abilities in general or specific topics, i.e., flora, fauna, transport, famous people, etc.; sufficient design skills to arrange for and position type; the ability to create artwork that will reduce to postage stamp size and still hold up with clarity and perfection. Familiarity with printing process and print call-outs a plus. Generally, the work we require is realistic art. In some cases, we supply the basic layout and reference material; however, we appreciate an artist who knows where to find references and can present new and interesting concepts. Initial contact should be made by phone for appointment."

THE IMAGINATION ASSOCIATION

P.O. Box 1780, Lake Dallas TX 75065-1780. (940)498-3308. Fax: (940)498-1596. E-mail: ellice@funnyaprons.com. Website: www.funnyaprons.com. **Creative Director:** Ellice Lovelady. Estab. 1992. Our primary focus is now on our subdivision, The Funny Apron Company, that manufactures humorous culinary-themed aprons and T-shirts for the gourmet marketplace."

Needs Works with 12 freelancers/year. Artists must be fax accessible and able to work on fast turnaround. Guidelines free for SAE with first-class postage. Uses freelancers for everything. "We're open to a variety of

styles." 100% of freelance work DEMANDS knowledge of Illustrator, Corel Draw, or programs with ability to electronically send vector-based artwork. (Photoshop alone is not sufficient.)

First Contact & Terms Send query letter with brochure, photographs, SASE and photocopies. Samples are filed or returned by SASE if requested by artist. Company will contact artist for portfolio review if interested. Portfolio should include final art, photographs or any material to give indication of range of artist's style. Negotiates rights and payment terms. Originals are returned at job's completion. Finds artists via word of mouth from other freelancers or referrals from publishers.

Tips Looking for artist "with a style we feel we can work with and a professional attitude. Understand that sometimes we require several revisions before final art, and all under tight deadlines. Even if we can't use your style, be persistent! Stay true to your creative vision and don't give up!"

INCOLAY STUDIOS INCORPORATED

520 Library St., San Fernando CA 91344. Fax: (818)365-9599. **Art Director:** Louise Hartwell. Estab. 1966. Manufacturer. "Basically we reproduce antiques in Incolay Stone, all handcrafted here at the studio. There were marvelous sculptors in that era, but we believe we have the talent right here in the U.S. today and want to reproduce living American artists' work."

 • Art director told *AGDM* that hummingbirds and cats are popular subjects in decorative art, as are angels, cherubs, endangered species and artwork featuring the family, including babies.

Needs Prefers local artists with experience in carving bas relief. Uses freelance artists mainly for carvings. Also uses artists for product design and model making.

First Contact & Terms Send query letter with résumé, or "call and discuss; 1-800-INCOLAY." Samples not filed are returned. Responds in 1 month. Call for appointment to show portfolio. Pays 5% of net. Negotiates rights purchased.

Tips "Let people know that you are available and want work. Do the best you can. Discuss the concept and see if it is right for 'your talent.' "

INSPIRATIONS UNLIMITED

P.O. Box 5097, Crestine CA 92325. (909)338-6758 or (800)337-6758. Fax: (909)338-2907. **Owner:** John Wiedefeld. Estab. 1983. Produces greeting cards, gift enclosures, note cards and stationery.

Needs Approached by 15 freelancers/year. Works with 4 freelancers/year. Buys 48 freelance designs and illustrations/year. Uses freelancers mainly for greeting cards. Will consider all media, all styles. Prefers 5×7 vertical only. Produces material for Christmas, Mother's Day, graduation, Valentine's Day, birthdays, everyday, sympathy, get well, romantic, thank you, serious illness. Submit seasonal material 1 year in advance.

First Contact & Terms Designers and illustrators send photocopies and photographs. Samples are filed and are not returned. Responds in 1 week. Company will contact artist for portfolio review if interested. Buys reprint rights; rights purchased vary according to project. Pays $100/piece of art. Also needs calligraphers, pays $25/hour. Finds freelancers through artists' submissions, art galleries and shows.

Tips "Send color copies of your artwork for review with a self-addressed envelope."

INTERCONTINENTAL GREETINGS LTD.

176 Madison Ave., New York NY 10016. (212)683-5830. Fax: (212)779-8564. E-mail: intertg@intercontinental-ltd.com. Website: www.intercontinental-ltd.com. **Art Director:** Thea Groene. Estab. 1967. Sells reproduction rights of designs to manufacturers of multiple products around the world. Reps artists in 50 different countries, with clients specializing in greeting cards, giftware, giftwrap, calendars, postcards, prints, posters, stationery, paper goods, food tins, playing cards, tabletop, bath and service ware and much more. "Prefers artwork previously made with few or no rights pending." Company guidelines free with SASE.

Needs Approached by several hundred artists/year. Seeking creative decorative art in traditional and computer media (Photoshop preferred; some Illustrator work accepted). Graphics, sports, occasions (i.e., Christmas, baby, birthday, wedding), humorous, "soft touch," romantic themes, animals. Accepts seasonal/holiday material any time. Prefer: artists/designers experienced in greeting cards, paper products, tabletop and giftware.

First Contact & Terms Query with samples. Send unsolicited color copies or CDs by mail with return SASE for consideration. Upon request, submit portfolio for review. Provide résumé, business card, brochure, flier, tearsheets or slides to be kept on file for possible future assignments. "Once your art is accepted, we use" original color art; Photoshop files on disk, TIFF, Mac, 300 dpi; 4×5, 8×10 transparencies and 35mm slides. Responds only if interested (will send back nonaccepted in SASE if given). Pays on publication. No credit line given.

Offers advance when appropriate. Sells one-time rights and exclusive product rights. Simultaneous submissions and previously published work OK. Please state reserved rights if any.

Tips Recommends the annual New York Surtex and Licensing shows. In portfolio samples, wants to see "a neat presentation, thematic in arrangement, a series of interrelated images (at least six). In addition to having good drawing/painting/designing skills, artists should be aware of market needs."

THE INTERMARKETING GROUP

29 Holt Rd., Amherst NH 03031. (603)672-0499. **President, licensing:** Linda L. Gerson. Estab. 1985. Licensing agent for all categories of consumer goods including greeting cards, stationery, calendars, posters, paper tableware products, tabletop, dinnerware, giftwrap, euro-bags, giftware, toys, needle crafts. The Intermarketing Group is a full-service art licensing agency representing artists' works for licensing with companies in consumer goods products, including the home furnishings, paper product, greeting card, giftware, toy, housewares, needlecraft and apparel industries.

Needs Approached by 100 freelancers/year. Works with 6 freelancers/year. Licenses work as developed by clients. Prefers freelancers with experience in full-color illustration. Uses freelancers mainly for tabletop, cards, giftware, calendars, paper tableware, toys, bookmarks, needlecraft, apparel, housewares. Will consider all media forms. "My firm generally represents illustrated works and illustrations for direct product applications. All works are themed." Prefers 5×7 or 8×10 final art. Produces material for all holidays and seasons and everyday. Submit seasonal material 6 months in advance.

Halloween is one of the most popular card-sending occasions. Loren Guttormson's jack-o-lantern was licensed by The Intermarketing Group to Marian Heath Greeting Cards.

© Loren Guttormson. Licensed by The Intermarketing Group

First Contact & Terms Send query letter with brochure, tearsheets, résumé, slides, SASE or color copies. Samples are not filed and are returned by SASE. Responds in 3 weeks. Originals are returned at job's completion. Requests work on spec before assigning a job. Pays royalties of 2-7% plus advance against royalties. Buys all rights. Considers buying second rights (reprint rights) to previously published work. Finds new artists "mostly by referrals and via artist submissions. I do review trade magazines, attend art shows and other exhibits to locate suitable clients."

Tips "Companies today seem to be leaning towards a fresh, trendy look in the art approach. Companies are selective in their licenses. A well-organized presentation is very helpful. Be aware of the market. See what is selling in stores and focus on specific products that would incorporate your art well. Get educated on market conditions and trends."

⋈ JILLSON & ROBERTS

3300 W. Castor St., Santa Ana CA 92704. (714)424-0111. Fax: (714)424-0054. Website: www.jillsonroberts.com. **Art Director:** Shawn Doll. Estab. 1974. Produces giftwrap and giftbags using more recycled/recyclable products.

Needs Works with 10 freelance artists/year. Prefers artists with experience in giftwrap design. Considers all media. "We are looking for colorful graphic designs as well as humorous, sophisticated, elegant or contemporary styles." Produces material for Christmas, Valentine's Day, Hanukkah, Halloween, graduation, birthdays, baby announcements and everyday. Submit 3-6 months before holiday.

First Contact & Terms Send query letter with brochure showing art style, tearsheets and slides. Samples are filed or are returned. Responds in 3 weeks. To show a portfolio, mail thumbnails, roughs, final reproduction/product, color slides and photographs. Originals not returned. Pays average flat fee of $250 or pays royalties (percentage negotiable).

KALAN LP

97 S. Union Ave., Lansdowne PA 19050. (610)623-1900. Fax: (610)623-0366. E-mail: kalanart@pond.com. **Art Director:** Chris Wiemer. Estab. 1973. Produces giftbags, greeting cards, school supplies, stationery and novelty items such as keyrings, mouse pads, shot glasses and magnets.

Greeting Cards & Gifts

Needs Approached by 50-80 freelancers/year. Buys 10 freelance designs and illustrations/year. Art guidelines are available. Uses freelancers mainly for fresh ideas, illustration and design. Considers all media and styles. 80% of freelance design and 50% of illustration demands knowledge of Photoshop 4 and Illustrator 7. Produces material for major holidays such as Christmas, Mother's Day, Valentine's Day; plus birthdays and everyday. Submit seasonal material 9-10 months in advance.

First Contact & Terms Designers send query letter with photocopies, photostats and résumé. Illustrators and cartoonists send query letter with photocopies and résumé. Accepts disk submissions compatible with Illustrator 7 or Photoshop 4.0. Send EPS files. Samples are filed. Responds in 1 month if interested in artist's work. Will contact artist for portfolio review of final art if interested. Buys first rights. Pays by the project, $75 and up. Finds freelancers through submissions and newspaper ads.

KENZIG KARDS, INC.

2300 Julia Goldbach Ave., Ronkonkoma NY 11779-6317. (631)737-1584. Fax: (631)737-8341. E-mail: kenzigkards@aol.com. **Contact:** Jerry Kenzig, President. Estab. 1999. Produces greeting cards and stationery. Specializes in greeting cards (seasonal and everyday) for a high-end, design-conscious market (all ages).

Needs Approached by 50 freelancers/year. Works with 3 freelancers/year. Prefers local designers/illustrators, however, we will consider freelancers working anywhere in US. Art guidelines free with SAE and first-class postage. Uses freelancers mainly for greeting cards/design and calligraphy. Considers watercolor, colored pencils; most media. Product categories include alternative/humor, business and cute. Produces material for baby congrats, birthday, cards for pets, Christmas, congratulations, everyday, get-well/sympathy, Valentine's Day and wedding/anniversary. Submit seasonal material 6 months in advance. Art size should be 5×7 or 5³/₄×5³/₄ square. 20% of freelance work demands knowledge of Illustrator, QuarkXPress and Photoshop.

First Contact & Terms Send query letter with brochure, résumé and tearsheets. After introductory mailing, send follow-up postcard sample every 6 months. Samples are filed. Responds in 2 weeks. Company will contact artist for portfolio review if interested. Portfolio should include color, original art, roughs and tearsheets. Buys one-time rights and reprint rights for cards and mugs. Negotiates rights purchased. Pays freelancers by the project, $150-350; royalties (subject to negotiation). Finds freelancers through industry contacts (Kenzig Kards, Inc. is a regular member of the Greeting Card Association [GCA]), artist's submissions and word of mouth.

Tips "We are open to new ideas and different approaches within our niche (i.e. dog- and cat-themed designs, watercolor florals, etc.) Looking for bright colors and cute, whimsical art. Floral designs require crisp colors."

✔ KOEHLER COMPANIES

8758 Woodcliff Rd., Bloomington MN 55438. (952)942-5666. Fax: (952)942-5208. E-mail: bob@koehlercompanies.com. Website: www.koehlercompanies.com. **President:** Bob Koehler. Estab. 1988. Manufactures wall decor, plaques, clocks and mirrors; artprints laminated to wood. Clients: gift-based and home decor mail order catalog companies. Clients include: Signals, Paragon, Potpourri and others.

Needs Works with 10 established artists; 8 mid-career artists and 10 emerging artists/year. Considers oil, acrylic, watercolor, mixed media, pastels and pen & ink. Preferred themes and styles: humorous, Celtic, inspirational, pet (cats and dogs), golf, fishing.

First Contact & Terms Send query letter with brochure, photocopies or photographs, résumé and tearsheets. Samples are not filed and are returned by SASE. Company will contact artist for portfolio review if interested. Pays royalties or negotiates payment. Does not offer an advance. Rights purchased vary according to project. Also works with freelance designers. Finds artists through word of mouth.

✔ THE LANG COMPANIES, LCC.

514 Wells St., Delafield WI 53018. (262)646-3399. Website: www.lang.com. **Product Development Coordinator:** Yvonne Moroni (product development and art submissions). Licensing: Robert Lang. Estab. 1982. Produces high quality linen-embossed greeting cards, stationery, calendars, candles, boxes, giftbags and earthenware.

Needs Approached by 300 freelance artists/year. Art guidelines available free for SASE. Works with 40 freelance artists/year. Uses freelancers mainly for card and calendar illustrations. Considers all media. Looking for traditional and non-abstract country, folk and fine art styles. Produces material for Christmas, birthdays and everyday. Submit seasonal material 6 months in advance.

First Contact & Terms Send query letter with SASE and brochure, tearsheets, photostats, photographs, slides, photocopies or transparencies. Samples are filed or are returned by SASE if requested by artist. Responds in 6 weeks. Pays royalties based on net wholesale sales. Rights purchased vary according to project.

Tips "Research the company and submit a compatible piece of art. Be patient awaiting a response. A phone call often rushes the review, and work may not be seriously considered."

✔ LEADER PAPER PRODUCTS/PAPER ADVENTURES

901 S. Fifth St., Milwaukee WI 53204. (414)383-0414. Fax: (414)383-0760. E-mail: caryn.g@paperadventures.com. Website: www.paperadventures.com. **Creative Department:** Caryn Gehm. Estab. 1901. Produces statio-

nery, imprintables; scrapbook and paper crafting. Specializes in stationery, patterned papers and related paper products.

Needs Approached by 50 freelancers/year. Works with 20 freelancers/year. Buys or licenses 150 freelance illustrations and design pieces/year. Prefers freelancers with experience in illustration/fine art, stationery design/surface design. Art guidelines available. Works on assignment only. Considers any medium that can be scanned. Also looking for designers for advertising and package design.

First Contact & Terms Freelancers send or e-mail query letter with nonreturnable color samples and bio. Send follow-up postcard or call every 3 months. Accepts Mac-compatible disk and e-mail submissions. Samples are filed. Will contact artist for more samples and to discuss project. Pays for illustration by the project, $300 and up. Also considers licensing for complete product lines. Finds freelancers through tradeshows and *Artist's & Graphic Designer's Market*.

Tips ''Send lots of samples, showing your best, neatest and cleanest work with a clear concept. Be flexible.''

⚡ THE LEMON TREE STATIONERY CORP.

95 Mahan St., West Babylon NY 11704. (631)253-2840. Fax: (631)253-3369. Website: www.lemontreestationery .com. **Contact:** Lucy Mlexzko. Estab. 1969. Produces birth announcements, Bar Mitzvah and Bat Mitzvah invitations and wedding invitations.

Needs Buys 100-200 pieces of calligraphy/year. Prefers local designers. Works on assignment only. Uses Mac designers. Also for calligraphy, mechanicals, paste-up, P-O-P. Looking for traditional, contemporary. 50% of freelance work demands knowledge of Photoshop, QuarkXPress, Illustrator.

First Contact & Terms Send query letter with résumé. Calligraphers send photocopies of work. Samples are not filed and are not returned. Responds only if interested. Company will contact artist for portfolio review of final art, photostats, thumbnails if interested. Pays for design by the project. Pays flat fee for calligraphy.

Tips ''Look around at competitors' work to get a feeling of the type of art they use.''

LIFE GREETINGS

P.O. Box 468, Little Compton RI 02837. (401)635-4918. **Editor:** Kathy Brennan. Estab. 1973. Produces greeting cards. Religious, inspirational greetings.

Needs Approached by 25 freelancers/year. Works with 5 freelancers/year. Uses freelancers mainly for greeting card illustration. Also for calligraphy. Considers all media but prefers pen & ink and pencil. Prefers $4\frac{1}{2} \times 6\frac{1}{4}$— no bleeds. Produces material for Christmas, religious/liturgical events, baptism, first communion, confirmation, ordination, etc.

First Contact & Terms Send query letter with photocopies. Samples are filed or returned by SASE if requested by artist. Responds only if interested. Portfolio review not required. Originals are not returned. Pays by the project. **''We pay on acceptance.''** Finds artists through submissions.

LPG GREETINGS, INC.

4000 Porett Dr., Gurnee IL 60031. (847)244-4414. Fax: (847)244-0188. E-mail: judy@lpggreetings.com. Website: www.lpggreetings.com. **Creative Director:** Judy Cecchi. Estab. 1992. Produces greeting cards. Specializes in boxed Christmas cards.

Needs Approached by 50-100 freelancers/year. Works with 20 freelancers/year. Buys 70 freelance designs and illustrations/year. Art guidelines free for SASE with first-class postage. Uses freelancers mainly for original artwork for Christmas cards. Considers any media. Looking for traditional and humorous Christmas. Greeting cards can be vertical or horizontal; 5×7 or 6×8. Usually prefers 5×7. Submit seasonal material 1 year in advance.

First Contact & Terms Send query letter with photocopies. Samples are filed if interested or returned by SASE. Portfolio review not required. Will contact artist for portfolio if interested. Rights purchased vary according to project. Pays for design by the project. For illustration pays flat fee. Finds freelancers through word of mouth and artists' submissions. Please do not send unsolicited samples via e-mail; they will not be considered.

Tips ''Be creative with fresh new ideas.''

LUNT SILVERSMITHS

298 Federal St., P.O. Box 1010, Greenfield MA 01302-1010. (413)774-2774. Fax: (413)774-4393. E-mail: design@l unt-silversmiths.com. Website: www.lunt-silversmiths.com. **Director of Design:** Carl F. Romboletti Jr. Estab. 1902. Produces collectible figurines, gifts, Christmas ornaments, babyware, tabletop products, sterling and steel flatware.

Needs Approached by 1-2 freelancers/year. Works with 1-5 freelancers/year. Contracts 35 product models/year. Prefers freelancers with experience in tabletop product, model-making. Uses freelancers mainly for model-making and prototypes. Also for mechanicals. Considers clay, plastaline, resins, hard models. Looking for traditional, florals, sentimental, contemporary. 25% of freelance design work demands knowledge of Photoshop, Illustrator,

AutoCad. Produces material for all holidays and seasons, Christmas, Valentine's Day, everyday.

First Contact & Terms Designers and sculptors should send query letter with brochure, photocopies, photographs, résumé. Sculptors should also send résumé and photos. Accepts disk submissions created in Photoshop. Samples are filed or returned by SASE. Responds in 1 week only if interested. Will contact for portfolio review if interested. Portfolio should include photographs, photostats, slides. Rights purchased vary according to project. Pays for design, illustration and sculpture according to project.

S.A. MAXWELL CO.

935 Campus Dr., Mundelein IL 60060. (847)932-3700. Fax: (847)932-3799. E-mail: jbrown@samaxwell.com **Contact:** Jaima Brown-Emmert, design director. Estab. 1851. Produces wallpaper. Specializes in traditional wallpaper for mass market and upper end product.

Needs Approached by 10 freelancers/year. Works with 3 freelancers/year. Buys 30 freelance designs and/or illustrations/year. Prefers freelancers with experience in wallpaper and different painting techniques who are good illustrators with good painting skills. Uses freelancers mainly for repeat design in surface printing areas for specific types of printing. Considers gouache, oils, acrylics, crackling etc. Product categories include traditional design and vintage style artwork. 20-30% of freelance work demands knowledge of Illustrator, Photoshop, AVA color and design experience.

First Contact & Terms Send photocopies, résumé, artwork examples. Accepts e-mail submissions with link to website. Prefers Windows-compatible, JPEG files. Samples are returned if not filed. Responds only if interested. Company will contact artist for portfolio review if interested. Portfolio should include original art. Buys all rights. Pays freelancers by the project. Finds freelancers through word of mouth.

Tips "Artists need to have repeat experience and to have good drawing skills and be able to produce a variety of styles of painting techniques, from oils to gouache to doing murals."

☑ NAPCO MARKETING

7800 Bayberry Rd., Jacksonville FL 32256-6893. (904)737-8500. Fax: (904)737-9526. E-mail: napco@leading.com. **Art Director:** Robert Keith. Estab. 1940. NAPCO Marketing supplies floral, garden and home interior markets with middle to high-end products. Clients: wholesale.

- NAPCO Marketing has a higher-end look for their floral market products.

Needs Works with 15 freelance illustrators and designers/year. 50% of work done on a freelance basis. No restrictions on artists for design and concept. Art guidelines available for SASE with first-class postage. Works on assignment only. Uses freelancers mainly for mechanicals and product design. "Need artists that are highly skilled in illustration for three-dimensional products."

First Contact & Terms Designers send query letter with brochure, résumé, photocopies, photographs, SASE, tearsheets and "any samples we can keep on file." Illustrators send brochure, résumé, photocopies, photographs and SASE. If work is in clay, send photographs. Samples are filed or returned by SASE. Responds in 2 weeks. Artist should follow up with letter after initial query. Portfolio should include samples which show a full range of illustration style. Sometimes requests work on spec before assigning a job. Pays for design by the project, $50-500. Pays by the project for illustration, $50-2,000. Pays $15/hour for mechanicals. Buys all rights. Considers buying second rights (reprint rights) to previously published work. Finds artists through word of mouth and self-promotions.

Tips "We are very selective in choosing new people. We need artists that are familiar with three-dimensional giftware and floral containers."

OATMEAL STUDIOS

Box 138, Rochester VT 05767. (802)767-3171. Fax: (802)767-9890. **Creative Director:** Helene Lehrer. Estab. 1979. Publishes humorous greeting cards and notepads, creative ideas for everyday cards and holidays.

Needs Approached by approximately 300 freelancers/year. Buys 100-150 freelance designs and illustrations/year. Art guidelines for SASE with first-class postage. Considers all media. Produces seasonal material for Christmas, Mother's Day, Father's Day, Easter, Valentine's Day and Hanukkah. Submit art year-round for all major holidays.

First Contact & Terms Send query letter with slides, roughs, printed pieces or brochure/flyer to be kept on file; write for artists' guidelines. "If brochure/flyer is not available, we ask to keep one slide or printed piece; color or b&w photocopies also acceptable for our files." Samples returned by SASE. Responds in 6 weeks. No portfolio reviews. Negotiates payment.

Tips "We're looking for exciting and creative, humorous (not cutesy) illustrations and single panel cartoons. If you can write copy and have a humorous cartoon style all your own, send us your ideas! We do accept work without copy too. Our seasonal card line includes traditional illustrations, so we do have a need for non-humorous illustrations as well."

◨ ONTARIO FEDERATION OF ANGLERS AND HUNTERS

P.O. Box 2800, Peterborough ON K9J 8L5 Canada. (705)748-6324. Fax: (705)748-9577. Website: www.ofah.org. **Graphic Designer:** Deborah Carew. Estab. 1928. Produces calendars, greeting cards, limited edition prints. "We are a nonprofit, conservation organization who publishes a high quality wildlife art calendar and a series of four Christmas cards each year. We also commission two paintings per year that we produce in limited edition prints."

Needs Approached by 60 freelancers/year. Works with 6-12 freelancers/year. Buys 12 freelance designs and illustrations/year. Prefers wildlife artists. Art guidelines free for SAE, e-mail or on website. Uses freelancers mainly for calendar/cards. Considers any media that gives realistic style. "We find talent through a yearly wildlife art calendar contest. Our criteria is specific to the wildlife art market with a slant towards hunting and fishing activities. We can only consider North American species found in Ontario. We welcome scenes involving sportsmen and women in the outdoors. Also sporting dogs. All art must be fine art quality, realistic, full color, with backgrounds. Any medium that gives these results is acceptable. No illustrative or fantasy-type work please. Look to successful wildlife artists like Robert Bateman or Michael Dumas for the style we're seeking." Prefers minimum 9×12 final art. Produces material for Christmas, wildlife art cards, i.e. no wording required.

First Contact & Terms Contact through contest only please. Samples are filed or returned. Responds following contest. Portfolio review not required. Buys one-time rights. Pays $150/calendar piece plus extras.

◨ OUT OF THE BLUE

7350 So. Tamiami Trial #227, Sarasota FL 34231. (941)966-4042. Fax: (941)966-8914. E-mail: outoftheblue.us@ mac.com. Website: www.out-of-the-blue.us. Estab. 2003. **President:** Michael Woodward. Creative Director: Maureen May. "Out of the Blue is a new division of Art Licensing International Inc. This new division specializes in creating 'Art Brands.' We are looking for artwork, designs, photography or character concepts that we can license for product categories such as posters and prints, greeting cards, calendars, stationery, gift products and the home décor market."

Needs Collections of art, illustrations or photography which have wide consumer appeal. CD presentation preferred, but photocopies/flyers are acceptable. If submitting character concepts, include a style guide showing all the characters and a synopsis with storylines.

First Contact & Terms Send samples on CD (JPEG files), short bio, color photocopies and SASE. E-mail presentations also accepted. Terms 50/50 with no expense to artist as long as artist can provide high-res scans if we agree on representation.

Tips "Pay attention to trends and color palettes. Artists need to consider actual products when creating new art. Look at products in retail outlets and get a feel for what is selling well. Get to know the markets you want to sell your work to."

◨ P.S. GREETINGS, INC.

5730 N. Tripp Ave., Chicago IL 60646. Website: www.psgreetings.com. **Contact:** Design Director. Manufacturer of boxed greeting and counter cards.

Needs Receives submissions from 300-400 freelance artists/year. Artists' guidelines are posted on website, or send SASE. Works with 50-100 artists/year on greeting card designs. Publishes greeting cards for everyday and holidays. 70% of work demands knowledge of QuarkXPress, Illustrator and Photoshop.

First Contact & Terms All requests as well as submissions must be accompanied by SASE. Samples will *not* be returned without SASE! Responds in 1 month. Pays flat fee. Buys exclusive worldwide rights for greeting cards and stationery.

Tips "Our line includes a whole spectrum: from everyday needs (florals, scenics, feminine, masculine, humorous, cute) to every major holiday (from New Year's to Thanksgiving) with a very extensive Christmas line. We continue to grow every year and are always looking for innovative talent."

◨ PANDA INK

Woodland Hills CA 91367. (818)340-8061. Fax: (818)883-6193. E-mail: ruthluvph@socal.rr.com. **Art Director:** Ruth Ann Epstein. Estab. 1982. Produces greeting cards, stationery, calendars and magnets. Products are Judaic, general, everyday, anniversay, etc. Also has a metaphysical line of cards.

Needs Approached by 8-10 freelancers/year. Works with 1-2 freelancers/year. Buys 3-4 freelance designs and illustrations/year. Uses freelancers mainly for design, card ideas. Considers all media. Looking for bright, colorful artwork, no risqué, more ethnic. Prefers 5×7. Produces material for all holidays and seasons, Christmas, Valentine's Day, Mother's Day, Father's Day, Easter, Hanukkah, Passover, Rosh Hashanah, graduation, Thanksgiving, New Year, Halloween, birthdays and everyday. Submit seasonal material 6 months in advance.

First Contact & Terms Send query letter with résumé, SASE, tearsheets and photocopies. Samples are filed. Responds in 1 month. Portfolio review not required. Rights purchased vary according to project. Originals are

returned at job's completion. Pay is negotiable; pays flat fee of $20; royalties of 2% (negotiable). Finds artists through word of mouth and submissions. "We have no guidelines available."

Tips "Looking for bright colors and cute, whimsical art. Be professional. Always send SASE. Make sure art fits company format."

PAPERPRODUCTS DESIGN U.S. INC.

60 Galli Dr., Suite 1, Novato CA 94949. (415)883-1888. Fax: (415)883-1999. E-mail: carol@paperproductdesign.com. **President:** Carol Florsheim. Estab. 1990. Produces paper napkins, plates, designer tissue, giftbags and giftwrap, porcelain accessories. Specializes in high-end design, fashionable designs.

Needs Approached by 50-100 freelancers/year. Buys multiple freelance designs and illustrations/year. Artists do not need to write for guidelines. They may send samples to the attention of Carol Florsheim at any time. Uses freelancers mainly for designer paper napkins. Looking for very stylized/clean designs and illustrations. Prefers 6½×6½. Produces seasonal and everyday material. Submit seasonal material 9 months in advance.

First Contact & Terms Designers send brochure, photocopies, photographs, tearsheets. Samples are not filed and are returned if requested with SASE. Responds in 6 weeks. Request portfolio review of color, final art, photostats in original query. Rights purchased vary according to project. Pays for design and illustration by the project in advances and royalties. Finds freelancers through agents, *Workbook*.

Tips "Shop the stores, study decorative accessories, fashion clothing. Read European magazines. We are a design house."

☑ PARAMOUNT CARDS INC.

400 Pine St., Pawtucket RI 02860. (401)726-0800, ext. 2182. Fax: (401)727-3890. Website: www.paramountcards.com. **Contact:** Freelance Art Coordinator. Estab. 1906. Publishes greeting cards. "We produce an extensive line of seasonal and everyday greeting cards which range from very traditional to whimsical to humorous. Almost all artwork is assigned." Art guidelines on website.

Needs Works with 50-80 freelancers/year. Uses freelancers mainly for finished art. Also for calligraphy. Considers watercolor, gouache, airbrush and acrylic. Prefers 5½×8⁵⁄₁₆. Produces material for all holidays and seasons. Submit seasonal holiday material 1 year in advance.

First Contact & Terms Send query letter, résumé, SASE (important), color photocopies, slides, CDs and printed card samples. Samples are filed only if interested or returned by SASE if requested by artist. Responds in up to 4 months if interested. Company will contact artist for portfolio review if interested. Portfolio should include tearsheets and card samples. Buys all rights. Originals are not returned. Pays by the project, $200-450. Finds artists through word of mouth and submissions.

Tips "Send a complete, professional package. Only include your best work; you don't want us to remember you from one bad piece. Always include SASE with proper postage and *never* send original art; color photocopies are enough for us to see what you can do. No phone calls please."

PATTERN PEOPLE, INC.

10 Floyd Rd., Derry NH 03038. (603)432-7180. **President:** Janice M. Copeland. Estab. 1988. Design studio servicing various manufacturers of consumer products. Designs wallcoverings, textiles and home furnishings.

Needs Approached by 5 freelancers/year. Works with 2 freelance designers/year. Prefers freelancers with professional experience in various media. Uses freelancers mainly for original finished artwork in repeat. "We use all styles but they must be professional." Special needs are "floral (both traditional and contemporary), textural (faux finishes, new woven looks, etc.) and geometric (mainly new wave contemporary)."

First Contact & Terms Send query letter with photocopies and transparencies. Samples are filed. Art Director will contact artist for portfolio review if interested. Portfolio should include original/final art and color samples. Sometimes requests work on spec before assigning a job. Pays for design by the project, $100-1,000. Buys all rights. Finds artists through sourcebooks and other artists.

ⓝ PRATT & AUSTIN COMPANY, INC.

1 Cabot St., Holyoke MA 01040. (800)848-8020 x577. E-mail: bruce@specialtyll.com. **Contact:** Bruce Pratt. Estab. 1931. Produces envelopes, children's items, stationery and calendars. Does not produce greeting cards. "Our market is the modern woman at all ages. Design must be bright, cute, busy and elicit a positive response."

● Now a division of Specialty Loose Leaf Inc.

Needs Approached by 100-200 freelancers/year. Works with 10 freelancers/year. Buys 50-100 designs and illustrations/year. Art guidelines available. Uses freelancers mainly for concept and finished art. Also for calligraphy.

First Contact & Terms Send nonreturnable samples, such as postcard or color copies. Samples are filed or are returned by SASE if requested. Will contact for portfolio review if interested. Portfolio should include thumb-

nails, roughs, color tearsheets and slides. Pays flat fee. Rights purchased vary. Interested in buying second rights (reprint rights) to previously published work. Finds artists through submissions and agents.

THE PRINTERY HOUSE OF CONCEPTION ABBEY

P.O. Box 12, 37112 State Hwy. VV, Conception MO 64433. (660)944-3110. Fax: (660)944-3116. E-mail: art@print eryhouse.org. Website: www.printeryhouse.org. **Art Director:** Brother Michael Marcotte, O.S.B. Creative Director: Ms. Lee Coats. Estab. 1950. Publishes religious greeting cards. Licenses art for greeting cards and wall prints. Specializes in religious Christmas and all-occasion themes for people interested in religious, yet contemporary, expressions of faith. "Our card designs are meant to touch the heart. They feature strong graphics, calligraphy and other appropriate styles."

Needs Approached by 75 freelancers/year. Works with 25 freelancers/year. Art guidelines available on website or for SASE with first-class postage. Uses freelancers for product illustration. Prefers acrylic, pastel, oil, watercolor, line drawings and classical and contemporary calligraphy. Looking for dignified styles and solid religious themes. Produces seasonal material for Christmas and Easter "as well as the usual birthday, get well, sympathy, thank you, etc. cards of a religious nature. Creative general message cards are also needed." Digital work is accepted in Photoshop or Illustrator format.

First Contact & Terms Send query letter with résumé, photocopies, CDs, photographs, SASE, slides or tearsheets. Calligraphers send any printed or finished work. Non-returnable samples preferred—or else samples with SASE. Accepts disk submissions compatible with Photoshop or Illustrator. Send TIFF or EPS files. Responds usually within 3 weeks. To show portfolio, mail appropriate materials only after query has been answered. "In general, we continue to work with artists once we have accepted their work." Pays flat fee of $250-400 for illustration/design, and $50-150 for calligraphy. Usually buys exclusive reproduction rights for a specified format; occasionally buys complete reproduction rights.

Tips "Remember our specific purpose of publishing greeting cards with a definite Christian/religious dimension but not piously religious. It must be good quality artwork. We sell mostly via catalogs so artwork has to reduce well for catalog."

PRISMATIX, INC.

324 Railroad Ave., Hackensack NJ 07601. (201)525-2800 or (800)222-9662. Fax: (201)525-2828. E-mail: prsmati x@optonline.net. **Vice President:** Miriam Salomon. Estab. 1977. Produces novelty humor programs. "We manufacture screen-printed novelties to be sold in the retail market."

Needs Works with 3-4 freelancers/year. Buys 100 freelance designs and illustrations/year. Works on assignment only. 90% of freelance work demands computer skills.

First Contact & Terms Send query letter with brochure, résumé. Samples are filed. Responds only if interested. Portfolio should include color thumbnails, roughs, final art. Payment negotiable.

PRIZM INC.

P.O. Box 1106, Manhattan KS 66505-1106. (785)776-1613. Fax: (785)776-6550. E-mail: michele@pipka.com. **President of Product Development:** Michele Johnson. Produces collectible figurines, decorative housewares, gifts, limited edition plates, ornaments. Manufacturer of exclusive collectible figurine line.

Needs Approached by 20 freelancers/year. Art guidelines free for SASE with first-class postage. Works on assignment only. Uses freelancers mainly for figurines, home decor items. Also for calligraphy. Considers all media. Looking for traditional, old world style, sentimental, folkart. Produces material for Christmas, Mother's Day, everyday. Submit seasonal material 1 year in advance.

First Contact & Terms Send query letter with photocopies, résumé, SASE, slides, tearsheets. Samples are filed. Responds in 2 months if SASE is included. Will contact for portfolio review of color, final art, slides. Rights purchased vary according to project. Pays royalties plus payment advance; negotiable. Finds freelancers through artist submissions, decorative painting industry.

Tips "People seem to be more family oriented—therefore more wholesome and positive images are important. We are interested in looking for new artists and lines to develop. Send a few copies of your work with a concept."

ⓝ PRODUCT CONCEPT MFG.

5061 N. 30th St., #104, Colorado Springs CO 80919. (719)594-4054. Fax: (719)594-4183. **President:** Susan Ross. Estab. 1986. New product development agency. "We work with a variety of companies in the gift and greeting card market in providing design, new product development and manufacturing services."

• This company has recently added children's books to its product line.

Needs Works with 20-25 freelancers/year. Buys 400 designs and illustrations/year. Prefers freelancers with 3-5 years experience in gift and greeting card design. Works on assignment only. Buys freelance designs and illustrations mainly for new product programs. Also for calligraphy, P-O-P display and paste-up. Considers all

media. 25% of freelance work demands knowledge of Illustrator, Streamline, QuarkXPress or FreeHand. Produces material for all holidays and seasons.

First Contact & Terms Send query letter with résumé, tearsheets, photocopies, slides and SASE. Samples are filed or are returned by SASE if requested by artist. Responds in 1 month. To show portfolio, mail color and b&w roughs, final reproduction/product, slides, tearsheets, photostats and photographs. Originals not returned. Pays average flat fee of $300 or pays by the project, $300-2,000. Rights purchased vary according to project.

Tips "Be on time with assignments." Looking for portfolios that show commercial experience.

PRUDENT PUBLISHING

65 Challenger Rd., Ridgefield Park NJ 07660. (201)641-7900. Fax: (201)641-9356. Website: www.gallerycollectio n.com. **Marketing:** Marian Francesco. Estab. 1928. Produces greeting cards. Specializes in business/corporate all-occasion and holiday cards.

Needs Buys calligraphy. Art guidelines available. Uses freelancers mainly for card design, illustrations and calligraphy. Considers traditional media. Prefers no cartoons or cute illustrations. Prefers $5\frac{1}{2} \times 7\frac{7}{8}$ horizontal format (or proportionate to those numbers). Produces material for Christmas, Thanksgiving, birthdays, everyday, sympathy, get well and thank you.

First Contact & Terms Designers, illustrators and calligraphers send query letter with brochure, photostats, photocopies, tearsheets. Samples are filed or returned by SASE if requested. Responds ASAP. Portfolio review not required. Buys all rights. No royalty or licensing arrangements. Payment is negotiable. Finds freelancers through artist's submissions, magazines, sourcebooks, agents and word of mouth.

Tips "No cartoons."

☑ RAINBOW CREATIONS, INC.

216 Industrial Dr., Ridgeland MS 39157. (601)856-2158. Fax: (601)856-5809. E-mail: phillip@rainbowcreations. net. Website: http://rainbowcreations.net. **President:** Steve Thomas. Art Director: Phillip McDaniel. Estab. 1976. Produces wallpaper.

Needs Approached by 10 freelancers/year. Works with 5 freelancers/year. Buys 45 freelance designs and illustrations/year. Prefers freelancers with experience in Illustrator, Photoshop. Art guidelines available on individual project basis. Works on assignment only. Uses freelancers mainly for images that are enlarged into murals. Also for setting designs in repeat. Considers Mac and hand-painted media. 50% of freelance design work demands knowledge of Photoshop and Illustrator. Produces material for everyday.

First Contact & Terms Designers send query letter with photocopies, photographs and résumé. "We will accept disk submissions if compatible with Illustrator 5.0." Samples are returned. Responds in 7 days. Buys all rights. Pays for design and illustration by the project. Payment based on the complexity of design.

Tips "Especially interested in paintings that are appealing to 3-9 year age group."

Gary Patterson's website reads "Creator of Smiles" and his artwork certainly delivers. This illustration, entitled "Cat Nap," has appeared on everything from greeting cards to mouse pads. See more of Patterson's work at www.garypatterson.com.

RECYCLED PAPER GREETINGS INC.

3636 N. Broadway, Chicago IL 60613. (773)348-6410. Fax: (773)281-1697. Website: www.recycledpapergreeti ngs.com. **Art Directors:** Gretchen Hoffman, John LeMoine. Publishes greeting cards and adhesive notes.

Needs Buys 1,000-2,000 freelance designs and illustrations. Considers b&w line art and color—"no real restrictions." Looking for "great ideas done in your own style with messages that reflect your own slant on the world." Prefers 5×7 vertical format for cards. "Our primary interest is greeting cards." Produces seasonal material for all major and minor holidays including Jewish holidays. Submit seasonal material 18 months in advance; everyday cards are reviewed throughout the year.

First Contact & Terms Send SASE to the Art Department or view website for artist's guidelines. "Please do not

send slides or tearsheets. We're looking for work done specifically for greeting cards.''Responds in 2 months. Portfolio review not required. Originals returned at job's completion. Sometimes requests work on spec before assigning a job. Pays average flat fee of $250 for illustration/design with copy. Some royalty contracts. Buys card rights.

Tips ''Remember that a greeting card is primarily a message sent from one person to another. The art must catch the customer's attention, and the words must deliver what the front promises. We are looking for unique points of view and manners of expression. Our artists must be able to work with a minimum of direction and meet deadlines. There is a renewed interest in the use of recycled paper; we have been the industry leader in this for over three decades.''

RIGHTS INTERNATIONAL GROUP

463 First St. #3C, Hoboken NJ 07030. (201)239-8118. Fax: (201)222-0694. E-mail: rhazaga@rightsinternational.com. Website: www.rightsinternational.com. **Contact:** Robert Hazaga. Estab. 1996. Agency for cross licensing. Licenses images for manufacturers of giftware, stationery, posters, home furnishing.

• This company also has a listing in the Posters & Prints section.

Needs Approached by 50 freelancers/year. Uses freelancers mainly for creative, decorative art for the commercial and designer market. Also for textile art. Considers oil, acrylic, watercolor, mixed media, pastels and photography.

First Contact & Terms Send brochure, photocopies, photographs, SASE, slides, tearsheets or transparencies. Accepts disk submissions compatible with PC format. Responds in 1 month. Will contact for portfolio review if interested. Negotiates rights purchased and payment.

RITE LITE LTD./THE JACOB ROSENTHAL JUDAICA-COLLECTION

333 Stanley Ave., Brooklyn NY 11207. (718)498-1700. Fax: (718)498-1251. E-mail: alex@riteliteltd.com. **President:** Alex Rosenthal. Estab. 1948. Manufacturer and distributor of a full range of Judaica ranging from mass-market commercial goods, such as decorative housewares, to exclusive numbered pieces, such as limited edition plates. Clients: department stores, galleries, gift shops, museum shops and jewelry stores.

• Company is looking for new menorah, mezuzah, children's Judaica, Passover and matza plate designs.

Needs Approached by 15 freelancers/year. Works with 4 freelancers/year. Art guidelines not available. Works on assignment only. Uses freelancers mainly for new designs for Judaic giftware. Must be familiar with Jewish ceremonial objects or design. Prefers ceramic, brass and glass. Also uses artists for brochure and catalog design, illustration and layout mechanicals, P-O-P and product design. 25% of freelance work requires knowledge of Illustrator and Photoshop. Produces material for Hannukkah, Passover, Hasharah. Submit seasonal material 1 year in advance.

First Contact & Terms Designers send query letter with brochure or résumé and photographs. Illustrators send photocopies. Do not send originals. Samples are filed. Responds in 1 month only if interested. Portfolio review not required. Art Director will contact for portfolio review if interested. Portfolio should include color tearsheets, photographs and slides. Pays flat fee of $500/design or royalties of 5-6%. Buys all rights. ''Works on a royalty basis.'' Finds artists through word of mouth.

Tips ''Be open to the desires of the consumers. Don't force your preconceived notions on them through the manufacturers. Know that there is one retail price, one wholesale price and one distributor price.''

ROCKSHOTS GREETING CARDS

20 Vandam St., 4th Floor, New York NY 10013-1274. (212)243-9661. Fax: (212)604-9060. **Editor:** Bob Vesce. Estab. 1979. Produces calendars, giftbags, giftwrap, greeting cards, mugs. ''Rockshots is an outrageous, sometimes adult, always hilarious card company. Our themes are sex, birthdays, sex, holiday, sex, all occasion and sex. Our images are mainly photographic, but we also seek out cartoonists and illustrators.''

Needs Approached by 10-20 freelancers/year. Works with 5-6 freelancers/year. Buys 10 freelance designs and illustrations/year. Art guidelines free for SASE with first-class postage. ''We like a line that has many different facets to it, encompassing a wide range of looks and styles. We are outrageous, adult, witty, off-the-wall, contemporary and sometimes shocking.'' Prefers any size that can be scaled on a greeting card to 5 inches by 7 inches. 10% of freelance illustration demands computer skills. Produces material for Christmas, New Year, Valentine's Day, birthdays, everyday, get well, woman to woman (''some male bashing allowed'') and all adult themes.

First Contact & Terms Illustrators and/or cartoonists send photocopies, photographs and photostats. Samples are filed. Responds only if interested. Portfolio review not required. Buys first rights. Pays per image.

Tips ''As far as trends go in the greeting card industry, we've noticed that 'retro' refuses to die. Vintage looking cards and images still sell very well. People find comfort in the nostalgic look of yesterday. Sex also is a huge seller. Rockshots is looking for illustrators that can come up with something a little out of mainstream. Our look is outrageous, witty, adult and sometimes shocking. Our range of style starts at cute and whimsical and runs the gamut all the way to totally wacky and unbelievable. Rockshots cards definitely stand out from the competition.

For our line of illustrations, we look for a style that can convey a message, whether through a detailed elaborate colorful piece of art or a simple 'gesture' drawing. Characters work well, such as the ever-present wisecracking granny to the nerdy 'everyman' guy. It's always good to mix sex and humor, as sex always sells. As you can guess, we do not shy away from much. Be creative, be imaginative, be funny, but most of all, be different.''

ROMAN, INC.

555 Lawrence Ave., Roselle IL 60172-1599. (630)529-3000. Fax: (630)529-1121. E-mail: dswetz@roman.com. Website: www.roman.com. **Vice President:** Julie Puntch. Estab. 1963. Produces collectible figurines, decorative housewares, decorations, gifts, limited edition plates, ornaments. Specializes in collectibles and giftware to celebrate special occasions.

Needs Approached by 25-30 freelancers/year. Works with 3-5 freelancers/year. Uses freelancers mainly for graphic packaging design, illustration. Also for a variety of services. Considers variety of media. Looking for traditional-based design. Roman also has an inspirational niche. 80% of freelance design and illustration demands knowledge of Photoshop, QuarkXPress, Illustrator. Produces material for Christmas, Mother's Day, graduation, Thanksgiving, birthdays, everyday. Submit seasonal material 1 year in advance.

First Contact & Terms Send query letter with photocopies. Samples are filed or returned by SASE. Responds in 2 months if artist requests a reply. Portfolio review not required. Pays by the project, varies. Finds freelancers through word of mouth, artists' submissions.

RUBBERSTAMPEDE

2550 Pellisier Place, Whittier CA 90601. (562)695-7969. Fax: (800)546-6888. E-mail: ochoa@dtccorp.com. Website: www.deltacrafts.com. **Senior Marketing Manager:** Olive Choa. Design Manager: Grace Taormina. Estab. 1978. Produces art and novelty rubber stamps, kits, glitter pens, ink pads, papers, stickers, scrapbooking products.

Needs Approached by 30 freelance artists/year. Works with 10-20 freelance artists/year. Buys 200-300 freelance designs and illustrations/year. Uses freelance artists for calligraphy, P-O-P displays, and original art for rubber stamps. Considers pen & ink. Looks for whimsical, feminine style and fashion trends. Produces seasonal material: Christmas, Valentine's Day, Easter, Hanukkah, Thanksgiving, Halloween, birthdays and everyday (includes wedding, baby, travel, and other life events). Submit seasonal material 6 months in advance.

First Contact & Terms Send nonreturnable samples. Samples are filed. Responds only if interested. Pays by the hour, $15-50; by the project, $50-1,000. Rights purchased vary according to project. Originals are not returned.

RUSS BERRIE AND COMPANY

111 Bauer Dr., Oakland NJ 07436. (800)631-8465. **Director Paper Goods:** Penny Shaw. Produces greeting cards, bookmarks and calendars. Manufacturer of impulse gifts for all age groups.

• This company is no longer taking unsolicited submissions.

N SANGRAY CORPORATION

2318 Lakeview Ave., Pueblo CO 81004. (719)564-3408. Fax: (719)564-0956. E-mail: linda@sangray.com. Website: www.sangray.com. **Licensing:** Vern Estes. Licenses art for gift and novelty. Estab. 1971. Produces refrigerator magnets, trivets, wall decor and other decorative accessories—all using full-color art. Art guidelines for SASE with first-class postage.

Needs Approached by 30-40 freelancers/year. Works indirectly with 6-7 freelancers/year. Buys 25-30 freelance designs and illustrations/year. Prefers florals, scenics, small animals and birds. Uses freelancers mainly for fine art for products. Considers all media. Prefers 7×7 or digital. Submit seasonal material 10 months in advance.

First Contact & Terms Send query letter with examples of work in any media. Samples are filed. Responds in 1 month. Company will contact artist for portfolio review if interested. Buys first rights. Originals are returned at job's completion. Pays by the project or royalty. Finds artists through submissions and design studios.

Tips "Try to get a catalog of the company products and send art that closely fits the style the company tends to use.''

☑ ⊕ ▢ SECOND NATURE, LTD.

10 Malton Rd., London, W105UP England. (020)8960-0212. Fax: (020)8960-8700. E-mail: contact@secondnatur e.co.uk. Website: www.secondnature.co.uk. **Contact:** Rod Schragger. Greeting card publisher specializing in unique 3-D/handmade cards and special finishes.

Needs Prefers interesting new contemporary but commercial styles. Also calligraphy and web design. Art guidelines available. Produces material for Christmas, Valentine's Day, Mother's Day and Father's Day. Submit seasonal material 19 months in advance.

First Contact & Terms Send query letter with samples showing art style. Samples not filed are returned only

if requested by artist. Responds in 2 months. Originals are not returned at job's completion. Pays flat fee.
Tips "We are interested in all forms of paper engineering or anything fresh and innovative."

ℕ THE SEPIA COLLECTION

P.O. Box 14334, Arlington TX 76094. E-mail: kim@thesepiacollection.com. Website: www.thesepiacollection.com. **Contact:** Kimberly See. Estab. 2003. Produces stationery. Specializes in multicultural stationery and invitations.

Needs Approached by 10-12 freelancers/year. Works with 5-6 freelancers/year. Buys 15-20 freelance designs and/or illustrations/year. Considers all media. Product categories include African-American, cute, and Hispanic. Produces material for all holidays and seasons, birthday, graduation and woman-to-woman. Submit seasonal material 8 months in advance. Art size varies, please discuss with contact. 75% of freelance work demands knowledge of FreeHand, Illustrator, QuarkXPress and Photoshop.

First Contact & Terms Send query letter with photocopies, résumé and SASE. Accepts e-mail submissions with image file. Prefers Windows-compatible, JPEG files. Samples are filed. Responds only if interested. Company will contact artist for portfolio review if interested. Portfolio should include color, finished art, roughs and thumbnails. Buys all rights and reprint rights. Pays freelancers by the project. Finds freelancers through artists' submissions.

SOURIRE

P.O. Box 1659, Old Chelsea Station, New York NY 10011. (718)573-4624. Fax: (718)573-5150. E-mail: greetings @cardsorbust.com. Website: www.cardsorbust.com. **Contact:** Submissions. Estab. 1998. Produces giftbags, giftwrap/wrapping paper, greeting cards, stationery, T-shirts. Specializes in exclusive designs for holidays and occasions. Target market is Black American and multiethnic men and women between ages 20 and 60.

Needs Approached by 50 freelancers/year. Buys 20 freelance designs and/or illustrations/year. Art guidelines free with SASE and first-class postage. Uses freelancers mainly for graphics, paintings, illustrations. Considers all media. Product categories include wedding, alternative/humor, cute, historical, handcrafted. Produces material for all holidays and seasons. Submit seasonal material 6 months in advance.

First Contact & Terms Send query letter and postcard sample with brochure, photocopies, SASE, tearsheets, URL. Samples are filed. If they are not filed, samples are returned by SASE. Responds in 3 months. Portfolio not required. Rights purchased vary according to project. Pays freelancers by the project, royalties or flat fee. Finds freelancers through artists' submissions and word of mouth.

✔ SPARROW & JACOBS

6701 Concord Park Dr., Houston TX 77040. (713)329-9400. Fax: (713)744-8799. E-mail: sparrowart@gabp.com. **Contact:** Product Merchandiser. Estab. 1986. Produces calendars, greeting cards, postcards and other products for the real estate industry.

Needs Buys up to 100 freelance designs and illustrations/year including illustrations for postcards and greeting cards. Considers all media. Looking for new product ideas featuring residential front doors, flowers, landscapes, animals, holiday themes and much more. "Our products range from, but are not limited to, humourous illustrations and comical cartoons to classical drawings and unique paintings." Produces material for Christmas, Easter, Mother's Day, Father's Day, Halloween, New Year, Thanksgiving, Valentine's Day, birthdays, everyday, time change. Submit seasonal material 1 year in advance.

First Contact & Terms Send query letter with color photocopies, photographs or tearsheets. We also accept e-mail submissions of low-resolution images. If sending slides, do not send originals. We are not responsible for slides lost or damaged in the mail. Samples are filed or returned in your SASE.

A SWITCH IN ART, Gerald F. Prenderville, Inc.

P.O. Box 246, Monmouth Beach NJ 07750. (732)389-4912. Fax: (732)389-4913. E-mail: aswitchinart@aol.com. **President:** G.F. Prenderville. Estab. 1979. Produces decorative switch plates. "We produce decorative switch plates featuring all types of designs including cats, animals, flowers, kiddies/baby designs, birds, etc. We sell to better gift shops, museums, hospitals, specialty stores, with large following in mail order catalogs."

Needs Approached by 4-5 freelancers/year. Works with 2-3 freelancers/year. Buys 10-20 designs and illustrations/year. Prefers artists with experience in card industry and cat rendering. Seeks cats and wildlife art. Prefers 8×10 or 10×12. Submit seasonal material 6 months in advance.

First Contact & Terms Send query letter with brochure, tearsheets and photostats. Samples are filed and are returned. Responds in 3-5 weeks. Pays by the project, $75-150. Interested in buying second rights (reprint rights) to previously published artwork. Finds artists mostly through word of mouth.

Tips "Be willing to accept your work in a different and creative form that has been very successful. We seek to go vertical in our design offering to insure continuity. We are very easy to work with and flexible. Cats have a huge following among consumers, but designs must be realistic."

☑ SYRACUSE CULTURAL WORKERS

Box 6367, Syracuse NY 13217. (315)474-1132. Fax: (877)265-5399. E-mail: scw@syrculturalworkers.com. Website: www.syrculturalworkers.com. **Art Director:** Karen Kerney. Estab. 1982. Syracuse Cultural Workers publishes and distributes peace and justice resources through their Tools For Change catalog. Produces posters, notecards, postcards, greeting cards, T-shirts and calendars that are feminist, progressive, radical, multicultural, lesbian/gay allied, racially inclusive and honoring of elders and children.

- SCW is specifically seeking artwork celebrating diverstiy, people's history and community building. Themes include environment, positive parenting, positive gay and lesbian images, multiculturalism and cross-cultural adoption.

Needs Approached by many freelancers/year. Works with 50 freelancers/year. Buys 40-50 freelance fine art images and illustrations/year. Considers all media (in slide form). Art guidelines available on website or free for SASE with first-class postage. Looking for progressive, feminist, liberating, vital, people- and earth-centered themes. "December and January are major art selection months."

First Contact & Terms Send query letter with slides, brochures, photocopies, photographs, SASE, tearsheets and transparencies. Samples are filed or returned by SASE. Responds in 1 month with SASE. Will contact for portfolio review if interested. Buys one-time rights. Pays flat fee of $85-450; royalties of 4-6% gross sales. Finds artists through word of mouth, our own artist list and submissions.

Tips "Please do NOT send original art or slides. Rather, send photocopies, printed samples or duplicate slides. Also, one postcard sample is not enough for us to judge whether your work is right for us. We'd like to see at least three or four different images. Include return postage if you would like your artwork/slides returned."

☑ 🏛 TALICOR, INC.

901 Lincoln Parkway, Plainwell MI 49080. (269)685-2345. E-mail: nikkih@talicor.com. Website: www.talicor.com. **President:** Nikki Hancock. Chairman of the Board: Lew Herndon. Estab. 1971. Manufacturer and distributor of educational and entertainment games and toys. Clients: chain toy stores, department stores, specialty stores and Christian bookstores.

Needs Works with 4-6 freelance illustrators and designers/year. Prefers local freelancers. Works on assignment only. Uses freelancers mainly for game design. Also for advertising, brochure and catalog design, illustration and layout; product design; illustration on product; P-O-P displays; posters and magazine design.

First Contact & Terms Send query letter with tearsheets, samples or postcards. Samples are not filed and are returned only if requested. Responds only if interested. Call or write for appointment to show portfolio. Pays for design and illustration by the project, $100-3,000. Negotiates rights purchased. Accepts digital submissions via e-mail.

TJ'S CHRISTMAS

14855 W. 95th St., Lenexa KS 66215. (913)888-8338. Fax: (913)888-8350. E-mail: mitch@imitchell.com. Website: www.imitchell.com. **Creative Coordinator:** Edward Mitchell. Estab. 1983. Produces figurines, decorative accessories, ornaments and other Christmas adornments. Primarily manufactures and imports Christmas ornaments, figurines and accessories. Also deals in some Halloween, Thanksgiving, gardening and everyday home decor items. Clients: higher-end floral, garden, gift and department stores.

Needs Uses freelancers mainly for unique and innovative designs. Considers most media. "Our products are often nostalgic, bringing back childhood memories. They also should bring a smile to your face. We are looking for traditional designs that fit with our motto, 'Cherish the Memories.' " Produces material for Christmas, Halloween, Thanksgiving and everyday. Submit seasonal material 18 months in advance.

First Contact & Terms Send query letter with résumé, SASE and photographs. Will accept work on disk. Portfolios may be dropped off Monday-Friday. Samples are not filed and are returned by SASE. Responds in 1 month. Negotiates rights purchased. Pays advance on royalties of 5%. Terms are negotiated. Finds freelancers through magazines, word of mouth and artists' reps.

Tips "Continually search for new and creative ideas. Sometimes silly, cute ideas turn into the best sellers (i.e., sad melting snowmen with a sign saying 'I Miss Snow'). Watch for trends (such as increasing number of baby boomers that are retiring). Try to target the trends you see. Think from the viewpoint of a consumer walking around a small gift store."

🏛 VAGABOND CREATIONS INC.

2560 Lance Dr., Dayton OH 45409. (937)298-1124. E-mail: vagabond@siscom.net. Website: www.vagabondcreations.com. **Art Director:** George F. Stanley, Jr. Publishes stationery and greeting cards with contemporary humor. 99% of artwork used in the line is provided by staff artists working with the company.

- Vagabond Creations Inc. now publishes a line of coloring books.

Needs Works with 3 freelancers/year. Buys 6 finished illustrations/year. Prefers local freelancers. Seeking line drawings, washes and color separations. Material should fit in standard-size envelope.

First Contact & Terms Query. Samples are returned by SASE. Responds in 2 weeks. Submit Christmas, Valentine's Day, everyday and graduation material at any time. Originals are returned only upon request. Payment negotiated.

Tips "Important! Currently we are *not* looking for additional freelance artists because we are very satisfied with the work submitted by those individuals working directly with us. We do not in any way wish to offer false hope to anyone, but it would be foolish on our part not to give consideration. Our current artists are very experienced and have been associated with us in some cases for over 30 years."

WANDA WALLACE ASSOCIATES

323 E. Plymouth, Suite 2, Inglewood CA 90302. (310)419-0376. Fax: (310)419-0382. **President:** Wanda Wallace. Estab. 1980. Nonprofit organization produces greeting cards and posters for general public appeal. "We produce black art prints, posters, originals and other media."

• This publisher is doing more educational programs, touring schools nationally with artists.

Needs Approached by 10-12 freelance artists/year. Works with varying number of freelance artists/year. Buys varying number of designs and illustrations/year from freelance artists. Prefers artists with experience in black/ethnic art subjects. Uses freelance artists mainly for production of originals and some guest appearances. Considers all media. Produces material for Christmas. Submit seasonal material 4-6 months in advance.

First Contact & Terms Send query letter with any visual aid. Some samples are filed. Policy varies regarding answering queries and submissions. Call or write to schedule an appointment to show a portfolio. Rights purchased vary according to project. Art education instruction is available. Pays by the project.

WHITEGATE FEATURES SYNDICATE

71 Faunce Dr., Providence RI 02906. (401)274-2149. **Contact:** Eve Green.

• This syndicate is looking for fine artists and illustrators. See their listing in Syndicates for more information about their needs.

Magazines

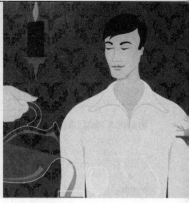

M agazines are a bonanza for freelance illustrators. The best proof of this fact is as close as your nearest newsstand. The colorful publications competing for your attention are chock-full of interesting illustrations, cartoons and caricatures. Since magazines are generally published on a monthly or bimonthly basis, art directors look for dependable artists who can deliver on deadline and produce quality artwork with a particular style and focus.

Art that illustrates a story in a magazine or newspaper is called editorial illustration. You'll notice that term as you browse through the listings. Art directors look for the best visual element to hook the reader into the story. In some cases this is a photograph, but often, especially in stories dealing with abstract ideas or difficult concepts, an illustration makes the story more compelling. A whimsical illustration can set the tone for a humorous article, for example, or an edgy caricature of movie stars in boxing gloves might work for an article describing conflicts within a film's cast. Flip through a dozen magazines in your local drugstore and you will quickly see that each illustration conveys the tone and content of articles while fitting in with the magazine's "personality."

The key to success in the magazine arena is matching your style to appropriate publications. Art directors work to achieve a synergy between art and text, making sure the artwork and editorial content complement each other.

TARGET YOUR MARKETS

Read each listing carefully. Within each listing are valuable clues. Knowing how many artists approach each magazine will help you understand how stiff your competition is. (At first, you might do better submitting to art directors who aren't swamped with submissions.) Look at the preferred subject matter to make sure your artwork fits the magazine's needs. Note the submission requirements and develop a mailing list of markets you want to approach.

Visit newsstands and bookstores. Look for magazines not listed in *Artist's & Graphic Designer's Market*. Check the cover and interior. If illustrations are used, flip to the masthead (usually a box in one of the beginning pages) and note the art director's name. The circulation figure is relevant too. As a rule of thumb, the higher the circulation, the higher the art director's budget. When art directors have a good budget, they tend to hire more illustrators and pay higher fees. Look at the illustrations and check the illustrator's name in the credit line in small print to the side of the illustration. Notice which illustrators are used often in the publications you wish to work with. You will notice that each illustrator they chose has a very definite style. After you have studied the illustrations in dozens of magazines, you will understand what types of illustrations are marketable.

Although many magazines can be found at a newsstand or library, some of your best markets may not be readily available on newsstands. If you can't find a magazine, check the listing in *Artist & Graphic Designer's Market* to see if sample copies are available. Keep in mind that many magazines also provide artists' guidelines on their websites.

CREATE A PROMO SAMPLE

Focus on one or two *consistent* styles to present to art directors in sample mailings. See if you can come up with a style that is different from every other illustrator's style, if only slightly. No matter how versatile you may be, limit styles you market to one or two. That way, you'll be more memorable to art directors. Pick a style or styles you enjoy and can work quickly in. Art directors don't like surprises. If your sample shows a line drawing, they expect you to work in that style when they give you an assignment. It's fairly standard practice to mail nonreturnable samples: either postcard-size reproductions of your work, photocopies or whatever is requested in the listing. Some art directors like to see a résumé; some don't. Look on pages 19-25 for some examples of good promotional pieces.

MORE MARKETING TIPS

- **Don't overlook trade magazines and regional publications.** While they may not be as glamorous as national consumer magazines, some trade and regional publications are just as lavishly produced. Most pay fairly well and the competition is not as fierce. Until you can get some of the higher circulation magazines to notice you, take assignments from smaller magazines, too. Alternative weeklies are great markets as well. Despite their modest payment, there are many advantages. You learn how to communicate with art directors, develop your signature style and learn how to work quickly to meet deadlines. Once the assignments are done, the tearsheets become valuable samples to send to other magazines.
- **Develop a spot illustration style in addition to your regular style.** "Spots"—illustrations that are half-page or smaller—are used in magazine layouts as interesting visual cues to lead readers through large articles or to make filler articles more appealing. Though the fee for one spot is less than for a full layout, art directors often assign five or six spots within the same issue to the same artist. Because spots are small in size, they must be all the more compelling. So send art directors a sample showing several power-packed small pieces along with your regular style.
- **Invest in a fax machine, e-mail and graphics software.** Art directors like to work with illustrators with fax machines and e-mail, because they can quickly fax or e-mail a layout with a suggestion. The artist can send back a preliminary sketch or "rough" the art director can OK. Also they will appreciate it if you can e-mail TIFF, EPS or JPEG files of your work.
- **Get your work into competition annuals and sourcebooks.** The term "sourcebook" refers to the creative directories published annually showcasing the work of freelancers. Art directors consult these publications when looking for new styles. If an art director uses creative directories, we often include that information in the listings to help you understand your competition. Some directories like *Black Book*, *The American Showcase* and *RSVP* carry paid advertisements costing several thousand dollars per page. Other annuals, like the *Print Regional Design Annual* or *Communication Art Illustration Annual* feature award winners of various competitions. An entry fee and some great work can put your work in a competition directory and in front of art directors across the country.

Magazines

- **Consider hiring a rep.** If after working successfully on several assignments you decide to make magazine illustration your career, consider hiring an artists' representative to market your work for you. (See the Artists' Reps section, page 556.)

Helpful resources

For More Info

- A great source for new magazine leads is in the business section of your local library. Ask the librarian to point out the business and consumer editions of the *Standard Rate and Data Service (SRDS)* and *Bacon's Magazine Directory*. These huge directories list thousands of magazines and will give you an idea of the magnitude of magazines published today. Another good source is a yearly directory called *Samir Husni's Guide to New Consumer Magazines* also available in the business section of the public library. Also read *Folio* magazine to find out about new magazine launches and redesigns.

- Each year the Society of Publication Designers sponsors a juried competition called, appropriately, SPOTS. The winners are featured in a prestigious exhibition. For information about the annual competition, contact the Society of Publication Designers at (212)983-8585 or visit their website at www.spd.org.

- Networking with fellow artists and art directors will help you find additional success strategies. The Graphic Artist's Guild, The American Institute of Graphic Artists (AIGA), your city's Art Director's Club or branch of the Society of Illustrators holds lectures and networking functions. Attend one event sponsored by each organization in your city to find a group you are comfortable with. Then join and become an active member.

Ⓝ AARP THE MAGAZINE

(formerly Modern Maturity), 601 E Street NW, Washington DC 20049. (202)434-2277. Fax: (202)434-6451. Website: www.aarpmagazine.org. **Design Director:** Eric Seidman. Art Director: Courtney Murphy-Price. Estab. 2002. Bimonthly 4-color magazine emphasizing health, lifestyles, travel, sports, finance and contemporary activities for members 50 years and over. Circ. 21 million. Originals are returned after publication.

• In 2002, *Modern Maturity* and *My Generation* merged to form *AARP The Magazine*.

Illustration Approached by 200 illustrators/year. Buys 30 freelance illustrations/issue. Assigns 60% of illustrations to well-known or "name" illustrators; 30% to experienced but not well-known illustrators; 10% to new and emerging illustrators. Works on assignment only. Considers digital, watercolor, collage, oil, mixed media and pastel.

First Contact & Terms Samples are filed "if I can use the work." Do not send portfolio unless requested. Portfolio can include original/final art, tearsheets, slides and photocopies and samples to keep. Buys first rights. Pays on completion of project; $700-3,500.

Tips "We generally use people with strong conceptual abilities. I request samples when viewing portfolios."

AD ASTRA

1620 I St. NW, Suite 615, Washington DC 20006. (202)429-1600. Fax: (202)463-8497. E-mail: adastra.editor@nss .org. Website: www.nss.org. **Editor-in-Chief:** Irene Mona Klotz. Estab. 1989. Quarterly feature magazine popularizing and advancing space exploration and development for the general public interested in all aspects of the space program.

Illustration Works with 40 freelancers/year. Uses freelancers for magazine illustration. Buys 10 illustrations/year. "We are looking for original artwork on space themes, either conceptual or representing specific designs, events, etc." Prefers acrylics, then oils and collage.

Design Needs freelancers for multimedia design. 100% of freelance work requires knowledge of Photoshop, QuarkXPress and Illustrator.

First Contact & Terms Illustrators: Send postcard sample or slides. "Color slides are best." Designers send query letter with brochure and photographs. Samples not filed are returned by SASE. Responds in 6 weeks. Pays $100-300 color cover; $25-100 color inside. "We do commission original art from time to time." Fees are for one-time reproduction of existing artwork. Considers rights purchased when establishing payment. Pays designers by the project.

Tips "Show a set of slides showing planetary art, spacecraft and people working in space. I do not want to see 'science-fiction' art. Label each slide with name and phone number. Understand the freelance assignments are usually made far in advance of magazine deadline."

☑ ADVANSTAR MEDICAL ECONOMICS

(formerly Thomson Medical Economics), Five Paragon Dr., 2nd Floor, Montvale NJ 07645. (973)944-7777. **Art Coordinator:** Sindi Price. Estab. 1909. Publishes 11 health related publications and special products. Interested in all media, including electronic and traditional illustrations. Accepts previously published material. Originals are returned at job's completion. Uses freelance artists for "all editorial illustration in the magazines."

Cartoons Prefers general humor topics: workspace, family, seasonal; also medically related themes. Prefers single panel b&w drawings and washes with gagline.

Illustration Prefers all media including 3-D illustration. Needs editorial and medical illustration that varies "but is mostly on the conservative side." Works on assignment only.

First Contact & Terms Cartoonists: Submissions accepted twice a year—in January and July **only**. Send unpublished cartoons only with SASE to Liz O'Brien, cartoon editor. Pays $150. Buys first world publication rights. Illustrators: Send samples to Sindi Price. Samples are filed. Responds only if interested. Write for portfolio review. Buys one-time rights. Pays $1,000-1,500 for color cover; $200-600 for b&w, $250-800 for color inside.

ADVENTURE CYCLIST

150 E. Pine St, Missoula MT 59802. (406)721-1776. Fax: (406)721-8754. E-mail: gsiple@adventurecycling.org. Website: www.adventurecycling.org. **Art Director:** Greg Siple. Estab. 1974. Published 9 times/year. A journal of adventure travel by bicycle. Circ. 30,000. Originals returned at job's completion. Sample copies available.

Illustration Buys 1 illustration/issue. Has featured illustrations by Margie Fullmer, Ludmilla Tomova and Kelly Sutherland. Works on assignment only.

First Contact & Terms Illustrators: Send printed samples. Samples are filed. Publication will contact artist for portfolio review if interested. Pays on publication, $50-350. Buys one-time rights.

ADVOCATE, PKA'S PUBLICATION

1881 Co. Rt. 2, Prattsville NY 12468. (518)299-3103. **Art Editor:** C.J. Karlie. Estab. 1987. Bimonthly b&w literary tabloid. "*Advocate* provides aspiring artists, writers and photographers the opportunity to see their works

published and to receive byline credit toward a professional portfolio so as to promote careers in the arts." Circ. 12,000. "Good quality photocopy or stat of work is acceptable as a submission." Sample copies with writers guidelines available for $4.00 with SASE.

• The Gaited Horse Association Newsletter is published within the pages of *Advocate, PKA's Publication*.
Cartoons Open to all formats.
Illustration Buys 10-15 illustrations/issue. Considers pen & ink, charcoal, linoleum-cut, woodcut, lithograph, pencil or photos, "either b&w or color prints (no slides). We are especially looking for horse-related art and other animals." Also needs editorial and entertainment illustration.
First Contact & Terms Cartoonists: Send query letter with SASE and submissions for publication. Illustrators: Send query letter with SASE and photos of artwork (b&w or color prints only). No simultaneous submissions. Samples are not filed and are returned by SASE. Portfolio review not required. Responds in 6 weeks. Buys first rights. Pays cartoonists/illustrators in contributor's copies. Finds artists through submissions and from knowing artists and their friends.
Tips "No postcards are acceptable. Many artists send us postcards to review their work. They are not looked at. Artwork should be sent in an envelope with a SASE."

N AGING TODAY

833 Market St., San Francisco CA 94103. (415)974-9619. Fax: (415)974-0300. Website: www.asaging.org. **Editor:** Paul Kleyman. Estab. 1979. "*Aging Today* is the bimonthly black & white newspaper of The American Society on Aging. It covers news, public policy issues, applied research and developments/trends in aging." Circ. 15,000. Accepts previously published artwork. Originals returned at job's completion if requested. Sample copies available for SASE with 77¢ postage.
Cartoons Approached by 50 cartoonists/year. Buys 1-2 cartoons/issue. Prefers political and social satire cartoons; single, double or multiple panel with or without gagline, b&w line drawings. Samples returned by SASE. Responds only if interested. Buys one-time rights.
Illustration Approached by 50 illustrators/year. Buys 1 illustration/issue. Works on assignment only. Prefers b&w line drawings and some washes. Considers pen & ink. Needs editorial illustration.
First Contact & Terms Cartoonists: Send query letter with brochure and roughs. Illustrators: Send query letter with brochure, SASE and photocopies. Pays cartoonists $15-25 for b&w. Samples are not filed and are returned by SASE. Responds only if interested. To show portfolio, artist should follow up with call and/or letter after initial query. Buys one-time rights. Pays on publication; pays illustrators $25 for b&w cover; $25 for b&w inside.
Tips "Send brief letter with two or three applicable samples. Don't send hackneyed cartoons that perpetuate ageist stereotypes."

N AGONYINBLACK, VARIOUS COMIC BOOKS

E-mail: editor@chantingmonks.com. Website: www.chantingmonks.com. **Editor:** Pamela Hazelton. Estab. 1994. Bimonthly "illustrated magazine of horror" for mature readers. Circ. 4-6,000. Art guidelines for #10 SASE with first-class postage.
Illustration Approached by 200-300 illustrators/year. Buys 5 illustrations/issue. Has featured illustrations by Bernie Wrightson, Louis Small and Ken Meyer. Features realistic and spot illustration. Assigns 50% of illustrations to well-known or "name" illustrators; 30% to experienced but not well-known illustrators; 20% to new and emerging illustrators. Prefers horror, disturbing truth. Considers all media.
First Contact & Terms Illustrators: Send query letter with printed samples, photocopies, SASE or tearsheets. Send follow-up samples every 3 months. Accepts disk submissions compatible with Photoshop, PageMaker files only or TIFFs, GIFs, JPG; no e-mail uploads. Samples are filed. Responds in 9 weeks. Buys first North American serial rights. Pays on publication; $50-300 for b&w cover; $25-50 maximum for spots. Will discuss payment for spots. Finds illustrators through conventions and referrals.
Tips "We publish comic books and occasionally pinup books. We mostly look for panel and sequential art. Please have a concept of sequential art. Please inquire via e-mail for all submissions."

N AIM

Box 1174, Maywod IL 60153. (312)874-6184. Website: www.aimmagazine.org. **Editor-in-Chief:** Ruth Apilado. Managing Editor: Dr. Myron Apilado. Estab. 1973. 8½×11 b&w quarterly with 2-color cover. Readers are those "wanting to eliminate bigotry and desiring a world without inequalities in education, housing, etc." Circ. 7,000. Responds in 3 weeks. Accepts previously published, photocopied and simultaneous submissions. Sample copy $5; artist's guidelines for SASE.
Cartoons Approached by 12 cartoonists/week. Buys 10-15 cartoons/year. Uses 1-2 cartoons/issue. Prefers education, environment, family life, humor in youth, politics and retirement; single panel with gagline. Especially needs "cartoons about the stupidity of racism."
Illustration Approached by 4 illustrators/week. Uses 4-5 illustrations/issue; half from freelancers. Prefers pen

& ink. Prefers current events, education, environment, humor in youth, politics and retirement.

First Contact & Terms Cartoonists: Send samples with SASE. Illustrators: Provide brochure to be kept on file for future assignments. Samples not returned. Responds in 1 month. Prefers b&w for cover and inside art. Buys all rights on a work-for-hire basis. Pays on publication. Pays cartoonists $5-15 for b&w line drawings. Pays illustrators $25 for b&w cover illustrations.

Tips "We could use more illustrations and cartoons with people from all ethnic and racial backgrounds in them. We also use material of general interest. Artists should show a representative sampling of their work and target the magazine's specific needs. Nothing on religion."

☐ ⚡ AKC GAZETTE

260 Madison Ave., 4th Floor, New York NY 10016. (212)696-8370. Fax: (212)696-8299. E-mail: gazette@akc.org. Website: www.akc.org. **Creative Director:** Tilly Grassa. Estab. 1889. Monthly consumer magazine about "breeding, showing, and training pure-bred dogs." Circ. 58,000. Sample copy available for 9×12 SASE.

- Also publishes *AKC Family Dog* (circ. 200,000) four times a year.

Illustration Approached by 200-300 illustrators/year. Buys 6-12 illustrations/issue. Assigns 20% of illustrations to new and emerging illustrators. Considers all media. 25% of freelance illustration demands knowledge of Photoshop, Illustrator, FreeHand and QuarkXPress.

Design Needs freelancers for design, production and multimedia projects. Prefers local designers with experience in QuarkXPress, Photoshop and Illustrator. 100% of freelance work demands knowledge of Photoshop, Illustrator and QuarkXPress.

First Contact & Terms Illustrators: Send query letter with printed samples, photocopies and tearsheets. Send follow-up postcard every 6 months. Designers: Send query letter with printed samples, photocopies, tearsheets and résumé. Accepts Mac platform submissions—compatible with QuarkXPress (latest revision). Send EPS or TIFF files at a high resolution (300 dpi). Samples are filed. Responds only if interested. Rights purchased vary according to project. Pays on publication; $500-1,000 for color cover; $50-150 for b&w, $150-800 for color inside. Pays $75-300 for color spots. Finds illustrators through artist's submissions.

Tips "Although our magazine is dog-oriented and a knowledge of dogs is preferable, it is not required. Creativity is still key."

Ⓝ ALASKA BUSINESS MONTHLY

P.O. Box 241288, Anchorage AK 99524-1288. (907)276-4373. Fax: (907)279-2900. E-mail: info@akbizmag.com. **Editor:** Debbie Cutler. Estab. 1985. Monthly business magazine. "*Alaska Business Monthly* magazine is written, edited and published by Alaskans for Alaskans and other U.S. and international audiences interested in business affairs of the 49th state. Its goal is to promote economic growth in the state by providing thorough and objective discussion and analyses of the issues and trends affecting Alaska's business sector and by featuring stories on the individuals, organizations and companies that shape the Alaskan economy." Circ. 10,000. Accepts previously published artwork. Originals returned at job's completion if requested. Sample copies available for SASE with 3 first-class stamps.

First Contact & Terms Rights purchased vary according to project. Pays on publication; $300-500 for color cover; $50-250 for b&w inside and $75-300 for color inside.

Tips "We usually use local photographers for photos and employees for illustrations. Read the magazine before submitting anything."

☑ ALASKA MAGAZINE

301 Arctic Slope Ave., Suite 300, Anchorage AK 99518-3035. (907)272-6070. Fax: (907)258-5360. E-mail: timblum@alaskamagazine.com. Website: www.alaskamagazine.com. **Art Director:** Tim Blum. Estab. 1935. Monthly 4-color regional consumer magazine featuring Alaskan issues, stories and profiles exclusively. Circ. 200,000.

Illustration Approached by 200 illustrators/year. Buys 1-4 illustration/issue. Has featured illustrations by Bob Crofut, Chris Ware, Victor Juhaz, Bob Parsons. Features humorous and realistic illustrations. On assignment only. Assigns 50% to new and emerging illustrators. 50% of freelance illustration demands knowledge of Illustrator, Photoshop and QuarkXPress.

First Contact & Terms Send postcard or other nonreturnable samples. Accepts Mac-compatible disk submissions. Samples are not returned. Responds only if interested. Will contact artist for portfolio review if interested. Buys first North American serial rights and electronic rights or rights purchased vary according to project. Pays on publication. Pays illustrators $125-300 for color inside; $400-600 for 2-page spreads; $125 for spots.

Tips "We work with illustrators who grasp the visual in a story quickly and can create quality pieces on tight deadlines."

☑ ALL ANIMALS

2100 L St. NW, Washington DC 20037-1525. (202)452-1100. Fax: (202)778-6132. E-mail: allanimals@hsus.org. Website: www.hsus.org. **Creative Director:** Paula Jaworski. Estab. 1954. Quarterly 4-color magazine focusing

on The Humane Society news and animal protection issues. Circ. 450,000. Accepts previously published art-work. Originals are returned at job's completion. Art guidelines not available.

Illustration Occasionally buys illustrations. Works on assignment only. Features natural history, realistic and spot illustration. Assigns 20% of illustrations to well-known or "name" illustrators; 80% to experienced but not well-known illustrators. Themes vary. Send query letter with samples. Samples are filed or returned. Responds in 1 month. To show a portfolio, mail appropriate materials. Portfolio should include printed samples, b&w and color tearsheets and slides. Buys one-time rights and reprint rights. **Pays on acceptance**; $300-500 for b&w inside; $300-500 for color inside; $300-600 for 2-page spreads; $75-150 for spots.

⛏ ALTERNATIVE THERAPIES IN HEALTH AND MEDICINE

169 Saxony Rd., Suite 103, Encinitas CA 92024-6779. (760)633-3910. Fax: (760)633-3918. Website: www.alterna tive-therapies.com. **Creative Art Director:** Lee Dixson. Estab. 1995. Bimonthly trade journal. *"Alternative Therapies* is a peer-reviewed medical journal established to promote integration between alternative and cross-cultural medicine with conventional medical traditions." Circ. 20,000. Accepts previously published artwork. Originals returned at job's completion. Sample copies available.

Illustration Buys 6 illustrations/year. "We purchase fine art for the covers, not graphic art."

First Contact & Terms Illustrators: Send query letter with slides. Samples are filed. Responds in 10 days. Publication will contact artist for portfolio review if interested. Portfolio should include photographs and slides. Buys one-time and reprint rights. Pays on publication; negotiable. Finds artists through agents, sourcebooks and word of mouth.

AMERICA

106 W. 56th St., New York NY 10019. (212)581-4640. Fax: (212)399-3596. Website: www.americamagazine.org. **Associate Editor:** James Martin. Estab. 1904. Weekly Catholic national magazine published by US Jesuits. Circ. 46,000. Sample copies for #10 SASE with first-class postage.

Illustration Buys 3-5 illustrations/issue. Has featured illustrations by Michael O'Neill McGrath, William Hart McNichols, Tim Foley, Stephanie Dalton Cowan. Features realistic illustration and spot illustration. Assigns 45% of illustrations to new and emerging illustrators. Considers all media.

First Contact & Terms Illustrators: Send query letter with printed samples and tearsheets. Buys first rights. Pays on publication; $300 for color cover; $150 for color inside.

Tips "We look for illustrators who can do imaginative work for religious, educational or topical articles. We will discuss the article with the artist and usually need finished work in two to three weeks. A fast turnaround is extremely valuable."

⛏ AMERICA WEST AIRLINES MAGAZINE

4636 E. Elwood St., Suite 5, Phoenix AZ 85040-1963. Estab. 1986. Monthly inflight magazine for national airline; 4-color, "conservative design. Appeals to an upscale audience of travelers reflecting a wide variety of interests and tastes." Circ. 130,000. Accepts previously published artwork. Original artwork is returned after publication. Sample copy $3. Art guidelines for SASE with first-class postage. Needs computer-literate illustrators familiar with Photoshop, Illustrator, QuarkXPress and FreeHand.

Illustration Approached by 100 illustrators/year. Buys 5 illustrations/issue from freelancers. Has featured illustrations by Pepper Tharp, John Nelson, Shelly Bartek, Tim Yearington. Assigns 95% of illustrations to experienced but not well-known illustrators. Buys illustrations mainly for spots, columns and feature spreads. Uses freelancers mainly for features and columns. Works on assignment only. Prefers editorial illustration in airbrush, mixed media, colored pencil, watercolor, acrylic, oil, pastel, collage and calligraphy.

First Contact & Terms Illustrators: Send query letter with color brochure showing art style and tearsheets. Looks for the "ability to intelligently grasp idea behind story and illustrate it. Likes crisp, clean colorful styles." Accepts disk submissions. Send EPS files. Samples are filed. Does not report back. Will contact for portfolio review if interested. Sometimes requests work on spec. Buys one-time rights. Pays on publication. "Send lots of good-looking color tearsheets that we can keep on hand for reference. If your work interests us we will contact you."

Tips "In your portfolio show examples of editorial illustration for other magazines, good conceptual illustrations and a variety of subject matter. Often artists don't send enough of a variety of illustrations; it's much easier to determine if an illustrator is right for an assignment if we have a complete grasp of the full range of abilities. Send high-quality illustrations and show specific interest in our publication."

⛏ THE AMERICAN ATHEIST

Box 5733, Parsippany NJ 07054-6733. (908)276-7300. Fax: (908)276-7402. Website: www.americanatheist.org. Editorial office (to which art and communications should be sent): 1352 Hunter Ave., Columbus OH 43201-2733. Phone: (614)299-1036. Fax: (614)299-3712. Editor: Frank Zindler. Estab. 1958. Monthly for atheists,

agnostics, materialists and realists. Circ. 10,000. Simultaneous submissions OK. Sample copy for self-addressed 9×12 envelope or label.

Cartoons Buys 5 cartoons/issue.

Illustration Buys 1 illustration/issue. Especially needs 4-seasons art for covers and greeting cards. Prefers pen & ink, then airbrush, charcoal/pencil and calligraphy. Covers are in color.

First Contact & Terms Illustrators: "Send samples to be kept on file. We do commission artwork based on the samples received. All illustrations must have bite from the atheist point of view and hit hard." To show a portfolio, mail final reproduction/product and b&w photographs. **Pays on acceptance**. Pays cartoonists $30 each. Pays illustrators $75-100 for cover; $25 for inside.

Tips *"American Atheist* looks for clean lines, directness and originality. We are not interested in side-stepping cartoons and esoteric illustrations. Our writing is hard-punching and we want artwork to match. The American Atheist Press (parent company) buys book cover designs and card designs. Nearly all our printing is in black & white, but several color designs (e.g. for covers and cards) are acceptable if they do not require highly precise registration of separations for printing."

AMERICAN BANKER

1 State St. Plaza, 26th Floor, New York NY 10004. (212)803-8229. Fax: (212)843-9628. E-mail: deborah.fogel@thomsonmedia.com. Website: www.americanbanker.com. **Art Director:** Debbie Fogel. Estab. 1865. Financial services daily newspaper specializing in banking, insurance/investments products, mortgages and credit. Circ. 14,000. Guidelines not available.

Illustration Approached by 250 illustrators/year. Buys 10 illustrations/year. Features spot illustrations. Prefers business. Prefers fine art with thick, heavy brush strokes and strong, vibrant colors. Assigns 1% to new and emerging illustrators.

First Contact & Terms Send postcard sample with additional printed samples. After introductory mailing, send follow-up postcard every 3 months. Samples are filed. Does not reply. Portfolio not required. **Pays on acceptance.** Buys electronic rights, one-time rights. Finds freelancers through word of mouth.

Tips "Please don't call, simply send in samples of your work and if we need you, we will contact you."

AMERICAN BANKERS ASSOCIATION-BANKING JOURNAL

345 Hudson St., 12th Floor, New York NY 10014-4502. (212)620-7256. Fax: (212)633-1165. E-mail: wwilliams@sbpub.com. Website: www.ababj.com. **Creative Director:** Wendy Williams. Associate Creative Director: Phil Desiere. Estab. 1908. 4-color; contemporary design. Emphasizes banking for middle and upper level banking executives and managers. Monthly. Circ. 31,440. Accepts previously published material. Returns original artwork after publication.

Illustration Buys 4-5 illustrations/issue from freelancers. Features charts & graphs, computer, humorous and spot illustration. Assigns 20% of illustrations to new and emerging illustrators. Themes relate to stories, primarily financial, from the banking industry's point of view; styles vary, realistic, surreal. Uses full-color illustrations. Works on assignment only.

First Contact & Terms Illustrators: Send finance-related postcard sample and follow-up samples every few months. To send a portfolio, send query letter with brochure and tearsheets, promotional samples or photographs. Negotiates rights purchased. **Pays on acceptance**; $250-950 for color cover; $250-450 for color inside; $250-450 for spots.

Tips Must have experience illustrating for business or financial publications.

AMERICAN BREWER MAGAZINE

P.O. Box 20268, Alexandria VA 22320-1268. (703)567-1962. Fax: (703)567-1963. E-mail: bill@americanbrewer.com. Website: www.americanbrewer.com. **Publisher:** Bill Metzger. Estab. 1985. Published 6 times a year. Trade journal in color with 4-color cover focusing on the microbrewing and distilling. Circ. 3,000. Accepts previously published artwork. Original artwork returned after publication. Sample copies for $5; art guidelines not available.

Cartoons Approached by 25-30 cartoonists/year. Occasionally buys cartoons. Prefers themes related to drinking or brewing handcrafted beer.

Illustration Buys 2 illustrations/issue. Works on assignment only. Prefers themes relating to beer, brewing or drinking; various media.

First Contact & Terms Cartoonists: Send query letter with roughs. Illustrators: Send postcard sample or query letter with photocopies. Samples are filed and are not returned without SASE. Responds in 2 weeks. Pays $50-150 for b&w or color inside. Buys reprint rights.

Tips "I prefer to work with San Francisco Bay Area artists. Work must be about microbrewing industry."

AMERICAN DEMOGRAPHICS

249 W. 17th St. #8, New York NY 10011. (212)204-1513. Website: www.demographics.com. **Art Director:** Tammy Morton-Fernandez. Estab. 1979. Monthly trade journal covering consumer trends. Circ. 42,000. Sample copies available.

Illustration Approached by 300 illustrators/year. Buys 2-3 illustrations/issue. Considers all media. Knowledge of Photoshop 3, Illustrator 5.5 helpful but not required.

First Contact & Terms Illustrators: Send postcard sample. Designers: Send query letter with tearsheets. Accepts disk submissions. Samples are filed and not returned. Will contact for portfolio review if interested; portfolio should include color tearsheets. Buys one-time rights. **Pays on acceptance**.

N AMERICAN FITNESS

15250 Ventura Blvd., Suite 200, Sherman Oaks CA 91403. (818)905-0040. Fax: (818)990-5468. E-mail: americanfitness@afaa.com. Website: www.afaa.com. **Editor-at-Large:** Meg Jordan. Managing Editor: Rosibel Guzman. Bimonthly magazine emphasizing fitness, health and exercise "for sophisticated, college-educated, active lifestyles." Circ. 42,900. Accepts previously published material. Original artwork returned after publication. Sample copy $3.

Illustration Approached by 12 illustrators/month. Assigns 2 illustrations/issue. Works on assignment only. Prefers "very sophisticated" 4-color line drawings.

First Contact & Terms Illustrators: Send query letter with samples showing art style. Acquires one-time rights.

Tips "Excellent source for never-before-published illustrators who are eager to supply full-page lead artwork."

THE AMERICAN GARDENER

7931 E. Boulevard Dr., Alexandria VA 22308. (703)768-5700. Fax: (703)768-7533. E-mail: editor@ahs.org. Website: www.ahs.org. **Editor:** David J. Ellis. Managing Editor: Mary Yee. Estab. 1922. Consumer magazine for advanced and amateur gardeners and horticultural professionals who are members of the American Horticultural Society. Bimonthly, 4-color magazine, "very clean and open, fairly long features." Circ. 35,000. Accepts previously published artwork. Original artwork is returned at job's completion. Sample copies for $5.

Illustration Buys 6-10 illustrations/year from freelancers. Works on assignment only. "Botanical accuracy is important for some assignments. All media used; digital media welcome."

First Contact & Terms Illustrators: Send query letter with résumé, tearsheets, slides and photocopies. Samples are filed. "We will call artist if their style matches our need." To show a portfolio, mail b&w and color tearsheets and slides. Buys one-time rights. Pays $150-300 color inside; on publication.

Tips "As a nonprofit we have a low budget, but we offer interesting subject matter, good display and we welcome input from artists."

N THE AMERICAN LEGION MAGAZINE

P.O.Box 1055, Indianapolis IN 46206. E-mail: Magazine@Legion.org. Website: www.legion.org. **Cartoon Editor:** Matt Grills. Emphasizes the development of the world at present and milestones of history; 4-color general-interest magazine for veterans and their families. Monthly. Original artwork not returned after publication.

Cartoons Uses 3 freelance cartoons/issue. Receives 150 freelance submissions/month. "Experience level does not matter and does not enter into selection process." Especially needs general humor in good taste. "Generally interested in cartoons with broad appeal. Those that attract the reader and lead us to read the caption rate the highest attention. Because of tight space, we're not in the market for spread or multipanel cartoons but use both vertical and horizontal single-panel cartoons. Themes should be home life, business, sports and everyday Americana. Cartoons that pertain only to one branch of the service may be too restricted for this magazine. Service-type gags should be recognized and appreciated by any ex-service man or woman. Cartoons that may offend the reader are not accepted. Liquor, sex, religion and racial differences are taboo.

First Contact & Terms Cartoonists: "No roughs. Send final product for consideration." Usually responds within 1 month. Buys first rights. **Pays on acceptance**; $150.

Tips "Artists should submit their work as we are always seeking new slant and more timely humor. Black & white submissions are acceptable, but we purchase only color cartoons. Want good, clean humor—something that might wind up on the refrigerator door. Consider the audience!"

AMERICAN LIBRARIES

50 E. Huron St., Chicago IL 60611-2795. (312)280-4216. Fax: (312)440-0901. E-mail: americanlibraries@ala.org. Website: www.ala.org/alonline. **Editor:** Leonard Kniffel. Estab. 1907. Monthly professional 4-color journal of the American Library Association for its members, providing independent coverage of news and major developments in and related to the library field. Circ. 58,000. Original artwork returned at job's completion if requested. Sample copy $6. Art guidelines available with SASE and first-class postage.

Cartoons Approached by 15 cartoonists/year. Buys no more than 1 cartoon/issue. Themes related to libraries only.

Illustration Approached by 20 illustrators/year. Buys 1-2 illustrations/issue. Assigns 25% of illustrations to new and emerging illustrators. Works on assignment only.

First Contact & Terms Cartoonists: Send query letter with brochure and finished cartoons. Illustrators: Send query letter with brochure, tearsheets and résumé. Samples are filed. Does not respond to submissions. To show a portfolio, mail tearsheets, photographs and photocopies. Portfolio should include broad sampling of typical work with tearsheets of both b&w and color. Buys first rights. **Pays on acceptance**. Pays cartoonists $35-50 for b&w. Pays illustrators $75-150 for b&w and $250-300 for color cover; $150-250 for color inside.

Tips "I suggest inquirer go to a library and take a look at the magazine first." Sees trend toward "more contemporary look, simpler, more classical, returning to fewer elements."

⋈ AMERICAN MEDICAL NEWS

515 N. State, Chicago IL 60610. (312)464-4432. Fax: (312)464-4445. E-mail: Jef_Capaldi@ama-assn.org. Website: www.amednews.com. **Art Director:** Jef Capaldi. Assistant Art Director: Casey Braun. Estab. 1958. Weekly trade journal. "We're the nation's most widely circulated publication covering socioeconomic issues in medicine." Circ. 250,000. Originals returned at job's completion. Sample copies available. 10% of freelance work demands knowledge of Photoshop and FreeHand.

Illustration Approached by 250 freelancers/year. Buys 2-3 illustrations/issue. Works on assignment only. Considers mixed media, collage, watercolor, acrylic and oil.

First Contact & Terms Send postcard samples. Samples are filed. Will contact for portfolio review if interested. Buys first rights. **Pays on acceptance**. Pays $300-500 for b&w, $500-850 for color inside. Pays $200-400 for spots. Finds artists through illustration contest annuals, word of mouth and submissions.

Tips "Illustrations need to convey a strong, clever concept."

⋈ AMERICAN MUSCLE MAGAZINE

Box 6100, Rosemead CA 91770. **Art Director:** Michael Harding. Monthly 4-color magazine emphasizing bodybuilding, exercise and professional fitness. Features general interest, historical, how-to, inspirational, interview/profile, personal experience, travel articles and experimental fiction (all sports-related). Circ. 457,611. Accepts previously published material. Original artwork returned after publication.

Illustration Buys 5 illustrations/issue.

First Contact & Terms Illustrators: Send query letter with résumé, tearsheets, slides and photographs. Samples are filed or are returned. Responds in 1 week. Buys first rights, one-time rights, reprint rights or all rights. **Pays on acceptance**.

Tips "Be consistent in style and quality."

⋈ AMERICAN MUSIC TEACHER

441 Vine St. Suite 505, Cincinnati OH 45202-2811. (513)421-1420. Fax: (513)421-2503. Website: www.mtna.org. **Art Director:** Brian Pieper. Estab. 1951. Bimonthly 4-color trade journal emphasizing music teaching. Features historical and how-to articles. "*AMT* promotes excellence in music teaching and keeps music teachers informed. It is the official journal of the Music Teachers National Association, an organization which includes concert artists, independent music teachers and faculty members of educational institutions." Circ. 26,424. Accepts previously published material. Original artwork returned after publication. Sample copies available.

Illustration Buys 1 illustration/issue. Uses freelancers mainly for diagrams and illustrations. Prefers musical theme. "No interest in cartoon illustration."

First Contact & Terms Illustrations: Send query letter with brochure or résumé, tearsheets, slides and photographs. Samples are filed or are returned only if requested with SASE. Responds in 3 months. To show a portfolio, mail printed samples, color and b&w tearsheets, photographs and slides. Buys one-time rights. Pays on publication; $50-150 for b&w and color, cover and inside.

⋈ AMERICAN SCHOOL BOARD JOURNAL

1680 Duke St., Alexandria VA 22314-3474. (703)838-6722. Fax: (703)549-6719. E-mail: msabatier@nsba.org. Website: www.asbj.com. **Production Manager/Art Director:** Michele Sabatier Mann. Estab. 1891. National monthly magazine for school board members and school administrators. Circ. 36,000. Sample copies available.

Illustration Buys 40-50 illustrations/year. Considers all media. Send postcard sample.

First Contact & Terms Illustrators: Send follow-up postcard sample every 3 months. Will not accept samples as e-mail attachment. Please send URL. Responds only if interested. Art director will contact artist for portfolio review of tearsheets if interested. Buys one-time rights. **Pays on acceptance.** Pays $1,200 maximum for color cover; $250-350 for b&w, $300-600 for color inside. Finds illustrators through agents, sourcebooks, online services, magazines, word of mouth and artist's submissions.

Tips "We're looking for new ways of seeing old subjects: children, education, management. We also write a great deal about technology and love high-tech, very sophisticated mediums. We prefer concept over narrative styles."

☑ THE AMERICAN SPECTATOR

1611 N. Kent St., Suite 901, Arlington VA 22209-2111. (703)807-2011. Fax: (703)807-2013. Website: www.specta tor.org. **Art Director:** Jesse Schoer. Monthly political, conservative, newsworthy literary magazine. "We cover political topics, human interest items and book reviews." Circ. 81,300. Original artwork returned after publication. Sample copies available; art guidelines not available.

Illustration Uses 3-5 illustrations/issue. Interested in "realism with a comic twist." Works on assignment only. Has featured illustrations by Dan Adel, Jack Davis, Phillipe Weisbecker and Blair Drawson. Features caricatures of celebrities and politicians; humorous and realistic illustration; informational graphics; spot illustration. Prefers pen & ink, watercolor, acrylic, colored pencil, oil and pastel.

First Contact & Terms Illustrators: Samples are filed or returned by SASE. Reports back on future assignment possibilities. Provide résumé, brochure and tearsheets to be kept on file for future assignments. No portfolio reviews. Responds in 2 weeks. Buys first North American serial rights. Pays on publication; $1,200-2,000 for color cover; $150-1,750 for color inside; $1,000-2,000 for 2-page spreads.

ANALOG

475 Park Ave. S., New York NY 10016. (212)686-7188. Fax: (212)686-7414. **Senior Art Director:** Victoria Green. Associate Art Director: June Levine. All submissions should be sent to June Levine, associate art director. Estab. 1930. Monthly consumer magazine. Circ. 80,000. Art guidelines free for #10 SASE with first-class postage.

Cartoons Prefers single panel cartoons.

Illustration Buys 4 illustrations/issue. Prefers science fiction, hardware, robots, aliens and creatures. Considers all media.

First Contact & Terms Cartoonists: Send query letter with photocopies and/or tearsheets and SASE. Samples are not filed and are returned by SASE. Illustrators: Send query letter with printed samples or tearsheets and SASE. Send follow-up postcard sample every 4 months. Accepts disk submissions compatible with QuarkXPress 7.5/version 3.3. Send EPS files. Files samples of interest, others are returned by SASE. Responds only if interested. "No phone calls." Portfolios may be dropped off every Tuesday and should include b&w and color tearsheets and transparencies. "No original art please, especially oversized." Buys one-time rights. **Pays on acceptance.** Pays cartoonists $35 minimum for b&w cartoons. Pays illustrators $1,200 for color cover; $125 minimum for b&w inside; $35-50 for spots. Finds illustrators through *Black Book, LA Workbook, American Showcase* and other reference books.

ℕ ANIMALS

350 S. Huntington Ave., Boston MA 02130. (617)541-5065. Fax: (617)522-4885. Website: www.mspca.org. **Contact:** Molly Lupica. Estab. 1868. "*Animals* is a national quarterly 4-color magazine published by the Massachusetts Society for the Prevention of Cruelty to Animals. We publish articles on and photographs of wildlife, domestic animals, conservation, controversies involving animals, animal-welfare issues, pet health and pet care." Circ. 90,000. Original artwork usually returned after publication. Sample copy $3.95 with SAE (8½×11); art guidelines not available.

Illustration Approached by 1,000 illustrators/year. Works with 1 illustrator/year. Buys 1 illustration/year from freelancers. Uses artists mainly for spots. Prefers pets or wildlife illustrations relating to a particular article topic. Prefers pen & ink, then airbrush, charcoal/pencil, colored pencil, watercolor, acrylic, oil, pastel and mixed media. Needs editorial and medical illustration.

First Contact & Terms Illustrators: Send query letter with brochure or tearsheets. Samples are filed or are returned by SASE. Responds in 1 month. Publication will contact artist for portfolio review if interested. Portfolio should include color roughs, original/final art, tearsheets and final reproduction/product. Negotiates rights purchased. **Pays on acceptance.**

Tips "In your samples, include work showing animals, particularly dogs and cats or humans with cats or dogs. Show a representative sampling."

☑ AOPA PILOT

421 Aviation Way, Frederick MD 21701-4756. (301)695-2350. Fax: (301)695-2180. E-mail: michael.kline@aopa. org. Website: www.aopa.org. **Art Director:** Michael Kline. Associate Art Director: Adrienne Rosone. Estab. 1958. Monthly 4-color trade publication for the members of the Aircraft Owners and Pilots Association. The world's largest aviation magazine. Circ. 371,000. Sample copies free for 8½×11 SASE.

Illustration Approached by 50 illustrators/year. Buys 3 illustrations/issue. Has featured illustrations by Jack Pardue, Byron Gin. Features charts & graphs, informational graphics, realistic, computer, aviation-related illus-

tration. Prefers variety of styles ranging from technical to soft and moody. Assigns 25% of illustrations to new and emerging illustrators. 10% of freelance illustration demands knowledge of Illustrator, Photoshop, FreeHand or 3-D programs.

First Contact & Terms Illustrators: Send postcard or other nonreturnable samples, such as photocopies and tearsheets. Accepts Mac-compatible disk submissions. Send EPS files. Samples are filed and are not returned. Will contact artist for portfolio review if interested. Rights purchased vary according to project; negotiable. **Pays on acceptance.** Finds illustrators through agents, sourcebooks, online services and samples.

Tips "We are looking to increase our stable of freelancers. Looking for a variety of styles and experience."

AQUARIUM FISH MAGAZINE

P.O. Box 6050, Mission Viejo CA 92690. (949)855-8822. Fax: (949)855-3045. E-mail: aquariumfish@fancypubs.com. Website: www.aquariumfish.com. **Editor:** Russ Case. Estab. 1988. Monthly magazine covering fresh and marine aquariums and garden ponds. Photo guidelines for SASE with first-class postage or on website.

Cartoons Approached by 30 cartoonists/year. Themes should relate to aquariums and ponds.

First Contact & Terms Cartoonists: Cartoon guidelines for SASE with first-class postage. Buys one-time rights. Pays $35 for b&w and color cartoons.

AREA DEVELOPMENT MAGAZINE

400 Post Ave., New York NY 11590-2267. (516)338-0900. Fax: (516)338-0100. E-mail: areadev@areadevelopment.com. Website: www.areadevelopment.com. **Art Director:** Marta Sivakoff. Estab. 1965. Monthly trade journal regarding economic development, relocation and site selection issues. Circ. 45,000.

Illustration Approached by 60 illustrators/year. Buys 3-4 illustrations/year. Features charts & graphs; informational graphics; realistic, biotechnology and computer illustration. Assigns 20% of illustration to experienced but not well-known illustrators. Prefers business/corporate themes with strong conceptual ideas. Considers all media. 50% of freelance illustration demands knowledge of Photoshop, Illustrator and QuarkXPress.

First Contact & Terms Illustrators: Send postcard sample. Accepts disk submissions compatible with QuarkXPress 4.0 for the Mac. Send EPS, TIFF files. Art director will contact artist for portfolio review of b&w, color tearsheets if interested. Rights purchased vary according to project. Pays on publication; $500-1,200 for color cover.

Tips "Must have corporate understanding and strong conceptual ideas. We address the decision-makers' needs by presenting their perspectives. Create a varied amount of subjects (business, retail, money concepts). Mail color self-promotions with more than one illustration."

ARMY MAGAZINE

2425 Wilson Blvd., Arlington VA 22201. (703)841-4300. Website: www.ausa.org. **Art Director:** Paul Bartels. Estab. 1950. Monthly trade journal dealing with current and historical military affairs. Also covers military doctrine, theory, technology and current affairs from a military perspective. Circ. 115,000. Originals returned at job's completion. Sample copies available for $3.00. Art guidelines available.

Cartoons Approached by 5 cartoonists/year. Buys 1 cartoon/issue. Prefers military, political and humorous cartoons; single or double panel, b&w washes and line drawings with gaglines.

Illustration Approached by 1 illustrator/year. Buys 1 illustration/issue. Works on assignment only. Prefers military, historical or political themes. Considers pen & ink, airbrush, acrylic, marker, charcoal and mixed media. "Can accept artwork done with Illustrator or Photoshop for Macintosh."

First Contact & Terms Cartoonists: Send query letter with brochure and finished cartoons. Responds to the artist only if interested. Illustrators: Send query letter with brochure, résumé, tearsheets, photocopies and photostats. Samples are filed or are returned by SASE if requested by artist. Publication will contact artist for portfolio review if interested. Portfolio should include b&w and color tearsheets, photocopies and photographs. Buys one-time rights. Pays on publication. Pays cartoonists $50 for b&w. Pays illustrators $300 minimum for b&w cover; $500 minimum for color cover; $50 for b&w inside; $75 for color inside; $35-50 for spots.

☑ ARTHRITIS TODAY MAGAZINE

1330 W. Peachtree St., Atlanta GA 30309-2922. (404)872-7100. Fax: (404)872-9559. E-mail: atmail@arthritis.org. Website: www.arthritis.org. **Art Director:** Susan Siracusa. Estab. 1987. Bimonthly consumer magazine. "*Arthritis Today* is the official magazine of the Arthritis Foundation. The award-winning publication is more than the most comprehensive and reliable source of information about arthritis research, care and treatment. It is a magazine for the whole person—from their lifestyles to their relationships. It is written both for people with arthritis and those who care about them." Circ. 700,000. Originals returned at job's completion. Sample copies available. 20% of freelance work demands knowledge of Illustrator, QuarkXPress or Photoshop.

Illustration Approached by over 100 illustrators/year. Buys 5-10 illustrations/issue. Works on assignment only; stock images used in addition to original art.

First Contact & Terms Illustrators: Send query letter with brochure, tearsheets, photostats, slides (optional) and transparencies (optional). Samples are filed. Publication will contact artist for portfolio review if interested. Portfolio should include color tearsheets, photostats, photocopies, final art and photographs. Buys first-time North American serial rights. Other usage negotiated. **Pays on acceptance.** Finds artists through sourcebooks, Internet, other publications, word of mouth, submissions.

Tips "No limits on areas of the magazine open to freelancers. Two to three departments in each issue use spot illustrations. Submit tearsheets for consideration. No cartoons."

THE ARTIST'S MAGAZINE

4700 E. Galbraith Rd., Cincinnati OH 45236. E-mail: tamedit@fwpubs.com. **Art Director:** Daniel Pessell. Monthly 4-color magazine emphasizing the techniques of working artists for the serious beginning, amateur and professional artist. Circ. 180,000. Occasionally accepts previously published material. Returns original artwork after publication. Sample copy $4.99 US, $7.99 Canadian or international; remit in US funds.

● Sponsors annual contest. Send SASE for more information. Also publishes a bimonthly magazine called *Artist's Sketchbook.*

Cartoons Buys 3-4 cartoons/year. Must be related to art and artists.

Illustration Buys 2-3 illustrations/year. Has featured illustrations by: Susan Blubaugh, Sean Kane, Jamie Hogan, Steve Dininno, Kathryn Adams. Features humorous and realistic illustration. Works on assignment only.

First Contact & Terms Cartoonists: Contact Cartoon Editor. Send query letter with brochure, photocopies, photographs and tearsheets to be kept on file. Prefers photostats or tearsheets as samples. Samples not filed are returned by SASE. Buys first rights. **Pays on acceptance.** Pays cartoonists $65 on acceptance for first-time rights. Pays illustrators $350-1,000 for color inside; $100-500 for spots.

Tips "Research past issues of publication and send samples that fit the subject matter and style of target publication."

ART:MAG

P.O. Box 70896, Las Vegas NV 89170-0896. (702)734-8121. E-mail: magman@iopener.net. **Art Director:** Peter Magliocco. Contributing Artist-at-Large: Bill Chown. Art Editor: "The Mag Man." Estab. 1984. Yearly b&w small press literary arts zine. Circ. 100. Art guidelines for #10 SASE with first-class postage.

Cartoons Approached by 5-10 cartoonists/year. Buys 5 cartoons/year. Prefers single panel, political, humorous and satirical b&w line drawings.

Illustration Approached by 5-10 illustrators/year. Buys 3-5 illustrations/year. Has featured illustrations by Amanda Rehagen, Carrie Christian, Dan Buck. Features caricatures of celebrities and politicians and spot illustrations. Preferred subjects: art, literature and politics. Prefers realism, hip, culturally literate collages and b&w line drawings. Assigns 30% of illustrations to new and emerging illustrators.

First Contact & Terms Cartoonists: Send query letter with b&w photocopies, samples, tearsheets and SASE. Samples are filed. Rights purchased vary according to project. Illustrators: Send query letter with photocopies, SASE. Responds in 3 months. Portfolio review not required. Buys one-time rights. Pays on publication. Pays cartoonists/illustrators 1 contributor's copy. Finds illustrators through magazines, word of mouth.

Tips "*Art:Mag* is basically for new or amateur artists with unique vision and iconoclastic abilities whose work is unacceptable to slick mainstream magazines. Don't be conventional, be idea-oriented."

☑ ASCENT MAGAZINE

837 Rue Gilford, Montreal QC H2J 1P1 Canada. (514)499-3999. Fax: (514)499-3904. E-mail: info@ascentmagazine.com. Website: www.ascentmagazine.com. **Contact:** Joe Ollmann, designer. Estab. 1999. Quarterly consumer magazine focusing on yoga and engaged spirituality. Circ. 7,500. Sample copies are available for $7. Art guidelines available on website or e-mail design@ascentmagazine.com.

Illustration Approached by 20-40 illustrators/year. Prefers b&w. Assigns 50% to new and emerging illustrators. 50% of freelance illustration demands knowledge of Illustrator, InDesign and Photoshop.

First Contact & Terms Send postcard sample or query letter with b&w photocopies, samples, URL. Accepts e-mail submissions with link to website or image file. Prefers Mac-compatible, TIFF files. Samples are filed. Responds in 2 months. Company will contact artist for portfolio review if interested. Portfolio should include b&w and color, finished art, photographs and tearsheets. Pays illustrators $300-800 for color cover; $50-300 for b&w inside; $150-500 for 2-page spreads. Pays on publication. Buys first rights, electronic rights. Finds freelancers through agents, artists' submissions, magazines and word of mouth.

Tips "Please be familiar with our magazine. Be open to working with specifications we want (artistic and technical)."

☒ ASIAN ENTERPRISE MAGAZINE

P.O. Box 2135, Walnut CA 91788-2135. (909)860-3316. Fax: (909)865-4915. E-mail: asianent@asianenterprise.com. Website: www.asianenterprise.com. **Contact:** Gelly Borromio. Associate Editor: Ryan Montex. Estab. 1993.

Monthly trade publication. "The largest Asian small business focus magazine in U.S." Circ. 40,000.
Cartoons Buys 12 cartoons/year. Prefers business-humorous, single-panel, political, b&w line drawings.
Illustration Buys 12 illustrations/issue. Features cariatures of politicians, humorous illustration and spot illustrations of business subjects. 100% of freelance illustrations demands knowledge of Photoshop, PageMaker and QuarkXPress.
First Contact & Terms Cartoonists: Send query letter with samples. Illustrators: Send query letter with tearsheets. Accepts disk submissions. Send TIFF files. Samples are filed. Responds only if interested. Portfolio review not required. Buys one-time rights. Negotiates rights purchased. Pays on publication. Pays cartoonists $25-50 for b&w, $25-50 for comic strips. Pays illustrators $25-50 for b&w, $200 maximum for color cover; $25-50 for b&w inside. Finds illustrators through promo samples and word of mouth.

ISAAC ASIMOV'S SCIENCE FICTION MAGAZINE

475 Park Ave. S., New York NY 10016. (212)686-7188. Fax: (212)686-7414. **Senior Art Director:** Victoria Green. All submissions should be sent to June Levine, associate art director. Estab. 1977. Monthly b&w with 4-color cover magazine of science fiction and fantasy. Circ. 61,000. Accepts previously published artwork. Original artwork returned at job's completion. Art guidelines available for #10 SASE with first-class postage.
Cartoons Approached by 20 cartoonists/year. Buys 10 cartoons/year. Two covers commissioned/year. The rest are second-time rights or stock images. Prefers single panel, b&w washes or line drawings with and without gagline. Address cartoons to Brian Bieniowski, editor.
Illustration No longer buys interior illustration.
First Contact & Terms Cartoonists: Send query letter with printed samples, photocopies and/or tearsheets and SASE. Accepts disk submissions compatible with QuarkXPress version 3.3. Send EPS files. Accepts illustrations done with Illustrator and Photoshop. Samples are filed or returned by SASE. Responds only if interested. Portfolios may be dropped off every Tuesday and should include b&w and color tearsheets. Buys one-time and reprint rights. **Pays on acceptance.** Pays cartoonists $35 minimum. Pays illustrators $600-1,200 for color cover.
Tips No comic book artists. Realistic work only, with science fiction/fantasy themes. Show characters with a background environment.

☑ ASPCA ANIMAL WATCH

345 Park Ave. S., 9th Floor, New York NY 10010. **Contact:** Samarra Khaja, creative director. Estab. 1960. Quarterly company magazine. Circ. 398,000. Accepts previously published artwork. Original artwork returned at job's completion.
Illustration Buys 10-12 illustrations/issue. Considers all media.
First Contact & Terms No phone calls please. Illustrators: Send nonreturnable samples. Samples are filed. Responds when needed. Rights purchased vary. Pays on publication; rates are commensurate with nonprofit marketplace.

Ⓝ ASPEN MAGAZINE

720 E. Durant Ave., Suite 8, Aspen CO 81611. (970)920-4040. Fax: (970)920-4044. E-mail: staff@aspenmagazine .com. Website: www.aspenmagazine.com. **Art Director:** Paul Alvarez. Bimonthly 4-color city magazine with the emphasis on Aspen and the valley. Circ. 18,300. Accepts previously published artwork. Original artwork returned at job's completion. Sample copies and art guidelines available.
Illustration Approached by 15 illustrators/year. Buys 2 illustrations/issue. Themes and styles should be appropriate for editorial content. Considers all media. Send query letter with tearsheets, photostats, photographs, slides, photocopies and transparencies. Samples are filed. Responds only if interested. Call for appointment to show a portfolio, which should include thumbnails, roughs, tearsheets, slides and photographs. Buys first, one-time or reprint rights. Pays on publication.

ASSOCIATION OF BREWERS

P.O. Box 1679, Boulder CO 80306. Website: www.beertown.org. **Magazine Art Director:** Kelli McPhail. Estab. 1978. "Our nonprofit organization hires illustrators for two magazines, *Zymurgy* and *The New Brewer*, each published bimonthly. *Zymurgy* is a journal of the American Homebrewers Association. The goal of the AHA division is to promote public awareness and appreciation of the quality and variety of beer through education, research and the collection and dissemination of information." Circ. 10,000. "*The New Brewer* is a journal of the Institute for Brewing Studies. The goal of the IBS division is to serve as a forum for the technical aspects of brewing and to seek ways to help maintain quality in the production and distribution of beer." Circ. 3,000.
Illustration Approached by 50 illustrators/year. Buys 3-6 illustrations/year. Prefers beer and homebrewing themes. Considers all media.
Design Prefers local design freelancers only with experience in Photoshop, QuarkXPress, Illustrator.
First Contact & Terms Illustrators: Send postcard sample or query letter with printed samples, photocopies,

tearsheets; follow-up sample every 3 months. Accepts disk submissions with EPS, TIFF or JPEG files. "We prefer samples we can keep." No originals accepted; samples are filed. Responds only if interested. Art director will contact artist for portfolio review of b&w, color, final art, photographs, photostats, roughs, slides, tearsheets, thumbnails, transparencies; whatever media best represents art. Buys one-time rights. Pays 60 day net on acceptance. Pays illustrators $700-800 for color cover; $200-300 for b&w inside; $200-400 for color inside. Pays $150-300 for spots. Finds artists through agents, sourcebooks (Society of Illustrators, *Graphis*, *Print*, *Colorado Creative*), mags, word of mouth, submissions. Designers: Send query letter with printed samples, photocopies, tearsheets.

Tips "Keep sending promotional material for our files. Anything beer-related for subject matter is a plus. We look at all styles."

[N] ASTRONOMY

21027 Crossroads Circle, Waukesha WI 53186-4055. (262)796-8776. Fax: (262)796-6468. E-mail: onlineeditor@astronomy.com. Website: www.astronomy.com. **Art Director:** Carole Ross. Estab. 1973. Monthly consumer magazine emphasizing the study and hobby of astronomy. Circ. 200,000.
• Published by Kalmbach Publishing. Also see listings for *Classic Toy Trains*, *Finescale Modeler*, *Model Railroader*, *Model Retailer*, *Bead and Button*, *Birder's World*, *Trains*, *The Writer* and *Dollhouse Miniatures*.
Illustration Approached by 20 illustrators/year. Buys 2 illustrations/issue. Has featured illustrations by James Yang, Gary Baseman. Considers all media. 10% of freelance illustration demands knowledge of Photoshop, Illustrator, QuarkXPress.
First Contact & Terms Illustrators: Send query letter with duplicate slides. Do not send originals. Accepts submissions on disk compatible with above software. Samples are filed and not returned. Buys one-time rights. Finds illustrators through word of mouth and submissions.

[N] ATHLON SPORTS COMMUNICATIONS, INC.

220 25th Ave. N, Suite 200, Nashville TN 37203. (615)327-0747. Fax: (615)327-1149. E-mail: mark.malone@athlonsports.com. Website: www.athlonsports.com. **Senior Production Designer:** Mark Malone. Estab. 1967. Consumer magazine; college and pro pre-season football annuals, pro baseball, and college and pro basketball pre-season annuals. Circ. 800,000. Accepts previously published artwork. Original artwork is returned at job's completion. Sample copies and/or art guidelines available.
• Athlon Sports publishes 13 annual magazines.
Illustration Approached by 6 illustrators/year. Buys 1 illustration/issue. Works on assignment only. Prefers sports figure illustration. Considers all media.
First Contact & Terms Illustrators: Send query letter with brochure, photographs, photocopies, slides, transparencies, samples and pricing information. Samples are filed. Responds only if interested within 3 weeks. Buys one-time rights.

[N] ATLANTA MAGAZINE

260 W. Peachtree St. NW, Suite 300, Atlanta GA 30303-1202. (404)527-5500. Fax: (404)527-5575. E-mail: sbogle@atlantamag.emmis.com. Website: www.atlantamagazine.com. **Contact:** Susan L. Bogle, design director. Associate Art Director: Alice Lynn McMichael. Estab. 1961. Monthly 4-color consumer magazine. Circ. 66,000.
Illustration Buys 3 illustrations/issue. Has featured illustrations by Fred Harper, Harry Campbell, Jane Sanders, various illustrators repped by Wanda Nowak, various illustrators repped by Gerald & Cullen Rapp, Inc. Features caricatures of celebrities, fashion illustration, humorous illustration and spot illustrations. Prefers a wide variety of subjects. Style and media depend on the story. Assigns 60% of illustrations to well-known or "name" illustrators; 30% to experienced but not well-known illustrators; 10% to new and emerging illustrators.
First Contact & Terms Illustrators: Send nonreturnable postcard sample. Samples are filed. Will contact artist for portfolio review if interested. Buys first rights. **Pays on acceptance.** Finds freelancers through promotional samples, artists' reps, *The Alternative Pick*.

AUTHORSHIP

3140 S. Peoria, #295, Aurora CO 80014. (303)841-0246. Fax: (303)841-2607. Website: www.nationalwriters.com. **Executive Director:** Sandy Whelchel. Estab. 1937. Quarterly magazine. "Our publication is for our 3,000 members and is cover-to-cover about writing."
First Contact & Terms Cartoonists: Samples are returned. Responds in 4 months. Buys first North American serial and reprint rights. **Pays on acceptance.** Pays cartoonists $25 minimum for b&w. Illustrators: Accepts disk submissions. Send TIFF or JPEG files.
Tips "We only take cartoons slanted to writers."

N: AUTO RESTORER

P.O. Box 6050, Mission Viejo CA 92690. (949)855-8822, ext. 412. Fax: (949)855-3045. E-mail: tkade@fancypubs. com. Website: www.autorestorermagazine.com. **Editor:** Ted Kade. Estab. 1989. Monthly b&w consumer magazine with focus on collecting, restoring and enjoying classic cars and trucks. Circ. 75,000. Originals returned at job's completion. Sample copies available for $5.50.

Illustration Approached by 5-10 illustrators/year. Buys 1 illustration/issue. Prefers technical illustrations and cutaways of classic/collectible automobiles through 1979. Considers pen & ink, watercolor, airbrush, acrylic, marker, colored pencil, oil, charcoal, mixed media and pastel.

First Contact & Terms Illustrators: Send query letter with SASE, slides, photographs and photocopies. Samples are filed or returned by SASE if requested by artist. Responds to the artist only if interested. Buys one-time rights. Pays on publication; technical illustrations negotiable. Finds artists through submissions.

Tips Areas most open to freelance work are technical illustrations for feature articles and renderings of classic cars for various sections.

N: AUTOMUNDO

2960 SW Eighth St., 2nd Floor, Miami FL 33135-2827. (305)541-4198. Fax: (305)541-5138. E-mail: editor@autom undo.com. Website: www.automundo.com. **Editor:** Carlos Guzman. Estab. 1982. Monthly 4-color Spanish automotive magazine. Circ. 50,000. Accepts previously published artwork. Originals returned at job's completion. Sample copies and art guidelines available.

Cartoons Approached by 2 cartoonists/year. Buys 1 cartoon/issue. Prefers car motifs. Prefers cartoons without gagline.

Illustration Needs editorial illustrations.

Design Needs freelancers for design with knowledge of Photoshop and Illustrator. Send brochure.

First Contact & Terms Cartoonists: Send query letter with brochure and roughs. Accepts disk submissions. Samples are filed. Responds only if interested. Rights purchased vary. Pays $10 for b&w cartoons. Designers: Send brochure. Will contact for portfolio review if interested. Portfolios may be dropped off every Monday.

BABYBUG

315 Fifth St., Peru IL 61354-0300. (815)223-2520. Fax: (815)224-6675. **Art Director:** Suzanne Beck. Estab. 1994. Magazine published every six weeks "for children six months to two years." Circ. 44,588. Sample copy for $4.95 plus 10% of total order ($4 minimum) for shipping and handling; art guidelines for SASE.

Illustration Approached by about 85 illustrators/month. Buys 23 illustrations/issue. Considers all media.

First Contact & Terms Illustrators: Send query letter with printed samples, photocopies and tearsheets. Samples are filed or returned if postage is sent. Responds in 45 days. Buys all rights. Pays 45 days after acceptance. Pays $500 minimum for color cover; $250 minimum per page inside. Finds illustrators through agents, *Creative Black Book*, magazines, word of mouth, artist's submissions and printed children's books.

N: BABYTALK

530 Fifth Ave., 3rd Floor, New York NY 10036. (212)522-8793. Fax: (212)522-8770. E-mail: steven_charny@time inc.com. Website: www.babytalk.com. **Contact:** Steven Charny, Art Director. Estab. 1937. *Babytalk* is a monthly consumer magazine with a non-newstand circulation of 2 million for new mothers and pregnant women. It is distributed via subscription and through physicians' offices and retail outlets. Sample copies available upon request.

Illustration Approached by hundreds of illustrators/year. Buys 25 illustrations/year. Has featured illustrations by Dan Yaccarino, Ward Schumaker, Janell Genovese, Robert DeMichell. Features humorous illustration, spot illustrations of children, families and women. Prefers style: hip, sophisticated, not too cartoony. Assigns 10% to new and emerging illustrators.

First Contact & Terms Illustrators: Send query letter and postcard sample with printed samples, URL. After introductory mailing, send follow-up postcard every 3 months. Samples are filed. Responds only if interested. Portfolios not required. Pays illustrators $250-500 for color inside; $500-1,000 for 2-page spreads. **Pays on acceptance.** Buys one-time rights, reprint rights, all rights, electronic rights. Finds freelancers through agents, artists' submissions, word of mouth, and sourcebooks.

Tips "Please no calls or e-mails. Postcards or mailers are best. We don't look at portfolios unless we request them. Websites listed on mailers are great."

N: BACKPACKER MAGAZINE

Rodale, 33 E. Minor St., Emmaus PA 18098-0001. (610)967-5171. Fax: (610)967-8181. E-mail: mbates@backpac ker.com. Website: www.backpacker.com. **Art Director:** Matthew Bates. Estab. 1973. Consumer magazine covering non-motorized wilderness travel. Circ. 306,500.

Illustration Approached by 200-300 illustrators/year. Buys 10 illustrations/issue. Considers all media. 60% of freelance illustration demands knowledge of FreeHand, Photoshop, Illustrator, QuarkXPress.

First Contact & Terms Illustrators: Send query letter with printed samples, photocopies and/or tearsheets. Send follow-up postcard sample every 6 months. Accepts disk submissions compatible with QuarkXPress, Illustrator and Photoshop. Samples are filed and are not returned. Art director will contact artist for portfolio review of color photographs, slides, tearsheets and/or transparencies if interested. Buys first rights or reprint rights. Pays on publication. Finds artists through submissions and other printed media.

Tips *Backpacker* does not buy cartoons. "Know the subject matter, and know *Backpacker Magazine*."

BALLOON LIFE MAGAZINE

2336 47th Ave. SW, Seattle WA 98116-2331. (206)935-3649. Fax: (206)935-3326. E-mail: tom@balloonlife.com. Website: www.balloonlife.com. **Editor:** Tom Hamilton. Estab. 1985. Monthly 4-color magazine emphasizing the sport of ballooning. "Contains current news, feature articles, a calendar and more. Audience is sport balloon enthusiasts." Circ. 4,000. Accepts previously published material. Original artwork returned after publication. Sample copy for SASE with 8 first-class stamps. Art guidelines for SASE with first-class postage.

- Only cartoons and sketches directly related to gas balloons or hot air ballooning are considered by *Balloon Life*.

Cartoons Approached by 20-30 cartoonists/year. Buys 1-2 cartoons/issue. Seeks gag, editorial or political cartoons, caricatures and humorous illustrations. Prefers single panel b&w line drawings with or without gaglines.

Illustration Approached by 10-20 illustrators/year. Buys 1-3 illustrations/year. Has featured illustrations by Charles Goll. Features humorous illustration; informational graphics; spot illustration. Needs computer-literate illustrators familiar with PageMaker, Illustrator, Photoshop, Colorit, Pixol Paint Professional and FreeHand.

First Contact & Terms Cartoonists: Send query letter with samples, roughs and finished cartoons. Illustrators: Send postcard sample or query letter with business card and samples. Accepts submissions on disk compatible with Macintosh files. Send EPS files. Samples are filed or returned. Responds in 1 month. Will contact for portfolio review if interested. Buys all rights. Pays on publication. Pays cartoonists $25 for b&w and $25-40 for color. Pays illustrators $50 for b&w or color cover; $25 for b&w inside; $25-40 for color inside.

Tips "Know what a modern hot air balloon looks like! Too many cartoons reach us that are technically unacceptable."

N BALTIMORE JEWISH TIMES

1040 Park Ave., Suite 200, Baltimore MD 21218. (410)752-3504. Fax: (443)451-6029. E-mail: artdirector@jewish times.com. Website: www.jewishtimes.com. **Art Director:** Caroline Geertz. Weekly b&w tabloid with 4-color cover emphasizing special interests to the Jewish community for largely local readership. Circ. 20,000. Accepts previously published artwork. Returns original artwork after publication, if requested. Sample copy available.

- This publisher also publishes *Style Magazine*, a Baltimore lifestyle magazine, and *Chesapeake Life*, covering lifestyle topics in southern Maryland and the Eastern Shore.

Illustration Approached by 50 illustrators/year. Buys 4-6 illustrations/year. Works on assignment only. Prefers high-contrast, b&w illustrations.

First Contact & Terms Illustrators: Send query letter with brochure showing art style or tearsheets and photocopies. Samples not filed are returned by SASE. Responds if interested. To show a portfolio, mail appropriate materials or write/call to schedule an appointment. Portfolio should include original/final art, final reproduction/product and color tearsheets and photostats. Buys first rights. Pays on publication; $200 for b&w cover and $300 for color cover; $50-100 for b&w inside.

Tips Finds artists through word of mouth, self-promotion and sourcebooks. Sees trend toward "more freedom of design integrating visual and verbal."

N BALTIMORE MAGAZINE

1000 Lancaster St., Suite 400, Baltimore MD 21202-4382. (410)752-4200. Fax: (410)625-0280. E-mail: wamanda @baltimoremag.com. Website: www.baltimoremag.com. **Art Director:** Amanda White-Iseli. Production Assistant: Staci Caquelin. Estab. 1908. Monthly city magazine featuring news, profiles and service articles. Circ. 57,000. Originals returned at job's completion. Sample copies available for $2.05/copy. 10% of freelance work demands knowledge of QuarkXPress, FreeHand, Illustrator or Photoshop or any other program that is saved as a TIFF or PICT file.

Illustration Approached by 60 illustrators/year. Buys 4 illustrations/issue. Works on assignment only. Considers all media, depending on assignment.

First Contact & Terms Illustrators: Send postcard sample. Accepts disk submissions. Samples are filed. Will contact for portfolio review if interested. Buys one-time rights. Pays on publication; $100-400 for b&w, $150-600 for color insides; 60 days after invoice. Finds artists through sourcebooks, publications, word of mouth, submissions.

Tips All art is freelance—humorous front pieces, feature illustrations, etc. Does not use cartoons.

☑ BARTENDER MAGAZINE

Box 158, Liberty Corner NJ 07938-0158. (908)766-6006. Fax: (908)766-6607. E-mail: barmag@aol.com. Website: www.bartender.com. **Editor:** Jackie Foley. Art Director: Todd Thomas. Estab. 1979. Quarterly 4-color trade journal emphasizing restaurants, taverns, bars, bartenders, bar managers, owners, etc. Circ. 150,000.

Cartoons Approached by 10 cartoonists/year. Buys 3 cartoons/issue. Prefers bar themes; single panel.

Illustration Approached by 5 illustrators/year. Buys 1 illustration/issue. Works on assignment only. Prefers bar themes. Considers any media.

Design Needs computer-literate designers familiar with QuarkXPress and Illustrator.

First Contact & Terms Cartoonists: Send query letter with finished cartoons. Buys first rights. Illustrators: Send query letter with brochure. Samples are filed. Negotiates rights purchased. Pays on publication. Pays cartoonists $50 for b&w and $100 for color inside. Pays illustrators $500 for color cover.

☑ ☒ BC OUTDOORS, HUNTING AND SHOOTING

1080 Howe St., Suite 900, Vancouver BC V6Z-2T1 Canada. (604)606-4644. Fax: (604)687-1925. E-mail: bcoutdoors@oppublishing.com. Website: www.bcosportfishing.com. **Art Director:** Kelly Craft. Bimonthly 4-color magazine, emphasizing fishing, hunting, camping, wildlife/conservation in British Columbia. Circ. 30,000. Original artwork returned after publication unless bought outright.

Illustration Approached by more than 10 illustrators/year. Has featured illustrations by Ian Forbes and Brad Nickason. Buys 4-6 illustrations/year. Prefers local artists. Interested in outdoors, wildlife (BC species only) and activities as stories require. Format: b&w line drawings and washes for inside and color washes for inside.

First Contact & Terms Works on assignment only. Samples returned by SAE (nonresidents include IRC). Reports back on future assignment possibilities. Arrange personal appointment to show portfolio or send samples of style. Subject matter and the art's quality must fit with publication. Buys first North American serial rights or all rights on a work-for-hire basis. Pays on publication; $40 minimum for spots.

Tips "Send us material on fishing and hunting. We generally just send back non-related work."

THE BEAR DELUXE

P.O. Box 10342, Portland OR 97296. (503)242-1047. Fax: (503)243-2645. E-mail: bear@orlo.org. Website: www.orlo.org. **Contact:** Thomas Cobb, art director. Editor-in-Chief: Tom Webb. Estab. 1993. Quarterly 4-color, b&w consumer magazine emphasizing environmental writing and visual art. Circ. 19,000. Sample copies free for $3. Art guidelines for SASE with first-class postage.

Cartoons Approached by 50 cartoonists/year. Buys 5 cartoons/issue. Prefers work related to environmental, outdoor, media, arts. Prefers single panel, political, humorous, b&w line drawings.

Illustration Approached by 50 illustrators/year. Has featured illustrations by Matt Wuerker, Ed Fella, Eunice Moyle and Ben Rosenberg. Caricature of politicians, charts & graphs, natural history and spot illustration. Assigns 30% of illustrations to new and emerging illustrators. 30% of freelance illustration demands knowledge of Illustrator, Photoshop and FreeHand.

First Contact & Terms Cartoonists: Send query letter with b&w photocopies and SASE. Samples are filed or returned by SASE. Responds in 4 months. Illustrators: Send postcard sample and nonreturnable samples. Accepts Mac-compatible disk submissions. Send EPS or Tiff files. Samples are filed or returned by SASE. Responds only if interested. Portfolios may be dropped off by appointment. Buys first rights. Pays on publication. Pays cartoonists $10-50 for b&w. Pays illustrators $200 b&w or color cover; $15-75 for b&w or color inside; $15-75 for 2-page spreads; $20 for spots. Finds illustrators through word of mouth, gallery visits and promotional samples.

Tips We are actively seeking new illustrators and visual artists, and we encourage people to send samples. Most of our work (besides cartoons) is assigned out as editorial illustration or independent art. Indicate whether an assignment is possible for you. Indicate your fastest turn-around time. We sometimes need people who can work with 2-3 week turn-around or faster.

☒ BEST'S REVIEW

Ambest Rd., Oldwick NJ 08858. (908)439-2200. Fax: (908)439-3363. E-mail: editor_br@ambest.com. Website: www.bestreview.com. **Manager of Production:** Susan Brown. Estab. 1930. Monthly insurance trade journal. Circ. 50,000. Sample copies and art guidelines available.

Illustration Approached by 50 illustrators/year. Buys 3 illustrations/issue. Considers all media. 75% of freelance illustration demands knowledge of Photoshop and Illustrator.

First Contact & Terms Illustrators: Send postcard sample. Accepts disk submissions. Samples are filed and are not returned. Responds in 1 month. Buys one-time rights. Pays on publication; $900-1,000 for b&w cover; $1,000-1,500 for color cover; $250-500 for b&w inside; $500-750 for color inside; $100-250 for spots.

N BETTER HEALTH MAGAZINE

1450 Chapel St., New Haven CT 06511-4405. (203)789-3972. Fax: (203)789-4053. Website: www.srhs.org/betterhealth.asp. **Editor/Publishing Director:** Cynthia Wolfe Boynton. Estab. 1979. Bimonthly, 4-color "consumer health magazine." Circ. 149,000. Accepts previously published artwork. Original artwork returned at job's completion. Sample copies available for $2.50. Some freelance work demands knowledge of Photoshop, QuarkXPress or Illustrator.

Illustration Approached by 100 illustrators/year. Buys 2-4 illustrations/issue. Works on assignment only. Considers watercolor, collage, airbrush, acrylic, colored pencil, oil, mixed media, pastel and computer illustration.

First Contact & Terms Illustrators: Send query letter with tearsheets. Accepts disk submissions compatible with Mac, Illustrator or Photoshop. Samples are filed. Responds only if interested. Mail postcard samples, photostats, photographs and photocopies. Portfolio should include rough, original/final art, color tearsheets, photostats, photographs and photocopies. Buys first rights. **Pays on acceptance**; $600 for color cover; $400 for color inside.

N BEVERAGE WORLD MAGAZINE

770 Broadway, New York NY 10003-9522. (646)545-4500. Fax: (646)654-7727. E-mail: pmoliver@beverageworld.com. Website: www.beverageworld.com. **Art Director:** Patti Moliver. Editor: Andrea Foote. Monthly magazine covering beverages (beers, wines, spirits, bottled waters, soft drinks, juices) for soft drink bottlers, breweries, bottled water/juice plants, wineries and distilleries. Circ. 34,000. Accepts simultaneous submissions. Original artwork returned after publication if requested. Sample copy $8.00. Art guidelines available.

Illustration Buys 2-3 illustrations/year. Has featured illustrations by Ned Shaw and Steven Morrell. Works on assignment only. Assigns 70% of illustrations to experienced but not well-known illustrators; 30% to new and emerging illustrators.

First Contact & Terms Illustrators: Send postcard sample, brochure, photocopies and photographs to be kept on file. Responds only if interested. Negotiates rights purchased. **Pays on acceptance**. Pays illustrators $500-$1,000 for color cover.

☑ BIRD WATCHER'S DIGEST

149 Acme St., Marietta OH 45750. (740)373-5285. Fax: (740)373-8443. E-mail: editor@birdwatchersdigest.com. Website: www.birdwatchersdigest.com. **Editor:** William H. Thompson III. Bimonthly magazine covering birds and bird watching for "bird watchers and birders (backyard and field; veteran and novice)." Circ. 90,000. Art guidelines available on website or free for SASE. Previously published material OK. Original work returned after publication. Sample copy $3.99.

Illustration Buys 1-2 illustrations/issue. Has featured illustrations by Julie Zickefoose, Tom Hirata, Kevin Pope and Jim Turanchik. Assigns 15% of illustrations to new and emerging illustrators.

First Contact & Terms Illustrators: Send samples or tearsheets. Responds in 2 months. Buys one-time rights. Pays $50 minimum for b&w; $100 minimum for color.

BITCH: FEMINIST RESPONSE TO POP CULTURE

1611 Telegraph Ave., Suite 515, Oakland CA 94612. (510)625-9390. Fax: (510)625-9717. E-mail: briar@bitchmagazine.com. Website: www.bitchmagazine.com. **Art Director:** Briar Levitt. Estab. 1996. Four times yearly b&w magazine. "We examine popular culture in all its forms for women and feminists of all ages." Circ. 45,000.

Illustration Approached by 300 illustrators/year. Buys 3-7 illustrations/issue. Has featured illustrations by Andi Zeisler, Hugh D'Andrade, Pamela Hobbs, Isabel Samaras and Pam Purser. Features caricatures of celebrities, conceptual, fashion and humorous illustration. Work on assignment only. Prefers b&w ink drawings and photo collage. Assigns 90% of illustrations to experienced but not well-known illustrators; 8% to new and emerging illustrators; 2% to well-known or "name" illustrators.

First Contact & Terms Illustrators: Send postcard sample, nonreturnable samples. Accepts Mac-compatible disk submissions. Samples are filed and are not returned. Will contact artist for portfolio review if interested. "We now are able to pay, but not much at all." Finds illustrators through magazines and word of mouth.

Tips "We have a couple of illustrators we work with generally but are open to others. Our circulation has been doubling annually, and we are distributed internationally. Read our magazine and send something we might like."

BLACK WARRIOR REVIEW

Box 862936, University of Alabama, Tuscaloosa AL 35486. (205)348-4518. Website: http://webdelsol.com/bwr. **Editor:** Aaron Welborn. Biannual literary magazine publishing contemporary poetry, fiction and nonfiction by new and established writers. Circ. 2,000. Accepts previously published artwork. Original artwork is returned at job's completion. Sample copy $8.

Illustration Considers color and b&w photography, pen & ink, watercolor, acrylic, oil, collage and marker for cover and inside portfolio.

First Contact & Terms Illustrators: Send postcard sample. Pays on publication; $150 for b&w or color cover; payment for portfolios varies.

Tips "Check out a recent issue."

BODY & SOUL

42 Pleasant St., Watertown MA 02472. (617)926-0200, ext. 338. Website: www.bodyandsoulmag.com. **Art Director:** Carolynn Decillo. Emphasizes alternative lifestyles, holistic health, ecology, personal growth, human potential, planetary survival. Bimonthly. Circ. 190,000. Accepts previously published material and simultaneous submissions. Originals are returned after publication by request. Sample copy $3.

Illustration Buys 60-90 illustrations/year. Works on assignment only.

First Contact & Terms Illustrators: Send tearsheets, slides or promo pieces. Samples returned by SASE if not kept on file. Portfolio may be dropped off. Pays $1,000 for color cover; $400 for color inside.

Tips Finds artists through sourcebooks and reps. "I prefer to see tearsheets or printed samples."

N BOSTONIA MAGAZINE

10 Lenox St., Brookline MA 02446-4042. (617)353-3081. Fax: (617)353-6488. E-mail: bostonia@bu.edu. Website: www.bu.edu/alumni/bostonia. **Art Director:** Kim Han. Estab. 1900. Quarterly 4-color alumni magazine of Boston University. Audience is "highly educated." Circ. 230,000. Sample copies free for #10 SASE with first-class postage. Art guidelines not available.

Illustration Approached by 500 illustrators/year. We buy 3 illustrations/issue. Features humorous and realistic illustration, medical, computer and spot illustration. Assigns 10% of illustrations to well-known or "name" illustrators; 50% experienced but not well-known illustrators; 40% to new and emerging illustrators. Considers all media. Works on assignment only.

First Contact & Terms Illustrators: Send query letter with photocopies, printed samples and tearsheets. Samples are filed and not returned. Responds within weeks only if interested. Will contact for portfolio review if interested. Portfolio should include color and b&w roughs, final art and tearsheets. Buys first North American serial rights. "Payment depends on final use and size." **Pays on acceptance**. Payment varies for cover and inside; pays $200-400 for spots. "Liberal number of tearsheets available at no cost." Finds artists through magazines, word of mouth and submissions.

Tips "Portfolio should include plenty of tearsheets/photocopies as handouts. Don't phone; it disturbs flow of work in office. No sloppy presentations. Show intelligence and uniqueness of style."

✔ BOTH SIDES NOW

10547 State Hwy. 110 N., Tyler TX 75704-3731. (903)592-4263. E-mail: bothsidesnow@prodigy.net. Website: www.bothsidesnow.info. **Editor/Publisher:** Elihu Edelson. Zine emphasizing the New Age "for people seeking holistic alternatives in spirituality, lifestyle, and politics." Irregular (4 times/year), photocopied publication. Circ. 200. Accepts previously published material. Original artwork returned by SASE. Sample copy $2.

Cartoons Buys various number of cartoons/issue. Prefers fantasy, political satire, religion and exposés of hypocrisy as themes. Prefers single or multi-panel b&w line drawings.

Illustration Buys variable amount of illustrations/issue. Prefers fantasy, surrealism, spirituality and realism as themes. Black & white only.

First Contact & Terms Cartoonists: Send query letter or e-mail with typical examples. Illustrators: Send query letter or e-mail with résumé and examples. Samples not filed are returned by SASE. Responds in 3 months. Pays cartoonists/illustrators on publication in copies and subscription.

Tips "Pay close attention to listing and website FAQ page. Do not send color or angst-laden downers, please."

BOW & ARROW HUNTING MAGAZINE

265 S. Anita Dr., #120, Orange CA 92868-3343. (714)939-9991. Fax: (714)939-9909. E-mail: editorial@bowandarrowhunting.com. Website: www.bowandarrowhunting.com. **Editor:** Joe Bell. Emphasizes the sport of bowhunting. Circ. 97,000. Published 9 times per year. Art guidelines free for SASE with first-class postage. Original artwork returned after publication.

Cartoons Buys occasional cartoon. Prefers single panel with gag line; b&w line drawings.

Illustration Buys 2-6 illustrations/issue; all from freelancers. Has featured illustrations by Tes Jolly and Cisco Monthay. Assigns 25% of illustrations to new and emerging illustrators. Prefers live animals/game as themes.

First Contact & Terms Cartoonists: Send finished cartoons. Illustrators: Send samples. Prefers photographs or original work as samples. Especially looks for perspective, unique or accurate use of color and shading, and an ability to clearly express a thought, emotion or event. Samples returned by SASE. Responds in 2 months.

Portfolio review not required. Buys first rights. Pays on publication; $500 for color cover; $100 for color inside; $50-100 for b&w inside.

BOYS' QUEST

P.O. Box 227, Bluffton OH 45817. (419)358-4610. Website: www.boysquest.com. **Assistant Editor:** Diane Winebar. Estab. 1995. Bimonthly consumer magazine "geared for elementary boys." Circ. 10,000. Sample copies $4 each; art guidelines for SASE with first-class postage.

Cartoons Buys 1-3 cartoons/issue. Prefers wholesome children themes. Prefers: single or double panel, humorous, b&w line drawings with gagline.

Illustration Approached by 100 illustrators/year. Buys 6 illustrations/issue. Has featured illustrations by Chris Sabatino, Gail Roth and Pamela Harden. Features humorous illustration; realistic and spot illustration. Assigns 40% of illustrations to new and emerging illustrators. Prefers childhood themes. Considers all media.

First Contact & Terms Cartoonists: Send finished cartoons. Illustrators: Send query letter with printed samples. Samples are filed or returned by SASE. Responds in 2 months. To arrange portfolio review of b&w work, artist should follow up with call or letter after initial query. Buys first rights. Pays on publication. Pays cartoonists $5-25 for b&w. Pays illustrators $200-250 for color cover; $25-35 for b&w inside; $50-70 for 2-page spreads; $10-25 for spots. Finds illustrators through artist's submissions.

Tips "Read our magazine. Send in a few samples of work in pen & ink. Everything revolves around a theme; the theme list is available with SASE."

N BRIDE'S MAGAZINE

Condé-Nast Publications, 4 Times Square, 6th Floor, New York NY 10036-6518. (212)286-7528. Fax: (212)286-8331. Website: www.brides.com. **Design Director:** Phyllis Cox. Estab. 1934. Bimonthly 4-color; "classic, clean, sophisticated design style." Circ. 440,511. Original artwork is returned after publication.

Illustration Buys illustrations mainly for spots and feature spreads. Buys 5-10 illustrations/issue. Works on assignment only. Considers pen & ink, airbrush, mixed media, colored pencil, watercolor, acrylic, collage and calligraphy. Needs editorial illustrations.

First Contact & Terms Illustrators: Send postcard sample. In samples or portfolio, looks for "graphic quality, conceptual skill, good 'people' style; lively, young but sophisticated work." Samples are filed. Will contact for portfolio review if interested. Portfolios may be dropped off every Monday-Thursday and should include color and b&w final art, tearsheets, slides, photostats, photographs and transparencies. Buys one-time rights or negotiates rights purchased. Pays on publication; $250-350 for b&w or color inside; $250 minimum for spots. Finds artists through word of mouth, magazines, submissions/self-promotions, sourcebooks, artists' agents and reps, attending art exhibitions.

N BRUTARIAN

9405 Ulysses Court, Burke VA 22015. E-mail: art@brutarian.com. Website: www.brutarian.com. **Publisher:** Dominick J. Salemi. Estab. 1991. Quarterly magazine. Circ. 5,000.

Illustration Approached by 100 illustrators/year. Buys 5 illustrations/issue. "We want artwork that is original, stylistically distinct and has impact. We have several avenues to display artwork, both in our published magazine and on our website."

First Contact & Terms "The original artwork may be in any medium, but submissions must be in electronic format or a photocopy. Electronic submissions must be 300 dpi or better and sent in separate e-mails to the address above. Artists may also send a direct link to specific pieces of art on their website (preferred method). Photocopies may be color or b&w. It is recommended that artists send several representative samples of their work. Along with your submission, please indicate if you're interested in doing on-demand illustration. Pay is $100/cover art, $50/full-page illustration and $25/filler art. We purchase print rights for the current issue and ongoing non-exclusive electronic rights for our website, artist gallery and archive. Payment is on or slightly after publication. Response time will vary. We typically respond within a month but recommend that you contact us if you have not heard from us after two months."

N BUCKMASTERS WHITETAIL MAGAZINE

10350 Hwy. 80 E., Montgomery AL 36117-6064. (334)215-3337. Fax: (334)215-3535. E-mail: lunger@buckmasters.com. Website: www.buckmasters.com. **Art Director:** Laura Unger. Estab. 1987. Magazine covering whitetail deer hunting. Seasonal—6 times/year. Circ. 400,000. Accepts previously published artwork. Originals are not returned. Sample copies and art guidelines available. 80% of freelance work demands knowledge of Illustrator, QuarkXPress, Photoshop or FreeHand.

- Also publishes *Rack* and *Young Bucks Outdoors*. Tim Martin is art director for *Rack*; John Manfredi is art director for *Young Bucks Outdoors*.

Cartoons Approached by 5 cartoonists/year. Buys 1 cartoon/issue.

Illustration Approached by 5 illustrators/year. Buys 1 illustration/issue. Works on assignment only. Considers all media.

Design Needs freelance designers for multimedia. 100% of freelance work requires knowledge of Photoshop, QuarkXPress or Illustrator.

First Contact & Terms Cartoonists: Send query letter with brochure and photos of originals. Illustrators: Send postcard sample. Accepts submissions on disk. Samples are filed. Responds in 3 months. Call or write for appointment to show portfolio. Portfolio should include final art, slides and photographs. Rights purchased vary. Pays on publication. Pays cartoonists $25 for b&w. Pays illustrators $500 for color cover; $150 for color inside. Pays designers by project.

Tips "Send samples related to whitetail deer or turkeys."

ⓝ BUGLE—JOURNAL OF ELK AND THE HUNT

2291 W. Broadway, Missoula MT 59808-1813. (406)523-4570. Fax: (406)549-7710. E-mail: jpeters@rmef.org. Website: www.rmef.org. **Art Director:** Jodie Peters. Estab. 1984. Bimonthly 4-color outdoor conservation and hunting magazine for a nonprofit organization. Circ. 130,000.

Illustration Approached by 30-40 illustrators/year. Buys 3-4 illustrations/issue. Has featured illustrations by Pat Daugherty, Cynthie Fisher, Joanna Yardley and Bill Gamradt. Features natural history illustration, humorous illustration, realistic illustrations and maps. Preferred subjects: wildlife and nature. "Open to all styles." Assigns 60% of illustrations to well-known or "name" illustrators; 20% to experienced but not well-known illustrators; 20% to new and emerging illustrators.

First Contact & Terms Illustrators: Send query letter with printed samples and tearsheets. Accepts Windows-compatible disk submissions. Send EPS or TIFF files. Samples are filed. Responds in 2 months. Will contact artist for portfolio review if interested. **Pays on acceptance**; $250-400 for b&w; $250-400 for color cover; $100-150 for b&w, $100-200 for color inside; $150-300 for 2-page spreads; $50 for spots. Finds illustrators through existing contacts and magazines.

Tips "We are looking for a variety of styles and techniques with an attention to accuracy."

☑ BUILDINGS MAGAZINE

615 Fifth St. SE, Cedar Rapids IA 52401-2158. (319)364-6167. Fax: (319)364-4278. E-mail: info@buildings.com. Website: www.buildings.com. **Art Director:** Elisa Geneser. Estab. 1906. Monthly trade magazine featuring "information related to current approaches, technologies and products involved in large commercial facilities." Circ. 57,000. Original artwork returned at job's completion.

Illustration Works on assignment only. Has featured illustrations by Jonathan Macagba, Pamela Harden, James Henry and Jeffrey Scott. Features informational graphics; computer and spot illustration. Assigns 50% of illustrations to new and emerging illustrators. Considers all media, themes and styles.

Design 60% of freelance work demands knowledge of Photoshop, Illustrator.

First Contact & Terms Illustrators: Send postcard sample. Designers: Send query letter with brochure, photocopies and tearsheets. Accepts submissions on disk compatible with Macintosh. Will contact for portfolio review if interested. Portfolio should include thumbnails, b&w/color tearsheets. Rights purchased vary. **Pays on acceptance**. Pays illustrators $250-500 for b&w, $500-1,500 for color cover; $50-200 for b&w inside; $100-350 for color inside; $30-100 for spots. Pays designers by the project. Finds artists through recommendations and submissions.

Tips "Send postcards with samples of your work printed on them. Show us a variety of work (styles), if available. Send only artwork that follows our subject matter: commercial buildings, products and processes, and facility management."

ⓝ BULLETIN OF THE ATOMIC SCIENTISTS

6042 S. Kimbark Ave., Chicago IL 60637-2898. (773)702-2555. Fax: (773)702-0725. E-mail: bulletin@thebulletin.org. Website: www.thebulletin.org. **Managing Editor:** Bret Lortie. Art Director: Thomas Lachemacher. Estab. 1945. Bimonthly magazine of international affairs and nuclear security. Circ. 15,000. Sample copies available.

Cartoons Approached by 5-10 cartoonists/year. Buys 6-10 cartoons/issue. Prefers single panel, general humor, b&w/color washes and line drawings.

Illustration Approached by 20-25 illustrators/year. Buys 2-3 illustrations/issue.

First Contact & Terms Send postcard sample and photocopies. Buys one-time rights. Responds only if interested. **Pays on acceptance**. Pays cartoonists $50-150 for b&w. Pays illustrators $300-500 for color cover; $100-300 for color inside. Publishes illustrators with a variety of experience.

Tips "We're eager to see cartoons that relate to our editorial content, so it's important to take a look at the magazine before submitting items."

☑ BUSINESS & COMMERCIAL AVIATION

(Division of the McGraw-Hill Companies), 6 International Dr., Suite 310, Rye Brook NY 10573. (914)939-0300. Fax: (914)939-1283. E-mail: william_garvey@aviationnow.com. Website: www.aviationnow.com/bca. **Art Direction:** Ringston Media. **Editor-in-Chief:** William Garvey. Monthly technical publication for corporate pilots and owners of business aircraft. 4-color; "contemporary design." Circ. 55,000.

Illustration Works with 12 illustrators/year. Buys 12 editorial and technical illustrations/year. Uses artists mainly for editorials and some covers. Especially needs full-page and spot art of a business-aviation nature. "We generally only use artists with a fairly realistic style. This is a serious business publication—graphically conservative. Need artists who can work on short deadline time." 70% of freelance work demands knowledge of Photoshop, Illustrator, QuarkXPress and FreeHand.

First Contact & Terms Illustrators: Query with samples and SASE. Responds in 1 month. Photocopies OK. Buys all rights, but may reassign rights to artist after publication. Negotiates payment. **Pays on acceptance**; $400 for color; $175-250 for spots.

☑ BUSINESS LAW TODAY

ABA Publishing, 321 N. Clark St., 20th Floor, Chicago IL 60610. (312)988-5000. Fax: (312)988-6081. E-mail: tedhamsj@staff.abanet.org. Website: www.abanet.org/buslaw/blt. **Art Director:** Jill Tedhams. Estab. 1992. Bimonthly magazine covering business law. Circ. 60,291. Art guidelines not available.

Cartoons Buys 20-24 cartoons/year. Prefers business law and business lawyers themes. Prefers single panel, humorous, b&w line drawings with gaglines.

Illustration Buys 6-9 illustrations/issue. Has featured illustrations by Tim Lee, Henry Kosinski and Jim Starr. Features humorous, realistic and computer illustrations. Assigns 10% of illustrations to new and emerging illustrators. Prefers editorial illustration. Considers all media. 10% of freelance illustration demands knowledge of Photoshop, Illustrator and QuarkXPress.

First Contact & Terms Cartoonists: Send photocopies and SASE to the attention of Ray DeLong. Samples are not filed and are returned by SASE. Responds in several days. Illustrators: "We will accept work compatible with QuarkXPress version 4.04. Send EPS or TIFF files." Samples are filed and are not returned. Responds only if interested. Buys one-time rights. Pays on publication. Pays cartoonists $150 minimum for b&w. Pays illustrators $850 for color cover; $520 for b&w inside, $650 for color inside; $175 for b&w spots.

Tips "Although our payment may not be the highest, accepting jobs from us could lead to other projects, since we produce many publications at the ABA. Sending samples (three to four pieces) works best to get a sense of your style; that way I can keep them on file."

Ⓝ ☑ BUSINESS LONDON MAGAZINE

Box 7400, London ON N5Y 4X3 Canada. (519)471-2907. Fax: (519)473-7859. E-mail: design@businesslondon. ca. Website: www.businesslondon.ca. **Art Director:** Rob Rodenhuis. Monthly magazine "covering London and area businesses, entrepreneurs, building better businesses." Circ. 14,000. Sample copies not available; art guidelines not available.

Cartoons Approached by 2 cartoonists/year. Buys 1 cartoon/issue. Prefers business-related line art. Prefers single panel, humorous b&w washes and line drawings without gagline.

Illustration Approached by 5 illustrators/year. Buys 2 illustrations/issue. Has featured illustrations by Nigel Lewis and Scott Finch. Features humorous and realistic illustration; informational graphics and spot illustration. Assigns 50% of illustrations to experienced but not well-known illustrators; 50% to new and emerging illustrators. Prefers business issues. Considers all media. 10% of freelance illustration demands knowledge of Photoshop 3, Illustrator 5.5, QuarkXPress 3.2.

First Contact & Terms Send query letter with roughs and printed samples. Accepts disk submissions compatible with QuarkXPress 7/version 3.3, Illustrator 5.5, Photoshop 3, TIFFs or EPS files. Samples are filed and are not returned. Responds only if interested. Art director will contact artist for portfolio review of b&w, color, final art, photographs, slides and thumbnails if interested. Pays on publication. Pays cartoonists $25-50 for b&w, $50-100 for color. Pays illustrators $125 maximum for cover; $25 minimum for b&w inside. Buys first rights. Finds illustrators through artist's submissions.

Tips "Arrange personal meetings, provide vibrant, interesting samples, start out cheap! Quick turnaround is a must."

Ⓝ BUSINESS TENNESSEE

2817 West End Ave., Suite 216, Nashville TN 37203. (615)843-8000. Fax: (615)843-4300. E-mail: finney@busine sstn.com. Website: www.businesstn.com. **Creative Director:** Lauren Finney. Estab. 1993. Monthly statewide business magazine. Circ. 45,000.

 • A publication of the Nashville Post Company (www.nashvillepost.com)

Cartoons Approached by 2 cartoonists/year. Buys 2-3 cartoons/year. Prefers whimsical single panel, political color washes and b&w line drawings. Responds only if interested.

Illustration Approached by 25 illustrators/year. Buys 2-3 illustrations/issue. Has featured illustrations by Lori Bilter, Pashur, Mike Harris, Dar Maleki, Kurt Lightner. Features caricatures of celebrities and politicians; charts & graphs; computer and spot illustrations of business subjects and country music celebs. Prefers bright colors and pastels, "all styles welcome except 'grunge.' " Assigns 50% of illustrations to experienced but not well-known illustrators; 50% to new and emerging illustrators. 10% of freelance illustration demands knowledge of Illustrator, Photoshop, FreeHand, QuarkXPress.

First Contact & Terms Send query letter with samples. Accepts Mac-compatible disk submissions. Send EPS files. Samples are filed and are not returned. Will contact artist for portfolio review if interested. Rights purchased vary according to project. **Pays on acceptance**. Pays cartoonists $50-150 for b&w; $60-200 for color cartoons. Pays illustrators $200-1,000 for color cover; $50-300 for b&w inside; $60-500 for color inside; $150-800 for 2-page spreads; $30 for spots. Finds freelancers through other publications.

⚇ BUTTERICK

11 Penn Plaza, New York NY 10001-2006. (212)465-6800. Fax: (212)465-6814. E-mail: rsvp@butterick.com. Website: www.butterick.com. **Art Director:** Chris Lipert. Associate Art Director: Judy Perry. Quarterly magazine and monthly catalog. "*Butterick Magazine* is for the home sewer, providing fashion and technical information about our newest sewing patterns through fashion illustration, photography and articles. The Butterick store catalog is a guide to all Butterick patterns, shown by illustration and photography." Magazine circ. 140,719. Catalog readership: 9 million. Originals are returned at job's completion.

Illustration "We have two specific needs: primarily fashion illustration in a contemporary yet realistic style, mostly depicting women and children in full-length poses for our catalog. We are also interested in travel, interior, light concept and decorative illustration for our magazine." Considers watercolor and gouache for catalog art; all other media for magazine.

First Contact & Terms Illustrators: Send query letter with tearsheets and color photocopies and promo cards. Samples are filed or are returned by SASE if requested by artist. Does not report back, in which case the artist should call soon if feedback is desired. Portfolio drop off every Monday or mail appropriate materials. Portfolio should include final art, tearsheets, photocopies and large format transparencies. Rights purchased vary according to project.

Tips "Send nonreturnable samples several times a year—especially if style changes. We like people to respect our portfolio drop-off policy. Repeated calling and response cards are undesirable. One follow-up call by illustrator for feedback is fine."

⚇ CALIFORNIA HOME & DESIGN

618 Santa Cruz Ave., Menlo Park CA 94025. (650)324-1818. Fax: (415)324-1888. E-mail: edit@18media.com. Website: www.18media.com. **Art Director:** Lisa Druri. Estab. 1994. Bimonthly magazine of Northern California lifestyle. Circ. 52,500. Sample copy free for 9×10 SASE and first-class postage.

Cartoons Approached by 200 cartoonists/year. Buys 4 cartoons/year. Prefers financial themes. Prefers single panel, humorous, color washes, without gagline.

Illustration Approached by 100 illustrators/year. Buys 6 illustrations/year. Prefers financial, fashion. Considers all media. 50% of freelance illustration demands knowledge of Photoshop, Illustrator, QuarkXPress.

Design Needs freelancers for design and production. Prefers local design freelancers. 100% of freelance work demands knowledge of Photoshop, Illustrator, QuarkXPress.

First Contact & Terms Cartoonists: Send photocopies. Illustrators: Send postcard sample, query letter with printed samples. Accepts disk submissions compatible with QuarkXPress (EPS files). Designers: Send printed samples. Samples are filed. Responds only if interested. Buys one-time rights. Pays on publication. Pays cartoonists $50-100 for b&w; $75-200 for color. Pays illustrators $100-250 for spots. Finds illustrators through artist's submissions.

Tips "Read our magazine."

⚇ ⚇ CALIFORNIA JOURNAL

2101 K St., Sacramento CA 95816-4920. (916)444-2840. Fax: (916)444-2339. E-mail: edit@statenet.com. Website: www.californiajournal.com. **Art Director:** Dagmar Thompson. Estab. 1970. Monthly magazine "covering politics, government and independent analysis of California issues." Circ. 15,000. Sample copies available. Art guidelines not available. Call.

Illustration Approached by 10-30 illustrators/year. Buys 30-40 illustrations/year. Features caricatures of politicians; realistic, computer and spot illustration. Assigns 5% of illustrations to well-known or "name" illustrators; 25% to experienced but not well-known illustrators; 70% to new and emerging illustrators. Prefers editorial. Considers all media. 10% of freelance illustration demands knowledge of Photoshop.

Design Prefers California design freelancers.

First Contact & Terms Illustrators: Send postcard sample or query letter with photocopies. Send follow-up

postcard sample every 4 months. Accepts disk submissions compatible with Mac Photoshop/Syquest on 3.5 or Zip disk. Samples are filed and not returned. Responds only if interested. Art director will contact artist for portfolio review if interested. Buys all rights. **Pays on acceptance**; $350 minimum for color cover; $150 minimum for b&w inside; $100 minimum for spots. Finds illustrators through magazines, word of mouth and artist's submissions.

Tips "We like to work with illustrators who understand editorial concepts and are politically current."

🍁 🔷 CANADIAN BUSINESS

One Mount Pleasant Rd., 11th Floor, Toronto ON M4Y 2Y5 Canada. (416)596-5100. Fax: (416)596-5155. E-mail: tdavin@canadianbusiness.com. Website: www.canadianbusiness.com. **Art Director:** Tim Davin. Associate Art Director: David Heath. Assistant Art Director: John Montgomery. Biweekly 4-color business magazine focusing on Canadian management and entrepreneurs. Circ. 85,000.

Illustration Approached by 200 illustrators/year. Buys 5-10 illustrations/issue. Has featured illustrations by Blair Drawson, Jason Schneider, Seth, Simon Ng, Michael Cho. Features caricatures of celebrities and informational graphics of business subjects. Assigns 70% of illustrations to well-known or "name" illustrators; 30% to new and emerging illustrators (who are on staff as contract designer/illustrators). 30% of freelance illustration demands knowledge of Illustrator and Photoshop.

First Contact & Terms Illustrators: Send postcard sample, printed samples and photocopies. Accepts Mac-compatible disk submissions. Responds only if interested. Will contact artist for portfolio review if interested. **Pays on acceptance**; $1,000-2,000 for color cover; $300-1,500 for color inside; $300 for spots. Finds illustrators through magazines, word of mouth and samples.

🍁 ✅ CANADIAN DIMENSION (CD)

91 Albert St., Room 2-B, Winnipeg MB R3B 1G5 Canada. (204)957-1519. Fax: (204)943-4617. E-mail: info@canadiandimension.mb.ca. Website: www.canadiandimension.mb.ca. **Art Director:** Kevin Matthews. Estab. 1963. Bimonthly consumer magazine published "by, for and about activists in the struggle for a better world, covering women's issues, aboriginal issues, the enrivonment, labour, etc." Circ. 3,100. Accepts previously published artwork. Originals returned at job's completion. Sample copies available for $2. Art guidelines available for SASE with first-class postage.

Illustrators Approached by 20 illustrators/year. Has featured illustrations by Kenneth Vincent, Darcy Muenchrath and Stephen King. Buys 10 illustrations/year.

First Contact & Terms Illustrators: Send query letter with brochure and SASE. Samples are filed or returned by SASE if requested by artist. Publication will contact artist for portfolio review if interested. Buys one-time rights. Pays on publication; $100 for b&w cover; $50 for b&w inside and spots. Finds artists through word of mouth and artists' submissions. E-mail inquiries, samples or URLs welcome.

🍁 CANADIAN GARDENING

340 Ferrier St., Suite 210, Markham ON L3R 2Z5 Canada. (905)475-8440. Fax: (905)475-9246. E-mail: mailbox@canadiangardening.com. Website: www.canadiangardening.com. **Art Director:** Bonnie Summerfeldt Boisseau. Estab. 1990. Special interest magazine published 8 times/year. "A down-to-earth, indispensable magazine for Canadians who love to garden." Circ. 152,000.

Illustration Approached by 50 illustrators/year. Prefers using Canadian artists. Buys 2 illustrations/issue. Considers all media. 50% of freelance illustration demands knowledge of Photoshop, Illustrator and QuarkXPress.

First Contact & Terms Illustrators: Send query letter with tearsheets. Accepts disk submissions compatible with Slide Show, QuarkXPress, Illustrator or Photoshop (Mac). Samples are filed and are not returned. Responds only if interested. Artist should follow up. Buys first rights. Pays within 45 days, $50-600 (CDN) for color inside. Pays $50-250 (CDN) for spots.

Tips Likes work that is "earthy and hip."

🍁 CANADIAN HOME WORKSHOP

340 Ferrier St., Suite 210, Markham ON L3R 2Z5 Canada. (905)475-8440. Fax: (905)475-9560. Website: www.canadianhomeworkshop.com. **Contact:** Amy McCleverty, art director. Estab. 1977. "The Do-it-Yourself" magazine published 10 times/year, which "includes instructions and plans for woodworking projects and step-by-step home improvement articles along with tips from the pros." Circ. 120,000. Sample copies are available on request. Art guidelines available.

Illustration Approached by several freelancers each year. Buys 20 illustrations/year. Has featured illustrations by Jason Schneider, Paul Perreault and Len Churchill. Features computer, humorous, realistic and spot illustration. Assigns 10% of illustrations to new and emerging illustrators. 90% of freelance illustration demands knowledge of Illustrator, Photoshop and QuarkXPress.

First Contact & Terms Send postcard sample or query letter with brochure, photocopies, photographs, samples

and tearsheets. Send follow-up postcard every 6 months. Accepts e-mail submissions with link to website or image file. Prefers Mac-compatible TIFF, JPEG, GIF or EPS files. Samples are filed and not returned. Responds only if interested. Company will contact for portfolio review if interested. Portfolio should include color finished art, photographs and tearsheets. Pays illustrators $150-800 for color inside; $600-1,200 for 2-page spreads. **Pays on acceptance.** Buys first rights, electronic rights. Finds freelancers through agents, artists' submissions and word of mouth.

⬛ 🔲 CANADIAN PHARMACEUTICAL JOURNAL

1785 Alta Vista Dr., Suite 105, Ottawa ON K1G 3Y6 Canada. (613)523-7877. Fax: (613)739-7765. E-mail: cpj@pharmacists.ca. Website: www.pharmacists.ca. **Editor:** Polly Thompson. Estab. 1867. Trade journal. Circ. 17,500. Accepts previously published artwork. Originals are returned at job's completion. Sample copies available.

Illustration Approached by 20 illustrators/year. Works on assignment only. "Stories are relative to the interests of pharmacists—scientific to lifestyle." Considers all media.

First Contact & Terms Illustrators: Send query letter with photostats and transparencies. Samples are filed. Responds only if interested. Call for an appointment to show a portfolio, which should include slides, photostats and photographs. Rights purchased vary. **Pays on acceptance**; $600-1,200 for color cover; $200-1,000 for color inside.

⬛ CAREERS AND COLLEGES

989 Sixth Ave., New York NY 10018. (732)264-0460. Fax: (732)264-0820. E-mail: paul@careersandcolleges.com. Website: www.careersandcolleges.com. **Art Director:** Barbara Hofrenning. Estab. 1980. 4-color educational magazine published four times a year, September-May. "Readers are college-bound high school juniors and seniors. Topics covered are: how to get into college, how to pay for college, careers and surviving life after high school." Circ. 750,000. Accepts previously published artwork.

Illustration "We're looking for contemporary, upbeat, sophisticated illustration. All techniques are welcome."

First Contact & Terms Illustrators: Send query letter with samples. "Please do not call. Will call artist if interested in style." Buys as work for hire.

THE CAROLINA QUARTERLY

Greenlaw Hall CB 3520, University of North Carolina, Chapel Hill NC 27599-3520. (919)962-0204. Fax: (919)962-3520. E-mail: cquarter@unc.edu. Website: www.unc.edu/depts/cqonline. **Contact:** Art Editor. Estab. 1948. Quarterly literary magazine featuring contemporary fiction, poetry, reviews, creative nonfiction, interviews and artwork by established and emerging artists. Circ. 800. Send only clear copies of artwork. Sample copy $5 (includes postage and handling). Art guidelines for SASE with first-class postage and on website.

Illustration Approached by 100 illustrators/year. Buys 3-15 illustrations/year. Prefers b&w line drawings, though open to other. Assigns 70% of illustrations to new and emerging illustrators.

First Contact & Terms Cartoonists/Illustrators: After introductory mailing, send follow-up postcard sample every year. Samples are filed unless return is requested and SASE included. When response is requested, responds in 6 months. Company will contact artist for portfolio review if interested. Pays cartoonists/illustrators maximum $50 for any image or sequence of images. Pays on publication. Rights purchased vary according to project. Finds freelancers through word of mouth and artists' submissions.

Tips "Bold, spare images often work best in our format. Look at a recent issue to get a clear idea of content and design."

CAT FANCY

Bowtie, Inc., Box 6050, Mission Viejo CA 92690. (949)855-8822. E-mail: query@catfancy.com. Website: www.catfancy.com. **Contact:** Susan Logan, editor. Monthly 4-color magazine for cat owners, breeders and fanciers; contemporary, colorful and conservative. Readers are interested in all phases of cat ownership. Circ. 250,000. No simultaneous submissions. Sample copy $5.50; artist's guidelines for SASE.

Cartoons Buys 4 cartoons/year. Seeks single, double and multipanel with gagline. Should be simple, upbeat and reflect love for and enjoyment of cats. Central character should be a cat.

Illustration Needs editorial, medical and technical illustration and images of cats.

First Contact & Terms Cartoonists: Send query letter with photostats or photocopies as samples and SASE. Illustrators: Send query letter with brochure, high-quality photocopies (preferably color), SASE and tearsheets. Article illustrations assigned. Portfolio review not required. Responds in 3 months. Buys first rights. Pays on publication. Pays cartoonists $35 for b&w line drawings. Pays illustrators $20-35 for spots; $50-300 for color insides; more for packages of multiple illustrations.

Tips "Seeking creative and innovative illustrators that lend a modern feel to our magazine. Please review a sample copy of the magazine before submitting your work to us."

CATHOLIC FORESTER

Box 3012, Naperville IL 60566-7012. (630)983-4900. Fax: (630)983-4057. E-mail: magazine@catholicforester.com. Website: www.catholicforester.com. **Contact:** Art Director. Estab. 1883. "We are a fraternal insurance company but use general-interest articles, art and photos. Audience is middle-class, many small town as well as big-city readers, patriotic, Catholic and traditionally conservative." National quarterly 4-color magazine. Circ. under 100,000. Accepts previously published material. Sample copy for 9×12 SASE with 3 first-class stamps.

Cartoons Buys less than 2 cartoons/year from freelancers. Considers "anything *funny* but it must be clean." Prefers single panel with gagline or strip; b&w line drawings.

Illustration Buys and commissions editorial illustration.

First Contact & Terms Cartoonists: Material returned by SASE. Responds in about 2 months. Illustrators: Will contact for portfolio review if interested. Requests work on spec before assigning job. Buys one-time rights, North American serial rights or reprint rights. Pays on publication. Pays cartoonists $30 for b&w. Pays illustrators $30-100 for b&w, $75-300 for color inside.

Tips "Know the audience you're drawing for; always read the article and don't be afraid to ask questions. Pick the art director's brain for ideas and be timely."

CATS & KITTENS

Pet Publishing Inc., 7-L Dundas Circle, Greensboro NC 27407. (336)292-4047. Fax: (336)292-4272. E-mail: rdavis@petpublishing.com. Website: www.catsandkittens.com. **Executive Director:** Rita Davis. Bimonthly 4-color consumer magazine about cats, including breed profiles, medical reports, training advice, cats at work, cat collectibles and cat stories. Circ. 50,000. Art guidelines free for #10 SASE with first-class postage.

Illustration Features realistic illustrations. Prefers watercolor, pen & ink, acrylics and color pencil. Assigns illustrations to experienced but not well-known illustrators and to new and emerging illustrators.

First Contact & Terms Illustrators: Send postcard sample. Send query letter with printed samples, photocopies, SASE and tearsheets. Accepts Windows-compatible disk submissions. Send EPS files at 266 dpi. Portfolio review not required. Pays on publication; $25 maximum for b&w, $25 maximum for color inside.

Tips "Need artists with ability to produce illustrations for specific story on short notice."

CED

P.O. Box 266007, Highlands Ranch CO 80163-6007. (303)470-4800. Fax: (303)470-4890. E-mail: druth@reedbusiness.com. Website: www.cedmagazine.com. **Art Director:** Don Ruth. Estab. 1978. Monthly trade journal dealing with "the engineering aspects of the technology in Cable TV. We try to publish both views on subjects." Circ. 22,815. Accepts previously published work. Original artwork not returned at job's completion. Sample copies and art guidelines available.

Illustration Buys 1 illustration/issue. Works on assignment only. Features caricatures of celebrities; realistic illustration; charts & graphs; informational graphics and computer illustrations. Assigns 10% of illustrations to new and emerging illustrators. Prefers cable TV-industry themes. Considers watercolor, airbrush, acrylic, colored pencil, oil, charcoal, mixed media, pastel, computer disk formatted in Photoshop, Illustrator or FreeHand.

First Contact & Terms Contact only through artist rep. Samples are filed. Call for appointment to show portfolio. Portfolio should include final art, b&w/color tearsheets, photostats, photographs and slides. Rights purchased vary according to project. **Pays on acceptance.** Pays illustrators $400-800 for color cover; $125-400 for b&w and color inside; $250-500 for 2-page spreads; $75-175 for spots.

Tips "Be persistent; come in person if possible. Be willing to change in mid course; be willing to have finished work rejected. Make sure you can draw and work fast."

N ☑ CHARLESTON MAGAZINE

782 Johnnie Dodds Blvd., Suite C, Mt. Pleasant SC 29464. (843)971-9811. Fax: (843)971-0121. E-mail: mmonk@charlestonmag.com. Website: www.charlestonmag.com. **Art Director:** Melinda Smith Monk. Editor: Darcy Shanklin. Estab. 1973. Quarterly 4-color consumer magazine. "Indispensible resource for information about modern-day Charleston SC, addresses issues of relevance and appeals to both visitors and residents." Circ. 20,000. Art guidelines are free for #10 SASE with first-class postage.

Illustration Approached by 35 illustrators/year. Buys 3 illustrations/issue. Has featured illustrations by Tate Nation, Nancy Rodden, Paige Johnson, Emily Thompson and local artists. Features realistic illustrations, informational graphics, spot illustrations, computer illustration. Prefers business subjects, children, families, men, pets, women and teens. Assigns 10% of illustrations to well-known or "name" illustrators; 30% to experienced but not well-known illustrators; 60% to new and emerging illustrators. 35% of freelance illustration demands knowledge of Illustrator, Photoshop, FreeHand, PageMaker, QuarkXPress.

First Contact & Terms Illustrators: Send postcard sample and follow-up postcard every month or send query letter with printed samples. Accepts Mac-compatible disk submissions. Samples are filed or returned by SASE.

Responds only if interested. Will contact artist for portfolio review if interested. Rights purchased vary according to project. Pays 30 days after publication; $175 for b&w, $200 for color cover; $100-400 for 2-page spreads; $50 for spots. Finds illustrators through sourcebooks, artists' promo samples, word of mouth.

Tips "Our magazine has won several design awards and is a good place for artists to showcase their talent in print. We welcome letters of interest from artists interested in semester-long, unpaid internships-at-large. If selected, artist would provide 4-5 illustrations for publication in return for masthead recognition and sample tearsheets. Staff internships (unpaid) also available on-site in Charleston S.C. Send letter of interest and samples of work to Art Director."

☑ CHARLOTTE MAGAZINE

127 W. Worthington Ave., Suite 208, Charlotte NC 28203-4474. (704)335-7181. Fax: (704)335-3739. E-mail: epotter@abartapub.com. Website: www.charlottemag.com. **Art Director:** Erin Potter. Estab. 1995. Monthly 4-color city-based consumer magazine for Charlotte and surrounding areas. Circ. 30,000. Sample copies free for #10 SAE with first-class postage.

Illustration Approached by many illustrators/year. Buys 1-5 illustrations/issue. Features caricatures of celebrities and politicians; computer illustration; humorous illustration; natural history, realistic and spot illustration. Prefers wide range of media/conceptual styles. Assigns 20% of illustrations to new and emerging illustrators.

First Contact & Terms Illustrators: Send postcard sample and follow-up postcard every 6 months. Send nonreturnable samples. Accepts e-mail submissions. Send EPS or TIFF files. Samples are filed. Responds only if interested. Portfolio review not required. Finds illustrators through artist promotional samples and sourcebooks.

Tips "We are looking for diverse and unique approaches to illustration. Highly creative and conceptual styles are greatly needed. If you are trying to get your name out there, we are a great avenue for you."

☒ CHEMICAL WEEK

110 William St., 11th Floor, New York NY 10038. (212)621-4900. Fax: (212)621-4950. E-mail: msotolongo@chemweek.com. Website: www.chemweek.com. **Director:** Mario Sotolongo. Assistant Art Director: Gen Yee. Estab. 1998. Bimonthly, 4-color trade publication emphasizing commercial developments in specialty chemical markets. Circ. 23,000.

- This publisher also publishes other trade magazines, such as *Modern Paints & Coatings, Adhesives Age* and *Soap and Cosmetics*, which have similar needs for illustration and are produced by the same staff. Check out their websites: www.modernpaintsandcoatings.com; www.adhesivesage.com. Art directors say these publications are open to submissions.

Illustration Features charts and graphs, computer illustration, informational graphics, natural history illustration, realistic illustrations, medical illustration of business subjects. Prefers bright colors and clean look. Assigns 100% of illustrations to experienced but not well-known illustrators. 100% of freelance illustration demands knowledge of Illustrator, Photoshop, QuarkXPress.

First Contact & Terms Illustrators: Send nonreturnable postcard sample and follow-up postcard every 6 months. Accepts Mac-compatible disk submissions. Send EPS or TIFF files. Samples are filed and are not returned. Responds only if interested. Portfolio review not required. Rights purchased vary according to project. Pays on publication; $500-800 for color.

Tips "Freelancers should be reliable and produce quality work. Promptness and the ability to meet deadlines are most important."

CHESAPEAKE BAY MAGAZINE

1819 Bay Ridge Ave., Annapolis MD 21403. (410)263-2662. Fax: (410)267-6924. E-mail: kashley@cbmmag.net. Website: www.cbmmag.net. **Art Director:** Karen Ashley. Estab. 1972. Monthly 4-color magazine focusing on the boating environment of the Chesapeake Bay—including its history, people, places and ecology. Circ. 45,000. Original artwork returned after publication upon request. Sample copies free for SASE with first-class postage. Art guidelines available.

Illustration Approached by 12 illustrators/year. Buys 2-3 technical and editorial illustrations/issue. Has featured illustrations by Jim Paterson, Kim Harroll, Jan Adkins, Tamzin C. Biles and Marcy Ramsey. Assigns 50% of illustrations to new and emerging illustrators. Considers pen & ink, watercolor, collage, acrylic, marker, colored pencil, oil, charcoal, mixed media and pastel. Usually prefers watercolor or acrylic for 4-color editorial illustration. "Style and tone are determined by the artist after he/she reads the story."

First Contact & Terms Illustrators: Send query letter with résumé, tearsheets and photographs. Samples are filed. Make sure to include contact information on each sample. Responds only if interested. Publication will contact artist for portfolio review if interested. Portfolio should include "anything you've got." No b&w photocopies. Buys one-time rights. "Price decided when contracted." Pays illustrators $100-300 (for ¼ page or spot illustrations) up to $1,200 (for spreads) for color inside.

Tips "Our magazine design is relaxed, fun, oriented toward people having fun on the water. Style seems to be

loosening up. Boating interests remain the same. But for the Chesapeake Bay—water quality and the environment are more important to our readers now than in the past. Colors brighter. We like to see samples that show the artist can draw boats and understands our market environment. Send tearsheets or call for an interview—we're always looking. Artist should have some familiarity with the appearance of different types of boats, boating gear and equipment.''

N ⊠ CHICKADEE

Bayard Press Canada, 49 Front St. E., 2nd Floor, Toronto ON M5E 1B3 Canada. (416)340-2700. Fax: (416)340-9769. E-mail: chickadee@owl.on.ca. Website: www.owlkids.com. **Creative Director:** Barb Kelly. Estab. 1979. 9 issues/year. Children's discovery magazine. Chickadee is a ''hands-on'' science, nature and discovery publication designed to entertain and educate 6-9 year-olds. Each issue contains photos, illustrations, an easy-to-read animal story, a craft project, fiction, puzzles, a science experiment and a pull-out poster. Circ. 150,000 in North America. Originals returned at job's completion. Sample copies available. Uses all types of conventional methods of illustration. Digital illustrators should be familiar with Illustrator or Photoshop.

● The same company that publishes *Chickadee* now also publishes *Chirp*, a science, nature and discovery magazine for pre-schoolers two to six years old, and *OWL*, a similar publication for children over eight years old.

Illustration Approached by 500-750 illustrators/year. Buys 3-7 illustrations/issue. Works on assignment only. Prefers animals, children, situations and fiction. All styles, loaded with humor but not cartoons. Realistic depictions of animals and nature. Considers all media and computer art. No b&w illustrations.

First Contact & Terms Illustrators: Send postcard sample, photocopies and tearsheets. Accepts disk submissions compatible with Illustrator 8.0. Send EPS files. Samples are filed or returned by SASE. Will contact for portfolio review if interested. Portfolio should include final art, tearsheets and photocopies. Buys all rights. Pays within 30 days of invoice; $500 for color cover; $100-750 for color/inside; $100-300 for spots. Finds artists through sourcebooks, word of mouth, submissions as well as looking in other magazines to see who's doing what.

Tips ''Please become familiar with the magazine before you submit. Ask yourself whether your style is appropriate before spending the money on your mailing. Magazines are ephemeral and topical. Ask yourself if your illustrations are editorial and contemporary. Some styles suit books or other forms better than magazines.'' Impress this art director by being ''fantastic, enthusiastic and unique.''

N CHILD LIFE

Children's Better Health Institute, P.O. Box 567, Indianapolis IN 46206. (317)636-8881. Fax: (317)684-8094. Website: www.childlifemag.org. **Art Director:** Phyllis Lybarger. Estab. 1921. 4-color magazine for children 9-11. Monthly, except bimonthly January/February, April/May, July/August and October/November. Circ. 39,000. Sample copy $1.25. Art guidelines for SASE with first-class postage.

● Art director reports *Child's Life* has gone through a format change from conventional to nostalgic. She is looking for freelancers whose styles lend themselves to a nostalgic look. This publisher also publishes *Children's Digest, Children's Playmate, Humpty Dumpty's Magazine, Jack and Jill, Turtle Magazine* and *U.S. Kids Weekly Reader Magazine.*

Illustration Approached by 200 illustrators/year. Works with 15 illustrators/year. Buys approximately 20 illustrations/year on assigned themes. Features humorous, realistic, medical, computer and spot illustration. 50% of work is pick-up art; the remaining 50% is assigned to new and emerging illustrators. Especially needs health-related (exercise, safety, nutrition, etc.) themes and stylized and realistic styles of children 9-11 years old. Uses freelance art mainly with stories and medical column and activities poems.

First Contact & Terms Illustrators: Send postcard sample or query letter with tearsheets or photocopies. ''Please send SASE and comment card with samples.'' Especially looks for an artist's ability to draw well consistently. Responds in 2 months. Buys all rights. Pays $275 for color cover; $35-90 for b&w inside; $70-155 for color inside; $210-310 for 2-page spreads; $35-80 for spots. Pays within 3 weeks prior to publication date. ''All work is considered work for hire.'' Finds artists through submissions, occasionally through a sourcebook.

Tips ''Artists should obtain copies of current issues to become familiar with our needs. I look for the artist's ability to illustrate children in group situations and interacting with adults and animals, in realistic styles. Also use unique styles for occasional assignments—cut paper, collage or woodcut art. No cartoons, portraits of children or slick airbrushed advertising work.''

N CHILDREN'S DIGEST

Children's Better Health Institute, P.O. Box 567, Indianapolis IN 46202. (317)636-8881. Fax: (317)684-8094. Website: www.childrensdigestmag.org. **Art Director:** Penny Rasdall. 4-color magazine with special emphasis on book reviews, health, nutrition, safety and exercise for preteens. Published 8 times/year. Circ. 106,000. Sample copy $1.25; art guidelines for SASE.

- Also publishes *Child Life, Children's Playmate, Humpty Dumpty's Magazine, Jack and Jill, Turtle Magazine* and *U.S. Kids Weekly Reader Magazine.*

Illustration Approached by 200 illustrators/year. Works with 2 illustrators/year. Buys 2 illustrations/year. Has featured illustrations by Len Ebert, Tim Ellis and Kathryn Mitter. Features humorous, realistic, medical, computer and spot illustrations. Assigns 90% of illustrations to experienced but not well-known illustrators; 10% to new and emerging illustrators. Uses freelance art mainly with stories, articles, poems and recipes. Works on assignment only.

First Contact & Terms Illustrators: Send query letter with brochure, résumé, samples and tearsheets to be kept on file. "Send samples with comment card and SASE." Portfolio review not required. Prefers photostats, slides and good photocopies as samples. Samples returned by SASE if not kept on file. Responds in 2 months. Buys all rights. Pays $275 for color cover; $35-90 for b&w inside; $60-120 for 2-color inside; $70-155 for 4-color inside; $35-70 for spots. Pays within 3 weeks prior to publication date. "All artwork is considered work for hire." Finds artists through submissions and sourcebooks.

Tips Likes to see situation and storytelling illustrations with more than 1 figure. When reviewing samples, especially looks for artist's ability to bring a story to life with illustrations and to draw well consistently. No advertising work, cartoon styles or portraits of children. Needs realistic styles and animals.

☑ CHILDREN'S PLAYMATE

Children's Better Health Institute, P.O. Box 567, Indianapolis IN 46206. (317)636-8881. Fax: (317)684-8094. Website: www.childrensplaymatemag.org. **Art Director:** Rob Falco. 4-color magazine for ages 6-8. Special emphasis on entertaining fiction, games, activities, fitness, health, nutrition and sports. Published 8 times/year. Circ. 78,000. Original art becomes property of the magazine and will not be returned. Sample copy $1.25.

- Also publishes *Child Life, Children's Digest, U.S. Kids Weekly Reader Magazine, Humpty Dumpty's Magazine, Jack and Jill* and *Turtle Magazine.*

Illustration Uses 8-12 illustrations/issue; buys 6-8 from freelancers. Interested in editorial, medical, stylized, humorous or realistic themes; also food, nature and health. Considers pen & ink, airbrush, charcoal/pencil, colored pencil, watercolor, acrylic, oil, pastel, collage, multimedia and computer illustration. Works on assignment only.

First Contact & Terms Illustrators: Send sample of style; include illustrations of children, families, animals—targeted to children. Provide brochure, tearsheet, stats or good photocopies of sample art to be kept on file. Samples returned by SASE if not filed. Artist should follow up with call or letter. Also considers b&w camera-ready art for puzzles, such as dot-to-dot, hidden pictures, crosswords, etc. Buys all rights on a work-for-hire basis. Payment varies. Pays $275 for color cover; up to $155 for color and $90 for b&w inside, per page. Finds artists through artists' submissions/self-promotions.

Tips "Become familiar with our magazine before sending anything. Don't send just two or three samples. I need to see a minimum of eight pieces to determine that the artist fits our needs. Looking for samples displaying the artist's ability to interpret text, especially in fiction for ages 6-8. Illustrators must be able to do their own layout with a minimum of direction."

⧉ CHILE PEPPER MAGAZINE

River Plaza 1701 River Run, Suite 901, Ft. Worth TX 76107. (817)877-1048. Fax: (817)877-8870. E-mail: aglazener@chilepepper.com. Website: www.chilepepper.com. **Creative Director:** Alan Glazener. Bimonthly magazine covering hot and spicy food/cuisine. Circ. 100,000.

Illustration Approached by 6-12 illustrators/year. Buys 2-3 illustrations/issue. Prefers Southwestern art or just playful; colorful and classy. Considers all media. 90% of freelance illustration demands knowledge of Photoshop, Illustrator and QuarkXPress.

First Contact & Terms Illustrators: Send postcard sample or printed samples. Accepts disk submissions compatible with Macintosh Photoshop 3, Illustrator 5, or other EPS or TIFF files. Samples are not filed and are not returned. Does not report back. Artist should follow-up in writing. Art director will contact artist for portfolio review of final art and tearsheets if interested. Rights purchased vary according to project. Pays $300-500. Finds illustrators through word of mouth, submissions.

Tips "World travel is addressed often in *Chile Pepper.* Ethnic art and photography or just local color images are regular fare, but must have a hot & spicy bent to them. While often associated with hot & spicy, sexually suggestive images are not considered."

⧉ THE CHRISTIAN CENTURY

104 S. Michigan, Chicago IL 60603-5905. (312)263-7510. Fax: (312)263-7540. E-mail: main@christiancentury.org. Website: www.christiancentury.org. Religious magazine; "a weekly ecumenical magazine with a liberal slant on issues of Christianity, culture and politics." Circ. 30,000. Accepts previously published artwork. Original artwork returned at job's completion. Art guidelines for SASE with first-class postage.

Illustration Usually works on assignment. Considers pen & ink, pastel, watercolor, acrylic and charcoal.
First Contact & Terms Cartoonist: Send query letter with finished cartoons. Illustrators: Send query letter with tearsheets. Samples are filed or returned by SASE. Responds in 1 month. Buys one-time rights. Pays on publication. Fees negotiable.

CHRISTIAN HOME & SCHOOL

3350 E. Paris Ave. SE, Grand Rapids MI 49512. (616)957-1070. Fax: (616)957-5022. E-mail: rogers@csionline.org. Website: www.CSIonline.org. **Senior Editor:** Roger W. Schmurr. Emphasizes current, crucial issues affecting the Christian home for parents who support Christian education. 4-color magazine; 4-color cover; published 6 times/year. Circ. 66,000. Sample copy for 9×12 SASE with 4 first-class stamps; art guidelines for SASE with first-class postage.
Cartoons Prefers family and school themes.
Illustration Buys approximately 2 illustrations/issue. Has featured illustrations by Patrick Kelley, Rich Bishop and Pete Sutton. Features humorous, realistic and computer illustration. Assigns 75% of illustrations to experienced but not well-known illustrators; 25% to new and emerging illustrators. Prefers pen & ink, charcoal/pencil, colored pencil, watercolor, collage, marker and mixed media. Prefers family or school life themes. Works on assignment only.
First Contact & Terms Illustrators: Send query letter with résumé, tearsheets, photocopies or photographs. Show a representative sampling of work. Samples returned by SASE, or "send one or two samples art director can keep on file." Will contact if interested in portfolio review. Buys first rights. Pays on publication. Pays cartoonists $75 for b&w. Pays illustrators $300 for 4-color full-page inside. Finds most artists through references, portfolio reviews, samples received through the mail and artist reps.

N CHRISTIAN PARENTING TODAY MAGAZINE

465 Gunderson Dr., Carol Stream IL 60188-2498. (630)260-6200. Fax: (630)260-0114. E-mail: jaardema@christianitytoday.com. Website: www.christianparenting.net. **Art Director:** John Aardema. Estab. 1988. Bimonthly 2-color and 4-color consumer magazine featuring advice for Christian parents raising kids. Circ. 90,000.
Illustration Approached by 100 illustrators/year. Buys 6 illustrations/issue (humorous and spot illustrations).
First Contact & Terms Illustrators: Send postcard or other nonreturnable samples or tearsheets. Samples are filed. Will contact artist for portfolio review if interested. Buys first rights and one-time rights. Pays on publication. Pay varies. Finds illustrators through agents, self promos and directories.

CHRISTIAN RESEARCH JOURNAL

30162 Tomas, Rancho Santa Margarita CA 92688-2124. (949)858-6100. Fax: (949)858-6111. E-mail: response@equip.org. Website: www.equip.org. **Contact:** Melanie Cogdil, managing editor. Estab. 1987. Quarterly religion and theology journal that probes "today's religious movements, promoting doctrinal discernment and critical thinking, and providing reason for Christian faith and ethics." Circ. 20,000. Art guidelines not available.
Illustration Has featured illustrations by Tom Fluharty, Phillip Burke, Tim O'Brian. Features caricatures of celebrities/politicians, humorous illustration, realistic illustrations of men and women and related to subjects of articles. Assigns 70% of illustrations to new and emerging illustrators.
First Contact & Terms Cartoonists/illustrators send postcard sample. Accepts e-mail submissions with link to website. Prefers JPEG files. Samples are not filed but are returned. Responds only if interested. Company will contact artist for portfolio review if interested. Pays on completion of assignment. Buys first rights. Finds freelancers through artists' submissions, word of mouth and sourcebooks.

N CHRISTIANITY TODAY

465 Gundersen Dr., Carol Stream IL 60188. (630)260-6200. Fax: (630)260-0114. Website: www.christianitytoday.com/ctmag/. **Art Director:** Carla Sonheim. Estab. 1956. Monthly magazine "of thoughtful essays and news reporting on the evangelical Christians around the world." Circ. 170,000.
Cartoons Approached by 50 cartoonists/year. Buys 1 cartoon/issue. Prefers pen & ink; "must have an understanding of our subculture (evangelical Christian)." Prefers single panel b&w drawings with gagline.
Illustration Approached by 100s of illustrators/year. Buys 1-4 illustrations/issue. Considers all media. 5% of freelance illustration demands computer knowledge.
First Contact & Terms Send query letter with printed samples or photocopies and SASE. Samples are filed or returned by SASE. Responds only if interested. Art director will contact artist for portfolio review if interested. Buys first North American serial rights. **Pays on acceptance.** Pays cartoonists $25-100 for b&w. Pays illustrators $500-1,000 for color cover; $200-450 for b&w, $300-700 for color inside; $100-250 for spots.
Tips "Though it is not necessary to be a Christian, it's very helpful if artists understand our subculture. I look for conceptual artists."

☑ THE CHURCH HERALD

4500 60th St. SE, Grand Rapids MI 49512-9642. (616)698-7071. Fax: (616)698-6606. E-mail: herald@rca.org. Website: www.herald.rca.org. **Managing Editor:** Terri DeYoung. Estab. 1837. Monthly magazine. "The official denominational magazine of the Reformed Church in America." Circ. 110,000. Accepts previously published artwork. Originals returned at job's completion. Sample copies available for $2. Open to computer-literate freelancers for illustration.

Illustration Buys up to 2 illustrations/issue. Works on assignment only. Considers pen & ink, watercolor, collage, marker and pastel.

First Contact & Terms Illustrators: Send postcard sample with brochure. Accepts disk submissions compatible with Illustrator 5.0 or Photoshop 3.0. Send EPS files. Also may submit via e-mail. Samples are filed. Responds to the artist only if interested. Portfolio review not required. Buys one-time rights. Pays on publication; $300 for color cover; $75 for b&w, $125 for color inside.

CICADA

Box 300, Peru IL 61354. Website: www.cricketmag.com. **Senior Art Editor:** Ron McCutchan. Estab. 1998. Bimonthly literary magazine for young adults (senior high-early college). Limited illustration (spots and frontis pieces). Black & white interior with full-color cover. Circ. 18,000. Original artwork returned after publication. Sample copy $7.95 plus 10% of total order ($4 minimum) for shipping and handling; art guidelines available on website or for SASE with first-class postage.

Illustration Works with 30-40 illustrators a year. Buys 120 illustrations/year. Has featured illustrations by Erik Blegvad, Victor Ambrus, Ted Rall and Whitney Sherman. Has a strong need for good figurative art with teen appeal, but also uses looser/more graphic/conceptual styles and photo illustrations. Works on assignment only.

First Contact & Terms Illustrators: Send query letter and 4-6 samples to be kept on file "if I like it." Prefers photocopies and tearsheets as samples. Samples not kept on file are returned by SASE only. Responds in 6 weeks. Pays 45 days from receipt of final art; $750 for color cover, $50-150 for b&w inside. Buys all rights.

CINCINNATI CITYBEAT

811 Race St., 5th Floor, Cincinnati OH 45202. (513)665-4700. Fax: (513)665-4369. Website: www.citybeat.com. **Art Director:** Sean Hughes. Estab. 1994. Weekly alternative newspaper emphasizing issues, arts and events. Circ. 50,000.

- Please research alternative weeklies before contacting this art director. He reports receiving far too many inappropriate submissions.

Cartoons Approached by 30 cartoonists/year. Buys 1 cartoon/year.

Illustration Buys 1-3 illustrations/issue. Has featured illustrations by Ryan Greis, Woodrow J. Hinton III and Jerry Dowling. Features caricatures of celebrities and politicians, computer and humorous illustration. Prefers work with a lot of contrast. Assigns 40% of illustrations to new and emerging illustrators. 10% of freelance illustration demands knowledge of Illustrator, Photoshop, FreeHand, QuarkXPress.

First Contact & Terms Cartoonists: Send query letter with samples. Illustrators: Send postcard sample or query letter with printed samples and follow-up postcard every 4 months. Accepts Mac-compatible disk submissions. Send EPS, TIFF or PDF files. Samples are filed. Responds in 2 weeks only if interested. Buys one-time rights. Pays on publication. Pays cartoonists $10-100 for b&w, $30-100 for color cartoons, $10-35 for comic strips. Pays illustrators $75-150 for b&w cover, $150-250 for color cover; $10-50 for b&w inside, $50-75 for color inside, $75-150 for 2-page spreads. Finds illustrators through word of mouth and artist samples.

Ⓝ CINCINNATI MAGAZINE

705 Central Ave., Suite 175, Cincinnati OH 45202. (513)421-4300. Fax: (513)562-2746. E-mail: nstetler@cintima g.emmis.com. **Art Director:** Nancy Stetler. Estab. 1960. Monthly 4-color lifestyle magazine for the city of Cincinnati. Circ. 30,000. Accepts previously published artwork. Original artwork returned at job's completion.

Illustration Approached by 20 illustrators/year. Has featured illustrations by Rowan Barnes-Murphy and C.F. Payne. Works on assignment only.

First Contact & Terms Send postcard samples. Samples are filed or returned by SASE. Responds only if interested. Buys one-time rights or reprint rights. Pays on publication; $200-800 for features; $40-150 for spots.

Tips Prefers traditional media with an interpretive approach. No cartoons or mass-market computer art, please.

CINEFANTASTIQUE

P.O. Box 34425, Los Angeles CA 90034-0425. (310)204-2029. Fax: (310)204-5882. **Editor-in-Chief:** David E. Williams. Bi-monthly magazine emphasizing science fiction, horror and fantasy films for "devotees of 'films of the imagination.' " Circ. 105,000. Original artwork not returned. Sample copy $8.

Illustration Uses 1-2 illustrations/issue. Interested in "dynamic, powerful styles, though not limited to a particular look." Works on assignment only.

First Contact & Terms Illustrators: Send query letter with résumé, brochure and samples of style to be kept on file. Samples not returned. Responds in 1 month. Buys all rights. Pays on publication; $150 maximum for inside b&w line drawings and washes; $600 maximum for cover color washes; $150 maximum for inside color washes.

☑ CITY & SHORE MAGAZINE

200 E. Las Olas Blvd., Ft. Lauderdale FL 33301-2299. (954)356-4685. Fax: (954)356-4612. E-mail: gcarannante@ sun-sentinel.com. Website: www.cityandshore.com. **Contact:** Greg Carannante, art director. Estab. 2000. Bimonthly "lifestyle magazine published for readers in South Florida." Circ. 42,000. Sample copies available for $4.95.

Illustration Features caricatures of celebrities/politicians; fashion, humorous and spot illustrations. Freelance artists should be familiar with QuarkXPress.

First Contact & Terms Accepts e-mail submissions with image file.

Ⓝ CITY LIMITS

120 Wall St., 20th Floor, New York NY 10005. (212)479-3344. Fax: (212)344-6457. E-mail: editor@citylimits.org. Website: www.citylimits.org. **Art Director:** Tracie McMillan. Estab. 1976. Monthly urban affairs magazine covering issues important to New York City's low- and moderate-income neighborhoods, including housing, community development, the urban environment, crime, public health and labor. Circ. 10,000. Originals returned at job's completion. Sample copies for 9×12 SASE and 4 first-class stamps.

Cartoons Buys 5 cartoons/year. Prefers N.Y.C. urban affairs—social policy, health care, environment and economic development. Prefers political cartoons; single, double or multiple panel b&w washes and line drawings without gaglines.

Illustration Buys 2-3 illustrations/issue. Has featured illustrations by Noah Scalin. Must address urban affairs and social policy issues, affecting low- and moderate-income neighborhoods, primarily in New York City. Considers pen & ink, watercolor, collage, airbrush, mixed media and anything that works in b&w.

First Contact & Terms Cartoonists: Send query letter with finished cartoons and tearsheets. Buys first rights and reprint rights. Illustrators: Send postcard sample or query letter with tearsheets, photocopies, photographs and SASE. Samples are filed. Responds in 1 month. Request portfolio review in original query. Buys first rights. Pays on publication. Pays cartoonists $50 for b&w. Pays illustrators $50-100 for b&w cover; $50 for b&w inside; $25-50 for spots. "Our production schedule is tight, so publication is generally within two weeks of acceptance, as is payment." Finds artists through other publications, word of mouth and submissions.

Tips "Our niche is fairly specific." Freelancers "are welcome to call and talk."

THE CLERGY JOURNAL

6160 Carmen Ave. E., Inver Grove Heights MN 55076-4420. (800)328-0200. Fax: (888)852-5524. E-mail: fig@log ostaff.com. Website: www.joinhands.com. **Assistant Editor:** Sharilyn Figueroa. Magazine for professional clergy and church business administrators; 2-color with 4-color cover. Monthly (except June, August and December). Circ. 10,000. Original artwork returned after publication if requested.

• This publication is one of many published by Logos Productions and Woodlake Books.

Cartoons Buys 4 single panel cartoons/issue from freelancers on religious themes.

First Contact & Terms Cartoonists: Send SASE. Responds in 1 month. Pays $25 on publication.

CLEVELAND MAGAZINE

1422 Euclid Ave., Suite 730, Cleveland OH 44115. (216)771-2833. Fax: (216)781-6318. E-mail: sluzewski@clevel andmagazine.com. **Contact:** Gary Sluzewski. Monthly city magazine, b&w with 4-color cover, emphasizing local news and information. Circ. 45,000.

Illustration Approached by 100 illustrators/year. Buys 3-4 editorial illustrations/issue on assigned themes. Sometimes uses humorous illustrations. 40% of freelance work demands knowledge of QuarkXPress, FreeHand or Photoshop.

First Contact & Terms Illustrators: Send postcard sample with brochure or tearsheets. E-mail submissions must include sample. Accepts disk submissions. Please include application software. Call or write for appointment to show portfolio of printed samples, final reproduction/product, color tearsheets and photographs. Pays $100-700 for color cover; $75-300 for b&w inside; $150-400 for color inside; $75-350 for spots.

Tips "Artists are used on the basis of talent. We use many talented college graduates just starting out in the field. We do not publish gag cartoons but do print editorial illustrations with a humorous twist. Full-page editorial illustrations usually deal with local politics, personalities and stories of general interest. Generally, we are seeing more intelligent solutions to illustration problems and better techniques. The economy has drastically affected our budgets; we pick up existing work as well as commissioning illustrations."

COBBLESTONE, DISCOVER AMERICAN HISTORY

Cobblestone Publishing, Inc., 30 Grove St., Suite C, Peterborough NH 03458-1438. (603)924-7209. Fax: (603)924-7380. E-mail: anndillon@yahoo.com. Website: www.cobblestonepub.com. **Art Director:** Ann Dillon. Monthly magazine emphasizing American history; features nonfiction, supplemental nonfiction, fiction, biographies, plays, activities and poetry for children ages 8-14. Circ. 38,000. Accepts previously published material and simultaneous submissions. Sample copy $4.95 with 8×10 SASE; art guidelines on website. Material must relate to theme of issue; subjects and topics published in guidelines for SASE. Freelance work demands knowledge of Illustrator, Photoshop and QuarkXPress.

- Other magazines published by Cobblestone include *Calliope* (world history), *Dig* (archaeology for kids), *Faces* (cultural anthropology), *Footsteps* (African-American history), *Odyssey* (science), all for kids ages 8-15, and *Appleseeds* (social studies), for ages 7-9.

Illustration Buys 2-5 illustrations/issue. Prefers historical theme as it pertains to a specific feature. Works on assignment only. Has featured illustrations by Annette Cate, Beth Stover, David Kooharian. Features caricatures of celebrities and politicians, humorous, realistic illustration, informational graphics, computer and spot illustration. Assigns 15% of illustrations to new and emerging illustrators.

First Contact & Terms Illustrators: Send query letter with brochure, résumé, business card and b&w photocopies or tearsheets to be kept on file or returned by SASE. Write for appointment to show portfolio. Buys all rights. Pays on publication; $20-125 for b&w inside; $40-225 for color inside. Artists should request illustration guidelines.

Tips "Study issues of the magazine for style used. Send update samples once or twice a year to help keep your name and work fresh in our minds. Send nonreturnable samples we can keep on file; we're always interested in widening our horizons."

N COMBAT AIRCRAFT: The International Journal of Military Aviation

P.O. Box 5074, Westport CT 06881-5074. (203)838-7979. Fax: (203)838-7344. E-mail: inquiries@airtimepublishing.com. Website: www.airtimepublishing.com. **Managing Editor:** Zaur Eylanbekov. Estab. 1997. 4-color consumer magazine with 8 issues/year. Military aviation magazine with a focus on modern-day topics. Circ. 50,000.

Illustration Approached by 25 illustrators/year. Buys 2 illustrations/issue. Has featured illustrations by Mark Styling, James Dietz, Ian Wyllie and Walter Wright. Features computer illustration and technical 3-views. Preferred subject: aviation. Prefers technical line drawings and accurate representations of aircraft. Assigns 33% of illustrations each to well-known or "name" illustrators; experienced but not well-known illustrators; and new and emerging illustrators.

First Contact & Terms Illustrators: Send query letter with printed samples. Accepts Mac-compatible disk submissions. Send EPS or TIFF files. Samples are filed. Responds in 1 month. Will contact artist for portfolio review if interested. Buys one-time rights. Pays $40-100 for color cover; $20 for color inside. Finds illustrators through artists' promotional samples.

Tips "Please do not call with descriptions of your work; send us the samples first."

N COMMON GROUND

3091 W. Broadway, Suite 201, Vancouver BC V6K 2G9 Canada. (604)733-2215. Fax: (604)733-4415. E-mail: admin@commonground.ca. Website: www.commonground.ca. **Contact:** Art Director. Estab. 1982. Monthly consumer magazine focusing on health and cultural activities and holistic personal resource directory. Circ. 70,000. Accepts previously published artwork and cartoons. Original artwork is returned at job's completion. Sample copies for SASE with first-class Canadian postage or International Postage Certificate.

Illustration Approached by 20-40 freelance illustrators/year. Buys 1-2 freelance illustrations/issue. Prefers all themes and styles. Considers cartoons, pen & ink, watercolor, collage and marker.

First Contact & Terms Illustrators: Send query letter with brochure, photographs, SASE and photocopies. Samples are filed or are returned by SASE if requested by artist. Responds only if interested. Buys one-time rights. Payment varies.

Tips "Send photocopies of your top one-three inspiring works in black & white or color. Can have all three on one sheet of 8½×11 paper or all in one color copy. I can tell from that if I am interested."

COMMONWEAL

475 Riverside Dr., Suite 405, New York NY 10115-0433. (212)662-4200. Fax: (212)662-4183. E-mail: editors@commonwealmagazine.org. Website: www.commonwealmagazine.org. **Editor:** Paul Baumann. Estab. 1924. Public affairs journal. "Journal of opinion edited by Catholic lay people concerning public affairs, religion, literature and all the arts"; b&w with 4-color cover. Biweekly. Circ. 20,000. Original artwork is returned at the job's completion. Sample copies for SASE with first-class postage. Guidelines for SASE with first-class postage.

Cartoons Approached by 20-40 cartoonists/year. Buys 3-4 cartoons/issue from freelancers. Prefers simple lines and high-contrast styles. Prefers single panel, with or without gagline; b&w line drawings.

Illustration Approached by 20 illustrators/year. Buys 3-4 illustrations/issue, 60/year from freelancers. Has

featured illustrations by Baloo. Assigns 10% of illustrations to new and emerging illustrators. Prefers high-contrast illustrations that "speak for themselves." Prefers pen & ink and marker.

First Contact & Terms Cartoonists: Send query letter with finished cartoons. Illustrators: Send query letter with tearsheets, photographs, SASE and photocopies. Samples are filed or returned by SASE if requested by artist. Responds in 2 weeks. To show a portfolio, mail b&w tearsheets, photographs and photocopies. Buys non-exclusive rights. Pays cartoonists $15 for b&w. Pays illustrators $15 for b&w inside. Pays on publication.

Tips "Be familiar with publication before mailing submissions."

COMMUNITY BANKER

900 19th St. NW, Washington DC 20006. (202)857-3100. Fax: (202)857-5581. E-mail: jbock@acbankers.org. Website: www.americascommunitybankers.com. **Art Director:** Jon C. Bock. Estab. 1993. Monthly trade journal targeting senior executives of high tech community banks. Circ. 12,000. Accepts previously published artwork. Originals returned at job's completion.

Illustration Approached by 200 illustrators/year. Buys 2 illustrations/issue. Has featured illustrations by Michael Gibbs, Kevin Rechin, Jay Montgomery and Matthew Trueman. Features humorous illustration, informational graphics, spot illustrations, computer illustration. Preferred subjects: business subjects. Prefers pen & ink with color wash, bright colors, painterly. Works on assignment only.

First Contact & Terms Illustrators: Send query letter, nonreturnable postcard samples and tearsheets. Accepts Mac-compatible disk submissions. Send TIFF files. Samples are filed. Responds only if interested. "Artists should be patient and continue to update our files with future mailings. We will contact artist when the right story comes along." Publication will contact artist for portfolio review if interested. Portfolio should include mostly finished work, some sketches. Buys first North American serial rights. Pays on publication; $1,200-2,000 for color cover; $800-1,200 for color inside; $250-300 for spots. Finds artists primarily through word of mouth and sourcebooks—*Directory of Illustration* and *Illustration Work Book*.

Tips "Looking for: high tech/technology in banking; quick turnaround; and new approaches to illustration."

COMPUTERUSER

220 S. Sixth St., Suite 500, Minneapolis MN 55402-4501. (612)339-7571. Fax: (612)339-5806. E-mail: edit@comp uteruser.com. Website: www.computeruser.com. **Art Director:** Kurt Guthmueller. National computing magazine that delivers how to buy, where to buy, and how to use editorial for PC and Mac business users. Emphasis is on reviews, how-tos, tutorials, investigative pieces and more. Current slant is heavy on intranet, e-commerce, and Internet topics. Published in 32 regional editions. Circ. 1,713,000. Considers previously published material. Original artwork is returned to the artist after publication. Art guidelines free for SASE with first-class postage and available on website.

Illustration Buys 24 cover illustrations/year in both digital and traditional form. Has featured illustrations by Mel Lindstrom, David Bishop, Steven Campbell. Assigns 30% of illustrations to well-known or "name" illustrators; 60% to experienced but not well-known illustrators; 10% to new and emerging illustrators.

First Contact & Terms Send query letter with samples, tearsheets or color photocopies that we can keep on file. Responds if interested. Rights revert to artist. Pays $800-1,000 for covers.

Tips "We're looking for experienced, professional artists who can work with editorial and deliver art to spec and on time. We're especially interested in artists with a distinct style who can work without constant supervision. Traditional layout and design experience a plus."

COMPUTERWORLD

500 Old Connecticut Path, Framingham MA 01701-4573. (508)879-0700. Fax: (508)875-8931. E-mail: stephanie_faucher@computerworld.com. Website: www.computerworld.com. **Art Director:** Stephanie Faucher. Weekly newspaper for information technology leaders. Circ. 180,000. Sample copies and art guidelines available.

Illustration Approached 150 illustrators/year. Buys 2 illustrations/issue. Prefers business/professional. Considers all media. 30% of freelance illustration demands knowledge of Photoshop, FreeHand and QuarkXPress.

Design Needs freelancers for design. Prefers local design freelancers only. 100% of freelance work demands knowledge of Photoshop, FreeHand and QuarkXPress.

First Contact & Terms Send postcard sample or query letter with printed samples. Designers: Send query letter with printed samples and résumé. Accepts disk submissions; EPS files are the best. Samples are filed. Responds only if interested. Art director will contact artist for portfolio review of b&w, color, final art, photographs, tearsheets and transparencies. Buys one-time rights. Pays on publication. Pays $1,000-2,000 for color cover; $100-250 b&w inside; $400-500 for color inside; $300-400 for spots.

Tips "Send a sample regularly. No phone calls please."

CONDÉ NAST TRAVELER

4 Times Square, 14th Floor, New York NY 10036-6518. (212)286-2860. Fax: (212)286-2190. Website: http://concierge.com/traveler. **Art Director:** Kerry Robertson. Estab. 1987. Monthly travel magazine with emphasis

on "truth in travel." Geared toward upper income 40-50 year olds with time to spare. Circ. 1 million. Originals are returned at job's completion. Freelance work demands knowledge of QuarkXPress, Illustrator and Photoshop.

Illustration Approached by 5 illustrators/week. Buys 5 illustrations/issue. Works on assignment only. Considers pen & ink, collage, oil and mixed media.

First Contact & Terms Illustrators: Send query letter with tearsheets. Samples are filed. Does not report back, in which case the artist should wait for assignment. To show a portfolio, mail b&w and color tearsheets. Buys first rights. Pays on publication; fees vary according to project.

CONFRONTATION: A LITERARY JOURNAL

English Department, C.W. Post, Long Island University, Brookville NY 11548. (516)299-2720. Fax: (516)299-2735. **Editor:** Martin Tucker. Estab. 1968. Semiannual literary magazine devoted to the short story and poem, for a literate audience open to all forms, new and traditional. Circ. 2,000. Sample copies available for $3. 20% of freelance work demands computer skills.

- *Confrontation* has won a long list of honors and awards from CCLM (now the Council of Literary Magazines and Presses) and NEA grants.

Illustration Approached by 10-15 illustrators/year. Buys 2-3 illustrations/issue. Works on assignment only. Considers pen & ink and collage.

First Contact & Terms Illustrators: Send query letter with SASE and photocopies. Samples are not filed and are returned by SASE. Responds in 2 months only if interested. Rights purchased vary according to project. Pays on publication; $50-100 for b&w, $100-250 for color cover; $25-50 for b&w, $50-75 for color inside; $25-75 for spots.

CONSTRUCTION DIMENSIONS

803 W. Broad St., Suite 600, Falls Church VA 22046. (703)534-8300. Fax: (703)534-8307. E-mail: freber@awci.org. Website: www.awci.org. **Art Director:** Erika Freber. Monthly magazine "for contractors, manufacturers, suppliers and allied trades in the wall and ceiling industry." Circ. 25,000. Sample copies available.

Cartoons Would like to start buying cartoons. Prefers single panel b&w line drawings. Has featured illustrations by Jim Patterson. Assigns 50% of illustrations to experienced but not well-known illustrators; 50% to new and emerging illustrators.

Illustration Buys 3-5 illustrations/year. Considers all media.

First Contact & Terms Send query letter with tearsheets. Accepts disk submissions. Samples are not filed and are returned. Responds only if interested. **Pays on acceptance**. Pays illustrators $300-800 for b&w cover; $500-1,000 for color cover; $100-400 for b&w inside; $300-500 for color inside; $50-200 for spots. Finds illustrators through queries, word of mouth.

Tips "We don't buy a lot of freelance artwork, but when we do, we usually need it fast. Prompt payment and extra copies are provided to the artist. Try to develop more than one style; be able to do cartoons as well as realistic drawings. Editors want different 'looks' for different articles. Keep sending samples (postcards), promotions, etc. to keep your name (and phone number) in front of the buyer as often as possible."

CONSUMERS DIGEST

8001 N. Lincoln Ave., 6th Floor, Skokie IL 60077. (847)763-9200. Fax: (847)763-0200. E-mail: lrutstein@consumersdigest.com. Website: www.consumersdigest.com. **Art Director:** Lori Rutstein. Estab. 1961. Frequency: Bimonthly consumer magazine offering "practical advice, specific recommendations and evaluations to help people spend wisely." Circ. 1,250,250. Art guidelines available.

Illustration 75% of freelance illustration demands knowledge of FreeHand, Photoshop, Illustrator.

First Contact & Terms Illustrators: Send postcard sample or query letter with printed samples, tearsheets. Accepts disk submissions compatible with Macintosh System 8.0. Samples are filed or are returned by SASE. Responds only if interested. Portfolio dropoffs are departmentally reviewed on the second Monday of each month and returned in the same week. Buys first rights. **Pays on acceptance**, $400 minimum for b&w inside; $300-1,000 for color inside; $300-400 for spots. Finds illustrators through *American Showcase* and *Workbook*, submissions and other magazines.

☑ COOK COMMUNICATIONS MINISTRIES

4050 Lee Vance View, Colorado Springs CO 80918-7100. (719)536-0100. Website: www.cookministries.org. **Creative Director:** Randy Maid. Publisher of teaching booklets, books, take home papers for Christian market, "all age groups." Art guidelines available for SASE with first-class postage only. No samples returned without SASE.

Illustration Buys about 10 full-color illustrations/month. Has featured illustrations by Richard Williams, Chuck

Hamrick, Ron Diciani. Assigns 5% of illustrations to new and emerging illustrators. Features realistic illustration; Bible illustration; computer and spot illustration.

First Contact & Terms Illustrators: Send tearsheets, color photocopies of previously published work; include self-promo pieces. No samples returned unless requested and accompanied by SASE. Work on assignment only. **Pays on acceptance**; $400-700 for color cover; $150-250 for b&w inside; $250-400 for color inside; $500-800 for 2-page spreads; $50-75 for spots. Considers complexity of project, skill and experience of artist and turnaround time when establishing payment. Buys all rights.

Tips "We do not buy illustrations or cartoons on speculation. Do *not* send book proposals. We welcome those just beginning their careers, but it helps if the samples are presented in a neat and professional manner. Our deadlines are generous but must be met. Fresh, dynamic, the highest of quality is our goal; art that appeals to everyone from preschoolers to senior citizens; realistic to humorous, all media."

☑ COPING WITH CANCER

P.O. Box 682268, Franklin TN 37068. (615)790-2400. Fax: (615)794-0179. E-mail: editor@copingmag.com. Website: www.copingmag.com. **Editor:** Julie McKenna. Estab. 1987. *"Coping with Cancer* is a bimonthly, nationally-distributed consumer magazine dedicated to providing the latest oncology news and information of greatest interest and use to its readers. Readers are cancer survivors, their loved ones, support group leaders, oncologists, oncology nurses and other allied health professionals. The style is very conversational and, considering its sometimes technical subject matter, quite comprehensive to the layman. The tone is upbeat and generally positive, clever and even humorous when appropriate, and very credible." Circ. 80,000. Accepts previously published artwork. Originals returned at job's completion. Sample copy available for $3. Art guidelines for SASE with first-class postage.

Ⓝ COSMO GIRL

224 W. 57th St., 3rd Floor, New York NY 10019-3212. (212)649-3852. Fax: (212)489-9664. Website: www.cosmo girl.com. Contact: Art Department. Estab. 1996. Monthly 4-color consumer magazine designed as a cutting-edge lifestyle publication exclusively for teenage girls. Circ. 1.5 million.

Illustration Approached by 350 illustrators/year. Buys 6-10 illustrations/issue. Has featured illustrations by Annabelle Verhoye, Kareem Iliya, Balla Pilar, Berto Martinez, Marc Stüwe, Chuck Gonzales and Marie Perron. Features caricatures of celebrities and music groups, fashion, humorous and spot illustration. Preferred subjects: teens. Assigns 10% of illustrations to well-known or "name" illustrators; 80% to experienced but not well-known illustrators; 10% to new and emerging illustrators.

First Contact & Terms Illustrators: Send postcard sample and follow-up postcard every 6 months. Samples are filed. Responds only if interested. Buys first rights. **Pays on acceptance.** Pay varies. Finds illustrators through sourcebooks and samples.

COSMOPOLITAN

The Hearst Corp., 224 W. 57th St., New York NY 10019-3299. (212)649-3570. Fax: (212)307-6563. E-mail: jlanuza@hearst.com. Website: www.cosmopolitan.com. **Art Director:** John Lanuza. Associate Art Director: Theresa Izzilo. Designer: John Hansen. Estab. 1886. Monthly 4-color consumer magazine for contemporary women covering a broad range of topics including beauty, health, fitness, fashion, relationships and careers. Circ. 3,021,720.

Illustration Approached by 300 illustrators/year. Buys 10-12 illustrations/issue. Has featured illustrations by Marcin Baranski and Aimee Levy. Features beauty, humorous and spot illustration. Preferred subjects: women and couples. Prefers trendy fashion palette. Assigns 5% of illustrations to new and emerging illustrators.

First Contact & Terms Illustrators: Send postcard sample and follow-up postcard every 4 months. Samples are filed. Responds only if interested. Buys first North American serial rights. **Pays on acceptance**; $1,000 minimum for 2-page spreads; $450-650 for spots. Finds illustrators through sourcebooks and artists' promotional samples.

CRAFTS 'N THINGS

2400 Devon, Suite 375, Des Plaines IL 60018-4618. (847)635-5800. Fax: (847)635-6311. Website: www.craftidea s.com. **President and Publisher:** Marie Clapper. Estab. 1975. General crafting magazine published 8 times yearly. Circ. 200,000. Sample copies available. Art guidelines for SASE with first-class postage.

- *Crafts 'n Things* is a "how to" magazine for crafters. The magazine is open to crafters submitting designs and step-by-step instruction for projects such as Christmas ornaments, cross-stitched pillows, knitted or crocheted items and quilts. They do not buy cartoons and illustrations. This publisher also publishes other craft titles including *Cross Stitcher* and *Pack-O-Fun.*

Design Needs freelancers for design.

First Contact & Terms Designers: Send query letter with photographs. Pays by project $50-300. Finds artists through submissions.

Tips "Our designers work freelance. Send us photos of your *original* craft designs with clear instructions. Skill level should be beginning to intermediate. We concentrate on general crafts and needlework. Call or write for submission guidelines."

THE CRAFTS·REPORT

P.O. Box 1992, Wilmington DE 19899. (302)656-2209. Fax: (302)656-4894. E-mail: mricci@craftsreport.com. Website: www.craftsreport.com. **Art Director:** Mike Ricci. Estab. 1975. Monthly magazine "for people who earn a living or someday intend to earn a living as a craftsperson, retailer or show promoter." Circ. 20,000. Sample copies and art guidelines available.

Illustration Buys about 12 illustrations/year. Considers all media. 75% of freelance illustration demands knowledge of Photoshop, Adobe Illustrator and FreeHand.

First Contact & Terms Illustrators: Send query letter with printed samples and photocopies. Accepts disk submissions compatible with Quark 3.3; TIFF or EPS. Samples are filed. Responds only if interested. Art director will contact artist for portfolio review of color and final art if interested. Buys first rights. Pays on publication; $50-150 for b&w, $100-300 for color inside. Pays $50 for spots. Finds illustrators through magazines, word of mouth, artist's submissions.

CRICKET

Box 300, Peru IL 61354-0300. Website: www.cricketmag.com. **Senior Art Director:** Ron McCutchan. Estab. 1973. Monthly magazine emphasizes children's literature for children ages 10-14. Design is fairly basic and illustration-driven; full-color with 2 basic text styles. Circ. 65,000. Original artwork returned after publication. Sample copy $4.95 plus 10% of total order ($4 minimum) for shipping and handling; art guidelines available on website or for SASE with first-class postage.

Cartoons "We rarely run cartoons."

Illustration Approached by 800-1,000 illustrators/year. Works with 75 illustrators/year. Buys 600 illustrations/ year. Has featured illustrations by Trina Schart Hyman, Kevin Hawkes and Deborah Nourse Lattimore. Assigns 25% to new and emerging illustrators. Uses artists mainly for cover and interior illustration. Prefers realistic styles (animal or human figure), but "we're also looking for humorous, folkloric and nontraditional styles." Works on assignment only.

First Contact & Terms Illustrators: Send query letter with SASE and samples to be kept on file, "if I like it." Prefers photocopies and tearsheets as samples. Samples not kept on file are returned by SASE. Responds in 6 weeks. Does not want to see "overly slick, cute commercial art (i.e., licensed characters and overly sentimental greeting cards)." Buys all rights. Pays 45 days from receipt of final art; $750 for color cover; $50-150 for b&w inside; $75-250 for color inside; $250-350 for 2-page spreads; $50-75 for spots.

Tips "We are trying to focus *Cricket* at a slightly older, preteen market. Therefore we are looking for art that is less sweet and more edgy and funky. Since a large proportion of the stories we publish involve people, particularly children, *please* try to include several samples with *faces* and full figures in an initial submission (that is, if you are an artist who can draw the human figure comfortably). It's also helpful to remember that most children's publishers need artists who can draw children from many different racial and ethnic backgrounds. Know how to draw the human figure from all angles, in every position. Send samples that tell a story (even if there is no story); art should be intriguing."

DAKOTA COUNTRY

Box 2714, Bismark ND 58502. (701)255-3031. Fax: (701)255-5038. E-mail: dcmag@btinet.net. Website: www.dakotacountrymagazine.com. **Publisher:** Bill Mitzel. Estab. 1979. *Dakota Country* is a monthly hunting and fishing magazine with readership in North and South Dakota. Features stories on all game animals and fish and outdoors. Basic 3-column format, b&w and 2-color with 4-color cover, feature layout. Circ. 14,200. Accepts previously published artwork. Original artwork is returned after publication. Sample copies for $2; art guidelines for SASE with first-class postage.

Cartoons Likes to buy cartoons in volume. Prefers outdoor themes, hunting and fishing. Prefers multiple or single panel cartoon with gagline; b&w line drawings.

Illustration Features humorous and realistic illustration of the outdoors. Portfolio review not required.

First Contact & Terms Send query letter with samples of style. Samples not filed are returned by SASE. Responds to queries/submissions within 2 weeks. Negotiates rights purchased. **Pays on acceptance.** Pays cartoonists $10-20, b&w. Pays illustrators $20-25 for b&w inside; $12-30 for spots.

Tips "Always need good-quality hunting and fishing line art and cartoons."

DAKOTA OUTDOORS

P.O. Box 669, Pierre SD 57501-0669. (605)224-7301. Fax: (605)224-9210. **Editor:** Kevin Hipple. Managing Editor: Rachel Engbrecht. Estab. 1978. Monthly outdoor magazine covering hunting, fishing and outdoor pursuits in

the Dakotas. Circ. 7,500. Accepts previously published artwork. Original artwork is returned at job's completion. Sample copies and art guidelines for SASE with first-class postage.

Cartoons Approached by 10 cartoonists/year. Buys 1-2 cartoons/issue. Prefers outdoor, hunting and fishing themes. Prefers cartoons with gagline.

Illustration Approached by 2-10 illustrators/year. Buys 1 illustration/issue. Features spot illustration. Prefers outdoor, hunting/fishing themes, depictions of animals and fish native to the Dakotas. Prefers pen & ink. Accepts submissions on disk compatible with Macintosh in Illustrator, FreeHand and Photoshop. Send TIFF, EPS and PICT files.

First Contact & Terms Cartoonists: Send query letter with appropriate samples and SASE. Illustrators: Send postcard sample or query letter with tearsheets, SASE and copies of line drawings. Samples are not filed and are returned by SASE. Responds in 2 months. To show a portfolio, mail "high-quality line art drawings." Rights purchased vary according to project. Pays on publication. Pays cartoonists $5 for b&w. Pays illustrators $5-50 for b&w inside; $5-25 for spots.

Tips "We especially need line-art renderings of fish, such as the walleye."

🅝 DECORATIVE ARTIST'S WORKBOOK

4700 E. Galbraith Rd., Cincinnati OH 45236. E-mail: cindyr@fwpubs.com. **Contact:** Art Director. Estab. 1987. "A step-by-step bimonthly decorative painting workbook. The audience is primarily female; slant is how-to." Circ. 89,000. Does not accept previously published artwork. Original artwork is returned at job's completion. Sample copy available for $4.65; art guidelines not available.

Illustration Buys occasional illustration; 1/year. Works on assignment only. Has featured illustrations by Barbara Maslen and Annie Gusman. Features humorous, realistic and spot illustration. Assigns 50% of illustrations to experienced but not well-known illustrators; 50% to new and emerging illustrators. Prefers realistic styles. Prefers pen & ink, watercolor, airbrush, acrylic, colored pencil, mixed media, pastel and digital art.

First Contact & Terms Send postcard sample or query letter with tearsheets. Accepts disk submissions compatible with the major programs. Send EPS or TIFF files. Samples are filed. Responds only if interested. Buys first or one-time rights. Pays on publication; $50-100 for b&w inside; $100-350 for color inside.

✅ DELAWARE TODAY MAGAZINE

3301 Lancaster Pike, Suite 5C, Wilmington DE 19805-1436. (302)656-1809. Fax: (302)656-5843. E-mail: kcarter @delawaretoday.com. Website: www.delawaretoday.com. **Creative Director:** Kelly Carter. Monthly 4-color magazine emphasizing regional interest in and around Delaware. Features general interest, historical, humorous, interview/profile, personal experience and travel articles. "The stories we have are about people and happenings in and around Delaware. Our audience is middle-aged (40-45) people with incomes around $79,000, mostly educated. We try to be trendy in a conservative state." Circ. 25,000. Needs computer-literate freelancers for illustration.

Cartoons Works on assignment only.

Illustration Buys approximately 3-4 illustrations/issue. Has featured illustrations by Nancy Harrison, Charles Stubbs and Paine Proffit. "I'm looking for different styles and techniques of editorial illustration!" Works on assignment only. Open to all styles.

First Contact & Terms Cartoonists: Do not send gaglines. Do not send folders of pre-drawn cartoons. Illustrators: Send postcard sample. "Will accept work compatible with QuarkXPress 7.5/version 4.0. Send EPS or TIFF files (RGB)." Send printed color promos. Samples are filed. Responds only if interested. Publication will contact artist for portfolio review if interested. Portfolio should include printed samples, color or b&w tearsheets and final reproduction/product. Pays on publication; $200-400 for cover; $100-150 for inside. Buys first rights or one-time rights. Finds artists through submissions and self-promotions.

Tips "Be conceptual, consistent and flexible."

✅ DELICIOUS LIVING MAGAZINE

1401 Pearl St., Boulder CO 80302. (303)939-8440. Fax: (303)440-9020. E-mail: delicious@newhope.com. Website: www.deliciouslivingmag.com. **Art Director:** Vicki Hopewell. Estab. 1984. Monthly magazine distributed through natural food stores focusing on health, natural living, alternative healing. Circ. 400,000 guaranteed. Sample copies available.

Illustration Approached by hundreds of illustrators/year. Buys approximately 1 illustration/issue. Prefers positive, healing-related and organic themes. Considers acrylic, collage, color washed, mixed media, pastel. 30% of illustration demands knowledge of Photoshop and Illustrator.

Design Needs freelancers for design, production. Prefers local designers with experience in QuarkXPress, Illustrator, Photoshop and magazines/publishing. 100% of freelance work demands knowledge of Photoshop, Illustrator, QuarkXPress.

First Contact & Terms Illustrators: Send postcard sample, query letter with printed samples, tearsheets. Send

follow-up postcard sample every 6 months. Designers: Send query letter with printed samples, photocopies, tearsheets and résumé. Accepts disk submissions compatible with QuarkXPress 3.32 (EPS or TIFF files). Samples are filed and are not returned. Art director will contact artist for portfolio review of color, final art, photographs, photostats, tearsheets, transparencies, color copies. Rights purchased vary according to project. **Pays on acceptance**. Pays illustrators $1,000 maximum for color cover; $250-700 for color inside; $250 for spots. Finds illustrators through *Showcase Illustration*, SIS, magazines and artist's submissions.

Tips "We like our people and designs to have a positive and upbeat outlook. Illustrators must be able to illustrate complex health articles well and have great concepts with single focus images."

☑ DERMASCOPE

Geneva Corporation, 2611 N. Belt Line Rd., Suite 101, Sunnyvale TX 75182. (972)226-2309. Fax: (972)226-2339. Website: www.dermascope.com. **Production Manager:** David Carter. Estab. 1978. Monthly magazine/trade journal, 128-page magazine for aestheticians, plastic surgeons and stylists. Circ. 15,000. Sample copies and art guidelines available.

Illustration Approached by 5 illustrators/year. Prefers illustrations of "how-to" demonstrations. Considers all media. 100% of freelance illustration demands knowledge of Photoshop, Illustrator, QuarkXPress, Fractil Painter.

First Contact & Terms Accepts disk submissions. Samples are not filed. Responds only if interested. Rights purchased vary according to project. Pays on publication.

DIVERSION MAGAZINE

888 Seventh Ave., 2nd Floor, New York NY 10019. Website: www.diversion.com. **Cartoon Editor:** Shari Hartford. Estab. 1976. Monthly travel and lifestyle magazine for physicians. Circ. 176,000. Art guidelines available free with SASE.

Cartoons Approached by 50 cartoonists/year. Buys 5 cartoons/year. Prefers travel, food/wine, sports, lifestyle, family, animals, technology, art and design, performing arts, gardening. Prefers single panel, humorous, b&w line drawings, with or without gaglines.

First Contact & Terms "SASE must be included or cartoons will be discarded." Samples are not filed and are returned by SASE. Responds in 5 days. Buys first North American serial rights. **Pays on acceptance**; $100.

THE EAST BAY MONTHLY

1301 59th St., Emeryville CA 94608. (510)658-9811. Fax: (510)658-9902. E-mail: artdirector@themonthly.com. **Art Director:** Andreas Jones. Estab. 1970. Consumer monthly tabloid; b&w with 4-color cover. Editorial features are general interests (art, entertainment, business owner profiles) for an upscale audience. Circ. 80,000. Accepts previously published artwork. Originals returned at job's completion. Sample copy and guidelines for SASE with 5 oz. first-class postage. No nature or architectural illustrations.

Cartoons Approached by 75-100 cartoonists/year. Buys 3 cartoons/issue. Prefers single panel, b&w line drawings; "any style, extreme humor."

Illustration Approached by 150-200 illustrators/year. Buys 2 illustrations/issue. Prefers pen & ink, watercolor, acrylic, colored pencil, oil, charcoal, mixed media and pastel.

Design Needs freelancers for design and production. 100% of freelance design requires knowledge of PageMaker, Macromedia FreeHand, Photoshop, QuarkXPress and Illustrator.

First Contact & Terms Cartoonists: Send query letter with finished cartoons. Illustrators: Send postcard sample or query letter with tearsheets and photocopies. Designers: Send query letter with résumé, photocopies or tearsheets. Accepts submissions on disk, Mac compatible with Macromedia FreeHand, Illustrator, Photoshop, PageMaker or QuarkXPress. Samples are filed or returned by SASE. Responds only if interested. Write for appointment to show portfolio of thumbnails, roughs, b&w tearsheets and slides. Buys one-time rights. Pays cartoonists $35 for b&w. Pays illustrators $100-200 for b&w inside; $25-50 for spots. Pays 15 days after publication. Pays for design by project.

Ⓝ 🌐 EAT!

15-B Temple St., Singapore 058562. Phone: (65)323 1119. Fax: (65)323 7779/323 7776. E-mail: jessie@mag_incorp.com. Website: www.eat_magazine.com. **Editor:** Pramila Kaur. Estab. 1998. Monthly 4-color cooking and dining magazine, consumer oriented, mass market. Circ. 30,000.

Cartoons Prefers single panel, humorous, b&w washes.

Illustration Features humorous and spot illustration of people and food/dining situations. Prefers brush and ink.

First Contact & Terms Cartoonists: Send query letter with b&w photocopies. Illustrators: Send query letter with photocopies. Accepts Mac-compatible disk submissions. Send TIFF files, JPEG acceptable. Samples are not filed and are not returned. Responds only if interested. Portfolio review required. Negotiates rights purchased. Pays

on publication. Pays cartoonists $50 minimum for b&w single panel. Pays illustrators $50 minimum for b&w inside. Finds illustrators through references.

Tips "Quick turnaround, electronic contact a must. Artist should be able to conceptualize cartoon panels from stories given. An idea of Asian humor an asset. Very open to new talent. Seeking a humorous style."

ELECTRICAL APPARATUS

Barks Publications, Inc., 400 N. Michigan Ave., Suite 900, Chicago IL 60611-4198. (312)321-9440. Fax: (312)321-1288. E-mail: eamagazine@aol.com. Website: www.eamagazine.com. **Senior Editor:** Kevin Jones. Estab. 1948. Monthly 4-color trade journal emphasizing industrial electrical/mechanical maintenance. Circ. 16,000. Art guidelines available free for SASE. Original artwork not returned at job's completion. Sample copy $4.

Cartoons Approached by several cartoonists/year. Buys 3-4 cartoons/issue. Has featured illustrations by Joe Buresch, James Estes, Bernie White and Mark Ziemann. Prefers themes relevant to magazine content; with gagline. "Captions are edited in our style."

Illustration "We have staff artists, so there is little opportunity for freelance illustrators, but we are always glad to hear from anyone who believes he or she has something relevant to contribute."

First Contact & Terms Cartoonists: Send query letter with roughs and finished cartoons. "Anything we don't use is returned." Responds in 3 weeks. Buys all rights. Pays $15-20 for b&w and color.

☒ ENTREPRENEUR MAGAZINE

2445 McCabe Way, Suite 400, Irvine CA 92614-6244. (949)261-4293. Fax: (949)261-0234. Website: www.entrepreneur.com. **Creative Director:** Mark Kozak. Design Director: Richard Olson. Estab. 1978. Monthly 4-color magazine offers how-to information for starting a business, plus ongoing information and support to those already in business. Circ. 525,000.

Illustration Approached by 500 illustrators/year. Buys 10-20 illustrations/issue. Has featured illustrations by Peter Crowther, Adam McCauley, J.T. Morrow, Simone Tieber, Scott Menchin and Victor Gad. Features computer, humorous and spot illustration and charts and graphs. Themes are business, financial and legal. Needs editorial illustration, "some serious, some humorous depending on the article. Illustrations are used to grab readers' attention."

First Contact & Terms Send nonreturnable postcard samples and follow-up postcard every 4 months or query letter with printed samples and tearsheets. Accepts Mac-compatible disk submissions. Send EPS files. Samples are filed and not returned. Will contact artist for portfolio review if interested. Buys one-time rights. **Pays on acceptance**; $700 for full-page spread; $425 for spots. Finds freelancers through samples, mailers, *Work Book*, SIS and artist reps.

Tips "We want illustrators that are creative, clean and have knowledge of business concepts. We are always open to new talent."

☒ ENVIRONMENT

1319 18th St. NW, Washington DC 20036-1802. (202)296-6267, ext. 237. Fax: (202)296-5149. E-mail: env@heldref.org. Website: www.heldref.org. **Editorial Assistant:** Brittany Engel. Estab. 1958. Emphasizes national and international environmental and scientific issues. Readers range from "high school students and college undergrads to scientists, business and government leaders, and college and university professors." 4-color magazine with "relatively conservative" design. Published 10 times/year. Circ. 7,500. Original artwork returned after publication. Sample copy $9.60.

Cartoons Buys 2-3 cartoons/year. Receives 5 submissions/week. Interested in single panel line drawings or b&w washes with or without gagline.

First Contact & Terms Cartoonists: Send finished cartoons and SASE. Responds in 2 months. Buys first North American serial rights. Pays on publication; $50 for b&w cartoon.

Tips "Regarding cartoons, we prefer witty or wry comments on the impact of humankind on the environment. Stay away from slapstick humor.'

☒ ☒ ESQUIRE

1790 Broadway, New York NY 10019. (212)649-4020. Fax: (212)977-3158. Website: www.esquire.com. **Design Director:** John Korpics. Contemporary culture magazine for men ages 28-40 focusing on current events, living trends, career, politics and the media. Estab. 1933. Circ. 750,000.

First Contact & Terms Illustrators: Send postcard mailers. Drop off portfolio on Wednesdays for review.

☒ EVENT

Douglas College, Box 2503, New Westminster BC V3L 5B2 Canada. (604)527-5293. Fax: (604)527-5095. E-mail: event@douglas.bc.ca. Website: event.douglas.bc.ca. **Editor:** Cathy Stonehouse. Assistant Editor: Ian Cockfield. Estab. 1971. For "those interested in literature and writing"; b&w with 4- or 2-color cover. Published 3 times/

year. Circ. 1,300. Art guidelines available free for SASE (Canadian postage/IRCs only). Slides/negatives of artwork returned after publication. Sample back issue for $5. Current issue for $8.

Illustration Buys approximately 3 illustrations/year. Has featured illustrations by Sharalee Regehr, Michael Downs and Jesus Romeo Galdámez. Assigns 50% of illustrations to new and emerging illustrators. Uses freelancers mainly for covers. "Interested in drawings and prints, b&w line drawings, photographs and lithographs for cover, and thematic or stylistic series of 3 works. SASE (Canadian postage or IRCs).

First Contact & Terms Reponse time varies; generally 4 months. Buys first North American serial rights. Pays on publication, $150 for color cover, 2 free copies plus 10 extra covers.

N EXECUTIVE FEMALE

260 Madison Ave., #3, New York NY 10016. (212)351-6450. Fax: (212)351-6486. E-mail: nafe@nafe.com. Website: www.nafe.com. **Art Director:** Carol Erger-Fass. Estab. 1972. Association magazine for National Association for Female Executives, 4-color. "Get-ahead guide for women executives, which includes articles on managing employees, personal finance, starting and running a business." Circ. 125,000. Accepts previously published artwork. Original artwork is returned after publication.

Illustration Buys illustrations mainly for spots and feature spreads. Buys 7 illustrations/issue. Works on assignment only. Send samples (not returnable).

First Contact & Terms Samples are filed. Responds only if interested. Buys first or reprint rights. Pays on publication; $100-800.

N ◨ EYE FOR THE FUTURE

493 Markham St., Toronto ON M6G 2L1 Canada. (416)654-5858. Fax: (416)654-5898. E-mail: eyefuture@eyefuture.com. Website: www.eyefuture.com. **Contact:** Peter Diplaros. Estab. 1995. Monthly b&w consumer magazine focusing on health and self development. Circ. 40,000.

Illustration Features humorous, realistic and medical illustration. Open to all subjects except children, teens, pets. Send postcard or other nonreturnable samples. Accepts Mac-compatible disk submissions. Send EPS files. Responds only if interested. Portfolio review not required. Buys one-time rights. Pays on publication.

Tips "Looking for art that can add emotional depth to entice a reader to read and article in its entirety. Our magazine is about personal growth and we do articles on psychology, image, health, New Age, humor and business. We are looking for emotional appeal—not intellect."

N EYECARE BUSINESS/BOUCHER COMMUNICATIONS, INC.

1300 Virginia Dr., Suite 400, Fort Washington PA 19034-3221. (215)643-8021. Fax: (215)643-1705. E-mail: murskogn@boucher1.com. **Art Director:** Greg Mursko. Estab. 1985. Monthly tabloid size trade magazine for opticians, optometrists and all others in the optical industry. Circ. 52,200. Sample copies available.

Illustration Approached by many illustrators/year. Buys 4 illustrations/issue. Has featured illustrations by Dave Klug, David Merrel, Michael Dinges, Greg Hargreaves and Dan Mcgeehan. Assigns 50% of illustrations to experienced but not well-known illustrators; 50% to new and emerging illustrators. Prefers business/editorial style. Considers acrylic, collage, color washed, mixed media, oil, pen & ink, watercolor. 30% of freelance illustration demands knowledge of Photoshop 3.05, Illustrator 6.0.

Design Needs freelancers for design and production. Prefers local design freelancers with experience in QuarkX-Press, Photoshop and/or Illustrator. 100% of freelance work demands knowledge of Photoshop, Illustrator, QuarkXPress. Phone art director.

First Contact & Terms Illustrators/Designers: Send query letter with printed samples, photocopies, tearsheets. Send follow-up postcard sample every 3 months. "After initial call, a portfolio interview is required if interested or needed."Accepts disk submissions compatible with QuarkXPress or Photoshop, EPS or JPEG or TIFF (low-res please), Zip 100 MB, or floppy. Samples are filed. Responds only if interested. Buys one-time rights. Pays on publication; $125-175 for b&w, $150-400 for color inside. Pays $200-400 for spots. Finds illustrators through *American Showcase*, consumer magazines, word of mouth, submissions, *Directory of Illustration*, *Black Book*.

Tips "We like work that follows current color trends in design and is a little edgy, yet freelancer should still be able to produce work for formatted pages. Should be fast and be familiar with magazine's style."

FASHION ACCESSORIES

P.O. BOX 859, Mahwah NJ 07430. (201)684-9222. Fax: (201)684-9228. **Publisher:** Sam Mendelson. Estab. 1951. Monthly trade journal; tabloid; emphasizing costume jewelry and accessories. Publishes both 4-color and b&w. Circ. 9,500. Accepts previously published artwork. Original artwork is returned to the artist at the job's completion. Sample copies for $3.

Illustration Works on assignment only. Needs editorial illustration. Prefers mixed media. Freelance work demands knowledge of QuarkXPress.

First Contact & Terms Illustrators: Send query letter with brochure and photocopies. Samples are filed. Re-

sponds in 1 month. Portfolio review not required. Rights purchased vary according to project. **Pays on acceptance**; $50-100 for b&w cover; $100-150 for color cover; $50-100 for b&w inside; $100-150 for color inside.

N FAST COMPANY

375 Lexington Ave., 8th Floor, New York NY 10017-5644. (212)499-2000. Fax: (212)389-5496. E-mail: rrees@fastcompany.com. Website: www.fastcompany.com. **Art Director:** Dean Markadakis. Deputy Art Director: Lisa Kelsey. Estab. 1996. Monthly cutting edge business publication supplying readers with tools and strategies for business today. Circ. 734,500.

Illustration Approached by ''tons'' of illustrators/year. Buys approximately 20 illustrations/issue. Has used illustrations by Bill Mayer, Ward Sutton and David Cowles. Considers all media.

First Contact & Terms Illustrators: Send postcard sample or printed samples, photocopies. Accepts disk submissions compatible with QuarkXPress for Mac. Send EPS files. Send all samples to the attention of: Julia Moburg. Samples are filed and not returned. Responds only if interested. Rights purchased vary according to project. **Pays on acceptance**, $300-1,000 for color inside; $300-500 for spots. Finds illustrators through submissions, illustration annuals, *Workbook* and *Alternative Pick*.

N FEDERAL COMPUTER WEEK

3141 Fairview Park Dr., Suite 777, Falls Church VA 22042. (703)876-5131. Fax: (703)876-5126. E-mail: jeffrey_langkau@fcw.com. Website: www.fcw.com. **Art Director:** Jeff Langkau. Estab. 1987. Four-color trade publication for federal, state and local government information technology professionals. Circ. 120,000.

Illustration Approached by 50-75 illustrators/year. Buys 5-6 illustrations/month. Features charts & graphs, computer illustrations, informational graphics, spot illustrations of business subjects. Assigns 5% of illustrations to well-known or ''name'' illustrators; 85% to experienced but not well-known illustrators; 10% to new and emerging illustrators.

First Contact & Terms Illustrators: Send postcard or other nonreturnable samples. Accepts Mac-compatible disk submissions. Samples are filed. Will contact artist for portfolio review if interested. Rights purchased vary according to project. Pays $800-1,200 for color cover; $600-800 for color inside; $200 for spots. Finds illustrators through samples and sourcebooks.

Tips ''We look for people who understand 'concept' covers and inside art and very often have them talk directly to writers and editors.''

✔ FIFTY SOMETHING MAGAZINE

1168 Beachview, Willoughby OH 44094. (440)951-2468. **Editor:** Linda L. Lindeman-DeCarlo. Estab. 1990. Quarterly magazine; 4-color. ''We cater to the fifty-plus age group with upbeat information, feature stories, travel, romance, finance and nostalgia.'' Circ. 25,000. Accepts previously published artwork. Original artwork is returned at the job's completion. Sample copies for SASE, 10×12, with $1.37 postage.

Cartoons Approached by 50 cartoonists/year. Buys 3 cartoons/issue. Prefers funny issues on aging. Prefers single panel b&w line drawings with gagline.

Illustration Approached by 50 illustrators/year. Buys 2 illustrations/issue. Prefers old-fashioned, nostalgia. Considers all media.

First Contact & Terms Cartoonists: Send query letter with brochure, roughs and finished cartoons. Illustrators: Send query letter with brochure, photographs, photostats, slides and transparencies. Samples are filed. Responds only if interested. To show a portfolio, mail thumbnails, printed samples, b&w photographs, slides and photocopies. Buys one-time rights. Pays on publication. Pays cartoonists $10, b&w and color. Pays illustrators $25 for b&w, $100 for color cover; $25 for b&w, $75 for color inside.

FILIPINAS MAGAZINE

1486 Huntington Ave., Suite 300, South San Francisco CA 94080. (650)872-8657. Fax: (650)872-8651. E-mail: r.virata@filipinasmag.com. Website: www.filipinasmag.com. **Art Director:** Raymond Virata. Estab. 1992. Monthly magazine ''covering issues of interest to Filipino Americans and Filipino immigrants.'' Circ. 30,000. Sample copies free for 9×12 SASE and $1.70. Contact Art Director for information.

Cartoons Buys 1 cartoon/issue. Prefers work related to Filipino/Filipino-American experience. Prefers single panel, humorous, b&w washes and line drawings with or without gagline.

Illustration Approached by 5 illustrators/year. Buys 1-3 illustrations/issue. Considers all media.

First Contact & Terms Cartoonists and illustrators: Send query letter with photocopies. Accepts disk submissions compatible with Mac, QuarkXPress 4.1, Photoshop 6, Illustrator 7; include any attached image files (TIFF or EPS) or fonts. Samples are filed. Responds only if interested. Pays on publication. Pays cartoonists $25 minimum. Pays illustrators $100 minimum for cover; $25 minimum for inside. Buys all rights.

Tips ''Read our magazine.''

�N⌁ FOLIO: MAGAZINE

Primedia, Inc., 249 W. 17th St., 3rd Floor, New York NY 10011. (212)462-3608. E-mail: bmoran@primediabusiness.com. Website: www.foliomag.com. **Art Director:** Brendan Moran. Trade magazine covering the magazine publishing industry. Circ. 9,380. Sample copies for SASE with first-class postage.

Illustration Approached by 200 illustrators/year. Buys 150-200 illustrations/year. Works on assignment only. Artists' online galleries welcome in lieu of portfolio.

First Contact & Terms Illustrators: Send postcard samples and/or photocopies or other appropriate samples. No originals. Samples are filed and returned by SASE if requested by artist. Responds only if interested. Call for appointment to show portfolio of tearsheets, slides, final art, photographs and transparencies. Buys one-time rights. Pays by the project.

Tips "Art director likes to see printed 4-color and b&w sample illustrations. Do not send originals unless requested. Computer-generated illustrations are used but not always necessary. Charts and graphs must be Macintosh-generated."

FORBES MAGAZINE

60 Fifth Ave., New York NY 10011. (212)620-2200. E-mail: bmansfield@forbes.com. **Art Director:** Robert Mansfield. Five associate art directors. Established 1917. Biweekly business magazine read by company executives and those who are interested in business and investing. Circ. 950,000. Art guidelines not available.

Illustration Assigns 20% of illustrations to new and emerging illustrators.

First Contact & Terms "Assignments are made by one of the art directors. We do not use, nor are we liable for, ideas or work that a Forbes art director didn't assign. We prefer contemporary illustrations that are lucid and convey an unmistakable idea with wit and intelligence. No cartoons please. Illustration art must be rendered on a material and size that can be separated on a drum scanner or submitted digitally. We are prepared to receive art on zip, scitex, CD, floppy disk, or downloaded via e-mail. Discuss the specifications and the fee before you accept the assignment. **Pays on acceptance** whether reproduced or not. Pays up to $3,000 for a cover assignment and an average of $450 to $700 for an inside illustration depending on complexity, time and the printed space rate. Dropping a portfolio off is encouraged. Deliver portfolios by 11 a.m. and plan to leave your portfolio for a few hours or overnight. Call first to make sure an art director is available. Address the label to the attention of the Forbes Art Department and the individual you want to reach. Attach your name and local phone number to the outside of the portfolio. Include a note stating when you need it. Robin Regensberg, the art traffic coordinator, will make every effort to call you to arrange for your pickup. Samples: Do not mail original artwork. Send printed samples, scanned samples or photocopies of samples. Include enough samples as you can spare in a portfolio for each person on our staff. If interested, we'll file them. Otherwise they are discarded. Samples are returned only if requested."

Tips "Look at the magazine to determine if your style and thinking are suitable. The art director and associate art directors are listed on the masthead, located within the first ten pages of an issue. The art directors make assignments for illustration. However, it is important that you include Robert Mansfield in your mailings and portfolio review. We get a large number of requests for portfolio reviews and many mailed promotions daily. This may explain why, when you follow up with a call, we may not be able to acknowledge receipt of your samples. If the work is memorable and we think we can use your style, we'll file samples for future consideration."

⌁N⌁ FOUNDATION NEWS & COMMENTARY

Council on Foundations, 1828 L St. NW, Washington DC 20036. (202)466-6512. Fax: (202)785-3926. Website: www.foundationnews.org. **Executive Editor:** Allan R. Clyde. Estab. 1959. Bimonthly 4-color nonprofit association magazine that "covers news and trends in the nonprofit sector, with an emphasis on foundation grantmaking and grant-funded projects." Circ. 10,440. Original artwork returned after publication. Sample copy available.

Illustration Approached by 50 illustrators/year. Buys 3 illustrations/issue. Considers all formats.

First Contact & Terms Send query letter with tearsheets, photostats, slides and photocopies. Samples are filed "if good"; none are returned. Buys first rights. **Pays on acceptance.**

Tips The magazine is "clean, uncluttered, sophisticated, simple but attractive. Its content is somewhat abstract and is therefore more visually conceptual than literal."

⌁N⌁ FUTURIFIC MAGAZINE

Foundation for Optimism, 305 Madison Ave., Suite 1A, New York NY 10165. Phone/fax: (212)297-0502. **Publisher:** B. Szent-Miklosy. Monthly b&w publication emphasizing future-related subjects for highly educated, upper income leaders of the community. Circ. 10,000. Previously published material and simultaneous submissions OK. Original artwork returned after publication. Sample copy for SASE with $5 postage and handling.

Cartoons Buys 5 cartoons/year. Prefers positive, upbeat, futuristic themes; no "doom and gloom." Prefers single, double or multiple panel with or without gagline, b&w line drawings.

Illustration Buys 5 illustrations/issue. Prefers positive, upbeat, futuristic themes; no "doom and gloom."

First Contact & Terms Cartoonists: Send finished cartoons. Illustrators: Send finished art. Samples returned by SASE. Responds in 1 month. To show a portfolio, walk in. Negotiates rights and payment. Pays on publication.

Tips "Only optimists need apply. Looking for good, clean art. Interested in future development of current affairs, but not science fiction."

ℕ THE FUTURIST

7910 Woodmont Ave., Suite 450, Bethesda MD 20814. (301)656-8274. Fax: (301)951-0394. Website: www.wfs.org. **Art Director:** Lisa Mathias. Managing Editor: Cynthia Wagner. Emphasizes all aspects of the future for a well-educated, general audience. Bimonthly b&w and color magazine with 4-color cover; "fairly conservative design with lots of text." Circ. 30,000. Accepts simultaneous submissions and previously published work. Return of original artwork following publication depends on individual agreement.

Illustration Approached by 50-100 illustrators/year. Buys fewer than 10 illustrations/year. Needs editorial illustration. Uses a variety of themes and styles "usually b&w drawings, often whimsical. We like an artist who can read an article and deal with the concepts and ideas." Works on assignment only.

First Contact & Terms Illustrators: Send samples or tearsheets to be kept on file. Accepts disk submissions compatible with Illustrator, QuarkXPress or Photoshop on a Mac platform. Send EPS files. Will contact for portfolio review if interested. Rights purchased negotiable. **Pays on acceptance**; $500-750 for color cover; $75-350 for b&w, $200-400 for color inside; $100-125 for spots.

Tips "Send samples that are strong conceptually with skilled execution. When a sample package is poorly organized, poorly presented—it says a lot about how the artists feel about their work." Sees trend of "moving away from realism; highly stylized illustration with more color." This publication does not use cartoons.

ℕ GARDEN GATE MAGAZINE

2200 Grand Ave., Des Moines IA 50312. (515)282-7000. Fax: (515)283-0447. E-mail: gardengate@gardengatemagazine.com. Website: www.gardengatemagazine.com. **Art Director:** Steven Nordmeyer. Estab. 1995. Bimonthly consumer magazine on how-to gardening for the novice and intermediate gardener. Circ. 300,000.

Illustration 90% of illustration needs are conventional/watercolor illustrations. Other styles require knowledge of Photoshop 3.0, QuarkXPress 3.31 and Corel Draw 5.0.

Design Prefers designers with experience in publication design. 98% of freelance work demands knowledge of Photoshop 3.0, QuarkXPress 3.31, Corel Draw 5.0.

First Contact & Terms Illustrators: Send postcard sample, query letter with tearsheets. Designers: Send query letter with printed samples and tearsheets. Accepts disk submissions compatible with QuarkXPress 7.5/version 3.31. Send EPS or TIF files. Samples are filed and are not returned. Responds only if interested. Art director will contact artist for portfolio review of slides, tearsheets if interested. Buys all rights. Finds illustrators through artist submissions, *Black Book*, word of mouth.

Tips "Become familiar with our magazine and offer an illustration style that is compatible."

ℕ GENTRY MAGAZINE

618 Santa Cruz Ave., Menlo Park CA 94025-4503. (650)324-1818. Fax: (650)324-1888. E-mail: info@18media.com. Website: www.18media.com. **Art Director:** Lisa Duri. Estab. 1994. Monthly community publication for affluent audience of designers and interior designers. Circ. 35,000. Sample copies and art guidelines available for 9×10 SASE.

Cartoons Approached by 200 cartoonists/year. Buys 4 cartoon/issue. Prefers political and humorous b&w line drawings without gaglines.

Illustration Approached by 100 illustrators/year. Buys 6 illustrations/issue. Features informational graphics and computer and spot illustration. Assigns 50% of illustrations to experienced but not well-known illustrators; 50% to new and emerging illustrators. Prefers financial and fashion themes. Considers all media. Knowledge of Photoshop, Illustrator and QuarkXPress helpful.

Design Needs freelancers for design and production. Prefers local designers. 100% of freelance work demands knowledge of Photoshop, Illustrator and QuarkXPress.

First Contact & Terms Cartoonists: Send query letter with tearsheets. Illustrators: Send postcard sample or send query letter with printed samples, photocopies or tearsheets. Accepts disk submissions if Mac compatible. Send EPS files. Samples are filed. Art director will contact artist for portfolio review if interested. Buys one-time rights. Pays on publication. Pays cartoonists $50-100 for b&w; $75-200 for color. Pays illustrators $200-500 for color inside; $100-500 for spots. Finds illustrators through submissions.

Tips "Read our magazine. Regional magazines have limited resources but are a great vehicle for getting your work printed and getting tearsheets. Ask people and friends (honest friends) to review your portfolio."

🖪 GEORGIA MAGAZINE

P.O. Box 1707, Tucker GA 30085-1707. (770)270-6950. Fax: (770)270-6995. E-mail: ann.orowski@georgiaemc.com. Website: www.georgiamagazine.org. **Editor:** Ann Orowski. Estab. 1945. Monthly consumer magazine promoting electric co-ops (largest read publication by Georgians for Georgians). Circ. 438,000 members.

Cartoons Approached by 10 cartoonists/year. Buys 2 cartoons/year. Prefers electric industry theme. Prefers single panel, humorous, b&w washes and line drawings.

Illustration Approached by 10 illustrators/year. Prefers electric industry theme. Considers all media. 50% of freelance illustration demands knowledge of Illustrator and QuarkXPress.

Design Uses freelancers for design and production. Prefers local designers with magazine experience. 80% of design demands knowledge of Photoshop, Illustrator and QuarkXPress.

First Contact & Terms Cartoonists: Send query letter with photocopies. Samples are filed and not returned. Illustrators: Send postcard sample or query letter with photocopies. Designers: Send query letter with printed samples and photocopies. Accepts disk submissions compatible with QuarkXPress 7.5. Samples are filed or returned by SASE. Responds in 1 month if interested. Rights purchased vary according to project. **Pays on acceptance.** Pays cartoonists $50 for b&w, $50-100 for color. Pays illustrators $50-100 for b&w, $50-200 for color. Finds illustrators through word of mouth and artist's submissions.

🖪 GIFTWARE NEWS UK

20 W. Kinzie, 12th Floor, Chicago IL 60610. (312)849-2220. Fax: (312)849-2174. E-mail: giftwarenews@talcott.com. Website: www.giftwarenews.com. **Production Manager:** Bev Mowry. Quarterly magazine "of gifts, collectibles, stationery, gift baskets, tabletop and home accessories in the UK." Circ. 10,000. Sample copy available.

Design Needs freelancers for design, production and multimedia projects. Prefers freelancers with experience in magazine layout. 100% of design demands knowledge of Photoshop 3.0, Illustrator 6.0 and QuarkXPress 3.3.

First Contact & Terms Designers: Send query letter with printed samples.

GIRLFRIENDS MAGAZINE

3415 Cesar Chavez, #101, San Francisco CA 94110. (415)648-9464. Fax: (415)648-4705. E-mail: ethan@girlfriendsmag.com. Website: www.girlfriendsmag.com. **Art Director:** Ethan Duran. Estab. 1994. Monthly lesbian magazine. Circ. 30,000. Sample copies available for $4.95. Art guidelines for #10 SASE with first-class postage.

Illustration Approached by 50 illustrators/year. Buys 3-4 illustrations/issue. Features caricatures of celebrities and realistic, computer and spot illustration. Assigns 40% of illustrations to new and emerging illustrators. Prefers any style. Considers all media. 10% of freelance illustration demands knowledge of Illustrator, QuarkXPress.

First Contact & Terms Illustrators: Send query letter with printed samples, tearsheets, résumé, SASE and color copies. Accepts disk submissions compatible with QuarkXPress (JPEG files). Samples are filed or returned by SASE on request. Responds in 2 months. To show portfolio, artist should follow up with call and/or letter after initial query. Portfolio should include color, final art, tearsheets, transparencies. Rights purchased vary according to project. Pays on publication; $50-200 for color inside; $150-300 for 2-page spreads; $50-75 for spots. Finds illustrators through word of mouth and submissions.

Tips "Read the magazine first; we like colorful work; ability to turn around in two weeks."

GIRLS' LIFE

4517 Hartford Rd., Baltimore MD 21214-3122. (410)426-9600. Fax: (410)254-0991. Website: www.girlslife.com. **Art Director:** Chun Kim. Estab. 1994. Bimonthly consumer magazine for 8- to 15-year-old girls. Originals sometimes returned at job's completion. Sample copies available for $5 on back order or on newsstands. Art guidelines not available. Sometimes needs computer literate freelancers for illustration. 20% of freelance work demands computer knowledge of Illustrator, QuarkXPress or Photoshop. Circ. 363,000.

Illustration Prefers anything pertaining to girls 8-15 years-old. Assigns 60% of illustrations to experienced but not well-known illustrators; 10% to new and emerging illustrators. Considers pen & ink, watercolor, airbrush, acrylic and mixed media.

First Contact & Terms Illustrators: Send query letter with SASE, tearsheets, photographs, photocopies, photostats, slides and transparencies. Samples are filed or are returned by SASE if requested by artist. Publication will contact artist for portfolio review if interested. Portfolio should include tearsheets, slides, photostats, photocopies, final art and photographs. Buys first rights. Pays on publication. Finds artists through artists' submissions.

Tips "Send work pertaining to our market."

🖪 GLAMOUR

4 Times Square, 16th Floor, New York NY 10036. (212)286-2860. Fax: (212)286-8336. Website: www.glamour.com. **Art Director:** Cynthia Harris. Deputy Art Director: Peter Hemmel. Monthly magazine. Covers fashion and

issues concerning working women (ages 20-35). Circ. 2 million. Originals returned at job's completion. Sample copies available on request. 5% of freelance work demands knowledge of Illustrator, QuarkXPress, Photoshop and FreeHand.

Cartoons Buys 1 cartoon/issue.

Illustration Buys 1 illustration/issue. Works on assignment only. Considers all media.

First Contact & Terms Illustrators: Send postcard-size sample. Samples are filed and not returned. Publication will contact artist for portfolio review if interested. Rights purchased vary according to project. Pays on publication.

☑ GOLF ILLUSTRATED

15115 S. 76th East Ave., Bixby OK 74008-4114. (918)366-6191. Fax: (918)366-6512. Website: www.Golfillustrated.com. **Art Director:** Bert McCall. Estab. 1914. Golf lifestyle magazine published 4 times/year with instruction, travel, equipment reviews and more. Circ. 150,000. Sample copies free for 9×11 SASE and 6 first-class stamps. Art guidelines available for #10 SASE with first-class postage.

Cartoons Approached by 25 cartoonists/year. Prefers golf. Prefers single panel, b&w washes or line drawings.

Illustration Approached by 50 illustrators/year. Buys 10 illustrations/issue. Prefers instructional, detailed figures, course renderings. Considers all media. 30% of freelance illustration demands knowledge of Photoshop, Illustrator and QuarkXPress.

First Contact & Terms Cartoonists: Send photocopies. Illustrators: Send query letter with photocopies, SASE and tearsheets. Accepts disk submissions. Samples are filed. Responds in 1 month. Portfolios may be dropped off Monday-Friday. Buys first North American serial and reprint rights. **Pays on acceptance.** Pays cartoonists $50 minimum for b&w. Pays illustrators $100-200 for b&w, $250-400 for color inside. Finds illustrators through sourcebooks, magazines, word of mouth and submissions.

Tips "Read our magazine. We need fast workers with quick turnaround."

Ⓝ GOLF TIPS MAGAZINE

12121 Wilshire Blvd., Suite 1200, Los Angeles CA 90025-1123. (310)820-1500. Fax: (310)820-2793. Website: www.golftipsmag.com. **Art Director:** Warren Keating. Estab. 1986. Monthly 4-color consumer magazine featuring golf instruction articles. Circ. 300,000.

Illustration Approached by 100 illustrators/year. Buys 3 illustrations/issue. Has featured illustrations by Phil Franké, Scott Matthews, Ed Wexler. Features charts & graphs, humorous illustration, informational graphics, realistic and medical illustration. Preferred subjects: men and women. Prefers realism or expressive, painterly editorial style or graphic humorous style. Assigns 30% of illustrations to well-known or "name" illustrators; 50% to experienced but not well-known illustrators; 20% to new and emerging illustrators. 15% of freelance illustration demands knowledge of Illustrator, Photoshop and FreeHand.

First Contact & Terms Illustrators: Send postcard or other nonreturnable samples. Accepts Mac-compatible disk submissions. Send EPS or TIFF files. Samples are filed. Will contact artist for portfolio review if interested. Rights purchased vary according to project. Pays on publication; $500-700 for color cover; $100-200 for b&w inside; $250-500 for color inside; $500-700 for 2-page spreads. Finds illustrators through *LA Workbook*, *Creative Black Book* and promotional samples.

Tips "Look at our magazine and you will see straightforward, realistic illustration, but I am also open to semi-abstract, graphic humorous illustration, gritty, painterly, editorial style, or loose pen & ink and watercolor humorous style."

☑ THE GOLFER

551 Fifth Ave., Suite 3010, New York NY 10176. (212)867-7070. Fax: (212)867-8550. E-mail: thegolfer@thegolfermag.com. Website: www.thegolfermag.com. **Contact:** Art Director. Estab. 1994. 6 times/year "sophisticated golf magazine with an emphasis on travel and lifestyle. Circ. 254,865.

Illustration Approached by 200 illustrators/year. Buys 6 illustrations/issue. Considers all media.

First Contact & Terms Illustrators: Send postcard sample. "We will accept work compatible with QuarkXPress 3.3. Send EPS files." Samples are not filed and are not returned. Responds only if interested. Rights purchased vary according to project. Pays on publication. Payment to be negotiated.

Tips "I like sophisticated, edgy, imaginative work. We're looking for people to interpret sport, not draw a picture of someone hitting a ball."

Ⓝ GOVERNING

1100 Connecticut Ave. NW, Suite 1300, Washington DC 20036-4109. (202)862-8802. Fax: (202)862-0032. E-mail: rsteadham@governing.com. Website: www.governing.com. **Art Director:** Richard Steadham. Estab. 1987. Monthly magazine. "Our readers are executives of state and local governments nationwide. They include governors, mayors, state legislators, county executives, etc." Circ. 86,284.

Illustration Approached by hundreds of illustrators/year. Buys 2-3 illustrations/issue. Prefers conceptual editorial illustration dealing with public policy issues. Considers all media. 10% of freelance illustration demands knowledge of Photoshop, Illustrator, FreeHand.

First Contact & Terms Send postcard sample with printed samples, photocopies and tearsheets. Send follow-up postcard sample every 3 months. "No phone calls please. We work in QuarkXPress, so we accept any format that can be imported into that program." Samples are filed. Responds only if interested. Art director will contact artist for portfolio review if interested. Buys one-time rights. Pays on publication; $700-1,200 for cover; $350-700 for inside; $350 for spots. Finds illustrators through *Blackbook*, *LA Workbook*, online services, magazines, word of mouth, submissions.

Tips "We are not interested in working with artists who can't take direction. If you can collaborate with us in communicating our words visually, then we can do business. Also, please don't call asking if we have any work for you. When I'm ready to use you, I'll call you."

☷ GRAND RAPIDS MAGAZINE

Gemini Publications, 549 Ottawa Ave., Grand Rapids MI 49503. (616)459-4545. **Editor:** Carole Valade. Monthly for greater Grand Rapids residents. Circ. 20,000. Original artwork returned after publication. Local artists only.

Cartoons Buys 2-3 cartoons/issue. Prefers Michigan, Western Michigan, Lake Michigan, city, issue, consumer/household, fashion, lifestyle, fitness and travel themes.

Illustration Buys 2-3 illustrations/issue. Prefers Michigan, Western Michigan, Lake Michigan, city, issue, consumer/household, fashion, lifestyle, fitness and travel themes.

First Contact & Terms Cartoonists and illustrators: Send query letter with samples. Samples not filed are returned by SASE. Responds in 1 month. To show a portfolio, mail printed samples and final reproduction/product or call for an appointment. Buys all rights. Pays on publication. Pays cartoonists $35-50 for b&w. Pays illustrators $200 minimum for color cover; $40 minimum for b&w inside; $40 minimum for color inside.

Tips "Particular interest in those who are able to capture the urban lifestyle."

GRAPHIC ARTS MONTHLY

360 Park Ave. S., 15th Floor, New York NY 10010. (646)746-7321. Fax: (646)746-7489. E-mail: rlevy@reedbusiness.com. Website: www.gammag.com/. **Creative Director:** Rani Levy. Estab. 1930. Monthly 4-color trade magazine for management and production personnel in commercial and specialty printing plants and allied crafts. Design is "direct, crisp and modern." Circ. 70,000. Accepts previously published artwork. Originals returned at job's completion. Needs computer-literate freelancers for illustration.

Illustration Approached by 150 illustrators/year. Buys 6 illustrations/issue. Works on assignment only. Considers all media, including computer.

First Contact & Terms Illustrators: Send postcard-sized sample to be filed. No phone calls please. Accepts disk submissions compatible with Photoshop, Illustrator or JPEG files. Will contact for portfolio review if interested. Portfolio should include final art, photographs, tearsheets. Buys one-time and reprint rights. **Pays on acceptance**; $750-1200 for color cover; $250-350 for color inside; $250 for spots. Finds artists through submissions.

GREENPRINTS

P.O. Box 1355, Fairview NC 28730. (828)628-1902. Website: www.greenprints.com. **Editor:** Pat Stone. Estab. 1990. Quarterly magazine "that covers the personal, not the how-to, side of gardening." Circ. 13,000. Sample copy for $5; art guidelines available on website or free for #10 SASE with first-class postage.

Illustration Approached by 46 illustrators/year. Works with 15 illustrators/issue. Has featured illustrations by Claudia McGehee, P. Savage, Marilynne Roach and Jean Jenkins. Assigns 50% of illustrations to new and emerging illustrators. Prefers plants and people. Considers b&w only.

First Contact & Terms Illustrators: Send query letter with photocopies, SASE and tearsheets. Samples accepted by US mail only. Accepts e-mail queries without attachments. Samples are filed or returned by SASE. Responds in 2 months. Buys first North American serial rights. Pays on publication; $250 maximum for color cover; $100-125 for b&w inside; $25 for spots. Finds illustrators through word of mouth, artist's submissions.

Tips "Read our magazine and study the style of art we use. Can you do both plants and people? Can you interpret as well as illustrate a story?"

☷ GROUP PUBLISHING—MAGAZINE DIVISION

P.O. Box 481, Loveland CO 80539. (970)669-3836. Fax: (970)292-4373. E-mail: info@group.com. Website: www.grouppublishing.com and www.onlinerev.com. Publishes *Group Magazine*, Art Director: Bill Fisher (6 issues/year; circ. 50,000; 4-color); *Children's Ministry Magazine*, Art Director: RoseAnne Sather (6 issues/year; circ. 65,000; 4-color), for adult leaders who work with kids from birth to 6th grade; *Rev. Magazine*, Art Director: Bill Fisher (6 issues; 4-color), an interdenominational magazine which provides innovative and practical ideas

for pastors. Previously published, photocopied and simultaneous submissions OK. Original artwork returned after publication. Sample copy $2 with 9×12 SAE.

• This company also produces books. See listing in Book Publishers section.

Cartoons Generally buys one spot cartoon per issue that deals with youth or children ministry.

Illustration Buys 2-10 illustrations/issue. Has featured illustrations by Matt Wood, Chris Dean, Dave Klug and Otto Pfandschimdt.

First Contact & Terms Illustrators: Send postcard samples, SASE, slides or tearsheets to be kept on file for future assignments. Accepts disk submissions compatible with Mac. Send EPS files. Responds only if interested. **Pays on acceptance**. Pays cartoonists $50 minimum. Pays illustrators $125-1,000, from b&w/spot illustrations (line drawings and washes) to full-page color illustrations inside. Buys first publication rights and occasional reprint rights.

Tips "We prefer contemporary, nontraditional (not churchy), well-developed styles that are appropriate for our innovative, youth-oriented publications. We appreciate artists who can conceptualize well and approach difficult and sensitive subjects creatively."

GUITAR PLAYER

2800 Campus Dr., San Mateo CA 94403. (650)513-4400. Fax: (650)513-4661. E-mail: guitplyr@musicplayer.com. Website: www.guitarplayer.com. **Art Director:** Alexandra Zeigler. Estab. 1975. Monthly 4-color magazine focusing on technique, artist interviews, etc. Circ. 150,000. Original artwork is returned at job's completion. Sample copies and art guidelines not available.

Illustration Approached by 15-20 illustrators/week. Buys 5 illustrations/year. Works on assignment only. Features caricature of celebrities; realistic, computer and spot illustration. Assigns 33% of illustrations to new and emerging illustrators. Prefers conceptual, "outside, not safe" themes and styles. Considers pen & ink, watercolor, collage, airbrush, computer based, acrylic, mixed media and pastel.

First Contact & Terms Illustrators: Send query letter with brochure, tearsheets, photographs, photocopies, photostats, slides and transparencies. Accepts disk submissions compatible with Mac. Samples are filed. Responds only if interested. Will contact for portfolio review if interested. Buys first rights. Pays on publication; $200-400 for color inside; $400-600 for 2-page spreads; $200-300 for spots.

HADASSAH MAGAZINE

50 W. 58th St., New York NY 10019. (212)451-6289. Fax: (212)451-6257. E-mail: egoldberg@hadassah.org. Website: www.hadassah.org. **Art Director:** Jodie Rossi. Estab. 1914. Consumer magazine. *Hadassah Magazine* is a monthly magazine chiefly of and for Jewish interests—both here and in Israel. Circ. 270,000.

Cartoons Buys 3-5 freelance cartoons/year. Preferred themes include the Middle East/Israel, domestic Jewish themes and issues.

Illustration Approached by 50 freelance illustrators/year. Works on assignment only. Features humorous, realistic, computer and spot illustration. Prefers themes of health, news, Jewish/family, Israeli issues, holidays.

First Contact & Terms Cartoonists: Send postcard sample or query letter with tearsheets. Samples are filed or are returned by SASE. Write for appointment to show portfolio of original/final art, tearsheets and slides. Buys first rights. Pays on publication. Pays illustrators $400-600 for color cover; $100-200 for b&w inside; $200-250 for color inside; $75-100 for spots.

HARPER'S MAGAZINE

666 Broadway, 11th Floor, New York NY 10012. (212)420-5720. Fax: (212)228-5889. E-mail: stacey@harpers.org. **Art Director:** Stacey D. Clarkson. Estab. 1850. Monthly 4-color literary magazine covering fiction, criticism, essays, social commentary and humor.

Illustration Approached by 250 illustrators/year. Buys 5-10 illustrations/issue. Has featured illustrations by Steve Brodner, Ralph Steadman, Polly Becker, Edmund Guy, Mark Ulriksen, Victoria Kann, Peter de Seve, Ray Bartkus, Danijel Zezelj, Tavis Coburn, Raymond Verdaguer, Andrew Zbihlyj. Features intelligent concept-oriented illustration. Preferred subjects: literary, artistic, social, fiction-related. Prefers intelligent, original thought and imagery in any media. Assigns 25% of illustrations to new and emerging illustrators. 10% of freelance illustration demands knowledge of Photoshop.

First Contact & Terms Illustrators: Send nonreturnable samples. Accepts Mac-compatible disk submissions. Samples are filed and are not returned. Will contact artist for portfolio review if interested. Portfolios may be dropped off for review; call first to schedule. Buys first North American serial rights. Pays on publication; $250-300 for b&w inside; $400-1,000 for color inside; $400 for spots. Finds illustrators through samples, annuals, reps, other publications.

Tips "Intelligence, originality and beauty in execution are what we seek. A wide range of styles is appropriate; what counts most is content."

HEARTLAND BOATING MAGAZINE

319 N. 4th St., #650, St. Louis MO 63102. (314)241-4310. Fax: (314)241-4207. Website: www.Heartlandboating.com. **Art Director:** John R. Cassady II. Estab. 1989. Specialty magazine published 9 times per year devoted to power (cruisers, houseboats) and sail boating enthusiasts throughout middle America. The content is both humorous and informative and reflects "the challenge, joy and excitement of boating on America's inland waterways." Circ. 20,000. Originals are returned at job's completion. Sample copies available for $5. Art guidelines for SASE with first-class postage or check our website.
Cartoons On assignment.
Illustration Buys 1-2 illustrations/issue. Works on assignment only. Prefers boating-related themes. Considers pen & ink.
First Contact & Terms Illustrators: Send postcard sample or query letter with SASE, photocopies and tearsheets. Samples are filed or returned by SASE. Responds in 2 months. Portfolio review not required. Negotiates rights purchased. Pays on publication. Pay is negotiated. Finds artists through submissions.

HEAVY METAL MAGAZINE

100 N. Village Rd., Suite 12, Rookville Center NY 11570. Website: www.metaltv.com. **Contact:** Submissions. Estab. 1977. Consumer magazine. *"Heavy Metal* is the oldest illustrated fantasy magazine in U.S. history."
- See listing in Book Publishers section.

☑ HIGHLIGHTS FOR CHILDREN

803 Church St., Honesdale PA 18431. (570)253-1080. Fax: (570)253-0179. Website: www.highlights.com. **Art Director:** Janet Moir McCaffrey. Senior Editor: Rich Wallace. Monthly 4-color magazine for ages 2-12. Circ. 3 million. Art guidelines for SASE with first-class postage.
Cartoons Receives 20 submissions/week. Buys 2-4 cartoons/issue. Interested in upbeat, positive cartoons involving children, family life or animals; single or multiple panel. "One flaw in many submissions is that the concept or vocabulary is too adult or that the experience necessary for its appreciation is beyond our readers. Frequently, a wordless self-explanatory cartoon is best."
Illustration Buys 30 illustrations/issue. Works on assignment only. Prefers "realistic and stylized work; upbeat, fun, more graphic than cartoon." Pen & ink, colored pencil, watercolor, marker, cut paper and mixed media are all acceptable. Discourages work in fluorescent colors.
First Contact & Terms Cartoonists: Send roughs or finished cartoons and SASE. Illustrators: Send query letter with photocopies, SASE and tearsheets. Samples to be kept on file. Responds in 10 weeks. Buys all rights on a work-for-hire basis. **Pays on acceptance.** Pays cartoonists $20-40 for line drawings. Pays illustrators $1,025 for color front and back covers; $50-600 for color inside. "We are always looking for good hidden pictures. We require a picture that is interesting in itself and has the objects well-hidden. Usually an artist submits pencil sketches. In no case do we pay for any preliminaries to the final hidden pictures." Hidden Pictures should be submitted to Jody Taylor.
Tips "We have a wide variety of needs, so I would prefer to see a representative sample of an illustrator's style."

ALFRED HITCHCOCK MAGAZINE

475 Park Ave. S., 11th Floor, New York NY 10016. (212)686-7188. Fax: (212)686-7414. **Contact:** June Levine, associate art director. Estab. 1956. Monthly b&w magazine with 4-color cover emphasizing mystery fiction. Circ. 202,470. Accepts previously published artwork. Original artwork returned at job's completion. Art guidelines available for #10 SASE with first-class postage.
Illustration Approached by 300 illustrators/year. Buys 2-3 illustrations/issue. Prefers semi-realistic, realistic style. Works on assignment only. Considers pen & ink. Send query letter with printed samples, photocopies and/or tearsheets and SASE.
First Contact & Terms Illustrators: Send follow-up postcard sample every 3 months. Samples are filed or returned by SASE. Responds only if interested. "No phone calls." Portfolios may be dropped off every Tuesday and should include b&w and color tearsheets. "No original art please." Rights purchased vary according to project. **Pays on acceptance**; $1,000-1,200 for color cover; $100 for b&w inside; $35-50 for spots. Finds artists through submissions drop-offs, RSVP.
Tips "No close-up or montages. Show characters within a background environment."

◼ HOME BUSINESS MAGAZINE

PMB 368, 9582 Hamilton, Suite 368, Huntington Beach CA 92646. (714)968-0331. Fax: (714)962-7722. E-mail: henderso@ix.netcom.com. Website: www.homebusinessmag.com. **Contact:** Creative Director. Estab. 1992. Bimonthly consumer magazine. Circ. 100,000. Sample copies free for 10×13 SASE and $2.21 in first-class postage.

Illustration Approached by 100 illustrators/year. Buys several illustrations/issue. Features natural history illustration, realistic illustrations, charts & graphs, informational graphics, spot illustrations and computer illustration of business subjects, families, men and women. Prefers pastel and bright colors. Assigns 40% of illustrations to well-known or "name" illustrators; 40% to experienced but not well-known illustrators; 20% to new and emerging illustrators. 100% of freelance illustration demands knowledge of Illustrator and QuarkXPress.

First Contact & Terms Illustrators: Send query letter with printed samples, photocopies and SASE. Send electronically as JPEG or TIFF files. Samples are filed or returned if requested. Responds only if interested. Will contact artist for portfolio review if interested. Buys reprint rights. Negotiates rights purchased. Pays on publication. Finds illustrators through magazines, word of mouth or via Internet.

HOPSCOTCH, The Magazine for Girls

Box 164, Bluffton OH 45817. (419)358-4610. Fax: (419)358-5027. Website: www.hopscotchmagazine.com. **Contact:** Marilyn Edwards. Estab. 1989. A bimonthly magazine for girls between the ages of 6 and 12; 2-color with 4-color cover; 52 pp.; 7×9 saddle-stapled. Circ. 15,000. Original artwork returned at job's completion. Sample copies available for $4. Art guidelines for SASE with first-class postage. 20% of freelance work demands computer skills.

 • Also publishes *Boys' Quest* (www.boysquest.com) and *Fun For Kidz* (www.funforkidz.com).

Illustration Approached by 200-300 illustrators/year. Buys 6-7 freelance illustrations/issue. Has featured illustrations by Chris Sabatino, Pamela Harden and Donna Catanese. Features humorous, realistic and spot illustration. Assigns 40% of illustrations to new and emerging illustrators. Artists work mostly on assignment. Needs story illustration. Prefers traditional and humor; pen & ink.

First Contact & Terms Illustrators: Send query letter with photocopies of pen & ink samples. Samples are filed. Responds in 2 months. Buys first rights and reprint rights. **Pays on acceptance**; $200-250 for color cover; $25-35 for b&w inside; $50-70 for 2-page spreads; $10-25 for spots.

Tips "Read our magazine. Send a few samples of work in pen and ink. Everything revolves around a theme. Our theme list is available with SASE."

HORTICULTURE MAGAZINE

98 N. Washington St., Boston MA 02114. (617)742-5600. Fax: (617)367-6364. E-mail: edit@hortmag.com. Website: www.hortmag.com. **Contact:** Linda Golon, art director. Estab. 1904. Monthly magazine for all levels of gardeners (beginners, intermediate, highly skilled). "*Horticulture* strives to inspire and instruct avid gardeners of every level." Circ. 300,000. Originals are returned at job's completion. Art guidelines are available.

Illustration Approached by 75 freelance illustrators/year. Buys 10 illustrations/issue. Works on assignment only. Features realistic illustration; informational graphics; spot illustration. Assigns 20% of illustrations to new and emerging illustrators. Prefers tight botanicals; garden scenes with a natural sense to the clustering of plants; people; hands and "how-to" illustrations. Considers all media.

First Contact & Terms Illustrators: Send query letter with brochure, résumé, SASE, tearsheets, slides. Samples are filed or returned by SASE. Publication will contact artist for portfolio review if interested. Buys one-time rights. Pays 1 month after project completed. Payment depends on complexity of piece; $800-1,200 for 2-page spreads; $150-250 for spots. Finds artists through word of mouth, magazines, artists' submissions/self-promotions, sourcebooks, artists' agents and reps, attending art exhibitions.

Tips "I always go through sourcebooks and request portfolio materials if a person's work seems appropriate and is impressive."

▧ HOW, Design Ideas at Work

4700 E. Galbraith Rd., Cincinnati OH 45236. E-mail: triciab@fwpubs.com. Website: www.howdesign.com. **Art Director:** Tricia Barlow. Estab. 1985. Bimonthly trade journal covering "how-to and business techniques for graphic design professionals." Circ. 40,000. Original artwork returned at job's completion. Sample copy $8.50.

 • Sponsors annual conference for graphic artists. Send SASE for more information.

Illustration Approached by 100 illustrators/year. Buys 4-8 illustrations/issue. Works on assignment only. Considers all media, including photography and computer illustration.

First Contact & Terms Illustrators: Send nonreturnable samples. Accepts disk submissions. Responds only if interested. Buys first rights or reprint rights. Pays on publication; $350-1,000 for color inside.

Tips "Send good samples that apply to the work I use. Be patient, art directors get a lot of samples."

IDEALS MAGAZINE

a division of Guideposts, 535 Metroplex Dr., Suite 250, Nashville TN 37211. (615)333-0478. Fax: (888)815-2759. Website: www.idealspublications.com. **Editor:** Marjorie Lloyd. Art Director: Eve DeGrie. Estab. 1944. 4-color bimonthly seasonal general interest magazine featuring poetry and family articles. Circ. 200,000. Accepts previously published material. Sample copy $4. Art guidelines free with #10 SASE with first-class postage.

Illustration Approached by 100 freelancers/year. Buys 8 illustrations/issue. Features realistic and spot illustration of children, families and pets. Uses freelancers mainly for flowers, plant life, wildlife, realistic people illustrations and botanical (flower) spot art. Prefers seasonal themes. Prefers watercolors. Assigns 90% of illustrations to experienced but not well-known illustrators; 10% to new and emerging illustrators. "We are not interested in computer generated art. Must *look* as hand-drawn as possible."

First Contact & Terms Illustrators: Send nonreturnable samples or tearsheets. Samples are filed. Responds only if interested. Do not send originals. Prefers to buy artwork outright. Pays on publication; payment negotiable.

Tips "In submissions, target our needs as far as style is concerned, but show representative subject matter. Artists should be familiar with our magazine before submitting samples of work."

IEEE SPECTRUM

3 Park Ave., 17th Floor, New York NY 10016-5902. (212)419-7555. Fax: (212)419-7570. Website: www.spectrum .ieee.org. **Contact:** Mark Montgomery, senior art director. Estab. 1964. Monthly nonprofit trade magazine serving electrical and electronics engineers worldwide. Circ. 380,000.

Illustration Buys 5 illustrations/issue. Has featured illustrations by John Hersey, David Plunkert, Gene Grief, Mick Wiggins. Features charts, graphs, computer illustration, informational graphics, realistic illustration and spot illustration. Preferred subjects: business, technology, science. Assigns 25% to new and emerging illustrators. Considers all media.

First Contact & Terms Illustrators: Send postcard sample or query letter with printed samples and tearsheets. Samples are filed and are not returned. Responds only if interested. Art director will contact artist for portfolio review if interested. Do *not* send samples via e-mail. Portfolio should include color, final art and tearsheets. Buys first rights and one year's use on website. **Pays on acceptance**; $1,500 minimum for cover; $400 minimum for inside. Finds illustrators through *American Showcase*, *Workbook*.

Tips "Please visit our website and review *Spectrum* before submitting samples. Most of our illustration needs are with 3-D technical diagrams and a few editorial illustrations."

N T THE INDEPENDENT WEEKLY

P.O. Box 2690, Durham NC 27715. (919)286-1972. Fax: (919)286-4274. E-mail: liz@indyweek.com. Website: www.indyweek.com. **Art Director:** Liz Holm. Estab. 1982. Weekly b&w with 4-color cover tabloid; general interest alternative. Circ. 50,000. Original artwork is returned if requested. Sample copies and art guidelines for SASE with first-class postage.

Illustration Buys 10-15 illustrations/year. Prefers local (North Carolina) illustrators. Has featured illustrations by Shelton Bryant, V. Cullum Rogers, Nathan Golub. Works on assignment only. Considers pen & ink; b&w; computer generated art and color.

First Contact & Terms Samples are filed or are returned by SASE if requested. Responds only if interested. Call for appointment to show portfolio or mail tearsheets. Pays on publication; $100-250 for cover; $50 for b&w inside and spots.

Tips "Have a political and alternative 'point of view.' Understand the peculiarities of newsprint. Be easy to work with. No prima donnas."

☑ INSIDE

2100 Arch St., Philadelphia PA 19103. (215)832-0797. E-mail: bleiter@insidemagazine.com. **Editor:** Robert Leiter. Estab. 1979. Quarterly. Circ. 75,000. Original artwork returned after publication.

Illustration Buys several illustrations/issue from freelancers. Has featured illustrations by: Sam Maitin, David Noyes, Robert Grossman. Assigns 15-20% of work to new and emerging illustrators. Prefers color and b&w drawings. Works on assignment only.

First Contact & Terms Illustrators: Send samples and tearsheets to be kept on file. Samples not kept on file are not returned. Call for appointment to show portfolio. Responds only if interested. Buys first rights. Pays on publication; minimum $500 for color cover; $350 for b&w and color inside. Prefers to see sketches.

Tips Finds artists through artists' promotional pieces, attending art exhibitions, artists' requests to show portfolio. "We like illustrations that are bold, edgy and hip. We have redesigned the magazine for a younger market (25-40 year olds)."

☑ ISLANDS

6309 Carpinteria Ave., Carpenteria CA 93013-2901. (805)745-7100. Fax: (805)745-7102. E-mail: islands@islands .com. Website: www.islandsmag.com. **Art Director:** Albert Chiang. Estab. 1981. Bimonthly magazine of "international travel exclusively about islands." 4-color with contemporary design. Circ. 225,000. Original artwork returned after publication. Sample copies available. Art guidelines for SASE with first-class postage. 100% of freelance work demands knowledge of QuarkXPress, FreeHand, Illustrator and Photoshop.

Illustration Approached by 20-30 illustrators/year. Buys 3-4 illustrations/issue. Needs editorial illustration. No theme or style preferred. Considers all media.

First Contact & Terms Illustrators: Send query letter with brochure, tearsheets, photographs and slides. "We prefer samples of previously published tearsheets." Samples are filed. Responds only if interested. Write for appointment to show portfolio or mail printed samples and color tearsheets. Buys first rights or one-time rights. **Pays on acceptance**; $500-750 for color cover; $100-400 per image inside.

Tips A common mistake freelancers make is that "they show too much, not focused enough. Specialize!" Notices "no real stylistic trends, but desktop publishing is affecting everything in terms of how a magazine is produced."

⊠ JACK AND JILL

Children's Better Health Institute, 1100 Waterway Blvd., Box 567, Indianapolis IN 46202. (317)636-8881. Fax: (317)684-8094. Website: www.jackandjillmag.org. **Art Director:** Mark Leslie. Emphasizes educational and entertaining articles focusing on health and fitness as well as developing the reading skills of the reader. For ages 7-10. Monthly except bimonthly January/February, April/May, July/August and October/November. Circ. 200,000. Magazine is 36 pages, 30 pages 4-color and 6 pages b&w. The editorial content is 50% artwork. Original artwork not returned after publication (except in case where artist wishes to exhibit the art; art must be available to us on request). Sample copy $1.25; art guidelines for SASE with first-class postage.

• Also publishes *Child Life, Children's Digest, Children's Playmate, Humpty Dumpty's Magazine* and *Turtle*.

Illustration Approached by more than 100 illustrators/year. Buys 25 illustrations/issue. Has featured illustrations by Alan MacBain, Phyllis Pollema-Cahill, George Sears and Mary Kurnick Maacs. Features humorous, realistic, medical, computer and spot illustration. Assigns 15% of illustrations to well-known or "name" illustrators; 70% to experienced but not well-known illustrators; 15% to new and emerging illustrators. Uses freelance artists mainly for cover art, story illustrations and activity pages. Interested in "stylized, realistic, humorous illustrations for mystery, adventure, science fiction, historical and also nature and health subjects. Works on assignment only. "Freelancers can work in FreeHand, Photoshop or Quark programs."

First Contact & Terms Illustrators: Send postcard sample to be kept on file. Accepts disk submissions. Publication will contact artist for portfolio review if interested. Portfolio should include printed samples, tearsheets, b&w and 2-color pre-separated art. Pays $275-335 for color cover; $90 maximum for b&w inside; $155-190 for color inside; $310-380 for 2-page spreads; $35-80 for spots. Company pays higher rates to artists who can provide color-separated art. Buys all rights on a work-for-hire basis. On publication date, each contributor is sent several copies of the issue containing his or her work. Finds artists through artists' submissions and self-promotion pieces.

Tips Portfolio should include "illustrations composed in a situation or storytelling way, to enhance the text matter. Send samples of published story for which you did illustration work, samples of puzzles, hidden pictures, mazes and self-promotion art. Art should appeal to children first. Artwork should reflect the artist's skill regardless of techniques used. Fresh, inventive colors and characters a strong point. Research publications to find ones that produce the kind of work you can produce. Send several samples (published as well as self-promotion art). The style can vary if there is a consistent quality in the work."

JACKSONVILLE

534 Lancaster St., Jacksonville FL 32204. (904)358-8330. Fax: (904)358-8668. E-mail: info@jacksonvillemag.com. Website: www.jacksonvillemag.com. **Creative Director:** Bronie Massey. Estab. 1983. City/regional lifestyle magazine covering Florida's First Coast. 12 times/yearly with 2 supplements. Circ. 25,000. Originals returned at job's completion. Sample copies available for $5 (includes postage).

Illustration Approached by 50 illustrators/year. Buys 1 illustration every 6 months. Has featured illustrations by Robert McMullen, Jennifer Kalis and Liz Burns. Assigns 75% of illustrations to local experienced but not well-known illustrators; 25% to new and emerging illustrators. Prefers editorial illustration with topical themes and sophisticated style.

First Contact & Terms Illustrators: Send tearsheets. Will accept computer-generated illustrations compatible with Macintosh programs: Illustrator and Photoshop. Samples are filed and are returned by SASE if requested. Publication will contact artist for portfolio review if interested. Portfolio should include b&w and color tearsheets and slides. Buys one-time rights. Pays on publication; $600 for color cover; $150-400 for inside depending on scope.

⊠ JAZZIZ

2650 N. Military Trail, Fountain Square II Bldg., Suite 140, Boca Raton FL 33431-6339. (561)893-6868, ext. 303. Fax: (561)893-6867. E-mail: mail@jazziz.com. Website: www.jazziz.com. **Art Director:** Ben Rennells. Estab. 1982. Monthly magazine covering "all aspects of adult-oriented music with emphasis on instrumental and improvisatory styles: jazz, blues, classical, world beat, sophisticated pop; as well as audio and video." Circ.

120,000. Originals returned at job's completion with four sheets. Art guidelines available for SASE with first class postage.

Illustration Approached by 100-200 illustrators/year. Buys 1-3 illustrations/issue. Works on assignment only.

First Contact & Terms Send query letter with résumé, tearsheets and samples. Samples are filed or returned by SASE only if requested. Responds only if interested. Buys first North American serial rights.

Tips "The old advice is the best advice. Be familiar with the magazine before querying."

☑ JEMS, Journal of Emergency Medical Services

525 B St., Suite 1900, San Diego CA 92101. (800)266-5367. E-mail: k.losavio@elsevier.com. Website: www.jems .com. **Senior Editor:** Keri Losavio. Estab. 1980. Monthly trade journal aimed at paramedics/paramedic instructors. Circ. 45,000. Accepts previously published artwork. Originals returned at job's completion. Sample copies available. Art guidelines for SASE. 95% of freelance work demands knowledge of QuarkXPress, Illustrator and Photoshop.

Illustration Approached by 240 illustrators/year. Has featured illustrations by Brook Wainwright, Keith Robinson, Randy Lyhus, Chris Murphy and Shayne Davidson. Buys 2-6 illustrations/issue. Works on assignment only. Prefers medical as well as general editorial illustration. Considers pen & ink, airbrush, colored pencil, mixed media, collage, watercolor, acrylic, oil and marker.

First Contact & Terms Illustrators: Send postcard sample or query letter with photocopies. Accepts disk submissions compatible with most current versions of Illustrator or Photoshop. Samples are filed and are not returned. Portfolio review not required. Publication will contact artist for portfolio review of final art, tearsheets and printed samples if interested. Rights purchased vary according to project. Pays on publication. Pays $150-400 for color, $10-25 for b&w inside; $25 for spots. Finds artists through directories, agents, direct mail campaigns.

Tips "Review magazine samples before submitting. We have had the most mutual success with illustrators who can complete work within one to two weeks and send finals in computer format. We use black & white and four-color medical illustrations on a regular basis."

⚕ JEWISH ACTION

11 Broadway, New York NY 10004. (212)613-8146. Fax: (212)613-0646. E-mail: ja@ou.org. Website: www.ou.o rg. **Editor:** Nechama Carmel. Art Director: Ed Hamway. Estab. 1986. Quarterly magazine "published by Orthodox Union for members and subscribers. Orthodox Jewish contemporary issues." Circ. 25,000. Sample copies available for 9×12 SASE and $1.75 postage or can be seen on website.

Cartoons Approached by 2 cartoonists/year. Prefers themes relevant to Jewish issues. Prefers single, double or multiple panel, political, humorous b&w washes and line drawings with or without gaglines.

Illustration Approached by 4-5 illustrators. Considers all media. Assigns 50% of illustrations to experienced but not well-known illustrators; 50% to new and emerging illustrators. Knowledge of Photoshop, Illustrator and QuarkXPress "not absolutely necessary, but preferred."

Design Needs freelancers for design and production. Prefers local design freelancers only.

First Contact & Terms Send query letter with photocopies and SASE. Accepts disk submissions. Prefer QuarkXPress TIFF or EPS files. Can send ZIP disk. Samples are not filed and are not returned. Responds only if interested. Art director will contact artist for portfolio review of photographs if interested. Buys one-time rights. Pays within 6 weeks of publication. Pays cartoonists $20-50 for b&w. Pays illustrators $25-75 for b&w, $50-300 for color cover; $50-200 for b&w, $25-150 for color inside. Finds illustrators through submissions.

Tips Looking for "sensitivity to Orthodox Jewish traditions and symbols."

JOURNAL OF ACCOUNTANCY

AICPA, Harborside 201 Plaza III, Jersey City NJ 07311. (201)938-3450. E-mail: jcostello@aicpa.org. **Art Director:** Jeryl Ann Costello. Monthly 4-color magazine emphasizing accounting for certified public accountants; corporate/business format. Circ. 360,000. Accepts previously published artwork. Original artwork returned after publication.

Illustration Approached by 200 illustrators/year. Buys 2-6 illustrations/issue. Prefers business, finance and law themes. Accepts mixed media, then pen & ink, airbrush, colored pencil, watercolor, acrylic, oil, pastel and digital. Works on assignment only. 35% of freelance work demands knowledge of Illustrator, QuarkXPress and FreeHand.

First Contact & Terms Illustrators: Send query letter with brochure showing art style. Samples not filed are returned by SASE. Portfolio should include printed samples, color and b&w tearsheets. Buys first rights. Pays on publication; $1,200 for color cover; $200-600 for color (depending on size) inside. Finds artists through submissions/self-promotions, sourcebooks and magazines.

Tips "I look for indications that an artist can turn the ordinary into something extraordinary, whether it be through concept or style. In addition to illustrators, I also hire freelancers to do charts and graphs. In portfolios, I like to see tearsheets showing how the art and editorial worked together."

JOURNAL OF ASIAN MARTIAL ARTS

821 W. 24th St., Erie PA 16502-2523. (814)455-9517. Fax: (814)455-2726. E-mail: info@goviamedia.com. Website: www.goviamedia.com. **Publisher:** Michael A. DeMarco. Estab. 1991. Quarterly journal covering all historical and cultural aspects of Asian martial arts. Interdisciplinary approach. College-level audience. Circ. 10,000. Accepts previously published artwork. Sample copies available for $10. Art guidelines for SASE with first-class postage.

Illustration Buys 60 illustrations/issue. Has featured illustrations by Oscar Ratti, Tony LaMotta and Michael Lane. Features realistic and medical illustration. Assigns 10% of illustrations to new and emerging illustrators. Prefers b&w wash; brush-like Oriental style; line. Considers pen & ink, watercolor, collage, airbrush, marker and charcoal.

First Contact & Terms Illustrators: Send query letter with brochure, résumé, SASE and photocopies. Accepts disk submissions compatible with PageMaker, QuarkXPress and Illustrator. Samples are filed. Responds in 6 weeks. Publication will contact artist for portfolio review if interested. Portfolio should include b&w roughs, photocopies and final art. Buys first rights and reprint rights. Pays on publication; $100-300 for color cover; $10-100 for b&w inside; $100-150 for 2-page spreads.

Tips "Usually artists hear about or see our journal. We can be found in bookstores, libraries or in listings of publications. Areas most open to freelancers are illustrations of historic warriors, weapons, castles, battles— any subject dealing with the martial arts of Asia. If artists appreciate aspects of Asian martial arts and/or Asian culture, we would appreciate seeing their work and discuss the possibilities of collaboration."

N JOURNAL OF LIGHT CONSTRUCTION

186 Allen Brook Lane, Williston VT 05495-9222. (802)879-3335. Fax: (802)879-9384. E-mail: jlc-editorial@hanley_wood.com. Website: www.jlconline.com. **Art Director:** Barbara Nevins. Monthly magazine emphasizing residential and light commercial building and remodeling. Focuses on the practical aspects of building technology and small-business management. Circ. 72,000. Accepts previously published material. Original artwork is returned after publication. Sample copy free.

Cartoons Buys cartoons relevent to construction industry, especially business topics.

Illustration Buys 10 illustrations/issue. "Lots of how-to technical illustrations are assigned on various construction topics."

Design Needs freelancers for design and production. 100% of freelance work demands knowledge of Photoshop, Illustrator and QuarkXPress on Macintosh.

First Contact & Terms Illustrators: Send query letter with SASE, tearsheets or photocopies. Designers: Send photocopies and résumé. Prefers local freelancers only. Samples are filed or are returned only if requested by artist. Responds if interested. Call or write for appointment to show portfolio of printed samples and tearsheets. Buys one-time rights. **Pays on acceptance.** Pays illustrators $500 for color cover; $100 for b&w inside; $200 for color inside; $150 for spots. Pays designers by the hour, $20-30.

Tips "Write for a sample copy. We are unusual in that we have drawings illustrating construction techniques. We prefer artists with construction and/or architectural experience. We prefer using freelancers in the New England area with home computers."

JUDICATURE

180 N. Michigan Ave., Suite 600, Chicago IL 60601-7401. E-mail: drichert@ajs.org. Website: www.ajs.org. **Contact:** David Richert. Estab. 1917. Journal of the American Judicature Society. 4-color bimonthly publication. Circ. 6,000. Accepts previously published material and computer illustration. Original artwork returned after publication. Sample copy for SASE with $1.52 postage; art guidelines not available.

Cartoons Approached by 10 cartoonists/year. Buys 1-2 cartoons/issue. Interested in "sophisticated humor revealing a familiarity with legal issues, the courts and the administration of justice."

Illustration Approached by 20 illustrators/year. Buys 1-2 illustrations/issue. Has featured illustrations by Estelle Carol, Mary Chaney, Jerry Warshaw and Richard Laurent. Features humorous and realistic illustration; charts & graphs; computer and spot illustration. Works on assignment only. Interested in styles from "realism to light humor." Prefers subjects related to court organization, operations and personnel. Freelance work demands knowledge of PageMaker and FreeHand.

Design Needs freelancers for design. 100% of freelance work demands knowledge of PageMaker and FreeHand.

First Contact & Terms Cartoonists: Send query letter with samples of style and SASE. Responds in 2 weeks. Illustrators: Send query letter, SASE, photocopies, tearsheets or brochure showing art style (can be sent electronically). Publication will contact artist for portfolio review if interested. Portfolio should include roughs and printed samples. Wants to see "black & white and color, along with the title and synopsis of editorial material the illustration accompanied." Buys one-time rights. Negotiates payment. Pays cartoonists $35 for unsolicited b&w cartoons. Pays illustrators $250-375 for 2-, 3- or 4-color cover; $250 for b&w full page, $175 for b&w half page inside; $75-100 for spots. Pays designers by the project.

Tips "Show a variety of samples, including printed pieces and roughs."

KALEIDOSCOPE: Exploring the Experience of Disability through Literature and the Fine Arts

701 S. Main St., Akron OH 44311-1019. (330)762-9755. E-mail: mshiplett@udsakron.org. Website: www.udsakron.org. **Editor-in-Chief:** Gail Willmott. Estab. 1979. Black & white with 4-color cover. Semiannual. "Elegant, straightforward design. Explores the experiences of disability through lens of the creative arts. Specifically seeking work by artists with disabilities. Work by artists without disabilities must have a disability focus." Circ. 1,500. Accepts previously published artwork. Sample copy $6; art guidelines for SASE with first-class postage.

Illustration Freelance art occasionally used with fiction pieces. More interested in publishing art that stands on its own as the focal point of an article. Approached by 15-20 artists/year. Has featured illustrations by Dennis J. Brizendine, Deborah Vidaver Cohen and Sandy Palmer. Features humorous, realistic and spot illustration.

First Contact & Terms Illustrators: Send query letter with résumé, photocopies, photographs, SASE and slides. Do not send originals. Prefers high contrast, b&w glossy photos, but will also review color photos or 35mm slides. Include sufficient postage for return of work. Samples are not filed. Publication will contact artist for portfolio review if interested. Acceptance or rejection may take up to a year. Pays $25-100 for color covers; $10-25 for b&w or color insides. Rights revert to artist upon publication. Finds artists through submissions/self-promotions and word of mouth.

Tips "Inquire about future themes of upcoming issues. Considers all mediums, from pastels to acrylics to sculpture. Must be high-quality art."

KALLIOPE, a journal of women's literature and art

11901 Beach Blvd., Jacksonville FL 32246. (904)646-2346. Website: www.fccj.org/kalliope. **Editor:** Mary Sue Koeppel. Estab. 1978. Literary b&w biannual which publishes an average of 27 pages of art by women in each issue. "Publishes poetry, fiction, reviews, and visual art by women and about women's concerns; high-quality art reproductions; visually interesting design." Circ. 1,600. Accepts previously published "fine" artwork. Original artwork is returned at the job's completion. Sample copy for $7. Art guidelines available for SASE with first-class postage.

Cartoons Approached by 1 cartoonist/year. Has featured art by Aimee Young Jackson, Kathy Keler, Lise Metzger, Joyce Tenneson. Topics should relate to women's issues.

Illustration Approached by 35 fine artists/year. Buys 27 photos of fine art/issue. Looking for "excellence in fine visual art by women (nothing pornographic)."

First Contact & Terms Cartoonists: Send query letter with roughs. Illustrators: Send query letter with résumé, SASE, photographs (b&w glossies) and artist's statement (50-75 words). Samples are not filed and are returned by SASE. Responds in 2 months. Rights acquired vary according to project. Pays 1 year subscription or 2 complimentary copies for b&w cover or inside.

Tips "Please study recent issues of *Kalliope*."

☑ ⚼ KANSAS CITY MAGAZINE

118 Southwest Blvd., 3rd Floor, Kansas City MO 64108. (816)421-4111. Fax: (816)221-8350. E-mail: akingsolver @abartapub.com. Website: www.kcmag.com. **Contact:** Alice Kingsolver, art director. Estab. 1994. Monthly lifestyle-oriented magazine, celebrating living in Kansas City. "We try to look at things from a little different angle (for added interest) and show the city through the eyes of the people." Circ. 27,000. Sample copies available for #10 SASE with first-class postage. Art guidelines not available.

Illustration Approached by 100-200 illustrators/year. Buys 3-5 illustrations/issue. Works on assignment only. Prefers conceptual editorial style. Considers all media. 25% of freelance illustration demands knowledge of Illustrator and Photoshop.

Design Needs freelancers for design and production. Prefers local freelancers only. 100% of freelance work demands knowledge of Photoshop, Illustrator and QuarkXPress.

First Contact & Terms Illustrators: Send postcard-size sample or query letter with tearsheets, photocopies and printed samples. Designers: Send query letter with printed samples, photocopies, SASE and tearsheets. Accepts disk submissions compatible with Macintosh files (EPS, TIFF, Photoshop, etc.). Samples are filed. Will contact artist for portfolio review if interested. Portfolio should include final art, photographs, tearsheets, photocopies and photostats. Buys reprint rights. **Pays on acceptance**; $500-800 for color cover; $50-200 for b&w, $150-300 for color inside. Pays $50-150 for spots. Finds artists through sourcebooks, word of mouth, submissions.

Tips "We have a high quality, clean, cultural, creative format. Look at magazine before you submit."

KASHRUS MAGAZINE—The Periodical for the Kosher Consumer

Box 204, Brooklyn NY 11204. (718)336-8544. Fax: (718)336-8550. Website: www.kashrus.com. **Editor:** Rabbi Yosef Wikler. Estab. 1980. Bimonthly magazine with 4-color cover which updates consumer and trade on issues involving the kosher food industry, especially mislabeling, new products and food technology. Circ. 10,000. Accepts previously published artwork. Original artwork is returned after publication. Sample copy $2; art guidelines not available.

Cartoons Buys 2 cartoons/issue. Accepts color for cover or special pages. Seeks "kosher food and Jewish humor."

Illustration Buys illustrations mainly for covers. Works on assignment only. Has featured illustrations by R. Keith Rugg and Theresa McCracken. Features humorous, realistic and spot illustration. Assigns 30% of illustrations to new and emerging illustrators. Prefers pen & ink.

First Contact & Terms Send query letter with photocopies. Request portfolio review in original query. Portfolio should include tearsheets. Pays cartoonists $25-35 for b&w; payment is negotiated by project. Pays illustrators $100-200 for color cover; $25-75 for b&w inside; $75-150 for color inside; $25-35 for spots. Finds artists through submissions and self-promotions.

Tips "Send general food or Jewish food- and travel-related material. Do not send off-color material."

Ⓝ KENTUCKY LIVING

Box 32170, Louisville KY 40232. (502)451-2430. Fax: (502)459-1611. E-mail: e-mail@kentuckyliving.com. Website: www.kentuckyliving.com. **Editor:** Paul Wesslund. 4-color monthly emphasizing Kentucky-related and general feature material for Kentuckians living outside metropolitan areas. Circ. 487,000. Accepts previously published material. Original artwork returned after publication if requested. Sample copy available.

Cartoons Approached by 10-12 cartoonists/year.

Illustration Buys occasional illustrations/issue. Works on assignment only. Prefers b&w line art.

First Contact & Terms Illustrators: Send query letter with résumé and samples. Samples not filed are returned only if requested. Buys one-time rights. **Pays on acceptance**. Pays cartoonists $30 for b&w. Pays illustrators $50 for b&w inside.

KEYNOTER

Kiwanis International, 3636 Woodview Trace, Indianapolis IN 46268. (317)875-8755. **Executive Editor:** Shanna Mooney. Art Director: Maria Malandrakis. Official publication of Key Club International, nonprofit high school service organization. 4-color; "contemporary design for mature teenage audience." Published 7 times/year. Circ. 170,000. Previously published, photocopied and simultaneous submissions OK. Original artwork returned after publication. Free sample copy with SASE and 65¢ postage.

Illustration Buys 3 editorial illustrations/issue. Works on assignment only.

First Contact & Terms Include SASE. Responds in 2 weeks. "Freelancers should call our Production and Art Department for interview." Buys first rights. **Pays on receipt of invoice**; $500 for b&w, $1,000 for color cover; $200 for b&w, $700 for color, inside.

KIPLINGER'S PERSONAL FINANCE

1729 H St. NW, Washington DC 20006. (202)887-6416. Fax: (202)331-1206. E-mail: ccurrie@kiplinger.com. Website: www.kiplinger.com. **Art Director:** Cynthia L. Currie. Estab. 1947. A monthly 4-color magazine covering personal finance issues including investing, saving, housing, cars, health, retirement, taxes and insurance. Circ. 800,000. Originals are returned at job's completion.

Illustration Approached by 350 illustrators/year. Buys 4-6 illustrations/issue. Works on assignment only. Has featured illustrations by Dan Adel, Tim Bower, Edwin Fotheringham. Features computer, conceptual editorial and spot illustration. Assigns 5% of illustrations to new and emerging illustrators. Interested in editorial illustration in new styles, including computer illustration.

First Contact & Terms Illustration: Send postcard samples. Accepts Mac-compatible disk submissions. Samples are filed or returned by SASE if requested by artist. Publication will contact artist for portfolio review if interested. Buys one-time rights. Pays on publication; $400-1,200 for color inside; $250-500 for spots. Finds illustrators through reps, online, magazines, *Workbook* and award books.

Tips "Send us high-caliber original work that shows creative solutions to common themes. A fresh technique, combined with a thought-out image, will intrigue art directors and readers alike. We strive to have a balance of seriousness and accessibility throughout."

KIWANIS

3636 Woodview Trace, Indianapolis IN 46268. (317)875-8755. Fax: (317)879-0204. E-mail: kiwanismail@kiwanis.org. Website: www.kiwanis.org. **Managing Editor:** Jack Brockley. Estab. 1918. 4-color magazine emphasizing civic and social betterment, business, education and domestic affairs for business and professional persons. Published 10 times/year. Original artwork returned after publication by request. Circ. 240,000. Art guidelines available for SASE with first-class postage.

Illustration Buys 0-2 illustrations/issue. Assigns themes that correspond to themes of articles. Works on assignment only. Keeps material on file after in-person contact with artist.

First Contact & Terms Illustration: Include SASE. Responds in 2 weeks. To show a portfolio, mail appropriate materials (out of town/state) or call or write for appointment. Portfolio should include roughs, printed samples,

final reproduction/product, color and b&w tearsheets, photostats and photographs. Buys first rights. **Pays on acceptance**; $600-1,000 for cover; $400-800 for inside; $50-75 for spots. Finds artists through talent sourcebooks, references/word of mouth and portfolio reviews.

Tips ''We deal direct—no reps. Have plenty of samples, particularly those that can be left with us. Too many student or unassigned illustrations in many portfolios.''

N L.A. PARENT MAGAZINE

443 E. Irving Dr., Suite A, Burbank CA 91504-2447. (818)846-0400. Fax: (818)841-4380. E-mail: laparent@comp userve.com. Website: www.parenthoodweb.com. **Editor:** Marilyn Martinez. Estab. 1979. Tabloid. A monthly city magazine for parents of young children, b&w with 4-color cover; ''bold graphics and lots of photos of kids and families.'' Circ. 120,000. Accepts previously published artwork. Originals are returned at job's completion.

Illustration Buys 2 freelance illustrations/issue. Assigns 50% of illustrations to experienced but not well-known illustrators; 50% to new and emerging illustrators. Works on assignment only. Send postcard sample. Accepts disk submissions compatible with Illustrator 5.0 and Photoshop 3.0. Samples are filed or returned by SASE. Responds in 2 months. To show a portfolio, mail thumbnails, tearsheets and photostats. Buys one-time rights or reprint rights. **Pays on acceptance**; $300 color cover (may use only 1 color cover/year); $75 for b&w inside; $50 for spots.

Tips ''Show an understanding of our publication. Since we deal with parent/child relationships, we tend to use fairly straightforward work. Read our magazine and find out what we're all about.''

N ☥ L.A. WEEKLY

6715 Sunset Blvd., Los Angeles CA 90028. (323)465-9909. Fax: (323)465-1550. E-mail: weeklyart@aol.com. Website: www.laweekly.com. **Assistant Art Director:** Laura Steele. Estab. 1978. Weekly alternative arts and news tabloid. Circ. 220,000. Art guidelines available.

Cartoons Approached by over 100 cartoonists/year. ''We contract about 1 new cartoonist per year.'' Prefers Los Angeles, alternative lifestyle themes. Prefers b&w line drawings without gagline.

Illustration Approached by over 200 illustrators/year. Buys 4 illustrations/issue. Themes vary according to editorial needs. Considers all media.

First Contact & Terms Cartoonists: Send query letter with photocopies. Rights purchased vary according to project. Illustrators: Send postcard sample or query letter with photocopies of cartoons. ''Can also e-mail final artwork.'' Samples are filed or returned by SASE. Responds only if interested. Portfolio may be dropped off Monday-Friday and should include any samples except original art. Artist should follow up with call and/or letter after initial query. Buys first rights. Pays on publication. Pays cartoonists $120-200 for b&w. Pays illustrators $400-1,000 for cover; $120-400 for inside; $120-200 for spots. Prefers submissions but will also find illustrations through illustrators' websites, *Black Book*, *American Illustration*, various Los Angeles and New York publications.

Tips Wants ''less polish and more content. Gritty is good, quick turnaround and ease of contact a must.''

LADYBUG, the Magazine for Young Children

Box 300, Peru IL 61354. **Art Director:** Suzanne Beck. Estab. 1990. Monthly 4-color magazine emphasizing children's literature and activities for children, ages 2-6. Design is ''geared toward maximum legibility of text and basically art-driven.'' Circ. 140,000. Accepts previously published material. Original artwork returned after publication. Sample copy $4.95 plus 10% of total order ($4 minimum) for shipping and handling; art guidelines for SASE with first-class postage.

Illustration Approached by 600-700 illustrators/year. Works with 40 illustrators/year. Buys 200 illustrations/ year. Has featured illustrations by Rosemary Wells, Tomie de Paola and Diane de Groat. Uses artists mainly for cover and interior illustration. Prefers realistic styles (animal, wildlife or human figure); occasionally accepts caricature. Works on assignment only.

First Contact & Terms Illustrators: Send query letter with photocopies, photographs and tearsheets to be kept on file, ''if I like it.'' Prefers photocopies and tearsheets as samples. Samples are returned by SASE if requested. Publication will contact artist for portfolio review if interested. Portfolio should show a strong personal style and include ''several pieces that show an ability to tell a continuing story or narrative.'' Does not want to see ''overly slick, cute commercial art (i.e., licensed characters and overly sentimental greeting cards).'' Buys all rights. **Pays 45 days after acceptance**; $750 for color cover; $250 for color full page; $100 for color, $50 for b&w spots.

Tips ''Has a need for artists who can accurately and attractively illustrate the movements for finger-rhymes and songs and basic informative features on nature and 'the world around you.' Multi-ethnic portrayal is also a *very* important factor in the art for *Ladybug*.''

LAW PRACTICE MANAGEMENT

24476 N. Echo Lake Rd., Hawthorn Woods IL 60047-9039. (847)550-9790. Fax: (847)550-9794. Website: www.a banet.org/lpm. **Art Director:** Mark Feldman, Feldman Communications, Inc. E-mail: mark@feldcomm.com. 4-color trade journal for the practicing lawyer about "the business of practicing law." Estab. 1975. Published 8 times/year. Circ. 20,833.

Illustration Uses cover and inside feature illustrations. Uses all media, including computer graphics. Mostly 4-color artwork.

First Contact & Terms Illustrators: Send postcard sample or query letter with samples. Pays on publication. Very interested in high quality, previously published works. Pay rates: $200-350/illustration. Original works negotiable. Cartoons very rarely used.

Tips "There's an increasing need for artwork to illustrate high-tech articles on technology in the law office. (We have two or more such articles each issue.) We're especially interested in computer graphics for such articles. Recently redesigned to use more illustration on covers and with features. Topics focus on management, marketing, communications and technology."

☑ LISTEN MAGAZINE

55 W. Oak Ridge Dr., Hagerstown MD 21740. (301)393-4010. E-mail: listen@healthconnection.org. **Editor:** Céleste Perrino Walker. Monthly magazine (September-May) for teens with specific aim to educate against alcohol, tobacco and other drugs and to encourage positive life choices. Circ. 30,000. Accepts previously published artwork. Originals returned at job's completion. Sample copies available for $1.

Cartoons Buys occasional cartoons. Prefers single panel b&w washes and line drawings.

Illustration Buys 6 illustrations/issue. Works on assignment only. Considers all media.

First Contact & Terms Cartoonists: Send query letter with brochure and roughs. Illustrators: Send postcard sample or query letter with brochure, résumé and tearsheets. Samples are filed or are returned by SASE. Responds only if interested. Publication will contact artist for portfolio review if interested. Buys reprint rights. **Pays on acceptance.** No longer uses illustrations for covers.

N LOG HOME LIVING

4125 Lafayette Center Dr., Suite 100, Chantilly VA 20151. (800)826-3893 or (703)222-9411. Fax: (703)222-3209. Website: www.loghomeliving.com. **Art Director:** Sonya Monsma. Estab. 1989. Monthly 4-color magazine "dealing with the aspects of buying, building and living in a log home. We emphasize upscale living (decorating, furniture, etc.)." Circ. 108,000. Accepts previously published artwork. Sample copies not available. Art guidelines for SASE with first-class postage. 20% of freelance work demands knowledge of QuarkXPress, Illustrator and Photoshop.

● Also publishes *Timberframe Homes* and *Building Systems.*

Illustration Buys 2-4 illustrations/issue. Works on assignment only. Prefers editoral illustration with "a strong style—ability to show creative flair with not-so-creative a subject." Considers watercolor, airbrush, colored pencil, pastel and digital illustration.

Design Needs freelancers for design and production once a year in the summer. 80% of freelance work demands knowledge of Photoshop, Illustrator and QuarkXPress.

First Contact & Terms Illustrators: Send postcard sample. Designers: Send query letter with brochure, résumé, and samples. Accepts disk submissions compatible with Illustrator, Photoshop and QuarkXPress. Samples are filed. Publication will contact artist for portfolio review if interested. Portfolio should include thumbnails, roughs, printed samples or color tearsheets. Buys all rights. **Pays on acceptance.** Pays illustrators $100-200 for b&w inside; $250-800 for color inside; $100-250 for spots. Pays designers by the project. Finds artists through submissions/self-promotions, sourcebooks.

☑ THE LOOKOUT

8121 Hamilton Ave., Cincinnati OH 45231. (513)931-4050. Fax: (513)931-0950. E-mail: lookout@standardpub.c om. Website: www.lookoutmag.com. **Administrative Assistant:** Sheryl Overstreet. Weekly 4-color magazine for conservative Christian adults and young adults. Circ. 100,000. Sample copy available for $1.

Illustration Prefers both humorous and serious, stylish illustrations featuring Christian families.

First Contact & Terms Illustrators: Send postcard or other nonreturnable samples.

Tips Do not send e-mail submissions.

N LOS ANGELES MAGAZINE

5900 Wilshire Blvd., 10th Floor, Los Angeles CA 90036. (323)801-0075. Fax: (323)801-0100. Website: www.losa ngelesmagazine.com. **Art Director:** Joe Kimberling. Monthly 4-color magazine with a contemporary, modern design, emphasizing lifestyles, cultural attractions, pleasures, problems and personalities of Los Angeles and the surrounding area. Circ. 170,000. Especially needs very localized contributors—custom projects needing

person-to-person concepting and implementation. Previously published work OK. Sample copy $3. 10% of freelance work demands knowledge of QuarkXPress, Illustrator and Photoshop.

Illustration Buys 10 illustrations/issue on assigned themes. Prefers general interest/lifestyle illustrations with urbane and contemporary tone. To show a portfolio, send or drop off samples showing art style (tearsheets, photostats, photocopies and dupe slides).

First Contact & Terms Pays on publication; negotiable.

Tips "Show work similar to that used in the magazine—a sophisticated style. Study a particular publication's content, style and format. Then proceed accordingly in submitting sample work. We initiate contact of new people per *Showcase* reference books or promo fliers sent to us. Portfolio viewing is all local."

☒ THE LUTHERAN

8765 W. Higgins Rd., Chicago IL 60631-4101. (773)380-2540. Fax: (773)380-2751. E-mail: lutheran@elca.org. Website: www.thelutheran.org. **Art Director:** Michael D. Watson. Estab. 1988. Monthly general interest magazine of the Evangelical Lutheran Church in America; 4-color, "contemporary" design. Circ. 650,000. Previously published work OK. Original artwork returned after publication on request. Free sample copy for 9×12 SASE and 5 first-class stamps. Freelancers should be familiar with Illustrator, QuarkXPress or Photoshop. Art guidelines available.

Cartoons Approached by 100 cartoonists/year. Buys 2 cartoons/issue from freelancers. Interested in humorous or thought-provoking cartoons on religion or about issues of concern to Christians; single panel b&w washes and line drawings with gaglines. Prefers finished cartoons.

Illustration Buys 6 illustrations/year from freelancers. Has featured illustrations by Rich Nelson, Jimmy Holder, Michael D. Watson. Assigns 30% of illustrations to well-known or "name" illustrators; 70% to experienced but not well-known illustrators. Works on assignment. Does not use spots.

First Contact & Terms Cartoonists: Send query letter with photocopies of cartoons and SASE. Illustrators: Send query letter with brochure and tearsheets to keep on file for future assignments. Buys one-time usage of art. Will return art if requested. Responds usually within 2 weeks. Accepts disk submississions compatible with Illustrator 5.0. Samples returned by SASE if requested. Portfolio review not required. Pays on publication. Pays cartoonists $50-100 for b&w line drawings and washes. Pays illustrators $600 for color cover; $150-350 for b&w, $500 for color inside. Finds artists mainly through submissions.

Tips "Include your phone number with submission. Send samples that can be retained for future reference. We are partial to computer illustrations. Would like to see samples of charts and graphs. Want professional looking work, contemporary, not too wild in style."

LYNX EYE

542 Mitchell Dr., Los Osos CA 93402. (805)528-8146. Fax: (805)528-7876. E-mail: pamccully@aol.com. **Co-Editor:** Pam McCully. Estab. 1994. Quarterly b&w literary magazine. Circ. 500.

Cartoons Approached by 100 cartoonists/year. Buys 10 cartoons/year. Prefers sophisticated humor. Prefers single panel, political and humorous b&w washes or line drawings.

Illustration Approached by 100 illustrators/year. Buys 20 illustrations/issue. Has featured illustrations by Wayne Hogan, Greg Kidd and Michael Greenstein. Features humorous, natural history, realistic or spot illustrations. Prefers b&w work that stands alone as a piece of art—does not illustrate story/poem. Assigns 100% of illustrations to new and emerging illustrators, as well as to experienced but not well-known illustrators.

First Contact & Terms Cartoonists: Send b&w photocopies and SASE. Illustrators: Send query letter with photocopies and SASE. Samples are not filed and are returned by SASE. Responds in 3 months. Will contact artist for portfolio review if interested. Buys first North American serial rights. **Pays on acceptance.** Pays $10 for b&w plus 3 copies.

Tips "We are always in need of artwork. Please note that your work is considered an individual piece of art and does not illustrate a story or poem."

MAD MAGAZINE

1700 Broadway, New York NY 10019. (212)506-4850. Fax: (212)506-4848. Website: www.madmag.com. **Art Director:** Sam Viviano. Associate Art Director: Nadina Simon. Assistant Art Director: Patricia Dwyer. Monthly irreverent humor, parody and satire magazine. Estab. 1952. Circ. 250,000.

Illustration Approached by 300 illustrators/year. Works with 50 illustrators/year. Has featured illustrations by Jack Davis, Paul Coker, Tom Bunk and Hermann Mejia. Features humor, realism, caricature.

First Contact & Terms Illustrators: Send query letter with tearsheets and SASE. Samples are filed. Portfolios may be dropped off every Wednesday and can be picked up same day 4:30-5:00 p.m. Buys all rights. Pays $2,500-3,200 for color cover; $400-725 for inside. Finds illustrators through direct mail, sourcebooks (all).

Design Uses local freelancers for design infrequently. 100% of freelance design demands knowledge of Illustrator, Photoshop and QuarkXPress.

Tips "Know what we do! *MAD* is very specific. Everyone wants to work for *MAD*, but few are right for what *MAD* needs! Understand reproduction process, as well as 'give-and-take' between artist and client."

☑ MAIN LINE TODAY

4699 W. Chester Pike, Newtown Business Center, Newtown Square PA 19703. (610)325-4630. Fax: (610)325-5215. Website: www.mainlinetoday.com. **Art Director:** Ingrid Hansen-Lynch. Estab. 1996. Monthly consumer magazine providing quality information to the Main Line and western suburbs of Philadelphia. Circ. 40,000. Sample copies for #10 SASE with first-class postage.

Illustration Approached by 100 illustrators/year. Buys 3-5 illustrations/issue. Considers acrylic, charcoal, collage, color washed, mixed media, oil, pastel and watercolor.

First Contact & Terms Send postcard sample or query letter with printed samples and tearsheets. Send follow-up postcard sample every 3-4 months. Samples are filed and are not returned. Responds only if interested. Buys one-time and reprint rights. Pays on publication; $400 maximum for color cover; $125-250 for b&w inside; $125-250 for color inside. Pays $125 for spots. Finds illustrators by word of mouth and submissions.

☒ MANY MOUNTAINS MOVING

420 22nd St., Boulder CO 80302-7909. (303)545-9942. Fax: (303)444-6510. E-mail: mmm@mmminc.org. Website: www.mmminc.org. **Art Director:** Naomi Horii. Estab. 1994. Quarterly literary magazine features poetry and invites fine art from artists from all walks of life. Circ. 3,000.

Illustration Approached by 100 illustrators/year. Buys 8-10 illustrations/issue. Has featured illustrations by Tony Ortega, Julie Maren. Features fine art and photography. Open to all subject matter and styles. Prefers b&w for inside art; b&w or color for cover. Assigns 30% of illustrations to well-known or "name" illustrators; 35% to experienced but not well-known illustrators; 35% to new and emerging illustrators.

First Contact & Terms Illustrators: Send query letter with SASE and photocopies. Responds in 2 months. Will contact artist for portfolio review if interested. Buys first North American serial rights. Pays on publication; $10 for b&w, $10 for color cover; $5 for b&w, $5 for color inside, $10 for 2-page spreads. Finds illustrators through artists' promotional samples, word of mouth, gallery exhibitions and magazine articles.

MASSAGE MAGAZINE

200 7th Ave. #240, Santa Cruz CA 95062-4628. (831)477-1176. Fax: (831)477-2918. E-mail: karen@massagemag .com. Website: www.massagemag.com. **Editor:** Karen Menehan. Estab. 1986. Bimonthly trade magazine for practitioners and their clients in the therapeutic massage and allied healing arts and sciences (acupuncture, aromatherapy, chiropractic, etc.) Circ. 45,000. Art guidelines not available.

Illlustration Not approached by enough illustrators/year. Buys 6-10 illustrations/year. Features medical illustration representing mind/body/spirit healing. Assigns 100% of illustrations to experienced but not well-known illustrators. Themes or style range from full-color spiritually moving to business-like line art. Considers all media. All art must be scanable.

First Contact & Terms Send postcard sample and query letter with printed samples or photocopies. Accepts disk-submitted artwork done in Freehand or Photoshop for use in QuarkXPress 4.0. Responds only if interested. Rights purchased vary according to project. Pays on publication; $75-200 for inside color illustration. Finds illustrators through word of mouth and artist's submissions.

Tips "I'm looking for quick, talented artists with an interest in the healing arts and sciences."

MB MEDIA

(Parent company of *Magical Blend*), PO Box 600, Chico CA 95927. (530)893-9037. Fax: (530)893-9076. E-mail: artdept@magicalblend.com. Website: www.magicalblend.com. **Art Director:** Mr. René Schmidt. Estab. 1980. Bimonthly 4-color magazine emphasizing spiritual exploration, transformation and New Age themes. Circ. 100,000. Original artwork returned after publication. Sample copy orders and art guidelines on website.

Illustration Works with 5-10 illustrators/year. Uses 23-35 illustrations/year. Has featured illustrations by Gage Taylor and Alex Grey. Assigns 30% of illustrations to new and emerging illustrators. "We keep samples on file and work by editorial fit according to the artist's style and content. Be patient; we have used art that's been on file for 5 years—when it fits, we go for it. We prefer eye-friendly and well-executed color work. We look for pieces with a positive, inspiring, uplifting feeling."

First Contact & Terms Illustrators: Prefer e-mail contact or mailed samples. NO ORIGINALS! Responds only if interested. Buys first North American serial rights. Pays in copies, subscriptions and possibly ad space. Will print contact information with artwork if desired by artist.

Tips "We want work that is energetic and thoughtful that has a hopeful outlook on the future. We like to print quality art by people who have talent but don't fit into any category and are usually unpublished. Have technical skill, be unique, show a range of styles; don't expect to get rich from us, 'cuz we sure aren't!'"

Magazines

☑ METRO PULSE

505 Market St., Suite 300, Knoxville TN 37902. (865)522-5399, ext. 21. Fax: (865)522-2955. E-mail: james@metr opulse.com. Website: www.metropulse.com. **Art Director:** Josh Coldiron. Estab. 1985. Weekly, 4-color, b&w, alternative news magazine for Knoxville, TN. Circ. 30,000.

Illustration Approached by 150 illustrators/year. Buys 2 illustrations/issue. Features humorous, spot, computer and editorial illustrations. Subject matter varies. Assigns 20% of illustrations to new and emerging illustrators. 10% of freelance illustration demands knowledge of Photoshop. No real need for computer knowledge, but it's helpful to send work digitally.

First Contact & Terms Illustrators: Send postcard sample or tearsheets. Accepts Mac-compatible disk submissions. Send JPEG, TIFF files. Samples are filed and are not returned. Responds only if interested. Portfolio review not required. Will contact artist for portfolio review if interested. Buys first rights or one-time rights. Pays on publication. Need approval/sketch stage before finished art is purchased. Kill fee is half of normal fee. Pays illustrators $200-400 for b&w cover; $200-400 for color cover; $50-150 for b&w inside; $50-150 for color inside. Finds illustrators through magazines and promo samples.

Tips "We look for editorial illustrators with a unique style; we never use realistic styles. I'm mostly looking for savvy interpretors of editorial content."

☒ METROKIDS

4623 S. Broad St., Philadelphia PA 19112. (215)291-5560. Fax: (215)291-5563. Website: www.metrokids.com. **Art Director:** Tracy Rucher. Estab. 1990. Monthly parenting tabloid. Circ. 125,000. Accepts previously published artwork. Sample copy free for 3 first-class stamps. Art guidelines free for SASE with first-class postage. Needs computer-literate freelancers for illustration.

Cartoons Approached by 12 cartoonists/year. Buys 1 cartoon/issue. Prefers parenting issues or kids' themes; single panel b&w line drawings.

Illustration Approached by 50 illustrators/year. Buys 100/year. Prefers parenting issues or kids' themes. Considers pen & ink.

First Contact & Terms Send query letter with tearsheets, SASE and photocopies. Samples are filed or returned by SASE if requested by artist. Responds in 3 months. Portfolio review not required. Buys reprint rights. Pays on publication. Pays cartoonists $25 for b&w. Pays illustrators $50 for color cover; $25 for b&w inside.

MICHIGAN OUT OF DOORS

Box 30235, Lansing MI 48909. (517)371-1041. Fax: (517)371-1505. E-mail: magazine@mucc.org. Website: www .mucc.org. **Contact:** Dennis C. Knickerbocker. 4-color magazine emphasizing outdoor recreation, especially hunting and fishing, conservation and environmental affairs. Circ. 100,000. "Conventional" design. Art guidelines available free for SASE. Sample copy $3.50.

Illustration "Following the various hunting and fishing seasons, we have a limited need for illustration material; we consider submissions 6-8 months in advance." Has featured illustrations by Ed Sutton and Nick Van Frankenhuyzen. Assigns 10% of illustrations to new and emerging illustrators.

First Contact & Terms Responds as soon as possible. **Pays on acceptance**; $30 for pen & ink illustrations in a vertical treatment.

MID-AMERICAN REVIEW

English Dept., Bowling Green State University, Bowling Green OH 43403. (419)372-2725. Website: www.bgsu. edu/midamericanreview. **Contact:** Editor-in-Chief. Estab. 1980. Semiannual literary magazine publishing "the best contemporary poetry, fiction, essays, and work in translation we can find. Each issue includes poems in their original language and in English." Circ. 700. Originals are returned at job's completion. Sample copies available for $5.

Illustration Approached by 10-20 illustrators/year. Buys 1 illustration/issue.

First Contact & Terms Send query letter with brochure, SASE, tearsheets, photographs and photocopies. Samples are filed or are returned by SASE if requested by artist. Responds in 3 months. Buys first rights. Pays on publication. Pays $50 when funding permits. Also pays in copies, up to 20.

Tips "*MAR* only publishes artwork on its cover. We like to use the same artist for one volume (two issues). We are looking for full-color artwork for a front-to-back, full bleed effect. Visit our website!"

☑ MODERN DRUMMER

12 Old Bridge Rd., Cedar Grove NJ 07009. (973)239-4140. E-mail: scottb@moderndrummer.com. Website: www.moderndrummer.com. **Art Director:** Scott Bienstock. Monthly magazine for drummers, "all ages and levels of playing ability with varied interests within the field of drumming." Circ. 103,000. Previously published work OK. Original artwork returned after publication. Sample copy for $4.99.

Cartoons Buys 10-12 cartoons/year. Interested in drumming themes; single and double panel. Prefers finished cartoons or roughs.

First Contact & Terms "Send nonreturnable samples only!" Responds in 3 weeks. Buys first North American serial rights. Pays on publication; $100.

Tips "We want strictly drummer-oriented gags."

[N] MODERN HEALTHCARE MAGAZINE

360 N. Michigan, 5th Floor, Chicago IL 60601. (312)649-5346. Fax: (312)280-3183. E-mail: khorist@crain.com. Website: www.modernhealthcare.com. **Assistant Managing Editor Graphics:** Keith Horist. Estab. 1976. Weekly 4-color trade magazine on healthcare topics, geared to CEO's, CFO's, COO's etc. Circ. 90,000.

Illustration Approached by 50 illustrators/year. Features caricatures of politicians, humorous illustration, charts & graphs, informational graphics, medical illustration, spot illustrations and computer illustration. Assigns 60% of illustrations to well-known or "name" illustrators; 40% to experienced but not well-known illustrators. 100% of freelance illustration demands knowledge of Illustrator, Photoshop, FreeHand.

First Contact & Terms Illustrators: Send postcard sample and nonreturnable printed samples. Accepts Mac or Windows-compatible disk submissions. Samples are filed. Responds only if interested. Will contact artist for portfolio review if interested. Buys all rights. "Usually buy all rights for cover art. If it is a generic illustration not geared directly to our magazine, then we might buy only first rights in that case." **Pays on acceptance**; $400-450 for color cover; $50-150 for color inside. Finds illustrators through word of mouth and staff members.

Tips "Keep sending out samples, someone will need your style. Don't give up!"

[N] MODERN SALON

Vance Publishing Corp., 400 Knightsbridge Pkwy., Lincolnshire IL 60069-3651. (847)634-2600. Fax: (847)634-4342. Website: www.modernsalon.com. **Art Director:** Brent Seehafer. Estab. 1913. Monthly trade publication that "highlights new hairstyles, products and gives how-to info." Circ. 136,000.

Illustration Approached by "tons" of illustrators/year. Buys 1-2 illustrations/issue. Has featured illustrations by Roberta Polfus, Magué Calanche. Features fashion illustration, spot illustrations and computer illustration of families, women, teens and collage/conceptual illustrations. Prefers clean lines, bright colors, texture. Assigns 90% of illustrations to experienced but not well-known illustrators; 10% to new and emerging illustrators.

First Contact & Terms Send postcard sample. Samples are filed. Responds only if interested. Portfolio review not required. Buys one-time rights. Pays on publication; $300-700 for color inside. Pays $200 for spots. Finds illustrators through samples and word of mouth.

Tips "I want an illustrator who is highly conceptual, easy to work with and get in touch with, and timely in regards to deadlines. We commission non-gritty, commercial-style illustrators with bright colors and highly stylized content."

☑ MOM GUESS WHAT NEWSPAPER

1103 T. St., Sacramento CA 95814. (916)441-6397. Fax: (916)441-6422. E-mail: info@mgwnews.com. Website: www.mgwnews.com. **Publisher/Editor:** Linda Birner. Estab. 1978. Semi-monthly newspaper "for gays/lesbians." Circ. 21,000. Sample copies for 10×13 SASE and 4 first-class stamps. Art guidelines for #10 SASE with first-class postage.

Cartoons Approached by 15 cartoonists/year. Buys 5 cartoons/issue. Prefers gay/lesbian themes. Prefers single and multiple panel political, humorous b&w line drawings with gagline. Pays cartoonists $5-50 for b&w.

Illustration Approached by 10 illustrators/year. Buys 3 illustrations/issue. Has featured illustrations by Andy Markley and Tim Brown. Features caricatures of celebrities; humorous, realistic and spot illustration. Assigns 50% of illustration to new and emerging illustrators. Prefers gay/lesbian themes. Considers pen & ink. 50% of freelance illustration demands knowledge of PageMaker.

Design Needs freelancers for design and production. Prefers local design freelancers. 100% of freelance work demands knowledge of PageMaker 6.5, QuarkXPress, Photoshop, Freehand, InDesign.

First Contact & Terms Cartoonists: Send query letter with photocopies and SASE. Illustrators: Send query letter with photocopies. Art director will contact artist for portfolio review of b&w photostats if interested. Rights purchased vary according to project. Pays on publication; $100 for b&w or color cover; $10-100 for b&w or color inside; $300 for 2-page spreads; $25 for spots. Finds illustrators through word or mouth and artist's submissions.

Tips "Send us copies of your ideas that relate to gay/lesbian issues, serious and humorous."

[N] MONEY

Time & Life Bldg. Rockefeller Cntr., New York NY 10020-1393. (212)522-0930. Fax: (212)522-1796. Website: www.money.com. **Contact:** Syndi Becker, art director. Deputy Art Director: Mary Ann Salvato Jones. Estab. 1972. Monthly 4-color consumer magazine. Circ. 1,000,000.

Illustration Approached by tons of illustrators/year. Buys 34 illustrations/issue. Features caricatures of business people, CEOs of visible companies, charts & graphs, humorous and spot illustrations of men and women. Assigns 10% of illustrations to well-known or "name" illustrators; 90% to experienced but not well-known illustrators.

First Contact & Terms Illustrators send query letter with 5 or 6 printed samples. Samples are not returned. Responds only if interested. Will contact artist for portfolio review if interested. Buys one-time rights. Pays $250-750 for spots. Finds illustrators through *Creative Black Book*, *LA Workbook*, artists' promotional samples.

Tips Because our publication is photo-driven, we don't use as much illustration as we'd like—but we love illustration. The trouble with some beginning illustrators is that they do not yet have the consistency of style that's so important in editorial work. I'll get a sample I love, ask to see more, and the illustrator shows work that's all over the place in terms of style. And I'll think "Oh, this isn't anything I like the sample I liked," and won't hire that illustrator. Make sure your samples show that there is consistency in your work.

THE MORGAN HORSE

Box 960, Shelburne VT 05482. (802)985-4944. Fax: (802)985-8897. Website: www.morganhorse.com. **Art Director:** Christopher R. Izzo. Emphasizes all aspects of Morgan horse breed including educating Morgan owners, trainers and enthusiasts on breeding and training programs; the true type of the Morgan breed; techniques on promoting the breed; how-to articles; as well as preserving the history of the breed. Monthly. Circ. 4,500. Accepts previously published material, simultaneous submissions. Original artwork returned after publication. Sample copy $4.

Illustration Approached by 10 illustrators/year. Buys 2-5 illustrations/year. Uses artists mainly for editorial illustration and mechanical production. "Line drawings are most useful for magazine work. We also purchase art for promotional projects dealing with the Morgan horse—horses must look like *Morgans*."

First Contact & Terms Illustrators: Send query letter with samples and tearsheets. Accepts "anything that clearly shows the artist's style and craftsmanship" as samples. Samples are returned by SASE. Responds in 6-8 weeks. Write for appointment to show portfolio. Buys all rights or negotiates rights purchased. **Pays on acceptance**; $25-100 for b&w; $100-300 for color inside.

Tips As trend sees "more of an effort on the part of art directors to use a broader style. Magazines seem to be moving toward more interesting graphic design. Our magazine design is a sophisticated blend of conservative and tasteful contemporary design. While style varies, the horses in our illustrations must be unmistakably Morgans."

MOTHER JONES

731 Market St., Suite 600, San Francisco CA 94103. (415)665-6637. Fax: (415)665-6696. Webiste: www.motherjones.com. **Design Director:** Jane Palecek. Estab. 1976. Bimonthly magazine. Focuses on investigative journalism, progressive politics and exposés. Circ. 201,233. Accepts previously published artwork. Originals returned at job's completion. Sample copies available.

Cartoons Approached by 25 cartoonists/year. Prints one cartoon/issue (6/year). Prefers full page, multiple-frame color drawings. Works on assignment only.

Illustration Approached by hundreds of illustrators/year. Has featured illustrations by Gary Baseman, Chris Ware, Juliette Borda and Gary Panter. Assigns 90% of illustrations to well-known or "name" illustrators; 5% to experienced but not well-known illustrators; 5% to new and emerging illustrators. Works on assignment only. Considers all media.

First Contact & Terms Cartoonists: Send query letter with postcard-size sample or finished cartoons. Illustrators: Send postcard-size sample or query letter with samples. Samples are filed or returned by SASE. Responds to the artist only if interested. Portfolio should include photographs, slides and tearsheets. Buys first rights. Pays on publication; payment varies widely. Finds artists through illustration books, other magazines, word of mouth.

MOTHERING MAGAZINE

P.O. Box 1690, Santa Fe NM 85504. (505)984-6287. E-mail: laurat@mothering.com. Website: www.mothering.com. **Contact:** Laura Egley Taylor, art director. Estab. 1976. Consumer magazine focusing on natural family living and natural/alternative practices in parenting. Circ. 80,000. Sample copies and art guidelines available.

Illustration Send query letter and/or postcard sample. Works on assignment only. Media and styles vary.

First Contact & Terms Illustrators: Send query with postcard samples or send EPS or PDF files. Director will contact for portfolio review if interested. Portfolio should include color tearsheets, photostats, photographs, slides and color photocopies. Samples are filed. Responds only if interested. Buys first rights. Pays on publication; $500 maximum for cover; $275-450 for inside. Payment for spots depends on size. Finds illustrators through submissions, sourcebooks, magazines, word of mouth.

Tips "Become familiar with tone and subject matter (mothers and babies) of our magazine."

MOTORING ROAD™

P.O. Box M, Franklin MA 02038. Phone/fax: (508)528-6211. **Contact:** Jay Kruza, editor. Estab. 2001. Bimonthly trade publication of automotive news affecting New England dealers, bodyshops, garages, mechanics and gas stations. Circ. 11,000. Sample copies available with SASE.

Cartoons Buys 24 cartoons/year. Prefers positive or corrective styles/themes. Prefers single panel, humorous, b&w washes and drawings.

Illustration Buys 6-12 illustrations/year. Features caricatures of celebrities/politicians, charts & graphs, computer illustration and informational graphics. Assigns 50% to new and emerging illustrators.

MUSCLEMAG INTERNATIONAL

5775 McLaughlin Rd., Mississauga ON L5R 3P7 Canada. (905)507-3545. E-mail: editorial@emusclemag.com. Website: www.emusclemag.com. **Contact:** Robert Kennedy. Estab. 1974. Monthly consumer magazine. Magazine emphasizes bodybuilding for men and women. Circ. 300,000. Originals not returned at job's completion. Sample copies available for $5; art guidelines not available.

Cartoons "We are interested in acquiring a cartoonist to produce one full-page cartoon each month."

Illustration Approached by 200 illustrators/year. Buys 130 illustrations/year. Has featured illustrations by Eric Blais and Gino Edwards. Features caricatures of celebrities; charts & graphs; humorous, medical and computer illustrations. Assigns 20% of illustrations to new and emerging illustrators. Prefers bodybuilding themes. Considers all media.

First Contact & Terms Cartoonists: Send photocopy of your work. Illustrators: Send query letter with photocopies. Samples are filed. Responds in 1 month. Portfolio review not required. Buys all rights. **Pays on acceptance.** Pays cartoonists $50-100. Pays illustrators $100-150 for b&w inside; $250-1,000 for color inside. "Higher pay for high-quality work." Finds artists through "submissions from artists who see our magazine."

Tips Needs line drawings of bodybuilders exercising. "Study the publication: Work to improve by studying others. Don't send out poor quality stuff. It wastes editor's time."

MY FRIEND, The Catholic Magazine for Kids

50 Saint Pauls Avenue, Boston MA 02130-3491. (617)522-8911. Fax: (617)541-9805. E-mail: myfriend@pauline. org. Website: www.myfriendmagazine.com. **Contact:** Sister Maria Grace Dateno, editor. Estab. 1979. Monthly Catholic magazine for kids, 4-color cover, containing information, entertainment and Christian information for young people ages 6-12. Circ. 11,000. Sample copies free for 9×12 SASE with first-class postage; art guidelines available for SASE with $1.29 postage.

Illustration Approached by 60 illustrators/year. Buys 6 illustrations/issue; 60/year. Works on assignment only. Has featured illustrations by Mary Rojas, Chris Ware, Larry Nolte and Virginia Esquinaldo. Features realistic illustration; informational graphics; spot illustration. Assigns 10% of illustrations to new and emerging illustrators. Prefers humorous, realistic portrayals of children. Considers pen & ink, watercolor, airbrush, acrylic, marker, colored pencil, oil, charcoal, mixed media and pastel.

Design Needs freelancers for design, production and multimedia projects. Design demands knowledge of PageMaker, Illustrator and Photoshop.

First Contact & Terms Illustrators: Send query letter with résumé, SASE, tearsheets, photocopies. Designers: Send query letter with résumé, photocopies and tearsheets. Accepts disc submissions compatible with Windows/Mac OS, PageMaker 6.5, Illustrator, Photoshop. Send TIFF or EPS files. Samples are filed or are returned by SASE if requested by artist. Responds within 2 months only if interested. Portfolio review not required. Rights purchased vary according to project. Pays on publication; $175 for color 2-page spread; $125 for color single-page spread, $75 for color half page. Pays designers by project.

NA'AMAT WOMAN

350 Fifth Ave., Suite 4700, New York NY 10118. (212)563-5222. Fax: (212)563-5710. E-mail: judith@naamat.o rg. **Editor:** Judith Sokoloff. Estab. 1926. Jewish women's magazine published 4 times yearly, covering a wide variety of topics that are of interest to the Jewish community, affiliated with NA'AMAT USA (a nonprofit organization). Originals are returned at job's completion. Sample copies available for $1.

Cartoons Approached by 5 cartoonists/year. Buys 4-5 cartoons/year. Prefers political cartoons; single panel b&w line drawings.

Illustration Approached by 20 illustrators/year. Buys 1-3 illustrations/issue. Has featured illustrations by Julie Delton, Miriam Katin and Ilene Winn-Lederer. Works on assignment only. Considers pen & ink, collage, marker and charcoal.

First Contact & Terms Cartoonists: Send query letter with brochure and finished cartoons. Illustrators: Send query letter with tearsheets. Samples are filed or are returned by SASE if requested by artist. Responds to the artist only if interested. Publication will contact artist for portfolio review if interested. Portfolio should include b&w tearsheets and final art. Rights purchased vary according to project. Pays on publication. Pays cartoonists

$50 for b&w. Pays illustrators $150-200 for b&w cover; $50-75 for b&w inside. Finds artists through sourcebooks, publications, word of mouth, submissions.

Tips "Give us a try! We're small, but nice."

[N] NAILPRO

7628 Densmore Ave., Van Nuys CA 91406. (818)782-7328. Fax: (818)782-7450. E-mail: nailpro@creativeage.com. Website: www.nailpro.com. **Art Director:** Dawn Clegman. Monthly trade magazine for the nail and beauty industry audience: nail technicians. Circ. 58,000. Sample copies available.

Cartoons Prefers subject matter related to nail industry. Prefers humorous color washes and b&w line drawings with or without gagline.

Illustration Approached by tons of illustrators. Buys 3-4 illustrations/issue. Has featured illustrations by Kelley Kennedy, Nick Bruel and Kathryn Adams. Assigns 20% of illustrations to well-known or "name" illustrators; 70% to experienced but not well-known illustrators; 10% to new and emerging illustrators. Prefers whimsical computer illustrations. Considers all media. 85% of freelance illustration demands knowledge of Photoshop 5.5, Illustrator 8.0 and QuarkXPress 4.04.

Design Needs freelancers for design, production and multimedia projects. Prefers local design freelancers only. 100% of freelance work demands knowledge of Photoshop 5.5, Illustrator 8.0 and QuarkXPress 4.04.

First Contact & Terms Cartoonists: Send query letter with samples. Responds only if interested. Rights purchased vary according to project. Illustrators: Send postcard sample. Designers: Send query letter with printed samples and tearsheets. Accepts disk submissions compatible with QuarkXPress 4.04, TIFFs, EPS files submitted on Zip, JAZ or CD (Mac format only). Send samples to attn: Art Director. Samples are filed. Responds only if interested. Art director will contact artist for portfolio review of b&w, color, final art and tearsheets if interested. Buys first rights. Payment to cartoonists varies with projects. Pays on publication. Pays illustrators $350-400 for 2-page, full-color feature spread; $300 for 1-page; $250 for ½ page. Pays $50 for spots. Finds illustrators through *Workbook*, samples sent in the mail, magazines.

NAILS

21061 S. Western Ave., Torrance CA 90501-1711. (310)533-2400. Fax: (310)533-2504. E-mail: nailsmag@nailsmag.com. Website: www.nailsmag.com. **Art Director:** Liza Samala. Estab. 1983. Monthly (*Nails*) and bimonthly (*Bella*) 4-color trade journals; "seeks to educate readers on new techniques and products, nail anatomy and health, customer relations, chemical safety, salon sanitation and business." Circ. 57,000. Originals can be returned at job's completion. Sample copies available. Art guidelines vary. Needs computer-literate freelancers for design, illustration and production. 100% of freelance work demands knowledge of QuarkXPress, Illustrator or Photoshop.

Illustration Buys 3 illustrations/issue. Works on assignment only. Needs editorial and technical illustration; charts and story art. Prefers "fashion-oriented styles." Interested in all media.

First Contact & Terms Illustrators: Send query letter with brochure and tearsheets. Samples are filed. Responds in 1 month or artist should follow up with call. Call for an appointment to show a portfolio of tearsheets and transparencies. Buys all rights. **Pays on acceptance**; $200-500 (depending on size of job) for b&w and color inside. Finds artists through self-promotion and word of mouth.

THE NATION

33 Irving Pl., 8th Floor, New York NY 10003. (212)209-5400. Fax: (212)982-9000. Production-ext. 5421. E-mail: studio@stevenbrowerdesign.com. Website: www.thenation.com. **Art Director:** Steven Brower. Estab. 1865. A weekly journal of "left/liberal political opinion, covering national and international affairs, literature and culture." Circ. 100,000. Originals are returned after publication upon request. Sample copies available. Art guidelines not available.

 • *The Nation*'s art director works out of his design studio at Steven Brower Design. You can send samples to *The Nation* and they will be forwarded. Brower is also A.D. for *Print*.

Illustration Approached by 50 illustrators/year. Buys 3-4 illustrations/issue. Works with 25 illustrators/year. Has featured illustrations by Robert Grossman, Luba Lukora, Igor Kopelnitsky and Karen Caldecott. Buys illustrations mainly for spots and feature spreads. Works on assignment only. Considers pen & ink, airbrush, mixed media and charcoal pencil; b&w only.

First Contact & Terms Illustrators: Send query letter with tearsheets and photocopies. "On top of a defined style, artist must have a strong and original political sensibility." Samples are filed or are returned by SASE. Responds only if interested. Buys first rights. Pays $100-150 for b&w inside; $175 for color inside.

[N] NATIONAL BUS TRADER

9698 W. Judson Rd., Polo IL 61064. (815) 946-2341. Fax: (815) 946-2347. **Editor:** Larry Plachno. Monthly magazine focusing on new and used transit and inter-city busses. Circ. 62,000.

• Also publishes books. See listing for Transportation Trails in Book Publishers section. Editor is looking for artists to commission oil paintings for magazine covers. He is also looking for artists who can render historic locomotives. He uses mostly paintings or drawings. He also considers silhouettes of locomotives and other historic transportation. He is open to artists who work on Illustrator and QuarkXPress.

⚄ NATIONAL ENQUIRER

1000 American Media Way, Boca Raton FL 33464. (561)997-7733. Fax: (561)989-1373. E-mail: jcannatafox@nationalenquirer.com. **Editor:** Joan Cannata-Fox. A weekly tabloid. Circ. 2 million (readership 14 million). Originals are returned at job's completion.

Cartoons "We get 1,000-1,500 cartoons weekly." Buys 200 cartoons/year. Has featured cartoons by Norm Rockwell, Glenn Bernhardt, Earl Engelman, George Crenshaw, Mark Parisi, Marty Bucella and Yahan Shirvanian. Prefers animal, family, husband/wife and general themes. Nothing political or off-color. Prefers single panel b&w line drawings and washes with or without gagline. Computer-generated cartoons are not accepted. Prefers to do own coloration.

First Contact & Terms Cartoonists: Send query letter with good, clean, clear copies of finished cartoons. Samples are not returned. Buys first and one-time rights. Pays $200 for b&w plus $20 each additional panel. Editor will notify if cartoon is accepted.

Tips "Study several issues to get a solid grasp of what we buy. Gear your work accordingly."

NATIONAL GEOGRAPHIC

17th and M Streets NW, Washington DC 20036. (202)857-7000. Website: www.nationalgeographic.com. **Art Director:** Chris Sloan. Estab. 1888. Monthly. Circ. 9 million. Original artwork returned 1 year after publication, but *National Geographic* owns the copyright.

• *National Geographic* receives up to 30 inquiries a day from freelancers. They report most are not appropriate to their needs. Please make sure you have studied several issues before you submit. They have a roster of artists they work with on a regular basis, and it's difficult to break in, but if they like your samples they will file them for consideration for future assignments.

Illustration Works with 20 illustrators/year. Contracts 50 illustrations/year. Interested in "full-color renderings of historical and scientific subjects. Nothing that can be photographed is illustrated by artwork. No decorative, design material. We want scientific geological cut-aways, maps, historical paintings, prehistoric scenes." Works on assignment only.

First Contact & Terms Illustrators: Send color copies, postcards, tearsheets, proofs or other appropriate samples. Art director will contact for portfolio review if interested. Samples are returned by SASE. **Pays on acceptance**; varies according to project.

Tips "Do your homework before submitting to any magazine. We only use historical and scientific illustrations, ones that are very informative and very accurate. No decorative, abstract or portraits."

⚄ NATIONAL LAMPOON

10850 Wilshire Blvd., Suite 1000, Los Angeles CA 90024. (310)474-5252. Fax: (310)474-1219. E-mail: srubin@nationallampoon.com. Website: www.nationallampoon.com. **Editor-in-Chief:** Scott Rubin. Art Director: Joe Oesterle. Estab. 1971. Online consumer magazine of humor and satire.

Cartoon Approached by 50 cartoonists/year. Buys 6 cartoons/issue. Prefers satire. Prefers humorous, b&w line drawings.

Illustration Approached by 10 illustrators/year. Buys 30 illustrations/issue. Considers all media.

First Contact & Terms Cartoonists: Send photocopies and SASE. E-mail submissions are preferred. Illustrators: Send e-mail with JPEG images or query letter with photocopies and SASE. Samples are filed. Responds only if interested. Rights purchased vary according to project. Payment negotiable.

Design Needs freelancers for design and production. Prefers local designers. 100% of freelance work demands knowledge of Photoshop and QuarkXPress.

Tips "Since we are a Web-based publication, I prefer artists who are experienced with JPEG images and who are familiar with e-mailing their work. I'm not going to discount some brilliant artist who sends traditional samples, but those who send e-mail samples have a better chance."

⚄ THE NATIONAL NOTARY

Box 2402, Chatsworth CA 91313-2402. (818)739-4000. Fax: (818)700-1942 (Attn: Editorial Department). E-mail: publications@nationalnotary.org. Website: www.nationalnotary.org. **Senior Editor:** Armando Aguirre. Production Editor: Conny Israelson. Emphasizes "notaries public and notarization—goal is to impart knowledge, understanding and unity among notaries nationwide and internationally." Readers are notaries of varying primary occupations (legal, government, real estate and financial), as well as state and federal officials and

foreign notaries. Bimonthly. Circ. 190,000. Original artwork not returned after publication. Sample copy $5.
- Also publishes *Notary Bulletin*.

Cartoons Approached by 5-8 cartoonists/year. Cartoons "must have a notarial angle"; single or multiple panel with gagline, b&w line drawings.

Illustration Approached by 3-4 illustrators/year. Uses about 3 illustrations/issue; buys all from local freelancers. Works on assignment only. Themes vary, depending on subjects of articles. 100% of freelance work demands knowledge of Illustrator, QuarkXPress or FreeHand.

First Contact & Terms Cartoonists: Send samples of style. Illustrators: Send business card, samples and tearsheets to be kept on file. Samples not returned. Responds in 6 weeks. Call for appointment. Buys all rights. Negotiates pay.

Tips "We are very interested in experimenting with various styles of art in illustrating the magazine. We generally work with Southern California artists, as we prefer face-to-face dealings."

NATIONAL REVIEW

215 Lexington Ave., New York NY 10016. (212)679-7330. Website: www.nationalreview.com. **Art Director:** Luba Myts. Emphasizes world events from a conservative viewpoint; bimonthly b&w with 4-color cover, design is "straight forward—the creativity comes out in the illustrations used." Originals are returned after publication. Uses freelancers mainly for illustrations of articles and book reviews, also covers. Circ. 150,000+.

Cartoons Buys 6 cartoons/issue. Interested in "light political, social commentary on the conservative side."

Illustration Buys 6-7 illustrations/issue. Especially needs b&w ink illustration, portraits of political figures and conceptual editorial art (b&w line plus halftone work). "I look for a strong graphic style; well-developed ideas and well-executed drawings." Style of Tim Bower, Jennifer Lawson, Janet Hamlin, Alan Nahigian. Works on assignment only.

First Contact & Terms Cartoonists: Send appropriate samples and SASE. Responds in 2 weeks. Illustrators: Send query letter with brochure showing art style or tearsheets and photocopies. No samples returned. Responds to future assignment possibilities. Call for an appointment to show portfolio of final art, final reproduction/product and b&w tearsheets. Include SASE. Buys first North American serial rights. Pays on publication. Pays cartoonists $50 for b&w. Pays illustrators $100 for b&w inside; $750 for color cover.

Tips "Tearsheets and mailers are helpful in remembering an artist's work. Artists ought to make sure their work is professional in quality, idea and execution. Recent printed samples alongside originals help. Changes in art and design in our field include fine art influence and use of more halftone illustration." A common mistake freelancers make in presenting their work is "not having a distinct style, i.e., they have a cross sample of too many different approaches to rendering their work. This leaves me questioning what kind of artwork I am going to get when I assign a piece."

N: NATION'S RESTAURANT NEWS

425 Park Ave., 6th Floor, New York NY 10022-3506. (212)756-5000. Fax: (212)756-5215. E-mail: postoffice@nrn .com. Website: www.nrn.com. **Art Director:** Joe Anderson. Assistant Art Director: Maureen Smith. Estab. 1967. Weekly 4-color trade publication/tabloid. Circ. 100,000.

Illustration Approached by 35 illustrators/year. Buys 15 illustrations/issue. Has featured illustrations by Stephen Sweny, Daryl Stevens, Elvira Regince, Garrett Kallenbach, Elizabeth Brandt, Kerry Talbott and Cedric Hohnstadt. Features computer, humorous and spot illustrations of business subjects in the food service industry. Prefers pastel and bright colors. Assigns 5% of illustrations to well-known or "name" illustrators; 70% to experienced but not well-known illustrators; 25% to new and emerging illustrators. 20% of freelance illustration demands knowledge of Illustrator or Photoshop.

First Contact & Terms Illustrators: Send postcard sample or other nonreturnable samples, such as tearsheets. Accepts Windows-compatible disk submissions. Send EPS files. Samples are filed. Will contact artist for portfolio review if interested. Buys one-time rights. Pays on publication; $700-900 for b&w cover; $1,000-1,500 for color cover; $300-400 for b&w inside; $275-350 for color inside; $450-500 for spots. Finds illustrators through *Creative Black Book* and *LA Work Book*, *Directory of Illustration* and *Contact USA*.

Tips "Great imagination and inspiration are essential for one's uniqueness in a field of such visual awareness."

N: NATURAL HISTORY

36 W. 25th St., 5th Floor, New York NY 10010. (646)356-6500. Website: www.nhmag.com. **Editor-in-Chief:** Peter Brown. Art Director: Elizabeth Meryman. Emphasizes social and natural sciences. For well-educated professionals interested in the natural sciences. Monthly. Circ. 250,000.

Illustration Buys 10-12 illustrations/year; 15-20 maps or diagrams/year. Works on assignment only.

First Contact & Terms Query with samples. Samples returned by SASE. Provide "any pertinent information" to be kept on file for future assignments. Buys one-time rights. Pays on publication; $200 and up for color inside.

Tips "Be familiar with the publication. Always looking for accurate and creative scientific illustrations, good diagrams and maps."

NERVE COWBOY

P.O. Box 4973, Austin TX 78765-4973. **Editors:** Joseph Shields and Jerry Hagins. Art Director: Mary Gallo. Estab. 1995. Biannual b&w literary journal of poetry, short fiction and b&w artwork. Sample copies for $5 postpaid. Art guidelines free for #10 SASE with first-class postage.

Illustration Approached by 400 illustrators/year. Buys work from 20 illustrators/issue. Has featured illustrations by Amanda Rehagen, Jennifer Stanley and Greta Shields. Features unusual illustration and creative b&w images. Strongly prefers b&w. "Color will be considered if a b&w half-tone can reasonably be created from the piece." Assigns 60% of illustrations to new and emerging illustrators.

First Contact & Terms Illustrators: Send printed samples, photocopies with a SASE. Samples are returned by SASE. Responds in 3 months. Portfolio review not required. Buys first North American serial rights. Pays on publication; 3 copies of issue in which art appears on cover; or 1 copy if art appears inside.

Tips "We are always looking for new artists with an unusual view of the world."

⁣[N] NETWORK COMPUTING

600 Community Dr., Manhasset NY 11030-3847. (516)562-5000. Fax: (516)562-7293. E-mail: editor@nwc.com. Website: www.networkcomputing.com. **Art Director:** David Yamada. Monthly trade magazine for those who professionally practice the art and business of networkology (a technology driver of networks). Circ. 220,000. Sample copies available.

Illustration Approached by 30-50 illustrators/year. Buys 6-7 illustrations/issue. Considers all media. 60% of freelance illustration demands knowledge of FreeHand, Photoshop, Illustrator.

First Contact & Terms Illustrators: Send postcard sample with follow-up sample every 3-6 months. Contact through artists' rep. Accepts disk submissions compatible with QuarkXPress 7.5/version 3.3. Send EPS files. Samples are returned. Responds only if interested. Art director will contact artist for portfolio review of tearsheets if interested. Buys one-time rights. **Pays on acceptance**: $700-1,000 for b&w, $1,500-2,000 for color cover; $300 minimum for b&w, $350-500 for color inside. Pays $350-500 for spots. Finds illustrators through agents, sourcebooks, word of mouth, submissions.

[N] NETWORK MAGAZINE

600 Harrison St., San Francisco CA 94107-1387. (415)947-6000. Fax: (415)947-6022. Website: www.networkma gazine.com. **Contact:** Rob Kirby. Estab. 1986. Monthly magazine covers local and wide area computer networks. Circ. 200,500.

Illustration Approached by 50 illustrators/year. Buys 5-7 illustrations/issue. "Half freelancers work electronically, half by hand. Themes are technology-oriented, but artwork doesn't have to be." Considers all media, color. 50% of freelance illustration demands knowledge of Photoshop.

First Contact & Terms Illustrators: Send postcard sample. Accepts disk submissions compatible with Photoshop files on Mac-formatted disks; "would recommend saving as JPEG (compressed) if you're sending a disk." Samples are filed. Responds only if interested. "Will look at portfolios if artists are local (Bay area), but portfolio review is not necessary." **Pays on acceptance;** $400 minimum for inside. Finds illustrators through postcards in the mail, agencies, word of mouth, artist's submissions.

Tips "Take a look at the magazine (on our website); all work is color; prefer contrast, not monochrome. Usually give freelancer a week to turn art around. The magazine's subject matter is highly technical, but the art doesn't have to be. (We use a lot of collage and hand-done work in addition to computer-assisted art.)"

☑ NEVADA

401 N. Carson St., #100, Carson City NV 89701-4291. (775)687-5416. Fax: (775)687-6159. E-mail: denise@nevad amagazine.com. Website: www.nevadamagazine.com. **Art Director:** Denise Barr. Estab. 1936. Bimonthly magazine "founded to promote tourism in Nevada." Features Nevada artists, history, recreation, photography, gaming. Traditional, 3-column layout with large 4-color photos. Circ. 80,000. Accepts previously published artwork. Originals are returned to artist at job's completion. Sample copies for $3.50. Art guidelines available.

Illustration Approached by 25 illustrators/year. Buys 2 illustrations/issue. Works on assignment only.

First Contact & Terms Illustrators: Send query letter with brochure, résumé and slides. Samples are filed. Responds in 2 months. To show portfolio, mail 20 slides and bio. Buys one-time rights. Pays $35 minimum for inside illustrations.

[N] NEW HAMPSHIRE MAGAZINE

150 Dow St., Manchester NH 03101. (603)624-1442. Fax: (603)624-1310. E-mail: ssauer@nhmagazine.com. Website: www.nhmagazine.com. **Creative Director:** Susan Sauer. Estab. 1990. Monthly 4-color magazine emphasizing New Hampshire lifestyle. Circ. 26,000.

Cartoons Approached by 2 cartoonists/year. NH related content.

Illustration Approached by 12 illustrators/year. Has featured illustrations by Brad Wuorinen and Stephen Sauer. Features humorous illustration, charts & graphs and spot illustration. Prefers illustrating concept of story. Assigns 50% to experienced but not well-known illustrators; 50% to new and emerging illustrators. 50% of freelance illustration demands knowledge of Illustrator.

First Contact & Terms Cartoonists: Send query letter with b&w photocopies. Illustrators: Send postcard sample and follow-up postcard every 3 months. Accepts Mac-compatible disk submissions. Send EPS or TIFF files. Sample are filed. Responds in 1 week. Portfolio review not required. Negotiates rights purchased. Pays on publication. Pays cartoonists $100-150 for b&w; $150-200 for color cartoons; $150-200 for comic strips. Pays illustrators $75-200 for b&w inside; $75-250 for color inside; $150-250 for 2-page spreads; $75 for spots. Finds illustrators through word of mouth.

Tips "Lifestyle magazines want 'uplifting' lifestyle messages, not dark or disturbing images."

NEW MOON: THE MAGAZINE FOR GIRLS AND THEIR DREAMS

34 E. Superior St., #200, Duluth MN 55802. (218)728-5507. Fax: (218)728-0314. E-mail: girl@newmoon.org. Website: www.newmoon.org. **Managing Editor:** Dawn Gorman. Estab. 1992. Bimonthly 4-color cover, 2-color inside consumer magazine. Circ. 30,000. Sample copies are $6.50.

Illustration Buys 3-4 illustrations/issue. Has featured illustrations by Neverne Covington, Tricia Tusa, Julie Paschkis, Amanda Harvey. Features realistic illustrations, informational graphics and spot illustrations of children, women and girls. Prefers b&w, ink. Assigns 30% of illustrations to new and emerging illustrators.

First Contact & Terms Illustrators: Send postcard sample or other nonreturnable samples. Final work can be submitted on disk or as original artwork. Send EPS files at 300 dpi or greater, hi-res. Samples are filed. Responds only if interested. Portfolio review not required. Buys one-time rights. Pays on publication; $400 maximum for color cover; $75 maximum for b&w inside. Finds illustrators through *Illustration Workbook*, samples and *PictureBook*.

Tips "Be very familiar with the magazine and our mission. We are a magazine for girls ages 8-14 and look for illustrators who portray people of all different shapes, sizes and ethnicities in their work. Women cover artists only. Men and women are welcome to submit black & white samples for inside. Send a 9×11 SASE for cover art guidelines."

N THE NEW REPUBLIC

1331 H St. NW, Suite 100, Washington DC 20005. (202)508-4444. E-mail: jheroun@tnr.com. Website: www.tnr.com. **Art Director:** Joe Heroun. Estab. 1914. Weekly political/literary magazine; political journalism, current events in the front section, book reviews and literary essays in the back; b&w with 4-color cover. Circ. 100,000. Original artwork returned after publication. Sample copy for $3.50. 50% of freelance work demands computer skills.

Illustration Approached by 400 illustrators/year. Buys up to 5 illustrations/issue. Uses freelancers mainly for cover art. Works on assignment only. Prefers caricatures, portraits, 4-color, "no cartoons." Style of Vint Lawrence.

First Contact & Terms Illustrators: Send query letter with tearsheets or postcard samples. Samples returned by SASE if requested. Publication will contact artist for portfolio review if interested. Portfolio should include color photocopies. Rights purchased vary according to project. Pays on publication; up to $600 for color cover; $250 for b&w and color inside.

NEW WRITER'S MAGAZINE

Box 5976, Sarasota FL 34277. Phone/fax: (941)953-7903. E-mail: newriters@aol.com. **Editor/Publisher:** George J. Haborak. Estab. 1986. Bimonthly b&w magazine. Forum "where all writers can exchange thoughts, ideas and their own writing. It is focused on the needs of the aspiring or new writer." Circ. 5,000. Rarely accepts previously published artwork. Original artwork returned after publication if requested. Sample copies for $3; art guidelines for SASE with first-class postage.

Cartoons Approached by 15 cartoonists/year. Buys 1-3 cartoons/issue. Features spot illustration. Assigns 80% of illustrations to new and emerging illustrators. Prefers cartoons "that reflect the joys or frustrations of being a writer/author"; single panel b&w line drawings with gagline.

Illustration Buys 1 illustration/issue. Works on assignment only. Prefers line drawings. Considers watercolor, mixed media, colored pencil and pastel.

First Contact & Terms Cartoonists: Send query letter with samples of style. Illustrators: Send postcard sample. Samples are filed or returned by SASE if requested. Responds in 1 month. To show portfolio, mail tearsheets. Buys first rights or negotiates rights purchased. Pays on publication. Payment negotiated.

NEW YORK ACADEMY OF SCIENCES UPDATE

2 E. 63rd St., New York NY 10021. (212)838-0230. Fax: (212)838-5226. E-mail: dvanatta@nyas.org. Website: www.nyas.org. **Contact:** Dan Van Atta, manager, print communications. Estab. 2001. Newsletter of science and health related articles for members of nonprofit New York Academy of Sciences. Circ. 25,000. Sample copies are available with SASE. Guidelines not available.

Illustration Buys 4-5 illustrations/year. Features science/health related charts & graphs, computer illustration, informational graphics, realistic illustration, medical illustration, spot illustrations. Assigns 2% of illustration to new and emerging illustrators. 80% of freelance illustration demands knowledge of QuarkXPress, Photoshop.

First Contact & Terms Send query letter with photographs, résumé, SASE and slides. Accepts e-mail submissions with TIFF image file. Samples are not filed but returned by SASE. Responds only if interested. Company will contact artist for portfolio review if interested. Pays illustrators $600 maximum. Pays on publication. Buys electronic rights, reprint rights. Rights purchased vary according to project. Finds freelancers through sourcebooks and word of mouth.

Tips "We are nonprofit, working on tight budgets, and rarely purchase original illustrations. We sometimes receive works by well-known illustrators, such as Marshall Arisman, at little or no cost to the Academy. We sometimes purchase medical illustrations or stock photography that relates to or creates added interest in articles on various developments in science and medicine."

N NEW YORK MAGAZINE

444 Madison Ave., 14th Floor, New York NY 10022. (212)508-0700. **Design Director:** Luke Hayman. Art Director: Chris Dixon. Emphasizes New York City life; also covers all boroughs for New Yorkers with upper-middle income and business people interested in what's happening in the city. Weekly. Original artwork returned after publication.

Illustration Works on assignment only.

First Contact & Terms Illustrators: Send query letter with tearsheets to be kept on file. Prefers photostats as samples. Samples returned if requested. Call or write for appointment to show portfolio (drop-offs). Buys first rights. Pays $1,000 for b&w and color cover; $800 for 4-color, $400 for b&w full page inside; $225 for 4-color, $150 for b&w spot inside.

THE NEW YORKER

4 Times Square, New York NY 10036. (212)286-5400. Fax: (212)286-5735. E-mail (cartoons): toon@cartoonbank.com. Website: www.cartoonbank.com. Emphasizes news analysis and lifestyle features. Circ. 938,600.

Cartoons Buys b&w cartoons. Receives 3,000 cartoons/week. Cartoon editor is Bob Mankoff, who also runs Cartoon Bank, a stock cartoon agency that features *New Yorker* cartoons.

Illustration All illustrations are commissioned. Portfolios may be dropped off Wednesdays between 10-6 and picked up on Thursdays. Art director is Caroline Mailhot.

First Contact & Terms Cartoonists: Accepts unsolicited submissions only by mail. Reviews unsolicited submissions every 1-2 weeks. Photocopies only. Strict standards regarding style, technique, plausibility of drawing. Especially looks for originality. Pays $575 minimum for cartoons. Contact cartoon editor. Illustrators: Mail samples, no originals. "Because of volume of submissions we are unable to respond to all submissions." No calls please. Emphasis on portraiture. Contact illustration department.

Tips "Familiarize yourself with *The New Yorker*."

NEWSWEEK

251 W. 57th St., 15th Floor, New York NY 10019. (212)445-4000. Website: www.newsweek.com. **Art Director:** Alexander Ha. Assistant Managing Editor/Design: Lynn Staley. Weekly news magazine. Circ. 3,180,000. Has featured illustrations by Daniel Adel and Zohar Lozar.

Illustration Prefers illustrations or situations in national and international news.

First Contact & Terms Illustrators: Send postcard samples or other nonreturnable samples. Portfolios may be dropped off at front desk Tuesday or Wednesday from 9 to 5. Call ahead.

NORTH AMERICAN HUNTER/NORTH AMERICAN FISHERMAN

12301 Whitewater Dr., #260, Minnetonka MN 55343-4103. (952)936-9333. Fax: (952)352-7001. Website: www.huntingclub.com. **Art Director:** Mark Simpson. Estab. 1978 (*N.A. Hunter*) and 1988 (*N.A. Fisherman*). Bimonthly consumer magazines. *North American Hunter* and *Fisherman* are the official publications of the North American Hunting Club and the North American Fishing Club. Circ. 700,000 and 500,000. Accepts previously published artwork. Originals are returned at job's completion. Sample copies available. Art guidelines for SASE with first-class postage. Needs computer-literate freelancers for illustration. 20% of freelance work demands computer knowledge of Illustrator, QuarkXPress, Photoshop or FreeHand.

• This publisher also publishes *Cooking Pleasures* (circ. 300,000), *Handy* (circ. 900,000), *PGA Partners* (circ. 600,000), *Health & Wellness* (circ. 300,000), *Creative Home Arts* (circ. 300,000), *History* (circ. 300,000) and *Gardening How-to* (circ. 500,000).

Cartoons Approached by 20 cartoonists/year. Buys 3 cartoons/issue. Prefers humorous work portraying outdoorsmen in positive image; single panel b&w washes and line drawings with or without gagline.

Illustration Approached by 40 illustrators/year. Buys 3 illustrations/issue. Prefers illustrations that portray wildlife and hunting and fishing in an accurate and positive manner. Considers pen & ink, watercolor, airbrush, acrylic, colored pencil, oil, charcoal, mixed media and pastel.

First Contact & Terms Cartoonists: Send query letter with brochure. Illustrators: Send query letter with brochure, tearsheets, résumé, photographs and slides. Samples are filed. Portfolio review not required. Rights purchased vary according to project. **Pays on acceptance**.

✓ THE NORTH AMERICAN REVIEW

University of Northern Iowa, Cedar Falls IA 50614. (319)273-6455. Fax: (319)273-4326. E-mail: nar@2edu. Website: webdelsol.com/NorthAmReview/NAR/. **Art Directors:** Roy R. Behrens and Gary Kelley. Estab. 1815. "General interest bimonthly, especially known for fiction (twice winner of National Magazine Award for fiction)." Accepts previously published work. Original artwork returned at job's completion. "Sample copies can be purchased on newsstand or examined in libraries."

• The NAR is the oldest literary magazine in America, and it continues to be one of the most respected. It's known for the creativity and excellence of its illustration and layouts.

Illustration Approached by 500 freelance artists/year. Buys 15 freelance illustrations/issue. Artists primarily work on assignment. Looks for "well-designed illustrations in any style. We prefer to use b&w media for illustrations reproduced in b&w and color for those reproduced in color. We prefer camera-ready line art for spot illustrations."

First Contact & Terms Illustrators: Send postcard samples, color photocopies or other nonreturnable samples. Please send no more than 5 pieces. Samples are filed if of interest or returned by SASE if requested by artist. Responds to the artist only if interested. No portfolio reviews. Buys one-time rights. Contributors receive 2 copies of the issue. Pays on publication $300 for color cover plus 50 tearsheets of cover only; $10 for b&w inside spot illustrations; $65 for b&w large illustration. No color inside.

Tips "Send b&w photocopies of spot illustrations (printed size about 2×2). For the most part, our color covers and major b&w inside illustrations are obtained by direct assignment from illustrators we contact, e.g., Gary Kelley, Chris Payne, Skip Liepke and others. Write for guidelines for annual cover competition."

N NORTH AMERICAN WHITETAIL MAGAZINE

2250 Newmarket Pkwy., Suite 110, Marietta GA 30067. (770)953-9222. Fax: (770)933-9510. Website: www.nort hamericanwhitetail.com. **Editorial Director:** Ken Dunwoody. Estab. 1982. Consumer magazine "designed for serious hunters who pursue whitetailed deer." 8 issues/year. Circ. 130,000. Accepts previously published artwork. Original artwork is returned at job's completion. Sample copies available for $3; art guidelines not available.

Illustration Approached by 30 freelance illustrators/year. Buys 6-8 freelance illustrations/year. Works on assignment only. Considers pen & ink and watercolor.

First Contact & Terms Illustrators: Send postcard sample and/or query letter with brochure and photocopies. Samples are filed or are returned by SASE if requested by artist. Responds only if interested. To show a portfolio, mail appropriate materials. Rights purchased vary according to project. Pays 10 weeks prior to publication; $25 minimum for b&w inside; $75 minimum for color inside.

THE NORTHERN LOGGER & TIMBER PROCESSOR

Northeastern Loggers Association, Inc., Box 69, Old Forge NY 13420. (315)369-3078. **Editor:** Eric A. Johnson. Trade publication (8½×11) with an emphasis on education. Focuses on methods, machinery and manufacturing as related to forestry. For loggers, timberland managers and processors of primary forest products. Monthly b&w with 4-color cover. Circ. 13,000. Previously published material OK. Free sample copy and guidelines available.

Cartoons Buys 1 cartoon/issue. Receives 1 submission/week. Interested in "any cartoons involving forest industry situations."

First Contact & Terms Cartoonists: Send finished cartoons with SASE. Responds in 1 week. **Pays on acceptance**. Pays cartoonists $25 for b&w line drawings. Pays $25 for b&w cover.

Tips "Keep it simple and pertinent to the subjects we cover. Also, keep in mind that on-the-job safety is an issue we like to promote."

NOTRE DAME MAGAZINE

535 Grace Hall, Notre Dame IN 46556. (574)631-4630. Website: www.ND.EDU/~NDMAG. **Art Director:** Don Nelson. Estab. 1971. Quarterly 4-color university magazine that publishes essays on cultural, spiritual and ethical topics, as well as news of the university for Notre Dame alumni and friends. Circ. 155,000. Accepts previously published artwork. Original artwork returned after publication.

Illustration Buys 5-8 illustrations/issue. Has featured illustrations by Ken Orvidas, Earl Keleny, Vivienne Fleshner, Darren Thompson and James O' Brien. Works on assignment only. Tearsheets, photographs, brochures and photocopies OK for samples. Samples are returned by SASE if requested. "Don't send submissions—only tearsheets or samples." Buys first rights.

Tips "Create images that can communicate ideas. Looking for noncommercial style editorial art by accomplished, experienced editorial artists. Conceptual imagery that reflects the artist's awareness of fine art ideas and methods is the kind of thing we use. Sports action illustrations not used. Cartoons not used. "

☑ NOW AND THEN

CASS/ETSU, Box 70556, Johnson City TN 37614-1707. (423)439-5348. Fax: (423)439-6340. E-mail: fischman@etsu.edu. Website: cass.etsu.edu/n&t/. **Managing Editor:** Nancy Fischman. Estab. 1984. Magazine covering Appalachian issues and arts, published 3 times a year. Circ. 1,000. Accepts previously published artwork. Originals are returned at job's completion. Sample copies available for $7. Art guidelines free for SASE with first class postage or on website.

Cartoons Approached by 5 cartoonists/year. Prefers Appalachia issues, political and humorous cartoons; b&w washes and line drawings.

Illustration Approached by 3 illustrators/year. Buys 1-2 illustrations/issue. Has featured illustrations by Nancy Jane Earnest, David M. Simon and Anthony Feathers. Features natural history; humorous, realistic, computer and spot illustration. Assigns 100% of illustrations to experienced but not well-known illustrators. Prefers Appalachia, any style. Considers b&w or 2- or 4-color pen & ink, collage, airbrush, marker and charcoal. Freelancers should be familiar with FreeHand, PageMaker or Photoshop.

First Contact & Terms Cartoonists: Send query letter with brochure, roughs and finished cartoons. Illustrators: Send query letter with brochure, SASE and photocopies. Samples are filed or will be returned by SASE if requested by artist. Responds in 6 months. Publication will contact artist for portfolio review if interested. Portfolio should include b&w tearsheets, slides, final art and photographs. Buys one-time rights. Pays on publication. Pays cartoonists $25 for b&w. Pays illustrators $50-100 for color cover; $25 maximum for b&w inside.

Tips "We have special theme issues. Illustrations have to have something to do with theme. Write for guidelines, see the website, enclose SASE."

⚕ NURSEWEEK

1156-C Aster Ave., Sunnyvale CA 94086. (408)249-5877. Fax: (408)249-8204. E-mail: youngk@nurseweek.com. Website: www.nurseweek.com. **Creative Director:** Young Kim. "*Nurseweek* is a biweekly 4-color tabloid mailed free to registered nurses nationwide. Combined circulation of all publications is over 1 million. *Nurseweek* provides readers with nursing-related news and features that encourage and enable them to excel in their work and that enhance the profession's image by highlighting the many diverse contributions nurses make. In order to provide a complete and useful package, the publication's article mix includes late-breaking news stories, news features with analysis (including in-depth bimonthly special reports), interviews with industry leaders and achievers, continuing education articles, career option pieces (Spotlight, Entrepreneur) and reader dialogue (Letters, Commentary, First Person)." Sample copy $3. Art guidelines not available. Needs computer-literate freelancers for production. 90% of freelance work demands knowledge of Quark, PhotoShop, Illustrator, Adobe Acrobat, CorelDraw.

Illustration Approached by 10 illustrators/year. Buys 1 illustration/year. Prefers pen & ink, watercolor, airbrush, marker, colored pencil, mixed media and pastel. Needs medical illustration.

Design Needs freelancers for design. 90% of design demands knowledge of Photoshop 4.0, QuarkXPress 4.0. Prefers local freelancers. Send query letter with brochure, résumé, SASE and tearsheets.

First Contact & Terms Illustrators: Send query letter with brochure, tearsheets, photographs, photocopies, photostats, slides and transparencies. Samples are not filed and are returned by SASE if requested by artist. Publication will contact artist for portfolio review if interested. Portfolio should include final art samples, photographs. Buys all rights. Pays on publication; $150 for b&w, $250 for color cover; $100 for b&w, $175 for color inside. Finds artists through sourcebooks.

NUTRITION HEALTH REVIEW

Box #406, Haverford PA 19041. (610)896-1853. Fax: (610)896-1857. **Contact:** A. Rifkin, publisher. Estab. 1975. Quarterly newspaper covering nutrition, health and medical information for the consumer. Circ. 285,000. Sample copies available for $3. Art guidelines available.

Cartoons Prefers single panel, humorous, b&w drawings.

Illustration Features b&w humorous, medical and spot illustrations pertaining to health.

First Contact & Terms Cartoonists/Illustrators: Send query letter with b&w photocopies. After introductory mailing, send follow-up postcard every 3-6 months. Samples are filed or returned by SASE. Responds in 6 months. Company will contact artist for portfolio review if interested. Pays cartoonists $20 maximum for b&w. Pays illustrators $200 maximum for b&w cover; $30 maximum for b&w inside. **Pays on acceptance.** Buys first rights, one-time rights, reprint rights. Finds freelancers through agents, artists' submissions, sourcebooks.

⊠ O&A MARKETING NEWS

Kal Publications, 559 S. Harbor Blvd., Suite A, Anaheim CA 92805-4525. (714)563-9300. Fax: (714)563-9310. Website: www.kalpub.com. **Editor:** Kathy Laderman. Estab. 1966. Bimonthly b&w trade publication about the service station/petroleum marketing industry. Circ. 8,000. Sample copies for 11×17 SASE with 10 first-class stamps.

- This publisher also published *Automotive Booster*.

Cartoons Approached by 10 cartoonists/year. Buys 1-2 cartoons/issue. Prefers humor that relates to service station industry. Prefers single panel, humorous, b&w line drawings.

First Contact & Terms Cartoonists: Send b&w photocopies, roughs or samples and SASE. Samples are returned by SASE. Responds in 1 month. Buys one-time rights. **Pays on acceptance**; $12 for b&w.

Tips "We run a cartoon (at least one) in each issue of our trade magazine. We're looking for a humorous take on business—specifically the service station/petroleum marketing/carwash/quick lube industry that we cover."

⊠ OFF DUTY MAGAZINE

3505 Cadillac, Suite 0-105, Costa Mesa CA 92626. Fax: (714)549-4222. E-mail: odutyedit@aol.com. Executive Editor: Tom Graves. Estab. 1970. Consumer magazine published 8 times/year "for U.S. military community worldwide." Sample copy for 8½×11 SASE and 6 first-class stamps.

- There are three versions of *Off Duty Magazine*: U.S., Europe and the Pacific.

Illustration Approached by 10-12 illustrators/year. Buys 2 illustrations/issue. Considers airbrush, colored pencil, marker, pastel, watercolor and computer art. Knowledge of Illustrator helpful but not required.

First Contact & Terms Illustrators: Send query letter with printed samples. Samples are filed. Does not reply. Artist should wait for call about an assignment. Buys one-time rights. **Pays on acceptance;** negotiable for cover; $200-300 for color inside. Finds illustrators through previous work and word of mouth.

Tips "We're looking for computer (Illustrator better than FreeHand, and/or Photoshop) illustrators for an occasional assignment."

✅ OFF OUR BACKS, a woman's news journal

2337B 18th St., NW, Washington DC 20009. (202)234-8072. Fax (202)234-8092. E-mail: offourbacks@cs.com. Website: www.offourbacks.org. **Managing Editors:** Jennie Ruby and Karla Mantilla. Estab. 1970. Monthly feminist news journal; magazine format; covers women's issues and the feminist movement. Circ. 18,000. Accepts previously published artwork. Original artwork is returned at the job's completion. Sample copies available; art guidelines free for SASE with first-class postage.

Cartoons Approached by 6 freelance cartoonists/year. Buys 2 freelance cartoons/issue. Prefers political, feminist themes.

Illustration Approached by 20 freelance illustrators/year. Prefers feminist, political themes. Considers pen & ink.

First Contact & Terms Cartoonists: Send query letter with roughs. Responds to the artist if interested within 2 months. Illustrators: Send query letter with photocopies. Samples are filed. Responds to the artist only if interested. To show a portfolio, mail appropriate materials.

Tips "Ask for a sample copy. Preference given to feminist, woman-centered, multicultural line drawings."

⊠ OFFICEPRO

5501 Backlick Rd., Suite 240, Springfield VA 22151-3940. (703)914-9200. Fax: (703)914-6777. E-mail: abrady@st rattonpub.com. Website: www.iaap-hq.org. **Editor:** Angela Hickman Brady. Estab. 1945. Trade journal published 9 times/year. Publication directed to the office support professional. Emphasis is on workplace issues, trends and technology. Readership is 98% female. Circ. 40,000. Accepts previously published artwork. Originals returned at job's completion upon request only. Sample copies available (contact subscription office at (816)891-6600, ext. 235).

Illustration Approached by 50 illustrators/year. Buys 20 or fewer illustrations/year. Works on assignment and purchases stock art. Prefers communication, travel, meetings and international business themes. Considers pen & ink, airbrush, colored pencil, mixed media, collage, charcoal, watercolor, acrylic, oil, pastel, marker and computer.

First Contact & Terms Illustrators: Send postcard-size sample or send query letter with brochure, tearsheets and photocopies. Samples are filed. Responds to the artist only if interested. Publication will contact artist for portfolio review if interested. Portfolio should include final art and tearsheets. Buys one-time rights usually, but rights purchased vary according to project. Pays $500-600 for color cover; $60-150 for b&w, $200-400 for color inside; $60 for b&w spots. Finds artists through word of mouth and artists' samples.

OHIO MAGAZINE

1422 Euclid Ave., Cleveland OH 44115. (216)771-2833 or (800)210-7293. Fax: (216)781-6318. E-mail: editorial@ ohiomagazine.com. Website: www.ohiomagazine.com. **Art Director:** Rob McGarr. 12 issues/year emphasizing traveling in Ohio. Circ. 95,000. Previously published work OK. Original artwork returned after publication. Sample copy $2.50; art guidelines not available.

Illustration Approached by 70 illustrators/year. Buys 2 illustrations/issue. Works on assignment only. Has featured illustrations by David and Amy Butler and Chris O'Leary. Features charts & graphs; informational graphics; spot illustrations. Assigns 10% of illustrations to new and emerging illustrators. Considers pen & ink, watercolor, collage, acrylic, marker, colored pencil, oil, mixed media and pastel. 20% of freelance work demands knowledge of Illustrator, QuarkXPress, Photoshop or FreeHand.

Design Needs freelancers for design and production. 100% of freelance work demands knowledge of Photoshop and QuarkXPress.

First Contact & Terms Illustrators: Send postcard sample or brochure, SASE, tearsheets and slides. Designers: Send query letter with tearsheets. Accepts disk submissions. Send Mac EPS files. Samples are filed or are returned by SASE. Responds in 1 month. Request portfolio review in original query. Portfolio should include b&w and color tearsheets, slides, photocopies and final art. Buys one-time rights. **Pays on acceptance**; $250-500 for color cover; $50-400 for b&w inside; $50-500 for color inside; $100-800 for 2-page spreads; $50-125 for spots. Finds artists through submissions and gallery shows.

Tips "Please take time to look at the magazine if possible before submitting."

OKLAHOMA TODAY MAGAZINE

15 N. Robinson, Suite 100, Oklahoma City OK 73102-5403. (405)521-2496. Fax: (405)522-4588. Website: www.o klahomatoday.com. **Editor:** Louisa McCune. Estab. 1956. Bimonthly regional, upscale consumer magazine focusing on all things that define Oklahoma and interest Oklahomans. Circ. 50,000. Accepts previously published artwork. Originals are returned at job's completion. Sample copies available with a SASE.

Illustration Approached by 24 illustrators/year. Buys 5-10 illustrations/year. Has featured illustrations by Rob Silvers, Tim Jossel, Steven Walker and Cecil Adams. Features caricatures of celebrities; natural history; realistic and spot illustration. Assigns 10% of illustrations to new and emerging illustrators. Considers pen & ink, watercolor, collage, airbrush, acrylic, marker, colored pencil, oil, charcoal and pastel. 20% of freelance work demands knowledge of PageMaker, Illustrator and Photoshop.

First Contact & Terms Illustrators: Send query letter with brochure, résumé, SASE, tearsheets and slides. Samples are filed. Responds in days if interested; months if not. Portfolio review required if interested in artist's work. Portfolio should include b&w and color thumbnails, tearsheets and slides. Buys one-time rights. Pays $200-500 for b&w cover; $200-750 for color cover; $50-500 for b&w inside; $75-750 for color inside. Finds artists through sourcebooks, other publications, word of mouth, submissions and artist reps.

Tips Illustrations to accompany short stories and features are most open to freelancers. "Read the magazine. Be willing to accept low fees at the beginning."

Ⓝ ON EARTH

(formerly The Amicus Journal), 40 W. 20th St., New York NY 10011. (212)727-2700. Fax: (212)727-1773. E-mail: onearthart@nrdc.org. Website: www.nrdc.org. **Art Director:** Gail Ghezzi. Associate Art Director: Irene Huang. Estab. 1979. Quarterly "award-winning environmental magazine exploring politics, nature, wildlife, science and solutions to problems." Circ. 140,000.

Illustration Buys 4 illustrations/issue.

First Contact & Terms Illustrators: Send postcard sample. "We will accept work compatible with QuarkXPress, Illustrator 8.0, Photoshop 5.5 and below." Responds only if interested. Buys one-time rights. Also may ask for electronic rights. Pays $100-300 for b&w inside. Payment for spots varies. Finds artists through sourcebooks and submissions.

Tips "We prefer 4-color. Our illustrations are often conceptual, thought-provoking, challenging. We enjoy thinking artists, and we encourage ideas and exchange."

ON OUR BACKS

3415 Ceasar Chavez, #101 San Francisco CA 94110-2351. (415)648-9464. Fax: (415)648-4705. E-mail: staff@ono urbacksmag.com. Website: www.onourbacksmag.com. **Contact:** Ethan Duran, art director. Estab. 1984. A b&w

with 4-color cover bimonthly magazine, covering lesbian sexuality. "One of our specialties is lesbian erotic photography." Accepts previously published artwork. Originals are returned at job's completion upon request with SASE. Submission guidelines available. Needs computer-literate freelancers for design and production. 10% of freelance work demands knowledge of PageMaker, FreeHand, Photoshop or Quark.

Cartoons Needs lesbian/sex humor. "We will accept a variety of styles."

First Contact & Terms Illustrators: Send query letter with photocopies. Samples are filed or are returned by SASE. Publication will contact artist for portfolio review if interested. Rights purchased vary according to project. Pays cartoonists $25 for b&w. Pays 30 days after publication. Pays illustrators $30 for b&w inside. Finds artists through artists' submissions/self-promotion, sourcebooks, artists' agents and reps, attending art exhibitions, other publications, press releases and public listings.

Tips "Lesbian sex photography is a pioneer effort, and we are constantly trying to enlarge our scope and possibilties. We explore a variety of sexual styles; and nudity, per se, is not necessarily the focus. An erotic and often emotional interpretation is. In general, we want a diversity of lesbians and intriguing themes that touch on our gay experience in a sexy and convincing manner."

THE OPTIMIST

4494 Lindell Blvd., St. Louis MO 63108-2404. (314)371-6000. Fax: (314)371-6006. E-mail: walkera@optimist.org. Website: www.optimist.org. **Graphic Designer:** Andrea Walker. 4-color magazine with 4-color cover that emphasizes activities relating to Optimist clubs in US and Canada (civic-service clubs). "Magazine is mailed to all members of Optimist clubs. Average age is 42; most are management level with some college education." Circ. 120,000. Sample copy for SASE; art guidelines not available.

Cartoons Buys 2 or 3 cartoons/issue. Has featured cartoons by Martin Bucella, Randy Glasbergen, Randy Bisson. Prefers themes of general interest: family-orientation, sports, kids, civic clubs. Prefers color single panel with gagline. No washes.

First Contact & Terms Illustrators: Send query letter with samples. Send art on a disk if possible (Macintosh compatible). Submissions returned by SASE. Buys one-time rights. **Pays on acceptance**; $30 for b&w or color.

Tips "Send clear cartoon submissions, not poorly photocopied copies."

▣ ORANGE COAST MAGAZINE

3701 Birch St., Suite 100, Newport Beach CA 92660. (949)862-1133. Fax: (949)862-0133. E-mail: editorial@orangecoastmag.com. Website: www.orangecoast.com. **Art Director:** Stacy Nunley. Estab. 1970. Monthly 4-color local consumer magazine with celebrity covers. Circ. 50,000.

Illustration Approached by 100 illustrators/year. Has featured illustrations by Cathi Mingus, Gweyn Wong, Scott Lauman, Santiago Veeda, John Westmark, Robert Rose, Nancy Harrison. Features computer, fashion and editorial illustrations featuring children and families. Prefers serious subjects; some humorous subjects. Assigns 10% of illustrations to well-known or "name" illustrators; 40% to experienced but not well-known illustrators; 50% to new and emerging illustrators. 40% of freelance illustration demands knowledge of Illustrator or Photoshop.

First Contact & Terms Illustrators: Send postcard or other nonreturnable samples. Accepts Mac-compatible disk submissions. Send EPS files. Samples are filed. Responds in 1 month. Will contact artist for portfolio review if interested. **Pays on acceptance**; $175 for b&w or color inside; $75 for spots. Finds illustrators through artist promotional samples.

Tips "Looking for fresh and unique styles. We feature approximately four illustrators per publication. I've developed great relationships with all of them."

OREGON CATHOLIC PRESS

5536 NE Hassalo, Portland OR 97213-3638. (503)281-1191. Fax: (503)282-3486. E-mail: jeang@ocp.org. Website: www.ocp.org/. **Art Director:** Jean Germano. Estab. 1988. Quarterly liturgical music planner in both Spanish and English with articles, photos and illustrations specifically for but not exclusive to the Roman Catholic market.

 • See *OCP*'s listing in the Book Publishers section to learn about this publisher's products and needs.

Illustration Approached by 10 illustrators/year. Buys 20 illustrations/issue. Has featured illustrations by John August Swanson and Steve Erspamer. Assigns 50% of illustrations to new and emerging illustrators.

First Contact & Terms Illustrators: Send query letter with printed samples, photocopies, SASE. Samples are filed or returned by SASE. Responds in 2 weeks. Portfolio review not required. Rights purchased vary according to project. **Pays on acceptance**; $100-250 for color cover; $30-50 for b&w spot art or photo.

◪ OREGON QUARTERLY

5228 University of Oregon, 130 Chapman Hall, Eugene OR 97403-5228. (541)346-5048. Fax: (541)346-5571. E-mail: quarterly@uoregon.edu. Website: www.uoregon.edu/~oq. **Editor:** Guy Maynard. Estab. 1919. Quarterly

4-color alumni magazine. "The Northwest perspective. Regional issues and events as addressed by UO faculty members and alumni." Circ. 91,000. Accepts previously published artwork. Originals are returned at job's completion. Sample copies available for SASE with first-class postage.
Illustration Approached by 25 illustrators/year. Buys 1 illustration/issue. Prefers story-related themes and styles. Interested in all media.
First Contact & Terms Illustrators: Send query letter with résumé, SASE and tearsheets. Samples are filed unless accompanied by SASE. Responds only if interested. Buys one-time rights. Portfolio review not required.
Pays on acceptance; $250 for b&w, $500 for color cover; $100 for b&w, $250 for color inside; $100 for spots.
Tips "Send postcard, not portfolio."

ORGANIC GARDENING
22 E. Second St., Emmaus PA 18098. (610)967-5171. Fax: (610)967-7846. E-mail: brian.goddard@rodale.com. Website: www.organicgardening.com. **Art Director:** Kim Brubaker. Magazine emphasizing gardening; 4-color; "uncluttered design." Published 6 times/year. Circ. 306,079. Usually buys first publication rights. Sample copies available only with SASE.
Illustration Buys 10 illustrations/issue. Works on assignment only.
First Contact & Terms Illustrators: Send tearsheets. Samples are filed or are returned by SASE only. Occasionally needs technical illustration. Buys first rights or one-time rights.
Tips "Our emphasis is 'how-to' gardening; therefore illustrators with experience in the field will have a greater chance of being published. Detailed and fine rendering quality is essential."

⦙ OUR STATE: DOWN HOME IN NORTH CAROLINA
P.O. Box 4552, Greensboro NC 27404. (336)286-0600. Fax: (336)286-0100. E-mail: croyston@ourstate.com. Website: www.ourstate.com. **Art Director:** Claudia Royston. Estab. 1933. Monthly 4-color consumer magazine featuring travel, history and culture of North Carolina. Circ. 111,000. Art guidelines are free for #10 SASE with first-class postage.
Illustration Approached by 6 illustrators/year. Buys 12 illustrations/issue. Features "cartoon-y" maps. Preferred subjects: maps of towns in NC. "Prefers pastel and bright colors." Assigns 100% to new and emerging illustrators. 100% of freelance illustration demands knowledge of Illustrator.
First Contact & Terms Illustrators: Send postcard sample or nonreturnable samples. Samples are not filed and are not returned. Portfolio review not required. Buys one-time rights. Pays on publication; $400-600 for color cover; $75-350 for b&w inside; $75-350 for color inside; $350 for 2-page spreads. Finds illustrators through word of mouth.

☑ OUR SUNDAY VISITOR
200 Noll Plaza, Huntington IN 46750. (260)356-8400. Fax: (260)356-8472. Website: www.osv.com. **Contact:** Design Dept. Estab. 1912. Weekly magazine which focuses on Catholicism. Audience is mostly older, conservative; adheres to the teachings of the magisterium of the church. Circ. 85,000. Accepts previously published artwork. Originals are returned at job's completion. Sample copies available. Art guidelines not available.
Illustration Approached by 25-30 illustrators/year. Buys 100 illustrations/year. Works on assignment only. Preferred themes are religious and social issues. Considers all types of media and photography—both traditional and digital.
First Contact & Terms Illustrators: Send query letter with photographs. Samples are filed. Portfolio review not required. Buys first rights. Pays on publication; $250 for b&w, $400 for color cover; $150 for b&w, $250 for color inside.

OUTER DARKNESS (Where Nightmares Roam Unleashed)
1312 N. Delaware Place, Tulsa OK 74110. (918)832-1246. E-mail: odmagazine@aol.com. **Editor:** Dennis Kirk. Estab. 1994. Quarterly digest/zine of horror and science fiction, poetry and art. Circ. 500. Sample copy for $3.95. Sample illustrations free for 6×9 SASE and 2 first-class stamps. Art guidelines free for #10 SASE with first-class postage.
Cartoons Approached by 15-20 cartoonists/year. Buys 15 cartoons/year. Prefers horror/science fiction slant, but not necessary. Prefers single panel, humorous, b&w line drawings.
Illustration Approached by 30-40 illustrators/year. Buys 5-7 illustrations/issue. Has featured illustrations by Allen Koszowski, Jeff Ward, Terry Campbell, Steve Rader. Features realistic science fiction and horror illustrations. Prefers b&w, pen & ink drawings. Assigns 20% of illustrations to new and emerging illustrators.
First Contact & Terms Cartoonists: Send query letter with b&w photocopies, samples, SASE. Samples are returned. Illustrators: Send query letter with photocopies, SASE. Responds in 2 weeks. Buys one-time rights. Pays on publication in contributor's copies. Finds illustrators through magazines and submissions.
Tips "Send samples of your work, along with a cover letter. Let me know a little about yourself. I enjoy learning

about artists interested in *Outer Darkness*. *Outer Darkness* is continuing to grow at an incredible rate. It's presently stocked in two out-of-state bookstores, and I'm working to get it into more. The latest issue of *OD* features a full color cover, and I hope to publish more such issues in the future. *Outer Darkness* is quickly moving through the ranks.''

[N] OVER THE BACK FENCE

14 S. Paint St., Suite 69, Chillicothe OH 45601. (740)772-2165. Fax: (740)773-7626. E-mail: backfenc@bright.net. Website: www.pantherpublishing.com. **Creative Director:** Rocky Alten. Estab. 1994. Quarterly consumer magazine emphasizing southern Ohio topics. Circ. 15,000. Sample copies for $4; art guidelines free for #10 SASE with first-class postage.

Illustration Features humorous and realistic illustration; informational graphics and spot illustration. Assigns 50% of illustration to experienced but not well-known illustrators; 50% to new and emerging illustrators.

First Contact & Terms Illustrators: Send query letter with photocopies, SASE and tearsheets. Ask for guidelines. Samples are occasionally filed or returned by SASE. Responds in 3 months. Creative director will contact artist for portfolio review if interested. Buys one-time rights. Pays $100 for b&w and color covers; $25-100 for b&w and color inside; $25-200 for 2-page spreads; $25-100 for spots. Finds illustrators through word of mouth and submissions.

Tips ''Our readership enjoys our warm, friendly approach. The artwork we select will possess the same qualities.''

[N] THE OXFORD AMERICAN

201 Donaghey Ave., Main 107, Conway AR 72035. (501)450-3483. E-mail: oamag@oxfordamericanmag.com. Website: www.oxfordamericanmag.com. **Editor:** Mark Smirnoff. Estab. 1992. Quarterly literary magazine. ''The Southern magazine of good writing.'' Circ. 33,000. Art guidelines on website.

• This award-winning magazine suspended publication in July 2003, but it relaunched in the fall of 2004 as a not-for-profit publication allied with the University of Central Arkansas. As *ADGM* goes to press, *OA* has not yet hired an art director. Check their website for updates.

Illustration Approached by many artists/year. Uses a varying number of illustrations/year. Considers all media.

First Contact & Terms Prefers digital submissions (attach JPEGs to e-mail) or include link to website. Also accepts printed tearsheets, photocopies or postcard sample of work. Samples are filed. Responds only if interested. To have materials returned, send SASE. Art director will contact artist for portfolio review of final art and roughs if interested. Buys one-time rights. Pays on publication. Finds artists through word of mouth and submissions.

Tips ''See the magazine.''

[■] OXYGEN

5775 Mclaughlin Rd., Mississauga ON L5R P37 Canada. (905)507-3545. Fax: (905)507-2372. E-mail: editorial@oxygenmag.com. Website: www.oxygenmag.com. **Art Director:** Robert Kennedy. Estab. 1997. Monthly consumer magazine. ''Oxygen is a magazine devoted entirely to women's fitness, health and physique.'' Circ. 300,000.

Illustration Buys 6-10 illustrations/issue. Has featured illustrations by Erik Blais, Ted Hammond and Marvin Hearld. Features caricatures of celebrities; charts & graphs; computer and realistic illustrations. Assigns 15% of illustrations to new and emerging illustrators. Prefers loose illustration, full color. Considers acrylic, airbrush, charcoal, collage, color washed, colored pencil, mixed media, pastel and watercolor. 50% of freelance illustration demands knowledge of Photoshop and QuarkXPress.

First Contact & Terms Illustrators: Send query letter with photocopies and tearsheets. Samples are filed and are not returned. Responds in 21 days. Buys all rights. **Pays on acceptance**; $1,000-2,000 for b&w and color cover; $50-500 for b&w and color inside; $100-1,000 for 2-page spreads. Finds illustrators through word of mouth and submissions.

Tips ''Artists should have a working knowledge of women's fitness. Study the magazine. It is incredible the amount of work that is sent that doesn't begin to relate to the magazine.''

[✓] PACIFIC PRESS PUBLISHING ASSOCIATION

1350 North Kings Rd., Nampa ID 83687. (208)465-2500. **Contact:** Dennis Ferree, graphic designer. Art Designer, Textbooks: Eucaris Galicia. Art Designer, Spanish and French Magazines: Ariel Fuentealba. Art Designer, *Signs of the Times*: Merwin Stewart. Estab. 1875. Book and magazine publisher. Specializes in Christian lifestyles and Christian outreach.

• This association publishes magazines and books. Also see *Signs of the Times* listing for needs.

[■] PACIFIC YACHTING MAGAZINE

1080 Howe St., Suite 900, Vancouver BC V6Z 2T1 Canada. (604)606-4644. Fax: (604)687-1925. E-mail: editorial @pacificyachting.net. Website: www.pacificyachting.com. **Editor:** Peter A. Robson. Estab. 1968. Monthly 4-

color magazine focused on boating on the West Coast of Canada. Power/sail cruising only. Circ. 25,000. Accepts previously published artwork. Original artwork returned at job's completion. Sample copies available for $5.95 cover price. Art guidelines not available.

Cartoons Approached by 12-20 cartoonists/year. Buys 2-3 illustrations or cartoons/issue. Boating themes only; single panel b&w line drawings.

Illustration Approached by 25 illustrators/year. Buys 10-20 illustrations/year. Has featured illustrations by Dave Alavoine, Roger Jackson and Tom Shardlow. Boating themes only. Considers pen & ink, watercolor, airbrush, acrylic, colored pencil, oil and charcoal.

First Contact & Terms Cartoonists and illustrators: Send query letter with brochure and roughs. "Will keep on file and contact if interested." Illustrators: Call for appointment to show portfolio of appropriate samples related to boating on the West Coast. Buys one-time rights. Pays on publication. Pays cartoonists $25-50 for b&w. Pays illustrators $300 for color cover; $50-100 for color inside; $25-50 for spots.

Tips "Know boats and how to draw them correctly. Know and love my magazine."

PAINT HORSE JOURNAL

Box 961023, Fort Worth TX 76161-0023. (817)834-2742. E-mail: dstreeter@apha.com. Website: www.painthorsejournal.com. **Art Director:** Paul Zinn. Monthly 4-color official publication of breed registry of Paint horses for people who raise, breed and show Paint horses. Circ. 30,000. Original artwork returned after publication if requested. Sample copy for $4.50; artist's guidelines for SASE.

Illustration Buys a few illustrations each year.

First Contact & Terms Illustrators: Send business card and samples to be kept on file. Prefers snapshots of original art or photostats as samples. Samples returned by SASE if not filed. Responds in 1 month. Buys first rights but may wish to use small, filler art many times. Payment varies by project.

Tips "No matter what style of art you use, you must include Paint Horses with conformation acceptable (to the APHA). Horses of Arabian-type conformation or with markings not appropriate for Paint Horses will not be considered."

☑ ☒ PALO ALTO WEEKLY

703 High St., Palo Alto CA 94302. (650)326-8210. Fax: (650)326-3928. E-mail: chubenthal@paweekly.com. Website: www.paloaltoonline.com/weekly/index2.shtml. **Design Director:** Carol Hubenthal. Estab. 1979. Semiweekly newspaper. Circ. 45,000. Accepts previously published artwork. Originals returned at job's completion. Sample copies available.

Illustration Buys 20-30 illustrations/year. Works on assignment only. Considers all media.

First Contact & Terms Illustrators: Send query letter with brochure, résumé, SASE, tearsheets, photographs and photocopies. Samples are filed. Publication will contact artist for portfolio review if interested. Pays on publication; $200 for color cover; $100 for b&w inside, $125 for color inside.

Tips Most often uses freelance illustration for covers and cover story, especially special section covers such as restaurant guides. "We call for artists' work in our classified ad section when we need some fresh work to look at. We work exclusively with local artists."

☒ PARABOLA MAGAZINE

656 Broadway, New York NY 10012-2317. (212)505-9037. Fax: (212)979-7325. E-mail: editors@parabola.org. Website: www.parabola.org. **Managing Editor:** Natalie Baan. Art Research: Miriam Faugno. Estab. 1974. Quarterly magazine of world myth, religious traditions and arts/comparative religion. Circ. 40,000. Sample copies available. Art guidelines for #10 SASE with first-class postage.

Illustration Approached by 20 illustrators/year. Buys 4-6 illustrations/issue. Prefers traditional b&w high contrast. Considers all media.

First Contact & Terms Illustrators: Send postcard or query letter with printed nonreturnable samples, photocopies and SASE. Accepts disk submissions. Samples are filed. Responds only if interested. Buys one-time rights. Pays on publication (kill fee given for commissioned artwork only); $300 maximum for cover; $150 maximum for b&w inside. Pays $50-100 for spots. Finds illustrators through sourcebooks, magazines, word of mouth and artist's submissions. "We rarely commission cover."

Tips "Familiarity with religious traditions and symbolism a plus. Timeless or classic look is preferred over 'trendy.'"

PARADE MAGAZINE

711 Third Ave., New York NY 10017-4014. (212)450-7000. Fax: (212)450-7284. E-mail: ira_yoffe@parade.com. Website: www.parade.com. **Creative Director:** Ira Yoffe. Photo Editor: Miriam White-Lorentzen. Art Director: Nick Torello. Weekly emphasizing general-interest subjects. Circ. 36 million (readership is 75 million). Original artwork returned after publication. Sample copy available. Art guidelines for SASE with first-class postage.

Illustration Uses varied number of illustrations/issue. Works on assignment only.

Design Needs freelancers for design. 100% of freelance work demands knowledge of Photoshop, Illustrator, QuarkXPress. Prefers local freelancers.

First Contact & Terms Illustrators: Send query letter with brochure, résumé, business card, postcard and/or tearsheets to be kept on file. Designers: Send query letter with résumé. Call or write for appointment to show portfolio. Responds only if interested. Buys first rights, occasionally all rights. Pays for design by the project, by the day or by the hour depending on assignment.

Tips "Provide a good balance of work."

[N] PARENTS

375 Lexington Ave., 10th Floor, New York NY 10017-5514. (212)499-2000. Fax: (212)499-2083. E-mail: schristensen@parentsmagazine.com. Website: www.parents.com. Contact: Andrea Amadio, art director. Designer: Taylor Newell. Deputy Art Director: Marian Fairweather. Creative Director: Jeffrey Saks. Estab. 1979. Monthly 4-color magazine with features to help parents raise happy, healthy children. Circ. 2,153,221.

Illustration Approached by 300 illustrators/year. Buys 5-6 illustrations/issue. Has featured illustrations by Bill Brown, Rob Blackhart, Katy Dockrill. Features humorous and spot illustrations of children, parents and babies. Assigns 80% of illustrations to experienced but not well-known illustrators; 20% to new and emerging illustrators.

First Contact & Terms Send postcard sample and follow-up postcard every 6 months or e-mail online portfolio. Samples are filed. Will contact artist for portfolio review if interested. Buys one-time rights for 1 year with option for more. Pay rates vary. Finds illustrators through sourcebooks, word of mouth, and artists' promotional samples.

[N] PARENTS' PRESS

1454 Sixth St., Berkeley CA 94710-1431. (510)524-1602. Fax: (510)524-0912. E-mail: parentsprs@aol.com. **Art Director:** Ann Skram. Estab. 1980. Monthly tabloid-size newspaper "for parents in the San Francisco Bay area." Circ. 75,000.

Illustration Approached by 10-20 illustrators. Buys occasional b&w cartoons and 4-color cover illustrations. Prefers parenting and child related. Considers all media. Send query letter with photocopies and SASE or URL for online samples; no e-mail attachments.

First Contact & Terms "We will accept work compatible with QuarkXPress 4.1, Photoshop and Illustrator. Responds only if interested. Art director will contact artist for portfolio review of b&w and color slides if interested. Buys one-time rights. Pays on publication; negotiable. Payment for spots negotiable.

[N] PASSPORT

6401 The Paseo, Kansas City MO 64131. (816)333-7000 ext. 2365. Fax: (816)333-4439. E-mail: jjsmith@nazarene.org. **Editor:** Mike Wonch. Editorial Assistant: Julie Smith. Estab. 1992. "*Passport* is a weekly 8 page, color story paper that focuses on the interests and concerns of the preteen (11- to 12-year-old). We try to connect what they learn in Sunday School with their daily lives." Circ. 18,000. Originals are not returned. Sample copies free for SASE with first-class postage.

• Not accepting new submissions until 2007.

Cartoons Buys 1 cartoon/issue. Prefers humor for the preteen; single panel b&w line drawings with gagline.

First Contact & Terms Cartoonists: Send query letter with finished cartoon samples and SASE. Samples are filed or are returned by SASE if requested. Responds in 2 months. Buys multi-use rights. Pays $15 for b&w.

[✓] PC MAGAZINE

Ziff-Davis Media, 28 E. 28th St., 11th Floor, New York NY 10016. (212)503-3500. **Art Director:** Richard Demler. Senior Associate Art Director: Cynthia Rhett. Estab. 1983. Bimonthly consumer magazine featuring comparative lab-based reviews of current PC hardware and software. Circ. 1.2 million. Sample copies available.

Illustration Approached by 100 illustrators/year. Buys 10-20 illustrations/issue. Considers all media.

First Contact & Terms Illustrators: Send postcard sample and/or printed samples, photocopies, tearsheets. Accepts CD or e-mail submissions. Samples are filed. Portfolios may be dropped off and should include tearsheets and transparencies; art department keeps for one week to review. **Pays on acceptance**. Payment negotiable for cover and inside; $350 for spots.

[N] [🌐] THE PEAK

158 Cecil St., 06-00, Dapenso Bldg., Singapore 063545. Phone: (65)323 1119. Fax: (65)323 7776/323 7779. E-mail: mag_inc@pacific.net.sg. Website: www.thepeakmagazine.com/english. **Editor:** Kannan Chandran. Monthly 4-color consumer magazine.

Illustration Approached by 20 illustrators/year. Buys 4 illustrations/issue. Has featured illustrations by local

illustrators and students. Features charts & graphs, informational graphics, geographic/maps, humorous, medical and spot illustration. Preferred subjects: business and concept illustrations. Prefers pastel/bright/b&w, depends on subject. Assigns 80% of illustrations to new and emerging illustrators; 20% to experienced but not well-known illustrators.

First Contact & Terms Illustrators: Send postcard sample and follow-up postcard; send nonreturnable samples. Accepts Mac-compatible disk submissions. Samples are filed and are not returned. Will contact artist for portfolio review if interested. Rights purchased vary according to project. Pays $40-60 for b&w; $50-100 for color inside; $50 for spots.

Tips "A sense of humor—where applicable—and a good interpretation of the subject matter are important."

N PEDIATRIC ANNALS

6900 Grove Rd., Thorofare NJ 08086-9447. (856)848-1000. Fax: (856)853-5991. Website: www.slackinc.com. **Managing Editor:** Shannon O'Conner. Art Director: Linda Baker. Monthly 4-color magazine emphasizing pediatrics for practicing pediatricians. "Conservative/traditional design." Circ. 49,000. Considers previously published artwork. Original artwork returned after publication. Sample copies available; art guidelines available.

Illustration Has featured illustrations by Peg Gerrity. Features realistic and medical illustration. Prefers "technical and conceptual medical illustration which relate to pediatrics." Considers watercolor, acrylic, oil, pastel and mixed media.

First Contact & Terms Illustrators: Send query letter with brochure, tearsheets, slides and photographs to be kept on file. Publication will contact artist for portfolio review if interested. Buys one-time rights or reprint rights. Pays $250-700 for color cover. Finds artists through submissions/self-promotions and sourcebooks.

Tips "Illustrators must be able to treat medical subjects with a high degree of accuracy. We need people who are experienced in medical illustration, who can develop ideas from manuscripts on a variety of topics and who can work independently (with some direction) and meet deadlines. Non-medical illustration is also used occasionally. We deal with medical topics specifically related to children. Include color work, previous medical illustrations and cover designs in a portfolio. Show a representative sampling of work."

PENNSYLVANIA LAWYER

Pennsylvania Bar Association, 100 South St., Harrisburg PA 17108-0186. (717)238-6715. E-mail: editor@pabar.org. Website: www.pabar.org. **Editor:** Geoff Yuda. Bimonthly association magazine "featuring nuts and bolts articles and features of interest to lawyers." Circ. 30,000. Sample copies for #10 SASE with first-class postage. Art guidelines available.

Illustration Approached by 30 illustrators/year. Buys 12 illustrations/year. Considers all media.

First Contact & Terms Illustrators: Send query letter with samples. Samples are filed or returned by SASE. Art director will contact artist for portfolio review if interested. Negotiates rights purchased. **Pays on acceptance**; $300-500 for color cover; $100 for inside. Pays $25-50 for spots. Finds illustrators through word of mouth and artists' submissions.

Tips "Artists must be able to interpret legal subjects. Art must have fresh, contemporary look. Read articles you are illustrating, provide three or more roughs in timely fashion."

PERSIMMON HILL

Published by the National Cowboy & Western Heritage Museum, 1700 NE 63rd St., Oklahoma City OK 73111. (405)478-6404. Fax: (405)478-4714. E-mail: editor@nationalmuseum.org. Website: www.nationalcowboymuseum.org. **Director of Publications:** M.J. Van Deventer. Estab. 1970. Quarterly 4-color journal of western heritage "focusing on both historical and contemporary themes. It features nonfiction articles on notable persons connected with pioneering the American West; art, rodeo, cowboys, floral and animal life; or other phenomena of the West of today or yesterday. Lively articles, well written, for a popular audience. Contemporary design follows style of *Architectural Digest* and *European Travel and Life*." Circ. 15,000. Original artwork returned after publication. Sample copy for $10.50.

Illustration Fine art only.

First Contact & Terms Send query letter with tearsheets, SASE, slides and transparencies. Samples are filed or returned by SASE if requested. Publication will contact artist for portfolio review if interested. Portfolio should include original/final art, photographs or slides. Buys first rights. Requests work on spec before assigning job. Payment varies. Finds artists through word of mouth and submissions.

Tips "We are a museum publication. Most illustrations are used to accompany articles. Work with our writers, or suggest illustrations to the editor that can be the basis for a freelance article or a companion story. More interest in the West means we have to provide more contemporary photographs and articles about what people in the West are doing today. Study the magazine first—at least four issues."

Ⓝ PET BUSINESS

333 Seventh Ave., 11th Floor, New York NY 10001-5004. (212)979-4800. Fax: (646)674-0102. Website: www.pet business.com. **Art Director:** Jennifer Bumgardner. Managing Editor: Mark Kalaygian. A monthly 4-color news magazine for the pet industry (retailers, distributors, manufacturers, breeders, groomers). Circ. 24,500. Accepts previously published artwork.

Illustration Occasionally needs illustration for business-oriented cover stories. Features realistic illustrations. Prefers watercolor, pen & ink, acrylics and color pencil.

First Contact & Terms Accepts Windows-compatible disk submissions. Send EPS files, 266 dpi. Portfolio review not required. Pays on publication; $100.

Tips "Send two or three samples and a brief bio, only."

PHI DELTA KAPPAN

Box 789, Bloomington IN 47402. (812)339-1156. Fax: (812)339-0018. Website: www.pdkintl.org/kappan/khpsu bmi.htm. **Design Director:** Carol Bucheri. Emphasizes issues, policy, research findings and opinions in the field of education. For members of the educational organization Phi Delta Kappa and subscribers. Black & white with 4-color cover and "conservative, classic design." Published 10 times/year. Circ. 100,000. Include SASE. Responds in 2 months. "We return illustrations and cartoons after publication." Sample copy for $7 plus $5 S&H. "The journal is available in most public and college libraries."

Cartoons Approached by over 100 cartoonists/year. Looks for "finely drawn cartoons, with attention to the fact that we live in a multi-racial, multi-ethnic world."

Illustration Approached by over 100 illustrators/year. Uses one 4-color cover and spread/issue. Features serious conceptual art; humorous, realistic, computer and spot illustraion. Prefers style of John Berry, Brenda Grannan and Jem Sullivan. Most illustrations depict some aspect of the education process (from pre-kindergarten to university level), often including human figures.

First Contact & Terms Illustrators: Send postcard sample and include Web address to online portfolio. "We can accept computer illustrations that are Mac formatted (EPS or TIFF files; Photoshop 6.0 or Illustrator 9.0)." Buys one-time print and electronic rights. Payment varies.

Tips "We look for artists who can create a finely crafted image that holds up when translated onto the printed page. Our journal is edited for readers with master's or doctoral degrees, so we look for illustrators who can take abstract concepts and make them visual, often through the use of metaphor. Submission specifications online."

PHILADELPHIA WEEKLY

1500 Sansom St., 3rd Floor, Philadelphia PA 19102-2800. (215)563-7400. Fax: (215)563-0620. E-mail: jcox@phil adelphiaweekly.com. Website: www.philadelphiaweekly.com. **Art Director:** Jeffrey Cox. Estab. 1971. Alternative weekly, 4-color, tabloid focusing on news and opinion and arts and culture. Circ. 105,500.

Cartoons Approached by 25 cartoonists/year. Buys 0-1 cartoon/issue. Prefers single panel, multiple panel, political, humorous, b&w washes, b&w line drawings.

Illustration Approached by scores of illustrators/year. Buys 3-5 illustrations/issue. Has featured illustrations by Brian Biggs, Jay Bevenour, James McHugh. Features caricatures of celebrities and politicians; humorous, realistic and spot illustrations. Prefers realism but considers wide range of styles.

First Contact & Terms Cartoonists: Send query letter with b&w photocopies. Illustrators: Send postcard sample or query letter with printed samples and photocopies. Send non-returnable samples. Samples are filed and are not returned. Responds only if interested. Buys one-time rights. Pays on publication; $300 for color cover; $75-150 for b&w inside; $100-250 for color inside; $75 for spots. Finds illustrators through promotional samples.

Ⓝ PHYSICAL MAGAZINE

11050 Santa Monica Blvd., 3rd Floor, Los Angeles CA 90025. (310)445-7528. Fax: (310)445-7587. E-mail: TPREIS S@Physicalmag.com. Website: www.physicalmag.com. **Contact:** Tamar Preiss, Art Director. Estab. 1998. Monthly fitness consumer magazine "with readers who enjoy working out and eating healthy. Supplements are a must!" Sample copies available on request. Art guidelines available when artist is hired.

Cartoons Buys 3-5 cartoons/year. Prefers clean but edgey. Prefers single or double panel, humorous, color washes.

Illustration Buys 8-10 illustrations/year. Features computer illustration, humorous illustration, realistic illustration, medical illustration and spot illustrations involving fitness and sports. Assigns 75% to new and emerging illustrators. 90% of freelance illustration demands knowledge of Illustrator, QuarkXPress and Photoshop.

First Contact & Terms Cartoonists/Illustrators: Send postcard sample. After introductory mailing, send follow-up postcard every 6-9 months. Responds only if interested. Company will contact artist for portfolio review if interested. Portfolio should include finished art. Pays cartoonists $800-1,200 for b&w and color cartoons. Pays

Magazines

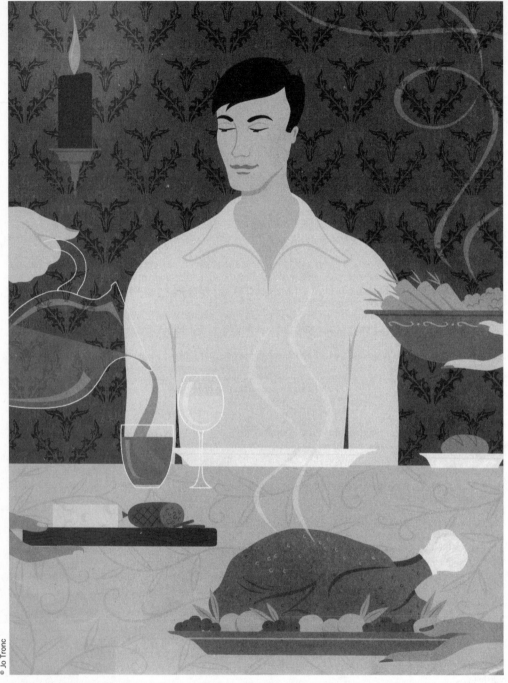

© Jo Tronc

Art Director Tamar Preiss chose Jo Tronc to illustrate an article about holiday eating for *Physical* magazine.
See more of Tronc's cool, contemporary illustrations and lettering at *www.watermarkltd.com*.

illustrators $800-1,200 for color inside, $1,000-1,300 for 2-page spreads. **Pays on acceptance.** Buys one-time rights and first North American serial rights. Finds freelancers through sourcebooks.

Tips "Don't waste your cards and postage if your style does not match the magazine."

PLANNING

American Planning Association, 122 S. Michigan Ave., Suite 1600, Chicago IL 60603. (312)431-9100. Website: www.planning.org. **Editor and Publisher:** Sylvia Lewis. Art Director: Richard Sessions. Monthly 4-color magazine for urban and regional planners interested in land use, housing, transportation and the environment. Circ. 35,000. Previously published work OK. Original artwork returned after publication, upon request. Free sample copy and artist's guidelines available. "Enclose $1 in postage for sample magazine—stamps only, no cash or checks, please."

Cartoons Buys 2 cartoons/year on the environment, city/regional planning, energy, garbage, transportation, housing, power plants, agriculture and land use. Prefers single panel with gaglines ("provide outside of cartoon body if possible").

Illustration Buys 20 illustrations/year on the environment, city/regional planning, energy, garbage, transportation, housing, power plants, agriculture and land use.

First Contact & Terms Cartoonists: Include SASE. Illustrators: Send samples of style we can keep on file. If you want a response, enclose SASE. Responds in 2 weeks. Buys all rights. Pays on publication. Pays cartoonists $50 minimum for b&w line drawings. Pays illustrators $250 maximum for b&w cover drawings; $100 minimum for b&w line drawings inside.

Tips "Don't send portfolio. No corny cartoons. Don't try to figure out what's funny to planners. All attempts seen so far are way off base. Your best chance is to send samples of any type of illustration—cartoons or other— that we can keep on file. If we like your style we will commission work from you."

PLAYBOY MAGAZINE

680 N. Lakeshore Dr., Chicago IL 60611. (312)751-8000. Website: www.playboy.com. **Art Director:** Tom Staebler. Estab. 1952. Monthly magazine. Circ. 3.5 million. Originals returned at job's completion.

Cartoons Playboy Enterprises Inc., Cartoon Dept., 730 Fifth Ave., New York NY 10019.

Illustration Approached by 700 illustrators/year. Buys 30 illustrations/issue. Prefers "uncommercial looking" artwork. Considers all media.

First Contact & Terms Illustrators: Send postcard sample or query letter with slides and photocopies or other appropriate sample. Does not accept originals. Samples are filed or returned. Responds in 2 weeks. Buys all rights. **Pays on acceptance**; $1,200/page; $2,000/spread; $250 for spots.

Tips "No phone calls, only formal submissions of five pieces."

N PN/PARAPLEGIA NEWS

2111 E. Highland Ave., Suite 180, Phoenix AZ 85016-4702. (602)224-0500. Fax: (602)224-0507. E-mail: susan@p nnews.com. Website: www.pn-magazine.com. **Art Director:** Susan Robbins. Estab. 1947. Monthly 4-color magazine emphasizing wheelchair living for wheelchair users, rehabilitation specialists. Circ. 30,000. Accepts previously published artwork. Original artwork not returned after publication. Sample copy free for large-size SASE with $3 postage.

Cartoons Buys 3 cartoons/issue. Prefers line art with wheelchair theme. Prefers single panel b&w line drawings with or without gagline.

Illustration Prefers wheelchair living or medical and financial topics as themes. 50% of freelance work demands knowledge of QuarkXPress, Photoshop or Illustrator.

First Contact & Terms Cartoonists: Send query letter with finished cartoons to be kept on file. Responds only if interested. Buys all rights. **Pays on acceptance.** Illustrators: Send postcard sample. Accepts disk submissions compatible with Illustrator 10.0 or Photoshop 7.0. Send EPS, TIFF or JPEG files. Samples not filed are returned by SASE. Publication will contact artist for portfolio review if interested. Portfolio should include final reproduction/product, color and b&w tearsheets, photostats, photographs. Pays on publication. Pays cartoonists $10 for b&w. Pays illustrators $250 for color cover; $25 for b&w inside, $50 for color inside.

Tips "When sending samples, include something that shows a wheelchair user. We regularly purchase cartoons that depict wheelchair users."

POCKETS

Box 340004, 1908 Grand Ave. V, Nashville TN 37203-0004. (615)340-7333. Fax: (615)340-7267. E-mail: pockets @upperroom.org. Website: www.pockets.org. **Editor:** Lynn W. Gilliam. Devotional magazine for children 6-12. 4-color. Monthly except January/February. Circ. 100,000. Accepts one-time previously published material. Original artwork returned after publication. Sample copy for 9×12 or larger SASE with 4 first-class stamps.

Illustration Approached by 50-60 illustrators/year. Features humorous, realistic and spot illustration. Assigns

15% of illustrations to new and emerging illustrators. Uses variety of styles; 4-color, flapped art appropriate for children. Realistic, fable and cartoon styles.

First Contact & Terms Illustrators: Send postcard sample, brochure, photocopies, SASE and tearsheets. No fax submissions accepted. Also open to more unusual art forms: cut paper, embroidery, etc. Samples not filed are returned by SASE. ''No response without SASE.'' Responds only if interested. Buys one-time or reprint rights. **Pays on acceptance**; $600 flat fee for 4-color covers; $75-350 for color inside.

Tips ''Decisions made in consultation with out-of-house designer. Send samples to our designer: Chris Schechner, 408 Inglewood Dr., Richardson, TX 75080.''

POWDER MAGAZINE

33046 Calle Aviador, San Juan Capistrano CA 92675. (949)496-5922. Fax: (949)496-7849. E-mail: sonny.cisto@p rimedia.com. Website: www.powdermag.com. **Art Director:** Sonny Cisto. Estab. 1972. Monthly consumer magazine ''for core skiers who live, eat and breathe skiing and the lifestyle that goes along with it.'' Circ. 110,000. Samples are available; art guidelines not available.

Illustration Approached by 20-30 illustrators/year. Buys 5-10 illustrations/year. Has featured illustrations by Peter Spacek, Dan Ball and Santiago Uceda. Features humorous and spot illustration. Assigns 10% of illustrations to well-known or ''name'' illustrators; 70% to experienced but not well-known illustrators; 20% to new and emerging illustrators. ''Illustrators have to know a little about skiing.'' Considers all media. 10% of freelance illustration demands knowledge of Photoshop 3.0, Illustrator 5.0 and QuarkXPress 3.3.

Design Needs freelancers for design and multimedia projects. Prefers local design freelancers. 100% of freelance work demands knowledge of Photoshop 3.0, Illustrator 5.0 and QuarkXPress 3.3.

First Contact & Terms Illustrators: Send postcard sample or tearsheets. Designers: Send query letter with printed samples and photocopies. Accepts Macintosh EPS files compatible with QuarkXPress 3.3. Samples are filed. Responds only if interested. Buys one-time rights. **Pays on acceptance;** $100-300 for b&w inside; $200-400 for color inside; $400-1000 for 2-page spreads; 100-300 for spots. Finds illustrators through sourcebooks and submissions.

Tips ''We like cutting-edge illustration, photography and design. We need it to be innovative and done quickly. We give illustrators a lot of freedom. Send sample or promo and do a follow-up call.''

☑ ⚏ PRAIRIE JOURNAL OF CANADIAN LITERATURE

(formerly Prairie Journal Trust), P.O. Box 61203 Brentwood Postal Services, Calgary AB T2L 2K6 Canada. E-mail: prairiejournal@yahoo.com. Website: www.geocities.com/prairiejournal. **Contact:** Editor (by mail). Estab. 1983. Biannual literary magazine. Circ. 600. Sample copies available for $6; art guidelines on website.

Illustration Approached by 25 illustrators/year. Buys 6 illustrations/year. Has featured illustrations by Hubert Lacey, Rita Diebolt, Lucie Chan. Considers artistic/experimental b&w line drawings or screened print.

First Contact & Terms Illustrators: Send postcard sample or query letter with b&w photocopies. Samples are filed. Responds only if interested. Portfolio review not required. Acquires one-time rights. Pays $50 maximum (Canadian) for b&w cover and $25 maximum for inside drawings. Pays on publication. Finds freelancers through unsolicited submissions and queries.

Tips ''We are looking for black & white line drawings easily reproducable and camera-ready copy. Never send originals through the mail.''

☑ PRAIRIE SCHOONER

University of Nebraska, 201 Andrews Hall, P.O. Box 880334, Lincoln NE 68588-0334. (402)472-0911. Fax: (402)472-9771. E-mail: kgrey2@unlnotes.unl.edu. Website: www.unl.edu/schooner/psmain.htm. **Contact:** Kelly Grey, managing editor. Estab. 1926. Quarterly b&w literary magazine with 2-color cover. ''*Prairie Schooner*, now in its 78th year of continuous publication, is called 'one of the top literary magazines in America' by *Literary Magazine Review*. Each of the four issues contains short stories, poetry, book reviews, personal essays, interviews or some mix of these genres. Contributors are both established and beginning writers. Readers live in all states in the U.S. and in most countries outside the U.S.'' Circ. 3,200. Original artwork is returned after publication. ''We rarely have the space or funds to reproduce artwork in the magazine but hope to do more in the future.'' Sample copies for $5.

Illustration Approached by 5-10 illustrators/year. Uses freelancers mainly for cover art.

First Contact & Terms ''Before submitting, artist should be familiar with our cover and format, 6×9, vertical images work best; artist should look at previous issues of *Prairie Schooner*. Portfolio review not required. We are rarely able to pay for artwork; have paid $50 to $100.''

Tips Finds artists through word of mouth.

PREMIERE MAGAZINE

1633 Broadway, 41st Floor, New York NY 10019. (212)767-6000. Fax: (212)767-5450. Website: www.premierem ag.com. **Art Director:** Richard Baker. Estab. 1987. ''Monthly popular culture magazine about movies and the

movie industry in the U.S. and the world. Of interest to both a general audience and people involved in the film business." Circ. 612,952. Original artwork is returned after publication.

Illustration Approached by 250 illustrators/year. Works with 150 illustrators/year. Buys 3-4 spot illustrations/issue. Buys illustrations mainly for spots. Has featured illustrations by Dan Adel, Brian Briggs, Anita Kunz and Roberto Parada. Works on assignment only. Considers all styles depending on needs.

First Contact & Terms Illustrators: Send query letter with tearsheets, photostats and photocopies. Samples are filed. Samples not filed are returned by SASE. Reports back about queries/submissions only if interested. Drop-offs Monday through Friday, and pick-ups the following day. Buys first rights or one-time rights. Pays $350 for b&w, $375-1,200 for color inside.

☒ THE PRESBYTERIAN RECORD

50 Wynford Dr., Toronto ON M3C 1J7 Canada. (416)441-1111. Fax: (416)441-2825. E-mail: pcrecord@presbyterian.ca. Website: www.presbyterian.ca/record. **Production and Design:** Tim Faller. Published 11 times/year. Deals with family-oriented religious themes. Circ. 50,000. Original artwork returned after publication. Simultaneous submissions and previously published work OK. Free sample copy and artists' guidelines for SASE with first-class postage.

Cartoons Approached by 12 cartoonists/year. Buys 1-2 cartoons/issue. Interested in some theme or connection to religion.

Illustration Approached by 6 illustrators/year. Buys 1 illustration/year on religion. Has featured illustrations by Ed Schnurr, Claudio Ghirardo and Chrissie Wysotski. Features humorous, realistic and spot illustration. Assigns 50% of illustrations to new and emerging illustrators. "We are interested in excellent color artwork for cover." Any line style acceptable—should reproduce well on newsprint. Works on assignment only.

First Contact & Terms Cartoonists: Send roughs and SAE (nonresidents include IRC). Illustrators: Send query letter with brochure showing art style or tearsheets, photocopies and photographs. Will accept computer illustrations compatible with QuarkXPress 4.1, Illustrator 8.0, Photoshop 6.0. Samples returned by SAE (nonresidents include IRC). Responds in 1 month. To show a portfolio, mail final art and color and b&w tearsheets. Buys all rights on a work-for-hire basis. Pays on publication. Pays cartoonists $25-50 for b&w. Pays illustrators $50-100 for b&w cover; $100-300 for color cover; $25-80 for b&w inside; $25-60 for spots.

Tips "We don't want any 'cute' samples (in cartoons). Prefer some theological insight in cartoons; some comment on religious trends and practices."

PRESBYTERIANS TODAY

100 Witherspoon St., Louisville KY 40202. (502)569-5637. Fax: (502)569-8632. E-mail: today@pcusa.org. Website: www.pcusa.org/today. **Art Director:** Linda Crittenden. Estab. 1830. 4-color; official church magazine emphasizing Presbyterian news and informative and inspirational features. Publishes 10 issues year. Circ. 58,000. Originals are returned after publication if requested. Some feature illustrations may appear on website. Sample copies for SASE with first-class postage.

Cartoons Approached by 20-30 cartoonists/year. Buys 1-2 freelance cartoons/issue. Prefers general religious material; single panel.

Illustration Approached by more than 50 illustrators/year. Buys 2-3 illustrations/issue, 30 illustrations/year from freelancers. Works on assignment only. Media varies according to need.

First Contact & Terms Cartoonists: Send roughs and/or finished cartoons. Responds in 1 month. Rights purchased vary according to project. Illustrators: Send query letter with tearsheets. Samples are filed and not returned. Responds only if interested. Buys one-time rights. Pays cartoonists $25, b&w. Pays illustrators $150-350, cover; $80-250, inside.

☒ PRIMAVERA

Box #37-7547, Chicago IL 60637-7547. (312)324-5920. **Contact:** Editorial Board. Estab. 1974. Annual b&w magazine with occasional 4-color cover emphasizing art and literature "for readers interested in contemporary literature and art which reflect the experiences of women." Includes a wide variety of styles of fiction, poetry, photographs, line drawings, paintings. Circ. 1,000. Original artwork returned after publication. Sample copy $5; art guidelines available for SASE.

Cartoons Original line drawings of great visual interest and impact.

Illustration Works with 5 illustrators/year. Would like to buy 15 illustrations/year. "We are open to a wide variety of styles and themes depicting experiences of women. Work must be in b&w with strong contrasts and should not exceed 5×7.

First Contact & Terms Cartoonists/Illustrators: Send finished art. Responds in 2 months. "If the artist lives in Chicago, she may call us for an appointment." Publication will contact artist for portfolio review if interested. Acquires first rights. "We pay in 2 free copies of the issue in which the artwork appears." Finds artists through attending exhibitions.

Tips "It's a good idea to take a look at a recent issue. Artists often do not investigate the publication and send work which may be totally inappropriate. We publish a wide variety of artists. We have increased the number of graphics per issue. Send us a *variety* of prints. It is important that the graphics work well with the literature and the other graphics we've accepted. Our decisions are strongly influenced by personal taste and work we know has already been accepted. Will consider appropriate cartoons and humorous illustrations."

N PRIME TIME SPORTS & FITNESS

P.O. Box 6097, Evanston IL 60201. Phone/fax: (847)784-1194. E-mail: RoadRallye@aol.com. **Contact:** D. Dorner. Art Director: Diane Thomas. Estab. 1977. Magazine published 8 times/year "covering sports and fitness, women's sports and swimwear fashion." Circ. 63,000. Sample copies available; art guidelines for #10 SASE with first-class postage. (Best by e-mail.)

Cartoons Approached by 50 cartoonists/year. Buys 11 cartoons/issue. Prefers sports-fitness theme. Prefers multiple panel, humorous, b&w washes.

Illustration Approached by over 200 illustrators/year. Buys 6-10 illustrations/issue. Has featured illustrations by Lynn Huntley, Nancy Thomas, Phil Greco and Larry Balsamo. Features caricatures of celebrities; fashion, humorous and realistic illustration; charts and graphs; informational graphics; medical, computer and spot illustration. Assigns 5% of illustrations to well-known or "name" illustrators; 25% to experienced but not well-known illustrators; 60% to new and emerging illustrators. Prefers women in sports. Considers all media. 40% of freelance illustration demands knowledge of PageMaker, Draw, Microsoft Publisher.

Design Needs freelancers for design, production and multimedia projects. Prefers local design freelancers. 40% of freelance work demands knowledge of Microsoft Publisher.

First Contact & Terms Send query letter with photocopies (e-mail OK too). Cartoon samples are filed and are not returned. Illustration samples are not filed and are returned by SASE. Responds in 3 months. Buys first North American serial rights, negotiates rights purchased for cartoons. Buys all rights for illustration. Pays on publication. Pays cartoonists $75-100 for b&w, $50-300 for color. Pays illustrators $10-200 for b&w cover; $20-200 for color cover; $10-25 for b&w inside; $10-100 for color inside; $25-100 for 2-page spreads; $5-25 for spots.

Tips "Don't waste time giving us credits; work stands alone by itself. In fact we are turned off by experience and credits and turned on by good artwork. Find out what articles and features are planned then work art to fill."

☑ PRINT MAGAZINE

38 E. 29th St., 3rd Floor, New York NY 10016. (212)447-1400. Fax: (212)447-5231. E-mail: steven.brower@print mag.com. Website: www.printmag.com. **Art Director:** Steven Brower. Estab. 1940. Bimonthly professional magazine for "art directors, designers and anybody else interested in graphic design." Circ. 55,000. Art guidelines available.

First Contact & Terms Illustrators/designers: Send postcard sample, printed samples and tearsheets. Samples are filed. Responds only if interested. Art director will contact artist for portfolio review if interested. Portfolios may be dropped off every Monday, Tuesday, Wednesday, Thursday and Friday. Buys first rights. Pays on publication. Finds illustrators through agents, sourcebooks, word of mouth and artist's submissions.

Tips "Read the magazine: We show art and design and don't buy and commission much, but it does happen."

N ☑ PRISM INTERNATIONAL

Department of Creative Writing, U.B.C., Buch E462—1866 Main Mall, Vancouver BC V6T 1Z1 Canada. (604)822-2514. Fax: (604)822-3616. E-mail: prism@interchange.ubc.ca. Website: www.prism.arts.ubc.ca. Estab. 1959. Quarterly literary magazine. "We use cover art for each issue." Circ. 1,200. Original artwork is returned to the artist at the job's completion. Sample copies for $5, art guidelines for SASE with first-class postage.

Illustration Approached by 20 illustrators/year. Buys 1 cover illustration/issue. Has featured illustrations by Annette Allwood, Maria Capolongo, Mark Korn, Scott Bakal, Chris Woods, Kate Collie and Angela Grossman. Features representational and non-representational fine art. Assigns 50% of illustrations to experienced but not well-known illustrators; 50% to new and emerging illustrators. "Most of our covers are full color; however, we try to do at least one black & white cover/year."

First Contact & Terms Illustrators: Send postcard sample. Accepts submissions on disk compatible with Corel-Draw 5.0 (or lower) or other standard graphical formats. Most samples are filed. Those not filed are returned by SASE if requested by artist. Responds in 6 months. Portfolio review not required. Buys first rights. Pays on publication; $250 (Canadian) for b&w and color cover; $40 (Canadian) for b&w and color inside and 3 copies. Finds artists through word of mouth and going to local exhibits.

Tips "We are looking for fine art suitable for the cover of a literary magazine. Your work should be polished, confident, cohesive and original. Send a postcard sample of your work. As with our literary contest, we will choose work which is exciting and which reflects the contemporary nature of the magazine."

⧖ PRIVATE PILOT

265 S. Anita Dr., Suite 120, Orange CA 92868. (714)939-9991. Website: www.privatepilotmag.com. **Editorial Director:** Bill Fedorko. Managing Editor: Kara Dodge. Art Director: Jerry Ford. Estab. 1965. Monthly magazine for owners/pilots of private aircraft, student pilots and others aspiring to attain additional ratings and experience. Circ. 105,000.

• Also publishes *Custom Planes*, a monthly magazine for homebuilders and restorers. Same guidelines apply.
Illustration Works with 2 illustrators/year. Buys 10 illustrations/year. Uses artists mainly for spot art.
First Contact & Terms Illustrators: Send query letter with photocopies, tearsheets and SASE. Accepts submissions on disk (call first). Responds in 3 months. Pays $50-500 for color inside. "We also use spot illustrations as column fillers." Buys 1-2 spot illustrations/issue. Pays $35/spot.
Tips "Know the field you wish to represent; we specialize in general aviation aircraft, not jets, military or spacecraft."

⧖ PROCEEDINGS

U.S. Naval Institute, 291 Wood Rd., Annapolis MD 21402-1254. (410)268-6110. Fax: (410)269-1049. Website: www.navalinstitute.org. **Creative Director:** Karen Eskew. Monthly 4-color magazine emphasizing naval and maritime subjects. "*Proceedings* is an independent forum for the sea services." Design is clean, uncluttered layout, "sophisticated." Circ. 85,000. Accepts previously published material. Sample copies and art guidelines available.
Cartoons Buys 23 cartoons/year from freelancers. Prefers cartoons assigned to tie in with editorial topics.
Illustration Buys 1 illustration/issue. Works on assignment only. Has featured illustrations by Tom Freeman, R.G. Smith and Eric Smith. Features humorous and realistic illustration; charts & graphs; informational graphics; computer and spot illustration. Needs editorial and technical illustration. "We like a variety of styles if possible. Do excellent illustrations and meet the requirement for military appeal." Prefers illustrations assigned to tie in with editorial topics.
First Contact & Terms Cartoonists: Send query letter with samples of style to be kept on file. Illustrators: Send query letter with printed samples, tearsheets or photocopies. Accepts submissions on disk (call production manager for details). Samples are filed or are returned only if requested by artist. Responds only if interested. Publication will contact artist for portfolio review if interested. Negotiates rights purchased. Sometimes requests work on spec before assigning job. Pays cartoonists $25-50 for b&w, $50 for color. Pays illustrators $50 for b&w inside, $50-75 for color inside; $150-200 for color cover; $25 minimum for spots. "Contact us first to see what our needs are."

⧖ PROFESSIONAL TOOL & EQUIPMENT NEWS AND BODYSHOP EXPO

1233 Janesville Ave., Fort Atkinson WI 53538-2738. (920)563-6388. Fax: (920)563-1699. E-mail: info@pten.com. Website: www.pten.com. **Managing Director:** Rudy Wolf. Estab. 1990. Bimonthly trade journals. "*PTEN* covers tools and equipment used in the automotive repair industry. *Bodyshop Expo* covers tools and equipment used in the automotive bodyshop industry." Circ. 110,000 for *Professional Tool*; 62,000 for *Bodyshop Expo*. Originals returned at job's completion. Art guidelines free for SASE with first-class postage.
Cartoons Approached by 3 cartoonists/year. Buys 2 cartoons/issue. Prefers auto service and tool-related, single panel color washes with gaglines.
Illustration Approached by 3 illustrators/year. Buys 2 illustrations/issue. Works on assignment only. Considers pen & ink and airbrush.
First Contact & Terms Cartoonists: Send query letter with finished cartoons. Illustrators: Send query letter with brochure and tearsheets. Samples are not filed and returned by SASE. Responds in 1 month. Buys one-time rights. **Pays on acceptance.** Pays cartoonists $50 for b&w. Pays illustrators $100-200 for b&w, $200-500 for color inside.

⧖ ⧖ PROFIT MAGAZINE

One Mount Pleasant Rd., 11th Floor, Toronto ON M4Y 2Y5 Canada. (416)764-1402. Fax: (416)764-1404. E-mail: jhull@profitmag.ca. Website: www.profitguide.com. **Art Director:** John Hull. Estab. 1982. 4-color business magazine for Canadian entrepreneurs published 6 times/year. Circ. 102,000.
Illustration Buys 3-5 illustrations/issue. Has featured illustrations by Jerzy Kolacz, Jason Schneider, Ian Phillips. Features charts & graphs, computer, realistic and humorous illustration, informational graphics and spot illustrations of business subjects. Assigns 50% of illustrations to well-known or "name" illustrations; 50% to experienced but not well-known illustrators.
First Contact & Terms Illustrators: Send postcard or other nonreturnable samples. Accepts Mac-compatible disk submissions. Samples are not returned. Will contact artist for portfolio review if interested. Buys first rights. **Pays on acceptance**; $500-750 for color inside; $750-1,000 for 2-page spreads; $350 for spots. Pays in Canadian funds. Finds illustrators through promo pieces, other magazines.

PROGRESSIVE RENTALS

1504 Robin Hood Trail, Austin TX 78703. (512)794-0095. Fax: (512)794-0097. E-mail: nferguson@apro-rto.com. Website: www.aprovision.org. **Art Director:** Neil Ferguson. Estab. 1983. Bimonthly association publication for members of the Association of Progressive Rental Organizations, the national association of the rental-purchase industry. Circ. 5,000. Sample copies free for catalog-size SASE with first-class postage.

Illustration Buys 3-4 illustrations/issue. Has featured illustrations by Barry Fitzgerald, Aletha Reppel, A.J. Garces, Edd Patton and Jane Marinsky. Features computer and conceptual illustration. Assigns 15% of illustrations to new and emerging illustrators. Prefers cutting edge; nothing realistic; strong editorial qualities. Considers all media. "Accepts computer-based illustrations (Photoshop, Illustrator).

First Contact & Terms Illustrators: Send postcard sample, query letter with printed samples, photocopies or tearsheets. Accepts disk submissions. (Must be Photoshop-accessible EPS high-resolution [300 dpi] files or Illustrator files.) Samples are filed or returned by SASE. Responds in 1 month if interested. Rights purchased vary according to project. Pays on publication; $300-400 for color cover; $200-300 for b&w, $250-350 for color inside; $75-125 for spots. Finds illustrators mostly through artist's submissions; some from other magazines.

Tips "Illustrators who work for us must have a strong conceptual ability—that is, they must be able to illustrate for editorial articles dealing with business/management issues. We are looking for cutting-edge styles and unique approaches to illustration. I am willing to work with new, lesser-known illustrators."

THE PROGRESSIVE

409 E. Main St., Madison WI 53703. (608)257-4626. Website: www.progressive.org. **Art Director:** Nick Jehlen. Estab. 1909. Monthly b&w plus 4-color cover. Circ. 65,000. Originals returned at job's completion. Free sample copy and art guidelines.

Illustration Works with 50 illustrators/year. Buys 10 b&w illustrations/issue. Features humorous and political illustration. Has featured illustrations by Luba Lukova, Alex Nabaum and Seymour Chwast. Assigns 30% of illustrations to new and emerging illustrators. Needs editorial illustration that is "original, smart and bold." Works on assignment only.

First Contact & Terms Illustrators: Send query letter with tearsheets and/or photocopies. Samples returned by SASE. Responds in 6 weeks. Portfolio review not required. Pays $1,000 for b&w and color cover; $300 for b&w line or tone drawings/paintings/collage inside. Buys first rights. Do not send original art. Send samples, postcards or photocopies and appropriate postage for materials to be returned.

Tips Check out a copy of the magazine to see what kinds of art we've published in the past. A free sample copy is available by visiting our website.

PROTOONER

P.O. Box 2270, Daly City CA 94017-2270. Phone/fax: (650)755-4827. E-mail: protooner@earthlink.net. Website: www.protooner.lookscool.com. **Editor:** Joyce Miller. Art Director: Ladd A. Miller. Estab. 1995. Monthly trade journal for the professional cartoonist and gagwriter. Circ. 1,075. Sample copy $6 U.S., $10 foreign. Art guidelines for #10 SASE with first-class postage.

Cartoons Approached by tons of cartoonists/year. Buys 5-6 cartoons plus cover cartoon/issue. Prefers good visual humorous impact. Prefers single panel, humorous, b&w line drawings, with or without gaglines.

Illustration Approached by 6-12 illustrators/year. Buys 3 illustrations/issue. Has featured illustrations by Brewster Allison, Dan Rosandich, Art McCourt, Chris Patterson and Bob Votjko. Assigns 20% of illustrations to new and emerging illustrators. Features humorous illustration; informational graphics; spot illustration. Prefers humorous, original. Avoid vulgarity. Considers pen & ink. 50% of freelance illustration demands computer knowledge. Query for programs.

First Contact & Terms Cartoonists: Send query letter with roughs, SASE, tearsheets. Illustrators: Send query letter with printed samples and SASE. Samples are filed. Responds in 1 month. Buys reprint rights. **Pays on acceptance**. "Pays cartoonists and illustrators $25/b&w front cover and $15/inside spot drawings. We assign illustrations to accompany articles, choosing from filed samples."

Tips "Pay attention to the magazine slant and SASE a must! Study sample copy before submitting. Request guidelines. Don't mail artwork not properly slanted!"

[N] PSM: 100% INDEPENDENT PLAYSTATION 2 MAGAZINE

150 North Hill Dr., #40, Brisbane CA 94005-1018. (415)656-8447. Fax: (415)468-4686. E-mail: dfitzpatrick@futurenetworkusa.com. Website: www.futurenetworkusa.com. **Art Director:** Dan Fitzpatrick. Editor-in-Chief: Chris Slate. Estab. 1997. Monthly 4-color consumer magazine focused on PlayStation video game for preteens and up—"comic booky." Circ. 400,000. Free sample copies available.

Cartoons Prefers multiple panel, humorous b&w line drawings; manga, comic book, image style.

Illustration Approached by 20-30 illustrators/year. Buys 24 illustrations/issue. Has featured illustrations by Joe Madureira, Art Adams, Adam Warren, Hajeme Soroyana, Royo, J. Scott Campbell and Travis Charest. Features

comic-book style, computer, humorous, realistic and spot illustration. Preferred subject: video game characters. Prefers liquid! BAD@$$ computer coloring. Assigns 80% of illustrations to well-known or "name" illustrators; 10% each to experienced, but not well-known, illustrators and new and emerging illustrators. 50% of freelance illustration demands knowledge of Illustrator and Photoshop.

First Contact & Terms Cartoonists: Send query letter with b&w and color photocopies and samples. Illustrators: Send postcard sample or nonreturnable samples; send query letter with printed samples, photocopies and tearsheets. Accepts Mac-compatible disk submissions. E-mail JPEG and/or Web link (preferred method). Samples are filed. Responds only if interested. Will contact artist for portfolio review if interested. Buys all rights. Pays on publication. Finds illustrators through magazines and word of mouth.

Tips "If you are an artist, confident that your vision is unique, your quality is the best, ever seeing anew, ever evolving, send us samples!"

PSYCHOLOGY TODAY
115 E. 23rd St., 9th Floor, New York NY 10010. (212)260-7210. Fax: (212)260-7566. Website: www.psychologyto day.com. **Art Director:** Philippe Garnier. Estab. 1991. Bimonthly consumer magazine for professionals and academics, men and women. Circ. 350,000. Accepts previously published artwork. Originals returned at job's completion.

Illustration Approached by 500 illustrators/year. Buys 5 illustrations/issue. Works on assignment only. Prefers psychological, humorous, interpersonal studies. Considers all media. Needs editorial, technical and medical illustration. 20% of freelance work demands knowledge of QuarkXPress or Photoshop.

First Contact & Terms Illustrators: Send query letter with brochure, photostats and photocopies. Samples are filed and are not returned. Responds only if interested. Buys one-time rights. Pays on publication; $200-500 for color inside; $50-350 for spots; cover negotiable.

☑ PUBLIC CITIZEN NEWS
1600 20th St., NW, Washington DC 20009. (202)588-1000. Fax: (202)588-7799. E-mail: bguldin@citizen.org. Website: www.citizen.org. **Editor:** Bob Guldin. Bimonthly magazine emphasizing consumer issues for the membership of Public Citizen, a group founded by Ralph Nader in 1971. Circ. 108,000. Accepts previously published material. Sample copy available for 9×12 SASE with first-class postage.

Illustration Buys up to 2 illustrations/issue. Assigns 15% of illustrations to new and emerging illustrators. Prefers contemporary styles in pen & ink.

First Contact & Terms Illustrators: Send query letter with samples to be kept on file. Buys first rights or one-time rights. Pays on publication. Payment negotiable.

Tips "Send several keepable samples that show a range of styles and the ability to conceptualize. Want cartoons that lampoon policies and politicians, especially on the far right of the political spectrum. Magazine was redesigned into a newspaper format in 1998."

〚N〛 PUBLISHERS WEEKLY
360 Park Avenue S., New York NY 10010. (646)746-6758. Fax: (646)746-6631. Website: www.publishersweekly. com. **Art Director:** Clive Chiu. Weekly magazine emphasizing book publishing for "people involved in the creative or the technical side of publishing." Circ. 50,000. Original artwork is returned to the artist after publication.

Illustration Buys 75 illustrations/year. Works on assignment only. "Open to all styles."

First Contact & Terms Illustrators: Send postcard sample or query letter with brochure, tearsheets, photocopies. Samples are not returned. Responds only if interested. **Pays on acceptance**; $350-500 for color inside.

QUEEN OF ALL HEARTS
Montfort Missionaries, 26 S. Saxon Ave., Bay Shore NY 11706-8993. (631)665-0726. Fax: (631)665-4349. E-mail: montfort@optonline.net. Website: www.montfortmissionaries.com. **Managing Editor:** Rev. Roger Charest. Estab. 1950. Bimonthly Roman Catholic magazine on Marian theology and spirituality. Circ. 2,500. Accepts previously published artwork. Sample copy available.

Illustration Buys 1 or 2 illustrations/issue. Works on assignment only. Prefers religious. Considers pen & ink and charcoal.

First Contact & Terms Illustrators: Send postcard samples. Samples are not filed and are returned by SASE if requested by artist. Buys one-time rights. **Pays on acceptance**; $50 minimum for b&w inside.

Tips Area most open to freelancers is illustration for short stories. "Be familiar with our publication."

〚N〛 ELLERY QUEEN'S MYSTERY MAGAZINE
475 Park Ave. S., New York NY 10016. (212)686-7188. Fax: (212)686-7414. **Senior Art Director:** Victoria Green. Associate Art Director: June Levine. All submissions should be sent to June Levine, associate art director.

Emphasizes mystery stories and reviews of mystery books. Art guidelines for SASE with first-class postage.

• Also publishes *Alfred Hitchcock Mystery Magazine, Analog* and *Isaac Asimov's Science Fiction Magazine*.
Cartoons "We are looking for cartoons with an emphasis on mystery, crime and suspense."
Illustration Prefers line drawings. All other artwork is done in house.
First Contact & Terms Cartoonists: Cartoons should be addressed to Lauren Kuczala, editor. Illustrators: Send SASE and tearsheets or transparencies. Accepts disk submissions. Responds in 3 months. **Pays on acceptance**; $1,200 for color covers; $125 for b&w interior art. Considers all media in b&w and halftones. Send SASE with tearsheets or photocopies and printed samples. Accepts finished art on disc.
Tips "Please see our magazine before submitting samples."

N 🖳 QUILL & QUIRE

70 The Esplanade, #210, Toronto ON M5E 1R2 Canada. (416)360-0044. Fax: (416)955-0794. E-mail: info@quilla ndquire.com. Website: www.quillandquire.com. **Editor:** Derek Weiler. Estab. 1935. Monthly trade journal of book news and reviews for booksellers, librarians, publishers, writers and educators. Circ. 7,000. Art guidelines not available.
Illustration Approached by 25 illustrators/year. Buys 3 illustrations/issue. Has featured illustrations by Barbara Spurll, Chum McLeod and Carl Wiens. Assigns 100% of illustrations to experienced but not well-known illustrators. Considers pen & ink and collage. 10% of freelance illustration requires knowledge of Photoshop, Illustrator and QuarkXPress.
First Contact & Terms Illustrators: Send postcard sample. Accepts disk submissions. Samples are filed. Responds only if interested. Negotiates rights purchased. **Pays on acceptance**; $200-300 for b&w and color cover; $100-200 for b&w and color inside. Finds illustrators through word of mouth, artist's submissions.
Tips "Read our magazine."

RANGER RICK

1100 Wildlife Center Dr., Reston VA 20190. (703)438-6000. Website: www.nwf.org. **Art Director:** Donna D. Miller. Monthly 4-color children's magazine focusing on wildlife and conservation. Circ. 500,000. Art guidelines are free for #10 SASE with first-class postage.
Illustration Approached by 100-200 illustrators/year. Buys 4-6 illustrations/issue. Has featured illustrations by Danielle Jones, Jack Desrocher, John Dawson and Dave Clegg. Features computer, humorous, natural science and realistic illustrations. Preferred subjects: children, wildlife and natural world. Assigns 1% of illustrations to new and emerging illustrators. 50% of freelance illustration demands knowledge of Illustrator, Photoshop.
First Contact & Terms Illustrators: Send query letter with printed samples, photocopies and SASE. Accepts Mac-compatible disk submissions. Samples are filed or returned by SASE. Responds in 3 months. Will contact artist for portfolio review if interested. Buys one-time rights. Pays on publication; $50-250 for b&w inside; $150-800 for color inside; $1,000-2,000 for 2-page spreads; $350-450 for spots. Finds illustrators through promotional samples, books and other magazines.
Tips "Looking for new artists to draw animals using Illustrator, Photoshop and other computer drawing programs. Please read our magazine before submitting."

N RDH

1421 S. Sheridan, Tulsa OK 74112-6619. (918)831-9742. Fax: (918)831-9804. E-mail: mark8@pennwell.com. Website: www.pennwell.com. **Editor:** Mark Hartley. Estab. 1980. Monthly trade journal for dental hygienists. Circ. 66,388.
Illustration Buys 5 illustrations/year. Prefers pen and ink. Knowledge of Photoshop, Illustrator and QuarkXPress "nice to have but not necessary."
First Contact & Terms Send postcard or other sample. Accepts disk submissions. "Can be Quark document, but we can obtain EPS image from Illustrator." Samples are filed. Responds only if interested. Art director will contact artist for portfolio review of photographs and thumbnails if interested. Buys first rights. **Pays on acceptance**; $800 minimum for cover; $100 minimum for b&w and $250 minimum for inside. "Looking for medical illustrators."
Design Needs freelancers for design. Prefers designers with experience in media kits, brochures, etc. Freelance work demands knowledge of Photoshop, Illustrator and QuarkXPress.
Tips "Audience is 99% female. Work should 'speak' to women."

☑ REDBOOK MAGAZINE

Redbook Art Dept., 224 W. 57th St., 6th Floor, New York NY 10019-3212. (212)649-2000. Website: www.redboo kmag.com. **Contact:** Michele Tessler, deputy design director. Monthly magazine "geared to married women ages 24-39 with young children and busy lives interested in fashion, food, beauty, health, etc." Circ. 7 million.

Accepts previously published artwork. Original artwork returned after publication with additional tearsheet if requested.

Illustration Buys 3-7 illustrations/issue. Illustrations can be in any medium. Accepts fashion illustrations for fashion page.

First Contact & Terms Send quarterly postcard. Art director will contact for more samples if interested. Portfolio drop off any day, pick up 2 days later. Buys reprint rights or negotiates rights.

Tips "We are absolutely open to seeing new stuff, but look at the magazine before you send anything, we might not be right for you. Generally, illustrations should look new, of the moment, fresh, intelligent and feminine. Keep in mind that our average reader is 30 years old, pretty, stylish (but not too 'fashion-y'). We do a lot of health pieces and many times artists don't think of health when sending samples to us—so keep that in mind too."

☑ REFORM JUDAISM
633 Third Ave., 7th Floor, New York NY 10017-6778. (212)650-4240. Website: www.urj.org/rjmag. **Managing Editor:** Joy Weinberg. Estab. 1972. Quarterly magazine. "The official magazine of the Reform Jewish movement. It covers developments within the movement and interprets world events and Jewish tradition from a Reform perspective." Circ. 310,000. Accepts previously published artwork. Originals returned at job's completion. Sample copies available for $3.50.

Cartoons Prefers political themes tying into editorial coverage.

Illustration Buys 8-10 illustrations/issue. Works on assignment. 10% of freelance work demands computer skills.

First Contact & Terms Cartoonists: Send query letter with finished cartoons. Illustrators: Send query letter with brochure, résumé, SASE and tearsheets. Samples are filed. Responds in 1 month. Publication will contact artist for portfolio review if interested. Portfolio should include tearsheets, slides and final art. Rights purchased vary according to project. **Pays on acceptance**; varies according to project. Finds artists through sourcebooks and artists' submissions.

THE REPORTER
Women's American ORT, 250 Park Ave. S., Suite 600, New York NY 10003. (212)505-7700. Fax: (212)674-3057. Website: www.waort.org. **Contact:** Dana Asher. Estab. 1966. Biannual organization magazine for Jewish women emphasizing Jewish and women's issues, lifestyle, education. *The Reporter* is the magazine of Women's American ORT, a membership organization supporting a worldwide network of technical and vocational schools. Circ. 60,000. Original artwork returned at job's completion. Sample copies for SASE with first-class postage.

Illustration Buys 4-8 illustrations/issue. Works on assignment only. Prefers contemporary art. Considers pen & ink, mixed media, watercolor, acrylic, oil, charcoal, airbrush, collage and marker.

First Contact & Terms Illustrators: Send postcard sample or query letter with brochure, SASE and photographs. Samples are filed. Responds to the artist only if interested. Rights purchased vary according to project. Pays on publication; $150 and up, depending on work.

⃞ REPRO REPORT
401 N. Michigan Ave., Chicago IL 60611. (312)245-1026. Fax: (312)527-6705. E-mail: acarolton@irga.com. Website: www.irga.com. **Managing Editor:** Amy Carlton. Estab. 1928. Trade journal of the International Reprographic Association. Circ. 1,000. Art guidelines not available.

Illustration Features informational graphics; computer illustration. Assigns 100% of illustrations to new and emerging illustrators.

Design Needs freelancers for design. 80% of freelance design demands knowledge of PageMaker, Photoshop, Illustrator and CorelDraw.

First Contact & Terms Illustrators: Send postcard sample or query letter with printed samples and tearsheets. Designers: Send query letter with brochure, photocopies, photographs and tearsheets. Art director will contact artist for portfolio review if interested. Negotiates rights purchased. **Pays on acceptance**. Pays illustrators $400-500 for color cover. Pays designers by the project, $400-500. Prefers local freelancers only. Finds illustrators through word of mouth, computer users groups, direct mail.

Tips "We demand a fast turnaround and prefer art utilizing the computer."

⃞ RESIDENT AND STAFF PHYSICIAN
241 Forsgate Dr., Jamesburg NJ 08831-1385. (732)656-1140. Fax: (732)656-1955. E-mail: dbuffrey@mwc.com. Website: www.mwc.com. **Editor:** Dalia Buffery. Monthly publication emphasizing hospital medical practice from clinical, educational, economic and human standpoints. For hospital physicians, interns and residents. Circ. 100,000.

Illustration "We commission qualified freelance medical illustrators to do covers and inside material. Artists should send sample work."

First Contact & Terms Illustrators: Send query letter with brochure showing art style or résumé, tearsheets, photostats, photocopies, slides and photographs. Call or write for appointment to show portfolio of color and b&w final reproduction/product and tearsheets. **Pays on acceptance**; $800 for color cover; payment varies for inside work.

Tips "We like to look at previous work to give us an idea of the artist's style. Since our publication is clinical, we require highly qualified technical artists who are very familiar with medical illustration. Sometimes we have use for nontechnical work. We like to look at everything. We need material from the *doctor's* point of view, *not* the patient's."

RESTAURANT HOSPITALITY

1300 E. Ninth St., Cleveland OH 44114. (216)931-9942. Fax: (216)696-0836. E-mail: croberto@penton.com. **Group Creative Director:** Christopher Roberto. Circ. 123,000. Estab. 1919. Monthly trade publication emphasizing restaurant management ideas and business strategies. Readers are restaurant operators, chefs and food service chain executives.

Illustration Approached by 150 illustrators/year. Buys 5-10 illustrations per issue (combined assigned and stock illustration). Prefers food- and business-related illustration in a variety of styles. Illustrations should tie-in with the restaurant industry. Has featured illustrations by Mark Shaver, Paul Watson and Brian Raszka. Assigns 10% of illustrations to well-known or "name" illustrators; 60% to experienced but not well-known illustrators; and 30% to new and emerging illustrators. Welcomes stock submissions.

First Contact & Terms Illustrators: Send postcard samples and follow-up card every 3-6 months. Buys one-time rights. **Pays on acceptance**; $400-500 full page; $300-350 quarter-page; $250-350 for spots.

Tips "I like to work with illustrators who are trying new techniques. I particularly enjoy contemporary styles and themes that are exciting and relevant to our industry. If you have a website, please include your URL on your sample so I can view more of your work online."

RHODE ISLAND MONTHLY

280 Kinsley Ave., Providence RI 02903-4161. (401)277-8280. Fax: (401)277-8080. **Art Director:** Ellen Dessloch. Estab. 1988. Monthly 4-color magazine which focuses on life in Rhode Island. Provides the reader with in-depth reporting, service and entertainment features and dining and calendar listings. Circ. 40,000. Accepts previously published artwork. Art guidelines not available.

• Also publishes a bride magazine and tourism-related publications.

Illustration Approached by 200 freelance illustrators/year. Buys 2-4 illustrations/issue. Works on assignment. Considers all media.

First Contact & Terms Illustrators: Send self-promotion postcards or samples. Samples are filed and not returned. Buys one-time rights. Pays on publication; $250 minimum for color inside, depending on the job. Pays $600-1,000 for features. Finds artists through submissions/self-promotions and sourcebooks.

Tips "Although we use a lot of photography, we are using more illustration, especially smaller, spot or quarter-page illustrations for our columns in the front of the magazine. If we see a postcard we like, we'll log on to the illustrator's website to see more work."

RICHMOND MAGAZINE

2201 W. Broad St., Suite 105, Richmond VA 23220. (804)355-0111. Fax: (804)355-5442. E-mail: art@richmag.com. Website: www.richmag.com. **Creative Director:** Steve Hedberg. Estab. 1980. Monthly 4-color regional consumer magazine focusing on Richmond lifestyles. Circ. 25,000. Art guidelines available.

Illustration Approached by 30 illustrators/year. Buys 2-4 illustrations/issue. Has featured illustrations by Robert Megmack, Sterling Hundley, Ismael Roldan. Features realistic, conceptional and spot illustrations. Assigns 25% of illustrations to new and emerging illustrators. Uses mostly Virginia-based illustrators.

First Contact & Terms Illustrators: Send postcard sample or query letter with photocopies, tearsheets or other nonreturnable samples. Send follow-up postcard every 3 months. Send JPEG files. Samples are not returned. Will contact artist for portfolio review if interested. Pays on publication. Pays $150-350 for color cover; $100-300 for color inside. Buys one-time rights. Finds illustrators through promo samples, word of mouth, regional sourcebooks.

Tips "Be dependable, on time and have strong concepts."

RISK MANAGEMENT MAGAZINE

655 Third Ave., 2nd Floor, New York NY 10017. (212)286-9292. Website: www.rmmag.com and www.rims.org. **Art Director:** Cate Behringer. Emphasizes the risk management and insurance fields; 4-color. Monthly. Circ. 11,600.

Illustration Buys 2 freelance illustrations/issue. Uses artists for covers, 4-color inside and spots. Works on assignment only.

First Contact & Terms Illustrators: Send card showing art style or tearsheets. No drop-off policy. To show a portfolio, mail tearsheets, postcards or send website address. Printed pieces as samples only. Samples are returned only if requested. Buys one-time rights. Needs conceptual illustration. Needs computer-literate freelancers for illustration and production. 100% of freelance work demands computer literacy in Illustrator, Photoshop.

Tips When reviewing an artist's work, looks for "strong concepts, creativity and craftsmanship. Our current design uses both illustration and photography."

THE ROANOKER MAGAZINE

P.O. Box 21535, Roanoke VA 24018. (540)989-6138. E-mail: art@leisurepublishing.com. Website: www.theroanoker.com. **Art Director:** William Alexander. Production Director: Patty Jackson. Estab. 1974. Bimonthly general interest magazine for the city of Roanoke, Virginia and the Roanoke valley. Circ. 10,000. Originals are returned. Art guidelines not available.

Illustration Approached by 20-25 freelance illustrators/year. Buys 2-5 illustrations/year. Works on assignment only.

First Contact & Terms Illustrators: Send query letter with brochure, tearsheets and photocopies. Samples are filed. Responds only if interested. No portfolio reviews. Buys one-time rights. Pays on publication; $100 for b&w or color cover; $75 for b&w or color inside.

Tips "Please *do not* call or send any material that needs to be returned."

ROLLING STONE MAGAZINE

1290 Avenue of the Americas, 2nd Floor, New York NY 10104-0298. (212)484-1616. Fax: (212)484-1664. Website: www.rollingstone.com. **Art Director:** Andy Cowles. Senior Art Director: Kory Kennedy. Deputy Art Director: Devin Pedzwater. Estab. 1967. Bimonthly magazine. Circ. 1.4 million. Originals returned at job's completion. 100% of freelance design work demands knowledge of Illustrator, QuarkXPress and Photoshop. (Computer skills not necessary for illustrators). Art guidelines on website.

Illustration Approached by "tons" of illustrators/year. Buys approximately 4 illustrations/issue. Works on assignment only. Considers all media.

First Contact & Terms Illustrators: Send postcard sample and/or query letter with tearsheets, photocopies or any appropriate sample. Samples are filed. Does not reply. Portfolios may be dropped off every Tuesday before 3 p.m. and should include final art and tearsheets. Portfolios may be picked back up on Friday after 3 p.m. "Please make sure to include your name and address on the outside of your portfolio." Publication will contact artist for portfolio review if interested. Buys first and one-time rights. **Pays on acceptance**; payment for cover and inside illustration varies; pays $300-500 for spots. Finds artists through word of mouth, *American Illustration*, *Communication Arts*, mailed samples and drop-offs.

THE ROTARIAN

1560 Sherman Ave., Evanston IL 60201-4818. (847)866-3000. Fax: (847)866-9732. E-mail: rotarian@rotaryintl.org. Website: www.rotary.org. Managing Editor: Janice Chambers. **Contact:** D. Lawrence, creative director. Estab. 1911. Monthly 4-color publication emphasizing general interest, business and management articles. The official magazine of Rotary International, a service organization for business and professional men and women, their families and other subscribers. Circ. 510,000. Accepts previously published artwork.

- This creative director told *ADGM* that although she accepts hardcopy submissions, she no longer has time to reply (even with SASE). She will, however, keep the samples she likes on file. She only responds directly to e-mail submissions.

Cartoons Buys 5-8 cartoons/year. Interested in general themes with emphasis on business and sports. Avoid topics of sex, national origin, politics.

Illustration "Rarely purchase illustrations. Primarily purchase photography."

First Contact & Terms Prefers digital submissions. Cartoonists: Send query letter to Cartoon Editor, with brochure showing art style. Illustrators: Send query letter to art director with photocopies or brochure showing art style. To show portfolio, artist should follow up with a call or letter after initial query. Buys all rights. **Pays on acceptance**. Pays cartoonists $100. Illustrator payment negotiable, depending on size, medium, etc.; $800-1,000 for color cover; $75-150 for b&w inside; $200-700 for color inside.

RUNNER'S WORLD

135 N. 6th St., Emmaus PA 18098. (610)967-5171. Fax: (610)967-8883. E-mail: rwedit@runnersworld.com. Website: www.runnersworld.com. **Art Director:** Robert Festino. Director of Special Editorial Projects: Ken Kleppert. Estab. 1965. Monthly 4-color with a "contemporary, clean" design emphasizing serious, recreational

Magazines

running. Circ. 530,511. Accepts previously published artwork "if appropriate." Returns original artwork after publication. Art guidelines not available.

Illustration Approached by hundreds of illustrators/year. Works with 50 illustrators/year. Buys average of 10 illustrations/issue. Has featured illustrations by Sam Hundley, Gil Eisner, Randall Enos and Katherine Adams. Features humorous and realistic illustration; charts & graphics; informational graphics; computer and spot illustration. Assigns 40% of illustrations to well-known or "name" illustrators; 40% to experienced but not well-known illustrators; 20% to new and emerging illustrators. Needs editorial, technical and medical illustrations. "Styles include tightly rendered human athletes, graphic and cerebral interpretations of running themes. Also, *RW* uses medical illustration for features on biomechanics." No special preference regarding media but appreciates electronic transmission. "No cartoons or originals larger than 11×14." Works on assignment only. 30% of freelance work demands knowledge of Illustrator, Photoshop or FreeHand.

First Contact & Terms Illustrators: Send postcard samples to be kept on file. Accepts submissions on disk compatible with Illustrator 5.0. Send EPS files. Publication will contact artist for portfolio review if interested. Buys one-time international rights. Pays $1,800 maximum for 2-page spreads; $400 maximum for spots. Finds artists through word of mouth, magazines, submissions/self-promotions, sourcebooks, artists' agents and reps and attending art exhibitions.

Tips Portfolio should include "a maximum of 12 images. Show a clean presentation, lots of ideas and few samples. Don't show disorganized thinking. Portfolio samples should be uniform in size. Be patient!"

N RUNNING TIMES

213 Danbury Rd., Wilton CT 06897. (203)761-1113. Fax: (203)761-9933. E-mail: editor@runningtimes.com. Website: www.runningtimes.com. **Art Director:** Troy Santi. Estab. 1977. Monthly consumer magazine covers sports, running. Circ. 80,098. Originals returned at job's completion. Sample copies available; art guidelines available.

Cartoons Used occasionally.

Illustration Buys 3-4 illustrations/issue. Works on assignment only. Has featured illustrations by Ben Fishman, Peter Hoex and Paul Cox. Features humorous, medical, computer and spot illustration. Considers pen & ink, colored pencil, mixed media, collage, charcoal, acrylic, oil. 100% of freelance work demands knowledge of QuarkXPress, Photoshop, FreeHand and Illustrator.

Design Needs freelancers for design and production. 100% of design demands knowledge of FreeHand 4.0, Photoshop 3.1, QuarkXPress 3.3 and Illustrator 5.0.

First Contact & Terms Illustrators: Send postcard sample or query letter with tearsheets. Designers: Send query letter with résumé and tearsheets. Accepts disk submissions compatible with Photoshop, FreeHand or Illustrator. Samples are filed. Publication will contact artist for portfolio review of roughs, final art and tearsheets if interested. Buys one-time rights. Pays illustrators on publication; $400-600 for color inside; $250 maximum for b&w inside; $350 maximum for color inside; $500 maximum for 2-page spreads; $300 maximum for spots. Pays designers by the hour, $20. Finds artists through illustration annuals, mailed samples, published work in other magazines.

Tips "Look at previous issues to see that your style is appropriate. Send multiple samples and send samples regularly. I don't usually give an assignment based on one sample. Send out cards to as many publications as you can and make phone calls to set up appointments with the ones you are close enough to get to."

N SACRAMENTO NEWS & REVIEW

Chico Community Publishing, 1015 20th St., Sacramento CA 95814. (916)498-1234. Fax: (916)498-7930. E-mail: andrewe@newsreview.com. Website: www.newsreview.com. **Art Director:** AJ Epstein. Estab. 1989. "An award-winning black & white with 4-color cover alternative newsweekly for the Sacramento area. We combine a commitment to investigative and interpretive journalism with coverage of our area's growing arts and entertainment scene." Circ. 90,000. Occasionally accepts previously published artwork. Originals returned at job's completion. Art guidelines not available.

• Also publishes issues in Chico, CA and Reno, NV.

Illustration Approached by 50 illustrators/year. Buys 1 illustration/issue. Works on assignment only. Features caricatures of celebrities and politicans; humorous, realistic, computer and spot illustrations. Assigns 50% of illustrations to new and emerging illustrators. For cover art, needs themes that reflect content.

First Contact & Terms Illustrators: Send postcard sample or query letter with photocopies, photographs, SASE, slides and tearsheets. Accepts disk submissions compatible with Photoshop. Samples are filed. Publication will contact artist for portfolio review if interested. Portfolio should include tearsheets, slides, photocopies, photographs or Mac floppy disk. Buys first rights. **Pays on acceptance**; $75-150 for b&w cover; $150-300 for color cover; $20-75 for b&w inside; $10-40 for spots. Finds artists through submissions.

Tips "Looking for colorful, progressive styles that jump off the page. Have a dramatic and unique style . . . not traditional or common."

ℕ SAILING MAGAZINE

P.O. Box 249, Port Washington WI 53074-0249. (262)284-3494. Fax: (262)284-7764. E-mail: sailingmag@amerit ech.net. Website: www.sailingonline.com. **Editor:** Greta Schanen. Estab. 1966. Monthly 4-color literary magazine featuring sailing with a photography-oriented large format. Circ. 43,223.

Illustration Has featured illustrations by Marc Castelli. Features realistic illustrations, spot illustrations, map art and technical illustrations (sailboat plans). Preferred subjects: nautical. Prefers pen & ink with color wash.

First Contact & Terms Illustrators: Send query letter with photocopies. Accepts Mac-compatible disk submissions. Send EPS, PDF or TIFF files. Samples are filed or returned by SASE. Responds within 2 months. Will contact artist for portfolio review if interested. Rights purchased vary according to project. Pays on publication; $25-100 for b&w inside, $25-100 for color inside, $200-500 for 2-page spreads, $25 for spots. "Freelancers find us; we have no need to look for them."

Tips "Freelance art very rarely used."

SALES & MARKETING MANAGEMENT MAGAZINE

770 Broadway., New York NY 10003. (646)654-7608. Fax: (646)654-7616. E-mail: abass@salesandmarketing.c om. Website: www.salesandmarketing.com. **Contact:** Andrew Bass, art director. Monthly trade magazine providing a much needed community for sales and marketing executives to get information on how to do their jobs with colleagues and receive exclusive research and tools that will help advance their careers. Circ. 65,000. Sample copies available on request (depending on availability).

Illustration Approached by 250-350 illustrators/year. Buys over 1,200 illustrations/year. Has featured illustrations by Douglas Fraser, Murray Kimber, Chris Sickels. Features charts & graphs, humorous, realistic and spot illustrations. Prefers business subjects. 5% of freelance illustration demands knowledge of Illustrator or Photoshop.

First Contact & Terms Illustrators: Send query letter with samples. Accepts Mac-compatible JPEG or EPS files, or link to website. Samples are filed. Will contact artist for portfolio review if interested. Portfolio should include photographs, slides and tearsheets. Buys first North American serial rights or one-time rights. Pays illustrators $1,000-1,500 for b&w cover; $1,500-2,000 for color cover; $250-950 for b&w inside; $450-1,000 for color inside; 1,200-1,650 for 2-page spreads. Finds illustrators through agents, artists' submissions, *WorkBook*, *Art Pick*, *American Showcase* and word of mouth.

SALT WATER SPORTSMAN

263 Summer St., Boston MA 02210. (617)303-3660. Fax: (617)303-3661. Website: www.saltwatersportsman.c om. **Art Director:** Chris Powers. Estab. 1939. Monthly consumer magazine describing the how-to and where-to of salt water sport fishing in the US, Caribbean and Central America. Circ. 163,369. Accepts previously published artwork. Originals returned at job's completion. Art guidelines available by e-mailing jason.wood@ti me4.com.

Illustration Buys 4-5 illustrations/issue. Works on assignment only. Considers pen & ink, watercolor, acrylic, charcoal and electronic art files.

Design Needs freelancers for design. 10% of freelance work demands knowledge of Photoshop, Illustrator, QuarkXPress.

First Contact & Terms Send query letter with tearsheets, photocopies, SASE and transparencies. Samples are not filed and are returned by SASE if requested by artist. Publication will contact artist for portfolio review if interested. Portfolio should include b&w and color tearsheets and final art. Buys first rights. **Pays on acceptance.** Pays illustrators $500-1,000 for color cover; $50 for b&w inside; $100 for color inside. Pays designers by the project. Finds artists mostly through submissions.

Tips Areas most open to freelancers are how-to, semi-technical drawings for instructional features and columns; occasional artwork to represent fishing action or scenes. "Look the magazine over carefully to see the kind of art we run—focus on these styles."

SAN FRANCISCO BAY GUARDIAN

135 Mississippi St., San Francisco CA 94103. (415)255-3100. Website: www.sfbg.com. **Art Director:** Victor Krummenacher. For "a young, liberal, well-educated audience." Circ. 157,000. Weekly newspaper; tabloid format, b&w with 4-color cover, "progressive design." Art guidelines not available.

Illustration Has featured illustrations by Mark Matcho, John Veland, Barbara Pollack, Gabrielle Drinard and Gus D'Angelo. Features caricatures of politicans; humorous, realistic and spot illustration. Assigns 30% of illustrations to new and emerging illustrators. Weekly assignments given to local artists. Subjects include political and feature subjects. Preferred styles include contemporary, painterly and graphic line—pen and woodcut. "We like intense and we like fun." Artists who exemplify desired style include Tom Tommorow and George Rieman.

Design 100% of freelance work demands knowledge of Photoshop, Illustrator, QuarkXPress. Prefers diversified talent.

First Contact & Terms Designers: Send query letter with photocopies, photographs and tearsheets. Pays illustrators on publication; $300-315 for b&w and color cover; $34-100 for b&w inside; $75-150 for color inside; $100-250 for 2-page spreads; $34-100 for spots. Pays for design by the project.

Tips "Please submit samples and letter before calling. Turnaround time is generally short, so long-distance artists generally will not work out." Advises freelancers to "have awesome work—but be modest."

SANTA BARBARA MAGAZINE

25 E. De La Guerra St., Santa Barbara CA 93101-2217. (805)965-5999. Fax: (805)965-7627. E-mail: editor@sbmag .com. Website: www.sbmag.com. **Art Director:** Alisa Baur. Estab. 1975. Bimonthly 4-color magazine with classic design emphasizing Santa Barbara culture and community. Circ. 32,500. Original artwork returned after publication if requested. Sample copy for $3.50.

Illustration Approached by 20 illustrators/year. Works with 2-3 illustrators/year. Buys about 1-3 illustrations/year. Uses freelance artwork mainly for departments. Works on assignment only.

First Contact & Terms Send postcard, tearsheets or photocopies. To show a portfolio, mail b&w and color art, final reproduction/product and tearsheets; will contact if interested. Buys first rights. **Pays on acceptance**; approximately $275 for color cover; $175 for color inside. "Payment varies."

Tips "Be familiar with our magazine."

THE SATURDAY EVENING POST

1100 Waterway Blvd., Indianapolis IN 46202. (317)634-1100. Fax: (317)637-0126. E-mail: Satevepst@aol.com. Website: www.satevepost.org. Estab. 1728. Preventative health magazine with a general-interest slant. Published 6 times/year. Circ. 400,000. Sample copy $5.

Cartoons Cartoon Editor: Steven Pettinga. Mail cartoon submissions to: Post Toons, Box 567, Indianapolis IN 46202. Buys about 30 cartoons/issue. Uses freelance artwork mainly for humorous fiction. Prefers single panel with gaglines. Receives 100 batches of cartoons/week. "We look for cartoons with neat line or tone art. The content should be in good taste, suitable for a general-interest, family magazine. It must not be offensive while remaining entertaining. Review our guidelines online and then review recent issues. Political, violent or sexist cartoons are not used. Need all topics, but particularly medical, health, travel and financial."

Illustration Art Director: Chris Wilhoite. Uses average of 3 illustrations/issue. Send query letter with brochure showing art style or résumé and samples. To show a portfolio, mail final art. Buys all rights, "generally. All ideas, sketchwork and illustrative art are handled through commissions only and thereby controlled by art direction. Do not send original material (drawings, paintings, etc.) or 'facsimiles of' that you wish returned." Cannot assume any responsibility for loss or damage.

First Contact & Terms Cartoonists: SASE. Illustrators: "If you wish to show your artistic capabilities, please send nonreturnable, expendable/sampler material (slides, tearsheets, photocopies, etc.)." Responds in 2 months. Pays on publication. Pays cartoonists $125 for b&w line drawings and washes, no pre-screened art. Pays illustrators $1,000 for color cover; $175 for b&w, $450 for color inside.

Tips "Send samples of work published in other publications. Do not send racy or too new wave looks. Have a look at the magazine. It's clear that 50% of the new artists submitting material have not looked at the magazine."

Ⓝ THE SCHOOL ADMINISTRATOR

%American Association of School Administrators, 801 N. Quincy St., Suite 700, Arlington VA 22203-1730. (703)528-0700. Fax: (703)841-1543. E-mail: lgriffin@aasa.org. Website: www@aasa.org. **Managing Editor:** Liz Griffin. Monthly association magazine focusing on education. Circ. 25,000.

Cartoons Approached by 75 editorial cartoonists/year. Buys 11 cartoons/year. Prefers editorial/humorous, b&w/color washes or b&w line drawings. "Humor should be appropriate to a CEO of a school system, not a classroom teacher."

Illustration Approached by 60 illustrators/year. Buys 1-2 illustrations/issue. Has featured illustrations by Michael Gibbs, Ralph Butler, Paul Zwolak, Heidi Younger and Claudia Newell. Features spot and computer illustrations. Preferred subjects: education K-12. Assigns 50% of illustrations to experienced but not well-known illustrators; 50% to well-known or "name" illustrators. Considers all media. "Prefers illustrators who can take a concept and translate it into a simple powerful image and who can deliver art in digital form."

First Contact & Terms Cartoonists: Send photocopies and SASE. Buys one-time rights. **Pays on acceptance**. Send nonreturnable samples. Samples are filed and not returned. Responds only if interested. Rights purchased vary according to project. Pays on publication. Pays illustrators $650 for color cover. Finds illustrators through word of mouth, stock illustration source and Creative Sourcebook.

Tips "Read our magazine. I like work that takes a concept and translates it into a simple, powerful image. Check out our website."

ⓃSCHOOL BUSINESS AFFAIRS

11401 N. Shore Dr., Reston VA 20190-4200. (703)478-0405. Fax: (703)478-0205. Website: www.asbointl.org. **Managing Editor:** Siobhan McMahon. Monthly trade publication for school business officials. Circ. 6,000. Accepts previously published artwork. Originals are returned at job's completion. Sample copies available; art guidelines not available.

Illustration Buys 2 illustrations/issue. Prefers business-related themes.

First Contact & Terms Illustrators: Send query letter with tearsheets. Accepts disk submissions compatible with IBM format; Illustrator 4.0. Samples are filed. Responds to the artist only if interested. Portfolio review not required. Rights purchased vary according to project.

Tips "Tell me your specialties, your style—do you prefer realistic, surrealistic, etc. Include range of works with samples."

ⓃSCIENTIFIC AMERICAN

415 Madison Ave., New York NY 10017-1111. (212)754-0550. Fax: (212)755-1976. Website: www.sciam.com. Contact: Jana Brenning, senior associate art director. Monthly 4-color consumer magazine emphasizing scientific information for educated readers, covering geology, astronomy, medicine, technology and innovations. Circ. 650,000.

Illustration Approached by 100 illustrators/year. Buys 5-6 illustrations/issue. Has featured illustrations by John McFaul, Dave Cutler, Jo Sloan, George Retseck, Matt Mahurin, Brian Cronin and Roz Chast. Features science related charts & graphs, natural history and spot illustrations and humorous spot illustration. Assigns 100% of illustrations to experienced but not well-known illustrators.

First Contact & Terms Illustrators: Send postcard sample and follow-up postcard every 3-4 months. Samples are filed. Responds only if interested. Will contact artist for portfolio review if interested. Buys one-time rights. **Pays on acceptance**; $750-1,000 for color inside; $350-750 for spots.

Tips "Illustrators should look at target markets more closely. Don't assume what a magazine wants, in terms of illustration, by its title. We're *Scientific American*, and we do use science illustration but we use a lot of other types of illustration as well, such as work by Roz Chast, which you might not think would fit with out publication. Many not-so-well-known publications have large budgets for illustration."

SCRAP

1325 G St. N.W., Suite 1000, Washington DC 20005-3104. (202)662-8547. Fax: (202)626-0947. E-mail: kentkiser @scrap.org. Website: www.scrap.org. **Editor:** Kent Kiser. Estab. 1987. Bimonthly 4-color trade publication that covers all aspects of the scrap recycling industry. Circ. 7,000.

Cartoons "We run single-panel cartoons that focus on the recycling theme/business."

Illustration Approached by 100 illustrators/year. Buys 0-2 illustrations/issue. Features realistic illustrations, business/industrial/corporate illustrations and international/financial illustrations. Prefered subjects: business subjects. Assigns 10% of illustrations to new and emerging illustrators.

First Contact & Terms Illustrators: Send postcard sample. Samples are filed. Responds in 2 weeks. Portfolio review not required. Buys first North American serial rights. **Pays on acceptance**; $1,200-2,000 for color cover; $300-1,000 for color inside. Finds illustrators through creative sourcebook, mailed submissions, referrals from other editors, and "direct calls to artists whose work I see and like."

Tips "We're always open to new talent and different styles. Our main requirement is the ability and willingness to take direction and make changes if necessary. No prima donnas, please. Send a postcard to let us see what you can do."

✔SCREEN ACTOR

5757 Wilshire Blvd., Los Angeles CA 90036. (323)549-6654. **National Director of Communication:** Ilyanne Morden Kichaven. Estab. 1933. Quarterly trade journal; magazine format. Covering issues of concern to performers. Circ. 120,000.

✔SEA MAGAZINE

17782 Cowan, Suite A, Irvine CA 92614. (949)660-6150. Fax: (949)660-6172. E-mail: editorial@goboatingameric a.com. Website: www.goboatingamerica.com. **Art Director:** Julie Hogan. Estab. 1908. Monthly 4-color magazine emphasizing recreational boating for owners or users of recreational powerboats, primarily for cruising and general recreation; some interest in boating competition; regionally oriented to 13 Western states. Circ. 55,000. Accepts previously published artwork. Return of original artwork depends upon terms of purchase. Sample copy for SASE with first-class postage.

• Also publishes *Go Boating* magazine.

Illustration Approached by 20 illustators/year. Buys 10 illustrations/year mainly for editorial. Considers airbrush, watercolor, acrylic and calligraphy.

First Contact & Terms Illustrators: Send query letter with brochure showing art style. Samples are returned only if requested. Publication will contact artist for portfolio review if interested. Portfolio should include tearsheets and cover letter indicating price range. Negotiates rights purchased. Pays on publication; $50 for b&w; $250 for color inside (negotiable).

Tips "We will accept students for portfolio review with an eye to obtaining quality art at a reasonable price. We will help start career for illustrators and hope that they will remain loyal to our publication."

⃞ᴺ SEATTLE MAGAZINE

1505 Western Ave., Suite 500, Seattle WA 98101. (206)284-1750. Fax: (206)284-2550. E-mail: sue@seattlemag.com. Website: www.seattlemag.com. **Art Director:** Sue Boylan. Estab. 1992. Monthly urban lifestyle magazine covering Seattle. Circ. 48,000. E-mail director directly for art guidelines.

Illustration Approached by hundreds of illustrators/year. Buys 2 illustrations/issue. Considers all media. "We can scan any type of illustration."

First Contact & Terms Illustrators: Prefers e-mail submissions. Samples are filed. Responds only if interested. Art director will contact artist for portfolio review of color, final art and transparencies if interested. Buys one-time rights. Sends payment on 15th of month of publication. Pays on publication; $150-1,100 for color cover; $50-400 for b&w; $50-1,100 for color inside; $50-400 for spots. Finds illustrators through agents, sourcebooks such as *Creative Black Book*, *LA Workbook*, online services, magazines, word of mouth, artist's submissions, etc.

Tips "Good conceptual skills are the most important quality that I look for in an illustrator as well as unique skills."

SEATTLE WEEKLY

1008 Western Ave., Suite 300, Seattle WA 98104. (206)623-0500. Fax: (206)467-4338. E-mail: ksteichen@seattleweekly.com. Website: www.seattleweekly.com. **Contact:** Art Director. Estab. 1975. Weekly consumer magazine; tabloid format; news with emphasis on local and national issues and arts events. Circ. 102,000. Accepts previously published artwork. Original artwork can be returned at job's completion if requested, "but you can come and get them if you're local." Sample copies available for SASE with first-class postage. Art guidelines not available.

Illustration Approached by 30-50 freelance illustrators/year. Buys 3 freelance illustrations/issue. Works on assignment only. Prefers "sophisticated themes and styles."

First Contact & Terms Illustrators: Send query letter with tearsheets and photocopies. Samples are filed and are not returned. Does not reply, in which case the artists should "revise work and try again." To show a portfolio, mail b&w and color photocopies; "always leave us something to file." Buys first rights. Pays on publication; $200-250 for color cover; $60-75 for b&w inside.

Tips "Give us a sample we won't forget. A really beautiful mailer might even end up on our wall, and when we assign an illustration, you won't be forgotten. All artists used must sign contract. Feel free to e-mail for a copy."

⃞ᴺ SELF EMPLOYED AMERICA

P.O. Box 612067, DFW Airport, Dallas TX 75261-2067. (817)310-4365. Fax: (817)310-4100. Website: www.nase.org. Contact: Patty Harkins, art director. Bimonthly 4-color trade publication for owners of small businesses. Circ. 200,000.

Illustration Approached by 200 illustrators/year. Buys 2 illustrations/issue. Features men's and women's home business or small business-related illustrations.

First Contact & Terms Illustrators: Send postcard sample. Samples are filed. Buys one-time rights. Payment varies.

⃞ᴺ THE $ENSIBLE SOUND

403 Darwin Dr., Snyder NY 14226. (716)833-0930. Fax: (716)833-0929 (5 p.m.-9 a.m.). E-mail: sensisound@aol.com. **Publisher:** John A. Horan. Editor: Karl Nehring. Bimonthly publication emphasizing audio equipment for hobbyists. Circ. 13,600. Accepts previously published material and simultaneous submissions. Original artwork returned after publication. Sample copy for $3.

Cartoons Uses 4 cartoons/year. Prefers single panel, with or without gagline; b&w line drawings.

First Contact & Terms Will accept material on Mac-formatted disk or format via e-mail. Responds in 1 month. Negotiates rights purchased. Pays on publication; rate varies.

Tips "Audio hobbyist material only please. We receive all types of material but never anything appropriate."

N SIERRA MAGAZINE

85 Second St., 2nd Floor, San Francisco CA 94105-3441. (415)977-5572. Fax: (415)977-5794. E-mail: sierra.letters @sierraclub.org. Website: www.sierraclub.org. **Art Director:** Martha Geering. Bimonthly consumer magazine featuring environmental and general interest articles. Circ. 500,000.

Illustration Buys 8 illustrations/issue. Considers all media. 10% of freelance illustration demands computer skills.

First Contact & Terms Illustrators: Send postcard samples or printed samples, SASE and tearsheets. Samples are filed and are not returned. Responds only if interested. Call for specific time for drop off. Art director will contact artist for portfolio review if interested. Buys one-time rights. Finds illustrators through illustration and design annuals, sourcebooks. submissions, magazines, word of mouth.

SIGNS OF THE TIMES

1350 N. King's Rd., Nampa ID 83687. (208)465-2592. E-mail: merste@pacificpress.com. Website: www.pacificp ress.com. **Art Director:** Merwin Stewart. A monthly Seventh-day Adventist 4-color publication that examines contemporary issues such as health, finances, diet, family issues, exercise, child development, spiritual growth and end-time events. ''We attempt to show that Biblical principles are relevant to everyone.'' Circ. 200,000. Art guidelines available for SASE with first-class postage.

• They accept illustrations in electronic form provided to their ftp site by prior arrangement or sent as e-mail attachments.

Illustration Buys 6-10 illustrations/issue. Works on assignment only. Has featured illustrations by Ron Bell, Darren Thompson, Consuelo Udave and Lars Justinen. Features realistic illustration. Assigns 10% of illustrations to new and emerging illustrators. Prefers contemporary ''realistic, stylistic, or humorous styles (but not cartoons).'' Considers any media.

First Contact & Terms Send postcard sample, brochure, photographs, tearsheets or transparencies. Samples are not returned. ''Tearsheets or color photos (prints) are best, although color slides are acceptable.'' Publication will contact artist for more samples of work if interested. Buys first-time North American publication rights. **Pays on acceptance** (30 days); $800 for color cover; $100-300 for b&w inside; $300-700 for color inside. Fees negotiable depending on needs and placement, size, etc. in magazine. Finds artists through submissions, sourcebooks and sometimes by referral from other art directors.

Tips ''Most of the magazine illustrations feature people. Approximately 20 visual images (photography as well as artwork) are acquired for the production of each issue, half in black & white, half in color, and the customary working time frame is 3 weeks. Quality artwork and timely delivery are mandatory for continued assignments. It is customary for us to work with highly skilled and dependable illustrators for many years.'' Advice for artists: ''Invest in a good art school education, learn from working professionals within an internship, and draw from your surroundings at every opportunity. Get to know lots of people in the field where you want to market your work, and consistently provide samples of your work so they'll remember you. Then relax and enjoy the adventure of being creative.''

N SKI MAGAZINE

929 Pearl St., Suite 200, Boulder CO 80302. (303)448-7649. Fax: (303)448-7638. Website: www.skimag.com. **Art Director:** Eleanor Williamson. Estab. 1936. Emphasizes instruction, resorts, equipment and personality profiles. For new, intermediate and expert skiers. Published 8 times/year. Circ. 450,000. Previously published work OK ''if we're notified.''

Illustration Approached by 30-40 freelance illustrators/year. Buys 25 illustrations/year.

First Contact & Terms Illustrators: Mail art and SASE. Responds immediately. Buys one-time rights. **Pays on acceptance;** $1,200 for color cover; $150-500 for color inside.

Tips ''The best way to break in is an interview and a consistent style portfolio. Then, keep us on your mailing list.''

SKIPPING STONES

P.O. Box 3939, Eugene OR 97403-0939. (541)342-4956. E-mail: editor@SkippingStones.org. Website: www.Skip pingStones.org. **Editor:** Arun Toké. Estab. 1988. Bimonthly b&w (with 4-color cover) consumer magazine. International nonprofit multicultural and nature education magazine for today's youth. Circ. 2,500. Art guidelines are free for SASE with first-class postage. Sample copy available for $5.

Cartoons Prefers multicultural, social issues, nature/ecology themes. Requests b&w washes and line drawings. Featured cartoons by Lindy Wojcicki of Florida. Prefers cartoons by youth under age 19.

Illustration Approached by 100 illustrators/year. Buys 10-20 illustrations/year. Has featured illustrations by Greg Acuna, Elizabeth Wilkinson, Vermont; Inna Svjatova, Russia; Jon Bush, US. Features humorous illustration, informational graphics, natural history and realistic, authentic illustrations. Preferred subjects: children and teens. Prefers pen & ink. Assigns 80% of work to new and emerging illustrators.

First Contact & Terms Cartoonists: Send b&w photocopies and SASE. Illustrators: Send nonreturnable photocopies and SASE. Samples are filed or returned by SASE. Responds in 3 months if interested. Portfolio review not required. Buys first rights, reprint rights. Pays on publication 1-5 copies. Finds illustrators through word of mouth, artists' promo samples.

Tips "We are a gentle, non-glossy, ad-free magazine not afraid to tackle hard issues. We are looking for work that challenges the mind, charms the spirit, warms the heart; handmade, non-violent, global, for youth 8-15 with multicultural/nature content. Please, no aliens or unicorns. We are especially seeking work by young artists under 19 years of age! People of color and international artists are especially encouraged."

Ⓝ SKYDIVING MAGAZINE

1725 N. Lexington Ave., DeLand FL 32724. (386)736-4793. Fax: (386)736-9786. E-mail: editor@skydivingmagazine.com. Website: www.skydivingmagazine.com. **Editor:** Sue Clifton. Estab. 1979. "Monthly magazine on the equipment, techniques, people, places and events of sport parachuting." Circ. 14,200. Originals returned at job's completion if requested. Sample copies available; art guidelines not available.

Cartoons Approached by 10 cartoonists/year. Buys 2 cartoons/issue. Has featured cartoons by Craig Robinson. Prefers skydiving themes; single panel, with gagline.

First Contact & Terms Cartoonists: Send query letter with roughs. Samples are filed. Responds in 2 weeks. Buys one-time rights. Pays $25 for b&w.

Ⓝ SLACK PUBLICATIONS

6900 Grove Rd., Thorofare NJ 08086-9447. (856)848-1000. Fax: (856)853-5991. E-mail: lbaker@slackinc.com. Website: www.slackinc.com. **Creative Director:** Linda Baker. Estab. 1960. Publishes 22 medical publications dealing with clinical and lifestyle issues for people in the medical professions. Accepts previously published artwork. Originals returned at job's completion. Art guidelines not available.

Illustration Approached by 50 illustrators/year. Buys 2 illustrations/issue. Works on assignment only. Features humorous and realistic illustration; charts & graphs; infomational graphics; medical, computer and spot illustration. "No cartoons." Assigns 5% of illustrations to well-known or "name" illustrators; 90% to experienced but not well-known illustrators; 5% to new and emerging illustrators. Prefers watercolor, airbrush, acrylic, oil and mixed media.

First Contact & Terms Send query letter with tearsheets, photographs, photocopies, slides and transparencies. Samples are filed and are returned by SASE if requested by artist. Responds to the artist only if interested. To show a portfolio, mail b&w and color tearsheets, slides, photostats, photocopies and photographs. Negotiates rights purchased. Pays on publication: $200-400 for b&w cover; $400-600 for color cover; $100-200 for b&w inside; $100-350 for color inside; $50-150 for spots.

Tips "Send samples."

SMALL BUSINESS TIMES

1123 N. Water St., Milwaukee WI 53202. (414)277-8181. Fax: (414)277-8191. Website: www.biztimes.com. **Art Director:** Shelly Paul. Estab. 1995. Biweekly newspaper/magazine business-to-business publication for southeast Wisconsin.

Illustration Approached by 80 illustrators/year. Uses 3-5 illustrations/issue. Has featured illustrations by Jennifer Ingram, Marla Campbell, Dave Crosland, Brad Hamann, Fedrico Jordan, Michael Waraska. Features charts & graphs, computer, humorous illustration, informational graphics, realistic and b&w spot illustrations. Prefers business subjects in simpler styles that reproduce well on newsprint. Assigns 75% of work to new and emerging illustrators.

First Contact & Terms Illustrators: Send postcard sample and follow-up postcard every year. Accepts Mac-compatible disk submissions. Send EPS or TIFF files. Will contact artist for portfolio review if interested. Buys one-time rights. Pays illustrators $200-400 for color cover; $80-100 for inside. **Pays on acceptance**.

Tips "Conceptual work wanted! Audience is business men and women in southeast Wisconsin. Need ideas relative to today's business issues/concerns (insurance, law, banking, commercial, real estate, health care, manufacturing, finance, education, technology, retirement). One- to two-week turnaround."

Ⓝ SMITHSONIAN MAGAZINE

750 Ninth St. NW, Suite 7100, Washington DC 20560-0001. (202)275-2000. Fax: (202)275-1986. Website: www.smithsonianmag.com. **Art Director:** Brian Noyes. Associate Art Director: Erik K. Washam. Monthly consumer magazine exploring lifestyles, cultures, environment, travel and the arts. Circ. 2,088,000.

Illustration Approached by hundreds of illustrators/year. Buys 1-3 illustrations/issue. Has featured illustrations by Elizabeth Wolf. Features charts & graphs, informational graphics, humorous, natural history, realistic and spot illustration.

First Contact & Terms Samples are filed. Responds only if interested. Will contact artist for portfolio review if

Magazines

interested. Buys first rights. **Pays on acceptance**; $200-1,000 for color inside. Finds illustrators through agents and word of mouth.

SOAP OPERA DIGEST
261 Madison Ave., 10th Floor, New York NY 10016-2303. (212)716-2700. **Design Creative:** Virginia Bassett. Estab. 1976. Emphasizes soap opera and prime-time drama synopses and news. Weekly. Circ. 2 million. Accepts previously published material. Returns original artwork after publication upon request. Sample copy available for SASE.
Tips "Review the magazine before submitting work."

SOAP OPERA WEEKLY
261 Madison Ave., New York NY 10016. (212)716-8400. **Art Director:** Susan Ryan. Estab. 1989. Weekly 4-color consumer magazine; tabloid format. Circ. 600,000-700,000. Original artwork returned at job's completion.
Illustration Approached by 50 freelance illustrators/year. Works on assignment only.
First Contact & Terms Illustrators: Send query letter with brochure and soap-related samples. Samples are filed. Request portfolio review in original query. Publication will contact artist for portfolio review if interested. Portfolio should include original/final art. Buys first rights. **Pays on acceptance**; $2,000 for color cover; $750 for color, full page.

SOLIDARITY MAGAZINE
Published by United Auto Workers, 8000 E. Jefferson, Detroit MI 48214. (313)926-5291. Fax: (313)331-1520. E-mail: uawsolidarity@uaw.net. Website: www.uaw.org. **Editor:** Larry Gabriel. Four-color magazine for "1.3 million member trade union representing U.S., Canadian and Puerto Rican workers in auto, aerospace, agricultural-implement, public employment and other areas." Contemporary design.
Cartoons Carries "labor/political" cartoons. Payment varies.
Illustration Works with 10-12 illustrators/year for posters and magazine illustrations. Interested in graphic designs of publications, topical art for magazine covers with liberal-labor political slant. Looks for "ability to grasp our editorial slant."
First Contact & Terms Illustrators: Send postcard sample or tearsheets and SASE. Samples are filed. Pays $500-600 for color cover; $200-300 for b&w inside; $300-450 for color inside. Graphic Artists Guild members only.

SPIDER
P.O. Box 300, Peru IL 61354. **Art Director:** Suzanne Beck. Estab. 1994. Monthly magazine "for children 6 to 9 years old. Literary emphasis, but also includes activities, crafts, recipes and games." Circ. 95,000. Sample copies available; art guidelines for SASE with first-class postage.
Illustration Approached by 800-1,000 illustrators/year. Buys 30-35 illustrations/issue. Has featured illustrations by Floyd Cooper, Jon Goodell and David Small. Features humorous and realistic illustration. Assigns 25% of illustrations to new and emerging illustrators. Prefers art featuring children and animals, both realistic and whimsical styles. Considers all media.
First Contact & Terms Send query letter with printed samples, photocopies, SASE and tearsheets. Send follow-up every 4 months. Samples are filed or are returned by SASE. Responds in 6 weeks. Buys all rights. Pays 45 days after acceptance; $750 minimum for cover; $150-250 for color inside. Pays $50-150 for spots. Finds illustrators through artists who've published work in the children's field (books/magazines); artist's submissions.
Tips "Read our magazine; include samples showing children and animals; and put your name, address and phone number on every sample. It's helpful to include pieces that take the same character(s) through several actions/emotional states. It's also helpful to remember that most children's publishers need artists who can draw children from many different racial and ethnic backgrounds."

ⓃⓃ SPITBALL, The Literary Baseball Magazine
5560 Fox Rd., Cincinnati OH 45239. (513)385-2268. E-mail: spitball5@hotmail.com. Website: www.angelfire. com/oh5/spitball. **Editor:** Mike Shannon. Quarterly 2-color magazine emphasizing baseball exclusively, for "well-educated, literate baseball fans." Sometimes prints color material in b&w on cover. Returns original artwork after publication if the work is donated; does not return if purchases work. Sample copy for $6.
 • *Spitball* has a regular column called "Brushes with Baseball" that features one artist and his work. Chooses artists for whom baseball is a major theme/subject. Prefers to buy at least one work from the artist to keep in its collection. *Spitball*'s editor, Mike Shannon, is organizing a national trading art show devoted to all-time baseball great Willie Mays. The show will celebrate Willie's 75th birthday, which occurs in May 2006. Artists interested in participating in the show should send Shannon a photo of baseball work of art completed by the artist and a SASE for more information. (This is not connected to *Spitball*.)

Magazines

© Don Pollard

Literary and smaller magazines may not pay as much as the *Rolling Stone* or *Readers Digest*, but they are great places to experiment and try new things. Don Pollard captured the swing of the St. Louis Cardinals' Albert Pujols for the cover for *Spitball, The Literary Baseball Magazine*. "This drawing is a departure for Don, in that it was done on computer. Previous covers he drew for us were by hand—pen and ink on board," said Editor-in-Chief Mike Shannon, who added he was pleased with the hand-drawn look of Pollard's computer style.

Cartoons Prefers single panel b&w line drawings with or without gagline. Prefers "old fashioned *Sport Magazine/ New Yorker* type. Please, cartoonists . . . make them funny, or what's the point?"

Illustration "We need two types of art: illustration (for a story, essay or poem) and filler. All work must be baseball-related; prefers pen & ink, airbrush, charcoal/ pencil and collage. Interested artists should write to find out needs for specific illustration." Buys 3 or 4 illustrations/issue.

First Contact & Terms Cartoonists: Query with samples of style, roughs and finished cartoons. Illustrators: Send query letter with b&w illustrations or slides. Target samples to magazine's needs. Samples not filed are returned by SASE. Responds in 1 week. Negotiates rights purchased. **Pays on acceptance**. Pays cartoonists $10, minimum. Pays illustrators $20-40 b&w inside. Needs short story illustration.

Tips "Usually artists contact us and if we hit it off, we form a long-lasting mutual admiration society. Please, you cartoonists out there, drag your bats up to the *Spitball* plate! We like to use a variety of artists."

SPORTS AFIELD

15621 Chemical Lane, Huntington Beach CA 92649. (714)373-4910. Fax: (714)894-4949. E-mail: assoced@s portsafield.com. Website: www.sportsafield.com. **Creative Director:** Peter Pawlyschyn. Estab. 1887. Monthly magazine. "*SA* is edited for outdoor enthusiasts with special interests in fishing and hunting. We are the oldest outdoor magazine and continue as the authority on all traditional sporting activities including camping, boating, hiking, fishing, mountain biking, rock climbing, canoeing, kayaking, rafting, shooting and wilderness travel." Circ. 459,396.

Illustration Buys 2-3 illustrations/issue. Prefers outdoor themes. Considers all media. Freelancers should be familiar with Photoshop, Illustrator, QuarkXPress.

First Contact & Terms Illustrators: Send postcard sample or query letter with photocopies and tearsheets. Accepts disk submissions. Samples are filed. Responds only if interested. Will contact for portfolio of b&w or color photographs, slides, tearsheets and transparencies if interested. Buys first North American serial rights. Pays on publication; negotiable. Finds illustrators through *Black Book*, magazines, submissions.

SPORTS 'N SPOKES

2111 E. Highland Ave., Suite 180, Phoenix AZ 85016-4702. (602)224-0500. Fax: (602)224-0507. E-mail: susan@p nnews.com. Website: www.sportsnspokes.com. **Art and Production Director:** Susan Robbins. Published 8 times a year. Consumer magazine with emphasis on sports and recreation for the wheelchair user. Circ. 15,000. Accepts previously published artwork. Sample copies for large SASE and $3.00 postage.

Cartoons Buys 3-5 cartoons/issue. Prefers humorous cartoons; single panel b&w line drawings with or without gagline. Must depict some aspect of wheelchair sport and/or recreation.

Illustration Works on assignment only. Considers pen & ink, watercolor and computer-generated art. 50% of freelance work demands knowledge of Illustrator, QuarkXPress or Photoshop.

First Contact & Terms Cartoonists: Send query letter with finished cartoons. Responds in 3 months. Buys all rights. **Pays on acceptance**; $10 for b&w. Illustrators: Send postcard sample or query letter with résumé and tearsheets. Accepts disk submissions compatible with Illustrator 10.0 or Photoshop 7.0. Send EPS, TIFF or JPEG files. Samples are filed or returned by SASE if requested by artist. Responds to the artist only if interested. Publication will contact artist for portfolio review if interested. Portfolio should include color tearsheets. Buys

one-time rights and reprint rights. Pays on publication; $250 for color cover; $25 for b&w inside; $50 for color inside.

Tips "We have not purchased an illustration or used a freelance designer for many years. We regularly purchase cartoons with wheelchair sports/recreation theme."

STONE SOUP, The Magazine by Young Writers and Artists

P.O. Box 83, Santa Cruz CA 95063. (831)426-5557. E-mail: editor@stonesoup.com. Website: www.stonesoup.c om. **Editor:** Gerry Mandel. Quarterly 4-color magazine with "simple and conservative design" emphasizing writing and art by children. Features adventure, ethnic, experimental, fantasy, humorous and science fiction articles. "We only publish writing and art by children through age 13. We look for artwork that reveals that the artist is closely observing his or her world." Circ. 20,000. Sample copies available for $4. Art guidelines for SASE with first-class postage.

Illustration Buys 12 illustrations/issue. Prefers complete and detailed scenes from real life. All art must be by children ages 8-13.

First Contact & Terms Illustrators: Send query letter with photocopies. Samples are filed or are returned by SASE. Responds in 1 month. Buys all rights. Pays on publication; $75 for color cover; $25 for color inside; $25 for spots.

STRATEGIC FINANCE

10 Paragon Dr., Montvale NJ 07645. (800)638-4427. Website: www.imanet.org and www.strategicfinancemag.com. **Editorial Director:** Kathy Williams. Art Director: Mary Zisk. Production Manager: Lisa Nasuta. Estab. 1919. Monthly 4-color with a 3-column design emphasizing management accounting for management accountants, controllers, chief financial officers, chief accountants and treasurers. Circ. 80,000. Accepts simultaneous submissions. Originals are returned after publication.

Illustration Approached by 6 illustrators/year. Buys 10 illustrations/issue.

First Contact & Terms Illustrators: Send nonreturnable postcard samples. Prefers financial accounting themes.

STUDENT LAWYER

321 N. Clark St., Chicago IL 60610. (312)988-6042. E-mail: kulcm@staff.abanet.org. **Art Director:** Mary Anne Kulchawik. Estab. 1972. Trade journal, 4-color, emphasizing legal education and social/legal issues. "*Student Lawyer* is a legal affairs magazine published by the Law Student Division of the American Bar Association. It is not a legal journal. It is a features magazine, competing for a share of law students' limited spare time—so the articles we publish must be informative, lively, good reads. We have no interest whatsoever in anything that resembles a footnoted, academic article. We are interested in professional and legal education issues, sociolegal phenomena, legal career features, and profiles of lawyers who are making an impact on the profession." Monthly (September-May). Circ. 35,000. Original artwork is returned to the artist after publication.

Illustration Approached by 20 illustrators/year. Buys 8 illustrations/issue. Has featured illustrations by Sean Kane and Jim Starr. Features realistic, computer and spot illustration. Assigns 50% of illustrations to experienced but not well-known illustrators; 50% to new and emerging illustrators. Needs editorial illustration with an "innovative, intelligent style." Works on assignment only. Needs computer-literate freelancers for illustration.

First Contact & Terms Send postcard sample, brochure, tearsheets and printed sheet with a variety of art images (include name and phone number). Samples are filed. Call for appointment to show portfolio of final art and tearsheets. Buys one-time rights. **Pays on acceptance**; $500-800 for color cover; $450-650 for color inside; $150-350 for spots.

Tips "In your samples, show a variety of styles with an emphasis on editorial work."

☑ 🌱 SUB-TERRAIN MAGAZINE

P.O. Box 3008, MPO, Vancouver BC V6B 3X5 Canada. (604)876-8710. Fax: (604)879-2667. E-mail: subter@porta l.ca. Website: www.subterrain.ca. **Managing Editor:** Brian Kaufman. Estab. 1988. Quarterly b&w literary magazine featuring contemporary literature of all genres. Art guidelines for SASE with first-class postage.

Cartoons Prefers single panel cartoons.

Illustration Assigns 50% of illustrations to new and emerging illustrators.

First Contact & Terms Send query letter with photocopies. Samples are filed. Responds if interested. Portfolio review not required. Buys first rights, first North American serial rights, one-time rights or reprint rights. Pays $35-100 (Canadian), plus contributor copies.

Tips "Take the time to look at an issue of the magazine to get an idea of what work we use."

🖥 TALCOTT PUBLISHING

20 W. Kinzie, 12th Floor, Chicago IL 60610. (312)849-2220. Fax: (312)849-2174. Website: www.talcott.com. **Art Director:** Dan von Rabenau. Monthly trade magazines. Sample copies available.

• Talcott Publishing houses the following trade magazines: *Giftware News, Giftware News UK, Chef Magazine, Chef Educator Today, Fancy Food & Culinary Products, Equipment Solutions,* and *Home Fashions & Furniture Trends.*

Design Needs freelancers for design, production, multimedia projects and Internet. Prefers Adobe suite, QuarkX-Press and Macromedia Suite.

First Contact & Terms Designers: Send query letter with printed samples.

TAMPA BAY MAGAZINE

2531 Landmark Dr., Clearwater FL 33761. (727)791-4800. **Editor:** Aaron Fodiman. Estab. 1986. Bimonthly local lifestyle magazine with upscale readership. Circ. 40,000. Accepts previously published artwork. Sample copy available for $4.50. Art guidelines not available.

Cartoons Approached by 30 cartoonists/year. Buys 6 cartoons/issue. Prefers single-panel color washes with gagline.

Illustration Approached by 100 illustrators/year. Buys 5 illustrations/issue. Prefers happy, stylish themes. Considers watercolor, collage, airbrush, acrylic, marker, colored pencil, oil and mixed media.

First Contact & Terms Cartoonists: Send query letter with finished cartoon samples. Illustrators: Send query letter with photographs and transparencies. Samples are not filed and are returned by SASE if requested. To show a portfolio, mail color tearsheets, slides, photocopies, finished samples and photographs. Buys one-time rights. Pays on publication. Pays cartoonists $15 for b&w, $20 for color. Pays illustrators $150 for color cover; $75 for color inside.

🅽 TEXAS MONTHLY

P.O. Box 1569, Austin TX 78767-1569. (512)320-6900. Fax: (512)476-9007. Website: www.texasmonthly.com. **Art Director:** Scott Dadich. Estab. 1973. Monthly general interest magazine about Texas. Circ. 350,000. Accepts previously published artwork. Originals are returned to artist at job's completion.

Illustrations Approached by hundreds of illustrators/year. Works on assignment only. Considers all media.

First Contact & Terms Illustrators: Send postcard sample of work or send query letter with tearsheets, photographs, photocopies. Samples are filed "if I like them" or returned by SASE if requested by artist. Publication will contact artist for portfolio review if interested. Portfolio should include tearsheets, photographs, photocopies. Buys one-time rights. Pays on publication; $1,000 for color cover; $800-2,000 for color inside; $150-400 for spots.

TIME

Attn: Art Dept., 1271 Avenue of the Americas, Rockefeller Center, New York NY 10020-1393. (212)522-4769. Fax: (212)522-0637. Website: www.time.com. **Art Director:** Arthur Hochstein. Deputy Art Directors: Cynthia Hoffman and D.W. Pine. Estab. 1923. Weekly magazine covering breaking news, national and world affairs, business news, societal and lifestyle issues, culture and entertainment. Circ. 5,000,000.

Illustration Considers all media. Send postcard sample, printed samples, photocopies or other appropriate samples.

First Contact & Terms Illustrators: Accepts disk submissions. Samples are filed. Responds only if interested. Portfolios may be dropped off every Wednesday between 11 and 1. They are kept for one week and may be picked up the following Wednesday, between 11 and 1. Buys first North American serial rights. Payment is negotiable. Finds artists through sourcebooks and illustration annuals.

TODAY'S CHRISTIAN

(formerly Christian Reader), 465 Gundersen Dr., Carol Stream IL 60188. (630)260-6200. Fax: (630)260-0114. Website: www.todays-christian.com. **Contact:** Phil Marcelo, senior designer. Estab. 1963. Bimonthly general interest magazine. "People of Faith. Stories of Hope." Circ. 175,000. Accepts previously published artwork. Originals returned at job's completion.

Illustration Works on assignment only. Has featured illustrations by Mary Chambers, Alain Massicotte, Rex Bohn, Ron Mazellan and Donna Kae Nelson. Features humorous, realistic and spot illustration. Prefers family, home and church life. Considers all media. Digital delivery preferred.

First Contact & Terms Illustrators: Samples are filed. Responds only if interested. To show a portfolio, mail appropriate materials. Buys one-time rights.

Tips "Send samples of your best work, in your best subject and best medium. We're interested in fresh and new approaches to traditional subjects and values."

🅽 TODAY'S CHRISTIAN WOMAN

465 Gundersen Dr., Carol Stream IL 60188. (630)260-6200. Fax: (630)260-0114. **Design Director:** Douglas A. Johnson. Estab. 1978. Bimonthly consumer magazine "for Christian women, covering all aspects of family,

faith, church, marriage, friendship, career and physical, mental and emotional development from a Christian perspective.'' Circ. 250,000.

• This magazine is published by Christianity Today, Intl. which also publishes 11 other magazines.

Illustration Buys 6 illustrations/issue. Considers all media.

First Contact & Terms Illustrators: Send postcard sample or query letter with printed samples, photocopies, SASE and tearsheets. Samples are filed. Responds only if interested. Buys first rights. Pays $200-1,000 for color inside.

☑ ⬜ TODAY'S PARENT

One Mount Pleasant Rd., 8th Floor, Toronto ON M4Y 2Y5 Canada. (416)764-2883. Fax: (416)764-2801. Website: www.todaysparent.com. **Art Director:** Jackie Shipley. Monthly parenting magazine. Circ. 175,000. Sample copies available.

Illustration Send query letter with printed samples, photocopies or tearsheets.

First Contact & Terms Illustrators: Send follow-up postcard sample every year. Portfolios may be dropped off on Mondays and picked up on Tuesdays. Accepts disk submissions. Art director will contact artist for portfolio review of b&w and color photographs, slides, tearsheets and transparencies if interested. Buys first rights. **Pays on acceptance**, $100-300 for b&w and $250-800 for color inside. Pays $400 for spots. Finds illustrators through magazines, submissions and word of mouth.

Tips Looks for ''good conceptual skills and skill at sketching children and parents.''

⬜ TRAINS

P.O. Box 1612, 21027 Crossroads Circle, Waukesha WI 53187. (262)796-8776. Fax: (262)796-1778. E-mail: tdanneman@kalmbach.com. Website: www.trains.com. **Art Director:** Thomas G. Danneman. Estab. 1940. Monthly magazine about trains, train companies, tourist RR, latest railroad news. Circ. 133,000. Art guidelines available.

• Published by Kalmbach Publishing. Also publishes *Classic Toy Trains, Astronomy, Finescale Modeler, Model Railroader, Model Retailer, Classic Trains, Bead and Button, Birder's World.*

Illustration 100% of freelance illustration demands knowledge of Photoshop CS 5.0, Illustrator CS 8.0.

First Contact & Terms Illustrators: Send query letter with printed samples, photocopies and tearsheets. Accepts disk submissions (opticals) or CDs, using programs above. Samples are filed. Art director will contact artist for portfolio review of color tearsheets if interested. Buys one-time rights. Pays on publication.

Tips ''Quick turnaround and accurately built files are a must.''

TRAVEL NATURALLY

P.O. Box 317, Newfoundland NJ 07435. (973)697-3552. Fax: (973)697-8313. E-mail: naturally@internaturally.com. Website: www.internaturally.com. **Publisher/Editor:** Bernard Loibl. Director of Operations: Brian J. Ballone. Estab. 1981. Quarterly magazine covering family nudism/naturism and nudist resorts and travel. Circ. 35,000. Sample copies for $7.50 and $4.25 postage; art guidelines for #10 SASE with first-class postage.

Cartoons Approached by 10 cartoonists/year. Buys approximately 3 cartoons/issue. Prefers nudism/naturism.

Illustration Approached by 10 illustrators/year. Buys approximately 3 illustrations/issue. Prefers nudism/naturism. Considers all media.

First Contact & Terms Cartoonists: Send query letter with finished cartoons. Illustrators: Contact directly. Accepts all digital formats or hard copies. Samples are filed. Responds only if interested. Buys one-time rights. Pays on publication. Pays cartoonists $15-70. Pays illustrators $200 for cover; $70/page inside. Fractional pages or fillers are prorated.

TURTLE MAGAZINE, For Preschool Kids

Children's Better Health Institute, 1100 Waterway Blvd., Box 567, Indianapolis IN 46202. (317)636-8881. Website: www.turtlemag.org. **Art Director:** Bart Rivers. Estab. 1979. Emphasizes health, nutrition, exercise and safety for children 2-5 years. Published 6 times/year; 4-color. Circ. 343,923. Original artwork not returned after publication. Sample copy for $1.75; art guidelines for SASE with first-class postage. Needs computer-literate freelancers familiar with Macromedia FreeHand and Photoshop for illustrations.

• Also publishes *Child Life, Children's Digest, Children's Playmate, US Kids, Humpty Dumpty's Magazine* and *Jack and Jill.*

Illustration Approached by 100 illustrators/year. Works with 20 illustrators/year. Buys 15-30 illustrations/issue. Interested in ''stylized, humorous, realistic and cartooned themes; also nature and health.'' Works on assignment only.

First Contact & Terms Illustrators: Send query letter with good photocopies and tearsheets. Accepts disk submissions. Samples are filed or are returned by SASE. Responds only if interested. Portfolio review not

required. Buys all rights. Pays on publication; $275 for color cover; $35-90 for b&w inside; $70-155 for color inside; $35-70 for spots. Finds most artists through samples received in mail.

Tips ''Familiarize yourself with our magazine and other children's publications before you submit any samples. The samples you send should demonstrate your ability to support a story with illustration.''

TV GUIDE

1211 Sixth Ave., New York NY 10036. (212)852-7500. Fax: (212)852-7470. Website: www.tvguide.com. **Art Director:** Theresa Griggs. Associate Art Director: Catherine Suhocki. Estab. 1953. Weekly consumer magazine for television viewers. Circ. 11,000,000. Has featured illustrations by Mike Tofanelli and Toni Persiani.

Illustration Approached by 200 illustrators/year. Buys 50 illustrations/year. Considers all media.

First Contact & Terms Send postcard sample. Samples are filed. Art director will contact artist for portfolio review of color tearsheets if interested. Negotiates rights purchased. **Pays on acceptance**; $1,500-4,000 for color cover; $1,000-2,000 for full page color inside; $200-500 for spots. Finds artists through sourcebooks, magazines, word of mouth, submissions.

[N] [V] U. THE NATIONAL COLLEGE MAGAZINE

12707 High Bluff Dr., Suite 2000, San Diego CA 92130-2035. (858)847-3350. Fax: (858)847-3340. E-mail: tony@c olleges.com. Website: www.colleges.com/umagazine.com. **Creative Art Director:** Tony Carrieri. Estab. 1986. Quarterly consumer magazine of news, lifestyle and entertainment geared to college students. Magazine is for college students by college students. Circ. 1.5 million. Sample copies and art guidelines available for SASE with first-class postage or on website. Do not submit unless you are a college student.

Cartoons Approached by 25 cartoonists/year. Buys 2 cartoons/issue. Prefers college-related themes. Prefers humorous color washes, single or multiple panel with gagline.

Illustration Approached by 100 illustrators/year. Buys 10-20 illustrations/issue. Features caricatures of celebrities; humorous illustration; informational graphics; computer and spot illustration. Assigns 100% of illustrations to new and emerging illustrators. Prefers bright, light, college-related, humorous, color only, no b&w. Considers collage, color washed, colored pencil, marker, mixed media, pastel, pen & ink or watercolor. 20% of freelance illustration demands knowledge of Photoshop, Illustrator and QuarkXPress.

First Contact & Terms Cartoonists: Send query letter with photocopies and tearsheets. Samples are filed and are not returned. Responds only if interested. Pays on publication. Pays cartoonists $25 for color.

Pays illustrators $100 for color cover; $25 for color inside; $25 for spots. Finds illustrators through college campus newspapers and magazines.

Tips ''We need light, bright, colorful art. We accept art from college students only.''

[N] UNIQUE OPPORTUNITIES, The Physician's Resource

214 South 8th Street., Suite 502, Louisville KY 40202-2738. (502)589-8250. Fax: (502)587-0848. E-mail: barb@uo works.com. Website: www.uoworks.com. **Publisher and Design Director:** Barbara Barry. Estab. 1991. Bi-monthly trade journal. ''Our audience is physicians who are looking for jobs. Editorial focus is on practice-related issues.'' Circ. 80,000. Originals returned at job's completion. Freelancers should be familiar with Illustrator, Photoshop and FreeHand.

Illustration Approached by 10 illustrators/year. Buys 1-2 illustrations/issue. Works on assignment only. Considers pen & ink, mixed media, collage, pastel and computer illustration. Prefers computer illustration.

First Contact & Terms Illustrators: Publication will contact artist for portfolio of final art, tearsheets, EPS files on a floppy disk if interested. Buys first or one-time rights. Pays 30 days after acceptance; $700 for color cover; $250 for spots. Finds artists through Internet only. Do not send samples in the mail.

[V] UTNE

1624 Harmon Place, Suite 330, Minneapolis MN 55403. (612)338-5040. Fax: (612)338-6043. Website: www.utne .com. **Art Director:** Kristi Anderson. Assistant Art Director: Jennifer Dix. Estab. 1984. Bimonthly digest featuring articles and reviews from the best of alternative media; independently published magazines, newsletters, books, journals and websites. Topics covered include national and international news, history, art, music, literature, science, education, economics and psychology. Circ. 250,000.

 • *Utne* seeks to present a lively diversity of illustration and photography ''voices.'' We welcome artistic samples which exhibit a talent for interpreting editorial content.

Illustration Buys 10-15 illustrations per issue. Buys 60-day North American rights. Finds artists through submissions, annuals and sourcebooks.

First Contact & Terms Illustrators: Send single-sided postcards, color or b&w photocopies, printed agency/rep samples or small posters. We are unlikely to give an assignment based on only one sample, and we strongly prefer that you send several samples in one package rather than single pieces in separate mailings. Clearly mark your full name, address, phone number, fax number, and e-mail address on everything you send. Do not

send electronic disks, e-mails with attachments or references to websites. Do not send original artwork of any kind. Samples cannot be returned.

VANITY FAIR

4 Times Square, 22nd Floor, New York NY 10036. (212)286-8180. Fax: (212)286-6707. E-mail: vfmail@vf.com. Website: www.vanityfair.com. **Deputy Art Director:** Julie Weiss. Design Director: David Harris. Estab. 1983. Monthly consumer magazine. Circ. 1.1 million. Does not use previously published artwork. Original artwork returned at job's completion. 100% of freelance design work demands knowledge of QuarkXPress and Photoshop.

Illustration Approached by "hundreds" of illustrators/year. Buys 3-4 illustrations/issue. Works on assignment only. "Mostly uses artists under contract."

VEGETARIAN JOURNAL

P.O. Box 1463, Baltimore MD 21203-1463. (410)366-8343. E-mail: vrg@vrg.org. Website: www.vrg.org. **Editor:** Debra Wasserman. Estab. 1982. Quarterly nonprofit vegetarian magazine that examines the health, ecological and ethical aspects of vegetarianism. "Highly educated audience including health professionals." Circ. 27,000. Accepts previously published artwork. Originals returned at job's completion upon request. Sample copies available for $3.

Cartoons Approached by 4 cartoonists/year. Buys 1 cartoon/issue. Prefers humorous cartoons with an obvious vegetarian theme; single panel b&w line drawings.

Illustration Approached by 20 illustrators/year. Buys 6 illustrations/issue. Works on assignment only. Prefers strict vegetarian food scenes (no animal products). Considers pen & ink, watercolor, collage, charcoal and mixed media.

First Contact & Terms Cartoonists: Send query letter with roughs. Illustrators: Send query letter with photostats. Samples are not filed and are returned by SASE if requested by artist. Responds in 2 weeks. Portfolio review not required. Rights purchased vary according to project. **Pays on acceptance.** Pays cartoonists $25 for b&w. Pays illustrators $25-50 for b&w/color inside. Finds artists through word of mouth and job listings in art schools.

Tips Areas most open to freelancers are recipe section and feature articles. "Review magazine first to learn our style. Send query letter with photocopy sample of line drawings of food."

ⓝ VERMONT MAGAZINE

P.O. Box 800, Middlebury VT 05753-0800. (802)388-8480. Fax: (802)388-8485. E-mail: vtmag@sover.net. Website: www.vermontmagazine.com. **Publisher:** Kate Fox. Estab. 1989. Bimonthly regional publication "aiming to explore what life in Vermont is like: its politics, social issues and scenic beauty." Circ. 50,000. Accepts previously published artwork. Original artwork returned at job's completion. Sample copies and art guidelines for SASE with first-class postage.

Illustration Approached by 100-150 illustrators/year. Buys 2-3 illustrations/issue. Works on assignment only. Has featured illustrations by Chris Murphy. Features humorous, realistic, computer and spot illustration. Assigns 50% of illustrations to experienced but not well-known illustrators; 50% to new and emerging illustrators. "Particularly interested in creativity and uniqueness of approach." Considers pen & ink, watercolor, colored pencil, oil, charcoal, mixed media and pastel.

First Contact & Terms Illustrators: Send query letter with tearsheets, "something I can keep." Materials of interest are filed. Publication will contact artist for portfolio review if interested. Portfolio should include final art and tearsheets. Buys one-time rights. Considers buying second rights (reprint rights) to previously published work. Pays $400 maximum for color cover; $75-150 for b&w inside; $75-350 for color inside; $300-500 for 2-page spreads; $50-75 for spots. Finds artists mostly through submissions/self-promos and from other art directors.

ⓝ VIBE

215 Lexington Ave., 6th Floor, New York NY 10016. (212)448-7300. Fax: (212)448-7377. E-mail: fbachleda@vibe.com. Website: www.vibe.com. **Design Director:** Florian Bachleda. Estab. 1993. Monthly consumer magazine focused on music, urban culture. Circ. 800,000. Accepts previously published artwork. Originals returned at job's completion. Sample copies available.

Illustration Works on assignment only.

First Contact & Terms Cartoonists: Send postcard-size sample or query letter with brochure and finished cartoons. Responds to the artist only if interested. Illustrators: Send postcard-size sample or query letter with photocopies. Samples are filed. Publication will contact artist for portfolio review of roughs, final art and photocopies if interested. Buys one-time or all rights.

N VOGUE PATTERNS

11 Penn Plaza, New York NY 10001. (212)465-6800. Fax: (212)465-6814. E-mail: mailbox@voguepatterns.com. Website: www.voguepatterns.com. **Associate Art Director:** Christine Lipert. Manufacturer of clothing patterns with the Vogue label. Circ. 99,162. Uses freelance artists mainly for fashion illustration for the *Vogue Patterns* catalog and editorial illustration for *Vogue Patterns* magazine. "The nature of catalog illustration is specialized; every button, every piece of top-stitching has to be accurately represented. Editorial illustration assigned for our magazine should have a looser-editorial style. We are open to all media."

Illustration Approached by 50 freelancers. Works with 10-20 illustrators and 1-5 graphic designers/year. Assigns 18 editorial illustration jobs and 100-150 fashion illustration jobs/year. Looking for "sophisticated modern fashion and intelligent creative and fresh editorial."

First Contact & Terms Illustrators: Send query letter with résumé, tearsheets, slides or photographs. Samples not filed are returned by SASE. Call or write for appointment to drop-off portfolio. Pays for design by the hour, $15-25; for illustration by the project, $150-300.

Tips "Drop off comprehensive portfolio with a current business card and sample. Make sure name is on outside of portfolio. When a job becomes available, we will call illustrator to view portfolio again."

WASHINGTONIAN MAGAZINE

1828 L St., NW, Suite 200, Washington DC 20036. (202)296-3600. E-mail: ecrowson@washingtonian.com. Website: www.washingtonian.com. **Contact:** Eileen Crowson, associate design director. Estab. 1965. Monthly 4-color consumer lifestyle and service magazine. Circ. 185,000. Sample copies free for #10 SASE with first-class postage.

Illustration Approached by 200 illustrators/year. Buys 7-10 illustrations/issue. Has featured illustrations by Pat Oliphant, Chris Tayne and Richard Thompson. Features caricatures of celebrities, caricatures of politicians, humorous illustration, realistic illustrations, spot illustrations, computer illustrations and photo collage. Preferred subjects: men, women and creative humorous illustration. Assigns 20% of illustrations to new and emerging illustrators. 20% of freelance illustration demands knowledge of Photoshop.

First Contact & Terms Illustrators: Send postcard sample and follow-up postcard every 6 months. Send nonreturnable samples. Send query letter with tearsheets. Accepts Mac-compatible submissions. Send EPS or TIFF files. Responds only if interested. Will contact artist for portfolio review if interested. Buys first rights. **Pays on acceptance**; $900-1,200 for color cover; $200-800 for b&w, $400-900 for color inside; $900-1,200 for 2-page spreads; $400 for spots. Finds illustrators through magazines, word of mouth, promotional samples, sourcebooks.

Tips "We like caricatures that are fun, not mean and ugly. Want a well-developed sense of color, not just primaries."

N WATERCOLOR MAGIC

4700 E. Galbraith Rd., Cincinnati OH 45236. (513)531-2690. Fax: (513)531-2902. E-mail: wcmedit@aol.com. **Art Director:** Brian Schroeder. Editor: Kelly Kane. Estab. 1995. Quarterly 4-color consumer magazine to "help artists explore and master watermedia." Circ. 92,000. Art guidelines free for #10 SASE with first-class postage.

First Contact & Terms Illustration: Pays on publication. Finds illustrators through word of mouth, visiting art exhibitions, unsolicited queries, reading books.

Tips "We are looking for watermedia artists who are willing to teach special aspects of their work and their techniques to our readers."

WEEKLY ALIBI

2118 Central Ave. SE, PMB 151, Albuquerque NM 87106-4004. (505)346-0660. Fax: (505)256-9651. E-mail: alibi@alibi.com. Website: www.Alibi.com. **Art Director:** Tom Nayder. Estab. 1992. Small, 4-color, alternative weekly newspaper/tabloid focusing on local news, music and the arts. Circ. 50,000. Sample copies free for 10×13 SAE and 4 first-class stamps. Art guidelines for #10 SAE with first-class postage.

Cartoons Approached by 30 cartoonists/year. Buys 10 cartoons/issue. Prefers strange, humorous and clean styles. Prefers single panel, double panel, multiple panel, political, humorous, b&w line drawings.

Illustration Approached by 50 illustrators/year. Buys 3-7 illustrations/issue. Has featured illustrations by Lloyd Dangle, Tony Millionair, Brian Biggs and Sean Tejaratchi. Features caricatures of politicians; humorous, realistic, spot illustration; charts & graphs; and informational graphics. Prefers "anything that looks good on newsprint." Assigns 20% of work to new and emerging illustrators.

First Contact & Terms Cartoonists: Send query letter with b&w photocopies. Illustrators: Accepts Mac-compatible disk submissions. Send TIFF files. Samples are filed. Responds only if interested. Will contact artist for portfolio review if interested. Rights purchased vary according to project. Pays on publication. Pays cartoonists $5-20 for b&w; $10-20 for comic strips. Pays illustrators $150-200 for b&w cover; $150-200 for color cover; $10-

20 for b&w inside; $15-25 for color inside; $25 for spots. Finds illustrators through artists' submissions/artists' websites.

Tips "Send finished art. We get a ton of unfinished pencil drawings that usually get thrown out!"

WEEKLY READER

Weekly Reader Corp., 200 First Stamford Place, Stamford CT 06912. (203)705-3500. Website: www.weeklyreade r.com. **Contact:** Amy Gery. Estab. 1928. Educational periodicals, posters and books. *Weekly Reader* teaches the news to kids pre-K through high school. The philosophy is to connect students to the world. Publications are 4-color. Accepts previously published artwork. Original artwork is returned at job's completion. Sample copies are available.

Illustration Needs editorial and technical illustration. Style should be "contemporary and age-level appropriate for the juvenile audience." Buys more than 50/week. Works on assignment only. Uses computer and reflective art.

First Contact & Terms Illustrators: Send brochure, tearsheets, SASE and photocopies. Samples are filed or are returned by SASE if requested by artist. Payment is usually made within 3 weeks of receiving the invoice. Finds artists through artists' submissions/self-promotions, sourcebooks, agents and reps. Some periodicals need quick turnarounds.

Tips "Our primary focus is the children's and young adult marketplace. Art should reflect creativity and knowl-edge of audience's needs. Our budgets are tight, and we have very little flexibility in our rates. We need artists who can work with our budgets. Avoid using fluorescent dyes. Use clear, bright colors. Work on flexible board."

N 🖋 WEST COAST LINE

2027 E. Academic Annex, Simon Fraser University, Burnaby BC V5A 1S6 Canada. (604)291-4287. Fax: (604)291-4622. E-mail: wcl@sfu.ca. Website: www.sfu.ca/west-coast-line. **Contact:** Managing Editor. Estab. 1990. Literary and visual arts journal published 3 times/year covering contemporary innovative writing and literary criti-cism/cultural studies by Canadians. Circ. 850. Art guidelines available free for SASE or send e-mail attachment/ in body of message. Sample copies available.

First Contact & Terms Illustration: Send query letter with photocopies. Samples are filed and are returned by SASE (IRC for U.S. submissions). Responds in 3 months. Buys one-time rights. Pays on publication. Pays $150 for color cover; $25 minimum for b&w inside. Has featured illustrations by Laiwan, Christine Davis and Monique Mees.

Tips "Each issue features full-color cover of visual artist's work—photo, painting, collage, etc."

N WESTWAYS

3333 Fairview Rd., Costa Mesa CA 92808. (714)885-2396. Fax: (714)885-2335. **Design:** Eric Van Eyke. Estab. 1918. A bimonthly lifestyle and travel magazine. Circ. 3,000,000. Original artwork returned at job's completion. Sample copies and art guidelines available for SASE.

Illustration Approached by 20 illustrators/year. Buys 2-6 illustrations/issue. Works on assignment only. Pre-ferred style is arty-tasteful, colorful. Considers pen & ink, watercolor, collage, airbrush, acrylic, colored pencil, oil, mixed media and pastel.

First Contact & Terms Illustrators: Send query letter with brochure, tearsheets and samples. Samples are filed. Responds in 2 weeks only if interested. To show a portfolio, mail appropriate materials. Portfolio should include thumbnails, final art, b&w and color tearsheets. Buys first rights. Pays on publication; $250 minimum for color inside.

WILDLIFE ART

P.O. Box 22439, Eagan MN 55337. (952)736-1020. Fax: (952)732-1030. **Publisher:** Robert Koenke. Estab. 1982. Bimonthly 4-color trade journal with award-winning design. Many two-page color art spreads. "The largest magazine in wildlife art originals, prints, duck stamps, artist interviews and industry information." Circ. 35,000. Accepts previously published artwork. Original artwork returned to artist at job's completion. Sample copy for $6.95; art guidelines for SASE with first-class postage.

Illustration Approached by 100 artists/year. Works on assignment only. Prefers nature, animal themes and landscapes. Considers pen & ink and charcoal.

First Contact & Terms Illustrators: Send postcard sample or query letter. Accepts disk submissions compatible with Mac—QuarkXPress, Illustrator and Photoshop. Send EPS files. Samples are not filed and are returned by SASE if requested by artist. Responds in 2 months. To show a portfolio, mail color tearsheets, slides and photocopies. Buys first rights. "We do not pay artists for illustration in publication material."

Tips "Interested wildlife artists should send SASE, three to seven clearly-marked slides or transparencies, short biography and be patient!

WIRE JOURNAL INTERNATIONAL

1570 Boston Post Rd., Guilford CT 06437-2312. (203)453-2777. Fax: (203)453-8384. Website: www.wirenet.org. **Contact:** Art Director. Emphasizes the wire industry worldwide, members of Wire Association International, industry suppliers, manufacturers, research/developers, engineers, etc. Monthly 4-color. Circ. 15,000. Design is "professional, technical and conservative." Original artwork not returned after publication. Free sample copy and art guidelines.

Illustration Illustrations are "used infrequently." Works on assignment only.

First Contact & Terms Illustrators: Provide samples, business card and tearsheets to be kept on file for possible assignments. To submit a portfolio, call for appointment. Responds "as soon as possible." Buys all rights. Payment is negotiable; on publication.

Tips "Show practical artwork that relates to industrial needs; avoid bringing samples of surrealism, for example. Also, show a variety of techniques and know something about who we are and the industry we serve."

WISCONSIN TRAILS

P.O. Box 317, BlackEarth WI 53515. (608)767-8000. Website: www.wistrails.com. **Creative Director:** Kathie Campbell. 4-color publication concerning travel, recreation, history, industry and personalities in Wisconsin. Published 6 times/year. Circ. 35,000. Previously published and photocopied submissions OK. Art guidelines for SASE.

Illustration Buys 6 illustrations/year. "Art work is done on assignment, to illustrate specific articles. All articles deal with Wisconsin. We allow artists considerable stylistic latitude."

First Contact & Terms Illustrators: Send postcard samples or query letter with brochure, photocopies, SASE, tearsheets, résumé, photographs, slides and transparencies. Samples kept on file for future assignments. Indicate artist's favorite topics, name, address and phone number. Include SASE. Publication will contact artist for portfolio review if interested. Buys one-time rights on a work-for-hire basis. Pays on publication; $50-150 for b&w inside; $50-400 color inside. Finds artists through magazines, submissions/self-promotions, artists' agents and reps and attending art exhibitions.

Tips "Keep samples coming of new work."

N THE WITNESS

Episcopal Church Publishing Co., 1714 Franklin St., #100-139, Oakland CA 94612-3409. (510)428-1872. E-mail: editor@thewitness.org. Website: www.thewitness.org. **Editor:** Ethan Flad. Estab. 1917. Christian journal historically published in print, currently published only online but with goal to re-launch print production in 2005, "focusing on faith context for addressing social justice issues. Episcopal Anglican roots—content is often serious yet occasionally quirky and irreverent." Circ. 4,500. Sample copies free for $9\frac{1}{2} \times 12\frac{1}{2}$ SASE and 4 first-class stamps.

Cartoons Buys 10-12 cartoons/year. Prefers single panel, political, b&w line drawings.

Illustration Has featured illustrations by Dierdre Luzwick, Betty LaDuke and Robert McGovern. Features humorous, realistic and spot illustration. "Themes: social and economic justice, though we like to use art in unusual and surprising combination with story topics. Style: We appreciate work that is subtle, provocative, never sentimental."

First Contact & Terms Cartoonists: Send query letter with finished cartoons, photographs, photocopies, roughs or tearsheets. Illustrators: Send postcard sample or query letter with printed samples, photocopies and tearsheets. Accepts disk submissions compatible with Apple OSX and Microsoft Office. Samples are filed if suitable and are not returned. "We like to keep samples of artists' work on file, with permission to use in the magazine. We rarely commission original work; we prefer to select from existing artwork." Responds only if interested. Buys one-time rights. Pays on publication. Pays cartoonists $50 maximum for b&w cartoons. Pays illustrators $150 maximum for b&w and color covers; $75 maximum for b&w and color inside.

☑ WORKBENCH

August Home Publishing, Inc., 2200 Grand Ave., Des Moines IA 50312. (515)875-7000. Website: www.workben chmagazine.com. **Art Director:** Kim Downing. Estab. 1957. Bimonthly 4-color magazine for woodworking and home improvement enthusiasts. Circ. 550,000. 100% of freelance work demands knowledge of Illustrator or QuarkXPress on PC or Macintosh.

Illustration Works with 10 illustrators/year. Buys 50 illustrations/year. Artists with experience in the area of technical drawings, especially house plans, exploded views of furniture construction, power tool and appliance cutaways, should send SASE for sample copy and art guidelines. Style of Eugene Thompson, Don Mannes and Mario Ferro.

First Contact & Terms Illustrators: Send query letter with nonreturnable samples. Publication will contact artist for portfolio review if interested. Sometimes requests work on spec before assigning job. Pays $50-1,200 for full color.

WORKFORCE MANAGEMENT

(formerly Workforce), 4 Executive Circle, Suite 185, Irvine CA 92614. (949)255-5345. Fax: (949)221-8964. E-mail: ddeay@workforce.com. Website: www.workforce.com. **Art Director:** Douglas R. Deay. Estab. 1922. Monthly trade journal for human resource business executives. Circ. 36,000. Sample copies available in libraries.
Illustration Approached by 100 illustrators/year. Buys 3-4 illustrations/issue. Prefers business themes. Considers all media. 40% of freelance illustration demands knowledge of Photoshop, QuarkXPress and Illustrator. Send postcard sample. Send follow-up postcard sample every 3 months. Samples are filed and are not returned. Does not reply, artist should call. Art director will contact for portfolio review if interested. Rights purchased vary according to project. **Pays on acceptance**; $350-500 for color cover; $100-400 for b&w and/or color inside; $75-150 for spots. Finds artists through agents, sourcebooks such as *LA Workbook*, magazines, word of mouth and submissions.
Tips "Read our magazine."

WORKING MOTHER MAGAZINE

260 Madison Ave., 3rd Floor, New York NY 10016-2401. (212)351-6400. Fax: (212)351-6487. Website: www.workingmother.com. **Art Director:** Langholz Cessarelli. Estab. 1979. "A monthly service magazine for working mothers focusing on work, money, children, food and fashion." Circ. 930,000. Original artwork is returned at job's completion. Sample copies and art guidelines available.
Illustration Approached by 100 illustrators/year. Buys 3-5 illustrations/issue. Works on assignment only. Prefers light humor and child/parent, work themes. Considers watercolor, collage, airbrush, acrylic, colored pencil, oil, mixed media and pastel.
First Contact & Terms Illustrators: Send query letter with postcard or printed samples of tearsheets. Samples are filed and are not returned. Does not report back, in which case the artist should call or drop off portfolio. Portfolio should include tearsheets, slides and photographs. Buys first rights. **Pays on acceptance**; $150-2,000 for color inside.

WORKSPAN

14040 N. Northsight Blvd., Scottsdale AZ 85260. (480)922-2063. Fax: (480)483-8352. E-mail: mmunoz@worldatwork.org. Website: www.worldatwork.org. **Contact:** Mark Anthony Munoz, Art Director. Estab. 2000. Monthly publication with a circulation of 26,000, targeting an audience which includes human resources, benefits, and compensation professionals. It serves as an informative resource with respect to practices, trends, knowledge and contemporary issues in the field. Sample copies available on request. Art guidelines are available by contacting the art director.
Illustration Approached by 500+ illustrators/year. Buys 20-25 illustrations/year. Has featured illustrations by Bill Mayer, Gerard DuBois, Curtis Parker, Charlie Hill, Adam Nikewicz, Doug Frasier, Tim Grasser. Features computer illustrations, realistic illustrations, spot illustrations or traditional illustrations of business. Prefers vibrant, rich, modern. Assigns 10% to new and emerging illustrators. 20% of freelance illustration demands knowledge of FreeHand, Illustrator, QuarkXPress and Photoshop.
First Contact & Terms Cartoonists/Illustrators: Send postcard samples with photocopies, samples, tearsheets, transparencies and URL. After introductory mailing, send follow-up postcard every 6 months. All samples are kept on file. Accepts e-mail submissions with link to website and e-mail submissions with image file. Prefers Mac-compatible TIFF and JPEG files. Samples are filed and returned by SASE. Responds only if interested. Portfolios may be dropped off every Monday. Company will contact artist for portfolio review if interested. Portfolio should include color photographs, tearsheets, thumbnails and film usage samples. Pays illustrators $1,500-3,000 for color cover, $900-2,000 for color inside; $1,000-2,000 for 2-page spreads. **Pays on acceptance.** Buys one-time rights, reprint rights (negotiated upon reprinting). Rights purchased vary according to project. Finds freelancers through agents, magazines, word of mouth, artists' submissions, sourcebooks, *Workbook*, GAD Directory, American Showcase and samples.
Tips "Research types of magazines that are appropriate before sending samples; although artwork may be exceptional, it may not fit our image guidelines. Also, any Web URLs should be tested before sending."

WORLD TRADE

23421 S. Pointe Dr., Suite 280, Laguna Hills CA 92653-1478. (949)830-1340. Fax: (949)830-1328. Website: www.worldtrademag.com. **Art Director:** Mike Powell. Estab. 1988. Monthly 4-color consumer journal; "read by upper management, presidents and CEOs of companies with international sales." Circ. 83,000. Accepts previously published artwork. Original artwork is returned to artist at job's completion. Sample copies and art guidelines not available.
Cartoons Prefers business/social issues.
Illustration Approached by 15-20 illustrators/year. Buys 1-2 illustrations/issue. Works on assignment only.

''We are open to all kinds of themes and styles.'' Considers pen & ink, colored pencil, mixed media and watercolor.

First Contact & Terms Illustrators: Send query letter with brochure and tearsheets. Samples are filed. Responds only if interested. Portfolio review not required. Buys first rights or reprint rights. Pays on publication; $800 for color cover; $275 for color inside.

Tips ''Send an example of your work. We prefer previous work to be in business publications. Artists need to understand we work from a budget to produce the magazine, and budget controls and deadlines are closely watched.''

N WRITER'S DIGEST

4700 E. Galbraith Rd., Cincinnati OH 45236. E-mail: writersdig@fwpubs.com. Website: www.writersdigest.com. **Art Director:** Tari Zumbaugh. Editor: Kristin Godsey. Monthly magazine emphasizing freelance writing for freelance writers. Circ. 175,000. Art guidelines free for SASE with first-class postage.

• Submissions are also considered for inclusion in annual *Writer's Yearbook* and other one-shot publications.

Illustration Buys 2-4 feature illustrations per month. Theme: the writing life. Works on assignment only. Send postcard or any printed/copied samples to be kept on file (limit size to $8\frac{1}{2} \times 11$).

First Contact & Terms Prefer snail-mail submissions to keep on file. Buys one-time rights **Pays on acceptance**; $500-1,000 for color cover; $100-800 for inside b&w. Can send final via e-mail. Prefer EPS, TIFF or JPEG, 300 dpi.

Tips ''We're also looking for black & white spots of writing-related subjects. We buy all rights; $15-25/spot. I like having several samples to look at. Online portfolios are great.''

N WRITER'S DIGEST GUIDES & YEARBOOKS

4700 E. Galbraith Rd., Cincinnati OH 45236. **Art Director:** Tari Zumbaugh. Publications featuring ''the best writing on writing.'' Topics include writing and marketing techniques, business issues for writers and writing opportunities for freelance writers and people getting started in writing. Affiliated with *Writer's Digest*. Illustrations and photos submitted to either publication are considered for both.

Illustration Uses 1-2 illustrations/issue. Theme: the writing life. Works on assignment only.

First Contact & Terms Send postcard or any printed/copied samples to be kept on file (limit size to $8\frac{1}{2} \times 11$). Can send final, purchased art via e-mail, JPEG, TIFF or EPS, 300 dpi. Buys first North American serial rights for one-time use. **Pays on acceptance**; $100-500 inside b&w, up to $700 for cover.

N YEMASSEE

English Dept., University of South Carolina, Columbia SC 29208. (803)777-2085. E-mail: yemassee@gwm.sc.edu. Website: www.cla.sc.edu/ENGL/yemassee/. **Contact:** Carl Jenkinson/Jill Carroll, co-editors. Estab. 1993. A biannual literary magazine with a circulation of 500, *Yemassee* is a high quality literary journal seeking both cover and inside page art. Sample copies available for $6 and art guidelines are available free with SASE or on website.

First Contact & Terms Accepts e-mail submissions with link to website. Prefers Windows-compatible, TIFF, JPEG and GIF files. Samples are filed and not returned. Responds in 3 months. Portfolio not required. Portfolio should include b&w finished art, original art, photographs and slides. ''We pay with 2 issues of journal—we are non-profit.'' Buys first rights.

Tips ''Anything goes; looking for quality.''

Posters & Prints

© Judy Kaufman

H ave you ever noticed, perhaps at the opening of an exhibition or at an art fair, that though you have many paintings on display, everybody wants to buy the same one? Do friends, relatives and co-workers ask you to paint duplicates of work you already sold? Many artists turn to the print market because they find certain images have a wide appeal and will sell again and again. This section lists publishers and distributors who can publish and market your work as prints or posters. It is important to understand the difference between the terms "publisher" and "distributor" before you begin your research. Art *publishers* work with you to publish a piece of your work in print form. Art *distributors* assist you in marketing a pre-existing poster or print. Some companies function as both publisher and distributor. Look in the first paragraph of each listing to determine if the company is a publisher, distributor or both.

RESEARCH THE MARKET

Some listings in this section are fine art presses, others are more commercial. Read the listings carefully to determine if they create editions for the fine art market or for the decorative market. Visit galleries, frame shops, furniture stores and other retail outlets that carry prints to see where your art fits in. You may also want to visit designer showrooms and interior decoration outlets.

To further research this market, check each publisher's website or send for each publisher's catalog. Some publishers will not send their catalogs because they are too expensive, but you can often ask to see one at a local poster shop, print gallery, upscale furniture store or frame shop. Examine the colors in the catalogs to make sure the quality is high.

What to send

To approach a publisher, send a brief query letter, a short bio, a list of galleries that represent your work and five to ten slides or whatever samples they specify in their listing. It helps to send printed pieces or tearsheets as samples, as these show publishers that your work reproduces well and that you have some understanding of the publication process. Most publishers will accept digital submissions via e-mail or CD.

Signing and numbering your editions

Before you enter the print arena, follow the standard method of signing and numbering your editions. You can observe how this is done by visiting galleries and museums and talking to fellow artists.

If you are creating a limited edition, with a specific set number of prints, all prints are

numbered, such as 35/100. The largest number is the total number of prints in the edition; the smaller number is the number of the print. Some artists hold out 10% as artist's proofs and number them separately with AP after the number (such as 5/100 AP). Many artists sign and number their prints in pencil.

Types of prints

Original prints. Original prints may be woodcuts, engravings, linocuts, mezzotints, etchings, lithographs or serigraphs. What distinguishes them is that they are produced by hand

Your publishing options

Important

1 **Working with a commercial poster manufacturer or art publisher.** If you don't mind creating commercial images and following current trends, the decorative market can be quite lucrative. On the other hand, if you work with a fine art publisher, you will have more control over the final image.

2 **Working with a fine art press.** Fine art presses differ from commercial presses in that press operators work side by side with you every step of the way, sharing their experience and knowledge of the printing process. You may be charged a fee for the time your work is on the press and for the expert advice of the printer.

3 **Working at a co-op press.** Instead of approaching an art publisher, you can learn to make your own hand-pulled original prints—such as lithographs, monoprints, etchings or silk-screens. If there is a co-op press in your city, you can rent time on a press and create your own editions. It is rewarding to learn printing skills and have the hands-on experience. You also gain total control of your work. The drawback is you have to market your images yourself by approaching galleries, distributors and other clients.

4 **Self-publishing with a printing company.** Several national printing concerns advertise heavily in artists' magazines, encouraging artists to publish their own work. If you are a savvy marketer who understands the ins and outs of trade shows and direct marketing, this is a viable option. However it takes a large investment up front. You could end up with a thousand prints taking up space in your basement, or if you are a good marketer, you could end up selling them all and making a much larger profit than if you had gone through an art publisher or poster company.

5 **Marketing through distributors.** If you choose the self-publishing route but don't have the resources to market your prints, distributors will market your work in exchange for a percentage of sales. Distributors have connections with all kinds of outlets like retail stores, print galleries, framers, college bookstores and museum shops.

by the artist (and consequently often referred to as hand-pulled prints). In a true original print the work is created specifically to be a print. Each print is considered an original because the artist creates the artwork directly on the plate, woodblock, etching stone or screen. Original prints are sold through specialized print galleries, frame shops and high-end decorating outlets, as well as fine art galleries.

Offset reproductions and posters. Offset reproductions, also known as posters and image prints, are reproduced by photochemical means. Since plates used in offset reproductions do not wear out, there are no physical limits on the number of prints made. Quantities, however, may still be limited by the publisher in order to add value to the edition.

Giclée prints. As color-copier technology matures, inkjet fine art prints, also called giclée prints, are gaining popularity. Iris prints, images that are scanned into a computer and output on oversized printers, are even showing up in museum collections.

Canvas transfers. Canvas transfers are becoming increasingly popular. Instead of, and often in addition to, printing an image on paper, the publisher transfers your image onto canvas so the work has the look and feel of a painting. Some publishers market limited editions of 750 prints on paper, along with a smaller edition of 100 of the same work on canvas. The edition on paper might sell for $150 per print, while the canvas transfer would be priced higher, perhaps selling for $395.

Pricing criteria for limited editions and posters

Because original prints are always sold in limited editions, they command higher prices than posters, which are not numbered. Since plates for original prints are made by hand, and as a result can only withstand a certain amount of use, the number of prints pulled is limited by the number of impressions that can be made before the plate wears out. Some publishers impose their own limits on the number of impressions to increase a print's value. These limits may be set as high as 700 to 1,000 impressions, but some prints are limited to just 250 to 500, making them highly prized by collectors.

A few publishers buy work outright for a flat fee, but most pay on a royalty basis. Royalties for handpulled prints are usually based on retail price and range from 5 to 20 percent, while percentages for posters and offset reproductions are lower (from $2^{1}/_{2}$ to 5 percent) and are based on the wholesale price. Be aware that some publishers may hold back royalties to cover promotion and production costs. This is not uncommon.

Prices for prints vary widely depending on the quantity available; the artist's reputation; the popularity of the image; the quality of the paper, ink and printing process. Since prices for posters are lower than for original prints, publishers tend to select images with high-volume sales potential.

Negotiating your contract

As in other business transactions, ask for a contract and make sure you understand and agree to all the terms before you sign. Make sure you approve the size, printing method, paper, number of images to be produced and royalties. Other things to watch for include insurance terms, marketing plans and a guarantee of a credit line or copyright notice.

Always retain ownership of your original work. Work out an arrangement in which you're selling publication rights only. You'll also want to sell rights only for a limited period of time. That way you can sell the image later as a reprint or license it for other use (for example as a calendar or note card). If you are a perfectionist about color, make sure your contract gives you final approval of your print. Stipulate that you'd like to inspect a press proof prior to the print run.

Posters & Prints

Posters & Prints

MORE INDUSTRY TIPS

Find a niche. Consider working within a specialized subject matter. Prints with Civil War themes, for example, are avidly collected by Civil War enthusiasts. But to appeal to Civil War buffs, every detail, from weapons and foliage in battlefields to uniform buttons, must be historically accurate. Signed limited editions are usually created in a print run of 950 or so and can average about $175-200; artist's proofs sell from between $195-250, with canvas transfers selling for $400-500. The original paintings from which images are taken often sell for thousands of dollars to avid collectors.

Sport art is another lucrative niche. There's a growing trend toward portraying sports figures from football, basketball and racing (both sports car and horse racing) in prints that include both the artist's and the athlete's signatures. Movie stars and musicians from the 1950s (such as James Dean, Marilyn Monroe and Elvis) are also cult favorites.

Work in a series. It is easier to market a series of small prints exploring a single theme than to market single images. A series of similar prints works well in long hospital corridors, office meeting rooms or restaurants. Also marketable are "paired" images. Hotels often purchase two similar prints for each of their rooms.

Study trends. If you hope to get published by a commercial art publisher or poster company, your work will have a greater chance of acceptance if you use popular colors and themes.

Attend trade shows. Many artists say it's the best way to research the market and make contacts. Increasingly it has become an important venue for self-published artists to market their work. Decor Expo is held each year in four cities: Atlanta, New York, Orlando and Los Angeles. For more information call (888)608-5300 or visit www.decormagazine.com/expo/home.htm.

Insider tips

Tips

- Read industry publications, such as *Decor* magazine and *Art Business News*, to get a sense of what sells.

- To find out what trade shows are coming up in your area, check the event calendars in industry trade publications. Many shows, such as the Decor Expo, coincide with annual stationery or gift shows, so if you work in both the print and greeting card markets, be sure to take that into consideration. Remember, traveling to trade shows is a deductible business expense, so don't forget to save your receipts!

- Consult *Business and Legal Forms for Fine Artists* by Tad Crawford (Allworth Press) for sample contracts.

☑ ACTION IMAGES INC.

7148 N. Ridgeway, Lincolnwood IL 60712. (847)763-9700. Fax: (847)763-9701. E-mail: actionim@aol.com. Website: www.actionimagesinc.com. **President:** Tom Green. Estab. 1989. Art publisher of sport art. Publishes limited edition prints, open edition posters as well as direct printing on canvas. Specializes in sport art prints for events such as the Super Bowl, World Series, Final Four, Indy 500 and NASCAR. Clients include galleries, distributors, sales promotion agencies. Current clients include E&J Gallo Winery, Duracell Battery, CocaCola, AllSport.

Needs Seeking sport art for posters and as promotional material for sporting events. Considers all media. Artists represented include Ken Call, Konrad Hack and Alan Studt. Approached by approximately 25 artists/year. Publishes the work of 1 emerging artist/year.

First Contact & Terms Send query letter with slides or color prints and SASE. Accepts submissions on disk compatible with Mac. Send EPS files. Samples are filed. Responds only if interested. If interested in samples, will ask to see more of artist's work. Pays flat fee: $1,000-2,000. Buys exclusive reproduction rights. Often acquires original painting. Provides insurance while work is at firm and outbound in-transit insurance. Promotional services vary depending on project. Also needs designers. Prefers designers who own Macs. Designers send query letter and samples. Finds artists through recommendations from other artists, word of mouth and submissions.

Tips "The trend seems to be moving away from superrealism toward more Impressionistic work. We like to work with artists who are knowledgable about the pre-press process. Sometimes artists don't understand that the colors they create in their studios will not reproduce the exact way they envision them. Greens are tough to reproduce accurately. When you finish an artwork, have a photographer shoot it and get a color print. You'll be surprised how the colors come out. For example, if you use dayglow colors, they will not show up well in the cromalin. When we hire an artist to create a piece, we need to know the cromalin print will come back with accurate colors. This can only occur when the artist understands how colors reproduce and plans his colors so the final version shows the intended color.''

☒ ADDI GALLERIES

2500 E. 2nd St., Reno NV 89502-1220. (775)324-5599. Fax: (702)323-1920. E-mail: Addicorp@addinet.com. **Vice President:** Winifred Addi. Estab. 1979. Art publisher, distributor and gallery. Clients: galleries, distributors and retail.

Needs Seeking art for the serious collector and the commercial market.

First Contact & Terms Send query letter with slides, photocopies, résumé, transparencies, tearsheets and photographs. Samples are not filed and are returned. Responds in 1 month. Gallery will contact artist for portfolio review if interested. Pays variable royalties. Provides promotion, insurance while work is at firm and written contract.

Tips Advises artists to attend Art Expo in New York and Las Vegas and ABC in Atlanta. "Submit photos, slides or JPEG of work presently available. We usually request that originals be sent if we are interested in art.''

ALEXANDRE ENTERPRISES

P.O. Box 34, Upper Marlboro MD 20773. (301)627-5170. Fax: (301)627-5106. **Artistic Director:** Walter Mussienko. Estab. 1972. Art publisher and distributor. Publishes and distributes handpulled originals, limited editions and originals. Clients: retail art galleries, collectors and corporate accounts.

Needs Seeking creative and decorative art for the serious collector and designer market. Considers oil, watercolor, acrylic, pastel, ink, mixed media, original etchings and colored pencil. Prefers landscapes, wildlife, abstraction, realism and impressionism. Artists represented include Cantin and Gantner. Editions created by collaborating with the artist. Approached by 30 artists/year. Publishes the work of 2 emerging artists/year. Distributes the work of 2-4 emerging artists/year.

First Contact & Terms Send query letter with résumé, tearsheets and photographs. Samples are filed. Responds in 6 weeks only if interested. Call to schedule an appointment to show a portfolio or mail photographs and original pencil sketches. Payment method is negotiated: consignment and/or direct purchase. Offers an advance when appropriate. Negotiates rights purchased. Provides promotion, a written contract and shipping from firm.

Tips "Artist must be properly trained in the basic and fundamental principles of art and have knowledge of art history. Have work examined by art instructors before attempting to market your work.''

☒ APPLEJACK LIMITED EDITIONS

P.O. Box 1527, Historic Rt. 7A, Manchester Center VT 05255. (802)362-3662. E-mail: tino@applajackart.com. Website: www.applejackart.com. **Administrative Assistant:** Tino Barbarossa. Major publisher of limited edition prints.

Needs Seeking fine art for the serious collector and the commercial market. Artists represented include Mort Künstler.

First Contact & Terms Send query letter with slides and SASE to Submissions. Publisher will contact artist for portfolio review if interested.

ARNOLD ART STORE & GALLERY

210 Thames St., Newport RI 02840. (401)847-2273. (800)352-2234. Fax: (401)848-0156. E-mail: info@arnoldart. com. Website: www.arnoldart.com. **Owner:** Bill Rommel. Estab. 1870. Poster company, art publisher, distributor, gallery specializing in marine art. Publishes/distributes limited and unlimited edition, fine art prints, offset reproduction and posters.

Needs Seeking creative, fashionable, decorative art for the serious collector, commercial and designer markets. Considers oil, acrylic, watercolor, mixed media, pastel, pen & ink, sculpture. Prefers sailing images—Americas Cup or other racing images. Artists represented include Kathy Bray, Thomas Buechner and James DeWitt. Editions created by working from an existing painting. Approached by 100 artists/year. Publishes/distributes the work of 10-15 established artists/year.

First Contact & Terms Send query letter with 4-5 photographs. Samples are filed or returned by SASE. Call to arrange portfolio review. Pays flat fee, royalties or consignment. Negotiates rights purchased; rights purchased vary according to project. Provides advertising and promotion. Finds artists through word of mouth.

HERBERT ARNOT, INC.

250 W. 57th St., New York NY 10107. (212)245-8287. Website: www.arnotart.com. **President:** Peter Arnot. Vice President: Vicki Arnot. Art dealer of original oil paintings. Clients: galleries, design firms.

Needs Seeking creative and decorative art for the serious collector and designer market. Considers oil and acrylic paintings. Has wide range of themes and styles—"mostly traditional/impressionistic, not abstract." Artists represented include Raymond Campbell, Christian Nesvadba, Gerhard Nesvadba and Lucien Delarue. Distributes the work of 250 artists/year.

First Contact & Terms Send query letter with brochure, résumé, business card, slides or photographs to be kept on file. Samples are filed or are returned by SASE. Responds in 1 month. Portfolios may be dropped off every Monday-Friday or mailed. Provides promotion.

Tips "Artist should be professional."

N ART DALLAS INC.

2325 Valdina St., Dallas TX 75207. (214)688-0244. Fax: (214)688-7758. E-mail: judymartin@artdallas.com. Website: www.artdallas.com. **President:** Judy Martin. Estab. 1988. Art distributor, gallery, framing and display company. Distributes handpulled originals, offset reproductions. Clients: designers, architects.

Needs Seeking creative art for the commercial and designer markets. Considers mixed media. Prefers abstract, landscapes. Artists represented include Tarran Caldwell, Jim Colley, Tony Bass and Mick Sharp. Editions created by working from an existing painting. Approached by 10 artists/year. Publishes the work of 2 and distributes the work of 4 established artists/year.

First Contact & Terms Send query letter with résumé, photocopies, slides, photographs and transparencies. Samples are filed or are returned. Responds in 2 weeks. Call for appointment to show portfolio of slides and photographs. Pays flat fee: $50-5,000. Offers advance when appropriate. Negotiates rights purchased.

ART EMOTION CORP.

1758 S. Edgar, Palatine IL 60067. (847)397-9300. E-mail: gperez@artcom.com. **President:** Gerard V. Perez. Estab. 1977. Art publisher and distributor. Publishes and distributes limited editions. Clients: corporate/residential designers, consultants and retail galleries.

Needs Seeking decorative art. Considers oil, watercolor, acrylic, pastel and mixed media. Prefers representational, traditional and impressionistic styles. Artists represented include Garcia, Johnson and Sullivan. Editions created by working from an existing painting. Approached by 50-75 artists/year. Publishes and distributes the work of 2-5 artists/year.

First Contact & Terms Send query letter with slides or photographs. "Supply a SASE if you want materials returned to you." Samples are filed. Does not necessarily reply. Pays royalties of 10%.

Tips "Send visuals first."

THE ART GROUP

146-150 Royal College St., London NW1 OTA England. 44 207 428 1700. Fax: 44 207 428 1705. E-mail: mail@artg roup.com. Website: www.artgroup.com. **Contact:** Research Dept. Rights Director. Fine art card and poster publisher/distributor handling posters for framers, galleries, museums, department stores and gift shops. Current clients include IKEA, Habitat, Pier One.

Needs Considers all media and broad subject matter. Fine art contemporary; digitally created artwork. Publishes the work of 100-200 mid-career and 200-400 established artists/year. Distributes the work of more than 2,000 artists/year.

First Contact & Terms Send query letter with brochure, photostats, photographs, photocopies, slides and transparencies. Samples are filed or are returned. Responds in 1 month. Publisher/Distributor will contact artists for portfolio review if interested.

Tips "Send only relevant samples of work. Visit poster and card shops to understand the market a little more before submitting ideas. Be clear and precise."

ART IN MOTION

2000 Brigatine Dr., Coquitlam BC V3K 7B5 Canada. (800)663-1308 or (604)525-3900. Fax: (877)525-6166. E-mail: artdirector@artinmotion.com. Website: www.artinmotion.com. **President:** Garry Peters. Artist Relations: Jessica Gibson. Fine art publisher, distributor and framer. Publishes, licenses and distributes open edition reproductions. Licenses all types of artwork for all industries including wallpaper, fabric, stationery and calendars. Clients: galleries, high-end retailers, designers, distributors worldwide and picture frame manufacturers.

Needs "Our collection of imagery reflects today's interior decorating tastes; we publish a wide variety of techniques. View our collection online before submitting. However, we are always interested in new looks, directions and design concepts." Considers oil and mixed media.

First Contact & Terms Please send slides, photographs and transparencies or e-mail digital files. Samples are filed or are returned. "Artists that are selected for publication can look forward to regular income from royalties (paid on a monthly basis); an arrangement that does not affect sales or originals in any way, allowing you to carry on business as you have always done with galleries and other outlets; additional royalty opportunities from licensing your images; worldwide exposure through advertising, publicity and marketing support; representation at over 70 North American and international trade shows each year; commitment to protecting your intellectual property rights (artist maintains copyright at all times); coverage of all costs, including reproduction, insurance and courier charges."

Tips "We are a world leader in fine art publishing with distribution in over 72 countries. The publishing process utilizes the latest technology and state-of-the-art printing equipment and uses the finest inks and papers available. Artist input and participation are highly valued and encouraged at all times. We warmly welcome artist inquiries."

ART LICENSING INTERNATIONAL INC.

7350 So. Tamiami Trail #227, Sarasota FL 34231. (941)966-8912. Fax: (941)966-8914. E-mail: artlicensing@comcast.net. Website: www.artlicensinginc.com. **Creative Director:** Michael Woodward. Estab. 1986. Licensing agency, which "represents artists who wish to establish a licensing program for their work."

- See listings in Greeting Cards, Gifts & Products and Artists' Rep sections of this book. This company licenses images internationally for a range of products including posters and prints, greeting cards, calendars, toys, etc.

First Contact & Terms Send a CD and photocopies or e-mail JPEGS or a link to your website. Send SASE for return of material. Commission rate is 50%.

Tips "Prints and posters should be in pairs or sets of 4 or more with regard for trends and color palettes related to the home décor market."

ARTBEATS, INC.

129 Glover Ave., Norwalk CT 06850-1311. (800)677-6947. Fax: (203)846-2105. Website: www.nygs.com. Estab. 2002. Art publisher. Publishes and distributes open edition posters and matted prints. Clients: retailers of fine wall decor. Current clients include Prints Plus, Michaels, Hobby Lobby, and others. Member of New York Graphic Society Publishing Group.

Needs Seeking creative, fashionable and decorative art for the home design market. Art guidelines free for SASE with first-class postage. Artwork should be current, appropriate for home decore, professional and polished. Publishes approx. 400 new works each year.

First Contact & Terms Send query letter with résumé, color-correct photographs, transparencies or lasers. Samples are not filed and are returned by SASE if requested by artist. Responds in 3 months. Publisher will contact artist for portfolio review if interested. DO NOT SEND ORIGINALS, AND DO NOT CALL. Terms negotiated at time of contact. Provides written contract. Finds artists through art shows, licensing agents, exhibits, word of mouth and submissions.

ARTEFFECT DESIGNS & LICENSING

P.O. Box 1090, Dewey AZ 86327. (928)632-0530. Fax: (928)632-9052. E-mail: moniqueart@earthlink.net. **Manager:** William F. Cupp. Product development, art licensing and representation of European publishers.

Needs Seeking creative, decorative art for the commercial and designer markets. Considers oil, acrylic, mixed media. Interested in all types of design. Artists represented include Debbie Meyers, Judy Kaufman, Wendy Stevenson, Timothy Easton, Joelle Katan and Nadia Clark. Editions created by working from an existing painting.
First Contact & Terms Send brochure, photographs, SASE, slides. "Must have SASE or will not return." Responds only if interested. Company will contact artist for portfolio review of transparencies if interested. Pays flat fee or royalties. No advance. Rights purchased vary according to project. Provides advertising and representation at international trade shows.

N ARTFINDERS.COM
2508 E. Marcia St., Inverness FL 34453. (352)344-2711. Fax (352)344-8711. E-mail: art@artfinders.net. Website: www.artfinders.com. **Contact:** Tammy and Jim Skodinski. Publisher/distributor of wildlife art.
 ● This publisher also owns www.artprintbargains.com.
Needs Seeking paintings, graphics, posters for the fine art and commercial markets. Specializes in all forms of art.
First Contact & Terms Send e-mail to art@artfinders.com. Publisher will contact for portfolio review if interested.

ARTS UNIQ' INC.
2299 Summerfield Rd., Box 305, Cookeville TN 38506. (615)526-3491 or (800)223-5020. Fax: (615)528-8904. E-mail: CarrieW@artsuniq.com. Website: www.artsuniq.com. **Contact:** Carrie Wallen. Licensing: Carol White. Estab. 1985. Art publisher. Publishes limited and open editions. Licenses a variety of artwork for cards, throws, figurines, etc. Clients: art galleries, gift shops, furniture stores and department stores.
Needs Seeking creative and decorative art for the designer market. Considers all media. Artists represented include D. Morgan, Jack Terry, Judy Gibson and Carolyn Wright. Editions created by collaborating with the artist or by working from an existing painting.
First Contact & Terms Send query letter with slides or photographs. Samples are filed or are returned by request. Responds in 2 months. Pays royalties monthly. Requires exclusive representation rights. Provides promotion, framing and shipping from firm.

ARTVISIONS
12117 SE 26th St., Bellevue WA 98005-4118. (425)746-2201. E-mail: ART@artvisions.com. Website: www.artvisions.com. **President:** Neil Miller. Estab. 1993. Markets include publishers of limited edition prints, calendars, home decor, stationery, note cards & greeting cards and posters and manufacturers of giftware, home furnishings, textiles, puzzles and games. See complete listing in Artists' Reps section.

BANKS FINE ART
1231 Dragon St., Dallas TX 75207. (214)352-1811. Fax: (214)352-6360. E-mail: bob@banksfineart.com. Website: www.banksfineart.com. **Owner:** Bob Banks. Estab. 1980. Distributor, gallery of original oil paintings. Clients: galleries, decorators.
Needs Seeking decorative, traditional and impressionistic art for the serious collector and the commercial market. Considers oil, acrylic. Prefers traditional and impressionistic styles. Artists represented include Joe Sambataro, Jan Bain and Marcia Banks. Approached by 100 artists/year. Publishes/distributes the work of 2 emerging artists/year.
First Contact & Terms Send photographs. Samples are returned by SASE. Responds in 1 week. Offers advance. Rights purchased vary according to project. Provides advertising, in-transit insurance, insurance while work is at firm, promotion, shipping from firm, written contract.
Tips Needs Paris and Italy street scenes. Advises artists entering the poster and print fields to attend Art Expo, the industry's largest trade event, held in New York City every spring. Also recommends reading *Art Business News*.

N BENJAMANS ART GALLERY
419 Elmwood Ave., Buffalo NY 14222. (716)886-0898. Fax: (716)886-0546. E-mail: eileen2134@aol.com. Licensing: Barry Johnson. Estab. 1970. Art publisher, distributor, gallery, frame shop and appraiser. Publishes and distributes handpulled originals, limited and unlimited editions, posters, offset reproductions and sculpture. Clients include P&B International.
Needs Seeking decorative art for the serious collector. Considers oil, watercolor, acrylic and sculpture. Prefers art deco and florals. Artists represented include J.C. Litz, Jason Barr and Eric Dates. Editions created by collaborating with the artist. Approached by 20-30 artists/year. Publishes and distributes the work of 4 emerging, 2 mid-career and 1 established artists/year.
First Contact & Terms Send query letter with SASE, slides, photocopies, résumé, transparencies, tearsheets

and/or photographs. Samples are filed or returned. Responds in 2 weeks. Company will contact artist for portfolio review if interested. Pays on consignment basis: firm receives 30-50% commission. Offers advance when appropriate. Rights purchased vary according to project. Does not require exclusive representation of artist. Provides advertising, promotion, shipping to and from firm, written contract and insurance while work is at firm.

Tips "Keep trying to join a group of artists and try to develop a unique style."

BENTLEY PUBLISHING GROUP

1410 Lesnick Lane, Suite J, Walnut Creek CA 94596. (925)935-3186. Fax: (925)935-0213. E-mail: alp@bentleypu blishinggroup.com. Website: www.bentleypublishinggroup.com. **Product Development Coordinator:** Jan Weiss. Estab. 1986. Art publisher of open and limited editions of offset reproductions and canvas replicas; also agency for licensing of artists' images worldwide. Licenses florals, teddy bear, landscapes, wildlife and Christmas images to appear on puzzles, tapestry products, doormats, stitchery kits, giftbags, greeting cards, mugs, tiles, wall coverings, resin and porcelain figurines, waterglobes and various other gift items. Clients: framers, galleries, distributors and framed picture manufacturers.

Needs Seeking decorative fine art for the designer, residential and commercial markets. Considers oil, watercolor, acrylic, pastel, mixed media and photography. Artists represented include Sherry Strickland, Lisa Chesaux and Andre Renoux. Editions created by collaborating with the artist or by working from an existing painting. Approached by 1,000 artists/year.

First Contact & Terms Submit JPEG images via e-mail or send query letter with brochure showing art style or résumé, advertisements, slides and photographs. Samples are filed or are returned by SASE if requested by artist. Responds in 6 weeks. Pays royalties of 10% net sales for prints monthly plus 50 artist proofs of each edition. Pays 50% monies received from licensing. Obtains all reproduction rights. Usually requires exclusive representation of artist. Provides national trade magazine promotion, a written contract, worldwide agent representation, 5 annual trade show presentations, insurance while work is at firm and shipping from firm.

Tips "Feel free to call and request guidelines. Bentley House is looking for experienced artists with images of universal appeal."

[N] BERGQUIST IMPORTS INC.

1412 Hwy. 33 S., Cloquet MN 55720. (218)879-3343. Fax: (218)879-0010. E-mail: bbergqu106@aol.com. **President:** Barry Bergquist. Estab. 1948. Distributor. Distributes unlimited editions. Clients: gift shops.

Needs Seeking creative and decorative art for the commercial market. Considers oil, watercolor, mixed media and acrylic. Prefers Scandinavian or European styles. Artists represented include Jacky Briggs, Dona Douma and Suzanne Tostey. Editions created by collaborating with the artist or by working from an existing painting. Approached by 20 artists/year. Publishes the work of 2-3 emerging, 2-3 mid-career and 2 established artists/year. Distributes the work of 2-3 emerging, 2-3 mid-career and 2 established artists/year.

First Contact & Terms Send brochure, résumé and tearsheets. Samples are not filed and are returned. Responds in 2 months. Artist should follow up. Portfolio should include color thumbnails, final art, photostats, tearsheets and photographs. Pays flat fee: $50-300, royalties of 5%. Offers advance when appropriate. Negotiates rights purchased. Provides advertising, promotion, shipping from firm and written contract. Finds artists through art fairs. Do not send art attached to e-mail. Will not download from unknown sources.

Tips Suggests artists read *Giftware News Magazine.*

BERKSHIRE ORIGINALS

2 Prospect Hill, Stockbridge MA 01263. (413)298-3691. Fax: (413)298-1293. E-mail: trumbull@marian.org. Website: www.marian.org. **Program Planner:** Alice Trumbull. Estab. 1991. Art publisher and distributor of offset reproductions and greeting cards.

Needs Seeking creative art for the commercial market. Considers oil, watercolor, acrylic, pastel and pen & ink. Prefers religious themes, but also considers florals, holiday and nature scenes, line art and border art.

First Contact & Terms Send query letter with brochure showing art style or other art samples. Samples are filed or are returned by SASE if requested by artist. Responds in 1 month. Write for appointment to show portfolio of slides, color tearsheets, transparencies, original/final art and photographs. Pays flat fee; $50-500. Buys all rights.

Tips "Good draftsmanship is a must, particularly with figures and faces. Colors must be harmonious and clearly executed."

BERNARD FINE ART

P.O. Box 1528, Manchester Center VT 05255. (802)362-0373. Fax: (802)362-1082. E-mail: Michael@applejackart .com. Website: www.applejackart.com. **Managing Director:** Michael Katz. Art publisher. Publishes open edi-

tion prints and posters. Clients: picture frame manufacturers, distributors, manufacturers, galleries and frame shops.

- This company is a division of Applejack Art Partners, along with the high-end poster lines Hope Street Editions and Rose Selavy of Vermont.

Needs Seeking creative, fashionable and decorative art for commercial and designer markets. Considers oil, watercolor, acrylic, pastel, mixed media and printmaking (all forms). Art guidelines free for SASE with first-class postage. Editions created by collaborating with the artist or by working from an existing painting. Artists represented include Erin Dertner, Kevin Daniel, Bill Bell, Shelly Rasche, John Zaccheo, Robin Betterly and Michael Harrison. Approached by hundreds of artists/year. Publishes the work of 8-10 emerging, 10-15 mid-career and 100-200 established artists.

First Contact and Terms Send query letter with brochure showing art style and/or résumé, tearsheets, photostats, photocopies, slides, photographs or transparencies. Samples are returned by SASE. Responds only if interested. Call or write for appointment to show portfolio of thumbnails, roughs, original/final art, b&w and color photostats, tearsheets, photographs, slides and transparencies. Pays royalty. Offers an advance when appropriate. Buys all rights. Usually requires exclusive representation of artist. Provides in-transit insurance, insurance while work is at firm, promotion, shipping from firm and a written contract. Finds artists through submissions, sourcebooks, agents, art shows, galleries and word of mouth.

Tips "We look for subjects with a universal appeal. Some subjects that would be appropriate are landscapes, still lifes, wildlife, religious themes and florals. Please send enough examples of your work so we can see a true representation of style and technique."

THE BILLIARD LIBRARY CO.

1570 Seabright Ave., Long Beach CA 90813. (562)437-5413. Fax: (562)436-8817. E-mail: info@billiardlibrary.com. **Creative Director:** Darian Baskin. Estab. 1973. Art publisher. Publishes unlimited and limited editions and offset reproductions. Clients: galleries, frame shops, decorators. Current clients include Deck the Walls, Prints Plus, Adventure Shops.

Needs Seeking creative, fashionable and decorative art for the commercial and designer markets. Considers oil, watercolor, mixed media, pastel, sculpture and acrylic. Artists represented include George Bloomfield, Dave Harrington and Lance Slaton. Approached by 100 artists/year. Publishes and distributes the work of 1-3 emerging, 1-3 mid-career and 1-2 established artists/year. Also uses freelancers for design. Prefers local designers only.

First Contact & Terms Send query letter with slides, photocopies, résumé, photostats, transparencies, tearsheets and photographs. Samples are filed and not returned. Responds only if interested. Publisher/Distributor will contact artists for portfolio review if interested. Pays royalties of 10%. Negotiates rights purchased. Provides promotion, advertising and a written contract. Finds artists through submissions, word of mouth and sourcebooks.

Tips "The Billiard Library Co. publishes and distributes artwork of all media relating to the sport of pool and billiards. Themes and styles of any type are reviewed with an eye towards how the image will appeal to a general audience of enthusiasts. We are experiencing an increasing interest in nostalgic pieces, especially oils. Will also review any image relating to bowling or darts."

☑ TOM BINDER FINE ARTS

825 Wilshire Blvd., #708, Santa Monica CA 90401. (800)332-4278. Fax: (800)870-3770. E-mail: info@artman.net. Website: www.artman.net and www.alexanderchen.com. **Owner:** Tom Binder. Wholesaler of handpulled originals, limited editions and fine art prints. Clients: galleries and collectors.

Needs Seeking art for the commercial market. Considers acrylic, mixed media, giclee and pop art. Artists represented include Alexander Chen, Ken Shotwell and Elaine Binder. Editions created by working from an existing painting.

First Contact & Terms Send brochure, photographs, photostats, slides, transparencies and tearsheets. Accepts disk submissions if compatible with Illustrator 5.0. Samples are not filed and are returned by SASE. Does not reply; artist should contact. Offers advance when appropriate. Rights purchased vary according to project. Provides shipping. Finds artists through New York Art Expo and World Wide Web.

🅽 THE BLACKMAR COLLECTION

P.O. Box 537, Chester CT 06412. (860)526-9303. E-mail: carser@mindspring.com. Estab. 1992. Art publisher. Publishes offset reproduction and giclée prints. Clients: individual buyers.

Needs Seeking creative art. "We are not actively recruiting at this time." Artists represented include DeLos Blackmar, Blair Hammond, Gladys Bates and Keith Murphey. Editions created by working from an existing painting. Approached by 24 artists/year. Publishes the work of 3 established artists/year. Provides advertising, in-transit insurance, insurance while work is at firm. Finds artists through personal contact.

☑ BON ART & ARTIQUE

divisions of Art Resources International Ltd., 281 Fields Lane, Brewster NY 10509. (845)277-8888 or (800)228-2989. Fax: (845)277-8602. E-mail: randy@fineartpublishers.com. Website: www.artiq.com. **Vice President:** Robin E. Bonnist. Estab. 1980. Art publisher. Publishes unlimited edition offset lithographs and posters. Does not distribute previously published work. Clients: galleries, department stores, distributors, framers worldwide.

Needs Seeking creative and decorative art for the commercial market. Considers oil, acrylic, giclée, watercolor and mixed media. Art guidelines free for SASE with first-class postage. Artists represented include Martin Wiscombe, Mid Gordon, Tina Chaden, Nicky Boehme, Jennifer Wiley, Claudine Hellmuth, Diane Knott, Joseph Kiley, Brenda Walton, Gretchen Shannon, Craig Biggs. Editions created by collaborating with the artist. Approached by hundreds of artists/year. Publishes the work of 15 emerging, 10 mid-career and 10 established artists/year.

First Contact & Terms E-mail or send query letter with photocopies, photographs, tearsheets, slides and photographs to be kept on file. Samples returned by SASE only if requested. Portfolio review not required. Prefers to see slides or transparencies initially as samples, then reviews originals. Responds in 2 months. Appointments arranged only after work has been sent with SASE. Negotiates payment. Offers advance in some cases. Requires exclusive representation for prints/posters during period of contract. Provides advertising, in-transit insurance, insurance while work is at publisher, shipping from firm, promotion and a written contract. Artist owns original work. Finds artists through art and trade shows, magazines and submissions.

Tips "Please submit decorative, fine quality artwork. We prefer to work with artists who are creative, professional and open to art direction."

⬛ BRINTON LAKE EDITIONS

Box 888, Brinton Lake Rd., Concordville PA 19331-0888. (610)459-5252. Fax: (610)459-2180. E-mail: galleryone@mindspring.com. **President:** Lannette Badel. Estab. 1991. Art publisher, distributor, gallery. Publishes/distributes limited editions and canvas transfers. Clients: independent galleries and frame shops. Current clients include: over 100 galleries, mostly East Coast.

Needs Seeking fashionable art. Considers oil, acrylic, watercolor, mixed media and pastel. Prefers realistic landscape and florals. Artists represented include Gary Armstrong and Lani Badel. Editions created by collaborating with the artist. Approached by 20 artists/year. Publishes/distributes the work of 1 emerging and 1 established artist/year.

First Contact & Terms Send query letter with samples. Samples are not filed and are returned. Responds in 2 months. Company will contact artist for portfolio review of final art, photographs, slides, tearsheets and transparencies if interested. Negotiates payment. Rights purchased vary according to project. Requires exclusive representation of artist.

Tips "Artists submitting must have good drawing skills no matter what medium used."

⬛ BROWN'S FINE ART & FRAMING

630 Fondren Place, Jackson MS 39216. (601)982-4844 or (800)737-4844. Fax: (601)982-0030. Website: www.brownsfineart.com. **Contact:** Joel Brown. Estab. 1965. Gallery/frame shop. Sells originals, limited editions, unlimited editions, fine art prints, monoprints, offset reproductions, posters, sculpture and "original art by Mississippi artists." Current clients include: doctors, lawyers, accountants, insurance firms, general public, other frame shops and distributors, decorators and architects, local companies large and small.

Needs Seeking creative, decorative and investment quality art for the serious collector, commercial and designer markets. Considers oil, acrylic, watercolor, mixed media, pastel, pen & ink and sculpture. Prefers landscapes, florals, unique, traditional and contemporary. Artists represented include Emmitt Thames, Sharon Richardson, Jackie Meena, "plus 30 other Mississippi artists."

First Contact & Terms Call to make appointment to bring original work. Samples are returned. Request portfolio review of final art and originals in original query. Pays on consignment basis: firm receives 50% commission. Requires exclusive representation of artist. Provides advertising, in-transit insurance, insurance while work is at firm, promotion, shipping from our firm and all framing.

Tips "Visit our website."

⬛ JOE BUCKALEW

1825 Annwicks Dr., Marietta GA 30062. (800)971-9530. Fax: (770)971-6582. E-mail: joesart@prodigy.com. Website: www.joebuckalew.com. **Contact:** Joe Buckalew. Estab. 1990. Distributor. Distributes limited editions, canvas transfers, fine art prints and posters. Clients: 600-800 frame shops and galleries.

Needs Seeking creative, fashionable, decorative art for the serious collector. Considers oil, acrylic and watercolor. Prefers florals, landscapes, Civil War and sports. Artists represented include B. Sumrall, R.C. Davis, F. Buckley, M. Ganeck, D. Finley, Dana Coleman, Jim Booth, Sandra Raper. Approached by 25-30 artists/year.

Distributes work of 10 emerging, 10 mid-career and 50 established artists/year. Art guidelines free for SASE with first-class postage.

First Contact & Terms Send sample prints. Accepts disk submissions. "Please call. Currently using a 460 commercial computer." Samples are filed or are returned. Does not reply. Artist should call. To show portfolio, artist should follow up with call after initial query. Portfolio should include sample prints. Pays on consignment basis: firm receives 50% commission paid net 30 days. Provides advertising, shipping from firm and company catalog. Finds artists through ABC shows, regional art & craft shows, frame shops, other artists.

Tips "Paint your own style."

☒ CANADIAN ART PRINTS INC.

110-6311 Westminster Hwy., Richmond BC V7C 4V4 Canada. (800)663-1166 or (604)276-4551. Fax: (604)276-4552. E-mail: sales@canadianartprints.com. Website: www.canadianartprints.com. **Creative Director:** Niki Krieger. Estab. 1965. Art publisher/distributor. Publishes or distributes unlimited edition, fine art prints, posters and art cards. Clients: galleries, decorators, frame shops, distributors, corporate curators, museum shops, gifts-hops and manufacturing framers. Licenses all subjects of open editions for wallpaper, writing paper, placemats, books, etc.

Needs Seeking fashionable and decorative art for the commercial and designer markets. Considers oil, acrylic, watercolor, mixed media, pastel. Prefers representational florals, landscapes, marine, decorative and street scenes. Artists represented include Linda Thompson, Jae Dougall, Philip Craig, Joyce Kamikura, Kiff Holland, Victor Santos, Dubravko Raos, Don Li-Leger, Michael O'Toole and Will Rafuse. Editions created by collaborating with the artist and working from an existing painting. Approached by 300-400 artists/year. Publishes/distributes the work of more than 150 artists/year.

First Contact & Terms Send query letter with photographs, SASE, slides, tearsheets, transparencies. Samples are not filed and are returned by SASE. Responds in 1 month. Will contact artist for portfolio review of photographs, slides or transparencies if interested. Pays range of royalties. Buys reprint rights or negotiates rights purchased. Provides advertising, in-transit insurance, insurance while work is at firm, promotion, shipping and contract. Finds artists through art exhibitions, art fairs, word of mouth, art reps, submissions.

Tips "Keep up with trends by following decorating magazines."

☑ CARMEL FINE ART PRODUCTIONS, LTD.

P.O. Box 11696, Milwaukee WI 53211. (414)967-4994. Fax: (414)967-4995. E-mail: carmelfineart@sbcglobal.net. Website: www.carmelprod.com. **Vice President Sales:** Louise Perrin. Estab. 1995. Art publisher/distributor. Publishes/distributes originals, limited and open edition fine art prints. Clients: galleries, corporate curators, distributors, frame shops, decorators.

Needs Seeking creative art for the serious collector, commercial and designer markets. Considers oil, acrylic, pastel. Prefers family-friendly abstract and figurative images. Artists represented include William Calhoun, Jon Jones, Okay Babs, G.L. Smothers and Anthony Armstrong. Editions created by collaborating with the artist and working from an existing painting. Approached by 10-20 artists/year. Publishes the work of 2-3 emerging, 1 mid-career and 2-3 established artists/year.

First Contact & Terms Send query letter with brochure, photographs. Samples are filed. Responds in 1 month. Will contact artist for portfolio review of final art, roughs if interested. Rights purchased vary according to project. Provides advertising, promotion, shipping from firm and contract. Finds artists through established networks.

Tips "Be true to your creative callings and keep the faith."

☑ CAVALIER GRAPHICS

17197 Old Jefferson, Prairieville LA 70769. (225)673-4612. Fax: (225)673-9503. E-mail: customerservice@cavaliergraphics.com. Website: www.cavaliergraphics.com. **Partner:** Al Cavalier. Estab. 1991. Poster company, art publisher and distributor. Publishes/distributes limited edition, unlimited edition, offset reproduction and posters. Clients: galleries, frame shops and distributors. "We have about 1,000 clients in over 40 states."

Needs Seeking creative, fashionable and decorative art for the commercial and designer market. Considers oil, acrylic, watercolor and mixed media. Prefers decorative, floral, southern genre. Editions created by collaborating with the artist and working from an existing painting. Approached by 20-40 artists/year.

First Contact & Terms Send query letter with brochure, photographs and tearsheets. Samples are not filed and are returned by SASE. Responds in 3 weeks. Company will contact artist for portfolio review if interested. Portfolio should include color, final art, photographs and tearsheets. Pays royalties and negotiates payment or pays in merchandise. Rights purchased vary according to project. Provides advertising. Finds artists through art exhibition, art fairs, word of mouth and artists' submissions.

Tips "Be aware of current color trends. Work in a series."

☑ CHALK & VERMILION FINE ARTS

55 Old Post Rd., #2, Greenwich CT 06830. (203)869-9500. Fax: (203)869-9520. E-mail: mail@chalk-vermilion.c om. **Contact:** Pam Ferraro. Estab. 1976. Art publisher. Publishes original paintings, handpulled serigraphs and lithographs, posters, limited editions and offset reproductions. Clients: 4,000 galleries worldwide.

Needs Publishes decorative art for the serious collector and the commercial market. Considers oil, mixed media, acrylic and sculpture. Artists represented include Thomas McKnight, Bruce Ricker and Fanny Brennan. Editions created by collaboration. Approached by 350 artists/year.

First Contact & Terms Send query letter with résumé and slides or photographs. Samples are filed or are returned by SASE if requested by artist. Responds in 3 months. Publisher will contact artist for portfolio review if interested. Payment "varies with artist, generally fees and royalties." Offers advance. Negotiates rights purchased. Prefers exclusive representation of artist. Provides advertising, in-transit insurance, promotion, shipping to and from firm, insurance while work is at firm and written contract. Finds artists through exhibitions, trade publications, catalogs, submissions.

CIRRUS EDITIONS

542 S. Alameda St., Los Angeles CA 90013. (213)680-3473. Fax: (213)680-0930. E-mail: cirrus@cirrusgallery.c om. Website: www.cirrusgallery.com. **Owner:** Jean R. Milant. Produces limited edition handpulled originals. Clients: museums, galleries and private collectors.

Needs Seeking contemporary paintings and sculpture. Prefers abstract, conceptual work. Artists represented include Lari Pittman, Joan Nelson, John Millei, Charles C. Hill and Bruce Nauman. Publishes and distributes the work of 6 emerging, 2 mid-career and 1 established artists/year.

First Contact & Terms Prefers slides as samples. Samples are returned by SASE.

CLASSIC COLLECTIONS FINE ART

1 Bridge St., Irvington NY 10533. (914)591-4500. Fax: (914)591-4828. **Acquisition Manager:** Larry Tolchin. Estab. 1990. Art publisher. Publishes unlimited editions and offset reproductions. Clients: galleries, interior designers, hotels. Licenses florals, landscapes, animals for kitchen/bathroom.

Needs Seeking decorative art for the commercial and designer markets. Considers oil, acrylic, watercolor, mixed media and pastel. Prefers landscapes, still lifes, florals. Artists represented include Harrison Rucker, Henrietta Milan, Sid Willis, Charles Zhan and Henry Peeters. Editions created by collaborating with the artist and by working with existing painting. Approached by 100 artists/year. Publishes the work of 6 emerging, 6 mid-career and 6 established artists/year.

First Contact & Terms Send slides and transparencies. Samples are filed. Responds in 3 months. Company will contact artist for portfolio review if interested. Offers advance when appropriate. Buys first and reprint rights. Provides advertising; insurance while work is at firm; and written contract. Finds artists through art exhibitions, fairs and competitions.

☑ THE COLONIAL ART CO.

1336 NW First St., Oklahoma City OK 73106. (405)232-5233. Fax: (405)232-6607. E-mail: info@colonialart@ms n.com. **Owner:** Willard Johnson. Estab. 1919. Publisher and distributor of offset reproductions for galleries. Clients: retail and wholesale. Current clients include Osburns, Grayhorse and Burlington.

Needs Artists represented include Felix Cole, Dennis Martin, John Walch and Leonard McMurry. Publishes the work of 2-3 emerging, 2-3 mid-career and 3-4 established artists/year. Distributes the work of 10-20 emerging, 30-40 mid-career and hundreds of established artists/year. Prefers realism and expressionism—emotional work.

First Contact & Terms Send sample prints. Samples not filed are returned only if requested by artist. Publisher/ distributor will contact artist for portfolio review if interested. Pays negotiated flat fee or royalties or on a consignment basis (firm receives 33% commission). Offers an advance when appropriate. Does not require exclusive representation of the artist. Considers buying second rights (reprint rights) to previously published work.

Tips "The current trend in art publishing is an emphasis on quality."

☒ COLOR CIRCLE ART PUBLISHING, INC.

P.O. Box 190763, Boston MA 02119. (617)437-1260. Fax: (617)437-9217. E-mail: t123@msn.com. Website: www.colorcircle.com. **Contact:** Bernice Robinson. Estab. 1991. Art publisher. Publishes limited editions, unlimited editions, fine art prints, offset reproductions, posters. Clients: galleries, art dealers, distributors, museum shops. Current clients include: Deck the Walls, Things Graphics, Essence Art.

Needs Seeking creative, decorative art for the serious collector and the commercial market. Considers oil, acrylic, watercolor, mixed media, pastel, pen & ink. Prefers ethnic themes. Artists represented include Paul Goodnight, Essud Fungcap, Charly and Dorothea Palmer. Editions created by collaborating with the artist or

by working from an existing painting. Approached by 12-15 artists/year. Publishes the work of 2 emerging, 1 mid-career artists/year. Distributes the work of 4 emerging, 1 mid-career artists/year.

First Contact & Terms Send query letter with slides. Samples are filed or returned by SASE. Responds in 2 months. Negotiates payment. Rights purchased vary according to project. Provides advertising, insurance while work is at firm, promotion, shipping from our firm and written contract. Finds artists through submissions, trade shows and word of mouth.

Tips "We like to present at least two pieces by a new artist that are similar in theme, treatment or colors."

CRAZY HORSE PRINTS

23026 N. Main St., Prairie View IL 60069. (847)634-0963. **Owner:** Margaret Becker. Estab. 1976. Art publisher and gallery. Publishes limited editions, offset reproductions and greeting cards. Clients: Native American art collectors.

Needs "We publish only Indian-authored subjects." Considers oil, pen & ink and acrylic. Prefers nature themes. Editions created by working from an existing painting. Approached by 10 artists/year. Publishes the work of 2 and distributes the work of 20 established artists/year.

First Contact & Terms Send résumé and photographs. Samples are filed. Responds only if interested. Publisher will contact artist for portfolio review if interested. Portfolio should include photographs and bio. Pays flat fee: $250-1,500 or royalties of 5%. Offers advance when appropriate. Buys all rights. Provides promotion and written contract. Finds artists through art shows and submissions.

☑ CREATIF LICENSING CORP.

31 Old Town Crossing, Mount Kisco NY 10549-4030. (914)241-6211. E-mail: info@creatifusa.com. Website: www.creatifusa.com. **Contact:** Marcie Silverman. Estab. 1975. Art licensing agency. Clients: manufacturers of gifts, stationery, toys and home furnishings.

- Creatif posts submission guidelines on its Web page.

CUPPS OF CHICAGO, INC.

225 Stanley St., Elk Grove IL 60007. (847)593-5655. Fax: (847)593-5550. E-mail: cuppsofchicago@aol.com. **President:** Gregory Cupp. Estab. 1967. Art publisher and distributor of limited and open editions, offset reproductions and posters and original paintings. Clients: galleries, frame shops, designers and home shows.

- Pay attention to contemporary/popular colors when creating work for this design-oriented market.

Needs Seeking creative and decorative art for the commercial and designer markets. Also needs freelance designers. Artists represented include Gloria Rose and Rob Woodrum. Editions created by collaborating with the artist or by working from an existing painting. Considers oil and acrylic paintings in "almost any style— only criterion is that it must be well done." Prefers individual works of art. Approached by 150-200 artists/year. Publishes and distributes the work of 25-50 emerging artists/year.

First Contact & Terms Send query letter with résumé, photographs, photocopies and tearsheets. Samples are filed or are returned by SASE if requested. Responds only if interested. Company will contact artist for portfolio review of color photographs if interested. Negotiates payment. Rights purchased vary according to project. Provides advertising, promotion, shipping from firm, insurance while work is at firm.

Tips This distributor sees a trend toward traditional and the other end of the spectrum—contemporary. "Please send in photos, original work, prints and photocopies in CD form."

☑ DARE TO MOVE

12932 SE Kent-Kangley Rd. #007, Kent WA 98030. (253)639-4493. Fax: (253)630-1865. E-mail: daretomove@aol.com. Website: www.daretomove.com. **President:** Steve W. Sherman. Estab. 1987. Art publisher, distributor. Publishes/distributes limited editions, unlimited editions, canvas transfers, fine art prints, offset reproductions. Licenses aviation and marine art for puzzles, note cards, book marks, coasters etc. Clients: art galleries, aviation museums, frame shops and interior decorators.

- This company has expanded from aviation-related artwork to work encompassing most civil service areas. Steve Sherman likes to work with artists who have been painting for 10-20 years. He usually starts off distributing self-published prints. If prints sell well, he will work with artist to publish new editions.

Needs Seeking naval, marine, firefighter, civil service and aviation-related art for the serious collector and commercial market. Considers oil and acrylic. Artists represented include John Young, Ross Buckland, Mike Machat, James Dietz, Jack Fellows, William Ryan, Patrick Haskett. Editions created by collaborating with the artist or working from an existing painting. Approached by 15-20 artists/year. Publishes the work of 1 emerging, 2-3 mid-career and established artists/year. Distributes the work of 9 emerging and 2-3 established artists/year.

First Contact & Terms Send query letter with photographs, slides, tearsheets and transparencies. Samples are filed or sometimes returned by SASE. Artist should follow up with call. Portfolio should include color photographs, transparencies and final art. Pays royalties of 20% commission of wholesale price. Buys one-time or

reprint rights. Provides advertising, in-transit insurance, insurance while work is at firm, promotion, shipping from firm and written contract.

Tips ''Present your best work—professionally.''

DECORATIVE EXPRESSIONS, INC.

3595 Clearview Place, Atlanta GA 30340. (770)457-8008. Fax: (770)457-8018. **President:** Robert Harris. Estab. 1984. Distributor. Distributes original oils. Clients: galleries, designers, antique dealers.

Needs Seeking creative and decorative art for the designer market. Styles range from traditional to contemporary to impressionistic. Artists represented include Javier Mulio and Giner Bueno. Approached by 6 artists/year. Distributes the work of 2-6 emerging, 2-4 mid-career and 10-20 established artists/year.

First Contact & Terms Send photographs. Samples are returned by SASE if requested by artist. Responds back only if interested. Portfolios may be dropped off every Monday. Portfolio should include final art and photographs. Negotiates payment. Offers advance when appropriate. Negotiates rights purchased. Requires exclusive representation of artist. Provides advertising, in-transit insurance, promotion and distribution through sale force and trade shows. Finds artists through word of mouth, exhibitions, travel.

Tips ''The design market is a major source for placing art. We seek art that appeals to designers.''

DELJOU ART GROUP, INC.

1630 Huber St., Atlanta GA 30318. (404)350-7190. Fax: (404)350-7195. E-mail: submit@deljouartgroup.com. **Contact:** Art Director. Estab. 1980. Art publisher, distributor and gallery of limited editions (maximum 250 prints), handpulled originals, monoprints/monotypes, sculpture, fine art photography, fine art prints and paintings on paper and canvas. Clients: galleries, designers, corporate buyers and architects. Current clients include Coca Cola, Xerox, Exxon, Marriott Hotels, General Electric, Charter Hospitals, AT&T and more than 3,000 galleries worldwide, ''forming a strong network throughout the world.''

Needs Seeking creative, fine and decorative art for the designer market and serious collectors. Considers oil, acrylic, pastel, sculpture and mixed media. Artists represented include Yunessi, T.L. Lange, Michael Emani, Vincent George, Nela Soloman, Alterra, Ivan Reyes, Mindeli, Sanford Wakeman, Niri Vessali, Lee White, Alexa Kelemen, Bika, Kamy, Craig Alan, Roya Azim, Jian Chang, Elya DeChino, Antonio Dojer and Mia Stone. Editions created by collaborating with the artist. Approached by 300 artists/year. Publishes the work of 10 emerging, 20 mid-career artists/year and 20 established artists/year.

First Contact & Terms Send query letter with photographs, slides, brochure, photocopies, tearsheets, SASE and transparencies. Samples not filed are returned only by SASE. Responds in 6 months. Will contact artist for portfolio review if interested. Payment method is negotiated. Offers an advance when appropriate. Negotiates rights purchased. Requires exclusive representation. Provides promotion, a written contract and advertising. Finds artists through visiting galleries, art fairs, word of mouth, World Wide Web, art reps, submissions, art competitions and sourcebooks. Pays highest royalties in the industry.

Tips ''We need landscape artists, monoprint artists, strong figurative artists, sophisticated abstracts and soft-edge abstracts. We are also beginning to publish sculptures and are interested in seeing slides of such. We have had a record year in sales and have recently relocated again into a brand new gallery, framing and studio complex. We also have the largest gallery in the country. We have added a poster division and need images in different categories for our poster catalogue as well.''

DIRECTIONAL PUBLISHING, INC.

2812 Commerce Square E., Birmingham AL 35210. (205)951-1965. Fax: (205)951-3250. E-mail: custsvc@directi onalart.com. Website: www.directionalart.com. **President:** David Nichols. Art Director: Tony Murray. Estab. 1986. Art publisher. Publishes limited and unlimited editions and offset reproductions. Clients: galleries, frame shops and picture manufacturers. Licenses: decorative stationery, rugs, home products.

Needs Seeking decorative art for the designer market. Considers oil, watercolor, acrylic and pastel. Prefers casual designs in keeping with today's interiors. Artists represented include A. Kamelhair, H. Brown, R. Lewis, L. Brewer, S. Cairns, N. Strailey, D. Swartzendruber, D. Nichols, M.B. Zeitz and N. Raborn. Editions created by working from an existing painting. Approached by 50 artists/year. Publishes and distributes the work of 5-10 emerging, 5-10 mid-career and 3-5 established artists/year.

First Contact & Terms Send query letter with slides and photographs or digital disc. Samples are not filed and are returned by SASE. Responds in 3 months. Pays royalties. Buys all rights. Provides in-transit insurance, insurance while work is at firm, promotion, shipping from firm and written contract.

Tips ''Always include SASE. Do not follow up with phone calls. All work published is first of all *decorative*. The application of artist-designed borders to artwork can sometimes greatly improve the decorative presentation. We follow trends in the furniture/accessories market. Aged and antiqued looks are currently popular—be creative! Check out what's being sold in home stores for trends and colors.''

DODO GRAPHICS, INC.

145 Cornelia St., P.O. Box 585, Plattsburgh NY 12901. (518)561-7294. Fax: (518)561-6720. **Manager:** Frank How. Art publisher of offset reproductions, posters and etchings for galleries and frame shops.

Needs Considers pastel, watercolor, tempera, mixed media, airbrush and photographs. Prefers contemporary themes and styles. Prefers individual works of art, 16×20 maximum. Publishes the work of 5 artists/year.

First Contact & Terms Send query letter with brochure showing art style or photographs, slides or CD ROM. Samples are filed or are returned by SASE. Responds in 3 months. Write for appointment to show portfolio of original/final art and slides. Payment method is negotiated. Offers an advance when appropriate. Buys all rights. Requires exclusive representation of the artist. Provides written contract.

Tips "Do not send any originals unless agreed upon by publisher."

DOLICE GRAPHICS

392 East 10th St., ℅ Internet Cafe/Ground Floor, New York NY 10009. (212)529-2025. Fax: (212)260-9217. E-mail: tech-man@erols.com. **Contact:** Joe Dolice, publisher. Estab. 1968. Art publisher. Publishes fine art prints, limited edition, offset reproduction, unlimited edition. Clients: architects, corporate curators, decorators, distributors, frame shops, galleries, gift shops and museum shops. Current clients include: Bloomingdale's (Federated Dept. Stores).

Needs Seeking decorative, representational, antiquarian "type" art for the commercial and designer markets. Considers acrylic, mixed media, pastel, pen & ink, prints (intaglio, etc.) and watercolor. Prefers traditional, decorative, antiquarian type. Editions created by collaborating with the artist and working from an existing painting. Approached by 12-20 artists/year.

First Contact & Terms Send query letter with color photocopies, photographs, résumé, SASE, slides and transparencies. Samples are returned by SASE or not returned. Responds only if interested. Company will contact artist for portfolio review if interested. Negotiates payment. Buys all rights on contract work. Rights purchased vary according to project. Provides free website space and promotion and written contract. Finds artists through art reps and artist's submissions.

Tips "We publish replicas of antiquarian-type art prints for decorative arts markets and will commission artists to create "works for hire" in the style of pre-century artists and occasionally to color black & white engravings, etchings, etc. Artists interested should be well schooled and accomplished in traditional painting and printmaking techniques and should be able to show samples of this type of work if we contact them."

EDELMAN FINE ARTS, LTD.

141 W. 20th St., Third Floor, New York NY 10011-3601. (646)336-6610. E-mail: artprices@aol.com. Website: www.hheatheredelmangallery.com. **Vice President:** H. Heather Edelman. Art distributor of original acrylic and oil paintings. "Additional company distributes works of art on paper, sculptures, blown glass, tapestry and unique objects d' Art." Clients: galleries, dealers, consultants, interior designers and furniture stores worldwide.

- The mainstream art market is demanding traditional work with great attention to detail. Impressionism is still in vogue but with a cutting edge to it, with strong colors; Madonna & Child old world, high quality landscapes; woman and woman-and-children in all techniques needed. Abstracts with an image.

Needs Seeking creative and decorative art for the serious collector and designer markets. Considers oil and acrylic paintings, watercolor, sculpture and mixed media. Artists represented include Marc Chagall, Joan Miro and Pablo Picasso. Distributes the work of 150 emerging, 70 mid-career and 150 established artists.

First Contact & Terms Send six 3×5 photos of your best work (no slides), résumé, tearsheets. Samples are filed. Call before dropping off portfolios. Portfolio should include bio, exhibition history, price of work, photographs and/or original/final art. Responds as soon as possible. Pays royalties of 40% on works on consignment basis, 20% commission for trade sales; 50/50 retail. Buys all rights. Provides in-transit insurance, insurance while work is at firm, promotion and shipping from firm.

Tips "Know what's salable and available in the marketplace."

EDITIONS LIMITED GALLERIES, INC.

4090 Halleck St., Emeryville CA 94608. (510)923-9770. Fax: (510)923-9777. Website: www.editionslimited.com. **Director:** Todd Haile. Art publisher and distributor of limited edition graphics and fine art posters. Clients: contract framers, galleries, framing stores, art consultants and interior designers.

Needs Seeking art for the original and designer markets. Considers oil, acrylic and watercolor painting, monoprint, monotype, photography and mixed media. Prefers landscape, floral and abstract imagery. Editions created by collaborating with the artist or by working from existing works.

First Contact & Terms Send query letter with résumé, slides and photographs or JPEG files (8" maximum at 72 dpi) via e-mail at website. Samples are filed or are returned by SASE. Responds in 2 months. Publisher/distributor will contact artist for portfolio review if interested. Payment method is negotiated. Negotiates rights purchased.

Tips ''We deal both nationally and internationally, so we need art with wide appeal. When sending slides or photos, send at least six so we can get an overview of your work. We publish artists, not just images.''

ENCORE GRAPHICS & FINE ART

P.O. Box 812, Madison AL 35758. (800)248-9240. E-mail: encore@randenterprises.com. Website: www.egart.com. **President:** J. Rand, Jr. Estab. 1995. Poster company, art publisher, distributor. Publishes/distributes limited edition, unlimited edition, fine art prints, offset reproduction, posters. Clients: galleries, frame shops, distributors.

Needs Creative art for the serious collector. Considers all media. Prefers African-American and abstract. Art guidelines available on company's website. Artists represented include Greg Gamble, Buck Brown, Mario Robinson, Lori Goodwin, Wyndall Coleman, T.H. Waldman, John Will Davis, Burl Washington, Henry Battle, Cisco Davis, Delbert Iron-Cloud, Gary Thomas and John Moore. All Buffalo Soldier Prints. Editions created by working from an existing painting. Approached by 15 artists/year. Publishes the work of 3 emerging artists, 1 mid-career artist/year. Distributes the work of 3 emerging, 2 mid-career and 3 established artists/year.

First Contact & Terms Send photocopies, photographs, résumé, tearsheets. Samples are filed. Responds only if interested. Company will contact artist for portfolio review of color, photographs, tearsheets if interested. Negotiates payment. Offers advance when appropriate. Requires exclusive representation of artist. Provides advertising, in-transit insurance, insurance while work is at firm, promotion, shipping from firm, written contract. Finds artists through the World Wide Web and art exhibits.

Tips ''Prints of African-Americans with religious themes or children are popular now. Paint from the heart.''

© Judy Kaufman

This print of calla lilies entitled ''Tuscany Dreams'' was created by oil painter Judy Kaufman, published by the Spanish company Dislama SL in Malaga, and marketed and distributed by ArtEffect Designs & Licensing of Dewey, Arizona. ''We at ArtEffect love working with Judy because she is very talented and versatile, and she is a wonderful person who understands the art business with its deadlines and color trends,'' said Monique Van Den Hurk of ArtEffect.

Posters & Prints

FAIRFIELD ART PUBLISHING

87 35th Street, 3rd Floor, Brooklyn NY 11232. (800)835-3539. **Vice President:** Peter Lowenkron. Estab. 1996. Art publisher. Publishes posters, unlimited editions and offset reproductions. Clients: galleries, frame shops, museum shops, decorators, corporate curators, giftshops, manufacturers and contract framers.
Needs Decorative art for the designer and commercial markets. Considers collage, oil, watercolor, pastel, pen & ink, acrylic. Artists represented include Daniel Pollera, Roger Vilarchao, Yves Poinsot.
First Contact & Terms Send query letter with slides and brochure. Samples are returned by SASE if requested by artist. Responds only if interested. Pays flat fee, $400-2,500 maximum, or royalties of 7-15%. Offers advance when appropriate. Rights purchased vary according to project. Interested in buying second rights (reprint rights) to previously published artwork.
Tips "If you don't think you're excellent, wait until you have something excellent. Posters are a utility, they go somewhere specific, so images I use fit somewhere—over the couch, kitchen, etc."

[N] NANNY FAYE FINE ART

408 N., Mountain Rd. PA 17112. (800)733-1144. Fax: (800)830-8640. E-mail: sales@nannyfaye. Website: www. nannyfaye.com. **President:** Wendy Augustine. Estab. 1990. Art publisher, distributor, wholesale framer/liscencing agent for gift industry. Publishes limited edition, unlimited edition, fine art prints, offset reproduction, posters. Clients: gift and furniture industry, retail catalogs, galleries and framers.
Needs Seeking creative and decorative art for the commercial market; also folk, country, traditional, trends in the gift industry. Connsiders oil, acrylic, watercolor. Artists represented include Anna Krajewski, Alex Krajewski, Stewart Sherwood, Nancy Young, Clint Hansen, Barbara Appleyard, Catherine Simpson. Editions created by collaborating with the artist or working from an existing painting. Approached by 20-50 artists/year. Publishes the work of 1 emerging, 1-2 mid-career and 2-3 established artists/year.
First Contact & Terms Send letter with brochure, photocopies, photographs, tearsheets and transparencies. Samples are filed or returned. Will contact for portfolio review of b&w, color, final art, photographs, tearsheets if interested. Payment negotiable. Offers advance when appropriate. Rights purchased vary according to project. Provides advertising, insurance while work is at firm, promotion. Also needs freelancers for design.

[✓] FLYING COLORS, INC.

4121 W. Jefferson Blvd., Los Angeles CA 90016. (323)732-9994. Fax: (323)731-0969. E-mail: joe@flying-colors.net. Website: www.flying-colors.net. **Art Director:** Lyle Siwkewich. Estab. 1993. Poster company and art publisher. Publishes unlimited edition, fine art prints, posters. Clients: galleries, frame shops, distributors, museum shops, giftshops, mail order, end-users, retailers, chains, direct mail.
Needs Seeking decorative art for the commercial market. Considers oil, acrylic, watercolor, mixed media, pastel. Prefers multicultural, religious, inspirational wildlife, Amish, country, scenics, stilllife, American culture. Also needs freelancers for design. Prefers designers who own Mac computers. Artists represented include Greg Gorman, Deidre Madsen. Editions created by collaborating with the artist or by working from an existing painting. Approached by 200 artists/year. Publishes the work of 20 emerging, 5-10 mid-career, 1-2 established artists/year.
First Contact & Terms May contact via e-mail or send photocopies, photographs, SASE, slides, transparencies. Accepts disk submissions if compatible with SyQuest, Dat, Jazzy, ZIP, QuarkXPress, Illustrator, Photoshop or FreeHand. Samples are filed or returned by SASE. Responds only if interested. Artist should follow-up with call to show portfolio. Portfolio should include color, photographs, roughs, slides, transparencies. Negotiates payment. Offers advance when appropriate. Negotiates rights purchased, all rights preferred. Provides advertising, promotion, written contract. Finds artists through attending art exhibitions, art fairs, word of mouth, artists' submissions, clients, local advertisements.
Tips "Ethnic and inspirational/religious art is very strong. Watch the furniture industry. Come up with themes, sketches and series of at least two pieces. Art has to work on 8×10, 16×20, 22×28, 24×36, greeting cards and other possible mediums."

FORTUNE FINE ART

(formerly Colville Publishing), 2908 Oregon Ct., #G3, Torrance CA 90503. (310)618-1231. Fax: (310)618-1232. E-mail: carolv@fortunefa.com. Website: www.fortunefa.com. **Contact:** Carol J. Vidic, President. Licensing: Peter Iwasaki. Publishes fine art prints, hand-pulled serigraphs, originals, limited edition, offset reproduction, posters and unlimited edition. Clients: art galleries, dealers and designers.
Needs Seeking creative art for the serious collector. Considers oil on canvas, acrylic on canvas, mixed media on canvas and paper. Artists represented include John Powell, Daniel Gerhartz, Marilyn Simandle and Don Hatfield. Publishes and distributes the work of a varying number of emerging artists/year.
First Contact & Terms Send query letter with résumé, slides, photographs, transparencies, biography and SASE. Samples are not filed. Responds in 1 month. To show a portfolio, mail appropriate materials. Payment method

and advances are negotiated. Prefers exclusive representation of artist. Provides in-transit insurance, insurance while work is at firm, promotion and written contract.

Tips "Establish a unique style, look or concept before looking to be published."

ⓃⒾ FUNDORA ART STUDIO

205 Camelot Drive, Tavernier FL 33070. (305)852-1516. Fax: (305)853-0345. E-mail: thomasfund@aol.com. **Director:** Manny Fundora. President: Thomas Fundora. Estab. 1987. Art publisher/distributor/gallery. Publishes limited edition fine art prints. Clients: galleries, decorators, frameshops. Current clients include: Ocean Reef Club, Paul S. Ellison.

Needs Seeking creative and decorative art for the serious collector. Considers oil, watercolor, mixed media. Prefers nautical, maritime, tropical. Artists represented include Tomas Fundora, Gaspel, Juan A. Carballo, Carlos Sierra. Editions created by collaborating with the artist and working from an existing painting. Approached by 15 artists/year. Publishes/distributes the work of 2 emerging, 1 mid-career and 3 established artists/year.

First Contact & Terms Send query letter with brochure, photographs, slides or printed samples. Samples are filed. Will contact artist for portfolio review if interested. Pays royalties. Buys first rights. Requires exclusive representation of artist in US. Provides advertising and promotion. Also works with freelance designers.

Tips "Trends to watch: tropical sea and landscapes."

☑ GALAXY OF GRAPHICS, LTD.

20 Murray Hill Pkwy., Suite 160, East Rutherford NJ 07073-2180. (201)806-2100. Fax: (201)806-2050. E-mail: colleen.buchweitz@kapgog.com. **Art Directors:** Colleen Buchweitz and Christine Pratti. Estab. 1983. Art publisher and distributor of unlimited editions. Licensing handled by Colleen Buchweitz. Clients: galleries, distributors and picture frame manufacturers.

Needs Seeking creative, fashionable and decorative art for the commerical market. Artists represented include Richard Henson, Betsy Brown, John Butler, Charlene Olson, Ros Oesterle, Joyce Combs, Christa Kieffer, Ruane Manning and Carol Robinson. Editions created by collaborating with the artist or by working from an existing painting. Considers any media. "Any currently popular and generally accepted themes." Art guidelines free for SASE with first-class postage. Approached by several hundred artists/year. Publishes and distributes the work of 20 emerging and 20 mid-career and established artists/year.

First Contact & Terms Send query letter with résumé, tearsheets, slides, photographs and transparencies. Samples are not filed and are returned by SASE. Responds in 2 weeks. Call for appointment to show portfolio. Pays royalties of 10%. Offers advance. Buys rights only for prints and posters. Provides insurance while material is in-house and while in transit from publisher to artist/photographer. Provides written contract to each artist.

Tips "There is a trend of strong jewel-tone colors and spice-tone colors. African-American art very needed."

ROBERT GALITZ FINE ART & ACCENT ART

(formerly Robert Galitz Fine Art), 166 Hilltop Lane, Sleepy Hollow IL 60118-1816. (847)426-8842. Fax: (847)426-8846. Website: www.galitzfineart.com. **Owner:** Robert Galitz. Estab. 1986. Distributor of fine art prints, hand-pulled originals, limited editions, monoprints, monotypes and sculpture. Clients: architects and galleries.

• See also listing in Galleries.

Needs Seeking creative, decorative art for the commercial and designer markets. Considers acrylic, mixed media, oil, sculpture and watercolor.

First Contact & Terms Send query letter with brochure, SASE, slides and photographs. Samples are not filed and are returned by SASE. Responds in 1 month. Company will contact artist for portfolio review if interested. Pays flat fee. No advance. Rights purchased vary according to project. Finds artists through art fairs and submissions.

GALLERIA FINE ARTS & GRAPHICS

7305 Edgewater Dr., Unit D, Oakland CA 94621. (510)553-0228. Fax: (510)553-9130. **Director:** Thomas Leung. Estab. 1985. Art publisher/distributor. Publishes/distributes limited editions, open editions, canvas transfers, fine art prints, offset reproductions, posters.

Needs Seeking creative, decorative art for the serious collector and the commercial market. Considers oil, acrylic, watercolor. Editions created by collaborating with the artist or by working from an existing painting. Approached by 50 artists/year.

First Contact & Terms Send query letter with photographs. Samples are filed. Responds only if interested. Company will contact artist for portfolio review of color photographs, slides, transparencies if interested. Negotiates payment. Buy all rights. Requires exclusive representation of artist. Provides advertising, in-transit insurance, insurance while work is at firm, promotion, shipping to and from our firm, written contract.

Tips "Color/composition/subject are important."

☑ GALLERY GRAPHICS

20136 St. Highway 59, P.O. Box 502, Noel MO 64854. (417)475-6191. Fax: (417)475-3542. E-mail: info@galleryg
raphics.com. Website: www.gallerygraphics.com. Estab. 1980. Wholesale producer and distributor of prints,
cards, sachets, stationery, calendars, framed art, stickers. Clients: frame shops, craft shops, florists, pharmacies
and gift shops.

Needs Seeking art with nostalgic look, country, Victorian, children, angels, florals, landscapes, animals—
nothing too abstract or non-representational. Considers oil, watercolor, mixed media, pastel and pen & ink.
10% of editions created by collaborating with artist. 90% created by working from an existing painting. Artists
include Barbara Mock, Glynda Turley and Mary Hughes.

First Contact & Terms Send query letter with brochure showing art style and tearsheets. Designers send
photographs, photocopies and tearsheets. Accepts disk submissions compatible with IBM or Mac. Samples are
filed or are returned by SASE. Responds in 2 months. To show portfolio, mail finished art samples, color
tearsheets. Can buy all rights or pay royalties of 5%. Provides insurance while work is at firm, promotion and
a written contract.

Tips "I wish artists would submit artwork on different subjects and styles. Some artists do certain subjects
particularly well, but you don't know if they can do other subjects. Don't concentrate on just one area—do
others as well. Don't limit yourself, or you could be missing out on some great opportunities. Paint the world
you live in."

GANGO EDITIONS, INC.

351 NW 12th Ave., Portland OR 97209. (503)223-9694. Fax: (503)223-0925. E-mail: info@gangoeditions.com.
Website: www.gangoeditions.com. **Contact:** Jackie Gango, art director. Estab. 1977. Art publisher/distributor.
Publishes/distributes offset reproduction and posters. Clients: architects, decorators, distributors, frame and
gift shops, and galleries.

Needs Seeking decorative art for the commercial and designer markets. Considers oil, watercolor, acrylic, pastel,
mixed media. Prefers art that follows current trends and colors. Artists represented include Amy Melious and
Pamela Gladding. Editions created by working from an existing painting or other artwork and by collaborating
with the artist. Publishes and distributes the work of 70 emerging artists/year.

First Contact & Terms Send query letter with slides, SASE, tearsheets, transparencies and/or photographs. E-
mail submissions accepted with link to website or image file. Prefers Windows-compatible JPEG files. Samples
returned by SASE. Artist is contacted by mail. Responds in 6 weeks. Company will contact artist for portfolio
review if interested. Portfolio should include b&w and color finished, original art, photographs, slides or trans-
parencies. Pays royalties of 10%. Requires exclusive representation of artist. Buys first rights and reprint rights.
Provides advertising, in-transit insurance, insurance while work is at firm, promotion, shipping from our firm
and written contract. Finds artists through art exhibits/fairs, art reps, artist's submissions, Internet and word
of mouth.

Tips "We require work that can be done in pairs. Artist may submit a single but must have a mate available if
piece is selected. To be a pair, the works must both be horizontal or vertical. Palette must be the same.
Perspective the same. Content must coordinate."

GEME ART INC.

209 W. Sixth St., Vancouver WA 98660. (360)693-7772. Fax: (360)695-9795. **Art Director:** Merilee Will. Estab.
1966. Art publisher. Publishes fine art prints and reproductions in unlimited and limited editions. Clients:
galleries, frame shops, art museums. Licenses designs.

Needs Considers oil, acrylic, watercolor and mixed media. "We use a variety of styles from realistic to whimsi-
cal, catering to "Mid-America art market." Artists represented include Lois Thayer, Crystal Skelley, Steve
Nelson.

First Contact & Terms Send color slides, photos or brochure. Include SASE. Publisher will contact artist for
portfolio review if interested. Simultaneous submissions OK. Payment on a royalty basis. Purchases all rights.
Provides promotion, shipping from publisher and contract.

Tips "We have added new sizes and more artists to our lines since last year."

☑ GHAWACO INTERNATIONAL INC.

P.O. Box 8365, Station T, Ottawa ON K1G 3H8 Canada. (613)293-1011 or (888)769-ARTS. Fax: (613)824-0842
or (888)769-5505. E-mail: buyart@ghawaco.com. Website: www.ghawaco.com. **Product Development:** Dr.
Kwasi Nyarko. Estab. 1994. Art publisher and distributor. Publishes/distributes limited edition, unlimited edi-
tion, canvas transfers and offset reproduction. Clients: museum shops, galleries, gift shops, frame shops, distrib-
utors, bookstores and other buyers.

Needs Seeking contemporary ethnic art. Considers oil and acrylic. Prefers artwork telling the stories of peoples
of the world. Emphasis on under-represented groups such as African and Aboriginal. Artists represented include

Wisdom Kudowor, Ablade Glover, Kofi Agorsor, A.K. Duah, Oumarou Traoré. Editions created working from an existing painting. Publishes work of 1 emerging artist/year. Also needs freelancers for design.

First Contact & Terms Send query letter with brochure, photographs, résumé and SASE. Samples are filed. Responds only if interested. Request portfolio review in original query. Company will contact artist for portfolio review if interested. Portfolio should include final art, photographs and slides. Pays royalties of up to 30% (net). Consignment basis: firm receives 50% commission or negotiates payment. Offers no advance. Negotiates rights purchased. Requires exclusive representation of artist. Provides advertising, insurance while work is at firm, promotion, shipping from our firm and written contract. Finds artists through referrals, word of mouth and art fairs.

Tips "To create good works that are always trendy, do theme-based compositions. Artists should know what they want to achieve in both the long and short term. Overall theme of artist must contribute to the global melting pot of styles."

GLEEDSVILLE ART PUBLISHERS

5 W. Loudoun St., Leesburg VA 20175. (703)771-8055. Fax: (703)771-0225. E-mail: buyart@gleedsvilleart.com. Website: www.gleedsvilleart.com. **Contact:** Lawrence J. Thomas, president. Estab. 1999. Art publisher and gallery. Publishes and/or distributes fine art prints and limited edition. Clients: decorators, distributors, frame shops and galleries.

Needs Seeking decorative art for the serious collector, commercial and designer markets. Considers acrylic, mixed media, oil, pastel, pen & ink and watercolor. Prefers impressionist, landscapes, figuratives, city scenes, realistic and whimsical. Artists represented include Lillian D. August, Anthony Andrews and Julie Lea. Editions created by collaborating with the artist.

First Contact & Terms Send photographs, slides, tearsheets, transparencies and URL. Accepts e-mail submissions with link to website. Prefers Windows-compatible, JPEG files. Samples are filed or returned. Responds in 3 months. Company will contact artist for portfolio review if interested. Portfolio should include original art, slides, tearsheets, thumbnails and transparencies. Pays royalties. Negotiates rights purchased. Requires exclusive representation of artist. Provides advertising, insurance while work is at firm, promotion, shipping from our firm and written contract. Finds artists through art competitions, art exhibits/fairs, artist's submissions and word of mouth.

☒ THE GOLTZ GROUP/CHICAGO ART SOURCE

1871 N. Clybourn Ave., Chicago IL 60614. (773)248-3100. Fax: (773)248-3926. E-mail: allison@chicagoartsource.com. Website: www.chicagoartsource.com. **Director Art Division:** Allison DiJohn. Estab. 1978. Gallery and designer showroom. Distributes handpulled originals, limited and unlimited editions, fine art and monoprints, offset reproductions, posters, photography, drawings, collage, etc. Clients: corporations, interior designers, restaurants and chain stores. Current clients include: Andersen Consulting, Lettuce Entertain You restaurants and Northwestern Memorial Hospital.

- This company is now active in corporate and residential interior design, in connection with their art and framing services. They also run a gallery and offer art consultation. A new division, Jayson Home and Garden, provides outdoor furnishings and accessories.

Needs Seeking creative and decorative art for corporate and residential markets. Represents the work of emerging, mid-career and established artists—all media.

First Contact & Terms Send brochure, photocopies, photographs, tearsheets, slides and SASE. Samples are filed "if we like them, returned by SASE if not." Company will contact artist for portfolio review of color final art and photographs if interested. Negotiates payment. Rights purchased vary according to project. Services are negotiated on a per project basis. Finds artists through art exhibitions and fairs, reps, sourcebooks, *Art Business News, Decor, Art in America, ArtNews* and sculpture and textile magazines.

Tips "We need art appropriate in color, subject matter and design for an urban, Midwestern business. No ducks, no glitter. Getting work in on time is essential. Don't try to surprise us with some new color not previously agreed to in commissioned work. Be objective and try not to be defensive about your artwork."

GRAPHIQUE DE FRANCE

9 State St., Woburn MA 01801. (781)935-3405. Fax: (781)935-5145. E-mail: artworksubmissions@graphiquedefrance.com. Website: www.graphiquedefrance.com. **Contact:** Licensing Department. Estab. 1979. Manufacturer of fine art, photographic and illustrative greeting cards, notecard gift boxes, posters and calendars. Clients: galleries, foreign distributors, museum shops, high-end retailers, book trade, museum shops.

First Contact & Terms Artwork may be submitted in the form of slides, transparencies or high-quality photocopies. Please do not send original artwork. Please allow 2 months for response. SASE is required for any submitted material to be returned.

Tips "It's best not to insist on speaking with someone at a targeted company prior to submitting work. Let the art speak for itself and follow up a few weeks after submitting."

RAYMOND L. GREENBERG ART PUBLISHING

42 Leone Lane, Chester NY 10918. (845)469-6699. Fax: (845)469-5955. E-mail: art@raymondlgreenberg.com. Website: www.raymondlgreenberg.com. **Owner:** Ray Greenberg. Licensing: Ray Greenberg. Estab. 1995. Art publisher. Publishes unlimited edition fine art prints for major framers and plaque manufacturers. Licenses inspirational, ethnic, Victorian, kitchen and bath artwork for prints for wall decor. Clients include Crystal Art Galleries, North American Art.

Needs Seeking decorative artwork in popular styles for the commercial and mass markets. Considers oil, acrylic, watercolor, mixed media, pastel and pen & ink. Prefers inspirational, ethnic, Victorian, nostalgic, country, floral and religious themes. Art guidelines free for SASE with first-class postage. Artists represented include Barbara Lanza, David Tobey, Diane Viera, Robert Daley and Marilyn Rea. Editions created by collaborating with the artist and/or working from an existing painting. Approached by 35 artists/year. Publishes 7 emerging, 13 mid-career and 5 established artists/year.

First Contact & Terms Send query letter with photographs, slides, SASE; "any good, accurate representation of your work." Samples are filed or returned by SASE. Responds in 6 weeks. Company will contact artist for portfolio review if interested. Pays flat fee: $50-200 or royalties of 5-7%. Offers advance against royalties when appropriate. Buys all rights. Prefers exclusive representation. Provides insurance, promotion, shipping from firm and contract. Finds artists through word of mouth.

Tips "Versatile artists who are willing to paint for the market can do very well with us. Be flexible and patient."

THE GREENWICH WORKSHOP, INC.

151 Main St., PO Box 231, Seymour CT 06483. Website: www.greenwichworkshop.com. **Contact:** Artist Selection Committee. Art publisher and gallery. Publishes limited and open editions, offset reproductions, fine art lithographs, serigraphs, canvas reproductions and fine art porcelains and books. Clients: independent galleries in US, Canada and United Kingdom.

Needs Seeking creative, fashionable and decorative art for the serious collector, commercial and designer markets. Considers oil, watercolor, mixed media, pastel and acrylic. Considers all but abstract. Artists represented include James C. Christensen, Howard Terpning, James Reynolds, James Bama, Bev Doolittle, Scott Gustafson, Braldt Bralds. Editions created by collaborating with the artist or by working from an existing painting. Approached by 100 artists/year. Publishes the work of 4-5 emerging, 15 mid-career and 25 established artists. Distributes the work of 4-5 emerging, 15 mid-career and 25 established artists/year.

First Contact & Terms Send query letter with brochure, slides, photographs, SASE and transparencies. Samples are not filed and are returned by SASE. Responds in 3 months. Publisher will contact artist for portfolio review if interested. Portfolio should include final art, tearsheets, photographs, slides and transparencies. Pays royalties. No advance. Rights purchased vary according to project. Requires exclusive representation of artist. Provides advertising, insurance while work is at firm, promotion, shipping to and from firm, and written contract. Finds artists through art exhibits, submissions and word of mouth.

⃞Ⓝ GREGORY EDITIONS

13003 Southwest Freeway, Suite 180, Stafford TX 77477. (800)288-2724. Fax: (281)494-4755. E-mail: mleace@aol.com. **President:** Mark Eaker. Estab. 1988. Art publisher and distributor of originals, limited editions, serigraphs and bronze sculptures. Licenses variety art for Texture Touch™ canvas reproduction. Clients: Retail art galleries.

Needs Seeking contemporary, creative artwork. Considers oil and acrylic. Open to all subjects and styles. Artists represented include G. Harvey, JD Challenger, Stan Solomon, James Talmadge, Denis Paul Noyer, Liliana Frasca, Michael Young, James Christensen, Gary Ernest Smith, Douglas Hofmann, Alan Hunt, Joy Kirton-Smith, BH Brody, Nel Whatmore, Larry Dyke, Tom DuBois, Michael Jackson, Robert Heindel and sculptures by Ting Shao Kuang and JD Challenger. Editions created by working from an existing painting. Publishes and distributes the work of 50 emerging, 20 mid-career and 25 established artists/year.

First Contact & Terms Send query letter with brochure or slides showing art style. Call for appointment to show portfolio of photographs and transparencies. Purchases paintings outright; pays percentage of sales. Negotiates payment on artist-by-artist basis based on flat negotiated fee per visit. Requires exclusive representation of artist.

GUILDHALL, INC.

P.O. Box 136550, Fort Worth TX 76136. (800)356-6733. Fax: (817)236-0015. E-mail: westart@guildhall.com. Website: www.guildhall.com. **President:** John M. Thompson III. Art publisher/distributor of limited and unlim-

ited editions, offset reproductions and handpulled originals for galleries, decorators, offices and department stores. Current clients include over 500 galleries and collectors nationwide.

Needs Seeking creative art for the serious and commercial collector and designer market. Considers pen & ink, oil, acrylic, watercolor, and bronze and stone sculptures. Prefers historical Native American, Western, equine, wildlife, landscapes and religious themes. Prefers individual works of art. Artists represented include Wayne Baize, Jack Hines and Ralph Wall. Editions created by collaborating with the artist and by working from an existing painting. Approached by 150 artists/year. Also needs freelancers for design. 15% of projects require freelance design.

First Contact & Terms Send query letter with résumé, tearsheets, photographs, slides and 4×5 transparencies, preferably cowboy art in photos or printouts. Samples are not filed and are returned only if requested. Responds in 1 month. Call or write for appointment to show portfolio, or mail thumbnails, color and b&w tearsheets, slides and 4×5 transparencies. Pays $200-15,000 flat fee; 10-20% royalties; 35% commission on consignment; or payment method is negotiated. Negotiates rights purchased. Requires exclusive representation for contract artists. Provides insurance while work is at firm, promotion, shipping from firm and written contract.

Tips "The new technologies in printing are changing the nature of publishing. Self-publishing artists have flooded the print market. Many artists are being told to print themselves. Most of them, in order to sell their work, have to price it very low. In many markets this has caused a glut. Some art would be best served if it was only one of a kind. There is no substitute for scarcity and quality."

HADDAD'S FINE ARTS INC.

3855 E. Miraloma Ave., Anaheim CA 92806. (714)996-2100. Website: www.haddadsfinearts.com. **President:** Paula Haddad. Art Director: Beth Hedstrom. Estab. 1953. Art publisher and distributor. Produces unlimited edition offset reproductions and posters. Clients: galleries, art stores, museum stores and manufacturers. Sells to the trade only—no retail.

Needs Seeking creative and decorative art for the commercial and designer markets. Prefers traditional, realism with contemporary flair; unframed individual works and pairs; all media including photography. Editions created by collaborating with the artist or by working from an existing painting. Approached by 200-300 artists/year. Publishes the work of 10-15 emerging artists/year. Also uses freelancers for design. 20% of projects require freelance design. Design demands knowledge of QuarkXPress and Illustrator.

First Contact & Terms Illustrators should send query letter with brochure, transparencies, slides, photos representative of work for publication consideration. Include SASE. Designers send query letter explaining skills. Responds in 3 months. Publisher/distributor will contact artist for portfolio review if interested. Portfolio should include slides, roughs, final art, transparencies. Pays royalties quarterly, 10% of base net price. Rights purchased vary according to project. Provides advertising and written contract.

◼ HEARTSTRINGS CREATIVE PUBLISHING LTD.

409-244 Wallace Ave., Toronto ON M6H 1V7 Canada. (416)532-3922. Fax: (416)532-6351. E-mail: posters@hear tstringscreative.com. **President:** Peter Pesic. Estab. 1975. Art publisher and distributor. Publishes/distributes canvas transfers and offset reproductions. Clients: galleries, frame shops, distributors and giftshops.

Needs Seeking creative and decorative art for the commercial market. Prefers home decor that is warm and color sensitive. Looking for landscape, wildlife, seascape, sentimental-figurative, floral and contemporary mixed media utilizing architectural elements. Editions created by collaborating with the artist. Approached by 15-20 artists/year. Publishes and distributes work of 6 emerging, 3 mid-career and 2 established artists/year. Also needs freelancers for design. Prefers designers who own a Mac computer.

First Contact & Terms Send query letter with photocopies, photographs, slides and transparencies. Accepts disk submissions compatible with Mac and Power Mac. Samples are filed or returned by SASE. Responds in 3 weeks. Company will contact artist for portfolio review if interested. Payment of royalties is negotiable. Offers advance when appropriate. Rights purchased vary according to project. Requires exclusive representation of artist. Provides advertising, insurance while work is at firm, promotion and written contract. Finds artists through art exhibitions, art fairs, word of mouth and artists' submissions.

Tips "Wildlife is selling well. Be aware of current color trends. Work in a series."

HOOF PRINTS

13849 N. 200E, Alexandria IN 46001. (765)724-7004. Fax: (765)724-4632. E-mail: gina@hoofprints.com. Website: www.hoofprints.com. Estab. 1991. Mail order art retailer and wholesaler. Handles handpulled originals, limited and unlimited editions, offset reproductions, posters and engravings. Clients: farriers, veterinarians, individuals, galleries, tack shops.

Needs Considers only existing horse and dog prints. Especially welcome submission of unpublished farrier and veterinarian art.

First Contact & Terms Send brochure, tearsheets, photographs and samples. Samples are filed. Will contact

artist for portfolio review if interested. Pays per print. No advance. Provides advertising and shipping from firm. Finds artists through sourcebooks, magazine ads, word of mouth.

IMAGE CONNECTION

456 Penn St., Yeadon PA 19050. (610)626-7770. Fax: (610)626-2778. E-mail: imageco@earthlink.net. Website: www.imageconnection.biz. **Art Coordinator:** Helen Casale. Estab. 1988. Publishes and distributes limited editions and posters. Represents several European publishers.

Needs Seeking fashionable and decorative art for the commercial market. Considers oil, pen & ink, watercolor, acrylic, pastel and mixed media. Prefers contemporary and popular themes, realistic and abstract art. Editions created by collaborating with the artist and by working from an existing painting. Approached by 200 artists/year.

First Contact & Terms Send query letter with brochure showing art style or résumé, slides, photocopies, photographs, tearsheets and transparencies. Accepts e-mail submissions with link to website or Mac-compatible image file. Samples are not filed and are returned by SASE. Responds in 2 months. Company will contact artist for portfolio review if interested. Portfolio should include b&w and color finished, original art, photographs, slides, tearsheets and transparencies. Payment method is negotiated. Offers advance when appropriate. Negotiates rights purchased. Requires exclusive representation of artist for product. Finds artists through art competitions, exhibits/fairs, reps, submissions, Internet, sourcebooks and word of mouth.

[N] IMAGE CONSCIOUS

147 Tenth St., San Francisco CA 94103. (415)626-1555. Fax: (415)626-2481. E-mail: cbardy@imageconscious.com. Website: www.imageconscious.com. **Creative Director:** Cindy Bardy. Estab. 1980. Art publisher and domestic and international distributor of offset and poster reproductions. Clients: poster galleries, frame shops, department stores, design consultants, interior designers and gift stores. Current clients include Z Gallerie, Deck the Walls and Pier 1.

Needs Seeking creative and decorative art for the designer market. Considers oil, acrylic, pastel, watercolor, tempera, mixed media and photography. Prefers individual works of art, pairs or unframed series. Artists represented include Bill Brauer, Aleah Koury, Susan Jokelson, Laurie Eastwood. Editions created by collaborating with the artist and by working from an existing painting or photograph. Approached by hundreds of artists/year. Publishes the work of 2-3 emerging, 2-3 mid-career and 4-5 established artists/year. Distributes the work of 50 emerging, 200 mid-career and 700 established artists/year.

First Contact & Terms Send query letter with brochure, résumé, tearsheets, photographs, slides and/or transparencies. Samples are filed or are returned by SASE. Responds in 1 month. Publisher/distributor will contact artist for portfolio review if interested. No original art. Payment method is negotiated. Negotiates rights purchased. Provides promotion, shipping from firm and a written contract.

Tips "Research the type of product currently in poster shops. Note colors, sizes and subject matter trends."

[N] [globe] IMAGE SOURCE INTERNATIONAL

630 Belleville Ave., New Bedford MA 02745. (508)999-0090. Fax: (508)999-9499. E-mail: pdownes@isiposters.com. Website: www.isiposters.com. **Contact:** Patrick Downes. **Art Editor:** Kevin Miller. Licensing: Patrick Downes. Estab. 1992. Poster company, art publisher, distributor, foreign distributor. Publishes/distributes unlimited editions, fine art prints, offset reproductions, posters. Clients: galleries, decorators, frame shops, distributors, architects, corporate curators, museum shops, gift shops, foreign distributors (Germany, Holland, Asia, South America).

• Image Source International is one of America's fastest-growing publishers.

Needs Seeking fashionable, decorative art for the designer market. Considers oil, acrylic, pastel. Artists represented include Micarelli, Kim Anderson, Bertram Bahner, Juarez Machado, Anthony Watkins, Rob Brooks and Karyn Frances Gray. Editions created by collaborating with the artist or by working from an existing painting. Approached by hundreds of artists/year. Publishes the work of 6 emerging, 2 mid-career and 2 established artists/year. Distributes the work of 50 emerging, 25 mid-career, 50 established artists/year.

First Contact & Terms Send query letter with brochure, photocopies, photographs, résumé, slides, tearsheets, transparencies, postcards. Samples are filed and are not returned. Responds only if interested. Company will contact artist for portfolio review if interested. Pays flat fee "that depends on artist and work and risk." Buys all rights. Requires exclusive representation of artist.

Tips Notes trends as sports art, neo-classical, nostalgic, oversize editions. "Think marketability. Watch the furniture market."

[N] IMAGES OF AMERICA PUBLISHING COMPANY

P.O. Box 608, Jackson WY 83001. (800)451-2211. Fax: (307)739-1199. E-mail: info@artsfortheparks.com. Website: www.artsfortheparks.com. **Executive Director:** Christopher Moran. Estab. 1990. Art publisher. Publishes

limited editions, posters. Clients: galleries, frame shops, distributors, gift shops, national parks, natural history associations.

- This company publishes the winning images in the Arts for the Parks competition which was created in 1986 by the National Park Academy of the Arts in cooperation with the National Park Foundation. The program's purpose is to celebrate representative artists and to enhance public awareness of the park system. The top 100 paintings tour the country and receive cash awards. Over $100,000 in prizes in all.

Needs Seeking national park images. Considers oil, acrylic, watercolor, mixed media, pastel, pen & ink. Prefers nature and wildlife images from one of the sites administered by the National Park Service. Art guidelines available on company's website. Artists represented include Jim Wilcox, Linda Tippetts, Howard Hanson, Dean Mitchell, Steve Hanks. Editions created by collaborating with the artist. Approached by over 2,000 artists/year.

First Contact & Terms Submit by entering the Arts for the Parks contest for a $40 entry fee. Entry form and slides must be postmarked by June 1 each year. Send for prospectus before April 1st. Samples are filed. Portfolio review not required. Pays flat fee of $50-50,000. Buys one-time rights. Provides advertising.

Tips "All artwork selected must be representational of a National Park site."

IMCON

68 Greene St., Oxford NY 13830. (607)843-5130. E-mail: imcon@mkl.com. **President:** Fred Dankert. Estab. 1986. Fine art printer of handpulled originals. "We invented the waterless litho plate, and we make our own inks." Clients: galleries, distributors.

Needs Seeking creative art for the serious collector. Editions created by collaborating with the artist "who must produce image on my plate. Artist given proper instruction."

First Contact & Terms Call or send query letter with résumé, photographs and transparencies.

Tips "Artists should be willing to work with me to produce original prints. We do *not* reproduce; we create new images. Artists should have market experience."

IMPACT IMAGES

4949 Windplay Dr., El Dorado Hills CA 95762. (916)933-4700. Fax: (916)933-4717. Website: www.impactimages direct.com. **Owner:** Benny Wilkins. Estab. 1975. Publishes unlimited edition prints and posters. Clients: frame shops, museum and gift shops, wholesalers, retailers, overseas importers, clock and plaque manufacturers. Current line includes 1,500 subjects of art and photography.

Needs Seeking traditional and contemporary artwork. Considers oils, acrylics, pastels, watercolors, mixed media. Accepts contemporary and traditional themes, including landscapes, domestic and wild animals, western, southwestern, country, children, floral, aviation, fantasy and humor. Also considers ethnic subjects, including Native American, Hispanic, African American and Oriental.

First Contact & Terms Send query letter with brochure, tearsheets, photographs, slides or transparencies. Samples are not filed and are returned if requested by SASE. Responds in 4-5 weeks. Offers royalty or flat-fee payment. Does not require exclusive rights to the artist or image. Provides written contract.

Tips "Published sizes are 16×20 and 8×10 therefore we need artwork that can be cropped to a 4 to 5 ratio."

INSPIRATIONART & SCRIPTURE, INC.

P.O. Box 5550, Cedar Rapids IA 52406. (319)365-4350. Fax: (319)861-2103. E-mail: charles@inspirationart.com. Website: www.inspirationart.com. **Creative Director:** Charles R. Edwards. Estab. 1993 (incorporated 1996). Produces Christian poster prints. "We create and produce jumbo-sized (24×36) posters targeted at pre-teens (10-14), teens (15-18) and young adults (18-30). A Christian message is contained in every poster. Some are fine art and some are very commercial. We prefer very contemporary images."

Needs Approached by 150-200 freelance artists/year. Works with 10-15 freelancers/year. Buys 10-15 designs, photos, illustrations/year. Christian art only. Uses freelance artists for posters. Considers all media. Looking for "something contemporary or unusual that appeals to teens or young adults and communicates a Christian message." Art guidelines available for SASE with first-class postage. Catalog available for $3.

First Contact & Terms Send query letter with photographs, slides, SASE or transparencies. Accepts submissions on disk (call first). Samples are filed or are returned by SASE. Responds in 6 months. Company will contact artist for portfolio review if interested. Portfolio should include color roughs, final art, photographs and transparencies. "We need to see the artist's range. It is acceptable to submit 'secular' work, but we also need to see work that is Christian-inspired." Originals are returned at job's completion. Pays by the project, $50-250. Pays royalties of 5% "only if the artist has a body of work that we are interested in purchasing in the future." Rights purchased vary according to project.

Tips "The better the quality of the submission, the better we are able to determine if the work is suitable for our use (slides are best). The more complete the submission (e.g., design, art layout, scripture, copy), the more likely we are to see how it may fit into our poster line. We do accept traditional work but are looking for work that is more commercial and hip (think MTV with values). A poster needs to contain a Christian message that

is relevant to teen and young adult issues and beliefs. Understand what we publish before submitting work. Artists can either purchase a catalog for $3 or visit our website to see what it is that we do. We are not simply looking for beautiful art, but rather we are looking for art that communicates a specific scriptural passage.''

INTERCONTINENTAL GREETINGS LTD.

176 Madison Ave., New York NY 10016. (212)683-5380. Fax: (212)779-8564. Website: www.intercontinental-ltd.com. **Art Director:** Thea Groene. Estab. 1967. Sells reproduction rights of designs to publisher/manufacturers in 50 countries around the world. Specializing in greeting cards, gift bags, stationery and novelty products, ceramics, textile, bed and bath accessories, and kitchenware.

Needs Seeking creative, commercial and decorative art in traditional and computer media and photography. Accepts seasonal and holiday material any time. Animals, children, babies, fruits/wine, sports, scenics and Americana themes are specially requested.

First Contact & Terms Send query letter with brochure, tearsheets, slides, photographs, photocopies or CDs. Samples are filed or returned by SASE if requested by artist. Pays the artist a percentage once used for publication. No credit line given. Sells one-time rights and exclusive product rights. Simultaneous submissions and previously published work okay. Please state reserved rights if any.

Tips Recommends New York Surtex Show held annually. "In addition to having good painting/designing skills, artists should be aware of market needs. We're looking for artists who possess a large collection of designs, and we are interested in series of interrelated images."

⊕ INTERNATIONAL GRAPHICS GMBH.

Junkersring 11, 76344, Eggenstein Germany. 011(49)721-978-0688. Fax: (49)721-978-0651. E-mail: LW@ig-team.de. Website: www.international-graphics.de. **President:** Lawrence Walmsley. Publishing Assistant: Evelyne Dennler. Estab. 1983. Poster company/art publisher/distributor. Publishes/distributes limited edition monoprints, monotypes, offset reproduction, posters, original paintings and silkscreens. Clients: galleries, framers, department stores, gift shops, card shops and distributors. Current clients include: Windsor Art, Intercontinental Art and Balangier.

Needs Seeking creative, fashionable and decorative art for the commercial and designer markets. Also seeking Americana art for our gallery clients. Considers oil, acrylic, watercolor, mixed media, pastel. Prefers landscapes, florals, still lifes. Art guidelines free for SASE with first-class postage. Artists represented include Christian Choisy, Benevolenza and Mansart. Editions created by working from an existing painting. Approached by 100-150 artists/year. Publishes the work of 4-5 emerging artists/year. Distributes the work of 40-50 emerging artists/year.

First Contact & Terms Send query letter with brochure, photocopies, photographs, photostats, résumé, slides, tearsheets. Accepts disk submissions in Mac or Windows. Samples are filed and returned. Responds in 2 months. Will contact artist for portfolio review if interested. Negotiates payment on basis of per-piece-sold arrangement. Offers advance when appropriate. Buys first rights. Provides advertising, promotion, shipping from our firm and contract. Also work with freelance designers. Prefers local designers only. Finds artists through exhibitions, word of mouth, submissions.

Tips "Pastel landscapes and still life pictures are good at the moment. Earthtones are popular—especially lighter shades."

◩ ISLAND ART

6687 Mirah Rd., Saanichton BC V8M 1Z4 Canada. (250)652-5181. Fax: (250)652-2711. E-mail: islandart@islandart.com. Website: www.islandart.com. **President:** Myron D. Arndt. Estab. 1985. Art publisher and distributor. Publishes and distributes limited and unlimited editions, offset reproductions, posters and art cards. Clients: galleries, department stores, distributors, gift shops. Current clients include: Disney, Host-Marriott, Ben Franklin.

Needs Seeking creative and decorative art for the serious collector, commercial and designer markets. Considers oil, watercolor and acrylic. Prefers lifestyle themes/Pacific Northwest. Also needs designers. 10% of products require freelance design and demand knowledge of Photoshop. Art guidelines available on company's website. Artists represented include Sue Coleman and Lissa Calvert. Editions created by working from an existing painting. Approached by 100 artists/year. Publishes the work of 2 emerging artists/year. Distributes the work of 4 emerging artists/year.

First Contact & Terms Send résumé, tearsheets, slides and photographs. Designers send photographs, slides or transparencies (do not send originals). Accepts submissions on disk compatible with Photoshop. Send EPS or TIFF files. Samples are not filed and are returned by SASE if requested by artist. Responds in 3 months. Publisher/distributor will contact artist for portfolio review if interested. Portfolio should include color roughs, final art, slides and 4 × 5 transparencies. Pays royalties of 5-10%. Offers advance when appropriate. Buys reprint rights. Requires exclusive representation of artist. Provides insurance while work is at firm, promotion, shipping

from firm, written contract, trade fair representation and Internet service. Finds artists through art fairs, referrals and submissions.

Tips "Provide a body of work along a certain theme to show a fully developed style that can be built upon. We are influenced by our market demands. Please ask for our submission guidelines before sending work on spec."

![N] ![icon] JADEI GRAPHICS INC.

4943 McConnell Ave., Suite "W", Los Angeles CA 90066. (310)578-0082. Fax: (310)823-4399. Website: www.jadeigraphics.com. **Contact:** Liz Hayden. Licensing: Dennis Gaskin and Allen Cathey. Poster company. Publishes limited edition, unlimited edition and posters. Clients: galleries, framers. Licenses calendars, puzzles, etc.

Needs Seeking creative, decorative art for the commercial market. Considers oil, acrylic, watercolor and photographs. Editions created by collaborating with the artist or by working from an existing painting. Approached by 100 artists/year. Publishes work of 3-5 emerging artists each year. Also needs freelancers for design. Prefers local designers only.

First Contact & Terms Send query letter with brochure, photocopies, photographs and slides. Accepts disk submissions. Samples are returned by SASE. Responds only if interested. Company will contact artist for portfolio review of color, photographs, slides and transparencies. Negotiates payment. Offers advance. Rights purchased vary according to project. Provides advertising.

![icon] LESLI ART, INC.

Box 6693, Woodland Hills CA 91365. (818)999-9228. E-mail: lesliart@adelthia.net. Website: www.lesliart.com. **President:** Stan Shevrin. Estab. 1965. Artist agent handling paintings for art galleries and the trade.

Needs Considers oil paintings and acrylic paintings. Prefers realism and impressionism—figures costumed with narrative content, landscapes, still lifes and florals. Works with 20 artists/year.

First Contact & Terms To show portfolio, mail slides or color photographs. Samples not filed are returned by SASE. Responds in 1 month. Payment method is negotiated. Offers an advance. Provides national distribution, promotion and written contract.

Tips "Considers only those artists who are serious about having their work exhibited in important galleries throughout the United States and Europe."

![icon] LOLA LTD./LT'EE

1817 Egret St. SW, Shallotte NC 28470-5433. (910)754-8002. E-mail: lolaltd@yahoo.com. **Owner:** Lola Jackson. Distributor of limited editions, offset reproductions, unlimited editions, handpulled originals, antique prints and etchings. Clients: art galleries, architects, picture frame shops, interior designers, major furniture and department stores, industry and antique gallery dealers.

 • This distributor also carries antique prints, etchings and original art on paper and is interested in buying/ selling to trade.

Needs Seeking creative and decorative art for the commercial and designer markets. "Handpulled graphics are our main area." Also considers oil, acrylic, pastel, watercolor, tempera or mixed media. Prefers unframed series, up to 30×40 maximum. Artists represented include Buffet, White, Brent, Jackson, Mohn, Baily, Carlson, Coleman. Approached by 100 artists/year. Publishes the work of 5 emerging, 5 mid-career and 5 established artists/year. Distributes the work of 40 emerging, 40 mid-career and 5 established artists/year.

First Contact & Terms Send query letter with sample. Samples are filed or are returned only if requested. Responds in 2 weeks. Payment method is negotiated. "Our standard commission is 50% less 50% off retail." Offers an advance when appropriate. Provides insurance while work is at firm, shipping from firm and written contract.

Tips "We find we cannot sell b&w only. Best colors: emerald, mauve, blues and gem tones. Leave wide margins on prints. Send all samples before end of May each year as our main sales are targeted for summer. We do a lot of business with birds, botanicals, boats and shells—anything nautical."

SEYMOUR MANN, INC.

230 Fifth Ave., Suite 910, New York NY 10001. (212)683-7262. Fax: (212)213-4920. E-mail: smanninc@aol.com. Website: www.seymourmann.com. Manufacturer.

Needs Seeking fashionable and decorative art for the serious collector and the commercial and designer markets. Also needs freelancers for design. 15% of products require freelance design. Considers watercolor, mixed media, pastel, pen & ink and 3-D forms. Editions created by collaborating with the artist. Approached by "many" artists/year. Publishes the work of 2-3 emerging, 2-3 mid-career and 4-5 established artists/year.

Tips "Focus on commercial end purpose of art."

![icon] MAPLE LEAF PRODUCTIONS

391 Steelcase Rd. W, Unit 24, Markham ON L3R 3V9 Canada. (905)940-9229. Fax: (905)940-9761. E-mail: ssillcox@ca.inter.net. Website: www.mapleleafproductions.com. **Contact:** Scott Sillcox, president. Estab. 1993.

Art publisher. Publishes sports art (historical), limited edition, posters, unlimited edition. Clients: distributors, frame shops, gift shops and museum shops.

Needs Considers watercolor. Please see our website for the theme and style. Artists represented include Tino Paolini, Nola McConnan, Bill Band. Editions created provide the artist with source material. Approached by 5 artists/year. Publishes/distributes 1 emerging artist/year.

First Contact & Terms Send e-mail. Accepts e-mail submissions with link to website. Prefers TIFF, JPEG, GIF, EPS. Responds in 1 week. Negotiates payment. Offers advance when appropriate. Buys all rights. Provides written contract. Finds artists through word of mouth.

Tips "We require highly detailed watercolor artists, especially those with an understanding of sports and the human body. Attention to small details is a must."

MARCO FINE ARTS

201 Nevada St., El Segundo CA 90245. (310)615-1818. Fax: (310)615-1850. E-mail: info@marcofinearts.com. Website: www.marcofinearts.com. Publishes/distributes limited edition, fine art prints and posters. Clients: galleries, decorators and frame shops.

Needs Seeking creative and decorative art for the serious collector and design market. Considers oil, acrylic and mixed media. Prefers landscapes, florals, figurative, Southwest, contemporary, impressionist, antique posters. Accepts outside serigraph production work. Artists represented include John Nieto, Aldo Luongo, John Axton, Guy Buffet, Linda Kyser Smith and Sergei Ossovsky. Editions created by collaborating with the artist or working from an existing painting. Approached by 80-100 artists/year. Publishes the work of 3 emerging, 3 mid-career and 3-5 established artists/year.

First Contact & Terms Send query letter with brochure, photocopies, photographs, photostats, résumé, SASE, slides, tearsheets and transparencies. Accepts disk submissions. Samples are filed and are returned by SASE. Responds only if interested. Company will contact artist for portfolio review or original artwork (show range of ability) if interested. Payment to be discussed. Requires exclusive representation of artist.

BRUCE MCGAW GRAPHICS, INC.

389 W. Nyack Rd., West Nyack NY 10994. (845)353-8600. Fax: (845)353-3155. E-mail: acquisitions@bmcgaw.com. Website: www.bmcgaw.com. **Acquisitions:** Martin Lawlor. Clients: poster shops, galleries, I.D., frame shops.

- Bruce McGaw publishes nearly 300 images per year.

Needs Artists represented include Diane Romanello, Romero Britto, David Doss, Ray Hendershot, Jacques Lamy, Bob Timberlake, Robert Bateman, Michael Kahn, Albert Swayhoover, William Mangum and P.G. Gravele. Other important fine art poster licenses include Disney, Andy Warhol, MOMA, New York and others. Publishes the work of 30 emerging and 30 established artists/year.

First Contact & Terms Send slides, transparencies or any other visual material that shows the work in the best light. "We review all types of 2-dimensional art with no limitation on media or subject. Review period is 1 month, after which time we will contact you with our decision. If you wish the material to be returned, enclose a SASE. If forwarding material electronically, send easily opened JPEG files for initial review consideration only. 10-15 JPEGs are preferred. Referrals to artists' websites will not be addressed." Contractual terms are discussed if work is accepted for publication." Forward 20-60 examples—we look for a body of work from which to publish.

Tips "Simplicity is very important in today's market (yet there still needs to be 'a story' to the image). Form and palette are critical to our decision process. We have a tremendous need for decorative pieces, especially new abstracts, landscapes and florals. Decorative still life images are very popular, whether painted or photographed, and much needed as well. There are a lot of prints and posters being published into the marketplace these days. Market your best material! There are a number of important shows—the largest American shows being Art Expo, New York (March); Galeria, New York (March); and the Atlanta A.B.C. Show (September). Review our catalog at your neighborhood gallery or poster shop or visit our website before submitting. Send your best."

MILITARY PUBLISHING

(formerly Universal Publishing), 821 E. Ojai Ave., Ojai CA 93023. (805)640-0057. Fax: (805)640-0059. E-mail: milgallery@aol.com. Website: www.militarygallery.com. **President:** Rick Taylor. Estab. 1967. Art publisher and distributor. Publishes/distributes limited edition, unlimited edition, canvas transfers, fine art prints, offset reproduction and posters. Clients: galleries and mail order. Current clients include: The Soldier Factory and Virginia Bader Fine Art.

Needs Seeking creative, fashionable and decorative art. Considers oil, acrylic, watercolor and pen & ink. Prefers aviation and maritime. Artists represented include Robert Taylor and Nicolas Trudgian. Editions created by

collaborating with the artist or by working from an existing painting. Approached by 10 artists/year. Publishes and distributes work of 1 emerging, 1 mid-career and 1 established artist/year.

First Contact & Terms Send query letter with photographs, slides, tearsheets and transparencies. Samples are not filed and are returned. Responds in 2 days. Company will contact artist for portfolio review if interested. Portfolio should include photographs, tearsheets and transparencies. Payment negotiable. Buys all rights. Requires exclusive representation of artist. Provides advertising, promotion and written contract. Finds artists through word of mouth.

Tips "Get to know us via our catalogs."

MILL POND PRESS COMPANIES

310 Center Court, Venice FL 34292-3500. (800)535-0331. Fax: (941)497-6026. E-mail: millpondPD@worldnet.att .net. Website: www.millpond.com. **Public Relations Director:** Ellen Collard. Licensing: Angela Sauro. Estab. 1973. Publishes limited editions, unlimited edition, offset reproduction and giclees. Divisions include Mill Pond Press, Loren Editions, Visions of Faith and Mill Pond Licensing. Clients: galleries, frameshops and specialty shops, Christian book stores, licensees. Licenses various genres on a range of products.

Needs Seeking creative, fashionable, decorative art. Open to all styles. Considers oil, acrylic, watercolor and mixed media. Prefers wildlife, spiritual, figurative and nostalgic. Artists represented include Robert Bateman, Carl Brenders, Peter Ellenshaw, Nita Engle, Luke Buck, Paco Young and Maynard Reece. Editions created by collaborating with the artist or by working from an existing painting. Approached by 400-500 artists/year. Publishes the work of 4-5 emerging, 5-10 mid-career and 15-20 established artists/year.

First Contact & Terms Send query letter with photographs, résumé, SASE, slides, transparencies and description of artwork. Samples are not filed and are returned by SASE. Responds in 1 year. Company will contact artist for portfolio review if interested. Pays royalties. Rights purchased vary according to project. Requires exclusive representation of artist. Provides advertising, in-transit insurance, insurance while work is at firm, promotion, shipping to and from firm and written contract. Finds artists through art exhibitions, submissions and word of mouth.

Tips "We continue to expand the genre published. Inspirational art has been part of expansion. Realism is our base but we are open to looking at all art."

ℕ MODERNART EDITIONS

165 Chubb Ave., Lyndhurst NJ 07071. (201)842-8500. Fax: (201)842-8546. E-mail: submitart@theartpublishingg roup.com. Website: www.modernarteditions.com. **Contact:** Sarah Donington. Estab. 1973. Art publisher and distributor of "top of the line" open edition posters and offset reproductions. Clients: galleries and custom frame shops worldwide.

Needs Seeking decorative art for the commercial and designer markets. Considers oil, watercolor, mixed media, pastel and acrylic. Prefers fine art landscapes, floral, abstracts, representational, still life, decorative, collage, mixed media. Size: 16×20. Artists represented include Carol Ann Curran, Diane Romanello, Pat Woodworth, Patrick Adam, Penny Feder and Neil Faulkner. Editions created by collaboration with the artist or by working from an existing painting. Approached by 200 artists/year. Publishes the work of 10-15 emerging artists/year. Distributes the work of 100 emerging artists/year.

First Contact & Terms Send postcard size sample of work, contact through artist rep, or send query letter with slides, photographs, brochure, photocopies, résumé, photostats, transparencies. Submissions via e-mail are preferred. Responds in 6 weeks. Request portfolio review in original query. Publisher/distributor will contact artist for portfolio review if interested. Portfolio should include color photostats, photographs, slides and transparencies. Pays flat fee of $200-300 or royalties of 10%. Offers advance against royalties. Provides insurance while work is at firm, shipping to firm and written contract. "Art submitted digitally should be in JPEG format. Limit 4 files; no more than 300 KB each."

Tips Advises artists to attend Art Expo New York City and Atlanta ABC.

MORIAH PUBLISHING, INC.

23500 Mercantile Rd., Unit B, Beechwood OH 44122. (216)595-3131. Fax: (216)595-3140. E-mail: rouven@mori ahpublishing.com. Website: www.moriahpublishing.com. **Contact:** Rouven R. Cyncynatus. Estab. 1989. Art publisher and distributor of limited editions. Licenses wildlife and nature on all formats. Clients: wildlife art galleries.

Needs Seeking artwork for the serious collector. Editions created by working from an existing painting. Approached by 100 artists/year. Publishes the work of 6 and distributes the work of 15 emerging artists/year. Publishes and distributes the work of 10 mid-career artists/year. Publishes the work of 30 and distributes the work of 10 established artists/year.

First Contact & Terms Send query letter with brochure showing art style, slides, photocopies, résumé, photostats, transparencies, tearsheets and photographs. Responds in 2 months. Write for appointment to show portfo-

lio or mail appropriate materials: rough, b&w, color photostats, slides, tearsheets, transparencies and photographs. Pays royalties. No advance. Buys reprint rights. Requires exclusive representation of artist. Provides in-transit insurance, promotion, shipping to and from firm, insurance while work is at firm and a written contract.

Tips "Artists should be honest, patient, courteous, be themselves, and make good art."

MUNSON GRAPHICS

1209 Parkway Dr., Suite A, Santa Fe NM 87507. (505)424-4112. Fax: (505)424-6338. E-mail: michael@munsongraphics.com. Website: www.munsongraphics.com. **President:** Michael Munson. Estab. 1997. Poster company, art publisher and distributor. Publishes/distributes limited edition, fine art prints and posters. Clients: galleries, museum shops, gift shops and frame shops.

Needs Seeking creative art for the serious collector and commercial market. Considers oil, acrylic, watercolor and pastel. Artists represented include O'Keeffe, Baumann, Nieto, Abeyta. Editions created by working from an existing painting. Approached by 75 artists/year. Publishes work of 3-5 emerging, 3-5 mid-career and 3-5 established artists/year. Distributes the work of 5-10 emerging, 5-10 mid-career and 5-10 established artists/year.

First Contact & Terms Send query letter with slides, SASE and transparencies. Samples are not filed and are returned by SASE. Responds in 1 month. Company will contact artist for portfolio review if interested. Negotiates payment. Offers advance. Rights purchased vary according to project. Provides written contract. Finds artists through art exhibitions, art fairs, word of mouth and artists' submissions.

NEW YORK GRAPHIC SOCIETY

129 Glover Ave., Norwalk CT 06850. (203)661-2400. Website: www.nygs.com. **Publisher:** Richard Fleischmann. President: Owen Hickey. Estab. 1925. Publisher of offset reproductions, posters, unlimited edition. Clients: galleries, frame shops and museums shops. Current clients include Deck The Walls, Artistry, Prints Plus.

Needs Considers oil, acrylic, pastel, watercolor, mixed media and colored pencil drawings. Publishes reproductions, posters. Artists represented include Dan Campanelli, Doug Brozu. Publishes and distributes the work of numerous emerging artists/year. Art guidelines free with SASE. Response to submissions in 90 days.

First Contact & Terms Send query letter with transparencies or photographs. All submissions returned to artists by SASE after review. Pays royalties of 10%. Offers advance. Buys all print reproduction rights. Provides in-transit insurance from firm to artist, insurance while work is at firm, promotion, shipping from firm and a written contract; provides insurance for art if requested. Finds artists through submissions/self promotions, magazines, visiting art galleries, art fairs and shows.

Tips "We publish a broad variety of styles and themes. We actively seek all sorts of fine decorative art."

N. NEXTMONET

444 Townsend St., 2nd Floor, San Francisco CA 94107. (888)914-5050. Fax: (415)977-6905. E-mail: jobs@nextmonet.com. Website: www.nextmonet.com. **Contact:** Artwork Submissions. Estab. 1998. Art publisher, distributor. Publishes/distributes limited edition and fine art prints as well as originals. Clients: decorators, corporate curators and private consumers.

Needs Seeking creative, decorative art for the serious collector, commercial and designer markets. Considers oil, acrylic, watercolor, mixed media, pastel, pen & ink and photography. Prefers all styles. Artists represented include James Stagg, Susan Friedman and Eric Zener. Editions created by collaborating with the artist and working from an existing painting. Approached by 1,000 artists/year.

First Contact & Terms Send query letter with résumé, SASE and slides. Accepts disk submissions in JPEG or BITMAP format compatible with Photoshop 5.5. Samples are filed, kept on disk or returned by SASE. Portfolio review not required. Finds artists through World Wide Web, sourcebooks, art exhibitions, art fairs, artists' submissions, publications and word of mouth.

NORTHLAND POSTER COLLECTIVE

1613 E. Lake St., Minneapolis MN 55407. (612)721-2273. E-mail: art@northlandposter.com. Website: www.northlandposter.com. **Manager:** Ricardo Levins Morales. Estab. 1979. Art publisher and distributor of handpulled originals, unlimited editions, posters and offset reproductions. Clients: mail order customers, teachers, bookstores, galleries, unions.

Needs "Our posters reflect themes of social justice and cultural affirmation, history, peace." Artists represented include Ralph Fasanella, Frank Escalet, Christine Wong, Beatriz Aurora, Betty La Duke, Ricardo Levins Morales and Janna Schneider. Editions created by collaborating with the artist or by working from an existing painting.

First Contact & Terms Send query letter with tearsheets, slides and photographs. Accepts digital files. Samples are filed or are returned by SASE. Responds in months; if does not report back, the artist should write or call

to inquire. Write for appointment to show portfolio. Payment method is negotiated. Offers an advance when appropriate. Negotiates rights purchased. Contracts vary, but artist always retains ownership of artwork. Provides promotion and a written contract.

Tips "We distribute work that we publish as well as pieces already printed. We screenprint as well as produce digital prints."

☑ NORZ GRAPHICA
P.O. Box 143, Woolwich ME 04579. Phone/fax: (207)422-7237. E-mail: info@norsgear.com. Website: www.nor sgear.com. **Publisher:** Alexander Bridge. Estab. 1989. Art publisher/distributor. Publishes and distributes limited and unlimited editions, posters, offset reproductions and stationery. Clients: framers, galleries.

Needs Seeking creative art for the commercial market. Specializes in rowing, sailing and sporting art. Considers oil, watercolor, mixed media, pen & ink, acrylic and b&w photography. Artists and photographers represented include John Gable, David Foster and Amy Wilton. Editions created by collaborating with the artist. Approached by 300 artists/year. Publishes and distributes the work of 4 mid-career artists and photographers and 3 established artists/year. Send 35mm slides.

Tips "Persist in your work to succeed!"

NOTTINGHAM FINE ART
P.O. Box 309, Chester NH 03036-0309. (603)887-7089. Fax: (603)887-2447. E-mail: robert@artandgift.com. Website: www.artandgift.com. **President:** Robert R. Lemelin. Estab. 1992. Art distributor. Distributes hand-pulled originals, limited editions, fine art prints, monoprints, monotypes, offset and digital reproductions. Clients: galleries, frame shops, architects.

Needs Seeking creative, fashionable, decorative art for the serious collector. Considers oil, acrylic, watercolor, mixed media, pastel. Prefers sporting, landscape, floral, creative, musical and lifestyle themes. Artists represented include Roger Blum, Barbie Tidwell, Cristina Martuccelli, Alice V. Morris, Catherin Colsher, Fred Swan, Monique Parry and Ronald Parry. Approached by 60 artists/year.

First Contact & Terms Send query letter with brochure, photographs, slides. Samples are filed or returned by SASE. Responds in 2 months. Company will contact artist for portfolio review of color photographs, slides and transparencies if interested. Pays in royalties or buys outright. Rights purchased vary according to project. Requires exclusive representation of artist. Provides insurance while work is at firm, promotion, shipping from firm, written contract. Finds artists through art fairs, submissions and referrals from existing customers.

Tips "If you don't have a marketing plan developed or $5,000 you don't need, don't self-publish. We look for artists with consistent quality and a feeling to their work."

NOVA MEDIA INC.
1724 N. State, Big Rapids MI 49307. (231)796-4637. E-mail: trund@nov.com. Website: www.nov.com. **Editor:** Tom Rundquist. Licensing: Arne Flores. Estab. 1981. Poster company, art publisher, distributor. Publishes/distributes limited editions, unlimited editions, fine art prints, posters, e-prints. Current clients: various galleries. Licenses e-prints.

Needs Seeking creative art for the serious collector. Considers oil, acrylic. Prefers expressionism, impressionism, abstract. Editions created by collaborating with the artist or by working from an existing painting. Approached by 14 artists/year. Publishes/distributes the work of 2 emerging, 2 mid-career and 1 established artists/year. Artists represented include Jill Everest Fonner. Also needs freelancers for design. Prefers local designers.

First Contact & Terms Send query letter with photographs, résumé, SASE, slides, tearsheets. Samples are returned by SASE. Responds in 2 weeks. Request portfolio review in original query. Company will contact artist for portfolio review of color photographs, slides, tearsheets if interested. Pays royalties of 10% or negotiates payment. No advance. Rights purchased vary according to project. Provides promotion.

Tips Predicts colors will be brighter in the industry. "Focus on companies that sell your style."

⃞N⃞ OLD GRANGE GRAPHICS
40 Scitico Rd., Somersville CT 06072. (800)282-7776. Fax: (800)437-3329. E-mail: ogg@denunzio.com. Website: www.oldgrangegraphics.com. **President:** Gregory Panjian. Estab. 1976. Distributor/canvas transfer studio. Publishes/distributes canvas transfers, posters. Clients: galleries, frame shops, museum shops, publishers, artists.

Needs Seeking decorative art for the commercial and designer markets. Considers lithographs. Prefers prints of artworks that were originally oil paintings. Editions created by working from an existing painting. Approached by 100 artists/year.

First Contact & Terms Send query letter with brochure. Samples are not filed and are returned. Responds in 1 month. Will contact artist for portfolio review of tearsheets if interested. Negotiates payment. Rights purchased vary according to project. Provides promotion and shipping from firm. Finds artists through art publications.

Tips Recommends Galeria, Artorama and ArtExpo shows in New York and *Decor*, *Art Trends*, *Art Business News* and *Picture Framing* as tools for learning the current market.

☑ OLD WORLD PRINTS, LTD.

2601 Floyd Ave., Richmond VA 23220-4305. (804)213-0600. Fax: (804)213-0700. E-mail: kwurdeman@yahoo.com. Website: www.oldworldprintsltd.com. **President:** Scott Ellis. Licensing: Lonnie Lemco. Estab. 1973. Art publisher and distributor of open-edition, hand-printed reproductions of antique engravings as well as all subject matter of color printed art. Clients: retail galleries, frame shops and manufacturers, hotels and fund raisers.

- Old World Prints reports the top-selling art in their 10,000-piece collection includes botanical and decorative prints.

Needs Seeking traditional and decorative art for the commercial and designer markets. Specializes in handpainted prints. Considers "b&w (pen & ink or engraved) art which can stand by itself or be hand painted by our artists or originating artist." Prefers traditional, representational, decorative work. Editions created by collaborating with the artist. Distributes the work of more than 1,000 artists. "Also seeking golf, coffee, tea, and exotic floral images."

First Contact & Terms Send query letter with brochure showing art style or résumé and tearsheets and slides. Samples are filed. Responds in 6 weeks. Write for appointment to show portfolio of photographs, slides and transparencies. Pays flat fee of $100/piece and royalties of 10% of profit. Offers an advance when appropriate. Negotiates rights purchased. Provides in-transit insurance, insurance while work is at firm, promotion, shipping from firm and a written contract. Finds artists through word of mouth.

Tips "We are a specialty art publisher, the largest of our kind in the world. We are actively seeking artists to publish and will consider all forms of art."

OPUS ONE PUBLISHING

129 Glover Ave., Norwach CT 06850. (203)847-2000. Fax: (203)846-2105. **Contact:** Owen F. Hickey. Estab. 1970. Art Publisher. Publishes fine art prints.

Needs Seeking creative, fashionable and decorative art for the commercial and designer markets. Considers all media. Art guidelines free for SASE with first-class postage. Artists represented include Kate Frieman, Jack Roberts, Jean Richardson, Richard Franklin, Lee White. Approached by 100 artists/year. Publishes the work of 20% emerging, 20% mid-career and 60% established artists.

First Contact & Terms Send brochure, tearsheets, slides, photographs, photocopies, transparencies. Samples are not filed and are returned. Responds in 1 month. Artist should follow up with call after initial query. Portfolio should include final art, slides, transparencies. Pays royalties of 10%. Rights purchased vary according to project.

Tips "Please attend the Art Expo New York City trade show."

PALOMA EDITIONS

2290 Enrico Fermi Dr., Suite 16, San Diego CA 92154. (619)671-0153. E-mail: customerservice@palomaeditions.com **Publisher:** Kim A. Butler. Art publisher/distributor of limited and unlimited editions, fine art prints, offset reproductions and posters. Specializes in African-American art. Clients include galleries, specialty shops, retail chains, framers, distributors, museum shops.

Needs Seeking creative and decorative art for the commercial and designer market. Considers all media. Prefers African-American art. Artists represented include Albert Fennell, Raven Williamson, Tod Hanskin Fredericks. Editions created by working from existing painting. Approached by hundreds of artists/year. Publishes the work of 4 emerging artists/year. Distributes the work of 10 emerging artists/year.

First Contact & Terms Send query letter with brochure, photocopies, photographs, tearsheets and/or transparencies or JPEGs. Samples are returned by SASE, only if requested. Responds in 2 months, only if interested. Publisher will contact for portfolio review of color final art, photographs, tearsheets and transparencies if interested. Payment negotiable, royalties vary. Offers advance when appropriate. Negotiates rights purchased. Requires exclusive representation of artist. Provides advertising, promotion, shipping and written contract. Also needs designers. Prefers designers who own IBM PCs. Freelance designers should be experienced in QuarkXPress, Photoshop, FreeHand. Finds artists through art shows, magazines and referrals.

Tips "African-American art is hot! Read the trade magazines and watch the furniture and fashion industry. Keep in mind that your work must appeal to a wide audience. It is helpful if fine artists also have basic design skills so they can present their artwork complete with border treatments. We advertise in *Decor*, *Art Business News*, *Art Trends*. See ads for examples of what we choose to publish."

☑ PANACHE EDITIONS LTD

234 Dennis Lane, Glencoe IL 60022. (847)835-1574. Fax: (847)835-2662. E-mail: info@artofrunning.com. Website: www.artofrunning.com. **President:** Donna MacLeod. Estab. 1981. Art publisher and distributor of offset

reproductions and posters focusing on marathon running. Clients: galleries, frame shops, domestic and international distributors. Current clients are mostly individual collectors.

Needs Considers acrylic, pastel, watercolor and mixed media. "Looking for contemporary compositions in soft pastel color palettes; also renderings of children on beach, in park, etc." Artists represented include Andrew Yelenak, Bart Forbes, Peter Eastwood and Carolyn Anderson. Prefers individual works of art and unframed series. Publishes and distributes work of 1-2 emerging, 2-3 mid-career and 1-2 established artists/year.

First Contact & Terms Send query letter with brochure showing art style or photographs, photocopies and transparencies. Samples are filed. Responds only if interested. To show portfolio, mail roughs and final reproduction/product. Pays royalties of 10%. Negotiates rights purchased. Requires exclusive representation of artist. Provides in-transit insurance, insurance while work is at firm, promotion, shipping to and from firm and written contract.

Tips "We are looking for artists who have not previously been published [in the poster market] with a strong sense of current color palettes. We want to see a range of style and coloration. Looking for a unique and fine art approach to collegiate type events, i.e., Saturday afternoon football games, Founders Day celebrations, homecomings, etc. We do not want illustrative work but rather an impressionistic style that captures the tradition and heritage of one's university. We are very interested in artists who can render figures."

MARK PATSFALL GRAPHICS, INC.

1312 Clay St., Cincinnati OH 45202. (513)241-3232. E-mail: mpginc@iac.net. Website: www.patsfallgraphics.com. **Contact:** Mark Patsfall, owner. Estab. 1981. Art publisher and contract printer. Publishes fine art prints, hand-pulled originals, limited edition. Clients: architects, corporate curators, decorators, galleries and museum print curators.

Needs Seeking art for the serious collector. Prefers conceptual/contemporary. Artists represented include Nam June Paik, Kay Rosen, Bill Allen, Bern Porter. Editions created by collaborating with the artist. Approached by 1-10 artists/year. Publishes the work of 2-3 emerging artists/year.

First Contact & Terms Contact only through artist rep. Accepts e-mail submissions with image file. Prefers Mac-compatible JPEG files. Responds in 1 week. Negotiates payment. Negotiates rights purchased. Services provided depend on contract. Finds artists through art reps, galleries and word of mouth.

⦚Ⓝ PENNY LANE PUBLISHING INC.

1791 Dalton Dr., New Carlisle OH 45344. (937)849-1101. Fax: (937)849-9666. E-mail: info@PennyLanePublishing.com. Website: www.PennyLanePublishing.com. **Art Coordinators:** Kathy Benton. Licensing: Renee Franck and Beth Schenck. Estab. 1993. Art publisher. Publishes limited editions, unlimited editions, offset reproductions. Clients: galleries, frame shops, distributors, decorators.

Needs Seeking creative, decorative art for the commercial market. Considers oil, acrylic, watercolor, mixed media, pastel. Artists represented include Linda Spivey, Becca Barton, Pat Fischer, Annie LaPoint, Fiddlestix, Mary Ann June. Editions created by collaborating with the artist or working from an existing painting. Approached by 40 artists/year. Publishes the work of 3-4 emerging, 15 mid-career and 6 established artists/year.

First Contact & Terms Send query letter with brochure, résumé, photographs, slides, tearsheets. Samples are filed or returned by SASE. Responds in 2 months. Company will contact artist for portfolio review of color, final art, photographs, slides, tearsheets if interested. Pays royalties. Buys first rights. Requires exclusive representation of artist. Provides advertising, shipping from firm, promotion, written contract. Finds artists through art exhibitions, art fairs, submissions, decorating magazines.

Tips Advises artists to be aware of current color trends and work in a series. "Please review our website to see the style of artwork we publish."

🌐 PORTER DESIGN—EDITIONS PORTER

The Old Estate Yard, Newton St. Loe, Bath, Somerset BA2 9BR, England. (01144)1225-874250. Fax: (01144)1225-874251. E-mail: Mary@porter-design.com. Website: www.porter-design.com. **Partners:** Henry Porter, Mary Porter. Estab. 1985. Publishes limited and unlimited editions and offset productions and hand-colored reproductions. Clients: international distributors, interior designers and hotel contract art suppliers. Current clients include Devon Editions, Top Art, Harrods and Bruce McGaw.

Needs Seeking fashionable and decorative art for the designer market. Considers watercolor. Prefers 16th-19th century traditional styles. Artists represented include Victor Postolle, Joseph Hooker and Adrien Chancel. Editions created by working from an existing painting. Approached by 10 artists/year. Publishes and distributes the work of 10-20 established artists/year.

First Contact & Terms Send query letter with brochure showing art style or résumé and photographs. Accepts disk submissions compatible with QuarkXPress on Mac. Samples are filed or are returned. Responds only if interested. To show portfolio, mail photographs. Pays flat fee or royalties. Offers an advance when appropriate. Negotiates rights purchased.

PORTFOLIO GRAPHICS, INC.

P.O. Box 17437, Salt Lake City UT 84117. (801)266-4844. E-mail: info@portfoliographics.com. Website: www.n ygs.com. **Creative Director:** Kent Barton. Estab. 1986. Publishes and distributes unlimited editions and posters. Clients: galleries, designers, poster distributors (worldwide) and framers. Licensing: All artwork is available for license for large variety of products. Portfolio Graphics works with a large licensing firm who represents all of their imagery.

Needs Seeking creative, fashionable and decorative art for commercial and designer markets. Considers oil, watercolor, acrylic, pastel, mixed media and photography. Publishes 80-100 new works/year. Editions created by working from an existing painting or transparency.

First Contact & Terms Send query letter with résumé, biography, slides and photographs. Samples are not filed. Responds in 3 months. To show portfolio, mail slides, transparencies, tearsheets and photographs with SASE. (Material will not be returned without an enclosed SASE.) Pays royalties of 10%. Provides promotion and a written contract.

Tips ''We find artists through galleries, magazines, art exhibits, submissions. We're looking for a variety of artists and styles/subjects.''

☑ POSTER PORTERS

P.O. Box 9241, Seattle WA 98109-9241. (206)286-0818. Fax: (206)286-0820. E-mail: markwithposterporters@ms n.com. Website: www.posterporters.com. **Marketing Director:** Mark Simard. Art rep/publisher/distributor/ gift wholesaler. Publishes/distributes limited and unlimited edition, posters and art T-shirts. Clients: galleries, decorators, frame shops, distributors, corporate curators, museum shops, giftshops. Current clients include: Prints Plus, W.H. Smith, Smithsonian, Nordstrom.

Needs Publishes/distributes creative art for regional commercial and designer markets. Considers oil, watercolor, pastel. Prefers regional art. Artists represented include Beth Logan, Carolin Oltman, Jean Casterline, M.J. Johnson. Art guidelines free for SASE with first-class postage. Editions created by collaborating with the artist or working from an existing painting. Approached by 144 artists/year. Publishes the work of 2 emerging, 2 mid-career and 1 established artist/year. Distributes the work of 50 emerging, 25 mid-career, 20 established artists/year.

First Contact & Terms Send photocopies, SASE, tearsheets. Accepts disk submissions. Samples are filed or returned by SASE. Will contact artist for Friday portfolio drop off. Pays flat fee: $225-500; royalties of 5%. Offers advance when appropriate. Buys all rights. Provides advertising, promotion, contract. Also works with freelance designers. Prefers local designers only. Finds artists through exhibition, art fairs, art reps, submissions.

Tips ''Be aware of what is going on in the interior design sector. Be able to take criticism. Be more flexible.''

☑ ⬆ POSTERS INTERNATIONAL

1200 Castlefield Ave., Toronto ON M6B 1G2 Canada. (416)789-7156. Fax: (416)789-7159. E-mail: artist@postersi nternational.net. Website: www.postersinternational.net. **President:** Esther Cohen-Bartfield. Creative Director: Lyn Kungel. Licensing: Richie Cohen. Estab. 1976. Poster company, art publisher. Publishes fine art posters. Licenses for gift and stationery markets. Clients: galleries, decorators, distributors, hotels, restaurants etc., in U.S., Canada and international. Current clients include: Holiday Inn and Bank of Nova Scotia.

Needs Seeking creative, fashionable art for the commercial market. Considers oil, acrylic, watercolor, mixed media, b&w and color photography. Prefers landscapes, florals, abstracts, photography, vintage, collage and tropical imagery. Artists represented include Patricia George, Scott Steele and Shojaei. Editions created by collaborating with the artist or by working from an existing painting. Approached by 100 artists/year. Art guidelines free for SASE with first-class postage or IRC.

First Contact & Terms Send query letter with brochure, photographs, slides, transparencies to Lyn Kungel. ''No originals please!'' Samples are filed or returned by SASE. Responds in 2 months. Company will contact artist for portfolio review of photographs, photostats, slides, tearsheets, thumbnails, transparencies if interested. Pays flat fee or royalties of 10%. Offers advance when appropriate. Rights purchased vary according to project. Provides advertising, promotion, shipping from firm, written contract. Finds artists through art fairs, art reps, submissions.

Tips ''Be aware of current color trends and always work in a series of two or more. Visit poster shops to see what's popular before submitting artwork.''

PRESTIGE ART INC.

3909 W. Howard St., Skokie IL 60076. (847)679-2555. E-mail: prestige@prestigeart.com. Website: www.prestige art.com. **President:** Louis Schutz. Estab. 1960. Publisher/distributor/art gallery. Represents a combination of 18th and 19th century work and contemporary material. Publishes and distributes handpulled originals, limited and unlimited editions, canvas transfers, fine art prints, offset reproductions, posters, sculpture. Licenses art-

work for note cards, puzzles, album covers and posters. Clients: galleries, decorators, architects, corporate curators.

• Company president Louis Shutz does consultation for new artists on publishing and licensing their art in various media.

Needs Seeking creative and decorative art. Considers oil, acrylic, mixed media, sculpture, glass. Prefers figurative art, impressionism, surrealism/fantasy, photo realism. Artists represented include Jean-Paul Avisse. Editions created by collaborating with the artist or by working from an existing painting. Approached by 15 artists/year. Publishes the work of 2 emerging artists/year. Distributes the work of 5 emerging artists/year.

First Contact & Terms Send query letter with résumé and tearsheets, photostats, slides, photographs and transparencies. Accepts IBM compatible disk submissions. Samples are not filed and are returned by SASE. Responds only if interested. Company will contact artist for portfolio review of tearsheets if interested. Pays flat fee. Offers an advance when appropriate. Rights purchased vary according to project. Provides insurance in-transit and while work is at firm, advertising, promotion, shipping from firm and written contract.

Tips "Be professional. People are seeking better quality, lower-sized editions, fewer numbers per edition—1/100 instead of 1/750."

☑ PRIME ART PRODUCTS

Tropical Frame & Art, 2800 S. Nova Rd., Bldg. A, Daytona Beach FL 32119. (800)749-7393. E-mail: tropicalframe &art@aol.com. Website: www.primeartproducts.com. **Owner:** Ken Kozimor. Estab. 1990. Art publisher, distributor. Publishes/distributes limited editions, unlimited editions, fine art prints, offset reproductions. Clients include: galleries, specialty giftshops, interior design and home accessory stores.

Needs Seeking art for the commercial and designer markets. Considers oil, acrylic, watercolor. Prefers realistic shore birds and beach scenes. Artists represented include Robert Binks, Keith Martin Johns, Christi Mathews, Art LaMay and Barbara Klein Craig. Editions created by collaborating with the artist or by working from an existing painting. Approached by 30 artists/year. Publishes the work of 1-2 emerging artists/year. Distributes the work of many emerging and 4 established artists/year.

First Contact & Terms Send photographs, SASE and tearsheets. Samples are filed or returned by SASE. Responds in 5 days. Company will contact artist for portfolio review if interested. Negotiates payment per signature. Offers advance when appropriate. Rights purchased vary according to project. Finds artists through submissions and small art shows.

THE PRINTS AND THE PAPER

106 Walnut St., Montclair NJ 07042. (973)746-6800. Fax: (973)746-6801. Estab. 1996. Distributor of handpulled originals, limited and unlimited edition antiques and reproduced illustration, prints, hand colored etchings and offset reproduction. Clients: galleries, decorators, frame shops, giftshops.

Needs Seeking reproductions of decorative art. Considers watercolor, pen & ink. Prefers illustration geared toward children; also florals. Artists represented include Helga Hislop, Raymond Hughes, Dorothy Wheeler, Arthur Rackham, Richard Doyle.

First Contact & Terms Send query letter with SASE, slides. Samples are filed or returned by SASE. Will contact artist for portfolio review of slides if interested. Negotiates payment. Rights purchased vary according to project. Finds artists through art exhibitions, word of mouth.

Tips "We are a young company (8 years). We have not established all guidelines. We are attempting to establish a reputation for having quality illustration which covers a broad range."

☒ PROGRESSIVE EDITIONS

37 Sherbourne St., Toronto ON M5A 2P6 Canada. (416)860-0983. Fax: (416)367-2724. E-mail: info@progressive editions.com. Website: www.progressiveeditions.com. **President:** Mike Havers. General Manager: Tom Shacklady. Estab. 1982. Art publisher. Publishes handpulled originals, limited edition fine art prints and monoprints. Clients: galleries, decorators, frame shops, distributors.

Needs Seeking creative and decorative art for the serious collector and designer market. Considers oil, acrylic, watercolor, mixed media, pastel. Prefers figurative, abstract, landscape and still lifes. Artists represented include Emilija Pasagic, Doug Edwards, Marsha Hammel. Editions created by working from an existing painting. Approached by 100 artists/year. Publishes the work of 4 emerging artists/year. Distributes the work of 10 emerging artists/year.

First Contact & Terms Send query letter with photographs, slides. Samples are not filed and are returned. Responds in 1 month. Will contact artist for portfolio review if interested. Negotiates payment. Offers advance when appropriate. Negotiates rights purchased. Requires exclusive representation of artist. Provides advertising, in-transit insurance, insurance while work is at firm, promotion, shipping and contract. Finds artists through exhibition, art fairs, word of mouth, art reps, sourcebooks, submissions, competitions.

Tips "Develop organizational skills."

RIGHTS INTERNATIONAL GROUP

463 First St., #3C, Hoboken NJ 07030. (201)239-8118. Fax: (201)222-0694. E-mail: info@rightsinternational.com. Website: www.rightsinternational.com. **Contact:** Robert Hazaga. Estab. 1996. Agency for cross licensing. Represents artists for licensing into publishing, stationery, posters, prints, calendars, giftware, home furnishing. Clients: giftware, stationery, posters, prints, calendars, wallcoverings and home decor publishers.

• This company is also listed in the Greeting Card, Gifts & Products section.

Needs Seeking creative, decorative art for the commercial and designer markets. Also looking for country/Americana with a new fresh interpretation of country with more of a cottage influence. Think Martha Stewart, *Country Living* magazine; globally inspired artwork. Considers all media. Prefers commercial style. Artists represented include Forest Michaels, Susan Hayes and Susan Osborne. Approached by 50 artists/year.

First Contact & Terms Send brochure, photocopies, photographs, SASE, slides, tearsheets, transparencies, JPEGs, CD-ROM. Accepts disk submissions compatible with PC platform. Samples are not filed and are returned by SASE. Responds in 2 weeks. Company will contact artist for portfolio review if interested. Negotiates payment.

Tips "Check our website for trend, color and style forecasts!"

RINEHART FINE ARTS, INC.

a division of Bentley Publishing Group, 250 W. 57th St., Suite 2202A, New York NY 10107. (212)399-8958. Fax: (212)399-8964. E-mail: hwrinehart@aol.com. Website: www.bentleypublishinggroup.com. Poster publisher. President: Harriet Rinehart. Licenses 2D artwork for posters. Clients include galleries, decorators, frame shops, corporate curators, museum shops, gift shops and substantial overseas distribution.

• Harriet Rinehart does product development for all five divisions of Bentley Publishing Group. See also listing for Bentley Publishing Group for more information on this publisher.

Needs Seeking creative, fashionable and decorative art. Considers oil, acrylic, watercolor, mixed media, pastel. Artists represented include Howard Behrens, Thomas McKnight, Tadashi Asoma, André Bourrié. Editions created by collaborating with the artist or working from an existing painting. Approached by 30-40 artists/year. Publishes the work of 10 emerging artists/year.

First Contact & Terms Send query letter with photographs, SASE, slides, tearsheets, transparencies or "whatever the artist has which represents artist." Samples are not filed. Responds in 3 months. Portfolio review not required. Pays royalties of 8-10%. Rights purchased vary according to project. Provides advertising, promotion, written contract and substantial overseas exposure.

Tips "Read *Home Furnishings News*. Work in a series. Attend trade shows."

🔌 RIVER HEIGHTS PUBLISHING INC.

82 Walmer Rd., Toronto ON M3H 6A7 Canada. (416)922-0500. E-mail: riverhpublishing@aol.com. **Publisher:** Paul Swartz. Art publisher. Publishes limited editions, unlimited editions, fine art prints, offset reproductions, sculpture. Clients: galleries, frame shops, marketing companies, corporations, mail order, chain stores, barter exchanges.

Needs Seeking decorative art for the commercial market. Considers oil, acrylic, and watercolor. Prefers wildlife, Southwestern, American Indian, impressionism, nostalgia and Victorian (architecture). Artists represented include A.J. Casson, Paul Rankin, George McLean, Rose Marie Condon. Editions created by collaborating with the artist. Approached by 50 artists/year. Publishes the work of 1 emerging, 2 mid-career, 1 established artists/year. Distributes the work of 3 emerging, 2 mid-career and 3 established artists/year.

First Contact & Terms Send photographs, résumé, SAE (nonresidents include IRC), slides, tearsheets. Samples are not filed and are returned by SAE. Responds in 3 weeks. Company will contact artist for portfolio review of final art if interested. Pays flat fee, royalties and/or consignment basis. Rights purchased vary according to project. Requires exclusive representation of artist. Provides advertising, insurance, promotion, shipping from firm, written contract and samples on greeting cards, calendars.

🅽 🌐 FELIX ROSENSTIEL'S WIDOW & SON LTD.

33-35 Markham St., London SW3 3NR United Kingdom. (44)207-352-3551. Fax: (44)207-351-5300. E-mail: sales@felixr.com. Website: www.felixr.com. **Contact:** Mrs. Lucy McDowell. Licensing: Miss Caroline Dyas. Estab. 1880. Publishes handpulled originals, limited edition, canvas transfers, fine art prints and offset reproductions. Licenses all subjects on any quality product. Art guidelines on website.

Needs Seeking decorative art for the serious collector and the commercial market. Considers oil, acrylic, watercolor, mixed media and pastel. Prefers art suitable for homes or offices. Artists represented include Spencer Hodge, Barbara Olsen, Ray Campbell and Richard Akerman. Editions created by collaborating with the artist or by working from an existing painting. Approached by 200-500 artists/year.

First Contact & Terms Send query letter with photographs. Samples are not filed and are returned by SAE. Responds in 2 weeks. Company will contact artist for portfolio review of final art and transparencies if interested.

Negotiates payment. Offers advance when appropriate. Rights purchased vary according to project.

Tips ''We don't view artwork sent digitally via e-mail or CD-Rom.''

N RUSHMORE HOUSE PUBLISHING

P.O. Box 1591, Sioux Falls SD 57107-1591. (800)456-1895. E-mail: info@rushmorehouse.com. Website: www.rushmorehouse.com. **Publisher:** Stan Cadwell. Estab. 1989. Art publisher and distributor of limited editions. Clients: art galleries and picture framers.

Needs Seeking artwork for the serious collector and commercial market. Considers oil, watercolor, acrylic, pastel and mixed media. Prefers realism, all genres. Artists represented include W.M. Dillard and Tom Phillips. Editions created by collaborating with the artist.

First Contact & Terms Send query letter with résumé, tearsheets, photographs and transparencies. Samples are filed or are returned by SASE if requested by artist. Responds in 1 month. Write for appointment to show portfolio of original/final art, tearsheets, photographs and transparencies. Payment method is negotiated. Offers an advance when appropriate. Negotiates rights purchased. Exclusive representation of artist is negotiable. Provides in-transit insurance, insurance while work is at firm, promotion, shipping and written contract. ''We market the artist and their work.''

Tips ''Current interests include: wildlife, Native American, Western.''

N SAGEBRUSH FINE ART

3065 South West Temple, Salt Lake City UT 84115. (801)466-5136. Fax: (801)466-5048. E-mail: chris@sagebrushfineart.com. **Art Review Coordinator:** Stephanie Merrit. Vice President: Dena Peat. Licensing: Mike Singleton. Estab. 1991. Art publisher. Publishes fine art prints and offset reproductions. Clients: frame shops, distributors, corporate curators and chain stores.

Needs Seeking decorative art for the commercial and designer markets. Considers oil, acrylic, watercolor and photography. Prefers traditional themes and styles. Current clients include: Mark Arian, Michael Humphries, Jo Moulton, Susan Seals. Editions created by collaborating with the artist or by working from an existing painting. Approached by 200 artists/year. Publishes the work of 20 emerging artists/year.

First Contact & Terms Send SASE, slides and transparencies. Samples are not filed and are returned by SASE. Responds in 3 weeks. Company will contact artist for portfolio review if interested. Pays royalties of 10% or negotiates payment. Offers advance when appropriate. Rights purchased vary according to project. Provides advertising, promotion, shipping from firm and written contract.

✓ SALEM GRAPHICS, INC.

P.O. Box 15134, Winston-Salem NC 27113. (336)727-0659. E-mail: bettyandrews@salemgraphics.com. Website: www.salemgraphics.com. **Contact:** Betty Andrews, office manager. Estab. 1981. Art publisher/distributor. Publishes/distributes canvas transfers, fine art prints, hand-pulled originals, limited edition, offset reproduction, unlimited edition.

Needs Seeking decorative art for the serious collector, commercial and designer markets. Prefers landscapes, seascapes, coastal scenes and florals. Artists represented include Phillip Philbeck, Amy Youngblood, Larry Burge.

First Contact & Terms Send query letter with slides or photographs and SASE. Publisher will contact for portfolio review if interested. Buys reprint rights. Requires exclusive representation of artist. Provides advertising, in-transit insurance and insurance while work is at firm, promotion and written contract.

N ⊕ SCANDECOR MARKETING AB

Box 656, 751 27, Uppsala Sweden. E-mail: mariekadestam@scandecor-marketing.se. Website: www.scandecor-marketing.se. **Contact:** Marie Kadestam. Poster company, art publisher/distributor. Publishes/distributes fine art prints and posters. Clients include gift and stationery stores, craft stores and frame shops.

Needs Seeking fashionable, decorative art. Considers acrylic, watercolor and pastel. Themes and styles vary according to current trends. Editions created by working from existing painting. Approached by 150 artists/year. Publishes the work of 5 emerging, 10 mid-career and 10 established artists/year. Also uses freelance designers. 25% of products require freelance design.

First Contact & Terms Send query letter with brochure, photocopies, photographs, slides, tearsheets, CDs, transparencies and SASE. Samples not filed are returned by SASE in 2 months. Company will contact artist for portfolio review if interested. Portfolio should include color photographs, slides, tearsheets and/or transparencies. Pays flat fee, $250-1,000. Rights vary according to project. Provides written contract. Finds artists through art exhibitions, art and craft fairs, art reps, submissions and looking at art already in the marketplace in other forms (e.g., collectibles, greeting cards, puzzles).

SCHIFTAN INC.

1300 Steel Rd. W, Suite 4, Morrisville PA 19067. (215)428-2900 or (800)255-5004. Fax: (215)295-2345. E-mail: schiftan@erols.com. Website: www.schiftan.com. **President:** Harvey S. Cohen. Estab. 1903. Art publisher, distributor. Publishes/distributes unlimited editions, fine art prints, offset reproductions, posters and hand-colored prints. Clients: galleries, decorators, frame shops, architects, wholesale framers to the furniture industry.

Needs Seeking fashionable, decorative art for the commercial market. Considers watercolor, mixed media. Prefers traditional, landscapes, botanicals, wildlife, Victorian. Editions created by collaborating with the artist. Approached by 15-20 artists/year. Also needs freelancers for design.

First Contact & Terms Send query letter with transparencies. Samples are not filed and are returned. Responds in 1 week. Company will contact artist for portfolio review of final art, roughs, transparencies if interested. Pays flat fee or royalties. Offers advance when appropriate. Negotiates rights purchased. Provides advertising, written contract. Finds artists through art exhibitions, art fairs, submissions.

SCHLUMBERGER GALLERY

P.O. Box 2864, Santa Rosa CA 95405. (707)544-8356. Fax: (707)538-1953. E-mail: sande@schlumberger.org. **Owner:** Sande Schlumberger. Estab. 1986. Art publisher, distributor and gallery. Publishes and distributes limited editions, posters, original paintings and sculpture. Specializes in decorative and museum-quality art and photographs. Clients: collectors, designers, distributors, museums, galleries, film and television set designers. Current clients include: Bank of America Collection, Fairmont Hotel, Editions Ltd., Sonoma Cutter Vineyards, Dr. Robert Jarvis Collection and Tom Sparks Collection.

Needs Seeking decorative art for the serious collector and the designer market. Prefers trompe l'oeil, realist, architectural, figure, portrait. Artists represented include Charles Giulioli, Deborah Deichler, Susan Van Camden, Aurore Carnero, Borislav Satijnac, Robert Hughes, Fletcher Smith, Jacques Henri Lartigue, Ruth Thorn Thompson, Ansel Adams and Tom Palmore. Editions created by collaborating with the artist or by working from an existing painting. Approached by 50 artists/year.

First Contact & Terms Send query letter with tearsheets and photographs. Samples are not filed and are returned by SASE if requested by artist. Publisher/distributor will contact artist for portfolio review if interested. Portfolio should include color photographs and transparencies. Negotiates payment. Offers advance when appropriate. Rights purchased vary according to project. Provides advertising, in-transit insurance, insurance while work is at firm, promotion, shipping to and from firm, written contract and shows. Finds artists through exhibits, referrals, submissions and "pure blind luck."

Tips "Strive for quality, clarity, clean lines and light, even if the style is impressionistic. Bring spirit into your images. It translates!"

N SEGAL FINE ART

594 S. Arthur Ave., Louisville CO 80027. (800)999-1297. (303)926-6800. Fax: (303)926-0340. E-mail: sfa@segalfineart.com. Website: www.segalfineart.com. **Artist Liason:** Ron Segal. Estab. 1986. Art publisher. Publishes limited editions. Clients: galleries and H-D dealerships.

Needs Seeking creative and fashionable art for the serious collector and commercial market. Considers oil, watercolor, mixed media and pastel. Artists represented include David Uhl, Scott Jacobs and Tom Fritz. Publishes limited edition serigraphs, mixed media pieces and posters.

First Contact & Terms Send query letter with slides or résumé, bio and photographs. Samples are not filed and are returned by SASE. Responds in 2 months. To show portfolio, mail slides, color photographs, bio and résumé. Offers advance when appropriate. Negotiates payment method and rights purchased. Requires exclusive representation of artist. Provides promotion.

Tips Advises artists to "remain connected to their source of inspiration."

ROSE SELAVY OF VERMONT

Division of Applejack Art Partners, P.O. Box 1528, Manchester Center VT 05255. (802)362-0373. Fax: (802)362-1082. E-mail: michael@applejackart.com. Website: www.applejackart.com. Publishes/distributes unlimited edition fine art prints. Clients: galleries, decorators, frame shops, distributors, architects, corporate curators, museum shops and giftshops.

Needs Seeking decorative art for the serious collector, commercial and designer markets. Considers oil, acrylic, watercolor, mixed media, pastel and pen & ink. Prefers folk art, antique, traditional and botanical. Artists represented include Susan Clickner and Valorie Evers Wenk. Editions created by collaborating with the artist or by working from an existing painting.

First Contact & Terms Send query letter with brochure, photocopies, photographs, slides and tearsheets. Samples are not filed and are returned by SASE. Responds only if interested. Company will contact artist for portfolio review if interested. Negotiates payment. Offers advance when appropriate. Rights purchased vary according

to project. Usually requires exclusive representation of artist. Provides promotion and written contract. Also needs freelancers for design. Finds artists through art exhibitions and art fairs.

SIDE ROADS PUBLICATIONS
177 NE 39th St., Miami FL 33137. (305)438-8828. Fax: (305)576-0551. E-mail: sideropub@aol.com. Website: www.sideroadspub.com. **Contact:** Tamar Erdberg. Estab. 1998. Art publisher and distributor of originals and handpulled limited edition serigraphs. Clients: galleries, decorators and frame shops.
Needs Seeking creative art for the commercial market. Considers oil, acrylic, mixed media and sculpture. Open to all themes and styles. Artists represented include Clemens Briels. Editions created by working from an existing painting.
First Contact & Terms Send query letter with brochure, photographs, résumé, slides and SASE. Samples are filed or returned by SASE. Company will contact artist for portfolio review if interested. Payment on consignment basis. Rights purchased vary according to project. Requires exclusive representation of artist. Provides advertising and promotion. Finds artists through art exhibitions and artists' submissions.

SIPAN LLC
300 Glenwood Ave., Raleigh NC 27603. Phone/fax: (919)833-2535. **Member:** Owen Walker III. Estab. 1994. Art publisher. Publishes handpulled originals. Clients: galleries and frame shops.
Needs Seeking art for the serious collector and the commercial market. Considers oil, acrylic, watercolor. Prefers traditional themes. Artists represented include Altino Villasante. Editions created by collaborating with the artist. Approached by 5 artists/year. Publishes/distributes the work of 1 emerging artist/year.
First Contact & Terms Send photographs, SASE and transparencies. Samples are not filed and are returned by SASE. Responds in 2 weeks. Company will contact artist for portfolio review of color final art if interested. Negotiates payment. Offers advance when appropriate. Buys all rights. Requires exclusive representation of artist. Provides advertising, in-transit insurance, insurance while work is at firm, promotion, written contract.

SOHO GRAPHIC ARTS WORKSHOP
433 W. Broadway, Suite 5, New York NY 10012. (212)966-7292. **Director:** Xavier H. Rivera. Estab. 1977. Art publisher, distributor and gallery. Publishes and distributes limited editions.
Needs Seeking art for the serious collector. Considers prints. Editions created by collaborating with the artist or working from an existing painting. Approached by 10-15 artists/year.
First Contact & Terms Send résumé. Responds in 2 weeks. Artist should follow up with letter after initial query. Portfolio should include slides and 35mm transparencies and SASE. Negotiates payment. No advance. Buys first rights. Provides written contract.

N SOMERSET HOUSE PUBLISHING
10688 Haddington Dr., Houston TX 77043. (800)444-2540. Fax: (713)465-6062. E-mail: sallen@somersethouse.com. Website: www.somersethouse.com. **Executive Vice President:** Stephanie Allen. Licensing: Daniel Klepper. Estab. 1972. Art publisher of fine art limited and open editions, handpulled original graphics, offset reproductions, giclees and canvas transfers. Clients include independent galleries in U.S., Canada, Australia.
Needs Seeking fine art for the serious collector and decorative art for the designer market. Considers oil, acrylic, watercolor, mixed media, pastel. Also prefer religious art. Artists represented include G. Harvey, Larry Dyke, Nancy Glazier, Martin Grelle, Tom du Bois, Christa Kieffer and J.D. Challenger. Editions created by collaborating with the artist or by working from an existing painting. Approached by 1,500 artists/year. Publishes the work of 7 emerging, 4 mid-career and 7 established artists/year.
First Contact & Terms Send query letter accompanied by 10-12 slides or photos representative of work with SASE. Samples are filed for future projects unless return is requested. Samples are not filed and are returned. Responds in 2 months. Publisher will contact artist for portfolio review if interested. Pays royalties. Rights purchased vary according to project. Provides advertising, insurance in-transit and while work is at firm, promotion, shipping from firm, written contract.
Tips "Considers mature, full-time artists. Special consideration given to artists with originals selling above $5,000. Be open to direction."

◪ SPORTS ART INC
1675 Powers Lake Rd., Powers Lake WI 53159. (800)552-4430. Fax: (262)279-9830. E-mail: angela@golfgiftsgallery.com. **President:** Dean Chudy. Estab. 1989. Art publisher and distributor of limited and unlimited editions, offset reproductions and posters. Clients: over 2,000 active art galleries, frame shops and specialty markets.
Needs Seeking artwork with creative artistic expression for the serious collector and the designer market. Considers oil, watercolor, acrylic, pastel, pen & ink and mixed media. Prefers sports themes. Artists represented include Ken Call and Brent Hayes. Editions created by collaborating with the artist or working from an existing

painting. Approached by 150 artists/year. Distributes the work of 30 emerging, 60 mid-career and 30 established artists/year.

First Contact & Terms Send query letter with brochure showing art style or résumé, tearsheets, SASE, slides and photographs. Accepts submissions on disk. Samples are filed or returned by SASE if requested by artist. To show a portfolio, mail thumbnails, slides and photographs. Pays royalties of 10%. Offers an advance when appropriate. Negotiates rights purchased. Sometimes requires exclusive representation of the artist. Provides promotion and shipping from firm.

Tips "We are interested in generic sports art that captures the essence of the sport as opposed to specific personalities."

N SUMMIT PUBLISHING

746 Higuera, Suite 4, San Luis Obispo CA 93401. (805)549-9700. Fax: (805)549-9710. E-mail: summit@summitart.com. Website: www.summitart.com. **Owner:** Ralph Gorton. Estab. 1987. Art publisher, distributor and gallery. Publishes and distributes handpulled originals and limited editions.

Needs Seeking creative, fashionable and decorative art for the serious collector. Considers oil, watercolor, mixed media and acrylic. Prefers fashion, contemporary work. Artists represented include Manuel Nunez, Catherine Abel and Tim Huhn. Editions created by collaborating with the artist or by working from an existing painting. Approached by 20 artists/year. Publishes and distributes the work of emerging, mid-career and established artists.

First Contact & Terms Send postcard-size sample of work or send query letter with brochure, résumé, tearsheets, slides, photographs and transparencies. Samples are filed. Responds in 5 days. Artist should follow up with call. Publisher/distributor will contact artist for portfolio review if interested. Portfolio should include color thumbnails, roughs, final art, tearsheets and transparencies. Pays royalties of 10-15%, 60% commission or negotiates payment. Offers advance when appropriate. Buys first rights or all rights. Requires exclusive representation of artist. Provides advertising, in-transit insurance, insurance while work is at firm, promotion, shipping to and from firm and written contract. Finds artists through attending art exhibitions, art fairs, word of mouth and submissions. Looks for artists at Los Angeles Expo and New York Expo.

Tips Recommends artists attend New York Art Expo, ABC Shows.

SUN DANCE GRAPHICS & NORTHWEST PUBLISHING

9580 Delegates Dr., Orlando FL 32837. (407)240-1091. Fax: (407)240-1951. E-mail: sales@northwestpublishing.com and sales@sundancegraphics.com. Website: www.northwestpublishing.com. **Art Director:** Kathy Anish. Estab. 1996. Publishes art prints.

Needs Approached by 300 freelancers/year. Works with 50 freelancers/year. Buys 200 freelance designs and illustrations/year. Art guidelines free for SASE with first-class postage. Works on assignment only. Looking for high-end art. 20% of freelance design work demands knowledge of Photoshop, Illustrator and QuarkXPress.

First Contact & Terms Designers send brochure photocopies, photographs, photostats, tearsheets and SASE. "No original art please." Samples are filed or returned by SASE. Responds in 6 weeks. Company will contact artists for portfolio review if interested. Portfolio should include color final art, slides, tearsheets and transparencies. Rights purchased vary according to project. Pays "either royalties or a flat fee. The artist may choose." Finds freelancers through SURTEX, word of mouth and art societies.

Tips "Read the trade magazines, *GSB, G&D, GN, Decor* and *Greetings Today.*"

N SUNSET MARKETING

5908 Thomas Dr., Panama City Beach FL 32408. (850)233-6261. Fax: (850)233-9169. E-mail: info@sunsetartprints.com. Website: www.sunsetartprints.com. **Product Development:** Leah Moseley. Estab. 1986. Art publisher and distributor of unlimited editions, canvas transfers and fine art prints. Clients: galleries, decorators, frame shops, distributors and corporate curators. Current clients include: Paragon, Propac, Uttermost, Lieberman's and Bruce McGaw.

Needs Seeking fashionable and decorative art for the commercial and designer market. Considers oil, acrylic and watercolor art and home decor furnishings. Artists represented include Steve Butler, Merri Paltinian, Van Martin, Kimberly Hudson, Carol Flallock and Barbara Shipman. Editions created by collaborating with the artist.

First Contact & Terms Send query letter with brochure, photocopies and photographs. Samples are filed. Company will contact artist for portfolio review of color final art, roughs and photographs if interested. Requires exclusive representation of artist.

✔ SYRACUSE CULTURAL WORKERS

P.O. Box 6367, Syracuse NY 13217. (315)474-1132. Fax (877)265-5399. E-mail: scw@syrculturalworkers.com. Website: www.syrculturalworkers.com. **Art Director:** Karen Kerney. Produces posters, notecards, postcards,

greeting cards, T-shirts and calendars that are feminist, multicultural, lesbian/gay allied, racially inclusive and honor elders and children.

Needs Art guidelines free for SASE with first-class postage and also available on company's website.

First Contact & Terms Pays flat fee, $85-400; royalties of 6% of gross sales.

JOHN SZOKE EDITIONS

591 Broadway, 3rd Floor, New York NY 10012-3232. (212)219-8300. Fax: (212)966-3064. E-mail: info@johnszok eeditions.com. Website: www.johnszokeeditions.com. **Director:** John Szoke. Retail gallery and art publisher. Estab. 1974. Represents 30 mid-career artists including Louise Bourgeois, Jean Cocteau, Ellsworth Kelly, Larry Rivers, Pablo Picasso, Donald Sultan. Publishes the work of Richard Haas, James Rizzi, Jeannette Pasin Sloan. Located downtown in Soho. Open all year. Clients include other dealers and collectors. 20% of sales are to private collectors.

• Not considering new artists at the present time.

Media Exhibits works on paper, multiples in relief, and intaglio and sculpture.

N TAKU GRAPHICS

5763 Glacier Hwy., Juneau AK 99801. (907)780-6310. Fax: (907)780-6314. E-mail: info@takugraphics.com. Website: www.takugraphics.com. **Owner:** Adele Hamey. Estab. 1991. Distributor. Distributes handpulled origi- nals, limited edition, unlimited edition, fine art prints, offset reproduction, posters, hand-painted silk ties, paper cast, bead jewelry and note cards. Clients: galleries and gift shops.

Needs Seeking art from Alaska and the Pacific Northwest exclusively. Considers oil, acrylic, watercolor, mixed media, pastel and pen & ink. Prefers regional styles and themes. Artists represented include JoAnn George, Ann Miletich, Brenda Schwartz and Barry Herem. Editions created by working from an existing painting. Approached by 30-50 artists/year. Distributes the work of 20 emerging, 6 mid-career and 6 established artists/ year.

First Contact & Terms Send query letter with brochure, photographs and tearsheets. Samples are not filed and are returned. Responds in 1 month. Company will contact artist for portfolio review if interested. Pays on consignment basis: firm receives 35% commission. No advance. Requires exclusive representation of artist. Provides advertising, insurance while work is at firm, promotion, sales reps, trade shows and mailings. Finds artists through word of mouth.

TELE GRAPHICS

153 E. Lake Brantley Dr., Longwood FL 32779. **President:** Ron Rybak. Art publisher/distributor handling origi- nal mixed media and handpulled originals. Clients: galleries, picture framers, interior designers and regional distributors.

Needs Seeking decorative art for the serious collector. Artists represented include Beverly Crawford, Diane Lacom, Joy Broe and W.E. Coombs. Editions created by collaborating with the artist or by working from an existing painting. Approached by 30-40 artists/year. Publishes the work of 1-4 emerging artists/year.

First Contact & Terms Send query letter with résumé and samples. Samples are not filed and are returned only if requested. Responds in 1 month. Call or write for appointment to show portfolio of original/final art. Pays by the project. Considers skill and experience of artist and rights purchased when establishing payment. Offers advance. Negotiates rights purchased. Requires exclusive representation. Provide promotions, shipping from firm and written contract.

Tips "Be prepared to show as many varied examples of work as possible. Show transparencies or slides plus photographs in a consistent style. We are not interested in seeing only one or two pieces."

✓ ULTIMATE LITHO

42 Leome Lane, Chester NY 10918. (845)469-6699. Fax: (845)469-5955. E-mail: info@ultimatelitho.com. Web- site: www.ultimatelitho.com. **Contact:** Ray Greenberg, owner. Estab. 1995. Art publisher. Publishes and/or distributes fine art prints, offset reproduction, posters and unlimited edition. Clients: distributors.

Needs Seeking decorative art for the commercial and designer markets; figurative art for wall decor. Considers acrylic, mixed media, oil, pastel, watercolor. Artists represented include Jason DeLancey, Shelley Jackson, Laura Loturco. Approached by 100 artists/year. Publishes work of 3-5 emerging artists/year.

First Contact & Terms Send query letter with brochure, photocopies, photographs, résumé, SASE, slides, tearsheets, transparencies. Samples are returned by SASE. Responds only if interested. Company will contact artist for portfolio review if interested. Portfolio should include color photographs, slides, tearsheets, transparen- cies, any good representation of the broadest range of styles and subjects the artist has done. Pays flat fee or advance against royalties. Offers advance when appropriate. Rights purchased vary according to project. Pro- vides advertising, insurance while work is at firm, promotion, shipping from our firm, written contract. Finds artists through art exhibits/fairs, art reps, artist's submissions, Internet, word of mouth.

☑ SHAWN VINSON FINE ART

119 E. Court St., Suite 100, Decatur GA 30030. (404)370-1720. E-mail: shawn@shawnvinsongallery.com. Website: www.shawnvinsongallery.com. **Owner:** Shawn Vinson. Fine arts gallery, dealer and consultant, specializing in contemporary paintings and works on paper. Clients: galleries, designers and collectors. Current clients include: Gallery 71, New York City, Universal Studios Florida, Naomi Judd.

Needs Seeking fine art originals for the serious collector. Considers oil, acrylic, mixed media and pastel. Prefers contemporary and painterly styles. Represents American, English and Dutch artists. Approached by 6-12 artists/year. Publishes the work of 1-2 emerging, 1-2 mid-career and 1-2 established artists/year. Distributes the work of 8-10 emerging, 8-10 mid-career and 8-10 established artists/year.

First Contact & Terms Send query letter with photographs, résumé, SASE, slides and tearsheets. Accepts disk submissions compatible with Microsoft applications. Samples are filed. Responds only if interested. Company will contact artist for portfolio review if interested. Pays on consignment basis or negotiates payment. Rights purchased vary according to project. Provides advertising, in-transit insurance, insurance while work is at firm and promotion.

Tips "Maintain integrity in your work. Limit number of dealers."

ℕ VLADIMIR ARTS USA INC.

2504 Sprinkle Rd., Kalamazoo MI 49001. (269)383-0032. Fax: (269)383-1840. E-mail: vladimir@vladimirarts.com. Website: www.vladimirarts.com. **Contact:** Lew Iwlew. Art publisher, distributor and gallery. Publishes/distributes handpulled originals, limited edition, unlimited edition, canvas transfers, fine art prints, monoprints, monotypes, offset reproduction, posters and giclee. Clients: galleries, decorators, frame shops, distributors, architects, corporate curators, museum shops, giftshops and West Point military market.

Needs Seeking creative, fashionable and decorative art for the serious collector, commercial market and designer market. Considers oil, acrylic, watercolor, mixed media, pastel, pen & ink and sculpture. Artists represented include Hongmin Zou, Ben Maile, Bev Doolittle, Charles Wysocki and Paul Steucke. Editions created by collaborating with the artist. Approached by 30 artists/year. Publishes work of 10 emerging, 10 mid-career and 10 established artists/year. Distributes work of 1-2 emerging, 1 mid-career and 1-2 established artists/year.

First Contact & Terms Send query letter with brochure, photocopies, photographs and tearsheets. Accepts disk submissions compatible with Illustrator 5.0 for Windows 95 and later. Samples are filed or returned with SASE. Responds only if interested. Company will contact artist for portfolio review if interested. Portfolio should include b&w, color, fine art, photographs and roughs. Negotiates payment. No advance. Provides advertising, promotion and shipping from our firm. Finds artists through attending art exhibitions, art fairs, word of mouth, World Wide Web, art reps, sourcebooks, artists' submissions and watching art competitions.

Tips "The industry is growing in diversity of color. There are no limits."

WANDA WALLACE ASSOCIATES

323 E. Plymouth, Suite #2, Inglewood CA 90306-0436. (310)419-0376. Fax: (310)419-0382. **President:** Wanda Wallace. Estab. 1980. Art publisher, distributor, gallery and consultant for corporations, businesses and residential. Publishes handpulled originals, limited and unlimited editions, canvas transfers, fine art prints, monotypes, posters and sculpture. Clients: decorators, galleries, distributors.

- This company operates a nonprofit organization called Wanda Wallace Foundation that educates children through utilizing art and creative focus.

Needs Seeking art by and depicting African-Americans. Considers oil, acrylic, watercolor, mixed media, pastel, pen & ink and sculpture. Prefers traditional, modern and abstract styles. Artists represented include Alex Beaujour, Dexter, Aziz, Momogu Ceesay, Charles Bibbs, Betty Biggs, Tina Allen, Adrian Won Shue. Editions created by collaborating with the artist or by working from an existing painting. Approached by 100 artists/year. Publishes/distributes the work of 10 emerging, 7 mid-career and 3 established artists/year.

First Contact & Terms Send query letter with brochure, photocopies, photographs, tearsheets and transparencies. Samples are filed and are not returned. Responds only if interested. Company will contact artist for portfolio review of color, final art, photographs and transparencies. Pays on consignment basis: firm receives 50% commission or negotiates payment. Offers advance when appropriate. Buys all rights. Requires exclusive representation of artist. Provides advertising, promotion, shipping from firm and written contract.

Tips "African-American art is very well received. Depictions that sell best are art by black artists. Be creative, it shows in your art. Have no restraints. Educational instruction available."

ℕ WEBSTER FINE ART LTD.

1003 High House Road, Suite 101, Cary NC 27513. (919)388-9370. Fax: (919)388-9377. E-mail: info@websterfineart.com. Website: www.websterfineart.com. **Contact:** Brandon Myers. Art publisher/distributor. Estab. 1987. Publishes unlimited editions and fine art prints. Clients: galleries, frame shops, distributors, giftshops.

Needs Considers oil, acrylic, watercolor, pastel, pen & ink, mixed media. "Seeking creative artists that can take

directions; decorative, classic, traditional, fashionable, realistic, impressionistic, landscape, artists who know the latest trends." Artists represented include Janice Brooks, Lorraine Rossi, Fiona Butler. Editions created by collaborating with the artist.
First Contact & Terms Send query letter with brochure, photocopies, photographs, slides, tearsheets, transparencies and SASE. Samples are filed or returned by SASE. Responds in 1 month. Company will contact artist for portfolio review if interested. Negotiates payment. Offers advance when appropriate. Buys all or reprint rights. Finds artists by word of mouth, attending art exhibitions and fairs, submissions and watching art competitions.
Tips "Check decorative home magazines—*Southern Accents, Architectural Digest, House Beautiful*, etc.—for trends. Understand the decorative art market."

WHITEGATE FEATURES SYNDICATE
71 Faunce Dr., Providence RI 02906. (401)274-2149. Website: www.whitegatefeatures.com. **Talent Manager:** Eve Green.
 • This syndicate is looking for fine artists and illustrators. See listing in Syndicates section for information on their needs.
First Contact & Terms "Please send (nonreturnable) slides or photostats of fine arts works. We will call if a project suits your work." Pays royalties of 50% if used to illustrate for newspaper or books.
Tips "We also work with collectors of fine art and we are starting a division that will represent artists to galleries."

Ⓝ WILD APPLE GRAPHICS, LTD.
526 Woodstock Rd., Woodstock VT 05091. (802)457-3003. Fax: (781)740-2265. E-mail: ray.morrison@wildapple.com. Website: www.wildapple.com. **Sourcing Specialist:** Ray Morrison. Estab. 1990. Wild Apple publishes, distributes and represents a diverse grop of contemporary artists. Clients: manufacturers, galleries, designers, poster distributors (worldwide) and framers. Licensing: Acting as an artist's agent, we present your artwork to manufacturers for consideration.
Needs We are always looking for fresh talent and varied images to show. Considers oil, watercolor, acrylic, pastel, mixed media and photography. Publishes 400+ new works each year.
First Contact & Terms Send query letter with résumé, biography, slides and photographs. Samples are not filed. Responds in 2 months. To show portfolio, e-mail JPGs or mail slides, transparencies, tearsheets and photographs with SASE. (Material will not be returned without an enclosed SASE.)
Tips "We would love to hear from you. Use the telephone, fax machine, e-mail, post office or carrier pigeon (you must supply your own) to contact us."

WILD ART GROUP
31630 Sierra Verde Rd., Homeland CA 92548. (800)669-1368. Fax: (888)219-2710. E-mail: sales@WildArtGroup.com. Website: www.WildArtGroup.com. Art Publisher/Distributor/Framer. Publishes lithographs, canvas transfers, serigraphs, giclée printing, digital photography and offset/digital printing.
Needs Seeking fine art for serious collectors and decorative art for the commercial market. Considers all media. Artists represented include Gamboa, Joan Sanford, Ediciones Selina, Annie Lee, Terry Wilson and Merryl Jaye.
First Contact & Terms Send query letter with slides, transparencies or other appropriate samples and SASE. Will accept submissions on disk or CD-ROM. Publisher will contact artist for portfolio review if interested.

WILD WINGS LLC
S. Highway 61, Lake City MN 55041. (651)345-5355. Fax: (651)345-2981. Website: www.wildwings.com. **Vice President:** Sara Koller. Estab. 1968. Art publisher, distributor and gallery. Publishes and distributes limited editions and offset reproductions. Clients: retail and wholesale.
Needs Seeking artwork for the commercial market. Considers oil, watercolor, mixed media, pastel and acrylic. Prefers wildlife. Artists represented include David Maass, Lee Kromschroeder, Ron Van Gilder, Robert Abbett, Michael Sieve and Persis Clayton Weirs. Editions created by working from an existing painting. Approached by 300 artists/year. Publishes the work of 36 artists/year. Distributes the work of numerous emerging artists/year.
First Contact & Terms Send query letter with slides and résumé. Samples are filed and held for 6 months then returned. Responds in 3 weeks if uninterested or 6 months if interested. Publisher will contact artist for portfolio review if interested. Pays royalties for prints. Accepts original art on consignment and takes 40% commission. No advance. Buys first rights or reprint rights. Requires exclusive representation of artist. Provides in-transit insurance, promotion, shipping to and from firm, insurance while work is at firm and a written contract.

WINN DEVON ART GROUP

6015 Sixth Ave. S., Seattle WA 98108. (206)763-9544. Fax: (206)762-1389. **Contact:** Aimee Clarke, vice president of product and marketing. Estab. 1976. Art publisher. Publishes open and limited editions, offset reproductions, giclees and serigraphs. Clients: mostly trade, designer, decorators, galleries, retail frame shops. Current clients include: Pier 1, Z Gallerie, Intercontinental Art, Chamton International, Bombay Co.

Needs Seeking decorative art for the designer market. Considers oil, watercolor, mixed media, pastel, pen & ink and acrylic. Artists represented include Buffet, Lourenco, Jardine, Hall, Goerschner, Schaar. Current clients include: Lourenco, Romeu, Shrack, Bernsen/Tunick, Tomao. Editions created by working from an existing painting. Approached by 300-400 artists/year. Publishes and distributes the work of 0-3 emerging, 3-8 mid-career and 8-10 established artists/year.

First Contact & Terms Send query letter with brochure, slides, photocopies, résumé, photostats, transparencies, tearsheets or photographs. Samples are returned by SASE if requested by artist. Responds in 4-6 weeks. Publisher will contact artist for portfolio review if interested. Portfolio should include "whatever is appropriate to communicate the artist's talents." Payment varies. Rights purchased vary according to project. Provides written contract. Finds artists through attending art exhibitions, agents, sourcebooks, publications, submissions.

Tips Advises artists to attend Art Expo New York City, ABC Atlanta. "I would advise artists to attend just to see what is selling and being shown, but keep in mind that this is not a good time to approach publishers/exhibitors with your artwork."

Book Publishers

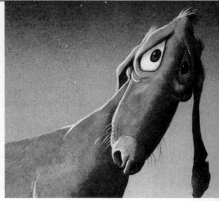

© Berkeley Breathed

Walk into any bookstore and start counting the number of images you see on books and calendars. Publishers don't have enough artists on staff to generate such a vast array of styles. The illustrations you see on covers and within the pages of books are, for the most part, created by freelance artists. If you like to read and work creatively to solve problems, the world of book publishing could be a great market for you.

While not as easy to break into as the magazine market, book publishing is an excellent market to specialize in. The artwork you create for book covers must grab readers' attention and make them want to pick up the book. Secondly, it must show at a glance what type of book it is and who it is meant to appeal to. In addition, the cover has to include basic information such as title, the author's name, the publisher's name, blurbs and price.

Most assignments for freelance work are for jackets/covers. The illustration on the cover, combined with typography and the layout choices of the designer, announce to the prospective readers at a glance the style and content of a book. If it is a romance novel, it will show a windswept couple and the title is usually done in calligraphy. Suspenseful spy novels tend to feature stark, dramatic lettering and symbolic covers. Covers for fantasy and science fiction novels, as well as murder mysteries and historical fiction, tend to show a scene from the story. Visit a bookstore and then decide which kind of book you'd like to work on.

Book interiors are also important. The page layouts and illustrations direct readers through the text and complement the story. This is particularly important in children's books and textbooks. Many publishing companies hire freelance designers with computer skills to design interiors on a contract basis. Look within each listing for the subheading Book Design to find the number of jobs assigned each year and how much is paid per project.

Finding your best markets

The first paragraph of each listing describes the types of books each publisher specializes in. This may seem obvious, but submit only to publishers who specialize in the type of book you want to illustrate or design. There's no use submitting to a publisher of literary fiction if you want to illustrate for children's picture books.

The publishers in this section are just the tip of the iceberg. You can find additional publishers by visiting bookstores and libraries and looking at covers and interior art. When you find covers you admire, write down the name of the books' publishers in a notebook. If the publisher is not listed in *Artist's & Graphic Designer's Market*, go to your public library and ask to look at a copy of *Literary Market Place*, also called *LMP*, published annually by Information Today, Inc. The cost of this large directory is prohibitive to most freelancers, but you should become familiar with it if you plan to work in the industry. Though it won't tell you how to submit to each publisher, it does give art directors' names.

Publishing terms to know

Important

- **Mass market** paperbacks are sold in supermarkets, newsstands, drugstores, etc. They include romance novels, diet books, mysteries and paperbacks by popular authors like Stephen King.

- **Trade books** are the hardcovers and paperbacks found only in bookstores and libraries. The paperbacks are larger than those on the mass market racks. They are printed on higher quality paper and often feature matte-paper jackets.

- **Textbooks** feature plenty of illustrations, photographs and charts to explain their subjects.

- **Small press** books are produced by small, independent publishers. Many are literary or scholarly in theme and often feature fine art on the cover.

- **Backlist titles** or **reprints** refer to publishers' titles from past seasons that continue to sell year after year. These books are often updated and republished with freshly designed covers to keep them up to date and attractive to readers.

Book Publishers

How to submit

Send one to five nonreturnable samples along with a brief letter. Never send originals. Most art directors prefer samples $8^1/_2 \times 11$ or smaller that can fit in file drawers. Bulky submissions are considered a nuisance. After sending your initial introductory mailing, you should follow up with postcard samples every few months to keep your name in front of art directors. If you have an e-mail account and can send TIFF or JPEG files, check the publishers' preferences and see if they will accept submissions via e-mail.

Getting paid

Payment for design and illustration varies depending on the size of the publisher, the type of project and the rights bought. Most publishers pay on a per-project basis, although some publishers of highly illustrated books (such as children's books) pay an advance plus royalties. A few very small presses may only pay in copies.

Children's book illustration

Working in children's books requires a specific set of skills. You must be able to draw the same characters in a variety of action poses and situations. Like other publishers, many children's publishers are expanding their product lines to include multimedia projects. While a number of children's publishers are listed in this book, *Children's Writer's & Illustrator's Market*, also published by Writer's Digest Books, is an invaluable resource if you enter this field. You can order this essential book on www.writersdigest.com/store/books.asp or by calling (800)448-0915.

Helpful resources

For More Info

If you decide to focus on book publishing, become familiar with *Publishers Weekly*, the trade magazine of the industry. Its website, www.publishersweekly.com, will keep you abreast of new imprints, publishers that plan to increase their title selection and the names of new art directors. You should also look for articles on book illustration and design in *HOW, Print* and other graphic design magazines. *Jackets Required: An Illustrated History of American Book Jacket Design, 1920-1950,* by Steven Heller and Seymour Chwast (Chronicle Books), offers nearly 300 examples of book jackets.

A&B PUBLISHERS GROUP

1000 Atlantic Ave., Brooklyn NY 11238. (718)783-7808. Fax: (718)783-7267. E-mail: maxtay@webspan.net. Website: www.anbdonline.com. **Production Manager:** Maxwell Taylor. Estab. 1992. Publishes trade paperback originals, calendars and reprints. Types of books include comic books, cookbooks, history, juvenile, preschool, reference, self-help and young adult. Specializes in history. Publishes 10 titles/year. Recent titles include: *Nutrition Made Simple*; *What They Never Told You in History Class, Vol. I and II.* 70% require freelance illustration; 25% require freelance design. Catalog available.

Needs Approached by 60 illustrators and 32 designers/year. Works with 12 illustrators and 6 designers/year. Prefers local illustrators experienced in airbrush and computer graphics. Uses freelancers mainly for "book covers and insides." 85% of freelance design demands knowledge of Photoshop, Illustrator and QuarkXPress. 60% of freelance design demands knowledge of Photoshop, Illustrator, QuarkXPress and Painter. 20% of titles require freelance art direction.

First Contact & Terms Designers send query letter with photocopies. Illustrators send postcard sample, photocopies, printed samples or tearsheets. Send follow-up postcard sample every 4 months. Accepts disk submissions from designers compatible with QuarkXPress, Photoshop and Illustrator. Send EPS and TIFF files. Samples are filed. Portfolio review required. Portfolio should include artwork portraying children, animals, perspective, anatomy and transparencies. Rights purchased vary according to project.

Book Design Assigns 14 freelance design jobs/year. Pays by the hour, $15-65 and also a flat fee.

Jackets/Covers Assigns 14 freelance design jobs and 20 illustration jobs/year. Pays by the project, $250-1,200. Prefers "computer generated titles, pen & ink and watercolor or airbrush for finish."

Text Illustration Assigns 11 freelance illustration jobs/year. Pays by the hour, $8-25 or by the project $800-2,400 maximum. Prefers "airbrush or watercolor that is realistic or childlike, appealing to young school-age children." Finds freelancers through word of mouth, submissions, NYC school of design.

Tips "I look for artists who are knowledgeable about press and printing systems—from how color reproduces to how best to utilize color for different presses."

HARRY N. ABRAMS, INC.

100 Fifth Ave., New York NY 10011. (212)206-7715. Website: www.abramsbooks.com. **Contact:** Michael Walsh, creative director. Estab. 1951. Company publishes hardcover originals, trade paperback originals and reprints. Types of books include fine art and illustrated books. Publishes 150 titles/year. 60% require freelance design. Visit website for art submission guidelines.

Needs Uses freelance designers to design complete books including jackets and sales materials. Uses illustrators mainly for maps and occasional text illustration. 90% of freelance design and 50% of illustration demands knowledge of Illustrator, QuarkXPress and Photoshop. Works on assignment only.

First Contact & Terms Send query letter with résumé, tearsheets, photocopies. Accepts disk submissions or supply web address. Samples are filed "if work is appropriate." Samples are returned by SASE if requested by artist. Art Director will contact artist for portfolio review if interested. Portfolio should include printed samples, tearsheets and/or photocopies. Originals are returned at job's completion, with published product. Finds artists through word of mouth, submissions, attending art exhibitions and seeing published work.

Book Design Assigns several freelance design jobs/year. Pays by the project.

Book Publishers

ADAMS MEDIA CORPORATION
imprint of F+W Publications, 57 Littlefield St., Avon MA 02322. (508)427-7100. Fax: (508)427-6790. E-mail: pbeatrice@adamsmedia.com. Website: www.adamsmedia.com. **Art Director:** Paul Beatrice. Estab. 1980. Company publishes hardcover originals, trade paperback originals and reprints. Types of books include biography, business, gardening, pet care, cookbooks, history, humor, instructional, New Age, nonfiction, reference, self-help and travel. Specializes in business and careers. Publishes 100 titles/year. 15% require freelance illustration. Recent titles include: *The Postage Stamp Garden Book*; *Test Your Cat's Psychic Powers*; *The Everything Cover Letter Book*. Book catalog free by request.
Needs Works with 8 freelance illustrators and 7-10 designers/year. Buys less than 100 freelance illustrations/year. Uses freelancers mainly for jacket/cover illustration, text illustration and jacket/cover design. 100% of freelance work demands computer skills. Freelancers should be familiar with QuarkXPress 4.1 and Photoshop.
First Contact & Terms Send postcard sample of work. Samples are filed. Art director will contact artist for portfolio review if interested. Portfolio should include tearsheets. Rights purchased vary according to project, but usually buys all rights.
Jackets/Covers Assigns 50 freelance design jobs/year. Pays by the project, $700-1,500.
Text Illustration Assigns 30 freelance illustration jobs/year.

☑ ALLYN AND BACON, INC.
75 Arlington St., Suite 300, Boston MA 02116. (617)848-6000. Fax: (617)848-6016. E-mail: AandBpub@aol.com. Website: www.ablongman.com. **Art Director:** Linda Knowles. Publishes more than 300 hardcover and paperback college textbooks/year. 60% require freelance cover designs. Subject areas include education, psychology and sociology, political science, theater, music and public speaking. Recent titles include: *Electronic Media, Psychology, Foundations of Education*.
Needs Designers must be strong in book cover design and contemporary type treatment. 50% of freelance work demands knowledge of Illustrator, Photoshop and FreeHand.
Jackets/Covers Assigns 100 design jobs and 2-3 illustration jobs/year. Pays for design by the project, $500-1,000. Pays for illustration by the project, $500-1,000. Prefers sophisticated, abstract style in pen & ink, airbrush, charcoal/pencil, watercolor, acrylic, oil, collage and calligraphy.
Tips "Keep stylistically and technically up to date. Learn *not* to over-design: read instructions and ask questions. Introductory letter must state experience and include at least photocopies of your work. If I like what I see, and you can stay on budget, you'll probably get an assignment. Being pushy closes the door. We primarily use designers based in the Boston area."

Ⓝ THE AMERICAN BIBLE SOCIETY
1865 Broadway, New York NY 10023-7505. (212)408-1200. Fax: (212)408-1259. E-mail: info@americanbible.org. Website: www.americanbible.org. **Associate Director, Product Development:** Christina Murphy. Estab. 1816. Company publishes religious products including Bibles/New Testaments, portions, leaflets, calendars and bookmarks. Additional products include religious children's books, posters, seasonal items, teaching aids, audio casettes, videos and CD-ROMs. Specializes in contemporary applications to the Bible. Publishes 15 titles/year. Recent titles include: *Contemporary English Children's Illustrated Bible*. 25% requires freelance illustration; 90% requires freelance design. Book catalog on website.
Needs Approached by 50-100 freelancers/month. Works with 10 freelance illustrators and 20 designers/year. Uses freelancers for jacket/cover illustration and design, text illustration, book design and children's activity books. 90% of freelance work demands knowledge of Illustrator, QuarkXPress, Photoshop. Works on assignment only. 5% of titles require freelance art direction.
First Contact & Terms Send postcard samples of work or send query letter with brochure and tearsheets. Samples are filed and/or returned. **Please do not call.** Responds in 2 months. Product design department will contact artist for portfolio review if additional samples are needed. Portfolio should include final art and tearsheets. Buys all rights. Finds artists through artists' submissions, *The Workbook* (by Scott & Daughters Publishing) and *RSVP Illustrator*.
Book Design Assigns 3-5 freelance interior book design jobs/year. Pays by the project, $350-1,000 depending on work involved.
Jackets/Covers Assigns 60-80 freelance design and 20 freelance illustration jobs/year. Pays by the project, $350-2,000.
Text Illustration Assigns several freelance illustration jobs/year. Pays by the project.
Tips "Looking for contemporary, multicultural artwork/designs and good graphic designers familiar with commercial publishing standards and procedures. Have a polished and professional-looking portfolio or be prepared to show polished and professional-looking samples."

⚂ AMERICAN EAGLE PUBLICATIONS, INC.

P.O. Box 5111, Sun City West AZ 85376. (623)556-2925. E-mail: ameagle@ameaglepubs.com. Website: www.a meaglepubs.com. **President:** Mark Ludwig. Estab. 1988. Publishes hardcover originals and reprints and trade paperback originals and reprints. Types of books include historical fiction, history and computer books. Publishes 10 titles/year. Titles include *The Little Black Book of E-mail Viruses*; *The Quest for Water Planets*. 100% require freelance illustration and design. Book catalog free for large SAE with 2 first-class stamps.

Needs Approached by 10 freelance artists/year. Works with 4 illustrators and 4 designers/year. Buys 20 illustrations/year. Uses freelancers mainly for covers. Also for text illustration. 100% of design and 25% of illustration demand knowledge of Ventura Publisher and CorelDraw. Works on assignment only.

First Contact & Terms Send query letter with résumé, SASE and photocopies. Accepts disk submissions compatible with CorelDraw or Ventura Publisher on PC. Send TIFF files. Samples are filed. Responds only if interested. Call for appointment to show portfolio, which should include final art, b&w and color photostats, slides, tearsheets, transparencies and dummies. Buys all rights. Originals are returned at job's completion.

Jackets/Covers Assigns 10 design and 10 illustration jobs/year. Payment negotiable (roughly $20/hr minimum). ''We generally do 2-color or 4-color covers composed on a computer.''

Text Illustration Assigns 7 illustration jobs/year. Pays roughly $20/hr minumum. Prefers pen & ink.

Tips ''Show us good work that demonstrates you're in touch with the kind of subject matter in our books. Show us you can do good, exciting work in two colors.''

⚂ AMERICAN INSTITUTE OF CHEMICAL ENGINEERING

3 Park Ave., Lobby 2, New York NY 10016-5991. (212)591-7338. Fax: (212)591-8888. E-mail: xpress@aiche.org. Website: www.aiche.org. **Contact:** Creative Director. Estab. 1925. Book and magazine publisher of hardcover originals and reprints, trade paperback originals and reprints and magazines. Specializes in chemical engineering.

Needs Approached by 30 freelancers/year. Works with 17-20 freelance illustrators/year. Prefers freelancers with experience in technical illustration. Macintosh experience a must. Uses freelancers for concept and technical illustration. Also for multimedia projects. 100% of design and 50% of illustration demand knowledge of all standard Mac programs.

First Contact & Terms Send query letter with tearsheets. Accepts disk submissions. Samples are filed. Responds only if interested. Call for appointment to show portfolio of color tearsheets and 3.5 Mac disk. Buys first rights or one-time rights. Originals are returned at job's completion.

Jackets/Covers Payment depends on experience, style.

Text Illustration Assigns 250 jobs/year. Pays by the hour, $15-40.

☑ ⚃ AMERICAN JUDICATURE SOCIETY

2700 University Ave., Des Moines IA 50311. (515)271-2281. Fax: (515)279-3090. E-mail: drichert@ajs.org. Website: www.ajs.org. **Editor:** David Richert. Estab. 1913. Publishes journals and books. Specializes in courts, judges and administration of justice. Publishes 5 titles/year. 75% requires freelance illustration. Catalog available free for SASE.

Needs Approached by 20 illustrators and 6 designers/year. Works with 3-4 illustrators and 1 designer/year. Prefers local designers. Uses freelancers mainly for illustration. 100% of freelance design demands knowledge of PageMaker, FreeHand, Photoshop and Illustrator. 10% of freelance illustration demands knowledge of PageMaker, FreeHand, Photoshop and Illustrator.

First Contact & Terms Designers send query letter with photocopies. Illustrators send query letter with photocopies and tearsheets. Send follow-up postcard every 3 months. Samples are not filed and are returned by SASE. Responds in 1 month. Will contact artist for portfolio review of photocopies, roughs and tearsheets if interested. Buys one-time rights.

Book Design Assigns 1-2 freelance design jobs/year. Pays by the project, $500-1,000.

Text Illustration Assigns 10 freelance illustration jobs/year. Pays by the project, $75-375.

⚂ AMERICAN PSYCHIATRIC PRESS, INC.

100 Wilson Blvd., Arlington VA 22209. Website: www.appi.org. **Contact:** Production Manager. Estab. 1981. Imprint of American Psychiatric Association. Company publishes hardcover originals and textbooks. Specializes in psychiatry and its subspecialties. Publishes 60 titles/year. Recent titles include: *Posttraumatic Stress Disorder*; *Textbook of Psychiatry*; *Textbook of Psychopharmacology*. 10% require freelance illustration; 10% require freelance design. Book catalog free by request.

Needs Uses freelancers for jacket/cover design and illustration. Needs computer-literate freelancers for design. 100% of freelance work demands knowledge of QuarkXPress, Illustrator 3.0, PageMaker 5.0. Works on assignment only.

First Contact & Terms Designers send query letter with brochure, photocopies, photographs and/or tearsheets.

Illustrators send postcard sample. Samples are filed. Promotions Coordinator will contact artist for portfolio review if interested. Portfolio should include final art, slides and tearsheets. Rights purchased vary according to project.

Book Design Pays by the project.

Jackets/Covers Assigns 10 freelance design and 10 illustation jobs/year. Pays by the project.

Tips Finds artists through sourcebooks. ''Book covers are now being done in Corel Draw 5.0 but will work with Mac happily. Book covers are for professional books with clean designs. Type treatment design are done in-house.''

AMHERST MEDIA, INC.

175 Rano St., Suite 200, Buffalo NY 14207. (716)874-4450. Fax: (716)874-4508. Website: www.AmherstMedia.com. **Publisher:** Craig Alesse. Estab. 1974. Company publishes trade paperback originals. Types of books include instructional and reference. Specializes in photography, how-to. Publishes 30 titles/year. Recent titles include: *Portrait Photographer's Handbook*; *Creating World Class Photography*. 20% require freelance illustration; 80% require freelance design. Book catalog free for 9×12 SAE with 3 first-class stamps.

Needs Approached by 12 freelancers/year. Works with 3 freelance illustrators and 3 designers/year. Uses freelance artists mainly for illustration and cover design. Also for jacket/cover illustration and design and book design. 80% of freelance work demands knowledge of QuarkXPress or Photoshop. Works on assignment only.

First Contact & Terms Send brochure, résumé and photographs. Samples are filed. Responds only if interested. Art director will contact artist for portfolio review if interested. Portfolio should include slides. Rights purchased vary according to project. Originals are returned at job's completion. Finds artists through word of mouth.

Book Design Assigns 12 freelance design jobs/year. Pays for design by the hour $25 minimum; by the project $2,000.

Jackets/Covers Assigns 12 freelance design and 4 illustration jobs/year. Pays $200-1200. Prefers computer illustration (QuarkXPress/Photoshop).

Text Illustration Assigns 12 freelance illustration jobs/year. Pays by the project. Prefers computer illustration (QuarkXPress).

✓ ANDREWS McMEEL PUBLISHING

4520 Main, Kansas City MO 64111-7701. (816)932-6700. Fax: (816)932-6781. E-mail: tlynch@amuniversal.com. Website: www.andrewsmcmeel.com. **Art Director:** Tim Lynch. Estab. 1972. Publishes hardcover originals and reprints; trade paperback originals and reprints. Types of books include humor, instructional, nonfiction, reference, self help. Specializes in calendars and cartoon/humor books. Publishes 200 titles/year. Recent titles include: *Millionaire Women Next Door*; *Diana*; *She's So Funny*; *Complete Far Side*. 10% requires freelance illustration; 80% requires freelance design.

Needs Approached by 100 illustrators and 10 designers/year. Works with 15 illustrators and 25 designers/year. Prefers freelancers experienced in book jacket design. 100% of freelance design demands knowledge of Illustrator, Photoshop, QuarkXPress. 100% of freelance illustration demands knowledge of traditional art skills: printing, watercolor, etc.

First Contact & Terms Designers send query letter with printed samples. Illustrators send query letter with printed samples or contact through artists' rep. Samples are filed and not returned. Responds only if interested. Portfolio review not required. Rights purchased vary according to project. Finds freelancers mostly through sourcebooks and samples sent in by freelancers.

Book Design Assigns 60 freelance design jobs/year. Pays by the project, $600-3,000.

Jackets/Covers Assigns 60 freelance design jobs and 20 illustration jobs/year. Pays for design $600-3,000.

Tips ''We want designers who can read a manuscript and design a concept for the best possible cover. Communicate well and be flexible with design.''

⊞ ANTARCTIC PRESS

7272 Wurzbach, Suite 204, San Antonio TX 78240. (210)614-0396. Fax: (210)614-5029. E-mail: ap_submissions @juno.com or apcog@hotmail.com. Website: www.antarctic-press.com. **Contact:** Rod Espinosa, submissions editor. Estab. 1985. Publishes CD ROMs, mass market paperback originals and reprints, trade paperback originals and reprints. Types of books include adventure, comic books, fantasy, humor, juvenile fiction. Specializes in comic books. Publishes 18 titles/year. Recent titles include: *Ninja High School*; *Gold Digger*; *Twilight X*. 50% requires freelance illustration. Book catalog free with 9×12 SASE ($3 postage). Submission guidelines on website.

Needs Approached by 60-80 illustrators/year. Works with 12 illustrators/year. Prefers local illustrators. 100% of freelance illustration demands knowledge of FreeHand and Photoshop.

First Contact & Terms Send query letter or postcard sample with brochure and photocopies. Do not send originals. Send copies only. Accepts e-mail submissions from illustrators. Prefers Mac-compatible, Windows-

compatible, TIFF, JPEG files. Samples are filed or returned by SASE. Portfolios may be dropped off every Monday-Friday. Portfolio should include b&w, color finished art. Buys first rights. Rights purchased vary according to project. Finds freelancers through anthologies we publish, artist's submissions, Internet, word of mouth. Payment is made on royalty basis after publication.

Text Illustration Negotiated.

Tips "You must love comics and be proficient in doing sequential art."

APPALACHIAN MOUNTAIN CLUB BOOKS

5 Joy St., Boston MA 02108. (617)523-0655. Fax: (617)523-0722. E-mail: amcbooks@amcinfo.org. Website: www.outdoors.org. **Production:** Belinda Thresher. Estab. 1876. Publishes trade paperback originals and reprints. Types of books include adventure, instructional, nonfiction, travel and children's nature books. Specializes in hiking guidebooks. Publishes 7-10 titles/year. Recent titles include: *Northeastern Wilds*; *Women on High*. 5% requires freelance illustration; 100% requires freelance design. Book catalog free for #10 SAE with 1 first-class stamp.

Needs Approached by 5 illustrators and 2 designers/year. Works with 1 illustrator and 2 designers/year. Prefers local freelancers experienced in book design. 100% of freelance design demands knowledge of FreeHand, Photoshop, QuarkXPress. 100% of freelance illustration demands knowledge of FreeHand, Illustrator.

First Contact & Terms Designers send postcard sample or query letter with photocopies. Illustrators send postcard sample. Accepts Mac-compatible disk submissions. Samples are not filed and are not returned. Will contact artist for portfolio review of book dummy, photocopies, photographs, tearsheets, thumbnails if interested. Negotiates rights purchased. Finds freelancers through professional recommendation (word of mouth).

Book Design Assigns 10-12 freelance design jobs/year. Pays for design by the project, $1,200-1,500.

Jackets/Covers Assigns 10-12 freelance design jobs and 1 illustration job/year. Pays for design by the project.

ART DIRECTION BOOK CO. INC.

456 Glenbrook Rd., Glenbrook CT 06906. (203)353-1441. Fax: (203)353-1371. **Contact:** Karyn Mugmon, production manager. Publishes hardcover and paperback originals on advertising design and photography. Publishes 10-12 titles/year. Titles include disks of *Scan This Book* and *Most Happy Clip Art*; book and disk of *101 Absolutely Superb Icons* and *American Corporate Identity #11*. Book catalog free on request.

Needs Works with 2-4 freelance designers/year. Uses freelancers mainly for graphic design.

First Contact & Terms Send query letter to be filed and arrange to show portfolio of 4-10 tearsheets. Portfolios may be dropped off Monday-Friday. Samples returned by SASE. Buys first rights. Originals are returned to artist at job's completion. Advertising design must be contemporary. Finds artists through word of mouth.

Book Design Assigns 8 freelance design jobs/year. Pays $350 maximum.

Jackets/Covers Assigns 8 freelance design jobs/year. Pays $350 maximum.

ARTIST'S & GRAPHIC DESIGNER'S MARKET

Writer's Digest Books, 4700 East Galbraith Rd., Cincinnati OH 45236. E-mail: artdesign@fwpubs.com. **Editor:** Mary Cox. Assistant Editor: Lauren Mosko. Annual directory of markets for designers, illustrators and fine artists. Buys one-time rights.

Needs Buys 35-45 illustrations/year. "I need examples of art that have been sold to the listings in *Artist's & Graphic Designer's Market*. Look through this book for examples. The art must have been freelanced; it cannot have been done as staff work. Include the name of the listing that purchased or exhibited the work, what the art was used for and, if possible, the payment you received. Bear in mind that interior art is reproduced in black and white, so the higher the contrast, the better. I also need to see promo cards, business cards and tearsheets."

First Contact & Terms Send printed piece, photographs or tearsheets. "Since *Artist's & Graphic Designer's Market* is published only once a year, submissions are kept on file for the upcoming edition until selections are made. Material is then returned by SASE if requested." Pays $75 to holder of reproduction rights and free copy of *Artist's & Graphic Designer's Market* when published.

ASSOCIATION OF COLLEGE UNIONS INTERNATIONAL

One City Centre, 120 W. Seventh St., Suite 200, Bloomington IN 47404-3925. (812)855-8550. Fax: (812)855-0162. E-mail: acui@indiana.edu. Website: www.acuiweb.org. Estab. 1914. Professional education association. Publishes hardcover and trade paperback originals. Specializes in multicultural issues, creating community on campus, union and activities programming, managing staff, union operations, and professional and student development.

● This association also publishes a magazine, *The Bulletin*. Note that most illustration and design is accepted on a volunteer basis. This is a good market if you're just looking to build or expand your portfolio.

Needs "We are a volunteer-driven association. Most people submit work on that basis." Uses freelancers mainly for illustration. Works on assignment only.

First Contact & Terms Send query letter with tearsheets. Samples are filed. Responds to the artist only if interested. Negotiates rights purchased. Originals are returned at job's completion.

Book Design Assigns 2 freelance design jobs/year.

Tips Looking for color transparencies of college student union activities.

☑ ATHENEUM BOOKS FOR YOUNG READERS

1230 Avenue of the Americas, New York NY 10020. (212)698-7000. Fax: (212)698-2798. Website: www.simonsayskids.com. **Art Director:** Ann Bobco. Imprint of Simon & Schuster Children's Publishing Division. Imprint publishes hardcover originals, picture books for young kids, nonfiction for ages 8-12 and novels for middle-grade and young adults. Types of books include biography, historical fiction, history, nonfiction. Publishes 60 titles/year. Recent titles include: *Olivia Saves the Circus*, by Ian Falconer; *Zeely*, by Virginia Hamilton. 100% requires freelance illustration. Book catalog free by request.

Needs Approached by hundreds of freelance artists/year. Works with 40-60 freelance illustrators/year. Buys 40 freelance illustrations/year. "We are interested in artists of varying media and are trying to cultivate those with a fresh look appropriate to each title."

First Contact & Terms Send postcard sample of work or send query letter with tearsheets, résumé and photocopies. Samples are filed. Portfolios may be dropped off every Tuesday between 9 a.m. and 4:30 p.m. Art Director will contact artist for portfolio review if interested. Portfolio should include final art if appropriate, tearsheets, and folded and gathered sheets from any picture books you've had published. Rights purchased vary according to project. Originals are returned at job's completion. Finds artists through submissions, magazines ("I look for interesting editorial illustrators"), word of mouth.

Jackets/Covers Assigns 20 freelance illustration jobs/year. Pays by the project, $1,200-1,800. "I am not interested in generic young adult illustrators."

Text Illustration Pays by the project, $500-2,000.

☑ ⚑ AVALANCHE PRESS, LTD.

543 Central Dr., Suite 220, Virginia Beach VA 23454. (757)306-0922. Fax: (757)306-0923. Website: www.avalanchepress.com. **Production Manager:** Peggy Gordon. Estab. 1993. Publishes roleplaying game books, game/trading cards, posters/calendars and board games. Main style/genre of games: science fiction, fantasy, humor, Victorian, historical, military and mythology. Uses freelance artists for "most everything." Publishes 40 titles or products/year. Game/product lines include: The *Epic* line of historical role playing games. 10% requires freelance illustration.

• The best way to reach the production manager is through the Contact Us page on this publisher's website.

Needs Approached by 50 illustrators and 150 designers/year. Works with 4 illustrators and 1 designer/year. Prefers local illustrators. Prefers freelancers experienced in professional publishing. 20% of freelance design demands knowledge of Illustrator. 30% of freelance illustration demands knowledge of QuarkXPress.

First Contact & Terms Send query letter with résumé and SASE. Send printed samples. Samples are not filed and are not returned. Will contact artist for portfolio review if interested. Buys all rights.

Visual Design Assigns 8-12 freelance design projects/year. Pays by the project.

Book Covers/Posters/Cards Assigns 10-12 illustration jobs/year. Pays by the project.

Tips "We need people who want to work with us and have done their homework. Study our product lines and do not send us blanket, mass-mailed queries. We really mean this—mail-merge inquiries land in the circular file."

☒ AVALON PUBLISHING GROUP

245 West 17th St., 11th Floor, New York NY 10011. (646)375-2570. Fax: (646)375-2571. Website: www.avalonpub.com. **Art Director:** Linda Kosarin. Company publishes cloth and trade paperbacks, hardcover originals and reprints. Types of books include fiction and non-fiction, including political, mystery, history, self-help, lifestyle, music and health. Publishes 300 titles/year. 30-40% require freelance book cover design. Recent titles include: *Endurance*; *Politics of Truth*; the *New Glucose Revolution* series; *Keeping Faith*.

Needs Prefers local freelancers only. Uses freelancers for jacket/cover illustration. Works on assignment only.

First Contact & Terms Designers send sample covers "by snail mail." Samples are not filed and are not returned. Responds only if interested. Portfolio review not required. Finds designers through submissions.

Jackets/Covers Assigns 60 freelance design jobs/year.

☑ BAEN BOOKS

P.O. Box 1403, Riverdale NY 10471. (919)570-1640. Fax: (919)570-1644. E-mail: jim@baen.com. Website: www.baen.com. **Publisher:** Jim Baen. Editor: Toni Weisskopf. Estab. 1983. Publishes science fiction and fantasy. Publishes 60-70 titles/year. Titles include: *Guardians of the Flame: Legacy* and *The Shadow of Saganami*. 75% requires freelance illustration; 80% requires freelance design. Book catalog free on request.

Book Publishers

First Contact & Terms Approached by 500 freelancers/year. Works with 10 freelance illustrators and 3 designers/year. 50% of work demands computer skills. Designers send query letter with résumé, color photocopies, tearsheets (color only) and SASE. Illustrators send query letter with color photocopies, SASE, slides and tearsheets. Samples are filed. Originals are returned to artist at job's completion. Buys exclusive North American book rights.

Jackets/Covers Assigns 64 freelance design and 64 illustration jobs/year. Pays by the project—$200 minimum, design; $1,000 minimum, illustration.

Tips Wants to see samples within science fiction, fantasy genre only. ''Do not send black & white illustrations or surreal art. Please do not waste our time and your postage with postcards. Serious submissions only.''

© Baen Books

BAY BOOKS & TAPES

444 De Haro St., Suite 130, San Francisco CA 94107. (415)252-4350. Fax: (415)252-4352. E-mail: info@baybooks.com. Website: www.baybooks.com. **Art Director:** Amy Armstrong. Estab. 1990. Imprints include Bay Books, KQED Video and Soma Books. Publishes hardcover and trade paperback originals and reprints, audio tapes and videos. Types of books include biography, coffee table books, cookbooks, travel and television related. Specializes in public television related. Publishes 15 titles/year. Recent titles include: *Orchids, A Splendid Obsession*. 5% require freelance illustration; 90% require freelance design. Catalog free.

Needs Approached by 5 illustrators and 30 designers/year. Works with illustrators and 10 designers/year. Prefers local freelancers with experience in book design and production. Uses freelancers mainly for design. 100% of freelance design demands knowledge of Photoshop, Illustrator and QuarkXPress. 75% of freelance illustration demands knowledge of Photoshop, Illustrator and QuarkXPress.

First Contact & Terms Designers send query letter with résumé and tearsheets. Illustrators send postcard sample, query letter with printed samples, résumé, SASE and follow-up postcard samples every 2 months. Accepts disk submissions compatible with Quark, Illustrator and Photoshop. Samples are filed or returned by SASE. Responds only if interested. Artist should follow up with call and/or letter after initial query or art director will contact artist for portfolio review of line art, book dummy and tearsheets if interested. Rights purchased vary according to project.

Book Design Assigns 10 freelance design jobs/year. Pays for design by the project.

Jackets/Covers Pays for design by the project. Pays for illustration by the project. Prefers Quark, illustrations in digital format OK.

Text Illustration Assigns 2 freelance illustration jobs/year. Pays by the project. Prefers illustrations in digital format. Finds freelancers through agents, word of mouth and submissions.

Tips ''We work primarily with cookbook illustrations.''

Artists who aspire to break into the bookcover market should first research various book publishers to find out their needs. Baen Books of Riverdale, NY, specializes in science fiction and fantasy, and its book covers are perfect showcases for science fiction and fantasy art. Freelance book cover artists should also be team-players who can take direction and meet deadlines. They are generally encouraged to read the titles they illustrate and must work closely with the publisher, editor, art director and/or cover designer and quite often the book's author to determine the cover image. This cover for Baen's *Guardians of the Flame* was illustrated by Dominic Harmon and designed by Carol Russo Design. Cover illustrators provide the image, while art directors and designers make layout and font choices.

BECKER&MAYER! LTD

11010 Northup Way, Bellevue WA 98004. Website: www.beckermayer.com. **Contact:** Adult or juvenile design department. Estab. 1973. Publishes nonfiction biography, humor, history and coffee table books. Publishes 100+ titles a year. Recent titles include: *Lennon Legend*; *Disney Treasures*; *Uncover the Human Body*. 10% of titles require freelance design; 75% require freelance illustration. Book catalog available on website.

Needs Works with 6 designers and 20-30 illustrators/year. Freelance design work demands skills in FreeHand,

Book Publishers

InDesign, Illustrator, Photoshop, QuarkXPress. Freelance illustration demands skills in FreeHand, Illustrator, Photoshop.

First Contact & Terms Designers: Send query letter with resume and tearsheets. Illustrators: Send query letter, postcard sample, resume and tearsheets. After introductory mailing, send follow-up postcard every 6 months. Does not accept e-mail submissions. Samples are filed. Responds only if interested. Company will request portfolio review of color finished art, roughs, thumbnails and tearsheets, only if interested. Rights purchased vary according to project.

Text illustration Assigns 30 freelance illustration jobs a year. Pays by the project.

Tips "Our company is divided into adult and juvenile divisions; please send samples to the appropriate division. No phone calls!"

BEDFORD/ST. MARTIN'S

75 Arlington St., Boston MA 02116. (617)399-4000. Fax: (617)350-7544. Website: www.bedfordstmartins.com. **Advertising Assistant Manager:** Jill Chmelko. Promotions Manager: Thomas Macy. Creative Supervisors: Hope Tompkins and Pelle Cass. Estab. 1981. Publishes college textbooks in English, history and communications. Publishes 40 titles/year. Recent titles include: *Rules for Writers*, Fifth Edition; *Media & Culture*, Updated Fourth Edition; *American's History*, Fifth Edition. Books have "contemporary, classic design." 5% require freelance illustration; 90% require freelance design.

Needs Approached by 25 freelance artists/year. Works with 2-4 illustrators and 6-8 designers/year. Buys 2-4 illustrations/year. Prefers artists with experience in book publishing. Uses freelancers mainly for cover and brochure design. Also for jacket/cover and text illustration and book and catalog design. 75% of design work demands knowledge of Adobe Illustrator, QuarkXPress and Adobe Photoshop.

First Contact & Terms Send query letter with brochure, tearsheets and SASE. Samples are filed or are returned by SASE if requested by artist. Responds only if interested. Request portfolio review in original query. Art director or promotions manager will contact artists for portfolio review if interested. Portfolio should include roughs, original/final art, color photostats and tearsheets. Interested in buying second rights (reprint rights) to previously published work. Originals are returned at job's completion.

Jackets/Covers Assigns 40 design jobs and 2-4 illustration jobs/year. Pays by the project. Finds artists through magazines, self-promotion and sourcebooks. Contact: Donna Dennison.

Tips "Regarding book cover illustrations, we're usually interested in buying reprint rights for artistic abstracts or contemporary, multicultural scenes and images of writers and writing-related scenes (i.e. desks with typewriters, paper, open books, people reading, etc.)."

☒ BEHRMAN HOUSE, INC.

11 Edison Place, Springfield NJ 07081. (973)379-7200. Fax: (973)379-7280. Website: www.behrmanhouse.com. **Executive Editor:** Gila Gevirtz. Director of Educational Services: Terry Kaye. Estab. 1921. Book and software publisher. Publishes textbooks. Types of books include preschool, juvenile, young adult, history (all of Jewish subject matter) and Jewish texts. Specializes in Jewish books for children and adults. Publishes 12 titles/year. Recent titles include: *Let's Discover Mitzvot*. "Books are contemporary with lots of photographs and artwork; colorful and lively. Design of textbooks is very complicated." 50% require freelance illustration; 100% require freelance design. Book catalog free by request.

Needs Approached by 50 freelancers/year. Works with 6 freelance illustrators and 6 designers/year. Prefers freelancers with experience in illustrating for children; "Jewish background helpful." Uses freelancers for textbook illustration and book design. Works on assignment only.

First Contact & Terms Send postcard samples or query letter with résumé and tearsheets. Samples are filed. Responds only if interested. Buys reprint rights. Sometimes requests work on spec before assigning a job.

Book Design Assigns 8 freelance design and 3 illustration jobs/year. Pays by project, $4,000-20,000.

Jackets/Covers Assigns 8 freelance design and 4 illustration jobs/year. Pays by the project, $500-1,000.

Text Illustration Assigns 6 freelance design and 4 illustration jobs/year. Pays by the project.

☒ THE BENEFACTORY, INC.

P.O. Box 128, Cohasset MA 02025. (781)383-8027. Fax: (781)383-8026. E-mail: thebenefactory@aol.com. Website: www.readplay.com. **Creative Director:** Cynthia A. Germain. Estab. 1990. Publishes audio tapes, hardcover and trade paperback originals. Types of books include children's picture books. Specializes in true stories about real animals. Publishes 13 titles/year. Recent titles include *Chocolate, A Glazier Grizzly; Condor Magic*. 100% requires freelance illustration. Book catalog free for 8½×11 SAE with 3 first-class stamps.

Needs Approached by 5 freelancers/year. Works with 9 illustrators/year.

First Contact & Terms Send nonreturnable postcard samples. Samples are filed. Will contact artist for portfolio review of artwork portraying animals, children, nature if interested. Rights purchased vary according to project.

Tips ''We look for realistic portrayal of children and animals with great expression. We bring our characters and stories to life for children.''

THE BENJAMIN/CUMMINGS PUBLISHING CO.

Imprint of Pearson Education, One Lake St., Upper Saddle River NJ 07458. (201)236-3304. Website: www.aw-bc.com. **Art Director:** Maureen Eide. Specializes in college textbooks in biology, chemistry, anatomy and physiology, computer science, computer information systems, engineering, nursing and allied health. Publishes 40 titles/year. 90% require freelance design and illustration. Recent titles include: *Human Anatomy and Physiology*, by Marieb; *Microbiology*, by Tortora; *Biology*, by Neil Campbell; *Computer Currents*, by George Beekman.

- Benjamin/Cummings has a West Coast office at 1301 Sansome St., San Francisco CA 94111. Contact Russell Chan or Blake Kim in Art Development. The SF branch also publishes textbooks.

Needs Approached by 100 freelance artists/year. Works with 30-40 illustrators and 10-20 designers/year. Specializes in 1-, 2- and 4-color illustrations—technical, biological and medical. ''Heavily illustrated books tying art and text together in market-appropriate and innovative approaches. Our biologic texts require trained bio/med illustrators. Proximity to Bay Area is a plus, but not essential.'' Needs computer-literate freelancers for design, illustration, and production. 80% of illustration and 90% of design demands knowledge of QuarkXPress, Photoshop, FreeHand or Illustrator. Works on assignment only.

First Contact & Terms Send query letter with résumé and samples. Samples returned only if requested. Originals not returned.

Book Design Assigns 40 jobs/year. ''From manuscript, designer prepares specs and layouts for review. After approval, final specs and layouts are required.'' Pays by the project, $1,000-3,500.

Jackets/Covers Assigns 60 jobs/year. Pays by the project, $800-5,000.

Text Illustration Pays by the project, $25-1,500.

Tips ''We are moving into digital pre-press for our technical illustrations, for page design and covers. We are producing our first multimedia. We need *good* text designers and illustrators who are computer literate.''

BENTLEY PUBLISHERS

1734 Massachusetts Ave., Cambridge MA 02138-1804. (617)547-4170. Fax: (617)876-9235. E-mail: sales@bentleypublishers.com. Website: www.bentleypublishers.com. **Publisher:** Michael Bentley. Publishes hardcover originals and reprints and trade paperback originals—reference books. Specializes in automotive technology and automotive how-to. Publishes 20 titles/year. Titles include: *Jeep Owner's Bible*, *Unbeatable BMW* and *Zora Arkus-Duntov: The Legend Behind Corvette*. 50% require freelance illustration; 50% require freelance design and layout. Book catalog for 9×12 SAE.

Needs Works with 5-10 illustrators and 15-20 designers/year. Buys 1,000 illustrations/year. Prefers artists with ''technical illustration background, although a down-to-earth, user-friendly style is welcome.'' Uses freelancers for jacket/cover illustration and design, text illustration, book design, page layout, direct mail and catalog design. Also for multimedia projects. 100% of design work requires computer skills. Works on assignment only.

First Contact & Terms Send query letter with résumé, SASE, tearsheets and photocopies. Accepts disk submissions. Samples are filed. Responds in 5 weeks. To show portfolio, mail thumbnails, roughs and b&w tearsheets and photographs. Buys all rights. Originals are not returned.

Book Design Assigns 10-15 freelance design and 20-25 illustration jobs/year. Pays by the project.

Jackets/Covers Pays by the project.

Text Illustration Prefers Illustrator files.

Tips ''Send us photocopies of your line artwork and résumé.''

BETHLEHEM BOOKS

10194 Garfield St., S, Bathgate ND 58216. (701)265-3725. Fax: (701)265-3716. E-mail: jack@bethlehembooks.com. Website: www.bethlehembooks.com. **Contact:** Jack Sharpe, publisher. Estab. 1993. Publishes hardcover originals, trade paperback originals and reprints. Types of books include adventure, biography, history, juvenile and young adult. Specializes in children's books. Publishes 5-10 titles/year. Recent titles include: *Galen and the Gateway to Medicine*. Catalog available.

Needs Approached by 25 illustrators/year. Works with 4 illustrators/year. Prefers freelancers experienced in b&w line drawings. Uses freelancers mainly for covers and book illustrations.

First Contact & Terms Illustrators send postcard sample or query letter with photocopies. Accepts disk submissions from illustrators compatible with IBM, prefers TIFFs or QuarkXPress 3.32 files. Samples are filed. Will contact artist for portfolio review if interested. Portfolio should include artwork portraying people in action. Negotiates rights purchased.

Jackets/Covers Assigns 2 freelance illustration jobs/year. Pays by the project, $800-1,000. Prefers oil or watercolor.

Text Illustration Assigns 2 freelance illustration jobs/year. Pays by the project, $100-2,000. Prefers pen and ink. Finds freelancers through books and word of mouth.

Tips "Artists should be able to produce life-like characters that fit the story line."

☑ BLOOMSBURY CHILDREN'S BOOKS

175 Fifth Ave., New York NY 10010. (212)674-5151, ext. 515. Website: www.bloomsburyusa.com. **Contact:** Lizzy Bromley, senior designer. Estab. 2001. Publishes children's hardcover originals and reprints, trade paperback and reprints. Types of books include children's picture books, fantasy, humor, juvenile and young adult fiction. Publishes 50 titles/year. Recent titles include: *The Goose Girl*; *Pirates*; *The Alphabet Room*. 50% requires freelance design; 100% requires freelance illustration. Book catalog not available.

Needs Works with 5 designers and 20 illustrators/year. Prefers local designers. 100% of freelance design work demands knowledge of Illustrator, QuarkXPress and Photoshop.

First Contact & Terms Designers send postcard sample or query letter with brochure, résumé, tearsheets. Illustrators send postcard sample or query letter with brochure, photocopies and SASE. After introductory mailing, send follow-up postcard sample every 6 months. Samples are filed or returned by SASE. Responds only if interested. Company will contact artist for potfolio review if interested. Portfolio should include color finished art and tearsheets. Buys all rights. Finds freelancers through word of mouth.

Jackets/Covers Assigns 5 freelance cover illustration jobs/year.

Ⓝ BONUS BOOKS, INC.

875 N. Michigan Ave., Suite 1416, Chicago IL 60611. (312)654-4330. Fax: (312)467-9271. E-mail: devon@bonus books.com. Website: www.bonusbooks.com. **Managing Editor:** Devon Freeny. Imprints include Precept Press, Volt Press. Company publishes textbooks and hardcover and trade paperback originals. Specializes in sports/gambling, broadcasting, biography, medical, fundraising, entertainment/pop culture, current events. Publishes 30 titles/year. Recent titles include: *Funding Evil*; *Casino Gambling*. 1% require freelance illustration; 40% require freelance design.

Needs Approached by 100 freelancers/year. Works with 0-1 freelance illustrator and 5 designers/year. Prefers local freelancers with experience in designing on the computer. Uses freelancers for jacket/cover illustration and design and direct mail design. Also for multimedia projects. 100% of design and 90% of illustration demand knowledge of Photoshop, Illustrator and QuarkXPress. Works on assignment only.

First Contact & Terms Designers send brochure, résumé and tearsheets. Illustrators send postcard sample or query letter with brochure, résumé. Samples are filed. Responds only if interested. Artist should not follow up with call. Portfolio should include color final art. Rights purchased vary according to project. Finds artists through artists' submissions and authors' contacts.

Book Design Assigns 4 freelance design jobs/year.

Jackets/Covers Assigns 10 freelance design and 0-1 illustration job/year. Pays by the project, $250-1,000.

Tips First-time assignments are usually regional, paperback book covers; book jackets for national books are given to "proven" freelancers.

Ⓝ BOOK DESIGN

Box 193, Moose WY 83012. **Art Director:** Robin Graham. Specializes in high quality hardcover and paperback originals. Publishes more than 12 titles/year. Recent titles include: *Tales of the Wolf*; *Wildflowers of the Rocky Mountains*; *Mattie: A Woman's Journey West*; *Cubby in Wonderland*; *Windswept*; *The Iron Shirt*.

Needs Works with 20 freelance illustrators and 10 designers/year. Works on assignment only. "We are looking for top-notch quality only." 90% of freelance work demands knowledge of PageMaker and FreeHand for electronic submissions.

First Contact & Terms Send query letter with "examples of past work and one piece of original artwork which can be returned." Samples not filed are returned by SASE if requested. Responds in 20 days. Originals are not returned. Write for appointment to show portfolio. Negotiates rights purchased.

Book Design Assigns 6 freelance design jobs/year. Pays by the project, $50-3,500.

Jackets/Covers Assigns 2 freelance design and 4 illustration jobs/year. Pays by the project, $50-3,500.

Text Illustration Assigns 26 freelance jobs/year. Prefers technical pen illustration, maps (using airbrush, overlays etc.), watercolor illustration for children's books, calligraphy and lettering for titles and headings. Pays by the hour, $5-20, or by the project, $50-3,500.

THOMAS BOUREGY & CO., INC. (AVALON BOOKS)

160 Madison Ave., 5th Floor, New York NY 10016-5412. (212)598-0222. Fax: (212)979-1862. Website: www.ava lonbooks.com. **Contact:** Art Director. Estab. 1950. Book publisher. Publishes hardcover originals. Types of books include romance, mysteries and Westerns. Publishes 60 titles/year. Recent titles include: *Two Cupids*

Too Many; *The Tomoka Mystery*. 100% require freelance illustration and design. Prefers local artists and artists with experience in dust jackets. Works on assignment only.

First Contact & Terms Send samples. Samples are filed if appropriate. Responds if interested.

BROADMAN & HOLMAN PUBLISHERS

127 Ninth Ave. N., Nashville TN 37234. (615)251-5825. Website: www.broadmanholman.com. **Contact:** Greg Pope, creative director. Estab. 1891. Religious publishing house. Publishes 104 titles/year. Types of books include children's picture books, mainstream fiction, reference, romance, self-help, young adult fiction; biography, coffee table books, history, instructional, preschool, religious, textbooks, home school educational curricula nonfiction. 20% of titles require freelance illustration. Recent titles include: *The Jericho Sanction*, by Oliver North; *Against All Odds*, by Chuck Norris. Books have contemporary look. Book catalog free on request.

Needs Works with 10 freelance illustrators and 15 freelance designers/year. Artist must be experienced, professional. Works on assignment only. 100% of titles require freelance art direction.

First Contact & Terms Send query letter and samples to be kept on file. Bio is helpful. Call or write for appointment to show portfolio. Send links, slides, tearsheets, postcards or photocopies; "samples *cannot* be returned." Responds only if interested. Pays for illustration by the project, $250-1,500. Negotiates rights purchased.

Book Design Pays by the project, $500-1,000.

Jackets/Covers "100% of our cover designs are now done on computer." Pays by the project, $1,500-5,000

Text Illustration Pays by the project, $150 and up.

Tips "We are looking for computer-literate experienced book designers with extensive knowledge of CBA Publishing."

◈ CANDLEWICK PRESS

2067 Massachusetts Ave., Cambridge MA 02140. (617)661-3330. Fax: (617)661-0565. **Contact:** Anne Moore, art resource coordinator. Estab. 1992. Imprints include Walker Books, London. Publishes hardcover, trade paperback children's books. Publishes 200 titles/year. 100% requires freelance illustration. Book catalog not available.

Needs Approached by 400 illustrators and 30 designers/year. Works with 170 illustrators and 1-2 designers/year. 100% of freelance design demands knowledge of Photoshop, Illustrator or QuarkXPress.

First Contact & Terms Designers send query letter with résumé. Illustrators send query letter with photocopies. Accepts nonreturnable disk submissions from illustrators. Samples are filed and are not returned. Will contact artist for portfolio review of artwork and tearsheets if interested. Buys all rights or rights purchased vary according to project.

Text Illustration Finds illustrators through agents, sourcebooks, word of mouth, submissions.

Tips "We generally use illustrators with prior trade book experience."

◈ CANDY CANE PRESS

Ideals Publications, a division of Guideposts, 535 Metroplex Dr., Suite 250, Nashville TN 37211. (615)333-0478. Fax: (615)781-1447. Website: www.idealspublications.com. **Art Director:** Eve DeGrie. Publisher: Patricia Pingry. Estab. 1996. Publishes hardcover and trade paperback originals. Types of books include children's picture books, juvenile and preschool. Publishes 10 titles/year.

• See listing for Ideals Publications.

◈ CARTWHEEL BOOKS

Imprint of Scholastic, Inc., 557 Broadway, New York NY 10012-3999. (212)343-6100. Fax: (212)343-4444. Website: www.scholastic.com. **Art Director:** Richard Deas. Estab. 1990. Publishes mass market and trade paperback originals. Types of books include children's picture books, instructional, juvenile, preschool, novelty books. Specializes in books for very young children. Publishes 100 titles/year. Titles include: *I Spy*, by Jean Marzollo and Walter Wick. 100% requires freelance illustration; 25% requires freelance design; 5% requires freelance art direction. Book catalog available for SASE with first-class stamps.

Needs Approached by 500 illustrators and 50 designers/year. Works with 75 illustrators, 5 designers and 3 art directors/year. Prefers local designers. 100% of freelance design demands knowledge of QuarkXPress.

First Contact & Terms Designers send query letter with printed samples, photocopies, SASE. Illustrators send postcard sample or query letter with printed samples, photocopies and follow-up postcard every 2 months. Samples are filed. Responds in 1 month. Will contact artist for portfolio review of artwork portraying children and animals, artwork of characters in sequence, tearsheets if interested. Rights purchased vary according to project. Finds freelancers through submissions on file, reps.

Book Design Assigns 10 freelance design and 2 art direction projects/year. Pays for design by the hour, $30-50; art direction by the hour, $35-50.

Text Illustration Assigns 200 freelance illustration jobs/year. Pays by the project, $500-10,000.

Tips "I need to see cute fuzzy animals, young, lively kids, and/or clear depictions of objects, vehicles and machinery."

▓ CELO VALLEY BOOKS

160 Ohle Rd., Burnsville NC 28714. (828)675-5918. **Production Manager:** Diana Donovan. Estab. 1987. Publishes hardcover originals and trade paperback originals. Types of books include biography, juvenile, mainstream fiction and nonfiction. Publishes 3-5 titles/year. Recent titles include: *Quaker Profiles*. 5% require freelance illustration.

Needs Approached by 5 illustrators/year. Works with 1 illustrator every 3 years. Prefers local illustrators. Uses freelancers mainly for working with authors during book design stage.

First Contact & Terms Illustrators send query letter with photocopies. Send follow-up postcard every year. Samples are filed. Responds only if interested. Negotiates rights purchased.

Jackets/Covers Assigns 1 freelance job every 3 years or so. Payment negotiable. Finds freelancers mostly through word of mouth.

Tips "Artist should be able to work with authors to fit ideas to production."

THE CENTER FOR WESTERN STUDIES

Box 727, Augustana College, Sioux Falls SD 57197. (605)274-4007. Website: http://inst.augie.edu/CWS/. **Publications Director:** Harry F. Thompson. Estab. 1970. Publishes hardcover originals and trade paperback originals and reprints. Types of books include western history. Specializes in history and cultures of the Northern Plains, especially Plains Indians, such as the Sioux and Cheyenne. Publishes 1-2 titles/year. Recent titles include: *Soldier, Settler, Sioux: Fort Ridgeley and the Minnesota River Valley*; *The Lizard Speaks: Essays on the Writings of Frederick Manfred*. 25% require freelance design. Books are conservative, scholarly and documentary. Book catalog free by request.

Needs Approached by 1-2 freelancers/year. Works with 1-2 freelance designers and 1-2 illustrators/year. Uses freelancers mainly for cover design. Also for book design and text illustration. Works on assignment only.

First Contact & Terms Send query letter with résumé, SASE and photocopies. Request portfolio review in original query. Responds only if interested. Portfolio should include roughs and final art. Sometimes requests work on spec before assigning a job. Rights purchased vary according to project. Originals are not returned. Finds illustrators and designers through word of mouth and submissions/self promotion.

Book Design Assigns 1-2 freelance design jobs/year. Pays by the project, $500-750.

Jackets/Covers Assigns 1-2 freelance design jobs/year. Pays by the project, $250-500.

Text Illustration Pays by the project, $100-500.

Tips "We are a small house, and publishing is only one of our functions, so we usually rely on the work of graphic artists with whom we have contracted previously. Send samples."

CENTERSTREAM PUBLISHING

P.O. Box 17878, Anaheim Hills CA 92807. (714)779-9390. E-mail: centerstrm@aol.com. Website: www.centerstream-usa.com. **Production:** Ron Middlebrook. Estab. 1978. Publishes DVDs, audio tapes, and hardcover and softcover originals. Types of books include music reference, biography, music history and music instruction. Publishes 10-20 titles/year. Recent titles include: *On Wings of Music: Jerry Byrd Bio*; *Melodic Lines for the Intermediate Guitarist*; *Tony Ellis*; *Banjo*; *The Early Minstrel Banjo*; "More Dobro" DVD. 100% requires freelance illustration. Book catalog free for 6×9 SAE with 2 first-class stamps.

Needs Approached by 12 illustrators/year. Works with 3 illustrators/year.

First Contact & Terms Illustrators send postcard sample or tearsheets. Accepts Mac-compatible disk submissions. Samples are not filed and are returned by SASE. Responds only if interested. Buys all rights, or rights purchased vary according to project.

Tips "Publishing is a quick way to make a slow buck."

CHARLESBRIDGE PUBLISHING

85 Main St., Watertown MA 02472. E-mail: tradeeditorial@charlesbridge.com. Website: www.charlesbridge.com. **Contact:** Art Director. Estab. 1980. Publishes hardcover and softcover children's trade picture books: nonfiction and a small fiction line. Publishes 25 titles/year. Recent titles include: *First Year Letters*, by Julie Danneberg; *The Deep-Sea Floor*, by Sneed B. Collard III. Books are "realistic art picture books depicting people, outdoor places and animals."

Needs Works with 5-10 freelance illustrators/year. "Specializes in detailed, color realism, although other styles are gladly reviewed."

First Contact & Terms Send résumé, tearsheets and photocopies. Samples not filed are returned by SASE.

Responds only if interested. Originals are not returned. Considers complexity of project and project's budget when establishing payment. Buys all rights.

Text Illustration Assigns 5-10 jobs/year. Pays royalty with advance.

[N] [符] CHATHAM PRESS, INC.

P.O. Box A, Old Greenwich CT 06870. (203)531-7755. **Art Director:** Arthur G.D. Mark. Estab. 1971. Publishes hardcover originals and reprints, trade paperback originals and reprints. Types of books include coffee table books, cookbooks, history, nonfiction, self-help, travel, western, political, Irish and photographic. Publishes 12 titles/year. Recent titles include: *Exploring Old Cape Cod*; *Photographers of New England*. 5% requires freelance illustration; 5% requires freelance design; 5% requires freelance art direction. Book catalog free for 7×10 SASE with 4 first-class stamps.

Needs Approached by 16 illustrators and 16 designers/year. Works with 2 illustrators, 2 designers and 2 art directors/year. Prefers local illustrators and designers. Seeks b&w photographs of maritime and New England-oriented coastal scenes.

First Contact & Terms Send query letter with photocopies and SASE. Samples are not filed and are returned by SASE. Responds in 2 months. Will contact artist for portfolio review if interested. Negotiates rights purchased. Finds freelancers through word of mouth and individual contacts.

Jackets/Covers Assigns 4 freelance design jobs and 1 illustration job/year. Pays for design by the project. Pays for illustration by the project.

Tips "We accept and look for contrast (black & whites rather than grays), simplicity in execution, and immediate comprehension (i.e., not cerebral, difficult-to-quickly-understand) illustrations and design. We have one-tenth of a second to capture our potential customer's eyes—book jacket art must help us do that."

[符] CHILDREN'S BOOK PRESS

2211 Mission St.,San Francisco CA 94110. (415)821-3080. Fax: (415)821-3081. E-mail: childrensbookpress@chil drensbookpress.org. Website: www.childrensbookpress.org. Estab. 1975. Publishes hardcover originals and trade paperback reprints. Types of books: juvenile picture books only. Specializes in multicultural. Publishes 4 titles/year. Recent titles include: *Xochitl and the Flowers*; *A Shelter in Our Car*; *Lakas and the Manilatown Fish*; *Featherless*. 100% requires freelance illustration and design. Catalog free for 9×6 SASE with 57¢ first-class stamps.

Needs Approached by 1,000 illustrators and 20 designers/year. Works with 2 illustrators and 2 designers/year. Prefers local designers experienced in QuarkXPress (designers) and previous children's picture book experience (illustrators). Uses freelancers for 32-page picture book design. 100% of freelance design demands knowledge of Photoshop, Illustrator and QuarkXPress.

First Contact & Terms Designers send query letter with brochure, photocopies, résumé, bio, SASE and tearsheets. Illustrators send postcard sample or query letter with photocopies, photographs, printed samples, résumé, SASE and tearsheets. Responds in 6 months if interested or if SASE is included. Will contact artist for portfolio review if interested. Buys all rights.

Book Design Assigns 2 freelance design jobs/year. Pays by the project.

Text Illustration Assigns 2 freelance illustration jobs/year. Pays royalty.

Tips "We look for a multicultural experience. We are especially interested in the use of bright colors and nontraditional instructive approach."

[✔] [符] CHILDSWORK/CHILDSPLAY, LLC

The Guidance Channel, 135 Dupont St., Plainview NY 11803-0760. (516)349-5520, ext. 313. Fax: (516)349-5521. E-mail: karens@guidancechannel.com. Website: http://childswork.com. **Editor:** Karen Schader. Estab. 1985. Types of books include children's picture books, instructional, juvenile, nonfiction, psychological/therapeutic books, games and counseling tools. Publishes 12-15 titles/year. Recent titles include: *No More Arguments*; *Healing Games*. 100% requires freelance illustration; 100% requires freelance design. Product catalog for 4 first-class stamps.

Needs Works with 6-8 illustrators and 2-4 designers/year. Prefers local illustrators. Prefers local designers. Freelance design demands knowledge of Illustrator, Photoshop, QuarkXPress. Freelance illustrations demands knowledge of Illustrator, Photoshop, QuarkXPress.

First Contact & Terms Designer send query letter with photocopies, SASE. Illustrators send query letter with photocopies, SASE. Send EPS or TIFF files. Samples are filed or returned by SASE. Responds only if interested. Portfolio review not required. Will contact artist for portfolio review if interested. Buys all rights. Finds freelancers through referral, recommendations, submission packets.

Book Design Assigns 12-15 freelance design jobs/year.

Jackets/Covers Assigns 6-8 freelance design jobs and 6-8 illustration jobs/year. Pays for design by the project.

Text Illustration Prefers freelancers experienced in children's educational/psychological materials.

Tips "Freelancers should be flexible and responsive to our needs, with commitment to meet deadlines and, if needed, be available during business hours. We use a wide range of styles, from cartoonish to realistic."

Ⓝ CHRISTIAN SCHOOL INTERNATIONAL

3350 E. Paris SE, Grand Rapids MI 49512-3054. (616)957-1070. Fax: (616)957-5022. E-mail: info@csionline.org. Website: www.csionline.org. **Production:** Judy Bandstra. Publishes textbooks. Types of books include juvenile, preschool, religious, young adult and teacher guides. Specializes in religious textbooks. Publishes 6-10 titles/year. Recent titles include: *Library Materials Guide*; *Science K-6*; *Literature 3-6*, Bible R-8. 20% requires freelance illustration. Book catalog free for 9×12 SAE with 3 first-class stamps.

Needs Approached by 30-40 illustrators/year. Works with no more than 5 illustrators/year. Prefers freelancers experienced in 4-color illustration for textbooks. 90% of freelance design and 50% of freelance illustration demands knowledge of QuarkXPress.

First Contact & Terms Send query letter with printed samples, photocopies. Samples are filed and are not returned. Will contact artist for portfolio review if interested. Buys first rights or rights purchased vary according to project. Finds freelancers through word of mouth, submission packets.

Text Illustration Assigns 5-10 freelance illustration jobs/year. Pays by the project.

CHRONICLE BOOKS

85 Second St., 6th Floor, San Francisco CA 94105. (415)537-4424. Website: www.chroniclebooks.com. **Creative Director:** Michael Carabetta. Estab. 1976. Company publishes high quality, affordably priced hardcover and trade paperback originals and reprints. Types of books include cookbooks, art, design, architecture, contemporary fiction, travel guides, gardening and humor. Publishes approximately 200 titles/year. Recent best-selling titles include *The Bad Girl's Sticky Notes*; *Mooses Come Walking*; *Worst Case Scenario Survival Handbooks*; *Extreme Dinosaurs*. Book catalog free on request (call 1-800-722-6657). Guidelines on website.

- Chronicle has a separate children's book division and a gift division, which produces blank greeting cards, calendars, address books, journals and the like.

Needs Approached by hundreds of freelancers/year. Works with 15-20 illustrators and 30-40 designers/year. Uses artists for cover and interior design and illustration. 99% of design work demands knowledge of PageMaker, QuarkXPress, FreeHand, Illustrator or Photoshop; "mostly QuarkXPress—software is up to discretion of designer." Works on assignment only.

First Contact & Terms Send query letter with tearsheets, color photocopies or printed samples no larger than 8½×11. Samples are filed or are returned by SASE. Responds only if interested. Art Director will contact artist for portfolio review if interested. Portfolio should include thumbnails, roughs, final art, photostats, tearsheets, slides, tearsheets and transparencies. Buys all rights. Originals are returned at job's completion. Finds artists through submissions, *Communication Arts* and sourcebooks.

Book Design Assigns 30-50 freelance design jobs/year. Pays by the project; $750-1200 for covers; varying rates for book design depending on page count.

Jackets/Covers Assigns 30 freelance design and 30 illustration jobs/year. Pays by the project.

Text Illustration Assigns 25 freelance illustration jobs/year. Pays by the project.

Tips "Please write instead of calling; don't send original material."

CIRCLET PRESS, INC.

1770 Massachusetts Ave., #278, Cambridge MA 02140. (617)864-0492. Fax: (617)864-0663. E-mail: circlet-info@circlet.com. Website: www.circlet.com. **Publisher:** Cecilia Tan. Estab. 1992. Company publishes trade paperback originals. Types of books include erotica, erotic science fiction and fantasy. Publishes 8-10 titles/year. Recent titles include: *Nymph*, by Francesca Lia Block; *Master Han's Daughter*, by Midori; *Sex Noir*, by Jamie Joy Gato. 100% require freelance illustration. Book catalog free for business size SAE with 1 first-class stamp.

Needs Approached by 300-500 freelancers/year. Works with 4-5 freelance illustrators/year. Uses freelancers for cover art. Needs computer-literate freelancers for illustration. 100% of freelance work demands knowledge of QuarkXPress or Photoshop. Works on assignment only. 10% of titles require freelance art direction.

First Contact & Terms Send e-mail with attachments, pitching an idea for specific upcoming books. List of upcoming books available for 37¢ SASE or on website. Ask for "Artists Guidelines." Samples are discarded. Responds only if interested. Portfolio review not required. Buys one-time rights or reprint rights. Originals are returned at job's completion. Finds artists through art shows at science fiction conventions and submission samples. "I need to see human figures well-executed with sensual emotion. No tentacles or gore! Photographs, painting, computer composites all welcomed. We use much more photography these days."

Book Design Assigns 2-4 freelance design jobs/year. Pays by the project, $15-100.

Jackets/Covers Assigns 2-4 freelance illustration jobs/year. Pays by the project, $100-200. Now using 4-color and halftones.

Tips "I have not bought and art from a physical submission in five years. It has all been via e-mail. Follow the instructions in this listing: Don't send me color samples on slides. I have no way to view them. Any jacket and book design experience is also helpful. I prefer to see a pitch idea for a cover aimed at a specific title, a way we can use an image that is already available to fit a theme. The artists I have hired in the past 3 years have come to me through the Internet by e-mailing JPEG or GIF files of samples in response to the guidelines on our website. The style that works best for us is photographic collage and post-modern."

CLARION BOOKS

215 Park Ave. S., 10th Floor, New York NY 10003. (212)420-5800. Website: www.hmco.com. **Art Director:** Joann Hill. Imprint of Houghton Mifflin Company. Imprint publishes hardcover originals and trade paperback reprints. Specializes in picture books, chapter books, middle grade novels and nonfiction, including historical and animal behavior. Publishes 60 titles/year. 90% requires freelance illustration. Book catalog free for SASE.
- *The Three Pigs*, by David Weisner was awarded the 2002 Caldecott Medal. *A Single Shard*, by Linda Sue Park was awarded the 2002 Newbery Medal.

Needs Approached by "countless" freelancers. Works with 48 freelance illustrators/year. Uses freelancers mainly for picture books and novel jackets. Also for jacket/cover and text illustration.

First Contact & Terms Send query letter with tearsheets and photocopies. Samples are filed "if suitable to our needs." Responds only if interested. Portfolios may be dropped off every Monday. Art Director will contact artist for portfolio review if interested. Rights purchased vary according to project. Originals are returned at job's completion.

Text Illustration Assigns 48 freelance illustration jobs/year. Pays by the project.

Tips "Be familiar with the type of books we publish before submitting. Send a SASE for a catalog or look at our books in the bookstore. Send us children's book-related samples."

CLEIS PRESS

P.O. Box 14684, San Francisco CA 94114-0684. (415)575-4700. Fax: (415)575-4705. E-mail: fdelacoste@cleispress.com. Website: www.cleispress.com. **Art Director:** Frederique Delacoste. Estab. 1979. Publishes trade paperback originals and reprints. Types of books include comic books, experimental and mainstream fiction, nonfiction and self-help. Specializes in lesbian/gay. Publishes 30 titles/year. Titles include: *Sexually Speaking: Collected Sex Writings*, by Gore Vidal. 100% requires freelance design. Book catalog free for SAE with 2 first-class stamps.

Needs Works with 4 designers/year. Prefers local illustrators. Freelance design demands knowledge of Illustrator, Photoshop, QuarkXPress.

First Contact & Terms Designers send postcard sample and follow-up postcard every 6 months or query letter with photocopies. Illustrators send postcard sample or query letter with printed samples, photocopies. Accepts Mac-compatible disk submissions. Send EPS or TIFF files. Samples are filed and are not returned. Will contact artist for portfolio review if interested.

Book Design Assigns 17 freelance design jobs/year. Pays for design by the project, $500.

Jackets/Covers Pays for design by the project, $500.

COUNCIL FOR AMERICAN INDIAN EDUCATION

2032 Woody Dr., Billings MT 59102-2852. (406)652-7598. Fax: (406)248-3465. E-mail: cie@cie-mt.org. Website: www.cie-mt.org. **Editor:** Hap Gilliland. Estab. 1970. Publishes trade paperback originals. Types of books include contemporary fiction, historical fiction, instruction, adventure, biography, pre-school, juvenile, young adult and history. Specializes in Native American life and culture. Titles include *Voices of Native America* and *Kamache and the Medicine Bead*. Look of design is realistic, Native American style. 50% require freelance illustration. Book catalog free for #10 SASE.

Needs Approached by 35 freelance artists/year. Works with 1-2 illustrators/year. Buys 5-15 illustrations/year. Uses freelancers for illustrating children's books. Works on assignment only.

First Contact & Terms Send query letter with SASE and photocopies. Samples are filed. Responds in 2 months. Buys one-time rights. Originals returned at job's completion.

Text Illustration Assigns 1-3 freelance illustration jobs/year. Prefers realistic pen & ink.

Tips "We are a small nonprofit organization publishing on a very small budget to aid Indian education. Contact us only if you are interested in illustrating for $5 per illustration."

COUNCIL FOR EXCEPTIONAL CHILDREN

1110 N. Glebe Rd., Suite 300, Arlington VA 22201-5704. (703)620-3660. Fax: (703)264-9494. E-mail: cecpubs@cec.sped.org. Website: www.cec.sped.org. **Senior Director for Publications:** Kathleen McLane. Estab. 1922. Publishes audio and videotapes, CD-ROMs, paperback originals. Specializes in professional development/in-

struction. Recent titles include: *IEP Team Guide*; *Adapting Instructional Material for the Inclusive Classroom*. Publishes 10 titles/year. Book catalog available.

Needs Prefers local illustrators, designers and art directors. Prefers freelancers experienced in education. Some freelance illustration demands knowledge of PageMaker, QuarkXPress.

First Contact & Terms Send query letter with printed samples, SASE. Accepts Windows-compatible disk submissions or TIFF files. Samples are not filed and are returned by SASE. Will contact artist for portfolio review showing book dummy and roughs if interested. Buys all rights.

THE COUNTRYMAN PRESS

(Division of W.W. Norton & Co., Inc.), Box 748, Woodstock VT 05091. (802)457-4826. Fax: (802)457-1678. E-mail: countrymanpress@wwnorton.com. Website: www.countrymanpress.com. **Prepress Manager:** Fred Lee. Estab. 1976. Book publisher. Publishes hardcover originals and reprints, and trade paperback originals and reprints. Types of books include history, travel, nature and recreational guides. Specializes in recreational (biking/hiking) guides. Publishes 35 titles/year. Titles include: *The King Arthur Flour Baker's Companion* and *Maine: An Explorer's Guide*. 10% require freelance illustration; 60% require freelance cover design. Book catalog free by request.

Needs Works with 4 freelance illustrators and 7 designers/year. Uses freelancers for jacket/cover and book design. Works on assignment only. Prefers working with computer-literate artists/designers within New England/New York with knowledge of PageMaker, Photoshop, Illustrator, QuarkXPress or FreeHand.

First Contact & Terms Send query letter with appropriate samples. Samples are filed. Responds to the artist only if interested. To show portfolio, mail best representations of style and subjects. Negotiates rights purchased.

Book Design Assigns 10 freelance design jobs/year. Pays for design by the project, $500-1,200.

Jackets/Covers Assigns 10 freelance design jobs/year. Pays for design $400-1,000.

Text Illustration Assigns 2 freelance illustration jobs/year.

CRC PRODUCT SERVICES

2850 Kalamazoo Ave. SE, Grand Rapids MI 49560. (616)224-0780. Fax: (616)224-0834. Website: www.crcna.o rg. **Art Director:** Dean Heetderks. Estab. 1866. Publishes hardcover and trade paperback originals and magazines. Types of books include instructional, religious, young adult, reference, juvenile and preschool. Specializes in religious educational materials. Publishes 8-12 titles/year. 85% requires freelance illustration.

Needs Approached by 30-45 freelancers/year. Works with 12-16 freelance illustrators/year. Prefers freelancers with religious education, cross-cultural sensitivities. Uses freelancers for jacket/cover and text illustration. Works on assignment only. 5% requires freelance art direction.

First Contact & Terms Send query letter with brochure, résumé, tearsheets, photographs, photocopies, slides and transparencies. Submissions will not be returned. Illustration guidelines are available on website. Samples are filed. Portfolio should include thumbnails, roughs, finished samples, color slides, tearsheets, transparencies and photographs. Buys one-time rights. Originals are returned at job's completion.

Jackets/Covers Assigns 2-3 freelance illustration jobs/year. Pays by the project, $200-1,000.

Text Illustration Assigns 50-100 freelance illustration jobs/year. Pays by the project, $75-100. ''This is high-volume work. We publish many pieces by the same artist.''

Tips ''Be absolutely professional. Know how people learn and be able to communicate a concept clearly in your art.''

Ⓝ ⊞ CROSS CULTURAL PUBLICATIONS, INC.

P.O. Box 506, Notre Dame IN 46556. (574)273-6526. Fax: (574)273-5973. E-mail: crosscult@aol.com. Website: www.crossculturalpub.com. **Marketing Manager:** Anand Pullapilly. Director of Graphic Art: Christine English. Business Manager: Kavita Pullapilly. Estab. 1980. Imprint is Cross Roads Books. Company publishes hardcover and trade paperback originals and textbooks. Types of books include biography, religious and history. Specializes in scholarly books on cross-cultural topics. Publishes 30 titles/year. Recent titles include: *She is With the Angels*, by August Swanenberg; *I Became a Fly*, by Donald McKnight; *Human Consciousness*; *The Material Soul*, by John Dedek.

Needs Approached by 25 freelancers/year. Works with 2 freelance illustrators/year. Prefers local artists only. Uses freelance artists mainly for jacket/cover illustration.

First Contact & Terms Send query letter with résumé and photocopies. Samples are not filed and are not returned. Responds only if interested. Art director will contact artist for portfolio review if interested. Portfolio should include b&w samples. Rights purchased vary according to project. Originals are not returned. Finds artists through word of mouth.

Jackets/Covers Assigns 4-5 freelance illustration jobs/year. Pays by the project.

Tips ''First-time assignments are usually book jackets. We publish books that push the boundaries of knowledge.''

☑ THE CROSSING PRESS

P.O. Box 7123, Berkeley CA 94707. (510)559-1600. Fax: (510)542-1052. E-mail: crossing@crossingpress.com. Website: www.crossingpress.com. **Art Director:** Nancy Austin. Estab. 1966. Publishes audio tapes, trade paperback originals and reprints. Types of books include nonfiction and self-help. Specializes in natural healing, New Age spirituality, cookbooks. Publishes 40 titles/year. Recent titles include: *A Woman's I Ching*; *Zen Judaism*; *Psycho Kitty*. Art guidelines on website.

• Part of Ten Speed Press.

Needs Freelance illustrators, photographers, artists and designers welcome to submit samples. Prefers designers experienced in Quark, Photoshop and book text design.

First Contact & Terms Send query letter with printed samples, photocopies or 3-5 slides, or color copies, SASE if materials are to be returned. Samples are filed or returned by SASE. Will contact artist for portfolio review if interested. Rights purchased vary according to project. Finds freelancers through submissions, promo mailings, *Directory of Illustration*, *California Image*, *Creative Black Book*.

Tips "We look for artwork that is expressive, imaginative, colorful, textural—abstract or representational—appropriate as cover art for books on natural healing or New Age spirituality. We also are interested in artists/photographers of prepared food for cookbooks."

CROWN PUBLISHERS, INC.

1745 Broadway, Mail Drop 13-1, New York NY 10019. (212)572-2600. **Art Director:** Whitney Cookman. Art Director: Mary Sarah Quinn. Specializes in fiction, nonfiction and illustrated nonfiction. Publishes 250 titles/year. Titles include: *Devil in the White City* and *Hallowed Ground*.

• Crown is an imprint of Random House. Within that parent company, several imprints—including Clarkson Potter, Crown Arts & Letters, and Harmony—maintain separate art departments.

Needs Approached by several hundred freelancers/year. Works with 15-20 illustrators and 25 designers/year. Prefers local artists. 100% of design demands knowledge of QuarkXPress and Illustrator. Works on assignment only.

First Contact & Terms Send query letter with samples showing art style. Responds only if interested. Originals are not returned. Rights purchased vary according to project.

Jackets/Covers Assigns 15-20 design and/or illustration jobs/year. Pays by the project.

Tips "There is no single style. We use different styles depending on nature of the book and its perceived market. Become familiar with the types of books we publish. For example, don't send juvenile, sci-fi or romance. Book design has changed to Mac-generated layout."

☑ CYCLE PUBLICATIONS, INC.

1282 Seventh Ave., San Francisco CA 94112-2526. (415)665-8214. Fax: (415)753-8572. E-mail: pubrel@cyclepublishing.com. Website: www.cyclepublishing.com. **Editor:** Rob van der Plas. Estab. 1985. Book publisher. Publishes trade paperback originals. Types of books include instructional and travel. Specializes in subjects relating to cycling and bicycles. Publishes 6 titles/year. Recent titles include: *Baseball's Hitting Secrets*; *Play Golf in the Zone*; *Bicycle Repair Step by Step*. 20% require freelance illustration. Book catalog for SASE with first-class postage.

Needs Approached by 5 freelance artists/year. Works with 2 freelance illustrators/year. Buys 100 freelance illustrations/year. Uses freelance artists mainly for technical (perspective) and instructions (anatomically correct hands, posture). Also uses freelance artists for text illustration; line drawings only. Also for design. 50% of freelance work demands knowledge of CorelDraw and FreeHand. Works on assignment only.

First Contact & Terms Send query letter with tearsheets. Accepts disk submissions. Please include print-out with EPS files. Samples are filed. Call "but only after we have responded to query." Portfolio should include photostats. Rights purchased vary according to project. Originals are not returned to the artist at the job's completion.

Book Design Pays by the project.

Text Illustration Assigns 5 freelance illustration jobs/year. Pays by the project.

Tips "Show competence in line drawings of technical subjects and 2-color maps."

☒ DA CAPO PRESS

Imprint of Perseus Books Group, 11 Cambridge Center, Cambridge MA 02142. (617)252-5241. E-mail: alex.camlin@perseusbooks.com. Website: www.dacapopress.com. **Contact:** Alex Camlin, art director. Estab. 1975. Publishes hardcover originals, trade paperback originals, trade paperback reprints. Types of books include self-help, biography, coffee table books, history, travel, music, and film. Specializes in music and history (trade). Publishes 100 titles/eyar. 25% requires freelance design; 5% requires freelance illustration.

Needs Approached by 30+ designers and 30+ illustrators/year. Works with 10 designers and 1 illustrator/year.

First Contact & Terms Send query letter with résumé, URL, color prints/copies. Send follow-up postcard sample every 6 months. Prefers Mac-compatible, JPEG, and PDF files. Samples are filed. Responds only if interested. Portfolios may be dropped off every Wednesday, Thursday and Friday and should include color finished art. Rights purchased vary according to project. Finds freelancers through art competitions, artists' submissions, Internet and word of mouth.

Jackets/Covers Assigns 20 freelance cover illustration jobs/year.

Text Illustration Does not assign freelance illustration jobs/year.

Tips "Visit our website (www.dacapopress.com) to view work produced/assigned by Da Capo."

DARK HORSE

10956 SE Main, Milwaukie OR 97222. E-mail: dhcomics@darkhorse.com. Website: www.darkhorse.com. **Contact:** Submissions. Estab. 1986. Publishes mass market and trade paperback originals. Types of books include comic books and graphic novels. Specializes in comic books. Recent titles include: *Astro Boy Volume 10 TPB*, by Osamu Tezuka; *Reid Fleming/Flaming Carrot Crossover #1*, by Bob Burden and David Boswell; *Joss Whedon's Fray #8*, by Joss Whedon, Karl Moline and Andy Owens. Book catalog available on website.

First Contact & Terms Send photocopies (clean, sharp, with name, address and phone number written clearly on each page). Samples are not filed and not returned. Responds only if interested. Company will contact artist for portfolio review interested.

Tips "If you're looking for constructive criticism, show your work to industry professionals at conventions."

JONATHAN DAVID PUBLISHERS

68-22 Eliot Ave., Middle Village NY 11379. (718)456-8611. Fax: (718)894-2818. E-mail: info@jdbooks.com. Website: www.jdbooks.com. **Contact:** Editorial Review. Estab. 1948. Company publishes hardcover and paperback originals. Types of books include biography, religious, young adult, reference, juvenile and cookbooks. Specializes in Judaica. Publishes 25 titles/year. Titles include: *Drawing a Crowd* and *The Presidents of the United States & the Jews*. 50% require freelance illustration; 75% require freelance design.

Needs Approached by numerous freelancers/year. Works with 5 freelance illustrators and 5 designers/year. Prefers freelancers with experience in book jacket design and jacket/cover illustration. 100% of design and 5% of illustration demand computer literacy. Works on assignment only.

First Contact & Terms Designers send query letter with résumé and photocopies. Illustrators send postcard sample and/or query letter with photocopies, résumé. Samples are filed. Production coordinator will contact artist for portfolio review if interested. Portfolio should include color final art and photographs. Buys all rights. Originals are not returned. Finds artists through submissions.

Book Design Assigns 15-20 freelance design jobs/year. Pays by the project.

Jackets/Covers Assigns 15-20 freelance design and 4-5 illustration jobs/year. Pays by the project.

Tips First-time assignments are usually book jackets, mechanicals and artwork.

DAW BOOKS, INC.

375 Hudson St., 3rd Floor, New York NY 10014-3658. (212)366-2096. Fax: (212)366-2090. **Art Director:** Betsy Wollheim. Estab. 1971. Publishes hardcover and mass market paperback originals and reprints. Specializes in science fiction and fantasy. Publishes 72 titles/year. Recent titles include: *This Alien Shore*, by C.S. Friedman; *Mountain of Black Glass*, by Tad Williams. 50% require freelance illustration. Book catalog free by request.

Needs Works with several illustrators and 1 designer/year. Buys more than 36 illustrations/year. Works with illustrators for covers. Works on assignment only.

First Contact & Terms Send postcard sample or query letter with brochure, résumé, tearsheets, transparencies, photocopies, photographs and SASE. "Please don't send slides." Samples are filed or are returned by SASE only if requested. Responds in 3 days. Originals returned at job's completion. Call for appointment to show portfolio of original/final art, final reproduction/product and transparencies. Considers complexity of project, skill and experience of artist and project's budget when establishing payment. Buys first rights and reprint rights.

Jacket/Covers Pays by the project, $1,500-8,000. "Our covers illustrate the story."

Tips "We have a drop-off policy for portfolios. We accept them on Tuesdays, Wednesdays and Thursdays and report back within a day or so. Portfolios should contain science fiction and fantasy color illustrations *only*. We do not want to see anything else. Look at several dozen of our covers."

DC COMICS

Time Warner Entertainment, 1700 Broadway, 5th Floor, New York NY 10019. (212)636-5400. Fax: (212)636-5481. Website: www.dccomics.com. **Vice President of Design and Retail Produce Development:** Georg Brewer. Estab. 1948. Publishes hardcover originals and reprints, mass market paperback originals and reprints,

trade paperback originals and reprints. Types of books include adventure, comic books, fantasy, horror, humor, juvenile, science fiction. Specializes in comic books. Publishes 1,000 titles/year.

- DC Comics does not accept unsolicited submissions.

N DELIRIUM BOOKS

P.O. Box 338, N. Webster IN 46555. (574)594-3200. E-mail: srstaley@deliriumbooks.com. Website: www.deliri umbooks.com **Contact:** Shane Ryan Staley, editor-in-chief. Estab. 1999. Publishes hardcover and trade paper-back originals. Types of books include horror. Specializes in limited edition small press titles. Publishes 8 titles/year. Recent titles include: *Fear of Gravity*, by Brian Keene; *Motivational Shrieker*, by Mark McLaughlin. 100% requires freelance illustration; 100% requires freelance design. Book catalog free on request for 1 first-class stamp.

Needs Approached by 50 illustrators and 20 designers/year. Works with 10 illustrators and 8 designers/year. Prefers freelancers experienced in cover art and horror design/typography. 100% of freelance design and illustration demands knowledge of Adobe Photoshop.

First Contact & Terms Designer send query letter with printed samples. Illustrators send query letter with printed samples Accepts Mac-compatible disk submissions as TIFF files. Samples are filed or returned by SASE. Responds only if interested. Will contact artist for Portfolio review if interested. Portfolio should include horror elements and photocopies. Buys first North American serial rights. Finds freelancers through submission packets placed on file.

Book Design Assigns 1 freelance design job/year. Assigns 1 freelance art direction project/year. Pays for design by the project, $100-800.

Jackets/Covers Assigns 1-2 freelance design jobs and 8-12 illustration jobs/year. Prefers digital format. Pays for design by the project, $100-800. Pays for illustration by the project, $100-800. Prefers experienced horror cover illustration.

Text Illustration Assigns 8-12 freelance illustration jobs/year. Pays by the project, $50-400. Prefers freelancers who can match mood and atmosphere of specific horror titles.

Tips Artists should be equipped to send high resolution digital files (CMYK) as TIFF format. Often times, the artist is assigned to do both the cover art and text illustrations. We prefer the usage of Adobe Photoshop.

DEVELOPING HEARTS SYSTEMS

(formerly Pre-emptive Products, Developing Hearts Systems), 2048 Elm St., Stratford CT 06615. (203)378-6725. Fax: (203)380-0456. E-mail: berquist@ntplx.net. **President:** Tom Berquist. Estab. 1985. Publishes children's picture and board books. Recent titles include: *Bonding with Baby Developmental Books.*

Needs Approached by 15-20 freelancers/year. Works with 3-5 freelancers/year on volunteer basis for credit only. Considers photography, art, acrylic and watercolor. Looking especially for developmental books for in-fants.

First Contact & Terms Designers and cartoonists send query letter with photocopies. Samples are filed and are not returned. Responds only if interested. Rights purchased vary according to project. Pays royalties of under 1% for original art. Finds freelancers through word of mouth.

N DIAL BOOKS FOR YOUNG READERS

345 Hudson St., New York NY 10014. (212)414-3415. Fax: (212)414-3398. **Editor:** Cecile Goyette. Specializes in juvenile and young adult hardcovers. Publishes 50 titles/year. Recent titles include: *Snowmen at Night*, by Caralyn and Mark Buchner; *Photographer's Mole*, by Dennis Haseley and Juli Kangas. 100% require freelance illustration. Books are "distinguished children's books."

Needs Approached by 400 freelancers/year. Works with 40 freelance illustrators/year. Prefers freelancers with some book experience. Works on assignment only.

First Contact & Terms Send query letter with photocopies, tearsheets and SASE. Samples are filed and returned by SASE. Responds only if interested. Originals returned at job's completion. Send query letter with samples for appointment to show portfolio of original/final art and tearsheets. Considers complexity of project, skill and experience of artist and project's budget when establishing payment. Rights purchased vary.

Jackets/Covers Assigns 8 illustration jobs/year. Pays by the project.

Text Illustration Assigns 40 freelance illustration jobs/year. Pays by the project.

DOMINIE PRESS, INC.

1949 Kellogg Ave., Carlsbad CA 92008-6582. (760)431-8000. Fax: (760)431-8777. E-mail: info@dominie.com. Website: www.dominie.com. **C.E.O.:** Raymond Yuen. Editors: Bob Rowland and Carlos Byfield. Estab. 1975. Publishes textbooks. Types of books include children's picture books, juvenile, nonfiction, preschool and young adult. Publishes 240 titles/year. Recent titles include: Dominie Collection of Myths & Legends (10 titles) and

Odyssey Series (60 titles). 90% requires freelance illustration; 50% requires freelance design; 30% requires freelance art direction. Book catalog free for 9×12 SASE with $2 postage.

Needs Approached by 50 illustrators and 50 designers/year. Works with 35 illustrators, 10 designers and 2 art directors/year. Prefers local designers and art directors. Prefers freelancers experienced in children's books and elementary textbooks. 100% of freelance design demands knowledge of Illustrator, Photoshop, FreeHand, PageMaker and QuarkXPress.

First Contact & Terms Designers send printed samples and tearsheets. Illustrators send query letter with printed samples and tearsheets. Samples are not filed and are returned by SASE. Responds in 6 months only if interested. Will contact artist for portfolio review if interested. Portfolio should include book dummy, photocopies, photographs, roughs, tearsheets, thumbnails, transparencies. Buys all rights.

Book Design Assigns 25 freelance designs and 5 freelance art direction projects/year. Pays by the project.

Jackets/Covers Assigns 30 freelance design jobs and 150 illustration jobs/year.

Text Illustration Assigns 150 freelance illustration jobs/year. Pays by the project.

DUTTON CHILDREN'S BOOKS

Penguin Putnam Inc., 345 Hudson St., New York NY 10014. **Art Director:** Sara Reynolds. Publishes hardcover originals. Types of books include biography, children's picture books, fantasy, humor, juvenile, preschool, young adult. Publishes 100-120 titles/year. 75% require freelance illustration.

Needs Prefers local designers.

First Contact & Terms Send postcard sample, printed samples, tearsheets. Samples are filed or returned by SASE. Will contact artist for portfolio review if interested. Portfolios may be dropped off every Tuesday and picked up by end of the day. Do not send samples via e-mail.

Jackets/Covers Pays for illustration by the project $1,800-2,500.

ECCO

Imprint of HarperCollins, 10 E. 53rd, New York NY 10022. (212)207-7000. Fax: (212)702-7633. E-mail: eccopress @snip.net. Website: www.harpercollins.com. **Art Director:** Roberto deVicq. Estab. 1972. Publishes hardcover and trade paperback originals and reprints. Types of books include biography, cookbooks, experimental and mainstream fiction, poetry, nonfiction and travel. Specializes in literary fiction, poetry and cookbooks. Publishes 60 titles/year. Recent titles include: *Blonde*, by Joyce Carol Oates; *Dirty Havana Trilogy*, by Pedro Juan Couitterez. 10% requires freelance illustration; 100% requires freelance design.

• Ecco is one of the world's most prestigious literary publishers. The press was acquired by HarperCollins in 1999.

Needs Approached by 40 illustrators and 60 designers/year. Works with 2 illustrators and 20 designers/year. Prefers freelancers experienced in book jacket design and interior book design. 100% of freelance design demands knowledge of QuarkXPress or InDesign. 80% of freelance illustration demands knowledge of Photoshop and Illustrator.

First Contact & Terms Designers and illustrators send postcard sample or query letter with photocopies and tearsheets. Accepts Mac-compatible disk submissions. Some samples filed, most not kept and not returned. Will contact artist for portfolio review if interested. You may also drop off portfolio on Wednesday and pick up Friday afternoon. Rights purchased vary according to project. Finds freelancers through word of mouth, sourcebooks, design magazines and browsing bookstores.

Book Design Pays for design by the project.

Jackets/Covers Assigns 60 freelance design jobs and 1 illustration job/year. Pays by the project, $500-1,000 for design, $200-500 for illustration. "We prefer sophisticated and hip experienced designers."

Tips "The best designers read the manuscript or part of the manuscript. Artwork should reflect the content of the book and be original and eye-catching. Submit design samples. Ask questions. Jacket font should be readable."

☑ EDUCATIONAL IMPRESSIONS, INC.

116 Washington Ave., Hawthorne NJ 07507. (973)423-4666. Fax: (973)423-5569. E-mail: awpeller@optionline.n et. Website: www.awpeller.com. **Art Director:** Karen Birchak. Estab. 1983. Publishes original workbooks with 2-4 color covers and b&w text. Types of books include instructional, juvenile, young adult, reference, history and educational. Specializes in all educational topics. Publishes 4-12 titles/year. Recent titles include: *September, October and November*, by Rebecca Stark; *Tuck Everlasting*; *Walk Two Moons Lit Guides*. Books are bright and bold with eye-catching, juvenile designs/illustrations.

Needs Works with 1-5 freelance illustrators/year. Prefers freelancers who specialize in children's book illustration. Uses freelancers for jacket/cover and text illustration. Also for jacket/cover design. 50% of illustration demands knowledge of QuarkXPress, FreeHand and Photoshop. Works on assignment only.

First Contact & Terms Send query letter with tearsheets, SASE, résumé and photocopies. Samples are filed.

Art director will contact artist for portfolio review if interested. Buys all rights. Interested in buying second rights (reprint rights) to previously published work. Originals are not returned. Prefers line art for the juvenile market. Sometimes requests work on spec before assigning a job.

Book Design Pays by the project, $20 minimum.

Jackets/Covers Pays by the project, $20 minimum.

Text Illustration Pays by the project, $20 minimum.

Tips ''Send juvenile-oriented illustrations as samples.''

☑ EDWARD ELGAR PUBLISHING INC.

136 West St., Suite 202, Northampton MA 01060. (413)584-5551. Fax: (413)584-9933. E-mail: elgarinfo@e-elgar.com. Website: www.e-elgar.com. **Promotions Manager:** Katy Wight. Estab. 1986. Publishes hardcover originals and textbooks. Types of books include instructional, nonfiction, reference, textbooks, academic monographs and references in economics. Publishes 200 titles/year. Recent titles include: *Who's Who in Economics, Fourth Edition*; *The IPO Decision*.

 • This publisher uses only freelance designers. Its academic books are produced in the United Kingdom. Direct Marketing material is done in U.S. There is no call for illustration.

Needs Approached by 2-4 designers/year. Works with 2 designers/year. Prefers local designers. Prefers freelancers experienced in direct mail and academic publishing. 100% of freelance design demands knowledge of Photoshop, QuarkXPress.

First Contact & Terms Designers send query letter with printed samples. Accepts Mac-compatible disk submissions. Samples are filed. Will contact artist for portfolio review if interested. Buys one-time rights or rights purchased vary according to project. Finds freelancers through word of mouth, local sources i.e. phone book, newspaper, etc.

☑ ▣ M. EVANS AND COMPANY, INC.

216 E. 49th St., New York NY 10017. (212)688-2810. Fax: (212)486-4544. E-mail: editorial@mevans.com. Website: www.mevans.com. **Contact:** Rik Lain Schell. Estab. 1956. Publishes hardcover and trade paperback originals. Types of books include adventure, humor (fiction); biography, cookbooks, history, instructional, self-help (nonfiction). Specializes in general nonfiction. Publishes 40 titles/year. Recent titles include: *Dr. Atkins' New Diet Revolution*, by Robert C. Atkins; *Women, Weight and Hormones*, by Elizabeth Lee Vliet, M.D.; *Unbelievable Desserts with Splenda*, by Marlene Koch. 5% requires freelance illustration and design.

Needs Approached by hundreds of freelancers/year. Works with approximately 10 freelance illustrators and 5 designers/year. Prefers local artists. Uses freelance artists mainly for jacket/cover illustration. Also for text illustration and jacket/cover design. Works on assignment only.

First Contact & Terms Send query letter with brochure and résumé. Samples are filed. Art Director will contact artist for portfolio review if interested. Portfolio should include original/final art and photographs. Rights purchased vary according to project. Originals are returned at job's completion upon request.

Book Design Assigns 10 freelance jobs/year. Pays by project, $200-500.

Jackets/Covers Assigns 40 freelance design jobs/year. Pays by the project, $600-1,200.

Text Illustration Assigns 2-5 freelance text illustration jobs/year. Pays by the project, $50-500.

EXCELSIOR CEE PUBLISHING

P.O. Box 5861, Norman OK 73070. (405)329-3909. Fax: (405)329-6886. E-mail: ecp@oecadvantage.net. Website: excelsiorcee.com. Estab. 1989. Publishes trade paperback originals. Types of books include how-to, instruction, nonfiction and self help. Specializes in how-to and writing. Publishes 6 titles/year. Titles include: *When I Want Your Opinion I'll Tell it to You*.

Needs Uses freelancers mainly for jacket and cover design.

First Contact & Terms Designers send query letter with SASE. Illustrators send query letter with résumé and SASE. Accepts disk submissions from designers. Samples returned by SASE. Negotiates rights purchased.

Book Design Assigns 2 freelance design jobs/year. Pays by the project.

Jackets/Covers Assigns 6 freelance illustration jobs/year. Pays by the project; negotiable.

Text Illustration Pays by the project. Finds freelancers through word of mouth and submissions.

FACTS ON FILE

132 W. 31st St., 17th Floor, New York NY 10001. (212)967-8800. Fax: (212)967-9196. Website: www.factsonfile.com. **Creative Director:** Zina Scarpulla. Estab. 1940. Publisher of school, library and trade books, CD-ROMs and OnFiles. Types of reference and trade books include science, history, biography, language/literature/writing, pop culture, self-help. Specializes in general reference. Publishes 200 titles/year. Recent titles include: *The Encyclopedia of American History*. 10% require freelance illustration. Book catalog free by request.

Needs Approached by 100 freelance artists/year. Works with 2 illustrators and 5 designers/year. Uses freelanc-

ers mainly for jacket and direct mail design. Needs computer-literate freelancers for design and illustration. Demands knowledge of Macintosh and IBM programs. Works on assignment only.

First Contact & Terms Send query letter with SASE, tearsheets and photocopies. Samples are filed. Responds only if interested. Call to show a portfolio, which should include thumbnails, roughs, color tearsheets, photographs and comps. Rights purchased vary. Originals returned at job's completion.

Jackets/Covers Assigns 50 freelance design jobs/year. Pays by the project, $500-1,000.

Tips "Our books range from straight black and white to coffee-table type four-color. We're using more freelancers for technical, computer generated line art—charts, graphs, maps. We're beginning to market some of our titles in CD-ROM and online format; making fuller use of desktop publishing technology in our production department."

⒩ FALCON PRESS PUBLISHING CO., INC.

825 Great Northern Blvd., Suite 327-328, Helena MT 59601. (406)442-6597. Fax: (406)457-5461. E-mail: falcon@ falcon.com. Website: www.falcon.com. **Art/Production Director:** Michael Cirone. Estab. 1978. Book publisher. Publishes hardcover originals and reprints, trade paperback originals and reprints, and mass market paperback originals and reprints. Types of books include instruction, juvenile, travel and cookbooks. Specializes in recreational guidebooks and high-quality, four-color coffeetable photo books. Publishes 130 titles/year. Recent titles include: *Allen and Mike's Really Cool Telemark Tips*, by John Pukite; *Birder's Dictionary*, by Randall Cox. Book catalog free by request.

Needs Approached by 250 freelance artists/year. Works with 2-5 freelance illustrators/year. Buys 100 freelance illustrations/year. Uses freelance artists mainly for illustrating children's books, map making and technical drawing.

First Contact & Terms Send postcard sample or query letter with résumé, tearsheets, photographs, photocopies or photostats. Samples are filed if they fit our style. Accepts disk submissions compatible with PageMaker, QuarkXPress or Illustrator. Responds to the artist only if interested. Do not send anything you need returned. Originals are returned at job's completion.

Book Production Assigns 30-40 freelance production jobs and 1-2 design projects/year. Pays by the project.

Jackets/Covers Assigns 1-4 freelance design and 1-4 illustration jobs/year.

Text Illustration Assigns approximately 10 freelance illustration jobs/year. Pays by the project. No preferred media or style.

Tips "If we use freelancers, it's usually to illustrate nature-oriented titles. These can be for various children's titles or adult titles. We tend to look for a more 'realistic' style of rendering but with some interest."

⒩ FARRAR, STRAUS & GIROUX, INC.

19 Union Square W., New York NY 10003. (212)741-6900. Fax: (212)741-6973. **Art Director:** Susan Mitchell. Book publisher. Estab. 1946. Publishes hardcover and trade paperback originals and trade paperback reprints. Publishes nonfiction and juvenile fiction. Publishes 200 titles/year. 20% require freelance illustration; 40% freelance design.

Needs Works with 12 freelance designers and 3-5 illustrators/year. Uses artists for jacket/cover and book design.

First Contact & Terms Send postcards, tearsheets, photocopies or other nonreturnable samples. Samples are filed and are not returned. Responds only if interested. Originals are returned at job's completion. Call or write for appointment to show portfolio of photostats and final reproduction/product. Portfolios may be dropped off every Wednesday before 2 p.m. Considers complexity of project and budget when establishing payment. Buys one-time rights.

Book Design Assigns 40 freelance design jobs/year. Pays by the project, $300-450.

Jackets/Covers Assigns 20 freelance design jobs/year and 10-15 freelance illustration jobs/year. Pays by the project, $750-1,500.

Tips The best way for a freelance illustrator to get an assignment is "to have a great portfolio."

☑ FORT ROSS INC.

26 Arthur Place, Yonkers NY 10701. (914)375-6448. Fax: (914)375-6439. E-mail: fortross@verizon.net. Website: www.fortross.net. **Executive Director:** Dr. Vladimir P. Kartsev. Represents leading Russian, Polish, Spanish, etc., publishing companies in the US and Canada. Estab. 1992. Hardcover originals, mass market paperback originals and reprints, and trade paperback reprints. Works with adventure, children's picture books, fantasy, horror, romance, science fiction and western. Specializes in romance, science fiction, fantasy, mystery. Represents 500 titles/year. Recent titles include: translations of *Judo*, by Vladamir Putin; *The Redemption*, by Howard Fast. 100% requires freelance illustration. Book catalog not available.

- "Since 1996 we have introduced a new generation of outstanding Russian book illustrators and designers to the American and Canadian publishing world. At the same time, we have drastically changed the exterior of books published in Europe using classical American illustrations and covers."

Needs Approached by 100 illustrators/year. Works with 40 illustrators/year. Prefers freelancers experienced in romance, science fiction, fantasy, mystery cover art.

First Contact & Terms Illustrators send query letter with printed samples, photocopies, SASE, tearsheets. Accepts Windows-compatible disk submissions. Send EPS files. Samples are filed. Will contact artist for portfolio review if interested. Buys secondary rights. Finds freelancers through agents, networking events, sourcebooks, *Black Book*, *RSVP*, *Spectrum*.

Jackets/Covers Buys up to 1,000 illustrations/year. Pays for illustration by the project, $50-150 for secondary rights (for each country). Prefers experienced romance, mystery, science fiction, fantasy cover illustrators.

Tips "Fort Ross is the best place for experienced cover artists to sell secondary rights for their images in Russia, Germany, Spain, Netherlands, Poland, Czech Republic, countries of the former USSR, Western, Central and Eastern Europe. We prefer realistic, thoroughly executed expressive images on our covers."

N FORWARD MOVEMENT PUBLICATIONS

412 Sycamore St., Cincinnati OH 45202-4195. (513)721-6659. Fax: (513)721-0729. E-mail: forward.movement@ msn.com. Website: www.forwardmovement.org. **Director/Editor:** Edward S. Gleason. Estab. 1934. Publishes trade paperback originals. Types of books include religious. Publishes 4 titles/year. Recent titles include: *Downsized*, by Leland Davis; *Alcoholism: A Family Affair*. 17% require freelance illustration.

Needs Works with 2-4 freelance illustrators and 1-2 designers/year. Uses freelancers mainly for illustrations required by designer. "We also keep original clip-art-type drawings on file to be paid for as used."

First Contact & Terms Send query letter with tearsheets, photocopies or postcard samples. Samples are sometimes filed. Art director will contact artist for portfolio review if interested. Sometimes requests work on spec before assigning a job. Interested in buying second rights (reprint rights) to previously published work. Rights purchased vary according to project. Originals sometimes returned at job's completion. Finds artists mainly through word of mouth.

Jackets/Covers Assigns 1-4 freelance design and 6 illustration jobs/year. Pays by the project, $25-175.

Text Illustration Assigns 1-4 freelance jobs/year. Pays by the project, $10-200; pays $5-25/picture. Prefers pen & ink.

Tips "We need clip art. If you send clip art, include fee you charge for use."

WALTER FOSTER PUBLISHING

23062 La Cadena, Laguna Hills CA 92653. (949)380-7510. Fax: (949)380-7575. E-mail: info@walterfoster.com. Website: www.walterfoster.com. **Art Director:** David Rosemeyer. Estab. 1922. Publishes trade paperback and mass market paperback originals and reprints. Types of books include instructional, juvenile, "all art related." Specializes in art & craft. Publishes 30-50 titles/year. 80% require freelance illustration; 20% require freelance design. Catalog $5 with 8½×11 SASE.

Needs Approached by 500 illustrators and 50-100 designers/year. Works with 25-30 illustrators and 5-10 designers/year. 70% of freelance design demands knowledge of Photoshop, Illustrator and QuarkXPress.

First Contact & Terms Designers send query letter with brochure. Illustrators send postcard sample or query letter with color photocopies. Accepts disk submissions. "If samples suit us they are filed." Responds only if interested. Art director will contact artist for portfolio review of photocopies, photographs, photostats, slides and transparencies if interested. Buys all rights.

Book Design Assigns 10-25 freelance design jobs/year. Pays by the project.

Jackets/Covers Assigns 10-25 freelance design jobs and 25-30 illustration jobs/year. Pays by the project. Finds freelancers through agents, sourcebooks, magazines, word of mouth and submissions.

N F+W PUBLICATIONS INC.

4700 E. Galbraith Rd., Cincinnati OH 45236. Website: www.fwpublications.com. **Art Director:** Clare Finney. Imprints: Writers Digest Books, North Light Books, Betterway Books, IMPACT Books, HOW Design Books, Adams Media, Krause. Publishes 120 books annually for writers, artists and photographers, plus selected trade (lifestyle, home improvement) titles. Recent titles include: *Writing for Young Adults*; *Quaint Birdhouses You Can Paint and Decorate*; *Colored Pencil Portraits Step by Step*; *Manga Madness*. Books are heavy on type-sensitive design.

Needs Works with 10-20 freelance illustrators and 5-10 designers/year. Uses freelancers for jacket/cover design and illustration, text illustration, direct mail and book design. Works on assignment only.

First Contact & Terms Send nonreturnable photocopies of printed work to be kept on file. Art director will contact artist for portfolio review if interested. Interested in buying second rights (reprint rights) to previously published illustrations. "We like to know where art was previously published." Finds illustrators and designers through word of mouth and submissions/self promotions.

Book Design Pays by the project, $600-1,000.

Jackets/Covers Pays by the project, $750.

Text Illustration Pays by the project, $100 minimum.

Tips "Don't call. Send appropriate samples we can keep. Clearly indicate what type of work you are looking for."

N FRANKLIN WATTS

90 Sherman Turnpike, Danbury CT 06816. (203)797-3500. Estab. 1942. Imprint of Scholastic Library Publishing.
- See listing for Scholastic Library Publishing. Its imprints include Children's Press and Grolier, in addition to Franklin Watts.

N THE FREE PRESS

A Division of Simon & Schuster Adult Publishing Group, 1230 Avenue of the Americas, New York NY 10020. (212)698-7000. Fax: (212)632-4989. Website: www.simonsays.com. **Art Director:** Eric Fuentecilla. Specializes in hardcover and paperback originals, concentrating on professional subjects and trade books in the social sciences. Publishes 85 titles/year. Recent titles include: *Eye of the Storm*; *The Educated Child*. Publishes conservative books on current events, social sciences, psychology and Judaica.

Needs Approached by dozens of freelance artists/year. Works with 2-3 freelancers/year. Works with 10-12 designers/year. Prefers artists with book publishing experience. Works on assignment only.

First Contact & Terms Send query letter with brochure showing art style or résumé and nonreturnable samples. Samples not filed are returned by SASE. Responds only if interested. Originals returned at job's completion. Considers complexity of project, skill and experience of artist, budget, turnaround time and rights purchased when establishing payment. Buys all rights.

Book Design Assigns 70 design jobs/year. Pays by the project, $250-400.

Jackets/Covers Assigns 70 design jobs/year. Pays by the project, $750-1,500.

Text Illustration Assigns 35 jobs/year. "It is largely drafting work, not illustration." Pays by the project.

Tips "Have book industry experience!"

N FULCRUM PUBLISHING

16100 Table Mountain Parkway #300, Golden CO 80403. (303)277-1623. Fax: (303)279-7111. Website: www.fulcrum-books.com. **Contact:** Art Director. Estab. 1986. Book and calendar publisher. Publishes hardcover originals and trade paperback originals and reprints. Types of books include biography, Native American, reference, history, self help, teacher resource books, travel, humor, gardening and nature. Specializes in history, nature, teacher resource books, travel, Native American and gardening. Publishes 50 titles/year. Recent titles include: *The Brave New World of Healthcare*, by Richard D. Lamm; *Rocky Mountain Garden Survival Guide*, by Susan Tweit. 15% requires freelance illustration; 85% requires freelance design. Book catalog free by request.

Needs Uses freelancers mainly for cover and interior illustrations for gardening books and images for calendars. Also for other jacket/covers, text illustration and book design. Works on assignment only.

First Contact & Terms Send query letter with tearsheets, photographs, photocopies and photostats. Samples are filed. Responds to artist only if interested. To show portfolio, mail b&w photostats. Buys one-time rights. Originals are returned at job's completion.

Book Design Pays by the project.

Jackets/Covers Pays by the project.

Text Illustration Pays by the project.

Tips Previous book design experience a plus.

GALISON BOOKS/MUDPUPPY PRESS

28 W. 44th St., New York NY 10036. (212)354-8840. Fax: (212)391-4037. E-mail: lorena@galison.com. Website: www.galison.com. **Contact:** Lorena Siminovich. Publishes note cards, journals, stationery, children's products. Publishes 120 titles/year.
- Also has listing in greeting cards, gifts and products section.

Needs Works with 20 illustrators and stock photographers/year. Assigns 30 freelance cover illustrations/year. Some freelance design demands knowledge of Photoshop, Illustrator and QuarkXPress.

First Contact & Terms Illustrators send photocopies, printed samples, tearsheets or e-mail to direct to website. Samples are filed or returned SASE. Will contact artist for portfolio review if interested. Rights purchased vary according to project.

GALLAUDET UNIVERSITY PRESS

800 Florida Ave. NE, Washington DC 20002-3695. (202)651-5025. Fax: (202)651-5429. E-mail: jill.porco@gallaudet.edu. Website: gupress.gallaudet.edu. **Contact:** Jill Porco, production coordinator. Estab. 1980. Publishes hardcover and trade paperback originals, hardcover and trade paperback reprints, videotapes and textbooks. Types of books include reference, biography, coffee table books, history, instructional and textbook nonfiction.

Specializes in books related to deafness. Publishes 12-15 new titles/year. Recent titles include: *Deaf People in Hitler's Europe*; *The Parents' Guide to Cochlear Inplants*. 90% requires freelance design; 2% requires freelance illustration. Book catalog free on request.

Needs Approached by 10-20 designers and 30 illustrators/year. Works with 15 designers/year. 100% of freelance design work demands knowledge of Illustrator, PageMaker, Photoshop and QuarkXPress.

First Contact & Terms Send query letter with postcard sample with résumé, sample of work and URL. After introductory mailing, send follow-up postcard sample every 6 months. Accepts disk submissions. Prefers Windows-compatible, PDF files. Samples are filed. Responds only if interested. Company will contact artist for portfolio review if interested. Portfolio should include color finished art. Rights purchased vary according to project. Finds freelancers through Internet and word of mouth.

Tips "Do not call us."

☑ GAUNTLET PRESS

309 Powell Road, Springfield PA 19064. Website: www.gauntletpress.com. **Contact:** Barry Hoffman, president. Estab. 1991. Publishes hardcover originals and reprints, trade paperback originals and reprints. Types of books include horror, science fiction and young adult. Specializes in signed limited collectibles. Publishes 4 titles/year. Recent titles include: *It Came From Outerspace*; *Gateways*; *Lost Souls*.

• Currently Gauntlet Press is not accepting submissions, as they are solidly booked for the next few years.

☑ 📠 GAYOT PUBLICATIONS

4911 Wilshire Blvd., Los Angeles CA 90010. (323)965-3529. Fax: (323)936-2883. E-mail: gayots@aol.com. Website: www.gayot.com. **Publisher:** Alain Gayot. Estab. 1986. Publishes trade paperback originals. Types of books include travel and restaurant guides. Publishes 8 titles/year. Recent titles include: *The Best of London*; *The Best of Las Vegas*; *The Best of New York*; *The Best of Hawaii*. 50% requires freelance design. Catalog available.

Needs Approached by 30 illustrators and 2 designers/year. Works with 2 designers/year. Prefers local designers. 50% of freelance design demands knowledge of Dreamweaver, Flash, Photoshop, Illustrator and QuarkXPress.

First Contact & Terms Designers send query letter with brochure, photocopies and résumé. Send follow-up postcard every 6 months. Accepts disk submissions compatible with Mac, any program. Samples are filed. Responds only if interested. Will contact artist for portfolio review if interested. Rights purchased vary according to project.

Book Design Pays by the hour or by the project.

Jackets/Covers Assigns 40 freelance design jobs/year. Pays for design by the hour. Pays for illustration by the project, $800-1,200.

Tips "We look for rapidity, flexibility, eclecticism and an understanding of the travel guide business."

GEM GUIDES BOOK CO.

315 Cloverleaf Dr., Suite F, Baldwin Park CA 91706. (626)855-1611. Fax: (626)855-1610. E-mail: gembooks@aol.com. Website: www.gemguidesbooks.com. **Editors:** Kathy Mayerski, Nancy Fox. Estab. 1964. Book publisher and wholesaler of trade paperback originals and reprints. Types of books include earth sciences, western, instructional, travel, history and regional (western US). Specializes in travel and local interest (western Americana). Publishes 7 titles/year. Recent titles include: *Baby's Day Out in Southern California: Fun Places to Go with Babies and Toddlers*, by Jobea Holt; *Downtown Los Angeles: A Walking Guide*, by Robert Herman; *Free Mining and Mineral Adventures in the Eastern U.S.*, by James Martin and Jeannette Hathaway Monaco. 75% requires freelance cover design.

Needs Approached by 24 freelancers/year. Works with one designer/year. Uses freelancers mainly for covers. 100% of freelance work demands knowledge of Quark, Photoshop. Works on assignment only.

First Contact & Terms Send query letter with brochure, résumé and SASE. Samples are filed. Editor will contact artist for portfolio review if interested. Requests work on spec before assigning a job. Buys all rights. Originals are not returned. Finds artists through word of mouth and "our files."

Jackets/Covers Pays by the project.

☑ GIBBS SMITH, PUBLISHER

P.O. Box 667, Layton UT 84041. (801)544-9800. Fax: (801)546-8853. E-mail: info@gibbs-smith.com. Website: www.gibbs-smith.com. **Contact:** Kurt Wahlner, art director. Estab. 1969. Imprints include Sierra Book Club for Children. Company publishes hardcover and trade paperback originals and textbooks. Types of books include children's picture books, coffee table books, cookbooks, humor, juvenile, nonfiction textbooks, western. Publishes 60 titles/year. Recent titles include: *Batter Up Kids: Delicious Desserts*; *Lost Coast: Stories from the Surf*. 10% requires freelance illustration; 90% requires freelance design. Book catalog free for 8½×11 SASE with $1.24 postage.

Needs Approached by 250 freelance illustrators and 50 freelance designers/year. Works with 5 freelance illustrators and 15 designers/year. Designers may be located anywhere with Broadband service. Prefers freelancers experienced in layout of photographic nonfiction. Uses freelancers mainly for cover design and book layout, cartoon illustration, children's book illustration. 100% of freelance design demands knowledge of QuarkXPress. 70% of freelance illustration demands knowledge of Photoshop, Illustrator and FreeHand.

First Contact & Terms Designers send samples for file. Illustrators send printed samples and photocopies. Samples are filed. Responds only if interested. Finds freelancers through submission packets and illustration annuals.

Book Design Assigns 50 freelance design jobs/year. Pays by the project, $10-15/page.

Jackets/Covers Assigns 50-60 freelance design jobs and 5 illustration jobs/year. Pays for design by the project, $500-800. Pays for illustration by the project.

Text Illustration Assigns 1 freelance illustration job/year. Pays by the project.

ⓝ GLENCOE/McGRAW-HILL PUBLISHING COMPANY

21600 Oxnard St., 5th Floor, Woodland Hills CA 91367. (818)615-2600. Fax: (818)615-2699. Website: www.glencoe.com. **Design Supervisor:** Margaret Sims. Estab. 1965. Book publisher. Publishes textbooks. Types of books include marketing and career education, art and music, health, religious education. Specializes in most el-hi (grades 7-12) subject areas, as well as post-secondary career subjects. Publishes 350 titles/year.
 • Glencoe also has divisions in Peoria, Illinois and Columbus, Ohio, with separate art departments.

Needs Approached by 50 freelancers/year. Works with 20-30 freelance illustrators and 10-20 designers/year. Prefers experienced artists. Uses freelance artists mainly for illustration and production. Also for jacket/cover design and illustration, text illustration and book design. 100% of design and 50% of illustration demand knowledge of QuarkXPress on Mac. Works on assignment only.

First Contact & Terms Send nonreturnable samples. Accepts disk submissions compatible with above program. Samples are filed. Sometimes requests work on spec before assigning a job. Negotiates rights purchased. Originals are not returned.

Book Design Assigns 10-20 freelance design and many illustration jobs/year. Pays by the project.

Jackets/Covers Assigns 10-20 freelance design jobs/year. Pays by the project.

Text Illustration Assigns 20-30 freelance design jobs/year. Pays by the project.

▣ GLENCOE/McGRAW-HILL PUBLISHING COMPANY

3008 W. Willow Knolls Rd., Peoria IL 61615. (309)689-3200. Fax: (309)689-3211. **Contact:** Ardis Parker, director of Art/Design & Production. Specializes in secondary educational materials (hardcover, paperback, CDs, software), in technology education, including industrial carpentry, computer, family consumer science, child care, family living, foods, nutrition, career education. Publishes more than 100 titles/year.

Needs Works with over 30 freelancers/year. 60% of freelance work demands knowledge of Illustrator, QuarkXPress or Photoshop. Works on assignment only.

First Contact & Terms Send query letter with brochure, résumé and "any type of samples." Samples not filed are returned if requested. Responds in weeks. Originals are not returned; works on work-for-hire basis with rights to publisher. Considers complexity of the project, skill and experience of the artist, project's budget, turnaround time and rights purchased when establishing payment. Buys all rights.

Book Design Assigns 20 freelance design jobs/year. Pays by the project.

Jackets/Covers Assigns 20 freelance design jobs/year. Pays by the project.

Text Illustration Assigns 40 freelance jobs/year. Pays by the hour or by the project.

Tips "Try not to cold call and never drop in without an appointment."

▨ GLOBE PEQUOT PRESS

246 Goose Lane, P.O. Box 480, Guilford CT 06437. (203)458-4500. Fax: (203)458-4604. E-mail: info@globepequot.com. Website: www.globepequot.com. **Production Director:** Kevin Lynch. Estab. 1947. Publishes hardcover and trade paperback originals and reprints. Types of books include (mostly) travel, kayak, outdoor, cookbooks, instruction, self-help and history. Specializes in regional subjects: New England, Northwest, Southeast bed-and-board country inn guides. Publishes 600 titles/year. 20% require freelance illustration; 75% require freelance design. Titles include: *Lost Lighthouses*, by John Grant; *Michael Shapiro's Internet Travel Planner*. Design of books is "classic and traditional, but fun." Book catalog available.

Needs Works with 10-20 freelance illustrators and 15-20 designers/year. Uses freelancers mainly for cover and text design and production. Also for jacket/cover and text illustration and direct mail design. Needs computer-literate freelancers for production. 100% of design and 75% of illustration demand knowledge of QuarkXPress 3.32, Illustrator 7.0 or Photoshop 5. Works on assignment only.

First Contact & Terms Send query letter with résumé, photocopies and photographs. Accepts disk submissions compatible with QuarkXPress 3.32, Illustrator 7.0 or Photoshop 5. Samples are filed and not returned. Request

portfolio review in original query. Artist should follow up with call after initial query. Art Director will contact artist for portfolio review if interested. Portfolio should include roughs, original/final art, photostats, tearsheets and dummies. Requests work on spec before assigning a job. Considers complexity of project, project's budget and turnaround time when establishing payment. Buys all rights. Originals are not returned. Finds artists through word of mouth, submissions, self promotion and sourcebooks.

Book Design Pays by the hour, $20-28 for production; or by the project, $400-600 for cover design.

Jackets/Covers Prefers realistic style. Pays by the hour, $20-35; or by the project, $500-1,000.

Text Illustration Pays by the project, $25-150. Mostly b&w illustration, preferably computer-generated.

Cover Illustration Pays by the project $500-700 for color.

Tips "Our books are being produced on Macintosh computers. We like designers who can use the Mac competently enough that their design looks as if it *hasn't* been done on the Mac."

GOLD RUSH GAMES

P.O. Box 2531, Elk Grove CA 95759-2531. Phone/fax: (916)313-3575. E-mail: mark@goldrushgames.com. Website: www.goldrushgames.com. **President:** Mark Arsenault. Vice President: Margaret Arsenault. Estab. 1992. Publishes roleplaying game books, newsletter. Main style/genre of games: science fiction, fantasy, historical (16th-century Japan) and superheroes. Uses freelance artists mainly for full-color covers and b&w interior book illustrations. Publishes 4-6 titles or products/year. Game/product lines include: *Gunslingers: Wild West Action*, *The Dragon's Gate* and miscellaneous roleplaying games. 100% requires freelance illustration; 50% requires freelance design; 25% requires freelance art direction. Art guidelines free for SASE with 2 first-class stamps. Art guidelines available on website.

Needs Approached by 100 illustrators and 25 designers/year. Works with 20 illustrators and 2 designers/year. 100% of freelance design demands knowledge of Illustrator, PageMaker, Photoshop. 50% of freelance illustration demands knowledge of Photoshop.

First Contact & Terms Send query letter with printed samples, such as postcards or photocopies. Accepts digital submissions. Although art director prefers to see hardcopy of art, he will accept e-mail submissions if art is sent as TIFF or JPEG files at 100-200 dpi "may use Zip or Stuff it compression. No LZW compressed Zip files." Samples are filed. Responds in 3 months if interested. Will contact artist for portfolio review if interested. Portfolio should include artwork portraying superheroes and historical Japanese (16th century), b&w, color photocopies. Buys first and reprint rights. Finds freelancers through submissions packets, conventions and referrals.

Visual Design Assigns 2 freelance design and 2 art direction projects/year. Pays for design by the project, $100-500; for art direction by the project, $100-300.

Book Covers/Posters/Cards Assigns 2 freelance design jobs and 6 illustration jobs/year. Pays for illustration by the project, $250-1,000; royalties of 2-3%. Prefers multicultural portrayal of characters, detailed backgrounds.

Text Illustration Assigns 18 freelance illustrations jobs/year. Pays by the full page, $75-150 pro-rated. Pays by the half page, $35-75.

Tips "We need reliable freelance artists and designers who can meet deadlines. We prefer a mix of 'action' and 'mood' illustrations. Historical accuracy for Japanese art a must."

GOOSE LANE EDITIONS LTD.

469 King St., Fredericton NB E3B 1E5 Canada. (506)450-4251. Fax: (506)450-4251. E-mail: gooselane@gooselane.com. Website: www.gooselane.com. **Art Director:** Julie Scriver. Estab. 1958. Publishes trade paperback originals of poetry, fiction and nonfiction. Types of books include biography, cookbooks, fiction, reference and history. Publishes 10-15 titles/year. 10% requires freelance illustration. Books are "high quality, elegant, generally with full-color fine art reproduction on cover." Book catalog free for SAE with Canadian first-class stamp or IRC.

Needs Approached by 3 freelancers/year. Works with 1-2 illustrators/year. Only works with freelancers in the region. Works on assignment only.

First Contact & Terms Send Web portfolio address. Illustrators may send postcard samples. Samples are filed or are returned by SASE. Responds in 2 months.

Book Design Pays by the project, $400-1,200.

Jackets/Covers Assigns 1 freelance design job and 2-3 illustration jobs/year. Pays by the project, $200-500.

Text Illustration Assigns 1 freelance illustration job/year. Pays by the project, $300-1,500.

GRAYWOLF PRESS

2402 University Ave., #203, St. Paul MN 55114. (651)641-0077. Fax: (651)641-0036. E-mail: czarniec@graywolf press.org. Website: www.graywolfpress.org. **Executive Editor:** Anne Czarniecki. Estab. 1974. Publishes hardcover originals, trade paperback originals and reprints. Specializes in novels, nonfiction, memoir, poetry, essays and short stories. Publishes 25 titles/year. Recent titles include: *The Weatherman*, by Clint McCown; *One*

Vacant Chair, by Joe Coomer; *Cocktails*, by D.A. Powell; *Disappearing Ink*, by Dana Gioia. 100% require freelance cover design. Books use solid typography, strikingly beautiful and well-integrated artwork. Book catalog free by request.

• Graywolf is recognized as one of the finest small presses in the nation.

Needs Approached by 100 freelance artists/year. Works with 7 designers/year. Buys 25 illustrations/year (existing art only). Prefers artists with experience in literary titles. Uses freelancers mainly for cover design. Works on assignment only.

First Contact & Terms Send query letter with résumé and photocopies. Samples are returned by SASE if requested by artist. Executive editor will contact artist for portfolio review if interested. Portfolio should include b&w, color photostats and tearsheets. Negotiates rights purchased. Interested in buying second rights (reprint rights) to previously published work. Originals are returned at job's completion. Pays by the project. Finds artists through submissions and word of mouth.

Jackets/Covers Assigns 25 design jobs/year. Pays by the project, $800-1,200. "We use existing art—both contemporary and classical—and emphasize fine typography."

Tips "Have a strong portfolio of literary (fine press) design."

GREAT QUOTATIONS PUBLISHING

8102 Lemont Rd., #300, Woodridge IL 60517. (630)390-3580. Fax: (630)390-3585. **Contact:** Tami Suite. Estab. 1985. Imprint of Greatime Offset Printing. Company publishes hardcover, trade paperback and mass market paperback originals. Types of books include humor, inspiration, motivation and books for children. Specializes in gift books. Publishes 50 titles/year. Recent titles include: *Only a Sister Could Be Such a Good Friend*; *Words From the Coach*. 50% requires freelance illustration and design. Book catalog available for $2 with SASE.

Needs Approached by 100 freelancers/year. Works with 20 designers and 20 illustrators/year. Uses freelancers to illustrate and/or design books and catalogs. 50% of freelance work demands knowledge of QuarkXPress and Photoshop. Works on assignment only.

First Contact & Terms Send letter of introduction and sample pages. Name, address and telephone number should be clearly displayed on the front of the sample. All appropriate samples will be placed in publisher's library. Design Editor will contact artist under consideration, as prospective projects become available. Rights purchased vary according to project.

Jackets/Covers Assigns 20 freelance cover illustration jobs/year. Pays by the project, $300-3,000.

Text Illustration Assigns 30 freelance text illustration jobs/year. Pays by the project, $100-1,000.

Tips "We're looking for bright, colorful cover design on a small size book cover (around 6 × 6). Outstanding humor or motivational titles will be most in demand."

☑ GREAT SOURCE EDUCATION GROUP

a Houghton Mifflin Co., 181 Ballardvale St., Wilmington MA 01887. (978)661-1564. Fax: (978)661-1331. E-mail: richard_spencer@hmco.com. Website: www.greatsource.com. **Contact:** Richard Spencer, design director. Specializes in supplemental educational materials. Publishes more than 25 titles/year. 90% requires freelance design; 80% requires freelance illustration. Book catalog free with 9 × 12 SASE or check website.

Needs Approached by more than 100 illustrators/year. Works with 25 illustrators/year. 50% of freelance illustration demands knowledge of Illustrator and Photoshop.

First Contact & Terms Send nonreturnable samples such as postcards, photocopies and/or tearsheets. After introductory mailing, send follow-up postcard sample every year. Accepts disk submissions from illustrators. Prefers Mac-compatible, JPEG files. Samples are filed or returned by SASE. Responds only if interested. Company will contact artist for portfolio review if interested. Portfolio should include b&w, color tearsheets. Rights purchased vary according to project. Finds freelancers through art reps, artist's submissions, Internet.

Jackets/Covers Assigns 10 freelance cover illustration jobs/year. Pays for illustration by the project, $500-3,000. Prefers kid-friendly styles.

Text Illustration Assigns 25 freelance illustration jobs/year. Pays by the project, $30-1,000. Prefers professional electronic submissions.

▣ GROUP PUBLISHING BOOK PRODUCT

1515 Cascade Ave., Loveland CO 80539. (970)669-3836. Fax: (970)669-1994. Website: www.grouppublishing.com. **Art Directors (for interiors):** Jeff Spencer, Jean Bruns, Kari Monson and Randy Kady. Webmaster: Fred Schuth. Company publishes books, Bible curriculum products (including puzzles, posters, etc.), clip art resources and audiovisual materials for use in Christian education for children, youth and adults. Publishes 35-40 titles/year. Recent titles include: *The Dirt on Learning*; *Group's Hands-On Bible Curriculum*; *Real Life Bible Curriculum*; *Group's Treasure Hunt Bible Adventure Vacation Bible School*; *Faith Weaver Bible Curriculum*.

• This company also produces magazines. See listing in Magazines section for more information.

Needs Uses freelancers for cover illustration and design. 100% of design and 50% of illustration demand knowledge of QuarkXPress 4.0, InDesign, Macromedia Freehand 8.0, Photoshop 7.0, Illustrator 9.0. Occasionally

uses cartoons in books and teacher's guides. Uses b&w and color illustration on covers and in product interiors.
First Contact & Terms Contact Jeff Storm, Marketing Art Director, if interested in cover design or illustration. Contact Jeff Spencer if interested in book and curriculum interior illustration and design and curriculum cover design. Send query letter with nonreturnable b&w or color photocopies, slides, tearsheets or other samples. Accepts disk submissions. Samples are filed, additional samples may be requested prior to assignment. Responds only if interested. Rights purchased vary according to project.
Jackets/Covers Assigns minimum 15 freelance design and 10 freelance illustration jobs/year. Pays for design, $250-1,200; pays for illustration, $250-1,200.
Text Illustration Assigns minimum 20 freelance illustration projects/year. **Pays on acceptance**: $40-200 for b&w (from small spot illustrations to full page). Fees for color illustration and design work vary and are negotiable. Prefers b&w line or line and wash illustrations to accompany lesson activities.
Tips "We prefer contemporary, nontraditional styles appropriate for our innovative and upbeat products and the creative Christian teachers and students who use them. We seek experienced designers and artists who can help us achieve our goal of presenting biblical material in fresh, new and engaging ways. Submit design/illustration on disk. Self promotion pieces help get you noticed. Have book covers/jackets, brochure design, newsletter or catalog design in your portfolio. Include samples of Bible or church-related illustration."

GRYPHON PUBLICATIONS

P.O. Box 209, Brooklyn NY 11228. **Publisher:** Gary Lovisi. Assistant Editor: Lucille Cali. Website: www.gryphon books.com. Estab. 1983. Book and magazine publisher of hardcover originals, trade paperback originals and reprints, reference and magazines. Types of books include science fiction, mystery and reference. Specializes in crime fiction and bibliography. Publishes 10 titles/year. Titles include *Difficult Lives*, by James Salli; and *Vampire Junkies*, by Norman Spinrad. 40% require freelance illustration; 10% require freelance design. Book catalog free for #10 SASE.

- Also publishes *Hardboiled*, a quarterly magazine of noir fiction, and *Paperback Parade* on collectible paperbacks.

Needs Approached by 75-200 freelancers/year. Works with 10 freelance illustrators and 1 designer/year. Prefers freelancers with "professional attitude." Uses freelancers mainly for book and magazine cover and interior illustrations. Also for jacket/cover, book and catalog design. Works on assignment only.
First Contact & Terms Send query letter with résumé, SASE, tearsheets or photocopies. Samples are filed. Responds in 2 weeks only if interested. Buys one-time rights. "I will look at reprints if they are of high quality and cost effective." Originals are returned at job's completion if requested. Send b&w samples only.
Jackets/Covers Assigns 2 freelance design and 5-6 illustration jobs/year. Pays by the project, $25-150.
Text Illustration Assigns 2 freelance jobs/year. Pays by the project, $10-100. Prefers b&w line drawings.
Tips "It is best to send photocopies of your work with an SASE and query letter. Then we will contact on a freelance basis."

N ⬛ 🅔 GUARDIANS OF ORDER

176 Speedvale West, Unit #2, Guelph ON N1H 1C2 Canada. (519)821-7174. Fax: (519)821-7635. E-mail: jeff@gu ardiansorder.com. Website: www.guardiansorder.com. **Art Director:** Jeff Mackintosh. Estab. 1997. Publishes roleplaying game books. Main style/genre of games: Japanimation. Uses freelance artists mainly for books and posters. Publishes 18 titles or products/year. Game/product lines include: *Big Eyes*, *Small Mouth* game line, *Magnum Opus* and *Silver Age Sentinels* superhero game line.

- As *ADGM* went to press, this publisher announced plans to move to another location in Guelph in Fall 2004, so please check their website for updates.

Needs Approached by 10 illustrators and 5 designers/year. Works with 5 illustrators and 2 designers/year. Prefers local illustrators. Prefers local designers and freelancers. Prefers freelancers experienced in color, CG and line art. 100% of freelance design demands knowledge of Illustrator, Photoshop and QuarkXPress. 50% of freelance illustration demands knowledge of Photoshop.
First Contact & Terms Send query letter with résumé, business card. Illustrators send printed samples, photo-copies and disk submissions. Send 10 samples. "We require 95% b&w, 5% color." Accepts disk submissions in Mac format. Send via CD. "Please do not e-mail digital samples." Samples are filed. Responds by e-mail only if interested. "Samples returned only by request and if accompanied by SAE and international postage coupons (*no* US stamps)." Portfolio review not required. Buys first or reprint rights. Finds freelancers through submission packets and conventions.
Visual Design Pays for design by the project, 50% 14 days after delivery of work and 50% 60 days after publication of project.
Text Illustration Assigns 6-10 freelance illustration jobs/year. Pays by the project. Prefers characters with backgrounds, scenic art, and/or technical illustrations.
Tips "We need fast, reliable workers who know what a roleplaying game is, with quick turnaround."

◆ GUERNICA EDITIONS

P.O. Box 117, Station P, Toronto ON M5S 2S6 Canada. (416)658-9888. Fax: (416)657-8885. E-mail: guernicaediti ons@cs.com. Website: www.guernicaeditions.com. **Publisher/Editor:** Antonio D'Alfonso. Editor: Joseph Pivato. Estab. 1978. Book publisher and literary press specializing in translation. Publishes trade paperback originals and reprints. Types of books include contemporary and experimental fiction, biography and history. Specializes in ethnic/multicultural writing and translation of European and Quebecois writers into English. Publishes 20-25 titles/year. Recent titles include: *Birdheart* and *Mask*, by Elana Wolff (artist: Normand Cousineau); *Isabelle's Notebooks*, by Sylvie Cheput (artist: Hono Lulu); *Borrowed Light*, by Merle Nudelman (artist: Normand Cousineau). 40-50% require freelance illustration. Book catalog available for SAE; nonresidents send IRC.

Needs Approached by 6 freelancers/year. Works with 6 freelance illustrators/year. Uses freelancers mainly for jacket/cover illustration.

First Contact & Terms Send query letter with résumé, SASE (or SAE with IRC), tearsheets, photographs and photocopies. Samples are filed or are returned by SASE if requested by artist. Responds only if interested. To show portfolio, mail photostats, tearsheets and dummies. Buys one-time rights. Originals are not returned at job completion.

Jackets/Covers Assigns 10 freelance illustration jobs/year. Pays by the project, $150-200.

Tips "We really believe that the author should be aware of the press they work with. Try to see what a press does and offer your own view of that look. We are looking for strong designers. We have three new series of books, so there is a lot of place for art work."

HARLAN DAVIDSON, INC.

773 Glenn Ave., Wheeling IL 60090-6000. (847)541-9720. Fax: (847)541-9830. E-mail: harlandavidson@harland avidson.com. Website: www.harlandavidson.com. **Production Manager:** Lucy Herz. Imprints include Forum Press and Crofts Classics. Publishes textbooks. Types of books include biography, classics in literature, drama, political science and history. Specializes in US and European history. Publishes 6-15 titles/year. Titles include: *The History of Texas*. 20% requires freelance illustration; 20% requires freelance design. Catalog available.

Needs Approached by 2 designers/year. Works with 1-2 designers/year. 100% of freelance design demands knowledge of Photoshop.

First Contact & Terms Designers send query letter with brochure and résumé. Samples are filed or are returned by SASE. Responds in 2 weeks. Portfolio review required from designers. Will contact artist for portfolio review of book dummy if interested. Buys all rights.

Book Design Assigns 3 freelance design jobs/year. Pays by the project, $500-1,000.

Jackets/Covers Assigns 3 freelance design jobs/year. Pays by the project, $500-1,000. Finds freelancers through networking.

Tips "Have knowledge of file preparation for electronic prepress."

◆ HARLEQUIN ENTERPRISES LTD.

225 Duncan Mill Rd., Toronto ON M3B 3K9 Canada. (416)445-5860. Fax: (416)445-8736. **Contact:** Vivian Ducas, creative art editor. Publishes mass market paperbacks. Specializes in women's fiction. Publishes more than 100 titles/year. 15% requires freelance design; 100% requires freelance illustration. Book catalog not available.

Needs Approached by 1-3 designers and 20-50 illustrators/year. Works with 2 designers and 25 illustrators/year. 100% of freelance design work demands knowledge of Illustrator, Photoshop and QuarkXPress.

First Contact & Terms Designers send postcard sample with brochure, photocopies, résumé, tearsheets and URL. Illustrators send postcard sample with brochure, photocopies, tearsheets and URL. After introductory mailing, send follow-up postcard sample every 6 months. Samples are filed and not returned. Does not reply. Company will contact artist for portfolio review if interested. Portfolio should include b&w and color tearsheets and color outputs. Buys all rights. Finds freelancers through art competitions, art exhibits/fairs, art reps, artist's submissions, competition/book credits, Internet, sourcebooks, word of mouth.

Jackets/Covers Assigns more than 50 freelance cover illustration jobs/year. Prefers variety of representational art—not just romance genre.

HARMONY HOUSE PUBLISHERS—LOUISVILLE

P.O. Box 90, Prospect KY 40059. (502)228-4446. Fax: (502)228-2010. **Art Director:** William Strode. Estab. 1980. Publishes hardcover books. Specializes in general books, cookbooks and education. Publishes 20 titles/year. Titles include *Sojourn in the Wilderness* and *Christmas Collections*. 10% require freelance illustration.

Needs Approached by 10 freelancers/year. Works with 2-3 freelance illustrators/year. Prefers freelancers with experience in each specific book's topic. Uses freelancers mainly for text illustration. Also for jacket/cover illustration. Usually works on assignment basis.

First Contact & Terms Send query letter with brochure, résumé, SASE and appropriate samples. Samples are

filed or are returned. Responds only if interested. "We don't usually review portfolios, but we will contact the artist if the query interests us." Buys one-time rights. Returns originals at job's completion. Assigns several freelance design and 2 illustration jobs/year. Pays by the project.

N THE HAWORTH PRESS, INC.

10 Alice St., Binghamton NY 13904-1580. (607)722-5857. Fax: (607)722-1424. E-mail: getinfo@haworth.com. Website: www.haworthpress.com. **Cover Design Director:** Marylouise E. Doyle. Estab. 1979. Imprints include Harrington Park Press, Haworth Pastoral Press, International Business Press, Food Products Press, Haworth Medical Press, Haworth Maltreatment, The Haworth Hospitality/Tourism Press and Trauma Press. Publishes hardcover originals, trade paperback originals and reprints and textbooks. Types of books include biography, new age, nonfiction, reference, religious and textbooks. Specializes in social work, library science, gerontology, gay and lesbian studies, addictions, etc. Catalog available.

Needs Approached by 2 illustrators and 5 designers/year. 100% of freelance design and illustration demands knowledge of PageMaker, Photoshop and Illustrator.

First Contact & Terms Designers send photocopies, SASE and slides. Illustrators send postcard sample or query letter with photocopies. Accepts disk submissions compatible with Illustrator and Photoshop 3.0. Samples are filed. Responds only if interested. Will contact artist for portfolio review of slides if interested. Buys reprint rights. Rights purchased vary according to project. Finds freelancers through word of mouth.

Book Design Pay varies.

Jackets/Covers Pay varies. Prefers a variety as long as camera ready art can be supplied.

▣ HAY HOUSE, INC.

P.O. Box 5100, Carlsbad CA 92018-5100. (800)431-7695. **Art Director:** Christy Salinas. Publishes hardcover originals and reprints, trade paperback originals and reprints, audio tapes, CD-ROM. Types of books include New Age, astrology, metaphysics, psychology and gift books. Specializes in self-help. Publishes 100 titles/year. Recent titles include: *The Western Guide to Feng Shui*; *Heal Your Body A-Z*; *New York Times* bestseller *Adventures of a Psychic*. 40% require freelance illustration; 30% require freelance design.

• Hay House is also looking for people who design for the gift market.

Needs Approached by 50 freelance illustrators and 5 freelance designers/year. Works with 20 freelance illustrators and 2-5 freelance designers/year. Uses freelancers mainly for cover design and illustration. 80% of freelance design demands knowledge of Photoshop, Illustrator, QuarkXPress. 20% of titles require freelance art direction.

First Contact & Terms Designers send photocopies (color), résumé, SASE "if you want your samples back." Illustrators send photocopies. "We accept TIFF and EPS images compatible with the latest versions of QuarkXPress, Photoshop and Illustrator. Samples are filed or are returned by SASE. Art director will contact artist for portfolio review of printed samples or original artwork if interested. Buys all rights. Finds freelancers through word of mouth, submissions.

Book Design Assigns 20 freelance design jobs/year; 10 freelance art direction projects/year.

Jacket/Covers Assigns 50 freelance design jobs and 25 illustration jobs/year. Pays for design by the project, $800-1,000. Payment for illustration varies for covers.

Text Illustration Assigns 10 freelance illustration jobs/year.

Tips "We look for freelancers with experience in graphic design, desktop publishing, printing processes, production and illustrators with strong ability to conceptualize."

HEAVY METAL

100 N. Village Rd., Suite 12, Rookvill Center NY 11570. Website: www.metaltv.com. **Contact:** Submissions. Estab. 1977. Publishes trade paperback originals. Types of books include comic books, fantasy and erotic fiction. Specializes in fantasy. Recent titles include: *The Universe of Cromwell*; *Serpieri Clone*. Art guidelines on website.

• See also listing in Magazine section.

First Contact & Terms Send contact information (mailing address, phone, fax, e-mail), photocopies, photographs, SASE, slides. Samples are returned only by SASE. Responds in 3 months.

Tips "Please look over the kinds of work we publish carefully so you get a feel for the kinds of work we are looking for."

N HERALDIC GAME DESIGN

1013 W. Virginia Ave., Peoria IL 61604. (305)686-0845. E-mail: www.heraldic@aol.com. Website: www.heraldicgame.com. **Owner:** Keith W. Sears. Estab. 1993. Publishes roleplaying game books. Main style/genre of games: science fiction, cyberpunk, fantasy, Victorian, horror. Recent titles include: *Steeltown: The Outsider Chronicles, Volume One*; *Inside Outsider: The Outsider Chronicles, Volume Two*. Uses freelance artists mainly for b&w interior illustrations. Publishes 2 titles or products/year. 100% requires freelance illustration.

First Contact & Terms Accepts disk submissions in Windows format. Send via CD, floppy disk, Zip or e-mail

as TIFF, GIF or JPEG files. Samples are filed. Portfolio review not required. Negotiates rights purchased. Finds freelancers through e-mail and submission packets.

Text Illustration Assigns 2 freelance text illustration jobs/year. Pays 5% royalty.

ℕ HILL AND WANG

19 Union Square W., New York NY 10003. (212)741-6900. Fax: (212)633-9385. Website: www.fsgbooks.com. **Art Director:** Susan Mitchell. Imprint of Farrar, Straus & Giroux. Imprint publishes hardcover, trade and mass market paperback originals and hardcover reprints. Types of books include biography, coffee table books, cookbooks, experimental fiction, historical fiction, history, humor, mainstream fiction, New Age, nonfiction and self-help. Specializes in literary fiction and nonfiction. Publishes 120 titles/year. Recent titles include: *Love Artist, Grace Paley Collected Stories*. 20% require freelance illustration; 10% require freelance design.

Needs Approached by hundreds of freelancers/year. Works with 10-20 freelance illustrators and 10-20 designers/year. Prefer artist without rep with a strong portfolio. Uses freelancers for jacket/cover illustration and design. Works on assignment only.

First Contact & Terms Send postcard sample of work or query letter with portfolio samples. Samples are filed and are not returned. Responds only if interested. Artist should continue to send new samples. Portfolios may be dropped off every Wednesday and should include printed jackets. Rights purchased vary according to project. Originals are returned at job's completion. Finds artists through word of mouth and submissions.

Book Design Pays by the project.

Jackets/Covers Assign 10-20 freelance design and 10-20 illustration jobs/year. Pays by the project, $500-1,500.

Text Illustration Assigns 10-20 freelance illustration jobs/year. Pays by the project, $500-1,500.

ℕ 🖍 HIPPOCRENE BOOKS INC.

171 Madison Ave., Suite 1602, New York NY 10016. (212)685-4371. Fax: (212)779-9338. Website: www.hippocrenebooks.com. **Editor:** Nicholas Williams. Estab. 1971. Publishes hardcover originals and trade paperback reprints. Types of books include biography, cookbooks, history, nonfiction, reference, travel, dictionaries, foreign language, bilingual. Specializes in dictionaries, cookbooks, love poetry. Publishes 60 titles/year. Recent titles include: *Hippocrene Children's Illustrated Foreign Language Dictionaries*; *St Patrick's Secrets*; *American Proverbs*. 10% requires freelance illustration. Book catalog free for 9 × 12 SAE with 4 first-class stamps.

Needs Approached by 150 illustrators and 50 designers/year. Works with 2 illustrators and 3 designers/year. Prefers local freelancers experienced in line drawings.

First Contact & Terms Designers send query letter with photocopies, SASE, tearsheets. Illustrators send postcard sample and follow-up postcard every 6 months. No disk submissions. Samples are filed. Will contact artist for portfolio review if interested. Portfolio should include photocopies of artwork portraying "love" poetry and food subjects. Buys one-time rights. Finds freelancers through promotional postcards and suggestion of authors.

Jackets/Covers Assigns 2 freelance design and 4 freelance illustration jobs/year. Pays by the project, $200-500.

Text Illustration Assigns 4 freelance illustration jobs/year. Pays by the project, $250-1,700. Prefers freelancers who create drawings/sketches for love or poetry books.

Tips "We prefer traditional illustrations appropriate for gift books and cookbooks."

✅ HOLCOMB HATHAWAY, PUBLISHERS

6207 N. Cattle Track Rd., Suite 5, Scottsdale AZ 85250. (480)991-7881. Fax: (480)991-4770. Website: www.hh-pub.com. E-mail: ckelly@hh-pub.com. **Production Director:** Gay Pauley. Managing Editor: Collette Kelly. Estab. 1997. Publishes college textbooks. Specializes in education, communication. Publishes 10 titles/year. Recent titles include: *Learning Is A Verb*. 50% requires freelance cover illustration; 10% requires freelance design. Book catalog not available.

Needs Approached by 15 illustrators and 15 designers/year. Works with 3 illustrators and 10 designers/year. Prefers freelancers experienced in cover design, typography, graphics. 100% of freelance design and 50% of freelance illustration demands knowledge of Photoshop, Illustrator, QuarkXPress.

First Contact & Terms Send query letter with brochure. Illustrators send postcard sample. Will contact artist for portfolio review of photocopies and tearsheets if interested. Rights purchased vary according to project.

Book Design Assigns 3 freelance design jobs/year. Pays for design by the project, $500-1,500.

Jackets/Covers Assigns 10 design jobs/year. Pays by the project, $750-1,000. Pays for cover illustration by the project.

Text Illustration Assigns 2 freelance illustration jobs/year. Pays by the piece. Prefers computer illustration. Finds freelancers through word of mouth, submissions.

Tips "It is helpful if designer has experience with college textbook design and good typography skills."

HOLIDAY HOUSE

425 Madison Ave., New York NY 10017. (212)688-0085. Website: www.holidayhouse.com. **Editor-in-Chief:** Regina Griffin. Art Director: Claire Counihan. Specializes in hardcover children's books. Publishes 50 titles/year. 75% require illustration. Recent titles include: *Here in Harlem: Poems in many voices*, by Walter Dean Myers; *Two by Two*, by John Winch; *Thanksgiving is . . .*, by Gail Gibbons.

Needs Only accepts art suitable for children and young adults. Works on assignment only.

First Contact & Terms Send cover letter with photocopies and SASE. Samples are filed or are returned by SASE. Request portfolio review in original query. Responds only if interested. Originals are returned at job's completion. Finds artists through submissions and agents.

Jackets/Covers Assigns 5-10 freelance illustration jobs/year. Pays by the project, $900-1,200.

Text Illustrations Assigns 35 freelance jobs/year (picture books). Pays royalty.

Ⓝ HOLLOW EARTH PUBLISHING

P.O. Box 51480, Boston MA 02205. (617)249-0161. Fax: (617)249-0161. E-mail: hep2@aol.com. **Publisher:** Helian Yvette Grimes. Estab. 1983. Company publishes hardcover, trade paperback and mass market paperback originals and reprints, textbooks, electronic books and CD-ROMs. Types of books include contemporary, experimental, mainstream, historical and science fiction, instruction, fantasy, travel and reference. Specializes in mythology, photography, computers (Macintosh). Publishes 5 titles/year. Titles include *Norse Mythology*, *Legend of the Niebelungenlied*. 50% require freelance illustration; 50% require freelance design. Book catalog free for #10 SAE with 1 first-class stamp.

Needs Approached by 250 freelancers/year. Prefers freelancers with experience in computer graphics. Uses freelancers mainly for graphics. Also for jacket/cover design and illustration, text illustration, book design and multimedia projects. 100% of freelance work demands knowledge of Illustrator, QuarkXPress, Photoshop, FreeHand, Director or rendering programs. Works on assignment only.

First Contact & Terms Send e-mail queries only. Responds in 1 month. Art director will contact artist for portfolio review if interested. Portfolio should include color thumbnails, roughs, tearsheets and photographs. Buys all rights. Originals are returned at job's completion. Finds artists through submissions and word of mouth.

Book Design Assigns 12 book and magazine covers/year. Pays by the project, $100 minimum.

Jackets/Covers Assigns 12 freelance design and 12 illustration jobs/year. Pays by the project, $100 minimum.

Text Illustration Assigns 12 freelance illustration jobs/year. Pays by the project, $100 minimum.

Tips Recommends being able to draw well. First-time assignments are usually article illustrations; covers are given to "proven" freelancers.

✓ HENRY HOLT BOOKS FOR YOUNG READERS

Imprint of Henry Holt and Company, 115 W. 18th St., 6th Floor, New York NY 10011. (212)886-9200. Fax: (212)633-0748. Website: www.henryholt.com. **Creative Director:** Raquel Jaramillo. Estab. 1833. Imprint publishes hardcover originals and reprints. Types of books include children's picture books, juvenile, preschool and young adult. Publishes 250 titles/year. Recent titles include: *Hondo & Fabian*, by Peter McCarty; *The House at Awful End*, by Philip Ardaugh. 100% requires freelance illustration. Book catalog free with 9×12 SASE.

Needs Approached by 2,500 freelancers/year.

First Contact & Terms Send query letter with photocopies and SASE. Samples are returned by SASE if requested by artist. Responds in 3 months if interested. Portfolios may be dropped off every Monday by 9 a.m. for 5 p.m. pickup. Art director will contact artist for portfolio review if interested. Portfolio should include tearsheets. "Anything artist feels represents style, ability and interests." Buys all rights. Finds artists through word of mouth, artists' submissions and attending art exhibitions.

Jackets/Covers Assigns 8-16 freelance illustration jobs/year. Pays by the project.

HOMESTEAD PUBLISHING

Box 193, Moose WY 83012. Phone/fax: (307)733-6248. **Contact:** Art Director. Estab. 1980. Publishes hardcover and paperback originals. Types of books include art, biography, history, guides, photography, nonfiction, natural history, and general books of interest. Publishes more than 30 titles/year. Recent titles include: *Cubby in Wonderland*; *Windswept*; *Banff-Jasper Explorer's Guide*. 75% requires freelance illustration. Book catalog free for SAE with 4 first-class stamps.

Needs Works with 20 freelance illustrators and 10 designers/year. Prefers pen & ink, airbrush, pencil and watercolor. 25% of freelance work demands knowledge of PageMaker or FreeHand. Works on assignment only.

First Contact & Terms Send query letter with printed samples to be kept on file or write for appointment to show portfolio. For color work, slides are suitable; for b&w, technical pen, photostats. Samples not filed are returned by SASE only if requested. Responds in 10 days. Rights purchased vary according to project. Originals are not returned.

Book Design Assigns 6 freelance design jobs/year. Pays by the project, $50-3,500.

Loren Long

An established illustrator on marketing, Madonna and Walt Whitman

Ask Loren Long to describe his work and he will say conventional realism with an edge. Ask celebrity-author Madonna, whose children's book *Mr. Peabody's Apples* Long recently illustrated, and she'll say "great." But no matter what you want to call his Thomas Hart Benton-inspired illustrations, you can find them in children's and young adult books, magazines, posters, and an art gallery.

Nicholas Callaway, founder of Callaway Editions, conducted a worldwide search for an illustrator for Madonna's second children's book. "We spent many months researching the project," Callaway explains. "We gave Loren a test and he passed with flying colors."

The test was to create an illustration based on the book's manuscript without any art direction. Long says he knew exactly what to paint, which was obviously to Madonna's liking as it became the cover image of the book.

Long and Madonna had an e-mail relationship of sorts during the six-month period it took to create the art for *Mr. Peabody's Apples*. Long would send sketches to Callaway who then forwarded them to Madonna for feedback. She would respond with her thoughts, feelings, and opinions—oftentimes in a very detailed manner. "She was very concise," says Long. "I was impressed that after she chose me she very much left me to search for my own vision of her story. I respected and appreciated her for that."

Long met Madonna in person three months after the book was completed. Madonna read excerpts from *Mr. Peabody's Apples* to an auditorium filled with elementary school children at a press conference in conjunction with the worldwide lauch of the book.

As proud as he is of the work he created with Madonna, Long is equally proud of his other children's books. He has several titles in progress, including one he's writing and illustrating himself. "I'm trying to take a story and develop the cinematography for the movie," he says of the illustration process. "The words are like a screenplay and I'm choosing which scenes to bring to life. It's very creative. The process of making a children's book is fulfilling. It's a way to touch children and to have an impact on American culture in general."

How did your marketing strategy develop over the years?

First I was trying to get anything and everything I could. I didn't know what market I wanted. Then I wised up a little and realized you can help yourself and your potential client when you figure out who you want to be. I thought about what I wanted to do and what I didn't want to do. I'm not a comic book artist. I'm not a greeting card artist. I wanted to be a children's book illustrator.

How does finding your calling affect the marketing of your work?

Once you figure out what illustration niche you want to get into, you know who to send work to. You don't send your portfolio to *Rolling Stone* if it's not geared to that market.

Once you decide on your market, what do you do next?

Portfolio, portfolio, portfolio. Don't put the cart before the horse. When students ask me about stressful details like contracts, I tell them, "Don't get ahead of yourself." This can be a simple field. But if you don't have a portfolio first and your work isn't as developed and strong as it can be, contracts and other things won't matter. Your portfolio should convey a certain amount of direction in your work, mainly stylistically. If you are all across the board stylistically and don't have one general look to your work—a signature look—you are not ready to go out and get work.

Once your portfolio is ready, you need to put your work in front of somebody who can buy it. If they have a need for illustration in your style, they buy it.

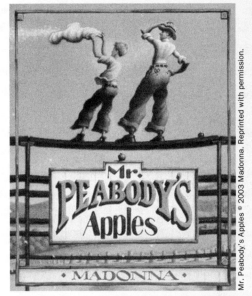

Mr. Peabody's Apples © 2003 Madonna. Reprinted with permission.

Madonna personally chose five different artists to illustrate her five children's books. She thought Loren Long's painting style fit the mood of her story *Mr. Peabody's Apples* set in 1949. Visit www.lorenlong.com to view Long's original sketches for *Mr. Peabody's Apples*. (Roll the cursor over the sketches and they magically transform into finished paintings).

Did you get help and advice from other illustrators?

When I was first starting out, I would go to C.F. Payne's house at 10:30 at night. He would be on a deadline for *Sports Illustrated* and he would let me paint some small details on his paintings. I was almost like his apprentice. I could bounce questions off of him—simple things like, "How do you send your work to possible clients?"

Does an illustrator need a rep?

When your portfolio is ready you should consider a rep, even if it's a small regional operation. It was good for me because while I worked on my portfolio, my rep was sending my work around. They can also give you advice. Even if they reject you, you can get some tips.

What about a mass promotional mailing?

I'm skeptical about mass mailings. This tactic has worked for some illustrators, but the market has changed in the last five to ten years. My publishers don't take unsolicited work.

I suggest entering your work in national juried exhibitions. The biggest ones are those held by *Communication Arts* magazine, *Communication Arts Illustration Annual*, the Society of Illustrators, American Illustration, *Step by Step* (trade magazine) and *Print* magazine.

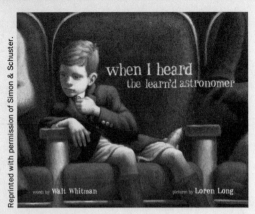

Reprinted with permission of Simon & Schuster.

Simon & Schuster editor Kevin Lewis thought of Long to illustrate Walt Whitman's poem "When I Heard The Learn'd Astronomer" for a picture book. Though the mystical theme was a challenge to illustrate, the poet's words inspired Long to paint images of wonder that will bring the classic poem to a new audience.

When I began getting my work in annual competitions, I began getting exposure, which put my work in front of people like Nick Callaway. The annuals attract the Who's Who in illustration. It's also a way to study what is going on in the field of illustration.

This has been a very busy year for you. What are you working on now?

I'm really proud of a book I've just finished illustrating for Simon & Schuster. For a long time my editor, Kevin Lewis, had an idea for a picture book based on the poem "When I Heard the Learn'd Astronomer," by Walt Whitman. He had been thinking about it for a long time but was waiting for the right illustrator. I was really honored and humbled when he asked me to illustrate Walt Whitman's words. The poem is only eight lines, but if you read it you might understand what a challenge it was to decide how to approach it visually—what image could illustrate each line. As I worked on the project I often wondered what Walt would think. I hope he would approve.

Illustrating the words of a contemporary pop icon and the poetry of Walt Whitman—how do you follow that?

With another challenge—illustrating a book written by me. My next project for Simon & Schuster is a book I'm both illustrating and writing. It's definitely stretching me, but I'm really enjoying it!

—*Marilyn Bauer*

Book Publishers

Jackets/Covers Assigns 2 freelance design and 4 illustration jobs/year. Pays by the project, $50-3,500.
Text Illustration Assigns 50 freelance illustration jobs/year. Prefers technical pen illustration, maps (using airbrush, overlays, etc.), watercolor illustrations for children's books, calligraphy and lettering for titles and headings. Pays by the hour, $5-20 or by the project, $50-3,500.
Tips "We are using more graphic, contemporary designs and looking for exceptional quality."

N HONOR BOOKS
Imprint of Cook Communications, 4050 Lee Vance View, Colorado Springs CO 80918. (719)536-0100. Fax: (719)536-3269. E-mail: info@honorbooks.com. Website: www.cookministries.com. **Creative Director:** Randy Maid. Estab. 1991. Publishes hardcover originals, trade paperback originals, mass market paperback originals and gift books. Types of books include biography, coffee table books, humor, juvenile, motivational, religious and self-help. Specializes in inspirational and motivational. Publishes 60-70 titles/year. Recent titles include: *God's Hands on my Shoulder*; *Breakfast for the Soul*. 40% require freelance illustration; 90% require freelance design.
Needs Works with 4 illustrators and 10 designers/year. Prefers illustrators experienced in line art; designers experienced in book design. Uses freelancers mainly for design and illustration. 100% of freelance design demands knowledge of FreeHand, Photoshop, Illustrator and QuarkXPress. 20% of freelance illustration demands knowledge of FreeHand, Photoshop and Illustrator. 15% of titles require freelance art direction.
First Contact & Terms Designers send query with photocopies and tearsheets. Illustrators send postcard, printed samples or tearsheets. Send follow-up postcard every 3 months. Accepts disk submissions compatible with QuarkXPress or EPS files. Samples are filed. Responds in 3 weeks. Request portfolio review in original query. Will contact artist for portfolio review of book dummy, photographs, roughs and tearsheets if interested. Rights purchased vary according to project.

Book Design Assigns 60 freelance design jobs/year. Pays by the project, $300-1,800.

Jackets/Covers Assigns 60 freelance design jobs and 30 illustration jobs/year. Pays for design by the project, $700-2,400. Pays for illustration by the project, $400-1,500.

Text Illustration Pays by the project. Finds freelancers through *Creative Black Book*, word of mouth, conventions and submissions.

Ⓝ HOUGHTON MIFFLIN COMPANY

Children's Book Department, 222 Berkeley St., Boston MA 02116. (617)351-3297. Fax: (617)351-1111. Website: www.hmco.com. **Creative Director:** Sheila Smallwood. Estab. 1880. Company publishes hardcover originals. Types of books include juvenile, preschool and young adult. Publishes 60-70 titles/year. 100% requires freelance illustration; 10% requires freelance design. Recent titles include: *What Do You Do with a Tail Like This*, by Steve Jenkins (winner of the Caldecott Medal); *Remember*, by Toni Morrison; *The Red Book*, by Barbara Lehman.

- Houghton Mifflin now has a new imprint, Graphia, a high-end literary fiction paperback book series for teens.

Needs Approached by 6-10 freelancers/year. Works with 50 freelance illustrators and 10 designers/year. Prefers artists with interest in or experience with children's books. Uses freelance illustrators mainly for jackets, picture books. Uses freelance designers primarily for photo essay books. 100% of freelance design work demands knowledge of QuarkXPress, Photoshop and Illustrator.

First Contact & Terms Please send samples through artist rep only. Finds artists through artists' reps, sourcebooks, word of mouth.

Book Design Assigns 10-20 freelance design jobs/year. Pays by the project.

Jackets/Covers Assigns 5-10 freelance illustration jobs/year. Pays by the project.

Text Illustration Assigns up to 50 freelance illustration jobs/year. Pays by the project.

Ⓘ HOWELL PRESS, INC.

1713-2D Allied Lane, Charlottesville VA 22903. (434)977-4006. Fax: (434)971-7204. E-mail: editorial@howellpress.com. Website: www.howellpress.com. **President:** Ross A. Howell Jr. Estab. 1985. Company publishes hardcover and trade paperback originals. Types of books include history, coffee table books, cookbooks, gardening, quilts and crafts, aviation, transportation and titles of regional interest. Publishes 6-8 titles/year. Recent titles include: *Colonial Churches of Virginia*, by Don and Sue Massey; *The Nation's Hangar*; the *Aircraft Study Collection of the National Air and Space Museum*, by Robert vanderLinden; *Swear Like a Trooper*, by William Priest. 50% require freelance illustration and design. Book catalog free by request.

Needs Approached by 15-20 freelancers/year. Works with 0-1 freelance illustrator and 3-5 designers/year. "It's most convenient for us to work with local freelance designers." Uses freelancers overwhelmingly for graphic design. Also for jacket/cover, direct mail, book and catalog design. 100% of freelance work demands knowledge of PageMaker, Illustrator, Photoshop or QuarkXPress.

First Contact & Terms Designers send query letter with résumé, SASE and tearsheets. Illustrators send query letter with résumé, photocopies, SASE and tearsheets. Samples are filed and are returned by SASE if requested by artist. Production manager will contact artist for portfolio review if interested. Portfolio should include color tearsheets and slides. Negotiates rights purchased. Originals are returned at job's completion. Finds artists through submissions.

Book Design Assigns 9-10 freelance design jobs/year. Pays for design by the hour, $25-50; by the project, $500-5,000.

Ⓜ HUMANICS PUBLISHING GROUP

12 S. Dixie Hwy., Suite 203, Lake Worth FL 33460. (800)874-8844. Fax: (888)874-8844. E-mail: humanics@mindspring.com. Website: www.humanicspub.com or www.humanicslearning.com. **Acquisitions Editor:** W. Arthur Bligh. Art Director: Hart Paul. Estab. 1976. Publishes college textbooks, paperback trade, New Age and educational activity books. Publishes 30 titles/year. Recent titles include: *Learning: Before and After School Activities*; *Homespun Curriculum*; *Learning Through Art*. Learning books are workbooks with 4-color covers and line art within; trade paperbacks are 6×9 with 4-color covers. Book catalog for 9×12 SASE. Specify which imprint when requesting catalog: Learning or trade paperbacks.

- No longer publishes children's fiction or picture books.

First Contact & Terms Send query letter with résumé, SASE and photocopies. Samples are filed or are returned by SASE if requested by artist. Rights purchased vary according to project. Originals are not returned.

Book Design Pays by the project.

Jackets/Covers Pays by the project.

Text Illustration Pays by the project.

Tips "We use 4-color covers, and our illustrations are line art with no halftones."

IDEALS PUBLICATIONS INC.

535 Metroplex Dr., Suite 250, Nashville TN 37211. (615)333-0478. Fax: (615)781-1447. **Editor:** Marjorie Lloyd. Art Director: Eve DeGrie. Publisher: Patricia Pinary. Estab. 1944. Imprints include Candy Cane Press. Company publishes hardcover originals and *Ideals* magazine. Specializes in nostalgia and holiday themes. Publishes 10-12 book titles and 6 magazine issues/year. Recent titles include: *My Funny Valentine*; *Five-Minute Devotions*. 100% requires freelance illustration. Guidelines free for #10 SASE with 1 first-class stamp.

Needs Approached by 100 freelancers/year. Works with 10-12 freelance illustrators/year. Prefers freelancers with experience in illustrating people, nostalgia, botanical flowers. Uses freelancers mainly for flower borders (color), people and spot art. Also for text illustration, jacket/cover and book design. Works on assignment only.

First Contact & Terms Send query letter with tearsheets and SASE. Samples are filed or returned by SASE. Responds only if interested. Buys all rights. Finds artists through submissions.

Text Illustration Assigns 75 freelance illustration jobs/year. Pays by the project, $125-400. Prefers oil, water-color, gouache, colored pencil or pastels.

Tips "Looking for illustrations with unique perspectives, perhaps some humor, that not only tells the story but draws the reader into the artist's world. Preferred illustrations will be somewhat realistic, not too stylized, and appropriate for religious and historical publications."

IDW PUBLISHING

4411 Morena Blvd., Suite 106, San Diego CA 92117. Website: www.idwpublishing.com. **Contact:** Jeff Mariotte, editor-in-chief. Publishes hardcover, mass market and trade paperback originals. Types of books include comic books, illustrated novel and art book nonfiction. Publishes 18 titles/year. Recent titles include: *30 Days of Night: Return to Barrow #4*; *24: One Shot*. Book catalog available on website.

First Contact & Terms Send proposal with cover letter, photocopies (5 fully inked and lettered 8½×11 pages showing story and art), 1-page synopsis of overall story. Samples are not returned. Responds only if interested.

Tips "Do not send original art. Make sure photocopies are clean, sharp, and easy to read. Be sure that each page has your name, address, and phone number written clearly on it." Do not call.

IMPACT BOOKS

Imprint of F+W Publications Inc., 4700 East Galbraith Rd., Cincinnati OH 45236. (513)531-2690. Fax: (513)531-2686. E-mail: pam.wissman@fwpubs.com. Website: www.fwpublications.com. **Aquisitions Editor:** Pam Wissman. Publishes trade paperback originals. Specializes in illustrated instructional books. Publishes 8 titles/year. Recent titles include: *Manga Madness*, by David Okum; *Comics Crash Course*, by Vince Giarrano. Book catalog free with 9×12 SASE (6 first-class stamps).

● IMPACT Books publishes titles that emphasize illustrated how-to-draw-comic-books instruction. Currently emphasizing traditional superhero, Japanese-style (Manga and Anime), and traditional-style comic characters. This market is for experienced comic-book artists who are willing to work with an IMPACT editor to produce a step-by-step how-to book about the artists' creative process.

Needs Approached by 25 author-artists/year. Works with 8 author-artists/year.

First Contact & Terms Send query letter with photocopies, photographs, résumé, SASE, slides, tearsheets, transparencies and URL. Accepts Mac-compatible e-mail submissions from artists (TIFF or JPEG). Samples are not filed and are returned. Responds only if interested. Company will contact artist for portfolio review of color finished art, roughs, photographs, slides, tearsheets and transparencies if interested. Buys all rights. Finds freelancers through artist's submissions, Internet, and word of mouth.

INNER TRADITIONS INTERNATIONAL/BEAR & COMPANY

One Park St., Rochester VT 05767. (802)767-3174. Fax: (802)767-3726. E-mail: peri@InnerTraditions.com. Website: www.InnerTraditions.com. **Art Director:** Peri Champine. Estab. 1975. Publishes hardcover originals and trade paperback originals and reprints. Types of books include self-help, psychology, esoteric philosophy, alternative medicine, Eastern religion, teen self-help and art books. Publishes 60 titles/year. Recent titles include: *Tibetan Sacred Dance*; *The Triple Goddess Tarot*; *The Cherokee Full Circle*. 50% requires freelance illustration; 50% requires freelance design. Book catalog free by request.

Needs Works with 8-9 freelance illustrators and 10-15 freelance designers/year. 100% of freelance design demands knowledge of QuarkXPress, Illustrator, FreeHand and Photoshop. Buys 30 illustrations/year. Uses freelancers for jacket/cover illustration and design. Works on assignment only.

First Contact & Terms Send query letter with résumé, SASE, tearsheets, photocopies, photographs and slides. Accepts disk submissions. Samples filed if interested or are returned by SASE if requested by artist. Responds to the artist only if interested. To show portfolio, mail tearsheets, photographs, slides and transparencies. Rights purchased vary according to project. Originals returned at job's completion. Pays by the project.

Jackets/Covers Assigns approximately 32 design and 26 illustration jobs/year. Pays by the project.

⊞ INTERNATIONAL MARINE/RAGGED MOUNTAIN PRESS

McGraw-Hill, Box 220, Camden ME 04843-0220. (207)236-4838. Fax: (207)236-6314. Website: www.books.mcg raw-hill.com/im. **Director of Editing, Design and Production:** Molly Mulhern Gross. Estab. 1969. Imprint of McGraw-Hill. Specializes in hardcovers and paperbacks on marine (nautical) and outdoor recreation topics. Publishes 50 titles/year. 50% require freelance illustration. Book catalog free by request.

Needs Works with 20 freelance illustrators and 20 designers/year. Uses freelancers mainly for interior illustration. Prefers local freelancers. Works on assignment only.

First Contact & Terms Send résumé and tearsheets. Samples are filed. Responds in 1 month. Considers project's budget when establishing payment. Buys one-time rights. Originals are not returned.

Book Design Assigns 20 freelance design jobs/year. Pays by the project, $150-550; or by the hour, $12-30.

Jackets/Covers Assigns 20 freelance design and 3 illustration jobs/year. Pays by the project, $100-500; or by the hour, $12-30.

Text Illustration Assigns 20 jobs/year. Prefers technical drawings. Pays by the hour, $12-30; or by the project, $30-80/piece.

Tips "Do your research. See if your work fits with what we publish. Write with a résumé and sample; then follow with a call; then come by to visit."

JAIN PUBLISHING CO.

Box 3523, Fremont CA 94539. (510)659-8272. Fax: (510)659-0501. E-mail: mail@jainpub.com Website: www.jai npub.com. **Publisher:** M.K. Jain. Estab. 1989. Publishes hardcover originals, trade paperback originals and reprints and textbooks. Types of books include business, health, self-help, religious and philosophies (Eastern). Publishes 8 titles/year. Recent titles include: *Introduction to the Lotus Sutra*; *Classical Korean Publishing*. Books are "uncluttered, elegant, using simple yet refined art." 100% require freelance jacket/cover design.

Needs Approached by 50 freelancers/year. Works with 4 freelance illustrators and designers/year. Prefers freelancers with experience in book cover design. Uses freelancers mainly for jacket/cover design. Also for jacket/cover illustration. 100% of freelance work demands knowledge of Illustrator, Photoshop and QuarkXPress.

First Contact & Terms Send postcard sample or query letter with tearsheets. Accepts disk submissions. Samples are filed. Responds to the artist only if interested. Rights purchased vary according to project. Originals are not returned.

Jackets/Covers Assigns 10 freelance design and 10 illustration jobs/year. Prefers "color separated disk submissions." Pays by the project, $300-500.

Tips Expects "a demonstrable knowledge of art suitable to use with health and religious (Eastern) books."

JALMAR PRESS/INNERCHOICE PUBLISHING

24426 S. Main St., Suite 702, Carson CA 90745. (310)816-3085. Fax: (310)816-3092. E-mail: jalmarpress@att.net. Website: www.jalmarpress.com. **President:** Bradley L. Winch. Operations Manager: Cathy Winch. Estab. 1971. Publishes books emphasizing healthy self-esteem, character building, emotional intelligence, nonviolent communication, peaceful conflict resolution, stress management and whole brain learning. Publishes 12 titles/year. Recent titles include: *How to Handle a Bully*; *The Anger Workout for Teens*; *Positive Attitudes and Peacemaking*. Books are contemporary, yet simple and activity-driven.

- Jalmar has developed a line of books to help counselors, teachers and other caregivers deal with the 'tough stuff' including violence, abuse, divorce, AIDS, low self-esteem, the death of a loved one, etc.

Needs Works with 3-5 freelance illustrators and 3 designers/year. Uses freelancers mainly for cover design and illustration. Also for direct mail and book design. Works on assignment only.

First Contact & Terms Send query letter with brochure showing art style. Samples not filed are returned by SASE. 80% of freelance work demands knowledge of Photoshop, Illustrator, QuarkXPress and PDF. Buys all rights. Considers reprints but prefers original works. Considers complexity of project, budget and turnaround time when establishing payment.

Book Design Pays by the project, $200 minimum.

Jackets/Covers Pay by the project, $200 minimum.

Text Illustration Pays by the project, $15 minimum.

Tips "Portfolio should include samples that show experience. Don't include 27 pages of 'stuff.' Stay away from the 'cartoonish' look. If you don't have any computer design and/or illustration knowledge—get some! If you can't work on computers, at least understand the process of using traditional artwork with computer generated electronic files. For us to economically get more of our product out (with fast turnaround and a minimum of rough drafts), we've gone exclusively to computers for total book design; when working with traditional artists, their artwork will be placed within the computer-generated document."

JEWISH LIGHTS PUBLISHING

Sunset Farm Offices, Rt. 4, P.O. Box 237, Woodstock VT 05091. (802)457-4000. Fax: (802)457-5032. E-mail: production@jewishlights.com. Website: www.jewishlights.com. **Production Manager:** Tim Holtz. Estab. 1990. Publishes hardcover originals, trade paperback originals and reprints. Types of books include children's picture books, history, juvenile, nonfiction, reference, religious, self help, spirituality, life cycle, theology and philosophy, wellness. Specializes in adult nonfiction and children's picture books. Publishes 50 titles/year. Recent titles include: *I am Jewish*; *The Quotable Jewish Woman*; *The Jewish Journaling Book*. 10% requires freelance illustration; 50% requires freelance design. Book catalog free on request.

Needs Approached by 75 illustrators and 20 designers/year. Works with 5 illustrators and 10 designers/year. Prefers freelancers experienced in fine arts, children's book illustration, typesetting and design. 100% of freelance design demands knowledge of QuarkXPress. 50% of freelance design demands knowledge of Photoshop.

First Contact & Terms Designers send postcard sample, query letter with printed samples, tearsheets. Illustrators send postcard sample or other printed samples. Samples are filed and are not returned. Portfolio review not required. Buys all rights. Finds freelancers through submission packets, websites, searching local galleries and shows, Graphic Artists' Guild's *Directory of Illustrators* and *Picture Book*.

Book Design Assigns 40 freelance design jobs/year. Pays for design by the project.

Jackets/Covers Assigns 30 freelance design jobs and 5 illustration jobs/year. Pays for design by the project.

Tips "We prefer a painterly, fine-art approach to our children's book illustration to achieve a quality that would intrigue both kids and adults. We do not consider cartoonish, caricature-ish art for our children's book illustration."

KAEDEN BOOKS

P.O. Box 16190, Rocky River OH 44116. (440)356-0030. Fax: (440)356-5081. E-mail: joanbackus@kaeden.com. Website: www.kaeden.com. **Publisher:** Craig Urmston. Estab. 1989. Publishes children's books and picture books. Types of books include preschool, picture books and early juvenile. Specializes in educational elementary content. Publishes 8-16 titles/year. 90% require freelance illustration; 10% require freelance design. Book catalog available upon request. Recent new titles include *When I Go to Grandma's House*; *Sammy's Hamburger Caper*; *Sammy's Slippery Day*; *The Fishing Contest*.

- Kaeden Books is now providing content for Thinkbox.com and the TAE Kindlepark Electronic Book Program.

Needs Approached by 100-200 illustrators/year. Works with 5-10 illustrators/year. Prefers freelancers experienced in juvenile/humorous illustration and children's picture books. Uses freelancers mainly for story illustration. 10% of freelance illustrations demands knowledge of Illustrator, QuarkXPress, CorelDraw 9, Pagemaker or Freehand.

First Contact & Terms Designers send query letter with brochure and résumé. Illustrators send postcard sample or query letter with photocopies, photographs, printed samples, tearsheets and résumé. Samples are filed and not returned. Responds only if interested. Art director will contact artist for portfolio review if interested. Buys all rights.

Jackets/Covers Assigns 10-25 illustration jobs/year. Pays by the project. Looks for a variety of styles.

Text Illustration Assigns 10-25 jobs/year. Pays by the project. "We accept all media, though most of our books are watermedia."

Tips "We look for professional-level drawing and rendering skills, plus the ability to interpret a juvenile story. There is a tight correlation between text and visual in our books, plus a need for attention to detail. Drawings of children are especially needed. Please send only samples that pertain to our market."

✓ KALMBACH PUBLISHING CO.

21027 Crossroads Circle, P.O. Box 1612, Waukesha WI 53187. (262)796-8776. Fax: (262)796-1142. E-mail: msoliday@kalmbach.com. Website: www.kalmbach.com. **Books Art Director:** Mike Soliday. Estab. 1934. Imprints include Greenberg Books. Company publishes hardcover and trade paperback originals. Types of books include instruction, reference and history. Specializes in hobby books. Publishes 25 titles/year. Recent titles include: *Atlas of the Moon*; *Bead Art*; *Model Railroad Wiring*. 10-20% require freelance illustration; 10-20% require freelance design. Book catalog free by request.

Needs Approached by 10 freelancers/year. Works with 2 freelance illustrators and 2 designers/year. Prefers freelancers with experience in the hobby field. Uses freelance artists mainly for book layout, line art illustrations. Also for book design. 90% of freelance work demands knowledge of Illustrator, QuarkXPress or Photoshop. "Freelancers should have most updated versions." Works on assignment only.

First Contact & Terms Send query letter with résumé, tearsheets and photocopies. Samples are filed. Art Director will contact artist for portfolio review if interested. Portfolio should include slides and final art. Rights purchased vary according to project. Originals are returned at job's completion. Finds artists through word of mouth, submissions.

Book Design Assigns 10-12 freelance design jobs/year. Pays by the project, $1,000-3,000.

Text Illustration Assigns 5 freelance illustration jobs/year. Pays by the project, $250-2,000.

Tips First-time assignments are usually text illustration, simple book layout; complex track plans, etc., are given to ''proven'' freelancers. Admires freelancers who ''present an organized and visually strong portfolio; meet deadlines (especially when first working with them) and listen to instructions.''

☑ KENZER & COMPANY

511 W. Greenwood Ave., Waukegan IL 60087. (847)540-0029. Fax: (847)680-8950. E-mail: artsub@kenzerco.com. Website: www.kenzerco.com. **Contact:** Art Direction. Publishes trade paperback originals and reprints and role-playing games. Types of books include adventure, comic books and fantasy fiction. Specializes in fantasy/adventure role-playing games. Recent titles include: *Goods & Gear: The Ultimate Adverturer's Guide*; *Trove of Treasure Maps*. Submission guidelines available on website.

First Contact & Terms Send photocopies ($8^{1/2} \times 11$), SASE. Accepts e-mail submissions from illustrators. Prefers images no larger than 1 megabyte or send link to website gallery. Samples are filed and not returned. Responds in 3 months. Buys all rights. Finds freelancers through artist's submissions.

Jackets/Covers Prefers full-color cover art. Send color samples. Do not send originals.

Tips Visit the website for instructions and follow them ''precisely.''

▣ KIRKBRIDE BIBLE CO. INC.

Kirkbride Bible & Technology, 335 W. 9th St., Indianapolis IN 46202-0606. (317)633-1900. Fax: (317)633-1444. E-mail: sales@kirkbride.com. Website: www.kirkbride.com. **Director of Production and Technical Services:** Michael B. Gage. Estab. 1915. Publishes hardcover originals, CD-ROM and many styles and translations of the Bible. Types of books include reference and religious. Specializes in reference and study material. Publishes 6 main titles/year. Recent titles include: *NIV Thompson Student Bible*. 5% require freelance illustration; 20% require freelance design. Catalog available.

Needs Approached by 1-2 designers/year. Works with 1-2 designers/year. Prefers freelancers experienced in layout and cover design. Uses freelancers mainly for artwork and design. 100% of freelance design and most illustration demands knowledge of PageMaker, FreeHand, Photoshop, Illustrator and QuarkXPress. 5-10% of titles require freelance art direction.

First Contact & Terms Designers send query letter with photostats, printed samples and résumé. Illustrators send query letter with photostats, printed samples and résumé. Accepts disk submissions compatible with QuarkXPress or Photoshop files—4.0 or 3.1. Samples are filed. Responds only if interested. Rights purchased vary according to project.

Book Design Assigns 1 freelance design job/year. Pays by the hour $100 minimum.

Jackets/Covers Assigns 1-2 freelance design jobs and 1-2 illustration jobs/year. Pays for design by the project, $100-1,000. Pays for illustration by the project, $100-1,000. Prefers modern with traditional text.

Text Illustration Assigns 1 freelance illustration/year. Pays by the project, $100-1,000. Prefers traditional. Finds freelancers through sourcebooks and references.

Tips ''Quality craftsmanship is our top concern, and it should be yours also!''

☑ DENIS KITCHEN PUBLISHING

P.O. Box 2250, Amherst MA 01004-2250. (413)259-1627. Fax: (413)259-1812. E-mail: publishing@deniskitchen.com. Website: www.deniskitchenpublishing.com. **Contact:** Denis Kitchen or Steven Krupp. Estab. 1999. Publishes hardcover originals and trade paperback originals. Types of books include art prints, coffee table books, graphic novels, illustrated books, postcard books, boxed trading cards and comic books. Specializes in comix and graphic novels. Publishes 4-6 titles/year. Recent titles include: *Heroes of the Blues*, by R. Crumb; *Grasshopper & Ant*, by Harvey Kurtzman; *Mr. Natural Postcard Book*, by R. Crumb. 50% requires freelance design; 10% requires freelance illustration. Book catalog not available.

Needs Approached by 50 illustrators and 100 designers/year. Works with 6 designers and 2 illustrators/year. Prefers local designers. 90% of freelance design work demands knowledge of QuarkXPress and Photoshop. Freelance illustration demands QuarkXPress, Photoshop and sometimes old-fashioned brush and ink.

First Contact & Terms Send postcard sample with SASE, tearsheets, URL and other appropriate samples. After introductory mailing, send follow-up postcard sample every 6 months. Samples are filed or returned by SASE. Responds in 4-6 weeks. Portfolio not required. Finds freelancers through artist's submissions, art exhibits/fairs and word of mouth.

Jackets/Covers Assigns 2-3 freelance cover illustrations/year. Prefers ''comic book'' look where appropriate.

B. KLEIN PUBLICATIONS

P.O. Box 6578, Delray Beach FL 33482. (561)496-3316. Fax: (561)496-5546. **Editor:** Bernard Klein. Estab. 1955. Publishes reference books, such as the *Guide to American Directories*. Publishes approximately 15-20 titles/year. 25% require freelance illustration. Book catalog free on request.

Needs Works with 1-3 freelance illustrators and 1-3 designers/year. Uses freelancers for jacket design and direct mail brochures. 25% of titles require freelance art direction.
First Contact & Terms Submit résumé and samples. Pays $50-300.

⃞ ALFRED A. KNOPF, INC.

subsidiary of Random House Inc., 1745 Broadway, New York NY 10019-4305. (212)751-2600. Fax: (212)572-2593. Website: www.randomhouse.com/knopf. **Art Director:** Carol Carson. Publishes hardcover originals for adult trade. Specializes in history, fiction, art and cookbooks. Publishes 200 titles/year. Recent titles include: *My Life*, by Bill Clinton; *A Good Year*, by Peter Mayle; *The Undressed Art: Why We Draw*, by Peter Steinhart.
• Random House Inc. and its publishing entities are not accepting unsolicited submissions via e-mail at this time.
Needs Works with 3-5 freelance illustrators and 3-5 freelance designers/year. Prefers artists with experience in b&w. Uses freelancers mainly for cookbooks and biographies. Also for text illustration and book design.
First Contact & Terms Send query letter with SASE. Request portfolio review in original query. Artist should follow up. Sometimes requests work on spec before assigning a job. Originals are returned at job's completion.
Book Design Pays by the hour, $15-30; by the project, $450 minimum.
Text Illustration Pays by the project, $100-5,000; $50-150/illustration; $300-800/maps.
Tips Finds artists through submissions, agents and sourcebooks. "Freelancers should be aware that Macintosh/Quark is a must for design and becoming a must for maps and illustration."

HJ KRAMER/STARSEED PRESS

P.O. Box 1082, Tiburon CA 94920. (415)435-5367. Fax: (415)435-5364. E-mail: hjkramer@jps.net. **Contact:** Linda Kramer, vice president. Estab. 1987. Publishes children's hardcover and trade paperback originals. Types of books include children's picture books, personal growth, spiritual (nondenominational) fiction and non-fiction. Publishes 3-7 titles/year. Recent titles include: *Truth in Dating*; *Smudge Bunny*; *God Believes in You*; *A Goose Named Gilligan*. 20% requires freelance illustration. Book catalog free on request.
Needs Approached by 100 illustrators/year. Works with 1-2 illustrators/year.
First Contact & Terms Send query letter with brochure, photocopies, résumé, SASE, tearsheets. Samples are filed or returned by SASE. Responds only if interested. Company will contact artist for portfolio review if interested. Buys all rights. Finds freelancers through artist's submissions, Internet and word of mouth.
Text Illustration Assigns 1-2 freelance illustration jobs/year. Pays by the project. Prefers children's illustrators.

⃞ PETER LANG PUBLISHING, INC.

275 Seventh Ave., 28th Floor, New York NY 10001. Website: www.peterlangusa.com. **Production & Creative Director:** Lisa Dillon. Publishes humanities textbooks and monographs. Publishes 300 titles/year. Book catalog available on request and on website.
Needs Works with a small pool of designers/year. Prefers local freelance designers experienced in scholarly book covers. Most covers will be CMYK. 100% of freelance design demands knowledge of Illustrator, Photoshop and QuarkXPress.
First Contact & Terms Send query letter with printed samples, photocopies and SASE. Accepts Windows-compatible and Mac-compatible disk submissions. Samples are filed. Responds only if interested. Will contact artist for portfolio review if interested. Finds freelancers through referrals.
Jackets/Covers Assigns 100 freelance design jobs/year. Only accepts Quark electronic files. Pays for design by the project.

LAREDO PUBLISHING CO./RENAISSANCE HOUSE DBA

9400 Lloydcrest Dr., Beverly Hills CA 90210. (310)860-9930. Fax: (310)860-9902. E-mail: laredo@renaissancehouse.net. Website: renaissancehouse.net. **Art Director:** Sam Laredo. Estab. 1991. Publishes juvenile, preschool textbooks. Specializes in Spanish texts, educational/readers. Publishes 16 titles/year. Recent titles include: *Legends of America* (series of 21 titles); *Extraordinary People* (series of 6 titles); *Breast Health with Nutribionics*.
Needs Approached by 10 freelance illustrators and 2 freelance designers/year. Works with 2 freelance designers/year. Uses freelancers mainly for book development. 100% of freelance design demands knowledge of Photoshop, Illustrator, QuarkXPress. 20% of titles require freelance art direction.
First Contact & Terms Designers send query letter with brochure, photocopies. Illustrators send photocopies, photographs, résumé, slides, tearsheets. Samples are not filed and are returned by SASE. Responds only if interested. Portfolio review required for illustrators. Art director will contact artist for portfolio review if interested. Portfolio should include book dummy, photocopies, photographs, tearsheets and artwork portraying children. Buys all rights or negotiates rights purchased.
Book Design Assigns 5 freelance design jobs/year. Pays for design by the project.

Jacket/Covers Pays for illustration by the project, page.
Text Illustration Pays by the project, page.

LEE & LOW BOOKS

95 Madison Ave., #606, New York NY 10016-7801. (212)779-4400. Fax: (212)582-6035. E-mail: info@leeandlow. com. Website: www.leeandlow.com. **Executive Editor:** Louise May. Publisher: Philip Lee. Estab. 1991. Book publisher. Publishes hardcover originals and reprints for the juvenile market. Specializes in multicultural children's books. Publishes 12-15 titles/year. First list published in spring 1993. Titles include: *Rent Party Jazz*, by William Miller; *Where On Earth Is My Bagel?*, by Frances Park and Ginger Park; and *Love to Mamá*, edited by Pat Mora. 100% requires freelance illustration and design. Book catalog available.

Needs Approached by 100 freelancers/year. Works with 12-15 freelance illustrators and 4-5 designers/year. Uses freelancers mainly for illustration of children's picture books. 100% of design work demands computer skills. Works on assignment only.

First Contact & Terms Contact through artist rep or send query letter with brochure, résumé, SASE, tearsheets or photocopies. Samples of interest are filed. Art director will contact artist for portfolio review if interested. Portfolio should include color tearsheets and dummies. Rights purchased vary according to project. Originals are returned at job's completion.

Book Design Pays by the project.

Text Illustration Pays by the project.

Tips "We want an artist who can tell a story through pictures and is familiar with the children's book genre. We are now also developing materials for younger children, ages 2-5, so we are interested in seeing work for this age group, too. Lee & Low Books makes a special effort to work with writers and artists of color and encourages new talent. We prefer filing samples that feature children, particularly from diverse backgrounds."

LEISURE BOOKS/LOVE SPELL

Divisions of Dorchester Publishing Co., Inc., 200 Madison Avenue, New York NY 10016. (212)725-8811. Fax: (212)532-1054. Website: www.dorchesterpub.com. **Vice President Art & Production:** K. Steinhilber. Estab. 1970. Specializes in paperback, originals and reprints, especially mass market category fiction—historical romance, western, adventure, horror, thrillers, chick lit. Publishes 200 titles/year. View covers at website.

Needs Works with 24 freelance illustrators and 6 designers/year for covers. Digital, oil or acrylic. By assignment only.

First Contact & Terms Send samples by mail. Send nonreturnable tearsheets. No samples will be returned without SASE. Will respond only if samples are appropriate and if SASE is enclosed. Complexity of project will determine payment. Usually buys first rights, but rights purchased vary according to project. Interested in buying second rights (reprint rights) to previously published work for romances and westerns only.

Jackets/Covers Pays by the project.

Tips Talented new artists welcome. Be familiar with the kind of artwork we use on our covers.

LERNER PUBLISHING GROUP

241 First Ave. N., Minneapolis MN 55401. (612)332-3344. Fax: (612)332-7615. E-mail: info@lernerbooks.com. Website: www.lernerbooks.com. **Art Director:** Zach Marell. Estab. 1975. Company publishes hardcovers and paperbacks. Publishes 200 titles/year. Recent titles include: *Uncommon Revolutionary*; *Chocolate by Hershey*; *The Country Artist*. 100% require freelance illustration. Book catalog free on request.

Needs Uses 10-12 freelance illustrators/year. Uses freelancers mainly for book illustration. Also for jacket/cover design and illustration, book design and text illustration.

First Contact & Terms Send query letter with samples or tearsheets showing skill in children's book illustration to be kept on file. Samples not filed are returned by SASE. Responds in 2 weeks only if SASE included. Originals are returned at job's completion. Considers skill and experience of artist and turnaround time when establishing payment. Pays by the project, $500-3,000 average, or advance plus royalty. Considers buying second rights (reprint rights) to previously published artwork.

Tips Send samples showing active children, not animals or still life. Don't send original art. "Look at our books and see what we do."

⚏ LITURGY TRAINING PUBLICATIONS

An agency of the Roman Catholic Archdiocese of Chicago, 1800 N. Hermitage, Chicago IL 60622. (773)486-8970. Fax: (773)486-7094. **Contact:** Design Manager. Estab. 1964. Publishes hardcover originals and trade paperback originals and reprints. Types of books include religious instructional books for adults and children. Publishes 50 titles/year. Recent titles include: *A Prayer Book for Remembering the Women*; *The Weekday Lectionary*; *Confirmation, a Parish Celebration*. 60% requires freelance illustration. Book catalog free by request.

Needs Approached by 30-50 illustrators/year. Works with 10-15 illustrators/year. 10% of freelance illustration demands knowledge of Photoshop.

First Contact & Terms Illustrators send postcard sample or send query letter with printed samples, photocopies and tearsheets. Accepts Mac-compatible disk submissions. Send EPS or TIFF files. Samples are filed and are not returned. Will contact artist for portfolio review if interested. Rights purchased vary according to project.

Text Illustration Assigns 15-20 freelance illustration jobs/year. Pays by the project. ''There is more opportunity for illustrators who are good in b&w or 2-color, but illustrators who work exclusively in 4-color are also utilized.''

Tips ''Two of our books were in the AIGA 50 Best Books of the Year show in recent years and we win numerous awards. Sometimes illustrators who have done religious topics for others have a hard time working with us because we do not use sentimental or traditional religious art. We look for sophisticated, daring, fine art-oriented illustrators and artists. Those who work in a more naturalistic manner need to be able to portray various nationalities well. We never use cartoons.''

LLEWELLYN PUBLICATIONS

Box 64383, St. Paul MN 55164-0383. Fax: (651)291-1908. E-mail: webmaster@llewellyn.com. Website: www.lle wellyn.com. **Art Director:** Lynne Menturweck. Estab. 1909. Book publisher. Publishes trade paperback and mass market originals and reprints, tarot kits and calendars. Types of books include reference, self-help, meta-physical, occult, mythology, health, women's spirituality and New Age. Publishes 80 titles/year. Books have photography, realistic painting and computer generated graphics. 60% require freelance illustration. Book catalog available for large SASE and 5 first-class stamps.

Needs Approached by 100 freelancers/year. Buys 30-50 freelance illustrations/year. Prefers freelancers with experience in book covers, New Age material and realism. Uses freelancers mainly for realistic paintings and drawings. Works on assignment only.

First Contact & Terms Send e-mail with link to your site or query letter with printed samples, tearsheets, photographs, photocopies or slides (preferred). Samples are filed or are returned by SASE. Art Director will contact artist for portfolio review if interested. Sometimes requests work on spec before assigning a job. Negoti-ates rights purchased.

Jackets/Covers Assigns 40 freelance illustration jobs/year. Pays by the illustration, $150-700. Media and style preferred ''are usually realistic, well-researched, airbrush, watercolor, acrylic, oil, colored pencil. Artist should know our subjects.''

Text Illustration Assigns 25 freelance illustration jobs/year. Pays by the project, or $30-100/illustration. Media and style preferred are pencil and pen & ink, ''usually very realistic; there are usually people in the illustrations.''

Tips ''I need artists who are aware of occult themes, knowledgeable in the areas of metaphysics, divination, alternative religions, women's spirituality, and who are professional and able to present very refined and polished finished pieces. Knowledge of history, mythology and ancient civilization is a big plus.''

LOOMPANICS UNLIMITED

P.O. Box 1197, Port Townsend WA 98368. (360)385-2230. Fax: (360)385-7785. E-mail: publicity@loompanics.c om. Website: www.loompanics.com. **Editor:** Gia Cosindas. Estab. 1973. Publishes mass market paperback originals and reprints, trade paperback originals and reprints. Types of books include nonfiction, crime, police science, illegal drug manufacture, self-sufficiency and survival. Specializes in how-to with an edge. Publishes 25 titles/year. Recent titles include: *I Am Not a Number*; *Deep Inside the Underground Economy—How Millions of Americans Are Practicing Free Enterprise in an Unfree Society*; *Don't Be A Victim*. 75% requires freelance illustration. Book catalog available for $5.

Needs Prefers freelancers experienced in action drawing, action comic ink drawings.

First Contact & Terms Send query letter with printed samples, photocopies and SASE. Samples are returned by SASE. Responds only if interested. Will contact artist for portfolio review if interested. Buys one-time rights. Usually works with freelancers publisher has worked with in the past.

Book Design Pays for design by the project.

Jackets/Covers Assigns 10 freelance design jobs and 15 illustration jobs/year. Pays for design and illustration by the project. Prefers creative illustrators willing to work with controversial and unusual material.

Text Illustration Assigns 50 freelance illustration jobs/year.

Tips ''Please do not call us. We develop good, long-lasting relationships with our illustrators, who are used to our 'we're-not-sure-what-we-want-but-we'll-know-it when-we-see-it' approach.''

LUGUS PUBLICATIONS

48 Falcon St., Toronto ON M4S 2P5 Canada. (416)322-5113. Fax: (416)484-9512. E-mail: cymro43@hotmail.c om. **President:** Gethin James. Estab. 1981. Publishes hardcover, trade paperback and mass market paperback originals and reprints and textbooks. Types of books include coffee table books, cookbooks, fantasy, history, humor, instructional, juvenile, mainstream fiction, nonfiction, preschool, romance, science fiction, self-help,

textbooks, travel and young adult. Specializes in school guidance. Publishes 6 titles/year. Recent titles include: *You Don't Have to Be Jewish: Commentaries on 50 Jewish Content Movies*. 10% require freelance illustration; 10% require freelance design. Book catalog free.

Needs Approached by 5 illustrators and 2 designers/year. Works with 2 illustrators and 1 designer/year. Prefers freelancers experienced in educational publishing. Uses freelancers mainly for covers and illustration. 100% of freelance work demands knowledge of Photoshop, QuarkXPress and Color It.

First Contact & Terms Designers send query letter with brochure. Illustrators send postcard sample. Accept disk submissions compatible with Ready Set Go! Samples are not filed and are not returned. Responds only if interested. Buys all rights or rights purchased vary according to project. Finds freelancers through submissions.

Book Design Assigns 2 freelance design jobs/year. Pays by the project.

Jackets/Covers Assigns 5 freelance design and 5 illustration jobs/year. Pays by the project. Prefers complete artwork on disk or SyQuest cartridge.

Text Illustration Assigns 5 freelance illustration jobs/year. Pays by the project. Prefers artwork stored on disk or SyQuest cartridge.

Tips "It is helpful if artist has familiarity with Docutech and high speed color copying."

☑ LUMEN EDITIONS/BROOKLINE BOOKS

Box 97, Newton MA 02464. (617)868-0360. Fax: (617)588-8011. E-mail: milt@brooklinebooks.com. Website: www.brooklinebooks.com. **Editor:** Milt Budoff. Estab. 1970. Publishes hardcover originals, textbooks, trade paperback originals and reprints. Types of books include biography, children's picture books, experimental and mainstream fiction, instructional, nonfiction, reference, self-help, textbooks, travel. Specializes in translations of literary works/education books. Publishes 30 titles/year. Titles include: *Writing*, by Marguerite Duras; *Pursuit of a Woman*, by Hans Koning; *Study Power*; *The Well Adjusted Dog*. 100% requires freelance illustration; 70% requires freelance design. Book catalog free for 6×9 SAE with 2 first-class stamps.

Needs Approached by 20 illustrators and 50 designers/year. Works with 5 illustrators and 20 designers/year. Prefers freelancers experienced in book jacket design. 100% of freelance design demands knowledge of Photoshop, PageMaker, QuarkXPress.

First Contact & Terms Send query letter with printed samples, SASE. Samples are filed. Will contact artist for portfolio review of book dummy, photocopies, tearsheets if interested. Negotiates rights purchased. Finds freelancers through agents, networking, other publishers, Book Builders.

Book Design Assigns 30-40 freelance design/year. Pays for design by the project, varies.

Jackets/Covers Pays for design by the project, varies. Pays for illustration by the project, $200-2,500. Prefers innovative trade cover designs. Classic type focus.

Text Illustration Assigns 5 freelance illustration jobs/year. Pays by the project, $200-2,500.

Tips "We have a house style, and we recommend that designers look at some of our books before approaching us. We like subdued colors—that still pop. Our covers tend to be very provocative, and we want to keep them that way. No 'mass market' looking books or display typefaces. All designers should be knowledgeable about the printing process and be able to see their work through production."

Ⓝ MADISON HOUSE PUBLISHERS

4501 Forbes Blvd., Suite 200, Lanham MD 20706. (301)459-3366. Fax: (301)429-5748. Website: www.rowmanlit tlefield.com. **Vice President, Design:** Gisele Byrd Henry. Estab. 1984. Publishes hardcover and trade paperback originals. Specializes in biography, history and popular culture. Publishes 10 titles/year. Titles include *Connected Lives*; *Love and Limerence*; *Three Golden Ages*. 40% require freelance illustration; 100% require freelance jacket design. Book catalog free by request.

● Madison House is just one imprint of Rowman & Littlefield Publishing Group, which has eight imprints.

Needs Approached by 20 freelancers/year. Works with 4 freelance illustrators and 12 designers/year. Prefers freelancers with experience in book jacket design. Uses freelancers mainly for book jackets. Also for catalog design. 80% of freelance work demands knowledge of Illustrator, QuarkXPress, Photoshop or FreeHand. Works on assignment only.

First Contact & Terms Send query letter with tearsheets, photocopies and photostats. Samples are filed or are returned by SASE if requested by artist. Responds to the artist only if interested. Call for appointment to show portfolio of roughs, original/final art, tearsheets, photographs, slides and dummies. Buys all rights. Interested in buying second rights (reprint rights) to previously published work.

Jackets/Covers Assigns 16 freelance design and 2 illustration jobs/year. Pays by the project, $400-1,000. Prefers typographic design, photography and line art.

Text Illustration Pays by project, $100 minimum.

Tips "We are looking to produce trade-quality designs within a limited budget. Covers have large type, clean lines; they 'breathe.' If you have not designed jackets for a publishing house but want to break into that area, have at least five 'fake' titles designed to show ability. I would like to see more Eastern European style incorpo-

rated into American design. It seems that typography on jackets is becoming more assertive, as it competes for attention on bookstore shelf. Also, trends are richer colors, use of metallics.''

☑ ⬚ MAPEASY, INC.

P.O. Box 80, 54 Industrial Rd., Wainscott NY 11975-0080. (631)537-6213. Fax: (631)537-4541. E-mail: info@map easy.com. Website: www.mapeasy.com. **Production:** Chris Harris. Estab. 1990. Publishes maps. 100% requires freelance illustration; 25% requires freelance design. Book catalog not available.

Needs Approached by 15 illustrators and 10 designers/year. Works with 3 illustrators and 1 designer/year. Prefers local freelancers. 100% of freelance design and illustration demands knowledge of Illustrator, Photoshop, QuarkXPress and Painter.

First Contact & Terms Send query letter with photocopies. Accepts Mac-compatible disk submissions. Samples are filed. Responds only if interested. Will contact artist for portfolio review if interested. Portfolio should include photocopies. Finds freelancers through ads and referrals.

Text Illustration Pays by the hour, $45 maximum.

McFARLAND & COMPANY, INC., PUBLISHERS

Box 611, Jefferson NC 28640-0611. (336)246-4460. Fax: (336)246-5018. E-mail: info@mcfarlandpub.com. Website: www.mcfarlandpub.com. **Sales Manager:** Rhonda Herman. Estab. 1979. Company publishes hardcover and trade paperback originals. Specializes in nonfiction reference and scholarly monographs, including film and sports. Publishes 190 titles/year. Recent titles include: *The Women of Afghanistan Under the Taliban*; *James Arness: An Autobiography*. Book catalog free by request.

Needs Approached by 50 freelancers/year. Works with 5-8 freelance illustrators/year. Prefers freelancers with experience in catalog and brochure work in performing arts and school market. Uses freelancers mainly for promotional material. Also for direct mail and catalog design. Works on assignment only. 20% of illustration demands knowledge of QuarkXPress, version 3.3.

First Contact & Terms Send query letter with résumé, SASE, tearsheets and photocopies. ''Send relevant samples. We aren't interested in children's book illustrators, for example, so we do not need such samples.'' Samples are filed. Responds in 2 weeks. Portfolio review not required. Buys all rights. Originals are not returned.

Tips First-time assignments are usually school promotional materials; performing arts promotional materials are given to ''proven'' freelancers. ''Send materials relevant to our subject areas, otherwise we can't fully judge the appropriateness of your work.''

ⓝ McGRAW HILL HIGHER EDUCATION GROUP

2460 Kerper Blvd., Dubuque IA 52001. (563)588-1451. Fax: (563)589-2955. Website: www.mhhe.com or www. mcgraw-hill.com. **Art Director:** Wayne Harms. Estab. 1944. Publishes hardbound and paperback college textbooks. Produces more than 200 titles/year. 10% require freelance design; 70% require freelance illustration.

Needs Works with 15-25 freelance designers and 30-50 illustrators/year. Uses freelancers for advertising. 90% of freelance work demands knowledge of PageMaker, Illustrator, QuarkXPress, Photoshop or FreeHand. Works on assignment only.

First Contact & Terms Prefers color 35mm slides and color or b&w photocopies. Send query letter with brochure, résumé, slides and/or tearsheets. ''Do not send samples that are not a true representation of your work quality.'' Responds in 1 month. Accepts disk submissions. Samples returned by SASE if requested. Responds on future assignment possibilities. Buys all rights. Pays $35-350 for b&w and color promotional artwork. Pays half contract for unused assigned work.

Book Design Assigns 100-140 freelance design jobs/year. Uses artists for all phases of process. Pays by the project. Payment varies widely according to complexity.

Jackets/Covers Assigns 100-140 freelance design jobs and 20-30 illustration jobs/year. Pays $1,700 for 4-color cover design and negotiates pay for special projects.

Text Illustration Assigns 75-100 freelance jobs/year. Considers b&w and color work. Prefers computer-generated, continuous tone, some mechanical line drawings; ink preferred for b&w. Pays $30-500.

Tips ''In the field, there is more use of color. There is need for sophisticated color skills—the artist must be knowlegeable about the way color reproduces in the printing process. Be prepared to contribute to content as well as style. Tighter production schedules demand an awareness of overall schedules. *Must* be dependable.''

ⓝ MEADOWBROOK PRESS

5451 Smetana Dr., Minnetonka MN 55343. (952)930-1100. Fax: (952)930-1940. E-mail: pwoods@meadowbrook press.com. Website: www.meadowbrookpress.com and www.production.meadowbrookpress.com. **Production Manager:** Paul Woods. Company publishes hardcover and trade paperback originals. Types of books include instruction, humor, juvenile, preschool and parenting. Specializes in parenting, humor. Publishes 20 titles/year. Titles include *When You Were One*; *What's Your Baby's Name*; *Slumber Parties*; *52 Romantic Eve-*

nings; 1440 Reasons to Quit Smoking. 80% require freelance illustration; 10% require freelance design.
Needs Uses freelancers mainly for humor, activity books, spot art. Also for jacket/cover and text illustration. 100% of design work demands knowledge of QuarkXPress, Photoshop or Illustrator. Works on assignment only.
First Contact & Terms Designers send query letter with résumé and photocopies. Illustrators send query letter with photocopies. Samples are filed and are not returned. Responds only if interested. Art director will contact artist for portfolio review if interested. Portfolio should include b&w and color final art and transparencies. Originals are returned at job's completion. Finds artists through agents, sourcebooks and submissions.
Book Design Assigns 2 freelance design jobs/year. "Pay varies with complexity of project."
Jackets/Covers Assigns 18 freelance design and 6 freelance illustration jobs/year. Pays by the project, $500-1,500.
Text Illustration Assigns 18 freelance illustration jobs/year. Pays by the project, $50-100/illustration.
Tips "We want hardcopy samples to keep on file for review, not on disk or via e-mail, but do appreciate ability to illustrate digitally."

MILKWEED EDITIONS

1011 Washington Ave. S., Suite 300, Minneapolis MN 55415. (612)332-3192. Fax: (612)215-2550. Website: www.milkweed.org. **Managing Editor:** Laurie Buss. Art and Design Coordinator: Christian Fünfhausen. Estab. 1979. Publishes hardcover and trade paperback originals and trade paperback reprints of contemporary fiction, poetry, essays, nonfiction about the natural world, and children's novels (ages 8-13). Publishes 16-18 titles/year. Recent titles include: *Good Heart,* by Deborah Keenan; *Every War Has Two Losers,* by Kim Stafford; *Toward the Livable City,* by Emilie Buchwald; *Ordinary Wolves,* by Seth Kantner; *The South Atlantic Coast and Piedmont,* by Sara St. Antoine. Books have "beautiful, high-quality trade" look. Book catalog available for $1.50.
Needs Approached by 300 illustrators/year. Works with 3-4 illustrators/year. Buys 100 illustrations/year. Prefers artists with experience in book illustration. Prefers freelancers experienced in color and b&w. Uses freelancers mainly for b&w text illustration. Works on assignment only.
First Contact & Terms Send query letter with résumé, SASE and tearsheets. Samples are filed. Editor will contact artists for portfolio review if interested. Portfolio should include best possible samples. Rights purchased vary according to project. Interested in buying second rights (reprint rights) to previously published work. Originals are returned at job's completion. Finds artists through word of mouth, submissions and "seeing their work in already published books."
Text Illustration Assigns 3-4 jobs/year. Pays by the project. Prefers various media and styles.
Tips "Show quality drawing ability and narrative imaging. Budgets have been cut, so any jobs tend to necessitate experience. We use a variety of styles. For adult nonfiction books we are especially interested in artists who depict the natural environment. For children's fiction, ability to depict people accurately is mandatory."

Ⓝ MITCHELL LANE PUBLISHERS, INC.

1104 Kelly Dr., Newark DE 19711. (302)234-9646. Fax: (302)834-4164. Website: www.mitchelllane.com. **Publisher:** Barbara Mitchell. Estab. 1993. Publishes hardcover and trade paperback originals. Types of books include biography. Specializes in multicultural biography for young adults. Publishes 35-40 titles/year. Recent titles include: *Unlocking the Secrets of Science.* 50% requires freelance illustration; 10% requires freelance design.
Needs Approached by 20 illustrators and 5 designers/year. Works with 2 illustrators/year. Prefers freelancers experienced in illustrations of people.
First Contact & Terms Send query letter with printed samples, photocopies. Interesting samples are filed and are not returned. Will contact artist for portfolio review if interested. Buys all rights.
Jackets/Covers Prefers realistic portrayal of people.

Ⓝ MONDO PUBLISHING

980 Avenue of the Americas, New York NY 10018. E-mail: mondopub@aol.com. Website: www.mondopub.com. **Executive Editor:** Susan DerKazarian. Estab. 1992. Publishes hardcover and trade paperback originals and reprints and audio tapes. Types of books include juvenile. Specializes in fiction, nonfiction. Publishes 50 titles/year. Recent titles include: *Right Outside My Window,* by Mary Ann Hoberman; *Signs of Spring,* by Justine Fontes; *Dreams by Day, Dreams by Night,* by Nikki Grimes. Book catalog for 9×12 SASE with $3.20 postage.
Needs Works with 40 illustrators and 10 designers/year. Prefers freelancers experienced in children's hardcovers and paperbacks, plus import reprints. Uses freelancers mainly for illustration, design. 100% of freelance design demands knowledge of Photoshop, Illustrator, QuarkXPress.
First Contact & Terms Send query letter with photocopies, printed samples and tearsheets. Samples are filed. Will contact for portfolio review if interested. Portfolio should include artist's areas of expertise, photocopies, tearsheets. Rights purchased vary according to project. Finds freelancers through agents, sourcebooks, illustrator shows, submissions, recommendations of designers and authors.

Book Design Assigns 40 jobs/year. Pays by project.
Text Illustration Assigns 45-50 freelance illustration jobs/year. Pays by project.

ⓝ MORGAN KAUFMANN PUBLISHERS, INC.

Academic Press, A Harcourt Science and Technology Company, 340 Pine St., Sixth Floor, San Francisco CA 94104. (415)392-2665. Fax: (415)982-2665. E-mail: design@mkp.com. Website: www.mkp.com. **Vice President Production and Manufacturing:** Scott Norton. Estab. 1984. Company publishes computer science books for academic and professional audiences in paperback, hardback and book/CD-ROM packages. Publishes 85 titles/year. Recent titles include: *GUI Bloopers*, by Jeff Johnson. 75% require freelance interior illustration; 100% require freelance text and cover design; 15% require freelance design and production of 4-color inserts.
Needs Approached by 150-200 freelancers/year. Works with 10-15 freelance illustrators and 10-15 designers/year. Uses freelancers for covers, text design and technical and editorial illustration, design and production of 4-color inserts. 100% of freelance work demands knowledge of at least one of the following: Illustrator, QuarkXPress, Photoshop, Ventura, Framemaker, or laTEX (multiple software platform). Works on assignment only.
First Contact & Terms Send query letter with samples. Samples must be nonreturnable or with SASE. ''No calls, please.'' Samples are filed. Production editor will contact artist for portfolio review if interested. Portfolio should include final printed pieces. Buys interior illustration on a work-for-hire basis. Buys first printing and reprint rights for text and cover design. Finds artists primarily through word of mouth and submissions.
Book Design Assigns freelance design jobs for 40-50 books/year. Pays by the project. Prefers Illustrator and Photoshop for interior illustration and QuarkXPress for 4-color inserts.
Jackets/Covers Assigns 40-50 freelance design; 3-5 illustration jobs/year. Pays by the project. Uses primarily stock photos. Prefers designers take cover design through production to film and MatchPrint. ''We're interested in a look that is different from the typical technical publication.'' For covers, prefers modern, clean, spare design, with emphasis on typography and high-impact imagery.
Tips ''Although experience with book design is an advantage, sometimes artists from another field bring a fresh approach, especially to cover design. Currently the tough find is an affordable Photoshop artist for manipulation of images and collage work for covers.''

ⓝ WILLIAM MORROW & CO. INC.

Harper Collins Publishers, 10 E. 53rd St., New York NY 10022. (212)261-6695. Fax: (212)207-6968. Website: www.harpercollins.com. **Art Director:** Richard Aquan. Specializes in hardcover originals and reprint children's books, adult trade, fiction and nonfiction. Publishes 70 titles/year. Recent titles include: *The Dream Room*; *Acid Tongues and Tranquil Dreams*. 100% require freelance illustration. Book catalog free for 8½×11" SASE with 3 first-class stamps.
First Contact & Terms Works with 30 freelance artists/year. Uses artists mainly for picture books and jackets. Works on assignment only. Send query letter with résumé and samples, ''followed by call.'' Samples are filed. Responds in 1 month. Originals returned to artist at job's completion. Portfolio should include original/final art and dummies. Considers complexity of project and project's budget when establishing payment. Negotiates rights purchased.
Book Design ''Most design is done on staff.'' Assigns 1 or 2 freelance design jobs/year. Pays by the project.
Jackets/Covers Assigns 1 or 2 freelance design jobs/year. Pays by the project.
Text illustration Assigns 70 freelance jobs/year. Pays by the project.
Tips ''Be familiar with our publications.''

☑ MOUNTAIN PRESS PUBLISHING CO.

P.O. Box 2399, Missoula MT 59806. (406)728-1900. Fax: (406)728-1635. E-mail: info@mtnpress.com. Website: www.mountain-press.com. **Graphic Design:** Kim Pryhorocki. Production Design: Jean Nuckolls. Estab. 1960s. Company publishes trade paperback originals and reprints; some hardcover originals and reprints. Types of books include western history, geology, natural history/nature. Specializes in geology, natural history, history, horses, western topics. Publishes 20 titles/year. Recent titles include: *From Angels to Hellcats: Legendary Texas Women*, regional photographic field guides. Book catalog free by request.
Needs Approached by 100 freelance artists/year. Works with 5-10 freelance illustrators/year. Buys 5-10 freelance illustrations/year. Prefers artists with experience in book illustration and design, book cover illustration. Uses freelance artists for jacket/cover illustration, text illustration and maps. 100% of design work demands knowledge of PageMaker, FreeHand or Illustrator. Works on assignment only.
First Contact & Terms Send query letter with résumé, SASE and any samples. Samples are filed or are returned by SASE. Responds only if interested. Project editor will contact artist for portfolio review if interested. Buys one-time rights or reprint rights depending on project. Originals are returned at job's completion. Finds artists through submissions, word of mouth, sourcebooks and other publications.
Book Design Pays by the project.

Jackets/Covers Assigns 0-1 freelance design and 3-6 freelance illustration jobs/year. Pays by the project.

Text Illustration Assigns 0-1 freelance illustration jobs/year. Pays by the project. Prefers b&w: pen & ink, scratchboard, ink wash, pencil.

Tips First-time assignments are usually book cover/jacket illustration or map drafting; text illustration projects are given to "proven" freelancers.

MOYER BELL

549 Old North Road, Kingston RI 02881. (401)783-5480. Fax: (401)294-0959. E-mail: britt@moyerbell.com. Website: www.moyerbell.com. **Contact:** Britt Bell. Estab. 1984. Imprints include Asphodel Press. Publishes hardcover originals, trade paperback originals and reprints. Types of books include biography, coffee table books, history, instructional, mainstream fiction, nonfiction, reference, religious, self-help. Publishes 20 titles/year. 25% require freelance illustration; 25% require freelance design. Book catalog free.

Needs Works with 5 illustrators and 5 designers/year. Prefers electronic media. Uses freelancers mainly for illustrated books and book jackets. 100% of design and illustration demand knowledge of Photoshop, Illustrator, QuarkXPress and Postscript.

First Contact & Terms Designers send query letter with photocopies. Illustrators send postcard sample and/or photocopies. Accepts disk submissions. Samples are filed or returned by SASE. Rights purchased vary according to project.

Book Design Assigns 5 freelance design jobs/year. Pays by project; rates vary.

Jackets/Covers Assigns 5 design jobs and 5 illustration jobs/year. Pays by project; rates vary. Prefers Postscript.

Text Illustration Assigns 5 freelance illustration jobs/year. Payment varies. Prefers Postscript.

NBM PUBLISHING INC.

555 Eighth Ave., Suite 1202, New York NY 10018. (212)643-5407. Fax: (212)643-1545. Website: www.nbmpub.c om. **Publisher:** Terry Nantier. Publishes graphic novels for an audience of 18-34 year olds. Types of books include adventure, fantasy, mystery, science fiction, horror and social parodies. Recent titles include: *A Treasury of Victorian Murder*; *Boneyard*. Circ. 5,000-10,000.

- Not accepting submissions unless for graphic novels. Publisher reports too many inappropriate submissions from artists who "don't pay attention." Check their website for instructions before submitting, so you're sure that your art is appropriate for them.

NELSON

A division of Thomson Canada Ltd., 1120 Birchmount Rd., Scarborough ON M1K 5G4 Canada. (416)752-9100 ext. 343. Fax: (416)752-7144. E-mail: acluer@nelson.com. Website: www.nelson.com. **Creative Director:** Angela Cluer. Estab. 1931. Company publishes hardcover originals and reprints and textbooks. Types of books include instructional, juvenile, preschool, reference, high school math and science, primary spelling, textbooks and young adult. Specializes in a wide variety of education publishing. Publishes 150 titles/year. Recent titles include: *Marketing Our Environment: A Canadian Perspective*; *Language Arts K-6*; *The Learning Equation: Mathematics 9*. 70% requires freelance illustration; 25% requires freelance design. Book catalog free by request.

Needs Approached by 50 freelancers/year. Works with 30 freelance illustrators and 10-15 designers/year. Prefers Canadian artists, but not a necessity. Uses freelancers for jacket/cover design and illustration, text illustration and book design. Also for multimedia projects. 100% of design and illustration demands knowledge of Illustrator, QuarkXPress and Photoshop. Works on assignment only.

First Contact & Terms Designers send query letter with tearsheets and résumé. Illustrators send postcard sample, brochure and tearsheets. Accepts disk submissions. Samples are filed. Art Director will contact artist for portfolio review if interested. Portfolio should include book dummy, transparencies, final art, tearsheets and photographs. Rights purchased vary according to project. Originals usually returned at job's completion. Finds artists through *American Showcase*, *Creative Source*, submissions, designers' suggestions (word of mouth).

Book Design Assigns 15 freelance design jobs/year. Pays by the project, $800-1,200 for interior design, $800-1,200 for cover design.

Jackets/Covers Assigns 15 freelance design and 40 illustration jobs/year. Pays by the project, $800-1,300.

Text Illustration Pays by the project, $30-450.

NEW ENGLAND COMICS (NEC PRESS)

P.O. 690346, Quincy MA 02269. Website: www.newenglandcomics.com. Types of books include comic books and games. Recent titles include: *The Tick*. Book catalog available on website.

Needs Pencillers and inkers. Is not currently interested in new stories.

First Contact & Terms Send SASE and 2 pages of pencil or ink drawings derived from the script posted on website. Responds in 2 weeks (with SASE only).

Tips Visit website for submissions script. Do not submit original characters or stories. Do not call.

Book Publishers

THE NEW ENGLAND PRESS

Box 575, Shelburne VT 05482. (802)863-2520. Fax: (802)863-1510. E-mail: nep@together.net. Website: www.ne press.com. **Managing Editor:** Christopher A. Bray. Specializes in paperback originals on regional New England subjects and nature. Publishes 6-8 titles/year. Recent titles include: *Rum Runners & Revenuers: Prohibition in Vermont*; *Green Mountain Boys of Summer: Vermonters in the Big Leagues*; *Spanning Time: Vermont's Covered Bridges*. 50% require freelance illustration. Books have "traditional, New England flavor."

First Contact & Terms Approached by 50 freelance artists/year. Works with 2-3 illustrators and 1-2 designers/year. Send query letter with photocopies and tearsheets. Samples are filed. Responds only if interested. Considers complexity of project, skill and experience of artist, project's budget and turnaround time when establishing payment. Negotiates rights purchased. Originals not usually returned to artist at job's completion, but negotiable.

Book Design Assigns 1-2 jobs/year. Payment varies.

Jackets/Covers Assigns 2-4 illustration jobs/year. Payment varies.

Text Illustration Assigns 2-4 jobs/year. Payment varies.

Tips Send a query letter with your work, which should be "generally representational, but also folk-style and humorous; nothing cute."

N NORTH LIGHT BOOKS

Imprint of F + W Publications Inc., 4700 East Galbraith Rd., Cincinnati OH 45236. (513)531-2690. Fax: (513)531-2686. E-mail: jamie.markle@fwpubs.com. Website: www.fwpublications.com. **Executive Editor:** Jamie Markle. Publishes trade paperback originals. Specializes in fine art instruction books. Publishes 75 titles/year. Recent titles include: *Lifelike Drawing with Lee Hammond*; *Charles Reid's Watercolor Secrets*; *Splash 8: Watercolor Discoveries*. Book catalog free with 9×12 SASE (6 first-class stamps).

- North Light Books publishes art, craft and design books, including watercolor, drawing, colored pencil and decorative painting titles that emphasize illustrated how-to art instruction. This market is for experienced fine artists who are willing to work with a North Light editor to produce a step-by-step how-to book about the artists' creative process.

Needs Approached by 100 author-artists/year. Works with 22 artists/year.

First Contact & Terms Send query letter with photographs, slides and transparencies. Does not accept e-mail submissions. Samples are not filed and are returned. Responds only if interested. Company will contact artist for portfolio review of color slides if interested. Buys all rights. Finds freelancers through art competitions, art exhibits, artist's submissions, Internet and word of mouth.

Tips "Send 30 slides along with a possible book idea and outline and a sample step-by-step demonstration."

NORTHLAND PUBLISHING

2900 Fort Valley Rd., Flagstaff AZ 86001. (928)774-5251. Fax: (928)774-0592. E-mail: info@northlandpub.com. Website: www.northlandpub.com. **Art Director:** David Jenney. Estab. 1958. Company publishes hardcover and trade paperback originals. Types of books include western, travel, Native American art, cookbooks and children's picture books. Publishes 25 titles/year. Recent titles include: *Southwest Slow Cooking*; *Outdoor Style*. 50% requires freelance illustration. Art guidelines on website.

- Rising Moon is Northland's children's imprint.

Needs Approached by 1,000 freelancers/year. Works with 5-12 freelance illustrators/year. Prefers freelancers with experience in illustrating children's titles. Uses freelancers mainly for children's books. 100% of freelance work demands knowledge of Illustrator, QuarkXPress or Photoshop. Works on assignment only.

First Contact & Terms Send query letter with résumé, SASE and tearsheets. Samples are filed or are returned by SASE if requested by artist. Will contact artist for portfolio review if interested. Portfolio should include color tearsheets. Rights purchased vary according to project. Originals are returned at job's completion. Finds artists mostly through submissions.

Jackets/Covers No jacket/cover art needed.

Text Illustration Assigns 5-12 freelance illustration jobs/year. Pays by the project, $1,000-10,000. Royalties are preferred—gives cash advances against royalties.

Tips "Creative presentation and promotional pieces filed."

NORTHWOODS PRESS

P.O. Box 298, Thomaston ME 04861. Division of the Conservatory of American Letters. Website: www.americanl etters.org. **Editor:** Robert Olmsted. Estab. 1972. Specializes in hardcover and paperback originals of poetry. Publishes approximately 6 titles/year. Titles include *Aesop's Eagles*. 10% require freelance illustration. Book catalog for SASE.

• The Conservatory of American Letters now publishes the *Northwoods Journal,* a quarterly literary maga-zine. They're seeking cartoons and line art and pay cash on acceptance. Get guidelines from website.

Needs Approached by 40-50 freelance artists/year. Works with 1-2 illustrators/year. Uses freelance artists mainly for cover illustration. Rarely uses freelance artists for text illustration.

First Contact & Terms Send query letter to be kept on file. Art Director will contact artist for portfolio review if interested. Sometimes requests work on spec before assigning a job. Considers complexity of project, skill and experience of artist, project's budget, turnaround time and rights purchased when establishing payment. Buys one-time rights and occasionally all rights. Originals are returned at job's completion.

Book Design Pays by the project, $10-100.

Jackets/Covers Assigns 2-3 design jobs and 4-5 illustration jobs/year. Pays by the project, $10-100.

Text Illustration Pays by the project, $5-20.

Tips Portfolio should include ''art suitable for book covers—contemporary, usually realistic.''

Ⓝ NORTHWORD BOOKS FOR YOUNG READERS

Imprint of Creative Publishing International, 18705 Lake Drive East, Chanhassen MN 55317. Website: www.nort hwordpress.com. **Executive Editor:** Aimee Jackson. Publishes juvenile fiction and nonfiction, children's picture books; hardcover, mass market and trade paperback originals and reprints. Specializes in nature, animals and natural history. Publishes 20 titles/year. Book catalog available on website.

Needs Approached by 1-2 designers/week and 10-20 illustrators/week. Works with 2 designers and 20 illustra-tors/year. Freelance design work demands skills in Illustrator, InDesign, QuarkXPress and Photoshop.

First Contact & Terms NorthWord is not looking for designers at this time, but illustrators can send postcard samples with nonreturnable photocopies and tearsheets to be kept on file. Does not accept e-mail submissions. Responds only if interested. Portfolio review not required. Buys all rights. Finds freelancers through art reps, artist's submissions, Internet, sourcebooks and word of mouth.

Text Illustration Assigns 4-8 freelance illustration jobs/year. Pays by the project. Prefers freelancers who can illustrate nature, animals and natural history subjects.

Tips ''Review our books to see what styles we use, what types of books we publish, etc.''

⬛ 🛈 NOVALIS PUBLISHING, INC.

49 Front St. E., 2nd Floor, Toronto ON M53 1B3 Canada. (416)363-3303. Fax: (416)363-9409. E-mail: novalis@in terlog.com. Website: www.novalis.ca. **Managing Editor:** Anne Louise Mahoney. Estab. 1936. Publishes hard-cover, mass market and trade paperback originals and textbooks. Primarily religious. Publishes at least 30 titles/year. 100% requires freelance illustration; 25% requires freelance design; and 25% require freelance art direction. Free book catalog available.

Needs Approached by 4 illustrators and 4 designers/year. Works with 3-5 illustrators and 2-4 designers/year. Prefers local freelancers experienced in graphic design and production. 100% of freelance work demands knowl-edge of Illustrator, Photoshop, PageMaker, QuarkXPress.

First Contact & Terms Send postcard sample or query letter with printed samples, photocopies, tearsheets. Samples are filed or returned on request. Will contact artist for portfolio review if interested. Rights purchased vary according to project; negotiable.

Book Design Assigns 10-20 freelance design and 2-5 art direction projects/year. Pays for design by the hour, $25-40.

Jackets/Covers Assigns 5-10 freelance design and 2-5 illustration jobs/year. Prefers b&w, ink, woodcuts, linocuts, varied styles. Pays for design by the project, $100-800, depending on project. Pays for illustration by the project, $100-600.

Text Illustration Assigns 2-10 freelance illustration jobs/year. Pays by the project, $100 minimum, depending on project.

Tips ''We look for dynamic design incorporating art and traditional, non-traditional, folk etc. with spiritual, religious, Gospel, biblical themes—mostly Judeo-Christian.''

ORCHARD BOOKS

Scholastic, 557 Broadway, New York NY 10012. (212)343-4490. Fax: (212)343-4890. Website: www.scholastic.c om. Book publisher. **Art Director:** David Saylor. Estab. 1987. Publishes hardcover children's books. Specializes in picture books and novels for children and young adults. Publishes 20-30 titles/year. Recent titles include: *Talkin About Bessi,* by Nikki Grimes, illustrated by E.B. Lewis. 100% require freelance illustration; 25% require freelance design. Book catalog free for SAE with 2 first-class stamps.

Needs Works with 50 illustrators/year. Works on assignment only. 5% of titles require freelance art direction.

First Contact & Terms Designers send brochure and/or photocopies. Illustrators send samples, photocopies and/or tearsheets. Samples are filed or are returned by SASE only if requested. Responds to queries/submissions only if interested. Portfolios may be dropped off on Mondays and are returned the same day. Originals returned

to artist at job's completion. Considers complexity of project, skill and experience of artist and project's budget when establishing payment.

Book Design Assigns 5 freelance design jobs/year. Pays by the project, $650 minimum.

Jackets/Covers Assigns 20 freelance design jobs/year. Pays by the project, $650 minimum.

Text Illustration Assigns 5 freelance jobs/year. Pays by the project, minimum $2,000 advance against royalties.

Tips "Send a great portfolio."

OREGON CATHOLIC PRESS

5536 NE Hassalo, Portland OR 97213-3638. (503)281-1191. Fax: (503)282-3486. E-mail: jeang@ocp.org. Website: www.ocp.org. **Art Director:** Jean Germano. Division estab. 1997. Types of books include religious and liturgical books specifically for, but not exclusively to, the Roman Catholic market. Publishes 2-5 titles/year. 30% requires freelance illustration. Book catalog available for 9×12 SAE with first-class stamps.

- Oregon Catholic Press (OCP Publications) is a nonprofit publishing company, producing music and liturgical publications used in parishes throughout the United States, Canada, England and Australia. This publisher also has listings in the Magazine and Record Labels sections.

Tips "I am always looking for appropriate art for our projects. We tend to use work already created on a one-time-use basis, as opposed to commissioned pieces. I look for tasteful, not overtly religious art."

N OREGON HISTORICAL SOCIETY PRESS

1200 SW Park Ave., Portland OR 97205. (503)222-1741. Fax: (503)221-2035. **Director:** Marianne Keddington-Lang. Estab. 1898. Company publishes hardcover originals, trade paperback originals and reprints, maps, posters, postcards. Types of books include biography, travel, reference, history, juvenile and fiction. Specializes in Pacific Northwest history, geography, natural history. Publishes 5 titles/year. Recent titles include: *Oregon Geographic Names* (7th ed.); *Williamette Landings* (3rd ed.); *Range of Glaciers*; *Reporting the Pacific Northwest*. 75% require freelance design. Book catalog free by request.

Needs Works with 2-5 freelance designers/year. Buys 0-50 freelance illustrations/year. Prefers local artists only. Uses freelance artists mainly for illustrations and maps. Also uses freelance artists for jacket/cover and text illustration, book design. 50% of freelance work demands knowledge of InDesign. Works on assignment only.

First Contact & Terms Send query letter with résumé, tearsheets and photocopies. Samples are filed or are returned by SASE. Responds in 10 days. Art Director will contact artist for portfolio review if interested. Portfolio should include b&w thumbnails, roughs, final art, slides and photographs. Buys one-time rights or rights purchased vary according to project. Originals are returned at job's completion.

Book Design Assigns 2-5 freelance design jobs/year. Pays by the project.

Jackets/Covers Assigns 2-5 freelance design jobs/year. Pays by the project.

N OREGON STATE UNIVERSITY PRESS

101 Waldo Hall, Corvallis OR 97331-6407. (541)737-3166. Fax: (541)737-3170. E-mail: osu.press@oregonstate.edu. Website: www.osu.orst.edu/dept/press. **Managing Editor:** Jo Alexander. Estab. 1961. Publishes hardcover and trade paperback originals and reprints and textbooks. Types of books include biography, history, nonfiction, reference, textbooks and western. Specializes in scholarly and regional trade. Publishes 20 titles/year. Recent titles include: *Now Go Home*, by Ana Marias; *Trask*, by Don Berry; *Oregon's Promise*, by David Petersen del Mar. Publishes 15-20 titles/year. 5% requires freelance illustration; 90% requires freelance design of cover, jacket. Book catalog for 8×11 SASE with 2 first-class stamps.

Needs Approached by 20 illustrators and 20 designers/year. Works with 2 illustrators and 5 designers/year. Prefers freelancers experienced in computer skills. 100% of freelance design demands knowledge of one or more: Illustrator, Photoshop, FreeHand, PageMaker and QuarkXPress.

First Contact & Terms Designers send query letter with printed samples or reference to website where we can view work. Accepts Mac-compatible disk submissions. Send TIFF files. Samples are filed. Responds only if interested. Portfolio review not required. Rights purchased vary according to project. Finds freelancers through submission packets and personal referrals.

Book Design Assigns 15 freelance design jobs/year. Pays by the project, $500-1,000.

Jackets/Covers Assigns 15 freelance design jobs/year. Computer design essential. Pays by the project, $500 minimum.

☑ ♟ THE OVERLOOK PRESS

141 Wooster St., New York NY 10012. (212)965-8400. Fax: (212)965-9834. Website: www.overlookpress.com. **Contact:** Art Director. Estab. 1970. Book publisher. Publishes hardcover originals. Types of books include contemporary and experimental fiction, health/fitness, history, fine art and children's books. Publishes 90 titles/year. Recent titles include: *Right Ho, Jeeves*, by P.G. Wodehouse. 60% require freelance illustration; 40% require freelance design. Book catalog for SASE.

Needs Approached by 10 freelance artists/year. Works with 4 freelance illustrators and 4 freelance designers/year. Buys 5 freelance illustrations/year. Prefers local artists only. Uses freelance artists mainly for jackets. Works on assignment only.

First Contact & Terms Send query letter with printed samples or other non-returnable material. Samples are filed. To show a portfolio, mail tearsheets and slides. Buys one-time rights. Originals returned to artist at job's completion.

Jackets/Covers Assigns 10 freelance design jobs/year. Pays by the project, $250-350.

☑ ⌾ THE OVERMOUNTAIN PRESS

Sabre Industries, Inc., P.O. Box 1261, Johnson City TN 37605. (423)926-2691. Fax: (423)929-2464. E-mail: beth@overmtn.com. Website: www.overmountainpress.com. **Senior Editor:** Elizabeth L. Wright. Estab. 1970. Publishes hardcover and trade paperback originals and reprints. Types of books include biography, children's picture books, cookbooks, history and nonfiction. Specializes in regional nonfiction (Appalachian). Publishes 40 titles/year. Recent titles include: *Lost Heritage*; *Our Living Heritage*; *Ten Friends*; *The Book of Kings: A History of Bristol TN/VA's Founding Family*. 20% requires freelance illustration. Book catalog free for 3 first-class stamps.

Needs Approached by 10 illustrators/year. Works with 3 illustrators/year. Prefers local illustrators, designers and art directors. Prefers freelancers experienced in children's picture books. 100% of freelance design and illustration demands knowledge of Photoshop and QuarkXPress.

First Contact & Terms Illustrators send query letter with printed samples. Samples are filed. Will contact artist for portfolio review including artwork and photocopies portraying children/kids' subjects if interested. Rights purchased vary according to project.

Jackets/Covers Assigns 5-10 illustration jobs/year. Considers any medium and/or style. Pays by the project, royalty only, no advance. Prefers children's book illustrators.

Text Illustration Assigns 2 freelance illustration jobs/year. Pays by the project, royalty only. Considers any style, medium, color scheme or type of work.

Tips "We are starting a file of children's book illustrators. At this time we are not 'hiring' freelance illustrators. We are collecting names, addresses, numbers and samples of those who would be interested in having an author contact them about illustration."

OXFORD UNIVERSITY PRESS

English as a Second Language (ESL), 198 Madison Ave., 9th Floor, New York NY 10016. E-mail: jun@oup-usa.org. Website: www.oup-usa.org. **Senior Art Editor:** Jodi Waxman. Chartered by Oxford University. Estab. 1478. Specializes in fully illustrated, not-for-profit, contemporary textbooks emphasizing English as a second language for children and adults. Also produces wall charts, picture cards, CDs and cassettes. Recent titles include: *Grammar Sense* and various Oxford Picture Dictionaries.

Needs Approached by 1,000 freelance artists/year. Works with 100 illustrators and 8 designers/year. Uses freelancers mainly for interior illustrations of exercises. Also uses freelance artists for jacket/cover illustration and design. Some need for computer-literate freelancers for illustration. 20% of freelance work demands knowledge of QuarkXPress or Illustrator. Works on assignment only.

First Contact & Terms Send query letter with brochure, tearsheets, photostats, slides or photographs. Samples are filed. Art Buyer will contact artist for portfolio review if interested. Artists work from detailed specs. Considers complexity of project, skill and experience of artist and project's budget when establishing payment. Artist retains copyright. Originals are returned at job's completion. Finds artists through submissions, artist catalogs such as *Showcase*, *Guild Book*, etc. occasionally from work seen in magazines and newspapers, other illustrators.

Jackets/Covers Pays by the project.

Text Illustration Assigns 500 jobs/year. Uses black line, half-tone and 4-color work in styles ranging from cartoon to realistic. Greatest need is for natural, contemporary figures from all ethnic groups, in action and interaction. Pays for text illustration by the project, $45/spot, $2,500 maximum/full page.

Tips "Please wait for us to call you. You may send new samples to update your file at any time. We would like to see more natural, contemporary, nonwhite people from freelance artists. Art needs to be fairly realistic and cheerful."

PARENTING PRESS, INC.

11065 Fifth Ave. NE, #F, Seattle WA 98125. (206)364-2900. Fax: (206)364-0702. E-mail: office@parentingpress.com. Website: www.parentingpress.com. **Contact:** Carolyn Threadgill, publisher. Estab. 1979. Publishes trade paperback originals and hardcover originals. Types of books include nonfiction; instruction and parenting fiction. Specializes in parenting and social skill building books for children. Recent titles include: *The Way I Feel*; *Family Matters*; *Please Don't Call My Mother*. 100% requires freelance design; 100% requires freelance illustration. Book catalog free on request.

Needs Approached by 10 designers/year and 100 illustrators/year. Works with 2 designers/year. Prefers local designers. 100% of freelance design work demands knowledge of PageMaker, Photoshop and QuarkXPress.

First Contact & Terms Send query letter with brochure, SASE, postcard sample with photocopies, photographs and tearsheets. After introductory mailing, send follow-up postcard sample every 6 months. Accepts e-mail submissions. Prefers Windows-compatible, TIFF, JPEG files. Samples returned by SASE if not filed. Responds only if interested. Company will contact artist for portfolio review if interested. Portfolio should include b&w or color tearsheets. Rights purchased vary according to project.

Jackets/Covers Assigns 4 freelance cover illustrations/year. Pays for illustration by the project $300-1,000. Prefers appealing human character—realistic or moderately stylized.

Text Illustration Assigns 3 freelance illustration jobs/year. Pays by the project or shared royalty with author.

Tips "Be willing to supply 2-4 roughs before finished art."

☑ PATHWAY BOOK SERVICE

(formerly Stemmer House Publishers, Inc.), 4 White Brook Rd., Gilsum NH 03448. (800)345-6665. Fax: (603)357-2073. E-mail: pbs@pathwaybook.com. Website: www.pathwaybook.com. **President/Publisher:** Ernest Peter. Specializes in hardcover and paperback nonfiction, art books, gardening books and design resource originals. Publishes 10 titles/year. Recent titles include: *William Morris Patterns & Designs*; *Medieval Floral Designs*. Books are "well illustrated." 10% requires freelance design; 75% requires freelance illustration.

• Pathway Book Service acquired Stemmer House Publishers as of June 2003.

Needs Approached by more than 200 freelancers/year. Works with 4 freelance illustrators and 1 designer/year. Works on assignment only.

First Contact & Terms Designers send query letter with brochure, tearsheets, SASE, photocopies. Illustrators send postcard sample or query letter with brochure, photocopies, photographs, SASE, slides and tearsheets. Do not send original work. Material not filed is returned by SASE. Call or write for appointment to show portfolio. Responds in 6 weeks. Works on assignment only. Originals are returned to artist at job's completion on request. Negotiates rights purchased.

Book Design Assigns 1 freelance design and 2 illustration projects/year. Pays by the project.

Jackets/Covers Assigns 4 freelance design jobs/year. Prefers paintings. Pays by the project.

Text Illustration Assigns 3 freelance jobs/year. Prefers full-color artwork for text illustrations. Pays by the project.

Tips Looks for "draftmanship, flexibility, realism, understanding of the printing process." Books are "rich in design quality and color, stylized while retaining realism; not airbrushed. We prefer non-computer. Review our books. No picture book illustrations considered currently."

☐ PAULINE BOOKS & MEDIA

50 St. Pauls Ave., Boston MA 02130-3491. (617)522-8911. Fax: (617)541-9805. E-mail: design@pauline.org. Website: www.pauline.org. **Art Director:** Sr. Helen Rita Lane. Estab. 1932. Book publisher. "We also publish a children's magazine and produce audio and video cassettes." Publishes hardcover and trade paperback originals and reprints and textbooks. Also electronic books and software. Types of books include instructional, biography, preschool, juvenile, young adult, reference, history, self-help, prayer and religious. Specializes in religious topics. Publishes 20 titles/year. Art guidelines available. Sample copies for SASE with first-class postage.

Needs Approached by 50 freelancers/year. Works with 10-20 freelance illustrators/year. Also needs freelancers for multimedia projects. 65% of freelance work demands knowledge of PageMaker, Illustrator, Photoshop, etc.

First Contact & Terms Send query letter with résumé, SASE, tearsheets and photocopies. Accepts disk submissions compatible with Windows 95, Mac. Send EPS, TIFF, GIF or TARGA files. Samples are filed or are returned by SASE. Responds in 3 months only if interested. Rights purchased vary according to project. Originals are returned at job's completion.

Jackets/Covers Assigns 1-2 freelance illustration jobs/year. Pays by the project.

Text Illustration Assigns 3-10 freelance illustration jobs/year. Pays by the project.

☐ PAULIST PRESS

997 Macarthur Blvd., Mahwah NJ 07430. (201)825-7300. Fax: (201)825-8345. E-mail: pmcmahon@paulistpress. com. Website: www.paulistpress.com. **Managing Editor:** Paul McMahon. Estab. 1869. Company publishes hardcover and trade paperback originals and textbooks. Types of books include biography, juvenile and religious. Specializes in academic and pastoral theology. Publishes 95 titles/year. Recent titles include: *The Voice*; *Father Mychal Judge*; *The Voice of the Irish*; *Navigating New Terrain*. 5% requires freelance illustration; 5% requires freelance design.

• Paulist Press recently began to distribute a general trade imprint HiddenSpring. Books in this imprint "help readers seek the spiritual."

Needs Works with 10-12 freelance illustrators and 15-20 designers/year. Prefers local freelancers. Uses freelanc-

ers for juvenile titles, jacket/cover and text illustration. 10% of freelance work demands knowledge of QuarkX-Press. Works on assignment only.

First Contact & Terms Send query letter with brochure, résumé and tearsheets. Samples are filed. Responds only if interested. Portfolio review not required. Negotiates rights purchased. Originals are returned at job's completion if requested.

Book Design Assigns 10-12 freelance design jobs/year.

Jackets/Covers Assigns 80 freelance design jobs/year. Pays by the project, $400-800.

Text Illustration Assigns 3-4 freelance illustration jobs/year. Pays by the project.

PEACHTREE PUBLISHERS

1700 Chattahoochee Ave., Atlanta GA 30318. (404)876-8761. Fax: (404)875-2578. E-mail: hello@peachtree-online.com. Website: www.peachtree-online.com. **Art Director:** Loraine Joyner. Production Manager: Melanie McMahon Ives. Estab. 1977. Publishes hardcover and trade paperback originals. Types of books include children's picture books, young adult fiction, early reader fiction, juvenile fiction, parenting, regional. Specializes in children's and young adult titles. Publishes 24-30 titles/year. Recent titles include: *Saturdays and Teacakes*; *Larabee*; *Rosa's Room*. 100% requires freelance illustration. Call for catalog.

Needs Approached by 750 illustrators/year. Works with 15-20 illustrators. "If possible, send samples that show your ability to depict subjects or characters in a consistent manner. See our website to view styles of artwork we utilize."

First Contact & Terms Illustrators send query letter with photocopies, SASE, tearsheets. "Prefer not to receive samples from designers." Accepts Mac-compatible disk submissions but not preferred. Samples are returned by SASE. Responds only if interested. Will contact artist for portfolio review if interested. Rights purchased vary according to project. Finds freelancers through submission packets, agents and sourcebooks, including *Directory of Illustration* and *Picturebook*.

Jackets/Covers Assigns 18-20 illustration jobs/year. Prefers acrylic, watercolor or a mixed media on flexible material. Pays for design by the project.

Text Illustration Assigns 4-6 freelance illustration jobs/year. Pays by the project.

Tips "We are an independent, high-quality house with a limited number of new titles per season, therefore each book must be a jewel. We expect the illustrator to bring creative insights which expand the readers' understanding of the storyline through visual clues not necessarily expressed within the text itself."

✅ PELICAN PUBLISHING CO.

Box 3110, Gretna LA 70054. (504)368-1175. Fax: (504)368-1195. E-mail: tcallaway@pelicanpub.com. Website: www.pelicanpub.com. **Contact:** Production Manager. Publishes hardcover and paperback originals and reprints. Publishes 70 titles/year. Types of books include travel guides, cookbooks, business/motivational, architecture, golfing, history and children's books. Books have a "high-quality, conservative and detail-oriented" look. Recent titles include: *The Jamlady Cookbook*; *CIA Spymaster*; *The Principal's Night Before Christmas*.

Needs Approached by 2000 freelancers/year. Works with 20 freelance illustrators/year. Uses freelancers for illustration and multimedia projects. Works on assignment only. 100% of design and 50% of illustration demand knowledge of QuarkXPress, Photoshop 4.0, Illustrator 4.0.

First Contact & Terms Designers send photocopies, photographs, SASE, slides and tearsheets. Illustrators send postcard sample or query letter with photocopies, SASE, slides and tearsheets. Samples are not returned. Responds on future assignment possibilities. Buys all rights. Originals are not returned.

Book Design Pays by the project, $500 minimum.

Jackets/Covers Pays by the project, $150-500.

Text Illustration Pays by the project, $50-250.

Tips "Show your versatility. We want to see realistic detail and color samples."

✅ PENGUIN GROUP (USA) INC.

375 Hudson St., New York NY 10014. (212)366-2000. Fax: (212)366-2666. Website: www.penguinputnam.com. **Art Director:** Paul Buckley. Publishes hardcover and trade paperback originals.

Needs Works with 100-200 freelance illustrators and 100-200 freelance designers/year. Uses freelancers mainly for jackets, catalogs, etc.

First Contact & Terms Send query letter with tearsheets, photocopies and SASE. Rights purchased vary according to project.

Book Design Pays by the project; amount varies.

Jackets/Covers Pays by the project; amount varies.

PENNY-FARTHING PRESS, INC.

10370 Richmond Ave., Suite 980, Houston TX 77042. (713)780-0300, Fax: (713)780-4004. E-mail: corp@pfpress.com. Website: www.pfpress.com. **Contact:** Submissions Editor. Publishes hardcover and trade paperback origi-

nals. Types of books include adventure, comic books, fantasy, science fiction. Specializes in comics and graphic novels. Recent titles include: *Captain Gravity*; *The Victorian: Act II*; *Self-Immolation*. Book catalog available on website.

Needs Pencillers: Send ''3-5 penciled pages showing story-telling skills and versatility. Do not include dialogue or narrative boxes.'' Inkers: Send at least 3-5 samples (full-sized and reduced to letter-sized) showing interior work. ''include copies of the pencils.'' Illustrators send color photocopies. ''Please do not send oversized copies.'' Samples are returned by SASE ONLY. Submissions in the form of URL's may be e-mailed to submissions @pfpress.com. See website for specific instructions. Responds in several months. Do not call to check on status of your submission.

Tips ''Do not send originals.''

PERFECTION LEARNING CORPORATION

10520 New York Ave., Des Moines IA 50322-3775. (515)278-0133, ext. 209. Fax: (515)278-2980. E-mail: rmesser @plconline.com. Website: www.perfectionlearning.com. **Art Director:** Randy Messer. Senior Designer: Deb Bell. Estab. 1927. Publishes hardcover originals and reprints, mass market paperback originals and reprints, educational resources, trade paperback originals and reprints, high general interest/low reading level, multicultural, nature, science, social issues, sports. Specializes in high general interest/low reading level and Lit-based teacher resources. Publishes 30 titles/year. Recent titles: *American Justice II*; *The Secret Room, the Message, the Promise, and How Pigs Figure in*; *River of Ice*; *Orcas—High Seas Supermen*. All 5 titles have been nominated for ALA Quick Picks. 50% requires freelance illustration.

• Perfection Learning Corporation has had several books nominated for awards including *Iditarod*, nominated for a Golden Kite award and *Don't Bug Me*, nominated for an ALA-YALSA award.

Needs Approached by 70 illustrators and 10-20 designers/year. Works with 30-40 illustrators/year. Prefers local designers and art directors. Prefers freelancers experienced in cover illustration and interior spot—4-color and b&w. 100% of freelance design demands knowledge of QuarkXPress.

First Contact & Terms Illustrators send postcard or query letter with printed samples, photocopies, SASE, tearsheets. Accepts Mac-compatible disk submissions. Send EPS. Samples are filed or returned by SASE. Responds only if interested. Portfolio review not required. Rights purchased vary according to project. Finds freelancers through tearsheet submissions, illustration annuals, phone calls, artists' reps.

Jackets/Covers Assigns 40-50 freelance illustration jobs/year. Pays for illustration by the project, $750-1,750, depending on project. Prefers illustrators with conceptual ability.

Text Illustration Assigns 40-50 freelance illustration jobs/year. Pays by the project. Prefers freelancers who are able to draw multicultural children and good human anatomy.

Tips ''We look for good conceptual skills, good anatomy, good use of color. Our materials are sold through schools for classroom use—they need to meet educational standards.''

☑ PETER PAUPER PRESS, INC.

202 Mamaroneck Ave., Suite 400, White Plains NY 10601-5387. (914)681-0144. Fax: (914)681-0389. E-mail: pauperp@aol.com. **Art Director:** Heather Zschock. Estab. 1928. Company publishes hardcover small format illustrated gift books and photo albums. Specializes in friendship, love, celebrations, holidays. Publishes 40-50 titles/year. Recent titles include: *Love Is a Beautiful Thing*; *A Friend for All Seasons*. 100% require freelance illustration; 100% require freelance design.

Needs Approached by 75-100 freelancers/year. Works with 15-20 freelance illustrators and 3-5 designers/ year. Uses freelancers for jacket/cover and text illustration. 100% of freelance design demands knowledge of QuarkXPress. Works on assignment only.

First Contact & Terms Send query letter with brochure, résumé, SASE, photographs, tearsheets or photocopies. Samples are filed or are returned by SASE. Responds in 1 month with SASE. Art Director will contact artist for portfolio review if interested. Portfolio should include book dummy, final art, photographs and photostats. Rights purchased vary according to project. Originals are returned at job's completion. Finds artists through submissions, gift and card shows.

Book Design Assigns 65 freelance design jobs/year. Pays by the project, $500-2,500.

Jackets/Covers Assigns 65 freelance design and 40 illustration jobs/year. Pays by the project, $800-1,200.

Text Illustration Assigns 65 freelance illustration jobs/year. Pays by the project, $1,000-2,800.

Tips ''Knowledge of the type of product we publish is extremely helpful in sorting out artists whose work will click for us. We are most likely to have a need for up-beat works.''

ℕ THE PILGRIM PRESS/UNITED CHURCH PRESS

700 Prospect Ave. E., Cleveland OH 44115-1100. (216)736-3715. Fax: (216)736-2207. Website: www.pilgrimpres s.com. **Art Director:** Martha Clark. Production: Janice Brown. Estab. 1957. Company publishes hardcover originals and trade paperback originals and reprints. Types of books include environmental ethics, human

sexuality, devotion, women's studies, justice, African-American studies, world religions, Christian education, curriculum, reference and social and ethical philosophical issues. Specializes in religion. Publishes 60 titles/year. Recent titles include: *In Good Company: A Woman's Journal for Spiritual Reflection*; *Still Groovin'*. 75% require freelance illustration; 50% require freelance design. Books are progressive, classic, exciting, sophisticated—conceptually looking for "high design." Book catalog free by request.

Needs Approached by 50 freelancers/year. Works with 20 freelance illustrators and 10 designers/year. Buys 50 illustrations/year. Prefers freelancers with experience in book publishing. Uses freelancers mainly for covers, catalogs and illustration. Also for book design. Works on assignment only.

First Contact & Terms Send query letter with résumé, tearsheets and photocopies. Samples are filed and are not returned. Art Director will contact artist for portfolio review if interested. Negotiates rights purchased. Interested in buying second rights (reprint rights) to previously published work based on need, style and concept/subject of art and cost. "I like to see samples." Originals are returned at job's completion. Finds artists through agents and stock houses.

Book Design Assigns 50 freelance design jobs/year. Pays by the project, $500.

Jackets/Covers Assigns 125 freelance design jobs/year. Prefers contemporary styles. Pays by the project, $500-700.

Text Illustration Assigns 15-20 design and 15-20 illustration jobs/year. Pays by the project, $200-500; negotiable, based on artist estimate of job, number of pieces and style.

Tips "I also network with other art directors/designers for their qualified suppliers/freelancers. If interested in curriculum illustration, show familiarity with illustrating biblical art and diverse races and ages."

☑ PIPPIN PRESS

229 E. 85th St., P.O. Box 1347, Gracie Station, New York NY 10028. (212)288-4920. Fax: (732)225-1562. **Publisher/Editor-in-Chief:** Barbara Francis. Estab. 1987. Company publishes hardcover juvenile originals. Publishes 4-6 titles/year. Recent titles include: *Abigail's Drums*; *A Visit from the Leopard: Memories of a Ugandan Childhood*. 100% require freelance illustration; 100% require freelance design. Book catalog free for SAE with 2 first-class stamps.

Needs Approached by 50-75 freelance artists/year. Works with 6 freelance illustrators and 2 designers/year. Prefers artists with experience in juvenile books for ages 4-10. Uses freelance artists mainly for book illustration. Also uses freelance artists for jacket/cover illustration and design and book design.

First Contact & Terms Send query letter with résumé, tearsheets, photocopies. Samples are filed "if they are good" and are not returned. Responds in 2 weeks. Portfolio should include selective copies of samples and thumbnails. Buys all rights. Originals are returned at job's completion.

Book Design Assigns 3-4 freelance design jobs/year.

Text Illustration All text illustration assigned to freelance artists.

Tips Finds artists "through exhibits of illustration and looking at recently published books in libraries and bookstores. Aspiring illustrators should be well acquainted with work of leading children's book artists. Visit children's rooms at local libraries to examine these books. Prepare a sketchbook showing animals and children in a variety of action drawings (running, jumping, sitting, etc.) and with a variety of facial expressions. Create scenes perhaps by illustrating a well-known fairytale. Know why you want to illustrate children's books."

PLAYERS PRESS

Box 1132, Studio City CA 91614. **Associate Editor:** Jean Sommers. Specializes in plays and performing arts books. Recent titles include: *Principles of Stage Combat*; *Theater Management*; *The American Musical Theatre*.

Needs Works with 3-15 freelance illustrators and 1-3 designers/year. Uses freelancers mainly for play covers. Also for text illustration. Works on assignment only.

First Contact & Terms Send query letter with brochure showing art style or résumé and samples. Samples are filed or are returned by SASE. Request portfolio review in original query. Art director will contact artist for portfolio review if interested. Portfolio should include thumbnails, final reproduction/product, tearsheets, photographs and "as much information as possible." Sometimes requests work on spec before assigning a job. Buys all rights. Considers buying second rights (reprint rights) to previously published work, depending on usage. "For costume books this is possible."

Book Design Pays by the project, rate varies.

Jackets/Covers Pays by the project, rate varies.

Text Illustration Pays by the project, rate varies.

Tips "Supply what is asked for in the listing and don't waste our time with calls and unnecessary cards. We usually select from those who submit samples of their work which we keep on file. Keep a permanent address so you can be reached."

Book Publishers

⑧ CLARKSON N. POTTER, INC.

Imprint of Crown Publishers. Parent company: Random House, 299 Park Ave., 6-3, New York NY 10171. (212)572-6165. Fax: (212)572-6181. Website: www.randomhouse.com. **Art Director:** Marysarah Quinn. Publishes hardcover originals and reprints. Types of books include biography, coffee table books, cookbooks, history, gardening, crafts, gift, style, decorating. Specializes in lifestyle (cookbooks, gardening, decorating). Publishes 65-70 titles/year. Recent titles include: *Martha Stewart's Hors d'oeuvres Handbook*; *Moosewood Restaurant's Daily Special*; *Living with Dogs*. 20% requires freelance illustration; 25% requires freelance design.

Needs Works with 10-15 illustrators and 15 designers/year. Prefers freelancers experienced in illustrating food in traditional styles and mediums and designers with previous book design experience. 100% of freelance design demands knowledge of Illustrator, Photoshop, QuarkXPress.

First Contact & Terms Send postcard sample or query letter with printed samples, photocopies, tearsheets. Samples are filed and are not returned. Will contact artist for portfolio review if interested or portfolios may be dropped off any day. Leave for 2-3 days. Negotiates rights purchased. Finds freelancers through submission packets, promotional postcards, Web sourcebooks and illustration annuals, previous books.

Book Design Assigns 20 freelance design jobs/year.

Jackets/Covers Assigns 20 freelance design and 15 illustration jobs/year. Pays for design by the project. Jackets are designed by book designer, i.e. the whole book and jacket are viewed as a package.

Text Illustration Assigns 15 freelance illustration jobs/year.

Tips "We no longer have a juvenile books department. We do not publish books of cartoons or humor. We look at a wide variety of design styles. We look at mainly traditional illustration styles and mediums and are always looking for unique food and garden illustrations."

P&R PUBLISHING

P.O. 817, Phillipsburg NJ 08865. (908)454-0505. Fax: (908)859-2390. E-mail: dawn@prpbooks.com. Website: www.prpbooks.com. **Contact:** Dawn Premako, art director. Estab. 1930. Publishes trade paperback and hardcover originals and reprints. Types of books include religious nonfiction. Specializes in confessional publications. Publishes 40 titles/year. Recent titles include: *The Afternoon of Life: Finding Purpose and Joy in Midlife*; *Rebel's Keep*; *Little Women*. 100% requires freelance design; 15% requires freelance illustration. Book catalog free with 9×12 SASE.

Needs Approached by 3 designers and 3 illustrators/year. Works with 3 designers and 3 illustrators/year. 100% of freelance design work demands knowledge of FreeHand, Illustrator, QuarkXPress, Photoshop.

First Contact & Terms Designers/Illustrators send query letter with résumé, tearsheets and samples. After introductory mailing, send follow-up postcard sample every 6 months. Responds only if interested. Company will contact artist for portfolio review if interested. Portfolio should include b&w and color finished art, photographs, tearsheets and thumbnails. Negotiates rights purchased. Finds freelancers through artist's submissions and word of mouth.

Jackets/Covers Assigns 2 freelance cover illustration jobs/year. Prefers color, oils/acrylics. Pays for illustration by the project. Prefers children's literature.

Text Illustration Assigns 2 freelance illustration jobs/year. Pays by the project.

Tips "Send letters of recommendation."

⑧ PRAKKEN PUBLICATIONS, INC.

832 Phoenix Dr., Box 8623, Ann Arbor MI 48107. (734)975-2800. Fax: (734)975-2787. Website: www.techdirections.com or www.eddigest.com. **Production and Design Manager:** Sharon Miller. Estab. 1934. Imprints include The Education Digest, Tech Directions. Company publishes educator magazines, reference books and posters. Specializes in vocational, technical, technology and general education. Publishes 2 magazines and 2 new book titles/year. Titles include: *High School-to-Employment Transition*, *Technology's Past*, *Workforce Preparation: An International Perspective* and *More Technology Projects for the Classroom*. Book catalog free by request.

Needs Rarely uses freelancers. 50% of freelance work demands knowledge of PageMaker. Works on assignment only.

First Contact & Terms Send samples. Samples are filed or are returned by SASE if requested by artist. Responds only if interested. Art director will contact artist for portfolio review if interested. Portfolio should include b&w and color final art and tearsheets.

PRENTICE HALL COLLEGE DIVISION

Pearson Education, 445 Hutchinson Ave., 4th Floor, Columbus OH 43235. (614)841-3700. Fax: (614)841-3645. Website: www.prenhall.com. **Design Coordinator:** Diane Lorenzo. Specializes in college textbooks in education and technology. Publishes 400 titles/year. Recent titles include: *Exceptional Children*, by Heward; *Electronics Fundamentals*, by Floyd.

Needs Approached by 25-40 designers/freelancers/year. Works with 15 freelance designers/illustrators/year.

Uses freelancers mainly for cover textbook design. 100% of freelance design and 70% of illustration demand knowledge of QuarkXPress 4.0, Illustrator 9.0 and Photoshop 7.0.

First Contact & Terms Send query letter with résumé and tearsheets; sample text designs on CD in Mac format. Accepts submissions on CD in Mac files only (not PC) in software versions stated above. Samples are filed and portfolios are returned. Responds in 30 days. Rights purchased vary according to project. Originals are returned at job's completion.

Book Design Pays by the project, $500-2,500.

Tips "Send a style that works well with our particular disciplines."

PRICE STERN SLOAN

The Penguin Putnam Group, 375 Hudson, New York NY 10014. (212)366-2000. Fax: (212)414-3396. **Contact:** Submissions Editor. Estab. 1971. Book publisher. Publishes juvenile only—hardcover, trade paperback and mass market originals and reprints. Types of books include picture books, middle-grade and young adult fiction, games, crafts and occasional novelty titles. Publishes 100 titles/year. 75% require freelance illustration; 10% require freelance design. Books vary from edgy to quirky to illustrative, "but always unique!"

Needs Approached by 300 freelancers/year. Works with 20-30 freelance illustrators and 10-20 designers/year. Prefers freelancers with experience in book or advertising art. Uses freelancers mainly for illustration. Also for jacket/cover and book design. Needs computer-literate freelancers for production.

First Contact & Terms Send query letter with brochure, résumé and photocopies. Samples are filed or are returned by SASE if requested by artist. Art Director will contact artist for portfolio review if interested. "Please don't call." Portfolio should include b&w and color tearsheets. Rights purchased vary according to project. Finds artists through word of mouth, magazines, submissions/self-promotion, sourcebooks and agents.

Book Design Assigns 5-10 freelance design jobs and 20-30 illustration jobs/year. Pays by the project.

Jackets/Covers Assigns 5-10 freelance design jobs and 10-20 illustration jobs/year. Pays by the project, rate varies.

Text Illustration Pays by the project and occasionally by participation.

Tips "Do not send original art. Become familiar with the types of books we publish. We are extremely selective when it comes to children's books, so please send only your best work."

PUFFIN BOOKS

Penguin Group (USA) Inc., 345 Hudson St., New York NY 10014-3657. (212)366-2000. Fax: (212)366-2040. Website: www.penguinputnam.com. **Art Director:** Deborah Kaplan. Division estab. 1941. Book publisher. Division publishes trade paperback originals and reprints and mass market paperback originals. Types of books include contemporary, mainstream, historical fiction, adventure, mystery, biography, preschool, juvenile and young adult. Specializes in juvenile novels. Publishes 175-200 titles/year. Titles include *Why Do Dogs Bark?* (easy-to-read series) and *Outlaws of Sherwood*. 50% require freelance illustration; 5% require freelance design.

Needs Approached by 20 artists/year. Works with 35 illustrators/year. Buys 60 illustrations/year. Prefers artists with experience in realistic juvenile renderings. Uses freelancers mainly for paperback cover 4-color art. Also for text illustration. Works on assignment only.

First Contact & Terms Send query letter with tearsheets and transparencies. Samples are filed or are returned by SASE if requested by artist. Responds to the artist only if interested. Call for appointment to show portfolio. Portfolio should include color tearsheets and transparencies. Rights purchased vary according to project. Originals returned to artist at job's completion.

Book Design Assigns 5 illustration jobs/year.

Jackets/Covers Assigns 60 illustration jobs/year. Prefers oil, acrylic, watercolor and 4-color. Pays by the project, $900-2,000.

Text Illustration Assigns 5 illustration jobs/year. Prefers b&w line drawings. Pays by the project, $500-1,500.

Tips "I need you to show that you have experience in painting tight, realistic, lively renderings of kids ages 6-18."

PULSE-FINGER PRESS

Box 488, Yellow Springs OH 45387. **Contact:** Orion Roche or Raphaello Farnese. Publishes hardbound and paperback fiction, poetry and drama. Publishes 5-10 titles/year.

Needs Prefers local freelancers. Works on assignment only. Uses freelancers for advertising design and illustration. Pays $25 minimum for direct mail promos.

First Contact & Terms Send query letter. "We can't use unsolicited material. Inquiries without SASE will not be acknowledged." Responds in 6 weeks; responds on future assignment possibilities. Samples returned by SASE. Send résumé to be kept on file. Artist supplies overlays for all color artwork. Buys first serial and reprint rights. Originals are returned at job's completion.

Jackets/Covers "Must be suitable to the book involved; artist must familiarize himself with text. We tend to

use modernist/abstract designs. Try to keep it simple, emphasizing the thematic material of the book.'' **Pays on acceptance**; $25-100 for b&w jackets.

Tips ''We do most of our work in-house; otherwise, we recruit from the rich array of talent in the colleges and universities in our area. We've used the same people—as necessary—for years; so it's very difficult to break into our line-ups. We're receptive, but our needs are so limited as to preclude much of a market.''

PUSSYWILLOW

1212 Punta Gorda St., #13, Santa Barbara CA 93103. Phone/fax: (805)899-2145. E-mail: bandanna@cox.net. **Contact:** Briar Newborn, publisher. Estab. 2002. Publishes fiction and poetry trade paperback originals and reprints. Types of books include erotic classics mainly in translation for the connoisseur or collector. Recent titles include *Wife of Bath*; *Aretino's Sonnetti Lussuriosi*. Target audience is mature adults of both sexes. No porn, yes erotica.

Needs Sensual suggestive art pieces in any genre.

First Contact & Terms Send samples for our files, not originals. Responds in 2 months only if interested.

Jackets/Covers Pays at least $200.

Text Illustration Pays by the project.

Tips ''We're more likely to commission pieces than to buy originals. Show us what you can do. Send samples we can keep on file.''

G.P. PUTNAM'S SONS, PHILOMEL BOOKS

345 Hudson St., 14th Floor, New York NY 10014-3657. (212)366-2000. Website: www.penguin.com. **Art Director, Children's Books:** Cecilia Yung. Publishes hardcover juvenile books. Publishes 60 titles/year. Free catalog available.

Needs Illustration on assignment only.

First Contact & Terms Provide flier, tearsheet, brochure and photocopy to be kept on file for possible future assignments. Samples are returned by SASE only. ''We take drop-offs on Tuesday mornings before noon and return them to the front desk after 4 p.m. the same day. Please call Katrina Damkoehler, (212)366-2000, in advance with the date you want to drop of your portfolio. Do not send samples via e-mail or CDs.''

Jackets/Covers ''Uses full-color paintings, realistic painterly style.''

Text Illustration ''Uses a wide cross section of styles for story and picture books.''

QUITE SPECIFIC MEDIA GROUP LTD.

7373 Pyramid Place, Hollywood CA 90046. (323)851-5797. Fax: (323)851-5798. Website: www.quitespecificmedia.com. **Contact:** Ralph Pine. Estab. 1967. Publishes hardcover originals and reprints, trade paperback reprints and textbooks. Specializes in costume, fashion, theater and performing arts books. Publishes 12 titles/year. Recent titles include: *The Medieval Tailor's Assistant*. 10% requires freelance illustration; 60% requires freelance design.

• Imprints of Quite Specific Media Group Ltd. include Drama Publishers, Costume & Fashion Press, By Design Press, Entertainment Pro and Jade Rabbit.

Needs Works with 2-3 freelance designers/year. Uses freelancers mainly for jackets/covers. Also for book, direct mail and catalog design and text illustration. Works on assignment only.

First Contact & Terms Send query letter with brochure and tearsheets. Samples are filed. Responds to the artist only if interested. Rights purchased vary according to project. Originals not returned. Pays by the project.

RAINBOW BOOKS, INC.

P.O. Box 430, Highland City FL 33846-0430. (863)648-4420. Fax: (863)647-5951. E-mail: RBIbooks@aol.com. **Media Buyer:** Betsy A. Lampe. Estab. 1979. Company publishes hardcover and trade paperback originals. Types of books include instruction, adventure, biography, travel, self-help, religious, mystery, reference, history and cookbooks. Specializes in nonfiction, self-help, mystery fiction, and how-to. Publishes 20 titles/year. Recent titles include: *How to Handle Bullies and Teasers and Other Meanies*; *Medical School Is Murder*.

Needs Approached by hundreds of freelance artists/year. Works with 2 illustrators/year. Prefers freelancers with experience in book-cover design and line illustration. Uses freelancers for jacket/cover illustration and design and text illustration. Needs computer-literate freelancers for design, illustration and production. 90% of freelance work demands knowledge of draw or design programs. Works on assignment only.

First Contact & Terms Send brief query, tearsheets, photographs and book covers or jackets. Samples are not returned. Responds in 2 weeks. Art director will contact artist for portfolio review if interested. Portfolio should include b&w and color tearsheets, photographs and book covers or jackets. Rights purchased vary according to project. Originals are returned at job's completion.

Jackets/Covers Assigns 10 freelance illustration jobs/year. Pays by the project, $250-1,000.

Text Illustration Pays by the project. Prefers pen & ink or electronic illustration.

Tips "Nothing Betsy Lampe receives goes to waste. After consideration for Rainbow Books, Inc., artists/designers are listed free in her newsletter (Publisher's Report), which goes out to over 500 independent presses (weekly). Then, samples are taken to the art department of a local school to show students how professional artists/designers market their work. Send samples (never originals), be truthful about the amount of time needed to complete a project, learn to use the computer. Study the competition (when doing book covers), don't try to write cover copy, learn the publishing business (attend small press seminars, read books, go online, make friends with the local sales reps of major book manufacturers). Pass along what you learn. Do not query via e-mail attachment."

☑ RANDOM HOUSE CHILDREN'S BOOK GROUP

1745 Broadway, New York NY 10019. (212)782-9000. Fax: (212)782-9452. Website: www.randomhouse.com/kids. **Art Director:** Jan Gerardi. Specializes in hardcover and mass market paperback originals and reprints. Publishes 250 titles/year. Titles include: *Wiggle Waggle Fun* and *Junie B. First Grader (at last!)*. 100% require freelance illustration.

Needs Works with 100-150 freelancers/year. Works on assignment only.

First Contact & Terms Send query letter with résumé, tearsheets and printed samples, photostats; no originals. Samples are filed. Negotiates rights purchased.

Book Design Assigns 5 freelance design jobs/year. Pays by the project.

Text Illustration Assigns 150 illustration jobs/year. Pays by the project.

RANDOM HOUSE VALUE PUBLISHING

1745 Broadway, New York NY 10019. (212)782-9000. **Contact:** Art Director. Imprint of Random House, Inc. Other imprints include Wings, Testament, Gramercy and Crescent. Imprint publishes hardcover, trade paperback and reprints, and trade paperback originals. Types of books include adventure, coffee table books, cookbooks, children's books, fantasy, historical fiction, history, horror, humor, instructional, mainstream fiction, New Age, nonfiction, reference, religious, romance, science fiction, self-help, travel and western. Specializes in contemporary authors' work. Recent titles include work by John Saul, Mary Higgins Clark, Tom Wolfe, Dave Barry, Stephen King, Rita Mae Brown and Michael Crichton (all omnibuses). 80% requires freelance illustration; 50% requires freelance design.

Needs Approached by 50 freelancers/year. Works with 20 freelance illustrators and 20 designers/year. Uses freelancers mainly for jacket/cover illustration and design for fiction and romance titles. 100% of design and 50% of illustration demands knowledge of Illustrator, QuarkXPress, Photoshop and FreeHand. Works on assignment only.

First Contact & Terms Designers send résumé and tearsheets. Illustrators send postcard sample, brochure, résumé and tearsheets. Samples are filed. Request portfolio review in original query. Art Director will contact artist for portfolio review if interested. Portfolio should include tearsheets. Buys first rights. Originals are returned at job's completion. Finds artists through *American Showcase*, *Workbook*, *The Creative Illustration Book*, artist's reps.

Book Design Pays by the project.

Jackets/Covers Assigns 50 freelance design and 20 illustration jobs/year. Pays by the project, $500-1,500.

Tips "Study the product to make sure styles are similar to what we have done: new, fresh, etc."

⊡ RED DEER PRESS

Room 813, MacKimmie Library Tower, 2500 University Dr., NW, Calgary AB T2N 1N4 Canada. (403)220-4334. Fax: (403)210-8191. E-mail: rdp@ucalgary.ca. **Managing Editor:** Dennis Johnson. Estab. 1975. Book publisher. Publishes hardcover and trade paperback originals. Types of books include contemporary and mainstream fiction, fantasy, biography, preschool, juvenile, young adult, humor and cookbooks. Specializes in contemporary adult and juvenile fiction, picture books and natural history for children. Recent titles include: *Hidden Buffalo*; *In Abby's Hands*. 100% require freelance illustration; 30% require freelance design. Book catalog available for SASE with Canadian postage.

Needs Approached by 50-75 freelance artists/year. Works with 10-12 freelance illustrators and 2-3 freelance designers/year. Buys 50 freelance illustrations/year. Prefers artists with experience in book and cover illustration. Also uses freelance artists for jacket/cover and book design and text illustration. Works on assignment only.

First Contact & Terms Send query letter with résumé, tearsheets, photographs and slides. Samples are filed. To show a portfolio, mail b&w slides and dummies. Rights purchased vary according to project. Originals returned at job's completion.

Book Design Assigns 3-4 design and 6-8 illustration jobs/year. Pays by the project.

Jackets/Covers Assigns 6-8 design and 10-12 illustration jobs/year. Pays by the project, $300-1,000 CDN.

Text Illustration Assigns 3-4 design and 4-6 illustration jobs/year. Pays by the project. May pay advance on royalties.

Tips Looks for freelancers with a proven track record and knowledge of Red Deer Press. "Send a quality portfolio, preferably with samples of book projects completed."

RED WHEEL/WEISER

(Publishers of RedWheel, Weiser Books and Conari Press), 368 Congress St., 4th Floor, Boston MA 02210. (617)542-1324. Fax: (617)482-9676. E-mail: kfivel@redwheelweiser.com. Website: www.redwheelweiser.com. **Contact:** Kathleen Wilson Fivel, art director. Specializes in hardcover and paperback originals, reprints and trade publications: Red Wheel: spunky self-help; Weiser Books: metaphysics/oriental philosophy/esoterical; Conari Press: self-help/inspirational. Publishes 70 titles/year.

Needs Freelancers for jacket/cover design and illustration.

First Contact & Terms Designers send query letter with résumé, photocopies and tearsheets. Illustrators send query letter with photocopies, photographs, SASE and tearsheets. "We can use art or photos. I want to see samples I can keep." Samples are filed or are returned by SASE only if requested by artist. Responds in 1 month only if interested. Originals are returned to artist at job's completion. To show portfolio, mail tearsheets, color photocopies or slides. Considers complexity of project, skill and experience of artist, project's budget, turnaround time and rights purchased when establishing payment. Buys one-time nonexclusive rights. Finds most artists through references/word of mouth, portfolio reviews and samples received through the mail.

Jackets/Covers Assigns 20 design jobs/year. Prefers a variety of media—depends entirely on project. Pays by the project, $100-500.

Tips "Send samples by mail, preferably in color. We work electronically and prefer digial artwork or scans. Do not send drawings of witches, goblins, and demons for Weiser Books; we don't put those kinds of images on our covers. Please take a moment to look at our books before submitting anything; we have characteristic looks for all three imprints."

[N] [E] REGNERY PUBLISHING INC.

Parent company: Eagle Publishing Inc., One Massachusetts Ave. NW, Washington DC 20001. (202)216-0601. Fax: (202)216-0612. E-mail: editorial@regnery.com. Website: www.regnery.com. **Contact:** Art Director. Estab. 1947. Publishes hardcover originals and reprints, trade paperback originals and reprints. Types of books include biography, health, exercise, diet, coffee table books, cookbooks, history, humor, instructional, nonfiction and self-help. Specializes in nonfiction. Publishes 30 titles/year. Recent titles include: *God, Guns and Rock & Roll*, by Ted Nugent; *The Diet Trap*. 20-50% requires freelance design. Book catalog available for SASE.

Needs Approached by 20 illustrators and 20 designers/year. Works with 6 designers/year. Prefers local illustrators and designers. Prefers freelancers experienced in Mac, QuarkXPress and Photoshop. 100% of freelance design demands knowledge of QuarkXPress. 50% of freelance illustration demands knowledge of Photoshop, QuarkXPress.

First Contact & Terms Send postcard sample and follow-up postcard every 6 months. Accepts Mac-compatible disk submissions. Send TIFF files. Samples are filed. Will contact artist for portfolio review if interested. Finds freelancers through *Workbook*, networking and submissions.

Book Design Assigns 5-10 freelance design jobs/year. Pays for design by the project; negotiable.

Jackets/Covers Assigns 5-10 freelance design and 1-5 illustration jobs/year. Pays by the project; negotiable.

Tips "We welcome designers with knowledge of Mac platforms . . . and the ability to design 'bestsellers' under extremely tight guidelines and deadlines!"

RIVER CITY PUBLISHING

1719 Mulberry St., Montgomery AL 36106. (334)265-6753. Fax: (334)265-8880. E-mail: web@rivercitypublishing.com. Website: www.rivercitypublishing.com. **Design and Production:** Lissa Monroe. Estab. 1991. Small press. Publishes hardcover and trade paperback originals. Types of books include biography, history, coffee table books, illustrated histories, novels and travel. Specializes in Americana, history, natural history. Publishes 15 titles/year. Recent titles include: *Speaks the Nightbird*, by Robert McCammon; *Nobody's Hero*, by Paul Hamphill; *Cloud Cuckoo Land*, by Lisa Borders.

[N] FRANK SCHAFFER PUBLICATIONS

3195 Wilson Dr. NW, Grand Rapids MI 49544. (800)417-3261. Fax: (888)203-9361. E-mail: info@schoolspecialty.com. Website: www.schoolspecialty.com. **Art Director:** John Kemler. Publishes supplemental educational print materials—secular and Christian print, and workbooks for teachers, parents, and home school educators at preschool through high school levels.

• Imprints include Instructional Fair Group, Judy Clock and Totline. Parent company is the Wisconsin-based publisher, School Specialty, which acquired imprints of McGraw-Hill Children's Publishing in 2004. Instructional Fair and Totline, two respected McGraw-Hill imprints, will remain an important part of the publishing program.

Needs Works with several freelancers/year. Full-color and blackline art. Prefers traditionally illustrated art in oils, acrylics, watercolors and markers, as well as computer-generated art.

First Contact & Terms Designers, illustrators and animators send query letter with photocopies and SASE. Samples are filed or are returned by SASE. Responds in 2 months if interested. Write for appointment to show portfolio, or mail samples. Pays by the project (amount negotiated), but generally pays $450/full-color cover and $30/page of text art. Considers client's budget and how work will be used when establishing payment. Buys all rights. Originals are not returned.

⟐ SCHOLASTIC INC.

557 Broadway, New York NY 10012. Website: www.scholastic.com. **Creative Director:** David Saylor. Specializes in hardcover and paperback originals of childen's picture books, young adult, biography, classics, historical and contemporary teen. Publishes 750 titles/year. Recent titles include: *The Three Questions*; *When Marian Sang*. 80% require freelance illustration.

• David Saylor is in charge of all imprints, from mass market to high end. Publisher uses digital work only for mass market titles. All other imprints usually prefer traditional media such as watercolors and pastels.

Needs Approached by thousands of freelancers/year. Works with 75 freelance illustrators and 2 designers/year. Prefers local freelancers with experience. Also for jacket/cover illustration and design and book design. 40% of illustration demands knowledge of QuarkXPress, Illustrator, Photoshop.

First Contact & Terms Illustrators send postcard sample or tearsheets. Samples are filed or are returned only if requested, with SASE. Art Director will contact artist for portfolio review if interested. Considers complexity of project and skill and experience of artist when establishing payment. Originals are returned at job's completion. Finds artists through word of mouth, *American Showcase*, *RSVP* and Society of Illustrators.

Book Design Pays by the project, $2,000 and up.

Jackets/Covers Assigns 200 freelance illustration jobs/year. Pays by the project, $2,000-5,000.

Text Illustration Pays by the project, $1,500 minimum.

Tips "Illustrators should research the publisher. Go into a bookstore and look at the books. Gear what you send according to what you see is being used. It is particularly helpful when illustrators include on their postcard a checklist of phrases, such as 'Please keep mailing samples' or 'No, your work is not for us.' That way, we can prevent the artists who we don't want from wasting postage and we can encourage those we'd like to work with."

SCHOLASTIC LIBRARY PUBLISHING

90 Old Sherman Turnpike, Danbury CT 06816. (800)621-1115. Website: www.scholastic.com/librarypublishing. Parent company of imprints Children's Press, Franklin Watts, Grolier and Grolier Online. Types of books include biography, young adult, reference, history and juvenile. Specializes in history, science and biography. Publishes 250 titles/year. 5% require freelance illustration; 10% require freelance design.

• Scholastic Library Publishing specializes in children's nonfiction, reference and online reference.

Needs Approached by over 500 freelance artists/year. Works with 10 freelance illustrators and 20 freelance designers/year. Buys 30 freelance illustrations/year. Uses freelance artists mainly for jacket/cover design and technical illustrations. Needs computer-literate freelancers for design. 100% of freelance work demands knowledge of Illustrator, QuarkXPress, Photoshop.

First Contact & Terms Send query letter with brochure, résumé, SASE and photocopies. Samples are not filed and are returned by SASE if requested by artist. Art Director will contact artist for portfolio review if interested. Portfolio should include website URL, b&w and color thumbnails, roughs, final art, tearsheets. Rights purchased vary according to project. Originals are returned at job's completion. Finds artists through artists' submissions.

Book Design Assigns 30 freelance design jobs/year. Pays by the project.

Jackets/Covers Assigns 75 freelance design and 10 freelance illustration jobs/year. Pays by the project.

Text Illustration Assigns 20-30 freelance illustration jobs/year. Pays by the project.

17TH STREET PRODUCTIONS

Division of Alloy, 151 W. 26th St., 11th Floor, New York NY 10001. (212)244-4307. **Contact:** Sandy Demarco, art director. Independent book producer/packager. Publishes mass market paperback originals. Publishes mainstream fiction, juvenile, young adult, self-help and humor. Publishes 125 titles/year. Recent titles include: *Roswell High*; *Sweet Valley High*; *Sweet Valley Twins* series; *Summer* series; *Bonechillers* series. 80% require freelance illustration; 25% require freelance design. Book catalog not available.

Needs Approached by 50 freelance artists/year. Works with 20 freelance illustrators and 5 freelance designers/

year. Only uses artists with experience in mass market illustration or design. Uses freelance artists mainly for jacket/cover illustration and design. Also uses freelance artists for book design. Works on assignment only.
First Contact & Terms Send query letter with résumé, SASE, tearsheets, photographs and photocopies. Samples are filed or returned by SASE if requested by artist. Responds to the artist only if interested. To show portfolio, mail original/final art, slides dummies, tearsheets and transparencies. Sometimes requests work on spec before assigning a job. Rights purchased vary according to project. Originals are returned at job's completion.
Jackets/Covers Assigns 10 freelance design and 50-75 freelance illustration jobs/year. Only criteria for media and style is that they reproduce well.
Tips "Know the market and have the professional skills to deliver what is requested on time. Book publishing is becoming very competitive. Everyone seems to place a great deal of importance on the cover design as that affects a book's sell through in the book stores."

☑ SIMON & SCHUSTER

Division of Viacom, 1230 Avenue of the Americas, New York NY 10020. (212)698-7000. Fax: (212)698-7336. E-mail: michael.accordino@simonandschuster.com. Website: www.simonsays.com. **Art Director:** Michael Accordino. Imprints include Pocket Books and Archway. Company publishes hardcover, trade paperback and mass market paperback originals, reprints and textbooks. Types of books include juvenile, preschool, romance, self-help, young adult and many others. Specializes in young adult, romance and self-help. Publishes 125 titles/year. Recent titles include: *Plan of Attack*, by Bob Woodward; *The Price of Loyalty*, by Ron Suskind. 95% require freelance illustration; 80% require freelance design.
Needs Works with 50 freelance illustrators and 5 designers/year. Prefers freelancers with experience working with models and taking direction well. Uses freelancers for hand lettering, jacket/cover illustration and design and book design. 100% of design and 75% of illustration demand knowledge of Illustrator and Photoshop. Works on assignment only.
First Contact & Terms Send query letter with tearsheets. Accepts disk submissions. Samples are filed and are not returned. Responds only if interested. Portfolios may be dropped off every Monday and Wednesday and should include tearsheets. Buys all rights. Originals are returned at job's completion.
Text Illustration Assigns 50 freelance illustration jobs/year.

SIMON & SCHUSTER CHILDREN'S PUBLISHING

1230 Avenue of the Americas, 4th Floor, New York NY 10020. (212)698-7000. Website: www.simonsays.com. **Vice President/Creative Director:** Lee Wade. Imprints include Alladin, Atheneum, McElderry, Simon & Schuster Books for Young Readers, Simon Pulse, Simon Spotlight. Imprint publishes hardcover originals and reprints. Types of books include picture books, nonfiction and young adult. Publishes 500 titles/year. 100% require freelance illustration; 1% require freelance design.
 • Simon & Schuster's Children's Publishing division has many different imprints, each with a unique specialty and its own art director. Imprints include Simon Spotlight (Chani Yammer), Simon Pulse (Russell Gordon), Books for Young Readers (Dan Potash), Alladin (Debbie Sfetsios) and McElderry (Ann Bobco).
Needs Approached by 200 freelancers/year. Works with 40 freelance illustrators and 2-3 designers/year. Uses freelancers mainly for jackets and picture books. 100% of design work demands knowledge of Illustrator, QuarkXPress and Photoshop. Works on assignment only.
First Contact & Terms Designers send query letter with résumé and photocopies. Illustrators send postcard sample or other nonreturnable samples. Accepts disk submissions. Art Director will contact artist for portfolio review if interested. Portfolio should include original art, photographs and transparencies. Originals are returned at job's completion. Finds artists through submissions, agents, scouting in nontraditional juvenile areas such as painters, editorial artists.
Jackets/Covers Assigns 20 freelance illustration jobs/year. Pays by the project, $800-2,500. "We use full range of media: collage, photo, oil, watercolor, etc."
Text Illustration Assigns 30 freelance illustration jobs/year. Pays by the project.

Ⓝ SMITH AND KRAUS, INC.

177 Lyme Rd., Hanover NH 03755. (603)643-6431. Website: www.smithkraus.com. **Production Manager:** Julia Hill. Company publishes hardcover and trade paperback originals. Types of books include young adult, drama and acting. Specializes in books for actors. Publishes 35 titles/year. Recent titles include: *The Best Men's/Women's Monologues of 1995*; *The Sanford Meisner Approach*; *Auditioning for Musical Theatre*. 20% require freelance illustration. Book catalog free for SASE with 3 first-class stamps.
Needs Approached by 2 freelancers/year. Works with 2-3 freelance illustrators/year. Uses freelancers mainly for cover art, inside illustration. Also for text illustration. 10% of freelance work demands knowledge of Illustrator, QuarkXPress and Photoshop. Works on assignment only.
First Contact & Terms Send postcard sample of work or send query letter with brochure, résumé. Samples are

filed. Art Director will contact artist for portfolio review if interested. Portfolio should include book dummy and roughs. Buys one-time and reprint rights. Originals are returned at job's completion. Finds artists through word of mouth.

Text Illustration Assigns 1-3 freelance illustration jobs/year. Pays by the project. Prefers pen & ink, oil, pastel.

Ⓝ SOUNDPRINTS

353 Main Ave., Norwalk CT 06851-1552. (203)846-2274. Fax: (203)846-1776. E-mail: soundprints@soundprints. com. Website: www.soundprints.com. **Art Director:** Martin Pilchowski. Associate Publisher: Ashley Andersen. Assistant Editor: Chelsea Shriver. Estab. 1989. Company publishes hardcover originals. Types of books include juvenile. Specializes in wildlife, worldwide habitats, social studies and history. Publishes 30 titles/year. Recent titles include: *Screech Owl at Midnight Hollow*, by Drew Lamm; *Koala Country*, by Deborah Dennand; *Box Turtle At Silver Pond Lane*, by Susan Korman. 100% require freelance illustration. Book catalog free for 9×12 SAE with $1.21 postage.

Needs Works with 8-10 freelance illustrators/year. Prefers freelancers with experience in realistic wildlife illustration and children's books. Heavy visual research required of artists. Uses freelancers for illustrating children's books (cover and interior).

First Contact & Terms Send query letter with samples, tearsheets, résumé and SASE. Samples are filed or returned by SASE if requested by artist. Responds in 1 month. Art director will contact artist for portfolio review if interested. Portfolio should include color final art and tearsheets. Rights purchased vary according to project. Originals are returned at job's completion. Finds artists through agents, sourcebooks, reference, unsolicited submissions.

Text Illustration Assigns 12-14 freelance illustration jobs/year.

Tips "Wants realism, not cartoons. Animals illustrated are not anthropomorphic. Artists who love to produce realistic, well-researched wildlife and habitat illustrations, and who care deeply about the environment, are most welcome."

SOURCEBOOKS, INC.

1935 Brookdale Rd., Suite 139, Naperville IL 60563. (630)961-3900. Fax: (630)961-2168. Website: www.sourceb ooks.com. Estab. 1987. Company publishes hardcover and trade paperback originals and ancillary items. Types of books include humor, New Age, nonfiction, fiction, preschool, reference, self-help and gift books. Specializes in business books and gift books. Publishes 150 titles/year. Recent titles include: *Poetry Speaks*; *Conscious Cuisine*; *The Last Noel*. Book catalog free for SAE with $2.86 postage.

Needs Uses freelancers mainly for ancillary items, journals, jacket/cover design and illustration, text illustration, direct mail, book and catalog design. 100% of design and 25% of illustration demand knowledge of QuarkXPress 4.0, Photoshop 5.0 and Illustrator 8.0. Works on assignment only.

First Contact & Terms Designers send query letter with photocopies. Illustrators send postcard sample. Accepts disk submissions compatible with Illustrator 8.0, Photoshop 5.0. Send EPS files. Responds only if interested. Request portfolio review in original query. Negotiates rights purchased.

Book Design Pays by the project.

Jackets/Covers Pays by the project.

Text Illustration Pays by the project.

Tips "We have expanded our list tremendously and are, thus, looking for a lot more artwork. We have terrific distribution in retail outlets and are looking to provide more great-looking material."

THE SPEECH BIN, INC.

1965 25th Ave., Vero Beach FL 32960. (561)770-0007. Fax: (561)770-0006. Website: www.speechbin.com. **Senior Editor:** Jan J. Binney. Estab. 1984. Publishes textbooks and educational games and workbooks for children and adults. Specializes in tests and materials for treatment of individuals with all communication disorders. Publishes 20-25 titles/year. Recent titles include: *I Can Say R*; *I Can Say S*; *R & L Stories Galore*. 50% require freelance illustration; 50% require freelance design. Book catalog available for 8½×11 SAE with $1.42 postage.

Needs Works with 8-10 freelance illustrators and 2-4 designers/year. Buys 1,000 illustrations/year. Work must be suitable for handicapped children and adults. Uses freelancers mainly for instructional materials, cover designs, gameboards, stickers. Also for jacket/cover and text illustration. Occasionally uses freelancers for catalog design projects. Works on assignment only.

First Contact & Terms Send query letter with SASE, tearsheets and photocopies. Samples are filed or are returned by SASE if requested by artist. Responds to the artist only if interested. Do not send portfolio; query only. Usually buys all rights. Considers buying second rights (reprint rights) to previously published work. Finds artists through "word of mouth, our authors and submissions by artists."

Book Design Pays by the project.

Jackets/Covers Assigns 10-12 freelance design jobs and 10-12 illustration jobs/year. Pays by the project.
Text Illustration Assigns 6-10 freelance illustration jobs/year. Prefers b&w line drawings. Pays by the project.

✅ SR BOOKS

(formerly Scholarly Resources Inc.), imprint of Rowman & Littlefield Publishers, 4501 Forbes Blvd., Suite 200, Lanham MD 20706. (301)459-3366. Fax: (301)429-5748. Website: www.rowmanlittlefield.com. **Contact:** Art Dept. Estab. 1972. Publishes textbooks and trade paperback originals. Types of books include American history, Latin-American studies, military history and reference books. Publishes 40 titles/year. Recent titles include: *A Gathering Darkness*, by Haruo Tohmatsu and H. Willmott; *Alanson B. Houghton*, by Jeffrey J. Matthews. 60% requires freelance illustration; 80% requires freelance design. Book catalog free.
Needs Works with 3 illustrators and 8 designers/year. Prefers freelancers experienced in book design. 100% of freelance design demands knowledge of PageMaker and QuarkXPress.
First Contact & Terms Designers and illustrators send query letter with printed samples, photocopies, tearsheets and SASE. Accepts Mac-compatible disk submissions. Samples are filed. Responds only if interested. Will contact artist for portfolio review if interested. Buys all rights. Finds freelancers through submission packets and networking events.
Book Design Assigns 12 freelance design jobs/year. Pays by the project, $400-800.
Jackets/Covers Assigns 30 freelance design jobs/year. Pays by the project, $1,000-1,500.

STAR PUBLISHING

Box 68, Belmont CA 94002. (650)591-3505. Fax: (650)591-3898. E-mail: mail@starpublishing.com. Website: www.starpublishing.com. **Publisher:** Stuart Hoffman. Estab. 1978. Specializes in original paperbacks and textbooks on science, art, business. Publishes 12 titles/year. 33% require freelance illustration. Titles include *Microbiology Techniques*; *Interpersonal Communications*; *Accounting*.

Ⓝ STOREY PUBLISHING

210 Mass MoCA Way, North Adams MA 01247. (413)346-2100. Fax: (413)346-2199. E-mail: meredith.maker@storey.com and cynthia.mcfarland@storey.com. Website: www.storey.com. **Art Director (covers):** Meredith Maker. Art Director (text): Cynthia McFarland. Estab. 1982. Publishes hardcover and trade paperback originals. Publishes: cookbooks, instructional, self-help, animal, gardening, crafts, building, herbs, natural healthcare. Publishes 50 titles/year. Recent titles include: *7 Simple Steps to Unclutter Your Life*; *The Guilt-Free Dog Owner's Guide*; *The Essential Oils Book*. 50% requires freelance illustration; 10% requires freelance design; 50% require freelance cover/jacket design.
Needs Approached by 100 illustrators and 30 designers/year. Works with 10 designers/year. Prefers local freelancers (but not necessary). Text freelancers must be experienced in book design and building. 100% of freelance design demands knowledge of QuarkXPress. Knowledge of Illustrator or Photoshop a plus.
First Contact & Terms Send query letter with printed samples, photocopies, SASE (if wish returned), tearsheets. Samples are filed or returned by SASE. Will contact artist for portfolio review if interested. Buys one-time rights or all rights. Finds freelancers through submission packets, ABA (BookExpo).
Book Design Assigns 5 freelance designs/year. Pays for design by the project, $500-3,000.
Jackets/Covers Assigns 25 freelance design jobs/year. Pays for design by the project, $250-1,000. Prefers strong type treatment, fresh looking, graphic appeal.
Tips "Storey Books are filled with how-to illustrations, tips, sidebars and charts. Storey covers are fresh, readable and clean."

JEREMY P. TARCHER, INC.

375 Hudson St., New York NY 10014. (212)366-2000. **Art Director:** David Walker. Estab. 1970s. Imprint of Penguin. Imprint publishes hardcover and trade paperback originals and trade paperback reprints. Types of books include instructional, New Age, adult contemporary and self-help. Publishes 45-50 titles/year. Recent titles include: *The End of Work*, by Jeremy Riskin; *The Artist's Way*, by Julia Cameron; *The New Drawing on the Right Side of the Brain*, by Betty Edwards. 30% require freelance illustration; 30% require freelance design.
Needs Approached by 10 freelancers/year. Works with 10-12 freelance illustrators and 4-5 designers/year. Works only with artist reps. Uses jacket/cover illustration. 50% of freelance work demands knowledge of QuarkXPress. Works on assignment only.
First Contact & Terms Send postcard sample of work or send query letter with brochure, tearsheets and photocopies. Samples are filed. Art Director will contact artist for portfolio review if interested. Portfolio should include book dummy, final art, photographs, roughs, tearsheets and transparencies. Buys first rights or one-time rights. Originals are returned at job's completion. Finds artists through sourcebooks, *Communication Arts*, word of mouth, submissions.
Book Design Assigns 4-5 freelance design jobs/year. Pays by the project, $800-1,000.

Jackets/Covers Assigns 4-5 freelance design and 10-12 freelance illustration jobs/year. Pays by the project, $950-1,100.
Text Illustration Assigns 1 freelance illustration job/year. Pays by the project, $100-500.

TAYLOR & FRANCIS, INC.

325 Chestnut St., Philadelphia PA 19106. (215)625-8900. Fax: (215)625-2940. Website: www.taylorandfrancis.com. **Vice President of Production:** Corey Gray. Estab. 1979. Book publisher. Publishes scholarly trade paperback and hardback originals. Types of books include business, politics and cultural studies. Specializes in gay and lesbian studies, women's studies, anthropology, archaeology, literary criticism and psychology. Publishes 100 titles/year. Desktop publishing only. Books are text oriented. Book catalog free by request.
Needs Approached by 20 freelance artists/year. Works with 4-8 freelance designers/year. Prefers artists with experience in book design. Also uses freelance artists for desktop publishing and book design. Works on assignment only.
First Contact & Terms Send query letter with brochure to art department. Samples are filed. Responds to the artist only if interested. Finds artists through word of mouth.
Jackets/Covers Prefers "interesting and provocative images and type interplay."

THISTLEDOWN PRESS LTD.

633 Main St., Saskatoon SK S7H 0J8 Canada. (306)244-1722. Fax: (306)244-1762. E-mail: tdpress@shaw.ca. Website: www.thistledown.sk.ca. **Director, Production:** Allan Forrie. Estab. 1975. Publishes trade and mass market paperback originals. Types of books include contemporary and experimental fiction, juvenile, young adult and poetry. Specializes in poetry and young adult fiction. Publishes 10-12 titles/year. Titles include *Filling the Belly*, by Tara Manuel; *Four Wheel Drift*, by Mel Dagg.
Needs Approached by 25 freelancers/year. Works with 8-10 freelance illustrators/year. Prefers local, Canadian freelancers. Uses freelancers for jacket/cover illustration. Uses only Canadian artists and illustrators for its title covers. Works on assignment only.
First Contact & Terms Designers send query letter with résumé and photocopies. Illustrators send postcard samples. Samples are filed or are returned by SASE. Responds to the artist only if interested. Call for appointment to show portfolio of original/final art, tearsheets, photographs, slides and transparencies. Buys one-time rights.
Jackets/Covers Assigns 10-12 illustration jobs/year. Prefers painting or drawing, "but we have used tapestry—abstract or expressionist to representational." Also uses 10% computer illustration. Pays by the project, $250-600.
Tips "Look at our books and send appropriate material. More young adult and adolescent titles are being published, requiring original cover illustration and cover design. New technology (Illustrator, Photoshop) has slightly altered our cover design concepts."

THOMSON DELMAR LEARNING

(formerly Delmar Publishers Inc.), 5 Maxwell Dr., Clifton Park NY 12065. (518)348-2300. Website: www.delmarlearning.com. **Contact:** Larry Main, auto cad, electronics, architecture, drafting; Mary Ellen Black, automotive, electrical, welding, construction; Linda Helfrich, allied health, travel, fashion; Wendy Troeger, agriculture, paralegal; Karen Leet, nursing and education; Andrew Crouth, Auto Desk. Estab. 1946. Specializes in original hardcovers and paperback textbooks—science, health, cosmetology, Auto Cad, education, automotive, electricity and electronics, graphic arts, fashion, paralegal, etc. Publishes 250+ titles/year. Titles include *License to Drive* and *Standard Textbook of Cosmetology*.
Needs Approached by 200 artists/year. Works with 40 artists/year. Prefers text illustrators and designers, paste-up artists, technical/medical illustrators and computer graphic/AUTOCAD artists. Works on assignment only.
First Contact & Terms Send query letter with brochure, résumé, tearsheets, photostats, photocopies, slides or photographs. Samples not requested to be returned will be filed for one year. Any material needed back must return via certified mail. Not responsible for loss of unsolicited material. Responds only if interested. Considers complexity of project, budget and turnaround time when establishing payment. Buys all rights.
Book Design Assigns 50 design jobs/year. Pays by the project.
Covers Assigns 150 design jobs/year. Pays by the project.
Text Illustration Assigns up to 125 jobs/year. Prefers electronic art. Two-color application is most common form. Four-color art is needed less frequently but still a requirement. Charts, graphs, technical illustration and general pictorials are common. Pays by the project/piece.
Tips "Quote prices for samples shown. Quality and meeting deadlines most important. Experience with textbook publishing a benefit." Look of design and illustration used is "basic, clean, conservative, straightforward technical art. Lots of elements in design, knowledge of web printing limitations a plus. Know style sheets and master pages."

TOP COW

Imprint of Image Comics, 10350 Santa Monica Blvd., #100, Los Angeles CA 90025. E-mail: submissions@topcow .com. Website: www.topcow.com. **Contact:** Submissions Editor. Types of books include comic books. Recent titles include: *Darkness #1*; *Witchblade #60*; *Battle of the Planets #4*. Book catalog and submissions guidelines available on website.

First Contact & Terms Send photocopies, résumé. It's best to include Top Cow characters. Show "3-4 pages of good storytelling using sequential panels." Accepts e-mail submissions from illustrators. Prefers JPEG files (under 500k). Samples not filed and not returned. Responds only if interested.

Tips "Include only your best work. Show your grasp of dynamic anatomy, ability to draw all types of people, faces and expressions. Show your grasp of perspective. Show us detailed background."

N TOR BOOKS

Tom Doherty Associates, LLC, 175 Fifth Ave., 14th Floor, New York NY 10010. (212)388-0100. Fax: (212)388-0191. Website: www.tor.com. **Art Director:** Irene Gallo (hardcover). Senior Designer: Pete Lutjen (mass market paperback). Specializes in hardcover and paperback originals and reprints: espionage, thrillers, horror, mysteries and science fiction. Publishes 425 titles/year; heavy on science fiction. Recent titles include: *Water Sleeps*, by Glen Cook; *The Eagle and the Raven*, by James Michener; *Mind Changer*, by James White.

First Contact & Terms All covers are freelance. Works with 50-100 freelance illustrators and 5-10 freelance designers/year. Works on assignment only. Send query letter with color photographs, slides or tearsheets to be kept on file "unless unsuitable." Portfolios may be dropped off Monday through Friday from 9:30-5:30; 24-hour turnaround. Samples not filed are returned by SASE. Responds only if interested. Original work returned after job's completion. Considers skill and experience of artist and project's budget when establishing payment. "We buy the right to use art on all editions of book it is commissioned for and in promotion of book."

Book Design Pays by the project.

Jackets/Covers Assigns 180 freelance illustration jobs/year. Pays by the project, $500 minimum.

Text Illustration Pays by the project.

Tips "We would like to see more technical proficiency. In science fiction, more realistic renditions of machinery, etc.; less wild, cartoony, colorful 'futuristic' stuff. Hardcover list tends to be a little more experimental in look. If your style is more commercial, send to Pete. If it's more experimental, send to Irene."

N TRAFTON PUBLISHING

109 Barcliff Terr., Cary NC 27511. (919)363-0999. E-mail: davidasinger@earthlink.net. Website: www.rogbates. com. **Owner:** Roger Bateman. Publisher: Rick Singer. Estab. 1993. Publishes trade paperback originals and audiotapes. Types of books include how-to, self-help and humor. Publishes 2-5 titles/year. Recent titles include: *How To Be Funnier*; *The Humor In Relationships Guide*; *Seeing The Lighter Side*. 50% require freelance illustration and design.

Needs Works with 1-4 freelance illustrators and 1-2 designers/year. Prefers freelancers experienced in simple, friendly, humorous line drawings. Uses freelancers mainly for illustrations and cover design.

First Contact & Terms Designers send query letter with photocopies and photographs. Illustrators send query letter with photocopies. Samples are filed and not returned. Responds only if interested. Buys all rights.

Jackets/Covers Assigns 1-3 freelance design and 1-3 freelance illustration jobs/year. Pays by the project.

Text Illustration Assigns 1-3 illustration jobs/year. Pay varies by the hour or by the project. Finds artists through submissions.

N TRANSPORTATION TRAILS, National Bus Trader, Inc.

9698 W. Judson Rd., Polo IL 61064. (815)946-2341. Fax: (815)946-2347. **Editor:** Larry Plachno. Production Manager: Joseph Plachno. Estab. 1977. Imprints include National Bus Trader, Transportation Trails Books; also publishes *Bus Tours Magazine*. Company publishes hardcover and mass market paperback originals and magazines. Types of books include "primarily transportation history but some instruction and reference." Publishes 5-7 titles/year. Titles include *Breezers—A Lighthearted History of The Open Trolley Car in America* and *The Steam Locomotive Directory of North America*. Book catalog free by request.

Needs Approached by 1 freelancer/year. Works with 3 freelance illustrators/year. Prefers local freelancers if possible with experience in transportation and rail subjects. Uses freelancers mainly for covers and chapter logo lines. Also for text illustration, maps, occasional magazine illustrations and oil paintings for Christmas magazine covers. Works on assignment only. 20% of freelance work requires knowledge of Illustrator.

First Contact & Terms Send query letter with "any reasonable sample." Accepts disk submissions compatible with Illustrator and QuarkXPress. Samples are returned by SASE if requested by artist. Artist should follow up with letter after initial query. Buys all rights. Originals are not returned.

Jackets/Covers Assigns 3-6 freelance illustration jobs/year. Pays by the project, $150-700. Prefers b&w pen & ink line drawing of subject with rubylith/amberlith overlays for color.

Text Illustration Assigns 3-6 freelance illustration jobs/year. Pays by the project, $50-200. Prefers silhouette b&w line drawing approximately 42×6 picas.

Tips First-time assignments are usually silhouette text illustrations; book jackets and magazine covers are given to "proven" freelancers. "Send samples and ask for our letter, which explains what we want."

▣ TREEHAUS COMMUNICATIONS, INC.

906 W. Loveland Ave., P.O. Box 249, Loveland OH 45140. (513)683-5716. Fax: (513)683-2882. E-mail: treehaus1 @earthlink.net. Website: www.treehaus1.com. **President:** Gerard Pottebaum. Estab. 1973. Publisher. Specializes in books, periodicals, texts, TV productions. Product specialties are social studies and religious education. Recent titles include: *The Stray*; *Rosanna The Rainbow Angel* for children ages 4-8.

Needs Approached by 12-24 freelancers/year. Works with 2 or 3 freelance illustrators/year. Prefers freelancers with experience in illustrations for children. Works on assignment only. Uses freelancers for all work. Also for illustrations and designs for books and periodicals. 5% of work is with print ads. Needs computer-literate freelancers for illustration.

First Contact & Terms Send query letter with résumé, transparencies, photocopies and SASE. Samples sometimes filed or are returned by SASE if requested by artist. Responds in 1 month. Art director will contact artist for portfolio review if interested. Portfolio should include final art, tearsheets, slides, photostats and transparencies. Pays for design and illustration by the project. Rights purchased vary according to project. Finds artists through word of mouth, submissions and other publisher's materials.

Tips "We are looking for original style that is developed and refined. Whimsy helps."

TRIUMPH BOOKS

601 LaSalle St., Suite 500, Chicago IL 60605. (312)939-3330. Fax: (312)663-3557. E-mail: triumphbks@aol.com. Estab. 1990. Publishes hardcover originals and reprints, trade paperback originals and reprints. Types of books include biography, coffee table books, humor, instructional, reference, sports. Specializes in sports titles. Publishes 50 titles/year. 5% requires freelance illustration; 60% requires freelance design. Book catalog free for SAE with 2 first-class stamps.

Needs Approached by 5 illustrators and 5 designers/year. Works with 2 illustrators and 8 designers/year. Prefers freelancers experienced in book design. 100% of freelance design demands knowledge of Photoshop, PageMaker, QuarkXPress.

First Contact & Terms Send query letter with printed samples, SASE. Accepts Mac-compatible disk submissions. Send TIFF files. Samples are filed or returned by SASE. Will contact artist for portfolio review if interested. Buys all rights. Finds freelancers through word of mouth, organizations (Chicago Women in Publishing), submission packets.

Book Design Assigns 20 freelance design jobs/year. Pays for design by the project.

Jackets/Covers Assigns 30 freelance design and 2 illustration jobs/year. Pays for design by the project. Prefers simple, easy-to-read, in-your-face cover treatment.

Tips "Most of our interior design requires a fast turnaround. We do mostly one-color work with occasional two-color and four-color jobs. We like a simple, professional design."

Ⓝ TWENTY-FIRST CENTURY BOOKS/A DIVISION OF MILLBROOK PRESS, INC.

2 Old New Milford Rd., Brookfield CT 06804. (203)740-2220. Fax: (203)740-2526. Website: www.millbrookpress .com. **Art Director:** Judie Mills. Estab. 1986. Publishes hardcover originals. Types of books include juvenile, young adult and nonfiction for school and library market. Specializes in biography, social studies, drug education and science. Publishes 25-38 titles/year. Recent titles include: *The Glass Ceiling*; *Confederate Ladies of Richmond*. 60% requires freelance illustration.

Needs Approached by up to 10 freelance artists/year. Works with 3-10 freelance illustrators/year. Buys 100-200 freelance illustrations/year. Prefers artists with experience in realistic narrative illustration. Uses freelance artists mainly for jacket/cover and text illustration. Works on assignment only.

First Contact & Terms Send query letter with tearsheets and any nonreturnable samples. Samples are filed. Responds only if interested. Write to schedule an appointment to show portfolio or mail tearsheets. Rights purchased vary according to project. Originals returned at job's completion.

Book Design Assigns 5-20 freelance illustration jobs/year.

Jackets/Covers Assigns 10-15 freelance illustration jobs/year. Pays by the project.

Text Illustration Assigns 10-20 freelance illustration jobs/year. Pays by the project.

Tips "Be competent, with a professional manner and a style that fits the project."

TYNDALE HOUSE PUBLISHERS, INC.

351 Executive Dr., Carol Stream IL 60188. (630)668-8300. E-mail: TML@tyndale.com. Website: www.tyndale.c om. **Art Buyer:** Talinda M. Laubach. Vice President, Production: Joan Major. Specializes in hardcover and

paperback originals as well as children's books on "Christian beliefs and their effect on everyday life." Publishes 200 titles/year. 50% require freelance illustration. Books have "high quality innovative design and illustration." Recent titles include: *Desecration*; *Bringing Up Boys*.

Needs Approached by 50-75 freelance artists/year. Works with 30-40 illustrators and cartoonists/year.

First Contact & Terms Send query letter, tearsheets and/or slides. Samples are filed or are returned by SASE. Responds only if interested. Considers complexity of project, skill and experience of artist, project's budget and rights purchased when establishing payment. Negotiates rights purchased. Originals are returned at job's completion except for series logos.

Jackets/Covers Assigns 40 illustration jobs/year. Prefers progressive but friendly style. Pays by the project.

Text Illustration Assigns 10 jobs/year. Prefers progressive but friendly style. Pays by the project.

Tips "Only show your best work. We are looking for illustrators who can tell a story with their work and who can draw the human figure in action when appropriate." A common mistake is "neglecting to make follow-up calls. Be able to leave sample(s). Be available by friendly phone reminders, sending occasional samples. Schedule yourself wisely, rather than missing a deadline."

☒ UAHC PRESS

A division of Union of American Hebrew Congregations, 633 Third Ave., New York NY 10017. (212)650-4100. Fax: (212)650-4119. E-mail: SBenick@uahc.org. Website: www.uahcpress.com. **Managing Director:** Stuart L. Benick. Produces books and magazines for Jewish school children and adult education. Recent titles include: *Good Morning Good Night*, by Michelle Shapiro Abraham.

Needs Approached by 20 freelancers/year.

First Contact & Terms Send samples or write for interview. Include SASE.

Jackets/Covers Pays by the project, $250-600.

Text Illustration Pays by the project, $150-200.

Tips Seeking "clean and catchy" design and illustration.

THE UNIVERSITY OF ALABAMA PRESS

Box 870380, Tuscaloosa AL 35487-0380. (205)348-5180 or (205)348-1571. Fax: (205)348-9201. E-mail: rcook@uapress.ua.edu. Website: www.uapress.ua.edu. **Production Manager:** Rick Cook. Designer: Michele Myatt Quinn. Specializes in hardcover and paperback originals and reprints of academic titles. Publishes 60-70 titles/year. Recent titles include: *Cradle of Freedom*, by Frye Gaillard; *Inside Alabama*, by Harvey H. Jackson III; *Twenty-three Minutes to Eternity*, by James L. Noles Jr. 35% requires freelance design.

Needs Works with 5-6 freelancers/year. Requires book design experience, preferably with university press work. Works on assignment only. 100% of freelance design demands knowledge of PageMaker 6.5, Photoshop 7.0, QuarkXPress, InDesign and Illustrator.

First Contact & Terms Send query letter with résumé, tearsheets and slides. Accepts disk submissions if compatible with Macintosh versions of above programs, provided that a hard copy that is color accurate is also included. Samples not filed are returned only if requested. Responds in a few days. To show portfolio, mail tearsheets, final reproduction/product and slides. Considers project's budget when establishing payment. Buys all rights. Originals are not returned.

Book Design Assigns 1-2 freelance jobs/year. Pays by the project, $600 minimum.

Jackets/Covers Assigns about 30 freelance design jobs/year. Pays by the project, $600 minimum.

Tips Has a limited freelance budget. "We often need artwork that is abstract or vague rather than very pointed or focused on an obvious idea. For book design, our requirements are that they be classy and, for the most part, conservative."

☑ ☐ UNIVERSITY OF PENNSYLVANIA PRESS

4200 Pine St., Philadelphia PA 19104-4011. (215)898-6261. Fax: (215)898-0404. E-mail: wmj@pobox.upenn.edu. Website: www.upenn.edu/pennpress/. **Design Director:** John Hubbard. Estab. 1920. Publishes hardcover originals. Types of books include biography, history, nonfiction, landscape architecture, art history, anthropology, literature and regional history. Publishes 80 titles/year. Recent titles include: *Debt for Sale*. 10% requires freelance design.

Needs Works with 4 designers/year. 100% of freelance work demands knowledge of Illustrator, Photoshop and QuarkXPress.

First Contact & Terms Designers send query letter with photocopies. Illustrators send postcard sample. Accepts Mac-compatible disk submissions. Samples are not filed or returned. Will contact artist for portfolio review if interested. Portfolio should include book dummy and photocopies. Rights purchased vary according to project. Finds freelancers through submission packets and word of mouth.

Book Design Assigns 2 freelance design jobs/year. Pays by the project, $600-1,000.

Jackets/Covers Assigns 6 freelance design jobs/year. Pays by the project, $600-1,000.

Book Publishers

VISUAL EDUCATION GROUP/MCGRAW-HILL

148 Princeton-Hightstown Rd., Hightstown NJ 08520-1412. (609)426-5000. **Director of Design and Production:** Barbara Kopel. Estab. 1969. Independent book producer/packager of textbooks and reference books. Specializes in social studies, history, geography, vocational, math, science, etc. Recent titles include: *The American Journey*; *The Middle Ages*. 80% require freelance design.

Needs Approached by 30 freelance artists/year. Works with 4-5 illustrators and 5-15 designers/year. Buys 5-10 illustrations/year. Prefers artists with experience in textbooks, especially health, medical, social studies. Works on assignment only.

First Contact & Terms Send query letter with tearsheets and résumé. Samples are filed. Responds to the artist only if interested. To show portfolio, mail roughs and tearsheets. Rights purchased vary according to project. Originals returned at job's completion.

Book Design Assigns 5-15 jobs/year. Pays by the project.

Jackets/Covers Assigns 1-2 design jobs/year. Pays by the project.

Tips "Designers, if you contact us with samples we will invite you to do a presentation and make assignments as suitable work arises. Graphic artists, when working assignments we review our files. Enclose typical rate structure with your samples."

VOYAGEUR PRESS

123 N. Second St., Stillwater MN 55082-5002. (651)430-2210. Fax: (651)430-2211. E-mail: books@voyageurpress.com. Website: www.voyageurpress.com. **Editorial Director:** Michael Dregni. Pre-Press Director: Andrea Rud. Estab. 1973. Book publisher. Publishes hardcover and trade paperback originals. Types of books include Americana, collectibles, travel, cookbooks, natural history and regional. Specializes in natural history, travel and regional subjects. Publishes 50 titles/year. Recent titles include: *Every Quilt Tells a Story*; *The Last Big Cats*. 10% require freelance illustration; 10% require freelance design. Book catalog free by request.

Needs Approached by 100 freelance artists/year. Works with 2-5 freelance illustrators and 2-5 freelance designers/year. Prefers artists with experience in maps and book and cover design. Uses freelance artists mainly for cover and book design. Also uses freelance artists for jacket/cover illustration and direct mail and catalog design. 100% of design requires computer skills. Works on assignment only.

First Contact & Terms Send postcard sample and/or query letter with brochure, photocopies, SASE and tearsheets, list of credits and nonreturnable samples of work that need not be returned. Samples are filed. Responds to the artist only if interested. "We do not review portfolios unless we have a specific project in mind. In that case, we'll contact artists for a portfolio review." Usually buys first rights. Originals returned at job's completion.

Book Design Assigns 2-5 freelance design jobs and 2-5 freelance illustration jobs/year.

Jackets/Covers Assigns 2-5 freelance design and 2-5 freelance illustration jobs/year.

Text Illustration Assigns 2-5 freelance design and 2-5 design illustration jobs/year.

Tips "We use more book designers than artists or illustrators, since most of our books are illustrated with photographs."

J. WESTON WALCH PUBLISHING

321 Valley St., Portland ME 04102. (207)772-2846. Fax: (207)772-3105. Website: www.walch.com. **Art Director:** David Sullivan. Estab. 1927. Company publishes supplementary educational books and other material (video, software, audio, posters, cards, games, etc.). Types of books include instructional and young adult. Specializes in all middle and high school subject areas. Recent titles include: Graphic Organizers for: English classes, science classes and social studies classes; *Portrait of American Music: Great Twentieth Century Musicians*. Publishes 100 titles/year. 15-25% require freelance illustration. Book catalog free by request.

Needs Approached by 70-100 freelancers/year. Works with 10-20 freelance illustrators and 5-10 designers/year. Prefers local freelancers only. Uses freelancers mainly for text and/or cover illustrations. Also for jacket/cover design, interior design, typography and typesetting.

First Contact & Terms Send tearsheets, SASE and photocopies. Samples are filed or returned by SASE. Accepts disk submissions compatible with Photoshop, QuarkXPress, FreeHand or Framemaker. Art Director will contact artist for portfolio review if interested. Portfolio should include final art, roughs and tearsheets. Buys one-time rights. Originals are returned at job's completion. Finds artists through submissions, reviewing with other art directors in the local area.

Jackets/Covers Assigns 10-15 freelance design and 10-20 illustration jobs/year. Pays by the project, $300-1,500.

Text & Poster Illustration Pays by the project, $300-4,000.

Tips "Show a facility with taking subject matter appropriate for middle and high school curriculums and presenting it in a new way."

☑ WARNER BOOKS INC.

imprint of AOL Time Warner Book Group, 1271 Avenue of the Americas, 9th Floor, New York NY 10020. (212)522-7200. Website: www.twbookmark.com. **Vice President and Creative Director:** Anne Twomey. Publishes mass market paperbacks and adult trade hardcovers and paperbacks. Publishes 300 titles/year. Recent titles include: *Find Me*, by Rosie O'Donnell; *The Millionaires*, by Brad Meltzer; *Cancer Schmancer*, by Fran Drescher. 20% requires freelance design; 80% requires freelance illustration.

 • Others in the department are Diane Luger and Flamur Tonuzi. Send them mailers for their files as well.
Needs Approached by 500 freelancers/year. Works with 75 freelance illustrators and photographers/year. Uses freelancers mainly for illustration and handlettering. Works on assignment only.
First Contact & Terms Do not call for appointment or portfolio review. Mail samples only. Send non-returnable brochure or tearsheets and photocopies. Samples are filed. Art Director will contact artist for portfolio review if interested. Negotiates rights purchased. Considers buying second rights (reprint rights) to previously published work. Originals are returned at job's completion (artist must pick up). "Check for most recent titles in bookstores." Finds artists through books, mailers, parties, lectures, judging and colleagues.
Jackets/Covers Pays for design and illustration by the project. Uses all styles of jacket illustrations.
Tips Industry trends include "graphic photography and stylized art." Looks for "photorealistic style with imaginative and original design and use of eye-catching color variations. Artists shouldn't talk too much. Good design and art should speak for themselves."

WATERBROOK PRESS

Random House, 2375 Telstar Dr., Suite 160, Colorado Springs CO 80920. (719)264-9404. Fax: (719)590-8977. E-mail: jthamilton@randomhouse.com. Website: www.waterbrookpress.com. **Contact:** John Hamilton, art director. Estab. 1997. Publishes audio tapes, hardcover, mass market paperback and trade paperback originals. Types of books include romance, science fiction, western, young adult fiction; biography, coffee table books, religious, self-help nonfiction. Specializes in Christian titles. Publishes 60 titles/year. Recent titles include *Thorn in My Heart*; *Winner Take All*; *Bad Girls of the Bible*. 30% requires freelance design; 10% requires freelance illustration. Book catalog free on request.
Needs Approached by 10 designers and 100 illustrators/year. Works with 4 designers and 2 illustrators/year. 90% of freelance design work demands knowledge of Illustrator, QuarkXPress and Photoshop.
First Contact & Terms Designer/Illustrators send postcard sample with brochure, tearsheets. After introductory mailing, send follow-up postcard sample every 3 months. Samples are filed and not returned. Portfolio not required. Buys one-time rights, first North American serial rights. Finds freelancers through artist's submissions, Internet.
Jackets/Covers Assigns 2 freelance cover illustration jobs/year. Pays for illustration by the project $600-1,000.
Text Illustration Assigns 4 freelance illustration jobs/year. Pays by the project $200-3,000.

☑ WEIGL EDUCATIONAL PUBLISHERS LIMITED.

6325 Tenth St. SE, Calgary AB T2H 2Z9 Canada. (403)233-7747. Fax: (403)233-7769. E-mail: info@weigl.com. Website: www.weigl.com. **Contact:** Managing Editor. Estab. 1979. Textbook and library series publisher catering to juvenile and young adult audience. Specializes in social studies, science-environmental, life skills, multicultural American and Canadian focus. Publishes over 100 titles/year. Titles include *The Love of Sports*, *A Guide to American States*, *20th Century USA*. Book catalog free by request.
Needs Approached by 300 freelancers/year. Uses freelancers only during peak periods. Prefers freelancers with experience in children's text illustration in line art/watercolor. Uses freelancers mainly for text illustration or design. Also for direct mail design. Freelancers should be familiar with QuarkXPress 5.0, Illustrator 10.0 and Photoshop 7.0.
First Contact & Terms Send résumé for initial review prior to selection for interview. Limited freelance opportunities. Graphic designers required on site. Extremely limited need for illustrators. Samples are returned by SASE if requested by artist. Responds to the artist only if interested. Write for appointment to show portfolio of original/final art (small), b&w photostats, tearsheets and photographs. Rights purchased vary according to project.
Text Illustration Pays on project basis, depending on job. Prefers line art and watercolor appropriate for elementary and secondary school students.

ALBERT WHITMAN & COMPANY

6340 Oakton, Morton Grove IL 60053-2723. Website: www.albertwhitman.com. **Editor:** Kathleen Tucker. Art Director: Carol Gildar. Specializes in hardcover original juvenile fiction and nonfiction—many picture books for young children. Publishes 25 titles/year. Recent titles include: *Mabella the Clever*, by Margaret Read MacDonal; *Bravery Soup*, by Maryann Cocca-Leffle. 100% requires freelance illustration. Books need "a young look— we market to preschoolers and children in grades 1-3."
Needs Prefers working with artists who have experience illustrating juvenile trade books. Works on assignment only.

First Contact & Terms Illustrators send postcard sample and tearsheets. "One sample is not enough. We need at least three. Do *not* send original art through the mail." Accepts disk submissions. Samples are not returned. Responds "if we have a project that seems right for the artist. We like to see evidence that an artist can show the same children and adults in a variety of moods, poses and environments." Rights purchased vary. Original work returned at job's completion.

Cover/Text Illustration Cover assignment is usually part of text illustration assignment. Assigns 2-3 covers per year. Prefers realistic and semi-realistic art. Pays by flat fee for covers; royalties for picture books.

Tips Especially looks for "an artist's ability to draw people, especially children and the ability to set an appropriate mood for the story."

☑ WILLIAMSON BOOKS

P.O. Box 185, Charlotte VT 05445. E-mail: susan@kidsbks.net. Website: www.idealspublications.com/williams onbooks.htm. **Editorial Director:** Susan Williamson. Estab. 1983. Publishes trade paperback originals. Types of books include children's nonfiction (science, history, the arts), creative play, early learning, preschool and educational. Specializes in children's active hands-on learning. Publishes 15 titles/year. Recent titles include: *Kaleidoscope Kids*; *Kids Can!*. Book catalog free for $8^{1}/_{2} \times 11$ SASE with 6 first-class stamps.

• This publisher is an imprint of Ideals Publications, a division of Guideposts.

Needs Approached by 200 illustrators and 10 designers/year. Works with 15 illustrators and 8 designers/year. 100% of freelance design demands computer skills. "We especially need illustrators with a vibrant black & white style—and with a sense of humor evident in illustrations." All illustrations must be provided in scanned, electronic form.

First Contact & Terms "Please do not e-mail large files to us. We prefer receiving postcards with references to your websites. We really will look if we are interested." Designers send query letter with brochure, photocopies, résumé, SASE. Illustrators send postcard sample and/or query letter with photocopies, résumé and SASE. Samples are filed. Responds only if interested.

Book Design Pays for design and illustration by the project.

Tips "We are actively seeking freelance illustrators and book designers to support our growing team. We are looking for mostly black & white and some 2-color illustration—step-by-step how-to (always done with personality as opposed to technical drawings). Go to the library and look up several of our books in our four series. You'll immediately see what we're all about. Then do a few samples for us. If we're excited about your work, you'll definitely hear from us. We always need designers who are interested in a non-traditional approach to kids' book design. Our books are award-winners, and design and illustration are key elements to our books' phenomenal success."

WILSHIRE BOOK CO.

12015 Sherman Rd., North Hollywood CA 91605. (818)765-8579. E-mail: mpowers@mpowers.com. Website: www.mpowers.com. **President:** Melvin Powers. Company publishes trade paperback originals and reprints. Types of books include internet marketing, humor, instructional, New Age, psychology, self-help, inspirational and other types of nonfiction. Publishes 25 titles/year. Titles include: *Think Like a Winner!*; *The Dragon Slayer with a Heavy Heart*; *The Knight in Rusty Armor*. 100% require freelance design. Catalog for SASE with first-class stamps.

Needs Uses freelancers mainly for book covers, to design cover plus type. Also for direct mail design. "We need graphic design ready to give to printer. Computer cover designs are fine."

First Contact & Terms Send query letter with fee schedule, tearsheets, photostats, photocopies (copies of previous book covers). Portfolio may be dropped off every Monday-Friday. Portfolio should include book dummy, slides, tearsheets, transparencies. Buys first, reprint or one-time rights. Interested in buying second rights (reprint rights) to previously published work. Negotiates payment.

Book Design Assigns 25 freelance design jobs/year.

Jackets/Covers Assigns 25 cover jobs/year.

Ⓝ ▣ THE H.W. WILSON COMPANY

950 University Ave., Bronx NY 10452-4224. (718)588-8400. Fax: (718)590-1617. E-mail: lamos@hwwilson.com. Website: www.hwwilson.com. **Art Director:** Lynn Amos. Estab. 1898. Publishes CD-ROMs, hardcover originals and Web databases. Types of books include reference. Specializes in periodical indexing, abstracting and full text. Publishes 13 titles/year. Recent titles include: *Radical Change: Books for Youth in a Digital Age*; *Wilson Biographies Plus*. 8% requires freelance design. Book catalog not available.

Needs Approached by 20 illustrators and 5 designers/year. Works with 1 illustrator and 5 designers/year. Prefers freelancers experienced in brochure and direct mail design and book design. 100% of freelance design demands knowledge of Illustrator, Photoshop and QuarkXPress.

First Contact & Terms Designers send query letter with photocopies. Illustrators send postcard sample and

follow-up postcard every year. Accepts Mac-compatible disk submissions. Samples are filed or returned by SASE. Responds only if interested. Will contact artist for portfolio review if interested. Rights purchsed vary according to project. Finds freelancers usually through word of mouth, sometimes postcard mailings.

Book Design Assigns 3 freelance design jobs/year. Pays for design by the project.

Jackets/Covers Assigns 2 freelance design jobs and 1 illustration job/year.

☑ ▣ WINDSTORM CREATIVE

P.O. Box 28, Port Orchard WA 98366. Website: www.windstormcreative.com. **Senior Editor:** Ms. Cris DiMarco. Art Director: Buster Blue. Publishes books, CD-ROMs, e-books, Internet guides. Trade paperback. Children's books as well as illustrated novels for adults. Genre work as well as general fiction and nonfiction. Recent titles: *Miss Panda in Japan*; *The New Star Tarot*; *Tonight I Heard the Ghost Cat*; *Roses & Thorns: Beauty & the Beast Retold*.

Needs Anime and Manga artists, versatile artists with an ability to work both with computer graphics as well as in nonelectronic media, b&w photorealism.

First Contact & Terms See webpage for guidelines. Portfolios submitted without SASE are not reviewed. Prefer a preprinted postcard for response. Portfolios kept on file. Must be able to take direction from art director and utilize author input on projects. Must be able to meet strict deadlines. Artists paid either a flat fee or on a royalty (up to 15%) for cover and/or interior work. Artist retains copyright and originals.

WIZARDS OF THE COAST

P.O. Box 707, Renton WA 98057-0707. (425)204-7289. E-mail: artdrop@wizards.com. Website: www.wizards.com. **Attn:** Art Submission. Estab. 1990.

● Because of large stable of artists, very few new artists are being given assignments.

Needs Prefers freelancers with experience in fantasy art. Art guidelines available on website. Works on assignment only. Uses freelancers mainly for cards, posters, books. Considers all media. Looking for fantasy, science fiction portraiture art. 100% of design demands knowledge of Photoshop, Illustrator, FreeHand, QuarkXPress. 30% of illustration demands computer skills.

First Contact & Terms Illustrators send cover letter and résumé with 6-10 non-returnable 8½×11 full color copies. Accepts submissions on CDs and transparencies. "We do not accept original artwork." Will contact for portfolio review if interested. Portfolios should include color, finished art or b&w pieces, photographs and tearsheets. Rights purchased vary according to project. Pays for design by the project, $300 minimum. Payment for illustration and sculpture depends on project. Finds freelancers through conventions, submissions and referrals. Submissions returned only if return postage included.

Tips "Remember who your audience is. Not everyone does 'babe' art."

WRIGHT GROUP-McGRAW HILL

Parent company: McGraw Hill Companies. 1 Prudential Plaza, 130 E. Randolph St., Suite 400, Chicago IL 60601. (312)233-6600. Website: www.wrightgroup.com. **Contact:** Vickie Tripp, Amy Krupp, design managers. Publishes educational children's books. Types of books include children's picture books, history, nonfiction, preschool, educational reading materials. Specializes in education pre K-8. Publishes 150 titles/year. 100% requires freelance illustration; 5% requires freelance design.

Needs Approached by 100 illustrators and 10 designers/year. Works with 50 illustrators and 2 designers/year. Prefers local designers and art directors. Prefers freelancers experienced in children's book production. 100% of freelance design demands knowledge of Photoshop, FreeHand, QuarkXPress.

First Contact & Terms Send query letter with printed samples, color photocopies and follow-up postcard every 6 months. Samples are filed or returned. Will contact artist for portfolio review if interested. Buys all rights. Finds freelancers through submission packets, agents, sourcebooks, word of mouth.

Book Design Assigns 2 freelance design and 2 freelance art direction projects/year. Pays for design by the hour, $30-35.

Text Illustration Assigns 150 freelance illustration jobs/year. Pays by the project, $3,000-3,800.

Tips "Illustrators will have fun and enjoy working on our books, knowing the end result will help children learn to love to read."

YE GALLEON PRESS

Box 287, Fairfield WA 99012. (509)283-2422. Estab. 1937. Publishes hardcover and paperback originals and reprints. Types of books include rare Western history, Indian material, antiquarian shipwreck and old whaling accounts, and town and area histories. Publishes 20 titles/year. 10% requires freelance illustration. Book catalog on request.

First Contact & Terms Works with 2 freelance illustrators/year. Query with samples and SASE. No advance. Pays promised fee for unused assigned work. Buys book rights.

Galleries

© Joan Ritchie

ost artists dream of seeing their work in a gallery. It's the equivalent of "making it" in the art world. That dream can be closer than you realize. The majority of galleries are actually quite approachable and open to new artists. Though there will always be a few austere establishments manned by snooty clerks, most are friendly places where people come to browse and chat with the gallery staff.

So don't let galleries intimidate you. The majority of galleries will be happy to take a look at your slides if you make an appointment or mail your slides to them. If they feel your artwork doesn't fit their gallery, most will steer you toward a more appropriate one.

A few guidelines

- **Never walk into a gallery without an appointment,** expecting to show your work to the gallery director. When we ask gallery directors for pet peeves they always discuss the talented newcomer walking into the gallery with paintings in hand. Send a polished package of about 8 to 12 neatly labeled, mounted duplicate slides of your work submitted in plastic slide sheet format. (Refer to the listings for more specific information on each gallery's preferred submission method.) Do not send original slides, as you will need them to reproduce later. Send a SASE, but realize you may not get your packet returned.
- **Seek out galleries that show the type of work you create.** Each gallery has a specific "slant" or mission.
- **Visit as many galleries as you can.** Browse for a while and see what type of work they sell. Do you like the work? Is it similar to yours in quality and style? What about the staff? Are they friendly and professional? Do they seem to know about the artists the gallery handles? Do they have convenient hours? If you are interested in galleries outside your city and you can't manage a personal visit before you submit, read the listing carefully to make sure you understand what type of work is shown in that gallery and get a feel for what the space is like. Ask a friend or relative who lives in that city to check out the gallery for you.
- **Attend openings.** You'll have a chance to network and observe how the best galleries promote their artists. Sign each gallery's guest book or ask to be placed on galleries' mailing lists. That's also one good way to make sure the gallery sends out professional mailings to prospective collectors.

Showing in multiple galleries

Most successful artists show in several galleries. Once you have achieved representation on a local level, you are ready to broaden your scope by querying galleries in other cities. You

Types of galleries

As you search for the perfect gallery, it's important to understand the different types of spaces and how they operate. The route you choose depends on your needs, the type of work you do, your long term goals and the audience you're trying to reach.

Retail or commercial galleries. The goal of the retail gallery is to sell and promote artists while turning a profit. Retail galleries take a commission of 40 to 50 percent of all sales.

Co-op galleries. Co-ops exist to sell and promote artists' work, but they are run by artists. Members exhibit their own work in exchange for a fee, which covers the gallery's overhead. Some co-ops also take a small commission of 20 to 30 percent to cover expenses. Members share the responsibilities of gallery-sitting, sales, housekeeping and maintenance.

Rental galleries. The gallery makes its profit primarily through renting space to artists and consequently may not take a commission on sales (or will take only a very small commission). Some rental spaces provide publicity for artists, while others do not. Showing in this type of gallery is risky. Rental galleries are sometimes thought of as "vanity galleries" and, consequently, they do not have the credibility other galleries enjoy.

Nonprofit galleries. Nonprofit spaces will provide you with an opportunity to sell work and gain publicity but will not market your work aggressively, because their goals are not necessarily sales-oriented. Nonprofits normally take a small commission of 20 to 30 percent.

Museums. Though major museums generally show work by established artists, many small museums are open to emerging artists.

Art consultancies. Generally, art consultants act as liasions between fine artists and buyers. Most take a commission on sales (as would a gallery). Some maintain small gallery spaces and show work to clients by appointment.

may decide to concentrate on galleries in surrounding states, becoming a "regional" artist. Some artists like to have an East Coast and a West Coast gallery.

If you plan to sell work from your studio, or from a website or other galleries, be up front with your gallery. Work out a commission arrangement you can all live with, and everybody wins.

Pricing your fine art

A common question of beginning artists is "What do I charge for my paintings?" There are no hard and fast rules. The better known you become, the more collectors will pay for your work. Though you should never underprice your work, you must take into consideration what people are willing to pay. Also keep in mind that you must charge the same amount for a painting sold in a gallery as you would for work sold from your studio.

Juried shows, competitions and other outlets

It may take months, maybe years, before you find a gallery to represent you. But don't worry; there are plenty of other venues to show in until you are accepted in a commercial gallery.

If you get involved with your local art community, attend openings and read the arts section of your local paper, you'll see there are hundreds of opportunities.

Enter group shows and competitions every chance you get. Go to the art department of your local library and check out the bulletin board, then ask the librarian to steer you to magazines like *Art Calendar* (www.artcalendar.com) that list "calls to artists" and other opportunities to exhibit your work. Subscribe to the *Art Deadlines List*, available in hard copy or online versions (www.artdeadlineslist.com). Join a co-op gallery and show your work in a space run by artists for artists.

Another opportunity to show your work is through local restaurants and retail shops that show the work of local artists. Ask the manager how you can show your work. Become an active member in an arts group. It's important to get to know your fellow artists. And since art groups often mount exhibitions of their members' work, you'll have a way to show your work until you find a gallery to represent you.

Helpful resources

For More Info

To develop a sense of various galleries and how to approach them, look to the myriad of art publications that contain reviews and articles. A few such publications are *ARTnews*, *Art in America* and regional publications such as *ARTweek* (West Coast), *Southwest Art*, *dialogue* and *Art New England*. Lists of galleries can be found in *Art in America's Guide to Galleries* and *Art Now*. *The Artist's Magazine*, *Art Papers* and *Art Calendar* are invaluable resources for artists and feature dozens of helpful articles about dealing with galleries.

ALABAMA

THE ATCHISON GALLERY

2847 Culver Rd., Birmingham AL 35223. (205)871-6233. **Director:** Larry Atchison. Retail gallery and art consultancy. Estab. 1974. Represents 35 emerging, mid-career and a few established artists/year. Exhibited artists include Bruno Zupan and Cynthia Knapp. Sponsors 12 shows/year. Average display time 1 month. Open all year; Monday-Friday, 9:30-5; Saturday, 10-2. Located in the Mountain Brook Village; 2,000 sq. ft.; open ceiling, large open spaces. 25-30% of space for special exhibitions; 75% of space for gallery artists. Clientele: upscale, residential and corporate. 70-75% private collectors, 25-30% corporate collectors. Overall price range: $600-15,000; most work sold at $1,800-3,500 (except for exclusive pieces, Dine's, Warhols, etc.).
Media Considers all media except fiber, paper and pen & ink. Considers engravings, lithographs and etchings. Most frequently exhibits oil-acrylic, mixed media and pastel.
Style Exhibits: expressionism, painterly abstraction, minimalism, impressionism, photorealism and realism. Genres include florals, landscapes and figurative work. Prefers: painterly abstraction, impressionism and realism/figurative.
Terms Accepts work on consignment (50% commission). Retail price set by both the gallery and artist. Gallery provides insurance, promotion and contract; shipping costs are shared. Prefers artwork unframed.
Submissions Most artists are full-time professionals. Send query letter with résumé, bio and artist's statement with slides, brochure, photographs and/or reviews. Write for appointment to show portfolio of photographs, slides and transparencies. Responds in 1 month. Files résumé, slides, bio, photographs, artist statement and brochure. Finds artists through referrals by other artists, submissions, visiting exhibits, reviewing art journals/magazines.

FAYETTE ART MUSEUM

530 N. Temple Ave., Fayette AL 35555. (205)932-8727. Fax: (205)932-8788. E-mail: fccfam@cyberjoes.com. **Director:** Jack Black. Museum. Estab. 1969. Exhibits the work of emerging, mid-career and established artists. Open all year; Monday-Friday, 9-4 and by appointment outside regular hours. Located downtown Fayette Civic Center; 16,500 sq. ft. Six galleries devoted to folk art.
Media Considers all media and all types of prints. Most frequently exhibits oil, watercolor and mixed media.
Style Exhibits expressionism, primitivism, painterly abstraction, minimalism, postmodern works, impressionism, realism and hard-edge geometric abstraction. Genres include landscapes, florals, Americana, wildlife, portraits and figurative work.
Terms Shipping costs negotiable. Prefers artwork framed.
Submissions Send query letter with résumé, brochure and photographs. Write for appointment to show portfolio of photographs. Files possible exhibit material.
Tips "Do not send expensive mailings (slides, etc.) before calling to find out if we are interested. We want to expand collection. Top priority is folk art from established artists."

🄽 GALLERY 54, INC.

54 Upham, Mobile AL 36607. (251)473-7995. E-mail: gallery54art1@aol.com. **Owner:** Leila Hollowell. Retail gallery. Estab. 1992. Represents 35 established artists/year. May be interested in seeing the work of emerging artists in the future. Exhibited artists inlcude Charles Smith and Lee Hoffman. Sponsors 5 shows/year. Average display time 1 month. Open all year; Tuesday-Saturday, 11-4:30. Located in midtown, about 560 sq. ft. Clientele: local. 70% private collectors, 30% corporate collectors. Overall price range: $20-6,000; most work sold at $200-1,500.
Media Considers oil, acrylic, watercolor, pastel, pen & ink, drawing, mixed media, collage, sculpture, ceramics, glass, photography, woodcuts, serigraphs and etchings. Most frequently exhibits acrylic/abstracts, watercolor and pottery.
Style Exhibits expressionism, painterly abstraction, impressionism and realism. Prefers realism, abstract and Impressionism.
Terms Accepts work on consignment (40% commission) or buys outright for 50% of retail price (net 30 days). Retail price set by the artist. Gallery provides contract. Artist pays shipping costs. Prefers artwork framed.
Submissions Southern artists preferred (mostly Mobile area). It's easier to work with artist's work on consignment. Send query letter with slides and photographs. Write for appointment to show portfolio of photographs and slides. Responds in 2 weeks. Files information on artist. Finds artists through art fairs, referrals by other artists and information in mail.
Tips "Don't show up with work without calling and making an appointment."

🄽 THE KENTUCK ART CENTER

503 Main Ave., Northport AL 35476-4483. (205)758-1257. Fax: (205)758-1258. E-mail: Kentuck@dbtech.net. Website: www.kentuck.org. **Executive Director:** Sara Anne Gibson. Nonprofit gallery. Estab. 1980. Exhibits

emerging artists. Approached by 400 artists/year. Represents 100 artists/year. Sponsors 18 exhibits/year. Average display time 1 month. Open all year; Monday-Friday, 9-5; weekends 10-4:30. Closed major holidays. Clients include local community. 5% of sales are to corporate collectors. Overall price range: $150-10,000; most work sold at $400.

Media Considers all media. Most frequently exhibits mixed media, oil and pastel. Considers all types of prints except posters.

Style Exhibits: Considers all styles. Most frequently exhibits painterly abstraction, expressionism, conceptulalism.

Terms Artwork is accepted on consignment and there is a 40% commission. Artwork is bought outright for 50% of retail price; net 30 days. Retail price set by the artist. Gallery provides insurance, promotion and contract. Accepted work should be mounted. Requires exclusive representation locally.

Submissions Write to arrange a personal interview to show portfolio of slides. Mail portfolio for review. Returns material with SASE. Responds in 6 months. Finds artists through word of mouth, submissions, portfolio reviews, art exhibits and referrals by other artists.

Tips "Submit professional slides."

Ⓝ MAYOR'S OFFICE FOLK ART GALLERY

5735 Hwy. 431, P.O. Box 128, Pittsview AL 36871. (334)855-3568. E-mail: www.mayorsoffice@webtv.net. Website: folkartisans.com/mayorsoffice. **Owner:** Frank Turner. Wholesale gallery. Estab. 1994. Represents 5-6 emerging, mid-career and established artists/year. Exhibited artists include: Buddy Snipes, Butch Anthony, John Henry Toney, Ned Berry and Rocky Wade. Average display time 6 months. Open all year; by chance or appointment. Located in rural community on main highway; 800-1,000 sq. ft.; folk/outsider art only. 75% of space for gallery artists. Clientele: tourists, upscale collectors, dealers. 50% private collectors (wholesale). Overall price range: $60-1,000; most work sold at $60-150.

Media Considers oil, acrylic, watercolor, pastel, pen & ink, drawing, mixed media, collage, paper, sculpture, fiber and glass; considers all types of prints. Most frequently exhibits oil, house paint and wood.

Style Exhibits: expressionism and primitivism. (It's folk art—you name it and they do it.)

Terms Buys outright. Retail price set by the gallery and the artist. Gallery provides promotion; shipping costs are shared.

Submissions Accepts only artists from east Alabama and west Georgia. Prefers folk/outsider only—must be "unique and true." Call to show portfolio of photographs and original art. Finds artists through word of mouth, referrals by other artists and submissions.

Tips "No craft items. Art must be true—straight from the heart and mind of the artist."

Ⓝ MOBILE MUSEUM OF ART

4850 Museum Dr., Mobile AL 36608-1917. (251)208-5200. E-mail: prichelson@mobilemuseumofart.com. Website: www.MobileMuseumOfArt.com. **Acting Director:** Paul Richelson. Clientele: tourists and general public. Sponsors 6 solo and 12 group shows/year. Average display time 6-8 weeks. Interested in emerging, mid-career and established artists. Overall price range: $100-5,000; most artwork sold at $100-500.

Media Considers all media and all types of visual art.

Style Exhibits all styles and genres. "We are a general fine arts museum seeking a variety of styles, media and time periods." Looking for "historical significance."

Terms Accepts work on consignment (20% commission). Retail price set by artist. Exclusive area representation not required. Gallery provides insurance, promotion, contract; shipping costs are shared. Prefers framed artwork.

Submissions Send query letter with résumé, brochure, business card, slides, photographs, bio and SASE. Write to schedule an appointment to show a portfolio, which should include slides, transparencies and photographs. Replies only if interested within 3 months. Files résumés and slides. All material is returned with SASE if not accepted or under consideration.

Tips "Be persistent—but friendly!"

RENAISSANCE GALLERY, INC.

431 Main Ave., Northport AL 35476. (205)752-4422. **Owners:** Judy Buckley and Kathy Groshong. Retail gallery. Estab. 1994. Represents 25 emerging, mid-career and established artists/year. Exhibited artists include: Elayne Goodman and John Kelley. Sponsors 12 shows/year. Average display time 6 months. Open all year; Monday-Saturday, 11-4:30. Located in downtown historical district; 1,000 sq. ft.; historic southern building. 25% of space for special exhibitions; 75% of space for gallery artists. Clientele: tourists and local community. 95% private collectors; 5% corporate collectors. Overall price range: $65-3,000; most work sold at $300-900.

Media Considers oil, acrylic, watercolor, pastel, pen & ink, mixed media, sculpture; types of prints include

woodcuts and monoprints. No mass-produced reproductions. Most frequently exhibits oil, acrylic and water-color.

Style Exhibits: painterly abstraction, impressionism, photorealism, realism, imagism and folk-whimsical. Genres include florals, portraits, landscapes, Americana and figurative work. Prefers: realism, imagism and abstract.

Terms Accepts work on consignment (50% commission). Retail price set by the artist. Gallery provides promotion; shipping costs are shared. Prefers artwork framed. "We are not a frame shop."

Submissions Prefers only painting, pottery and sculpture. Send query letter with slides or photographs. Write for appointment to show portfolio of photographs and sample work. Responds only if interested within 1 month. Files artists slides/photographs, returned if postage included. Finds artists through referrals by gallery artists.

Tips "Do your homework. See the gallery before approaching. Make an appointment to discuss your work. Be open to suggestions, not defensive. Send or bring decent photos. Have work that is actually available, not already given away or sold. Don't bring in your first three works. You should be comfortable with what you are doing, past the experimental stage. You should have already produced many works of art (zillions!) before approaching galleries."

MARCIA WEBER/ART OBJECTS, INC.

1050 Woodley Rd., Montgomery AL 36106. (334)262-5349. Fax: (334)567-0060. E-mail: weberart@mindspring.com. Website: www.marciaweberartobjects.com. **Owner:** Marcia Weber. Retail, wholesale gallery. Estab. 1991. Represents 21 emerging, mid-career and established artists/year. Exhibited artists include: Woodie Long, Jimmie Lee Sudduth. Sponsors 6 shows/year. Open all year except July by appointment only. Located in Old Cloverdale near downtown in older building with hardwood floors in section of town with big trees and gardens. 100% of space for gallery artists. Clientele: tourists, upscale. 90% private collectors, 10% corporate collectors. Overall price range: $300-20,000; most work sold at $300-4,000.

- This gallery owner specializes in the work of self-taught, folk, or outsider artists. Many artists shown generally "live down dirt roads without phones," so a support person first contacts the gallery for them. Marcia Weber moves the gallery to New York's Soho district 3 weeks each winter and routinely shows in the Atlanta area.

Media Considers all media except prints. Must be original one-of-a-kind works of art. Most frequently exhibits acrylic, oil, found metals, found objects and enamel paint.

Style Exhibits genuine contemporary folk/outsider art, self-taught art and some Southern antique original works.

Terms Accepts work on consignment (variable commission) or buys outright. Gallery provides insurance, promotion and contract if consignment is involved. Prefers artwork unframed so the gallery can frame it.

Submissions Folk/outsider artists usually do not contact dealers. They have a support person or helper, who might write or call, send query letter with photographs, artist's statement. Call or write for appointment to show portfolio of photographs, original material. Finds artists through word of mouth, other artists and "serious collectors of folk art who want to help an artist get in touch with me." Gallery also accepts consignments from collectors.

Tips "An artist is not a folk artist or an outsider artist just because their work resembles folk art. They have to *be* folks who began creating art without exposure to fine art. Outsider artists live in their own world outside the mainstream and create art. Academic training in art excludes artists from this genre." Prefers artists committed to full-time creating.

ALASKA

ALASKA STATE MUSEUM

395 Whittier St., Juneau AK 99801-1718. (907)465-2901. Fax: (907)465-2976. E-mail: bruce_kato@eed.state.ak.us. Website: museums.state.ak.us. **Curator of Exhibitions:** Mark Daughhetee. Museum. Estab. 1900. Approached by 40 artists/year; exhibits 4 emerging, mid-career and established artists. Sponsors 10 exhibits/year. Average display time 6-10 weeks. Downtown location—3 galleries exhibiting temporary exhibitions.

Media Considers all media. Most frequently exhibits painting, photography and mixed media. Considers engravings, etchings, linocuts, lithographs, mezzotints, serigraphs and woodcuts.

Style Considers all styles.

Submissions Write to arrange a personal interview to show portfolio of slides. Returns material with SASE. Finds artists through submissions and portfolio reviews.

BUNNELL STREET GALLERY

106 W. Bunnell, Suite A, Homer AK 99603. (907)235-2662. Fax: (907)235-9427. E-mail: bunnell@xyz.net. Website: www.xyz.net/~bunnell/. **Director:** Asia Freeman. Nonprofit gallery. Estab. 1990. Approached by 50

GET A FREE ISSUE OF I.D.
THE INTERNATIONAL DESIGN MAGAZINE

I.D. magazine gives you in-depth, multi-disciplinary analysis of design trends, practices, experiments, and innovators. From furniture and posters to packaging and websites, **I.D.** brings you the latest work from emerging designers — the design that changes lives and changes our world.

And now you can get a **FREE** issue — with no obligation and no risk. Just send in your reply card and try **I.D.** today.

THE BEST IN...

PRODUCT DESIGN: from cars to kitchen sinks, tires to televisions, we cover the new and notable

GRAPHIC DESIGN: breakout design in books, periodicals, brochures, annual reports, packaging, signage, and more

INTERACTIVE DESIGN: the latest games, websites, CD-ROMs, and software

ENVIRONMENTAL DESIGN: from restaurants and museums to schools, offices, and boutiques, you'll take a tour of the world's best environmental design

I.D. THE BEST IN DESIGN

artists/year. Represents 35 emerging, mid-career and established artists. Sponsors 12 exhibits/year. Average display 1 month. Open Monday-Saturday, 10-6; Sunday, 12-4 (summer only). Closed January. Located on corner of Main and Bunnell Streets, Old Town, Homer; 30×25 exhibition space; good lighting, hardwood floors. Clients include local community and tourists. 10% of sales are to corporate collectors. Overall price range: $50-2,500; most work sold at $500.

Media Considers all media. Most frequently exhibits painting, ceramics and installation. No prints; originals only.

Style Considers all styles and genres. Most frequently exhibits painterly abstraction, impressionism, conceptualism.

Terms Artwork is accepted on consignment and there is a 35% commission. A donation of time is requested. Gallery provides insurance, promotion and contract. Accepted work should be framed. Does not require exclusive representation locally.

Submissions Call or write to arrange a personal interview to show portfolio of slides or mail portfolio for review. Returns material with SASE. Responds in 1 month. Finds artists through word of mouth, submissions, art exhibits and referrals by other artists.

ARIZONA

▣ ARIZONA STATE UNIVERSITY ART MUSEUM

Nelson Fine Arts Center and Ceramics Research Center, Arizona State University, Tempe AZ 85287-2911. (480)965-2787. Website: asuartmuseum.asu.edu. **Director:** Marilyn Zeitlin. Estab. 1950. Presents mid-career, established and emerging artists. Sponsors 12 shows/year. Average display time 2 months. Open all year. Located downtown Tempe ASU campus. Nelson Fine Arts Center features award-winning architecture, designed by Antoine Predock. "The Ceramics Research Center, located just next to the main museum, features open storage of our 3,000 works plus collection and rotating exhibitions. The museum also presents an annual short film and video festival."

Media Considers all media. Greatest interests are contemporary art, crafts, video, and work by Latin American and Latin artists.

Submissions "Interested artists should submit slides to the director or curators."

Tips "With the University cutbacks, the museum has scaled back the number of exhibitions and extended the average show's length. We are always looking for exciting exhibitions that are also inexpensive to mount."

☑ ARTISIMO ARTSPACE

Scottsdale AZ 85251. (480)949-0433. Fax: (480)994-0959. E-mail: artisimo@artisimogallery.com. Website: www.artisimogallery.com. Contact: Amy Wenk, director. For-profit gallery. Estab. 1991. Approached by 30 artists/year. Represents 20 emerging, mid-career and established artists. Exhibited artists include: Carolyn Gareis (mixed media), Korey Gulbrandson (mixed media). Sponsors 3 exhibits/year. Average display time 5 weeks. Clients include local community, upscale, designers, corporations, restaurants. Overall price range: $200-4,000; most work sold at $1,500.

Media Considers all media and all types of prints.

Style Exhibits: geometric abstraction and painterly abstraction. Genres include figurative work, florals, landscapes and abstract.

Terms "Available art is displayed on the Artisimo website. Artisimo will bring desired art to the client's home or business. If art is accepted, it will be placed on the website." There is a 50% commission upon sale of art. Retail price set by the artist. Gallery provides insurance and promotion. Requires exclusive representation locally.

Submissions Send query e-mail with artist's statement, bio, photographs, résumé or link to website. Responds in 3 weeks. Files photographs and bios. Finds artists through word of mouth, submissions, portfolio reviews, art exhibits, art fairs and referrals by other artists.

⬚ EL PRADO GALLERIES, INC.

Tlaquepaque Village, Box 1849, Sedona AZ 86339. (928)282-7390. E-mail: elprado@sedona.net. Website: www.elpradogalleries.com. **President:** Don H. Pierson. Estab. 1976. Represents 60 emerging, mid-career and established artists. Exhibited artists include Guy Manning and John Cogan. Open all year. Located in Sedona's Tlaquepaque Village: 5,000 sq. ft. 95% private collectors, 5% corporate collectors. Accepts artists from all regions. Overall price range: $75-125,000.

Media Considers oil, acrylic, watercolor, pastel, mixed media, collage, works on paper, sculpture, ceramic, craft, fiber and glass. Considers woodcuts, engravings, lithographs, wood engravings, mezzotints, serigraphs, linocuts and etchings. Most frequently exhibits oil, acrylic, watercolor and sculpture.

Style Exhibits all styles and genres. Prefers landscapes, Southwestern and Western styles. Does not want to see avant-garde.

Terms Accepts work on consignment (50% commission). Retail price set by the gallery and the artist. Gallery provides insurance and promotion; shipping costs are shared. Prefers framed work.

Submissions Send query letter with photographs. Call or write to schedule an appointment to show a portfolio which should include photographs. "A common mistake artists make is presenting work not up to our standards of quality." Responds in 3 weeks. Files material only if interested.

Tips "The artist's work must be original, not from copyrighted photos, and must include SASE. Our clients today are better art educated than before."

ELEVEN EAST ASHLAND INDEPENDENT ART SPACE

11 E. Ashland, Phoenix AZ 85004. (602)257-8543. Fax: (602)257-8543. **Contact:** David Cook. Estab. 1986. Represents emerging, mid-career and established artists. Exhibited artists include David Cook, Frank Mell, Ron Crawford and Mark Dolce. Sponsors 2 invitationals: Fall—Best of the West—non-Cowboy Art Show; Spring—Adults Only—Open Invitational; 2 months each; group/solo shows. Located in "two-story old farm house in central Phoenix, off Central Ave." Overall price range: $100-5,000; most artwork sold at $100-800.

- An anniversary exhibition is held every year in April and is open to national artists. Work must be submitted by the end of February. Work will be for sale and considered for permanent collection and traveling exhibition.

Media Considers all media and all types of prints. Most frequently exhibits photography, painting, mixed media and sculpture.

Style Exhibits all styles, preferably conceptualism, minimalism and neo-expressionism.

Terms Accepts work on consignment (25% commission); rental fee for space covers 2 months. Retail price set by artist. Artist pays for shipping.

Submissions Accepts proposal in person or by mail to schedule shows 6 months in advance. Send query letter with résumé, brochure, business card, 3-5 slides, photographs, bio and SASE. Call or write for appointment to show portfolio of slides and photographs. Be sure to follow through with proposal format. Responds only if interested within 1 month. Samples are filed or returned if not accepted or under consideration.

Tips "Be active and enthusiastic."

ETHERTON GALLERY

135 S. Sixth Ave., Tucson AZ 85701. (520)624-7370. Fax: (520)792-4569. E-mail: ethertongallery@mindspring.com. Website: www.ethertongallery.com. **Contact:** Terry Etherton. Retail gallery and art consultancy. Specializes in vintage and contemporary photography. Estab. 1981. Represents 50+ emerging, mid-career and established artists. Exhibited artists include Holly Roberts, Kate Breakey, James G. Davis and Mark Klett. Sponsors 12 shows/year. Average display time 5 weeks. Open year round. Located "downtown; 3,000 sq. ft.; in historic building—wood floors, 16' ceilings." 75% of space for special exhibitions; 10% of space for gallery artists. Clientele: 50% private collectors, 25% corporate collectors, 25% museums. Overall price range: $100-50,000; most work sold at $500-2,000.

Media Considers oil, acrylic, drawing, mixed media, collage, sculpture, ceramic, all types of photography, original handpulled prints, woodcuts, wood engravings, linocuts, engravings, mezzotints, etchings and lithographs. Most frequently exhibits photography, painting and sculpture.

Style Exhibits expressionism, neo-expressionism, primitivism, postmodern works. Genres include landscapes, portraits and figurative work. Prefers expressionism, primitive/folk and post-modern. Interested in seeing work that is "cutting-edge, contemporary, issue-oriented, political."

Terms Accepts work on consignment (50% commission). Buys outright for 50% of retail price (net 30 days). Retail price set by gallery and artist. Gallery provides insurance and promotion; shipping costs are shared. Prefers framed artwork.

Submissions Only "cutting-edge contemporary—no decorator art." No "unprepared, incomplete works or too wide a range—not specific enough." Send résumé, brochure, disk, slides, photographs, reviews, bio and SASE. Call or write to schedule an appointment to show a portfolio, which should include slides. Responds in 6 weeks only if interested. Files slides, résumés and reviews.

Tips "Become familiar with the style of our gallery and with contemporary art scene in general."

▣ THE GALLOPING GOOSE

162 S. Montezuma, Prescott AZ 86303. (520)778-7600. E-mail: gallopgoose@aol.com. Website: www.gallopingg oosegallery.com. **Owner:** Zack Batikh. Retail gallery. Estab. 1987. Represents 200 emerging, mid-career and established artists. Exhibited artists include Bev Doolittle and Maija. Average display time 2 weeks. Open all year. Located in the "SW corner of historic Whiskey Row across from the courthouse in downtown Prescott; newly remodeled with an additional 2,000 sq. ft. of gallery space." 10% of space for special exhibitions. Clients:

established art collectors and tourists. 95% private collectors, 5% corporate collectors. Overall price range: $20-5,000; most work sold at $150-1,000.

Media Considers oil, pen & ink, fiber, acrylic, drawing, sculpture, watercolor, mixed media, ceramic, pastel, original handpulled prints, reliefs, lithographs, offset reproductions and posters. Most frequently exhibits pastel, oil, tempera and watercolor.

Style Exhibits surrealism, imagism and realism. Genres accepted include landscapes, Americana, Southwestern, Western, wildlife and Indian themes only. Prefers wildlife, Southwestern cowboy art and landscapes.

Terms Buys outright for 50% of the retail price; net 30 days. Customer discounts and payment by installment are available. Retail price set by the gallery and the artist. Gallery pays for shipping costs to gallery. Prefers artwork unframed.

Submissions Send query letter with bio, brochure, photographs and business card. To show a portfolio, call for appointment. Gallery prefers written correspondence. Files photographs, brochures and biographies. Finds artists through visiting exhibitions, word of mouth and various art publications.

Tips "Stop by to see our gallery, determine if artwork would be appropriate for our clientele and meet the owner to see if an arrangement is possible."

TEMPLE BETH ISRAEL SYLVIA PLOTKIN JUDAICA MUSEUM/CONTEMPORARY ARTS GALLERY

10460 N. 56th St., Scottsdale AZ 85253. (480)951-0323. Fax: (480)951-7150. E-mail: museum@templebethisrael. org. **Director:** Pamela S. Levin. Museum. Estab. 1997. Represents 75 emerging, mid-career and established artists. Exhibited artists include Robert Lipnich and Elizabeth Mears. Clients include local community, tourists and upscale. Overall price range: $50-5,000; most work sold at $500.

Media Considers all media. Most frequently exhibits craft, glass and ceramics. Considers all types of prints.

Styles Considers all styles. Genre: Judaica.

Making Contact & Terms Artwork is accepted on consignment and there is a 40% commission. Retail price set by the artist. Gallery provides insurance and promotion. Accepted work should be framed. Prefers only Judaica.

Submissions Call to arrange a personal interview to show portfolio. Send query letter with bio, brochure, photocopies, photographs, résumé, reviews, slides. Returns material with SASE. Responds in 1 month.

ARKANSAS

☑ ARKANSAS STATE UNIVERSITY FINE ARTS CENTER GALLERY

P.O. Drawer 1920, State University AR 72467. (870)972-3050. E-mail: csteele@astate.edu. Website: www.clt.ast ate.edu/art/. **Chair, Department of Art:** Curtis Steele. University—Art Department Gallery. Estab. 1968. Represents/exhibits 3-4 emerging, mid-career and established artists/year. Sponsors 3-4 shows/year. Average display time 1 month. Open fall, winter and spring; Monday-Friday, 10-4. Located on university campus; 1,600 sq. ft.; 60% of time devoted to special exhibitions; 40% to faculty and student work. Clientele: students/community.

Media Considers all media. Considers all types of prints. Most frequently exhibits painting, sculpture and photography.

Style Exhibits conceptualism, photorealism, neo-expressionism, minimalism, hard-edge geometric abstraction, painterly abstraction, postmodern works, realism, impressionism and pop. "No preference except quality and creativity."

Terms Exhibition space only; artist responsible for sales. Retail price set by the artist. Gallery provides insurance, promotion and contract; shipping costs are shared. Prefers artwork framed.

Submissions Send query letter with résumé, slides and SASE. Portfolio should include photographs, transparencies and slides. Responds only if interested within 2 months. Files résumé. Finds artists through call for artists published in regional and national art journals.

Tips "Show us 20 slides of your best work. Don't overload us with lots of collateral materials (reprints of reviews, articles, etc.). Make your vita as clear as possible."

✠ ARTISTS WORKSHOP

810 Central Ave., Hot Springs AR 71913. (501)623-6401. Website: www.artistsworkshopgallery.com. **Chairman:** David McLean. Cooperative gallery. Estab. 1990. Represents 35 emerging, mid-career and established artists/year. Sponsors 12 shows/year. Average display time 2 months. Open all year; Monday-Saturday, 10-4. Located in historic district; approximately 920 sq. ft.; in historic building. 10% of space for special exhibitions; 90% of space for gallery artists. Clientele: primarily tourist, some local. 100% private collectors. Overall price range: $12-4,500; most work sold at $100-800.

Media Considers all media and all types of prints.

Style Exhibits: painterly abstraction, impressionism, photorealism and realism. Exhibits all genres.

Terms Co-op membership fee plus donation of time (15% commission). Retail price set by the artist. Gallery provides promotion; artist pays for shipping. Prefers framed artwork.

Submissions Accepts only artists from Arkansas. Send query letter with bio and SASE. Call or write for appointment to show examples of work brought to co-op membership meeting (held once/month). Does not reply. Artist should attend monthly meetings. Finds artists through word of mouth, referrals by other artists, visiting art fairs and exhibitions and submissions.

EILEEN'S GALLERY OF FINE ARTS

10720 N. Rodney Parham, Little Rock AR 72212. (501)223-0667. **Owner:** Eileen Lindemann. Retail gallery. Estab. 1987. Represents 30 emerging and mid-career artists/year. Exhibited artists include: Robert Moore and Dale Terbush. Sponsors 2 shows/year. Average display time 6 months. Open all year; Tuesday-Saturday, 10-5. Located west Little Rock; 1,800 sq. ft. 100% of space for gallery artists. Clientele: local (statewide) and upscale. 95% private collectors; 5% corporate collectors. Overall price range: $300-15,000; most work sold at $1,500-3,500.

Media Considers oil, acrylic, watercolor and sculpture. Most frequently exhibits oils, well-executed acrylics and wood and marble sculpture.

Style Exhibits: impressionism, photorealism and realism. Genres include florals, landscapes Americana and figurative work. Prefers: florals, figuratives and landscapes.

Terms Accepts work on consignment (40% commission). Retail price set by the artist. Gallery provides promotion and contract for out-of-state artists; shipping costs are shared. "If the artist is out of state, the gallery will provide frames."

Submissions Prefers only canvas. Send query letter with bio and photographs. Call or write for appointment to show portfolio of photographs and information on shows, other galleries and years in profession. Responds ASAP. Artist should send stamped return envelope. Finds artists through word of mouth, my excellent reputation, visiting galleries in travel, requests by my clients for interest in special artists.

Tips "Artists should not send unrequested work or walk in uninvited and take up my time before they know I'm interested."

Ⓝ LEONARD FINE ARTS

520 Central Ave., Hot Springs AR 71901. (501)623-9847. Fax: (501)623-8957. E-mail: brian@leonardfinearts.com. Website: www.leonardfinearts.com. Retail gallery. Estab. 2003. Represents/exhibits 15 established artists/year. Interested in seeing the work of emerging artists. Exhibited artists include Benini, Galardini and Cunningham. Sponsors 12 shows/year. Average display time 1 month. Open daily and during Hot Springs Gallery Walks and by appointment. Located on historic Central Avenue; 5,000 sq. ft.; housed in 1886 brick structure restored in 1988 according to National Historic Preservation Guidelines. Clientele: tourists, upscale, community and students. 90% private collectors, 10% corporate collectors.

Media Considers all media except prints. Most frequently exhibits painting, sculpture, drawing/photography.

Style Exhibits contemporary Italian masters.

Tips Considers "individual style and quality" when choosing artists.

Ⓝ WALTON ARTS CENTER

P.O. Box 3547, 495 N. Dickson St., Fayetteville AR 72702. (479)443-9216. Fax: (479)443-9784. Website: www.waltonartscenter.org. **Contact:** Michele McGuire, curator of exhibits. Nonprofit gallery. Estab. 1990. Approached by 50 artists/year. Represents 10 emerging, mid-career and established artists. Exhibited artists include: E. Fay Jones, Judith Leiber (handbags). Sponsors 2 exhibits/year. Average display time X2 months. Open all year; Monday-Friday, 10-6; weekends 12-4. Closed Thanksgiving, Christmas, July 4. Joy Pratt Markham Gallery is 2,500 sq. ft. with approximately 200 running wall feet. McCoy Gallery also has 200 running wall feet in the Education Building. Clients include local community and upscale. Overall price range: $100-10,000. "Walton Arts Center serves as a resource to showcase a variety of thought-provoking visual media that will challenge new and traditional insights and encourage new dialogue in a museum level environment."

Media Considers all media and all types of prints. Most frequently exhibits oil, installation, paper.

Style Considers all styles and genres.

Terms Artwork is accepted on consignment and there is a 30% commission. Retail price set by the artist. Gallery provides insurance and contract. Accepted work should be framed. Requires exclusive representation locally.

Submissions Mail portfolio for review. Send query letter with artist's statement, bio, business card, résumé, reviews, SASE and slides. Returns material with SASE. Responds in 3 months. Finds artists through submissions, art exhibits, referrals by other artists and travelling exhibition companies.

N CENTRAL CALIFORNIA ART ASSOCIATION/MISTLIN GALLERY

1015 J St., Modesto CA 95354. (209)529-3369. Fax: (209)529-9002. Website: www.ccartassn.org. **Gallery Director:** Thorjia Brierly. Cooperative, nonprofit sales, rental and exhibition gallery. Estab. 1951. Represents emerging, mid-career and established artists. Average display time 3 months. Open all year. Located downtown. Overall price range: $50-3,000; most artwork sold at $300-800.

Media Considers oil, pen & ink, works on paper, fiber, acrylic, drawing, sculpture, watercolor, mixed media, ceramic, pastel, collage, photography and original handpulled prints. Most frequently exhibits watercolor, oil and acrylic.

Style Exhibits mostly impressionism, realism and abstract. Will consider all styles and genres.

Terms Artwork is accepted on consignment (40% commission). Price set by artist. Installment payment available. Prefers framed artwork.

Submissions Call for information. All works subject to jury process. Portfolio review not accepted. Finds artists primarily through referrals from other artists.

N COAST GALLERIES

Big Sur, Carmel, Pebble Beach, CA; Hana, HI. Mailing address: P.O. Box 223519, Carmel CA 93922. (831)625-8688. Fax: (831)625-8699. E-mail: gary@coastgalleries.com. Website: www.coastgalleries.com. **Owner:** Gary Koeppel. Retail gallery. Estab. 1958. Represents 300 emerging, mid-career and established artists. Sponsors 3-4 shows/year. Open all year. Located in both rural and resort hotel locations; 4 separate galleries—square footage varies, from 1,500-3,000 sq. ft. "The Hawaii galleries feature Hawaiiana; our Big Sur gallery is constructed of redwood water tanks and features Central California Coast artists and imagery." 100% of space for special exhibitions. Clientele: 90% private collectors, 10% corporate collectors. Overall price range: $25-60,000; most work sold at $400-4,000.

- They enlarged their Big Sur Coast Gallery and added a 100-seat restaurant.
- The new Carmel gallery features both fine art and master crafts.

Media Considers all media; engravings, lithographs, posters, etchings, wood engravings and serigraphs. Most frequently exhibits bronze sculpture, limited edition prints, watercolor and oil on canvas.

Style Exhibits impressionism and realism. Genres include landscapes, marine and wildlife.

Terms Accepts work on consignment (50% commission), or buys outright for 40% of retail price (net 30 days.) Retail price set by gallery. Gallery provides insurance, promotion and contract; artist pays for shipping. Requires artwork framed.

Submissions Accepts only artists from Hawaii for Maui gallery; coastal and wildlife imagery for California galleries; California painting and American crafts in Carmel gallery; interested in Central California Coast imagery for Pebble Beach gallery. Send query letter with résumé, slides, bio, brochure, photographs, SASE, business card and reviews. Write for appointment to show portfolio of photographs, slides and transparencies. Responds in 2 weeks.

CUESTA COLLEGE ART GALLERY

P.O. Box 8106, San Luis Obispo CA 93403-8106. (805)546-3202. Fax: (805)546-3904. E-mail: pmckenna@cuesta .edu. Website: academic.cuesta.cc.ca.us/finearts/gallery.htm. **Contact:** Pamela McKenna, gallery assistant. Nonprofit gallery. Estab. 1965. Exhibits the work of emerging, mid-career and established artists. Exhibited artists include Italo Scanga and JoAnn Callis. Sponsors 5 shows/year. Average display time 4½ weeks. Open all year. Space is 1,300 sq. ft.; 100% of space for special exhibitions. Overall price range: $250-5,000; most work sold at $400-1,200.

Media Considers all media and all types of prints. Most frequently exhibits painting, sculpture and photography.

Style Exhibits all styles, mostly contemporary.

Terms Accepts work on consignment (20% commission). Retail price set by artist. Customer payment by installment available. Gallery provides insurance, promotion and contract; shipping costs are shared. Prefers artwork framed.

Submissions Send query letter with résumé, slides, bio, brochure, SASE and reviews. Call for appointment to show portfolio. Responds in 6 months. Finds artists mostly by reputation and referrals, sometimes through slides.

Tips "We have a medium budget, thus cannot pay for extensive installations or shipping. Present your work legibly and simply. Include reviews and/or a coherent statement about the work. Don't be too slick or too sloppy."

F FALKIRK CULTURAL CENTER

1408 Mission Ave., P.O. Box 151560, San Rafael CA 94915-1560. (415)485-3328. Fax: (415)485-3404. Website: www.falkirkculturalcenter.org. Nonprofit gallery. Estab. 1974. Approached by 500 artists/year. Exhibits 350

emerging, mid-career and established artists. Sponsors 8 exhibits/year. Average display time 2 months. Open Tuesday, Wednesday, Thursday, 1-5; Saturday, 10-1. Closed Sundays. Three galleries located on second floor with lots of natural light (UV filtered). National historic place (1888 Victorian) converted to multi-use cultural center. Clients include local community, students, tourists and upscale.

Media Considers all media and all types of prints. Most frequently exhibits painting, sculpture and works on paper.

Making Contact & Terms Artwork is accepted on consignment, and there is a 30% commission. Retail price set by the artist. Gallery provides insurance. Prefers only Marin County artists.

Submissions Marin County and San Francisco Bay Area artists only. Send artist's statement, bio, résumé and slides. Returns material with SASE. Responds within 3 months.

Ⓝ FRESNO ART MUSEUM

2233 N. First St., Fresno CA 93703. (559)441-4221. Fax: (559)441-4227. E-mail: info@fresnoartmuseum.org. Website: www.fresnoartmuseum.org. **Executive Director:** Carlos Martinez. Associate Curator: Jacquelin Pilar. Estab. 1948. Exhibitions change approximately every 8 weeks. Exhibited artists for 2004/2005 include Olga Seem, Frank Lobdell, Hardy Hanson, Robert Cremean and Jusy Tuwaletstiwa. Open Tuesday-Sunday, 11-5; and until 8 on Thursdays. Accredited by AAM.

Media Considers acrylic, ceramics, collage, drawing, glass, installation, mixed media, oil, paper, pastel, pen & ink, sculpture and watercolor. Most frequently exhibits painting, sculpture and prints. Types of prints include engravings, etchings, linocuts, lithographs, serigraphs, woodcuts and fine books.

Style Exhibits: contemporary and modernist art.

Making Contact & Terms Museum does not take commission. Retail price set by the artist. Gallery provides insurance.

Submissions Write to arrange a personal interview to show portfolio of transparencies and slides or mail portfolio for review. Send query letter with bio, résumé and slides. Files letters and bio/résumé. Finds artists through portfolio reviews and art exhibits.

GALLERY BERGELLI

483 Magnolia Ave., Larkspur CA 94939. (415)945-9454. Fax: (415)945-0311. E-mail: rcritelli@bergelli.com. Website: www.gallerybergelli.com. **Contact:** Robin Critelli, owner. For-profit gallery. Estab. 2000. Approached by 200 artists/year; exhibits 15 emerging artists/year. Exhibited artists include Jeff Faust and James Leonard (acrylic painting). Sponsors 8-9 exhibits/year. Average display time 6 weeks. Open all year; Tuesday-Saturday, 10-5; Sunday, 12-5. "We're located in affluent Marin County, just across the Golden Gate Bridge from San Francisco. The Gallery is in the center of town, on the main street of Larkspur, a charming village known for its many fine restaurants. It is spacious and open with 2,500 square feet of exhibition space with large window across the front of the building. Moveable hanging walls (see the home page of our website) give us great flexibility to customize the space to best show the current exhibition." Clients include local community, upscale in the Marin County & Bay Area. Overall price range is $2,000-26,000; most work sold at $4,000-10,000.

Media Considers acrylic, collage, mixed media, oil, pastel, sculpture. Most frequently exhibits acrylic, oil and sculpture.

Style Exhibits geometric abstraction, imagism, new-expressionism, painterly abstraction, postmodernism, surrealism. Most frequently exhibits painterly abstraction, imagism and neo-expressionism.

Terms Artwork is accepted on consignment and there is a 50% commission. Retail price set by the artist with gallery input. Gallery provides insurance and promotion. Accepted work should be matted, stretched, unframed and ready to hang. Requires exclusive representation locally. Artwork evidencing geographic and cultural differences is viewed favorably.

Submissions Mail portfolio for review or send query letter with artist's statement, bio, brochure, business card, photographs, résumé, reviews, SASE and slides. Returns material with SASE. Responds to queries in 1 month. Files material not valuable to the artist (returns slides) that displays artist's work. Finds artists through art exhibits, portfolio reviews, referrals by other artists, submissions and word of mouth.

Tips "Your submission should be about the artwork, the technique, the artist's accomplishments, and perhaps the artist's source of creativity. Many artist's statements are about the emotions of the artist, which is irrelevant when selling paintings."

GALLERY EIGHT

7464 Girard Ave., La Jolla CA 92037. (858)454-9781. **Director:** Ruth Newmark. Retail gallery with focus on contemporary crafts. Estab. 1978. Represents 100 emerging and mid-career artists. Interested in seeing the work of emerging artists. Exhibited artists include Philip Moulthrop, Patrick Crab and Karen Massaro. Sponsors 6 shows/year. Average display time 6-8 weeks. Open all year; Monday-Saturday, 10-5. Located downtown; 1,200

sq. ft. 25% of space for special exhibitions; 75% of space for gallery artists. Clientele: upper middle class, mostly 35-60 in age. Overall price range: $5-5,000; most work sold at $25-150.

Media Considers ceramics, mixed media, sculpture, craft, fiber, glass. Most frequently exhibits ceramics, jewelry, mixed media.

Terms Accepts work on consignment (50% commission) or buys outright for 50% of retail price (net 30 days). Retail price set by the gallery and the artist. Gallery provides insurance, promotion and shipping costs from gallery; artist pays shipping costs to gallery.

Submissions Send query letter with résumé, slides, photographs, reviews and SASE. Call or write for appointment to show portfolio of photographs and slides. Responds in 3 weeks. Files "generally only material relating to work by artists shown at gallery." Finds artists by visiting exhibitions, word of mouth, various art publications and sourcebooks, submissions, through agents, and juried fairs.

Tips "Enclose résumé, cost of item (indicate if retail or wholesale), make appointment."

☑ JUDITH HALE GALLERY

2890 Grand Ave., P.O. Box 884, Los Olivos CA 93441-0884. (805)688-1222. Fax: (805)688-2342. E-mail: info@judithhalegallery.com. Website: www.judithhalegallery.com. **Owner:** Judy Hale. Retail gallery. Estab. 1987. Represents 70 mid-career and established artists. Exhibited artists include Dirk Foslien, Howard Carr, Kelly Donovan and Mehl Lawson. Sponsors 4 shows/year. Average display time 6 months. Open all year. Located downtown; 2,100 sq. ft.; "the gallery is eclectic and inviting, an old building with six rooms." 20% of space for special exhibitions which are regularly rotated and rehung. Clientele: homeowners, tourists, decorators, collectors. Overall price range: $500-15,000; most work sold at $500-5,000.

• This gallery opened a second location and connecting sculpture garden next door at 2884 Grand Ave. Representing nationally recognized artists, including Ted Goerschner, Marilyn Simandle, Dave DeMatteo, Dick Heichberger, this old building once housed the blacksmith's shop.

Media Considers oil, acrylic, watercolor, pastel, sculpture, engravings and etchings. Most frequently exhibits watercolor, oil, acrylic and sculpture.

Style Exhibits impressionism and realism. Genres include landscapes, florals, western and figurative work. Prefers figurative work, western, florals, landscapes, structure. No abstract or expressionistic.

Terms Accepts work on consignment (40% commission). Retail price set by artist. Offers payment by installments. Gallery arranges reception and promotion; artist pays for shipping. Prefers artwork framed.

Submissions Send query letter with 10-12 slides, bio, brochure, photographs, business card and reviews. Call for appointment to show portfolio of photographs. Responds in 2 weeks. Files bio, brochure and business card.

Tips "Create a nice portfolio. See if your work is comparable to what the gallery exhibits. Do not plan your visit when a show is on; make an appointment for future time. I like 'genuine' people who present quality with fair pricing. Rotate artwork in a reasonable time, if unsold. Bring in your best work, not the 'seconds' after the show circuit."

HEARST ART GALLERY, SAINT MARY'S COLLEGE

P.O. Box 5110, Moraga CA 94575. (925)631-4379. Fax: (925)376-5128. Website: http://gallery.stmarys-ca.edu. College gallery. Estab. 1931. Exhibits mid-career and established artists. Exhibited artists include: William Keith (painting). Sponsors 6 exhibits/year. Average display time 5-6 weeks. Open Wednesday-Sunday, 11-4:30; weekends from 11-4:30. Closed major holidays, installation periods. Located on college campus, 1,650 square feet exhibition space. Clients include local community, students and tourists.

Media Considers all media. Most frequently exhibits paintings, works on paper and sculpture. Considers all types of prints.

Submissions Send query letter with artist's statement, bio, résumé, SASE and slides. Returns material with SASE. Finds artists through submissions, art exhibits, art fairs, referrals by other artists.

ⓝ LEUCADIA GALLERY

1038 N. Coast Highway 101, Leucadia CA 92024. (760)753-8829.

• This gallery was opened by the owners of Grove St. Gallery in Illinois. Leucadia Gallery specializes in original and limited edition ocean/surf artwork and custom framing. See Grove St. listing for information on needs and submissions policies.

☑ LINCOLN ARTS

580 Sixth St., Lincoln CA 95648. (916)645-9713. Fax: (916)645-3945. E-mail: lincolnarts@sbcglobal.net. Website: www.lincolnarts.org. **Executive Director:** Claudia Renati. Nonprofit gallery and cultural foundation. Estab. 1986. Represents more than 100 emerging, mid-career and established artists/year. More than 400 members. Sponsors 14 shows/year (9 gallery, 4 alternative and 1 major month-long ceramics exhibition). Average display time 5 weeks. Open all year; Tuesday-Friday, 9-4; Saturday, 10-3. Located in the heart of downtown Lincoln.

"Our annual 'Feats of Clay®' exhibition is held inside the 128-year-old Gladding McBean terra cotta factory." 70% of space for gallery artists. 90% private collectors, 10% corporate collectors. Overall price range: $90-7,000; most work sold at $150-2,000.

Media Considers all media including linocut prints. Most frequently exhibits ceramics and mixed media.

Style Exhibits all styles, all genres.

Terms Accepts work on consignment (35% commission)."Membership donation (min. $35) is encouraged but not required." Retail price set by the artist. Gallery provides promotion; artist pays shipping costs to and from gallery. Prefers artwork framed.

Submissions Send query letter with résumé, slides or photographs, bio and SASE. Call or write for appointment to show portfolio of originals (if possible) or photographs or slides. Responds in 1 month. Artist should include SASE for return of slides/photos. Files bio, résumé, review notes. "Scheduling is done minimum one year ahead in August for following calendar year. Request prospectus for entry information for Feats of Clay© exhibition." Finds artists through visiting exhibitions, word of mouth, art publications and sourcebooks and submissions.

LIZARDI/HARP GALLERY

P.O. Box 91895, Pasadena CA 91109. (626)791-8123. Fax: (626)791-8887. E-mail: lizardiharp@earthlink.net. Director: Grady Harp. Retail gallery and art consultancy. Estab. 1981. Represents 15 emerging, mid-career and established artists/year. Exhibited artists include Wes Hempel, Gerard Huber, Wade Reynolds, Robert Peterson and William Fogg. Sponsors 4 shows/year. Average display time 2 months. Open all year; Tuesday-Saturday by appointment only. 80% private collectors, 20% corporate collectors. Overall price range: $900-80,000; most work sold at $2,000-15,000.

Media Considers oil, acrylic, watercolor, pastel, pen & ink, drawing, mixed media, sculpture, installation, photography, lithographs, and etchings. Most frequently exhibits works on paper and canvas, sculpture, photography.

Style Exhibits representational art. Genres include landscapes, figurative work—both portraiture and narrative and still life. Prefers figurative, landscapes and experimental.

Terms Accepts work on consignment (50% commission). Retail price set by the gallery and the artist. Gallery provides insurance, promotion, contract; artist pays shipping costs.

Submissions Send query letter with artist's statement, résumé, 20 slides, bio, photographs, SASE and reviews. Write for appointment to show portfolio of photographs, slides and transparencies. Responds in 1 month. Files "all interesting applications." Finds artists through studio visits, group shows, submissions.

Tips "Timelessness of message is a plus (rather than trendy). Our emphasis is on quality or craftsmanship, evidence of originality . . . and maturity of business relationship concept." Artists are encouraged to send an "artist's statement with application and at least one 4×5 or print along with 20 slides. Whenever possible, send images over the Internet via e-mail."

N JESSEL MILLER GALLERY

1019 Atlas Peak Rd., Napa CA 94558. (707)257-2350. E-mail: jessel@napanet.net. Website: www.jesselgallery.com. **Owner:** Jessel. Retail gallery. Represents 300 emerging, mid-career and established artists. Exhibited artists include Clark Mitchell and Jessel. Sponsors 6 shows/year. Average display time 1 month. Open all year; 7 days/week 9:30-5:30. Located 1 mile out of town; 9,000 sq. ft. 20% of space for special exhibitions; 50% of space for gallery artists. Clientele: upper income collectors. 95% private collectors, 5% corporate collectors. Overall price range: $100-10,000; most work sold at $2,000-3,500.

Media Oil, acrylic, watercolor, pastel, collage, sculpture, ceramic and craft. Most frequently exhibits acrylic, watercolor and pastel.

Style Exhibits painterly abstraction, photorealism, realism and traditional. Genres include landscapes, florals and figurative work. Prefers figurative, landscape and abstract.

Terms Accepts work on consignment (50% commission). Retail price set by gallery. Gallery provides promotion; artist pays for shipping costs. Prefers artwork framed.

Submissions Send query letter with résumé, slides, bio, SASE and reviews. Call (after sending slides and background info) for appointment to show portfolio of photographs or slides. Responds in 1 month.

MOCTEZUMA BOOKS & GALLERY

289 Third Ave., Chula Vista CA 91910-2721. (619)426-1283. Fax: (619)426-0212. E-mail: lisamoctezuma@hotmail.com. Website: www.latambooks.com. **Contact:** Lisa Moctezuma, owner. For-profit gallery. Estab. 1999. Approached by 40 artists/year. Represents 12 emerging, mid-career and established artists. Exhibited artists include: Alberto Blanco (painting, Chinese ink drawings, collage, mixed media) and Norma Michel (painting, mixed media and boxes). Sponsors 8 exhibits/year. Average display time 6 weeks. Open all year; Monday-Saturday, 10-5. Located just south of San Diego, in downtown Chula Vista. The gallery space is approximately

1,000 sq. ft. and is coupled with a bookstore. Clients include local community and upscale. 10% of sales are to corporate collectors. Overall price range: $200-2,000; most work sold at $800.

Media Considers all media and all types of prints. Most frequently exhibits paper, canvas, watercolor and acrylic.

Style Considers all styles and genres. Most frequently exhibits painterly abstraction, primitivism realism and conceptualism.

Terms Artwork is accepted on consignment and there is a 40% commission. Retail price set by the gallery. Gallery provides promotion and contract. Accepted work should be framed. Does not require exclusive representation locally. We focus on established and emerging artists from the San Diego/Tijuana border area, Mexico and the Californias.

Submissions Mail portfolio for review. Send query letter with artist's statement, bio, photocopies, photographs, résumé, reviews, SASE and slides. Responds in 2 months. Finds artists through word of mouth and referrals by other artists.

MUSEUM WEST FINE ART

332 Commercial St., San Jose CA 95112. (650)323-3666. **Director:** Anne Larsen. Retail gallery. Estab. 1995. Of artists represented 35% are emerging, 35% are mid-career and 30% are established. Exhibited artists include Robert Motherwell, Bill Barrett, Franco Prayer, Ricardo Mazal, Janette Urso, Shawn Dulaney, Pat Sherwood, Richard Diebenkorn, John Kapel, Donna McGinnis and Joan Miro. Sponsors 4-5 shows/year. Average display time 40 days in rotation. Open all year; Monday-Friday, 10-9; Saturday, 10-7; Sunday, 11-6. Located in the heart of the Silicon Valley; 2,000 sq. ft.; 40% of space for special exhibitions. Clientele: international collectors and private art consultants. 70% private collectors, 20% corporate collectors, 10% private art consultants. Overall price range: $500-40,000; most work sold at $2,000-8,000. Works with architects and designers for site-specific commissions—often in the $8,000-60,000 range.

Media Considers oil, acrylic, sculpture, watercolor, mixed media, pastel, collage, photography, original hand-pulled prints, woodcuts, wood engravings, linocuts, engravings, mezzotints, etchings, lithographs and serigraphs. Most frequently exhibits high-quality paintings, prints, sculpture and photography.

Style Exhibits primarily abstract work. Genres include landscapes, florals, figurative work and city scapes.

Terms Retail price set by gallery and artist. Gallery provides insurance, promotion, contract and shipping costs from gallery; artist pays for shipping costs to gallery.

Submissions Prefers mature artists who know quality and who are professional in their creative and business dealings. "Know how to put together a submittal properly. Artists can no longer be temperamental." Send query letter with résumé, minimum of 20 current slides, bio, brochure, photographs, SASE, business card and reviews. Responds if interested within 3 weeks; if not interested, replies in a few days.

Tips "First, determine just how unique or well crafted or conceived your work really is. Secondly, determine your market—who would want this type of art and especially your type of art; then decide what is the fair price for this work and how does this price fit with the price for similar work by artists of similar stature. Lastly, have a well-thought-out presentation that shows consistent work and/or consistent development over a period of time. We work best with full-time artists."

A NEW LEAF GALLERY/SCULPTURESITE.COM

1286 Gilman St., Berkeley CA 94706. (510)525-7621. Fax: (510)525-5282. E-mail: info@sculpturesite.com. **Contact:** Staff. Retail gallery. Estab. 1990. Represents 100 emerging, mid-career and established artists. Sponsors 3-6 sculpture shows/year. Average display time 6 months. Open Wednesday-Friday, 11-5; weekends, 10-5. Closed December 23-January 1. Clients include local community and upscale. Overall price range: $1,000-1,000,000; most work sold at $5,000-10,000.

Media Considers sculpture, mixed media, ceramic and glass. Most frequently exhibits sculpture (considers only sculptural media for outdoors). "No paintings or works on paper, please."

Style Exhibits only contemporary abstract and abstract figurative.

Terms Accepts artwork on consignment (40-50% commission). Exclusive area representation required. Retail price set by artist in cooperation with gallery. Gallery provides insurance. Accepted work should be mounted.

Submissions Write to arrange personal interview to show a small portfolio of photographs, slides, digital images; or mail portfolio of small selection of images in any format; or send e-mail link to your site for review; or send artist's statement, bio, photocopies, photographs, SASE and slides. Responds in 1 month.

Tips "We suggest artists visit us if possible—this is a unique setting. Sculpturesite.com, our extensive website, shows a wider range of sculpture than our outdoor gallery can."

ORANGE COUNTY CENTER FOR CONTEMPORARY ART

117 N. Sycamore St., Santa Ana CA 92701. (714)667-1517. E-mail: grau@prodigy.net. Website: www.occca.org. **Exhibitions Director:** Pamela Grau Twena. Cooperative, nonprofit gallery. Exhibits emerging and mid-career

artists. 20 members. Sponsors 12 shows/year. Average display time 1 month. Open all year; Wednesday-Sunday 11-4. 3,000 sq. ft. 25% of time for special exhibitions; 75% of time for gallery artists.
Media Considers all media.
Terms Co-op membership fee plus a donation of time. Retail price set by artist.
Submissions Accepts artists generally in and within 50 miles of Orange County. Send query letter with SASE. Responds in 1 week.
Tips "This is an artist-run nonprofit. Send SASE for application prospectus. Membership means 20 hours monthly working in and for the gallery and programs; educational outreach; specific theme special exhibitions; hands-on gallery operations and professional career development."

PEPPERS ART GALLERY

1200 E. Colton Ave., P.O. Box 3080, Redlands CA 92373-0999. (909)793-2121 ext. 3660. **Contact:** Terre Hodgson, administrative assistant. Nonprofit university gallery. Estab. 1960s. Represents/exhibits 4-6 mid-career and established California artists/year. Exhibited artists include Greg Kennedy (ceramics). Work for sale. Open fall and spring; Tuesday-Saturday, 1-5; Sunday, 2-5. Closed June, July, August. Located in the city of Redlands; 980 sq. ft.; 12' high walls. 100% of space for special exhibitions. Clientele: local community, students. Overall price range: $1,500-20,000.
Media Considers all media, all types of prints except posters. Most frequently exhibits sculpture, painting and ceramics.
Style Exhibits expressionism, neo-expressionism, primitivism, painterly abstraction, postmodern works, realism and imagism.
Terms Gallery provides insurance and promotion. Prefers artwork framed.
Submissions Files résumés only. Finds artists through visiting gallerys and referrals.
Tips "Don't follow trends—be true to yourself."

SAN DIEGO ART INSTITUTE (SDAI: Museum of the Living Artist)

House of Charm, Balboa Park 1439 El Prado, San Diego CA 92101-1617. (619)236-0011. Fax: (619)236-1974. E-mail: director@sandiego-art.org. Website: www.sandiego-art.org. **Executive Director:** Timothy J. Field. Membership Associate: Kerstin Robers. Art Director: K.D. Benton. Nonprofit gallery. Estab. 1941. Represents 600 emerging and mid-career member/artists. 2,400 artworks juried into shows each year. Exhibited artists include Tim Caton, Alejandro Martinez Pena. Sponsors 12 all-media exhibits/year. Average display time 4-6 weeks. Open Tuesday-Saturday, 10-4; Sunday 12-4. Closed major holidays—all Mondays. 10,000 sq. ft. located in the heart of Balboa Park. Clients include local community, students and tourists. 10% of sales are to corporate collectors. Overall price range $100-4,000. Most work sold at $800.
Media Considers all media and all types of prints. Most frequently exhibits oil, mixed media and pastel.
Styles Considers all styles and genres.
Making Contact & Terms Artwork is accepted on consignment, and there is a 40% commission. Membership fee: $125. Retail price set by the artist. Accepted work should be framed. Work must be hand carried in for each monthly show except for annual international show juried by slides.
Submissions Request membership packet and information about juried shows. Membership not required for submittal in monthly juried shows, but fee required. Returns material with SASE. Finds artists through word of mouth and referrals by other artists.
Tips "All work submitted must go through jury process for each monthly exhibition. Work required to be framed in professional manner."

N SANTA BARBARA CONTEMPORARY ARTS FORUM

653 Paseo Nuevo, Santa Barbara CA 93101. (805)966-5373. Fax: (805)962-1421. E-mail: sbcaf@sbcaf.org. Website: www.sbcaf.org. **Contact:** Program Committee. Nonprofit gallery. Estab. 1976. Approached by 300 artists/year. Exhibited artists include Linda Stark, Marco Brambilla, Sandow Birk. Sponsors 16 exhibits/year. Does not represent artists' work. Average display time 6-8 weeks. Open Tuesday-Saturday, 11-5; Sunday, 12-5. Located in 2,800 sq. ft. of exhibition space. Clients include local community, students, tourists and upscale.
Media Considers all media and all types of prints.
Style Considers all styles. Genres include anything other than traditional genres.
Submissions Mail portfolio of slides for review. Returns material with SASE. Responds in 6 months. Files all materials except slides. Finds artists through word of mouth, submissions, portfolio review, art exhibits, referrals by other artists and studio visits.

N TERCERA GALLERY

24 North Santa Cruz Ave., Los Gatos CA 95030. (408)354-9484. E-mail: lg@terceragallery.com. Website: www.t erceragallery.com. **Director:** Michele Scott. For profit gallery. Estab. 1989. Exhibits emerging, mid-career and

established artists. Exhibited artists include: Gordon Smedt and James Shay. Average display time 3 weeks. Open Tuesday through Saturday from 10 to 5:30. Clients include upscale.

Media Considers ceramics, drawing, mixed media, oil, paper, sculpture and watercolor.

Style Considers all styles of contemporary art.

Terms Retail price of the art set by the gallery.

Submissions Send query with résumé and slides. Returns material with SASE. Finds artists through word of mouth, art exhibits and portfolio reviews.

JILL THAYER GALLERIES AT THE FOX

1700 20th St., Bakersfield CA 93301-4329. (661)328-9880. Fax: (661)631-9711. E-mail: jill@jillthayer.com. Website: www.jillthayer.com. **Director:** Jill Thayer. For profit gallery. Estab. 1994. Represents 20 emerging, mid-career and established artists. Features 6-8 exhibits/year. Average display time 6 weeks. Open Thursday-Friday, 10-4; Saturday 1-4 or by appointment. Closed holidays. Located at the historic Fox Theater, built in 1930. Thayer renovated the 400 sq. ft. space in 1994. The space features large windows, high ceilings, wood floor and bare wire, solux halogen lighting system. Clients include regional southern California upscale. 50% of sales are to corporate collectors. Overall price range: $250-10,000; most work sold at $1,500.

Media Considers all media and all types of prints. Exhibits painting, drawing, photography, montage, assemblage, glass.

Style Color field, conceptualism, expressionism, impressionism, neo-expressionism and painterly abstraction. Most frequently exhibits contemporary, abstract, impressionistic and expressionistic.

Terms Artwork is accepted on consignment and there is a 50% commission. Artist pays all shipping. Retail price set by the gallery and the artist. Gallery provides promotion and contract. Artist shares cost of mailings and receptions.

Submissions Send query letter with artist's statement bio, résumé, reviews, SASE and slides. Responds in 1 month if interested. Finds artists through submissions and portfolio reviews.

Tips ''When submitting to galleries, be concise, professional, send up-to-date vitae (listing of exhibitions and education/bio) and a slide sheet.''

NATALIE AND JAMES THOMPSON ART GALLERY

School of Art Design, San José State University, San José CA 95192-0089. (408)924-4723. Fax: (408)924-4326. E-mail: jfh@cruzio.com. Website: www.sjsu.edu. **Contact:** Jo Farb Hernandez, director. Nonprofit gallery. Approached by 100 artists/year. Sponsors 6 exhibits/year of emerging, mid-career and established artists. Average display time 1 month. Open during academic year; Tuesday, 11-4, 6-7:30; Wednesday-Friday, 11-4. Closed semester breaks, summer and weekends. Clients include local community, students and upscale.

Media Considers all media and all types of prints.

Style Considers all styles and genres.

Terms Retail price set by the artist. Gallery provides insurance, transportation and promotion. Accepted work should be framed and/or ready to display. Does not require exclusive representation locally.

Submissions Send query letter with artist's statement, bio, résumé, reviews, SASE and slides. Returns material with SASE.

ATELIER RICHARD TULLIS

1 N. Calle Cesar Chaves, #9, Santa Barbara CA 93103. (805)965-1091. Website: www.tullis-art.com. **Director:** Richard Tullis II. Specializes in collaborations with artists. Exploration of material and image-making on various media. Estab. 1992. Exhibited artists Kirkeby, Millei, Carroll, Haynes, Kaneda, Humphries, Gipe, Tullis, Fierro, Walker, Oulton. Hours by appointment. Located in industrial area; 6,500 sq. ft.; sky lights in saw tooth roof; 27' ceiling.

Submissions By invitation.

☑ SYLVIA WHITE GALLERY CONTEMPORARY ARTISTS' SERVICES

1013 Pico Blvd, Santa Monica CA 90405. (310)452-4000. E-mail: info@artadvice.com. Website: www.artadvice.com. **Owner:** Sylvia White. Retail gallery, art consultancy and artist's career development services. Estab. 1979. Represents 25 emerging, mid-career and established artists. Interested in seeing work of emerging artists. Exhibited artists include Martin Mull, John White. Sponsors 12 shows/year. Average display time 1 month. Open all year; Tuesday-Friday, 10-5; Saturday by appointment. Located in downtown Santa Monica; 2,000 sq. ft.; 100% of space for special exhibitions. Clientele: upscale. 50% private collectors, 50% corporate collectors. Overall price range: $1,000-10,000; most work sold at $3,000.

• Sylvia White also has representatives in Chicago and San Francisco.

Media Considers all media, including photography. Most frequently exhibits painting and sculpture.

Style Exhibits all styles, including painterly abstraction and conceptualism.

Galleries

Terms Retail price set by gallery and artist. Gallery provides insurance, promotion and contract. Artist pays for shipping costs.
Submissions Send query letter with résumé, slides, bio and SASE. Portfolio should include slides.

ℕ THE WING GALLERY

13632 Ventura Blvd., Sherman Oaks CA 91423. (818)981-WING and (800)422-WING. Fax: (818)981-ARTS. E-mail: robin@winggallery.com. Website: www.winggallery.com. **Director:** Robin Wing. Retail gallery. Estab. 1974. Represents 100+ emerging, mid-career and established artists. Exhibited artists include Doolittle and Wysocki. Sponsors 6 shows/year. Average display time 2 weeks-3 months. Open all year. Located on a main boulevard in a charming freestanding building, carpeted; separate frame design area. 80% of space for special exhibitions. Clientele: 90% private collectors, 10% corporate collectors. Overall price range: $50-50,000; most work sold at $150-5,000.
Media Considers oil, acrylic, watercolor, pen & ink, drawings, sculpture, ceramic, craft, glass, original hand-pulled prints, offset reproductions, engravings, lithographs, monoprints and serigraphs. Most frequently exhibits offset reproductions, watercolor and sculpture.
Style Exhibits primitivism, impressionism, realism and photorealism. Genres include landscapes, Americana, Southwestern, western, wildlife and fantasy.
Terms Accepts work on consignment (40-50% commission). Retail price set by gallery and artist. Sometimes offers customer discounts and payment by installments. Gallery provides insurance, promotion and contract; shipping costs are shared. Prefers unframed artwork.
Submissions Send query letter with résumé, slides, bio, brochure, photographs, SASE, reviews and price list. "Send complete information with your work regarding price, size, medium, etc., and make an appointment before dropping by." Portfolio reviews requested if interested in artist's work. Responds in 2 months. Files current information and slides. Finds artists through agents, by visiting exhibitions, word of mouth, various publications, submissions, and referrals.
Tips Artists should have a "professional presentation" and "consistent quality."

LEE YOUNGMAN GALLERIES

1316 Lincoln Ave., Calistoga CA 94515. (707)942-0585. Fax: (707)942-6657. E-mail: leeyg@sbcglobal.net. Website: www.leeyoungmangalleries.com. **Owner:** Ms. Lee Love Youngman. Retail gallery. Estab. 1985. Represents 40 established artists. Exhibited artists include Ralph Love and Paul Youngman. Sponsors 3 shows/year. Average display time 1 month. Open all year. Located downtown; 3,000 sq. ft.; "contemporary decor." Clientele: 100% private collectors. Overall price range: $500-24,000; most artwork sold at $1,000-3,500.
Media Considers oil, acrylic, watercolor and sculpture. Most frequently exhibits oils, bronzes and alabaster.
Style Exhibits impressionism and realism. Genres include landscapes, Southwestern, Western and wildlife. Interested in seeing American realism. No abstract art.
Terms Accepts work on consignment (50% commission). Retail price set by gallery. Customer discounts and payment by installment are available. Gallery provides insurance and promotion. Artist pays for shipping to and from gallery. Prefers framed artwork.
Submissions Accepts only artists from Western states. "No unsolicited portfolios." Portfolio review requested if interested in artist's work. "The most common mistake artists make is coming on weekends, the busiest time, and expecting full attention." Finds artists through publication, submissions and owner's knowledge.
Tips "Don't just drop in—make an appointment. No agents."

LOS ANGELES

ACADEMY GALLERY

8949 Wilshire Blvd., Beverly Hills CA 90211. (310)247-3000. Fax: (310)247-3610. E-mail: gallery@oscars.org. Website: www.oscars.org. Nonprofit gallery. Estab. 1992. Exhibitions focus on all aspects of the film industry and the filmmaking process. Sponsors 3-5 exhibitions/year. Average display time 3 months. Open all year; Tuesday-Friday, 10-5; weekends 12-6. Gallery begins in building's Grand Lobby and continues on the 4th floor. Total square footage is approx. 8,000. Clients include students, senior citizens, film aficionados and tourists.
Submissions Call or write to arrange a personal interview to show portfolio of photographs, slides and transparencies. Must be film process or history related.

DEL MANO GALLERY

11981 San Vicente Blvd., W. Los Angeles CA 90049. (310)476-8508. E-mail: gallery@delmano.com. Website: www.delmano.com. **Contact:** Kirsten Muenster, director of exhibitions. Retail gallery. Estab. 1973. Represents more than 300 emerging, mid-career and established artists. Interested in seeing the work of emerging artists

working in wood, glass, ceramics, fiber and metals. Gallery deals heavily in turned and sculpted wood, showing work by David Ellsworth, William Hunter and Ron Kent. Gallery hosts approximately 5 exhibitions per year. Average display time 2-6 months. Open Tuesday-Sunday. Gallery located in Brentwood (a scenic corridor). Space is 3,000 sq. ft. 25% of space for special exhibitions; 75% of space for gallery artists. Clientele: professionals and affluent collectors. 20% private collectors, 5% corporate collectors. Overall price range: $50-20,000; most work sold at $250-5,000.

Media Considers contemporary art in craft media—ceramics, glass, jewelry, wood, fiber. No prints. Most frequently exhibits wood, glass, ceramics, fiber, metal and jewelry.

Style Exhibits all styles and genres.

Terms Accepts work on consignment (50% commission) or 30 days net. Retail price set by gallery and artist. Customer discounts and payment by installment are available. 10-mile exclusive area representation required. Gallery provides insurance, promotion and shipping costs from gallery. Prefers artwork framed.

Submissions Send query letter with résumé, slides, bio and prices. Portfolio should include slides, price list, artist's statement and bio.

GALLERY 825, LA Art Association

825 N. La Cienega Blvd., Los Angeles CA 90069. (310)652-8272. Fax: (310)652-9251. **Director:** Ashley Emenegger. Associate Director: Sinéad Finnerty. Nonprofit gallery. Estab. 1925. Exhibits emerging and established artists. "Artists must be Southern California-based." Interested in seeing the work of emerging artists. Approximately 300 members. Sponsors 11 juried shows/year. Average display time 3-4 weeks. Open all year; Tuesday-Saturday, 12-5. Located in Beverly Hills/West Hollywood. 25% of space for special exhibitions (2 rooms); 75% for gallery artists (2 large main galleries). Clientele: set decorators, interior decorators, general public. 90% private collectors.

Media Considers all media and original handpulled prints. "Fine art only. No crafts." Most frequently exhibits mixed media, oil/acrylic and watercolor.

Style All styles.

Terms Requires $150 annual membership fee plus entry fees or 12 hours volunteer time for artists. Retail price set by artist (33% commission). Gallery provides promotion. "No shipping allowed." "Artists must apply via jury process held at the gallery 2 times per year in February and August." Phone for information.

Tips "No commercial work (e.g. portraits/advertisements)."

LA LUZ DE JESUS GALLERY

4633 Hollywood Blvd., Los Angeles CA 90027. (323)666-7667. Fax: (323)663-0243. E-mail: sales@laluzdejesus.com. Website: www.laluzdejesus.com. **Gallery Manager:** Michel Chenelle. Retail gallery, retail store attached with ethnic/religious and pop culture merchandise. "We provide a space for low-brow/cutting edge and alternative artists to show their work." Estab. 1986. Represents emerging, mid-career and established artists. Exhibited artists include Shag, the Clayton brothers, Owen Smith, and Michael Hussar. Sponsors 12 shows/year; "each show ranges from 1 person to large group (as many as 100)." Average display time 4 weeks. Open all year; Sunday, 12-6; Monday-Wednesday, 11-7; Thursday-Saturday, 11-9. Clientele: "mostly young entertainment biz types, celebrities, studio and record company types, other artists, business people, tourists." 95% private collectors, 5% corporate collectors. Overall price range: $500-10,000; most work sold at $500-2,500.

Media Considers all media except digitally produced work. Considers all types of prints, which are usually shown with paintings and drawings by the same artist. Most frequently exhibits acrylic or oil, pen & ink.

Style Prefers alternative/underground/cutting-edge, comix-inspired.

Terms Accepts work on consignment (50% commission). Retail price set by the gallery and the artist."We ask for an idea of what artist thinks and discuss it." Gallery provides insurance, promotion, contract. Gallery pays shipping costs from gallery, artist pays shipping costs to gallery, buyer pays for shipping if piece goes out of town. Prefers artwork framed.

Submissions Send query letter with résumé, slides, bio, photographs, SASE, reviews and an idea price range for artist's work. Responds on a quarterly basis. Finds artists through word of mouth (particularly from other artists), artists' submissions, visiting exhibitions.

Tips "Visit the space before contacting us. If you are out of town, ask a friend to visit and give you an idea. We are a very different gallery."

LOS ANGELES MUNICIPAL ART GALLERY

Barnsdall Art Park, 4804 Hollywood Blvd., Los Angeles CA 90027. **Curators:** Noel Korten and Scott Canty. Nonprofit gallery. Estab. 1971. Interested in emerging, mid-career and established artists. Sponsors 5 solo and group shows/year. Average display time 2 months. 10,000 sq. ft. Accepts primarily Southern California artists.

Media Considers oil, acrylic, watercolor, pastel, pen & ink, drawings, contemporary sculpture, ceramic, fiber,

photography, craft, mixed media, performance art, video, collage, glass, installation and original handpulled prints.

Style Exhibits contemporary works only. ''We organize and present exhibitions which primarily illustrate the significant developments and achievements of living Southern California artists. The gallery strives to present works of the highest quality in a broad range of media and styles. Programs reflect the diversity of cultural activities in the visual arts in Los Angeles.''

Terms Gallery provides insurance, promotion and contract. This is a curated exhibition space, not a sales gallery.

Submissions Send query letter, résumé, brochure, slides and photographs. Slides and résumés are filed. Submit slides to Noel Korten.

Tips ''No limits—contemporary only.''

SAN FRANCISCO

INTERSECTION FOR THE ARTS

446 Valencia, San Francisco CA 94103. (415)626-2787. E-mail: info@theintersection.org. Website: www.theinte rsection.org **Program Director:** Kevin B. Chen. Alternative space and nonprofit gallery. Estab. 1965. Exhibits the work of 10 emerging and mid-career artists/year. Sponsors 8 shows/year. Average display time 6 weeks. Open all year. Located in the Mission District of San Francisco; 1,000 sq. ft.; gallery has windows at one end and cement pillars betwen exhibition panels. 100% of space for special exhibitions. Clientele: 100% private collectors.

• This gallery supports emerging and mid-career artists who explore experimental ideas and processes. Interdisciplinary, new genre, video performance and installation are encouraged.

Media Considers oil, pen & ink, acrylic, drawings, watercolor, mixed media, installation, collage, photography, site-specific installation, video installation, original handpulled prints, woodcuts, lithographs, posters, wood engravings, mezzotints, linocuts and etchings.

Style Exhibits all styles and genres.

Terms Retail price set by artist. Customer discounts and payment by installment are available. Gallery provides promotion; shipping costs are shared.

Submissions Send query letter with résumé, 20 slides, reviews, bio, clippings and SASE. Portfolio review not required. Responds within 6 months only if interested and SASE has been included. Files slides.

Tips ''Create proposals which consider the unique circumstances of this location, utilizing the availability of the theater and literary program/resources/audience.''

⦿ THE LAB

2948 16th St., San Francisco CA 94103. (415)864-8855. Website: www.thelab.org. **Program Manager:** Kristen Chappa. Nonprofit gallery and alternative space. Estab. 1983. Exhibits numerous emerging, mid-career artists/ year. Interested in seeing the work of emerging artists. Sponsors 5-7 shows/year. Average display time 1 month. Open all year; Wednesday-Saturday, 1-6. 40×55'; 17' height; 2,200 sq. ft.; white walls. Doubles as a performance and gallery space. Clientele: artists and Bay Area communities.

• The LAB often curates panel discussions, performances or other special events in conjunction with exhibitions. They also sponsor an annual conference and exhibition on feminist activism and art.

Media Considers all media with emphasis on interdisciplinary and experimental art. Most frequently exhibits installation art, interdisciplinary art, media art and group exhibitions.

Terms Artists receive honorarium from the art space. Work can be sold, but that is not the emphasis.

Submissions Submission guidelines online. Finds artists through word of mouth, submissions, calls for proposals.

Tips Ask to be put on their mailing list to get a sense of the LAB's curatorial approach and interests.

⦿ THE MEXICAN MUSEUM

Ft. Mason Center Bldg. D, San Francisco CA 94123. (415)202-9700. Fax: (415)441-7683. E-mail: curator@mexica nmuseum.org. Website: www.mexicanmuseum.org. **Curator:** Tere Romo. Museum. Estab. 1975. Represents Mexican and Latino emerging, mid-career and established artists. Sponsors 3 exhibits/year. Average display time 3 months. Open Wednesday-Saturday, 11-5. Closed major holidays. Clients include local community, students, tourists and upscale.

Media Considers all media and all types of art.

Style Considers all styles. Most frequently exhibits modernist, popular and pre-conquest.

Submissions Send query letter with artist's statement, bio, brochure, business card, photocopies, photographs, résumé, reviews and slides. Responds only if interested and within 6 months.

MUSEO ITALOAMERICANO

Fort Mason Center Bldg. C, San Francisco CA 94123. (415)673-2200. Fax: (415)673-2292. E-mail: museo@firstw orld.net. Website: www.museoitaloamericano.org. Museum. Estab. 1978. Approached by 80 artists/year. Exhibits 15 emerging, mid-career and established artists/year. Exhibited artists include: Sam Provenzano. Sponsors 7 exhibits/year. Average display time 3-4 months. Open all year; Wednesday-Sunday, 12-5; weekends 12-5. Closed major holidays. Located in the San Francisco Marina District with beautiful view of the Golden Gate Bridge. 3,500 sq. ft. of exhibition space. Clients include local community, students, tourists, upscale and members.

Media Considers all media and all types of prints. Most frequently exhibits mixed media, paper, photography, oil, sculpture and glass.

Style Considers all styles and genres. Most frequently exhibits primitivism realism, geometric abstraction, figurative and conceptualism; 20th century and contemporary art.

Terms The museum sells pieces in agreement with the artist, and if it does, it takes 25% of the sale. Gallery provides insurance and promotion. Accepted work should be framed, mounted and matted. Accepts only Italian or Italian-American artists.

Submissions Submissions accepted with artist's statement, bio, brochure, photography, résumé, reviews, SASE and slides or CDs. Returns material with SASE. Responds in 2 months. Files 2 slides and biography and artist's statement for each artist. Finds artists through word of mouth and submissions.

Tips Looks for good quality slides and clarity in writing statements and résumés. "Be concise."

☑ OCTAVIA'S HAZE GALLERY

498 Hayes St., San Francisco CA 94102. (415)255-6818. Fax: (415)255-6827. E-mail: octaviashaze@mindspring. com. Website: www.octaviashaze.com. **Director:** Clare Haggarty. For profit gallery. Estab. 1999. Approached by 60 artists/year. Represents 30 emerging and mid-career artists. Exhibited artists include: Tsuchida Yasuhiko and Stanley Mouse. Sponsors 6 exhibits/year. Average display time 60 days. Open all year; Wednesday-Sunday, 12-6; Sunday, 11-5. Closed Christmas through New Years. Clients include local community, tourists and upscale. 13% of sales are to corporate collectors. Overall price range: $200-6,000; most work sold at $600.

Media Most frequently exhibits glass, paintings (all media) and photography. Considers all types of prints.

Style Considers all styles. Most frequently exhibits abstract, surrealism and expressionism. Genres include figurative work and landscapes.

Terms Artwork is accepted on consignment and there is a 50% commission. Retail price set by the gallery. Gallery provides promotion and contract. Accepted work should be framed and matted.

Submissions Send query letter with artist's statement, résumé, SASE and slides. Returns material with SASE. Responds in 4 months. Finds artists through word of mouth, submissions and art exhibits.

☑ 🔅 SAN FRANCISCO ARTS COMMISSION GALLERY

401 Van Ness Ave., San Francisco CA 94102. (415)554-6080. Fax: (415)252-6093. Website: www.sfacgallery.org. **Director:** Rupert Jenkins. Nonprofit municipal gallery; alternative space. Estab. 1983. Exhibits innovative contemporary work by emerging and mid-career artists primarily from the Bay Area region. Sponsors 20-25 indoor group shows/year at 3 sites: Gallery, City Hall, Window Gallery. Average display time 5-12 weeks (indoor). Open all year. Located at the Civic Center. Clientele: cross section of San Francisco/Bay Area including tourists, upscale, local and students. Sales are minimal.

Media Considers all media. Most frequently exhibits installation, mixed media, sculpture/3-D, painting, photography.

Style Exhibits all styles.

Terms Accepts artwork on consignment (25% commission). Retail price set by artist. Gallery provides insurance, promotion and contract; artist pays for shipping.

Submissions Emphasizes artists residing in one of nine Bay Area counties. Download gallery guidelines from website.

Tips "The Art Commission Gallery serves as a forum for exhibitions which reflect the aesthetic and cultural diversity of contemporary art in the Bay Area and beyond. Gallery does not promote sale of art, as such, but will handle sale of available work if a visitor wishes to purchase it. Exhibit themes, artists, and selected works are recommended by the gallery director and advisory board to the San Francisco Art Commission for approval. Gallery operates for the benefit of the public as well as the artists. It is not a commercial venue for art."

COLORADO

☑ 🔅 CORE NEW ART SPACE

900 Sante Fe Dr., Denver CO 80205. (303)297-8428. E-mail: art@corenewartspace.com. Website: www.corenew artspace.com. **Directors:** Bruce Clark and Dave Griffin. Cooperative, alternative and nonprofit gallery. Estab.

1981. Exhibits 30 emerging and mid-career artists. Sponsors 30 solo and 6-10 group shows/year. Average display time: 3 weeks. Open Friday-Sunday. Open all year. Located "in lower downtown, former warehouse area; 3,400 sq. ft." Accepts mostly artists from front range Colorado. Clientele: 97% private collectors; 3% corporate clients. Overall price range: $75-3,000; most work sold at $100-600.

Media Considers all media. Specializes in cutting edge work. Prefers quality rather than marketability.

Style Exhibits expressionism, neo-expressionism, painterly abstraction, conceptualism; considers all styles and genres, but especially contemporary and alternative (non-traditional media and approach), including installations.

Terms Co-op membership fee plus donation of time. Retail price set by artist. Exclusive area representation not required. Also rents loft gallery space to non-members for $125-275/3 week run. Send slides for consideration to gallery attention: Annette Coleman.

Submissions Send query letter with SASE. Quarterly auditions to show portfolio of originals, slides and photographs. Request membership or supporting member application. "Our gallery gives an opportunity for emerging artists in the metro-Denver area to show their work. We run four to six open juried shows a year. There is an entry fee charged, but no commission is taken on any work sold. The member artists exhibit in a one-person show once a year. Member artists generally work in more avant-garde formats, and the gallery encourages experimentation. Members are chosen by slide review and personal interviews. Due to time commitments we require that they live and work in the area. There is a yearly Associate Members Show." Finds artists through invitations, word of mouth, art publications.

Tips "We want to see challenging art. If your intention is to manufacture coffee-table and over-the-couch art for suburbia, we are not a good place to start."

FORT COLLINS MUSEUM OF CONTEMPORARY ART

201 S. College Ave., Ft. Collins CO 80524. (970)482-2787. Website: www.fcmoca.org. **Executive Director:** Jeanne Shoaff. Private nonprofit non-collecting museum. Estab. 1983. Presents 10 rotating exhibitions/year in two galleries, 1,800 sq. ft. each. Showing the work of emerging and mid-career regional, national and international artists. Open all year; Tuesday-Saturday, 10-6. Located downtown; in 1911 renovated Italian renaissance post office building.

Media Considers all media.

Style Exhibits work by living artists with emphasis on new media, form or techniques and work that gives visual expression to contemporary issues.

Submissions Send 15-20 slides of latest work with résumé and artist's statement with SASE. Slides may be kept for 4 months before responding; if works accepted for exhibition, slides will be kept for promotional and educational purposes. Works may be made available for sale, MOCA keeps 30% commission.

☑ GALLERY M

2830 E. Third Ave., Denver CO 80206. (303)331-8400. Fax: (303)331-8522. E-mail: newartists@gallerym.com. Website: www.gallerym.com. **Contact:** Managing Partner. For-profit gallery. Estab. 1996. Represents emerging, mid-career and established artists. Exhibited artists include: Alfred Elsenstaedt (photography). Average display time 6-12 weeks. Clients include local community, tourists and upscale. Overall price range: $265 and up; most work sold at $1,000-5,000.

Media Considers acrylic, collage, drawing, glass, installation, mixed media, oil, paper, pastel, pen & ink, watercolor, engravings, etchings, linocuts, lithographs, mezzotints, serigraphs, woodcuts, photography and sculpture.

Style Exhibits: color field, expressionism, geometric abstraction, neo-expressionism, postmodernism, primitivism, realism and surrealism. Considers all genres.

Terms Retail price set by the gallery and the artist. Gallery provides insurance and promotion. Requires exclusive local and regional representation.

Submissions Write to arrange a personal interview to show portfolio of photographs, slides and transparencies. Mail portfolio for review. Returns materials with SASE. Finds artists through current artists represented, other gallery referral, museum referral and select art exhibits.

☷ WILLIAM HAVU GALLERY

1040 Cherokee St., Denver CO 80204 (303)893-2360. Fax: (303)893-2813. E-mail: bhavu@mho.net. Website: www.williamhavugallery.com. **Owner:** Bill Havu. Gallery Administrator: Kate Thompson. For-profit gallery. Estab. 1998. Approached by emerging, mid-career and established artists. Exhibits 50 artists. Exhibited artists include: Emilio Lobato, painter and printmaker; Amy Metier, painter. Sponsors 7-8 exhibits/year. Average display time 6-8 weeks. Open all year; Tuesday-Friday, 10-6; Saturday, 11-5. Closed Sundays, Christmas and New Year's Day. Located in the Golden Triangle Arts District of downtown Denver. The only gallery in Denver designed as a gallery; 3,000 square feet, 18 foot high ceilings, 2 floors of exhibition space; sculpture garden.

Clients include local community, students, tourists, upscale, interior designers and art consultants. Overall price range: $250-18,000; most work sold at $1,000-4,000.

Media Considers acrylic, ceramics, collage, drawing, mixed media, oil, paper, pastel, pen & ink, sculpture and watercolor. Most frequently exhibits painting, prints. Considers etchings, linocuts, lithographs, mezzotints, woodcuts, monotypes, monoprints and silkscreens.

Style Exhibits: expressionism, geometric abstraction, impressionism, minimalism, postmodernism, surrealism and painterly abstraction. Most frequently exhibits painterly abstraction and expressionism.

Terms Artwork is accepted on consignment and there is a 50% commission. Retail price set by the gallery and the artist. Gallery provides insurance, promotion and contract. Accepted work should be framed. Primarily accepts only artists from Rocky Mountain, Southwestern region.

Submissions Mail portfolio for review. Send query letter with artist's statement, bio, brochure, résumé, SASE and slides. Returns material with SASE. Responds only if interested within 1 month. Files slides and résumé, if we are interested in the artist. Finds artists through word of mouth, submissions and referrals by other artists.

Tips Always mail a portfolio packet. We do not accept walk-ins or phone calls to review work. Explore website or visit gallery to make sure work would fit with the gallery's objective. Archival-quality materials play a major role in selling fine art to collectors. We only frame work with archival-quality materials and feel its inclusion in work can "make" the sale.

N PINE CREEK ART GALLERY

2419 W. Colorado Ave., Colorado Springs CO 80904. (719)633-6767. Website: www.pinecreekgallery.com. **Owner:** Nancy Stovall. Retail gallery. Estab. 1991. Represents 10+ established artists. Exhibited artists include Lorene Lovell, Kirby Sattler, Karol Brown and Irene Braun. Average display time 4 months. Open all year Monday-Saturday, 10-6; Sunday, 11-5. 2,200 sq. ft.; in a National Historic District. 30% of space for special exhibitions. Clientele: middle to upper income. Overall price range: $30-5,000; most work sold at $100-500.

Media Considers most media, including bronze, pottery and all types of prints.

Style Exhibits all styles and genres.

Terms Accepts artwork on consignment (40% commission). Retail price set by gallery and artist. Gallery provides insurance, promotion and shipping costs from gallery. Prefers artwork "with quality frame only."

Submissions No fantasy or abstract art. Prefer experienced artists only—no beginners. Send query letter with 6-12 slides and photographs. Call or write for appointment to show portfolio or originals, photographs, slides and tearsheets. Responds in 2 weeks.

Tips "Make sure your presentation is professional. We like to include a good variety of work, so show us more than one or two pieces."

N REISS GALLERY

429 Acoma St., Denver CO 80204. (303)778-6924. **Director:** Rhoda Reiss. Retail gallery. Estab. 1978. Represents 160 emerging and mid-career artists. Exhibited artists include Sica, Nancy Hannum and Jim Foster. Sponsors 3-4 shows/year. Average display time 6-8 weeks. Open all year. Located 6 blocks south of downtown; 2,100 sq. ft.; "in an old Victorian house." 40% of space for special exhibitions. Clientele: "corporate and interior designers." 30% private collectors, 70% corporate collectors. Overall price range: $100-12,000; most artwork sold at $600-1,000.

Media Considers oil, acrylic, watercolor, pastel, mixed media, collage, works on paper, sculpture, ceramic, fiber, glass, original handpulled prints, offset reproductions, woodcuts, engravings, lithographs, posters, wood engravings, mezzotints, serigraphs, linocuts and etchings. Most frequently exhibits oil, prints and handmade paper.

Style Exhibits painterly abstraction, color field and impressionism. Genres include landscapes, Southwestern and Western. Does not want to see "unsalable imagery, figurative work or traditional oil paintings." Interested in seeing large abstract work on canvas or landscapes on canvas.

Terms Accepts work on consignment (50% commission). Retail price set by the artist. Gallery provides insurance and promotion; artist pays for shipping. Prefers unframed artwork.

Submissions Send query letter with résumé, slides, bio, brochure, photographs, SASE and reviews. Call to schedule appointment to show portfolio, which should include originals, photographs and slides. Responds in 2-4 weeks. Files bios, slides and photos.

Tips Suggests "that artist send large-scale work. Small pieces do not work in corporate spaces. Contemporary work shows best in our gallery. I look at craftsmanship, composition and salability of subject matter. Don't send poor slides or poorly framed work."

SANGRE DE CRISTO ARTS CENTER AND BUELL CHILDREN'S MUSEUM

210 N. Santa Fe Ave., Pueblo CO 81003. (719)295-7200. Fax: (719)295-7230. E-mail: mail@sdc-arts.org. **Curator of Visual Arts:** Jina Pierce. Nonprofit gallery and museum. Estab. 1972. Exhibits emerging, mid-career and

established artists. Sponsors 20 shows/year. Average display time 10 weeks. Open all year. Admission $4 adults; $3 children. Located "downtown, right off Interstate I-25"; 16,000 sq. ft.; six galleries, one showing a permanent collection of western art; changing exhibits in the other five. Also a new 12,000 sq. ft. children's museum with changing, interactive exhibits. Clientele: "We serve a 19-county region and attract 200,000 visitors yearly." Overall price range for artwork: $50-100,000; most work sold at $50-2,500.

Media Considers all media.

Style Exhibits all styles. Genres include southwestern, regional and contemporary.

Terms Accepts work on consignment (40% commission). Retail price set by artist. Gallery provides insurance, promotion, contract and shipping costs. Prefers artwork framed.

Submissions "There are no restrictions, but our exhibits are booked into 2007 right now." Send query letter with portfolio of slides. Responds in 2 months.

☑ PHILIP J. STEELE GALLERY AT ROCKY MOUNTAIN COLLEGE OF ART + DESIGN

1600 Pierce St., Lakewood CO 80214. (303)753-6046. Fax: (303)225-8610. E-mail: lspivak@rmcad.edu. Website: www.rmcad.edu. **Gallery Director:** Lisa Spivak. For-profit college gallery. Estab. 1962. Represents emerging, mid-career and established artists. Sponsors 10-12 shows/year. Exhibited artists include Christo, Jenny Holzer. Average display time 1 month. Open all year; Monday-Friday, 12-5; Saturday, 12-5. Located between downtown Denver and the mountains; 1,700 sq. ft.; in very prominent location (art college with 450 students enrolled). 100% of space for gallery artists. Clientele: local community, students, faculty.

Media Considers all media and all types of prints.

Style Exhibits all styles.

Terms Artists sell directly to buyer; gallery takes no commission. Retail price set by the artist. Gallery provides insurance and promotion; artist pays shipping costs to and from gallery.

Submissions Send query letter with résumé, slides, bio, SASE and reviews by April 15 for review for exhibit the following year.

Tips Impressed by "professional presentation of materials, good-quality slides or catalog."

CONNECTICUT

ALVA GALLERY

54 State St., New London CT 06320. (860)437-8664. Fax: (860)437-8665. E-mail: Alva@Alvagallery.com. Website: www.alvagallery.com. For-profit gallery. Estab. 1999. Approached by 50 artists/year. Represents 30 emerging, mid-career and established artists. Exhibited artists include: Maureen McCabe (assemblage), Sol LeWitt (gouaches) and Judith Cotton (paintings). Average display time 6 weeks. Open all year; Tuesday-Saturday, 11-5. Closed between Christmas and New Year and last 2 weeks of August. Clients include local community, tourists and upscale. 5% of sales are to corporate collectors. Overall price range: $250-10,000; most work sold at $1,500.

Media Considers acrylic, collage, drawing, fiber, glass, mixed media, oil, paper, pastel, pen & ink, sculpture and watercolor. Most frequently exhibits oil, photography and mixed media. Considers all types of prints.

Style Considers all styles and genres.

Terms Artwork is accepted on consignment and there is a 50% commission. Retail price set by the artist. Gallery provides insurance and promotion. Does not require exclusive representation locally.

Submissions Mail portfolio for review. Responds in 2 months. Finds artists through word of mouth, portfolio reviews and referrals by other artists.

ARTWORKS GALLERY

233 Pearl St., Hartford CT 06103. (860)247-3522. E-mail: artworks.gallery@snet.net. Website: www.artworksgallery.org. **Executive Director:** Freddy McInerny. Cooperative nonprofit gallery. Estab. 1976. Exhibits 200 emerging, mid-career and established artists. Interested in seeing the work of emerging artists. 40 members. Sponsors 12 shows/year. Average display time 1 month. Open Wednesday-Friday, 11-5; Saturday, 12-3. Open all year. Located in downtown Hartford; 1,300 sq. ft.; large, first floor, store front space. 20% of space for special exhibitions; 80% of space for gallery artists. Clientele: 80% private collectors, 20% corporate collectors. Overall price range: $200-5,000; most work sold at $200-1,000.

Media Considers all media and all types of prints. Most frequently exhibits paintings, photography and sculpture. No crafts or jewelry.

Style Exhibits all styles and genres, especially contemporary.

Terms Co-op membership fee plus a donation of time. There is a 30% commission. Retail price set by artist. Offers customer discounts and payment by installments. Gallery provides insurance, promotion and contract.

Artist pays for shipping costs. Accepts only artists from Connecticut for membership. Accepts artists from New England and New York for juried shows.

Submissions For membership, send query letter with résumé, slides, bio and $25 application fee. Call for appointment to show portfolio of slides. Responds in 1 month. Finds artists through visiting exhibitions, various art publications and sourcebooks, artists' submissions, art collectors' referrals, but mostly through word of mouth and 2 juried shows/year.

MONA BERMAN FINE ARTS

78 Lyon St., New Haven CT 06511. (203)562-4720. Fax: (203)787-6855. E-mail: info@monabermanfinearts.com. Website: www.monabermanfinearts.com. **Director:** Mona Berman. Art consultant. Estab. 1979. Represents 100 emerging and mid-career artists. Exhibited artists include Tom Hricko, David Dunlop, Pierre Dardignac and S. Wind-Greenbaum. Sponsors 1 show/year. Open all year by appointment. Located near downtown; 1,400 sq. ft. Clientele: 25% private collectors, 75% corporate collectors. Overall price range: $200-20,000; most artwork sold at $500-5,000.

Media Considers all media except installation. Shows very little sculpture. Considers all limited edition prints except posters and photolithography. Also considers limited and carefully selected, well-priced, high-quality digital media. Most frequently exhibits works on paper, painting, relief and ethnographic arts.

Style Exhibits most styles. Prefers abstract, landscape and transitional. Little figurative, little still life.

Terms Accepts work on consignment (50% commission; net 30 days). Retail price is set by gallery and artist. Customer discounts and payment by installment are available. Gallery provides insurance; artist pays for shipping. Prefers artwork unframed.

Submissions Accepts digital submissions by e-mail and links to websites or send query letter, résumé, CD or "about 20 slides," bio, SASE, reviews and "retail price list—including stated commission." Portfolios are reviewed only after CD or slide submission. Include e-mail address for faster response or responds in 1 month. Slides and reply returned only if SASE is included. Finds artists through word of mouth, art publications and sourcebooks, submissions and self-promotions and other professionals' recommendations.

Tips "We will not carry artists who list prices on their websites, especially those who do not maintain consistent retail pricing. We are not a gallery, although we do a few exhibits so please do not submit if you are looking for an exhibition venue. We are primarily art consultants. We continue to be busy selling high-quality art and related services to the corporate, architectural, design and private sectors. Read our listings, then you don't have to call first. A follow-up e-mail is preferrable to a phone call."

☑ CONTRACT ART INTERNATIONAL, INC.

P.O. Box 629, Old Lyme CT 06371-0629. (860)434-9799. Fax: (860)434-6240. E-mail: info@contractartinternational.com. Website: www.contractartinternational.com. **President:** K. Mac Thames. In business approximately 32 years. "We contract artwork for blue-chip businesses." Represents emerging, mid-career and established artists. Assigns site-specific commissions to artists based on project needs, theme and client preferences. Studio is open all year to corporate art directors, architects and designers. 1,600 sq. ft. Clientele: 98% commercial. Overall price range: $500-500,000.

Media Places all types of art mediums.

Terms Pays for design by the project, negotiable; 50% up front. Rights purchased vary according to project.

Submissions Send letter of introduction with résumé, slides, bio, brochure, photographs and SASE. If local, write for appointment to present portfolio; otherwise, mail appropriate materials, which should include slides and photographs. "Show us a good range of your talent. Also, we recommend you keep us updated if you've changed styles or media." Responds in 1 week. Files all samples and information in registry library.

Tips "We exist mainly to art direct commissioned artwork for specific projects."

FARMINGTON VALLEY ARTS CENTER'S FISHER GALLERY

25 Arts Center Lane, Avon CT 06001. (860)678-1867. Website: www.fvac.net. Nonprofit gallery. Estab. 1972. Exhibits the work of 100 emerging, mid-career and established artists. Open all year; Wednesday-Saturday, 11-5; Sunday, 12-4; extended hours November-December. Located in Avon Park North just off Route 44; 600 sq. ft.; "in a beautiful 19th-century brownstone factory building once used for manufacturing." Clientele: upscale contemporary craft buyers. Overall price range: $35-500; most work sold at $50-100.

Media Considers "primarily crafts," also considers some mixed media, works on paper, ceramic, fiber, glass and small size prints. Most frequently exhibits jewelry, ceramics and fiber.

Style Exhibits contemporary, handmade craft.

Terms Accepts artwork on consignment (50% commission). Retail price set by the artist. Gallery provides promotion and contract; shipping costs are shared. Requires artwork framed where applicable.

Submissions Send query letter with résumé, bio, slides, photographs, SASE. Responds only if interested. Files a slide or photo, résumé and brochure.

BILL GOFF, INC.

5 Bridge St., P.O. Box 977, Kent CT 06757-0977. (860)927-1411. Fax: (860)927-1987. Website: goodsportsart.com. **President:** Bill Goff. Estab. 1977. Exhibits, publishes and markets baseball art. 95% private collectors, 5% corporate collectors.

Needs Baseball subjects for prints. Realism and photorealism. Represents 10 artists; emerging, mid-career and established. Exhibited artists include Andy Jurinko and William Feldman, Bill Purdom, Bill Williams.

First Contact & Terms Send query letter with bio and photographs. Write to schedule an appointment to show a portfolio, which should include photographs. Responds only if interested within 2 months. Files photos and bios. Accepts work on consignment (50% commission) or buys outright for 50% of retail price. Overall price range: $95-30,000; most work sold at $125-220 (published lithographs). Retail price set by the gallery. Gallery provides insurance and promotion; shipping costs are shared. Prefers artwork unframed.

Tips "Do not waste our time or your own by sending non-baseball items."

DELAWARE

BEYOND DIMENSIONS

59 S. Governors Ave., Dover DE 19904. Phone/fax: (302)674-9070. **Owner:** Jean Francis. Retail gallery. Estab. 1990. Represents 15-20 emerging and mid-career artists; 25-30 emerging and mid-career craftspersons. Average display time 4-6 weeks. Open all year; Monday-Friday, 10-6; Saturday, 10-4. Located downtown; Victorian house with contemporary interior. Clientele: tourists, upscale. Overall price range: $10-1,000; most work sold at $30-95.

Media Considers all media; types of prints include limited artist pulled.

Style Exhibits expressionism, painterly abstraction, conceptualism, photorealism and realism.

Terms Accepts work on consignment (35% commission) or buys outright for 50% of retail price (net 30 days) fine craft only. Retail price set by the artist. Gallery provides insurance and promotion. Shipping costs are shared. Prefers artwork framed (acid free, clean, well presented).

Submissions Send query letter with résumé or brochure, photographs, artist's statement and telephone number. Call or write for appointment to show portfolio of photographs. Responds only if interested within 3 weeks. Files all relative to specific works and of artist/craftsperson. Finds artists through referrals, juried art fairs and exhibitions, artist submissions.

N DELAWARE ART MUSEUM ART SALES & RENTAL GALLERY

2301 Kentmere Parkway, Wilmington DE 19806. (302)571-9590 ext. 550. Fax: (302)571-0220. E-mail: ahupfel@delart.org. Website: www.delart.org. **Director, Art Sales & Rental:** Alice B. Hupfel. Nonprofit retail gallery, art consultancy and rental gallery. Estab. 1975. Represents 50-100 emerging artists. Open all year; Tuesday-Saturday, 9-4 and Sunday 10-4. Located seven minutes from the center of Wilmington; 1,200 sq. ft.; "state-of-the-art gallery and sliding racks." Clientele: 40% private collectors; 60% corporate collectors. Overall price range: $500-12,000; most work sold at $1,500-2,500.

Media Considers all media and all types of prints except posters and reproductions.

Style Exhibits all styles.

Terms Accepts artwork on consignment (40% commission). Rental fee for artwork covers 2 months. Retail price set by artist. Gallery provides insurance while on premises and contract. Artist pays shipping costs. Artwork must be framed.

Submissions Artist must be able to pick up and deliver.

DELAWARE CENTER FOR THE CONTEMPORARY ARTS

200 S. Madison St., Wilmington DE 19801. (302)656-6466. Fax: (302)656-6944. Website: www.thedca.org. **Director:** Steve Lanier. Nonprofit gallery. Estab. 1979. Exhibits the work of emerging, mid-career and established artists. Sponsors 30 solo/group shows/year of both national and regional artists. Average display time is 1 month. 3,000 sq. ft. Overall price range: $50-10,000; most artwork sold at $500-1,000.

Media Considers all media, including contemporary crafts.

Style Exhibits contemporary, abstract, figurative, conceptual, representational and non-representational, painting, sculpture, installation and contemporary crafts.

Terms Accepts work on consignment (35% commission). Retail price is set by the gallery and the artist. Exclusive area representation not required. Gallery provides insurance and promotion; shipping costs are shared.

Submissions Send query letter, résumé, slides and/or photographs and SASE. Write for appointment to show portfolio. Seeking consistency within work as well as in presentation. Slides are filed. Submit up to 20 slides with a corresponding slide sheet describing the work (i.e. media, height by width by depth), artist's name and address on top of sheet and title of each piece in the order in which you would like them reviewed.

Tips "Before submitting slides, call and inquire about an organization's review schedule so your slides won't be tied up for an extended period. Submit at least ten slides that represent a cohesive body of work."

MICHELLE'S OF DELAWARE

831 North Market St., Wilmington DE 19801. (302)655-3650. Fax: (302)661-ARTS. **Art Director:** Raymond Bullock. Retail gallery. Estab. 1991. Represents 18 mid-career and established artists/year. May be interested in seeing the work of emerging artists in the future. Exhibited artists include: Ernie Barnes (acrylic) and Verna Hart (oil). Sponsors 8 shows/year. Average display time 1-2 weeks. Open all year; Saturday-Sunday, 11-5 and 1-5 respectively. Located in Market Street Mall (downtown); 2,500 sq. ft. 50% of space for special exhibitions. Clientele: local community. 97% private collectors; 3% corporate collectors. Overall price range: $300-20,000; most work sold at $1,300-1,500.

Media Considers all media except craft and fiber; considers all types of prints. Most frequently exhibits acrylic, pastel and oil.

Style Exhibits geometric abstraction and impressionism. Prefers: jazz, landscapes and portraits.

Terms Retail price set by the artist. Gallery provides insurance and contract; shipping costs are shared. Prefers artwork framed.

Submissions Send slides. Write for appointment to show portfolio of artwork samples. Responds only if interested within 1 month. Files bio. Finds artists through art trade shows and exhibitions.

Tips "Use conservation materials to frame work."

REHOBOTH ART LEAGUE, INC.

12 Dodds Lane, Henlopen Acres DE 19971. (302)227-8408. Nonprofit gallery; offers education in visual arts. Estab. 1938. Exhibits the work of 1,000 emerging, mid-career and established artists. Sponsors 8-10 shows/year. Average display time 3½ weeks. Open January through November. Located in a residential area just north of town; "3½ acres, rustic gardens, built in 1743; listed in the National Register of Historic Places; excellent exhibition and studio space. Regional setting attracts artists and arts advocates." 100% of space for special exhibitions. Clientele: members, artists (all media), arts advocates.

Media Considers all media (except installation and photography) and all types of prints.

Style Exhibits all styles and all genres.

Terms Accepts artwork on consignment (30% commission). Retail price set by the artist. Gallery provides insurance and promotion. Artist pays for shipping. Prefers artwork framed for exhibition, unframed for browser sales.

Submissions Send query letter with résumé, slides and bio. Write to schedule an appointment to show a portfolio, which should include appropriate samples. Responds in 6 weeks. Files bios and slides in Member's Artist Registry.

DISTRICT OF COLUMBIA

ADDISON/RIPLEY FINE ART

1670 Wisconsin Ave., NW, Washington DC 20007. (202)338-5180. Fax: (202)338-2341. E-mail: addisonrip@aol.com. Website: www.addisonripleyfineart.com. **Owner:** Christopher Addison. For-profit gallery and art consultancy. Estab. 1981. Approached by 100 artists/year. Represents 25 emerging, mid-career and established artists. Exhibited artists include: Wolf Kahn (paintings, pastels). Sponsors 13 exhibits/year. Average display time 6 weeks. Open all year; Tuesday-Saturday, 11-6. Closed end of summer. Upper Georgetown, large, open gallery space that is light filled. Clients include local community, tourists and upscale. 20% of sales are to corporate collectors. Overall price range: $500-80,000; most work sold at $2,500-5,000.

Media Considers acrylic, ceramics, collage, drawing, fiber, glass, installation, mixed media, oil, paper, pastel, sculpture and watercolor. Most frequently exhibits oil and acrylic. Considers etchings, linocuts, lithographs, mezzotints, photography and woodcuts.

Style Considers all styles. Most frequently exhibits painterly abstraction, color field and expressionism. Considers all genres.

Terms Terms depend on the circumstances. Retail price set by the gallery and the artist. Gallery provides insurance, promotion and contract. Accepted work should be framed, mounted and matted. No restrictions regarding art or artists.

Submissions Mail portfolio for review. Send query letter with artist's statement, bio, photocopies, résumé and SASE. Returns material with SASE. Responds in 1 month. Call. "Files ones we like." Finds artists through word of mouth, submissions, and referrals by other artists.

Tips "Submit organized, professional-looking materials."

DADIAN GALLERY

4500 Massachusetts Ave. NW, Washington DC 20016. (202)885-8674. Fax: (202)885-8605. E-mail: dsokolove@ wesleysem.edu. Website: www.luceartsandreligion.org/dadian.htm. **Curator:** Deborah Sokolove. Nonprofit gallery. Estab. 1989. Approached by 50 artists a year. Exhibits 7-10 emerging, mid-career and established artists. Sponsors 7 exhibits/year. Average display time 2 months. Open Monday-Friday, 11-5. Closed August, December 24-January 1. Gallery is within classroom building of Methodist seminary; 550 sq. ft.; glass front open to foyer, moveable walls for exhibition and design flexibility.

Media Considers all media and all types of prints. Most frequently exhibits painting, drawing and sculpture.

Style Considers all styles and genres.

Terms Artists are requested to make a donation to the Henry Luce III Center for the Arts and Religion at Wesley Theological Seminary from any sales. Gallery provides insurance. Accepted work should be framed. "We look for strong work with a spiritual or religious intention."

Submissions Send query letter with artist's statement, SASE and slides. Returns material with SASE. Responds only if interested within 1 year. Finds artists through word of mouth, submissions, art exhibits and referrals by other artists.

THE FRASER GALLERY

1054 31st St., NW, Washington DC 20007. (202)298-6450. Fax: (202)298-6450. E-mail: frasergallery@hotmail.c om. Website: www.thefrasergallery.com. **Director:** Catriona Fraser. For profit gallery. Estab. 1996. Approached by 400 artists/year. Represents 40 emerging, mid-career and established artists and sells the work of another 100 artists. Exhibited artists include: David FeBland (oil painting) and Joyce Tenneson (photography). Sponsors 12 exhibits/year. Average display time 1 month. Open all year; Tuesday-Friday, 12-3; weekends, 12-6. 400 sq. ft. Located in the center of Georgetown, Ind—inside courtyard with 3 other galleries. Clients include local community, tourists, Internet browsers and upscale. Overall price range: $200-15,000; most work sold under $5,000. The Fraser Gallery is charter associate dealer for Southebys.com and member of Art Dealers Association of Greater Washington.

Media Considers acrylic, drawing, mixed media, oil, paper, pastel, pen & ink, sculpture and watercolor. Most frequently exhibits oil, photography and drawing. Considers engravings, etchings, linocuts, mezzotints and woodcuts.

Style Most frequently exhibits contemporary realism. Genres include figurative work and surrealism.

Terms Artwork is accepted on consignment and there is a 50% commission. Retail price set by the artist. Gallery provides insurance, promotion and contract. Accepted work should be framed. Requires exclusive representation locally.

Submissions Write to arrange a personal interview to show portfolio of photographs and slides. Send query letter with bio, photographs, résumé, reviews, SASE and slides or CD-ROM with images and résumé. Returns material with SASE. Responds in 3 weeks. Finds artists through submissions, portfolio reviews, art exhibits and art fairs.

Tips "Research the background of the gallery and apply to galleries that show your style of work. All work should be framed or matted to full museum standards."

JANE HASLEM GALLERY

2025 Hillyer St. NW, Washington DC 20009-1005. (202)232-4644. Fax: (202)387-0679. E-mail: haslem@artline.com. Website: www.JaneHaslemGallery.com. For-profit gallery. Estab. 1960. Approached by hundreds of artists/year; exhibits 75-100 emerging, mid-career and established artists/year. Exhibited artists include Garry Trudeau (cartoonist), Mark Adams (paintings, prints, tapestry), Nancy McIntyre (prints). Sponsors 6 exhibits/year. Average display time 7 weeks. Open by appointment. Located at DuPont Circle across from Phillips Museum; 2 floors of 1886 building; 3,000 square feet. Clients include local community, students, upscale and collectors worldwide. 5% of sales are to corporate collectors. Overall price range is $30-30,000; most work sold at $500-2,000.

Media Considers acrylic, collage, drawing, mixed media, oil, paper, pastel, pen & ink, watercolor. Most frequently exhibits prints and works on paper. Considers engravings, etchings, linocuts, lithographs, mezzotints, serigraphs, woodcuts and digital images.

Style Exhibits expressionism, geometric abstraction, neo-expressionism, pattern painting, painterly abstraction, postmodernism, surrealism. Most frequently exhibits abstraction, realism and geometric. Genres include figurative work, florals and landscapes.

Terms Artwork is accepted on consignment and there is a 50% commission. Retail price set by the artist and the gallery. Gallery provides promotion and contract. Accepts only artists from the US. Prefers only prints, works on paper and paintings.

Submissions Artists should contact via e-mail. Returns material with SASE. Responds to queries only if interested in 3 months. Finds artists through art fairs and exhibits, referrals by other artists and word of mouth.

Tips "100% of our sales are Internet generated. We prefer all submissions initially by e-mail."

ⓃHEMPHILL

(formerly Hemphill Fine Arts), 1027 33rd St. NW, Washington DC 20007. (202)342-5610. Fax: (202)289-0013. Website: www.hemphillfinearts.com. Art consultancy and for-profit gallery. Estab. 1993. Represents 30 emerging, mid-career and established artists. Exhibited artists include: Jacob Kainen, Colby Caldwell and William Christenberry. Sponsors 8 exhibits/year. Average display time 6-8 weeks. Open all year; Tuesday-Saturday, 10-5; weekends, 10-5. Closed December 24-January 1. Clients include upscale. 40% of sales are to corporate collectors. Overall price range: $800-200,000; most work sold at $8,000.

Media Most frequently exhibits painting, sculpture, prints and photography.

Style 20th century/contemporary art.

Terms Artwork is accepted on consignment and there is a 50% commission.

Submissions "Does not review unsolicited material."

▣ SPECTRUM GALLERY

1132 29th St. NW, Washington DC 20007. (202)333-0954. E-mail: director@spectrumgallery.org. Website: www .spectrumgallery.org. **Contact:** John Blee, director. Retail/cooperative gallery. Estab. 1966. Exhibits the work of 29 mid-career artists. Sponsors 10 solo and 2 group shows/year. Average display time 1 month. Accepts only artists from Washington area. Open year round. Located in Georgetown. Clientele: 80% private collectors, 20% corporate clients. Overall price range: $50-5,000; most artwork sold at $450-1,200.

Media Considers oil, acrylic, watercolor, pastel, pen & ink, drawings, mixed media, collage, works on paper, sculpture, ceramic, fiber, woodcuts, mezzotints, etchings, lithographs and serigraphs. Most frequently exhibits acrylic, watercolor and oil.

Style Exhibits impressionism, realism, minimalism, painterly abstraction, pattern painting and hard-edge geometric abstraction. Genres include landscapes, florals, Americana, portraits and figurative work.

Terms Co-op membership fee plus donation of time; 35% commission. Retail price set by artist. Sometimes offers payment by installment. Exclusive area representation not required. Gallery provides promotion and contract.

Submissions Artists must live in the Washington area because of the cooperative aspect of the gallery. Bring actual painting at jurying; application forms needed to apply. "Contact gallery for application."

▣ TOUCHSTONE GALLERY

406 Seventh St. NW, Washington DC 20004-2217. (202)347-2787. E-mail: info@touchstonegallery.com. Website: www.touchstonegallery.com. **Director:** Camille Mosley-Pasley. Cooperative gallery, rental gallery. Estab. 1976. Interested in emerging, mid-career and established artists. Approached by 240 artists a year; represents over 35 artists. Exhibited artists include Danny Conant (alternative processes) and Chuck Bress (Ilfochrome and silver gelatin prints). Sponsors 12 total exhibits/year; 3 photography exhibits/year. Average display time 1 month. Open Wednesday through Friday from 11 to 5; weekends from 12 to 5. Closed Christmas through New Years. Located downtown Washington, DC on Gallery Row. Large main gallery with several additional exhibition areas. High ceilings. Clients include local community, students, tourists, upscale. Overall price range: $100-2,500. Most artwork sold at $600.

Media/Style Considers all media. Most frequently exhibits photography, paintings, sculpture, prints, with painterly abstraction and conceptualism. Considers all genres.

Terms There is a co-op membership fee plus a donation of time. There is a 40% commission. There is a rental fee for space. The rental fee covers 1 month. Retail price set by artist. Gallery provides contract. Accepted work should be framed and matted. Exclusive area representation not required.

Submissions Call. Returns material with SASE. Responds to queries in 1 month. Finds artists through referrals by other artists and word of mouth.

Tips "Visit website first. Read new members prospectus on the front page. Call with additional questions. Do not 'drop in' with slides or art. Do not show everything you do. Show 10-25 images that are cohesive in subject, style and presentation."

☑ WASHINGTON PRINTMAKERS GALLERY

1732 Connecticut Ave. NW, Washington DC 20009. (202)332-7757. E-mail: wpg@visi.net. Website: www.washi ngtonprintmakers.com. **Director:** Jen Watson. Cooperative gallery. Estab. 1985. Exhibits 40 emerging and mid-career artists/year. Exhibited artists include Lee Newman, Max-Karl Winkler, Trudi Y. Ludwig and Margaret Adams Parker. Sponsors 12 exhibitions/year. Average display time 1 month. Open all year; Tuesday-Thursday, 12-6; Friday, 12-9; Saturday-Sunday, 12-5. Located downtown in Dupont Circle area. 100% of space for gallery artists. Clientele: varied. 90% private collectors, 10% corporate collectors. Overall price range: $65-1,500; most work sold at $200-400.

Media Considers all types of original prints, except posters, hand pulled by artist. Most frequently exhibits etchings, lithographs, serigraphs, relief prints.

Style Considers all styles and genres. Prefers expressionism, abstract, realism.

Terms Co-op membership fee plus donation of time (35% commission). Retail price set by artist. Gallery provides promotion, pays shipping costs to and from gallery. Purchaser pays shipping costs of work sold.

Submissions Send query letter. Call for appointment to show portfolio of original prints. Responds in 1 month.

Tips "There is a monthly jury for prospective members. Call to find out how to present work. We are especially interested in artists who exhibit a strong propensity for not only the traditional conservative approaches to printmaking, but also the looser, more daring and innovative experimentation in technique."

FLORIDA

☷ ALBERTSON-PETERSON GALLERY

329 Park Ave. S., Winter Park FL 32789. (407)628-1258. Fax: (407)647-6928. **Owner:** Judy Albertson. Retail gallery. Estab. 1984. Represents 10-25 emerging, mid-career and established artists/year. "We no longer have a retail space—open by appointment only."

Media Considers oil, acrylic, watercolor, pastel, mixed media, collage, paper, sculpture, ceramics, craft, fiber, glass, installation, photography, woodcut, engraving, lithograph, wood engraving, mezzotint, serigraphs, linocut and etching. Most frequently exhibits paintings, ceramic, sculpture.

Style Exhibits all styles. Prefers abstract, contemporary landscape and nonfunctional ceramics.

Terms Accepts work on consignment (varying commission). Retail price set by the gallery and the artist. Gallery provides insurance, promotion, contract and shipping costs from gallery; artist pays shipping costs to gallery. Prefers artwork unframed.

Submissions Accepts only artists "exclusive to our area." Send query letter with résumé, slides, bio, photographs, SASE and reviews. Call or write for appointment to show portfolio of photographs, slides and transparencies. Responds within a month. Finds artists through exhibitions, art publications and artists' submissions.

☑ ALLIANCE FOR THE ARTS GALLERY

(formerly Frizzell Cultural Centre Gallery), 10091 McGregor Blvd., Ft. Myers FL 33919. (239)939-2787. Fax: (239)939-0794. Website: www.artinlee.org. Contact: Exhibition committee. Nonprofit gallery. Estab. 1979. Represents emerging, mid-career and established artists. 800 members. Sponsors 12 shows/year. Average display time 1 month. Open all year; Monday-Friday, 9-5; Saturday, 10-3. Located in Central Lee County—near downtown; 1,400 sq. ft.; high ceiling, open ductwork—ultra modern and airy. Clientele: local to national. 90% private collectors, 10% corporate collectors. Overall price range: $200-100,000; most work sold at $500-5,000.

Media Considers all media and all types of print. Most frequently exhibits oil, sculpture, watercolor, print, drawing and photography.

Style Exhibits all styles, all genres.

Terms Retail price set by the artist. Prefers artwork framed. Only 30% commission.

Submissions Send query letter with slides, bio and SASE. Write for appointment to show portfolio of photographs and slides. Responds in 3 months. Files "all material unless artist requests slides returned." Finds artists through visiting exhibitions, word of mouth and artists' submissions.

☑ ☷ THE ART GALLERY AT GOVERNMENT CENTER

(formerly Cultural Resource Center Metro-Dade), 111 NW First St., Miami FL 33128. (305)375-4635. Fax: (305)375-3068. E-mail: culture@miamidade.gov. Website: www.miamidadearts.com. **Contact:** Rem Cabrera, chief of cultural development. Alternative space/nonprofit gallery. Estab. 1989. Exhibits Miami-Dade County resident artists. Sponsors rotating shows year round. Average display time 2 months. Open all year; Monday-Friday 10-3. Located in Government Center in downtown Miami.

Media Most frequently exhibits oil, mixed media, photography and sculpture.

Terms Retail price set by artist. Gallery provides insurance and promotion; artist pays shipping costs. Prefers artwork framed.

Submissions Accepts only artists from Miami-Dade County. Call for more information. Files slides, résumés, brochures, photographs.

☷ ARTS ON DOUGLAS

123 Douglas, New Smyrna Beach FL 32168. (386)428-1133. Fax: (386)428-5008. E-mail: aod@ucnsb.net. Website: www.douglas.com. **Gallery Manager:** Meghan F. Martin. For profit gallery. Estab. 1996. Approached by many artists/year. We represent 56 professional Florida artists and exhibit 12 established artists/year. Average display time 1 month. Open all year; Tuesday-Friday, 11-6; Saturday, 10-2. 5,000 sq. ft. of exhibition space. Clients include local community, tourists and upscale. Overall price range varies.

Media Considers all media except installation.

Style Considers all styles and genres. Exhibits vary.

Terms Artwork is accepted on consignment and there is a 50% commission. Retail price set by the artist. Gallery provides insurance and promotion. Accepted work should be framed. Requires exclusive representation locally. Accepts only professional artists from Florida.

Submissions Send query letter with artist's statement, bio, brochure, résumé, reviews, SASE and slides. Returns material with SASE. Files slides, bio and résumé. Artists may want to call gallery prior to sending submission package—not always accepting new artists.

Tips "We want current bodies of work—please send slides of what you're presently working on."

SETH JASON BEITLER FINE ARTS

520 SE Fifth Ave., Suite 2501, Ft. Lauderdale FL 33301. (954)832-0414. Fax: (305)933-0939. E-mail: info@sethjas on.com. Website: www.sethjason.com. **Contact:** Seth Beitler, owner. For-profit gallery, art consultancy. Estab. 1997. Approached by 300 artists/year. Represents 40 mid-career, established artists. Exhibited artists include Florimond Dufoor, oil paintings; Terje Lundaas, glass sculpture. Sponsors 5 exhibits/year. Average display time 2-3 months. Open Tuesday through Saturday, 12-5. Closed June-August. Located in downtown Ft. Lauderdale, Florida in a 1,000 sq. ft. private showroom. Clients include local community and upscale. 5-10% of sales are to corporate collectors. Overall price range: $2,000-300,000; most work sold at $5,000.

Media Considers acrylic, glass, mixed media, sculpture, drawing, oil. Most frequently exhibits sculpture, painting, photography. Considers etchings, linocuts, lithographs.

Style Exhibits: color field, geometric abstraction and painterly abstraction. Most frequently exhibits geometric sculpture, abstract painting, photography. Genres include figurative work and landscapes.

Terms Artwork is accepted on consignment and there is a 50% commission. Retail price set by the gallery. Gallery provides insurance, promotion and contract. Accepted work should be mounted.

Submissions Write to arrange personal interview to show portfolio of photographs, slides , transparencies. Send query letter with artist's statement, bio, photographs, résumé, SASE. Returns material with SASE. Responds to queries in 2 months. Files photos, slides, transparencies. Finds artists through art fairs, portfolio reviews, referrals by other artists and word of mouth.

Tips Send "easy to see photographs. E-mail submissions for quicker response."

BOCA RATON MUSEUM OF ART

501 Plaza Real, Mizner Park, Boca Raton FL 33432. (561)392-2500. Fax: (561)391-6410. E-mail: info@bocamuse um.org. Website: www.BocaMuseum.org. **Executive Director:** George S. Bolge. Museum. Estab. 1950. Represents established artists. 5,500 members. Exhibits change every 2 months. Open all year; Tuesday, Thursday and Friday, 10-5; Wednesday, 10-9; Saturday and Sunday, 12-5. Located one mile east of I-95 in Mizner Park in Boca Raton; 44,000 sq. ft.; national and international temporary exhibitions and impressive second-floor permanent collection galleries. Three galleries—one shows permanent collection, two are for changing exhibitions. 66% of space for special exhibitions.

Media Considers all media. Exhibits modern masters including Braque, Degas, Demuth, Glackens, Klee, Matisse, Picasso and Seurat; 19th and 20th century photographers; Pre-Columbian and African art, contemporary sculpture.

Submissions "Contact executive director, in writing."

Tips "Photographs of work of art should be professionally done if possible. Before approaching museums, an artist should be well-represented in solo exhibitions and museum collections. Their acceptance into a particular museum collection, however, still depends on how well their work fits into that collection's narrative and how well it fits with the goals and collecting policies of that museum."

[N] BUTTERFIELD GARAGE ART GALLERY

137 King St., St. Augustine FL 32084. **Coordinator:** Jan Miller. Cooperative gallery. Estab. 1999. Represents 22 established artists. Exhibited artists include Jan Miller (acrylic painting) and Beau Redmond (oil painting). Sponsors 12 exhibits/year. Average display time 28 days. Open all year; Wednesday-Monday, 11 to 5, closed Tuesday. Located downtown St. Augustine—3200 sq. ft. exhibition space. Garage renovated into art space. Built in 1929 originally. Clients include local community, tourists, and upscale. 5% of sales are to corporate collectors. Overall price range: $50-5,000; most work sold at $500.

Media Considers all media. Most frequently exhibits acrylic, watercolor and mixed media. Considers prints including engravings, etchings, linocuts, lithographs, mezzotints, serigraphs, woodcuts and monoprint.

Style Considers all styles. Most frequently exhibits painterly abstration, impressionsm and postmodernism. Genres include figurative work, florals, wildlife and landscapes.

Terms Artwork is accepted on consignment and there is a 40% commission for nonmembers. There is a co-op membership fee plus a donation of time. There is a 10% commission for members. There is a rental fee for space. The rental covers 1 month for invited guest artist. Retail price set by the artist. Gallery provides contract.

Accepted work should be framed. Does not require exclusive representation locally. Accepts only artists from 50 mile radius of St. Augustine.

Submissions Write to arrange personal interview to show portfolio of slides or mail portfolio for review. Send query letter with artist's statement, bio, résumé, SASE and slides. Returns material with SASE. Responds to queries in 1 month. Finds artists through referrals by other artists and word of mouth.

☑ ☷ CAPITOL COMPLEX EXHIBITION PROGRAM

Division of Cultural Affairs, 1001 Desoto Park Dr., Tallahassee FL 32301. (850)245-6470. Fax: (850)245-6492. E-mail: elong@dos.state.fl.us. Website: www.florida-arts.org. **Arts Consultant:** Erin Long. Exhibition spaces (4 galleries). Represents 12 emerging, mid-career and established artists/year. Sponsors 12 shows/year. Average display time 3 months. Open all year; Monday-Friday, 8-5. "Exhibition spaces include 22nd Floor Capitol Gallery, Cabinet Meeting Room, Old Capitol-Gallery and The Governor's Gallery."

Media Considers all media and all types of prints. Most frequently exhibits oil, watercolor and acrylic.

Style Exhibits all genres.

Terms Free exhibit space—artist sells works. Retail price set by the artist. Gallery provides insurance; artist pays for shipping to and from gallery.

Submissions Accepts only artists from Florida. "To apply, complete the application form on the website: www.florida-arts.org/programs/cceprogram.htm."

FLORIDA ART CENTER & GALLERY

208 First St. NW, Havana FL 32333. (850)539-1770. E-mail: drdox@juno.com. **Executive Director:** Dr. Kim Doxey. Retail gallery, studio and art school. Estab. 1993. Represents 30 emerging, mid-career and established artists. Interested in seeing the work of emerging artists. Open all year. Located in small but growing town in north Florida; 2,100 st. ft.; housed in a large renovated 50-year-old building with exposed rafters and beams. Clientele: private collectors. 100% private collectors.

Media Considers all media and original handpulled prints (a few).

Style Exhibits all styles, tend toward traditional styles. Genres include landscapes and portraits.

Terms Accepts work on consignment (45% commission). Retail price set by gallery and artist. Gallery provides insurance, promotion and contract.

Submissions Send query letter with slides. Call or write for appointment.

Tips "Prepare a professional presentation for review, (i.e. quality work, good slides, clear, concise and informative backup materials). Include size, medium, price and framed condition of painting. In order to effectively express your creativity and talent, you must be a master of your craft, including finishing and presentation."

FLORIDA STATE UNIVERSITY MUSEUM OF FINE ARTS

250 Fab, corner of Copeland & W. Tennessee St., Tallahassee FL 32306-1140. (850)644-6836. Fax: (850)644-7229. E-mail: apcraig@mailer.fsu.edu. Website: www.mofa.fsu.edu. **Director:** Allys Palladino-Craig. Estab. 1970. Shows work by over 100 artists/year; emerging, mid-career and established. Sponsors 12-22 shows/year. Average display time 3-4 weeks. Located on the university campus; 16,000 sq. ft. 50% of space for special exhibitions.

Media Considers all media, including electronic imaging and performance art. Most frequently exhibits painting, sculpture and photography.

Style Exhibits all styles. Prefers contemporary figurative and non-objective painting, sculpture, printmaking, photography.

Terms "Sales are almost unheard of; the museum takes no commission." Retail price set by the artist. Museum provides insurance, promotion and shipping costs to and from the museum for invited artists.

Submissions Send query letter or call for Artist's Proposal Form.

Tips "The museum offers a yearly competition with an accompanying exhibit and catalog. Artists' slides are kept on file from this competition as a resource for possible inclusion in other shows. Write for prospectus, available late December through January."

☑ ☷ BARBARA GILLMAN GALLERY

3814 NE Miami Court, Miami Beach FL 33137. (305)573-1920. Fax: (305)573-1940. E-mail: bggart@att.net. Website: www.barbaragillman-gallery.com. **Director:** Barbara Gillman. For profit gallery. Estab. 1960. Approached by 20 artists/year. Represents 20 established artists. Exhibited artists include: Herman Leonard and William Gettlieb. Sponsors 4 exhibits/year. Average display time 2 months. Open all year by appointment. Clients include local community, tourists and upscale. 30% of sales are to corporate collectors. Overall price range: $1,000-20,000; most work sold at $10,000.

Media Considers painting, sculpture, prints, photography and mixed media. Most frequently exhibits photography, prints, paintings. Considers engravings, etchings, linocuts, lithographs, mezzotints and serigraphs.

Style See website. Considers all genres.

Terms Artwork is bought on consignment and there is a 50% commission. Gallery provides promotion. Accepted work should be framed, mounted and matted. Requires exclusive representation locally. Accepts only artists from Florida.

Submissions Please call for how and what to submit.

GLASS CANVAS GALLERY, INC.

146 Second St., N., St. Petersburg FL 33701. (727)821-6767. Fax: (727)821-1775. Website: www.glasscanvasgall ery.com. **President:** Dick Fortune. Retail gallery. Estab. 1992. Represents 350 emerging and established artists. Exhibited artists from US, Canada, Australia, England. Open all year; Monday-Friday, 10-6; Saturday, 10-5; Sunday, 12-5.

Media Considers glass only.

Style Exhibits color field. Prefers unique, imaginative, contemporary, colorful and unusual.

Terms Accepts work on consignment and buys at wholesale price (net 30 days). Retail price set by the gallery. Gallery provides insurance, promotion, contract and shipping costs from gallery; artist pays shipping costs to gallery. Prefers artwork framed.

Submissions Prefers only glass. Send query letter with résumé, brochure, photographs and business card. Call for appointment to show portfolio of photographs. Responds in 2 weeks. Files all material.

Tips "We look at the pieces themselves (and not the slides) to evaluate the technical expertise prior to making the decision to represent an artist."

KENDALL CAMPUS ART GALLERY, MIAMI-DADE COMMUNITY COLLEGE

11011 SW 104 St., Miami FL 33176-3393. (305)237-2322. Fax: (305)237-2901. E-mail: Lfontana@MDCC.edu. **Interim Director:** Lilia Fontana. College gallery. Estab. 1970. Represents emerging, mid-career and established artists. Exhibited artists include Komar and Melamid. Sponsors 8 shows/year. Average display time 5 weeks. Open all year except for 2 weeks at Christmas and 3 weeks in August. Located in suburban area, southwest of Miami; 3,000 sq. ft.; "space is totally adaptable to any exhibition." 100% of space for special exhibitions. Clientele: students, faculty, community and tourists. "Gallery is not primarily for sales, but sales have frequently resulted."

Media Considers all media, all types of original prints. "No preferred style or media. Selections are made on merit only."

Style Exhibits all styles and genres.

Terms "Purchases are made for permanent collection; buyers are directed to artist." Retail price set by artist. Gallery provides insurance and promotion; arrangements for shipping costs vary. Prefers artwork framed.

Submissions Send query letter with résumé, slides, bio, brochure, SASE, and reviews. Write for appointment to show portfolio of slides. "Artists commonly make the mistake of ignoring this procedure." Files résumés and slides (if required for future review).

Tips "Present good-quality slides of works which are representative of what will be available for exhibition."

LOCUST PROJECTS

105 NW 23rd St., Miami FL 33127. (305)576-8570. E-mail: locustprojects@yahoo.com. Website: www.locustpro jects.org. Alternative space and nonprofit gallery. 1,271 sq. ft. Estab. 1998. Exhibited artists include: Randy Moore (video/drawing), David Rohn (installation) and Elizabeth Wild (installation). Sponsors 6 exhibits/year. Average display time 4-6 weeks. Open by appointment; weekends, 12-4. Closed summer.

Media Most frequently exhibits installation.

Style Exhibits: postmodernism and contemporary.

Terms Retail price set by the artist. Gallery provides promotion. Does not require exclusive representation locally.

Submissions Send query letter with artist's statement, bio, résumé, reviews, slides and SASE. Returns material with SASE. Responds in 6 months. Finds artists through curated shows.

NUANCE GALLERIES

804 S. Dale Mabry, Tampa FL 33609. (813)875-0511. **Owner:** Robert A. Rowen. Retail gallery. Estab. 1981. Represents 70 emerging, mid-career and established artists. Sponsors 3 shows/year. Open all year. 3,000 sq. ft. "We've reduced the size of our gallery to give the client a more personal touch. We have a large extensive front window area."

Media Specializing in watercolor, original mediums and oils.

Style "Majority of the work we like to see are realistic landscapes, escapism pieces, bold images, bright colors and semitropical subject matter. Our gallery handles quite a selection, and it's hard to put us into any one class."

Terms Accepts work on consignment (50% commission). Retail price set by gallery and artist. Offers customer discounts and payment by installments. Gallery provides insurance and contract; shipping costs are shared.

Submissions Send query letter with slides and bio, SASE if want slides/photos returned. Portfolio review requested if interested in artist's work.

Tips "Be professional; set prices (retail) and stick with them. There are still some artists out there that are not using conservation methods of framing. As far as submissions we would like local artists to come by to see our gallery and get the idea what we represent. Tampa has a healthy growing art scene, and the work has been getting better and better. But as this town gets more educated, it is going to be much harder for up-and-coming artists to emerge."

☑ OPUS 71 FINE ARTS, HEADQUARTERS

(formerly Opus 71 Galleries, Headquarters), 4115 Carriage Dr., Villa P-2, Misty Oaks, Pompano Beach FL 33069. (954)974-4739. E-mail: lionxsx@aol.com. **Co-Directors:** Charles Z. Candler III and Gary R. Johnson. Retail and wholesale private gallery, alternative space, art consultancy and salon style organization. Estab. 1969. Represents 40 (15-20 on regular basis) emerging, mid-career and established artists/year. By appointment only. Clientele: upscale, local, international and regional. 75% private collectors; 25% corporate collectors. Overall price range: $200-85,000; most work sold at $500-7,500.

- This gallery is a division of The Leandros Corporation. Other divisions include The Alexander Project and Opus 71 Art Bank.

Media Considers oil, acrylic, pastel, pen & ink, drawing, mixed media, collage, sculpture and ceramics; types of prints include woodcuts and wood engravings. Most frequently exhibits oils or acrylic, bronze and marble sculpture and pen & ink or pastel drawings.

Style Exhibits: expressionism, neo-expressionism, primitivism, painterly abstraction, surrealism, conceptualism, minimalism, color field, postmodern works, impressionism, photorealism, hard-edge geometric abstraction (paintings), realism and imagism. Exhibits all genres. Prefers: figural, objective and nonobjective abstraction and realistic bronzes (sculpture).

Terms Accepts work on consignment or buys outright. Retail price set by "consulting with the artist initially." Gallery provides insurance (with limitations), promotion and contract; artist pays for shipping to gallery and for any return of work. Prefers artwork framed, unless frame is not appropriate.

Submissions Telephone call is important. Call for appointment to show portfolio of photographs and actual samples. "We will not look at slides." Responds in 2 weeks. Files résumés, press clippings and some photographs. "Artists approach us from a far flung area. We currently have artists from about 12 states and 4 foreign countries. Most come to us. We approach only a handful of artists annually."

Tips "Know yourself . . . be yourself . . . ditch the jargon. Quantity of work available not as important as quality and the fact that the presenter is a working artist. We don't want hobbyists."

☑ 🖼 P.A.S.T.A. FINE ART (PROFESSIONAL ARTISTS OF ST. AUGUSTINE) GALLERY INC.

214 Charlotte St., St. Augustine FL 32084. (904)824-0251. E-mail: jwtart479@aol.com. Website: www.staugustinegalleries.com. **President and Director:** Jean W. Treimel. Cooperative nonprofit gallery. Estab. 1984. Represents 18 emerging, mid-career and established artists/year; all artist members. Exhibited artists include Jean W. Treimel and Linda Brandt. Continuous exhibition of members' work plus a featured artist each month. Average display time 2 months. Open all year; Monday-Friday, 12-4; Saturday and Sunday, 12-5. Located downtown—"South of The Plaza"; 1,250 sq. ft.; a 100-year-old building adjoining a picturesque antique shop and located on a 400-year-old street in our nation's oldest city." 100% of space for gallery artists. Clientele: tourists and visitors. 100% private collectors. "We invite two guest artists for two month exhibitions. Same conditions as full membership."

Overall price range: $10-3,000; most work sold at $10-800.

Media Considers oil, acrylic, watercolor, pastel, pen & ink, drawing, mixed media, collage, sculpture, ceramics, photography, alkyd, serigraphs and mono prints. Most frequently exhibits watercolor, oil and alkyd.

Style Exhibits expressionism, primitivism, painterly abstraction, impressionism and realism. Genres include landscapes, florals, portraits and figurative work. Prefers impressionism and realism.

Terms Co-op membership fee (30% commission). Retail price set by the artist. Gallery provides insurance, promotion and contract; artist pays shipping costs to and from gallery.

Submissions Accepts only artists from Northeast Florida. Work must be no larger than 60 inches. Send query letter with résumé, 5 slides or photographs, bio, brochure, and SASE. Call or write for appointment to show portfolio of originals, photographs and brochures. "New members must meet approval of a committee and sign a 4-month contract with the 1st and 4th month paid in advance." Responds only if interested within 2 weeks. Finds artists through visiting exhibitions, word of mouth, artists' submissions.

Tips "We can tell when artists are ready for gallery representation by their determination to keep producing and improving regardless of negative sales plus individual expression and consistent good workmanship. They

should have up to ten works—large pieces, medium sizes and small pieces—in whatever medium they choose. Every exhibited artwork should have a bio of the artist on the books. A résumé on the backside of each art work is good publicity for the artist and gallery.''

N: PALM AVENUE GALLERY

45 S. Palm Ave., Sarasota FL 34236. (941)953-5757. E-mail: info@palmavenuegallery.com. Website: www.palm avenuegallery.com. **Owners/Directors:** Mary and Marsh Bates. Vice President: Sandra Manor. Retail gallery. Represents 20 emerging and mid-career artists. Sponsors 6 shows/year. Average display time 1 month. Open all year; Monday-Saturday, 10-5. Located in arts and theater district downtown; 1,700 sq. ft.; ''high tech, 10 ft. ceilings with street exposure in restored hotel.'' 50% of space for special exhibitions. Clientele: 75% private collectors, 25% corporate collectors. Overall price range: $500-5,000; most artwork sold at $500-2,000.
Media Considers oil, acrylic, watercolor, mixed media, collage, works on paper, sculpture, glass and pottery. Most frequently exhibits painting, graphics and sculpture.
Style Exhibits expressionism, painterly abstraction, surrealism, impressionism, realism and hard-edge geometric abstraction. All genres. Prefers impressionism, surrealism.
Terms Accepts artwork on consignment (50% commission). Retail price set by artist. Sometimes offers customer discounts. Gallery provides insurance, promotion and contract. Prefers framed work. Exhibition costs shared 50/50.
Submissions Send résumé, brochure, slides, bio and SASE. Write for appointment to show portfolio of originals and photographs. ''Be organized and professional. Come in with more than slides; bring P.R. materials, too!'' Responds in 1 week.

N: PARADISE ART GALLERY

1359 Main St., Sarasota FL 34236. (941)366-7155. Fax: (941)366-8729. Website: www.paradisegallery.com. **President:** Gudrún Newman. Retail gallery, art consultancy. Represents hundreds of emerging, mid-career and established artists/year. May be interested in seeing the work of emerging artists in the future. Exhibited artists include: John Lennon, Sheri, Pradzynski, G. Newman. Open all year; Monday-Saturday, 10-5; Sunday by appointment. Located in downtown Sarasota; 3,500 sq. ft. 50% of space for special exhibitions. Clientele: tourists, upscale. 90% private collectors, 10% corporate collectors. Overall price range: $500-30,000; most work sold at $2,000.
Media Considers all media. Most frequently exhibits original artwork, acrylics, 3-D art.
Style Exhibits all styles. Prefers contemporary, pop.
Terms Accepts work on consignment (50% commission). Buys outright for 50-70% of retail price (net 30-60 days). Retail price set by the gallery. Gallery provides promotion and contract; shipping costs are shared. Prefers artwork framed.
Submissions Send query letter with résumé, brochure, photographs, artist's statement and bio. Call for appointment to show portfolio of photographs. Responds in 3 weeks.

POLK MUSEUM OF ART

800 E. Palmetto St., Lakeland FL 33801-5529. (863)688-7743. Website: www.PolkMuseumofArt.org. **Contact:** Todd Behrens, curator of art. Estab. 1966. Approached by 75 artists/year. Sponsors 19 exhibits/year. Open all year; Tuesday through Saturday, 10-5. Closed Mondays and major holidays. Four different galleries of various sizes and configurations. Visitors include local community, students and tourists.
Media Considers all media. Most frequently exhibits prints, photos and paintings. Considers all types of prints except posters.
Style Considers all styles. Considers all genres, provided the artistic quality is very high.
Terms Gallery provides insurance, promotion and contract. Accepted work should be framed.
Submissions Mail portfolio for review. Send query letter with artist's statement, bio, résumé and SASE. Returns material with SASE. Reviews 2-3 times/year and responds shortly after each review. Files slides and résumé.

N: SANTE FE TRAILS GALLERY

1429 Main St., Sarasota FL 34236. (813)954-1972. E-mail: sftgallery@aol.com. Website: www.eltallerpublishing. com. **Owner:** Beth Segreti. Retail gallery. Emphasis is on Native American and contemporary Southwestern art. Estab. 1990. Represents/exhibits 25 emerging, mid-career and established artists/year. May be interested in seeing the work of emerging artists in the future. Exhibited artists include Amado Peña and R.C. Gorman. Sponsors 5-6 shows/year. Average display time 1 month. Open all year; Tuesday-Saturday, 10-5. Located downtown; 1,000 sq. ft.; 100% of space for special exhibitions featuring gallery artists. Clientele: tourists, upscale and local community. 100% private collectors. Overall range: $35-12,000; most work sold at $500-1,500.

Media Considers all media, etchings, lithographs, serigraphs and posters. Most frequently exhibits lithographs, mixed media and watercolor.

Style Prefers Southwestern. "Southwestern art has made a dramatic increase in the past few months. This could be the start of another seven-year cycle."

Terms Artwork is accepted on consignment (50% commission) or is bought outright for 50% of the retail price. Retail price set by the gallery and the artist. Gallery provides promotion. Shipping costs are shared. Artist pays for shipping costs to gallery. Prefers artwork unframed.

Submissions Send query letter with résumé, slides or photographs, bio and SASE. Write for appointment to show portfolio of photographs, slides and transparencies. Responds only if interested within 2 weeks. Finds artists through word of mouth, referrals by other artists and submissions.

Tips "Make an appointment. No walk-ins!!"

GEORGIA

BRENAU UNIVERSITY GALLERIES

One Centennial Circle, Gainesville GA 30501. (770)534-6263. Fax: (770)538-4599. E-mail: gallery@lib.brenau.edu. Website: www.brenau.edu. **Gallery Director:** Jean Westmacott. Nonprofit gallery. Estab. 1980s. Exhibits emerging, mid-career and established artists. Sponsors 7-9 shows/year. Average display time 6-8 weeks. Open all year; Monday-Friday, 10-4; Sunday, 2-5 during exhibit dates. "Please call for Summer hours." Located near downtown; 3,958 sq. ft., 3 galleries—the main one in a renovated 1914 neoclassic building, the other in an adjacent renovated Victorian building dating from the 1890s, the third gallery is in the new center for performing arts. 100% of space for special exhibitions. Clientele: tourists, upscale, local community, students. "Although sales do occur as a result of our exhibits, we do not currently take any percentage, except in our invitational exhibitions. Our purpose is primarily educational."

Media Considers all media.

Style Exhibits wide range of styles. "We intentionally try to plan a balanced variety of media and styles."

Terms Retail price set by the artist. Gallery provides insurance and promotion; shipping costs are shared, depending on funding for exhibits. Prefers artwork framed. "Artwork must be framed or otherwise ready to exhibit."

Submissions Send query letter with résumé, 10-20 slides, photographs and bio. Write for appointment to show portfolio of slides and transparencies. Responds within months if possible. Artist should call to follow up. Files one or two slides or photos with a short résumé or bio if interested. Remaining material returned. Finds artists through referrals, direct viewing of work and inquiries.

Tips "Be persistent, keep working, be organized and patient. Take good slides and develop a body of work. Galleries are limited by a variety of constraints—time, budgets, location, taste—and rejection does not mean your work may not be good; it may not 'fit' for other reasons at the time of your inquiry."

☑ THE CITY GALLERY AT CHASTAIN

135 W. Wieuca Rd. NW, Atlanta GA 30342. (404)252-2927. **Contact:** Erin Bailey. Nonprofit gallery. Estab. 1979. Average display time 6-8 weeks. Open all year; hours vary. Located in Northwest Atlanta; 2,000 sq. ft.; historical building; old architecture with much character. Clientele: local community, students. Overall price range: $50-10,000.

• For submissions, call or write Erin Bailey, art center supervisor, at address above. You can also reach her by e-mail: cac135@mindspring.com. She reports that "all policies regarding media, style, genre, etc. are currently being reviewed." So we advise you to call or write for updated information before submitting.

Media Considers all media. Most frequently exhibits sculpture, painting, mixed media.

Terms Retail price set by the artist. Gallery provides insurance.

Submissions Send query letter with résumé, brochure, slides, photographs, reviews, artist's statement, bio. Call or write for appointment to show portfolio of photographs, slides. Finds artists through word of mouth, referrals by other artists, visiting art fairs and exhibitions, submissions.

SKOT FOREMAN FINE ART

315 Peters St. SW, Atlanta GA 30313. (404)222-0440. E-mail: info@skotforeman.com. Website: www.skotforeman.com. **Contact:** Erica Stevens, assistant. For-profit gallery. Estab. 1994. Approached by 1,500-2,000 artists/year; exhibits 30 mid-career and established artists/year. In-house exhibited artists include Purvis Young (house paint on wood), Chris Dolan (oil/acrylic on canvas). Also brokering works by Warhol, Haring, Finster, Escher, Dali, Wesselman and Matta. Sponsors 6-8 exhibits/year. Average display time 30-45 days. Open Tuesday-Friday, 11-5; Saturday-Sunday, 12-5. Closed August. Located "in a downtown metropolitan loft district of Atlanta. The 100-year-old historical building features 2,000 sq. ft. of hardwood floors and 18′ ceilings." Clients

include local community, tourists, upscale and art consultants. 25% of sales are to corporate collectors. Overall price range is $500-50,000; most work sold at $3,000-5,000.

Media Considers acrylic, collage, drawing, glass, installation, mixed media, oil, paper, pastel, pen & ink, sculpture, watercolor. Most frequently exhibits acrylic, oil and mixed media. Considers engravings, etchings, linocuts, lithographs, mezzotints, posters, serigraphs, woodcuts.

Style Exhibits expressionism, realism, neo-expressionism, painterly abstraction, postmodernism, surrealism. Most frequently exhibits painterly abstraction, neo-expressionism and realism. Genres include figurative work, landscapes, portraits and perspective.

Terms Artwork is accepted on consignment and there is a variable commission. Retail price set by the gallery. Gallery provides insurance, promotion and contract. Requires exclusive representation locally. No outdoor Fair self-representation.

Submissions Send e-mail with bio and digital photos. Returns material with SASE. Responds to queries only if interested in 3 weeks. Finds artist's through art fairs and exhibits, portfolio reviews, referrals by other artists, submissions and word of mouth.

Tips "Be concise. Not too much verbage—let the art speak on your behalf."

HEAVEN BLUE ROSE CONTEMPORARY GALLERY

"The Contemporary Gallery in Roswell's Historic District." 934 Canton St., Roswell GA 30075. (770)642-7380. Fax: (770)640-7335. E-mail: inquiries@heavenbluerose.com. Website: www.heavenbluerose.com. **Contact:** Catherine Moore or Nan Griffith, partners/owners. Cooperative, for-profit gallery. Estab. 1991. Approached by 8 artists/year. Represents 13 emerging, mid-career and established artists. Exhibited artists include: CG Stretch (mixed media on canvas), Leslie Cohen (mixed media and oils), Diana Folds (mixed media photography), Robb Helfrick (photography), Dawn Walker (oils, encaustic, mixed media), Ronald Pircio (oils and pastels). Average display time 6 weeks. Open all year; Tuesday-Friday, 11-5:30; Saturday, 11-5:30 and 7-10; Sunday, 1-4. "Located in the Historic District of Roswell GA. Space is small but fantastic energy! Beautifully curated to an overall gallery look. Open, white spaces. Two levels; great reputation." 10% of sales are to corporate collectors. Overall price range: $200-7,000; most work sold at $1,000.

Media Considers acrylic, collage, drawing, fiber, glass, mixed media, oil, paper, pastel, sculpture, watercolor, giclée (only of works whose originals were shown in gallery first). Also digital art. Most frequently exhibits oils, mixed media and pastel.

Style Exhibits: color field, conceptualism, expressionism, geometric abstraction, minimalism, neo-expressionism, primitivism realism, surrealism and painterly abstraction. Most frequently exhibits geometric abstraction, neo-expressionism and conceptualism. Considers all genres.

Terms Artwork is accepted on consignment and there is a 50% commission—3D only. There is a co-op membership fee plus a donation of time. There is a 20% commission. Retail price set by the gallery and the artist. Gallery provides contract. Accepted work should be framed. Requires exclusive representation locally. Accepts only artists from metro Atlanta and local to Roswell GA. We want to promote our local artists. We are all well recognized and/or awarded and/or collected.

Submissions Call or write to arrange a personal interview to show portfolio of photographs, slides, transparencies or framed work. Send query letter with artist's statement, bio, photographs, résumé and SASE. Returns material with SASE. Responds in 1 month. Files contact information. Finds artists through word of mouth, submissions and referrals by other artists.

Tips "Framing is very important. Our clients want properly framed pieces. Consistency of work, available inventory, quality and integrity of artist and work are imperative."

RAIFORD GALLERY

1169 Canton St., Roswell GA 30075. (770)645-2050. Fax: (770)992-6197. E-mail: raifordgallery@mindspring.com. Website: www.raifordgallery.com. For profit gallery. Estab. 1996. Approached by many artists/year. Represents 400 mid-career and established artists. Exhibited artists include: Cathryn Hayden (collage, painting and photography), Richard Jacobus (metal). Sponsors 8 exhibits/year. Average display time 6 weeks. Open all year; Tuesday-Saturday, 10-6. Located in historic Roswell GA; 4,500 sq. ft. in an open 2-story timber frame space. Clients include local community, tourists and upscale. Overall price range: $10-7,000; most work sold at $200-300.

Media Considers all media except installation. Most frequently exhibits painting, sculpture and glass.

Style Exhibits: contemporary American art & craft.

Terms Artwork is accepted on consignment and there is a 50% commission. Retail price set by the artist. Gallery provides insurance, promotion and contract. Accepted work should be framed. Requires exclusive representation locally.

Submissions Call or write to arrange a personal interview to show portfolio of photographs, slides and originals. Send query letter with artist's statement, bio, brochure, photocopies, photographs, résumé, reviews, SASE and

slides. Returns material with SASE. Responds in 2 months. Files nothing if not interested; "all if we are." Finds artists through submissions, portfolio reviews, art exhibits and art fairs.

Tips "Please no handwritten notes. Please include SASE. Please no bizarre poetry."

TRINITY GALLERY

315 E. Paces Ferry Rd., Atlanta GA 30305. (404)237-0370. Fax: (404)240-0092. E-mail: info@trinitygallery.com. Website: www.trinitygallery.com. **President:** Alan Avery. Retail gallery and corporate sales consultants. Estab. 1983. Represents/exhibits 67 mid-career and established artists and old masters/year. Exhibited artists include Cheryl Warrick, Randall Lagro, Jason Rolf and Russell Whiting. Sponsors 6-8 shows/year. Average display time 6 weeks. Open all year; Tuesday-Friday, 10-6; Saturday, 11-5 and by appointment. Located mid-city; 6,700 sq. ft.; 25-year-old converted restaurant. 50-60% of space for special exhibitions; 40-50% of space for gallery artists. Clientele: upscale, local, regional, national and international. 70% private collectors, 30% corporate collectors. Overall price range: $2,500-100,000; most work sold at $2,500-5,000.

Media Considers all media and all types of prints. Most frequently exhibits painting, sculpture and work on paper.

Style Exhibits expressionism, conceptualism, color field, painterly abstraction, postmodern works, realism, impressionism and imagism. Genres include landscapes, Americana and figurative work. Prefers realism, abstract and figurative.

Terms Artwork is accepted on consignment (negotiable commission). Retail price set by gallery. Gallery pays promotion and contract. Shipping costs are shared. Prefers artwork framed.

Submissions Send query letter with résumé, at least 20 slides, bio, prices, medium, sizes and SASE. Reviews every 6 weeks. Finds artists through word of mouth, referrals by other artists and artists' submissions.

Tips "Be as complete and professional as possible in presentation. We provide submittal process sheets listing all items needed for review. Following this sheet is important."

HAWAII

⚥ DOLPHIN GALLERIES

230 Hana Highway, Suite 12, Kahalui HI 96732. (800)669-5051, ext. 207. Fax: (808)873-0820. E-mail: ChristianAdams@DolphinGalleries.com. **Contact:** Christian Adams, director of sales. For-profit gallery. Estab. 1976. Exhibits emerging, mid-career and established artists. Exhibited artists include Alexandra Nechita, Pino and Thomas Pradzynski. Sponsors numerous exhibitions/year; running at all times through 9 separate Fine Art or Fine Jewelry Gallery. Average display time varies from one-night events to a 30-day run. Open 7 days a week, 9 a.m. to 10 p.m. Located in upscale, high traffic tourist locations throughout Hawaii. On Oahu, Dolphin has galleries at the Hilton Hawaiian Village. On Big Island they have galleries located at the Kings Shops at Waikoloa. Clients include local community and upscale tourists. Overall price range $100-100,000; most work sold at $1,000-5,000.

- The above address is for Dolphin Galleries' corporate offices. Dolphin Galleries has 9 locations throughout the Hawaiian islands.

Media Considers all media. Most frequently exhibits oil and acrylic paintings and limited edition works of art. Considers all types of prints.

Style Most frequently exhibits impressionism, figurative and abstract art. Considers American landscapes, portraits and florals.

Terms Artwork is accepted on consignment with negotiated commission, promotion and contract. Retail price set by the gallery. Gallery provides insurance, promotion and contract. Accepted work should be framed, mounted and matted. Requires exclusive representation locally.

Submissions E-mail submissions to ChristianAdams@DolphinGalleries.com. Finds artists mainly through referrals by other artists, art exhibits, submissions, portfolio reviews and word of mouth.

MAYOR'S OFFICE OF CULTURE AND THE ARTS

530 S. King, #404, Honolulu HI 96813. (808)523-4674. Fax: (808)527-5445. E-mail: pradulovic@co.honolulu.hi. us. Website: www.co.honolulu.hi.us/moca. **Executive Director:** Peter Radulovic. Local government/city hall exhibition areas. Estab. 1965. Exhibits group shows coordinated by local residents. Sponsors 50 shows/year. Average display time 3 weeks. Open all year; Monday-Friday, 7:45-4:30. Located at the civic center in downtown Honolulu; 3 galleries—courtyard (3,850 sq. ft.), lane gallery (873 sq. ft.), 3rd floor (536 sq. ft.); Mediterranean-style building, open interior courtyard. "City does not participate in sales. Artists make arrangements directly with purchaser."

Media Considers all media and all types of prints. Most frequently exhibits oil/acrylic, photo/print and clay.

Terms Local artists deliver work to site. Prefers artwork framed.

Submissions "Local artists are given preference." Send query letter with résumé, slides and bio. Write for appointment to show portfolio of slides. "We maintain an artists' registry for acquisition review for the art in City Buildings Program."

Tips "Selections of exhibitions are made through an annual application process. Have a theme or vision for exhibit. Plan show at least one year in advance."

RAMSAY MUSEUM

1128 Smith St., Honolulu HI 96817. (808)537-ARTS. Fax: (808)531-MUSE. E-mail: ramsay@lava.net. Website: www.ramsaymuseum.org. **CEO:** Ramsay. Gallery, museum shop, permanent exhibits and artists' archive documenting over 200 exhibitions including 500 artists of Hawaii. Estab. 1981. Open all year; Monday-Friday, 10-5; Saturday, 10-4. Located in downtown historic district; 5,000 sq. ft.; historic building with courtyard. 25% of space for special exhibitions; 25% of space for gallery artists. 50% of space for permanent collection of Ramsay Quill and Ink originals spanning 50 years. Clientele: 50% tourist, 50% local. 25% private collectors, 75% corporate collectors.

Media Especially interested in ink.

Style Currently focusing on the art of tattoo.

Terms Accepts work on consignment. Retail price set by the artist.

Submissions Send query letter with résumé, 20 slides, bio, SASE. Write for appointment to show portfolio of original art. Responds only if interested within 1 month. Files all material that may be of future interest.

Tips "Keep a record of all artistic endeavors for future use, and to show your range to prospective commissioners and galleries. Prepare your gallery presentation packet with the same care that you give to your art creations. Quality counts more than quantity. Show samples of current work with an exhibit concept in writing."

VOLCANO ART CENTER GALLERY

P.O. Box 129, Volcano HI 96785. (808)967-7565. Fax: (808)967-8512. E-mail: gallery@volcanoartcenter.org. Website: www.volcanoartcenter.org. **Gallery Manager:** Fia Mattice. Nonprofit gallery to benefit arts education; nonprofit organization. Estab. 1974. Represents 300 emerging, mid-career and established artists/year. 1,400 member organization. Exhibited artists include Dietrich Varez and Brad Lewis. Sponsors 8 shows/year. Average display time 6 weeks. Open all year; daily 9-5 except Christmas. Located Hawaii Volcanoes National Park; 3,000 sq. ft.; in the historic 1877 Volcano House Hotel. 15% of space for special exhibitions; 85% of space for gallery artists. Clientele: affluent travelers from all over the world. 95% private collectors, 5% corporate collectors. Overall price range: $20-12,000; most work sold at $50-400.

Media Considers all media, all types of prints. Most frequently exhibits wood, ceramics, glass and 2 dimensional.

Style Prefers traditional Hawaiian, contemporary Hawaiian and contemporary fine crafts.

Terms "Artists must become Volcano Art Center members." Accepts work on consignment (50% commission). Retail price set by the gallery. Gallery provides promotion and contract; artist pays shipping costs to gallery.

Submissions Prefers only work relating to the area or by Hawaiian artists. Call for appointment to show portfolio. Responds only if interested within 1 month. Files "information on artists we represent."

WAILOA CENTER

Division of State Parks, Department of Land & Natural Resources State of Hawaii, DLNR P.O. Box 936, Hilo HI 96721. (808)933-0416. Fax: (808)933-0417. E-mail: wailoa@yahoo.com. **Contact:** Codie M. King, director. Nonprofit gallery and museum. Focus is on propagation of the culture and arts of the Hawaiian Islands and their many ethnic backgrounds. Estab. 1968. Represents/exhibits 300 emerging, mid-career and established artists. Interested in seeing work of emerging artists. Sponsors 60 shows/year. Average display time 1 month. Open all year; Monday, Tuesday, Thursday, and Friday, 8:30-4:30; Wednesday, noon-4:30; closed weekends and state holidays. Located downtown; 10,000 sq. ft.; 4 exhibition areas: main gallery, mini fountain gallery, rotunda gallery, and one local airport. Clientele: tourists, upscale, local community and students. Overall price range: $25-25,000; most work sold at $1,500.

Media Considers all media and all types of prints. No giclée prints; original artwork only. Most frequently exhibits mixed media.

Style Exhibits all styles. "We cannot sell, but will refer buyer to seller." Gallery provides promotion. Artist pays for shipping costs. Artwork must be framed.

Submissions Send query letter with résumé, slides, photographs and reviews. Call for appointment to show portfolio of photographs and slides. Responds in 3 weeks. Finds artists through word of mouth, referrals by other artists, visiting art fairs and exhibitions, submissions.

Tips "We welcome all artists, and try to place them in the best location for the type of art they have. Drop in and let us review what you have."

Galleries

IDAHO

DEVIN GALLERIES

507 Sherman Ave., Coeur d'Alene ID 83814. Phone/fax: (208)667-2898. E-mail: info@devingalleries.com. Website: www.devingalleries.com. **Owners:** Skip and Debbie Peterson. Retail gallery. Estab. 1982. Represents 100 established artists. Exhibited artists include Chester Fields, Oranes Berberian, J. Nelson. Sponsors 4 shows/ year. Average display time 3 months. Open all year. Located ''in main business district downtown;'' 5,000 sq. ft.; antique and rustic. 30% of space for special exhibitions. Clientele: middle to upper income. 82% private collectors, 18% corporate collectors. Overall price range: $1,000-25,000; most work sold at $1,500.

Media Considers all media.

Style Exhibits all styles. Genres include landscapes, florals, Western, wildlife and portraits. Prefers contemporary styles.

Terms Accepts artwork on consignment (50% commission). Retail price set by gallery and artist. Gallery provides insurance, promotion and contract; artist pays for shipping. Prefers artwork framed.

Submissions Send query letter with bio, photographs, SASE and business card. Write for appointment to show portfolio of originals and photographs. Responds within 2 weeks only if interested. Files all material for 6 months.

Tips ''Devin Galleries now has a complete custom frame shop with 23 years experience in framing.''

⚡ POCATELLO ART CENTER GALLERY & SCHOOL

444 N. Main, Pocatello ID 83204. (208)232-0970. **President:** Jan Stanek. Nonprofit gallery featuring work of artist/members. Estab. 1970. Represents approximately 60 emerging, mid-career and established artists/year. Approximately 150 members. Exhibited artists include: Barbara Ruffridge, Jerry Younkin, Onita Asbury and Barbara Swanson. Sponsors 10-12 shows/year. Average display time 2 months. Open all year; Monday-Friday, 10-4 (varies occasionally). Located downtown in ''Old Town.'' ''We sponsor the 'Sagebrush Arts Fes' each year, usually in September, on the Idaho State University Campus.'' We hold classes, feature all levels of artists and are a gathering place for artists. Clientele: tourists, local community, students and artists. 100% private collectors. Overall price range: $25-1,000; most work sold at $25-300.

Media Considers oil, acrylic, watercolor, pastel, pen & ink, drawing, mixed media, collage, paper, sculpture, ceramics, high-end craft, fiber, glass and photography; types of prints include woodcuts, engravings, wood engravings, serigraphs, linocuts and etchings. Most frequently exhibits watercolor, oil and pastel.

Style Exhibits: Expressionism, neo-expressionism, primitivism, painterly abstraction, surrealism, minimalism, impressionism, photorealism, hard-edge geometric abstraction, realism and imagism. Exhibits all genres. Prefers: impressionism, realism and painterly abstraction.

Terms Co-op membership fee plus donation of time. Donations-monetary. Retail price set by the artist. Gallery provides promotion; hand delivered works only. Prefers artwork framed.

Submissions Accepts only artists from Southeast Idaho. Memberships open to all artists and persons interested in the visual arts. Send query letter or visit gallery. Finds artists through word of mouth, referrals by other artists, visiting art fairs and exhibitions.

Tips ''Have work ready to hang.''

ANNE REED GALLERY

P.O. Box 597, Ketchum ID 83340. (208)726-3036. Fax: (208)726-9630. E-mail: gallery@annereedgallery.com. Website: www.annereedgallery.com. **Director:** L'Anne Gilman. Retail Gallery. Estab. 1980. Represents mid-career and established artists. Exhibited artists include Robert Kelly, Deborah Butterfield, Kenro Izu and Andrew Young. Sponsors 10 exhibitions/year. Average display time 1 month. Open all year. Located at 391 First Avenue North. 10% of space for special exhibitions; 90% of space for gallery artists. Clientele: 80% private collectors, 20% corporate collectors.

Media Most frequently exhibits sculpture, wall art and photography.

Style Exhibits expressionism, abstraction, conceptualism, impressionism, photorealism, realism. Prefers contemporary.

Terms Accepts work on consignment (50% commission). Retail price set by gallery and artist. Sometimes offers customer discounts and payment by installment. Gallery provides insurance, promotion, contract and shipping costs from gallery. Prefers artwork framed.

Submissions Send query letter with résumé, 40 slides, bio and SASE. Call or write for appointment to show portfolio of originals (if possible), slides and transparencies. Responds in 2 months. Finds artists through word of mouth, exhibitions, publications, submissions and collector's referrals.

Tips ''Please send only slides or other visuals of current work accompanied by updated résumé. Check gallery representation prior to sending visuals. Always include SASE.''

THE ROLAND GALLERY

Sun Valley Rd. & East Ave., P.O. Box 221, Ketchum ID 83340. (208)726-2333. Fax: (208)726-6266. E-mail: rolandgallery@aol.com. Website: Website: www.rolandgallery.com. **Owner:** Roger Roland. Retail gallery. Estab. 1990. Represents 100 emerging, mid-career and established artists. Sponsors 8 shows/year. Average display time 1 month. Open all year; daily 11-5. 800 sq. ft. 50% of space for special exhibitions; 50% of space for gallery artists. Clientele: 75% private collectors, 25% corporate collectors. Overall price range: $10-10,000; most work sold at $500-1,500.

Media Considers oil, pen & ink, paper, fiber, acrylic, sculpture, glass, watercolor, mixed media, ceramic, installation, pastel, collage, craft and photography, engravings, mezzotints, etchings, lithographs. Most frequently exhibits glass, paintings and jewelry.

Style Considers all styles and genres.

Terms Accepts work on consignment (50% commission) or buys outright for 50% of the retail price (net 30 days). Retail price set by artist. Gallery provides insurance, promotion, shipping costs from gallery. Prefers artwork framed.

Submissions Send query letter with résumé, slides, bio, brochure, photographs, SASE, business card and reviews. Write for appointment to show portfolio of photographs, slides and transparencies. Responds only if interested within 2 weeks.

ILLINOIS

☒ CEDARHURST CENTER FOR THE ARTS

Richview Road, Mt. Vernon IL 62864. (618)242-1236. Fax: (618)242-9530. E-mail: mitchellmuseum@cedarhurst .org. Website: www.cedarhurst.org. **Director of Visual Arts:** Kevin Sharp. Museum. Estab. 1973. Exhibits emerging, mid-career and established artists. Average display time six weeks. Open all year; Tuesday through Saturday, 10-5; Sunday 1-5; closed Mondays and federal holidays.

Submissions Call or send query letter with artist's statement, bio, résumé, SASE and slides.

FREEPORT ARTS CENTER

121 N. Harlem Ave., Freeport IL 61032. (815)235-9755. Fax: (815)235-6015. E-mail: artscenter@aeroinc.net. **Director:** Stephen H. Schwartz. Estab. 1975. Interested in emerging, mid-career and established artists. Sponsors 21 solo and group shows/year. Open all year; Tuesdays, 10-6; Wednesday-Sunday, 10-5. Clientele: 30% tourists; 60% local; 10% students. Average display time 7 weeks.

Media Considers all media and prints.

Style Exhibits all styles and genres. "We are a regional museum serving Northwest Illinois, Southern Wisconsin and Eastern Iowa. We have extensive permanent collections and 8-9 special exhibits per year representing the broadest possible range of regional and national artistic trends. Some past exhibitions include 'Regional Juried Exhibition II,' 'Pattterns of Life: New Indonesian Textiles from the Collection,' and 'Through the Camera's Eye: Last Freeport Photographs and Works by David Anderson.'"

Terms Gallery provides insurance and promotion; artist pays shipping costs. Prefers artwork framed.

Submissions Send query letter with résumé, slides, SASE, brochure, photographs and bio. Responds in 4 months. Files résumés.

Tips "The Exhibition Committee meets quarterly each year to review the slides submitted."

☒ HEUSER ART CENTER GALLERY & HARTMANN CENTER ART GALLERY

Bradley University: 1501 West Bradley Ave., Peoria IL 61625. Heuser Art Center: 1400 West Bradley Ave. (309)677-2989. Fax: (309)677-3642. E-mail: payresmc@bradley.edu. Website: gcc.bradley.edu/art/. **Director of galleries, exhibition and collections:** Pamela Ayres. Alternative space, nonprofit gallery, educational. Estab. 1984. Approached by 260 artists/year. Represents 50 emerging, mid-career and established artists. Sponsors 10 exhibits/year; 1 photography exhibit/year. Average display time 4-6 weeks. Open Tuesday through Friday, 9-4; Thursday, 9-7; closed weekends and during Christmas break. Clients include local community and upscale. 10% of sales are to corporate collectors. Overall price range: $100-5,000; most work sold at $500.

Media Considers all media. Most frequently exhibits printmaking, photo and group theme exhibitions. Considers all types of prints except posters.

Style Considers all styles and genres. Most frequently exhibits conceptualism, painter abstration and neo-expressionism.

Terms Artwork is accepted on consignment and there is a 30% commission. Retail price set by the artist. Gallery provides promotion and contract. Accepted work should be framed. Does not require exclusive representation locally. "We consider all professional artists."

Submissions Mail portfolio of 20 slides for review. Send query letter with artist's statement, bio, brochure,

business card, photocopies, photographs, résumé, reviews, SASE, slides and CD. Returns material with SASE. Does not reply to queries. Queries are reviewed in January and artists are notified in June. Files résumé, artist statments and bios. Finds artists through art exhibits, portfolio reviews, referrals by other artists, submissions and national calls.

Tips ''Please, no hand-written letters. Print or type slide lables. Only send 20 slides total.''

☑ NAF GALLERY

4448 Oakton, Skokie IL 60076. (847)674-7990. Fax: (847)675-8116. Website: www.nafgallery.com. **Contact:** Harry Hagen. Retail/wholesale gallery and art consultancy. Estab. 1987. Represents/exhibits 60-80 emerging, mid-career and established artists/year. Interested in seeing the work of emerging artists. Exhibited artists include Christana-Sahagian. Sponsors 3-4 shows/year. Average display time 4-6 weeks. Open all year; Monday-Sunday, 10-4. Located on main street of Skokie; 2,000 sq. ft. 80-100% of space for gallery artists. 5-10% private collectors, 5-10% corporate collectors. Overall price range: $50-3,000; most work sold at: $200-2,000.

Media Considers acrylic, ceramics, mixed media, oil, pastel, sculpture and watercolor. Most frequently exhibits oil, watercolor.

Style Exhibits expressionism, imagism, impressionism, painterly abstraction, postmodernism, surrealism. Genres include Americana, figurative work, florals, landscapes, portraits, Southwestern and wildlife. Prefers impressionism, abstraction and realism.

Terms Artwork is accepted on consignment (30% commission). Retail price set by the gallery and the artist. Gallery provides insurance and promotion. Artist pays for shipping costs. Prefers artwork framed.

Submissions Send query letter with résumé, slides and SASE. Include price and size of artwork. Call or write for appointment to show portfolio of photographs, slides and transparencies. Responds in 2 weeks. Finds artists through word of mouth, referrals by other artists, visiting art fairs and exhibitions, submissions.

Tips ''Be persistent.''

LAURA A. SPRAGUE ART GALLERY

Joliet Junior College, 1215 Houbolt Rd., Joliet IL 60431-8938. (815)280-2423. **Gallery Director:** Joe B. Milosevich. Nonprofit gallery. Estab. 1978. Interested in emerging and established artists. Sponsors 6-8 solo and group shows/year. Average display time is 3-4 weeks.

Media Considers all media except performance. Most frequently exhibits painting, drawing and sculpture (all media).

Style Considers all styles.

Terms Gallery provides insurance and promotion.

Submissions Send query letter with résumé, brochure, slides, photographs and SASE. Call or write for appointment to show portfolio of originals and slides. Query letters and résumés are filed.

CHICAGO

A.R.C. GALLERY/EDUCATIONAL FOUNDATION

734 N. Milwaukee Ave., Chicago, IL 60622. (312)733-2787. E-mail: ARCgallery@yahoo.com. Website: www.AR Cgallery.org. **President:** Carolyn King. Nonprofit gallery. Estab. 1973. Exhibits emerging, mid-career and established artists. Interested in seeing the work of emerging artists. 21 members. Exhibited artists include Miriam Schapiro. Average display time 1 month. Closed August. Located in the River West area; 3,500 sq. ft. Clientele: 80% private collectors, 20% corporate collectors. Overall price range $50-40,000; most work sold at $200-4,000.

Media Considers oil, acrylic, drawings, mixed media, paper, sculpture, ceramics, installation, photography and original handpulled prints. Most frequently exhibits painting, sculpture (installation) and photography.

Style Exhibits all styles and genres. Prefers postmodern and contemporary work.

Terms Rental fee for space. Rental fee covers 1 month. Gallery provides promotion; artist pays shipping costs. Prefers work framed.

Submissions Send query letter with résumé, slides, bio and SASE. Call for deadlines for review. Portfolio should include slides.

Ⓝ ATLAS GALLERIES, INC.

Two locations: 535 N. Michigan Ave.; 900 N. Michigan Ave., Level 6, Chicago IL 60611. (312)329-9330 (535 N.) and (312)649-0999 (900 N.). Fax: (312)329-9436. E-mail: cpagel@atlasgalleries.com. Website: www.atlasgal leries.com. **President:** Susan Petle. For-profit gallery. Estab. 1967. Exhibits established artists. Sponsors 14 exhibits/year. Average display time 2 days solo/then permanently with collection. Open all year; Sunday through Saturday, 10-8. Located on Michigan Avenue's Magnificent Mile. Clients include local community,

tourists, upscale. 5% of sales are to corporate collectors. Overall price range: $200-100,000; most work sold at $2,000.

Media Considers acrylic, ceramics, collage, drawing, glass, mixed media, oil, paper, pastel, pen & ink, sculpture and watercolor. Most frequently exhibits oil, acrylic and sculpture. Considers prints of engravings, etchings, linocuts, lithographs, serigraphs, woodcuts and giclée.

Style Considers all styles and genres. Most frequently exhibits impressionism, surrealism/post modern. Exhibits all genres.

Terms Artwork is accepted on consignment. Artwork is bought outright. Retail price set by the gallery. Gallery provides insurance, promotion and contract. Requires exclusive representation locally.

Submissions Send query letter with artist's statement, bio, photocopies, photographs and slides. Returns material with SASE. Responds to queries if interested within 3 months. Does not file materials unless we are interested in artist. Finds artists through art exhibits, portfolio reviews, referrals by other artists, submissions and word of mouth.

BALZEKAS MUSEUM OF LITHUANIAN CULTURE ART GALLERY

6500 S. Pulaski Rd., Chicago IL 60629. (773)582-6500. Fax: (773)582-5133. Museum, museum retail shop, nonprofit gallery and rental gallery. Estab. 1966. Approached by 20 mid-career and established artists/year. Sponsors 8 exhibits/year. Average display time 6 weeks. Open 7 days a week. Closed holidays. Clients include local community, tourists and upscale. 74% of sales are to corporate collectors. Overall price range: $150-6,000; most work sold at $545.

Media Considers all media and all types of prints.

Style Considers all styles and genres.

Terms Artwork is accepted on consignment and there is a 33% commission. Retail price set by the gallery. Gallery provides promotion. Accepted work should be framed.

Submissions Write to arrange a personal interview to show portfolio. Cannot return material. Responds in 2 months. Finds artists through word of mouth, art exhibits, and referrals by other artists.

☒ MARY BELL GALLERIES

740 N. Franklin, Chicago IL 60610. (312)642-0202. Fax: (312)642-6672. **President:** Mary Bell. Retail gallery. Estab. 1975. Represents mid-career artists. Interested in seeing the work of emerging artists. Exhibited artists include Mark Dickson. Sponsors 4 shows/year. Average display time 6 weeks. Open all year. Located downtown in gallery district; 5,000 sq. ft. 25% of space for special exhibitions. Clientele: corporations, designers and individuals. 50% private collectors, 50% corporate collectors. Overall price range: $500-15,000.

Media Considers oil, acrylic, pastel, mixed media, collage, paper, sculpture, ceramic, fiber, glass, original handpulled prints, offset reproductions, woodcuts, engravings, lithographs, pochoir, posters, wood engravings, mezzotints, serigraphs, linocuts and etchings. Most frequently exhibits canvas, unique paper and sculpture.

Style Exhibits expressionism, painterly abstraction, impressionism, realism and photorealism. Genres include landscapes and florals. Prefers abstract, realistic and impressionistic styles. Does not want "figurative or bizarre work."

Terms Accepts artwork on consignment (50% commission). Retail price set by gallery and artist. Offers customer discounts and payment by installments. Gallery provides insurance and contract; shipping costs are shared. Prefers artwork unframed.

Submissions Send query letter with slides and SASE. Portfolio review requested if interested in artist's work. Portfolio should include slides or photos.

☒ BELL STUDIO

3428 N. Southport Ave., Chicago IL 60657. Website: www.bellstudio.net. **Director:** Paul Therieau. For-profit gallery. Estab. 2001. Approached by 60 artists/year. Represents 10 emerging artists. Sponsors 10 exhibits/year; 3 photography exhibits/year. Average display time 6 weeks. Open all year; Monday through Friday from 12 to 7; weekends from 12 to 5. Located in brick storefront, 750 sq. ft. exhibition space. Clients include local community, tourists, upscale. 1% of sales are to corporate collectors. Overall price range: $150-3,500; most work sold at $600.

Media Considers acrylic, collage, drawing, mixed media, oil, paper, pastel, pen & ink and watercolor. Considers all types of prints except posters. Most frequently exhibits watercolor, oils and photography.

Style Exhibits: minimalism, postermodernism and painterly abstraction. Genres include figurative work and landscapes.

Terms Artwork is accepted on consignment and there is a 50% commission. Retail price set by the gallery. Gallery provides insurance, promotion and contract. Accepted work should be framed. Requires exclusive representation locally.

Submissions Write to arrange personal interview to show portfolio and include a bio and résumé. Returns

material with SASE. Responds to queries only if interested with 3 months. Finds artists through referrals by other artists, submissions and word of mouth.

Tips "Type submission letter and include your show history, résumé and a SASE."

CHIAROSCURO

700 N. Michigan Ave., Chicago IL 60611. (312)988-9253. Proprietors: Ronna Isaacs and Peggy Wolf. Contemporary retail gallery. Estab. 1987. Represents over 200 emerging artists. Located on Chicago's "Magnificent Mile"; 2,500 sq. ft. on Chicago's main shopping boulevard, Michigan Ave. "Space was designed by award winning architects Himmel & Bonner to show art and contemporary crafts in an innovative way." Overall price range: $5-2,000; most work sold at $50-200.

Media All 2-dimensional work—mixed media, oil, acrylic; ceramics (both functional and decorative works); sculpture, art furniture, jewelry. "We moved out of Chicago's gallery district to a more 'retail' environment 12 years ago because many galleries were closing. Paintings seemed to stop selling, even at the $500-1,000 range, where functional pieces (i.e. furniture) would sell at that price."

Style "Generally we exhibit bright contemporary works representative of those being done by today's leading contemporary craft artists. We specialize in affordable art for the beginning collector, and are focusing on 'functional works' and gifts for the home.

Terms Accepts work on consignment (50% commission).

Submissions Send query letter (Attn: Peggy Wolf) with résumé, slides, photographs, price list, bio and SASE. Portfolio review requested if interested in artist's work. All material is returned if not accepted or under consideration. Finds artists through agents, by visiting exhibitions and national craft and gift shows, word of mouth, various art publications and sourcebooks, submissions/self-promotions and art collectors' referrals.

Tips "Don't be afraid to send photos of anything you're working on. I'm happy to work with the artist, suggest what's selling (at what prices). If it's not right for this gallery, I'll let them know why."

CHICAGO CENTER FOR THE PRINT & POSTER

1509 W. Fullerton, Chicago IL 60614. (773)477-1585. Fax: (773)477-1851. E-mail: rkasvin@prints-posters.com. Website: www.prints-posters.com. **Owner/Director:** Richard H. Kasvin. Retail gallery. Estab. 1979. Represents 100 mid-career and established artists/year. Interested in seeing the work of emerging artists. Exhibited artists include Hiratsuka, J. Buck, David Bumbeck, Scott Sandel, Armin Hoffmann and Herbert Leupin. Sponsors 2-3 shows/year. Average display time 6-8 weeks. Open all year; Tuesday-Saturday, 11-7; Sunday, 12-5. Located in Lincoln Park, Chicago; 3,000 sq. ft. "We represent works on paper, Swiss graphics and European vintage posters." 40% of space for special exhibitions; 60% of space for gallery artists. 90% private collectors, 10% corporate collectors. Overall price range: $300-3,000; most work sold at $500-1,300.

Media Considers mixed media, paper, woodcuts, engravings, lithographs, wood engravings, mezzotints, serigraphs, linocuts, etchings and vintage posters. Most frequently exhibits prints and vintage posters.

Style Exhibits all styles. Genres include landscapes and figurative work. Prefers abstract, figurative and landscape.

Terms Accepts work on consignment (50% commission) or buys outright for 40-60% of the retail price (30-60 days). Retail price set by the gallery and the artist. Gallery provides promotion; shipping costs are shared. Prefers artwork unframed.

Submissions Send query letter with résumé, slides and photographs. Write for appointment to show portfolio of originals, photographs and slides. Files everything. Finds new artists through agents, by visiting exhibitions, word of mouth, art publications and sourcebooks, submissions.

▣ CONTEMPORARY ART WORKSHOP

542 W. Grant Place, Chicago IL 60614. (773)472-4004. Fax: (773)472-4505. E-mail: info@contemporaryartworkshop.org. Website: www.contemporaryartworkshop.org. **Director:** Lynn Kearney. Nonprofit gallery. Estab. 1949. Interested in emerging and mid-career artists. Average display time is $4\frac{1}{2}$ weeks "if it's a show, otherwise we can show the work for an indefinite period of time." Open Tuesday-Friday, 12:30-5:30; Saturday, 12-5. Clientele: art-conscious public. 75% private collectors, 25% corporate clients. Overall price range: $100-1,000; most artwork sold at $400."

- This gallery also offers studios for sculptors, painters and fine art crafts on a month-to-month arrangement and open space for sculptors.

Media Considers oil, acrylic, mixed media, works on paper, sculpture, installations and original handpulled prints. Most frequently exhibits paintings, sculpture, works on paper and fine art furniture.

Style "Any high-quality work" is considered.

Terms Accepts work on consignment (33% commission). Retail price set by gallery or artist. "Discounts and payment by installments are seldom and only if approved by the artist in advance." Exclusive area representation not required. Gallery provides insurance and promotion.

Submissions Send query letter with résumé, slides (a full sheet), artist statement and SASE. Slides and résumé are filed. "First we review slides and then send invitations to bring in a portfolio based on the slides." Finds artists through call for entries in arts papers; visiting local BFA, MFA exhibits; referrals from other artists, collectors.

Tips "Looks for a professional approach and a fine art school degree (or higher). Artists a long distance from Chicago will probably not be considered."

FINE ARTS BUILDING GALLERY

410 S. Michigan Ave., #433, Chicago IL 60605-1300. (312)913-0537. Website: www.fabgallery.com. Cooperative for profit gallery. Estab. 1995. Represents 24 mid-career and established artists. Average display time 1 month. Open all year; Wednesday-Saturday, 12-6. Closed Sundays and holidays. Located on 4th floor of historic landmark building; Venetian court (open courtyeard in addition to gallery). Clients include local community, tourists and upscale. 15% of sales are to corporate collectors. Overall price range: $100-15,000; most work sold at $1,500.

Media Considers acrylic, ceramics, collage, drawing, mixed media, oil, paper, pastel, pen & ink, sculpture and watercolor. Most frequently exhibits paintings on canvas, works on paper, mixed media sculpture. Considers etchings, linocuts, lithographs and monotypes.

Style Exhibits: color field, geometric abstraction, imagism, pattern painting, surrealism, painterly abstraction and realism. Most frequently exhibits realism, surrealism and painterly abstraction. Considers all genres.

Terms Artwork is accepted on consignment and there is a 35% commission. There is a co-op membership fee plus a donation of time. There is a 25% commission. There is a rental fee for space. The rental fee covers 1 month. Retail price set by the artist. Gallery provides insurance and promotion. Accepted work should be framed and matted. Does not require exclusive representation locally. Member artists must be from the Chicago area. Guest artists may come from anywhere.

Submissions Send query letter with artist's statement, bio, brochure, business card, photocopies, photographs, résumé, reviews, SASE and slides. Returns material with SASE. Files résumés and artist's statements. Finds artists through word of mouth, submissions, portfolio reviews, art exhibits, and referrals by other artists.

Tips "Quality of slides and or transparencies or photocopies must be of high quality and correctly represent the artwork! Archival-quality materials play a very important role. Hopefully even if the artist uses 'new materials,' he/she tries to learn about the archival quality of the materials that are used. Materials do not have to be expensive or official art materials."

GALLERY 400, UNIVERSITY OF ILLINOIS AT CHICAGO

1240 W. Harrison (MC034), Chicago IL 60607. (312)996-6114. Fax: (312)355-3444. Website: gallery400.aa.uic.edu. **Director:** Lorelei Stewart. Nonprofit gallery. Estab. 1983. Approached by 500 artists/year. Exhibits 80 emerging and mid-career artists. Exhibited artists include: Rubén Ortiz Torres, Jenny Perlin and Scott Reeder. Sponsors 6 exhibits/year. Average display time 4-6 weeks. Open Tuesday-Friday, 10-6; Saturday, 12-6. Closed holiday season. Located in 2,400 sq. ft. former supermarket. Clients include local community, students, tourists and upscale.

Media Considers drawing, installation, mixed media and sculpture. Most frequently exhibits sculpture, drawing and installation.

Style Exhibits: conceptualism, minimalism and postmodernism. Most frequently exhibits contemporary conceptually based artwork.

Terms Gallery provides insurance and promotion.

Submissions Send query letter with SASE. Returns material with SASE. Responds in 5 months. Files résumé only. Finds artists through word of mouth, art exhibits and referrals by other artists.

Tips Please check our website for guidelines for proposing an exhibition.

GALLERY 1633

1633 N. Damen Ave., Chicago IL 60647. (773)384-4441. E-mail: montanaart@att.net. Website: home.att.net/~montanaart. **Director:** Montana Morrison. Consortium of contributing artists. Estab. 1986. Represents/exhibits a number of emerging, mid-career and established artists. Interested in seeing the work of emerging artists. Exhibited artists include painters, printmakers, sculptors, photographers. Sponsors 11 shows/year. Average display time 1 month. Open all year; Friday, 12-9:30; Saturday and Sunday, 12-5. Located in Bucktown; 900 sq. ft.; original tin ceiling, storefront charm. 35% of space for special exhibitions; 65% of space for gallery artists. Clientele: tourists, local community, local artists, "suburban visitors to popular neighborhood." Sells to both private collectors and commercial businesses. Overall price range: $50-5,000; most work sold at $250-500.

Media Considers all media and types of prints. Most frequently exhibits painting and drawing; ceramics, sculpture and photography.

Style Exhibits all styles including usable crafts (i.e. tableware). All genres. Montana Morrison shows neo-expressionism, activated minimalism and post modern works.

Terms Artwork is accepted on consignment, and there is a 25% commission. There is a rental fee for space. Available memberships include "gallery artists" who may show work every month for 1 year; associate gallery artists who show work for 6 months; and guest artists, who show for one month. Retail price set by the artist. Gallery provides promotion and contract. Artist pays for shipping costs. Call for appointment to show portfolio. Artist should call and visit gallery.

Tips "If you want to be somewhat independent and handle your own work under an 'umbrella' system where artists work together, in whatever way fits each individual—join us."

HYDE PARK ART CENTER

5307 S. Hyde Park Blvd., Chicago IL 60615. (773)324-5520. Fax. (773)324-6641. E-mail: info@hydeparkart.org. Website: hydeparkart.org. **Executive Director:** Chuck Thurow. Nonprofit gallery. Estab. 1939. Exhibits emerging artists. Sponsors 8 group shows/year. Average display time is 4-6 weeks. Located in the historic Del Prado building, in a former ballroom. "Primary focus on Chicago area artists not currently affiliated with a retail gallery." Clientele: general public. Overall price range: $100-10,000.

Media Considers all media. Interested in seeing "innovative work by new artists; also interested in proposals from curators, groups of artists."

Terms Accepts work "for exhibition only." Retail price set by artist. Sometimes offers payment by installment. Exclusive area representation not required. Gallery provides insurance and contract.

Submissions Send query letter with résumé, no more than 10 slides and SASE. Will not consider poor slides. "A coherent artist's statement is helpful." Portfolio review not required. Send Attn: Allison Peters, Exhibition Coordinator. Finds artists through open calls for slides, curators, visiting exhibitions (especially MFA programs) and artists' submissions. Prefers not to receive phone calls.

Tips "Do not bring work in person."

N DAVID LEONARDIS GALLERY

1346 N. Paulina St., Chicago IL 60622. (773)278-3058. E-mail: david@dlg-gallery.com. Website: www.DLG-GALLERY.COM. **Owner:** David Leonardis. For-profit gallery. Estab. 1992. Approached by 100 artists/year. Represents 12 emerging, mid-career and established artists. Exhibited artists include: Kristen Thiele and Christopher Makos. Average display time 30 days. Open all year; Tuesday-Saturday, 12-7; weekends from 12-6. Located in downtown Chicago. Clients include local community, tourists, upscale. 10% of sales are to corporate collectors. Overall price range: $50-5,000; most work sold at $500.

Media Most frequently exhibits painting, photography and lithography. Considers lithographs and serigraphs.

Style Exhibits: pop. Most frequently exhibits contemporary, pop, folk, photo. Genres include figurative work and portraits.

Terms Artwork is accepted on consignment and there is a 50% commission. Retail price set by the gallery and the artist. Gallery provides promotion. Accepted work should be framed. Does not require local representation. Prefers artists who are professional and easy to deal with.

Submissions E-mail. Responds only if interested. Files e-mail and JPEGs. Finds artists through word of mouth, art exhibits, and referrals by other artists.

LOYOLA UNIVERSITY CHICAGO

Crown Center Gallery, 6525 N. Sheridan Rd., Chicago IL 60626. (773)508-3811. Fax: (773)508-2282. **Contact:** Fine Arts Department. Nonprofit gallery. Estab. 1983. Approached by more than 100 artists/year. Sponsors 6 exhibits/year. Open all year; Monday-Friday, 10-3. Located on Chicago lakefront adjacent to glass wall overlooking lake and Michigan. Gallery is 85×19 with large lobby and auditorium. Clients include local community, students and upscale.

Media Considers all media except performance art.

Style Considers all styles and genres.

Terms We are nonprofit. Pass sales on to artists. Retail price set by the artist. Gallery provides insurance, promotion and contract. Accepted work should be framed, mounted and matted. Does not require exclusive representation locally. Prefer midwest and international artists.

Submissions Send query letter with artist's statement, bio, SASE and slides. Returns material with SASE. Responds in 3 months. Finds artists through word of mouth and portfolio reviews.

LYDON FINE ART

309 W. Superior St., Chicago IL 60610. (312)943-1133. Fax: (312)943-8090. E-mail: lydonart@earthlink.net. Website: www.lydonfineart.com. **President:** Douglas K. Lydon. Retail gallery. Estab. 1989. Represents contemporary European and American artists. Exhibited artists include Trevor Bell, Bernd Haussmann, Stephen McCly-

mont and Maria Olivieri Quinn. Exhibits 7-8 shows/year. Average display time 1-2 months. Open all year; Tuesday-Sunday, 10-5. Located in River North Gallery District; 3,000 sq. ft.; features several adjoining spaces allowing for varied exhibition. 70% of space for special exhibitions; 30% of space for gallery artists. Clientele: regional and national collectors, major corporate collections. 60% private collectors, 40% corporate collectors. Overall price range: $1,000-25,000; most work sold at $4,000-19,000.

Media Considers oil, acrylic, sculpture, mixed media, all types of prints. Most frequently exhibits painting.

Style Exhibits: color field, painterly abstraction, realism. Genres include landscapes. Prefers realism-landscape, abstract painting.

Terms Accepts work on consignment. Price set by the gallery in consultation with the artists. Gallery provides insurance, promotion and contract; shipping costs are shared. Prefers artwork framed.

Submissions Send query letter with résumé, slide reviews, artist's statement, bio, SASE. Send one slide sheet with a full range of work. The majority should be current, but include some older pieces to give a sense of where you've come from. Responds in 2 months.

PETER MILLER GALLERY
118 N. Peoria St., Chicago IL 60607. (312)226-5291. Fax: (312)226-5441. E-mail: info@petermillergallery.com. Website: petermillergallery.com. **Director:** Natalie R. Domchenko. Retail gallery. Estab. 1979. Represents 15 emerging, mid-career and established artists. Sponsors 9 solo and 3 group shows/year. Average display time is 1 month. Clientele: 80% private collectors, 20% corporate clients. Overall price range: $500-30,000; most artwork sold at $5,000 and up.

Media Considers oil, acrylic, mixed media, collage, sculpture, installations and photography. Most frequently exhibits oil and acrylic on canvas and mixed media.

Style Exhibits abstraction, conceptual and realism.

Terms Accepts work on consignment (50% commission). Retail price set by gallery and artist. Exclusive area representation required. Insurance, promotion and contract negotiable.

Submissions Send a sheet of 20 slides of work done in the past 18 months with a SASE. Slides, show card are filed.

UNION STREET GALLERY
1655 Union Ave., Chicago Heights IL 60411. (708)754-2601. Fax: (708)754-8779. Website: www.unionstreetgall ery.org. **Gallery Administrator:** Karen Leluga. Nonprofit gallery. Estab. 1995. Represents more than 100 emerging and mid-career artists. Studio artists include: Renee Klyczek/Nordstrom (acrylic) and Marikay Peter Witlock (graphite/pastels). Sponsors 6 exhibits/year. Average display time 6 weeks. Open all year; Monday-Friday, 10-2 or by appointment. Gallery's studio complex houses emerging, professional artists, creating, teaching, hosting seminars, and curating exhibitions for the state-of-the art gallery. Loft spaces with polished maple floors, tall paned windows, and a 3rd floor view energizes this space for artists and viewers alike. Overall price range: $30-3,000; most work sold at $300-600.

Media Considers all media and all types of prints.

Style Considers all styles.

Terms Artwork is accepted on consignment and there is a 20% commission. Retail price set by the artist. Gallery provides promotion. Accepted work should be framed.

Submissions To receive prospectus for all juried events, call, write or fax to be added to mailing list. Artists interested in studio space or solo/group exhibitions should contact Union Street to request information packets.

VALE CRAFT GALLERY
230 W. Superior St., Chicago IL 60610. (312)337-3525. Fax: (312)337-3530. E-mail: peter@valecraftgallery.com. Website: www.valecraftgallery.com. **Owner:** Peter Vale. Retail gallery. Estab. 1992. Represents 100 emerging, mid-career artists/year. Exhibited artists include Tana Acton, Mark Brown, Tina Fung Holder, John Neering and Kathyanne White. Sponsors 4 shows/year. Average display time 3 months. Open all year; Tuesday-Friday, 10:30-5:30; Saturday, 11-5. Located in River North gallery district near downtown; 2,100 sq. ft.; lower level of prominent gallery building; corner location with street-level windows provides great visibility. Clientele: private collectors, tourists, people looking for gifts, interior designers and art consultants. Overall price range; $50-2,000; most work sold at $100-500.

Media Considers paper, sculpture, ceramics, craft, fiber, glass, metal, wood and jewelry. Most frequently exhibits fiber wall pieces, jewelry, glass, ceramic sculpture and mixed media.

Style Exhibits contemporary craft. Prefers decorative, sculptural, colorful, whimsical, figurative, and natural or organic.

Terms Accepts work on consignment (50% commission). Retail price set by the artist. Gallery provides insurance, promotion, contract and shipping costs from gallery; artist pays shipping costs to gallery.

Submissions Accepts only craft media. No paintings, prints, or photographs, please. By mail: Send query letter

Galleries

with résumé, bio or artist's statement, reviews if available, 10-20 slides, CD of images (in JPEG format) or photographs (including detail shots if possible), price list, record of previous sales, and SASE if you would like materials returned to you. By e-mail, please include a link to your website or send JPEG images, as well as any additional information listed above. Call for appointment to show portfolio of originals and photographs. Responds in 2 months. Files résumé (if interested). Finds artists through submissions, art and craft fairs, publishing a call for entries, artists' slide registry and word of mouth.

Tips "Call ahead to find out if the gallery is interested in showing the particular type of work that you make. Try to visit the gallery ahead of time or check out the gallery's website to find out if your work fits into the gallery's focus. I would suggest you have completed at least 20 pieces in a body of work before approaching galleries."

INDIANA

☑ EDITIONS LIMITED GALLERY OF FINE ART

838 E. 65th St., Indianapolis IN 46220. (317)466-9940. **Owner:** John Mallon. Director: Marta Blades. Retail gallery. Represents emerging, mid-career and established artists. Sponsors 4 shows/year. Average display time 1 month. Open all year. Located "north side of Indianapolis; track lighting, exposed ceiling, white walls." Clientele: 60% private collectors, 40% corporate collectors. Overall price range: $100-8,500; most artwork sold at $200-1,200.

Media Considers oil, acrylic, watercolor, pastel, pen & ink, drawings, mixed media, collage, works on paper, sculpture, ceramics, craft, fiber, glass, photography, original handpulled prints, woodcuts, engravings, mezzotints, etchings, lithographs, pochoir and serigraphs. Most frequently exhibits mixed media, acrylic and pastel.

Style Exhibits all styles and genres. Prefers abstract, landscapes and still lifes.

Terms Accepts work on consignment (50% commission). Retail price set by artist. "I do discuss the prices with artist before I set a retail price." Sometimes offers customer discounts and payment by installment. Gallery provides insurance; shipping costs are shared. Prefers artwork unframed.

Submissions Send query letter with slides, SASE and bio. Portfolio review requested if interested in artist's work. Portfolio should include originals, slides, résumé and bio. Files bios, reviews, slides and photos.

Tips Does not want to see "hobby art."

GREATER LAFAYETTE MUSEUM OF ART

102 S. Tenth St., Lafayette IN 47901. (765)742-1128. E-mail: glma@glmart.org. Website: glma.org. **Executive Director:** Les Reker. Museum. Estab. 1909. Temporary exhibits of American and Indiana art as well as work by emerging, mid-career and established artists from Indiana and the midwest. 1,340 members. Sponsors 5-7 shows/year. Average display time 10 weeks. Located 6 blocks from city center; 3,318 sq. ft.; 4 galleries. Clientele: includes Purdue University faculty, students and residents of Lafayette/West Lafayette and 14 county area.

Style Exhibits all styles. Genres include landscapes, still life, portraits, abstracts, non-objective and figurative work.

Terms Accepts some crafts for consignment in gift shop (35% mark-up).

Submissions Send query letter with résumé, slides, artist's statement and letter of intent.

Tips "Indiana artists specifically encouraged to apply."

☑ INDIANAPOLIS ART CENTER

820 E. 67th St., Indianapolis IN 46220. (317)255-2464. Fax: (317)254-0486. E-mail: exhibs@indplsartcenter.org. Website: www.indplsartcenter.org. Director of Exhibitions and Artist Services: Julia Moore. Exhibitions Associate: Susan Grade. Nonprofit art center. Estab. 1934. Prefers emerging artists. Exhibits approximately 100 artists/year. 2,600 members. Sponsors 15-20 shows/year. Average display time 5 weeks. Open Monday-Friday, 9-10; Saturday, 9-3; Sunday, 12-3. Located in urban residential area; 2,560 sq. ft. in 3 galleries; "Progressive and challenging work is the norm!" 100% of space for special exhibitions. Clientele: mostly private. 90% private collectors, 10% corporate collectors. Overall price range: $50-15,000; most work sold at $100-5,000. Also sponsors annual Broad Ripple Art Fair in May.

Media Considers all media and all types of original prints. Most frequently exhibits painting, sculpture installations and fine crafts.

Style All styles. "In general, we do not exhibit genre works. We do maintain a referral list, though." Prefers postmodern works, installation works, conceptualism, large-scale outdoor projects.

Terms Accepts work on consignment (35% commission). Commission is in effect for 3 months after close of exhibition. Retail price set by artist. Gallery provides insurance, promotion, contract; artist pays for shipping. Prefers artwork framed.

Submissions "Special consideration for IN, OH, MI, IL, KY artists." Send query letter with résumé, minimum

of 20 slides, SASE, reviews and artist's statement. Accepted July 1-December 31 each year. Season assembled in February.

Tips "Research galleries thoroughly; get on their mailing lists, and visit them in person at least twice before sending materials. Find out the 'power structure' of the targeted galleries and use it to your advantage. Most artists need to gain experience exhibiting in smaller or non-profit spaces before approaching a gallery. Work needs to be of consistent, dependable quality. Have slides done by a professional if possible. Stick with one style—no scattershot approaches. Have a concrete proposal with installation sketches (if it's never been built). We book two years in advance—plan accordingly. Do not call. Put me on your mailing list one year before sending application so I can be familiar with your work and record. Ask to be put on my mailing list so you know the gallery's general approach. It works!"

[N] NEW HARMONY GALLERY OF CONTEMPORARY ART

506 Main St., New Harmony IN 47631. E-mail: emyersbro@usi.edu. Website: www.nhgallery.com. **Director:** April Vasher-Dean. Nonprofit gallery. Approached by 25 artists/year. Represents 8 emerging and mid-career artists. Exhibited artists include: Patrick Dougherty, sculpture/installation. Sponsors 8 exhibits/year. Average display time 6 weeks. Open all year; Tuesday-Saturday, 10-5; Sundays, 12-4; closed Sundays, January-April. Clients include local community, students, tourists and upscale.

Media Considers all media and all types of prints. Most frequently exhibits sculpture and installation.

Style Exhibits: Considers all styles including contemporary. No genre specified.

Terms Artwork is accepted on consignment and there is a 35% commission. Gallery provides insurance, promotion and contract. Accepted work should be framed, mounted and matted. Does not require exclusive representation locally. Prefers midwestern artists.

Submissions Send query letter with artist's statement, bio, résumé, SASE and slides. Returns material with SASE. Finds artists through art fairs, art exhibits, portfolio reviews and submissions.

IOWA

ARTS FOR LIVING CENTER

P.O. Box 5, Burlington IA 52601-0005. Located at Seventh & Washington. (319)754-8069. Fax: (319)754-4731. E-mail: arts4living@aol.com. Website: www.artguildofburlington.org. **Executive Director:** Lois Rigdon. Nonprofit gallery. Estab. 1974. Exhibits the work of mid-career and established artists. May consider emerging artists. 425 members. Sponsors 10 shows/year. Average display time 3 weeks. Open all year; Tuesday-Friday, 12-5; weekends, 1-4. Located in Heritage Hill Historic District, near downtown; 2,500 sq. ft.; "former sanctuary of 1868 German Methodist church with barrel ceiling, track lights." 35% of space for special exhibitions. Clientele: 80% private collectors, 20% corporate collectors. Overall price range: $25-1,000; most work sold at $75-500.

Media Considers all media and all types of prints. Most frequently exhibits watercolor, intaglio and sculpture.

Style Exhibits all styles.

Terms Accepts work on consignment (25% commission). Retail price set by artist. Gallery provides insurance, promotion and contract; artist pays for shipping. Prefers artwork framed.

Submissions Send query letter with résumé, slides, bio, brochure, photographs, SASE and reviews. Call or write for appointment to show portfolio of slides and gallery experience verification. Responds in 1 month. Files résumé and photo for reference if interested.

[N] ARTS IOWA CITY

129 E. Washington St., Suite 1, Iowa City IA 52245-3925. (319)337-7447. E-mail: members@artsiowacity.com. Website: www.artsiowacity.com. **Gallery director:** Elise Kendrot. Nonprofit gallery. Estab. 1975. Approached by 65± artists/year. Represents 30± emerging, mid-career and established artists. Sponsors 11 exhibits/year. Average display time 1 month. Open all year; Monday-Friday, 11 to 6; weekends, 12-4. Several locations include: AIC @ The Galleries Downtown—219 E. Washington St., Iow City, IA; The Space, AIC Center & Gallery—129 E. Washington St.; Satellite Galleries—local storefronts, locations vary. Clients include local community, students and tourists. 10% of sales are to corporate collectors. Overall price range: $200-6,000; most work sold at $500.

Media Considers all media, types of prints, and all genres. Most frequently exhibits painting, drawing and mixed media.

Terms Artwork is accepted on consignment and there is a 50% commission. Retail price set by the artist. Gallery provides insurance (in gallery, not during transit to/from gallery), promotion and contract. Accepted work should be framed, mounted and matted. Does not require exclusive representation locally.

Submissions "We represent artists who are members of Arts Iowa City; to be a member one must pay a

membership fee. Most people are from Iowa and surrounding states." Call or write to arrange personal interview to show portfolio of photographs, slides and transparencies. Send query letter with artist's statement, bio, brochure, business card, photographs, résumé, reviews, SASE and slides. Returns material with SASE. Responds to queries in 1 month. Files printed material and CDs. Slides sent back to artist after review. Finds artists through referrals by other artists, submissions and word of mouth.

Tips "We are a non-profit gallery with limited staff. Most work is done by volunteers. Artists interested in submitting work should visit our website at www.artsiowacity.com to gain a better understanding of the services we provide and to obtain membership and show proposal information. Please submit applications according to the guidelines on the website."

CORNERHOUSE GALLERY AND FRAME

2753 First Ave. SE, Cedar Rapids IA 52402. (319)365-4348. Fax: (319)365-1707. E-mail: info@cornerhousegaller y.com. Website: www.cornerhousegallery.com. **Director:** Janelle McClain. Retail gallery. Estab. 1976. Represents 150 emerging, mid-career and established midwestern artists. Exhibited artists include Fred Basker, Thomas C. Jackson, Ann Royer, John Preston, Nicholas Simmons, Karen Strohbeen, Bill Luchsinger. Sponsors 2 shows/year. Average display time 1 month. Open all year; Monday-Friday, 9:30-5:30; Saturday, 9:30-4. 3,000 sq. ft.; "converted 1907 house with 3,000 sq. ft. matching addition devoted to framing, gold leafing and gallery." 25% of space for special exhibitions. Clientele: "residential/commercial, growing collectors." 80% private collectors. Overall price range: $200-100,000; most artwork sold at $500-2,000.

Media Considers oil, acrylic, watercolor, pastel, drawings, mixed media, collage, works on paper, sculpture, ceramic, fiber, glass, original handpulled prints, woodcuts, wood engravings, linocuts, engravings, mezzotints, jewelry, etchings, lithographs and serigraphs. Most frequently exhibits oil, acrylic, original prints and ceramic works.

Style Exhibits all styles. Genres include florals, landscapes, figurative work. Prefers regionalist/midwestern subject matter. Exhibits only original work—no reproductions.

Terms Accepts work on consignment (45% commission) or artwork is bought outright for 50% of retail price (net 30 days). Retail price set by artist and gallery. Gallery provides insurance and promotion. Prefers artwork unframed.

Submissions Prefers only Midwestern artists. Send résumé, 20 slides, photographs and SASE. Portfolio review requested if interested in artist's work. Responds in 1 month. Files résumé and photographs. Finds artists through word of mouth, submissions/self promotions and art collectors' referrals. Do not stop in unannounced.

Tips "Send a written letter of introduction along with five representative images and retail prices. Ask for a return call and appointment. Once appointment is established, send a minimum of 20 images and résumé so it can be reviewed before appointment. Do not approach a gallery with only a handful of works to your name. I want to see a history of good quality works. I tell artists they should have completed at least 50-100 high quality works with which they are satisfied. An artist also needs to know which works to throw away!"

N THE GALLERIES DOWNTOWN

218 E. Washington Street, Iowa City IA 52240. (319)338-4442. Fax: (319)338-3380. E-mail: GalleryDowntown@a ol.com. **Director:** Benjamin Chait. For-profit gallery. Estab. 2003. Approached by 300 artists/year. Represents 30 emerging, mid-career and established artists. Exhibited artists include: Jerry Eskin (clay sculpture); Gene Anderson (multi-media sculpture). Sponsors 12 exhibits/year. Average display time 90 days. Open all year; Monday-Friday, 11-6; weekends, 12-5. Located in a downtown building restored to its original look (circa 1882), with 14 ft. molded ceiling and original 9 ft. front door. Professional museum lighting and scamozzi-capped columns complete the elegant gallery. Clients include local community, students, tourists, upscale. Overall price range: $50-4,000; most work sold at $500.

Media/Style Considers all media, all types of prints, all styles and all genres. Most frequently exhibits sculpture, ceramic and acrylic.

Terms Artwork is accepted on consignment and there is a 50% commission. Retail price set by the gallery and the artist. Gallery provides insurance, promotion and contract. Accepted work should be framed. Requires exclusive representation locally.

Submissions Call, mail portfolio for review. Returns material with SASE. Responds to queries in 2 weeks. Finds artists through art fairs, art exhibits, portfolio reviews and referrals by other artists.

GUTHART GALLERY & FRAMING

506 Clark St., Suite A, Charles City IA 50616. (641)228-5004. **Owner:** John R. Guthart. Retail gallery and art consultancy. Estab. 1992. Represents 12 emerging, mid-career and established artists. Exhibited artists include: John Guthart. Average display time is 2 months. Open all year; Monday-Saturday, 10-5, and by appointment. Located downtown—close to art center and central park. 700 sq. ft. 50% of space for special exhibitions; 50%

of space for gallery artists. Clientele: tourists, upscale, local community and students. 80% private collectors, 20% corporate collectors. Overall price range: $25-10,000; most work sold at $200-800.

Media Considers all media. Considers all types of prints. Most frequently exhibits watercolors, oils and prints.

Style Exhibits expressionism, primitivism, painterly abstraction, surrealism, postmodernism, impressionism and realism. Exhibits all genres. Prefers florals, wildlife and architectural art.

Terms Accepts artwork on consignment (30% commission) or buys outright for 50% of retail price (net 30 days). Retail price set by gallery. Gallery provides insurance and promotion. Shipping costs are shared. Prefers artwork framed.

Submissions Send query letter with résumé, slides and brochure. Write for appointment to show portfolio of photographs and slides. Responds only if interested in 2 weeks. Files résumé, letter and slides. Finds artists through word of mouth, referrals, submissions and visiting art fairs and exhibitions.

KAVANAUGH ART GALLERY

131 Fifth St., W. Des Moines IA 50265. (515)279-8682. Fax: (515)279-7609. E-mail: kagallery@aol.com. Website: www.kavanaughgallery.com. **Director:** Carole Kavanaugh. Retail gallery. Estab. 1990. Represents 25 mid-career and established artists/year. May be interested in seeing the work of emerging artists in the future. Exhibited artists include Kati Roberts, Don Hatfield, Dana Brown, Gregory Steele, August Holland, Ming Feng and Larry Guterson. Sponsors 3-4 shows/year. Averge display time 3 months. Open all year; Monday-Saturday, 10-5. Located in Old Town shopping area; 6,000 sq. ft. 70% private collectors, 30% corporate collectors. Overall price range: $300-20,000; most work sold at $800-3,000.

Media Considers all media and all types of prints. Most frequently exhibits oil, acrylic and pastel.

Style Exhibits color field, impressionism, realism, florals, portraits, western, wildlife, southwestern, landscapes, Americana and figurative work. Prefers landscapes, florals and western.

Terms Accepts work on consignment (50% commission). Retail price set by the artist. Gallery provides insurance, promotion and contract. Shipping costs are shared. Prefers artwork unframed.

Submissions Send query letter with résumé, bio and photographs. Portfolio should include photographs. Responds in 3 weeks. Files bio and photos. Finds artists through word of mouth, referrals by other artists, visiting art fairs and exhibitions, artist's submissions.

Tips "Get a realistic understanding of the gallery/artist relationship by visiting with directors. Be professional and persistent."

MACNIDER ART MUSEUM

303 Second St. SE, Mason City IA 50401. (641)421-3666. E-mail: macnider@macniderart.org. Website: www.macniderart.org. Nonprofit gallery. Estab. 1966. Exhibits 1-10 emerging, mid-career and established artists. Sponsors 12-20 exhibits/year. Average display time 3 months. Open all year; Tuesday and Thursday, 9-9; Wednesday, Friday and Saturday, 9-5; Sunday, 1-5. Closed Mondays. Large gallery space with track system which we hang works on monofiliment line. Smaller gallery items are hung or mounted. Clients include local community, students, tourists and upscale. Overall price range: $50-2,500; most work sold at $200-$500.

Media Considers all media and all types of prints.

Style Considers all styles and genres.

Terms Artwork is accepted on consignment and there is a 40% commission. Retail price set by the artist. Gallery provides insurance, promotion and contract. Accepted work should be framed. Does not require exclusive representation locally.

Submissions Mail portfolio for review. Returns material with SASE. Responds only if interested within 3 months. Finds artists through word of mouth, submissions, portfolio reviews, art exhibits, art fairs and referrals by other artists.

Tips "Exhibition opportunities include exhibition in 2 different gallery spaces, entry into competitive exhibits (1 fine craft exhibit open to Iowa artists and 1 all media open to artists within 100 miles of Mason City Iowa), features in museum shop on consignment, booth space in Festival Art Market in August."

KANSAS

GALLERY XII

412 E. Douglas, Suite A, Wichita KS 67202. (316)267-5915. E-mail: dougprintart@aol.com. **President:** Rosemary Dugan. Consignment Committee: Judy Dove. Cooperative nonprofit gallery. Estab. 1977. Represents 50 mid-career and established artists/year and 20 members. Average display time 1 month. Open all year; Monday-Saturday, 10-5. Usually open with other galleries for "Final Fridays" gallery tour 7-10 p.m., final Friday of month. Located in historic Old Town which is in the downtown area; 1,300 sq. ft.; historic building. 20% of

space for special exhibitions; 80% of space for gallery artists. Clientele: private collectors, corporate collectors, people looking for gifts, tourists. Overall price range: $10-2,000.

Terms Only accepts 3-D work on consignment (35% commission). Co-op membership screened and limited. Annual exhibition fee, 15% commission and time involved. Artist pays shipping costs to and from gallery.

Submissions Limited to local artists or those with ties to area. Work juried from slides. "We are a co-op gallery whose members rigorously screen prospective new members."

☑ ALICE C. SABATINI GALLERY

1515 SW Tenth, Topeka KS 66604-1374. (785)580-4516. Fax: (785)580-4496. E-mail: sbest@mail.tscpl.org. Website: www.tscpl.org. **Gallery Director:** Sherry Best. Nonprofit gallery. Estab. 1976. Exhibits emerging, mid-career and established artists. Sponsors 8-9 shows/year. Average display time 1 month. Open all year; Monday-Friday, 9-9; Saturday, 9-9; Sunday, 12-9. Located 1 mile west of downtown; 2,500 sq. ft.; security, track lighting, plex top cases; recently added five moveable walls. 100% of space for special exhibitions and permanent collections. Overall price range: $150-5,000.

Media Considers oil, fiber, acrylic, sculpture, glass, watercolor, mixed media, ceramic, pastel, collage, metal work, woodcuts, wood engravings, linocuts, engravings, mezzotints, etchings, lithographs and photography. Most frequently exhibits ceramic, oil and watercolor.

Style Exhibits neo-expressionism, painterly abstraction, postmodern works and realism. Prefers painterly abstraction, realism and neo-expressionism.

Terms Artwork accepted or not accepted after presentation of portfolio/résumé. Retail price set by artist. Gallery provides insurance; artist pays for shipping costs. Prefers artwork framed.

Submissions Usually accepts only artists from KS, MO, NE, IA, CO, OK. Send query letter with résumé and 12-24 slides. Call or write for appointment to show portfolio of slides. Responds in 2 months. Files résumé. Finds artists through visiting exhibitions, word of mouth and submissions.

Tips "Find out what each gallery requires from you and what their schedule for reviewing artists' work is. Do not go in unannounced. Have good quality slides—if slides are bad they probably will not be looked at. Have a dozen or more to show continuity within a body of work. Your entire body of work should be at least 50-100 pieces. Competition gets heavier each year. Looks for originality."

STRECKER-NELSON GALLERY

406.5 Poyntz Ave., Manhattan KS 66502. (785)537-2099. E-mail: gallery@kansas.net. Website: www.strecker-nelsongallery.com. **President:** Jay Nelson. Retail gallery. Estab. 1979. Represents 40 emerging and mid-career artists. Exhibited artists include John Gary Brown, Louis Copt, Ann Piper. Sponsors 6 shows/year. Average display time 6 weeks. Open all year; Monday-Saturday, 10-6. Located downtown; 3,000 sq. ft.; upstairs in historic building. 50% of space for special exhibitions; 50% of space for gallery artists. Clientele: university and business. 80% private collectors, 20% corporate collectors. Overall price range: $300-2,000; most work sold at $300-1,000.

Media Considers all media and all types of prints (no offset reproductions). Most frequently exhibits watercolor, intaglio and oil.

Style All styles. Genres include landscapes, still life, portraits and figurative work. Prefers landscapes, figurative and architectural subjects.

Terms Accepts work on consignment (50% commission). Retail price set by artist. Sometimes offers payment by installment. Gallery provides promotion; artist pays for shipping costs. Prefers artwork framed.

Submissions Send query letter with résumé, slides, reviews, bio and SASE. Write for appointment to show portfolio of slides. Responds in 2 weeks.

Tips "I look for uniqueness of vision, quality of craftsmanship and realistic pricing. Our gallery specializes in Midwest regionalists with a realistic or naturalistic approach."

KENTUCKY

Ⓝ CAPITOL ARTS ALLIANCE GALLERIES

416 E. Main St., Bowling Green KY 42101. E-mail: Gallery@Capitolarts.com. **Contact:** Gallery Director. Nonprofit gallery. Approached by 30-40 artists/year. Represents 16-20 emerging, mid-career and established artists. Exhibited artists include: C. David Jones (oil paintings). Sponsors 10 exhibits/year. Average display time 3-4 weeks. Open all year; Sunday-Saturday, 9 to 4; closed Christmas-New Years. Located adjacent to and mezzanine of theatre featuring chamber orchestra, community theatre and professional touring production. Clients include local community and tourists.

Media Considers all media except crafts and all types of prints except posters.

Style Considers all styles.

Terms Artwork is accepted on consignment and there is a 20% commission. Retail price set by the artist. Gallery provides promotion and contract. Accepted work should be framed. Accepts only artists within a 100 mile radius.
Submissions "Contact Capitol Arts to be added to 'Call to Artists List.'" Finds artists through submissions and word of mouth.

☷ CENTRAL BANK GALLERY

300 W. Vine St., Lexington KY 40507. (859)253-6161. Fax: (606)253-6069. **Curator:** John Irvin. Nonprofit gallery. Estab. 1985. Interested in seeing the work of emerging artists. Represented more than 1,400 artists in the past 17 years. Exhibited artists include Helen Price Stacy and Catherine Wells. Sponsors 12 shows/year. Average display time 3 weeks. Open all year; Monday-Friday, 9-4:30. Located downtown. 100% of space for special exhibitions. Clientele: local community. 100% private collectors. Overall price range: $100-5,000; most work sold at $350-500.
 ● Central Bank Gallery considers Kentucky artists only.
Media Considers all media. Most frequently exhibits oils, watercolor, sculpture.
Style Exhibits all styles. "Please, no nudes."
Terms Retail price set by the artist "100% of proceeds go to artist." Gallery provides insurance and promotion; artist pays for shipping.
Submissions Call or write for appointment.
Tips "Don't be shy, call me. We pay 100% of the costs involved once the art is delivered."

☷ CHAPMAN FRIEDMAN GALLERY

624 West Main St., Louisville KY 40202. E-mail: friedman@imagesol.com. Website: www.imagesol.com. **Owner:** Julius Friedman. For-profit gallery. Estab. 1992. Approached by 100 or more artists/year. Represents 25 emerging, mid-career and established artists. Exhibited artists include: Steve Cull (painter); John McNaugton (furniture). Sponsors 7 exhibits/year. Average display time 1 month. Open Wednesday-Friday, 10 to 5; weekends 10 to 5; closed August. Located downtown, approx. 3,500 sq. ft. with 15 foot ceilings and white walls. Clients include local community and tourists. 5% of sales are to corporate collectors. Overall price range: $75-10,000; most work sold at $1,000+.
Media Considers all media except craft. Considers prints including engravings, etchings, lithographs, posters, serigraphs and woodcuts. Most frequently exhibits painting, ceramics and photography.
Style Exhibits: color field, geometric abstraction, primitivism realism, painterly abstraction. Most frequently exhibits abstract, primitive and color field.
Terms Artwork is accepted on consignment and there is a 50% commission. Retail price set by the artist. Gallery provides insurance, promotion and contract. Accepted work should be framed. Requires exclusive representation locally.
Submissions Send query letter with artist's statement, bio, brochure, photographs, résumé, SASE and slides. Returns material with SASE. Responds to queries in 1 month. Finds artists through portfolio reviews and referrals by other artists.

☷ KENTUCKY MUSEUM OF ARTS & DESIGN

715 West Main, Louisville KY 40202. Website: www.kentuckyarts.org. **Contact:** Brion Clinkingbeard, deputy director of programming/curator. Nonprofit gallery, museum. Estab. 1981. Approached by 300 artists/year. Represents 100 emerging, mid-career and established artists. Sponsors 20 exhibits/year. Average display time 4-6 weeks. Open all year; Monday-Saturday, 10-5; weekends, 10-4. Located in downtown Louisville, one block from the river; 3 galleries, one on each floor. Clients include local community, students, tourists, upscale. 10% of sales are to corporate collectors. Overall price range: $50-40,000; most work sold at $200.
Media Considers all media and all types of prints. Most frequently exhibits ceramics, glass, craft.
Style Exhibits primitivism realism.
Terms Artwork is accepted on consignment and there is a 50% commission. Retail price set by the artist. Gallery provides insurance, promotion and contract. Accepted work should be framed and matted. Does not require exclusive representation locally.
Submissions Send query letter with artist's statement, bio, photocopies, photographs, SASE and slides. Returns material with SASE. Responds to queries in 1 month. Files bio, artist's statement and copy of images. Finds artists through art fairs, art exhibits, portfolio reviews, referrals by other artists and submissions.
Tips "Clearly identify reason for wanting to work with KMA&D. Show a level of professionalism and a proven track record of exhibitions."

MAIN AND THIRD FLOOR GALLERIES

Northern Kentucky University, Nunn Dr., Highland Heights KY 41099. (859)572-5148. Fax: (859)572-6501. E-mail: knight@nku.edu. Website: www.nku.edu/~art/galleries.html. Gallery Director of Exhibitions and Collec-

tions: David Knight. University galleries. Program established 1975. Main gallery and third floor gallery. Represents emerging, mid-career and established artists. Sponsors 10 shows/year. Average display time 1 month. Open Monday-Friday, 9-9 or by appointment; closed major holidays and between Christmas and New Year's. Located in Highland Heights, KY, 8 miles from downtown Cincinnati; 3,000 sq. ft.; two galleries—one small and one large space with movable walls. 100% of space for special exhibitions. 90% private collectors, 10% corporate collectors. Overall price range; $25-50,000; most work sold at $25-2,000.

Media Considers all media and all types of prints. Most frequently exhibits painting, printmaking and photography.

Style Exhibits all styles, all genres.

Terms Proposals are accepted for exhibition. Retail price set by the artist. Gallery provides insurance, promotion and contract; shipping costs are shared. Prefers artwork framed "but we are flexible." Commission rate is 20%.

Submissions Send query letter with résumé, slides, bio, photographs, SASE and reviews. Write for appointment to show portfolio of originals, photographs and slides. Submissions are accepted in December for following academic school year. Files résumés and bios. Finds artists through agents, visiting exhibitions, word of mouth, art publications, sourcebooks and submissions.

UNIVERSITY ART GALLERIES

Murray State University, 604 Fine Arts Bldg., Murray KY 42071-3342. (270)762-3052. Fax: (502)762-3920. Website: www.murraystate.edu/artgallery. **Director:** Jim Bryant. University gallery. Estab. 1971. Represents emerging, mid-career and established artists. Sponsors 8-15 shows/year. Average display time 6 weeks. Open all year; Monday-Friday, 8-5; Saturday-Sunday, 1-4; closed during university holidays. Located on campus, small town; 4,000 sq. ft.; modern multi-level dramatic space. 100% of space for special exhibitions. Clientele: "10,000 visitors per year."

Media Considers all media and all types of prints.

Style Exhibits all styles.

Terms "We supply the patron's name to the artist for direct sales. We take no commission." Retail price set by the artist. Gallery provides insurance, promotion and shipping costs from gallery. Prefers artwork framed.

Submissions Send query letter with résumé and 10-20 slides. Responds in 1 month.

Tips "Do good work that *expresses* something."

☑ YEISER ART CENTER INC.

200 Broadway, Paducah KY 42001-0732. (270)442-2453. E-mail: yacenter@paducah.com. Website: www.yeiser artcenter.com. **Contact:** Ms. Robin Taffler, executive director. Nonprofit gallery. Estab. 1957. Exhibits emerging, mid-career and established artists. 450 members. Sponsors 8-10 shows/year. Average display time 6-8 weeks. Open all year. Located downtown; 1,800 sq. ft.; "in historic building that was farmer's market." 90% of space for special exhibitions. Clientele: professionals and collectors. 90% private collectors. Overall price range: $200-8,000; most artwork sold at $200-1,000.

Media Considers all media. Prints considered include original handpulled prints, woodcuts, wood engravings, linocuts, mezzotints, etchings, lithographs and serigraphs.

Style Exhibits all styles and genres.

Terms Gallery takes 40% commission on all sales (60/40 split) and expenses are negotiated.

Submissions Send résumé, slides, bio, SASE and reviews. Responds in 3 months.

Tips "Do not call. Give complete information about the work: media, size, date, title, price. Have good-quality slides of work, indicate availability and include artist statement. Presentation of material is important."

☒ ZEPHYR GALLERY

610 E. Market St., Louisville KY 40202. (502)585-5646. **Directors:** Patrick Donley, Peggy Sue Howard. Cooperative gallery and art consultancy with regional expertise. Estab. 1987. Exhibits 18 emerging and mid-career artists. Exhibited artists include C. Radtke, K. Malloy, G. Smith, W. Smith, J.P. Begley, J. Kirstein, S. Howerton Leightty. Sponsors 11 shows/year. Average display time 1 month. Open all year. Located downtown; approximately 1,800 sq. ft. Clientele: 25% private collectors, 75% corporate collectors. Most work sold at $200-2,000.

Media Considers all media. Considers only small edition handpulled print work by the artist. Most frequently exhibits painting, photography and sculpture.

Style Exhibits individual styles.

Terms Co-op membership fee plus donation of time (25% commission). Must live within 50-mile radius of Louisville. Prefers artwork framed. No glass.

Submissions No functional art (jewelry, etc.). Send query letter with résumé and slides. Call for appointment to show portfolio of slides; may request original after slide viewing. Responds in 6 weeks. Files slides, résumés and reviews (if accepted). Submissions accepted on quarterly deadlines of May 20, 2003; August 19, 2003; November 2003 and February 2004 for January 15 and June 15 review.

Tips "Submit well-organized slides with slide list. Include professional résumé with notable exhibitions."

GET 2 FREE ISSUES of THE ARTIST'S MAGAZINE...

And Enjoy a Private Art Lesson!

The Artist's Magazine is your prime source of creative inspiration for all the major artistic disciplines. You get easy-to-understand, step-by-step instruction without having to pay for expensive art lessons!

Every month more than 200,000 fine artists rely on, and trust, *The Artist's Magazine* to bring them tips and techniques from today's hottest international artists. You'll find expert advice on how to:

- Achieve stunning effects in watercolor, oil, acrylic, pastel, gouache, pen and ink, and many other mediums
- Choose and use supplies, and get the most mileage from all your materials
- Keep up to date on current seminars, workshops, competitions and exhibits
- And so much more!

Now, through this special trial offer in *Artist's and Graphic Designer's Market*, you can get 2 FREE ISSUES of *THE ARTIST'S MAGAZINE!*

Return the attached RISK-FREE RSVP card today!

Discover why artists just like you rate *The Artist's Magazine* as the "Most Useful Art Magazine!"

Packed with innovative ideas, creative inspiration, and detailed demonstrations from the best artists in the world, *The Artist's Magazine* brings you everything you need to take your art to the next level. Here's just a sample of what you'll find inside…

- Top artists discuss the benefits of applying various techniques to your art for greater success
- Expert floral painters offer tips on how to set up a stunning floral still life
- Artists from around the globe share ideas on how to choose your subjects
- Special Reports on painting outdoors, using your computer in the studio, colored pencils…and much more!

The Artist's Magazine always gives you easy-to-understand instructions, inspiration to spark your creativity, and advice from the most-trusted artists in the world.

Send for your 2 FREE ISSUES today!

LOUISIANA

⊠ CASELL GALLERY

818 Royal St., New Orleans LA 70116. (800)548-5473. Website: casellartgallery@yahoo.com. Website: www.ge ocities.com/casell_gallery. **Title/Owner-Directors:** Joachim Casell. Retail gallery. Estab. 1970. Represents 20 mid-career artists/year. Exhibited artists include J. Casell and Don Picou. Sponsors 2 shows/year. Average display time 10 weeks. Open all year; 10-6. Located in French Quarter; 800 sq. ft. 25% of space for special exhibitions. Clientele: tourists and local community. 20-40% private collectors, 10% corporate collectors. Overall price range: $100-1,200; most work sold at $300-600.
Media Considers all media, wood engravings, etchings, lithographs, serigraphs and posters. Most frequently exhibits pastel and pen & ink drawings.
Style Exhibits impressionism. All genres including landscapes. Prefers pastels.
Terms Artwork is accepted on consignment (50% commission). Retail price set by the artist. Gallery provides promotion and pays for shipping costs. Prefers artwork unframed.
Submissions Accepts only local area and southern artists. Responds only if interested within 1 week.

CONTEMPORARY ARTS CENTER

900 Camp, New Orleans LA 70130. (504)528-3805. Fax: (504)528-3828. Website: cacno.org. **Curator of Visual Arts:** David S. Rubin. Alternative space, nonprofit gallery. Estab. 1976. Exhibits emerging, mid-career and established artists. Open all year; Tuesday-Sunday, 11-5; weekends 11-5. Closed Mardi Gras, Christmas and New Year's Day. Located in Central Business District of New Orleans; renovated/converted warehouse. Clients include local community, students, tourists and upscale.
Media Considers all media and all types of prints. Most frequently exhibits painting, sculpture, installation and photography.
Style Considers all styles. Exhibits anything contemporary.
Terms Artwork is accepted on loan for curated exhibitions. Retail price set by the artist. CAC provides insurance and promotion. Accepted work should be framed. Does not require exclusive representation locally. The CAC is not a sales venue, but will refer inquiries. CAC receives 20% on items sold as a result of an exhibition.
Submissions Send query letter with bio, SASE and slides or CDs. Responds in 4 months. Files letter and bio— slides when appropriate. Finds artists through word of mouth, submissions, art exhibits, art fairs, referrals by other artists, professional contacts and periodicals.
Tips "Use only one slide sheet with proper labels (title, date, medium and dimensions)."

⊠ STELLA JONES GALLERY

201 St. Charles Ave., New Orleans LA 70170. (504)568-9050. Fax: (504)568-0840.E-mail: jones6941@aol.com. Website: www.stellajones.com. **Contact:** Stella Jones. For-profit gallery. Estab. 1996. Approached by 40 artists/ year. Represents 121 emerging, mid-career and established artists. Exhibited artists include: Elizabeth Catlett (prints and sculpture), Richard Mayhew (paintings). Sponsors 7 exhibits/year. Average display time 6-8 weeks. Open all year; Monday-Friday, 11-6; Saturday, 12-5. Located in downtown New Orleans, one block from French Quarter. Clients include local community, tourists and upscale. 10% of sales are to corporate collectors. Overall price range: $500-150,000; most work sold at $1,000-5,000.
Media Considers all media. Most frequently exhibits oil and acrylic. Considers all types of prints except posters.
Style Considers all styles. Most frequently exhibits postmodernism and geometric abstraction. Exhibits all genres.
Terms Artwork is accepted on consignment and there is a 50% commission. Retail price set by the artist. Gallery provides insurance, promotion and contract. Accepted work should be framed. Requires exclusive representation locally.
Submissions To show portfolio of photographs, slides and transparencies, mail for review. Send query letter with artist's statement, bio, brochure, business card, photocopies, photographs, résumé, reviews, SASE and slides. Returns material with SASE. Responds in 1 month. Files all. Finds artists through word of mouth, submissions, portfolio reviews, art exhibits, and referrals by other artists.
Tips "Send organized, good visuals."

STONE AND PRESS GALLERIES

238 Chartres St., New Orleans LA 70130. (504)561-8555. Fax: (504)561-5814. E-mail: info@stoneandpress.com. Website: www.stoneandpress.com. **Owner:** Earl Retif. Retail gallery. Estab. 1988. Represents/exhibits 20 mid-career and established artists/year. Interested in seeing the work of emerging artists. Exhibited artists include Carol Wax and Benton Spruance. Sponsors 9 shows/year. Average display time 1 month. Open all year; Monday-Saturday, 10:30-5:30. Located in historic French Quarter; 1,200 sq. ft.; in historic buildings. 50% of space for special exhibitions; 50% of space for gallery artists. Clientele: collectors nationwide also tourists. 90% private

collectors, 10% corporate collectors. Overall price range: $50-10,000; most work sold at $400-900.

Media Considers all drawing, pastel and all types of prints. Most frequently exhibits mezzotint, etchings and lithograph.

Style Exhibits realism. Genres include Americana, portraits and figurative work. Prefers American scene of '30s and '40s and contemporary mezzotint.

Terms Artwork is accepted on consignment (50% commission). Retail price set by the gallery and the artist. Gallery provides insurance, promotion and contract; shipping costs are shared. Prefers artwork unframed.

Submissions Send query letter with résumé, slides and SASE. Write for appointment to show portfolio of photographs. Responds in 3 weeks.

Tips Finds artists through word of mouth and referrals of other artists.

MAINE

GOLD/SMITH GALLERY

41 Commercial St., BoothBay Harbor ME 04538. (207)633-6252. Director: Karen Swartsberg. Retail gallery. Estab. 1974. Represents 30 emerging, mid-career and established artists. Exhibited artists include John Vander and John Wissemann. Sponsors 6 shows/year. Average display time 6 weeks. Open May-December; Monday-Saturday, 10-6; Sunday, 12-5. Located downtown across from the harbor. 1,500 sq. ft.; traditional 19th century house converted to contemporary gallery. 75% of space for special exhibitions; 25% of space for gallery artists. Clientele: residents and visitors. 90% private collectors, 10% corporate collectors. Overall price range: $350-5,000; most work sold at $350-1,500.

- One of 2 Gold/Smith Galleries. The other is in Sugar Loaf; the 2 are not affiliated with each other. Artists creating traditional and representational work should try another gallery. The work shown here is strong, self-assured and abstract.

Media Considers oil, acrylic, watercolor, pastel, pen & ink, drawing, mixed media, collage, paper, sculpture, photography, woodcuts, engravings, lithographs, wood engravings, mezzotints, serigraphs, linocuts and etchings. Most frequently exhibits acrylic and watercolor.

Style Exhibits expressionism, painterly abstraction "emphasis on nontraditional work." Prefers expressionist and abstract landscape.

Terms Commission negotiated. Retail price set by the artist. Gallery provides insurance and promotion; artist pays shipping costs to and from gallery. Prefers artwork framed.

Submissions No restrictions—emphasis on artists from Maine. Send query letter with slides, bio, photographs, SASE, reviews and retail price. Write for appointment to show portfolio of originals. Responds in 2 weeks. Artist should write the gallery.

Tips "Present a consistent body of mature work. We need 12 to 20 works of moderate size. The sureness of the hand and the maturity interest of the vision are most important."

GREENHUT GALLERIES

146 Middle St., Portland ME 04101. (207)772-2693. E-mail: greenhut@maine.com. Website: www.greenhutgalle ries.com. **Contact:** Peggy Greenhut Golden. Retail gallery. Estab. 1990. Represents/exhibits 20 emerging and mid-career artists/year. Sponsors 12 shows/year. Exhibited artists include: Connie Hayes (oil/canvas), Sarah Knock (oil/canvas). Average display time 3 weeks. Open all year; Monday-Friday, 10-5:30; Saturday, 10-5. Located in downtown-Old Port; 3,000 sq. ft. with neon accents in interior space. 60% of space for special exhibitions. Clientele: tourists and upscale. 55% private collectors, 10% corporate collectors. Overall price range: $500-12,000; most work sold at $600-3,000.

Media Considers acrylic, paper, pastel, sculpture, drawing, oil, watercolor. Most frequently exhibits oil, watercolor, pastel.

Style Considers all styles; etchings, lithographs, mezzotints. Genres include figurative work, landscapes, still life, seascape. Prefers landscape, seascape and abstract.

Terms Artwork is accepted on consignment (50% commission). Retail price set by the gallery and artist. Gallery provides insurance and promotion. Artists pays for shipping costs. Prefers artwork framed (museum quality framing).

Submissions Accepts only artists from Maine or New England area with Maine connection. Send query letter with slides, reviews, bio and SASE. Call for appointment to show portfolio of slides. Responds in 1 month. Finds artists through word of mouth, referrals by other artists, visiting art shows and exhibitions, and submissions.

Tips "Visit the gallery and see if you feel your work fits in."

JAMESON GALLERY & FRAME AND THE JAMESON ESTATE COLLECTION

(formerly Jameson Gallery & Frame), 305 Commercial St., Portland ME 04101. (207)772-5522. Fax: (207)774-7648. E-mail: info@jamesongallery.com. **Gallery Director:** Michael Rancourt. Retail gallery, custom framing,

restoration, appraisals, consultation. Estab. 1992. Represents 20 emerging, mid-career and established artists/year. Exhibited artists include Tillman Crane, Vincent Vallarino, Alicia Czechowski and Nathaniel Larrabee. Sponsors 6 shows/year. Average display time 3-4 weeks. Open all year; Monday-Saturday, 10-6; Holiday season Monday-Sunday, 10-6. Located on the waterfront in the heart of the shopping district; 4,000 sq. ft. 50% of space for contemporary artists; 25% of space for frame shop; 25% of space for The Jameson Estate Collection dealing later 19th and early 20th century paintings, drawings and photographs. Clientele: local community, tourists, upscale. 80% private collectors, 20% corporate collectors. Overall price range: most work sold at $1,500-30,000.
Media Most frequently exhibits oil, watercolor, photographs, sculpture and fine woodworking.
Style Exhibits: strong focus on American realism and b&w photography, but all media are considered. Genres include landscapes, figures and still life.
Terms Negotiable. Retail price set by the gallery. Gallery provides insurance, promotion and contract; artist pays for shipping costs. Prefers artwork unframed, but will judge on a case by case basis. Artist may buy framing contract with gallery.
Submissions Send CV and artist's statement, a sampling of images on a PC-compatible CD, zip of floppy disc and SASE if you would like the materials returned.

THE LIBRARY ART STUDIO
1467 Rt. 32 at Munro Brook, Round Pond ME 04564. (207)529-4210. **Contact:** Sally DeLorme Pedrick, owner/director. Art consultancy and gallery. Estab. 1989. Exhibits established artists. Number of exhibits varies each year. Average display time 6 weeks. Open year round by appointment or chance. Located in a small coastal village (Round Pond) on the Pemaquid Peninsula, midcoast Maine. Clients include local community, tourists and upscale. Overall price range: $50-7,500; most work sold at $350.
Media Considers all media. Most frequently exhibits oil, woodcuts, and mixed media with glass.
Style Considers all styles. Most frequently exhibits painterly abstraction, expressionism, conceptualism. "Most art is associated with literature, thus *The Library Art Studio*."
Terms Artwork is accepted on consignment and there is a 30% commission. Retail price set by the artist. Gallery provides promotion. Accepted work should be framed. Does not require exclusive representation locally.
Submissions Send query letter with SASE and slides. Returns material with SASE. Responds in 1 month.

MATHIAS FINE ART
10 Mathias Dr., Trevett ME 04571. (207)633-7404. **President:** Cordula Mathias. For profit gallery. Estab. 1992. Approached by 20-30 artists/year. Represents 15-20 emerging, mid-career and established artists. Exhibited artists include: Brenda Bettinson and Mike Culver. Sponsors 6 exhibits/year. Average display time 2 months. Open all year; Wednesday-Sunday, 12-5; and by appointment. Mid-November through mid-May: by appointment only. Located in Mid-Coast area of Maine; 400 sq. ft. combination of natural and artificial lighting. Clients include local community, tourists and upscale. Percentage of sales to corporate collectors varies. Overall price range: $50-25,000; most work sold at $1,200.
Media Considers acrylic, collage, drawing, original prints, mixed media, oil, paper and pen & ink. Most frequently exhibits painting, drawing and photography. Considers all types of prints except posters.
Style Considers all styles and genres.
Terms Artwork is accepted on consignment and there is a 50% commission. Retail price set by the gallery and the artist. Gallery provides promotion and contract. Accepted work should be framed and matted. Requires exclusive representation locally. Prefers paintings or works on paper. Prefers artists who can deliver and pick up.
Submissions Send query letter with bio, photographs, résumé, reviews, SASE and slides. Returns material with SASE. Responds in 6 weeks. Files CV, artist's statement, visuals if of interest within 6-18 months. Finds artists through word of mouth, submissions, portfolio reviews, art exhibits, and referrals by other artists.
Tips "Clearly labeled slides or photographs, well organized vita, informative artist's statement. Archival-quality materials are 100% essential in selling fine art to collectors."

STEIN GALLERY CONTEMPORARY GLASS
195 Middle St., Portland ME 04101. (207)772-9072. E-mail: astein@steinglass.com. Website: www.steinglass.com. Contact: Anne Stein. Retail gallery. Represents 100 emerging, mid-career and established artists. Open all year. Located in "old port" area. 100% of space for gallery artists.
Media Considers glass and jewelry.
Terms Retail price set by the artist. Gallery provides insurance and promotion.
Submissions Send query letter with résumé and slides.

N UNION RIVER GALLERY
17 School St., Ellsworth ME 04605. (207)667-7700. E-mail: urg@midmaine.com. Website: www.maineartgallery.com. Owner: Tammie Anderson. Manager: Cathy Brann. Retail gallery. Estab. 1995. Represents 30 emerging,

mid-career and established artists. Exhibited artists include Terrell Lester and Consuelo Hanks. Open all year; Monday-Friday, 9:30-5; Saturday, 10-3. Located downtown; 1,000 sq. ft.; high ceilings, attractive old building. Clientele: tourists, upscale, summer residents and locals.

Terms Prefers artwork to be of Maine subject or content. Prefers artwork unframed. Gallery provides insurance. Price set by artist. Gallery receives 40% commission. Artist pays for shipping costs.

Submissions Send query letter with résumé, slides or photographs. Write for appointment to show portfolio of photographs or slides. Responds in 2 weeks. Files résumé, slides and articles. Finds artists through artist's submissions and word of mouth.

N: UNIVERSITY OF MAINE MUSEUM OF ART

40 Harlow St., Bangor ME 04401-5102. (207)561-3350. Fax: (207)561-3351. E-mail: umma@umit.maine.edu. Website: www.umma.umaine.edu. The Museum of Art hosts an annual calendar of exhibitions and programs featuring contemporary artists and ideas in a variety of traditional and non-traditional media, as well as exhibitions organized from the permanent collection. The permanent collection has grown to over 6,000 works of art. Included in the collection are works by artists such as Richard Estes, Ralph Blakelock, Georges Braque, Mary Cassatt, Honore Daumier, George Inness, Diego Rivera, Pablo Picasso and Giovanni Battista Piranesi. In addition, each year the Museum organizes The Vincent Hartgen Traveling Exhibition Program: Museums by Mail, a statewide effort that circulates more than 50 exhibitions, drawn from the permanent collection. This program reaches hundreds of institutions such as schools, libraries, town halls and hospitals throughout the state.

Media Considers all media and all types of prints.

Style Exhibits all styles and genres.

Terms Gallery provides insurance and promotion; shipping costs are shared. Prefers artwork framed.

Submissions Send query letter with résumé, slides, bio and reviews. Write for appointment to show portfolio of originals and slides. Responds in 1 month. Files bio, slides, if requested, and résumé.

MARYLAND

ARTEMIS, INC.

4715 Crescent St., Bethesda MD 20816. (301)229-2058. Fax: (301)229-2186. E-mail: sjtropper@aol.com. **Owner:** Sandra Tropper. Retail and wholesale dealership and art consultancy. Represents more than 100 emerging and mid-career artists. Does not sponsor specific shows. Clientele: 40% private collectors, 60% corporate clients. Overall price range: $100-10,000; most artwork sold at $1,000-3,000.

Media Considers oil, acrylic, watercolor, mixed media, collage, works on paper, sculpture, ceramic, craft, fiber, glass, installations, woodcuts, engravings, mezzotints, etchings, lithographs, pochoir, serigraphs and offset reproductions. Most frequently exhibits prints, contemporary canvases and paper/collage.

Style Exhibits impressionism, expressionism, realism, minimalism, color field, painterly abstraction, conceptualism and imagism. Genres include landscapes, florals and figurative work. "My goal is to bring together clients (buyers) with artwork they appreciate and can afford. For this reason I am interested in working with many, many artists." Interested in seeing works with a "finished" quality.

Terms Accepts work on consignment (50% commission). Retail price set by dealer and artist. Exclusive area representation not required. Gallery provides insurance and contract; shipping costs are shared. Prefers unframed artwork.

Submissions Send query letter with résumé, slides, photographs and SASE. Write to schedule an appointment to show a portfolio, which should include originals, slides, transparencies and photographs. Indicate net and retail prices. Responds only if interested within 1 month. Files slides, photos, résumés and promo material. All material is returned if not accepted or under consideration.

Tips "Many artists have overestimated the value of their work. Look at your competition's prices."

THE FRASER GALLERY

7700 Wisconsin Ave., Suite E, Bethesda MD 20814. (301)718-9651. Fax: (301)718-9652. E-mail: frasergallery@h otmail.com. Website: www.thefrasergallery.com. **Contact:** Catriona Fraser, director. For-profit gallery. Estab. 1996. Approached by 400 artists/year; represents 25 emerging, mid-career and established artists/year and sells the work of another 100 artists. Exhibited artists include Joyce Tenneson (figurative photography) and David FeBland (oil painting). Average display time 1 month. Open all year; Tuesday-Saturday, 12-6. Located in the center of Bethesda in courtyard next to Discovery Channel HQ. 1,680 square feet. Clients include local community, internet browsers, tourists and upscale. Overall price range: $200-25,000; most work sold at under $5,000.

• The Fraser Gallery is charter associate dealer for Southebys.com and member of Art Dealers Association of Greater Washington and Bethesda Chamber of Commerce. See their listing in the Washington D.C. section for their submission requirements.

THE GLASS GALLERY

ongoing display at 4720 Hampden Lane, Bethesda MD 20814. (301)657-3478. **Owner:** Sally Hansen. Retail gallery. Estab. 1981. Sponsors 5 shows/year. Open all year; Monday-Saturday 11-5. Clientele: collectors.

Media Considers sculpture in glass and monoprints (only if they are by glass sculptors who are represented by The Glass Gallery). Also interested in sculpture in glass incorporated with additional materials (bronze, steel etc.). "Focus is on creativity as well as on ability to handle the material well. The individuality of the artist must be evident."

Terms Accepts work on consignment. Retail price set by artist. Sometimes offers customer discounts and payment by installment. Gallery provides insurance (while work is in gallery), promotion, contract and shipping costs from gallery.

Submissions Send query letter with résumé, slides, photographs, reviews, bio and SASE. Portfolio review requested if interested in artist's work.

Tips Finds artists through visits to exhibitions and professional glass conferences, plus artists' submissions and keeping up-to-date with promotion of other galleries (show announcements and advertising). "Send good slides with SASE and clear, concise cover letter and/or description of process. Familiarize yourself with the work of gallery displays to evaluate whether the quality of your work meets the standard."

MARIN-PRICE GALLERIES

7022 Wisconsin Ave., Chevy Chase MD 20815. (301)718-0622. E-mail: fmp@marin-price.com. Website: www.m arin-pricegalleries.com. **President:** F.J. Marin-Price. Retail/wholesale gallery. Estab. 1992. Represents/exhibits 25 established painters and 4 sculptors/year. Exhibited artists include Joseph Sheppard. Sponsors 24 shows/year. Average display time 3 weeks. Open Monday-Sunday, 11-8. 1,500 sq. ft. 50% of space for special exhibitions. Clientele: upscale. 90% private collectors, 10% corporate collectors. Overall price range: $3,000-25,000; most work sold at 6,000-12,000.

Media Considers oil, drawing, watercolor and pastel. Most frequently exhibits oil, watercolor and pastels.

Style Exhibits expressionism, photorealism, neo-expressionism, primitivism, realism and impressionism. Genres include landscapes, florals, Americana and figurative work.

Terms Retail price set by the gallery and the artist. Gallery provides insurance, promotion and contract. Artist pays for shipping costs. Prefers artwork framed.

Submissions Prefers only oils. Send query letter with résumé, slides, bio and SASE. Responds in 6 weeks.

[N] MONTPELIER CULTURAL ARTS CENTER

12826 Laurel-Bowie Rd., Laurel MD 20708. (301)953-1993. Fax: (301)206-9682. E-mail: montpelierarts@pgpark s.com. Website: www.pgparks.com. **Director:** Richard Zandler. Alternative space, nonprofit gallery, public arts center. Estab. 1979. Exhibits 1,000 emerging, mid-career, established artists/year. Sponsors 24 shows/year. Average display time 1 month. Open all year; 7 days/week, 10-5. Located midway between Baltimore and Washington on 80 acre estate; 2,500 sq. ft. (3 galleries): cathedral ceilings up to 32'. 85% of space for special exhibitions; 15% of space for gallery artists. Clientele: diverse, general public. Overall price range: $50-50,000; most work sold at $200-300.

Media Considers oil, pen & ink, paper, fiber, acrylic, drawing, sculpture, glass, watercolor, mixed media, ceramic, installation, pastel, collage, craft, photography, media arts, performance and mail art. Also considers all types of prints.

Style Exhibits all styles and genres.

Terms Special exhibitions only. 25% commission on sales during show. Retail price set by artist. Offers customer discount (seniors and members). Gallery provides insurance, promotion, contract and shipping costs from gallery. Prefers artwork framed.

Submissions "Different shows target different media, theme and region. Call first to understand programs." Send résumé, slides and SASE. Responds only if interested within 8 months. Files résumés and cover letters. Slides are returned. Finds artists through recommendations and artists' submissions.

Tips "Focuses on Maryland artists. Offers many juried apportunities."

[N] PYRAMID ATLANTIC

8230 Georgia Ave., Silver Spring MD 20910. (301)608-9101 or (301)608-9102. E-mail: info@pyramid-atlantic.o rg. Website: www.pyramidatlanticartcenter.org. **Artistic Director:** Helen Frederick. Nonprofit gallery/library. Estab. 1981. Represents emerging, mid-career and established artists. Sponsors 6 shows/year. Average display time 2 months. Open all year; 10-6. 15% of space for special exhibitions; 10% of space for gallery artists. Also features research library. Clientele: print and book collectors, general audiences. Overall price range: $1,000-10,000; most work sold at $800-2,500.

Media Considers watercolor, pastel, pen & ink, drawing, mixed media, collage, paper, sculpture, craft, installation, photography, artists' books and all types of prints. Most frequently exhibits works in and on paper, prints

and artists' books and mixed media by faculty who teach at the facility and members of related programs.

Style Exhibits all styles and genres.

Terms Accepts work on consignment (50-60% commission). Print subscription series produced by Pyramid; offers 50% to artists. Retail prices set by gallery and artist. Gallery provides insurance, promotion and contract; shipping costs are shared.

Submissions Send query letter with résumé, slides, bio, brochure, SASE and reviews. Call or write for an appointment to show portfolio, which should include originals and slides. Responds in 1 month. Files résumés.

N RESURGAM GALLERY

910 S. Charles St., Baltimore MD 21230. (410)962-0513. **Office Manager:** P. Randall Whitlock. Cooperative gallery. Estab. 1990. Represents 34 emerging, mid-career and established artists/year. 34 members. Exhibited artists include Ruth Pettus and Beth Wittenberg. Sponsors 14 shows/year. Average display time 3 weeks. Open all year; Wednesday-Saturday, noon-6; closed in August. Located downtown; 600 sq. ft.; in Baltimore's historic Federal Hill district. 100% of space for gallery artists. Clientele: urban professionals. 100% private collectors. Overall price range: $100-1,800; most work sold at $200-800.

Media Considers oil, acrylic, watercolor, pastel, pen & ink, drawing, mixed media, collage, paper, sculpture, ceramics, craft, fiber, glass, photography and all types of prints. Most frequently exhibits painting, sculpture (mid-sized) and fine crafts.

Style Exhibits all styles, all genres.

Terms Co-op membership fee plus donation of time. Retail prices set by the artist. Gallery provides insurance. "Artists are responsible for their own promotion." Artist pays shipping costs to and from gallery. Prefers artwork framed.

Submissions "Artists must be available to sit in gallery—or pay a sitter—five days each year." Memberships for calendar year decided in June. Rolling-basis jurying throughout the year. Send query letter with SASE to receive application form. Portfolio should include slides.

ROMBRO'S ART GALLERY

1805 St. Paul St., Baltimore MD 21202. (301)962-0451. Retail gallery, rental gallery. Estab. 1984. Represents 3 emerging, mid-career and established artists/year. May be interested in seeing the work of emerging artists in the future. Exhibited artists include Dwight Whitley and Judy Wolpert. Sponsors 4 shows/year. Average display time 3 months. Open all year; Tuesday-Saturday, 9-5; closed August. Located in downtown Baltimore; 3,500 sq. ft. Clientele: upscale, local community. Overall price range: $350-15,000.

Media Considers oil, acrylic, watercolor, pastel, pen & ink, drawing, mixed media, collage, paper, sculpture and ceramics. Considers all types of prints. Most frequently exhibits oil, pen & ink, lithographs.

Style Exhibits expressionism, painterly abstraction, color field, postmodern works, hard-edge geometric abstraction. Genres include florals and figurative work. Prefers florals and figurative.

Terms Accepts work on consignment (50% commission) or buys outright for 35% of the retail price; net 45 days. Rental fee for space ($650). Retail price set by the gallery and the artist. Gallery provides promotion and contract; artist pays for shipping costs to gallery. Prefers artwork framed.

Submissions Send query letter with résumé, brochure, slides and artist's statement. Write for appointment to show portfolio of slides. Files slides. Finds artists through visiting exhibitions.

STEVEN SCOTT GALLERY

9169 Reisterstown Rd., Owings Mill MD 21117. (410)752-6218. Website: www.stevenscottgallery.com. **Director:** Steven Scott. Retail gallery. Estab. 1988. Represents 20 mid-career and established artists/year. May be interested in seeing the work of emerging artists in the future. Exhibited artists include Hollis Sigler, Gary Bukovnik. Sponsors 6 shows/year. Average display time 2 months. Open all year; Tuesday-Saturday, 12-6. Located in the suburbs of NW Baltimore; 1,000 sq. ft.; white walls, grey carpet—minimal decor. 80% of space for special exhibitions; 20% of space for gallery artists. 80% private collectors, 20% corporate collectors. Overall price range: $300-15,000; most work sold at $1,000-7,500.

Media Considers oil, acrylic, watercolor, pastel, pen & ink, drawing, mixed media, collage, paper and photography. Considers all types of prints. Most frequently exhibits oil, prints and drawings.

Style Exhibits expressionism, neo-expressionism, surrealism, postmodern works, photorealism, realism and imagism. Genres include florals, landscapes and figurative work. Prefers florals, landscapes and figurative.

Terms Retail price set by the gallery and the artist. Gallery provides insurance, promotion and contract; shipping costs are shared. Prefers artwork unframed.

Submissions Accepts only artists from US. Send query letter with résumé, brochure, slides, photographs, reviews, bio and SASE. Call for appointment to show portfolio of photographs and slides. Responds in 2 weeks.

Tips "Don't send slides which are unlike the work we show in the gallery, i.e. abstract or minimal."

☑ ✦ VILLA JULIE COLLEGE GALLERY

1525 Green Spring Valley Rd., Stevenson MD 21153. (443)334-2163. Fax: (410)486-3552. E-mail: dea-dian@mail .vjc.edu. Website: www.vjc.edu. **Contact:** Diane DiSalvo. College/university gallery. Estab. 1997. Approached by many artists/year. Represents numerous emerging, mid-career and established artists. Sponsors 14 exhibits/ year. Average display time 8 weeks. Open all year; Monday-Tuesday and Thursday-Friday, 11-5; Wednesday, 11-8; Saturday, 1-4. Located in the Greenspring Valley 5 miles north of downtown Baltimore; beautiful space in renovated academic center and student center. "We do not take commission; if someone is interested in an artwork we send them directly to the artist."

Media Considers all media and all types of prints except posters. Most frequently exhibits painting, sculpture, photography and works on paper.

Style Considers all styles and genres.

Terms Artwork is accepted on consignment and there is no commission. Retail price set by the artist. Gallery provides insurance. Does not require exclusive representation locally. Has emphasis on mid-Atlantic regional artists but does not set geographic limitations.

Submissions Write to arrange a personal interview to show portfolio of slides. Send query letter with artist's statement, bio, résumé, reviews, SASE and slides. Returns material with SASE. Responds in 3 months. Files bio, statement, reviews, letter but will return slides. Finds artists through word of mouth, submissions, portfolio reviews, art exhibits, and referrals by other artists.

Tips "Be clear and concise, and have good slides."

☑ WASHINGTON COUNTY MUSEUM OF FINE ARTS

91 Key St., P.O. Box 423, Hagerstown MD 21741. (301)739-5727. Fax: (301)745-3741. E-mail: WCMFA@myactv. net. Website: www.washcomuseum.org. **Curator:** Amy Hunt. Museum. Estab. 1929. Approached by 30 established artists/year. Open all year; Tuesday-Saturday, 10-5; Sunday, 1-5. Closed holidays. Located in western Maryland; facility includes 12 galleries. Overall price range: $300-1,500; most work sold at $800-900.

Media Considers all media except installation and craft. Most frequently exhibits oil, watercolor and ceramics. Considers all types of prints except posters.

Style Exhibits: impressionism. Genres include florals, landscapes, portraits and wildlife.

Terms Sales from exhibits only—30% commission. Retail price set by the artist. Gallery provides insurance. Accepted work should be framed. Does not require exclusive representation locally.

Submissions Write to arrange a personal interview to show portfolio of photographs and slides. Mail portfolio for review. Returns material with SASE. Responds in 1 month. Finds artists through word of mouth, portfolio reviews, art exhibits, and referrals by other artists.

MASSACHUSETTS

BROMFIELD ART GALLERY

450 Harrison Ave., Boston MA 02118. (617)451-3605. E-mail: bromfieldartgallery@earthlink.net. Website: www .bromfieldartgallery.com. **Contact:** Laurie Alpert, director of exhibitions. Gallery Director: Gary Duehr. Cooperative gallery. Estab. 1974. Represents 18 emerging and mid-career artists. Exhibited artists include Florence Yoshiko Montgomery, Adam Sherman, George Hancin and Tim Nichols. Sponsors 25 shows/year. Average display time 1 month. Open all year; Wednesday-Saturday 12-5. Located in South End. 50% of space for special exhibitions; 50% of space for gallery artists. Clientele: 70% private collectors, 30% corporate collectors. Overall price range: $300-6,000; most work sold at $300-2,000.

• Broomfield Art Gallery is Boston's oldest artist-run gallery.

Media Considers all media and original handpulled prints. Most frequently exhibits paintings, prints, sculpture.

Style Exhibits all styles and genres.

Terms Co-op membership fee plus donation of time (gallery charges 40% commission for members, 50% for visiting artists). Retail price set by artist. Offers customer discounts and payment by installments. Gallery provides promotion and contract; artist pays for shipping costs.

Submissions Send query letter with résumé, slides and SASE. Write for appointment to show portfolio of originals. Responds in 1 month. Files all info on members and visiting artists. Finds artists through word of mouth, various art publications and sourcebooks, submissions/self-promotions and referrals.

Ⓝ BRUSH ART GALLERY

256 Market St., Lowell MA 01852. (978)459-7819. E-mail: information@thebrush.org. Website: www.thebrush. org. **Contact:** E. Linda Poras. Estab. 1982. Represents 13 mid-career and established artists. May be interested in seeing the work of emerging artists in the future. Sponsors 6 shows/year. Average display time 2 months. Open all year; Tuesday-Sunday, 11-5. Located in National Park Complex; 2,000 sq. ft.; old, restored mill building.

35% of space for special exhibitions; 65% of space for gallery artists. Clientele: tourists, local community. Overall price range: $25-2,500; most work sold at $50-1,000.

Media Considers oil, acrylic, watercolor, pastel, pen & ink, mixed media, collage, paper, ceramics, fiber, glass, photography, woodcuts and serigraphs. Most frequently exhibits watercolor, glass and fiber.

Style Exhibits all styles. Genres include florals, portraits, landscapes, figurative work. Prefers landscapes, florals, figures.

Terms Accepts work on consignment (40% commission). Rental fee for space; covers 1 year. Retail price set by the artist. Gallery provides insurance, promotion and contract. Gallery pays for shipping from gallery. Artist pays shipping to gallery.

Submissions Send query letter with résumé, slides and SASE. Call for appointment to show portfolio of photographs. Responds in 1 month. Files résumé and slides.

☑ CHASE GALLERY

129 Newbury St., Boston MA 02116-0292. (617)859-7222. Website: www.chasegallery.com. **Director:** Stephanie L. Walker. Retail gallery. Estab. 1990. Represents 20 mid-career and established artists/year. Exhibited artists include Enrique Santana, Cynthia Packard. Sponsors 11 shows/year. Average display time 1 month. Open all year; Monday-Saturday, 10-6. 1,400 sq. ft. 80% of space for special exhibitions; 20% of space for gallery artists. 95% private collectors, 5% corporate collectors. Overall price range: $500-25,000; most work sold at $2,000-10,000.

Media Considers oil, acrylic and sculpture. Most frequently exhibits oil paintings, alkyd, acrylic.

Style Exhibits narrative/representational. Genres include landscapes and figurative work.

Terms Accepts work on consignment (50% commission). Retail price set by the artist. Gallery provides insurance and promotion; artist pays shipping costs. Prefers artwork framed.

Submissions Prefers only oil, acrylic, alkyd. Send query letter with résumé, brochure, slides, reviews and SASE. Responds in 1 month. Files cards; "SASE should be provided for return of materials." Finds artists through referrals, submissions.

Tips "Don't send one or two images—20 slides of recent work should be submitted."

☷ GALLERY NAGA

67 Newbury St., Boston MA 02116. (617)267-9060. Fax: (617)267-9040. E-mail: mail@gallerynaga.com. Website: www.gallerynaga.com. **Director:** Arthur Dion. Retail gallery. Estab. 1977. Represents 30 emerging, mid-career and established artists. Exhibited artists include Robert Ferrandini and George Nick. Sponsors 9 shows/year. Average display time 1 month. Open Tuesday-Saturday 10-5:30. Closed August. Located on "the primary street for Boston galleries; 1,500 sq. ft.; housed in an historic neo-gothic church." Clientele: 90% private collectors, 10% corporate collectors. Overall price range: $500-40,000; most work sold at $2,000-10,000.

Media Considers oil, acrylic, mixed media, sculpture, photography, studio furniture and monotypes. Most frequently exhibits painting and furniture.

Style Exhibits expressionism, painterly abstraction, postmodern works and realism. Genres include landscapes, portraits and figurative work. Prefers expressionism, painterly abstraction and realism.

Terms Accepts work on consignment (50% commission). Retail price set by gallery and artist. Gallery provides insurance and promotion; artist pays for shipping. Prefers artwork framed.

Submissions "Not seeking submissions of new work at this time."

Tips "We focus on Boston and New England artists. We exhibit the most significant studio furnituremakers in the country. Become familiar with any gallery to see if your work is appropriate before you make contact."

☑ KAJI ASO STUDIO/GALLERY NATURE AND TEMPTATION

40 St. Stephen St., Boston MA 02115. (617)247-1719. Fax: (617)247-7564. E-mail: mail@gallerynaga.com. Website: www.gallerynaga.com. **Administrator:** Kate Finnegan. Nonprofit gallery. Estab. 1975. Represents 40-50 emerging, mid-career and established artists. 35-45 members. Exhibited artists include Kaji Aso and Katie Sloss. Sponsors 10 shows/year. Average display time 3 weeks. Open all year by appointment. Located in city's cultural area (near Symphony Hall and Museum of Fine Arts); "intimate and friendly." 30% of space for special exhibitions; 70% of space for gallery artists. Clientele: urban professionals and fellow artists. 80% private collectors, 20% corporate collectors. Overall price range: $150-8,000; most work sold at $150-1,000.

Media Considers oil, acrylic, watercolor, pastel, pen & ink, drawing, ceramics and etchings. Most frequently exhibits watercolor, oil or acrylic and ceramics.

Style Exhibits painterly abstraction, impressionism and realism.

Terms Co-op membership fee plus donation of time (35% commission). Retail price set by the artist. Gallery provides promotion; artist pays shipping costs to and from gallery. Prefers artwork framed.

Submissions Send query letter with résumé, slides, bio, photographs and SASE. Write for appointment to show

portfolio of originals, photographs, slides or transparencies. Does not reply; artist should contact. Files résumé. Finds artists through advertisements in art publications, word of mouth, submissions.

MICHIGAN

THE ANN ARBOR CENTER/GALLERY SHOP
117 W. Liberty, Ann Arbor MI 48104. (734)994-8004. Fax: (734)994-3610. E-mail: info@annarborartcenter.org. Website: www.annarborartcenter.org. **Gallery Shop Director:** Millie Rae Webster. Gallery Shop Assistant Directors: Ana Evora, Cindy Marr. Estab. 1978. Represents over 350 artists, primarily Michigan and regional. Gallery Shop purchases support the Art Center's community outreach programs.
- The Ann Arbor Art Center also has exhibition opportunities for Michigan artists in its Exhibition Gallery and Art Consulting Program.

Media Considers original work in virtually all 2- and 3-dimensional media, including jewelry, prints and etchings, ceramics, glass, fiber, wood, photography and painting.

Style "The gallery specializes in well-crafted and accessible artwork. Many different styles are represented, including innovative contemporary."

Terms Accepts work on consignment. Retail price set by artist. Offers member discounts and payment by installments. Exclusive area representation not required. Gallery provides contract; artist pays for shipping.

Submissions "The Art Center seeks out artists through the exhibition visitation, wholesale and retail craft shows, networking with graduate and undergraduate schools, word of mouth, in addition to artist referral and submissions."

ARTS EXTENDED GALLERY, INC.
2966 Woodward Ave., The Art Bldg., Detroit MI 48201. (313)831-0321. Fax: (313)831-0415. **Director:** Dr. C.C. Taylor. Retail, nonprofit gallery, educational 501C3 space art consultancy and appraisals. Estab. 1959. Represents/exhibits many emerging, mid-career and established artists. Exhibited artists include: Michael Kelly Williams, Samuel Hodge, Marie-Helene Cauvin and Charles McGee. Sponsors 6 shows/year. Average display time 8-10 weeks. Open all year; Wednesday-Saturday, 11-5. Located near Wayne State University; 1,000 sq. ft. Clients include tourists, upscale, local community. 80% of sales are to private collectors, 20% corporate collectors. Overall price range: $150-4,000 up; most work sold at $200-500 (for paintings—craft items are considerably less).
- Gallery also sponsors art classes and exhibits outstanding work produced there.

Media Considers all media, woodcuts, engravings, linocuts, etchings and monoprints. Most frequently exhibits painting, fibers, photographs and antique African art.

Style "The work which comes out of the community we serve is varied but rooted in realism, ethnic symbols and traditional designs/patterns with some exceptions."

Terms Artwork is accepted on consignment, and there is a 45% commission, or artwork is bought outright for 55% of the retail price. Retail price set by the gallery and the artist. Gallery provides insurance, promotion and contract; shipping costs are shared. Prefers artwork framed or ready to install.

Submissions Send query letter with résumé, slides, photographs and reviews. Call for appointment to show a portfolio of photographs, slides and bio. Responds in 3 weeks. Files biographical materials sent with announcements, catalogs, résumés, visual materials to add to knowledge of local artists, letters, etc.

Tips "Our work of recruiting local artists is known, and consequently artists beginning to exhibit or seeking to expand are sent to us. Many are sent by relatives and friends who believe that ours would be a logical place to inquire. Study sound technique—there is no easy way or scheme to be successful. Work up to a standard of good craftsmanship and honest vision. Come prepared to show a group of artifacts. Have clearly in mind a willingness to part with work and understand that market moves fairly slowly."

⊠ ARTS MIDLAND: GALLERIES & SCHOOL
of the Midland Center for the Arts, 1801 W. St. Andrews, Midland MI 48640. (269)631-3250. **Director:** B.B. Winslow. Nonprofit visual art gallery and school. Estab. 1956. Exhibits emerging, mid-career and established artists. Sponsors 20 shows/year. Average display time 2 months. Open all year, 7 days a week, 10-6. Located in a cultural center; "an Alden B. Dow design." 100% of space for special exhibitions.

Media Considers all media and all types of prints.

Style Exhibits all styles and genres.

Terms "Exhibited art may be for sale" (30% commission). Retail price set by the artist. Gallery provides insurance, promotion and contract; shipping costs are shared. Artwork must be exhibition ready.

Submissions Send query letter with résumé, slides, bio, SASE and proposal. Write to schedule an appointment

to show a portfolio, which should include slides, photographs and transparencies. Responds only if interested as appropriate. Files résumé, bio and proposal.

ℕ CAIN GALLERY

322 Butler St., Saugatuck MI 49453. (269)857-4353. **Owners:** Priscilla and John Cain. Retail gallery. Estab. 1973. Represents 75 emerging, mid-career and established artists. "Although we occasionally introduce unknown artists, because of high overhead and space limitations, we usually accept only artists who are somewhat established, professional and consistently productive." Sponsors 6 solo shows/year. Average display time 6 months. Clientele: 80% private collectors, 20% corporate clients. Overall price range: $100-6,000; most artwork sold at $500-1,000.

Media Considers oil, acrylic, watercolor, mixed media, collage, sculpture, crafts, ceramic, woodcuts, engravings, mezzotints, etchings, lithographs and serigraphs. Most frequently exhibits acrylic, watercolor and serigraphs.

Style Exhibits impressionism, realism, surrealism, painterly abstraction, imagism. Genres include landscapes, florals, figurative work. Prefers impressionism, abstraction and realism. "Our gallery is a showcase for living American artists—mostly from the Midwest, but we do not rule out artists from other parts of the country who attract our interest. The gallery attracts buyers from all over the country."

Terms Accepts artwork on consignment. Retail price set by artist. Sometimes offers customer payment by installment. Exclusive area representation required. Gallery provides insurance, promotion, contract and shipping costs from gallery. Prefers artwork framed.

Submissions Send query letter with résumé and slides. Portfolio review requested if interested in artist's work. Portfolio should include originals and slides. Finds artists through visiting exhibitions, word of mouth, submissions/self-promotions and art collectors' referrals.

Tips "We are now showing more fine crafts, especially art glass and sculptural ceramics. The most common mistake artists make is amateurish matting and framing."

CENTRAL MICHIGAN UNIVERSITY ART GALLERY

Wightman 132, Art Department, Mt. Pleasant MI 48859. (989)774-3800. Fax: (989)774-2278. E-mail: julia.morris roe@cmich.edu. Website: www.uag.cmich.edu. **Director:** Julia Morrisroe. Nonprofit gallery. Estab. 1970. Approached by 250 artists/year. Represents 40 emerging, mid-career and established artists. Exhibited artists include: Ken Fandell, Jan Estep, Sang-Ah-Choi, Amy Yoes, Scott Anderson, Richard Shaw. Sponsors 7 exhibits/year. Average display time 1 month. Open all year; Monday, Tuesday, Thursday and Friday, 10-5; Wednesday, 12-8; Saturday, 12-5. Clients include local community, students and tourists. Overall price range: $200-5,000.

Media Considers all media and all types of prints. Most frequently exhibits sculpture, painting and photography.

Style Considers all styles.

Terms Buyers are referred to the artist. Gallery provides insurance, promotion and contract. Accepted work should be framed. Does not require exclusive representation locally.

Submissions Write to arrange a personal interview to show portfolio of slides. Mail portfolio for review. Send query letter with artist's statement, bio, résumé, reviews, SASE and slides. Returns material with SASE. Responds only if interested within 2 months. Files résumé, reviews, photocopies and brochure. Finds artists through word of mouth, submissions, portfolio reviews, art exhibits, and referrals by other artists.

ℕ DE GRAAF FORSYTHE GALLERIES, INC.

Park Place No. 4, 403 Water St. on Main, Saugatuck MI 49453. (616)857-1882. Fax: (616)857-3514. E-mail: degraaffa@aol.com. Website: www.degraaffineart.com. **Director:** Tad De Graaf. Retail gallery and art consultancy. Estab. 1950. Represents/exhibits 18 established artists/year. May be interested in seeing emerging artists in the future. Exhibited artists include: Stefan Davidek and C. Jagdish. Average display time 3-4 weeks. Open May-December; Monday-Saturday, 11-5; Sunday, 1-5. Located in center of town, 1,171 sq. ft.; adjacent to two city parks. 60% of space for gallery artists. Clients include: upscale. 50% of sales are to private collectors; 10% corporate collectors. Overall price range: $500-50,000; most work sold at $2,000-5,000.

Media Considers all media except photography and crafts. Most frequently exhibits sculpture, paintings and tapestry.

Style Exhibits all styles.

Terms Artwork is accepted on consignment and there is a 50% commission. Retail price set by the gallery and the artist. Gallery provides promotion. Shipping costs are shared.

Submissions Accepts only artists with endorsements from another gallery or museum. Send query letter with résumé, brochure, slides, photographs, reviews, bio and SASE. Write for appointment to show portfolio. Responds in 2 months, or if interested 3 weeks. Files résumé if possible future interest.

✓ ▣ DETROIT ARTISTS MARKET

4719 Woodward Ave., Detroit MI 48201. (313)832-8540. Fax: (313)832-8543. E-mail: info@detroitartistsmarket. org. Website: www.detroitartistmarket.org. **Executive Director:** Aaron Timlin. Gallery Manager: Christine Sta-

mas. Nonprofit gallery. Estab. 1932. Exhibits the work of emerging, mid-career and established artists/year; 1,000 members. Sponsors 6-8 shows/year. Average display time 6 weeks. Open Wednesday-Sunday, 11-6. Located in downtown Detroit; 2,600 sq. ft. 85% of space for special exhibitions. Clientele: "extremely diverse client base—varies from individuals to the Detroit Institute of Arts." 95% private collectors; 5% corporate collectors. Overall price range: $200-15,000; most work sold at $100-500.

Media Considers all media. No posters. Most frequently exhibits multimedia.

Style All contemporary styles and genres.

Terms Accepts artwork on consignment (33% commission). Retail price set by the artist. Gallery provides insurance; artist pays for partial shipping.

Tips "Detroit Artists Market educates the Detroit metropolitan community about the work of emerging and established Detroit and Michigan artists through exhibitions, sales and related programs."

GALLERY SHOP AND GALLERIES: BIRMINGHAM BLOOMFIELD ART CENTER

1516 S. Cranbrook Rd., Birmingham MI 48009. (248)644-0866. Fax: (248)644-7904. Website: www.bbartcenter. org. Nonprofit gallery shop. Estab. 1962. Represents emerging, mid-career and established artists. Sponsors ongoing exhibition. Open all year; Monday-Saturday, 9-5. Suburban location. 100% of space for gallery artists. Clientele: upscale, local. 100% private collectors. Overall price range: $50-2,000.

Media Considers all media. Most frequently exhibits glass, jewelry, ceramics and 2D work.

Style Exhibits all styles.

Terms Accepts work on consignment (40% commission). Retail price set by the artist. Gallery provides promotion and contract; artist pays for shipping costs to gallery.

Submissions Send query letter with résumé, brochure, slides, photographs, reviews, artist's statement, bio, SASE; "as much information as possible." Files résumé, bio, brochure, photos.

Tips "We consider the presentation of the work (framing, matting, condition) and the professionalism of the artist."

GRAND RAPIDS ART MUSEUM

155 Division N, Grand Rapids MI 49503-3154. (616)831-1000. Fax: (616)559-0422. E-mail: pr@gr-artmuseum.o rg. Website: www.gramonline.org. Museum. Estab. 1910. Exhibits established artists. Sponsors 3 exhibits/year. Average display time 4 months. Open all year; Tuesday-Thursday, 10-5; Friday, 10-8:30; Sunday, 12-5. Closed Mondays and major holidays. Located in the heart of downtown Grand Rapids, the Grand Rapids Art Museum presents exhibitions of national caliber and regional distinction. The museum collection spans Renaissance to modern art, with particular strength in 19th and 20th century paintings, prints and drawings. Clients include: local community, students, tourists, upscale.

Media Considers all media and all types of prints. Most frequently exhibits paintings, prints and drawings.

Style Considers all styles and genres. Most frequently exhibits impressionist, modern and Renaissance.

ELAINE L. JACOB GALLERY

Wayne State University, 480 W. Hancock, Detroit MI 48202. (313)993-7813. Fax: (313)577-8935. E-mail: ac1370 @wayne.edu. Website: www.art.wayne.edu. **Curator of Exhibition:** Sandra Dupret. Nonprofit university gallery. Estab. 1997. Exhibits national and international artists. Approached by 40 artists/year. Sponsors 5 exhibits/year. Average display time 6 weeks. Open Tuesday-Friday, 10-6; Saturdays, 11-5. Closed week between Christmas and the New Year. Call for summer hours. Located in the annex of the Old Main building on campus. The gallery space is roughly 3,000 sq. ft. and is divided between 2 floors. Clients include local community, students, tourists.

Media Considers all types of media.

Style Mainly contemporary art exhibited.

Terms Exhibition only, with occasional sales. Retail price set by the artist. Gallery provides insurance, promotion and contract. Accepted work should be framed, mounted and matted. Does not require exclusive representation locally.

Submissions Send query letter with artist's statement, bio, brochure, business card, photocopies, photographs, résumé. reviews, SASE and slides to attn: Sandra Dupret, 150 Community Arts Bldg., Detroit MI 48202. Responds in 2 months. Files slides, curriculum vitae and artist statements.

Tips "Include organized and pertinent information, professional slides, and a clear and concise artist statement."

KRASL ART CENTER

707 Lake Blvd., St. Joseph MI 49085. (269)983-0271. Fax: (269)983-0275. E-mail: info@krasl.org. Website: www.krasl.org. **Director:** Dar Davis. Retail gallery of a nonprofit arts center. Estab. 1980. Clients include community residents and summer tourists. Sponsors 30 solo and group shows/year. Average display time is 1 month. Interested in emerging and established artists.

Media Considers oils, acrylics, watercolor, pastels, pen & ink, drawings, mixed media, collage, paper, sculpture, ceramics, crafts, fibers, glass, installations, photography and performance.

Style Exhibits all styles. "The works we select for exhibitions reflect what's happening in the art world. We display works of local artists as well as major traveling shows from SITES. We sponsor sculpture invitationals and offer holiday shows each December."

Terms Accepts work on consignment (35% commission). Retail price is set by artist. Sometimes offers customer discounts. Exclusive area representation not required. Gallery provides insurance, promotion, shipping and contract.

Submissions Send query letter, résumé, slides, and SASE. Call for appointment to show portfolio of originals.

N PERCEPTION

7 Ionia SW, Grand Rapids MI 49503. (616)451-2393. **Owner:** Kim L. Smith. Retail gallery. Estab. 1989. Represents 20 emerging, mid-career and established artists/year. Exhibited artists include Mathias J. Alten and Jack Smith. Sponsors 4-6 shows/year. Average display time 6-8 weeks. Open all year; Monday-Friday, 10-5:30. Open Saturday, 10-2 from Labor Day to Memorial Day. Located downtown; 2,200 sq. ft.; "open space, unique design." 100% of space for gallery artists. Clientele: private collectors, dealers. 75% private collectors, 5% corporate collectors. Overall price range: $500-75,000; most work sold at $1,000-4,000.

Media Considers oil, acrylic, watercolor, pastel, pen & ink, drawing, mixed media, collage, paper, sculpture, ceramics, craft, stone, bronze, woodcuts, engravings, lithographs, wood engravings, mezzotints, serigraphs, linocuts and etchings. Most frequently exhibits oils, etchings and lithographs.

Style Exhibits all styles; prefers impressionism and realism. Genres include landscapes and figurative work. Prefers American impressionism, contemporary figurative and still life, fine art prints—1900-present.

Terms Accepts work on consignment (40% commission) or buys outright for 50% of retail price (net 10 days). Retail prices set by the gallery and the artist. Gallery provides insurance, promotion and shipping costs from gallery; artist pays shipping costs to gallery. Prefers artwork unframed.

Submissions Send query letter with slides and photographs. Call for appointment to show portfolio of originals and slides. Responds in 1 month. Files bios and résumés. Finds artists through visiting exhibitions, word of mouth, submissions.

Tips "We are interested in seeing at least 30 to 40 examples and/or pieces that represent work done within a three to four year period."

PEWABIC POTTERY

10125 E. Jefferson, Detroit MI 48214. (313)822-0954. Fax: (313)822-6266. E-mail: pewabic@pewabic.com. Website: www.pewabic.com. Historic, nonprofit gallery in ceramics education and fabrication center. Estab. 1903. Represents 80 emerging, mid-career and established artists/year. Sponsors 7 shows/year. Average display time 6-52 weeks. Open all year; Monday-Saturday, 10-6; open 7 days during holiday. Located 3 miles east of downtown Detroit; historic building (1906). 40% of space for special exhibitions; 60% of space for gallery artists. Clients include: tourists, ceramic collectors. 98% of sales are to private collectors, 2% corporate collectors. Overall price range: $15-1,500; most work sold at $85-150.

Media Considers ceramics, mixed media, ceramic jewelry.

Style Exhibits utilitarian and sculptural clay.

Terms Accepts work on consignment (50% commission). Retail price set by the artist. Gallery provides insurance and promotion; shipping costs are shared.

Submissions Only ceramics. Send query letter with résumé, slides, artist's statement, price list and SASE. Write for appointment to show portfolio of slides. Responds in 3 months. Finds artists through word of mouth, referrals by other artists, visiting art fairs and exhibitions, submissions.

Tips "Avoid sending poor-quality slides."

SAPER GALLERIES

433 Albert Ave., East Lansing MI 48823. Phone/fax: (517)351-0815. E-mail: roy@sapergalleries.com. Website: www.sapergalleries.com. **Director:** Roy C. Saper. Retail gallery. Estab. in 1978; in 1986 designed and built new location. Displays the work of 150 artists; mostly mid-career, and artists of significant national prominence. Exhibited artists include: Picasso, Peter Max, Rembrandt. Sponsors 2 shows/year. Average display time 2 months. Open all year. Located downtown; 5,700 sq. ft.; "We were awarded *Decor* magazine's Award of Excellence for gallery design." 50% of space for special exhibitions. Clients include students, professionals, experienced and new collectors. 80% of sales are to private collectors, 20% corporate collectors. Overall price range: $100-100,000; most work sold at $1,000.

Media Considers oil, acrylic, watercolor, pastel, drawings, mixed media, collage, paper, sculpture, ceramic, craft, glass and original handpulled prints. Considers all types of prints except offset reproductions. Most frequently exhibits intaglio, serigraphy and sculpture. "Must be of highest professional quality."

Style Exhibits expressionism, painterly abstraction, surrealism, postmodern works, impressionism, realism, photorealism and hard-edge geometric abstraction. Genres include landscapes, florals, southwestern and figurative work. Prefers abstract, landscapes and figurative. Seeking extraorinarily talented, outstanding artists who will continue to produce exceptional work.

Terms Accepts work on consignment (negotiable commission); or buys outright for negotiated percentage of retail price. Retail price set by the artist. Offers payment by installments. Gallery provides insurance, promotion and contract; shipping costs are shared. Prefers artwork unframed (gallery frames).

Submissions Prefers digital pictures e-mailed to roy@sapergalleries.com. Call for appointment to show portfolio of originals or photos of any type. Responds in 1 week. Files any material the artist does not need returned. Finds artists mostly through NY Art Expo.

Tips "Present your very best work to galleries which display works of similar style, quality and media. Must be outstanding, professional quality. Student quality doesn't cut it. Must be great. Be sure to include prices and SASE."

SWORDS INTO PLOWSHARES

Peace Center and Gallery, 33 E. Adams, Detroit MI 48226. (313)963-7575. Fax: (313)963-2569. E-mail: swordsint oplowshares@prodigy.net. Website: www.swordsintoplowshares.org. **Contact:** Lois White, administrative assistant. Nonprofit gallery. "Our theme is 'World Peace.' " Estab. 1985. Represents 3-4 emerging, mid-career and established artists/year. Sponsors 4-6 shows/year. Average display time 2½ months. Open all year; Tuesday, Thursday, Saturday, 11-3. Located in downtown Detroit in the Theater District; 2,881 sq. ft.; 1 large gallery, 3 small galleries. 100% of space for special exhibitions. Clients include walk-in, church, school and community groups. 100% of sales are to private collectors. Overall price range: $75-6,000; most work sold at $75-700.

Media Considers all media. Considers all types of prints. "We have a juried show every two years for Ontario and Michigan artists about our theme. The juries make the selection of 2- and 3-dimensional work."

Terms Accepts work on consignment (35% commission). Retail price set by the artist. Gallery provides insurance and promotion; shipping costs from gallery.

Submissions Accepts artists primarily from Michigan and Ontario. Send query letter with statement on how other work relates to our theme. Responds in 2 months. Finds artists through lists of Michigan Council of the Arts, Windsor Council of the Arts.

URBAN INSTITUTE FOR CONTEMPORARY ARTS

41 Sheldon Blvd.,Grand Rapids MI 49503. (616)459-5994. Fax: (616)459-9395. E-mail: jteunis@uica.org. Website: www.uica.org. **Visual and Performing Arts Program Manager:** Janet Teunis. Alternative space, nonprofit gallery. Estab. 1977. Approached by 250 artists/year. Exhibits 50 emerging, mid-career and established artists. "We have four galleries—and places for site-specific work." Exhibited artists include: Sally Mann, photography. Sponsors 20 exhibits/year. Average display time 6 weeks. Open Tuesday-Saturday, 12-10; Sunday, 12-7.

Media Considers all media and all types of prints. Most frequently exhibits mixed media and nontraditional.

Style Exhibits: conceptualism and postmodernism.

Terms Gallery provides insurance, promotion and contract.

Submissions Check website for gallery descriptions and how to apply. Send query letter with artist's statement, bio, résumé, reviews, SASE, application fee, and slides. Returns material with SASE. Does not reply. Artist should see website, inquire about specific calls for submissions. Finds artists through submissions.

Tips "Get submission requirements before sending materials."

MINNESOTA

🖳 ART DOCK INC.

394 Lake Ave. S., Duluth MN 55802. (218)722-1451. E-mail: artdock@qwest.net. **Contact:** Bev L. Johnson. Retail consignment gallery. Estab. 1985. Represents 185 emerging and mid-career artists/year. Exhibited artists include: Cheng Khee Chee and Jay Steinke. Sponsors 2 exhibitions/year. Average display time 6 months. Open all year; January 1-April 30; Monday-Friday,10-9; Saturday, 10-8; Sunday, 11-5; May 1-December 31, Monday-Friday, 10-9; Saturday, 10-8; Sunday, 11-5. Located downtown-Canal Park, 1,200 sq. ft. historical building. #1 tourist attraction in the state on the shores of Lake Superior. We feature local artists within a 100-mile radius of Duluth. Clientele: 50% local, 50% tourists. 95% private collectors, 5% corporate collectors. Over all price range: $1-5,000; most work sold at $30-75.

Media Considers acrylic, ceramics, collage, craft, drawing, fiber, glass, mixed media, oil, paper, pastel, pen & ink, sculpture, watercolor, jewelry, wood all types of prints. Most frequently exhibits watercolor, pottery and photographs.

Style Exhibits: painterly abstraction, photorealism and realism. Genres include regional images.

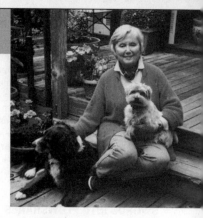

Constance Coleman

Pet Portraitist finds opportunities

I n a 19th century townhouse near the center of Cincinnati, Constance Coleman creates her much-adored portraits of family pets. She stands at the head of a retailing empire—perhaps a crass comment when talking about such fine art. But the dogs she paints, draws or brings to life through pastels can be found on everything from greeting cards to tote bags.

Her clients include Oprah Winfrey, Oscar de la Renta, T. Boone Pickens and Lilly Pulitzer. She's been featured on television, in newspapers and magazines throughout the country, and the dogs and other pets she paints live all over the world.

Right now she is working on a family of Scotties from the Netherlands. With her easel set up on the sunny side of the townhouse where she lives with her husband and a menagerie of pets, she is painting in the bucolic background—a grassy hill and big sky overlooking a fjord—that sets her portraits apart from others.

"This client found me through the Internet," she explains. The Web is just one of the many avenues Coleman uses to promote her work.

But her business was not always so techno. Born in New York and an artist by the time she was in first grade, Coleman is the daughter of John Depler, the All-American football player from the University of Illinois who started the Brooklyn Dodgers. The family moved from fashionable apartment to fashionable apartment throughout the country. Coleman attended 20 different schools, including the Elizabeth Holloway School of Drama in San Francisco where she was considered for a part in *National Velvet*.

"I didn't get the part," she says, "because I was taller than Mickey Rooney."

Coleman studied with Mark Rothko at the California School of Fine Arts and attended the Art Academy of Cincinnati. Eventually she settled in Carmel, California where she met her future husband.

"I was doing dog caricatures, people as their dogs," she says. "And they came to the attention of Abercrombie & Fitch. The buyer loved my idea."

From the beginning of her career, Coleman was always looking for ways to market her dog paintings. Early on, she did a line of hand-painted glassware. From that job came another, and another.

For Coleman, personal contact is very important. "From one store I was introduced to the buyer from another. I always drop a name when showing my work to new clients. 'So-and-so told me you might be interested.' Never underestimate personal contact."

It wasn't long before Coleman came across a couple of agents interested in repping her work. Unfortunately, she did not have a good experience. The agents didn't sell her work; they had other clients they spent more time on.

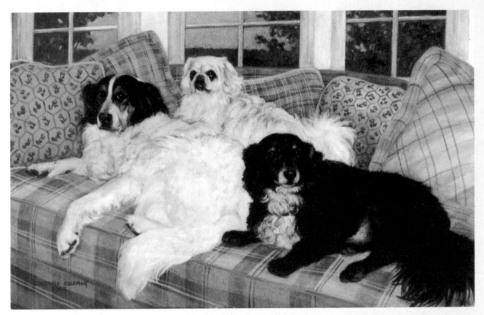

Pets become members of the family and Coleman often portrays them sitting in their favorite spots. Pet owners prize Coleman's portraits because she captures the essence of each pet's distinct personality.

"I was very young and naïve," she says. "I've found a lot of people I thought would be great agents, but they fizzled out. None of them were truly agents. They were just people who thought they would make good agents. I learned never send money in advance."

What did come out of her short association with these reps were contacts with a playing card company and the Leacock Company who she eventually designed for.

"They produced scenic wallpapers," she says. "I showed them the Barhounds. I just walked right in the front door."

The Barhounds are sophisticated drawings of groups of dogs out on the town enjoying cards, liquor and each other. Although she initially made them to order—picturing families or clubs together as dogs—the drawings were so well-executed and so funny, the wallpaper company wanted them.

"There was a paper company, a gift company," she says. "I even did a series of dogs as famous paintings. But things were different then, more specialized. Marketing has changed a lot. Back then I made the rounds of ad agencies on foot. That was why I was disappointed in my agents. I thought I had someone to do it for me."

As a fine arts painter, a successful portraitist and a graphic artist—three separate careers—she pushes her own work. Coleman does her homework, finding out what a company has produced, who their customers are, what products were successful. Then she approaches them by saying, "Here's what you do and here's what I do. Wouldn't it be interesting if we could do this together?"

"You have to think for the other person," she says. "You have to let them get rolling and get into their point of view. You've got to pay attention to who your market is. You have to psyche them out."

Gift shows can be particularly productive. As you walk the aisles, Coleman suggests

"Rocky" the Great Dane has found fame through Coleman's portrayal of him lounging on a comfy sofa. Rocky has appeared on boxed greeting cards, as well as Coleman's personal business card.

you look for companies who sell comparable products; for example, at one show she found a company selling placemats featuring cats and approached them suggesting a similar product featuring dogs. She always looks for firms she could connect with.

"There's nothing wrong with marketing," she says. "It won't taint you. It's what you have to do to be successful. Some artists have images of themselves living in a garret, painting for their souls. They have to change their attitudes. You just have to say, this is part of the process."

From her experience working for the former Gibson Greeting Card Company, she was able to show a portfolio to other card companies and get work. She noticed the Papyrus chain of stores carried only cat cards and made her pitch. A walk into an upscale shop landed Coleman her first gallery show.

"In the beginning I found my own niche," she says. "I haven't been known until the last 15 years as a portrait painter. It was always the animals. To get established, an artist has to have an angle. He has to get into a market. He has to be good, but if you want to make a living, you have to be commercial."

That includes becoming involved in charity events where a percentage of sales or commissions go to an organization like a local animal shelter. "It's good to do these in high rent areas," Coleman says. "But always retain your reproduction rights. You can write your contract that way."

Perhaps the most staggering influence on Coleman's career came when she signed with MHS Licensing in Minneapolis.

"I was finding it was getting more and more difficult to sell my work," Coleman remembers. "People didn't want to deal with artists anymore. Through the woman I dealt with at Blankety Blank Gifts, I found MHS."

A leading licensing and consulting company, MHS works both with artists and manufac-

turers. Her deal with them guarantees Coleman's works will be professionally shown at gift shows, furniture markets, textile markets, hobby shows, stationary shows, tabletop shows and gourmet product shows all year long. Diverse manufacturers see her work in categories she hasn't approached before.

"If Oscar de la Renta can go to Bed Bath & Beyond—the middle mass market—so can I," she says. "Bed Bath & Beyond has 1,000 stores and a stable of 17 artists."

Signing with MHS also required Coleman take a new look at her businesses. She had to become up to date on the latest computer technology. MHS demands the newest work in the best format possible, available for shows, on the Web and in their electronic archives.

Lately, Coleman has branched out into "little pastels." The stores have told her they need something to sell, something on the walls for their customers to see.

"You have to use your intuition and market yourself in an artistic manner," she says. "That's how to be successful." Things I've been told to do never worked out. You've got to tap into your potential clients' needs and look at things from their point of view."

—Marilyn Bauer

Terms Accepts work on consignment (40% commission). Retail price set by the artist. Gallery provides insurance, promotion and contract; artists pays for shipping.
Submissions Accepts only artists from 100-mile radius of Duluth. Send query letter with photographs, or call for appointment to show portfolio of photographs and slides. Responds in 2 months. Files current artist information. Finds artists through submissions.
Tips "They should present as if they are selling the work. No portfolio."

ART OPTIONS GALLERY
132 E. Superior St., Duluth MN 55802. (218)727-8723. E-mail: artoptions@netzero.net. Website: www.artoptions.com. **President:** Sue Pavlatos. Retail gallery. Estab. 1988. Represents 35 mid-career artists/year. Sponsors 4 shows/year. Average display time 1 month. Open all year; Tuesday-Friday, 10:30-5; Monday and Saturday, 10:30-2. Located downtown. Clients include tourists and local community. 70% of sales are to private collectors, 30% corporate collectors. Overall price range: $50-1,000; most work sold at $300.
Media Considers all media and all types of prints. Most frequently exhibits watercolor, mixed media and oil.
Style Exhibits all styles and genres. Prefers: landscape, florals and Americana.
Terms Accepts work on consignment (40% commission). Retail price set by the artist. Gallery provides insurance and promotion; artist pays for shipping. Prefers artwork framed.
Submissions Send query letter with résumé, slides and bio. Write for appointment to show portfolio of slides. Responds in 2 weeks. Files bio and résumé. Finds artists through word of mouth.
Tips "Paint or sculpt as much as you can. Work, work, work. You should have at least 50-100 pieces in your body of work before approaching galleries."

N FARIBAULT ART CENTER, INC.
212 Central Ave., Suite A, Faribault MN 55021. (507)332-7372. E-mail: fac@deskmedia.com. Website: www.faribaultart.org. **Contact:** Executive Director. Nonprofit gallery. Represents 10-12 emerging and mid-career artists/year. 200 members. Sponsors 8 shows/year. Average display time 1 month. Open all year; Monday-Saturday, 9:30-5. Located downtown; 1,600 sq. ft. 50% of space for special exhibitions; 50% of space for gallery artists. Clientele: local and tourists. 90% private collectors.
Media Considers all media and all types of prints.
Style Open.
Terms Accepts work on consignment (30% commission for nonmembers). Retail price set by the artist. Artist pays for shipping. Prefers artwork framed.
Submissions Accepts local and regional artists. Send query letter with slides, bio, photographs, SASE and artist's statement. Call or write for appointment to show portfolio of photographs or slides. Responds only if interested within 2 weeks. Artist should call. Finds artists through word of mouth, referrals by other artists, visiting art fairs and exhibitions and submissions.
Tips "Artists should respond quickly upon receiving reply."

FLANDERS CONTEMPORARY ART

3012 Lyndale Ave. South, Minneapolis MN 55408. (612)344-1700. Fax: (612)344-1643. **Director:** Douglas Flanders. Retail gallery. Estab. 1972. Represents emerging, mid-career and established artists. Exhibited artists include: Jim Dine and David Hockney. Sponsors 8 shows/year. Average display time 6 weeks. Open all year; Tuesday-Saturday 10-5. Located uptown, over 5,000 sq. ft. exhibition space with 13' ceiling. Clients include private, public institutions, corporations, museums. Price range starts as low as $85. Most work sold at $9,500-55,000.

Media Considers all media and original handpulled prints. Most frequently exhibits sculpture, paintings and various prints; some photography.

Style Exhibits all styles and genres. Prefers abstract expressionism, impressionism and post-impressionism.

Terms Accepts work on consignment (50% commission). Gallery provides insurance, promotion and contract; shipping costs are shared. Prefers artwork framed.

Submissions Send query letter with résumé, 20 slides, bio and SASE. Write for appointment to show portfolio of slides. Responds in 1 week.

Tips ''Include a statement about your ideas and artwork.''

ICEBOX QUALITY FRAMING & GALLERY

1500 Jackson St., Suite 443, Minneapolis MN 55413. (612)788-1790. E-mail: icebox@bitstream.net. Website: www.iceboxminnesota.com. **Fine Art Representative:** Howard Christopherson. Retail gallery and alternative space. Estab. 1988. Represents emerging and mid-career artists. Sponsors 4-7 shows/year. Average display time 1-2 months. Open all year. Historic Northrup King Building.

Media Considers photography and all fine art with some size limitations.

Style Exhibits: any thought-provoking artwork.

Terms ''Exhibit expenses and promotional material paid by the artist along with a sliding scale commission.'' Gallery provides great exposure, mailing list of 2,000 and good promotion.

Submissions Accepts predominantly Minnesota artists but not exclusively. Send 20 slides, materials for review, letter of interest.

Tips ''Be more interested in the quality and meaning in your artwork than in a way of making money.''

MIKOLS RIVER STUDIO INC.

717 Main St. NW, Elk River MN 55330. (763)441-6385. Website: www.mikolsriverstudio.com. **President:** Anthony Mikols. Retail gallery. Estab. 1985. Represents 12 established artists/year. Exhibited artists include: Steve Hanks. Sponsors 2 shows/year. Open all year; 6 days, 9-6. Located in downtown; 2,200 sq. ft. 10% of space for special exhibitions; 50% of space for gallery artists. Overall price range: $230-595.

Media Considers watercolor, sculpture, acrylic, paper and oil; types of prints include lithographs, posters and seriographs.

Style Genres include florals, portraits, wildlife, landscapes and western. Prefers: wildlife, florals and portraits.

Terms Buys outright for 50% of retail price (net on receipt). Retail price set by the gallery. Gallery provides insurance; gallery pays for shipping.

Submissions Send photographs. Artist's portfolio should include photographs. Responds only if interested within 2 weeks. Files artist's material. Finds artists through word of mouth.

THE CATHERINE G. MURPHY GALLERY

The College of St. Catherine, 2004 Randolph Ave., St. Paul MN 55105. (612)690-6637. Fax: (612)690-6024. E-mail: kmdaniels@stkate.edu. Website: www.stkate.edu. **Director:** Kathleen M. Daniels. Nonprofit gallery. Estab. 1973. Represents emerging, mid-career and nationally and regionally established artists. ''We have a mailing list of 1,000.'' Sponsors 5 shows/year. Average display time 4-5 weeks. Open September-June; Monday-Friday, 8-8; Saturday, 12-6; Sunday, 12-6. Located in the Visual Arts Building on the college campus of the College of St. Catherines; 1,480 sq. ft.

- This gallery also exhibits historical art and didactic shows of visual significance. Gallery shows 75% women's art since it is an all-women's undergraduate program.

Media Considers a wide range of media for exhibition.

Style Exhibits: Considers a wide range of styles.

Terms Artwork is loaned for the period of the exhibition. Gallery provides insurance. Shipping costs are shared. Prefers artwork framed.

Submissions Send query letter with artist statement and checklist of slides (title, size, medium, etc.), résumé, slides, bio and SASE. Responds in 6 weeks. Files résumé and cover letters. Serious consideration is given to artists who do group proposals under one inclusive theme.

NORTH COUNTRY MUSEUM OF ARTS

301 Court St., P.O. Box 328, Park Rapids MN 56470. (218)732-5237. **Curator/Administrator:** Johanna M. Verbrugghen. Museum. Estab. 1977. Interested in seeing the work of emerging and established artists. 100

members. Sponsors 8 shows/year. Average display time 3 weeks. Open all year; May-October; Tuesday-Sunday, 11-5. Located next to courthouse; 5 rooms in a Victorian building built in 1900 (on Register of Historic Monuments). 50% of space for special exhibitions; 50% of space for gallery artists.

Media Considers all media and all types of prints. Most frequently exhibits acrylic, watercolor and sculpture.

Style Exhibits all genres; prefers realism.

Terms Accepts work on consignment (20% commission). Retail price set by the artist. Artist pays shipping costs to and from gallery. Prefers artwork framed.

Submissions "Work should be of interest to general public." Send query letter with résumé and 4-6 slides. Portfolio should include photographs or slides. Responds only if interested within 2 months. Finds artists through word of mouth.

N SILVERTSON GALLERY

12 Wisconsin St., Grand Marais MN 55604. (218)387-2491. Fax: (218)387-1350. Or 361 Canal Park Dr., Duluth MN 55802. (218)723-7877. Fax: (218)723-8669. **Proprietor:** Jan Silvertson. Retail gallery. Estab. 1980. Represents 20 established artists/year. Exhibited artists include: Howard Silvertson and Betsy Bowen. Sponsors 3-4 shows/year. Average display time 6 months. Open all year; daily with evening hours additional in summer. Located in downtown Grand Marais (1,700 sq. ft.) and downtown Duluth (800 sq. ft.). 25% of space for special exhibitions; 75% of space for gallery artists. Clientele: tourists and local community. 100% private collectors. Overall price range: $25-10,000; most work sold at $100-1,000.

Media Considers oil, acrylic, watercolor, pastel, mixed media, collage, paper, sculpture, ceramics, craft and fiber; all types of prints. Most frequently exhibits oil/acrylics, watercolors and original prints, preferably woodcuts.

Style Exhibits: regional representational, not abstract. Genres include wildlife and landscapes. Prefers: area landscape-regional, wildlife and variety of work from Alaska and Inuit natives.

Terms Accepts work on consignment (50% commission) or buys outright for 50% of retail price (net 30 days). Retail price set by the gallery and artist. Gallery provides promotion; artist pays for shipping. Prefers artwork framed.

Submissions Accepts only artists from northeast Minnesota or Canadian/Alaskan. The artwork must fit the gallery theme-art of the north. Send query letter with résumé, slides, bio and artist's statement. Call for appointment to show portfolio of photographs or slides. Responds in 1 month. Finds artists through word of mouth, referrals by other artists, visiting art fairs and exhibitions and submissions. "We review portfolios, 1-2 a year."

Tips "Don't come in with artwork in hand during busy season."

JEAN STEPHEN GALLERIES

917 Nicollet Mall, Minneapolis MN 55402. (612)338-4333. Fax: (612)337-8435. E-mail: jsgalleries@leodusa.net. Website: jeanstephengalleries.com. Directors: Steve or Jean Danko. Retail gallery. Estab. 1987. Represents 12 established artists. Interested in seeing the work of emerging artists. Exhibited artists include: Jiang, Hart, Yuroz and Dr. Seuss. Sponsors 2 shows/year. Average display time 4 months. Open all year; Monday-Saturday, 10-6. Located downtown; 2,300 sq. ft. 15% of space for special exhibitions; 85% of space for gallery artists. Clients include upper income. 90% of sales are to private collectors, 10% corporate collectors. Overall price range: $600-12,000; most work sold at $1,200-2,000.

Media Considers oil, acrylic, pastel, pen & ink, drawing, mixed media, collage, paper, sculpture, ceramics, woodcuts, engravings, lithographs, wood engravings, mezzotints, serigraphs, linocuts and etchings. Most frequently exhibits serigraphs, stone lithographs and sculpture.

Style Exhibits: expressionism, neo-expressionism, surrealism, minimalism, color field, postmodern works and impressionism. Genres include landscapes, southwestern, portraits and figurative work. Prefers Chinese contemporary, abstract and impressionism.

Terms Accepts work on consignment (50% commission). Retail price set by the gallery. Gallery provides insurance and contract; artist pays shipping costs to and from gallery.

Submissions Send query letter with résumé, slides and bio. Call for appointment to show portfolio of originals, photographs and slides. Responds in 2 months. Finds artists through art shows and visits.

N STUDIO 10

2100 Snelling Ave. N., Suite 54, Roseville MN 55113-6000. (651)646-3346. **Manager:** Jenifer Gitzen. Retail gallery owned and operated by artists. Estab. 1989. Represents 100 artists/year. Interested in seeing the work of emerging artists and fine craftspeople. Exhibited artists include Betsy Bowen, Bart Galle, Michael Bond, Michael Shoop and Joan Gray. Average display time 1 year. Open all year; daily, 10-9; Saturday, 10-6. Located in HarMar Mall; 1,600 sq. ft. 100% of space for gallery artists. 95% private collectors, 5% corporate collectors. Overall price range: $5-800; most work sold at $20-100.

Media Considers all 2D and 3D media.

Style Exhibits all styles and genres. Prefers florals, wildlife and southwestern.

Terms Accepts work on consignment (36% commission and 3% on all charge sales). Retail price set by the artist. Gallery provides promotion and contract. Artist pays for shipping.

Submissions Accepts only artists from Midwest. Send query letter with 10-12 slides, brochure, SASE, business card and artist's statement. Call or write for appointment to show portfolio of original art. Responds in 2 weeks. Finds artists through word of mouth, referrals by other artists, visiting art fairs and exhibitions and artist's submissions.

Tips "Learn to frame and mat professionally, use top quality frames, mats, glass and wiring apparatus. Keep your work clean and unscratched. Strive to be an expert in one medium."

TWEED MUSEUM OF ART

1201 Ordean Court, Duluth MN 55812. (218)726-7823. Fax: (218)726-8503. E-mail: tma@d.umn.edu. Website: www.d.umn.edu/tma. **Contact:** Peter Spooner, curator. Museum and museum retail shop. Estab. 1950. Exhibits emerging, mid-career and established artists. Sponsors 10 exhibits/year. Average display time 2-3 months. Open Tuesday-Friday, 9-4:30; Saturday-Sunday, 1-5. Closed from late December to early January.

Media Considers all media and all types of prints.

Style Considers all styles and genres.

Submissions Send query letter with artist's statement, bio, résumé and slides. Cannot return material.

WINGS 'N WILLOWS ART GALLERY & FRAME SHOP

42 NW Fourth St., Grand Rapids MN 55744. (218)327-1649. **Owner:** Linda Budrow. Retail gallery, custom frame shop. Estab. 1976. Represents 30 established artists/year. Exhibited artists include Redlin and Bateman. Sponsors 1 show/year. Average display time 3 months. Open all year; Monday-Saturday, 10-5. Located downtown; 1,000 sq. ft. 5% of space for special exhibitions; 95% of space for gallery artists. Clientele: tourists, local community. 95% private collectors, 5% corporate collectors. Overall price range: $30-1,000; most work sold at $150-600.

Media Considers paper, ceramics, glass, photography, wood carvings, lithographs and posters. Most frequently exhibits limited edition prints, posters and wood carvings.

Style Genres include wildlife and landscapes. Prefers wildlife, landscape and nostalgic.

Terms Buys outright for 50% of retail price (net 30 days). Retail price set by the artist. Gallery provides promotion. Gallery pays shipping costs. Prefers artwork unframed.

Submissions Send query letter with bio, brochure and photographs. Write for appointment to show portfolio of photographs. Responds only if interested within 2 weeks. Finds artists through visiting art fairs and exhibitions, artist's submissions and publishers.

MISSISSIPPI

N CHIMNEYVILLE CRAFTS GALLERY

Agricultural & Forestry Museum, 1150 Lakeland Dr., Jackson MS 39216. (601)981-2499. **Director:** Kit Barksdale. Retail and nonprofit gallery. Estab. 1985. Represents 70 emerging, mid-career and established guild members. 250 members. Exhibited artists include George Berry and Ann Baker. Open all year; Monday-Saturday, 9-5; closed some holidays. Located on the grounds of the State Agricultural & Forestry Museum; 2,000 sq. ft.; in a traditional log cabin. Clientele: travelers and local patrons. 99% private collectors. Overall price range: $250-900; most work sold at $10-60. Also sponsors Chimneyville Crafts Festival first weekend of December.

Media Considers paper, sculpture, ceramic, craft, fiber and glass. Most frequently exhibits clay, basketry and metals.

Style Exhibits all styles. Crafts media only. Interested in seeing a "full range of craftwork—Native American, folk art, production crafts, crafts as art, traditional and contemporary. Work must be small enough to fit our limited space."

Terms Accepts work on consignment (40% commission), first order; buys outright for 50% of retail price (net 30 days), subsequent orders. Retail price set by the gallery and the artist. Gallery provides promotion and shipping costs to gallery.

Submissions Accepts only artists from the Southeast. Artists must be juried members of the Craftsmen's Guild of Mississippi. Ask for standards review application form. Standards Review: 1st Saturday in March and September.

Tips "All emerging craftsmen should read *Crafts Report* regularly and know basic business procedures. Read books on the business of art like *Crafting as a Business* by Wendy Rosen, distributed by Chilton—available by mail order through our crafts center or the *Crafts Report*. An artist should have mastered the full range of his

medium—numbers don't matter, except that you have to do a lot of practice pieces before you get good or fully professional."

HILLYER HOUSE, INC.

207 E. Scenic Dr., Pass Christian MS 39571. (228)452-4810. Fax: (228)452-3712. E-mail: hillyerhouse@yahoo.c om. Website: www.hillyerhouse.com. **Owners:** Katherine and Paige Reed. Retail gallery. Estab. 1970. Represents 200 emerging, mid-career and established artists including: 19 artists, 34 potters, 46 jewelers, 10 glassblowers. Interested in seeing the work of emerging artists. Exhibited artists include: Kathie Calhoun and Jeri Gremillion. Sponsors 12 shows/year. Average display time 2 months. Open all year; Monday-Saturday 10-5; Sunday 12-5. Located beachfront-middle of CBD historic district; 1,700 sq. ft. 50% of space for special exhibitions; 50% of space for gallery artists. Clients include visitors to the Mississippi Gulf Coast (80%), private collectors (20%). Overall price range: $25-700; most work sold at $30-150; paintings $250-700.

 • Hillyer House has special exhibitions in all areas.

Media Considers oil, watercolor, pastel, mixed media, sculpture (metal fountains), ceramic, craft and jewelry. Most frequently exhibits watercolor, pottery and jewelry.

Style Exhibits: expressionism, imagism, realism and contemporary. Genres include aquatic/nautical. Prefers: realism, impressionism and expressionism.

Terms Accepts work on consignment (35% commission); or artwork is bought outright for 50% of the retail price (net 30 days). Retail price set by gallery or artist. Gallery provides promotion and contract; artist pays for shipping. Prefers artwork framed.

Submissions Send query letter with résumé, slides, bio, brochure and/or photographs, SASE and reviews. Call or write for appointment to show portfolio of originals and photographs. Responds only if interested within 3 weeks. Files photograph and bio. (Displays photo and bio with each person's art.)

Tips "Work must be done in last nine months. Watercolors sell best. Make an appointment. Looking for artists with a professional attitude and approach to work. Be sure the work submitted is in keeping with the nature of our gallery."

MERIDIAN MUSEUM OF ART

628 25th Ave., P.O. Box 5773, Meridian MS 39302. (601)693-1501. E-mail: MeridianMuseum@aol.com. **Director:** Terence Heder. Museum. Estab. 1970. Represents emerging, mid-career and established artists. Interested in seeing the work of emerging artists. Exhibited artists include Terry Cherry, Alex Loeb, Jere Allen, Patt Odom, James Conner, Joseph Gluhman, Bonnie Busbee and Hugh Williams. Sponsors 15 shows/year. Average display time 5 weeks. Open all year; Tuesday-Sunday, 1-5. Located downtown; 1,750 sq. ft.; housed in renovated Carnegie Library building, originally constructed 1912-13. 50% of space for special exhibitions. Clientele: general public. Overall price range: $150-2,500; most work sold at $300-1,000.

 • Sponsors annual Bi-State Art Competition for Mississippi and Alabama artists.

Media Considers all media. Most frequently exhibits oils, watercolors and sculpture.

Style Exhibits all styles, all genres.

Terms Work available for sale during exhibitions (25% commission). Retail price set by the artist. Gallery provides insurance and promotion; shipping costs are shared. Prefers artwork framed.

Submissions Prefers artists from Mississippi, Alabama and the Southeast. Send query letter with résumé, slides, bio and SASE. Responds in 3 months. Finds artists through submissions, referrals, work included in competitions and visiting exhibitions.

THE UNIVERSITY MUSEUMS

The University of Mississippi, P.O. Box 1848, University MS 38677. (662)915-7073. Fax: (662)915-7035. E-mail: museums@olemiss.edu. Website: olemiss.edu/depts/u_museum. Museum. Estab. 1939. Approached by 5 artists/year. Represents 2 emerging, mid-career and established artists. Average display time 3 months. Open Tuesday-Saturday, 9:30-4:30; Sunday, 1-4. Closed 2 weeks at Christmas and major holidays. Clients include local community, students and tourists.

Media Considers all media. Most frequently exhibits acrylic, oil and drawings. Considers all types of prints.

Style Considers all styles. Genres include Americana, landscapes and wildlife.

Terms Artwork is bought outright. Retail price set by the artist. Gallery provides insurance. Accepted work should be framed. Does not require exclusive representation locally. Accepts only artists from Mississippi, Tennessee, Alabama, Arkansas and Louisiana.

Submissions Send query letter with artist's statement, bio, photographs and slides. Returns material with SASE. Responds in 3 months. Finds artists through word of mouth, submissions, and referrals by other artists.

MISSOURI

☑ THE ASHBY-HODGE GALLERY OF AMERICAN ART

Central Methodist University, Fayette MO 65248. (660)248-6324 or (660)248-6304. Fax: (660)248-2622. E-mail: jgeistecoin.org. Website: www.centralmethodist.edu. **Curator:** Joseph E. Geist. Nonprofit gallery, "Not primarily a sales gallery—only with special exhibits." Estab. 1993. Exhibits the work of 50 artists in permanent collection. Exhibited artists include Robert MacDonald Graham, Jr. and Birger Sandzén. Sponsors 5 shows/year. Average display time 2 months. Open all year; Tuesday-Thursday, 1:30-4:30. Located on campus of Central Methodist college. 1,400 sq. ft.; on lower level of campus library. 100% of gallery artists for special exhibitions. Clientele: local community and surrounding areas of Mid-America. Physically impaired accessible. Tours by reservation.

Media Considers all media. Most frequently exhibits acrylic, lithographs, oil and fibers.

Style Exhibits Midwestern regionalists. Genres include portraits and landscapes. Prefers: realism.

Terms Accepts work on consignment (30% commission.) Retail price set by the gallery. Gallery provides insurance and promotion; shipping costs are shared. Prefers artwork framed.

Submissions Accepts primarily Midwestern artists. Send query letter with résumé, slides, photographs and bio. Call for appointment to show portfolio of photographs, transparencies and slides. Finds artists through recommendations and submissions.

BARUCCI'S ORIGINAL GALLERIES

8101 Maryland Ave., St Louis MO 63105. (314)727-2020. E-mail: baruccigallery@dellmail.com. Website: barucci gallery.com. **President:** Shirley Taxman Schwartz. Retail gallery and art consultancy specializing in hand-blown glass by national juried artists. Estab. 1977. Represents 40 artists. Interested in emerging and established artists. Sponsors 3-4 solo and 4 group shows/year. Average display time is 6 weeks. Located in "affluent county, a charming area." Clientele: affluent young area. 70% private collectors, 30% corporate clients. Overall price range: $100-10,000; most work sold at $1,000.

• This gallery has moved into a corner location featuring three large display windows. They specialize in hand blown glass by national juried artists.

Media Considers oil, acrylic, watercolor, pastel, collage and works on paper. Most frequently exhibits watercolor, oil, acrylic and hand blown glass.

Style Exhibits painterly abstraction, primitivism and impressionism. Genres include landscapes and florals. Currently seeking contemporary works: abstracts in acrylic and fiber, watercolors and some limited edition serigraphs.

Terms Accepts work on consignment (50% commission). Retail price set by gallery or artist. Sometimes offers payment by installment. Gallery provides contract.

Submissions Send query letter with résumé, slides and SASE. Portfolio review requested if interested in artist's work. Slides, bios and brochures are filed.

Tips "More clients are requesting discounts or longer pay periods."

☑ BOODY FINE ARTS, INC.

10706 Trenton Ave., St. Louis MO 63132. (314)423-2255. E-mail: bfa@boodyfinearts.com. Website: www.boody finearts.com. Retail gallery and art consultancy. "Gallery territory is nationwide. Staff travels on a continual basis to develop collections within the region." Estab. 1978. Represents 200 mid-career and established artists. Clientele: 20% private collectors, 30% public and 50% corporate clients. Overall price range: $500-1,000,000.

Media Considers oil, acrylic, watercolor, pastel, drawings, mixed media, collage, sculpture, ceramic, fiber, metalworking, glass, works on handmade paper, neon and original handpulled prints.

Style Exhibits color field, painterly abstraction, minimalism, impressionism and photorealism. Prefers nonobjective, figurative work and landscapes.

Terms Accepts work on consignment. Retail price is set by gallery and artist. Customer discounts and payment by installments available. Gallery provides insurance, promotion and contract; shipping costs are shared.

Submissions Send query letter, résumé and slides. "Accepts e-mail introductions with referrals or invitations to websites; no attachments. Write to schedule an appointment to show a portfolio, which should include originals, slides and transparencies. All material is filed. Finds artists by visiting exhibitions, word of mouth, artists' submissions, Internet and art collectors' referrals.

Tips "I very seldom work with an artist until they have been out of college about ten years."

Ⓝ CENTRAL MISSOURI STATE UNIVERSITY ART CENTER GALLERY

217 Clark St., Warrensburg, MO 64093. (660)543-4498. Fax: (660)543-8006. **Gallery Director:** Morgan Gallatin. University Gallery. Estab. 1984. Exhibits emerging, mid-career and established artists. Sponsors 11 exhibitions/year. Average display time 1 month. Open Monday through Friday, 8-5; Saturday, 10-2. Open during academic

year. Located on the University campus. 3,778 sq. ft. 100% of space is devoted to special exhibitions. Clientele: local community, students.

Media Considers all media and all styles.

Terms No commission: "We are primarily an education gallery, not a sales gallery." Gallery provides insurance. Shipping costs are shared. Prefers artwork framed.

Submissions Send query letter with résumé, slides, bio, photographs, SASE. Write for appointment to show portfolio of photographs and slides. Responds in 6 months. Finds artists through The Greater Midwest International Art Competition sponsored by the Gallery.

☑ CONTEMPORARY ART MUSEUM OF ST. LOUIS

3750 Washington Blvd., St. Louis MO 63108. (314)535-4660. Fax: (314)535-1226. E-mail: info@contemporarystl .org. Website: www.contemporarystl.org. **Director:** Paul Ha. Nonprofit museum. Estab. 1980. Is a noncollecting museum dedicated to exhibiting contemporary art from international, national and local established and emerging artists. Open Tuesday-Saturday, 10-5; Thursday, 10-7; Sunday, 11-4. Located mid-town, Grand Center; 27,200 sq. ft. building designed by Brad Cloepfil, Allied Works.

MILDRED COX GALLERY AT WILLIAM WOODS UNIVERSITY

One University Dr., Fulton MO 65251. (573)642-2251. Website: www.williamwoods.edu. **Contact:** Julie Gaddy, gallery coordinator. Nonprofit gallery. Estab. 1970. Approached by 20 artist/year; exhibits 8 emerging, mid-career and established artists/year. Exhibited artists include Elizabeth Ginsberg and Terry Martin. Average display time 2 months. Open Monday-Friday, 8-4:30; Saturday-Sunday, 1-4. Closed Christmas-January 20. Located within large moveable walls; 300 running feet. Clients include local community, students, upscale and foreign visitors. Overall price range: $1,000-10,000; most work sold at $800-1,000. Gallery takes no commission. "Our mission is education."

Media Considers all media except installation. Most frequently exhibits drawing, painting and sculpture. Considers all prints except commercial off-set.

Style Exhibits expressionism, geometric abstraction, impressionism, surrealism, painterly abstraction and realism. Most frequently exhibits figurative and academic. Genres include Americana, figurative work, florals, landscapes and portraits.

Terms Artists work directly with person interested in purchase. Retail price of the art set by the artist. Gallery provides insurance and contract. Accepted work should be framed and matted. Does not require exclusive representation locally. Artists are selected by a committee from slides or original presentation to faculty committee.

Submissions Write to arrange a personal interview to show portfolio of slides or send query letter with artist's statement, résumé and slides. Returns material with SASE. Does not reply to queries. Artist should call. Files slides, statement and resume until exhibit concludes. Finds artists through word of mouth.

Tips To make your gallery submissions professional you should send "good quality slides! Masked with sliver opaque tape—no distracting backgrounds."

☑ CRAFT ALLIANCE GALLERY

6640 Delmar, St. Louis MO 63130. (314)725-1177, ext. 322. Fax: (314)725-2068. E-mail: gallery@craftalliance.o rg. Website: www.craftalliance.org. **Contact:** Gregory Wilkerson, gallery director. Nonprofit gallery with exhibition and retail galleries. Estab. 1964. Represents 500 emerging, mid-career and established artists. Exhibited artists include: Thomas Mann, Ellen Shankin and Randall Darwall. Exhibition space sponsors 10-12 exhibits/year. Average display time 4-6 weeks. Open all year. Located in the university area; storefront; adjacent to education center. Clients include local community, students, tourists and upscale. Retail gallery price range: $20 and up. Most work sold at $100.

Media Considers ceramics, metal, fiber and glass. Most frequently exhibits jewelry, glass and clay. Doesn't consider prints.

Style Exhibits contemporary craft.

Terms Exhibition artwork is sold on consignment and there is a 50% commission. Artwork is bought outright. Retail price set by the gallery and the artist. Gallery provides insurance and promotion. Requires exclusive representation locally.

Submissions Call or write to arrange a personal interview to show portfolio of slides or call first, then send slides or photographs. Returns material with SASE.

Tips "Call and talk. Have professional slides and attitude."

GALERIE BONHEUR

10046 Conway Rd., St. Louis MO 63124. (314)993-9851. Cell: (314)409-6057. Fax: (314)993-9260. E-mail: gbonh eur@aol.com. Website: www.galeriebonheur.com. **Owner:** Laurie Griesedieck Carmody. Gallery Assistant:

Sharon Ross. Private retail and wholesale gallery. Focus is on international folk art. Estab. 1980. Represents 60 emerging, mid-career and established artists/year. Exhibited artists include: Milton Bond and Justin McCarthy. Sponsors 6 shows/year. Average display time 1 year. Open all year; by appointment. Located in Ladue (a suburb of St. Louis); 3,000 sq. ft.; art is displayed all over very large private home. 75% of sales to private collectors. Overall price range: $25-25,000; most work sold at $50-1,000.

 • Galerie Bonheur also has a location at 9243 Clayton Rd., Ladue, MO.

Media Considers oil, acrylic, watercolor, pastel, pen & ink, drawing, mixed media, collage, paper, sculpture, ceramics and craft. Most frequently exhibits oil, acrylic and metal sculpture.

Style Exhibits: expressionism, primitivism, impressionism, folk art, self-taught, outsider art. Genres include landscapes, florals, Americana and figurative work. Prefers genre scenes and figurative.

Terms Accepts work on consignment (50% commission) or buys outright for 50% of retail price. Retail price set by the gallery and the artist. Gallery provides promotion; artist pays shipping costs to and from gallery. Prefers artwork framed.

Submissions Prefers only self-taught artists. Send query letter with bio, photographs and business card. Write for appointment to show portfolio of photographs. Responds only if interested within 6 weeks. Finds artists through agents, visiting exhibitions, word of mouth, art publications and sourcebooks and submissions.

Tips "Be true to your inspirations. Create from the heart and soul. Don't be influenced by what others are doing; do art that you believe in and love and are proud to say is an expression of yourself. Don't copy; don't get too sophisticated or you will lose your individuality!"

N SHERRY LEEDY CONTEMPORARY ART

2004 Baltimore Ave., Kansas City MO 64108. (816)474-1919. **Director:** Sherry Leedy. Retail gallery. Estab. 1985. Represents 50 mid-career and established artists. May be interested in seeing the work of emerging artist in the future. Exhibited artists include: Jun Kancke, Michael Eastman. Sponsors 6 shows/year. Average display time 6 weeks. 5,000 sq. ft. of exhibit area in 3 galleries. Clients include established and beginning collectors. 80% of sales are to private collectors, 20% corporate clients. Price range: $50-100,000; most work sold at $3,500-35,000.

Media Considers all media and one-of-a-kind or limited-edition prints; no posters. Most frequently exhibits painting, photography, ceramic sculpture and glass.

Style Exhibits: Considers all styles.

Terms Accepts work on consignment (50% commission). Retail price set by gallery. Sometimes offers customer discounts and payment by installment. Exclusive area representation required. Gallery provides insurance, promotion; shipping costs are shared. Prefers artwork framed.

Submissions Send query letter, résumé, good slides, prices and SASE. Write for appointment to show portfolio of originals, slides and transparencies. Bio, vita, slides, articles, etc. are filed if they are of potential interest.

Tips "Please allow three months for gallery to review slides."

N LYSS FINE ART

722 S. Meramec, St. Louis MO 63105. (314)726-6140. **Owner:** Esther Lyss. Retail and wholesale gallery. Estab. 1971. Represents emerging, mid-career and established artists. Open all year by appointment. Located mid-town. Clientele: corporate and upper end.

Media Considers all media and all types of prints.

Style Exhibits all styles and genres.

Terms Retail price set by gallery and/or artist. Prefers artwork unframed.

Submissions Send query letter with résumé, slides, brochure, photographs, business card, reviews, bio and SASE. Call or write for appointment to show portfolio. Responds in 2-3 weeks. Files all material sent with query.

Tips "I am always happy to speak with artists. I am a private dealer and specialize in helping my clients select works for their home or office."

N MORGAN GALLERY

114 Southwest Blvd., Kansas City MO 64108. (816)842-8755. Fax: (816)842-3376. E-mail: dmorgangallery@sbcglobal.net. Website: www.morgangallery.com. **Director:** Dennis Morgan. For-profit gallery. Estab. 1969. Exhibits emerging, mid-career and established artists. Sponsors 6 exhibits/year. Average display time 6-8 weeks. Open all year; Tuesday-Friday, 10-5:30; Saturday 10-4. Closed Sundays. Clients include local community, students, tourists and upscale.

Media Considers all media and all types of prints.

Style Considers all styles.

Terms Artwork is accepted on consignment and there is a 50% commission. Retail price set by the gallery and the artist. Gallery provides insurance, promotion and contract. Requires exclusive representation locally.

Submissions Call or write to arrange a personal interview to show portfolio. Send query letter with artist's

statement, bio, résumé, reviews, SASE and 20 slides. Returns material with SASE. Responds in 6 months. Files contact information. Finds artists through word of mouth, submissions, portfolio reviews, art exhibits, art fairs, and referrals by other artists.

☑ THE SOURCE FINE ARTS, INC.

1505 Westport Rd. #102, Kansas City MO 64111. (816)931-8282. Fax: (816)931-8283. **President:** Denyse Ryan Johnson. Gallery Consultant. Estab. 1985. Represents/exhibits 50 mid-career artists/year. Exhibited artists include: Jack Roberts and John Gary Brown. Sponsors 3-4 openings/year. Open all year; Monday-Friday, 9-5; Saturday, by appointment only. Located in midtown Westport Shopping District; 1,500 sq. ft. Clients include designers, architects and residential clients. 60% of sales are to corporate collections or residential clients, 40% to interior design firms. Overall price range: $200-6,500; most work sold at $1,000-4,500.

Media Considers all media except photography. Most frequently exhibits oil, acrylic, mixed media, ceramics and glass.

Style Exhibits: expressionism, minimalism, color field, hard-edge geometric abstraction, painterly abstraction and impressionism. Genres include landscapes. Prefers: non-objective, abstraction and impressionism.

Terms Artwork is accepted on consignment (50% commission). Retail price set by the gallery. Gallery provides insurance, promotion and contract; show and shipping costs are shared.

Submissions Prefers Midwest artists with exhibit, sales/gallery record. Send query letter with résumé, brochure, business card, 8-12 slides, photographs, reviews and SASE. Call for appointment to show portfolio of photographs, slides and transparencies. Responds in 1 month. Files slides and résumé. Finds artists through word of mouth, referrals by other artists, visiting art fairs and exhibitions and artists' submissions. Reviews submissions in January and July.

Tips Advises artists who hope to gain gallery representation to "visit the gallery to see what media and level of expertise is represented. If unable to travel to a gallery outside your region, review gallery guides for area to find out what styles the gallery shows. Prior to approaching galleries, artists need to establish an exhibition record through group shows. When you are ready to approach galleries, present professional materials and make follow-up calls."

MONTANA

ARTISTS' GALLERY

111 S. Grand, #106, Bozeman MT 59715. (406)587-2127. **Chairperson:** Justine Heisel. Retail and cooperative gallery. Estab. 1992. Represents the work of 20 emerging and mid-career artists, 20 members. Sponsors 12 shows/year. Average display time 3 months. Open all year; Monday-Saturday, 10-5. Located near downtown; 900 sq. ft.; located in Emerson Cultural Center with other galleries, studios, etc. Clients include tourists, upscale, local community and students. 100% of sales are to private collectors. Overall price range: $35-600; most work sold at $100-300.

Media Considers oil, acrylic, watercolor, pastel, pen & ink, drawing, mixed media, collage, paper, sculpture, ceramics and glass, woodcuts, engravings, linocuts and etchings. Most frequently exhibits oil, watercolor and ceramics.

Style Exhibits: painterly abstraction, impressionism, photorealism and realism. Exhibits all genres. Prefers realism, impressionism and western.

Terms Co-op membership fee plus donation of time (20% commission). Rental fee for space; covers 1 month. Retail price set by the artist. Gallery provides promotion; artist pays for shipping costs to gallery. Prefers artwork framed.

Submissions Artists must be able to fulfill "sitting" time or pay someone to sit. Send query letter with résumé, slides, photographs, artist's statement and actual work. Write for appointment to show portfolio of photographs and slides. Responds in 2 weeks.

☒ CORBETT GALLERY

Box 339, 459 Electric Ave. B, Bigfork MT 59911. (406)837-2400. E-mail: corbett@digisys.net. Website: www.corbettgallery.com. **Director:** Jean Moore. Retail gallery. Estab. 1993. Represents 20 mid-career and established artists. Exhibited artists include: Cynthia Fisher. Sponsors 2 shows/year. Average display time 3 weeks. Open all year; Sunday-Friday, 10-7 summer, 10-5 winter. Located downtown; 2,800 sq. ft. Clients include tourists and upscale. 90% of sales are to private collectors. Overall price range: $250-10,000; most work sold at $2,400.

Media Considers all media; types of prints include engravings, lithographs, serigraphs and etchings. Most frequently exhibits oil, watercolor, acrylic and pastels.

Style Exhibits: photorealism. Genres include western, wildlife, southwestern and landscapes. Prefers: wildlife, landscape and western.

Terms Accepts work on consignment (40% commission). Retail price set by the artist. Gallery provides insurance, promotion and contract. Shipping costs are shared. Prefers artwork framed.

Submissions Send query letter with slides, brochure and SASE. Call for appointment to show portfolio of photographs or slides. Responds in 1 week. Files brochures and bios. Finds artists through art exhibitions and referrals.

Tips "Don't show us only the best work, then send mediocre paintings that do not equal the same standard."

YELLOWSTONE GALLERY

216 W. Park St., P.O. Box 472, Gardiner MT 59030. (406)848-7306. E-mail: jckahrs@aol.com. Website: yellowsto negallery.com. **Owner:** Jerry Kahrs. Retail gallery. Estab. 1985. Represents 20 emerging and mid-career artists/year. Exhibited artists include: Mary Blain and Nancy Glazier. Sponsors 2 shows/year. Average display time 2 months. Open all year; seasonal 7 days; winter, Tuesday-Saturday, 10-6. Located downtown; 3,000 sq. ft. new building. 25% of space for special exhibitions; 50% of space for gallery artists. Clientele: tourist and regional. 90% private collectors, 10% corporate collectors. Overall price range: $25-8,000; most work sold at $75-600.

Media Considers oil, acrylic, watercolor, ceramics, craft and photography; types of prints include wood engravings, serigraphs, etchings and posters. Most frequently exhibits watercolors, oils and limited edition, signed and numbered reproductions.

Style Exhibits: impressionism, photorealism and realism. Genres include western, wildlife and landscapes. Prefers: wildlife realism, western and watercolor impressionism.

Terms Accepts work on consignment (45% commission). Retail price set by the artist. Gallery provides contract; artist pays for shipping. Prefers artwork framed.

Submissions Send query letter with brochure or 10 slides. Write for appointment to show portfolio of photographs. Responds in 1 month. Files brochure and biography. Finds artists through word of mouth, regional fairs and exhibits, mail and periodicals.

Tips "Don't show up unannounced without an appointment."

NEBRASKA

N ARTISTS' COOPERATIVE GALLERY

405 S. 11th St., Omaha NE 68102. (402)342-9617. Website: www.artistsco-opgallery.com. **President:** Susan Barnes. Cooperative and nonprofit gallery. Estab. 1974. Exhibits the work of 30-35 emerging, mid-career and established artists. 35 members. Exhibited artists include Mary Kolar and Jerry Jacoby. Sponsors 14 shows/year. Average display time 1 month. Open all year. Located in historic Old Market area; 5,000 sq. ft.; "large open area for display with 25' high ceiling." 20% of space for special exhibitions. Clientele: 85% private collectors, 15% corporate collectors. Overall price range: $20-2,000; most work sold at $20-1,000.

Media Considers oil, acrylic, watercolor, pastel, drawings, mixed media, collage, paper, sculpture, ceramic, fiber, glass, photography, woodcuts, serigraphs. Most frequently exhibits sculpture, acrylic, oil and ceramic.

Style Exhibits all styles and genres.

Terms Co-op membership fee plus donation of time. Retail price set by artist. Sometimes offers payment by installment. Artist provides insurance; artist pays for shipping. Prefers artwork framed. No commission charged by gallery.

Submissions Accepts only artists from the immediate area. "We each work one day a month." Send query letter with résumé, slides and bio. Write for appointment to show portfolio of originals and slides. "Applications are reviewed and new members accepted and notified in August if any openings are available." Files applications.

Tips "Fill out application and touch base with gallery in July."

N GERI'S ART AND SCULPTURE GALLERY

Omaha NE 68132. (402)556-4311. **President:** Geri. Retail gallery and art consultancy featuring restrike etchings and tapestry. Open by appointment only. Estab. 1975. Exhibited artists include Agam, Alvar, Ting and Calder. Open all year. Located in midtown Omaha. Clientele: collectors, designers, residential and corporate. 50% private collectors, 50% corporate collectors. Overall price range: $35-10,000; most work sold at $500-1,000.

Media Considers watercolor, mixed media, collage, paper, sculpture, ceramic and tapestry. Considers all types of prints, especially lithographs, serigraphs and monoprints.

Style Considers all styles and genres. "We carry mostly original limited editions."

Terms Artwork is bought outright or leased. Sometimes offers discounts to gallery customers.

Submissions Portfolio review not required. Finds artists through agents, visiting exhibitions, word of mouth, art publications and sourcebooks, artists' submissions, self-promotions and art collectors' referrals.

☑ NOYES ART GALLERY

119 S. 9th St., Lincoln NE 68508. (402)475-1061. E-mail: rnoyes1348@aol.com. Website: www.noyesartgallery.com. **Director:** Julia Noyes. Nonprofit gallery. Estab. 1992. Exhibits 150 emerging artists. 25 members. Average display time 1 month minimum. (If mutually agreeable this may be extended or work exchanged.) Open all year. Located downtown, "near historic Haymarket District; 3093 sq. ft.; renovated 100-year-old building." 25% of space for special exhibitions. Clientele: private collectors, interior designers and decorators. 90% private collectors, 10% corporate collectors. Overall price range: $100-5,000; most work sold at $200-750.

Media Considers oil, acrylic, watercolor, pastel, pen & ink, drawings, mixed media, collage, paper, sculpture, ceramic, fiber, glass and photography; original handpulled prints, woodcuts, wood engravings, linocuts, engravings, mezzotints, etchings, lithographs and serigraphs. Most frequently exhibits oil, watercolor and mixed media.

Style Exhibits expressionism, neo-expressionism, impressionism, realism, photorealism. Genres include landscapes, florals, Americana, wildlife, figurative work. Prefers realism, expressionism, photorealism.

Terms Accepts work on consignment (10-35% commission). Retail price set by artist (sometimes in conference with director). Gallery provides promotion and contract; artist pays for shipping. Prefers artwork framed.

Submissions Send query letter with résumé, slides, bio, SASE; label slides concerning size, medium, price, top, etc. Submit at least 6-8 slides. Reviews submissions monthly. Responds in 1 month. Files résumé, bio and slides of work by accepted artists (unless artist requests return of slides). All materials are returned to artists whose work is declined.

WAREHOUSE GALLERY

381 N. Walnut St., Grand Island NE 68801. (308)382-8589. **Contact:** Alan E. Lienert. Retail gallery and custom framing. Estab. 1971. Represents 25-30 emerging artists/year. Exhibited artists include: Doug Johnson and Cindy Duff. Sponsors 3 shows/year. Average display time 1 month. Open all year; Monday-Friday, 10-5; Saturday, 10-3. Located in old downtown; 900 sq. ft.; old tin ceilings and skylights. 50% of space for special exhibitions. Clients include upscale and local community. Overall price range: $150-2,000; most work sold at $200-300.

Media Considers oil, acrylic, watercolor, pastel, pen & ink, mixed media, collage, sculpture, ceramics, fiber, glass and photography; types of prints include woodcuts, wood engravings, serigraphs and linocuts. Most frequently exhibits watercolor, oil, acrylic and pastel.

Style Exhibits: realism. Genres include florals and landscapes. Prefers: landscapes, florals and experimental.

Terms Accepts work on consignment (40% commission). Retail price set by the artist. Gallery provides insurance, promotion and contract; artist pays for shipping. Prefers artwork framed.

Submissions Accepts only artists from the Midwest. Send query letter with résumé, slides, photographs and SASE. Write for appointment to show portfolio of photographs or slides. Responds only if interested within 3 weeks. Finds artists through referrals by other artists, art fairs and exhibitions.

NEVADA

ART ENCOUNTER

3979 Spring Mountain Rd., Las Vegas NV 89102. (702)227-0220. Fax: (702)227-3353. E-mail: rod@artencounter.com. Website: www.artencounter.com. **Director:** Rod Maly. Retail gallery. Estab. 1992. Represents 100 emerging and established artists/year. Exhibited artists include: Jennifer Main, Jan Harrison and Vance Larson. Sponsors 4 shows/year. Open all year; Tuesday-Friday, 10-6; Saturday and Monday, 12-5. Located near the famous Las Vegas strip; 8,000 sq. ft. 20% of space for special exhibitions; 80% of space for gallery artists. Clients include upscale tourists and locals. 95% of sales are to private collectors, 5% corporate collectors. Overall price range: $200-20,000; most work sold at $500-2,500.

Media Considers all media and all types of prints. Most frequently exhibits watercolor, oil and acrylic.

Style Exhibits all styles and genres.

Terms Rental fee for space; covers 6 months. Retail price set by the gallery and artist. Gallery provides promotion and contract; artist pays for shipping. Prefers artwork framed.

Submissions Send 5-10 slides, photographs and SASE. Write for appointment to show portfolio of photographs or slides. Responds only if interested within 2 weeks. Files artist bio and résumé. Finds artists by advertising in the *Artist's Magazine*, *American Artist*, art shows and word of mouth.

Tips "Poor visuals and no SASE are common mistakes."

☒ ARTIST'S CO-OP OF RENO

627 Mill St., Reno NV 89502. (775)322-8896. Cooperative nonprofit gallery. Estab. 1966. 20 emerging, mid-career and established artists. Sponsors 6 shows/year. Average display time 6 months. Exhibits 12 feature shows/year and quarterly all-gallery change of show. Open all year; Monday-Sunday, 11-4. Located downtown;

1,000 sq. ft. in historic, turn of century "French laundry" building. 10% of space for special exhibitions; 90% of space for gallery artists. Clients include tourists, upscale and local community. 90% of sales are to private collectors, 10% corporate collectors. Overall price range: $50-2,000.
Media Considers all media. Most frequently exhibits watercolor, oil, mixed media and pottery.
Style Exhibits: conceptualism, photorealism, color field, realism and imagism. Genres include western, landscapes, florals, wildlife, Americana, portraits, southwestern and figurative work. Prefers Nevada landscapes and Americana.
Terms There is co-op membership fee plus a donation of time. There is a 15% commission. Retail price set by the artist. Gallery provides promotion. Artist pays for shipping costs from gallery. Prefers art framed.
Submissions Accepts only artists from northern Nevada. Send query letter with résumé, slides, photographs, reviews and bio. Call for appointment to show portfolio. Finds artists through word of mouth and artists' visits.
Tips "We limit our membership to 20 local artists so that each artist has ample display space."

✔ CONTEMPORARY ARTS COLLECTIVE

101 E. Charlesten Blvd., Suite 101, Las Vegas NV 89104. (702)382-3886. Website: www.cac-lasvegas.org. **Acting President:** Jacie Maynard. Alternative space, nonprofit gallery. Estab. 1989. Represents emerging and mid-career artists, 250 members. Exhibited artists include: Mary Warner, Eric Murphy, Wendy Kveck and Daryl DePry. Sponsors 9 shows/year. Average display time 5 weeks. Open all year; Tuesday-Saturday, 12-4. Located downtown; 800 sq. ft. Clients include tourists, local community and students. 75% of sales are to private collectors, 25% corporate collectors. Overall price range: $250-2,000; most work sold at $400.
Media Considers all media and all types of prints. Most frequently exhibits painting, photography and mixed media.
Style Exhibits: conceptualism, group shows of contemporary fine art. Genres include all contemporary art/all media. Artist pays shipping costs. Prefers artwork ready for display. Finds artists through entries.
Tips "We prioritize group shows that are self curated, or curated by outside curators. Groups need to be three to four artists or more. Annual guidelines are sent out in January for next coming year. We are looking for experimental and innovative work."

Ⓝ RED MOUNTAIN GALLERY AND STURM GALLERY

(Truckee Meadows Community College), 7000 Dandini Blvd., Reno NV 89512. (775)674-7698. E-mail: eml@scs. unr.cdu. **Curator:** Noland Preece. Nonprofit and college gallery. Estab. 1991. Represents emerging and mid-career artists. Sponsors 7 shows/year. Average display time 1 month. Located north of downtown Reno; 1,200 sq. ft.; "maximum access to entire college community—centrally located." 100% of space for special exhibitions. Clientele: corporate art community and students/faculty. 95% private collectors, 5% corporate collectors. Overall price range: $150-1,500; most work sold at $300-800.
Media Considers oil, acrylic, watercolor, pastel, pen & ink, drawings, mixed media, collage, paper, sculpture, ceramic, fiber and photography. "Video is a new addition." Considers original handpulled prints, woodcuts, engravings, lithographs, wood engravings, mezzotints, serigraphs, linocuts and etchings. Most frequently exhibits painting, photography, sculpture and printmaking.
Style Exhibits all styles and genres. Prefers primitivism and socio-political works. Looks for "more contemporary concerns—less traditional/classical approaches. Subject matter is not the basis of the work—innovation and aesthetic exploration are primary."
Terms Accepts work on consignment (20% commission). Retail price set by gallery and artist. Gallery provides insurance, full color announcements, promotion, contract and shipping from gallery. Prefers artwork unframed.
Submissions Accepts artists from the U.S.A. Send query letter with résumé, 15 slides, SASE, reviews and artist's statement. Deadline for submissions: February 15 of each year. Responds in 2 months. Files résumé. Submission fee: $15.

NEW HAMPSHIRE

✔ Ⓣ DOWNTOWN ARTWORKS

67 Main St., Plymouth NH 03264. Phone/fax: (603)536-8946. E-mail: dtaw@worldpath.net. **Manager:** Cathy Dupuis. Retail and nonprofit gallery. Estab. 1991. Represents 30 emerging artists/year. 30 members. Exhibited artists include: Cam Sinclair. Sponsors 10 shows/year. Average display time 3 weeks. Open all year; Monday-Friday, 9-5; Saturday, 9-2. Located downtown Plymouth; 600 sq. ft. 25% of space for special exhibitions; 25% of space for gallery artists. Clients include tourists and locals. Overall price range: $50-2,000; most work sold at $150-250.
Media Considers all media and all types of prints (limited edition). Most frequently exhibits oil, watercolor and mixed.

Galleries

Style Exhibits: photorealism. Genres include florals, wildlife and landscapes. Prefers: landscapes, florals and wildlife.

Terms Accepts work on consignment (35% commission). Retail price set by the artist. Gallery provides insurance, promotion, contract, patron's list and tax information; artist pays for shipping. Prefers artwork framed.

Submissions Accepts only artists from New Hampshire. Send business card and artist's statement. Call for appointment to show portfolio of photographs. Responds in 1 month. Finds artists by going to exhibitions and shows.

Tips "Work should not be poorly framed and artists should not be unsure of price range. Frame all pieces with quality to match your work."

MILL BROOK GALLERY & SCULPTURE GARDEN

236 Hopkinton Rd., Concord NH 03301. (603)226-2046. E-mail: artsculpt@mindspring.com. Website: www.the millbrookgallery.com. For-profit gallery. Estab. 1996. Exhibits over 70 emerging, mid-career and established artists. Exhibited artists include: John Bott (painter), Laurence Young (painter), John Lee (sculptor) and Wendy Klemperer (sculptor). Sponsors 7 exhibits/year. Average display time 6 weeks. Open Tuesday-Saturday, 11-5; April 1-December 24th. Otherwise, by appointment. Located 3 miles west of The Concord NH Center; surrounding gardens, field and pond; outdoor juried sculpture exhibit. Three rooms inside for exhibitions, 1,800 sq. ft. Clients include local community, tourists and upscale, 10% of sales are to corporate collectors. Overall price range: $80-30,000; most work sold at $500-1,000.

Media Considers acrylic, ceramics, collage, drawing, glass, mixed media, oil, pastel, sculpture, watercolor, etchings, mezzotints, serigraphs and woodcuts. Most frequently exhibits oil, acrylic and pastel.

Style Considers all styles. Most frequently exhibits color field/conceptualism, expressionism. Genres include landscapes. Prefers more contemporary art.

Terms Artwork is accepted on consignment and there is a 50% commission. Retail price set by the artist. Gallery provides insurance, promotion and contract. Accepted work should be framed and matted.

Submissions Call or write to show portfolio of photographs and slides. Send query letter with artist's statement, bio, photocopies, photographs, résumé, SASE and slides. Returns material with SASE. Responds in 1 month. Finds artists through word of mouth, submissions, art exhibits and referrals by other artists.

THE OLD PRINT BARN—ART GALLERY

P.O. Box 978, Winona Rd., Meredith NH 03253-0978. (603)279-6479. Fax: (603)279-1337. **Director:** Sophia Lane. Retail gallery. Estab. 1976. Represents 100-200 mid-career and established artists/year. May be interested in seeing the work of emerging artists in the future. Exhibited artists include: Michael McCurdy, Ryland Loos and Joop Vegter. Sponsors 3-4 shows/year. Average display time 3-4 months. Open daily 10-5 (except Thanksgiving and Christmas Day). Located in the country; over 4,000 sq. ft.; remodeled antique 18th century barn. 30% of space for special exhibitions; 70% of space for gallery artists. Clients include tourists and local. 99% of sales are to private collectors. Overall price range: $10-30,000; most work sold at $200-900.

Media Considers watercolor, pastel and drawing; types of prints include woodcuts, engravings, lithographs, mezzotints, serigraphs, linocuts and etchings. Most frequently exhibits etchings, engravings (antique), watercolors.

Style Exhibits: color field, expressionism, postmodernism, realism. Most frequently exhibits color field, realism, postmodernism. Genres include florals, wildlife, landscapes and Americana.

Terms Accepts work on consignment. Retail price set by the gallery and artist. Gallery provides promotion; shipping costs are shared. Prefers artwork unframed but shrink-wrapped with 1 inch on top for clips so work can hang without damage to image or mat.

Submissions Prefers only works of art on paper. No abstract art. Send query letter with résumé, brochure, 10-12 slides and artist's statement. Title, medium and size of artwork must be indicated clearly on slide label. Call or write for appointment to show portfolio or photographs. Responds in a few weeks. Files query letter, statements, etc. Finds artists through word of mouth, referrals of other artists, visiting art fairs and exhibitions and submissions.

Tips "Show your work to gallery owners in as many different regions as possible. Most gallery owners have a feeling of what will sell in their area. I certainly let artists know if I feel their images are not what will move in this area."

THORNE-SAGENDORPH ART GALLERY

Keene State College, Wyman Way, Keene NH 03435-3501. (603)358-2720. E-mail: thorne@keene.edu. Website: www.keene.edu/tsag. **Director:** Maureen Ahern. Nonprofit gallery. Estab. 1965. Represents emerging, mid-career and established artists. 600 members. Exhibited artists include: Jules Olitski and Fritz Scholder. Sponsors 5 shows/year. Average display time 4-6 weeks. Open Saturday-Wednesday, 12-4; Thursday and Friday evenings

till 7. Follows college schedule. Located on campus; 4,000 sq. ft.; climate control, security. 50% of space for special exhibitions. Clients include local community and students.

Media Considers all media and all types of prints.

Style Exhibits: Considers all styles.

Terms Accepts work on consignment (40% commission). Retail price set by the artist. Gallery provides insurance, promotion and contract; shipping costs are shared. Prefers artwork framed.

Submissions Artist's portfolio should include photographs and transparencies. Responds only if interested within 2 months. Files all material.

NEW JERSEY

ARC-EN-CIEL

267 Fairview Ave., Long Valley NJ 07853. (908)876-9671. E-mail: reed267@comcast.net. **Owner:** Ruth Reed. Retail gallery and art consultancy. Estab. 1980. Exhibited artists include: Andre Pierre, Petian Savain, Alexander Gregoire, Micius Stephane, Gerard Valcin and Seymore Bottex. 50% of sales are to private collectors, 50% corporate clients. Open by appointment only. Represents emerging, mid-career and established artists. Overall price range: $150-158,000; most artwork sold at $250-2,000.

Media Considers oil, acrylic, wood carvings, sculpture. Most frequently exhibits acrylic, painted iron, oil.

Style Exhibits minimalism, primitivism and some insider art. "I exhibit country-style paintings, native art from around the world. The art can be on wood, iron or canvas."

Terms Accepts work on consignment (50% commission). Retail price is set by gallery and artist. Customer discounts and payment by installment are available. Exclusive area representation required. Gallery provides promotion; shipping costs are shared.

Submissions Send query letter, photographs and SASE. Portfolio review requested if interested in artist's work. Photographs are filed. Finds artists through word of mouth and art collectors' referrals.

BARRON ARTS CENTER

582 Rahway Ave., Woodbridge NJ 07095. (732)634-0413. **Director:** Cynthia Knight. Nonprofit gallery. Estab. 1977. Interested in emerging, mid-career and established artists. Sponsors several solo and group shows/year. Average display time is 1 month. Clients include culturally minded individuals mainly from the central New Jersey region. 80% of sales are to private collectors, 20% corporate clients. Overall price range: $200-5,000.

Media Considers oil, acrylic, watercolor, pastel, pen & ink, drawings, mixed media, collage, works on paper, sculpture, ceramic, craft, fiber, glass, installation, photography, performance and original handpulled prints. Most frequently exhibits acrylic, photography and mixed media.

Style Exhibits: painterly abstraction, impressionism, photorealism, realism and surrealism. Genres include landscapes and figurative work. Prefers painterly abstraction, photorealism and realism.

Terms Accepts work on consignment. Retail price set by artist. Exclusive area representation not required. Gallery provides insurance, promotion and contract; artist pays for shipping.

Submissions Send query letter, résumé and slides. Call for appointment to show portfolio. Résumés and slides are filed.

Tips Most common mistakes artists make in presenting their work are "improper matting and framing and poor quality slides. There's a trend toward exhibition of more affordable pieces—pieces in the lower end of price range."

BLACKWELL ST. CENTER FOR THE ARTS

P.O. Box 808, Denville NJ 07834. (973)316-0857. E-mail: wblakeart2004@yahoo.com. Website: www.blackwell-st-artists.org. **Director:** Annette Hanna. Nonprofit group. Estab. 1983. Exhibits the work of approximately 15 or more emerging and established artists. Sponsors 3-4 group shows/year. Average display time 1 month. Overall price range $100-5,000; most work sold at $150-350.

Media Considers oil, acrylic, watercolor, pastel, pen & ink, drawings, mixed media, collage, paper, sculpture, ceramics, photography, egg tempera, woodcuts, wood engravings, linocuts, engravings, mezzotints, etchings, lithographs and serigraphs. Most frequently exhibits oil, photography and pastel.

Style Exhibits all styles and genres. Prefers painterly abstraction, realism and photorealism.

Terms Membership fee plus donation of time; 20% commission. Retail price set by artist. Sometimes offers payment by installments. Exclusive area representation not required. Artist pays for shipping. Prefers artwork framed.

Submissions Send query letter with résumé, brochure, slides, photographs, bio and SASE. Call or write for appointment to show portfolio of originals and slides. Responds in 1 month. Files slides of accepted artists. All material returned if not accepted or under consideration.

Tips "Show one style of work and pick the best—less is more. Slides and/or photos should be current work. Enthusiasm and organization are big pluses!"

DAVID GARY LTD. FINE ART
158 Spring St., Millburn NJ 07041. (973)467-9240. Fax: (973)467-2435. **Director:** Steve Suskauer. Retail and wholesale gallery. Estab. 1971. Represents 17-20 mid-career and established artists. Exhibited artists include: John Talbot and Theo Raucher. Sponsors 3 shows/year. Average display time 3 weeks. Open all year. Located in the suburbs; 2,000 sq. ft.; high ceilings with sky lights. Clients include "upper income." 70% of sales are to private collectors, 30% corporate collectors. Overall price range: $250-25,000; most work sold at $1,000-15,000.
Media Considers oil, acrylic, watercolor, drawings, sculpture, pastel, woodcuts, engravings, lithographs, wood engravings, mezzotints, linocuts, etchings and serigraphs. Most frequently exhibits oil, original graphics and sculpture.
Style Exhibits: primitivism, painterly abstraction, surrealism, impressionism, realism and collage. All genres. Prefers impressionism, painterly abstraction and realism.
Terms Accepts artwork on consignment (50% commission). Retail price set by gallery and artist. Gallery services vary; artist pays for shipping. Prefers artwork unframed.
Submissions Send query letter with résumé, photographs and reviews. Call for appointment to show portfolio of originals, photographs and transparencies. Responds in 2 weeks. Files "what is interesting to gallery."
Tips "Have a basic knowledge of how a gallery works, and understand that the gallery is a business."

KEARON-HEMPENSTALL GALLERY
536 Bergen Ave., Jersey City NJ 07304. (201)333-8855. Fax: (201)333-8488. E-mail: suzann@khgallery.com. Website: www.khgallery.com. **Director:** Suzann Anderson. Retail gallery. Estab. 1981. Represents emerging, mid-career and established artists. Exhibited artists include: Dong Sik-Lee, Mary Buondies, Jesus Rivera, Stan Mullins, Linda Marchand, Stephen McKenzie, Elizabeth Bisbing and Kamil Kubik. Sponsors 3 shows/year. Average display time 2 months. Open Monday-Friday, 10-3; closed July and August. Located on a major commercial street; 150 sq. ft.; brownstone main floor, ribbon parquet floors, 14 ft. ceilings, ornate moldings, traditional. 100% of space for special exhibitions. Clients include local community and corporate. 60% of sales are to private collectors, 40% corporate collectors. Overall price range: $200-8,000; most work sold at $1,500-2,500.
Media Considers oil, acrylic, watercolor, pastel, drawing, mixed media, collage, paper, sculpture, fiber, glass, installation, photography, engravings, lithographs, serigraphs, etchings and posters. Most frequently exhibits mixed media painting, photography and sculpture.
Style Prefers figurative expressionism and realism.
Terms Accepts work on consignment (50% commission). Retail price set by the gallery. Gallery provides promotion; artist pays for shipping. Prefers artwork framed.
Submissions Send query letter with résumé, slides, bio, brochure, SASE, reviews, artist's statement, price list of sold work. Write for appointment to show portfolio of photographs and slides. Responds in 6 weeks. Files slides and résumés. Finds artists through art exhibitions, magazines (trade), submissions.
Tips "View gallery website for artist requirements."

KERYGMA GALLERY
38 Oak St., Ridgewood NJ 07450. (201)444-5510. Gallery Directors: Ron and Vi Huse. Retail gallery. Estab. 1988. Represents 30 mid-career artists. Sponsors 9 shows/year. Average display time 4-6 weeks. Open all year. Located in downtown business district; 2,000 sq. ft.; "professionally designed contemporary interior with classical Greek motif accents." Clientele: primarily residential, some corporate. 80-85% private collectors, 15-20% corporate collectors. Most work sold at $2,000-5,000.
Media Considers oil, acrylic, watercolor, pastel, mixed media, sculpture. Prefers oil or acrylic on canvas.
Style Exhibits painterly abstraction, impressionism and realism. Genres include landscapes, florals, still life and figurative work. Prefers impressionism and realism.
Terms Accepts artwork on consignment (50% commission). Retail price set by gallery and artist. Gallery provides insurance, promotion and in some cases, a contract; shipping costs are shared.
Submissions Send query letter with résumé, slides, bio, photographs, reviews and SASE. Call for appointment to show portfolio originals, photographs and slides "only after interest is expressed by slide/photo review." Responds in 1 month. Files all written information, returns slides/photos.
Tips "An appointment is essential—as is a slide register."

LIMITED EDITIONS & COLLECTIBLES
697 Haddon, Collingswood NJ 08108. (856)869-5228. Fax: (856)869-5228. E-mail: JDL697ltd@juno.com. Website: www.LTDeditions.net. **Owner:** John Daniel Lynch, Sr. For profit gallery. Estab. 1997. Approached by 24 artists/year. Exhibited artists include: Richard Montmurro, James Allen Flood and Gino Hollander. Open all

year. Located in downtown Collingswood; 700 sq. ft. Overall price range: $190-20,000; most work sold at $450.
Media Considers all media and all types of prints. Most frequently exhibits acrylic, watercolors and oil.
Style Considers all styles and genres.
Terms Artwork is accepted on consignment and there is a 30% commission. Retail price set by the artist. Gallery provides insurance, promotion and contract. Accepted work should be framed, mounted and matted. Does not require exclusive representation locally.
Submissions Call or write to arrange a personal interview to show portfolio. Send query letter with bio, business card and résumé. Responds in 1 month. Finds artists through word of mouth, portfolio reviews, art exhibits, and referrals by other artists.

MARKEIM ART CENTER
Lincoln Ave. and Walnut St., Haddonfield NJ 08033. Phone/fax: (856)429-8585. E-mail: markeimartcenter@msn.com. Website: www.markeim.org. **Center Manager:** Lisa Hamill. Nonprofit gallery. Estab. 1956. Represents emerging, mid-career and established artists. 465 members. Exhibited artists include Ben Cohen and Steve Kuzma. Sponsors 8-10 shows/year, both on and off site. Average display time 1 month. Open all year; Monday-Thursday, 10-4; Friday, 11-1; Saturday and Sunday, by appointment. Located downtown; 600 sq. ft. 75% of space for special exhibitions; 20% of space for gallery artists. Overall price range: $100-2,000.
Media Considers all media. Must be original. Most frequently exhibits paintings, photography and sculpture.
Style Exhibits all styles and genres.
Terms Work not required to be for sale (20% commission taken if sold). Retail price set by the artist. Gallery provides promotion and contract. Artwork must be ready to hang.
Submissions Send query letter with résumé, slides, bio/brochure, photographs, SASE, business card, reviews and artist's statement. Write for appointment to show portfolio of photographs and slides. Files slide registry.

THE NOYES MUSEUM OF ART
Lily Lake Rd., Oceanville NJ 08231. (609)652-8848. Fax: (609)652-6166. Website: www.noyesmuseum.org. **Curator of Collections and Exhibitions:** A.M. Weaver. Museum. Estab. 1983. Exhibits emerging, mid-career and established artists. Sponsors 9-12 shows/year. Average display time 6 weeks to 3 months. Open all year; Tuesday-Saturday, 10-4:30; Sunday, 12-5. 9,000 sq. ft.; "modern, window-filled building successfully integrating art and nature; terraced interior central space with glass wall at bottom overlooking Lily Lake." 75% of space for special exhibitions. Clients include rural, suburban, urban mix; high percentage of out-of-state vacationers during summer months.
Media All types of American fine art, craft and folk art.
Style Exhibits all styles and genres.
Submissions Send query letter with résumé, slides, photographs and SASE. "Letter of inquiry must be sent; then museum will set up portfolio review if interested." Portfolio should include slides. "Materials only kept on premises if artist is from New Jersey and wishes to be included in New Jersey Artists Resource File or if artist is being considered for inclusion in future exhibitions."

SERAPHIM FINE ARTS GALLERY
Dept. AM, 19 Engle St., Tenafly NJ 07670. (201)568-4432. **Directors:** E. Bruck and M. Lipton. Retail gallery. Represents 150 emerging, mid-career and established artists. 90% of sales are to private collectors, 10% corporate clients. Overall price range: $700-20,000; most work sold at $2,000-5,000.
Media Considers oil, acrylic, watercolor, drawings, collage, sculpture and ceramic. Most frequently exhibits oil, acrylic and sculpture.
Style Exhibits: impressionism, realism, painterly abstraction and conceptualism. Considers all genres. Prefers impressionism, realism and figure painting. "We are located in New Jersey, but we function as a New York gallery. We put together shows of artists who are unique. We represent fine contemporary artists and sculptors."
Terms Accepts work on consignment. Retail price set by gallery and artist. Exclusive area representation required. Gallery provides insurance and promotion. Prefers framed artwork.
Submissions Send query letter with résumé, slides and photographs. Portfolio should include originals, slides and photographs. Responds in 1 month. Files slides and bios.
Tips Looking for "artistic integrity, creativity and an artistic ability to express self." Notices a "return to interest in figurative work."

BEN SHAHN GALLERIES
William Paterson University, 300 Pompton Rd, Wayne NJ 07470. (973)720-2654. E-mail: universitygalleries@wpunj.edu. Website: www.wpunj.edu. **Director:** Dr. Nancy Einreinhofer. Nonprofit gallery. Estab. 1968. Interested in emerging and established artists. Sponsors 5 solo and 10 group shows/year. Average display time is 6 weeks. Clients include college, local and New Jersey metropolitan-area community.

Galleries

• The gallery specializes in contemporary art and encourages site-specific installations. They also have a significant public sculpture collection and welcome proposals.

Media Considers all media.

Style Specializes in contemporary and historic styles, but will consider all styles.

Terms Accepts work for exhibition only. Gallery provides insurance, promotion and contract; shipping costs are shared.

Submissions Send query letter with résumé, brochure, slides, photographs and SASE. Write for appointment to show portfolio. Finds artists through submissions, referrals and exhibits.

WALKER-KORNBLUTH ART GALLERY

7-21 Fair Lawn Ave., Fair Lawn NJ 07410. (201)791-3374. **Director:** Sally Walker. Retail gallery. Estab. 1965. Represents 20 mid-career and established artists/year. Exhibited artists include Stuart Shils, Larry Horowitz and Richard Segalman. Sponsors 8 shows/year. Open Tuesday-Saturday, 10-5:30; Sunday, 1-5; closed August. 2,000 sq. ft., 1920's building (brick), 2 very large display windows. 75% of space for special exhibitions; 25% of space for gallery artists. Clientele: mostly professional and business people. 85% private collectors, 15% corporate collectors. Overall price range: $400-45,000; most work sold at $1,000-4,000.

Media Considers all media except installation. Considers all types of original prints (no limited edition prints). Most frequently exhibits oil, watercolor, pastel and monoprints.

Style Exhibits: painterly abstraction, impressionism, realism, landscapes, figurative work. Prefers painterly realism, impressionism.

Terms Accepts work on consignment (40-50% commission). Retail price set by the gallery and the artist. Gallery provides insurance and promotion; shipping costs are shared. Prefers artwork framed.

Submissions "We don't usually show local artists." Send query letter with résumé, slides, reviews and SASE. Write for appointment to show portfolio of transparencies and slides. Files slides. Finds artists through word of mouth, referrals by other artists, visiting exhibitions and submissions.

Tips "If you've never shown in a commercial gallery, please don't send slides. Have some idea of the kind of work we show; submitting inappropriate work is a waste of everyone's time."

NEW MEXICO

☑ THE ALBUQUERQUE MUSEUM

2000 Mountain Rd. NW, Albuquerque NM 87104. (505)243-7255. **Curator of Art:** Doug Fairfield. Nonprofit museum. Estab. 1967. Interested in emerging, mid-career and established artists. Sponsors mostly group shows. Average display time is 3-6 months. Located in Old Town (near downtown).

Media Considers all media.

Style Exhibits all styles. Genres include landscapes, florals, Americana, western, portraits, figurative and nonobjective work. "Our shows are from our permanent collection or are special traveling exhibitions originated by our staff. We also host special traveling exhibitions originated by other museums or exhibition services."

Submissions Send query letter, résumé, slides, photographs and SASE. Call or write for appointment to show portfolio.

Tips "Artists should leave slides and biographical information in order to give us a reference point for future work or to allow future consideration."

ℕ BAREISS GALLERY

15 Route 150, Box 2739, Taos NM 87571. (505)776-2284. E-mail: pbareiss@newmex.com. Website: www.taosar tappraisal.com. **Owner:** Philip Bareiss. Retail gallery and 3-acre sculpture park. Estab. 1989 at current location "but in business over ten years in Taos." Represents 21 mid-career and established artists. Exhibited artists include Jim Wagner and Patricia Sanford. Sponsors 8 shows/year. Average display time 2 months. Open all year. "Located in the countryside, close to town next to Taos Pueblo reservation under stunning aspect of Taos Mountain.; 4,000 sq. ft.; gallery is unique metal building with sculptural qualities, walls 10-20 ft. high." Clientele: 99% private collectors, 1% corporate collectors. Overall price range: $250-65,000.

Media Most frequently exhibits outdoor sculpture, paintings and monotypes.

Styles Exhibits all styles and genres, including abstract. Interested in seeing original contemporary art, especially outdoor sculpture by artists who are committed to being represented in Taos.

Terms Accepts work on consignment (varying commission). Gallery provides contract; artist pays for shipping.

Submissions Currently interested in outdoor sculpture. Send query letter with photographs. Do not send slides. Write for appointment to show portfolio of photographs. Responds only if interested. Files résumés and photos only if interested.

Tips "Gallery representation should be seen as only one part of an artist's promotional effort. An artist would

do well to have an active market before looking to a gallery. We offer Taos Art Appraisal, expert appraisal of Western and Southwestern art. Free initial consultation (including estimates)."

BENT GALLERY AND MUSEUM

117 Bent St., Box 153, Taos NM 87571. (505)758-2376. **Owner:** Tom Noeding. Retail gallery and museum. Estab. 1961. Represents 15 emerging, mid-career and established artists. Exhibited artists include E. Martin Hennings, Charles Berninghaus, C.J. Chadwell and Leal Mack. Open all year. Located 1 block off of the Plaza; "in the home of Charles Bent, the first territorial governor of New Mexico." 95% of sales are to private collectors, 5% corporate collectors. Overall price range: $100-10,000; most work sold at $500-1,000.

Media Considers oil, acrylic, watercolor, pastel, pen & ink, drawings, sculpture, original handpulled prints, woodcuts, engravings and lithographs.

Style Exhibits: impressionism and realism. Genres include traditional, landscapes, florals, southwestern and western. Prefers: impressionism, landscapes and western works. "We continue to be interested in collectors' art: deceased Taos artists and founders' works."

Terms Accepts work on consignment (33⅓-50% commission). Retail price set by gallery and artist. Artist pays for shipping. Prefers artwork framed.

Submissions Send query letter with brochure and photographs. Write for appointment to show portfolio of originals and photographs. Responds if applicable.

Tips "It is best if the artist comes in person with examples of his or her work."

N PETER ELLER GALLERY & APPRAISERS

206 Dartmouth NE, Albuquerque NM 87106. (505)268-7437. Fax: (505)268-6442. E-mail: pelgal@nmia.com. For-profit gallery. Estab. 1981. Approached by 20 artists a year. Exhibits established artists. Sponsors 2-3 exhibits/year. Average display time 4-5 weeks. Open all year; Wednesday-Friday, 1-5; weekends, 11-4. A small gallery in Albuquerque's historic Nob Hill, specializing in Albuquerque artists and minor New Mexico masters, 1925-1985. Overall price range: $1,000-75,000.

Media Considers acrylic, ceramics, drawing, mixed media, oil, pastel, pen & ink, sculpture, watercolor, engravings, etchings, linocuts, lithographs, mezzotints, serigraphs and woodcuts. Most frequently exhibits oil, sculpture and acrylic.

Style Considers all styles and genres. Most frequently exhibits Southwestern realism and geometric abstraction.

Terms Primarily accepts resale works. Holds shows for contemporary artists occasionally.

Submissions Call or write to arrange a personal interview to show portfolio or photographs. Finds artists through word of mouth and art exhibits.

516 MAGNIFICO ARTSPACE

516 Central SW, Albuquerque NM 87102. (505)242-8244. Fax: (505)242-0174. E-mail: melody@magnifico.org. Website: www.magnifico.org. **Executive Director:** Suzanne Sbarge. Associate Director: Melody Mock. Alternative space, nonprofit. Estab. 1999. Approached by 100 artists/year. Sponsors 10 exhibits/year. Average display time 1 month. Open all year; Tuesday-Saturday, 12-5. Closed between exhibitions. Located in downtown Albuquerque; features track lighting, cement floors and is 3,000 sq. ft. total; handicap accessible; approximately 90 ft. deep and 22 ft. wide, the east wall has 3 divider panels which divide the space into 4 areas; the front section is 2 stories high and lit by north facing glasswall. Overall price range: $300-10,000.

Media Considers contemporary works in all media. Most frequently exhibits painting, photography and sculpture. Considers all types of prints except posters.

Style Considers all styles particularly contemporary works.

Terms Retail price set by the artist. Gallery provides insurance and contract. Requests 50% commission of works sold.

Submissions Call or visit website for proposal information and entry form. Exhibition proposals are reviewed by committee. Returns material with SASE. Responds in 3 months after the visual arts advisory committee meets. Files all selected materials; if not selected we will file the proposal and résumé. Finds artists through submissions, and proposals to gallery and referrals from our committee.

Tips "Call for submission information and send only the required information. Write a specific and detailed proposal for the exhibition space. Do not send unsolicited materials, or portfolio, without the application materials from the gallery. Please call if you have questions about the application or your proposal."

N GIACOBBE-FRITZ FINE ART

702 Canyon Rd., Santa Fe NM 87501. (505)986-1156. Fax: (505)986-1158. E-mail: art@giacobbefritz.com. Website: www.giacobbefritz.com. **Contact:** Artist Submissions. For-profit gallery. Estab. 2000. Approached by 300+ artists/year. Represents 12 emerging, mid-career and established artists. Exhibited artists include: Connie Dillman (painting) and Tom Corbin (sculpture). Sponsors 12-20 exhibits/year. Average display time 2 weeks. Open

all year; Monday-Saturday, 10 to 5; Sunday from 12 to 4. Located on prestigious Canyon Rd. in top Santa Fe art market. Classic adobe with 5 exhibit rooms. Clients include local community, tourists and upscale.

Media Considers acrylic, collage, mixed media, oil, pastel, sculpture, watercolor and etchings. Prints include etchings and mezzotints. Most frequently exhibits oil, sculpture and acrylic.

Style Exhibits: impressionism, abstract and realism. Considers all styles including expressionism, impressionism, surrealism and patinerly abstraction. Genres include figurative work, landscapes and figures.

Terms Artwork is accepted on consignment and there is a 50% commission. Retail price set by the gallery. Gallery provides insurance, promotion and contract. Accepted work should be framed. Requires exclusive representation locally. No agents.

Submissions Call, write, or e-mail to arange personal interview to show portfolio of photographs, transparencies and slides. Prefers to receive e-mailed portfolios. Send query letter with artist's statement, bio, photocopies, photographs, SASE, slides and CD. Returns material with SASE only. Responds to queries in 2 weeks. Finds artists through art fairs, art exhibits, portfolio reviews, referrals by other artists, submissions, word of mouth.

Tips "Enclose SASE, brief query letter, and a few samples of your best work."

THE HARWOOD MUSEUM OF ART

238 Ledoux St., Taos NM 87571-6004. (505)758-9826. Fax: (505)758-1475. E-mail: harwood@unm.edu. **Contact:** Charles Lovell or David Witt, curator. Museum. Estab. 1923. Approached by 100 artists/year. Represents more than 200 emerging, mid-career and established artists. Exhibited artists include: Agnes Martin (painting) and Chuck Close (painting). Sponsors 10 exhibits/year. Average display time 2 months. Open all year; Tuesday-Saturday, 10-5; Sunday, 1-5. Consists of 7 galleries, 2 of changing exhibitions. Clients include local community, students and tourists. 1% of sales are to corporate collectors. Overall price range: $5,000-10,000; most work sold at $2,000.

Media Considers all media and all types of prints.

Style Considers all styles and genres.

Terms Artwork is accepted on consignment and there is a 25% commission. Retail price set by the artist. Gallery provides insurance and contract. Accepted work should be framed, mounted and matted. Does not require exclusive representation locally.

Submissions Mail portfolio for review. Send query letter with artist's statement, bio, brochure, résumé, reviews, SASE and slides. Responds in 3 months. Returns slides. Files everything else. Finds artists through word of mouth, submissions, art exhibits and referrals by other artists.

Tips Professional presentation and quality work are imperative.

CHARLOTTE JACKSON FINE ART

200 W. Marcy St., #101, Santa Fe NM 87501. (505)989-8688. Fax: (505)989-9898. E-mail: cgjart@aol.com. Webiste: www.charlottejackson.com. **Contact:** Charlotte Jackson, director. For-profit gallery. Estab. 1989. Approached by 50 artists/year; exhibits 25 emerging, mid-career and established artists/year. Exhibited artists include Joseph Marioni and Florence Pierce. Sponsors 12 exhibits/year. Average display time 3-4 weeks. Open all year; Tuesday-Friday, 10-5:30, Saturday, 11-4. Located in 2 exhibition spaces and offices. Clients include local community and upscale.

Media Considers acrylic, drawing, oil and watercolor. Reductive work only. Emphasis on monochrome painting.

Style Exhibits reductive style.

Terms Retail price of the art set by the artist. Gallery provides promotion. Requires exclusive representation locally. Prefers only reductive and monochrome.

Submissions Mail portfolio for review or send query letter with bio, photographs, SASE and slides. Returns material with SASE. Responds to queries in 6 months.

☑ MARGEAUX KURTIE MODERN ART

39 Yerba Buena, Cerrillos NM 87010. (505)473-2250. E-mail: mkmamadrid@att.net. Website: www.mkmamadr id.com. **Contact:** Jill Alikas St. Thomas, director. Art consultancy. Estab. 1996. Approached by 200 artists/year. Represents 13 emerging, mid-career and established artists. Exhibited artists include: Thomas St. Thomas, mixed media painting and sculpture; Gary Groves, color infrared film photography. Sponsors 8 exhibits/year. Average display time 5 weeks. Open Thursday-Tuesday, 11-5. Closed February. Located within an historic adobe home, 18 miles S.E. of Santa Fe; 5,000 sq. ft. Clients include local community, students and tourists. 5% of sales are to corporate collectors. Overall price range: $500-15,000; most work sold at $2,800.

Media Considers acrylic, glass, mixed media, paper, sculpture. Most frequently exhibits acrylic on canvas, oil on canvas, photography.

Style Exhibits: conceptualism, pattern painting. Most frequently exhibits narrative/whimsical, pattern painting, illusionistic. Genres include figurative work, florals.

Terms Artwork is accepted on consignment and there is a 50% commission. Retail price set by the gallery.

Gallery provides insurance. Accepted work should be framed, mounted or matted. Requires exclusive representation locally.

Submissions Website lists criteria for review process. Send query letter with artist's statement, bio, résumé, reviews, SASE, slides, $25 review fee, check payable to gallery. Returns material with SASE. Responds to queries in 1 month. Finds artists through art fairs, art exhibits, portfolio reviews, referrals by other artists, submissions, word of mouth.

Tips "Label all slides, medium, size, title and retail price, send only works that are available."

NEDRA MATTEUCCI GALLERIES

1075 Paseo De Peralta, Santa Fe NM 87501. (505)982-4631. Fax: (505)984-0199. E-mail: inquiry@matteucci.com. Website: www.matteucci.com. **Director of Advertising/Public Relations:** Alex Hanna. For-profit gallery. Estab. 1972. Main focus of gallery is on deceased artists of Taos, Sante Fe and the West. Approached by 20 artists/year. Represents 100 established artists. Exhibited artists include: Dan Ostermiller and Glenna Goodacre. Sponsors 3-5 exhibits/year. Average display time 1 month. Open all year; Monday-Saturday, 8:30-5. Clients include upscale.

Media Considers ceramics, drawing, oil, pen & ink, sculpture and watercolor. Most frequently exhibits oil, watercolor and bronze sculpture.

Style Exhibits: impressionism. Most frequently exhibits impressionism, modernism and realism. Genres include Americana, figurative work, landscapes, portraits, Southwestern, Western and wildlife.

Terms Artwork is accepted on consignment. Retail price set by the gallery and the artist. Requires exclusive representation within New Mexico.

Submissions Write to arrange a personal interview to show portfolio of transparencies. Send query letter with bio, photographs, résumé and SASE.

NEW MILLENNIUM ART/THE FOX GALLERY

217 W. Water, Santa Fe NM 87501. (505)983-2002. **Owner:** S.W. Fox. Retail gallery. Estab. 1980. Represents 12 mid-career artists. Exhibited artists include R.C. Gorman and T.C. Cannon. Sponsors 4 shows/year. Average display time 1 month. Open all year. Located 3 blocks from plaza; 3,000 sq. ft.; "one large room with 19' ceilings." 20% of space for special exhibitions. Clientele: "urban collectors interested in Indian art and contemporary Southwest landscapes." 90% private collectors; 10% corporate collectors.

Media Considers oil, acrylic, watercolor, pastel, mixed media, sculpture, original handpulled prints, offset reproductions, woodcuts, lithographs, serigraphs and posters. Most frequently exhibits acrylic, woodblock prints and posters.

Style Exhibits expressionism and impressionism. Genres include Southwestern.

Terms Accepts artwork on consignment (40% commission). Retail price set by the gallery. Gallery provides insurance and promotion. Shipping costs are shared. Prefers artwork framed.

Submissions Accepts only Native American artists from the Southwest. Send query letter with résumé, brochure, photographs and reviews. Write for appointment to show a portfolio of photographs. Responds in 2 weeks.

Tips "We are primarily interested in art by American Indians; occasionally we take on a new landscapist."

Ⓝ UNIVERSITY ART GALLERY, NEW MEXICO STATE UNIVERSITY

Williams Hall, Box 30001, MSC 3572, University Ave. E. of Solano, Las Cruces NM 88003-8001. (505)646-2545. E-mail: artglry@nmsu.edu. Website: www.nmsu.edu/~artgal. **Director:** Mary Anne Redding. Estab. 1972. Represents emerging, mid-career and established artists. Exhibited artists include Judy Chicago, Joyce & Max Kozloff and Luis Jimenez. Sponsors 5-6 shows/year. Average display time 6-8 weeks. Closed on university holidays. Located at university; 4,600 sq. ft. 100% of space for special exhibitions. Overall price range $200-10,000; most artwork sold at $1,000.

Media Considers all media and all types of prints.

Style Exhibits all styles and genres.

Terms Accepts work on consignment (33% commission). Retail price set by the artist. Shipping costs are paid by the gallery. Prefers artwork framed, or ready to hang.

Submissions Send query letter with résumé, 20 slides, bio, SASE, brochure, photographs, business card and reviews. Write for appointment to show portfolio of originals, photographs, transparencies and slides. Responds in 4 months. Files résumés.

Tips "Tenacity is a must."

NEW YORK

COURTHOUSE GALLERY, LAKE GEORGE ARTS PROJECT

1 Amherst St., Lake George NY 12845. (518)668-2616. Fax: (518)668-3050. E-mail: mail@lakegeorgearts.org. **Gallery Director:** Laura Von Rosk. Nonprofit gallery. Estab. 1986. Approached by 200 artists/year. Exhibits 10-

15 emerging, mid-career and established artists. Sponsors 5-8 exhibits/year. Average display time 5-6 weeks. Open all year; Tuesday-Friday, 12-5; Saturday, 12-4. Closed mid-December to mid-January. Clients include local community, tourists and upscale. Overall price range: $100-5,000; most work sold at $500.

Media Considers all media and all types of prints. Most frequently exhibits painting, mixed media and sculpture.

Style Considers all styles and genres.

Terms Artwork is accepted on consignment and there is a 25% commission. Retail price set by the artist. Gallery provides insurance, promotion and contract. Accepted work should be framed, mounted and matted.

Submissions Mail portfolio for review. Deadline always January 31st. Send query letter with artist's statement, bio, résumé, SASE and slides. Returns material with SASE. Responds in 2 months. Finds artists through word of mouth, submissions, portfolio reviews, art exhibits, art fairs and referrals by other artists.

N EVERSON MUSEUM OF ART

401 Harrison St., Syracuse NY 13202. (315)474-6064. Fax: (315)474-6943. E-mail: everson@everson.org. Website: www.everson.org. **Contact:** Debora Ryan, curator. Museum. Estab. 1897. Approached by many artists/year. Exhibited artists include: Adelaide Alsop Robineau (ceramics), Lynn Underhill, Ron Jude (photography), Robyn Tomlin (video sculpture). Sponsors 22 exhibits/year. Average display time 3 months. Open all year; Tuesday-Friday, 12-5; Saturday, 10-5; Sunday, 12-5. Located in a distinctive I.M. Pei-designed building in downtown Syracuse NY. The museum features 4 large galleries with 24 ft. ceilings, back lighting and oak hardwood, a sculpture court, a children's gallery, a ceramic study center and 5 smaller gallery spaces.

Media Considers all media. Most frequently exhibits painting, ceramics, works on paper, photography and video.

Style Considers all styles and genres. Most frequently exhibits contemporary work, realism and abstraction.

Submissions Send query letter with artist's statement, bio, résumé, reviews, SASE and slides. Returns material with SASE. Responds in 3 months. If interested for future exhibition, files slides, résumé, bio, reviews and artist's statement. Finds artists through submissions, portfolio reviews and art exhibits.

FOCAL POINT GALLERY

321 City Island Ave., City Island NY 10464. Phone/fax: (718)885-1403. E-mail: RonTerner@aol.com. Website: www.FocalPointGallery.com. **Contact:** Ron Terner. Retail gallery and alternative space. Estab. 1974. Interested in emerging and mid-career artists. Exhibited artists include Marguerite Chadwick-Juner (watercolor). Sponsors 2 solo and 6 group shows/year. Average display time 3-4 weeks. Clients include locals and tourists. Overall price range: $175-750; most work sold at $300-500.

Media Considers all media. Most frequently exhibits photography, watercolor, oil. Also considers etchings, giclée, color prints, silver prints.

Style Exhibits all styles. Most frequently exhibits painterly abstraction, conceptualism, expressionism. Genres include figurative work, florals, landscapes, portraits. Open to any use of photography.

Terms Accepts work on consignment (30% commission). Exclusive area representation required. Customer discounts and payment by installment are available. Gallery provides promotion. Prefers artwork framed.

Submissions "Please call for submission information. Do not include résumés. The work should stand by itself. Slides should be of high quality."

Tips "Care about your work."

✓ THE GRAPHIC EYE GALLERY OF LONG ISLAND

402 Main St., Port Washington NY 11050. (516)883-9668. Cooperative gallery. Estab. 1974. Represents 25 artists. Sponsors solo, 2-3 person and 4 group shows/year. Average display time: 1 month. Interested in emerging and established artists. Overall price range: $35-7,500; most artwork sold at $500-800.

Media Considers mixed media, collage, works on paper, pastels, photography, paint on paper, woodcuts, wood engravings, linocuts, engravings, mezzotints, etchings, lithographs, serigraphs, and monoprints.

Style Exhibits impressionism, expressionism, realism, primitivism and painterly abstraction. Considers all genres.

Terms Co-op membership fee plus donation of time. Retail price set by artist. Offers payment by installments. Exclusive area representation not required. Prefers framed artwork.

Submissions Send query letter with résumé, SASE, slides and bio. Portfolio should include originals and slides. "When submitting a portfolio, the artist should have a body of work, not a 'little of this, little of that.' " Files historical material. Finds artists through visiting exhibitions, word of mouth, artist's submissions and self-promotions.

Tips "Artists must produce their *own* work and be actively involved. We have a competitive juried art exhibit annually. Open to all artists who work on paper."

GUILD HALL MUSEUM

158 Main St., East Hampton NY 11937. (516)324-0806. Fax: (516)324-2722. **Contact:** Christina Mossaides Strassfield, curator. Maura Doyle, Assistant Curator. Museum. Estab. 1931. Represents emerging, mid-career and established artists. Sponsors 6-10 shows/year. Average display time 6-8 weeks. Open all year; Wednesday-Sunday, 11-5. 750 running feet; features artists who live and work on eastern Long Island. 85% of space for special exhibitions.

Media Considers all media and all types of prints. Most frequently exhibits painting, prints and sculpture.

Style Exhibits all styles and genres.

Terms Artwork is donated or purchased. Gallery provides insurance and promotion. Artwork must be framed.

Submissions Accepts only artists from eastern Long Island. Send query letter with résumé, slides, bio, brochure, SASE and reviews. Write for appointment to show portfolio of originals and slides. Responds in 2 months.

EDWARD HOPPER HOUSE ART CENTER

82 North Broadway, Nyack NY 10960. Phone/Fax: (845)358-0774. E-mail: edwardhopper.house@verizon.net. Website: www.edwardhopperhouseartcenter.org. **Director:** Cathy Shiga-Gattullo. Nonprofit gallery, historic house. Estab. 1971. Approached by 200 artists/year. Exhibits 100 emerging, mid-career and established artists. Sponsors 11 exhibits/year. Average display time 1 month. Open all year; Thursday-Sunday from 1-5. The house was built in 1858. There are four gallery rooms on the first floor. Clients include local community, students, tourists, upscale. Overall price range: $100-12,000; most work sold at $750.

Media Considers all media and all types of prints except posters. Most frequently exhibits watercolor, photography, oil.

Style Considers all styles and genres. Most frequently exhibits realism, abstraction, expressionism.

Terms Artwork is accepted on consignment and there is a 30% commission. Retail price set by the artist. Gallery provides insurance, promotion and contract. Accepted work should be framed, mounted and matted. Does not require exclusive representation locally.

Submissions Call. Mail portfolio for review. Send query letter with artist's statement, bio, brochure, business card, photocopies, photographs, résumé, reviews, SASE and slides. Returns material with SASE. Responds to queries in 3 weeks. Files all materials unless return specified and paid. Finds artists through art fairs, art exhibits, portfolio reviews, referrals by other artists, submissions and word of mouth.

Tips "When shooting slides, don't have your artwork at an angle and don't have a chair or hands in the frame. Make sure the slides look professional and are an accurate representation of your work."

ISLIP ART MUSEUM

50 Irish Lane, East Islip NY 11730. (516)224-5402. **Director:** M.L. Cohalan. Nonprofit museum gallery. Estab. 1973. Interested in emerging and mid-career artists. Sponsors 14 group shows/year. Average display time is 6 weeks. Clients include contemporary artists from Long Island, New York City and abroad.

Media Considers oil, acrylic, watercolor, pastel, pen & ink, drawings, mixed media, collage, works on paper, sculpture, ceramic, craft, fiber, glass, installation, photography, performance and original handpulled prints. Most frequently exhibits installation, oil and sculpture.

Style Exhibits: Considers all styles, emphasis on experimental. Genres include landscapes, Americana, portraits, figurative work and fantasy illustration. "We consider many forms of modern work by artists from Long Island, New York City and abroad when organizing exhibitions. Our shows are based on themes, and we only present group exhibits. Museum expansion within the next two years will allow for one and two person exhibits to occur simultaneously with the ongoing group shows."

Terms Gallery provides insurance, promotion, contract and shipping.

Submissions Send résumé, brochure, slides and SASE. Slides, résumés, photos and press information are filed. The most common mistake artists make in presenting their work is that "they provide little or no information on the slides they have sent to the museum for consideration."

LIMNER GALLERY

59 Main St., Phoenicia NY 12464. (845)688-7129. E-mail: slowart@aol.com. Website: www.slowart.com. **Director:** Tim Slowinski. Limner Gallery is an artist-owned alternative retail (consignment) gallery. Estab. 1987. Represents emerging and mid-career artists. Hosts periodic thematic exhibitions of emerging artists selected by competition, cash awards up to $1,000. Entry available for SASE or from website. Sponsors 6-8 shows/year. Average display time one month. Open Thursday-Sunda, 12-6; yearround, by appointment. Located in storefront 400 sq. ft. 60-80% of space for special exhibitions; 20-40% of space for gallery artists. Clients include lawyers, real estate developers, doctors, architects. 95% of sales are to private collectors, 5% corporate collectors. Overall price range: $300-10,000.

Media Considers all media, all types of prints except posters. Most frequently exhibits painting, sculpture and works on paper.

Style Exhibits: primitivism, surrealism, political commentary, satire, all styles, postmodern works, all genres. "Gallery exhibits all styles but emphasis is on non-traditional figurative work."

Terms Accepts work on consignment (50% commission). Retail price set by the gallery and the artist. Gallery provides promotion and contract; artist pays shipping costs to and from gallery. Prefers artwork framed.

Submissions Send query letter with résumé, slides, bio and SASE. Call for appointment to show portfolio of originals, photographs, slides and transparencies. Responds in 3 weeks. Files slides, résumé. Finds artists through word of mouth, art publications and sourcebooks, submissions.

⬚ MAIN STREET GALLERY

105 Main Street, P.O. Box 161, Groton NY 13073. Phone/Fax: (607)898-9010. E-mail: maingal@localnet.com. **Director:** Adrienne Smith. For-profit gallery, art consultancy. Estab. 2003. Exhibits 15 emerging, mid-career and established artists. Sponsors 8 exhibits/year. Average display time 5-6 weeks. Open all year; Thursday-Saturday from 11 to 8P.M.; Sunday from from 1-5; closed January and February. Located in the village of Groton in the Finger Lakes Region of New York, 20 minutes to Ithaca; 900 sq. ft. space. Clients include local community, tourists, upscale. Overall price range: $120-5,000.

Media Considers all media. Considers prints, including engravings, etchings, linocuts, lithographs, mezzotints and woodcuts. Most frequently exhibits painting, sculpture, ceramics, prints.

Style Considers all styles and genres.

Terms Artwork is accepted on consignment and there is a 40% commission. Retail price set by the artist. Gallery provides insurance, promotion and contract. Accepted work should be framed, mounted and matted. Requires exclusive representation locally.

Submissions Write to arrange personal interview to show portfolio of photographs and slides. Send query letter with artist's statement, bio, brochure, photographs, résumé, reviews, SASE and slides. Returns material with SASE. Responds to queries only if interested in 4 weeks. Finds artists through art exhibits, portfolio reviews, referrals by other artists, submissions and word of mouth.

Tips 1. After initial submitting of materials, the artist will be set an appointment to talk over work.
2. Slides should be subject matter without background.
3. Artists should send up-to-date résumé and artist's statement.

⬚ PRAKAPAS GALLERY

One Northgate 6B, Bronxville NY 10708. (914)961-5091. Fax: (914)961-5192. E-mail: eugeneprakapas@earthlink.net. Private dealers. Estab. 1976. Represents 50-100 established artists/year. Exhibited artists include: Leger and Hodgkin. Located in suburbs. Clients include institutions and private collectors. Overall price range: $500-500,000.

Media Considers all media with special emphasis on photography.

Style Exhibits all styles. "Emphasis is on classical modernism."

Submissions Finds artists through word of mouth, visiting art fairs and exhibitions. Does not consider unsolicited material.

☑ QUEENS COLLEGE ART CENTER

Benjamin S. Rosenthal Library, Queens College/CUNY, Flushing NY 11367. (718)997-3770. Fax: (718)997-3753. E-mail: suzanna_simor@qc.edu. Website: www.qc.edu/library/art/artcenter.html. **Director:** Suzanna Simor. Curator: Alexandra de Luise. Nonprofit university gallery. Estab. 1955. Exhibits work of emerging, mid-career and established artists. Sponsors approximately 5 shows/year. Average display time 6 weeks. Open all year; when school is in session, hours are: Monday-Thursday, 9-8; Friday, 9-5. Call for summer and other hours. Located in borough of Queens; 1,000 sq. ft. The gallery is wrapped "Guggenheim Museum" style under a circular skylight in the library's atrium. 100% of space for special exhibitions. Clients include "college and community, some commuters." Nearly all sales are to private collectors. Overall price range: up to $10,000; most work sold at $300.

Media Considers all media and all types of prints. Most frequently exhibits paintings, prints, drawings and photographs, smaller sculpture.

Style Exhibits: Considers all styles.

Terms Accepts work on consignment (40% commission). Retail price set by the artist. Gallery provides promotion. Artist pays for shipping costs, announcements and other materials. Prefers artwork framed.

Submissions Cannot exhibit large 3-D objects. Send query letter with résumé, brochure, slides, photographs, reviews, bio and SASE. Responds in 3 weeks. Files all documentation.

Tips "We are interested in high-quality original artwork by anyone. Please send sufficient information."

⬚ ROCKLAND CENTER FOR THE ARTS

27 S. Greenbush Rd., West Nyack NY 10994. (914)358-0877. Fax: (914)358-0971. Website: www.rocklandartcenter.org. **Executive Director:** Julianne Ramos. Nonprofit gallery. Estab. 1972. Exhibits emerging, mid-career and

established artists. 1,500 members. Sponsors 6 shows/year. Average display time 8 weeks. Open September-May. Located in suburban area; 2,000 sq. ft.; "contemporary space." 100% of space for special exhibitions. 100% of sales are to private collectors. Overall price range: $500-50,000; most artwork sold at $1,000-5,000.

Media Considers oil, acrylic, watercolor, pastel, pen & ink, mixed media, sculpture, ceramic, fiber, glass, photography and installation. Most frequently exhibits painting, sculpture and craft.

Style Exhibits all styles and genres.

Terms Accepts work on consignment (33% commission). Retail price set by artist. Gallery provides insurance, promotion and shipping costs to and from gallery. Prefers artwork framed.

Submissions "Proposals accepted from curators only in main gallery. Artists may apply for one-person shows in smaller gallery." Responds in 2 months.

Tips "Curator may propose a curated thematic show of three or more artists. Request curatorial guidelines."

THE SCHOOLHOUSE GALLERIES

3 Owens Rd., Box #300, Croton Falls NY 10519. (914)277-3461. Fax: (914)277-2269. **Director:** Lee Pope. Retail gallery. Estab. 1979. Represents 30 emerging and mid-career artists/year. Exhibited artists include: Randell Reid and Jim Madden. Average display time 1 month. Open all year; Wednesday-Sunday, 1-5. Located in a suburban community of New York City; 1,200 sq. ft.; 70% of space for special exhibitions; 30% of space for gallery artists. Clients include residential, corporate, consultants. 50% of sales are to private collectors, 50% corporate collectors. Overall price range: $75-6,000; most work sold at $350-2,000.

Media Considers oil, acrylic, watercolor, pastel, pen & ink, drawing, mixed media, collage, paper, sculpture, ceramics, fiber and photography, all types of prints. Most frequently exhibits paintings.

Style Exhibits: expressionism, painterly abstraction, impressionism and realism. Genres include landscapes. Prefers: impressionism and painterly abstraction.

Terms Accepts work on consignment (40% commission). Retail price set by the artist. Gallery provides insurance and promotion; shipping costs are shared.

Submissions Send query letter with slides, photographs and SASE. "We will call for appointment to view portfolio of originals." Responds in 2 months. Files slides, bios if interested. Finds artists through visiting exhibitions and referrals.

BJ SPOKE GALLERY

299 Main St., Huntington NY 11743. (631)549-5106. Website: www.bjspokegallery.com. **Contact:** Marilyn Lavi. Cooperative and nonprofit gallery. Estab. 1978. Exhibits the work of 26 emerging, mid-career and established artists. Sponsors 2-3 invitationals and juried shows/year. Average display time 1 month. Open all year. "Located in center of town; 1,400 sq. ft.; flexible use of space—3 separate gallery spaces." Generally, 66% of space for special exhibitions. Overall price range: $300-2,500; most work sold at $900-1,600. Artist is eligible for a 2-person show every 2 years. Entire membership has ability to exhibit work 11 months of the year.

 • Sponsors annual international/national juried show. Deadline November. Send SASE for prospectives.

Media Considers all media except crafts, all types of printmaking. Most frequently exhibits paintings, prints and sculpture. Craft sold separately.

Style Exhibits all styles and genres. Prefers painterly abstraction, realism and expressionism.

Terms Co-op membership fee plus donation of time (25% commission). Monthly fee covers rent, other gallery expenses. Retail price set by artist. Payment by installment is available. Gallery provides promotion and publicity; artists pay for shipping. Prefers artwork framed; large format artwork can be tacked.

Submissions For membership, send query letter with résumé, high-quality slides, bio, SASE and reviews. For national juried show send SASE for prospectus and deadline. Call or write for appointment to show portfolio of originals and slides. Files résumés; may retain slides for awhile if needed for upcoming exhibition.

Tips "Send slides that represent depth and breadth in the exploration of a theme, subject or concept. They should represent a cohesive body of work."

Ⓝ UPSTREAM GALLERY

26 Main Street, Dobbs Ferry NY 10522. (914)674-8548. E-mail: upstreamgallery@aol.com. Cooperative gallery. Estab. 1990. Exhibits 24 mid-career artists. Sponsors 11 exhibits/year. Average display time 1 month. Open Thursday-Sunday, 12:30-5:30; closed July and August. We have two store fronts approx. 15×30 each. Clients include local community, upscale and our own clients. Overall price range: $300-2,000; most work sold at $500.

Media Considers acrylic, collage, drawing, installation, mixed media, oil, paper, pastel, pen & ink, sculpture and watercolor. Considers all types of prints.

Style Considers all styles and genres. Most frequently exhibits impressionism, abstract and neo-expressionism.

Terms There is a co-op membership fee plus a donation of time. There is a 10% commission. Retail price set by the artist. Gallery provides insurance. Accepted work should be framed, mounted and matted. Does not require exclusive representation locally.

Submissions Write to arrange personal interview to show portfolio of photographs and slides. Also include artist's statement, bio, brochure, business card, photographs, résumé, reviews, SASE and slides. Returns material with SASE. Responds to queries in 2 months. Finds artists through referrals by other artists and submissions.

WINDHAM FINE ARTS

5380 Main Street, Windham NY 12496. (518)734-6850. E-mail: info@windhamfinearts.com. Website: www.windhamfinearts.com. **Director:** Victoria Alten. For-profit gallery, art consultancy. Estab. 2001. Exhibits around 40 emerging, mid-career and established artists. Exhibited artists include: Stoyshzn Kzrner (modern) and Kevin Cook (Hudson River School). Sponsors 12 exhibits/year. Average display time 1 month. Open all year; Friday-Monday from 11 to 5; weekends from 11 to 5. Clients include local community, tourists and upscale. 5% of sales are to corporate collectors. Most work sold at $2,000-10,000.

Media Considers all media. Considers print types including etchings and woodcuts.

Style Exhibits expressionism, impressionism, postmodernism and painterly abstraction. Genres include Americana, figurative work, florals and landscapes.

Terms Artwork is accepted on consignment and there is a 45% commission. Gallery provides insurance, promotion and contract. Accepted work should be framed, mounted and matted. Requires exclusive representation locally.

Submissions Call or write to arrange personal interview to show portfolio of photographs and CDs. Send query letter with artist's statement, bio, photocopies, photographs, résumé, reviews and CD. Responds to queries in 2 weeks. Files name, contact information and images. Finds artists through art exhibits, portfolio reviews, referrals by other artists, submissions and word of mouth.

NEW YORK CITY

ADC GALLERY

106 W. 29th St., New York NY 10001. (212)643-1440. Fax: (212)643-4266. Website: www.adcglobal.org. **Executive Director:** Myrna Davis. Nonprofit gallery. Exhibits groups in the field of visual communications (advertising, graphic design, publications, art schools). Estab. 1920. Exhibits emerging and professional work; 6-8 shows/year. Average display time 1 month. Closed August; Monday-Friday, 10-6. Located in Chelsea district; 4,500 sq. ft.; 1 gallery street level. 100% of space for special exhibitions. Clients include professionals, students.

Media Considers all media and all types of prints. Most frequently exhibits posters, printed matter, photos, digital media and 3-D objects.

Style Genres include advertising, graphic design, publications, packaging, photography, illustration and interactive media.

Terms The space is available by invitation and/or approved rental.

Submissions Submissions are through professional groups. Group rep should send reviews and printed work. Responds within a few months.

AESTHETIC REALISM FOUNDATION/TERRAIN GALLERY

141 Greene Street, New York NY 10012. E-mail: Terrain@AestheticRealism.org. Website: www.TerrainGallery.org. **Coordinator:** Carrie Wilson. Nonprofit gallery. Estab. 1955. Exhibits emerging, mid-career and established artists. Open all year; Wednesday-Saturday from 2 to 5. The gallery is located on the first floor of the Aesthetic Realism Foundation building, approximately 26×100 feet. Clients include local community, students, tourists and upscale. Overall price range: $150-1,500; most work sold at $250. Prospective buyers deal directly with the artists.

Media Considers acrylic, collage, drawing, mixed media, oil, pastel, pen & ink and watercolor. Considers all types of prints except posters. Most frequently exhibits oil paintings, prints and photographs.

Style Exhibits: expressionism, geometric abstraction and painterly abstraction. Considers all styles. Most frequently exhibits realism, painterly and geometric abstraction.

Terms The gallery exhibits but does not sell work and there is no commission. Prospective buyers deal directly with the artists. Retail price set by the artist. Gallery provides promotion. Accepted work should be framed. Does not require exclusive representation locally.

Submissions Send query letter with artist's statement, bio, résumé, reviews, SASE, slides and computer printouts. Returns material with SASE. Responds to queries in 4 weeks. Finds artists through art exhibits, portfolio reviews, referrals by other artists and submissions.

AGORA GALLERY

415 W. Broadway, Suite 5B, New York NY 10012. (212)226-4151, ext. 206. Fax: (212)966-4380. E-mail: Angela@Agora-Gallery.com. Website: www.Agora-Gallery.com. **Director:** Angela DiBello. For-profit gallery. Estab. 1984.

Approached by 1,500 artists/year. Exhibits 100 emerging, mid-career and established artists. Sponsors 10 exhibits/year. Average display time 3 weeks. Open all year; Tuesday-Saturday, 12-6; weekends, 12-6. Closed national holidays. Located in Soho between Prince and Spring; 2,000 sq. ft. of exhibition space, landmark building; elevator to gallery, exclusive gallery block. Clients include upscale. 10% of sales are to corporate collectors. Overall price range: $550-10,000; most work sold at $3,500-6,500.

Media Considers acrylic, collage, digital, drawing, mixed media, oil, pastel, photography, sculpture, watercolor.

Style Considers all styles.

Terms There is a representation fee. There is a 35% commission to the gallery; 65% to the artist. Retail price set by the gallery and the artist. Gallery provides insurance and promotion. Does not require exclusive representation locally.

Submissions Mail portfolio for review or upload to our website. Send artist's statement, bio, brochure, photographs, reviews if available, SASE. Responds in 3 weeks. Files bio, slides/photos and artist statement. Finds artists through word of mouth, submissions, portfolio reviews, art exhibits, referrals by other artists and website links.

Tips "Follow instructions!"

THE ARSENAL GALLERY

The Arsennal Bldg., Central Park, New York NY 10021. (212)360-8163. Fax: (212)360-1329. E-mail: adrian.sas@parks.nyc.gov. Website: www.nyc.gov/parks. **Public Art Curator:** Adrian Sas. Nonprofit gallery. Estab. 1971. Approached by 100 artists/year. Exhibits 8 emerging, mid-career and established artists. Sponsors 10 exhibits/year. Average display time 1 month. Open all year; Monday-Friday, 9-5. Closed holidays and weekends. 100 linear feet of wall space on the 3rd floor of the Administrative Headquarters of the Parks Department located in Central Park. Clients include local community, students, tourists and upscale. Overall price range: $100-1,000.

Media Considers all media and all types of prints except 3-dimensional work.

Style Considers all styles. Genres include florals, landscapes and wildlife.

Terms Artwork is accepted on consignment and there is a 15% commission. Retail price set by the artist. Gallery provides promotion. Does not require exclusive representation locally.

Submissions Mail portfolio for review. Send query letter with artist's statement, bio, brochure, business card, photocopies, résumé, reviews and SASE. Returns material with SASE. Responds only if interested within 6 months. Riles résumé and photocopies. Finds artists through word of mouth, portfolio reviews, art exhibits and referrals by other artists.

Tips Appear organized and professional.

CITYARTS, INC.

525 Broadway, Suite 700, New York NY 10012. (212)966-0377. Fax: (212)966-0551. E-mail: tsipi@cityarts.org. Website: www.cityarts.org. **Executive and Artistic Director:** Tsipi Ben-Haim. Art consultancy, nonprofit public art organization. Estab. 1968. Represents 1,000 emerging, mid-career and established artists. Produces 4-8 projects/year. Average display time varies. "A mural or public sculpture will last up to 15 years." Open all year; Monday-Friday, 10-5. Located in Soho; "the city is our gallery. CityArts's 200 murals are located in all 5 boroughs on NYC. We are funded by foundations, corporations, government and membership ('Friends of CityArts')."

Media Considers oil, acrylic, drawing, sculpture, mosaic and installation. Most frequently exhibits murals (acrylic), mosaics and sculpture.

Style Produces all styles and all genres depending on the site.

Terms Artist receives a flat commission for producing the mural or public art work. Retail price set by the gallery. Gallery provides insurance, promotion, contract, shipping costs.

Submissions "We prefer New York artists due to constant needs of a public art work created in the city." Send query letter with SASE. Call for appointment to show portfolio of originals, photographs and slides. Responds in 1 month. "We reply to original query with an artist application. Then it depends on commissions." Files application form, résumé, slides, photos, reviews. Finds artists through recommendations from other art professionals.

Tips "We look for artists who are dedicated to making a difference in people's lives through art, working in collaboration with schools and community members."

CJG PROJECTS INTERNATIONAL, INC.

POB 202 Prince Street Station, New York NY 10012. **Director:** Cortland Jessup. Estab. 1990. Represents mid-career and established artists. Exhibited artists include Juliet Holland, Patrick Webb and Kate Millett. Sponsors 6 shows/year. Average display time 6 weeks. Wednesday-Saturday, 12-5:30. "We curate special exhibitions in various project spaces international."

Media Considers all media.

Style Prefers mixed media painterly abstraction, conceptual neo-expressionism and periodically, figurative works and special emphasis on photography by mid-career or established artists.

Terms Accepts work on consignment. 60/40 split on sales, 60% to artist, 40% to gallery.

Submissions Send résumé, slides, bio and SASE. Responds only if interested. Files material of interest or for consideration for future projects. Finds artists through word of mouth, referrals by other artists, travel and submissions.

Tips "Don't walk in with slides and/or art under arm and expect to be seen. We will look only if sent by mail with SASE—and we will never look at original art work carried in without appointment. We are highly selective and slides are reviewed regularly for the projects/exhibitions being produced."

N CLAMPART

531 W. 25th Street, New York NY 10001. E-mail: info@clampart.com. Website: www.clampart.com. **Director:** Brian Clamp. For-profit gallery. Estab. 2000. Approached by 1200 artists/year. Represents 15 emerging, mid-career and established artists. Exhibited artists include: Arthur Tress (photography) and Joyce Tenneson (photography). Sponsors 6 exhibits/year. Average display time 2 months. Open Tuesday-Saturday from 11 to 6; closed last two weeks of August. Located on the ground floor on Main Street in Chelsea. Small exhibition space. Clients include local community, tourists and upscale. 5% of sales are to corporate collectors. Overall price range: $300-50,000; most work sold at $2,000.

Media Considers acrylic, collage, drawing, mixed media, oil, paper, pastel, pen & ink and watercolor. Considers all types of prints. Most frequently exhibits photo, oil and paper.

Style Exhibits: conceptualism, geometric abstraction, minimalism and postmodernism. Considers genres including figurative work, florals, landscapes and portraits. Most frequently exhibits postmodernism, conceptualism and minimalism.

Terms Artwork is accepted on consignment and there is a 50% commission. Retail price set by the gallery. Gallery provides insurance, promotion and contract. Accepted work should be framed, mounted and matted. Does not require exclusive representation locally.

Submissions E-mail query letter with artist's statement, bio and JPGS. Cannot return material. Responds to queries in 2 weeks. Files JPGS. Finds artists through portfolio reviews, referrals by other artists and submissions.

Tips "Include a bio and well-written artist statement. Do not submit work to a gallery that does not handle the general kind of work you produce."

CORPORATE ART PLANNING INC.

27 Union Square W., Suite 407, New York NY 10003. (212)242-8995. Fax: (212)242-9198. **Principal:** Maureen McGovern. Fine art exhibitors, virtual entities. Estab. 1986. Represents 2 illustrators, 2 photographers, 5 fine artists (includes 1 sculptor). Guidelines available for #10 SASE. Markets include: corporate collections; design firms; editorial/magazines; publishing/books; art publishers; private collections. Represents: Richard Rockwell, Suzanne Brookers, Michael Freidman and Barry Michlin.

Handles Fine art only.

Terms Consultant receives 50%. For promotional purposes, prefers all artists have museum connections and auction profiles. Advertises in *The Workbook, Art in America,* Americans for the Arts, in NYC, Art Now Gallery Guide, and five targeted industry guides.

How to Contact Will contact artist if artwork is requested by the corporate board. Portfolio should include color photocopies only (nonreturnable).

STEPHEN E. FEINMAN FINE ARTS LTD.

448 Broome St., New York NY 10012. (212)925-1313. E-mail: sef29@aol.com. **Contact:** S.E. Feinman. Retail/wholesale gallery. Estab. 1972. Represents 20 emerging, mid-career and established artists/year. Exhibited artists include: Mikio Watanabe, Johnny Friedlaender, Andre Masson, Felix Sherman, Nick Kosciuk, Robert Trondsen and Miljenko Bengez. Sponsors 4-6 shows/year. Average display time 10 days. Open all year; Monday-Sunday, 12-6. Located in Soho; 1,000 sq. ft. 100% of space for gallery artists. Clients include prosperous middle-aged professionals. 90% of sales are to private collectors, 10% corporate collectors. Overall price range, $300-20,000; most work sold at $1,000-3,500.

Media Considers oil, acrylic, watercolor, pastel, pen & ink, drawing, mixed media, sculpture, woodcuts, engravings, lithographs, mezzotints, serigraphs, linocuts and etchings. Most frequently exhibits mezzotints, aquatints and oils. Looking for artists that tend toward abstract-expressionists (watercolor/oil or acrylic) in varying sizes.

Style Exhibits representational, painterly abstraction and surrealism, all genres. Prefers abstract, figurative, representative and surrealist.

Terms Consignment. Retail price set by the gallery. Gallery provides insurance, promotion, contract and shipping costs from gallery; artist pays shipping costs to gallery. Artwork must be unframed.

Submissions Send query letter with résumé, slides and photographs. Responds in 3 weeks. No submissions by e-mail.

Tips Currently seeking representative paintings and artists of quality who see a humorous bent in their works (sardonic, ironic) and are not pretentious. "Artists who show a confusing presentation drive me wild. Artists should remember that dealers and galleries are not critics. They are merchants who try to seduce their clients with aesthetics. Artists who have a chip on their shoulder or an 'attitude' are self-defeating. A sense of humor helps!"

FIRST STREET GALLERY

526 W. 26th St., #915, New York NY 10001. (646)336-8053. Fax: (646)336-8054. E-mail: firststreetgallery@earthl ink.net. Website: www.firststreetgallery.net. or www.artincontext.org. Contact: Members Meeting. Cooperative gallery. Estab. 1964. Represents emerging and mid-career artists. 22 members. Sponsors 10-13 shows/year. Average display time 1 month. Open Tuesday-Saturday, 11-6. Closed in August. 100% of space for gallery artists. Clients include collectors, consultants, retail. 50% of sales are to private collectors, 50% corporate collectors. Overall price range: $500-40,000; most work sold at $1,000-3,000.

Media Considers oil, acrylic, watercolor, pastel, drawing, prints, sculpture. Considers prints "only in connection with paintings." Most frequently exhibits oil on canvas and works on paper.

Style Exhibits: representational art. Genres include landscapes and figurative work. "First Street's reputation is based on showing representational art almost exclusively."

Terms Co-op membership fee plus a donation of time (no commission). "We occasionally rent the space in August for $1,500-3,000." Retail price set by the artist. Artist pays shipping costs to and from gallery.

Submissions Send query letter with résumé, slides, bio and SASE. "Artists' slides reviewed by membership at meetings once a month—call gallery for date in any month. We need to see original work to accept a new member." Responds in 1 month.

Tips "Before approaching a gallery make sure they show your type of work. Physically examine the gallery if possible. Try to find out as much about the gallery's reputation in relation to its artists (many well-known galleries do not treat artists well). Show a cohesive body of work with as little paperwork as you can, no flowery statements, the work should speak for itself. You should have enough work completed in a professional manner to put on a cohesive-looking show."

ⓝ FISCHBACH GALLERY

210 Eleventh Ave., New York NY 10001. (212)759-2345. Fax: (212)366-1783. E-mail: info@fischbachgallery.c om. Website: www.fischbachgallery.com. **Director:** Lawrence DiCarlo. Retail gallery. Estab. 1960. Represents 30 emerging, mid-career and established artists. Sponsors 12 shows/year. Average display time 1 month. Open all year. Located in midtown; 3,500 sq. ft. 80% of space for special exhibitions. Clients include private, corporate and museums. 70% of sales are to private collectors, 30% corporate collectors. Overall price range: $3,000-300,000; most work sold at $10,000-20,000.

Media Considers oil, acrylic, watercolor, pastel, pen & ink and drawings. Interested in American contemporary representational art; oil on canvas, watercolor and pastel.

Style Exhibits: contemporary American realism. Genres include landscapes, florals, figurative work and still lifes. Prefers landscapes, still lifes and florals.

Terms Accepts artwork on consignment (50% commission). Retail price set by gallery. Gallery provides promotion and shipping costs from gallery.

Submissions Send query letter with résumé, slides, bio and SASE. Portfolio should include slides. Responds in 1 week.

Tips "No videotapes—slides only with SASE. All work is reviewed."

GALLERY@49

322 W. 49th St., New York NY 10019. (212)767-0855. Fax: (212)664-1534. E-mail: info@gallery49.com. Website: www.gallery49.com. **Contact:** Monica or Coca Rotaru. For-profit gallery. Estab. 1998. Approached by 800 artists/year; exhibits 15 emerging, mid-career and established artists. Exhibited artists include Librado Romero (painting) and Judith Wilde (painting). Sponsors 10 exhibits/year. Average display time is 1 month. Open all year; Tuesday-Saturday, 12-6. Located in Midtown Manhattan's Theater District, ground-floor, bi-level gallery, 1,200 square feet. Clients include local community and tourists. 5% of sales are to corporate collectors. Overall price range is $500-20,000; most work sold at $3,000.

Media Considers all media. Most frequently exhibits painting, drawing and mixed media. Also considers engravings, etchings and lithographs.

Style Exhibits conceptualism, neo-expressionism, postmodernism and painterly abstraction. Most frequently exhibits painterly abstraction.

Terms Artwork is accepted on consignment and there is a 50% commission. Retail price of the art set by the

gallery and the artist. Gallery provides insurance, promotion and contract. Accepted work should be framed. Does not require exclusive representation locally.

Submissions Send query letter with artist's statement, bio, photographs, résumé, reviews and SASE. Returns material with SASE. Responds to queries only if interested in 6 months. Files photographs and resume. Finds artists through art fairs, portfolio reviews, referrals by other artists.

Tips "Before submitting any material, artists should become familiar with the gallery and be sure their work is compatible with its aesthetic."

GALLERY JUNO

568 Broadway, Suite 604B, New York NY 10012. (212)431-1515. Fax: (212)431-1583. **Gallery Director:** June Ishihara. Retail gallery, art consultancy. Estab. 1992. Represents 18 emerging artists/year. Exhibited artists include: Pierre Jacquemon, Kenneth McIndoe and Otto Mjaanes. Sponsors 8 shows/year. Average display time 6 weeks. Open all year; Tuesday-Saturday, 11-6. Located in Soho; 1,000 sq. ft.; small, intimate space. 50% of space for special exhibitions; 50% of space for gallery artists. Clients include corporations, private, design. 20% of sales are to private collectors, 80% corporate collectors. Overall price range: $600-10,000; most work sold at $2,000-5,000.

Media Considers oil, acrylic, watercolor, pastel, pen & ink, drawing, mixed media. Most frequently exhibits painting and works on paper.

Style Exhibits: expressionism, neo-expressionism, painterly abstraction, pattern painting and abstraction. Genres include landscapes. Prefers: contemporary modernism and abstraction.

Terms Accepts work on consignment (50% commission). Retail price set by the gallery and the artist. Gallery provides insurance and promotion; artist pays shipping costs. Prefers artwork framed.

Submissions Send query letter with résumé, slides, bio, photographs, SASE, business card and reviews. Write for appointment to show portfolio of originals, photographs and slides. Responds in 3 weeks. Files slides, bio, photos, résumé. Finds artists through visiting exhibitions, word of mouth and submissions.

JEANETTE HENDLER

55 E. 87th St., Suite 15E, New York NY 10128. (212)860-2555. Fax: (212)360-6492. Art consultancy. Exhibits established artists. Exhibited artists include: Warhol, DeKooning and Haring. Open all year by appointment. Located uptown. 50% of sales are to private collectors, 50% corporate collectors.

Media Considers oil and acrylic. Most frequently exhibits oils, acrylics and mixed media.

Style Exhibits: Considers all styles. Genres include landscapes, florals, figurative and Latin. Prefers: realism, classical, neo classical, pre-Raphaelite, still lifes and florals.

Terms Artwork is accepted on consignment and there is a commission. Retail price set by the gallery and the artist. Gallery provides insurance, promotion and contract.

Submissions Finds artists through word of mouth, referrals by other artists, visiting art fairs and exhibitions.

Ⓝ HOORN-ASHBY GALLERY

766 Madison Avenue, New York NY 10021. (212)628-3199. Fax: (212)861-8162. E-mail: info@hoornashby.com. Website: www.hoornashby.com. For-profit gallery. Estab. 1990. Approached by 100 artists/year. Exhibits 25 emerging, mid-career and established artists. Exhibited artists include: Donald Jurney (oil/canvas) and Janet Rickus (oil/panel). Sponsors 8 exhibits/year. Average display time for solo shows is 3 weeks. Open September-July, Monday-Saturday 10-6. Closed August and all Sundays, and reduced hours in July. Located on 2nd floor, 766 Madison, Brownstone width and length. Clients include local community, tourists and upscale. 5% of sales are to corporate collectors. Overall price range: $3,000-80,000; most work sold at $10,000.

Media Considers drawing, oil, sculpture, watercolor and tempera. Types of prints include etchings, lithographs and mezzotints. Most frequently exhibits tempera and oil.

Style Exhibits: impressionism and realism. Genres include figurative work, florals, landscapes, wildlife and still life.

Terms Artwork is accepted on consignment. Retail price set by the artist. Gallery provides insurance and promotion. Accepted work should be framed. Requires exclusive representation locally.

Submissions Mail portfolio for review with artist's statement, bio, brochure, photocopies, photographs, résumé, reviews, SASE, slides and retail prices. Responds to queries in 6 weeks to 3 months. Files copies of bio and show invites only if interested for feature. Finds artists through art fairs, art exhibits, portfolio reviews, referrals by other artists, submissions and word of mouth.

Tips "Include return envelope, other show invitations and retail prices of work."

🖼 MICHAEL INGBAR GALLERY OF ARCHITECTURAL ART

568 Broadway, New York NY 10012. (212)334-1100. **Curator:** Millicent Hathaway. Retail gallery. Estab. 1977. Represents 145 emerging, mid-career and established artists. Exhibited artists include: Richard Haas and Judith

Turner. Sponsors 6 shows/year. Average display time 6 weeks. Open all year; Tuesday-Saturday, 12-6. Located in Soho; 1,000 sq. ft. 60% of sales are to private collectors, 40% corporate clients. Overall price range: $500-10,000; most work sold at $5,000.

Media Considers all media and all types of prints. Most frequently exhibits paintings, works on paper and b&w photography.

Style Exhibits: photorealism, realism and impressionism. Specializes in New York City architecture. Prefers: New York City buildings, New York City structures (bridges, etc.) and New York City cityscapes.

Terms Artwork accepted on consignment (50% commission). Artists pays shipping costs.

Submissions Accepts artists only from New York City metro area. Send query letter with SASE to receive "how to submit" information sheet. Responds in 1 week.

Tips "Study what the gallery sells before you go through lots of trouble and waste their time. Be professional in your presentation." The most common mistakes artists make in presenting their work are "coming in person, constantly calling, poor slide quality (or unmarked slides) and not understanding how to price their work."

JADITE GALLERIES

413 W. 50th St., New York NY 10019. (212)315-2740. Fax: (212)315-2793. E-mail: jaditeart@aol.com. Website: www.jadite.com. **Director:** Roland Sainz. Retail gallery. Estab. 1985. Represents 25 emerging and established, national and international artists. Sponsors 10 solo and 2 group shows/year. Average display time 3 weeks. Clientele: 80% private collectors, 20% corporate clients. Overall price range: $500-9,000; most artwork sold at $1,000-3,000.

Media Considers oil, acrylic, watercolor, pastel, pen & ink, drawings, mixed media, collage, sculpture and original handpulled prints. Most frequently exhibits oils, acrylics, pastels and sculpture.

Style Exhibits minimalism, postmodern works, impressionism, neo-expressionism, realism and surrealism. Genres include landscapes, florals, portraits, western collages and figurative work. Features mid-career and emerging international artists dealing with contemporary works.

Terms Accepts work on consignment (40% commission). Retail price set by gallery and artist. Exclusive area representation not required. Gallery provides insurance, promotion and contract; exhibition costs are shared.

Submissions Send query letter, résumé, brochure, slides, photographs and SASE. Call or write for appointment to show portfolio of originals, slides or photos. Resume, photographs or slides are filed.

N HAL KATZEN GALLERY

459 Washington Street, New York NY 10013. Phone/fax: (212)925-9777. E-mail: hkatzen916@aol.com. For-profit gallery. Estab. 1984. Exhibits established artists. Open Monday-Friday from 10 to 6, closed August. Clients include local community, tourists and upscale. 10-20% of sales are to corporate collectors. Overall price range: $2,000-20,000; most work sold at $5,000.

Media Considers acrylic, collage, drawing, oil, paper, pen & ink, sculpture and watercolor. Most frequently exhibits paintings, works on paper and sculpture. Considers all types of prints.

Style Considers all styles and genres.

Terms Artwork is accepted on consignment or is bought outright. Accepts only established artists.

☑ LA MAMA LA GALLERIA

6 E. First St., New York NY 10003. (212)505-2476. **Curator:** Gretchen Green. Nonprofit gallery. Estab. 1981. Exhibits the work of emerging, mid-career and established artists. Sponsors 14 shows/year. Average display time 3 weeks. Open September-June; Thursday-Sunday 1-6. Located in East Village; 2,500 sq. ft. "Large and versatile space." 20% of sales are to private collectors, 20% corporate clients. Overall price range: $500-1,000; most work sold at $500 or less.

Media Considers oil, acrylic, watercolor, pastel, pen & ink, mixed media, collage, fiber, paper, craft. "No performance art." Prefer flat 2-D work. Most frequently exhibits acrylic, watercolor, installation.

Style Considers all types of prints. Considers all styles. Most frequently exhibits postmodernism, expressionism, primitive realism. Genres include pop-culture art, landscapes, cityscapes.

Terms Accepts work on consignment (20% commission). Retail price set by artist, approved by gallery. Artist is responsible for delivery of sales. Artwork must be framed and ready to hang.

Submissions "Call first to see if we are accepting slides at the time. Must include return mailer including postage."

Tips "Most important is to call first to see if I'm currently looking at work. I sometimes make special acceptances. Try to have a clean and neat portfolio or book."

THE MARBELLA GALLERY, INC.

28 E. 72nd St., New York NY 10021. (212)288-7809. **President:** Mildred Thaler Cohen. Retail gallery. Estab. 1971. Represents/exhibits established artists of the nineteenth century. Exhibited artists include: The Ten and

The Eight. Sponsors 1 show/year. Average display time 6 weeks. Open all year; Tuesday-Saturday, 11-5:30. Located uptown; 750 sq. ft. 100% of space for special exhibitions. Clients include tourists and upscale. 50% of sales are to private collectors, 10% corporate collectors, 40% dealers. Overall price range: $1,000-60,000; most work sold at $2,000-4,000.

Style Exhibits: expressionism, realism and impressionism. Genres include landscapes, florals, Americana and figurative work. Prefers Hudson River, "The Eight" and genre.

Terms Artwork is bought outright. Retail price set by the gallery. Gallery provides insurance.

N JAIN MARUNOUCHI GALLERY

24 W. 57th St., New York NY 10019. (212)969-9660. Fax: (212)969-9715. E-mail: jainmar@aol.com. Website: www.jainmargallery.com. **President:** Ashok Jain. Retail gallery. Estab. 1991. Represents 30 emerging artists. Exhibited artists include: Fernando Pomalaza and Pauline Gagnon. Open all year; Tuesday-Saturday, 11-5:30. Located in New York Gallery Bldg., 800 sq. ft. 100% of space for special exhibitions. Clients include corporate and designer. 50% of sales are to private collectors, 50% corporate collectors. Overall price range: $1,000-20,000; most work sold at $5,000-10,000.

Media Considers oil, acrylic and mixed media. Most frequently exhibits oil, acrylic and collage.

Style Exhibits: painterly abstraction. Prefers: abstract and landscapes.

Terms Accepts work on consignment (50% commission). Retail price set by artist. Offers customer discount. Gallery provides contract; artist pays for shipping costs. Prefers artwork framed.

Submissions Send query letter with résumé, brochure, slides, reviews and SASE. Portfolio review requested if interested in artist's work. Portfolio should include originals, photographs, slides, transparencies and reviews. Responds in 1 week. Finds artists through referrals and promotions.

N Y MULTIPLE IMPRESSIONS, LTD.

128 Spring Street, New York NY 10012. (212)925-1313. Fax: (212)431-7146. E-mail: info@multipleimpressions.com. Website: www.multipleimpressions.com. **Contact:** Director. Estab. 1972. For-profit gallery. Approached by 100 artists/year. Represents 50 emerging, mid-career and established artists. Sponsors 5 exhibits/year. Average display time is 2 weeks. Open Monday-Friday from 11 to 6:30; weekends from 12 to 6:30; closed December 29-January 5. Located in the center of Soho, street level, 1,400 sq. ft. mezzanine and full basement. Clients: local community, tourists and upscale. 10% of sales are to corporate collectors. Overall price range: $500-40,000; most work sold at $1,500.

Media Considers oil and pastel and prints of engravings, etchings, lithographs and mezzotints. Most frequently exhibits etchings, oils and pastels.

Styles Exhibits imagism and painterly abstraction. Genres include figurative work, landscapes and abstract.

Terms Artwork is accepted on consignment and there is a 40% commission. Retail price set by the gallery and the artist. Requires exclusive representation locally.

Submissions Send query letter with artist's statement, bio, photocopies, photographs, résumé, SASE, slide and price list. Returns material with SASE. Responds to queries in 1 week. Finds artists through art fairs, portfolio reviews, referrals by other artists, submissions, word of mouth and travel.

THE PAINTING CENTER

52 Greene St., New York NY 10013. Phone/fax: (212)343-1060. E-mail: paintingcenter@aol.com. Website: www.thepaintingcenter.com. **Contact:** Christina Chow, administrative director. Nonprofit, cooperative gallery. Estab. 1993. Exhibits emerging mid-career and established artists. Open all year; Tuesday-Saturday, 11-6; weekends, 11-6. Closed Thanksgiving, Christmas/New Year's Day. Clients include artists, local community, students, tourists and upscale businessmen.

Media Considers all media except: sculpture, photographs and some installations. Most frequently exhibits paintings in oil, acrylic and drawings.

Style Considers all styles and genres.

Terms There is a 20% commission. Retail price set by the artist. Accepted work should be framed and mounted. Does not require exclusive representation locally.

Submissions Mail portfolio for review. Send artist's statement, bio, résumé, SASE and slides. Returns material with SASE. responds in 8 months. Finds artists through word of mouth, submissions, art exhibits and referrals by other artists and curators.

Tips "Submit a letter addressed to the 'review committee,' a sheet of slides of your work, SASE, résumé, and publications/reviews about your work if you have any."

RAYDON GALLERY

1091 Madison Ave., New York NY 10028. (212)288-3555. **Director:** Alexander R. Raydon. Retail gallery. Estab. 1962. Represents established artists. Sponsors 12 group shows/year. Clientele: tri-state collectors and institutions (museums). Overall price range: $100-100,000; most work sold at $1,800-4,800.

Media Considers all media. Most frequently exhibits oil, prints and watercolor.

Style Exhibits all styles and genres. "We show fine works of arts in all media, periods and schools from the Renaissance to the present with emphasis on American paintings, prints and sculpture." Interested in seeing mature works of art of established artists or artist's estates.

Terms Accepts work on consignment or buys outright.

Tips "Artists should present themselves in person with background back-up material (bios, catalogs, exhibit records and original work, slides or photos). Join local, regional and national art groups and associations for grants exposure, review, criticism and development of peers and collectors."

N SOHO 20 GALLERY

511 W. 25th St., Suite 605, New York NY 10001. (212)367-8994. **Contact:** Lucy Terzis, manager. Nonprofit cooperative gallery and alternative space. Estab. 1973. Represents/exhibits 55 emerging, mid-career and established artists/year. Sponsors approximately 50 shows/year. Average display time 3½-4 weeks. Open all year; Tuesday-Saturday, 12-6. Located in Soho; 1,700 sq. ft.; ground floor space in historical building; 12 ft. ceilings; "Greene St. Window." 25-35% of space for special exhibitions; 75% of space for gallery artists. Clientele: wide range: private, corporate. 75% private collectors, 25% corporate collectors. Overall price range: $100-20,000; most work sold at $500-7,500.

Media Considers all media and all types of prints except posters. Most frequently exhibits painting, sculpture, mixed media and installations.

Style Exhibits all styles and genres.

Terms There is a co-op membership fee plus a donation of time, a 20% commission and a rental fee for space. The rental fee covers exhibition dates. Retail price set by the artist. Gallery provides promotion. Artists usually pays for shipping costs. Prefers artwork framed "ready to exhibit. Artists generally install their own exhibits."

Submissions "Soho 20 is a feminist cooperative gallery. The gallery exhibits work by women artists." Send résumé, brochures, slides, reviews SASE and letter stating which exhibit opportunities they are interested in (call gallery first). Call for appointment to show portfolio of slides and résumé. Responds in 1 month. Finds artists through word of mouth, referrals by other artists, visiting art fairs and exhibitions, artist's submissions and advertising.

Tips "We have several categories of exhibition opportunities. Call first in order to decide which category best meets the artist's and gallery's needs/intent. Clearly state exhibition category that you are applying for. Send all materials SASE."

SYNCHRONICITY FINE ARTS

106 W. 13th St., Ground Floor, New York NY 10011. (646)230-8199. Fax: (646)230-8198. E-mail: synchspa@best web.net. Website: www.synchronicityspace.com. Nonprofit gallery. Estab. 1989. Approached by several hundred artists/year. Exhibits 12-16 emerging and established artists. Exhibited artists include: Rosalyn Jacobs, oil on linen; Diana Postel, oil on linen; John Smith-Amato, oil on linen. Sponsors 6 exhibits/year. Average display time 1 month. Open all year; Tuesday-Saturday, 12-6. Closed in August for 2 weeks. Located in the heart of West Village—tree-lined street; 1,500 sq. ft; 8-9 ft. ceilings; all track/Halogen lighting. Clients include local community, students, tourists and upscale. 20% of sales are to corporate collectors. Overall price range: $1,500-10,000; most work sold at $3,000-5,000.

Media Considers acrylic, collage, drawing, mixed media, oil, paper, pastel, pen & ink, sculpture, watercolor, engravings, etchings, mezzotints and woodcuts. Most frequently exhibits oil, sculpture and photography.

Style Exhibits: color field, expressionism, impressionism, postmodernism and painterly abstraction. Most frequently exhibits semi-abstract and semi-representational abstract. Genres include figurative work, landscapes and portraits.

Terms Alternative based upon existing funding resources. Retail price set by the gallery. Gallery provides insurance, promotion and contract. Accepted work should be framed, mounted and matted. Does not require exclusive representation locally. Only semi-abstract and semi-representational.

Submissions Write to arrange a personal interview to show portfolio of photographs, slides and transparencies. Mail portfolio for review or make an appointment by phone. Send query letter with photocopies, photographs, résumé, SASE and slides. Returns material with SASE. Responds in 3 weeks. Files all unless artist requests return. Finds artists through submissions, portfolio reviews, art exhibits and referrals by other artists.

Tips Include clear and accurate transparencies; cover letter; investigate gallery history to apply consistently with styles and type of work we show.

✓ JOHN SZOKE EDITIONS

591 Broadway, 3rd Floor, New York NY 10012. (212)219-8300. Fax: (212)219-0864. E-mail: info@johnszokeediti ons.com. Website: www.johnszokeeditions.com. **President/Director:** John Szoke. Retail gallery and art publisher. Estab. 1974. Represents 30 mid-career artists. Exhibited artists include Jasper Johns, Picasso. Publishes

GET A FREE ISSUE OF **HOW**

From creativity crises to everyday technology, HOW covers every aspect of graphic design — so you have all the tools, techniques and resources you need for design success.

CREATIVITY idea-boosting tips from the experts and the inspiration behind some innovative new designs

BUSINESS how to promote your work, get paid what you're worth, find new clients and thrive in any economy

DESIGN an inside look at the hottest design workspaces, what's new in production and tips on designing for different disciplines

TECHNOLOGY what's happening with digital design, hardware and software reviews, plus how to upgrade on a budget

With this special introductory offer, you'll get a FREE issue of HOW. If you like what you see, you'll get a full year of HOW at our lowest available rate — a savings of 56% off the newsstand price.

I WANT TO TRY HOW.

Yes! Send my FREE issue and start my trial subscription. If I like what I see, I'll pay just $29.96 for 5 more issues (6 in all). If not, I'll write "cancel" on the invoice, return it and owe nothing. The FREE issue is mine to keep.

Name _____

Company _____

Address _____

City _____

State _____ZIP_____

SEND NO MONEY NOW.

In Canada: add $15 (includes GST/HST). Outside the U.S. and Canada: add $22 ($65 airmail) and remit payment in U.S. funds with order. Please allow 4-6 weeks for first-issue delivery. Annual newsstand rate $68.70.

Important! Please take a moment to complete the following information.

My business is best described as:
(choose one)
○ Advertising agency
○ Design studio
○ Graphic arts vendor
○ Company
○ Educational institution
○ Other
(specify)_____

My job title/occupation is:
(choose one)
○ Owner/management
○ Creative director
○ Art director/designer
○ Advertising/marketing staff
○ Instructor
○ Student
○ Other
(specify)_____

J4FAMK

You get three huge annuals:

SELF-PROMOTION — discover the keys to promoting your work and see the winners of our exclusive Self-Promotion Competition

INTERNATIONAL DESIGN — explore the latest design trends from around the world, plus the winning entries from the HOW International Design Competition

BUSINESS — get the scoop on protecting your work, building your business and your portfolio, and growing your career

Plus, get three acclaimed special issues — each focused on one aspect of design, so you'll get everything you need to know about Digital Design, Creativity and Trends & Type.

the work of Richard Haas, James Rizzi, Jeannette Pasin Sloan. Open all year. Located downtown in Soho. Clients include other dealers and collectors. 20% of sales are to private collectors.

● Not considering new artists at the present time.

Media Exhibits works on paper, multiples in relief and intaglio and sculpture.

Ṉ "U" GALLERY

221 E. Second St., New York NY 10009. (212)995-0395. E-mail: saccadik@bellatlantic.net. Website: www.ugalle ry.cjb.net. **Contact:** Darius. Alternative space, for-profit gallery, art consultancy and rental gallery. Estab. 1989. Approached by 100 artists/year. Represents 3 emerging, and established artists. Sponsors 2 exhibits/year. Open all year. Located in Manhattan; 800 sq. ft.

Media Considers acrylic, drawing, oil, paper, pastel, sculpture and watercolor. Considers all types of prints.

Style Exhibits: conceptualism, geometric abstraction, impressionism, minimalism and surrealism. Genres include figurative work, landscapes, portraits and wildlife.

Submissions Write to arrange a personal interview to show portfolio of photographs and slides. Send query letter with artist's statement, photocopies, photographs and slides. Cannot return material. Finds artists through word of mouth and portfolio reviews.

ALTHEA VIAFORA

205 E. 72nd St., New York NY 10021. (212)628-2402. **Contact:** Althea Viafora-Kress. Private art dealer and art consultancy. Estab. 1981. Works with 10 emerging, mid-career and established artists/year. Exhibited artists include: Matthew Barney and Emil Lukas. Open by appointment. Clients include upscale. 100% of sales are to private collectors. Overall price range: $2,000-2,000,000; most work sold at $40,000-60,000.

Media Considers oil, pen & ink, paper, acrylic, drawing, sculpture, watercolor, mixed media, installation, collage, murals, photography, mezzotint, etching, lithograph and serigraphs.

Style Old masters, 19th century, modern, post-modern and contemporary.

Terms Retail price set by the marketplace. Dealer provides insurance and promotion. Dealer pays for shipping costs. Prefers artwork framed.

Submissions "Artists must be currently exhibiting in a commercial gallery." Send query letter with slides, reviews, bio and SASE. Contact through the mail. Responds in 1 month. Files bio. Finds artists through museums and commercial galleries.

Tips "Go to galleries and museums to view your peers' work. Know the history of the dealer, curator, critic you are contacting."

ELAINE WECHSLER P.D.

245 W. 104th St., Suite 5B, New York NY 10025. (212)222-4357. **Contact:** Elaine Wechsler. Art consultant, private dealer. Estab. 1985. Represents mid-career and established artists/year. Exhibited artists include John Hultberg (acrylic on canvas); Jacqueline R. Hud (oil/canvas). Open by appointment. Located uptown; 1,500 sq. ft.; pre-war suite—paintings hung as they would be in a home; art brokerage American painting: 1940s-1970s. Full catalog production/printing. Clientele: upscale. 80% private collectors. Overall price range: $800-50,000.

Media Considers oil, acrylic, watercolor, mixed media, collage, paper, photography, lithograph and etching. Most frequently exhibits acrylic, oil, mixed media.

Style Exhibits expressionism, painterly abstraction and surrealism. Genres include landscapes, florals and figurative work. Most frequently exhibits painterly abstraction, expressionism and surrealism. Finds appropriate New York venues for artists. Acts as career coach.

Terms Charges 50% commission. Retail price set by the gallery and the artist. Gallery provides promotion and contract. Prefers artwork framed.

Submissions Send query letter with résumé, slides, bio, brochure, SASE and reviews. Write for appointment to show portfolio of originals, photographs, slides and promotion material. Responds in 6 months. Files promotion brochures and bios. Finds artists through visiting exhibitions, slide files, referrals, artists' submissions.

Tips Looks for "professional attitude, continuing production and own following of collectors."

Ṉ WALTER WICKISER GALLERY

568 Broadway, Suite #104B, New York NY 10012. (212)941-1817. Fax: (212)625-0601. E-mail: wwickiserg@aol. com. Website: www.walterwickisergallery.com. For-profit gallery. Exhibits mid-career artists. Exhibited artists include: Siri Bert, Irma Gilgore and David Hales.

Submissions Mail portfolio for review. Send query letter with résumé and slides. Resopnds in 6 weeks. Finds artists through submissions, portfolio reviews and referrals by other artists.

PHILIP WILLIAMS POSTERS

85 W. Broadway, New York NY 10007. (212)513-0313. E-mail: posters@mail.com. Website: www.postermuseu m.com. **Contact:** Philip Williams. Retail and wholesale gallery. Represents/exhibits 40 emerging, mid-career and established artists. Open all year; Monday-Sunday, 11-7

Terms Shipping costs are shared. Prefers artwork unframed.

Submissions Prefers only vintage posters and outsider artist. Send query letter with photographs. Call for appointment to show portfolio of photographs.

N WORLD FINE ART GALLERY

511 West 25th Street #803, New York NY 10001-5501. (646)336-1677. Fax: (646)336-8644. E-mail: info@worldfi nart.com. Website: www.worldfineart.com. **Director:** O'Delle Abney. Cooperative gallery. Estab. 1992. Approached by 1,500 artists/year. Represents 50 mid-career artists. Exhibited artists include: James Eugene Albert (prints); Sandra Gottlieb (photography). Average display time 1 month. Open Tuesday-Saturday from 12 to 6; closed August. Located in Chelsea, NY, 1,000 sq. ft. Clients include local community and tourists. 10% of sales are to corporate collectors. Overall price range: $500-5,000; most work sold at $1,500.

Media Considers all media; types of prints include lithographs, serigraphs and woodcuts. Most frequently exhibits acrylic, oil and mixed media.

Style Exhibits: color field. Considers all styles and genres. Most frequently exhibits painterly abstraction, color field and surrealism.

Terms There is a rental fee for space. The rental fee covers 1 month or 1 year. Retail price set by the artist. Gallery provides insurance, promotion and contract. Accepted work should be framed. Does not require exclusive representation locally. Must be considered suitable for exhibition.

Submissions Write or e-mail (www.worldfineart.com/inforequest.html) JPG images. Responds to queries in 1 week. Files JPG images. Finds artists through the Internet.

Tips "Have website available for review."

NORTH CAROLINA

ARTSOURCE CONSULTANTS INC.

509-105 W. Whitaker Mill Rd., Raleigh NC 27608. (919)833-0013. Fax: (919)833-2210. E-mail: localart@bellsout h.net. Website: www.artsource-raleigh.com. **Contact:** Claire Ciardella or Sharon Tharrington. Retail gallery, art consultancy. Estab. 1990. Represents at least 60 emerging, mid-career and established artists/year. Exhibited artists include James P. Kerr, Patsy Howell, Kyle Highsmith, Victoria Josephson and Ted Jaslow. Sponsors 4 shows/year. Average display time 6 weeks; consignment period 6 months. Open all year; Monday-Saturday, 10-6. Located in Five Points area (1½ miles from downtown); 1,600 sq. ft. 50% of space for special exhibitions; 50% of space for gallery artists. Clientele: 40% private collectors, 60% corporate collectors. Overall price range: $100-7,500; most work sold at $500-2,000.

Media Considers all media and all types of prints. Most frequently exhibits oils/acrylics and watercolors.

Style Exhibits expressionism, painterly abstraction, impressionism, realism; Genres include landscapes, florals, wildlife, Americana and figurative work. Prefers landscapes/seascapes, florals/still lifes, abstraction (soft edge).

Terms Accepts work on consignment (50% commission). Retail price set by the artist. Gallery provides insurance, promotion and shipping costs from gallery; artist pays shipping costs to gallery. Prefers artwork framed but "can be discussed."

Submissions Prefers artists from Southeastern region. Send query letter with résumé, slides or photographs, bio and SASE. Call for appointment to show portfolio of originals, photographs, slides and transparencies. Responds in 6 weeks. Files résumé, bio info, reviews, photos (if possible). Finds artists through publications, sourcebooks, submissions.

Tips To make gallery submissions professional, artists must have "a well put together artist package—including clear visuals, complete title/price list, impressive bio/résumé."

BLUE SPIRAL 1

38 Biltmore Ave., Asheville NC 28801. (828)251-0202. Fax: (828)251-0884. E-mail: info@bluespiral1.com. Website: www.bluespiral1.com. **Director:** John Cram. Retail gallery. Estab. 1991. Represents emerging, mid-career and established artists living in the Southeast. Over 100 exhibited artists including Julyan Davis, Gary Beecham, Suzanne Stryk, Tommie Rush and Will Henry Stephens. Sponsors 15-20 shows/year. Average display time 6-8 weeks. Open all year; Monday-Saturday, 10-6; Sundays (May-October), 12-5. Located downtown; 15,000 sq. ft.; historic building. 50% of space for special exhibitions; 50% of space for gallery artists. Clientele: "across the range." 90% private collectors, 10% corporate collectors. Overall price range: less than $100-50,000; most work sold at $100-2,500.

Media Considers all media. Most frequently exhibits painting, clay, sculpture and glass.

Style Exhibits all styles, all genres.

Terms Accepts work on consignment (50% commission). Retail price set by the artist. Gallery provides insurance, promotion and contract; artist pays shipping costs to and from gallery. Prefers artwork framed.

Submissions Accepts only artists from Southeast. Send query letter with résumé, slides, prices, statement and SASE. Responds in 3 months. Files slides, name and address. Finds artists through word of mouth, referrals and travel.

Tips "Work must be technically well executed and properly presented."

BROADHURST GALLERY

2212 Midland Rd., Pinehurst NC 28374. (910)295-4817. E-mail: Judy@broadhurst.com. Website: Broadhurstgallery.com. **Owner:** Judy Broadhurst. Retail gallery. Estab. 1990. Represents/exhibits 25 established artists/year. Sponsors about 4 large shows and lunch and Artist Gallery Talks on most Fridays. Average display time 1-3 months. Open all year; Tuesday-Friday, 11-5; Saturday, 1-4; and by appointment. Located on the main road between Pinehurst and Southern Pines; 3,000 sq. ft.; lots of space, ample light, large outdoor sculpture garden. 50% of space for special exhibitions; 50% of space for gallery artists. Clientele: people building homes and remodeling, also collectors. 80% private collectors, 20% corporate collectors. Overall price range: $5,000-40,000; most work sold at $5,000 and up.

Media Considers oil, acrylic, watercolor, pastel, mixed media and collage. Most frequently exhibits oil and sculpture (stone and bronze).

Style Exhibits all styles, all genres.

Terms Retail price set by the artist. Gallery provides insurance, promotion and contract; shipping costs are shared. Prefers artwork framed.

Submissions Send query letter with résumé, slides and/or photographs, and bio. Write for appointment to show portfolio of originals and slides. Responds only if interested within 3 weeks. Files résumé, bio, slides and/or photographs. Finds artists through agents, by visiting exhibitions, word of mouth, various art publications and sourcebooks and artists' submissions.

Tips "Talent is always the most important factor, but professionalism is very helpful."

N DURHAM ART GUILD, INC.

120 Morris St., Durham NC 27701. (919)560-2713. E-mail: artguild1@yahoo.com. Website: www.durhamartguild.org. **Gallery Director:** Lisa Morton. Gallery Assistant: Diane Amato. Nonprofit gallery. Estab. 1948. Represents/exhibits 500 emerging, mid-career and established artists/year. Sponsors more than 20 shows/year including an annual juried art exhibit. Average display time 5 weeks. Open all year; Monday-Saturday, 9-9; Sunday, 1-6. Free and open to the public. Located in center of downtown Durham in the Arts Council Building; 3,600 sq. ft.; large, open, movable walls. 100% of space for special exhibitions. Clientele: general public. 80% private collectors, 20% corporate collectors. Overall price range: $100-14,000; most work sold at $200-1,200.

Media Considers all media. Most frequently exhibits painting, sculpture and photography.

Style Exhibits all styles, all genres.

Terms Artwork is accepted on consignment (30-40% commission). Retail price set by the artist. Gallery provides insurance and promotion. Artist installs show. Prefers artwork framed.

Submissions Artists 18 years or older. Send query letter with résumé, slides and SASE. We accept slides for review by February 1 for consideration of a solo exhibit or special projects group show. Artist should include SASE. Finds artists through word of mouth, referral by other artists, call for slides.

Tips "Before submitting slides for consideration, be familiar with the exhibition space to make sure it can accommodate any special needs your work requires for showing. Does the gallery have moveable walls which cannot support heavy art work? These points are important."

N GALLERY C

3532 Wade Ave., Raleigh NC 27607. (919)828-3165. Fax: (919)828-7795. E-mail: art@galleryc.net. Website: www.galleryc.net. For-profit gallery. Estab. 1985. Approached by 80 artists/year. Exhibits 25 established artists. Exhibited artists include: Joseph Cave (oil on canvas) and Henry Isaacs (oil on canvas). Sponsors 10 exhibits/year. Average display time 1 month. Open all year; Monday, Tuesday, Thursday, Friday, 10-6; Wednesday, 10-8; Saturday, 10-5; Sunday, 1-5. 3,000 sq. ft., neoclassical interior, track lights, 10 foot ceilings. Clients include local community and upscale. 20% of sales are to corporate collectors. Overall price range: $100-20,000; most work sold at $3,000.

Media Considers acrylic, drawing, fiber, installation, oil, paper, pastel, sculpture, watercolor, engravings, etchings, linocuts, stone lithographs, mezzotints and serigraphs. Most frequently exhibits oil, mixed and acrylic.

Style Considers all styles. Most frequently exhibits abstract expressionism, figurative and landscape. Genres include figurative work and landscapes.

Terms Artwork is accepted on consignment and there is a 50% commission. Retail price set by the artist. Gallery provides insurance, promotion and contract. Accepted work should be framed. Requires exclusive representation in eastern NC.

Submissions Call to request 'guidelines for artists' form. Returns material with SASE. Responds in 3 months. Finds artists through portfolio reviews, art fairs and referrals by other artists.

Tips "Follow the requirements outlined on our guidelines sheet."

WELLINGTON B. GRAY GALLERY, EAST CAROLINA UNIVERSITY

Jenkins Fine Art Center, Greenville NC 27858. (919)757-6336. Fax: (919)757-6441. Website: ecuuax.cis.@cu. edu/academics/schdept/art/art.htm. **Director:** Gilbert W. Leebrick. Nonprofit university gallery. Estab. 1977. Represents emerging, mid-career and established artists. Sponsors 12 shows/year. Average display time 5-6 weeks. Open all year. Located downtown, in the university; 5,500 sq. ft.; "auditorium for lectures, sculpture garden." 100% of space for special exhibitions. Clientele: 25% private collectors, 10% corporate clients, 50% students, 15% general public. Overall price range: $1,000-10,000.

Media Considers all media plus environmental design, architecture, crafts and commercial art, original prints, relief, intaglio, planography, stencil and offset reproductions. Most frequently exhibits paintings, printmaking and sculpture.

Style Exhibits all styles and genres. Interested in seeing contemporary art in a variety of media.

Terms 30% suggested donation on sales. Retail price set by artist. Gallery provides insurance and promotion; shipping costs are shared. Prefers artwork framed.

Submissions Send query letter with résumé, slides, brochure and SASE. Write for appointment to show portfolio of originals, slides, photographs and transparencies. Responds in 6 months. Files "all mailed information for interesting artists. The rest is returned."

N JERALD MELBERG GALLERY INC.

625 S. Sharon Amity Rd., Charlotte NC 28211. (704)365-3000. Fax: (704)365-3016. **President:** Jerald Melberg. Retail gallery. Estab. 1983. Represents 35 emerging, mid-career and established artists/year. Exhibited artists include Robert Motherwell and Wolf Kahn. Sponsors 15-16 shows/year. Average display time 6 weeks. Open all year; Monday-Saturday, 10-6. 4,000 sq. ft. 100% of space for gallery artists. Clientele: national. 70-75% private collectors, 25-30% corporate collectors. Overall price range: $1,000-80,000; most work sold at $2,000-15,000.

Media Considers all media except photography. Considers all types of prints. Most frequently exhibits pastel, oil/acrylic and monotypes.

Style Genres include painterly abstraction, color field, impressionism and realism. Genres include florals and landscapes. Prefers landscapes, abstraction and still life.

Terms Artwork is accepted on consignment (50% commission). Retail price set by the gallery and the artist. Gallery provides insurance, promotion. Gallery pays for shipping costs from gallery. Artists pays for shipping costs to gallery. Prefers artwork unframed.

Submissions Send query letter with résumé, slides, reviews, bio, SASE and price structure. Responds in 2-3 weeks. Finds artists through art fairs, other artists, travel.

Tips "The common mistake artists make is not finding out what I handle and not sending professional quality materials."

RALEIGH CONTEMPORARY GALLERY

323 Blake St., Raleigh NC 27601. (919)828-6500. E-mail: RCGallery@mindspring.com. Website: www.rcgallery. com. **Director:** Rory Parnell. Retail gallery. Estab. 1984. Represents 20-25 emerging and mid-career artists/year. Sponsors 6 shows/year. Average display time 1 month. Open all year; Monday-Saturday, 11-4. Located downtown; 1,300 sq. ft.; architect-designed; located in historic property in a revitalized downtown area. 30% of space for special exhibitions; 70% of space for gallery artists. Clients include corporate and private. 35% of sales are to private collectors, 65% corporate collectors. Overall price range: $500-5,000; most work sold at $1,200-2,500.

Media Considers oil, acrylic, watercolor, pastel, pen & ink, drawing, woodcut, engraving and lithograph. Most frequently exhibits oil/acrylic paintings, drawings and lithograph.

Style Exhibits all styles. Genres include landscapes and florals. Prefers landscapes, realistic and impressionistic; abstracts.

Terms Accepts work on consignment (50% commission). Retail price set by the gallery and the artist. Gallery provides insurance, promotion and contract; shipping costs are shared.

Submissions Send query letter with résumé, slides, bio, SASE and reviews. Call or write for appointment to show portfolio of slides. Responds in 1 month. Finds artists through exhibitions, word of mouth, referrals.

SOMERHILL GALLERY

3 Eastgate E. Franklin St., Chapel Hill NC 27514. (919)968-8868. Fax: (919)967-1879. **Director:** Joseph Rowand. Retail gallery. Estab. 1972. Represents emerging, mid-career and established artists. Sponsors 10 major shows/ year, plus a varied number of smaller shows. Open all year. 10,000 sq. ft.; gallery features "architecturally significant spaces, pine floor, 18' ceiling, 6 separate gallery areas, stable, photo, glass." 50% of space for special exhibitions.

Media Considers all media, woodcuts, wood engravings, linocuts, engravings, mezzotints, etchings, lithographs and serigraphs. Does not consider installation. Most frequently exhibits painting, sculpture and glass.

Style Exhibits all styles and genres.

Submissions Focus is on contemporary art of the United States; however artists from all over the world are exhibited. Send query letter with résumé, slides, bio, SASE and any relevant materials. Responds in 2 months. Files slides and biographical information of artists.

N TYLER-WHITE ART GALLERY

307 State St. Station, Greensboro NC 27408. (336)279-1124. Fax: (336)279-1102. **Owners:** Marti Tyler and Judy White. Retail gallery. Estab. 1985. Represents 60 emerging, mid-career and established artists. Exhibited artists include Marcos Blahove, Geoffrey Johnson and Connie Winters. Sponsors 8 shows/year. Open all year. Located in State Street Station, a unique shopping district 1 mile from downtown. Overall price range: $100-4,000; most work sold at $1,500.

Media Considers oil, acrylic, watercolor and pastel.

Style Considers contemporary expressionism, impressionism and realism. Genres include landscapes, florals and figurative work.

Terms Accepts artwork on consignment. Retail price set by the artist. Gallery provides some insurance, promotion and contract; artist pays for shipping. Prefers artwork framed if oil, or a finished canvas. Prefers matted watercolors.

Submissions Send query letter with slides, résumé, brochure, photographs and SASE. Write to schedule an appointment to show a portfolio, which should include originals, slides and transparencies. Responds in 1 month. Files brochures, résumé and some slides.

Tips "We only handle original work."

NORTH DAKOTA

N THE ARTS CENTER

115 Second St. SW, Box 363, Jamestown ND 58402. (701)251-2496. **Director:** Taylor Barnes. Nonprofit gallery. Estab. 1981. Sponsors 8 solo and 4 group shows/year. Average display time 6 weeks. Interested in emerging artists. Overall price range: $50-600; most work sold at $50-350.

Style Exhibits contemporary, abstraction, impressionism, primitivism, photorealism and realism. Genres include Americana, figurative and 3-dimensional work.

Terms 20% commission on sales from regularly scheduled exhibitions. Retail price set by artist. Gallery provides insurance, promotion and contract; shipping costs are shared.

Submissions Send query letter, résumé, brochure, slides, photograph and SASE. Write for appointment to show portfolio. Invitation to have an exhibition is extended by Arts Center gallery manager.

Tips "We are interested in work of at least 20-30 pieces, depending on the size."

NORTHWEST ART CENTER

Minot State University, 500 University Ave. W., Minot ND 58707. (701)858-3264. Fax: (701)858-3894. E-mail: nac@minotstateu.edu. **Director:** Catherine Walker. Nonprofit gallery. Estab. 1970. Represents emerging, mid-career and established artists. Sponsors 18-20 shows/year. Average display time 4-6 weeks. Open all year. Two galleries: Hartnett Hall Gallery: Monday-Friday, 8-4:30; The Library Gallery: Sunday-Thursday, 8-9. Located on university campus; 1,000 sq. ft. 100% of space for special exhibitions. 100% private collectors. Overall price range: $100-40,000; most work sold at $100-4,000.

Media Considers all media and all types of prints except posters.

Style Exhibits all styles, all genres.

Terms Retail price set by the artist. 30% commission. Gallery provides insurance, promotion and contract; shipping costs are shared. Prefers artwork framed.

Submissions Send query letter with résumé, slides, bio, SASE and artist's statement. Call for appointment to show portfolio of originals, photographs, slides and transparencies. Responds in 4 months. Files all material. Finds artists through submissions, visiting exhibitions, word of mouth.

Ｎ LILLIAN AND COLEMAN TAUBE MUSEUM OF ART

Box 325, Minot ND 58702. (701)838-4445. **Executive Director:** Jeanne M. Rodgers. Nonprofit gallery. Estab. 1970. Represents emerging, mid-career and established artists. Sponsors 12-20 shows/year. Average display time 1-2 months. Open all year. Located at 2 North Main; 3,000 sq. ft.; "historic landmark building." 100% of space for special exhibitions. Clientele: 100% private collectors. Overall price range: $50-2,000; most work sold at $100-400.

Media Considers oil, acrylic, watercolor, pastel, pen & ink, drawings, mixed media, collage, works on paper, sculpture, ceramic, fiber, glass, photograph, woodcuts, engravings, lithographs, serigraphs, linocuts and etchings. Most frequently exhibits watercolor, acrylic and mixed media.

Style Exhibits all styles and genres. Prefers figurative, Americana and landscapes. No "commercial-style work (unless a graphic art display)." Interested in all media.

Terms Accepts work on consignment (30% commission, members; 40% nonmembers). Retail price set by artist. Offers discounts to gallery members and sometimes payment by installments. Gallery provides insurance, promotion and contract; pays shipping costs from gallery or shipping costs are shared. Requires artwork framed.

Submissions Send query letter with résumé and slides. Write for appointment to show portfolio of good quality photographs and slides. "Show variety in your work." Files material interested in. Finds artists through visiting exhibitions, word of mouth, submissions of slides and members' referrals.

Tips "We will take in a small show to fill in an exhibit. Show your best. When shipping show, be uniform on sizes and frames. Have flat backs to pieces so work does not gouge walls. Be uniform on wire placement. Avoid sawtooth hangers."

OHIO

THE ART EXCHANGE

539 E. Town St., Columbus OH 43215. (614)464-4611. Fax: (614)464-4619. E-mail: artexg@ix.netcom.com. Art consultancy. Estab. 1978. Represents 40 emerging, mid-career and established artists/year. Exhibited artists include Mary Beam, Carl Krabill. Open all year; Monday-Friday, 9-5. Located near downtown; historic neighborhood; 2,000 sq. ft.; showroom located in Victorian home. 100% of space for gallery artists. Clientele: corporate leaders. 20% private collectors; 80% corporate collectors. Overall price range: $150-6,000; most work sold at $1,000-1,500.

Media Considers oil, acrylic, watercolor, pastel, mixed media, collage, sculpture, ceramics, fiber, glass, photography and all types of prints. Most frequently exhibits oil, acrylic, watercolor.

Style Exhibits painterly abstraction, impressionism, realism, folk art. Genres include florals and landscapes. Prefers impressionism, painterly abstraction, realism.

Terms Accepts work on consignment. Retail price set by the gallery and the artist.

Submissions Send query letter with résumé and slides or photographs. Write for appointment to show portfolio. Responds in 2 weeks. Files slides or photos and artist information. Finds artists through word of mouth, referrals by other artists, visiting art fairs and exhibitions, submissions.

Tips "Our focus is to provide high-quality artwork and consulting services to the corporate, design and architectural communities. Our works are represented in corporate offices, health care facilities, hotels, restaurants and private collections throughout the country."

CINCINNATI ART MUSEUM

953 Eden Park Dr., Cincinnati OH 45202. (513)639-2995. Fax: (513)639-2888. E-mail: information@cincyart.org. Website: www.cincinnatiartmuseum.org. Museum. Estab. 1881. Exhibits 6-10 emerging, mid-career and established artists. Sponsors 20 exhibits/year. Average display time 3 months. Open all year; Tuesday-Sunday, 11-5; Wednesdays open until 9. General art museum with a collection spanning 6,000 years of world art. Over 100,000 objects in the collection with exhibitions on view annually. Clients include local community, students, tourists and upscale.

Media Considers all media and all types of prints. Most frequently exhibits paper, mixed media and oil.

Style Considers all styles and genres.

Submissions Send query letter with artist's statement, photographs, reviews, SASE and slides.

THE DAYTON ART INSTITUTE

456 Belmonte Park North, Dayton OH 45405-4700. (937)223-5277. Fax: (937)223-3140. E-mail: info@daytonartinstit ute.org. Website: www.daytonartinstitute.org. Museum. Estab. 1919. Open all year; Monday-Wednesday, 10-4; Thursday, 10-8; Friday-Sunday, 10-4. Open 365 days of the year! Clients include local community, students and tourists.

Media Considers all media.

Submissions Send query letter with artist's statement, reviews and slides.

☑ MALTON GALLERY

2703 Observatory, Cincinnati OH 45208. (513)321-8614. Fax: (513)321-8716. E-mail: info@maltonartgallery.c om. Website: www.maltonartgallery.com. **Director:** Sylvia Rombis. Retail gallery. Estab. 1974. Represents about 100 emerging, mid-career and established artists. Exhibits 20 artists/year. Exhibited artists include Carol Henry, Mark Chatterley, Terri Hallman and Esther Levy. Sponsors 7 shows/year. Average display time 1 month. Open all year; Tuesday-Friday, 11-5; Saturday, 12-5. Located in high-income neighborhood shopping district. 2,500 sq. ft. "Friendly, non-intimidating environment." 2-person shows alternate with display of gallery artists. Clientele: private and corporate. Overall price range: $250-10,000; most work sold at $400-2,500.

Media Considers oil, acrylic, drawing, sculpture, watercolor, mixed media, pastel, collage and original hand-pulled prints.

Style Exhibits all styles. Genres include contemporary landscapes, figurative and narrative and abstractions work.

Terms Accepts work on consignment (50% commission). Retail price set by artist (sometimes in consultation with gallery). Gallery provides insurance, promotion, contract and shipping costs from gallery; artist pays shipping costs to gallery. Prefers framed works for canvas; unframed works for paper.

Submissions Send query letter with résumé, slides or photographs, reviews, bio and SASE. Responds in 4 months. Files résumé, review or any printed material. Slides and photographs are returned.

Tips "Never drop in without an appointment. Be prepared and professional in presentation. This is a business. Artists themselves should be aware of what is going on, not just in the 'art world,' but with everything."

Ⓝ MILLER GALLERY

2715 Erie Ave., Cincinnati OH 45208. (513)871-4420. Fax: (513)871-4429. E-mail: millergallery@fuse.net. Web-site: www.miller-gallery.com. **Owner:** Barbara Miller. Retail gallery. Estab. 1960. Interested in emerging, mid-career and established artists. Represents about 50 artists. Sponsors 5 solo and 4 group shows/year. Average display time 1 month. Located in affluent suburb. Clientele: private collectors. Overall price range: $100-35,000; most artwork sold at $300-12,000.

Media Considers oil, acrylic, mixed media, collage, works on paper, ceramic, fiber, bronze, stone, glass and original handpulled prints. Most frequently exhibits oil or acrylic, glass, sculpture and ceramics.

Style Exhibits impressionism, realism and painterly abstraction. Genres include landscapes, interior scenes and still lifes. "Everything from fine realism (painterly, impressionist, pointilist, etc.) to beautiful and colorful abstractions (no hard-edge) and everything in between. Also handmade paper, collage, fiber and mixed mediums."

Terms Accepts artwork on consignment (50% commission). Retail price set by artist and gallery. Sometimes offers payment by installment. Exclusive area representation is required. Gallery provides insurance, promotion and contract; shipping and show costs are shared.

Submissions Send query letter with résumé, brochure, 10-12 slides or photographs with sizes, wholesale (artist) and selling price and SASE. All submissions receive phone or written reply. Finds artists through agents, visiting exhibitions, word of mouth, various art publications and sourcebooks, submissions/self-promotions, art collectors' referrals, and *Artist's and Graphic Designer's Market.*

Tips "Artists often either completely omit pricing info or mention a price without identifying as artist's or selling price. Submissions without SASE will receive reply, but no return of materials submitted. Make appointment—don't walk in without one. Quality, beauty, originality are primary. Minimal, conceptual, political works not exhibited."

MARK PATSFALL GRAPHICS, INC.

1312 Clay St., Cincinnati OH 45202. (513)241-3232. E-mail: mpginc@iac.net. Website: www.patsfallgraphics.c om. **Contact:** Mark Patsfall. Publisher/printer Fine Art editions. Estab. 1981. Exhibits emerging, mid-career and established artists. Exhibited artists include Nam June Paik and Kay Rosen (prints). Clients include local community, students and upscale. 25% of sales are to corporate collectors. Overall price range $350-2,500; most work sold at $1,000.

Media Considers engravings, etchings, linocuts, lithographs, mezzotints, serigraphs and woodcuts.

Style Exhibits conceptualism and postmodernism.

Terms Gallery exhibits projects produced by the shop. Work is published by gallery or produced in collaboration with other publishers and/or artists.

Submissions Call for submission information. Responds to queries in 1 week.

SPACES

2220 Superior Viaduct, Cleveland OH 44113. (216)621-2314. E-mail: info@spacesgallery.org. Website: www.sp acesgallery.org. Alternative space. Estab. 1978. Represents emerging artists. Has 300 members. Sponsors 10

shows/year. Average display time 6 weeks. Open all year; Tuesday-Sunday. Located downtown Cleveland; 6,000 sq. ft.; "loft space with row of columns." 100% private collectors.

Media Considers all media. Most frequently exhibits installation, painting, video and sculpture.

Style Exhibits all styles. Prefers challenging new ideas.

Terms Accepts work on consignment. 20% commission. Retail price set by the artist. Sometimes offers payment by installment. Gallery provides insurance, promotion and contract.

Submissions Contact for an application. Annual deadline in spring for submissions.

Tips "Present yourself professionally and don't give up."

OKLAHOMA

BONE ART GALLERY

114 S. Broadway, Geary OK 73040. (405)884-2084. E-mail: jim@boneartgallery.com. Website: www.boneartgall ery.com. **Owner/Operator:** Jim Ford. Retail and wholesale gallery. Estab. 1988. Represents 6 emerging, mid-career and established artists/year. Exhibited artists include Jim Ford and Jerome Bushyhead. Average display time 6 months. Open all year; Monday-Friday, 10-6; Saturday, 10-6; Sunday by appointment. Located downtown. ⅔% of space for gallery artists. Clientele: tourists, upscale. 50% private collectors; 50% corporate collectors. Overall price range: $15-1,000; most work sold at $15-650.

Media Considers oil, acrylic, watercolor, pastel, drawing, mixed media, sculpture, ceramics, lithographs and posters. Most frequently exhibits watercolor, sculpture and carvings, pipe making.

Style Exhibits primitivism. Genres include Western, wildlife, Southwestern and landscapes. Prefers Southwestern, Western and landscapes.

Terms Accepts work on consignment (20% commission). Retail price set by the artist. Gallery provides insurance and promotion; shipping costs are shared. Prefers artwork framed.

Submissions Prefers only Southwestern, Western, landscapes and wildlife. Send query letter with résumé, brochure, photographs and business card. Write for appointment to show portfolio of photographs. Responds in 1 month. Files business cards, résumé, brochure and letter of introduction. Finds artists through referrals and visiting art exhibitions.

Tips "New artists should be familiar with the types of artwork each gallery they contact represents. If after contacting a gallery you haven't had a response after 2-3 months, make contact again. Be precise, but not overbearing with your presentations."

INDIVIDUAL ARTISTS OF OKLAHOMA

P.O. Box 60824, Oklahoma City OK 73146. (405)232-6060. Fax: (405)232-6061. E-mail: iao@telepath.com. Website: www.IAOgallery.org. **Director:** Shirley Blaschke. Administrative Assistant: Bethani Baum. Art space located at: One N. Hudson, Suite 150. Alternative space. Founding member of NAAO. Estab. 1979. Approached by 60 artists/year. Represents 30 emerging, mid-career and established artists/year. Sponsors 30 exhibits/year. Average display time 3-4 weeks. Open all year; Tuesday-Friday, 11-4; Saturday, 1-4. Located in downtown arts district; 2,300 sq. ft.; 10 foot ceilings; track lighting. Clients include local community, students, tourists and upscale. 33% of sales are to corporate collectors. Overall price range: $100-1,000; most work sold at $400.

Media Considers all media. Most frequently exhibits photography, painting, installation.

Style Considers all styles. Most frequently exhibits "bodies of work with cohesive style and expressed in a contemporary viewpoint." Considers all genres.

Making Contact & Terms Artwork is accepted on consignment and there is a 20% commission. Retail price set by the artist. Gallery provides insurance, promotion and contract. Prefers artwork framed. Preference to Oklahoma artists.

Submissions Mail portfolio for review. Send artist's statement, bio, photocopies or slides, résumé and SASE. Returns material with SASE. Responds in 3 months. Finds artists through word of mouth, art exhibits and referrals by other artists.

Tips "Individual Artists of Oklahoma is committed to sustaining and encouraging emerging and established artists in all media who are intellectually and aesthetically provocative or experimental in subject matter or technique."

🎨 LACHENMEYER ARTS CENTER

700 S. Little, P.O. Box 586, Cushing OK 74023. (918)225-7525. E-mail: roblarts@brightok.net. **Director:** Rob Smith. Nonprofit. Estab. 1984. Exhibited artists include Darrell Maynard, Steve Childers and Dale Martin. Sponsors 3 shows/year. Average display time 2 weeks. Open in August, September, December; Monday, Wednesday, Friday, 9-5; Tuesday, Thursday, 6-9. Located inside the Cushing Youth and Community Center; 550 sq. ft. 80% of space for special exhibitions; 80% of space for gallery artists. 100% private collectors.

Media Considers oil, acrylic, watercolor, pastel, pen & ink, drawing, mixed media, collage, paper, sculpture, ceramics, fiber, photography, woodcuts, engravings, lithographs, wood engravings, mezzotints, serigraphs, linocuts and etchings. Most frequently exhibits oil, acrylic and works on paper.
Style Exhibits all styles. Prefers: landscapes, portraits and Americana.
Terms Retail price set by the artist. Gallery provides promotion; shipping costs are shared. Prefers artwork framed.
Submissions Send query letter with résumé, professional quality slides, SASE and reviews. Call or write for appointment to show portfolio of originals. Responds in 1 month. Files résumés. Finds artists through visiting exhibits, word of mouth, other art organizations.
Tips ''We prefer local and regional artists.''

OREGON

COOS ART MUSEUM
235 Anderson Avenue, Coos Bay OR 97420. (541)267-3901. Website: www.coosart.org. **Executive Director:** M.J. Koreiva. Nonprofit art museum. Estab. 1950. Approached by 30 artists/year. Exhibits group shows of 140+ artists and single/solo shows of established artists. Sponsors 12 exhibits/year. Average display time 4-6 weeks. Open Tuesday-Friday from 10-4; Saturday only from 1-4; closed 3rd Tuesday in December until the 1st Tuesday in January. Located downtown Coos Bay. One large main gallery and 3 smaller gallery areas. Clients include local community, students, tourists and upscale.
Media Considers all media except computer generated and craft and all types of prints except posters. Most frequently exhibits paintings (oil, acrylic, watercolor), sculpture (glass, metal), drawings, etchings and prints.
Style Considers all styles and genres. Most frequently exhibits primitivism, realism, postmodernism and expressionism.
Terms No gallery floor sales. All inquiries are referred directly to the artist. Artist handles the sale. Retail price set by the artist. Museum provides insurance, promotion and contract. Accepted work should be framed, mounted and matted. Does not require exclusive representation locally. Accepts only artists from Oregon or Western USA.
Submissions Send query letter with artist's statement, bio, résumé, SASE, JPEGs and web address. Responds to queries in 6 months. Never send only copies of slides, résumés or portfolios. Files proposals. Finds artists through portfolio reviews and submissions.
Tips ''Have complete files electronically on a web site or CD. Have a completely written positioning statement and proposal of their show. Do no expect the museum to produce or create their exhibition. They should have all costs figured ahead of time and submit only when they have their work completed and ready. We do not develop artists. They must be professional.''

FRAME DESIGN & SUNBIRD GALLERY, INC.
916 Wall St., Bend OR 97701. (541)389-9196. Fax: (541)389-8831. E-mail: sunbird@empnet.com Website: www.sunbirdartgallery.com. Retail gallery. Estab. 1980. Represents/exhibits 20 mid-career and established artists/year. Average display time ongoing. Open all year; Monday-Saturday, 11-5:30 or by appointment. Located downtown; 2,000 sq. ft. Clients include local community, tourists, upscale. 90% of sales are to private collectors, 2% corporate collectors. Overall price range: $100-25,000; most work sold at $200-5,000.
Media Most frequently exhibits painting, sculpture, mixed media and ceramics.
Style Exhibits all styles. All genres, with emphasis on original Pacific Northwest contemporary artwork.
Tips ''Know the kind of artwork represented in the gallery before approaching. Do your ''homework'' by first visiting the gallery to see if your artwork is a good fit. Be professional.''

MINDPOWER GALLERY
417 Fir Ave., Reedsport OR 97467. (800)644-2485 or (541)271-2485. E-mail: gallery@mindpowergallery.com. Website: www.mindpowergallery.com. **Manager:** Tamara Szalewski. Retail gallery. Estab. 1989. Currently exhibiting over 100 artists. Exhibited artists include: John Stewart. Sponsors 6 shows/year. Average display time 2 months to continuous. Open all year; Tuesday-Saturday, 10-5. Located in ''Oldtown'' area—front street is Hwy. 38; 5,000 sq. ft.; 8 rooms with 500' of wall space. 20% of space for ''Infinity'' gift store (hand-crafted items up to $100 retail, New Age music, books); 10% for special exhibitions; 70% of space for gallery artists. Clients include ⅔ from state, ⅓ travelers. 90% of sales are to private collectors, 10% small business collectors. Overall price range: $100-20,000; most work sold at $500.
Media Considers oil, acrylic, watercolor, pastel, mixed media, paper, batik, computer, sculpture: wood, metal, clay, glass; all types of prints. Most frequently exhibits sculpture, acrylic/oil, watercolor, pastel.

Style Exhibits all styles and genres. "We have a visual computer catalog accessible to customers, showing work not currently at gallery."

Terms Accepts work on consignment (40% commission). Retail price set by the artist. Gallery provides promotion, contract and insurance; artist pays shipping costs to and from gallery. Prefers artwork framed.

Submissions Send query letter with typewritten résumé, slides, photographs and SASE. Responds within 1 month. Files résumés. Finds artists through artists' submissions, visiting exhibitions, word of mouth.

Tips Please call between 9-9:30 and 5-5:30 to verify your submission was received.

ROGUE GALLERY & ART CENTER

40 S. Bartlett, Medford OR 97501. (541)772-8118. Fax: (541)772-0294. E-mail: judy@roguegallery.org. Website: www.roguegallery.org. **Executive Director:** Judy Barnes. Nonprofit sales rental gallery. Estab. 1961. Represents emerging, mid-career and established artists. Sponsors 8 shows/year. Average display time 6 weeks. Open all year; Tuesday-Friday, 10-5; Saturday, 11-3. Located downtown; main gallery 240 running ft. (2,000 sq. ft.); rental/sales and gallery shop, 1,800 sq. ft.; classroom facility, 1,700 sq. ft. "This is the only gallery/art center/exhibit space of its kind in the region, excellent facility, good lighting." 33% of space for special exhibitions; 33% of space for gallery artists. 95% of sales are to private collectors. Overall price range: $100-5,000; most work sold at $400-1,000.

Media Considers all media and all types of prints. Most frequently exhibits mixed media, drawing, installation, painting, sculpture, watercolor.

Style Exhibits all styles and genres. Prefers: figurative work, collage, landscape, florals, handpulled prints.

Terms Accepts work on consignment (35% commission to members; 40% non-members). Retail price set by the artist. Gallery provides insurance, promotion and contract; in the case of main gallery exhibit.

Submissions Send query letter with résumé, 10 slides, bio and SASE. Call or write for appointment. Responds in 1 month.

Tips "The most important thing an artist needs to demonstrate to a prospective gallery is a cohesive, concise view of himself as a visual artist and as a person working with direction and passion."

PENNSYLVANIA

THE BINNEY & SMITH GALLERY

25 W. Third St., Bethlehem PA 18015. (610)332-1300. Fax: (610)332-1312. E-mail: jlipzen@fest.org. Website: www.bananafactory.org. **Director of Visual Arts and Education:** Janice Lipzin. Nonprofit gallery. Estab. 1997. Approached by 100 artists/year. Represents emerging, mid-career and established artists. Average display time 6 weeks. Open Wednesday-Sunday, 10-5. Closed the first week of August. Clients include local community, students, tourists, upscale. Overall price range: $75-15,000; most work sold at $300.

Media Considers all media and all types of prints. Most frequently exhibits oil/acrylic paintings, sculpture, watercolor and photography.

Style Considers all styles and genres.

Terms Artwork is accepted on consignment and there is a 35% commission. Retail price set by the artist. Gallery provides insurance, promotion and contract. Accepted work should be framed. Does not require exclusive representation locally.

Submissions Mail portfolio for review. Send query letter with artist's statement, bio, brochure, photographs, résumé, reviews, SASE and slides. Responds only if interested within 6 months. Files artists approved by gallery committee. Finds artists through word of mouth, submissions, portfolio reviews, art exhibits, art fairs, and referrals by other artists.

Tips "Have good slides, computer résumé and artist statement."

☑ THE CLAY PLACE

5416 Walnut St., Pittsburgh PA 15232. (412)682-3737. Fax: (412)682-3239. E-mail: clayplacel@aol.com. Website: www.clayplace.com. **Director:** Elvira Peake. Retail gallery. Estab. 1973. Represents 50 emerging, mid-career and established artists. Exhibited artists include Jack Troy and Kirk Mangus. Sponsors 7 shows/year. Open all year. Located in small shopping area; "second level modern building with atrium." 1,200 sq. ft. 50% of space for special exhibition. Overall price range: $10-2,000; most work sold at $40-100.

Media Considers ceramic, sculpture, glass and pottery. Most frequently exhibits clay, glass and enamel.

Terms Accepts artwork on consignment (50% commission) or buys outright for 50% of retail price (net 30 days). Retail price set by artist. Sometimes offers customer discounts and payment by installments. Gallery provides insurance, promotion and shipping costs from gallery.

Submissions Prefers only clay, some glass and enamel. Send query letter with résumé, slides, photographs, bio and SASE. Write for appointment to show portfolio. Portfolio should include actual work rather than slides.

Responds in 1 month. Does not reply when busy. Files résumé. Does not return slides. Finds artists through visiting exhibitions and art collectors' referrals.

Tips "Functional pottery sells well. Emphasis on form, surface decoration. Some clay artists have lowered quality in order to lower prices. Clientele look for quality, not price."

N I EVERHART MUSEUM

1901 Mulberry St., Scranton PA 18510-2390. (570)346-7186. Fax: (570)346-0652. E-mail: everhart@adelphia.n et. Website: www.everhart-museum.org. **Curator:** Edward McMullen. Museum. Estab. 1908. Represents established artists. 2,400 members. Sponsors 2 shows/year. Average display time 2-3 months. Open all year; Wednesday-Sunday, 12-4; Thursday till 8; closed Monday and Tuesday. Closed in January. Located in urban park; 300 linear feet. 20% of space for special exhibitions.

Media Considers all media.

Style Prefers regional, Pennsylvania artists.

Terms Gallery provides insurance, promotion and shipping costs. 2-D artwork must be framed.

Submissions Send query letter with résumé, slides, bio, brochure and reviews. Write for appointment. Responds in 1-2 months. Files letter of query, selected slides or brochures, other information as warranted. Finds artists through agents, by visiting exhibitions, word of mouth, art publications and sourcebooks, artists' submissions.

Tips Sponsors regional juried exhibition in the summer. "Write for prospectus."

FLEISHER/OLLMAN GALLERY

1616 Walnut St., Suite 100, Philadelphia PA 19103. (215)545-7562. Fax: (215)545-6140. **Director:** John Ollman. Retail gallery. Estab. 1952. Represents 12 emerging and established artists. Exhibited artists include James Castle and Bill Traylor. Sponsors 10 shows/year. Average display time 5 weeks. Closed August. Located downtown; 4,500 sq. ft. 75% of space for special exhibitions. Clientele: primarily art collectors. 90% private collectors, 10% corporate collectors. Overall price range: $2,500-100,000; most work sold at $2,500-30,000.

Media Considers oil, acrylic, watercolor, pastel, pen & ink, drawing, mixed media and collage. Most frequently exhibits drawing, painting and sculpture.

Style Exhibits self-taught and contemporary works.

Terms Accepts artwork on consignment (commission) or buys outright. Retail price set by the gallery. Gallery provides insurance and promotion; shipping costs are shared. Prefers artwork framed.

Submissions Send query letter with résumé, slides, bio and SASE; gallery will call if interested within 1 month.

Tips "Be familiar with our exhibitions and the artists we exhibit."

N GALLERY 500

3502 Scotts Ln., Philadelphia PA 19129-1561. (215)849-9116. E-mail: gallery500@hotmail.com. **Owner:** Rita Greenfield. Retail gallery, art consultancy. Estab. 1969. Represents emerging, mid-career and established artists. Sponsors 6-8 shows/year. Average display time 1 month. Open all year; Monday-Saturday, 10-5:30. Located in 3,000 sq. ft.; 40% of space for special exhibitions; 60% of space for gallery artists. 20% private collectors, 30% corporate collectors. Overall price range: $50-6,000; most work sold at $200-3,000.

Media Considers oil, acrylic, watercolor, pastel, drawing, mixed media, collage, handmade paper, sculpture, ceramics, metal, wood, furniture, jewelry, fiber and glass. Most frequently exhibits jewelry, ceramics, glass, furniture and painting.

Style Exhibits painterly abstraction, color field, pattern painting and geometric abstraction. Genres include landscape, still life and figurative work.

Terms Accepts work on consignment (50% commission) or buys outright for 50% of retail price (net 30 days). Retail price set by the gallery and the artist. Gallery provides insurance, promotion, contract and shipping costs from gallery; artist pays shipping costs to gallery. Prefers artwork framed.

Submissions Accepts only artists from US and Canada. Send query letter with résumé, at least 6 slides, bio, brochure, price list and SASE. Responds in 1 month. Files all materials pertaining to artists who are represented. Finds artists through craft shows, travel to galleries.

Tips "Creativity! Creativity! Creativity!"

LANCASTER MUSEUM OF ART

135 N. Lime St., Lancaster PA 17602. (717)394-3497. Website: www.lancastermuseumart.org. **Executive Director:** Cindi Morrison. Nonprofit organization. Estab. 1965. Represents over 100 emerging, mid-career and established artists/year. 700 members. Sponsors 12 shows/year. Average display time 6 weeks. Open all year; Monday-Saturday, 10-4; Sunday, 12-4. Located downtown Lancaster; 4,000 sq. ft.; neoclassical architecture. 100% of space for special exhibitions. 100% of space for gallery artists. Overall price range: $100-25,000; most work sold at $100-10,000.

Media Considers all media.

Terms Accepts work on consignment (30% commission). Retail price set by the artist. Gallery provides insurance; shipping costs are shared. Artwork must be ready for presentation.

Submissions Send query letter with résumé, slides, photographs, SASE, and artist's statement for review by exhibitions committee. Annual deadline: February 1st.

Tips Advises artists to submit quality slides and well-presented proposal. "No phone calls."

ⓝ MATTRESS FACTORY

500 Sampsonia Way, Pittsburgh PA 15212. (412)231-3169. Fax: (412)322-2231. E-mail: info@mattress.org. Website: www.mattress.org. **Contact:** Curatorial Dept. Nonprofit contemporary arts museum. Estab. 1977. Represents 8-12 emerging, mid-career and established artists/year. Exhibited artists include: James Turrell, Bill Woodrow, Ann Hamilton, Jessica Stockholder, John Cage, Allan Wexler, Winnifred Lutz and Christian Boltanski. Sponsors 8-12 shows/year. Average display time 6 months. Tuesday-Saturday, 10-5; Sunday 1-5; closed August. Located in Pittsburgh's historic Mexican War streets; 14,000 sq. ft.; a six-story warehouse and a turn-of-the century general store present exhibitions of temporary and permanent work.

Media Considers site-specific installations—completed in residency at the museum.

Submissions Send query letter with résumé, slides, bio. Responds in 1 year.

NEWMAN GALLERIES

1625 Walnut St., Philadelphia PA 19103. (215)563-1779. Fax: (215)563-1614. E-mail: info@newmangalleries1865.com. Website: www.newmangalleries1865.com. **Owners:** Walter A. Newman, Jr., Walter A. Newman III, Terrence C. Newman. Retail gallery. Estab. 1865. Represents 10-20 emerging, mid-career and established artists/year. Exhibited artists include Elise Phillips, Randolph Bye, James Mcginley, Anthony J. Rudisill, Leonard Mizerek, Mary Anna Goetz, John Murray, George Gallo and John English. Sponsors 2-4 shows/year. Average display time 1 month. Open September through June, Monday-Friday, 9-5:30; Saturday, 10-4:30; July through August, Monday-Friday, 9-5. Located in Center City Philadelphia. 4,000 sq. ft. "We are the largest and oldest gallery in Philadelphia." 50% of space for special exhibitions; 100% of space for gallery artists. Clientele: traditional. 70% private collectors, 30% corporate collectors. Overall price range: $1,000-100,000; most work sold at $2,000-20,000.

Media Considers oil, acrylic, watercolor, pastel, sculpture, engraving, mezzotint and etching. Most frequently exhibits watercolor, oil/acrylic, and pastel.

Style Exhibits expressionism, impressionism, photorealism and realism. Genres include landscapes, florals, Americana, wildlife and figurative work. Prefers: landscapes, Americana, marines and still life.

Terms Accepts work on consignment (45% commission). Retail price set by gallery and artist. Gallery provides insurance. Promotion and shipping costs are shared. Prefers oils framed; prints, pastels and watercolors unframed but matted.

Submissions Send query letter with résumé, 12-24 slides, bio and SASE. Call for appointment to show portfolio of originals, photographs and transparencies. Responds in 1 month. Files "things we may be able to handle but not at the present time." Finds artists through agents, visiting exhibitions, word of mouth, art publications, sourcebooks and artists' submissions.

ⓝ NEXUS/FOUNDATION FOR TODAYS ART

137 North Second Street, Philadelphia PA 19106. E-mail: info@nexusphiladelphia.org. Website: www.nexusphiladelphia.org. **Executive Director:** Nick Cassway. Alternative space, cooperative gallery, nonprofit gallery. Estab. 1975. Approached by 40 artists/year. Represents 20 emerging and mid-career artists. Exhibited artists include: Matt Pruden (illegal art extravaganza). Sponsors 10 exhibits/year. Average display time 1 month. Open Wednesday-Sunday from 12 to 6p.m.; closed July and August. Located Old City, Philadelphia; 2 gallery spaces approx. 750 sq. ft. each. Clients include local community, students, tourists and upscale. Overall price range: $75-1,200; most work sold at $200-400.

Media Considers acrylic, ceramics, collage, craft, drawing, fiber, glass, installation, mixed media, oil, paper, pen & ink and sculpture. Prints include etchings, linocuts, lithographs, posters, serigraphs and woodcuts. Most frequently exhibits installation, collage and mixed media.

Style Exhibits: conceptualism, expressionism, neo-expressionism, postmodernism and surrealism. Most frequently exhibits conceptualism, expressionism and postmodernism.

Terms Artwork is accepted on consignment and there is a 50% commission. Retail price set by the artist. Gallery provides promotion. Accepted work should be framed. Does not require exclusive representation locally. Accepts only artists from Philadelphia for membership in organization.

Submissions Send query letter with artist's statement, bio, photocopies, photographs, SASE and slides. Returns material with SASE. Finds artists through portfolio reviews, referrals by other artists, submissions. Nexus juries artists 3 times a year. Please visit our website for submission dates.

Tips ''Get great slides made by someone who knows how to take professional slides. Learn how to write a cohesive and understandable artist statement.''

PENTIMENTI GALLERY
145 North Second St., Philadelphia PA 19106. (215)625-9990. Fax: (215)625-8488. E-mail: mail@pentimenti.c om. Website: www.pentimenti.com. **Contact:** Christine Pfister, director. Retail and commercial gallery. Estab. 1992. Represents 20-30 emerging, mid-career and established artists. Sponsors 7-9 exhibits/year. Average display time 4-6 weeks. Open all year; Wednesday-Friday, 12-5:30; weekends 12-5. Closed Sundays, August, Christmas and New Year. Located in the heart of Old City Cultural district in Philadelphia. Overall price range: $250-12,000; most work sold at $1,500-7,000.
Media Considers all media. Most frequently exhibits paintings—all media except pastel/watercolor.
Style Exhibits: conceptualism, minimalism, postmodernism and painterly abstraction. Most frequently exhibits postmodernism, minimalism and conceptualism.
Terms Artwork is accepted on consignment and there is a 50% commission. Retail price set by the gallery and the artist. Gallery provides insurance and promotion. Requires exclusive representation locally.
Submissions Call to arrange a personal interview to show portfolio of photographs, slides and transparencies. Send query letter with artist's statement, bio, brochure, photographs, résumé, SASE and slides. Returns material with SASE. Responds in 3 months. Finds artists through word of mouth, submissions, portfolio reviews, art exhibits, art fairs and referrals by other artists.

THE PRINT CENTER
1614 Latimer St., Philadelphia PA 19103. (215)735-6090. Fax: (215)735-5511. E-mail: info@printcenter.org. Website: www.printcenter.org. Nonprofit gallery. Estab. 1915. Exhibits emerging, mid-career and established artists. Approached by 500 artists/year. Sponsors 11 exhibits/year. Average display time 2 months. Open all year; Tuesday-Saturday, 11-5:30. Closed December 21-January 3. Gallery houses 3 exhibit spaces as well as a separate Gallery Store. We are located in historic Rittenhouse area of Philadelphia. Clients include local community, students, tourists and high end collectors. 30% of sales are to corporate collectors. Overall price range: $15-15,000; most work sold at $200.
Media Considers all forms of printmaking, photography and digital printing. Send original artwork—no reproductions.
Style Considers all styles and genres.
Terms Artwork is accepted on consignment and there is a 50% commission. Retail price set by the artist. Gallery provides insurance, promotion and contract. Accepted work should be framed and matted for exhibitions; unframed for Gallery Store. Does not require exclusive representation locally. Only accepts prints and photos.
Submissions Membership based—slides of members reviewed by Curator and Gallery Store Manager. Send membership. Finds artists through submissions, art exhibits and membership.
Tips Be sure to send proper labeling and display of slides with attached slide sheet.

N SAMEK ART GALLERY OF BUCKNELL UNIVERSITY
Elaine Langone Center, Lewisburg PA 17837. (570)577-3792. Fax: (570)577-3215. E-mail: peltier@bucknell.edu. Website: www.departments.bucknell.edu/samek-artgallery/. **Director:** Dan Mills. Gallery Manager: Cynthia Peltier. Nonprofit gallery. Estab. 1983. Exhibits emerging, mid-career and established artists. Sponsors 6 shows/ year. Average display time 6 weeks. Open all year; Monday-Friday, 11-5; Saturday-Sunday, 1-4. Located on campus; 3,500 sq. ft. including main gallery, project room and video screening room.
Media Considers all media, all types of contemporary and historic prints. Most frequently exhibits painting, prints and photographs.
Style Exhibits all styles, genres and periods.
Terms Retail price set by the artist. Gallery provides insurance, promotion (local) and contract; artist pays shipping costs to and from gallery. Prefers artwork framed or prepared for exhibition.
Submissions Send query letter with résumé, slides and bio. Write for appointment to show portfolio of originals. Responds in 3 months. Files bio, résumé, slides. Finds artists through occasional artist invitationals/ competitions.
Tips ''We usually work with themes and then look for work to fit that theme.''

RHODE ISLAND

ARNOLD ART
210 Thames, Newport RI 02840. (401)847-2273. E-mail: info@arnoldart.com. Website: www.arnoldart.com. **President:** William Rommel. Retail gallery. Estab. 1870. Represents 40 emerging, mid-career and established

artists. Exhibited artists include John Mecray, Willard Bond. Sponsors 4 exhibits/year. Average display time 1 month. Open Monday-Saturday, 9:30-5:30; Sunday, 12-5. Clientele: local community, students, tourists and Newport collectors. 1% of sales are to corporate clients. Overall price range: $100-35,000; most work sold at $300.

Media Considers oil, acrylic, watercolor, pastel, pen & ink, drawings, mixed media. Most frequently exhibits oil and watercolor.

Style Genres include marine sailing, classic yachts, America's cup, yachting/sailing.

Terms Accepts work on consignment and there is a 40% commission. Retail price set by artist. Exclusive area representation not required. Gallery provides promotion.

Submissions Send e-mail. Call or e-mail for appointment to show portfolio of originals. Returns materials with SASE.

Tips To make your submissions professional you must "Frame them well."

ARTIST'S COOPERATIVE GALLERY OF WESTERLY

12 High St., Westerly RI 02891. (401)596-2020. E-mail: info@westerlyarts.com. Website: www.westerlyarts.com. Cooperative gallery and nonprofit corporation. Estab. 1992. Represents 45-50 emerging, mid-career and established artists/year. Sponsors 12 shows/year. Average display time 1 month. Offers spring and fall open juried shows. Open all year; Tuesday-Saturday, 10-5. Located downtown on a main street; 30′×80′; ground level, store front, arcade entrance, easy parking. 80% of sales are to private collectors, 20% corporate collectors. Overall price range: $20-3,000; most work sold at $20-300.

Media Considers all media and all types of prints. Most frequently exhibits oils, watercolors, ceramics, sculpture and jewelry.

Style Exhibits: expressionism, primitivism, painterly abstraction, postmodern works, impressionism and realism.

Terms Co-op membership fee of $120/year, plus donation of time and hanging/jurying fee of $10. Gallery takes no percentage. Regional juried shows each year. Retail price set by the artist. Gallery provides promotion; artist pays for shipping. Prefers artwork framed.

Submissions Send query letter with 3-6 slides or photos and artist's statement. Call or write for appointment. Responds in 3 weeks. Membership flyer and application available on request.

Tips "Take some good quality pictures of your work in person, if possible, to galleries showing the kind of work you want to be associated with. If rejected, reassess your work, presentation and the galleries you have selected. Adjust what you are doing appropriately. Try again. Be upbeat and positive."

BANNISTER GALLERY/RHODE ISLAND COLLEGE ART CENTER

600 Mt. Pleasant Ave., Providence RI 02908. (401)456-9765 or 8054. E-mail: domalley@grog.ric.edu. Website: www.ric.edu/bannister. **Gallery Director:** Dennis O'Malley. Nonprofit gallery. Estab. 1978. Represents emerging, mid-career and established artists. Sponsors 9 shows/year. Average display time 3 weeks. Open September-May. Located on college campus; 1,600 sq. ft.; features spacious, well-lit gallery space with off-white walls, gloss black tile floor; two sections with 9 foot and 12 foot ceilings. 100% of space for special exhibitions. Clientele: students and public.

Media Considers all media and all types of original prints. Most frequently exhibits painting, photography and sculpture.

Style Exhibits all styles.

Terms Artwork is exhibited for educational purposes—gallery takes no commission. Retail price set by artist. Gallery provides insurance, promotion and limited shipping costs from gallery. Prefers artwork framed.

Submissions Send query letter with résumé, slides, bio, brochure, SASE and reviews. Files addresses, catalogs and résumés.

CADEAUX DU MONDE

26 Mary St., Newport RI 02835. (401)848-0550. Fax: (401)849-3225. E-mail: info@cadeauxdumonde.com. Website: www.cadeauxdumonde.com. **Owners:** Jane Perkins, Katie Dyer and Bill Perkins. Retail gallery. Estab. 1987. Represents emerging, mid-career and established artists. Exhibited artists include: John Lyimo and A.K. Paulin. Sponsors 7 changing shows and 1 ongoing show/year. Average display time 3-4 weeks. Open all year; daily, 10-6 and by appointment. Located in commercial district; 1,300 sq. ft. Located in historic district in "the Anna Pell House (circa 1840), recently restored with many original details intact including Chiswick tiles on the fireplace and an outstanding back stairway 'Galerie Escalier' (the servant's staircase), which has rotating exhibitions from June to December." 15% of space for special exhibitions; 85% of space for gallery artists. Clients include tourists, upscale, local community and students. 95% of sales are to private collectors, 5% corporate collectors. Overall price range: $20-5,000; most work sold at $100-300.

Media Considers all media suitable for display in a stairway setting for special exhibitions. No prints.

Style Exhibits: folk art. "Style is unimportant, quality of work is deciding factor—look for unusual, offbeat and eclectic."

Terms Accepts work on consignment (30% commission). Retail price set by the artist. Gallery provides insurance. Artist pays shipping costs and promotional costs of opening. Prefers artwork framed.

Submissions Send query letter with résumé, 10 slides, bio, photographs and business card. Call for appointment to show portfolio of photographs or slides. Responds only if interested within 2 weeks. Finds artists through word of mouth, referrals by other artists, visiting art fairs and exhibitions, artist's submissions.

Tips Artists who want gallery representation should "present themselves professionally; treat their art and the showing of it like a small business; arrive on time and be prepared; and meet deadlines promptly."

COMPLEMENTS ART GALLERY

Fine Art Investments, Ltd., 50 Lambert Lind Hwy., Warwick RI 02886. (401)739-9300. Fax: (401)739-7905. E-mail: fineartinv@aol.com. Website: www.complementsartgallery.com. **President:** Domenic B. Rignanese. Retail gallery. Estab. 1986. Represents hundreds of international and New England emerging, mid-career and established artists. Exhibited artists include Fairchild and Hatfield. Sponsors 6 shows/year. Average display time 2-3 weeks. Open all year; Monday-Friday, 8:30-6; Saturday-Sunday, 9-5. 2,250 sq. ft.; "we have a piano and beautiful hardwood floors, also a great fireplace." 20% of space for special exhibitions; 60% of space for gallery artists. Clientele: upscale. 40% private collectors, 15% corporate collectors. Overall price range: $25-5,000; most work sold at $600-1,200.

Media Considers all media except offset prints. Types of prints include engravings, lithographs, wood engravings, mezzotints, serigraphs and etchings. Most frequently exhibits serigraphs, oils and etchings.

Style Exhibits expressionism, painterly abstraction, impressionism, photorealism, realism and imagism. Genres include florals, portraits and landscapes. Prefers realism, impressionism and abstract.

Terms Accepts work on consignment (30% commission) or bought outright for 50% of retail price (90 days). Retail price set by the gallery. Gallery provides insurance, promotion and contract. Shipping costs are shared. Prefers artwork unframed.

Submissions Size limitation due to wall space. Drawings no larger than 40×60, sculpture not heavier than 150 pounds. Send query letter with résumé, bio, 6 slides or photographs. Call for appointment to show portfolio of photographs and slides. Responds in 1 month. Files all materials from artists. Finds artists through word of mouth, referrals by other artists, visiting art fairs and all exhibitions and artist's submissions.

Tips "Artists need to have an idea of the price range of their work and provide interesting information about themselves."

THE DONOVAN GALLERY

3895 Main Rd., Tiverton Four Corners RI 02878. (401)624-4000. Fax: (401)624-4100. E-mail: kris@donovangallery.com. Website: www.donovangallery.com. **Owner:** Kris Donovan. Retail gallery. Estab. 1993. Represents 50 emerging, mid-career and established artists/year. Average display time 1 month. Open all year; Monday-Saturday, 10-5; Sunday, 12-5; shorter winter hours. Located in a rural shopping area; 2,000 sq. ft.; located in 1750s historical home. 100% of space for gallery artists. Clientele: tourists, upscale, local community and students. 90% private collectors, 10% corporate collectors. Overall price range: $80-6,500; most work sold at $250-800.

Media Considers oil, acrylic, watercolor, pastel, mixed media, collage, paper, sculpture, ceramics, some craft, fiber and glass; and all types of prints. Most frequently exhibits watercolors, oils and pastels.

Style Exhibits conceptualism, impressionism, photorealism and realism. Exhibits all genres. Prefers: realism, impressionism and representational.

Terms Accepts work on consignment (45% commission). Retail price set by the artist. Gallery provides limited insurance, promotion and contract; artist pays for shipping. Prefers artwork framed.

Submissions Accepts only artists from New England. Send query letter with résumé, 6 slides, bio, brochure, photographs, SASE, business card, reviews and artist's statement. Call or write for appointment to show portfolio of photographs or slides or transparencies. Responds in 1 week. Files material for possible future exhibition. Finds artists through networking and submissions.

Tips "Do not appear without an appointment, especially on a weekend. Be professional, make appointments by telephone, be prepared with résumé, slides and (in my case) some originals to show. Don't give up. Join local art associations and take advantage of show opportunities there."

FINE ARTS CENTER GALLERIES/UNIVERSITY OF R.I.

105 Upper College Rd., Kingston RI 02881-0820. (401)874-2627. Fax: (401)874-2007. E-mail: shar@uri.edu. Website: www.uri.edu/artgalleries. Nonprofit gallery. Estab. 1968. Exhibits emerging, mid-career and established. Sponsors 15-20 exhibits/year. Average display time 1-3 months. Open all year; Tuesday-Friday, 12-4;

weekends, 1-4. Reduced hours in summer. Composed of 3 galleries—main (largest space), photography and corridor (hallway) galleries. Clients include local community, students, tourists and upscale.
Media Considers all types of prints.
Style Considers all styles and genres.
Terms Retail price set by the artist. Gallery provides insurance. Accepted work should be framed. Does not require exclusive representation locally.
Submissions Mail portfolio for review. Returns material with SASE. Responds in 1 month. Finds artists through word of mouth, submissions, art exhibits and referrals by other artists.

HERA EDUCATIONAL FOUNDATION, HERA GALLERY

327 Main St., P.O. Box 336, Wakefield RI 02880-0336. (401)789-1488. E-mail: info@heragallery.org. Website: www.heragallery.org. **Director:** Katherine Veneman. Nonprofit professional artist cooperative gallery. Estab. 1974. Located in downtown Wakefield, a Northeast area resort community (near beaches, Newport and Providence). Exhibits the work of emerging and established artists who live in New England, Rhode Island and throughout the US. 30 members. Sponsors 9-10 shows/year. Average display time 4-5 weeks. Hours: Wednesday, Thursday and Friday, 1-5; Saturday, 10-4. Closed January. Located downtown; 1,200 sq. ft. 40% of space for special exhibitions.
Media Considers all media and original handpulled prints.
Style Exhibits installations, conceptual art, expressionism, neo-expressionism, painterly abstraction, surrealism, conceptualism, postmodern works, realism and photorealism, basically all styles. "We are interested in innovative, conceptually strong, contemporary works that employ a wide range of styles, materials and techniques." Prefers "a culturally diverse range of subject matter which explores contemporary social and artistic issues important to us all."
Terms Co-op membership. Retail price set by artist. Sometimes offers customer discount and payment by installments. Gallery provides promotion; artist pays for shipping and shares expenses like printing and postage for announcements. Commission is 25%. No insurance.
Submissions Send query letter with SASE. "After sending query letter and SASE, artists interested in membership receive membership guidelines with an application. Twenty slides or a CD-Rom are required for application review along with résumé, artist statement and slide list." Portfolio required for membership; slides for invitational/juried exhibits. Finds artists through word of mouth, advertising in art publications, and referrals from members.
Tips "Please write for membership guidelines. We have two categories of membership, one of which is ideal for out of state artists."

SOUTH CAROLINA

CITY ART GALLERY

1224 Lincoln St., Columbia SC 29201. (803)252-3613. Fax: (803)252-3595. E-mail: gallerydirector@cityartonline. com. Website: www.cityartonline.com. **Contact:** Teri Tynes, gallery director. For-profit gallery. Estab. 1997. Approached by 400 artists/year. Represents 50 emerging, mid-career and established artists. Exhibited artists include: Tarleton Blackwell (oil, mixed media), Scotty Peek (charcoal), Michael Brodeur (oil on canvas), and Alex Powers (mixed media). Sponsors 5 exhibits/year. Average display time 6 weeks. Open all year; Monday-Friday, 10-6; weekends, 11-3. Located in the Vista, the gallery is housed in a spacious 19th century warehouse. City Art features a large main gallery, an adjacent small works gallery and a large second floor exhibition space. 2% of sales are to corporate collectors. Overall price range: $65-5,000; most work sold at $500-1,200.
Media Considers all media. Most frequently exhibits oil on canvas, mixed media and photography.
Style Considers contemporary. Most frequently exhibits abstraction, narrative, contemporary realism and expressionism,
Terms Artwork is accepted on consignment and there is a 50% commission. Retail price set by the artist. Gallery provides insurance, promotion and contract. Accepted work should be framed. Requires exclusive representation locally.
Submissions Mail portfolio for review. Returns material with SASE. Responds in 3 months. Files slides and biography. Finds artists through word of mouth, portfolio reviews, art exhibits and referrals by other artists.
Tips Include full résumé with list of collectors; include digital images as well as slides. Specific list of solo and group shows.

N COLEMAN FINE ART

79 Church St., Charleston SC 29401. (843)853-7000. Fax: (843)722-2552. E-mail: info@colemanfineart.com. Website: www.colemanfineart.com. **Gallery Director:** Rebecca Ansert. Retail gallery, frame making and restora-

tion. Estab. 1974. Represents 5 emerging, mid-career and established artists/year. Exhibited artists include Mary Whyte, Jan Pawlowski, Earl B. Lewis, John Phillip Osborne, Kim Weiland and William P. Duffy. Hosts 2 shows/year. Average display time 1 month. Open all year; Monday, 10-4; Tuesday-Saturday, 10-6. "Both a fine art gallery and restoration studio, Coleman Fine Art has been representing regional and national artists for over 30 years. Located on the corner of Church and Tradd streets, the gallery reinvigorates one of the country's oldest art studios of Elizabeth O'Neill Verner." Clientele: tourists, upscale and locals. 95-98% private collectors, 2-5% corporate collectors. Overall price range: $1,000-50,000; most work sold at $3,000-8,000.

Media Considers oil, watercolor, pastel, pen & ink, drawing, mixed media, sculpture, ceramics, glass, woodcuts, engravings, lithographs, serigraphs and etchings. Most frequently exhibits watercolor, oil and sculpture.

Style Exhibits expressionism, impressionism, photorealism and realism. Genres include portraits, landscapes, still lifes and figurative work. Prefers: figurative work/expressionism, realism and impressionism.

Terms Accepts work on consignment (40% commission) or buys outright for 50% of retail price; net 90 days. Retail price set by the gallery and the artist. Gallery provides promotion and contract. Shipping costs are shared. Prefers artwork framed.

Submissions Send query letter with brochure, 20 slides, reviews, bio and SASE. Write for appointment to show portfolio of photographs, slides and transparencies. Responds only if interested within 1 month. Files slides. Finds artists through submissions.

Tips "Do not approach gallery without an appointment."

McCALLS

111 W. Main, Union SC 29379. (864)427-8781. **Contact:** Bill McCall. Retail gallery. Estab. 1972. Represents 5-7 established artists/year. Open all year; Tuesday-Friday, 10-5 (10 months); Monday-Saturday, 10-6 (2 months). Located downtown; 900 sq. ft. 10% of space for special exhibitions; 90% of space for gallery artists. Clientele: upscale. 60% private collectors, 40% corporate collectors. Overall price range: $150-2,500; most work sold at $150-850.

Media Considers oil, pen & ink, acrylic, glass, craft (jewelry), watercolor, mixed media, pastel, collage; considers all types of prints. Most frequently exhibits jewelry, collage and watercolor.

Style Exhibits painterly abstraction, primitivism, realism, geometric abstraction and impressionism. Genres include florals, western, southwestern, landscapes, wildlife and Americana. Prefers: southwestern, florals and landscapes.

Terms Accepts work on consignment (negotiable commission). Retail price set by the gallery and the artist. Gallery provides insurance, promotion and contract.

Submissions "I prefer to see actual work by appointment only."

Tips "Present only professional quality slides and/or photographs."

SOUTH DAKOTA

SOUTH DAKOTA ART MUSEUM

Medary Ave. at Harvey Dunn St., SDSU, P.O. Box 2250, Brookings SD 57007. (605)688-5423. Fax: (605)688-4445. **Curator of Exhibits:** John Rychtarik. Museum. Estab. 1970. Exhibits 12-20 emerging, mid-career and established artists. Sponsors 17 exhibits/year. Average display time 4-6 months. Open all year; Monday-Friday, 10-5; Saturday, 10-4; Sunday, 12-4. Closed state holidays. Consists of 6 galleries; 26,000 sq. ft. Clients include local community, students, tourists and collectors. Overall price range: $200-6,000; most work sold at $500.

Media Considers all media and all types of prints. Most frequently exhibits painting, sculpture and fiber.

Style Considers all styles.

Terms Artwork is accepted on consignment and there is a 30% commission. Retail price set by the artist. Gallery provides insurance and promotion. Accepted 2-dimensional work must be framed and ready to hang. Does not require exclusive representation locally.

Submissions Send artist's statement, bio, résumé, SASE and slides. Returns material with SASE. Responds only if interested within 3 months. Finds artists through word of mouth, portfolio reviews, art exhibits and referrals by other artists.

N VISUAL ARTS CENTER, WASHINGTON PAVILION OF ARTS & SCIENCE

301 S. Main, Sioux Falls SD 57104. (605)367-6000. Fax: (605)367-7399. E-mail: info@washingtonpavilion.org. Website: washingtonpavilion.org. Nonprofit museum. Estab. 1961. Open Monday-Saturday, 10-5; Sundays 12-5.

Media Considers all media.

Style Exhibits local, regional and national artists.

Submissions Send query letter with résumé and slides.

TENNESSEE

BENNETT GALLERIES

5308 Kingston Pike, Knoxville TN 37919. (865)584-6791. Fax: (865)588-6130. Website: www.bennettgalleries.c om. **Director:** Mary Morris. Owner: Rick Bennett. Retail gallery. Represents emerging and established artists. Exhibited artists include Richard Jolley, Carl Sublett, Scott Duce, Andrew Saftel and Tommie Rush. Sponsors 10 shows/year. Average display time 1 month. Open all year; Monday-Thursday, 10-6; Friday-Saturday, 10-5:30. Located in West Knoxville. Clientele: 70% private collectors, 30% corporate collectors. Overall price range: $200-20,000; most work sold at $2,000-8,000.

Media Considers oil, acrylic, watercolor, pastel, drawing, mixed media, works on paper, sculpture, ceramic, craft, photography, glass, original handpulled prints. Most frequently exhibits painting, ceramic/clay, wood, glass and sculpture.

Style Exhibits contemporary works in abstraction, figurative, non-objective, narrative, primitivism.

Terms Accepts artwork on consignment (50% commission). Retail price set by the gallery and the artist. Sometimes offers customer discounts and payment by installments. Gallery provides insurance on works at the gallery, promotion and contract. Prefers artwork framed. Shipping to gallery to be paid by the artist.

Submissions Send query letter with résumé, no more than 20 slides, bio, photographs, SASE and reviews. Portfolio review requested if interested in artist's work. Responds in 6 weeks. Files samples and résumé. Finds artists through agents, visiting exhibitions, word of mouth, various art publications, sourcebooks, submissions/ self-promotions and referrals.

Tips "When approaching a new gallery, do your research to determine if the establishment is the right venue for your work. Also make a professional presentation with clearly labeled slides and relevant reference material along with a self-addressed envelope."

JAY ETKIN GALLERY

409 S. Main St., Memphis TN 38103. (901)543-0035. E-mail: etkinart@hotmail.com. Website: www.jayetkingall ery.com. **Owner:** Jay S. Etkin. Retail gallery. Estab. 1989. Represents/exhibits 20 emerging, mid-career and established artists/year. Exhibited artists include: Annabelle Meacham, Jeff Scott and Pamela Cobb. Sponsors 10 shows/year. Average display time 1 month. Open all year; Tuesday-Saturday, 10-5. Located in downtown Memphis; 10,000 sq. ft.; gallery features public viewing of works in progress. 30% of space for special exhibitions; 5% of space for gallery artists. Clientele: young upscale, corporate. 80% private collectors, 20% corporate collectors. Overall price range $200-12,000; most work sold at $1,000-3,000.

Media Considers all media except craft, papermaking. Also considers kinetic sculpture and conceptual work. "We do very little with print work." Most frequently exhibits oil on paper canvas, mixed media and sculpture.

Style Exhibits expressionism, conceptualism, neo-expressionism, painterly abstraction, postmodern works, realism, surrealism. Genres include landscapes and figurative work. Prefers: figurative expressionism, abstraction, landscape.

Terms Artwork is accepted on consignment (60% commission). Retail price set by the gallery and the artist. Gallery provides promotion. Artist pays for shipping or costs are shared at times.

Submissions Accepts artists generally from mid-south. Prefers only original works. Looking for long-term committed artists. Send query letter with 6-10 sildes or photographs, bio and SASE. Write for appointment to show portfolio of photographs, slides and cibachromes. Responds only if interested within 1 month. Files bio/slides if interesting work. Finds artists through referrals, visiting area art schools and studios, occasional drop-ins.

Tips "Be patient. The market in Memphis for quality contemporary art is only starting to develop. We choose artists whose work shows technical know-how and who have ideas about future development in their work. Make sure work shows good craftsmanship and good ideas before approaching gallery. Learn how to talk about your work."

LISA KURTS GALLERY

766 S. White Station Rd., Memphis TN 38117. (901)683-6200. Fax: (901)683-6265. E-mail: art@lisakurts.com. Website: www.lisakurts.com. **Contact:** Stephen Barker, communications. For-profit gallery. Estab. 1979. Approached by 500 artists/year; exhibits 20 mid-career and established nationnally and internationally known aritsts. Exhibited artists include Marcia Myers and Anita Huffington. Sponsors 9 total exhibitions/year. Average display time 4-6 weeks. Open all year; Tuesday-Friday, 10-5; Saturday, 11-4. "Lisa Kurts Gallery is Memphis' oldest gallery and is known to be one of the leading galleries in the USA. Exhibits nationally in International Art Fairs and is regularly reviewed in the national press. Publishes catalogues and works closely with serious collectors and museums. This gallery's sister company, Lisa Kurts Ltd. specializes in blue chip Impressionist and Early Modern paintings and sculpture." Clients include national and international. Overall price range: $5,000-100,000; most work sold at $7,500-15,000.

Media Exhibits "80% oil painting, 18% sculpture, 2% photography."

Style Most frequently exhibits "artists with individual vision and who create works of art that are well crafted or painted." Considers all genres.

Terms Artwork is accepted on consignment and there is a 50% commission. Retail price of the art set by the artist and the market if the artist's career is mature; set by the gallery if the artist's career is young. Gallery provides insurance, promotion and contract. Accepted work should be "professionally framed or archively mounted as approved by gallery's standards." Requires exclusive representation in the South.

Submissions Send query letter with artist's statement, résumé, reviews and slides. Returns materials with SASE. Responds to queries in 3 months. Files slides and complete information. Finds artists through art fairs and exhibits, portfolio reviews, referrals by other artists, submissions and word of mouth.

Tips To make their gallery submissions professional artists must send "clearly labeled slides and a minimum of 1 sheet, with the total resume, artist's statement, letter why they contacted our gallery reviews, etc. Do not call. E-mail if you've not heard from us in 3 months."

THE PARTHENON

Centennial Park, Nashville TN 37201. (615)862-8431. Fax: (615)880-2265. E-mail: susan@parthenon.org. Website: www.parthenon.org. **Curator:** Susan E. Shockley. Nonprofit gallery in a full-size replica of the Greek Parthenon. Estab. 1931. Exhibits the work of emerging to mid-career artists. Clientele: general public, tourists. Sponsors 10-12 shows/year. Average display time 3 months. Overall price range: $300-2,000. "We also house a permanent collection of American paintings (1765-1923)."

Media Considers "nearly all" media.

Style "Interested in both objective and non-objective work. Professional presentation is important."

Terms "Sale requires a 20% commission." Retail price set by artist. Gallery provides a contract and limited promotion. The Parthenon does not represent artists on a continuing basis.

Submissions Send 20 well-organized slides, résumé and artist's statement addressed to curator.

Tips "We plan our gallery calendar at least one year in advance."

RIVER GALLERY

400 E. Second St., Chattanooga TN 37403. (423)265-5033, ext. 5. Fax: (423)265-5944. E-mail: details@river-gallery.com. **Owner Director:** Mary R. Portera. Retail gallery. Estab. 1992. Represents 150 emerging, mid-career and established artists/year. Exhibited artists include: Leonard Baskin and Scott E. Hill. Sponsors 12 shows/year. Display time 1 month. Open all year; Monday-Saturday, 10-5; Sunday, 1-5. Located in Bluff View Art District in downtown area; 2,500 sq. ft.; restored early New Orleans-style 1900s home; arched openings into rooms. 20% of space for special exhibitions; 80% of space for gallery artists. Clients include upscale tourists, local community. 95% of sales are to private collectors, 5% corporate collectors. Overall price range: $5-5,000; most work sold at $200-1,000.

Media Considers all media. Most frequently exhibits oil, original prints, photography, watercolor, mixed media, clay, jewelry, wood, glass and sculpture.

Style Exhibits all styles and genres. Prefers painterly abstraction, impressionism, photorealism.

Terms Accepts work on consignment (50% commission). Retail price set by the gallery. Gallery provides insurance, promotion and contract; shipping costs are shared. Prefers artwork framed.

Submissions Send query letter with résumé, slides, bio, photographs, SASE, reviews and artist's statement. Call or e-mail for appointment to show portfolio of photographs and slides. Files all material "unless we are not interested then we return all information to artist." Finds artists through word of mouth, referrals by other artists, visiting art fairs and exhibitions, submissions, ads in art publications.

TEXAS

BARNARDS MILL ART MUSEUM

307 SW. Barnard St., Glen Rose TX 76043. (817)897-2611. **Contact:** Richard H. Moore, president. Museum. Estab. 1989. Represents 30 mid-career and established artists/year. Interested in seeing the work of emerging artists. Sponsors 2 shows/year. Open all year; Saturday, 10-5; Sunday, 1-5. Located 2 blocks from the square. "Barnards Mill is the oldest structure (rock exterior) in Glen Rose. 20% of space for special exhibitions; 80% of space for gallery artists.

Media Considers oil, acrylic, watercolor, pastel, pen & ink, drawing, mixed media, collage, paper, sculpture, ceramics, fiber, glass, installation, photography, woodcuts, engravings, lithographs, wood engravings, mezzotints, serigraphs, linocuts and etchings. Most frequently exhibits oil, pastel and watercolor.

Style Exhibits expressionism, postmodern works, impressionism and realism, all genres. Prefers realism, impressionism and Western.

Terms Gallery provides promotion. Prefers artwork framed.

Submissions Send query letter with résumé, slides or photographs, bio and SASE. Write for appointment to show portfolio of photographs or slides. Responds only if interested within 3 months. Files résumés, photos, slides.

CARSON COUNTY SQUARE HOUSE MUSEUM

P.O. Box 276, Panhandle TX 79068. (806)537-3524. Fax: (806)537-5628. E-mail: shm@squarehousemuseum.org. Website: www.squarehousemuseum.org. **Executive Director:** Viola Moore. Regional museum. Estab. 1967. Exhibits emerging, mid-career and established artists. Sponsors 12 shows/year (6 in each of 2 galleries). Average display time 2 months. Open all year. Purvines Gallery: 870 sq. ft (64.5 linear ft) in historic house; Brown Gallery: 1,728 sq. ft. (1,200 linear ft) in modern education building. Clientele: 100% private collectors. Overall price range: $50-1,200; most work sold at $150-500.
Media Considers all media.
Style All genres. No nudes.
Terms Artwork accepted in exchange for a contributed piece at the end of the show. Artist and buyer make private arrangements; museum stays out of sale. Retail price set by artist. Gallery provides insurance, promotion and contract; artist pays shipping costs. Prefers artwork framed.
Submissions Accepts only artists from Texas panhandle and adjacent states. Send query letter with résumé, slides, brochure, photographs, review and SASE. Write for appointment to show portfolio of photographs and slides. Responds only if interested within 1 month. Files all material.

N THE DALLAS CENTER FOR CONTEMPORARY ART

2801 Swiss Ave., Dallas TX 75204. (214)821-2522. Fax: (214)821-9103. E-mail: info@thecontemporary.net. Website: www.thecontemporary.net. Nonprofit gallery. Estab. 1981. Represents emerging, mid-career and established artists. Presents 10 shows/year. Average display time 3-6 weeks. Open all year. Located "downtown; 15,000 sq. ft.; newly constructed facility." Provides information about opportunities for local artists, including resource center.
Media Considers all media.
Style Exhibits all styles and genres.
Terms Invitational and juried exhibitions are determined through review panels. Invitational exhibits, including insurance and promotion, are offered at no cost to the artist. The annual *Critics Choice* exhibition is juried by well-respected curators and museum directors from other arts institutions. They also offer an annual membership exhibition open to all members.
Submissions Supports Texas-area artists. Send query letter with résumé, slides, bio and SASE.
Tips "We offer a lot of information on grants, commissions and exhibitions available to Texas artists. We are gaining members as a result of our in-house resource center and non-lending library. Our Business of Art seminar series provides information on marketing artwork, presentation, museum collection, tax/legal issues and other related business issues."

DIVERSEWORKS ARTSPACE

1117 E. Freeway, Houston TX 77002. (713)223-8346. Fax: (713)223-4608. E-mail: info@diverseworks.org. **Visual Arts Director:** Diane Barber. Nonprofit gallery/performance space. Estab. 1982. Represents 1,400 members; emerging and mid-career artists. Sponsors 10-12 shows/year. Average display time 6 weeks. Open all year. Located just north of downtown (warehouse district). Has 4,000 sq. ft. for exhibition, 3,000 sq. ft. for performance. "We are located in the warehouse district of Houston. The complex houses five artists's studios (20 artists), and a conservator/frame shop." 75% of space for special exhibition.
Style Exhibits all contemporary styles and all genres.
Terms "DiverseWorks does not sell artwork. If someone is interested in purchasing artwork in an exhibit we have, the artist contacts them." Gallery provides insurance, promotion and shipping costs. Accepts artwork framed or unframed, depending on the exhibit and artwork.
Submissions All proposals are put before an advisory board made up of local artists. Send query letter with résumé, slides and reviews. Call or write to schedule an appointment to show a portfolio, which should include originals and slides. Responds in 3 months.
Tips "Call first for proposal guidelines."

EL TALLER GALLERY-AUSTIN

2438 W. Anderson Lane, #C-3, Austin TX 78757. (800)234-7362. Fax: (512)302-4895. **Owner:** Olga. Retail gallery, art consultancy. Estab. 1980. Represents 20 emerging, mid-career and established artists/year. Exhibited artists include R.C. Gorman and Amado Peña. Sponsors 3 shows/year. Average display time 2-4 weeks. Open all year; Tuesday-Saturday, 10-6. 1,850 sq. ft. 50% of space for special exhibitions; 100% of space for gallery

artists. Clientele: tourists, upscale. 90% private collectors, 10% corporate collectors. Overall price range: $500-15,000; most work sold at $2,500-4,000.

Media Considers all media and all types of prints. Most frequently exhibits mixed media, pastels and watercolors.

Style Exhibits expressionism, primitivism, conceptualism, impressionism. Genres include florals, western, southwestern, landscapes. Prefers: southwestern, landscape, florals.

Terms Accepts work on consignment (50% commission). Retail price set by the artist. Gallery provides promotion and contract; artist pays shipping costs. Prefers artwork framed.

Submissions Send query letter with bio, photographs and reviews. Write for appointment to show portfolio of photographs and actual artwork. Responds only if interested within 2 months.

N MCMURTREY GALLERY

3508 Lake St., Houston TX 77098. (713)523-8238. Fax: (713)523-0932. E-mail: info@mcmurtreygallery.com. **Owner:** Eleanor McMurtrey. Retail gallery. Estab. 1981. Represents 20 emerging and mid-career artists. Exhibited artists include Robert Jessup and Jenn Wetta. Sponsors 10 shows/year. Average display time 1 month. Open all year. Located near downtown; 2,600 sq. ft. Clients include corporations. 75% of sales are to private collectors, 25% corporate collectors. Overall price range: $400-17,000; most work sold at $1,800-6,000.

Media Considers oil, acrylic, pastel, drawings, mixed media, collage, works on paper, photography and sculpture. Most frequently exhibits mixed media, acrylic and oil.

Style Exhibits figurative, narrative, painterly abstraction and realism.

Terms Accepts work on consignment (50% commission). Retail price set by gallery and artist. Prefers artwork framed.

Submissions Send query letter with résumé, slides and SASE. Call for appointment to show portfolio of originals and slides.

Tips ''Be aware of the work the gallery exhibits and act accordingly. Please make an appointment.''

N MONTICELLO FINE ARTS GALLERY

3700 W. Seventh, Fort Worth TX 76107. (817)731-6412. Fax: (817)731-6413 or (888)374-3435. E-mail: glenna@ monticellogallery.com. Website: www.monticellofineartsgallery.com. **Owner:** Glenna Crocker. Retail gallery and art consultancy. Estab. 1983. Represents about 50 artists; emerging, mid-career and established. Interested in seeing the work of emerging artists. Exhibited artists include Carol Anthony, Patricia Nix and Alexandra Nechita. Sponsors 9 shows/year. Average display time 3 weeks. Open all year; Monday-Friday, 10-6; Saturday, 10-5. Located in museum area; 2500 sq. ft.; diversity of the material and artist mix. ''The gallery is warm and inviting.'' 66% of space for special exhibitions. Clientele: upscale, community, tourists. 90% private collectors. Overall price range: $30-10,000.

Media Considers oil, acrylic, watercolor, pastel, mixed media, collage, sculpture, ceramic; original handpulled prints; woodcuts, wood engravings, linocuts, engravings, mezzotints, etchings, lithographs and serigraphs. Most frequently exhibits painting and sculpture.

Style Exhibits expressionism, neo-expressionism, painterly abstraction, color field, impressionism, realism and Western. Genres include landscapes, florals and figurative work. Prefers: landscape, florals, interiors and still life.

Terms Accepts work on consignment (50% commission). Retail price set by gallery and artist. Gallery provides insurance, promotion and contract. Artist pays for shipping. Prefers artwork framed.

Submissions Send query letter with résumé, slides and bio. Call or write for appointment to show portfolio of two of the following: originals, photographs, slides and transparencies, or e-mail digital images and bio.

Tips Artists must have an appointment.

SELECT ART

4040 Avondale Ave., Suite 102, Dallas TX 75219. (214)521-6833. Fax: (214)521-6344. E-mail: selart@swbell.net. postoffice.swbell.net. **Owner:** Paul Adelson. Private art gallery. Estab. 1986. Represents 25 emerging, mid-career and established artists. Exhibited artists include Barbara Elam and Larry Oliverson. Open all year; Monday-Saturday, 9-5 by appointment only. Located in North Dallas; 2,500 sq. ft. ''Mostly I do corporate art placement.'' Clientele: 15% private collectors, 85% corporate collectors. Overall price range: $200-7,500; most work sold at $500-1,500.

Media Considers oil, fiber, acrylic, sculpture, glass, watercolor, mixed media, ceramic, pastel, collage, photography, woodcuts, linocuts, engravings, etchings and lithographs. Prefers monoprints, paintings on paper and photography.

Style Exhibits photorealism, minimalism, painterly abstraction, realism and impressionism. Genres include landscapes. Prefers: abstraction, minimalism and impressionism.

Terms Accepts work on consignment (50% commission). Retail price set by consultant and artist. Sometimes

offers customer discounts. Provides contract (if the artist requests one). Consultant pays shipping costs from gallery; artist pays shipping to gallery. Prefers artwork unframed.

Submissions "No florals or wildlife." Send query letter with résumé, slides, bio and SASE. Call for appointment to show portfolio of slides. Responds only if interested within 1 month. Files slides, bio, price list. Finds artists through word of mouth and referrals from other artists.

Tips "Be timely when you say you are going to send slides, artwork, etc., and neatly label slides."

WOMEN & THEIR WORK GALLERY

1710 Lavaca St., Austin TX 78701. (512)477-1064. Fax: (512)477-1090. E-mail: wtw@texas.net. Website: www.womenandtheirwork.org. **Associate Director:** Kathryn Davidson. Alternative space and nonprofit gallery. Estab. 1978. Approached by more than 200 artists/year. Represents 8-10 one person and seasonal juried shows of emerging and mid-career Texas women. Exhibited artists include: Margo Sawyer, Jill Bedgood and Connie Arismendi. Sponsors 12 exhibits/year. Average display time 5 weeks. Open Monday-Friday, 9-5; Saturday, 12-4. Closed Christmas holidays, December 24 through January 2. Located downtown; 2,000 sq. ft. Clients include local community, students, tourists and upscale. 10% of sales are to corporate collectors. Overall price range: $500-5,000; most work sold at $800-1,000.

Media Considers all media and all types of prints. Most frequently exhibits photography, sculpture, installation and painting.

Style Exhibits: contemporary. Most frequently exhibits minimalism, conceptualism and imagism.

Terms Selects artists through a juried process and pays them to exhibit. Takes 25% commission if something is sold. Retail price set by the gallery and the artist. Gallery provides insurance, promotion and contract. Accepted work should be framed, mounted and matted. Does not require exclusive representation locally. Accepts Texas women-all media-in one person shows only. All other artists, male or female in juried show—once a year if member of W&TW organization.

Submissions Call or e-mail to arrange a personal interview to show portfolio. Returns materials with SASE. Responds in 1 month. Filing of material depends on artist and if they are members. We have a slide registry for all our artists if they are members. Finds artists through submissions and annual juried process.

Tips "Send quality slides, typed résumé, and clear statement with artistic intent. 100% archival material required for framed works. It's important for collectors to understand care of artwork."

UTAH

BINGHAM GALLERY

136 S. Main St., #210, Salt Lake City UT 84101. (801)832-9220 or (800)992-1066. Website: www.binggallery.com. Foundation Website: www.maynarddixon.com. **Owners:** Susan and Paul Bingham. Retail and wholesale gallery. Also provides art by important living and deceased artists for collectors. Estab. 1974. Represents 8 established artists. Exhibited artists include Carolyn Ward, Patricia Smith, Kraig Kiedrowski and many others. "Nationally known for works by Maynard Dixon. Represents the Estate of John Stenvall and have exclusive representation of G. Russel Case. Gallery owns the Maynard Dixon home and studio in Mount Carmel, Utah and Founders of the Thunderbird Foundation for the Arts." Sponsors 4 shows/year. Average display time 5 weeks. Open all year. Located downtown; 2,500 sq. ft.; high ceiling/great lighting, open space. 60% of space for special exhibitions; 40% for gallery artists. Clientele: serious collectors. 100% private collectors. Overall price range: $1,000-300,000; most work sold at $1,800-5,000.

Media Considers oil, acrylic, watercolor, pastel, pen & ink, drawing and sculpture; original handpulled prints and woodcut. Most frequently exhibits oil, acrylic and pencil.

Style Exhibits painterly abstraction, impressionism and realism. Genres include landscapes, florals, southwestern, western, figurative work and all genres. Prefers California landscapes, Southwestern and impressionism.

Terms Accepts work on consignment (50% commission), or buys outright for 30% of retail price (net 30 days). Retail price set by gallery and artist. Gallery provides insurance, promotion, contract and shipping costs from gallery. Prefers artwork unframed.

Submissions Prefers artists be referred or present work in person. Call for appointment to show portfolio of originals. Responds in 1 week or gives an immediate yes or no on sight of work.

Tips "Gallery has moved to downtown Salt Lake City." The most common mistake artists make in presenting their work is "failing to understand the market we are seeking."

Ⓝ PHILLIPS GALLERY

444 E. 200 S., Salt Lake City UT 84111. (801)364-8284. Fax: (801)364-8293. Website: www.phillips-gallery.com. **Director:** Meri DeCaria. Retail gallery, art consultancy, rental gallery. Estab. 1965. Represents 80 emerging, mid-career and established artists/year. Exhibited artists include Tony Smith, Doug Snow, Lee Deffebach.

Sponsors 8 shows/year. Average display time 1 month. Open all year; Tuesday-Friday, 10-6; Saturday, 10-4; closed August 1-20 and December 25-January 1. Located downtown; has 3 floors at 2,000 sq. ft. and a 2,400 sq. ft. sculpture deck on the roof. 40% private collectors, 60% corporate collectors. Overall price range: $100-10,000; most work sold at $200-4,000.

Media Considers all media, woodcuts, engravings, lithographs, wood engravings, linocuts, etchings. Most frequently exhibits oil, acrylic, sculpture/steel.

Style Exhibits expressionism, conceptualism, neo-expressionism, minimalism, pattern painting, primitivism, color field, hard-edge geometric abstraction, painterly abstraction, postmodern works, realism, surrealism, impressionism. Genres include Western, Southwestern, landscapes, figurative work, contemporary. Prefers abstract, neo-expressionism, conceptualism.

Terms Accepts work on consignment (50% commission). Gallery provides insurance and promotion; shipping costs are shared. Prefers artwork framed.

Submissions Accepts only artists from western region/Utah. Send query letter with résumé, slides, reviews, artist's statement, bio and SASE. Finds artists through word of mouth, referrals.

SERENIDAD GALLERY

360 W. Main, P.O. Box 326, Escalante UT 84726. (435)826-4720 and (888)826-4577. E-mail: hpriska@juno.com. Website: www.escalante-cc.com/serenidad/html and www.escalanteretreat.com/gallery/html. **Co-owners:** Philip and Harriet Priska. Retail gallery. Estab. 1993. Represents 8 mid-career and established artists and two deceased artists. Exhibited artists include Lynn Griffin, Clay Wagstaff, Rachel Bentley, Kipp Greene, Harriet Priska, Howard Hutchinson, Laurent Martres, Valerie Orelmann and Mary Kellog. All work is on continuous display. Open all year; Monday-Saturday, 8-8. Located on Highway 12 in Escalante; 1,700 sq. ft.; ''rustic western decor with log walls.'' 50% of space for gallery artists. Clientele: tourists. 100% private collectors. Overall price range: $100-4,000; most work sold at $300-3,000.

Media Considers oil, acrylic, watercolor, sculpture, fiber (Zapotec rugs), photography and china painting. Most frequently exhibits acrylics, watercolors, photography, pen & ink and oils.

Style Exhibits realism. Genres include western, southwestern and landscapes. Prefers: Utah landscapes—prefer local area here, northern Arizona-Navajo reservation and California-Nevada landscapes.

Terms Accepts work on consignment (commission set by artist) or buys outright (prices set by artist). Retail price set by the gallery. Gallery provides promotion.

Submissions Finds artists ''generally by artists coming into the gallery.''

Tips ''Work must show professionalism and have quality. This is difficult to explain; you know it when you see it.''

VERMONT

🅽 CONE EDITIONS

Powder Spring Rd., East Topsham VT 05076. (802)439-5751. Fax: (802)439-6501. **E-mail: jcone@aol.com. Owner:** Jon Cone. Gallery workshop. Printmakers, publishers and distributors of computer and digitally made works of art. Estab. 1980. Represents/exhibits 12 emerging, mid-career and established artists/year. Exhibited artists include Norman Bluhm and Wolf Kahn. Sponsors 4 shows/year. Average display time 3 months. Open all year; Monday-Friday, 7:30-5. Located downtown; 1,000 sq. ft.; post and beam, high ceilings, natural light. 50% of space for special exhibitions; 50% of space for gallery artists. Clientele: private, corporate. 40% private collectors, 60% corporate collectors. Overall price range: $300-5,000; most work sold at $500-1,500.

Media Considers computer and digital art and computer prints. Most frequently exhibits iris ink jet print, digitial monoprint and digital gravure.

Style Exhibits expressionism, minimalism, color field, painterly abstraction and imagism.

Terms Artwork is accepted on consignment (50% commission). Retail price set by the artist. Gallery provides promotion; shipping costs are shared. Prefers artwork unframed.

Submissions Prefers computer and digital art. Contact through e-mail. Call for appointment to show portfolio of CD-ROM. Responds in 1-3 weeks. Files slides and CD-ROM.

Tips ''We find most of the artists we represent by referrals of our other artists.''

PARADE GALLERY

Box 245, Warren VT 05674. (802)496-5445. Fax: (802)496-4994. E-mail: jeff@paradegallery.com. Website: www.paradegallery.com. **Owner:** Jeffrey S. Burnett. Retail gallery. Estab. 1982. Represents 15-20 emerging, mid-career and established artists. Clients include tourist and upper middle class second-home owners. 98% of sales are to private collectors. Overall price range: $20-2,500; most work sold at $50-300.

Media Considers oil, acrylic, watercolor, pastel, mixed media, collage, limited edition prints, fine arts posters,

works on paper, sculpture and original handpulled prints. Most frequently exhibits etchings, silkscreen and watercolor. Currently looking for oil/acrylic and watercolor.

Style Exhibits: primitivism, impressionistic and realism. "Parade Gallery deals primarily with representational works with country subject matter. The gallery is interested in unique contemporary pieces to a limited degree." Does not want to see "cutesy or very abstract art."

Terms Accepts work on consignment (40% commission) or occasionally buys outright (net 30 days). Retail price set by gallery or artist. Sometimes offers customer discounts and payment by installment. Exclusive area representation required. Gallery provides insurance and promotion.

Submissions Send query letter with résumé, slides and photographs. Portfolio review requested if interested in artist's work. A common mistake artists make in presenting their work is having "unprofessional presentation or poor framing." Biographies and background are filed. Finds artists through customer recommendations, shows, magazines or newspaper stories and photos.

Tips "We need to broaden offerings in price ranges which seem to offer a good deal for the money."

▓ TODD GALLERY

614 Main, Weston VT 05161. (802)824-5606. E-mail: ktodd@sover.net. Website: www.toddgallery.com. **Manager:** Karin Todd. Retail gallery. Estab. 1986. Represents 10 established artists/year. May be interested in seeing the work of emerging artists in the future. Exhibited artists include Robert Todd and Judith Carbine. Sponsors 2 shows/year. Average display time 1 month. Open all year; daily, 10-5; closed Tuesday and Wednesday. Located at edge of small VT village; 2,000 sq. ft.; 1840 refurbished barn and carriage house—listed in National Register of Historic Places. Clientele: tourists, local community and second home owners. 80% private collectors, 20% corporate collectors. Overall price range: $200-5,000; most work sold at $400-1,000.

Media Considers oil, acrylic, watercolor, pastel, ceramics, photography, woodcuts, engravings, lithographs, wood engravings, serigraphs, linocuts and etchings. Most frequently exhibits watercolor, oil and pastel.

Style Exhibits expressionism, minimalism, impressionism and realism. Genres include florals, landscapes and Americana. Prefers landscapes (New England), foreign (Ireland and Britain) and seascapes (New England).

Terms Accepts work on consignment (40% commission). Retail price set by the artist. Gallery provides insurance and promotion.

Submissions Prefers only artists from Vermont or New England. Prefers only oil, watercolor and pastel. Send query letter with résumé, slides, bio, SASE and artist's statement. Call for appointment to show portfolio of slides, transparencies and originals. Responds in 2 weeks. Files for potential inclusion in gallery. "We generally seek artists out whose work we have seen."

Tips "Don't make the mistake of having no appointment, staying too long, or having work badly preserved."

WOODSTOCK FOLK ART PRINTS & ANTIQUITIES

P.O. Box 300, Woodstock VT 05091. (802)457-2012. E-mail: wfolkart@sover.net. Website: www.woodstockfolk art.com. **Art Director:** Gael Cantlin. Retail gallery. Estab. 1995. Represents 45 emerging, mid-career and established artists. Exhibited artists include Sabra Field, Anne Cady and Katie Upton. Sponsors 4 shows/year. Open all year; Monday-Saturday, 10-5; Sunday, 10-4. Located downtown in village; 900 sq. ft. Clients include tourists, local. 20% of sales are to private collectors. Overall price range: $20-10,000; most work sold at $400-600.

Media Considers oil, acrylic, watercolor, pastel, drawing, mixed media, sculpture, ceramics, glass, photography and woodcuts. Most frequently exhibits woodcuts (prints), oil and watercolor.

Style Exhibits primitivism, color field, impressionism and photorealism. Genres include florals, landscapes and Americana. Prefers bold, colorful art.

Terms Accepts work on consignment (50% commission). Retail price set by the artist. Gallery provides promotion. Prefers artwork framed.

Submissions Send query letter with bio and photographs. Write for appointment to show portfolio of photographs. Responds only if interested within 1 month. Finds artists through word of mouth, referrals by other artists, visiting art fairs and exhibitions and artist's submissions.

VIRGINIA

ℕ ARTSPACE

Zero East Fourth Street, Richmond VA 23224. (804)232-6464. Fax: (804)232-6465. E-mail: artspacegallery@att.n et. Website: www.artspacegallery.org. **Exhibition Committee:** Judy Anderson. Nonprofit gallery. Estab. 1988. Approached by 100 artists/year. Represents approx. 50 emerging, mid-career artists. Sponsors approx. 2 exhibits/year. Average display time 1 month. Open all year; Wednesday-Sunday from 12-4. Located in the newly designated Arts District in Manchester, in Richmond, VA. Brand new gallery facilities; 4 exhibition spaces;

approx. 3,000 sq. ft. Clients include local community, students, tourists and upscale. 2% of sales are to corporate collectors. Overall price range: $100-800; most work sold at $450.

Media Considers all media and all types of prints. Most frequently exhibits photography, painting and graphic design.

Style Considers all styles and genres.

Terms There are exhibition fees; work sold = 33% commission. Retail price set by the artist. Gallery provides insurance and contract. Accepted work should be framed, mounted and matted. Does not require exclusive representation locally.

Submissions Send query letter with artist's statement, bio, résumé, SASE, slides and proposal form. Returns material with SASE. Responds to queries in 3 weeks. If accepted, all materials submitted are filed. Finds artists through referrals by other artists, submissions and word of mouth.

MARSH ART GALLERY

University of Richmond Museums, Richmond VA 23173. (804)289-8276. Fax: (804)287-1894. E-mail: museums @richmond.edu. Website: oncampus.richmond.edu/museums. **Director:** Richard Waller. Museum. Estab. 1968. Represents emerging, mid-career and established artists. Sponsors 10 shows/year. Average display time 6 weeks. Open all year; with limited summer hours May-August. Located on University campus; 5,000 sq. ft. 100% of space for special exhibitions.

Media Considers all media and all types of prints. Most frequently exhibits painting, sculpture, photography and drawing.

Style Exhibits all styles and genres.

Terms Work accepted on loan for duration of special exhibition. Retail price set by the artist. Gallery provides insurance, promotion, contract and shipping costs. Prefers artwork framed.

Submissions Send query letter with résumé, 8-12 slides, brochure, SASE, reviews and printed material if available. Write for appointment to show portfolio of photographs, slides, transparencies or "whatever is appropriate to understanding the artist's work." Responds in 1 month. Files résumé and other materials the artist does not want returned (printed material, slides, reviews, etc.).

▣ ▣ McLEAN PROJECT FOR THE ARTS

1234 Ingleside Ave., McLean VA 22101. (703)790-1953. Fax: (703)790-1012. E-mail: mpaart@aol.com. Website: www.mpaart.org. Alternative space. Estab. 1962. Exhibited artists include Yuriko Yamaguchi and Christopher French. Sponsors 12-15 shows/year. Average display time 5-6 weeks. Open Tuesday-Friday, 10-5; Saturday, 1-5. 3,000 sq. ft.; large luminous "white cube" type of gallery; moveable walls. 85% of space for special exhibitions. Clientele: local community, students, artists' families. 100% private collectors. Overall price range: $200-15,000; most work sold at $800-1,800.

Media Considers all media except graphic design and traditional crafts; all types of prints except posters. Most frequently exhibits painting, sculpture and installation.

Style Exhibits all styles, all genres.

Terms Artwork is accepted on consignment (25% commission). Retail price set by the artist. Gallery provides insurance and promotion. Artist pays for shipping costs. Prefers artwork framed (if works on paper).

Submissions Accepts only artists from Maryland, DC, Virginia and some regional Mid-Atlantic. Send query letter with résumé, slides, reviews and SASE. Responds within 4 months. Artists' slides, bios and written material kept on file for 2 years. Finds artists through referrals by other artists and curators; by visiting exhibitions and studios.

Tips Visit the gallery several times before submitting proposals, so that the work you submit fits the framework of art presented.

THE PRINCE ROYAL GALLERY

204 S. Royal St., Alexandria VA 22314. (703)548-5151. E-mail: princeroyal@earthlink.net. Website: www.prince royalgallery.com. **Director:** John Byers. Retail gallery. Estab. 1977. Interested in emerging, mid-career and established artists. Sponsors 6 shows/year. Average display time 3-4 weeks. Located in middle of Old Town Alexandria. "Gallery is the ballroom and adjacent rooms of historic hotel." Clientele: primarily Virginia, Maryland and Washington DC residents. 95% private collectors, 5% corporate clients. Overall price range: $75-8,000; most artwork sold at $700-1,200.

Media Considers oil, acrylic, watercolor, mixed media, sculpture, egg tempera, engravings, etchings and lithographs. Most frequently exhibits oil, watercolor and sculptures in wood, stone, and bronze.

Style Exhibits impressionism, expressionism, realism, primitivism and painterly abstraction. Genres include landscapes, florals, portraits, still lifes, and figurative work. "The gallery deals primarily in original, representational art. Abstracts are occasionally accepted but are hard to sell in northern Virginia. Limited edition prints are accepted only if the gallery carries the artist's original work."

Terms Accepts work on consignment (40% commission). Retail price set by artist. Customer discounts and payment by installment are available, but only after checking with the artist involved and getting permission. Exclusive area representation required. Gallery provides insurance, promotion and contract. Requires framed artwork.

Submissions Send query letter with résumé, brochure, slides and SASE. Call or write to schedule an appointment to show a portfolio, which should include originals, slides and transparencies. Responds in 1 week. Files résumés and brochures. All other material is returned.

Tips "Write or call for an appointment before coming. Have at least six pieces framed and ready to consign if accepted. Can't speak for the world, but in northern Virginia collectors are slowing down. Lower-priced items continue okay, but sales over $3,000 are becoming rare. More people are buying representational rather than abstract art. Impressionist art is increasing. Get familiar with the type of art carried by the gallery and select a gallery that sells your style work. Study and practice until your work is as good as that in the gallery. Then call or write the gallery director to show photos or slides."

WASHINGTON

FOSTER/WHITE GALLERY

123 S. Jackson St., Seattle WA 98104. (206)622-2833. Fax: (206)622-7606. E-mail: seattle@fosterwhite.com. Website: www.fosterwhite.com. **Owner/Director:** Phen Huang. Retail gallery. Estab. 1973. Represents 60 emerging, mid-career and established artists. Interested in seeing the work of local emerging artists. Exhibited artists include Dale Chihuly, Mark Tobey, George Tsutakawa, Morris Graves, and William Morris. Average display time 1 month. Open all year; Monday-Saturday, 10-5:30; Sunday, 12-5. Located historic Pioneer Square; 5,800 sq. ft. Clientele: private, corporate and public collectors. Overall price range: $300-35,000; most work sold at $2,000-8,000.

 • Gallery has additional spaces at 107 Park Lane, Kirkland WA 98033 (425)822-2305. Fax: (425)828-2270, and Ranier Square, 1331 Fifth Ave., Seattle WA 98101, (206)583-0100. Fax (206)583-7188.

Media Considers oil, acrylic, watercolor, pastel, pen & ink, drawing, mixed media, collage, paper, sculpture, ceramics, craft, fiber, glass and installation. Most frequently exhibits glass sculpture, works on paper and canvas and ceramic and metal sculptures.

Style Contemporary Northwest art. Prefers contemporary Northwest abstract, contemporary glass sculpture.

Terms Gallery provides insurance, promotion and contract.

Submissions Send query letter with résumé, slides, bio and reviews. Write for appointment to show portfolio of slides. Responds in 3 weeks.

N KIRSTEN GALLERY, INC.

5320 Roosevelt Way NE, Seattle WA 98105. (206)522-2011. Website: www.kirstengallery.com. **President:** R.J. Kirsten. Retail gallery. Estab. 1974. Represents 60 emerging, mid-career and established artists. Exhibited artists include Birdsall and Daiensai. Sponsors 4 shows/year. Average display time 1 month. Open all year. 3,500 sq. ft.; outdoor sculpture garden. 40% of space for special exhibitions; 60% of space for gallery artists. 90% private collectors, 10% corporate collectors. Overall price range: $75-15,000; most work sold at $75-2,000.

Media Considers oil, acrylic, watercolor, mixed media, sculpture, glass and offset reproductions. Most frequently exhibits oil, watercolor and glass.

Style Exhibits surrealism, photorealism and realism. Genres include landscapes, florals, Americana. Prefers: realism.

Terms Accepts work on consignment (50% commission). Retail price set by artist. Offers payment by installments. Gallery provides promotion; artist pays shipping costs. "No insurance; artist responsible for own work."

Submissions Send query letter with résumé, slides and bio. Write for appointment to show portfolio of photographs and/or slides. Responds in 2 weeks. Files bio and résumé. Finds artists through visiting exhibitions and word of mouth.

Tips "Keep prices down. Be prepared to pay shipping costs both ways. Work is not insured (send at your own risk). Send the best work—not just what you did not sell in your hometown. Do not show up without an appointment."

PAINTERS ART GALLERY

30517 S.R. 706 E., P.O. Box 106, Ashford WA 98304-0106. (360)569-2644. E-mail: mtwoman@mashell.com. Website: www.mashell.com/~mtwoman/. **Owner:** Joan Painter. Retail gallery. Estab. 1972. Represents 20 emerging, mid-career and established artists. Open all year. Located 5 miles from the entrance to Mt. Rainier National Park; 1,200 sq. ft. 50% of space for work of gallery artists. Clientele: collectors and tourists. Overall price range $10-7,500; most work sold at $300-2,500.

● The gallery has over 60 people on consignment. It is a very informal, outdoors atmosphere.

Media Considers oil, acrylic, watercolor, pastel, mixed media, stained glass, reliefs, offset reproductions, lithographs and serigraphs. "I am seriously looking for totem poles and outdoor carvings." Most frequently exhibits oil, pastel and acrylic.

Style Exhibits primitivism, surrealism, imagism, impressionism, realism and photorealism. All genres. Prefers: Mt. Rainier themes and wildlife. "Indians and mountain men are a strong sell."

Terms Accepts artwork on consignment (30% commission on prints and sculpture; 40% on paintings). Retail price set by gallery and artist. Gallery provides promotion; artist pays for shipping. Prefers artwork framed.

Submissions Send query letter or call. "I can usually tell over the phone if artwork will fit in here." Portfolio review requested if interested in artist's work. Does not file materials.

Tips "Sell paintings and retail price items for the same price at mall and outdoor shows that you price them in galleries. I have seen artists underprice the same paintings/items, etc. when they sell at shows. Do not copy the style of other artists. To stand out, have your own style."

WEST VIRGINIA

THE ART STORE

1013 Bridge Rd., Charleston WV 25314. (304)345-1038. Fax: (304)345-1858. **Director:** E. Schaul. Retail gallery. Estab. 1974. Represents 16 mid-career and established artists. Sponsors 6 shows/year. Average display time 3 weeks. Open all year. Located in a suburban shopping center; 2,000 sq. ft. 50% of space for special exhibitions. Clientele: professionals, executives, decorators. 80% private collectors, 20% corporate collectors. Overall price range: $200-8,000; most work sold at $2,000.

Media Considers oil, acrylic, watercolor, pastel, mixed media, works on paper, ceramics, wood and metal.

Style Exhibits expressionism, painterly abstraction, color field and impressionism.

Terms Accepts artwork on consignment (50% commission). Retail price set by gallery and artist. Gallery provides insurance, promotion and shipping costs from gallery. Prefers artwork unframed.

Submissions Send query letter with résumé, slides, SASE, announcements from other gallery shows and press coverage. Gallery makes the contact after review of these items; responds in 6 weeks.

Tips "Do not send slides of old work."

⦿ JULIET MUSEUM OF ART, AVAMPATO DISCOVERY MUSEUM

1 Clay Square, 300 Leon Sullivan Way, Charleston WV 25301. (304)561-3575. Fax: (304)347-2313. E-mail: info@avampatodiscoverymuseum.org. Website: www.avampatodiscoverymuseum.org. **Curator:** Ric Ambrose. Museum. Estab. 1974. Represents emerging, mid-career and established artists. Sponsors 6 shows/year. Average display time 2-3 months. Open all year. Located in the South Hills, residential area; 9,000 sq. ft.; historical mansion.

Media Considers oil, acrylic, watercolor, pastel, pen & ink, drawings, mixed media, collage, works on paper, sculpture, installations, photography and prints.

Style Considers all styles and genres.

Terms Retail price set by artist. Gallery pays shipping costs. Prefers artwork framed.

Submissions Send query letter with résumé, slides, brochure, photographs, reviews, bio and SASE. Write for appointment to show portfolio of slides. Replies only if interested within 2 weeks. Files everything or returns in SASE.

WISCONSIN

⦿ CHARLES ALLIS ART MUSEUM

1801 N. Prospect Avenue, Milwaukee WI 53202. (414)278-8295. Fax: (414)278-0335. E-mail: shaberstroh@cavt museums.org. Website: www.cavtmuseums.org. **Manager of Exhibitions & Collections:** Sarah Haberstroh. Museum. Estab. 1947. Approached by 20 artists/year. Represents 6 emerging, mid-career and established artists that have lived or studied in Wisconsin. Exhibited artists include: Anne Miotke (watercolor); Evelyn Patricia Terry (pastel, acrylic, multi-media). Sponsors 6-8 exhibits/year. Average display time 2 months. Open all year; Wednesday-Sunday from 1-5. Located in an urban area, historical home, 3 galleries. Clients include local community, students and tourists. 10% of sales are to corporate collectors. Overall price range: $200-6,000; most work sold at $300.

Media Considers acrylic, collage, drawing, installation, mixed media, oil, pastel, pen & ink, sculpture, watercolor and photography. Print types include engravings, etchings, linocuts, lithographs, serigraphs and woodcuts. Most frequently exhibits acrylic, oil and watercolor.

Style Considers all styles and genres. Most frequently exhibits realism, impressionism and minimalism.

Terms Artwork is accepted on consignment. Artwork can be purchased during a run of an exhibition. There is a 30% commission. Retail price set by the artist. Museum provides insurance, promotion and contract. Accepted work should be framed. Does not require exclusive representation locally. Accepts only artists from or with a connection to Wisconsin.

Submissions Send query letter with artist's statement, bio, business card, résumé, reviews, SASE and slides. Material is returned if the artist is not chosen for our exhibition. Responds to queries in 1 year. Finds artists through art exhibits, referrals by other artists, submissions and word of mouth.

Tips "All materials should be typed. Slides should be labeled and accompanied by a complete checklist."

GRACE CHOSY GALLERY

1825 Monroe St., Madison WI 53711. (608)255-1211. Fax: (608)663-2032. E-mail: gchosy@chorus.net. **Director:** Karin Ketarkus. Retail gallery. Estab. 1979. Represents/exhibits 80 emerging, mid-career and established artists/year. Exhibited artists include Wendell Arneson, John Mominee, and William Weege. Sponsors 11 shows/year. Average display time 3 weeks. Open all year; Tuesday-Saturday, 10-5. Located downtown; 2,000 sq. ft.; "open uncluttered look." 45% of space for special exhibitions; 55% of space for gallery artists. Clientele: primarily local community. 60% private collectors, 40% corporate collectors. Overall price range: $200-7,000; most work sold at $500-2,000.

Media Considers all media except photography and fiber; all types of original prints except giclées, reproductions, and posters. Most frequently exhibits paintings, drawings and sculpture.

Style Exhibits all styles. Genres include landscapes, florals and figurative work. Prefers landscapes, still life and abstract.

Terms Artwork is accepted on consignment. Retail price set by the gallery and the artist. Gallery provides insurance, promotion and contract. Artist pays for shipping costs.

Submissions Send query letter with résumé, bio and SASE. Call or write for appointment to show portfolio. Responds in 3 months.

ℕ TORY FOLLIARD GALLERY

233 N. Milwaukee St., Milwaukee WI 53202. (414)273-7311. Fax: (414)273-7313. Website: www.toryfolliard.com. **Contact:** Richard Knight. Retail gallery. Estab. 1988. Represents emerging and established artists. Exhibited artists include Tom Uttech and John Wilde. Sponsors 8-9 shows/year. Average display time 4-5 weeks. Open all year; Tuesday-Friday, 11-5; Saturday, 11-4. Located downtown in historic Third Ward; 3,000 sq. ft. 60% of space for special exhibitions; 40% of space for gallery artists. Clientele: tourists, upscale, local community and artists. 90% private collectors, 10% corporate collectors. Overall price range: $500-25,000; most work sold at $1,500-8,000.

Media Considers all media except installation and craft. Most frequently exhibits painting, sculpture.

Style Exhibits expressionism, abstraction, realism, surrealism and imagism. Prefers: realism.

Terms Accepts work on consignment. Retail price set by the gallery and the artist. Gallery provides insurance and promotion; artist pays shipping costs. Prefers artwork framed.

Submissions Prefers artists working in midwest regional art. Send query letter with résumé, slides, photographs, reviews, artist's statement and SASE. Portfolio should include photographs or slides. Responds in 2 weeks. Finds artists through referrals by other artists.

GALLERY 218

218 S. Second St., Milwaukee WI 53204. (414)643-1732. E-mail: info@gallery218.com or jhha23@usa.net. Website: www.gallery218.com. **President:** Judith Hooks. Nonprofit gallery, cooperative gallery, alternative space. "Gallery 218 is committed to providing exhibition opportunities to area artists. 218 sponsors exhibits, poetry readings, performances, recitals and other cultural events. 'The audience is the juror.'" Estab. 1990. Represents over 200 emerging, mid-career and established artists/year. Exhibited artists include Cathy Jean Clark, Steven Bleicher, Fred Stein, Judith Hooks, George Jones, Paul Drewry. Sponsors 15 shows and 1 fair/year. Average display time 1 month. Open all year; Wednesday, 12-5; Friday, 12-5; Saturday and Sunday 11-5. Located just south of downtown; 1,500 sq. ft.; warehouse-type space—wooden floor, halogen lights; includes information area. 100% of space for gallery artists. 75% private collectors, 25% corporate collectors. Overall price range: $100-1,000; most work sold at $100-600.

 ● Gallery 218 has a "bricks and mortar" gallery as well as a great website, which provides lots of links to helpful art resources.

Media Considers all media except crafts. Considers linocuts, monotypes, woodcuts, mezzotints, etchings, lithographs and serigraphs. Most frequently exhibits paintings/acrylic, photography, mixed media.

Style Exhibits expressionism, conceptualism, photorealism, neo-expressionism, minimalism, hard-edge geometric abstraction, painterly abstraction, postmodern works, realism, surrealism, imagism, fantasy, comic book

art. Exhibits all genres, portraits, figurative work; "anything with an edge." Prefers abstract expressionism, fine art photography, personal visions.

Terms There is a yearly Co-op membership fee plus a monthly fee, and donation of time (25% commission.) Membership good 1 year. There is a rental fee for space; covers 1 month. Group shows at least 8 times a year (small entry fee). Retail price set by the artist. Gallery provides promotion; artist pays for shipping. Prefers artwork framed.

Submissions Prefers only adults (21 years plus), no students (grad students OK), serious artists pursuing their careers. E-mail query letter with résumé, business card, slides, photographs, bio, SASE or request for application with SASE. E-mail for appointment to show portfolio of photographs, slides, résumé, bio. Responds in 1 month. Files all. Finds artists through referrals, visiting art fairs, submissions. "We advertise for new members on a regular basis."

Tips "Don't wait to be 'discovered'. Get your work out there—not just once, but over and over again. Don't get distracted by material things, like houses, cars and real jobs. Be prepared to accept suggestions and/or criticism. Read entry forms carefully."

THE FANNY GARVER GALLERY

230 State St., Madison WI 53703. (608)256-6755. E-mail: art@fannygarvergallery.com. Website: www.fannygarvergallery.com. **President:** Jack Garver. Retail Gallery. Estab. 1972. Represents 100 emerging, mid-career and established artists/year. Exhibited artists include Lee Weiss, Harold Altman and Josh Simpson. Sponsors 11 shows/year. Average display time 1 month. Open all year; Monday-Wednesday, 10-6; Thursday-Saturday, 10-8, Sunday, 12-4. Located downtown; 3,000 sq. ft.; older refurbished building in unique downtown setting. 33% of space for special exhibitions; 95% of space for gallery artists. Clientele: private collectors, gift-givers, tourists. 40% private collectors, 10% corporate collectors. Overall price range: $10-10,000; most work sold at $100-1,000.

Media considers oil, pen & ink, paper, fiber, acrylic, drawing, sculpture, glass, watercolor, mixed media, ceramics, pastel, collage, craft, woodcuts, wood engravings, linocuts, engravings, mezzotints, etchings, lithographs and serigraphs. Most frequently exhibits watercolor, oil and glass.

Style Exhibits all styles. Prefers: landscapes, still lifes and abstraction.

Terms Accepts work on consignment (50% commission) or buys outright for 50% of retail price (net 30 days). Retail price set by gallery. Gallery provides promotion and contract, artist pays shipping costs both ways. Prefers artwork framed.

Submissions Send query letter with résumé, 8 slides, bio, brochure, photographs and SASE. Write for appointment to show portfolio, which should include originals, photographs and slides. Responds only if interested within 1 month. Files announcements and brochures.

Tips "Don't take it personally if your work is not accepted in a gallery. Not all work is suitable for all venues."

ℕ NEW VISIONS GALLERY, INC.

at Marshfield Clinic, 1000 N. Oak Ave., Marshfield WI 54449. E-mail: newvisions.gallery@verizon.net. Website: www.newvisionsgallery.org. **Executive Director:** Ann Waisbrot. Nonprofit educational gallery. Runs museum and art center program for community. Represents emerging, mid-career and established artists. Organizes a variety of group and thematic shows (10 per year), very few one-person shows, sponsors Marshfield Art Fair and "Mighty Midwest Biennial" every two years (send SASE for prospectus). "Culture and Agriculture": annual springtime invitational exhibit of art with agricultural themes. Does not represent artists on a continuing basis but does accept exhibition proposals. Av-

© Joan Ritchie

Joan Ritchie's oil painting "Don't Be Shy" was very popular with visitors who came to see "Culture and Agriculture," a popular annual group show at New Visions Gallery in Marshfield, Wisconsin. "There is something so personal about the animals Joan Ritchie portrays in her work," says Ann Waisbrot, executive director of the gallery. "Our 'Culture and Ag' show is very popular and gets better and better every year. I notice that farmers really connect with Joan's paintings and will often remark 'We had a cow just like that. She was so sweet' or 'We had a cow like that. She was so stubborn.'" New Visions gallery is located in Marshfield Clinic, one of the largest medical clinics in the country. "Visitors are often people who would not otherwise go to a museum or gallery, so it's a great way to bring art to the people," says Waisbrot.

Galleries

erage display time 6 weeks. Open all year. 1,500 sq. ft. Price range varies with exhibit. Small gift shop with original jewelry, notecards and crafts at $10-50. "We do not show 'country crafts.'"
Media Considers all media.
Style Exhibits all styles and genres.
Terms Accepts work on consignment (35% commission). Retail price set by artist. Gallery provides insurance and promotion. Prefers artwork framed.
Submissions Send query letter with résumé, high-quality slides and SASE. Label slides with size, title, media. Responds in 1 month. Files résumé. Will retain some slides if interested, otherwise they are returned.
Tips "Meet deadlines, read directions, make appointments—in other words respect yourself and your work by behaving as a professional."

LATINO ARTS, INC.

1028 S. Ninth, Milwaukee WI 53204. (414)384-3100 ext. 61. Fax: (414)649-4411. **Visual Artist Specialist:** Zulay Oszkay. Nonprofit gallery. Represents emerging, mid-career and established artists. Sponsors up to 5 individual and group exhibitions/year. Average display time 2 months. Open all year; Monday-Friday, 9-4. Located in the near southeast side of Milwaukee; 1,200 sq. ft.; one-time church. Clientele: the general Hispanic community. Overall price range: $100-2,000.
Media Considers all media, all types of prints. Most frequently exhibits original 2- and 3-dimensional works and photo exhibitions.
Style Exhibits all styles, all genres. Prefers artifacts of Hispanic cultural and educational interests.
Terms "Our function is to promote cultural awareness (not to be a sales gallery)." Retail price set by the artist. Artist is encouraged to donate 15% of sales to help with operating costs. Gallery provides insurance, promotion, contract, shipping costs to gallery; artist pays shipping costs from gallery. Prefers artwork framed.
Submissions Send query letter with résumé, slides, bio, business card and reviews. Call or write for appointment to show portfolio of photographs and slides. Responds in 2 weeks. Finds artists through recruiting, networking, advertising and word of mouth.

RAHR-WEST ART MUSEUM

610 N. Eighth St., Manitowoc WI 54220. (920)683-4501. Fax: (920)683-5047. E-mail: rahrwest@manitowoc.org. Website: www.rahrwestartmuseum.org. **Contact:** Jan Smith. Museum. Estab. 1950. Six exhibits, preferably groups of mid-career and established artists. Sponsors 8-10 shows/year. Average display time 6-8 weeks. Open all year; Monday-Friday, 10-4; Wednesday, 10-8; weekends, 11-4. Closed major holidays. Clients include local community and tourists. Overall price range: $50-2,200; most work sold at $150-200.
Media Considers all media and all types of prints except posters. Most frequently exhibits painting, pastel and prints.
Style Considers all styles. Most frequently exhibits impressionism, realism and various abstraction. Genres include figurative work, florals, landscapes and portraits.
Terms Artwork is accepted on consignment and there is a 30% commission. Retail price set by the artist. Gallery provides insurance. Accepted work should be framed.
Submissions Send query letter with artist's statement, bio, SASE and slides. Returns material with SASE if not considered. Responds only if interested. Files slides, contact and bio.

STATE STREET GALLERY

1804 State St., La Crosse, WI 54601. (608)782-0101. E-mail: ssg1804@yahoo.com. Website: www.statestreetartgallery.com. **President:** Ellen Kallies. Retail gallery. Estab. 2000. Approached by 15 artists/year. Represents 40 emerging, mid-career and established artists. Exhibited artists include: Diane French, Phyllis Martino, Michael Martino and Barbara Hart Decker. Sponsors 6 exhibits/year. Average display time 4-6 months. Open all year; Tuesday-Saturday, 10-3; weekends by appointment. Located across from the University of Wisconsin/La Crosse on one of the main east/west streets. "We are next to a design studio, parking behind gallery." Clients include local community, tourists, upscale. 40% of sales are to corporate collectors, 60% to private collectors. Overall price range: $150-25,000; most work sold at $500-5,000.
Media Considers acrylic, collage, drawing, glass, mixed media, oil, pastel, sculpture, watercolor and photography. Most frequently exhibits oil, dry pigment, drawing, watercolor and mixed media collage. Considers all types of prints.
Style Considers all styles and genres. Most frequently exhibits contemporary representational, realistic watercolor, collage.
Terms Artwork is accepted on consignment and there is a 40% commission. Retail price set by the gallery and the artist. Gallery provides insurance, promotion, contract. Accepted work should be framed and matted.
Submissions Call to arrange a personal interview or mail portfolio for review. Send query letter with artist's

statement, photographs or slides. Returns material with SASE. Responds in 1 month. Finds artists through word of mouth, art exhibits, art fairs, and referrals by other artists.

Tips "Be organized, be professional in presentation, be flexible! Most collectors today are savvy enough to want recent works on archival quality papers/boards, mattes etc. Have a strong and consistant body of work to present."

N VILLA TERRACE DECORATIVE ARTS MUSEUM

2220 N. Terrace Avenue, Milwaukee WI 53202. (414)271-3656. Fax: (414)271-3986. E-mail: shaberstroh@cavtm useums.org. Website: www.cavtmuseums.org. **Manager of Exhibitions & Collections:** Sarah Haberstroh. Museum. Estab. 1965. Approached by 20 artists/year. Represents 6 emerging, mid-career and established artists. Sponsors 6-8 exhibits/year. Average display time 2 months. Open all year; Wednesday-Sunday from 1-5. Located in a historic home, featuring two galleries. Clients include local community, students, tourists and upscale. 10% of sales are to corporate collectors. Overall price range: $200-3,000; most work sold at $300.

Media Considers all media; print types include engravings, etchings, linocuts, lithographs, serigraphs and woodcuts. Most frequently exhibits textile, oil and photography.

Style Considers all styles. Genres include florals and landscapes. Most frequently exhibits decorative art, impressionism and realism.

Terms Artwork is sold during a run of an exhibition. There is a 30% commission. Retail price set by the artist. Museum provides insurance, promotion and contract. Accepted work should be framed. Does not require exclusive representation locally. Prefers only decorative art.

Submissions Send query letter with artist's statement, bio, business card, résumé, reviews and slides. Materials will be returned if the artist is not chosen for our exhibition. Responds to queries in 1 year. Finds artists through referrals by other artists, submissions and word of mouth.

Tips "All materials should be typed. Slides should be labeled and accompanied by a complete checklist."

N WALKER'S POINT CENTER FOR THE ARTS

911 W. National Ave., Milwaukee WI 53204. (414)672-2787. E-mail: staff@wpca-milwaukee.org. Website: www.wpca-milwaukee.org. **Executive Director:** Jessica St. John. Alternative space and nonprofit gallery. Estab. 1987. Represents emerging and established artists; 200+ members. Exhibited artists include Sheila Hicks and Carol Emmons. Sponsors 6-8 shows/year. Average display time 2 months. Open all year. Located in urban, multicultural area; gallery 23'6"×70.

Media Considers all media. Prefers installation, sculpture and video.

Style Considers all styles. Our gallery often presents work with Latino themes.

Terms We are nonprofit and do not provide honoria. Gallery assumes a 20% commission. Retail prices set by the artist. Gallery provides insurance, contract and shipping costs. Prefers artwork framed.

Submissions Send query letter with résumé, slides, bio, photographs, SASE and reviews. Call to schedule an appointment to show a portfolio, which should include slides, photographs and transparencies. Responds in 6-12 months. Files résumés and slides.

Tips "WPCA is an alternative space, showing work for which there are not many venues. Experimental work is encouraged. Suggesting an exhitib (rather than just trying to get your work shown) can work for a small, understaffed space like ours."

WYOMING

MANITOU GALLERY

1715 Carey Ave., Cheyenne WY 82001. (307)635-0019. Fax: (307)778-3926. **President:** Robert L. Nelson. Retail, wholesale gallery and art consultancy. Estab. 1975. 50 emerging, mid-career and established artists/year. Exhibited artists include Jie Wei Zhou, Lyle Tayson and Santa Fe. Open all year; Monday-Friday, 8-5. Located downtown; 10,000 sq. ft. for gallery artists. Clients include tourists, upscale. 25% of sales are to collectors, 75% wholesale or other dealers. Overall price range: $100-75,000; most work sold at $300-5,000.

Media Considers all media. Most frequently exhibits oil, sculpture and watercolor.

Style Exhibits all styles. Genres include florals, Western, wildlife, Southwestern and landscapes. Prefers Western, florals and landscapes.

Terms Accepts work on consignment (50% commission). Retail price set by the gallery and the artist. Gallery provides insurance, promotion and contract; artist pays shipping costs. Artwork must be framed.

Submissions Prefers only Western subject matter. Send query letter with slides, bio, brochure and photographs. Write for appointment to show portfolio of photographs and slides. Responds only if interested within 1 week.

Tips "Many artists who contact our gallery are not ready to show in a gallery setting."

NICOLAYSEN ART MUSEUM

400 E. Collins Dr., Casper WY 82601. (307)235-5247. Fax: (307)235-0923. E-mail: info@thenic.org. Website: www.thenic.org. **Director:** Holly Turner. Regional contemporary art museum. Estab. 1967. Average display time 3-4 months. Interested in emerging, mid-career and established artists. Sponsors 10 solo and 10 group shows/year. Open all year. Clientele: 90% private collectors, 10% corporate clients.

Media Considers all media with special attention to regional art.

Style Exhibits all subjects.

Terms Accepts work on consignment (40% commission). Retail price set by artist. Exclusive area representation not required. Gallery provides insurance, promotion and shipping costs from gallery.

Submissions Send query letter with slides. Write to schedule an appointment to show a portfolio, which should include originals or slides. Responds in 2 months.

WYOMING ARTS COUNCIL GALLERY

2320 Capitol Ave., Cheyenne WY 82002. (307)777-7742. Fax: (307)777-5499. E-mail: lfranc@state.wy.us. Website: wyoarts.state.wy.us. **Visual Arts Specialist:** Liliane Francuz. Nonprofit gallery. Estab. 1990. Sponsors up to 5 exhibitions/year. Average display time 6 ½ weeks. Open 11 months out of the year, Monday-Friday 8-5. Located downtown in capitol complex; 660 sq. ft.; in historical carriage house. 100% of space devoted to special exhibitions. Clientele: tourists, upscale, local community. 98% private collectors. Overall price range $50-$1,500; most work sold at $100-250.

Media Considers all media. Most frequently exhibits photography, paintings/drawings, mixed media and fine crafts.

Style Exhibits all styles and all genres. Most frequently exhibits contemporary styles and craft.

Terms Retail price set by the artist. Gallery provides insurance, promotion and contract. Shipping costs are shared. Prefers artwork framed.

Submissions Accepts only artists from Wyoming. Send query letter with résumé, slides and bio. Call for portfolio review of photographs and slides. Responds in 2 weeks. Files résumé and slides. Finds artists through artist registry slide bank, word of mouth and studio visits.

Tips "I appreciate artists letting me know what they are doing. Send me updated slides, show announcements, or e-mail to keep me current on your activities."

CANADA

DALES GALLERY

537 Fisgard St., Victoria BC V8W 1R3 Canada. Fax: (250)383-1552. E-mail: dalesgallery@shaw.ca. Website: www.dalesgallery.ca. **Contact:** Sheila Watson. Museum retail shop. Estab. 1976. Approached by 6 artists/year; represents 40 emerging, mid-career and established artists/year. Exhibited artists include: Grant Fuller and Graham Clarke. Sponsors 2-3 exhibits/year. Average display time 2 weeks. Open all year; Monday-Saturday, 10-5:30; Sunday, 12-4. Gallery situated in Chinatown (Old Town); approximately 650 sq. ft. of space—one side brick wall. Clients include: local community, students, tourists and upscale. Overall price range: $100-4,600; most work sold at $350.

Media Considers most media except photography. Most frequently exhibits oils, etching and watercolor. Considers all types of prints.

Style Exhibits: expressionism, impressionism, postmodernism, primitivism, realism and surrealism. Most frequently exhibits impressionism, realism and expressionism. Genres include figurative, florals, landscapes, humorous whimsical.

Terms Accepts work on consignment (40% commission) or buys outright for 50% of retail price (net 30 days). Retail price set by both gallery and artist. Gallery provides promotion. Accepted work should be framed by professional picture framers. Does not require exclusive representation locally.

Submissions Call to arrange a personal interview to show portfolio of photographs or slides or send query letter with photographs. Portfolio should include résumé, reviews, contact number and prices. Responds only if interested within 2 months. Finds artists through word of mouth, art exhibits, submissions, art fairs, portfolio reviews and referral by other artists.

FEDERATION OF CANADIAN ARTISTS

1241 Cartwright, Vancouver BC V6H 4B7 Canada. (604)681-8534. Fax: (604)681-2740. E-mail: fca@istar.ca. Website:www.artists.ca. **Gallery Manager:** Nancy Clayton. Nonprofit membership organization with gallery. Estab. 1995. Approached by 1,200 member artists/year; represents 1,200 member emerging, mid-career, established artists. Exhibited artists include: Ed Loenen, AFCA; Joyce Kamikura, SFCA, NWS; Kiff Holland, SFCA, AWS; and Alan Wylie, SFCA, AWS. Average display time 2-4 weeks. Open Tuesday-Sunday, 10-4; mid May to

Labor Day 10-5. Federation gallery is located on Granville Island, a specialty shopping district described as the second most popular tourist destination in Vancouver (after Stanley Park). Clientele: local community, students, tourists, upscale, members and other clientele. Overall price range: $150-7,000; most work sold at $1,500.

Media Considers acrylic, collage, drawing, mixed media, oil, pastel, pen & ink and watercolor. Most frequently exhibits watercolor, oil, acrylic, pastels. Considers engraving, etching, linocut, lithographs, serigraphs, woodcut.

Style Exhibits: impressionism, surrealism, painterly abstraction. Considers all genres.

Terms There is a co-op membership fee plus a donation of time and rental fee for space. Retail price set by the artist. Gallery provides promotion. Accepted work should be framed. Does not require exclusive representation locally. Artists must be members.

Submissions Call or write to arrange jurying of slides. Send artist's statement, bio, résumé, SASE. Portfolio should include photos or slides only. Returns material with SASE. Responds in 2-8 weeks. Files photos and bio. Finds artists through word of mouth, submissions, portfolio reviews, referrals by other artists.

Tips "Have professional slides taken of your work before submitting to galleries. Using archival-quality materials is very important."

KAMENA GALLERY & FRAMES LTD.

5718-104 St., Edmonton AB T6H 2K2 Canada. (403)944-9497. Fax: (403)430-0476. E-mail: kamena@junctionnet .com. Website: www.kamengallery.com. **Assistant Manager:** Willie Wong. Retail gallery. Estab. 1993. Approached by 10-20 artists/year; represents 20-25 emerging, mid-career and established artists/year. Exhibited artists include: Ted Harrison and Willie Wong. Sponsors 6-8 exhibits/year. Average display time 30-45 days. Open all year; Monday-Saturday, 10-6; weekends, 10-5. Clientele: local community and tourists. 10% corporate collectors. Overall price range: $150-1,200; most work sold at $300.

Media Considers all media except installation and craft. Most frequently exhibits watercolor and mixed media. Considers etching, linocut, serigraph and woodcut.

Style Exhibits: color field, conceptualism, expressionism, impressionism and primitivism realism. Most frequently exhibits conceptualism, color field and expressionism. Genres include figurative work, florals and landscapes.

Terms Artwork is accepted on consignment and there is a 40% commission. Retail price set by the artist. Gallery provides insurance and promotion. Accepted work should be framed. Requires exclusive representation locally. Prefers only watercolor, acrylic and oil.

Submissions Call or write to arrange a personal interview to show portfolio of slides, bio, photographs, SASE. Returns material with SASE. Responds in 2 weeks. Files slides and bio. Finds artists through submissions.

Tips "Have clean slides or photos, a large volume of reasonably priced work, short bio (one page)."

OPEN SPACE

510 Fort St., Victoria BC V8W 1E6 Canada. (250)383-8833. Fax: (250)383-8841. E-mail: openspace@openspace. ca. Website: www.openspace.ca. **Director:** Todd Davis. Gallery Administrator: Jill Margo. Alternative space and nonprofit gallery. Estab. 1971. Represents emerging, mid-career and established artists. 150 members. Sponsors 8-10 shows/year. Average display time 3½ weeks. Open all year. Located downtown; 2,700 sq. ft.; "multi-disciplinary exhibition venue." 100% of space for gallery artists. Overall price range: $300-10,000.

Media Considers oil, acrylic, watercolor, pastel, pen & ink, drawing, mixed media, collage, works on paper, sculpture, ceramic, installation, photography, video, performance art, original handpulled prints, woodcuts, wood engravings, linocuts, engravings, mezzotints and etchings.

Style Exhibits conceptualism, postmodernism.

Terms "No acquisition. Artists selected are paid exhibition fees for the right to exhibit their work." Retail price set by artist. Gallery provides insurance, promotion, contract and fees; shipping costs shared. Only artwork "ready for exhibition." Artists should be aware of the trend of "de-funding by governments at all levels."

Submissions "Non-Canadian artists must submit by September 30 in order to be considered for visiting foreign artists' fees." Send query letter with recent curriculm vitae, 10-20 slides, bio, a list of any special equipment required, SASE (with IRC, if not Canadian), reviews and proposal outline. "No original work in submission." Responds in 3 months.

MARCIA RAFELMAN FINE ARTS

10 Clarendon Ave., Toronto ON M4V 1H9 Canada. (416)920-4468. Fax: (416)968-6715. E-mail: info@mrfinearts. com. Website: www.mrfinearts.com. **President:** Marcia Rafelman. Semi-private gallery. Estab. 1984. Approached by 100s of artists/year. Represents emerging and mid-career artists. Average display time 1 month. Open by appointment except the first 2 days of art openings which is open full days. Centrally located in Toronto's mid-town, 2,000 sq. ft. on 2 floors. Clients include local community, tourists and upscale. 40% of sales are to corporate collectors. Overall price range: $500-30,000; most work sold at $1,500-5,000.

Media Considers all media. Most frequently exhibits photography, painting and graphics. Considers all types of prints.

Style Exhibits: geometric abstraction, minimalism, neo-expressionism, primitivism and painterly abstraction. Most frequently exhibits high realism paintings. Considers all genres except southwestern, western and wildlife.

Terms Artwork is accepted on consignment (50% commission); net 30 days. Retail price set by the gallery and the artist. Gallery provides insurance, promotion and contract. Requires exclusive representation locally.

Submissions Prefer artists to send images by e-mail. Otherwise, mail portfolio of photographs, bio and reviews for review. Returns material with SASE if in Canada. Responds only if interested within 2 weeks. Files bios and visuals. Finds artists through word of mouth, submissions, art fairs and referrals by other artists.

INTERNATIONAL

🌐 ABEL JOSEPH GALLERY

Avenue Maréchal Foch, 89 Bruxelles Belgique 1030. Phone: 32-2-2456773. E-mail: abeljoseph_brsls@hotmail.com. Website: www.cardoeditions.com. **Directors:** Kevin and Christine Freitas. Commercial gallery and alternative space. Estab. 1989. Represents young and established national and international artists. Exhibited artists include Carrie Ungerman, Diane Cole, Régent Pellerin and Ron DeLegge. Sponsors 6-8 shows/year. Average display time 6 weeks. Open all year. Located in Brussels. 100% of space for work of gallery artists. Clientele: varies from first time buyers to established collectors. 80% private collectors; 20% corporate collectors. Overall price range: $500-15,000; most work sold at $1,000-8,000.

Media Considers most media except craft. Most frequently exhibits sculpture, painting/drawing and installation (including active-interactive work with audience—poetry, music, etc.).

Style Exhibits painterly abstraction, conceptualism, minimalism, post-modern works and imagism. "Interested in seeing all styles and genres." Prefers abstract, figurative and mixed-media.

Terms Accepts artwork on consignment (50% commission). Retail price set by the gallery with input from the artist. Customer discounts and payment by installments are available. Gallery provides insurance, promotion and contract; shipping costs are shared.

Submissions Send query letter with résumé, 15-20 slides, bio, SASE and reviews. Portfolio review requested if interested in artist's work. Portfolio should include slides, photographs and transparencies. Responds in 1 month. Files résumé, bio and reviews.

Tips "Submitting work to a gallery is exactly the same as applying for a job in another field. The first impression counts. If you're prepared, interested, and have any initiative at all, you've got the job. Know what you want before you approach a gallery and what you need to be happy, whether its fame, glory or money, be capable to express your desires right away in a direct and honest manner. This way, the gallery will be able to determine whether or not it can assist you in your work."

✅ 🌐 🖥 THE BRACKNELL GALLERY/THE MANSION SPACES

South Hill Park Arts Centre, Ringmead, Bracknell Berkshire RG12-7PA, United Kingdom. (44)(0)1344-484858. Fax: (44)(0)1344-411427. E-mail: enquiries@southhillpark.org.uk. Website: www.southhillpark.org.uk. **Contact:** Elvned Myhre, head of visual arts. Alternative space/nonprofit gallery. Estab. 1991. Approached by at least 20 artists/year; exhibits 6-7 shows of emerging, mid-career and established artists. "For Mansion Spaces **very** many artists approach us. All applications are looked at." Exhibited artists include Anne-Marie Carroll (video) and Michael Porter (painting and photography). Average display time 1-2 months. Open all year; Wednesday-Friday, 7-9:30; Saturday and Sunday, 1-5. Located "within a large Arts centre, including theatre, studios, workshops, restaurants, etc.; one large room and one smaller with high ceilings, plus more exhibiting spaces around the centre." Clients include local community and students.

Media Considers all media. Most frequently exhibits craftwork (ceramics, glasswork, jewelry, installations, group shows, video-digital works). Considers all types of prints.

Style Considers all styles and genres.

Terms Artwork is accepted on consignment and there is a 20% commission. Retail price set by the artist. Gallery provides insurance, promotion and contract. Does not require exclusive representation locally.

Submissions Send query letter with artist's statement, bio, photographs and slides. Returns material with SASE. Responds to queries only if interested. Files all material "unless return of slides/photos is requested." Finds artists through art exhibits, referrals by other artists, submissions and word of mouth.

Tips "We have a great number of applications for exhibitions in The Mansion Spaces—make yours stand out! Exhibitions at The Bracknell Gallery are planned 2-3 years in advance."

🌐 CHICHESTER GALLERY

8 The Hornet, Chichester, West Sussex PO19 4JG United Kingdom. Phone: 01243-779821. **Proprietor:** Thomas J.P. McHale. Cooperative period picture gallery/retail. Estab. 1997. Represents established artists. Exhibited

artists include: Copley Fielding, George Leonard Lewis, Jessie Mellor. Located in Georgian period building. Interior has undergone careful and sympathetic restoration of cornices, ceiling and arches, shirting and other mouldings. Clientele: local, regional and national community. "Contemporary work now stocked and displayed by gifted local and nationally respected artists."

Media Considers mixed media, oil, pastel, watercolor. Considers etching, engraving, mezzotint, lithographs, prints and woodcut. Representational painting only.

Style Genres include costal scenes, landscapes, marines, portraits and still life.

Terms Retail price set by the gallery.

Submissions Replies promptly by fax or mail. Finds artists through art exhibits, art fairs, auctions, private buyers.

GARDEN SUBURB GALLERY

16 Arcade House Hampstead Way, London NW11 7TL United Kingdom. Phone/fax: +44 181 455 9132. Website: www.hgs.org.uk. **Manager:** R.J. Wakefield. Nonprofit gallery. Estab. 1995. Approached by 5 artists/year. Represents 32 emerging, mid-career and established artists. Exhibited artists include: Annie Walker, Judy Bermant and Jennie Dunn. Average display time 1 month. Open all year; Monday-Saturday, 10-5. Located in conservation area. Very small utyens summer house; $18 \times 10'$. Clientele: local community, tourists. Overall price range: $250. Most work sold at $250.

Media Considers all media and all types of prints.

Style Considers all styles. Genres include florals, landscapes, portraits.

Terms Artwork is accepted on consignment (40% commission). Retail price set by the gallery. Gallery provides insurance and promotion. Accepted work should be framed or mounted.

Submissions Write to arrange a personal interview to show portfolio. Returns material with SASE. Responds in 2 weeks. Finds artists through word of mouth, submissions, art exhibits and referrals by other artists.

N HONOR OAK GALLERY

52 Honor Oak Park, London SE23 1DY United Kingdom. Phone: 020-8291-6094. **Contact:** John Broad or Sanchia Lewis. Estab. 1986. Approached by 15 artists/year. Represents 40 emerging, mid-career and established artists. Exhibited artists include: Jenny Devereux, Norman Ackroyd, Clare Leighton, Robin Tanner and Karolina Larusdottir. Sponsors 2 total exhibits/year. Average display time 6 weeks. Open all year; Tuesday-Friday, 9:30-6; Saturday, 9:30-5. Closed 2 weeks at Christmas, New Years and August. Located on a main thoroughfare in South London. Exhibition space of 1 room $12 \times 17'$. Clientele: local community and upscale. 2% corporate collectors. Overall price range: £18-2,000; most work sold at £150.

Media Considers collage, drawing, mixed media, pastel, pen & ink, watercolor, engravings, etchings, linocuts, lithographs, mezzotints, engravings, woodcuts, screenprints, wood engravings. Most frequently exhibits etchings, wood engravings, watercolor.

Style Exhibits: postmodernism, primitivism, realism, 20th century works on paper. Considers all styles. Most frequently exhibits realism. Genres include figurative work, florals, landscapes, wildlife, botanical illustrations.

Terms Artwork is accepted on consignment (40% commission). Retail price set by the gallery and the artist. Gallery provides promotion. Does not require exclusive representation locally. Prefers only works on paper.

Submissions Write to arrange a personal interview to show portfolio of recent original artwork. Send query letter with bio, photographs. Responds in 1 month. Finds artists through word of mouth, submissions, art fairs.

Tips "Show a varied, but not too large selection of recent work. Be prepared to discuss a pricing policy. Present work neatly and in good condition. As a gallery which also frames work, we always recommend conservation mounting and framing and expect our artists to use good quality materials and appropriate techniques."

N NEVILL GALLERY

43 St. Peters St., Canterbury, Kent CT1 2BG England. Phone/fax: (0044)1227 765291. E-mail: chris@nevillgallery .com. Website: www.nevillgallery.com. **Director:** Christopher Nevill. Rental gallery. Estab. 1970. Approached by 6 artists/year. Represents 30 emerging, mid-career and established artists. Exhibited artists include: Matthew Alexander and David Napp. Average display time 3 weeks. Open all year; Monday-Saturday, 10-5. Located on High St. in the heart of Canterbury. Clientele: local community, tourists and upscale. Overall price range: £100-5,000.

Media Considers acrylic, collage, mixed media, oil, paper, pastel, pen & ink, watercolor, engravings, etchings, linocuts, mezzotints and woodcuts. Most frequently exhibits oils, watercolor and pastels.

Style Exhibits: expressionism, impressionism and painterly abstraction. Genres include abstract, figurative work, florals and landscapes.

Terms Artwork is accepted on consignment (40% commission). Retail price set by the artist. Gallery provides insurance while on the premises. Accepted work should be framed. Does not require exclusive representation locally.

Submissions Call or write to arrange a personal interview to show portfolio of photographs, slides, transparencies. Send query letter with photographs and résumé. Return material with SASE. Responds in 2 weeks. Finds artists through word of mouth, submissions, portfolio reviews, art exhibits, art fairs and referrals by other artists.

☑ 🌐 THE OCTOBER GALLERY

24 Old Gloucester St., Bloomsbury, London WC1N 3AL, United Kingdom. 44(0)20 7242 7367. Fax: 44(0)20 7405 1851. E-mail: octobergallery@compuserve.com. Website: www.theoctobergallery.com. **Contact:** Elisabeth Lalouschek, artistic director. Nonprofit gallery. Estab. 1979. Approached by 60 artist/year; exhibits 20 established artists/year. Exhibited artists include Ablade Glover (oil on canvas) and El Anatsui (mixed media). Average display time 1 month. Open Tuesday-Saturday, 12:30-5:30. Closed Christmas, Easter and August. Gallery is centrally located near the British Museum. Clients include local community and upscale. Overall price range: $80-18,000.
Media Considers acrylic, ceramics, collage, drawing, mixed media, oil, paper, pen & ink, sculpture and watercolor. Most frequently exhibits mixed media, acrylic and collage. Also considers posters and woodcuts.
Style Exhibits color field, conceptualism, expressionism, imagism, pattern painting, painterly abstraction, postmodernism and primitivism realism. Most frequently exhibits expressionism, painterly abstraction and primitivism realism. Genres include contemporary art from around the world.
Terms Artwork is accepted on consignment and there is a 50% commission. Retail price set by the gallery and the artist. Gallery provides insurance, promotion and contract. Accepted work should be mounted. Does not require exclusive representation locally.
Submissions Write to arrange a personal interview to show portfolio of photographs and slides. Send query letter with artist's statement, bio, brochure, business card, photocopies, photographs, résumé, SASE and slides. Returns material with SASE. Responds to queries in 3 months. Finds artists through referrals by other artists, submissions and word of mouth.
Tips "Ensure all personal details are labeled clearly and correctly."

🌐 PARK WALK GALLERY

20 Park Walk, London SW10 0AQ United Kingdom. Phone/fax: (0207)351 0410. E-mail: mail@jonathancooper.co.uk. Website: www.jonathancooper.co.uk. **Gallery Owner:** Jonathan Cooper. Gallery. Estab. 1988. Approached by 5 artists/year. Represents 16 mid-career and established artists. Exhibited artists include: Kate Nessler. Sponsors 8 exhibits/year. Average display time 3 weeks. Open all year; Monday-Saturday, 10-6:30; Sunday, 11-4. Located in Park Walk which runs between Fulham Rd. to Kings Rd. Clientele: upscale. 10% corporate collectors. Overall price range: £500-50,000; most work sold at £4,500.
Media Considers drawing, mixed media, oil, paper, pastel, pen & ink, photography, sculpture, watercolor. Most frequently exhibits watercolor, oil and sculpture.
Style Exhibits: conceptualism, impressionism. Genres include florals, landscapes, wildlife, equestrian.
Terms Artwork is accepted on consignment (50% commission). Retail price set by the gallery. Gallery provides promotion. Requires exclusive representation locally.
Submissions Call to arrange a personal interview to show portfolio. Returns material with SASE. Responds in 1 week. Finds artists through submissions, portfolio reviews, art exhibits, art fairs, referrals by other artists.
Tips "Include full curriculum vitae and photographs of work."

☑ 🌐 PRAXIS MÈXICO

Arquímedes 175, Colonia Polanco Mexico D.F. 11570, Mexico. (5255)5254-8813. Fax: (5255)5255-5690. E-mail: info@praxismexico.com. Website: www.praxismexico.com. For-profit gallery. Estab. 1998. Exhibits emerging, mid-career and established artists. Approached by 8 artists/year. Sponsors 4 exhibitions/year. Average display time 30 days. Open all year; Monday-Friday, 10-7:30, Saturday and Sunday, 10-3. Located in a basement with two separate rooms, a temporary room and the collective space. Clients include local community and tourists. 70% of sales are to corporate collectors. Overall price range: $5,000-100,000.
Media Considers acrylic, craft, drawing, oil and sculpture. Also considers etchings, lithographs and serigraphs.
Style Exhibits postmodernism. Genres include figurative work.
Terms Artwork is accepted on consignment and there is a 50% commission or artwork is bought outright; net 30 days. There is a co-op membership fee plus a donation of time. There is a 10% commission. Retail price set by the gallery. Gallery provides promotion. Accepted work should be framed. Requires exclusive representation locally.
Submissions Send e-mail. Returns material with SASE. Responds to queries in 1 month. Finds artists through art fairs and exhibits, portfolio reviews and referrals by other artists.

Syndicates & Cartoon Features

© Todd Schowalter for Plain Label Press

yndicates are agents who sell comic strips, panels and editorial cartoons to newspapers and magazines. If you want to see your comic strip in the funny papers, you must first get the attention of a syndicate. They promote and distribute comic strips and other features in exchange for a cut of the profits.

Be forewarned, the syndicate business is one of the hardest markets to break into. Newspapers are reluctant to drop long-established strips for new ones. Consequently, spaces for new strips do not open up often. When they do, syndicates look for a "sure thing," a feature they'll feel comfortable investing more than $25,000 in for promotion and marketing. Even after syndication, much of your promotion will be up to you.

To crack this market, you have to be more than a fabulous cartoonist. The art won't sell if the idea isn't there in the first place. Work worthy of syndication must be original, salable and timely, and characters must have universal appeal to attract a diverse audience. And you'll need lots of fortitude in the face of rejection along the way.

Although newspaper syndication is still the most popular and profitable method of getting your comic strip to a wide audience, the Web has become an exciting new venue for comic strips. There are hundreds of strips available on the Web. With the click of your mouse, you can be introduced to *A Twisted Mind*, by Skip Towne; *Cleats*, by Bill Hinds; and *La Cucaracha*, by Lalo Alcaraz. (UComics.com provides a great list of online comics.)

Such sites may not make much money for cartoonists, but it's clear they are a great promotional tool. It is rumored that scouts for the major syndicates have been known to surf the more popular comic strip sites in search of fresh voices.

HOW TO SUBMIT TO SYNDICATES

Each syndicate has a preferred method for submissions, and most have guidelines you can send for or access on the syndicate's website. Availability is indicated in the listings.

To submit a strip idea, send a brief cover letter (50 words or less is ideal) summarizing your idea, along with a character sheet (the names and descriptions of your major characters) and photocopies of 24 of your best strip samples on $8^{1}/_{2} \times 11$ paper, six daily strips per page. Sending at least one month of samples shows that you're capable of producing high-quality humor, consistent artwork and a long lasting idea. Never submit originals; always send photocopies of your work. Simultaneous submissions are acceptable. It is often possible to query syndicates online, attaching art files or links to your website. Response time can take several months. Syndicates understand it would be impractical for you to wait for replies before submitting your ideas to other syndicates.

Syndicates

Editorial cartoons

If you're an editorial cartoonist, you'll need to start out selling your cartoons to a base newspaper (probably in your hometown) and build up some clips before approaching a syndicate. Submitting published clips proves to the syndicate that you have a following and are able to produce cartoons on a regular basis. Once you've built up a good collection of clips, submit at least 12 photocopied samples of your published work along with a brief cover letter.

Payment and contracts

If you're one of the lucky few to be picked up by a syndicate, your earnings will depend on the number of publications in which your work appears. It takes a minimum of about 60 interested newspapers to make it profitable for a syndicate to distribute a strip. A top strip such as *Garfield* may be in as many as 2,000 papers worldwide.

Newspapers pay in the area of $10-15 a week for a daily feature. If that doesn't sound like much, multiply that figure by 100 or even 1,000 newspapers. Your payment will be a percentage of gross or net receipts. Contracts usually involve a 50/50 split between the syndicate and cartoonist. Check the listings for more specific payment information.

Before signing a contract, be sure you understand the terms and are comfortable with them.

Self-syndication

Self-syndicated cartoonists retain all rights to their work and keep all profits, but they also have to act as their own salespeople, sending packets to newspapers and other likely outlets. This requires developing a mailing list, promoting the strip (or panel) periodically, and developing a pricing, billing and collections structure. If you have a knack for business and the required time and energy, this might be the route for you. Weekly suburban or alternative newspapers are the best bet here. (Daily newspapers rarely buy from self-syndicated cartoonists.)

Helpful resources

For More Info

You'll get an excellent overview of the field by reading *Your Career in Comics*, by Lee Nordling (Andrews McMeel), a comprehensive review of syndication from the viewpoints of the cartoonist, the newspaper editor and the syndicate. *Successful Syndication: A Guide for Writers and Cartoonists*, by Michael H. Sedge (Allworth Press), also offers concrete advice to aspiring cartoonists.

If you have access to a computer, another great source of information is Stu's Comic Strip Connection at www.stus.com. Here you'll find links to most syndicates and other essential sources, including helpful books, courtesy of Stu Rees.

ARLINGTON CONNECTION

7913 W. Park Dr., McLean VA 22102. (703)917-6400. Fax: (703)917-0991. **Managing Editor:** Jim Silver. Estab. 1986. Publishes weekly newspapers covering Arlington.

Needs Works with 2 paid established freelancers exclusively. Prefers local or Virginia artists. Prefers pen & ink with washes.

First Contact & Terms Send postcard samples or tearsheets. Samples are filed or are returned by SASE. Responds only if interested. To show portfolio, mail tearsheets. Does not offer payment. Will send artist newspaper clipping upon publication for credits.

Tips "We prefer local Northern Virginia freelancers who have local themes in their work."

ARTISTMARKET.COM (AKA A.D. KAHN, INC.)

35336 Spring Hill Rd., Farmington Hills MI 48331-2044. (248)661-8585. E-mail: editors@artistmarket.com. Website: www.artistmarket.com. **Publisher:** David Kahn. Website estab. 1996. Feature syndicate serving daily and weekly newspapers, monthly magazines.

- Artistmarket.com proactively invites newspaper and magazine editors, website designers and book publishers to use the Internet's largest resource of professional cartoonists, puzzle makers and writers. Sales have been generated worldwide.

Needs Considers comic strips, editorial/political cartoons, gag cartoons, puzzles/games, written features for publication.

First Contact & Terms E-mail or postal sample package should include material that best represents artist's work. Files samples of interest; others returned by SASE if requested by artist. Pays 50% of net proceeds. Negotiates rights purchased according to project. The artist owns original art and characters.

ARTIZANS.COM

11149 65th St. NW, Edmonton AB T5W 4K2 Canada. **Submission Editor:** Malcom Mayes. E-mail: submissions@ artizans.com. Website: www.artizans.com. Estab. 1998. Artist agency and syndicate providing commissioned artwork, stock illustrations, political cartoons, gag cartoons, global caricatures, humorous illustrations to magazines, newspapers, websites, corporate and trade publications and ad agencies. Submission guidelines available on website. Artists represented include Jan Op De Beeck, Aaron Bacall and Dusan Petricic.

Needs Works with 30-40 artists/year. Buys 30-40 features/year. Needs single panel cartoons, caricatures, illustrations, graphic and clip art. Prefers professional artists with track records who create artwork regularly and artists who have archived work or a series of existing cartoons, caricatures and/or illustrations.

First Contact & Terms Send cover letter and copies of cartoons or illustrations. Send 6-20 examples if sending via e-mail; 24 if sending via snail mail. "In your cover letter, tell us briefly about your career. This should inform us about your training, what materials you use and where your work has been published." Résumé and samples of published cartoons would be helpful but are not required. E-mail submission should include a link to other online examples of your work. Replies in 2 months. Artist receives 50-75%. Payment varies depending on artist's sales. Artists retain copyright. Our clients purchase a variety of rights from the artist.

Tips We are only interested in professional artists with a track record. See our website for guidelines.

ATLANTIC SYNDICATION/EDITORS PRESS

1970 Barber Rd., Sarasota FL 34240. (941)371-2252. Fax: (941)342-0999. E-mail: kslagle@atlanticsyndication.com. Website: www.atlanticsyndication.com. **President:** Mr. Kerry Slagle. Estab. 1933. Syndicate representative servicing 1,700 publications: daily and weekly newspapers and magazines. International, US and Canadian sales. Recent introductions include *Pooch Cafe* and *Pepe*.

- Several of this syndicate's strips are offered in multiple languages. *Pepe* is offered in Spanish and English.

Needs Buys from 1-2 freelancers/year. Introduces 1-2 new strips/year. Considers comic strips, gag cartoons, caricatures, editorial/political cartoons and illustrations. Considers single, double and multiple panel, pen & ink. Prefers non-American themes. Maximum size of artwork: 11×17. Does not accept unsolicited submissions.

First Contact & Terms Send cover letter, finished cartoons, tearsheets and photocopies. Include 24-48 strips/panels. Does not want to see original artwork. Include SASE for return of materials. Pays 50% of gross income. Buys all rights. Minimum length of contract: 2 years. Artist owns original art and characters.

Tips "Look for niches. Study, but do not copy the existing competition. Read the newspaper!" Looking for "well-written gags and strong character development."

BLACK CONSCIENCE SYNDICATION, INC.

308A Deer Park Rd., Dix Hills NY 11746. (631)486-8546. Website: cldavis@suffolk.lib.ny.us. **President:** Clyde R. Davis. Estab. 1987. Syndicate serving 10,000 daily and weekly newspapers, regional magazines, schools, television and websites.

Needs Considers comic strips, gag cartoons, caricatures, editorial or political cartoons, illustrations and spot drawings. Prefers single, double or multipanel cartoons. "All material must be of importance to the Black community in America and the world." Especially needs material on gospel music and its history. "Our new format is a TV video magazine project. This half-hour TV program highlights our clients' material. We are accepting ½″ tapes, two minutes maximum. Tape must describe the artist's work and provide brief bio of the artist. Mailed to 25 different Afrocentric publications every other month."

First Contact & Terms Send query letter with résumé, tearsheets and photocopies. Samples are filed or are returned by SASE only if requested by artist. Responds in 2 months. Portfolio review not required. Pays on publication; 50% of net proceeds. Considers client's preferences when establishing payment. Buys first rights.

Tips "We need positive Afrocentric information. All material must be inspiring as well as informative. Our main search is for the truth."

☑ CELEBRATION: AN ECUMENICAL WORSHIP RESOURCE

Box 419281, Kansas City MO 64141-6493. (800)444-8910. Fax: (816)968-2268. E-mail: patmarrin@aol.com. Website: www.ncrpub.com. **Editor:** Patrick Marrin. Syndicate serving churches, clergy and worship committees.

Needs Buys 50 religious theme cartoons/year. Does not run an ongoing strip. Buys cartoons on church themes (worship, clergy, scripture, etc.) with a bit of the offbeat.

First Contact & Terms Originals returned to artist at job's completion. Payment upon use, others returned. Send copies. Simultaneous submissions OK. Pays $30/cartoon. "We grant reprint permission to subscribers to use cartoons in parish bulletins, but we request they send the artist an additional $5."

Tips "We only use religious themes (black & white). The best cartoons tell the 'truth'—about human nature, organizations—by using humor."

CITY NEWS SERVICE

Box 39, Willow Springs MO 65793. (417)469-2423. E-mail: cns@townsqr.com. **President:** Richard Weatherington. Estab. 1969. Editorial service providing editorial and graphic packages for magazines.

Needs Buys from 12 or more freelance artists/year. Considers caricature, editorial cartoons and tax and business subjects as themes; considers b&w line drawings and shading film.

First Contact & Terms Send query letter with résumé, tearsheets or photocopies. Samples should contain business subjects. "Send 5 or more b&w line drawings, color drawings, shading film or good line drawing editorial cartoons." Does not want to see comic strips. Samples not filed are returned by SASE. Responds in 4-6 weeks. To show a portfolio, mail tearsheets or photostats. Pays 50% of net proceeds; pays flat fee of $25 minimum. "We may buy art outright or split percentage of sales."

Tips "We have the markets for multiple sales of editorial support art. We need talented artists to supply specific projects. We will work with beginning artists. Be honest about talent and artistic ability. If it isn't there then don't beat your head against the wall."

☑ CREATORS SYNDICATE, INC.

5777 W. Century Blvd., Suite 700, Los Angeles CA 90045. (310)337-7003. Fax: (310)337-7625. E-mail: info@crea tors. Website: www.creators.com. Address work to Editorial Review Board—Comics. **President:** Richard S. Newcombe. Director of Operations: Christina Lee. Estab. 1987. Serves 2,400 daily newspapers, weekly and monthly magazines worldwide. Guidelines on website.

Needs Syndicates 100 writers and artists/year. Considers comic strips, caricatures, editorial or political cartoons and "all types of newspaper columns." Recent introductions: *Speedbump*, by Dave Coverly; *Strange Brew*, by John Deering.

First Contact & Terms Send query letter with brochure showing art style or résumé and "anything but originals." Samples are not filed and are returned by SASE. Responds in a minimum of 10 weeks. Considers salability of artwork and client's preferences when establishing payment. Negotiates rights purchased.

Tips "If you have a cartoon or comic strip you would like us to consider, we will need to see at least four weeks of samples, but not more than six weeks of dailies and two Sundays. If you are submitting a comic strip, you should include a note about the characters in it and how they relate to each other. As a general rule, drawings are most easily reproduced if clearly drawn in black ink on white paper, with shading executed in ink wash or Benday® or other dot-transfer. However, we welcome any creative approach to a new comic strip or cartoon idea. Your name(s) and the title of the comic or cartoon should appear on every piece of artwork. If you are already syndicated elsewhere, or if someone else owns the copyright to the work, please indicate this."

🌐 DRAWN & QUARTERED LTD.

4 Godmersham Park, Canterbury, Kent CT4 7DT United Kingdom. Phone/fax: (44) 1227-730-565. E-mail: red@d rawnandquartered.com. Website: www.drawnandquartered.com. **Contact:** Robert Edwards, chief executive.

Estab. 2000. Syndicate serving over 100 weekly and monthly Internet sites, magazines, newsletters, newspapers and tabloids. Guidelines available.

• This company operates similarly to a stock agency. See their website for details.

Needs Considers caricatures, cartoons, single panel, line, pen & ink, spot drawings, editorial/political cartoons, illustrations, portrait art of politicians and celebrities. Prefers topical, timely, as-the-news-happens images; newspaper emphasis (i.e. political, sports, entertainment figures). Maximum size of artwork 7″ height; artwork must be reducible to 20% of original size. Prefers to receive CDs or Zips of work, JPEGs or PNGs; b&w or RGB color, resolution: 250-350dpi.

First Contact & Terms Sample package should include cover letter, brochure, photocopies, résumé, contact information, tearsheets and self-caricature/portrait if possible. 5-10 samples should be included. Samples are filed. Samples are returned by SASE if requested by artist. Portfolio not required. Pays 50% of net proceeds or gross income. Established average amount of payment US $20 per download. Pays on publication or downloads by client. Responds to submissions in 1 week. Minimum length of contract is 1 year. Offers automatic renewal. Artist owns copyright, original art and original characters.

Tips ''Identify and date'' samples.

☑ HISPANIC LINK NEWS SERVICE

1420 N St. NW, Washington DC 20005. (202)234-0280. Fax: (202)234-4090. E-mail: charlie@hispaniclink.org. Website: www.hispaniclink.org. **Editor:** Charles Ericksen. Syndicated column service to 70 newspapers and a newsletter serving 2,000 subscribers: ''movers and shakers in the Hispanic community in U.S., plus others interested in Hispanics.'' Guidelines available.

Needs Buys from 20 freelancers/year. Considers single panel cartoons; b&w, pen & ink line drawings. Work should have a Hispanic angle; ''most are editorial cartoons, some straight humor.''

First Contact & Terms Send query letter with résumé and photocopies to be kept on file. Samples not filed are returned by SASE. Responds in 3 weeks. Portfolio review not required. **Pays on acceptance**; $25 flat fee (average). Considers clients' preferences when establishing payment. Buys reprint rights and negotiates rights purchased. ''While we ask for reprint rights, we also allow the artist to sell later.''

Tips Interested in seeing more cultural humor. ''While we accept work from all artists, we are particularly interested in helping Hispanic artists showcase their work. Cartoons should offer a Hispanic perspective on current events or a Hispanic view of life.''

KING FEATURES SYNDICATE

888 Seventh Ave., 2nd Floor, New York NY 10019. (212)455-4000. Website: www.Kingfeatures.com. **Editor-in-Chief:** Jay Kennedy. Estab. 1915. Syndicate servicing over 3,000 newspapers worldwide. Guidelines available for #10 SASE.

• This is one of the oldest, most established syndicates in the business. It runs such classics as *Blondie*, *Hagar*, *Dennis the Menace* and *Beetle Bailey* and such contemporary strips as *Zippy the Pinhead*, *Zits* and *Mutts*.

Needs Approached by 6,000 freelancers/year. Introduces 3 new strips/year. Considers comic strips and single panel cartoons. Prefers humorous single or multiple panel, b&w line drawings. Maximum size of artwork 8½×11. Comic strips must be reducible to 6½″ wide; single panel cartoons must be reducible to 3½″ wide.

First Contact & Terms Sample package should include cover letter, character sheet that names and describes major characters, and photocopies of finished cartoons. ''Résumé optional but appreciated.'' 24 samples should be included. Returned by SASE. Full submission guidelines available on website. Responds in 2 months. Pays 50% of net proceeds. Rights purchased vary according to project. Artist owns original art and characters. Length of contract and other terms negotiated.

Tips ''We look for a uniqueness that reflects the cartoonist's own individual slant on the world and humor. If we see that slant, we look to see if the cartoonist is turning his attention to events other people can relate to. We also study a cartoonist's writing ability. Good writing helps weak art, better than good art helps weak writing.''

PLAIN LABEL PRESS

P.O. Box 240331, Ballwin MO 63024. E-mail: mail@plainlabelpress.com. Website: www.plainlabelpress.com. **Contact:** Laura Meyer, submissions editor. Estab. 1989. Syndicate serving over 100 weekly magazines, newspapers and Internet sites. Guidelines available on website.

Needs Approached by 500 cartoonists and 100 illustrators/year. Buys from 2-3 cartoonists/illustrators/year. Introduces 1-2 new strips/year. Strips introduced include *Barcley & Co.*, by Todd Schowalter and *The InterPETS!* Considers cartoons (single, double and multiple panel), comic strips, editorial/political cartoons and gag cartoons. Prefers comics with cutting edge humor, NOT mainstream. Maximum size of artwork 8½×11; artwork must be reducible to 25% of original size.

First Contact & Terms Sample package should include an intro. letter, character descriptions, 3-4 weeks of material, photocopies or disk, no original art, SASE if you would like your materials returned. 18-24 samples should be included. Samples are not filed. If samples are not filed, samples are returned by SASE if requested by artist. Portfolio not required. Pays 60% of net proceeds, upon publication. Pays on publication. Responds to submissions in 2 months. Contract is open and may be cancelled at any time by the creator and/or by Plain Label Press. Artist owns original art and original characters.

Tips "Be FUNNY! Remember readers read the comics as well as look at them. Don't be afraid to take risks. Plain Label Press does not wish to be the biggest syndicate, just the funniest. A large portion of our material is purchased for use online so a good knowledge of digital color and imaging puts a cartoonist at an advantage. Good luck!"

ⓝ TRIBUNE MEDIA SERVICES, INC.

435 N. Michigan Ave., Suite 1400, Chicago IL 60611. (312)222-4444. E-mail: submissions@tribune.com. Website: www.comicspage.com. **Submissions Editor:** Tracy Clark. Managing Editor: Eve Becker. Syndicate serving daily domestic and international and Sunday newspapers as well as weeklies and new media services. Strips syndicated include *Broom-Hilda*, *Dick Tracy*, *Brenda Starr* and *Helen, Sweetheart of the Internet*. "All are original comic strips, visually appealing with excellent gags." Art guidelines available on website or for SASE with first-class postage or on website.

• Tribune Media Services is a leading provider of Internet and electronic publishing content, including the WebPoint Internet Service.

Needs Seeks comic strips and newspaper panels, puzzles and word games. Recent introductions include *Cats With Hands*, by Joe Martin; *Dunagin's People*, by Ralph Dunagin. Prefers original comic ideas, with excellent art and timely, funny gags; original art styles; inventive concepts; crisp, funny humor and dialogue.

First Contact & Terms Send query letter with résumé and photocopies. Sample package should include 4-6 weeks of daily strips or panels. Send 8½×11 copies of your material, not the original. "Interactive submissions invited." Samples not filed are returned only if SASE is enclosed. Responds in 2 months. Pays 50% of net proceeds.

Tips "Comics with recurring characters should include a character sheet and descriptions. If there are similar comics in the marketplace, acknowledge them and describe why yours is different."

UNITED FEATURE SYNDICATE/NEWSPAPER ENTERPRISE ASSOCIATION

200 Madison Ave., New York NY 10016. (212)293-8500. Website: www.unitedfeatures.com. **Contact:** Comics Editor. Syndicate serving 2,500 daily/weekly newspapers. Guidelines available for #10 SASE and on website.

• This syndicate told *AGDM* they receive more than 4,000 submissions each year and only accept two or three new artists. Nevertheless, they are always interested in new ideas.

Needs Approached by 5,000 cartoonists/year. Buys 2-3 cartoons/year. Introduces 2-3 new strips/year. Strips introduced include *Dilbert*, *Luann*, *Over the Hedge*. Considers comic strips, editorial political cartoons and panel cartoons.

First Contact & Terms Sample package should include cover letter and nonreturnable photocopies of finished cartoons. 18-36 dailies. Color Sundays are not necessary with first submissions. Responds in 4 months. Does not purchase one shots. Does not accept submissions via fax or e-mail.

Tips "No oversize packages, please."

☑ UNIVERSAL PRESS SYNDICATE

4520 Main St., Suite 700, Kansas City MO 64111. (816)932-6600. Website: www.ucomics.com. **Editorial Director:** Lee Salem. Syndicate serving 2,750 daily and weekly newspapers.

Needs Considers single, double or multiple panel cartoons and strips; b&w and color. Requests photocopies of b&w, pen & ink, line drawings.

First Contact & Terms Responds in 6 weeks. To show a portfolio, mail photostats. Send query letter with photocopies.

Tips "Be original. Don't be afraid to try some new idea or technique. Don't be discouraged by rejection letters. Universal Press receives 100-150 comic submissions a week and only takes on two or three a year, so keep plugging away. Talent has a way of rising to the top."

WHITEGATE FEATURES SYNDICATE

71 Faunce Dr., Providence RI 02906. (401)274-2149. Website: www.whitegatefeatures.com. **Talent Manager:** Eve Green. Estab. 1988. Syndicate serving daily newspapers internationally, book publishers and magazines. Guidelines available on website.

• Send nonreturnable samples. This syndicate says they are not able to return samples "even with SASE" because of the large number of submissions they receive.

Needs Introduced Dave Berg's *Roger Kaputnik*. Considers comic strips, gag cartoons, editorial/political cartoons,

illustrations and spot drawings; single, double and multiple panel. Work must be reducible to strip size. Also needs artists for advertising and publicity. Looking for fine artists and illustrators for book publishing projects.

First Contact & Terms Send cover letter, résumé, tearsheets, photostats and photocopies. Include about 12 strips. Does not return materials. To show portfolio, mail tearsheets, photostats, photographs and slides; include b&w. Pays 50% of net proceeds upon syndication. Negotiates rights purchased. Minimum length of contract 5 years (flexible). Artists owns original art; syndicate owns characters (negotiable).

Tips Include in a sample package "info about yourself, tearsheets, notes about the strip and enough samples to tell what it is. Don't write asking if we want to see; just send samples." Looks for "good writing, strong characters, good taste in humor. No hostile comics. We like people who have cartooned for a while and are printed. Get published in local papers first."

Stock Illustration & Clip Art Firms

© Julie Lonneman for TheSpirtSource.com

Stock illustration firms market images to book publishers, advertising agencies, magazines, corporations and other businesses through catalogs and websites. Art directors flip through stock illustration catalogs or browse the Web for artwork at reduced prices, while firms split fees with illustrators.

There are those who maintain stock illustration hurts freelancers. They say it encourages art directors to choose ready-made artwork at reduced rates instead of assigning illustrators for standard industry rates. Others maintain the practice gives freelancers a vehicle to resell their work. Marketing your work as stock allows you to sell an illustration again and again instead of filing it away in a drawer. That illustration can mean extra income every time someone chooses it from a stock catalog.

Stock vs. clip art

When most people think of clip art, they think of booklets of copyright-free graphics and cartoons, the kind used in church bulletins, high school newspapers, club newsletters and advertisments for small businesses. But these days, especially with some of the digital images available on disk and CD-ROMs, perceptions are changing. With the popularity of desktop publishing, newsletters that formerly looked homemade look more professional.

Copyright and payment

There is another crucial distinction between stock illustration and clip art. That distinction is copyright. Stock illustration firms do not sell illustrations. They license the right to reprint illustrations, working out a "pay-per-use" agreement. Fees charged depend on how many times and for what length of time their clients want to reproduce the artwork. Stock illustration firms generally split their fees 50-50 with artists and pay the artist every time his image is used. You should be aware that some agencies offer better terms than others. So weigh your options before signing any contracts.

Clip art, on the other hand, generally implies buyers are granted a license to use the image as many times as they want, and furthermore, they can alter it, crop it or retouch it to fit their purposes. Some clip art firms repackage artwork created many years ago because it is in the public domain, and therefore, they don't have to pay an artist for the use of the work. But in the case of clip art created by living artists, firms either pay the artists an agreed-upon fee for all rights to the work or negotiate a royalty agreement. Keep in mind that if you sell all rights to your work, you will not be compensated each time it is used unless you also negotiate a royalty agreement. Once your work is sold as clip art, the buyer of that clip art can alter your work and resell it without giving you credit or compensation.

How to submit artwork

Companies are identified as either stock illustration or clip art firms in the first paragraph of each listing. Some firms, such as Metro Creative Graphics and Dynamic Graphics, seem to be hybrids of clip art firms and stock illustration agencies. Read the information under "Needs" to find out what type of artwork each firm needs. Then check "First Contact & Terms" to find out what type of samples you should send. Most firms accept samples in the form of slides, photocopies and tearsheets. Increasingly, disk and e-mail submissions are encouraged in this market.

✓ AGFA MONOTYPE TYPOGRAPHY

200 Ballardvale St., Wilmington MA 01887. (978)284-5955. Fax: (978)657-8268. E-mail: allanhaley@agfamonotype.com. Website: www.fonts.com. **Director of Words & Letters:** Allan Haley. Estab. 1897. Font foundry. Specializes in high-quality Postscript and Truetype fonts for graphic design professionals and personal use. Clients include advertising agencies, magazines and desktop publishers. Submission guidelines on website.
- Does not want clip art or illustration—only fonts.

Needs Approached by 10 designers/year. Works with 5 typeface designers/year. Prefers typeface and font designs. Freelance work demands knowledge of Illustrator, Photoshop, QuarkXPress.

First Contact & Terms E-mail examples of font (PDF files or EPS or TIFF). Samples are not filed. Responds only if interested. Rights purchased vary according to project. Finds designers through word of mouth.

⊕ ARTBANK ILLUSTRATION LIBRARY

114 Clerkenwell Rd., London EC1M 5SA England. Phone: (+44)020 7608 2288. Fax: (+44)020 8906 2289. E-mail: info@artbank.com. Website: www.artbank.com. Estab. 1989. Picture library. Artists include Rafal Olbinski, Jane Spencer. Clients include advertising agencies, design groups, book publishers, calendar companies, greeting card companies and postcard publishers.

Needs Prefers 4×5 transparencies.

CUSTOM MEDICAL STOCK PHOTO, INC.

The Custom Medical Building, 3660 W. Irving Park Rd., Chicago IL 60618-4132. (800)373-2677. Fax: (773)267-6071. E-mail: info@cmsp.com. Website: www.cmsp.com. **Contact:** Mike Fisher or Henry Schleichkorn. Estab. 1985. Medical and scientific stock image agency. Specializes in medical photography, illustration, medical cartoons and animation for the healthcare industry. Distributes to magazines, advertising agencies and design firms. Clients include textbook publishers, continuing medical education, movie producers. Guidelines available for #10 SASE.

Needs Approached by 20 illustrators/year. Works with 50 illustrators and animators/year. Themes include healthcare. Knowledge of Photoshop, Illustrator and Aldus Freehand helpful.

First Contact & Terms "Call first to discuss before shipping." Accepts CD-ROM submissions compatible with Mac or PC; send "low res files for viewing." Responds in 1 month. Call or write for portfolio review. Pays royalties of 40%. Licenses non-exclusive rights to clients. Finds artists through word of mouth. "Our reputation precedes us among individuals who produce medical imagery. We also advertise in several medical and photographer's publications."

Tips "Our industry is motivated by current events and issues that affect healthcare—new drug discoveries, advances and F.D.A. approval on drugs and medical devices."

DRAWN & QUARTERED LTD.

4 Godmersham Park, Canterbury Kent CT4-7DT United Kingdom. Phone/fax: (44)1227-730-565. E-mail: red@drawnandquartered.com. Website: www.drawnandquartered.com. **Contact:** Robert Edwards, chief executive.
- See listing in Syndicates & Cartoon Features section.

✓ DYNAMIC GRAPHICS INC.

6000 N. Forest Park Dr., Peoria IL 61614-3592. (800)255-8800 or (309)688-8800. Fax: (309)688-8515. Website: www.dgusa.com. **Art Director:** Mike Ulrich. Distributes clip art, stock images and animation to thousands of magazines, newspapers, agencies, industries and educational institutions.
- Dynamic Graphics is a stock image firm and publisher of *Step into Design*, *Digital Design* newsletter, and *Dynamic Graphics Magazine*. Uses illustrators from all over the world; 99% of all artwork sold as clip art is done by freelancers.

Needs Works with more than 50 freelancers/year. Prefers illustration, symbols and elements; buying color and b&w, traditional or electronic images. "We are currently seeking to contact established illustrators capable of

handling b&w or color stylized and representational illustrations of contemporary subjects and situations."

First Contact & Terms Submit portfolio of at least 15 current samples with SASE. Responds in 2 weeks. **Pays on acceptance**. Negotiates payment. Buys all rights.

Tips "We are interested in quality, variety and consistency. Illustrators contacting us should have top-notch samples that show consistency of style (repeatability) over a range of subject matter. We often work with artists who are getting started if their portfolios look promising. Because we publish a large volume of artwork monthly, deadlines are extremely important, but we do provide long lead time. (4-6 weeks is typical.) We are also interested in working with illustrators who would like an ongoing relationship. Not necessarily a guaranteed volume of work, but the potential exists for a considerable number of pieces each year for marketable styles."

⚆ GETTY IMAGES

601 N. 34th St., Seattle WA 98103. (800)462-4379 or (206)925-5000. Fax: (206)925-5600. Website: www.gettyimages.com. Visual content provider offering licensed and royalty-free images.

Needs Approached by 1,500 artists/year. Buys from 100 freelancers/year. Considers illustrations, photos, typefaces and spot drawings.

First Contact & Terms Sample package should include submission form (from website), tearsheets, slides, photocopies or digital files. 10 samples should be included. Samples are filed. Buys all rights or licenses image. Minimum length of contract is indefinite. Offers automatic renewal.

✓ ⚆ GRAPHIC CORP.

a division of Corel Corporation, 1600 Carling Ave., Ottawa ON K1Z 8R7 Canada. (613)728-0826. Fax: (613)728-9790. E-mail: janiesh@corel.com. Website: www.corel.com and www.creativeanywhere.com/clipart/. **Contact:** Nick Davies, senior creative manager. Estab. 1986. Software company specializing in clip art, animation, stock illustration, photos and fonts for use by computer hardware and software companies.

● If you are adept at creating artwork using Corel software, attempt to submit work using a Corel graphic program.

Needs Approached by 50 cartoonists and 50 illustrators/year. Buys from 20 cartoonists and 20 illustrators/year. Considers custom created clip art, software, photos, gag cartoons, caricature and illustrations. Prefers single panel. Also uses freelancers for computer illustration.

First Contact & Terms Sample package should include cover letter, finished clip art in electronic samples. Maximum amount of samples possible should be included. "GraphicCorp recommends that image submissions: be provided in WMF and/or EPS format (preferably both); be provided on diskette; contain a *minimum* of 50 color images (no black & white images, please); and contain the following subject-matter: holidays, borders, greeting card-style, animals, religious, flowers, office and business imagery, family and educational subjects. (See our website for the type of graphics we use.)" Samples are not filed and are returned by SASE if requested by artist. Responds only if interested. Negotiates rights purchased.

Tips "We prefer prolific artists or artists with large existing collections. Images must be in electronic format. We are not interested in expensive works of art. We buy simple, but detailed, images that can be used by anybody to convey an idea in one look. We are interested in quantity, with some quality."

IDEAS UNLIMITED FOR EDITORS

Omniprint Inc., 9700 Philadelphia Court, Lanham MD 20706. (301)731-5202. Fax: (301)731-5203. E-mail: editor@omniprint.net. **Editorial Director:** Rachel Brown. Stock illustration and editorial firm serving corporate in-house newsletters. Guidelines not available.

● This new clip art firm is a division of Omni Print, Inc., which provides publishing services to corporate newsletter editors. Ideas Unlimited provides clip art in both hard copy and disk form.

Needs Buys from 2 cartoonists and 5 illustrators/year. Prefers single panel with gagline.

First Contact & Terms Sample package should include cover letter, tearsheets, résumé and finished cartoons or illustrations. 10 samples should be included. Samples are filed. Responds only if interested. Mail photocopies and tearsheets. Pays $50-100. **Pays on acceptance**. Buys all rights. Minimum length of contract is 6 months.

✓ INNOVATIVE CLIP ART.COM

(formerly Innovation Multimedia), 31 Fairview Dr., Essex Junction VT 05452. (802)879-1164. Fax: (802)878-1768. E-mail: info@innovativeCLIPart.com. Website: www.innovativeCLIPart.com. **Owner:** David Dachs. Estab. 1985. Clip art publisher. Specializes in clip art for publishers, ad agencies, designers. Clients include US West, Disney, *Time* Magazine.

Needs Prefers clip art, illustration, line drawing. Themes include animals, business, education, food/cooking, holidays, religion, restaurant, schools. 100% of design demands knowledge of Illustrator.

First Contact & Terms Send samples and/or Macintosh disks (Illustrator files). Artwork should be saved as EPS files. Samples are filed. Responds only if interested. Pays by the project. Buys all rights.

METRO CREATIVE GRAPHICS, INC.

519 Eighth Ave., New York NY 10018. (212)947-5100. Fax: (212)714-9139. Website: www.metrocreativegraphics.com. **Senior Art Director:** Darrell Davis. Estab. 1910. Creative graphics/art firm. Distributes to 7,000 daily and weekly paid and free circulation newspapers, schools, graphics and ad agencies and retail chains. Guidelines available. (Send letter with SASE or e-mail art director on website.)

Needs Buys from 100 freelancers/year. Considers all styles of illustrations and spot drawings; b&w and color. Editorial style art, cartoons for syndication not considered. Special emphasis on computer-generated art for Macintosh. Send floppy disk samples using Illustrator 5.0. or Photoshop. Prefers all categories of themes associated with newspaper advertising (retail promotional and classified). Also needs covers for special-interest newspaper, tabloid sections.

First Contact & Terms Send query letter with non-returnable samples, such as photostats, photocopies, slides, photographs or tearsheets to be kept on file. Accepts submissions on disk compatible with Illustrator 5.0 and Photoshop. Send EPS or TIFF files. Samples returned by SASE if requested. Responds only if interested. Works on assignment only. **Pays on acceptance**; flat fee of $25-1,500 (buy out). Considers skill and experience of artist, saleability of artwork and clients' preferences when establishing payment.

Tips This company is "very impressed with illustrators who can show a variety of styles." When creating electronic art, make sure all parts of the illustration are drawn completely, and then put together. "It makes the art more versatile to our customers."

MILESTONE GRAPHICS

1093 A1A Beach Blvd., #388, St. Augustine FL 32080. Phone/fax: (904)823-9962. E-mail: miles@aug.com. Website: www.milestonegraphics.com. **Owner:** Jill O. Miles. Estab. 1993. Clip art firm providing targeted markets with electronic graphic images.

Needs Buys from 20 illustrators/year. 50% of illustration demands knowledge of Illustrator.

First Contact & Terms Sample package should include nonreturnable photocopies or samples on computer disk. Accepts submissions on disk compatible with Illustrator on the Macintosh. Send EPS files. Interested in b&w and some color illustrations. All styles and media are considered. Macintosh computer drawings accepted (Illustrator preferred). "Ability to draw people a plus, but many other subject matters needed as well. We currently have a need for golf and political illustrations." Reports back to the artist only if interested. Pays flat fee of $25 minimum/illustration, based on skill and experience. A series of illustrations is often needed.

ONE MILE UP, INC.

7011 Evergreen Court, Annandale VA 22003. (703)642-1177. Fax: (703)642-9088. E-mail: gene@onemileup.com. Website: www.onemileup.com. **President:** Gene Velazquez. Estab. 1988.

• Gene Velazquez told *AGDM* he is looking for aviation graphics. He does not use cartoons.

Needs Approached by 10 illustrators and animators/year. Buys from 5 illustrators/year. Prefers illustration.

First Contact & Terms Send 3-5 samples via e-mail with résumé and/or link to your website. Pays flat fee; $30-120. **Pays on acceptance.** Negotiates rights purchased.

N THE SPIRIT SOURCE.COM

1310 Pendleton St., Cincinnati OH 45202. (513)241-7473. Fax: (513)241-7505. E-mail: mpwiggins@thespiritsource.com. Website: www.thespiritsource.com. **Owner:** Paula Wiggins. Estab. 2003. Stock illustration firm. Specializes in religious, spiritual and inspirational images for the print market. Distributes to book publishers, greeting card companies, magazine publishers, newspapers. Clients include *Sojourners* Magazine, St. Anthony Messenger Press, Gainey Conference Center. Guidelines available on website.

Needs Approached by 25 illustrators/year. Works with 11 illustrators/year. Prefers digital art, b&w and color drawings with line, pen & ink, spot and any high-quality artwork in any medium that is inspirational in nature. Themes include education, families, fine art, holidays, landscapes/scenics, multicultural and religious. 100% of illusration demands skills in Photoshop.

First Contact & Terms Send brochure, photocopies, URL, images on a CD or e-mail low-res files. Samples are filed or returned by SASE. Accepts e-mail submissions with link to website and with image file. Prefers low-res JPEGs or images on a CD. Responds in 1 week. Portfolio should include at least 10 images, preferably in a digital format or b&w and color finished art. No originals. Pays for illustration 50% of negotiated fee. Buys one-time rights. Finds artists through artists' submissions and word of mouth.

Tips "Although we are a website that specializes in religious/spiritual/inspirational work, that can be interpreted broadly. Our categories include family life, human relationships, nature, virtues/vices and holidays. No overdone or clichéd images. Artist should be prepared to submit digital images for the site according to our specifications."

☑ STOCK ILLUSTRATION SOURCE

16 W. 19th St., 9th Floor, New York NY 10011. (212)849-2900, (800)4-IMAGES. Fax: (212)691-6609. E-mail: submissions@images.com. Website: www.images.com. **Acquisitions Manager:** Margaret Zacharon. Estab. 1992. Stock illustration agency. Specializes in illustration for corporate, advertising, editorial, publishing industries. Guidelines available.

Needs "We deal with 500 illustrators." Prefers painterly, conceptual images, including collage and digital works. Themes include corporate, business, education, family life, healthcare, law and environment, lifestyle.

First Contact & Terms Illustrators should scan sample work onto CD or disk and send that rather than e-mailing links to their sites. Will do portfolio review. Pays royalties of 50% for illustration sales. Negotiates rights purchased.

☑ STOCKART.COM

155 N. College Ave., Suite 225, Ft. Collins CO 80524. (970)493-0087 or (800)297-7658. Fax: (970)493-6997. E-mail: art@stockart.com. Website: www.stockart.com. **Art Manager:** Maile Fink. Estab. 1995. Stock illustration and representative. Specializes in b&w and color illustration for ad agencies, design firms and publishers. Clients include BBDO, Bozell, Pepsi, Chase, Saatchi & Saatchi.

Needs Approached by 250 illustrators/year. Works with 150 illustrators/year. Themes include business, family life, financial, healthcare, holidays, religion and many more.

First Contact & Terms Illustrators send at least 10 samples of work. Accepts hard copies, e-mail or disk submissions compatible with TIFF or EPS files less than 600K/image. Pays 50% stock royalty, 70% commission royalty (commissioned work—artist retains rights) for illustration. Rights purchased vary according to project. Finds artists through sourcebooks, online, word of mouth. "Offers unprecedented easy-out policy. Not 100% satisfied, will return artwork within 60 days."

Tips "Stockart.com has many artists earning a substantial passive income from work that was otherwise in their file drawers collecting dust."

*G*et a FREE ISSUE of *Watercolor Magic* and discover a world of watermedia inspiration!

*O*pen your FREE ISSUE of *Watercolor Magic* and you'll find superior instruction, clear demonstrations and gorgeous artwork. Whether you're passionate about watercolor or acrylic, gouache or any other water-based media, then *Watercolor Magic* is sure to help you develop your own unique style!

Watercolor Magic helps you:

- Choose a great subject every time
- Capture light and shadows to add depth and drama
- Experiment by combining media
- Master shape, detail, texture and color
- Explore cutting-edge techniques and materials
- Get inspired and create breathtaking art
- And more!

Return the attached No-Risk RSVP card today to get your FREE ISSUE!

NO-RISK RSVP

☑ *Yes!* Send my FREE trial issue of *Watercolor Magic* and start my introductory subscription. If I like what I see, I'll get 5 more issues (total of 6) for just $19.96. If not, I'll write "cancel" on the bill, return it and owe nothing. The FREE ISSUE will be mine to keep!

Send no money now...we'll bill you later.

Name _____

Address _____

City _____

State/Prov._____ ZIP/PC _____

Subscribers in Canada will be charged an additional US$7 (includes GST/HST) and invoiced. Outside the U.S. and Canada, add US$7 and remit payment in U.S. funds with this order. Annual newsstand rate: $35.94. Please allow 4-6 weeks for first-issue delivery.

Watercolor Magic *www.watercolormagic.com*

J4FARM

Get a **FREE ISSUE** of *Watercolor Magic*
The #1 Magazine for Watermedia Artists!

No matter your skill level — beginner or beyond — *Watercolor Magic* helps you turn ordinary works into extraordinary art! *Watercolor Magic* is published six times a year, and you'll always get tips and insights from the world's best watermedia artists. Plus, a regular subscription to *Watercolor Magic* includes these two exclusive annuals:

Watercolor Yearbook **takes a look back at the year in watermedia, and**

Watercolor Handbook **is the perfect watermedia guide for artists of all skill levels!**

Step into a fresh new world of watercolor and mail the card below today to get your FREE ISSUE of *Watercolor Magic*!

Advertising, Design & Related Markets

© Gary Ciccarelli

I f you are an illustrator who can work in a consistent style or a designer with excellent skills, and you can take direction, this section offers a glimpse at one of the most lucrative markets for artists. Because of space constraints, the markets listed are just the tip of the proverbial iceberg. There are thousands of advertising agencies and public relations, design and marketing firms across the country and around the world. All rely on freelancers. Look for additional firms in industry directories, such as *Workbook* (Scott & Daughters Publishing), *Standard Directory of Advertisers* (National Register Publishing) and *The Adweek Directory*, available in the business section of most large public libraries. Find local firms in the yellow pages and your city's business-to-business directory. You can also pick up leads by reading *Adweek*, *HOW*, *Print*, *STEP inside design*, *Communication Arts* and other design and marketing publications.

Find your best clients

Read listings to identify firms whose clients and specialties are in line with the type of work you create. (You'll find clients and specialties in the first paragraph of each listing.) For example, if you create charts and graphs, contact firms whose clients include financial institutions. Fashion illustrators should approach firms whose clients include department stores and catalog publishers. Sculptors and modelmakers might find opportunities with firms specializing in exhibition design.

Payment and copyright

You will most likely be paid by the hour for work done on the firm's premises (in-house) and by the project if you take the assignment back to your studio. Most checks are issued 40-60 days after completion of assignments. Fees depend on the client's budget, but most companies are willing to negotiate, taking into consideration the experience of the freelancer, the lead time given and the complexity of the project. Be prepared to offer an estimate for your services and ask for a purchase order (P.O.) before you begin an assignment.

Some art directors will ask you to provide a preliminary sketch on speculation or "on spec," which, if approved by the client, can land you a plum assignment. If you are asked to create something "on spec," be aware that you may not receive payment beyond an hourly fee for your time if the project falls through. So be sure to ask upfront about payment policy before you start an assignment.

If you're hoping to retain usage rights to your work, you'll want to discuss this upfront, too. You can generally charge more if the client is requesting a buyout. If research and travel are required, make sure you find out ahead of time who will cover these expenses.

ALABAMA

COMPASS MARKETING, INC.

175 Northshore Place, Gulf Shores AL 36542. (251)968-4600. Fax: (251)968-5938. E-mail: awboone@compassbiz.com. Website: www.compassbiz.com. **Editor:** April W. Boone. Estab. 1988. Number of employees: 20-25. Approximate annual billing: $4 million. Integrated marketing communications agency and publisher. Specializes in tourism products and programs. Product specialties are business and consumer tourism. Current clients include Alabama Bureau of Tourism and Alabama Gulf Coast CVB. Client list available upon request. Professional affiliations: STS, Mobile 7th Dist. Ad Fed, MCAN and AHA.

Needs Approached by 2-10 illustrators/year and 5-20 designers/year. Works with 2 illustrators and 4-6 designers/year. Prefers freelancers with experience in magazine work. Uses freelancers mainly for sales collateral, advertising collateral and illustration. 5% of work is with print ads. 100% of design demands skills in Photoshop 5.0 and QuarkXPress. Some illustration demands computer skills.

First Contact & Terms Designers send query letter with photocopies, résumé and tearsheets. Illustrators send postcard sample of work. Samples are filed and are not returned. Responds in 1 month. Art director will contact artist for portfolio review of slides and tearsheets if interested. Pays by the project, $100 minimum. Rights purchased vary according to project. Finds artists through sourcebooks, networking and print.

Tips "Be fast and flexible. Have magazine experience."

A. TOMLINSON/SIMS ADVERTISING, INC.

250 S. Poplar St., Florence AL 35630. (256)766-4222. Fax: (256)766-4106. E-mail: atsadv@hiwaay.net. Website: ATSA-USA.com. **President:** Allen Tomlinson. Estab. 1990. Number of employees: 9. Approximate annual billing: $5.0 million. Ad agency. Specializes in magazine, collateral, catalog—business-to-business. Product specialties are home building products. Client list available upon request.

Needs Approached by 20 illustrators and 20 designers/year. Works with 5 illustrators and 5 designers/year. Also for airbrushing, billboards, brochure and catalog design and illustration, logos and retouching. 35% of work is with print ads. 85% of design demands skills in PageMaker 6.5, Photoshop, Illustrator and QuarkXPress 4.1. 85% of illustration demands skills in PageMaker 6.5, Photoshop, Illustrator and QuarkXPress 4.1.

First Contact & Terms Designers send query letter with brochure and photocopies. Illustrators send query letter with brochure, photocopies and résumé. Samples are filed and are not returned. Does not reply; artist should call. Artist should also call to arrange for portfolio review of color photographs, thumbnails and transparencies. Pays by the project. Rights purchased vary according to project.

ARIZONA

ⓝ ARIZONA CINE EQUIPMENT, INC.

2125 E. 20th St., Tucson AZ 85719. (520)623-8268. Fax: (520)623-1092. **Vice President:** Linda A. Bierk. Estab. 1967. Number of employees: 11. Approximate annual billing: $850,000. AV firm. Full-service, multimedia firm. Specializes in video. Product specialty is industrial.

Needs Approached by 5 freelancers/year. Works with 5 illustrators and 5 freelance designers/year. Prefers local artists. Uses freelancers mainly for graphic design. Also for brochure and slide illustration, catalog design and illustration, print ad design, storyboards, animation and retouching. 20% of work is with print ads. Also for multimedia projects. 70% of design and 80% of illustration demand knowledge of PageMaker, QuarkXPress, FreeHand, Illustrator or Photoshop.

First Contact & Terms Send query letter with brochure, résumé, photocopies, tearsheets, transparencies, photographs, slides and SASE. Samples are filed. Responds only if interested. Will contact artist for portfolio review if interested. Portfolio should include color thumbnails, final art, tearsheets, slides, photostats, photographs and transparencies. Pays for design by the project, $100-5,000. Pays for illustration by the project, $25-5,000. Buys first rights or negotiates rights purchased.

ⓝ 🖳 BOELTS-STRATFORD ASSOCIATES

345 E. University Blvd., Tucson AZ 85705-7848. (520)792-1026. Fax: (520)792-9720. E-mail: bsa@boelts-stratford.com. Website: www.boelts-stratford.com. **Principal:** Jackson Boelts. Estab. 1986. Specializes in annual reports, brand identity, corporate identity, display design, direct mail design, environmental graphics, package design, publication design and signage. Client list available upon request.

● This firm has won over 400 international, national and local awards.

Needs Approached by 100 freelance artists/year. Works with 10 freelance illustrators and 5-10 freelance designers/year. Works on assignment only. Uses designers and illustrators for brochure, poster, catalog, P-O-P and ad illustration, mechanicals, retouching, airbrushing, charts/graphs and audiovisual materials.

First Contact & Terms Send query letter with brochure, tearsheets and résumé. Samples are filed. Responds only if interested. Call to schedule an appointment to show portfolio. Portfolio should include roughs, original/final art, slides and transparencies. Pays for design by the hour and by the project. Pays for illustration by the project. Negotiates rights purchased.

Tips When presenting samples or portfolios, artists "sometimes mistake quantity for quality. Keep it short and show your best work."

CRICKET CONTRAST GRAPHIC DESIGN

6232 N. 7th St., Suite 208, Phoenix AZ 85014. (602)258-6149. Fax: (602)258-0113. E-mail: cricket@thecricketcon trast.com. **Owner:** Kristie Bo. Estab. 1982. Number of employees: 5. Specializes in annual reports, corporate identity, web page design, advertising, package and publication design. Clients: corporations. Professional affiliations: AIGA, Phoenix Society of Communicating Arts, Phoenix Art Museum, Phoenix Zoo.

Needs Approached by 25-50 freelancers/year. Works with 5 freelance illustrators and 5 designers/year. Also uses freelancers for ad illustration, brochure design and illustration, lettering and logos. Needs computer-literate freelancers for design and production. 100% of freelance work demands knowledge of Illustrator, Photoshop and QuarkXPress.

First Contact & Terms Send photocopies, photographs and résumé. Will contact artist for portfolio review if interested. Portfolio should include b&w photocopies. Pays for design and illustration by the project. Negotiates rights purchased. Finds artists through self-promotions and sourcebooks.

Tips "Beginning freelancers should call and set up an appointment or meeting and show their portfolio and then make a follow-up call or calls."

☑ CHARLES DUFF ADVERTISING

301 W. Osborn Rd., Suite 3600, Phoenix AZ 85013. (602)285-1660. Fax: (602)207-2193. E-mail: bdawes@mail.fa rnam.com. Website: www.farnam.com. **Executive Art Director:** Brian Dawes. Estab. 1948. Number of employees: 13. Approximate annual billing: $1 million. Ad agency. Full-service multimedia firm. Specializes in agri-marketing promotional materials—literature, audio, video, trade literature. Specializes in animal health.

- Charles Duff Advertising is the in-house ad agency for Farnam Companies, a multi-million dollar company specializing in horse care and agricultural products.

Needs Approached by 50 freelancers/year. Works with 10 freelance illustrators and 10 designers/year. Prefers freelancers with experience in animal illustration: equine, pets and livestock. Uses freelancers mainly for brochure, catalog and print ad illustration and retouching, billboards and posters. 35% of work is with print ads. Needs computer-literate freelancers for design, illustration, production and presentation. 25% of freelance work demands knowledge of Photoshop, QuarkXPress and Illustrator.

First Contact & Terms Send query letter with brochure, photocopies, SASE, résumé, photographs, tearsheets, slides or transparencies. Samples are filed or are returned by SASE if requested by artist. Responds in 2 weeks. Reviews portfolios "only by our request." Pays by the project, $100-500 for design; $100-700 for illustration. Buys one-time rights.

Ⓝ PAUL S. KARR PRODUCTIONS

2925 W. Indian School Rd., Phoenix AZ 85017. (602)266-4198. **Contact:** Kelly Karr. Utah Division: 1024 N. 300 E. Orem UT 84057. (801)226-3001. **Contact:** Michael Karr. Film and video producer. Clients: industry, business, education, TV, cable and feature films.

Needs Occasionally works with freelance filmmakers in motion picture and video projects. Works on assignment only.

First Contact & Terms Advise of experience, abilities and funding for project.

Tips "If you know about motion pictures and video or are serious about breaking into the field, there are three avenues: 1) have relatives in the business; 2) be at the right place at the right time; or 3) take upon yourself the marketing of your idea, or develop a film or video idea for a sponsor who will finance the project. Go to a film or video production company, such as ours, and tell them you have a client and the money. They will be delighted to work with you on making the production work and approve the various phases as it is being made. Have your name listed as the producer on the credits. With the knowledge and track record you have gained, you will be able to present yourself and your abilities to others in the film and video business and to sponsors."

Ⓝ THE M. GROUP GRAPHIC DESIGN

8722 E. Via De Commercio, Scottsdale AZ 85258. (480)998-0600. Fax: (480)998-9833. E-mail: mail@themgroupi nc.com. Website: www.themgroupinc.com. **Head Designer:** Michael Carmagiano. Estab. 1987. Number of employees: 7. Approximate annual billing: 2.75 million. Specializes in annual reports, corporate identity, direct mail and package design, and advertising. Clients: corporations and small business. Current clients include BankOne, Dole Foods, Giant Industries, Intel, Coleman Spas, Subway and Teksoft.

Needs Approached by 50 freelancers/year. Works with 5-10 freelance illustrators/year. Uses freelancers for ad, brochure, poster and P-O-P illustration. 95% of freelance work demands skills in Illustrator, Photoshop and QuarkXPress.

First Contact & Terms Send postcard sample or query letter with samples. Samples are filed or returned by SASE if requested by artist. Responds only if interested. Request portfolio review in original query. Artist should follow-up. Portfolio should include b&w and color final art, photographs and transparencies. Rights purchased vary according to project. Finds artists through publications (trade) and reps.

Tips Impressed by "good work, persistence, professionalism."

☑ PAPAGALOS STRATEGIC COMMUNICATIONS

7330 N. 16th St., Suite B102, Phoenix AZ 85020. (602)906-3210. Fax: (602)277-7448. E-mail: nicholas@papagalos.com. Website: www.papagalos.com. **Creative Director:** Nicholas Papagalos. Specializes in advertising, brochures, annual corporate identity, displays, packaging, publications and signage. Clients: major regional, consumer and business-to-business. Clients include Arizona State University, Phoenix Children's Hospital, Prudential.

Needs Works with 10-20 freelance artists/year. Works on assignment only. Uses artists for illustration, retouching, design and production. Needs computer-literate freelancers, HTML programmers and web designers for design, illustration and production. 100% of freelance work demands skills in Illustrator, QuarkXPress or Photoshop.

First Contact & Terms E-mail résumé and samples. Pays for design by the hour or by the project. Pays for illustration by the project. Considers complexity of project, client's budget, skill and experience of artist, how work will be used, turnaround time and rights purchased when establishing payment. Rights purchased vary according to project.

Tips In presenting samples or portfolios, "three samples of the same type/style are enough."

ARKANSAS

TAYLOR MACK ADVERTISING

509 W. Spring #450, Fayetteville AR 72071. (479)444-7770. Fax: (479)444-7977. E-mail: Greg@TaylorMack.com. Website: www.TaylorMack.com. **Creative Director:** Greg Mack. Estab. 1990. Number of employees: 16. Approximate annual billing: $3 million. Ad agency. Specializes in collateral. Current clients include Cobb, Colliers, Jose's, Honeysuckle White and Marathon. Client list available upon request.

Needs Approached by 12 illustrators and 20 designers/year. Works with 4 illustrators and 6 designers/year. Uses freelancers mainly for brochure, catalog and technical illustration, TV/film graphics and web page design. 30% of work is with print ads. 50% of design and illustration demands skills in Photoshop, Illustrator and QuarkXPress.

First Contact & Terms Designers send query letter with brochure and photocopies. Illustrators send postcard sample of work. Samples are filed or are returned. Responds only if interested. Art director will contact artist for portfolio review of photographs if interested. Pays for design by the project or by the day; pays for illustration by the project, $10,000 maximum. Rights purchased vary according to project.

Ⓝ MANGAN/HOLCOMB RAINWATER/CULPEPPER & PARTNERS

2300 Cottondale Lane, Suite 300, Little Rock AR 72201. (501)376-0321. E-mail: chip@people-energy-ideas.com. Website: www.people-energy-ideas.com. **Vice President Creative Director:** Chip Culpepper. Number of employees: 12. Marketing, advertising and public relations firm. Approximate annual billing: $3 million. Ad agency. Clients: recreation, financial, tourism, retail, agriculture.

Needs Approached by 50 freelancers/year. Works with 8 freelance illustrators and 20 designers/year. Uses freelancers for consumer magazines, stationery design, direct mail, brochures/flyers, trade magazines and newspapers. Also needs illustrations for print materials. Needs computer-literate freelancers for production and presentation. 30% of freelance work demands skills in Macintosh page layout and illustration software.

First Contact & Terms Query with samples, flier and business card to be kept on file. Include SASE. Responds in 2 weeks. Call or write for appointment to show portfolio of final reproduction/product. Pays by the project, $250 minimum.

CALIFORNIA

Ⓝ ▣ THE ADVERTISING CONSORTIUM

10536 Culver Blvd., Suite D, Culver City CA 90232. (310)287-2222. Fax: (310)287-2227. E-mail: theadco@packbell.net. **Contact:** Kim Miyade. Estab. 1985. Ad agency. Full-service, multimedia firm. Specializes in print, collateral, direct mail, outdoor, broadcast. Current clients include Bernini, Davante, Westime, Modular Communication Systems.

Needs Works with 1 illustrator and 2 art directors/month. Prefers local artists only. Works on assignment only. Uses freelance artists and art directors for everything (none on staff), including brochure, catalog and print ad design and illustration and mechanicals and logos. 80% of work is with print ads. Also for multimedia projects. 100% of freelance work demands knowledge of PageMaker, QuarkXPress, FreeHand, Illustrator and Photoshop.

First Contact & Terms Send postcard sample or query letter with brochure, tearsheets, photocopies, photographs and anything that does not have to be returned. Samples are filed. Write for appointment to show portfolio. "No phone calls, please." Portfolio should include original/final art, b&w and color photostats, tearsheets, photographs, slides and transparencies. Pays for design by the hour, $60-75. Pays for illustration by the project, based on budget and scope.

Tips Looks for "exceptional style."

N ADVERTISING DESIGNERS, INC.

7087 Snyder Ridge Rd., Mariposa CA 95338-9642. (209)742-6704. Fax: (209)742-6314. E-mail: ad@yosemite.net. **President:** Tom Ohmer. Estab. 1947. Number of employees: 2. Specializes in annual reports, corporate identity, ad campaigns, package and publication design and signage. Clients: corporations. Professional affiliations: LAADC.

Needs Approached by 50 freelancers/year. Works with 2 freelance illustrators and 2 designers/year. Works on assignment only. Uses freelancers mainly for editorial and annual reports. Also for brochure design and illustration, mechanicals, retouching, lettering, logos and ad design. Needs computer-literate freelancers for design and illustration. 100% of design and 70% of illustration demand skills in PageMaker, Quark XPress, FreeHand, Illustrator and Photoshop.

First Contact & Terms Send query letter with postcard sample. Samples are filed. Does not reply. Artist should call. Write for appointment to show portfolio. Pays for design by the hour, $35 minimum or by the project, $500-7,500. Pays for illustration by the project, $500-5,000. Rights purchased vary according to project.

B&A DESIGN GROUP

634-C W. Broadway, Glendale CA 91204-1008. (818)547-4080. Fax: (818)547-1629. **Owner/Creative Director:** Barry Anklam. Full-service advertising and design agency providing ads, brochures, P-O-P displays, packaging, corporate identity, posters and menus. Product specialties are food products, electronics, hi-tech, real estate and medical. Clients: high-tech, electronic, financial institutions and restaurants. Current clients include Mixtec Group, Humanomics Inc., Teasdale Quality Foods, DMG Marketing, DocuMedia Group Inc.

Needs Works with 3 freelancers/year. Assigns 10-15 jobs/year. Uses freelancers mainly for brochure, editorial newspaper and magazine ad illustration, mechanicals, retouching, direct mail packages, lettering, charts/graphs. Needs editorial, technical and medical illustration, photography, production on collateral materials, lettering and editorial cartoons. Needs computer-literate freelancers for design, illustration and production. 95% of freelance work demands skills in QuarkXPress, Photoshop and FreeHand.

First Contact & Terms Contact through artist's agent or send query letter with brochure showing art style. Samples are filed. Responds only if interested. To show a portfolio, mail color and b&w tearsheets and photographs. Pays for production by the hour, $25-35. Pays for design by the hour, $75-150; or by the project, $500-2,000. Pays for illustration by the project, $250-3,000. Considers complexity of project, client's budget and turnaround time when establishing payment. Rights purchased vary according to project. Finds artists through agents, sourcebooks and sometimes by submissions.

☑ BASIC/BEDELL ADVERTISING & PUBLISHING

P.O. Box 6068, Ventura CA 93006. (805)650-1565. E-mail: barriebedell@earthlink.net. **President:** C. Barrie Bedell. Specializes in advertisements, direct mail, how-to books, direct response websites and manuals. Clients: publishers, direct response marketers, retail stores, software developers, web entrepreneurs, plus extensive self-promotion of proprietary advertising how-to manuals.

- This company's president is seeing "a glut of 'graphic designers,' and an acute shortage of 'direct response' designers."

Needs Uses artists for publication and direct mail design, book covers and dust jackets, and camera-ready computer desktop production. Especially interested in hearing from professionals experienced in e-commerce and in converting printed training materials to electronic media, as well as designers of direct response websites.

First Contact & Terms Portfolio review not required. Pays for design by the project, $100-2,500 and up and/or royalties based on sales.

Tips "There has been a substantial increase in use of freelance talent and increasing need for true professionals with exceptional skills and responsible performance (delivery as promised and 'on target'). It is very difficult to locate freelance talent with expertise in design of advertising and direct mail with heavy use of type. Contact with personal letter and photocopy of one or more samples of work that needn't be returned."

◨ THE BASS GROUP

Dept. AM, 102 Willow Ave., Fairfax CA 94930. (415)455-8090. **Producer:** Herbert Bass. Number of employees: 2. Approximate annual billing: $300,000. ''A multimedia, full-service production company providing corporate communications to a wide range of clients. Specializes in multimedia presentations, video/film, and events productions for corporations.''

Needs Approached by 30 freelancers/year. Works with a variety of freelance illustrators and designers/year. Prefers solid experience in multimedia and film/video production. Works on assignment only. Uses freelancers for logos, charts/graphs and multimedia designs. Needs graphics, meeting theme logos, electronic speaker support and slide design. Needs computer-literate freelancers for design, illustration and production. 90% of freelance work demands skills in QuarkXPress, FreeHand, Illustrator and Photoshop.

First Contact & Terms Send résumé and slides. Samples are filed and are not returned. Responds in 1 month if interested. Will contact artist for portfolio review if interested. Sometimes requests work on spec before assigning a job. Pays by the project. Considers turnaround time, skill and experience of artist and how work will be used when establishing payment. Rights purchased vary according to project. Finds illustrators and designers mainly through word of mouth recommendations.

Tips ''Send résumé, samples, rates. Highlight examples in speaker support—both slide and electronic media—and include meeting logo design.''

☑ BRAINWORKS DESIGN GROUP, INC.

5 Harris Court, Building T, Monterey CA 93940. (831)657-0650. Fax: (831)657-0750. E-mail: mail@brainwks.com. Website: www.brainwks.com. **Contact:** Alfred Kahn, president. Marketing Director: Martin Blind. Creative Services Coordinator: Amanda Curreri. Estab. 1970. Number of employees: 8. Specializes in ERC (Emotional Response Communications), graphic design, corporate identity, direct mail and publication. Clients: colleges, universities, nonprofit organizations; majority are colleges and universities. Current clients include City College of New York, Manhattanville, University of South Carolina-Spartanburg, Queens College, Manhattan College, Nova University, American International College, Teachers College Columbia.

Needs Approached by 100 freelancers/year. Works with 4 freelance illustrators and 10 designers/year. Prefers freelancers with experience in type, layout, grids, mechanicals, comps and creative visual thinking. Works on assignment only. Uses freelancers mainly for mechanicals and calligraphy. Also for brochure, direct mail and poster design; mechanicals; lettering; and logos. 100% of design work demands knowledge of QuarkXPress, Illustrator and Photoshop.

First Contact & Terms Send brochure or résumé, photocopies, photographs, tearsheets and transparencies. Samples are filed. Artist should follow up with call and/or letter after initial query. Will contact artist for portfolio review if interested. Portfolio should include thumbnails, roughs, final reproduction/product and b&w and color tearsheets, photostats, photographs and transparencies. Pays for design by the project, $200-2,000. Considers complexity of project and client's budget when establishing payment. Rights purchased vary according to project. Finds artists through sourcebooks and self-promotions.

Tips ''Creative thinking and a positive attitude are a plus.'' The most common mistake freelancers make in presenting samples or portfolios is that the ''work does not match up to the samples they show.'' Would like to see more roughs and thumbnails.

JANN CHURCH PARTNERS, INC./PHILANTHROPY CONSULTANTS GROUP, INC.

P.O. Box 9527, Newport Beach CA 92660. (949)640-6224. Fax: (949)640-1706. **President:** Jann Church. Estab. 1970. Specializes in annual reports, brand and corporate identity, display, interior, direct mail, package and publication design, and signage. Clients: real estate developers, medical/high technology corporations, private and public companies. Current clients include The Nichols Institute, The Anden Group, Institute for Biological Research & Development. Client list available upon request.

Needs Approached by 100 freelance artists/year. Works with 3 illustrators and 5 designers/year. Works on assignment only. Needs technical illustration. 10% of freelance work demands computer literacy.

First Contact & Terms Send query letter with résumé, photographs and photocopies. Samples are filed. Responds only if interested. To show a portfolio, mail appropriate materials. Portfolio should be ''as complete as possible.'' Pays for design and illustration by the project. Rights purchased vary according to project.

☑ ⬚ CLIFF & ASSOCIATES

10061 Riverside Dr. #808, Toluca Lake CA 91602. (626)799-5906. Fax: (626)799-9809. E-mail: design@cliffassoc.com. **Owner:** Greg Cliff. Estab. 1984. Number of employees: 10. Approximate annual billing: $1 million. Specializes in annual reports, corporate identity, direct mail and publication design and signage. Clients: Fortune 500 corporations and performing arts companies. Current clients include BP, IXIA, WSPA, IABC, Capital Research and ING.

Needs Approached by 50 freelancers/year. Works with 30 freelance illustrators and 10 designers/year. Prefers

local freelancers and Art Center graduates. Uses freelancers mainly for brochures. Also for technical, "fresh" editorial and medical illustration; mechanicals; lettering; logos; catalog, book and magazine design; P-O-P and poster design and illustration; and model making. Needs computer-literate freelancers for design and production. 90% of freelance work demands knowledge of QuarkXPress, FreeHand, Illustrator, Photoshop, etc.

First Contact & Terms Send query letter with résumé and a nonreturnable sample of work. Samples are filed. Art director will contact artist for portfolio review if interested. Portfolio should include thumbnails, b&w photostats and printed samples. Pays for design by the hour, $25-35. Pays for illustration by the project, $50-3,000. Buys one-time rights. Finds artists through sourcebooks.

N COAKLEY HEAGERTY ADVERTISING & PUBLIC RELATIONS

1155 N. First St., Suite 201, San Jose CA 95112-4925. (408)275-9400. Fax: (408)995-0600. E-mail: info@coakley-heagerty.com. Website: www.coakley-heagerty.com. **Art Director:** Bob Meyerson. Estab. 1961. Number of employees: 25. Approximate annual billing: $300 million. Full-service ad agency and PR firm. Clients: consumer, senior care, banking/financial, insurance, automotive, real estate, tel com, public service. Client list available upon request. Professional affiliation: MAGNET (Marketing and Advertising Global Network).

Needs Approached by 100 freelancers/year. Works with 50 freelance illustrators and 3 designers/year. Works on assignment only. Uses freelancers for illustration, retouching, animation, lettering, logos and charts/graphs. Freelance work demands skills in Illustrator, Photoshop or QuarkXPress.

First Contact & Terms Send query letter with nonreturnable samples showing art style or résumé, slides and photographs or e-mail link to website or PDF files. Samples are filed or are returned by SASE. Does not report back. Call for an appointment to show portfolio. Pays for design and illustration by the project, $600-5,000.

N ▣ DESIGN 2 MARKET

(formerly Yamaguma & Associates), 909 Weddell Ct., Sunnyvale CA 94089. (408)744-6671. Fax: (408)744-6686. E-mail: info@design2market.com. Website: www.design2market.com. **Production Manager:** Ray Long. Estab. 1980. Specializes in corporate identity, displays, direct mail, publication design, signage and marketing. Clients: high technology, government and business-to-business. Clients include Sun Microsystems, ASAT, BOPS, Hewlett Packard and Xporta. Client list available upon request.

Needs Approached by 6 freelancers/year. Works with 3 freelance illustrators and 2 designers/year. Works on assignment only. Uses illustrators mainly for 4-color, airbrush and technical work. Uses designers mainly for logos, layout and production. Also uses freelancers for brochure, catalog, ad, P-O-P and poster design and illustration; mechanicals; retouching; lettering; book, magazine, model-making; direct mail design; charts/graphs; and AV materials. Also for multimedia projects (Director SuperCard). Needs editorial and technical illustration. 100% of design and 75% of illustration demand knowledge of PageMaker, QuarkXPress, FreeHand, Illustrator, Model Shop, Strata, MMDir. or Photoshop.

First Contact & Terms Send postcard sample or query letter with brochure and tearsheets. Accepts disk submissions compatible with Illustrator, QuarkXPress, Photoshop and Strata. Samples are filed. Will contact artist for portfolio review if interested. Portfolio should include thumbnails, roughs, b&w and color photostats, tearsheets, photographs, slides and transparencies. Sometimes requests work on spec before assigning a job. Pays for design by the hour, $15-50. Pays for illustration by the project, $300-3,000. Rights purchased vary according to project. Finds artists through self-promotions.

Tips Would like to see more Macintosh-created illustrations.

N ERVIN/BELL ADVERTISING

16400 Pacific Coast Hwy., Suite 217, Huntington Beach CA 92649-1822. (562)592-3827. Fax: (562)592-4186. E-mail: mervin@ervinbell.com. Website: www.ervinbell.com. Estab. 1981. Specializes in annual reports, branding and brand management, corporate identity, retail, direct mail, package and publication design. Clients: corporations, malls, financial firms, industrial firms and software publishers. Current clients include First American Financial, Certus Corporation, Toyota Certified, Ropak Corporation. Client list available upon request.

Needs Approached by 100 freelancers/year. Works with 10 freelance illustrators and 6 designers/year. Works on assignment only. Uses illustrators mainly for package designs, annual reports. Uses designers mainly for annual reports, special projects. Also uses freelancers for brochure design and illustration, P-O-P and ad illustration, mechanicals, audiovisual materials, lettering and charts/graphs. Needs computer-literate freelancers for production. 100% of freelance work demands knowledge of QuarkXPress or Photoshop.

First Contact & Terms Send résumé and photocopies. Samples are filed and are not returned. Responds only if interested. Request portfolio review in original query. Portfolio should include color roughs, tearsheets and transparencies. Pays for design by the hour, $15-30; by the project (rate varies); by the day, $120-240. Pays for illustration by the project (rate varies). Buys all rights.

Tips Finds artists through sourcebooks, submitted résumés, mailings.

⬛ EVENSON DESIGN GROUP

4445 Overland Ave., Culver City CA 90230. (310)204-1995. Fax: (310)204-4879. E-mail: edgmail@evensondesign.com. Website: evensondesign.com. **Principal:** Stan Evenson. Estab. 1976. Specializes in annual reports, brand and corporate identity, display design, direct mail, package design and signage. Clients: ad agencies, hospitals, corporations, law firms, entertainment companies, record companies, publications, PR firms. Current clients include MGM, Pepsi Cola Company, Columbia Tri-Star, Sony Pictures Entertainment.

Needs Approached by 75-100 freelance artists/year. Works with 10 illustrators and 15 designers/year. Prefers artists with production experience as well as strong design capabilities. Works on assignment only. Uses illustrators mainly for covers for corporate brochures. Uses designers mainly for logo design, page layouts, all overflow work. Also for brochure, catalog, direct mail, ad, P-O-P and poster design and illustration, mechanicals, lettering, logos and charts/graphs. 100% of design work demands skills in QuarkXPress, FreeHand, Photoshop or Illustrator.

First Contact & Terms Send query letter with résumé and samples or send samples via e-mail. Responds only if interested. Portfolio should include b&w and color photostats and tearsheets and 4×5 or larger transparencies.

Tips "Be efficient in the execution of design work, producing quality designs over the quantity of designs. Professionalism, as well as a good sense of humor, will prove you to be a favorable addition to any design team."

⬛ FREEASSOCIATES

2800 28th St., Suite 305, Santa Monica CA 90405-2934. (310)399-2340. Fax: (310)399-4030. E-mail: jfreeman@freeassoc.com. Website: www.freeassoc.com. **President:** Josh Freeman. Estab. 1974. Number of employees: 4. Design firm. Specializes in marketing materials for corporate clients. Client list available upon request. Professional affiliations: AIGA.

Needs Approached by 50 illustrators and 30 designers/year. Works with 5 illustrators and 5 designers/year. Prefers freelancers with experience in top level design and advertising. Uses freelancers mainly for design, production, illustration. Also for airbrushing, brochure design and illustration, catalog design and illustration, lettering, logos, mechanicals, multimedia projects, posters, retouching, signage, storyboards, technical illustration and web page design. 30% of work is with print ads. 90% of design and 50% of illustration demand skills in Photoshop, InDesign CS, Illustrator.

First Contact & Terms Designers send query letter with photocopies, photographs, résumé, tearsheets and transparencies. Illustrators send postcard sample of work and/or photographs and tearsheets. Accepts Mac-compatible disk submissions to view in current version of major software or self-running presentations. CD-ROM OK. Samples are filed or returned by SASE. Will contact for portfolio review if interested. Pays for design and illustration by the project; negotiable. Rights purchased vary according to project. Finds artists through *LA Workbook, CA, Print, Graphis,* submissions and samples.

Tips "Designers should have their own computer and high speed Internet connection. Must have sensitivity to marketing requirements of projects they work on. Deadline commitments are critical."

DENNIS GILLASPY/BRANDON TAYLOR DESIGN

6498 Weathers Place, Suite 100, San Diego CA 92121-2752. (858)623-9084. Fax: (858)452-6970. E-mail: dennis@brandontaylor.com. Website: www.brandontaylor.com. **Owner:** Dennis Gillaspy. Co-Owner: Robert Hines. Estab. 1977. Specializes in corporate identity, displays, direct mail, package and publication design and signage. Clients: corporations and manufacturers. Client list available upon request.

Needs Approached by 20 freelance artists/year. Works with 15 freelance illustrators and 10 freelance designers/year. Prefers local artists. Works on assignment only. Uses freelance illustrators mainly for technical and instructional spots. Uses freelance designers mainly for logo design, books and ad layouts. Also uses freelance artists for brochure, catalog, ad, P-O-P and poster design and illustration, retouching, airbrushing, logos, direct mail design and charts/graphs.

First Contact & Terms Send query letter with brochure, résumé, photocopies and photostats. Samples are filed. Responds in 2 weeks. Write to schedule an appointment to show a portfolio or mail thumbnails, roughs, photostats, tearsheets, comps and printed samples. Pays for design by the assignment. Pays for illustration by the project, $400-1,500. Rights purchased vary according to project.

⬛ GRAPHIC DESIGN CONCEPTS

15329 Yukon Ave., El Camino Village CA 90260-2452. (310)978-8922. **President:** C. Weinstein. Estab. 1980. Specializes in package, publication and industrial design, annual reports, corporate identity, displays and direct mail. Current clients include Trust Financial Financial Services (marketing materials). Current projects include new product development for electronic, hardware, cosmetic, toy and novelty companies.

Needs Works with 15 illustrators and 25 designers/year. "Looking for highly creative idea people, all levels of experience." All styles considered. Uses illustrators mainly for commercial illustration. Uses designers mainly

for product and graphic design. Also uses freelancers for brochure, P-O-P, poster and catalog design and illustration; book, magazine, direct mail and newspaper design; mechanicals; retouching; airbrushing; model-making; charts/graphs; lettering; logos. Also for multimedia design, program and content development. 50% of freelance work demands knowledge of PageMaker, Illustrator, QuarkXPress, Photoshop or FreeHand.

First Contact & Terms Send query letter with brochure, résumé, tearsheets, photostats, photocopies, slides, photographs and/or transparencies. Accepts disk submissions compatible with Windows on the IBM. Samples are filed or are returned if accompanied by SASE. Responds in 10 days with SASE. Portfolio should include thumbnails, roughs, original/final art, final reproduction/product, tearsheets, transparencies and references from employers. Pays by the hour, $15-50. Considers complexity of project, client's budget, skill and experience of artist, how work will be used, turnaround time and rights purchased when establishing payment.

Tips "Send a résumé if available. Send samples of recent work or *high quality* copies. Everything sent to us should have a professional look. After all, it is the first impression we will have of you. Selling artwork is a business. Conduct yourself in a business-like manner."

▣ THE HITCHINS COMPANY

22756 Hartland St., Canoga Park CA 91307. (818)715-0150. Fax: (775)806-2687. E-mail: whitchins@socal.rr.com. **President:** W.E. Hitchins. Estab. 1985. Advertising agency. Full-service, multimedia firm.

Needs Works with 1-2 illustrators and 3-4 designers/year. Works on assignment only. Uses freelance artists for brochure and print ad design and illustration, storyboards, mechanicals, retouching, TV/film graphics, lettering and logo. Needs editorial and technical illustration and animation. 60% of work is with print ads. 90% of design and 50% of illustration demand knowledge of PageMaker, Illustrator, QuarkXPress or FreeHand.

First Contact & Terms Send postcard sample. Samples are filed if interested and are not returned. Responds only if interested. Call for appointment to show portfolio. Portfolio should include tearsheets. Pays for design and illustration by the project, according to project and client. Rights purchased vary according to project.

▣ IMPACT COMMUNICATIONS GROUP

18627 Brookhurst St., #4200, Fountain Valley CA 92708. Phone/fax: (714)963-0080. E-mail: info@impactgroup.com. Website: www.impactgroup.com. **Creative Director:** Brad Vinikow. Estab. 1983. Number of employees: 15. Marketing communications firm. Full-service, multimedia firm. Specializes in electronic media, business-to-business and print design. Current clients include Yamaha Corporation, Prudential, Isuzu. Professional affiliations: IICS, NCCC and ITVA.

Needs Approached by 12 freelancers/year. Works with 12 freelance illustrators and 12 designers/year. Uses freelancers mainly for illustration, design and computer production. Also for brochure and catalog design and illustration, multimedia and logos. 10% of work is with print ads. 90% of design and 50% of illustration demands knowledge of Photoshop, QuarkXPress, Illustrator and Macro Mind Director.

First Contact & Terms Designers send query letter with photocopies, photographs, résumé and tearsheets. Illustrators send postcard sample. Samples are filed and are not returned. Will contact artist for portfolio review if interested. Portfolio should include b&w and color final art, photographs, photostats, roughs, slides, tearsheets and thumbnails. Pays for design and illustration by the project, depending on budget. Rights purchased vary according to project. Finds artists through sourcebooks and self-promotion pieces received in mail.

Tips "Be flexible."

▣ LINEAR CYCLE PRODUCTIONS

P.O. Box 2608, San Fernando CA 91393-0608. **Producer:** Rich Brown. Production Manager: R. Borowy. Estab. 1980. Number of employees: 30. Approximate annual billing: $200,000. AV firm. Specializes in audiovisual sales and marketing programs and also in teleproduction for CATV. Current clients include Katz, Inc. and McDave and Associates.

Needs Works with 7-10 freelance illustrators and 7-10 designers/year. Prefers freelancers with experience in teleproductions (broadcast/CATV/non-broadcast). Works on assignment only. Uses freelancers for storyboards, animation, TV/film graphics, editorial illustration, lettering and logos. 10% of work is with print ads. 25% of freelance work demands knowledge of FreeHand, Photoshop or Tobis IV.

First Contact & Terms Send query letter with résumé, photocopies, photographs, slides, transparencies, video demo reel and SASE. Samples are filed or are returned by SASE if requested by artist. Responds only if interested. To show portfolio, mail audio/videotapes, photographs and slides; include color and b&w samples. Pays for design and illustration by the project, $100 minimum. Considers skill and experience of artist, how work will be used and rights purchased when establishing payment. Negotiates rights purchased. Finds artists through reviewing portfolios and published material.

Tips "We see a lot of sloppy work and samples, portfolios in fields not requested or wanted, poor photos, photocopies, graphics, etc. Make sure your materials are presentable."

JACK LUCEY/ART & DESIGN

84 Crestwood Dr., San Rafael CA 94901. (415)453-3172. **Contact:** Jack Lucey. Estab. 1960. Art agency. Specializes in annual reports, brand and corporate identity, publications, signage, technical illustration and illustrations/cover designs, courtroom art (trial drawing). Clients: businesses, ad agencies and book publishers. Current clients include U.S. Air Force, California Museum of Art & Industry, ABC-TV, CBS-TV,NBC-TV, CNN, Associated Press. Client list available upon request. Professional affiliations: Art Directors Club; Academy of Art Alumni, San Francisco, CA.

Needs Approached by 20 freelancers/year. Works with 1-2 freelance illustrators/year. Uses mostly local freelancers. Uses freelancers mainly for type and airbrush. Also for lettering for newspaper work.

First Contact & Terms Query. Prefers photostats and published work as samples. Provide brochures, business card and résumé to be kept on file. Portfolio review not required. Originals are not returned to artist at job's completion. Requests work on spec before assigning a job. Pays for design by the project.

Tips "Show variety in your work. Many samples I see are too specialized in one subject, one technique, one style (such as air brush only, pen & ink only, etc.). Subjects are often all similar too."

MARKETING BY DESIGN

2012 19th St., Suite 200, Sacramento CA 95818. (916)441-3050. **Creative Director:** Joel Stinghen. Estab. 1977. Specializes in corporate identity and brochure design, publications, direct mail, trade show, signage, display and packaging. Client: associations and corporations. Client list not available.

Needs Approached by 50 freelance artists/year. Works with 6-7 freelance illustrators and 1-3 freelance designers/year. Works on assignment only. Uses illustrators mainly for editorial. Also uses freelance artists for brochure and catalog design and illustration, mechanicals, retouching, lettering, ad design and charts/graphs.

First Contact & Terms Send query letter with brochure, résumé, tearsheets. Samples are filed or are not returned. Does not report back. Artist should follow up with call. Call for appointment to show portfolio of roughs, b&w photostats, color tearsheets, transparencies and photographs. Pays for design by the hour, $10-30; by the project, $50-5,000. Pays for illustration by the project, $50-4,500. Rights purchased vary according to project. Finds designers through word of mouth; illustrators through sourcebooks.

SUDI MCCOLLUM DESIGN

3244 Cornwall Dr., Glendale CA 91206. (818)243-1345. Fax: (818)243-1345. E-mail: sudimccollum@earthlink.net. **Contact:** Sudi McCollum. Specializes in product design and illustration. Majority of clients are medium- to large-size businesses. "No specialty in any one industry." Clients: home furnishing and giftware manufacturers, advertising agencies and graphic design studios.

Needs Use freelance production people—either on computer or with painting and product design skills. Potential to develop into full-time job.

First Contact & Terms Send query letter "with whatever you have that's convenient." Samples are filed. Responds only if interested.

N: NEALE-MAY & PARTNERS

409 Sherman Ave., Palo Alto CA 94306. (650)328-5555. Fax: (650)328-5016. E-mail: info@nealemay.com. Website: www.nealemay.com. **Senior Vice President:** Derek L. Kober. Estab. 1986. Number of employees: 50. Approximate annual billing: $8.5 million. PR firm. Specializes in promotions, packaging, corporate identity, collateral design, annuals, graphic and ad design. Product specialties are Internet, hi-tech, computer systems and peripherals, medical and consumer packaged goods. Clients include eDiets.com, Ernst & Young, Hyperion.

● This agency also has an office in New York at 144 E. 30th St., New York NY 10016.

Needs Approached by 20 freelance artists/month. Works with 2-3 freelance illustrators and 2-3 freelance designers/month. Prefers local artists only with experience in all areas of manual and Mac capabilities. Works on assignment only. Uses freelance artists mainly for brochure design and illustration, print ad illustration, mechanicals, retouching, posters, lettering, logos and cartoons. Needs editorial and technical illustration for cartoons and caricatures. Needs freelancers for design, illustration, production and presentation.

First Contact & Terms Send query letter with "best work samples in area you're best in." Samples are filed. Responds in 2 weeks. To show a portfolio, mail thumbnails, roughs and color slides. Pays for design by the hour. Negotiates rights purchased.

N: ON-Q PRODUCTIONS, INC.

618 E. Gutierrez St., Santa Barbara CA 93103. (805)963-1331. Fax: (805)963-1333. E-mail: vince@onqpro.com. Website: www.onqpro.com. **President:** Vincent Quaranta. AV firm. "We are producers of multi-projector slide presentations and websites. We produce computer-generated slides for business presentations and interactive touchscreen development." Clients: banks, ad agencies, R&D firms and hospitals.

Needs Works with 10 freelancers/year. Uses freelancers mainly for slide presentations. Also for editorial and

medical illustration, retouching, animation, web design and programming, and lettering. 75% of freelance work demands skills in QuarkXPress, FreeHand Photoshop or Aldus Persuasion.

First Contact & Terms Send query letter with brochure or résumé. Responds only if interested. Write for appointment to show portfolio of original/final art and slides. Pays for design and illustration by the hour, $25 minimum; or by the project, $100 minimum.

Tips "Artist must be *experienced* in computer graphics and on the board. The most common mistakes freelancers make are poor presentation of a portfolio (small pieces fall out, scratches on cover acetate) and they do not know how to price out a job. Know the rates you're going to charge and how quickly you can deliver a job. Client budgets are tight."

N. Y. POWERS DESIGN INTERNATIONAL

A Division of Creative Powers, Inc., 828 Production Place, Newport Beach CA 92663. (949)645-2265. Fax: (949)645-9947. E-mail: info@powersdesign.com. Website: www.powersdesign.com. **President:** Ron Powers. Estab. 1978. Specializes in corporate identity; displays; and landscape, interior, package and transportation design. Clients: large corporations. Current clients include Paccar Inc., McDonnell Douglas, Ford Motor Co. and GM. Client list available upon request.

Needs Works with varying number of freelance illustrators and 5-10 freelance designers/year. Prefers local artists only with experience in transportation design (such as those from Art Center College of Design), or with "SYD MEAD" type abilities. Works on assignment only. Uses freelance designers and illustrators for brochure, ad and catalog design, lettering, logos, model making and Alias Computer Cad-Cam 16 abilities.

First Contact & Terms Send query letter with résumé and appropriate samples. Samples are returned. Responds only if interested. Call to schedule an appointment to show a portfolio, which should include best work and references. Pays for design and illustration by the project.

N. ☐ Y. DEBORAH RODNEY CREATIVE SERVICES

1511 Pacific St., Santa Monica CA 90405. (310)477-2119. Fax: (310)477-2661. E-mail: deborah@tnlmarketing.com. Website: www.drcs.net. **Owner:** Deborah Rodney. Estab. 1975. Number of employees: 1. Specializes in advertising design and collateral. Current clients include Mattel, Disney, CBS, Long Beach Memorial Medical Center, California Casualty Insurance.

Needs Approached by 30 freelancers/year. Works with 6-10 freelance illustrators and 4-5 designers/year. Prefers local freelancers. Uses illustrators mainly for finished art and lettering. Uses designers mainly for logo design. Also uses freelancers for mechanicals, charts/graphs, ad design and illustration, Photoshop and web page design. Especially needs freelancers with Photoshop and digital imaging expertise. 100% of design demands knowledge of QuarkXPress, Illustrator 7.0 or Photoshop. Needs production help.

First Contact & Terms Designers send postcard sample or query letter with brochure, tearsheets and photocopies. Illustrators send postcard samples and tearsheets. Request portfolio review in original query. Portfolio should include final reproduction/product and tearsheets or "whatever best shows work." Accepts disk submissions compatible with Illustrator 7.0. Send EPS files. Pays for design by the hour, $25-50; by the project; by the day, $100 minimum. Pays for illustration by the project, $200-500; varies. Negotiates rights purchased. Considers buying second rights (reprint rights) to previously published work. Finds artists through sourcebooks and referrals.

Tips "I do more concept and design work inhouse and hire out production and comps because it is faster, cheaper that way. For illustrators, it helps to be in sourcebooks such as *Workbook, Black Book, Showcase,* etc." Advice to freelancers who want to get work in advertising/design: "Offer a free trial of your services or offer to intern at an ad agency or design firm. Decide who you want to work for and design a campaign to get yourself hired."

☑ ☐ SOFTMIRAGE

2900 Bristol St., Suite J103, Costa Mesa CA 92626. E-mail: contact@softmirage.com. Website: www.softmirage.com. **Design Director:** Steve Pollack. Estab. 1995. Number of employees: 12. Approximate annual billing: $2 million. Visual communications agency. Specializes in architecture, real estate and entertainment. Needs people with strong spatial design skills, modeling and ability to work with computer graphics. Current clients include Four Seasons Hotels, UCLA, Ford, Richard Meier & Partners and various architectural firms.

Needs Approached by 15 computer freelance illustrators and 5 designers/year. Works with 6 freelance 3D modelers, and 10 graphic designers/year. Prefers West coast designers with experience in architecture, engineering, technology. Uses freelancers mainly for concept, work in process computer modeling. Also for animation, brochure design, mechanicals, multimedia projects, retouching, technical illustration, TV/film graphics. 50% of work is renderings. 100% of design and 30% of illustration demand skills in Photoshop, 3-D Studio Max, SoftImage, VRML, Flash and Director. Need Macromedia Flash developers.

First Contact & Terms Designers send e-mail query letter with samples. 3-D modelers send e-mail query letter with

photocopies or link to website. Accepts disk and video submissions. Samples are filed or returned by SASE. Will contact for portfolio review if interested. Pays for design by the hour, $15-85. Pays for modeling by the project, $100-2,500. Rights purchased vary according to project. Finds artists through Internet, AIGA and referrals.

Tips "Be innovative, push the creativity, understand the business rationale and accept technology. Check our website, as we do not use traditional illustrators, all our work is now digital. Send information electronically, making sure work is progressive and emphasizing types of projects you can assist with."

☑ SPLANE DESIGN ASSOCIATES

30634 Persimmon Lane, Valley Center CA 90282. (760)749-6018. E-mail: splane@pacificnet.net. Website: www. splanedesign.com. **President:** Robson Splane. Specializes in product design. Clients: small, medium and large companies. Current clients include Hanson Research, Accuride Corp., Hewlett Packard, Sunrise Corp. Client list available upon request.

Needs Approached by 25-30 freelancers/year. Works with 1-2 freelance illustrators and 6-12 designers/year. Works on assignment only. Uses illustrators mainly for logos, mailings to clients, renderings. Uses designers mainly for sourcing, drawings, prototyping, modeling. Also uses freelancers for brochure design and illustration, ad design, mechanicals, retouching, airbrushing, model making, lettering and logos. 75% of freelance work demands skills in FreeHand, Ashlar Vellum, Solidworks and Excel.

First Contact & Terms Send query letter with résumé and photocopies. Samples are filed or are returned. Responds only if interested. Will contact artist for portfolio review if interested. Portfolio should include color roughs, final art, photostats, slides and photographs. Pays for design and illustration by the hour, $7-25. Rights purchased vary according to project. Finds artists through submissions and contacts.

☑ JULIA TAM DESIGN

2216 Via La Brea, Palos Verdes CA 90274. (310)378-7583. Fax: (310)378-4589. E-mail: julia.tam@verizon.net. **Contact:** Julia Tam. Estab. 1986. Specializes in annual reports, corporate identity, brochures, promotional material, packaging and design. Clients: corporations. Current clients include Southern California Gas Co., *Los Angeles Times*, UCLA. Client list available upon request. Professional affiliations: AIGA.

- Julia Tam Design won numerous awards including American Graphic Design Award, Premier Print Award, *Creativity, American Corporate Identity* and work showcased in Rockport Madison Square Press and North-light graphic books.

Needs Approached by 10 freelancers/year. Works with 6-12 freelance illustrators and 2 designers/year. "We look for special styles." Works on assignment only. Uses illustrators mainly for brochures. Also uses freelancers for catalog and ad illustration; retouching; and lettering. 50-100% of freelance work demands knowledge of QuarkXPress, Illustrator or Photoshop.

First Contact & Terms Designers send query letter with brochure and résumé. Illustrators send query letter with résumé and tearsheets. Samples are filed. Responds only if interested. Artist should follow up. Portfolio should include b&w and color final art, tearsheets and transparencies. Pays for design by the hour, $10-20. Pays for illustration by the project. Negotiates rights purchased. Finds artists through *LA Workbook*.

THARP DID IT

50 University Ave., Loft 21, Los Gatos CA 95030. Website: www.TharpDidIt.com. **Art Director/Designer:** Mr. Tharp. Estab. 1975. Specializes in brand identity; corporate, non-corporate, and retail visual identity; packaging; and environmental graphic design. Clients: direct and through agencies. Current clients include Harmony Foods, Buckhorn Grill, Cinequest Film Festival, Steven Kent Winery. Professional affiliations: American Institute of Graphic Arts (AIGA), Society for Environmental Graphic Design (SEGD), Western Art Directors Club (WADC), TDCTJHTBIPC (The Design Conference That Just Happens To Be In Park City).

- Tharp Did It won a gold medal in the International Packaging Competition at the 30th Vinitaly in Verona, Italy, for wine label design. Their posters for BRIO Toys are in the Smithsonian Institution's National Design Museum archives.

Needs Approached by 150-300 freelancers/year. Works with 3-5 freelance illustrators each year.

First Contact & Terms Send query letter with printed promotional material. Samples are filed or are returned by SASE. Will contact artist for portfolio review if interested. "No phone calls please. We'll call you." Pays for illustration by the project, $100-10,000. Considers client's budget and how work will be used when establishing payment. Rights purchased vary according to project. Finds artists through awards annuals, sourcebooks, and submissions/self-promotions.

☒ TRIBOTTI DESIGNS

22907 Bluebird Dr., Calabasas CA 91302-1832. (818)591-7720. Fax: (818)591-7910. E-mail: bob4149@aol.com. Website: www.tribotti.com. **Contact:** Robert Tribotti. Estab. 1970. Number of employees: 2. Approximate an-

nual billing: $200,000. Specializes in graphic design, annual reports, corporate identity, packaging, publications and signage. Clients: PR firms, ad agencies, educational institutions and corporations.

Needs Approached by 8-10 freelancers/year. Works with 2-3 freelance illustrators and 1-2 designers/year. Prefers local freelancers only. Works on assignment only. Uses freelancers mainly for brochure illustration. Also for catalogs, charts/graphs, lettering and ads. Prefers computer illustration. 100% of freelance design and 50% of illustration demand knowledge of PageMaker, Illustrator, QuarkXPress, Photoshop, FreeHand. Needs illustration for annual reports/brochures.

First Contact & Terms Send postcard sample or query letter with brochure, photocopies and résumé. Accepts submissions on disk compatible with PageMaker 6.5, Illustrator or Photoshop. Send EPS files. Will contact artist for portfolio review if interested. Portfolio should include thumbnails, roughs, original/final art, final reproduction/product and b&w and color tearsheets, photostats and photographs. Pays for design by the hour, $50-75. Pays for illustration by the project, $100-1,000. Rights purchased vary according to project. Finds artists through word of mouth and self-promotion mailings.

Tips ''We will consider experienced artists only. Must be able to meet deadlines. Send printed samples. We look for talent and a willingness to do a very good job.''

THE VAN NOY GROUP

3315 Westside Rd., Healdsburg CA 95448-9453. (707)433-3944. Fax: (707)433-0375. E-mail: jim@vannoygroup.com. Website: www.vannoygroup.com. **Vice President:** Ann Van Noy. Estab. 1972. Specializes in brand and corporate identity, displays and package design. Clients: corporations. Current clients include Waterford, Wedgewood USA, Leiner Health Products, Pentel of America. Client list available upon request.

Needs Approached by 1-10 freelance artists/year. Works with 2 illustrators and 3 designers/year. Prefers artists with experience in Macintosh design. Works on assignment only. Uses freelancers for packaging design and illustration, Quark and Photoshop production and lettering.

First Contact & Terms Send query letter with résumé and photographs. Samples are filed. Will contact artist for portfolio review if interested. If no reply, artist should follow up. Pays for design by the hour, $35-100. Pays for illustration by the hour or by the project at a TBD fee. Finds artists through sourcebooks, self-promotions and primarily agents. Also have permanent positions available.

Tips ''I think more and more clients will be setting up internal art departments and relying less and less on outside designers and talent. The computer has made design accessible to the user who is not design-trained.''

Ⓝ VIDEO RESOURCES

1809 E. Dyer Road, #307, Santa Ana CA 92705. (949)261-7266. Fax: (949)261-5908. E-mail: brad@videoresouces.com. **Producer:** Brad Hagen. Number of employees: 10. Video and multimedia firm. Specializes in automotive, banks, restaurants, computer, health care, transportation and energy.

Needs Approached by 10-20 freelancers/year. Works with 5-10 freelance illustrators and 5-10 designers/year. Works on assignment only. Uses freelancers for graphics, multimedia, animation, etc.

First Contact & Terms Send query letter with brochure showing art style or résumé, business card, photostats and tearsheets to be kept on file. Samples not filed are returned by SASE. Considers complexity of the project and client's budget when establishing payment. Buys all rights.

▣ VISUAL AID/VISAID MARKETING

Box 4502, Inglewood CA 90309. (310)399-0696. **Manager:** Lee Clapp. Estab. 1961. Number of employees: 3. Distributor of promotion aids, marketing consultant service, ''involved in all phases.'' Specializes in manufacturers, distributors, publishers and graphics firms (printing and promotion) in 23 SIC code areas.

Needs Approached by 25-50 freelancers/year. Works with 1-2 freelance illustrators and 6-12 designers/year. Prefers freelancers with experience in animation, film/video production, multimedia. Uses freelancers for animation, billboards, brochure illustration, catalog design and illustration, direct mail, logos, posters, signage.

First Contact & Terms Works on assignment only. Send postcard sample or query letter with brochure, photostats, duplicate photographs, photocopies and tearsheets to be kept on file. Responds if interested and has assignment. Write for appointment to show portfolio. Negotiates payment. $100-500. Considers skill and experience of artist and turnaround time when establishing payment.

Tips ''Do not say 'I can do anything.' We want to know the best media you work in (pen & ink, line drawing, illustration, layout, etc.).''

LOS ANGELES

⊞ BRAMSON + ASSOCIATES

7400 Beverly Blvd., Los Angeles CA 90036. (323)938-3595. Fax: (323)938-0852. E-mail: gbramson@aol.com. **Principal/Senior Creative Director:** Gene Bramson. Estab. 1970. Number of employees: 15. Approximate

annual billing: more than $2 million. Advertising agency. Specializes in magazine ads, collateral, ID, signage, graphic design, imaging, campaigns. Product specialties are healthcare, consumer, business to business. Current clients include Johnson & Johnson, Chiron Vision, Lawry's and Isuzu Motors of America.

Needs Approached by 150 freelancers/year. Works with 10 freelance illustrators, 2 animators and 5 designers/year. Prefers local freelancers. Works on assignment only. Uses freelancers for brochure and print ad design; brochure, technical, medical and print ad illustration, storyboards, mechanicals, retouching, lettering, logos. 30% of work is with print ads. 50% of freelance work "prefers" knowledge of Pagemaker, Illustrator, QuarkXPress, Photoshop, Freehand or 3-D Studio.

First Contact & Terms Send query letter with brochure, photocopies, résumé, photographs, tearsheets, SASE. Samples are filed. Will contact artist for portfolio review if interested. Portfolio should include roughs, color tearsheets. Sometimes requests work on spec before assigning job. Pays for design by the hour, $15-25. Pays for illustration by the project, $250-2,000. Buys all rights or negotiates rights purchased. Finds artists through sourcebooks.

Tips Looks for "very unique talent only." Price and availability are also important.

ⓝ FOOTE, CONE & BELDING

17600 Gillette Ave., Irvine CA 92614. (949)851-3050. Fax: (949)567-9465. Website: www.fcb.com. **Art Buyer:** Connie Mangam. Estab. 1950. Ad agency. Full-service, multimedia firm. Product specialties are package goods, toys, entertainment and retail.

- This is the Southern California office of FCB, a global agency with offices all over the world. FCB is one of the top 3 agencies in the United States, with 188 offices in 102 countries. Main offices are in New York. Other offices are located in Chicago and San Francisco.

Needs Approached by 15-20 freelance artists/month. Works with 3-4 freelance illustrators and 2-3 freelance designers/month. Prefers local artists only with experience in design and sales promotion. Designers must be able to work in-house and have Mac experience. Uses freelance artists for brochure, catalog and print ad design and illustration, storyboards, mechanicals, retouching, lettering, logos and computer (Mac). 30% of work is with print ads.

First Contact & Terms Designers send query letter with résumé, photocopies and tearsheets. Illustrators send postcard, color photocopies, tearsheets or other nonreturnable samples. Samples are filed. Responds only if interested. Write to schedule an appointment to show a portfolio. Portfolio should include roughs and color. Pays for design based on estimate on project from concept to mechanical supervision. Pays for illustration per project. Rights purchased vary according to project.

▣ RHYTHMS PRODUCTIONS

P.O. Box 34485, Los Angeles CA 90034. (310)836-4678. **President:** Ruth White. Estab. 1955. AV firm. Specializes in music production/publication. Product specialty is educational materials for children.

Needs Works with 2 freelance illustrators and 2 designers/year. Prefers artists with experience in cartoon animation and graphic design. Works on assignment only. Uses freelancers mainly for cassette covers, books, character design. Also for catalog design, multimedia, animation and album covers. 2% of work is with print ads. 75% of design and 50% of illustration demands graphic design computer skills.

First Contact & Terms Send query letter with photocopies and SASE (if you want material returned). Samples are returned by SASE if requested. Responds in 2 months only if interested. Will contact artist for portfolio review if interested. Pays for design and illustration by the project. Buys all rights. Finds artists through word of mouth and submissions.

SAN FRANCISCO

▣ THE AD AGENCY

P.O. Box 470572, San Francisco CA 94147. **Creative Director:** Michael Carden. Estab. 1972. Ad agency. Full-service multimedia firm. Specializes in print, collateral, magazine ads. Client list available upon request.

Needs Approached by 120 freelancers/year. Works with 120 freelance illustrators and designers/year. Uses freelancers mainly for collateral, magazine ads, print ads. Also for brochure, catalog and print ad design and illustration, mechanicals, billboards, posters, TV/film graphics, multimedia, lettering and logos. 60% of freelance work is with print ads. 50% of freelance design and 45% of illustration demand computer skills.

First Contact & Terms Send query letter with brochure, photocopies and SASE. Samples are filed or returned by SASE. Responds in 1 month. Portfolio should include color final art, photostats and photographs. Buys first rights or negotiates rights purchased. Finds artists through word of mouth, referrals and submissions.

Tips "We are an eclectic agency with a variety of artistic needs."

N HOWRY DESIGN ASSOCIATES

354 Pine St., Suite 600, San Francisco CA 94104. (415)433-2035. Fax: (415)433-0816. E-mail: info@howry.com. Website: www.howry.com. **Principal/Creative Director:** Jill Howry. Estab. 1988. Full service design studio. Number of employees: 12. Specializes in annual reports, corporate identity, print, advertising and multimedia. Clients: startups to Fortune 100 companies. Current clients include Del Monte, Affymetrix, Geron Corporation, McKesson Inc., First Republic Bank, View our website for current information and portfolio viewing. Professional affiliations: AIGA.

Needs Works with 30 freelance illustrators, photographers and web and print designers/year. Works on assignment only. Uses illustrators for "anything that applies." Uses designers mainly for newsletters, brochures, corporate identity. Also uses freelancers for production, programming, retouching, photography/illustration, logos and charts/graphs. 100% of design work, 10% of illustration work demands knowledge of QuarkXPress, Illustrator or Photoshop.

First Contact & Terms Samples are filed. Responds only if interested. Portfolios may be dropped off every Thursday. Pays for design/production by the hour, or by the job, $25-60. Pays for photography and illustration on a per-job basis. Rights purchased vary according to project.

Tips Finds artists through sourcebooks, samples, representatives.

N I PACE DESIGN GROUP

379 Day St., San Francisco CA 94131. (415)931-3400. Fax: (415)931-3484. E-mail: info@pacedesign.com. Website: www.pacedesign.com. **Creative Director:** Joel Blum. Estab. 1988. Number of employees: 6. Approximate annual billing: $1.2 million. Specializes in branding, advertising and collateral. Product specialties are financial services, high tech, Internat and computer industries. Current clients include: E*Trade Securities, Providian Financial Corp., Charles Schwab & Co., Inc., Montgomery Asset Management, LoanCity.com, 401k Forum, Van Wagoner Capital Management, Bank of America, Aldon Computer Group, Informix, Bio-Rad Laboratories, Interex and Sybex. Client list available upon request. Professional affiliations: AIP (Artists in Print).

Needs Approached by 100 illustrators and 75 designers/year. Works with 3-5 illustrators and 3-5 designers/year. Prefers local designers with experience in QuarkXPress and Photoshop. Uses freelancers mainly for illustration and graphics. Also for brochure design and illustration, logos, technical illustration and web page design. 2% of work is with print ads. 100% of design and 85% of illustration demand skills in the latest versions of Photoshop, Illustrator and QuarkXPress.

First Contact & Terms Designers send query letter with photocopies and résumé. Illustrators send query letter with photocopies, tearsheets, follow-up postcard samples every 6 months. Accepts disk submissions. Submit latest version software, System 7.5, EPS files. Samples are filed and are not returned. Will contact for portfolio review of color final art and printed pieces if interested. Pays for design by the hour, $25-35. Pays for illustration by the project. Rights purchased vary according to project. Finds artists through sourcebooks, word of mouth, submissions.

N ROY RITOLA, INC.

100 Ebbtide, Suite 520, Sausalito CA 94965. (415)332-8611. Fax: (415)332-8607. E-mail: info@royritolainc.com. Website: www.royritolainc.com. **President:** Roy Ritola. Specializes in brand and corporate identity, displays, direct mail, packaging, signage. Clients: manufacturers.

Needs Works with 6-10 freelancers/year. Uses freelancers for design, illustration, airbrushing, model-making, lettering and logos.

First Contact & Terms Send query letter with brochure showing art style or résumé, tearsheets, slides and photographs. Samples not filed are returned only if requested. Responds only if interested. To show portfolio, mail final reproduction/product. Pays for design by the hour, $25-100. Considers complexity of project, client's budget, skill and experience of artist, turnaround time and rights purchased when establishing payment.

TOKYO DESIGN CENTER

703 Market St., Suite 252, San Francisco CA 94103. (415)543-4886. **Creative Director:** Kaoru Matsuda. Specializes in annual reports, brand identity, corporate identity, packaging and publications. Clients: consumer products, travel agencies and retailers.

Needs Uses artists for design and editorial illustration.

First Contact & Terms Send business card, slides, tearsheets and printed material to be kept on file. Samples not kept on file are returned by SASE only if requested. Will contact artist for portfolio review if interested. Pays for design and illustration by the project, $100-1,500 average. Sometimes requests work on spec before assigning job. Considers client's budget, skill and experience of artist, turnaround time and rights purchased when establishing payment. Interested in buying second rights (reprint rights) to previously published work. Finds artists through self-promotions and sourcebooks.

Advertising & Design

COLORADO

☑ ▣ ⚡ BARNSTORM VISUAL COMMUNICATIONS, INC.

530 E. Colorado Ave., Colorado Springs CO 80903. (719)630-7200. Fax: (719)630-3280. Website: www.barnstor mcreative.biz. **Owner:** Becky Houston. Estab. 1975. Specializes in corporate identity, brochure design, publications, web design and Internet marketing. Clients: high-tech corporations, nonprofit fundraising, business-to-business and restaurants. Current clients include Liberty Wire and Cable, Colorado Springs Visitors Bureau and Billiard Congress of America.

Needs Works with 2-4 freelance artists/year. Prefers local, experienced (clean, fast and accurate) artists with experience in TV/film graphics and multimedia. Works on assignment only. Uses freelancers mainly for editorial and technical illustration and production. Needs computer-literate freelancers for production. 90% of freelance work demands knowledge of Illustrator, QuarkXPress, Photoshop, Macromedia FreeHand, InDesign and Flash.

First Contact & Terms Send query letter with résumé and samples to be kept on file. Prefers "good originals or reproductions, professionally presented in any form" as samples. Samples not filed are returned by SASE. Responds only if interested. Call or write for appointment to show portfolio. Pays for design by the hour/$15-40. Pays for illustration by the project, $500 minimum for b&w. Considers client's budget, skill and experience of artist, and turnaround time when establishing payment.

Tips "Portfolios should reflect an awareness of current trends. We try to handle as much inhouse as we can, but we recognize our own limitations (particularly in illustration). Do not include too many samples in your portfolio."

Ⓝ CINE DESIGN FILMS

Box 6495, Denver CO 80206. (303)777-4222. E-mail: jghusband@aol.com. Website: www.cinedesignfilms.com. **Producer/Director:** Jon Husband. AV firm. Clients: automotive companies, banks, restaurants, etc.

Needs Works with 3-7 freelancers/year. Works on assignment only. Uses freelancers for layout, titles, animation and still photography. Clear concept ideas that relate to the client in question are important.

First Contact & Terms Send query letter to be kept on file. Responds only if interested. Write for appointment to show portfolio. Pays by the project. Considers complexity of project, client's budget and rights purchased when establishing payment. Rights purchased vary according to project.

Ⓝ ⚡ PAGEWORKS COMMUNICATION DESIGN, INC.

Two Tamarac Plaza, 7535 E. Hampden Ave., Suite 350, Denver CO 80231. (303)337-7770. Fax: (303)337-7780. E-mail: info@pageworksthebigidea.com. Website: www.pageworksthebigidea.com. **CEO/Creative Director:** Michael Guzofsky. Art Director: Marcie Fischer. Estab. 1981. Specializes in annual reports, corporate identity, direct mail, product development and packaging and publication design. Clients: corporations, associations. Clients include Cherry Creek Country Club, Tetra Tech Wired Communication Group, Miller Global Properties, Loup Development Company, Liteye MicroDisplay Systems.

Needs Approached by 50 freelance artists/year. Works with 5 illustrators and 5 designers/year. Prefers local artists with computer experience. Works on assignment only. Uses freelance designers and illustrators for brochure, catalog, magazine, direct mail and ad design; brochure, catalog and ad illustration; logos; and charts/graphs. Needs computer-literate freelancers for design, illustration and production. 90% of freelance work demands knowledge of QuarkXPress, Illustrator or Photoshop.

First Contact & Terms Send query letter with brochure, résumé, tearsheets and photocopies. Samples are filed and are not returned. Responds only if interested. Write for appointment to show portfolio or mail appropriate materials. Portfolio should include thumbnails, roughs, b&w and color tearsheets, printed samples. Pays for design and illustration by the hour, $20-50 or by the project. Negotiates rights purchased.

CONNECTICUT

Ⓝ BRANDLOGIC

(formerly JMK Corp.), 15 River Rd., Suite 310, Wilton CT 06897. (203)834-0087. Website: www.brandlogic.com. **Creative Director:** Karen Lukas-Hardy. Specializes in annual reports, corporate brand identity, website design, and publications. Clients: IBM, GE, Texaco, Avon Products, Pepsi Cola.

Needs Works with 30 artists/year. Works on assignment only. Uses artists for editorial illustration. Needs computer-literate freelancers for illustration. 30% of freelance work demands knowledge of Illustrator.

First Contact & Terms "*No* phone calls!" Send query letter with tearsheets, slides, photostats or photocopies. Samples not kept on file are returned by SASE only. Responds only if interested. Pays for illustration by the project $300-3,500 average. Considers client's budget, skill and experience of artist and how work will be used when establishing payment.

FORDESIGN GROUP

87 Dayton Rd., Redding CT 06896. (203)938-0008. Fax: (203)938-3326. E-mail: steven@fordesign.net. Website: www.fordesign.net. **Principal:** Steve Ford. Estab. 1990. Specializes in brand and corporate identity, package and website design. Clients: corporations. Current clients include Sony, IBM, Cadbury Beverage, Carrs, MasterCard. Professional affiliations: AIGA, PDC.

Needs Approached by 100 freelancers/year. Works with 6-10 freelance illustrators and 4-6 designers/year. Uses illustrators mainly for brochures, ads. Uses designers mainly for corporate identity, packaging, collateral. Also uses freelancers for ad and brochure design and illustration, logos. Needs bright, conceptual designers and illustrators. 90% of freelance work demands skills in Illustrator, Photoshop, FreeHand and Dreamweaver.

First Contact & Terms Send postcard sample of work or send photostats, slides and transparencies. Samples are filed or returned by SASE if requested by artist. Will contact artist for portfolio review if interested. Portfolio should include b&w and color samples. Pays for design by the hour or by the project. Pays for illustration by the project.

Tips "We are sent all *Showcase, Workbook*, etc." Impressed by "great work, simply presented." Advises freelancers entering the field to save money on promotional materials by partnering with printers. Create a joint project or tie-in. "Send out samples—good luck!"

🖹 FREEMAN DESIGN GROUP

3 Stoneleigh Knls, Old Lyme CT 06371-1432. (860)434-2474. **President:** Bill Freeman. Estab. 1972. Specializes in annual reports, corporate identity, package and publication design and signage. Clients: corporations. Current projects include company magazines. Current clients include Pitney Bowes, Continental Grain Co., IBM Credit, CB Commercial Real Estate. Client list available upon request.

Needs Approached by 35 artists/year. Works with 5 illustrators and 5 designers/year. Prefers artists with experience in production. Works on assignment only. Uses illustrators for mechanicals, retouching and charts/graphs. Looking for technical illustration and editorial illustration with "montage, minimal statement."

First Contact & Terms Send query letter with promotional piece showing art style, résumé and tearsheets. Samples are filed or are returned if accompanied by SASE. Does not report back. Call for appointment to show portfolio or mail appropriate materials and tearsheets. Pays for design by the hour, $25 minimum; by the project, $150-3,000.

🖹 🗓 MACEY NOYES ASSOCIATES, INC.

232 Danbury Rd., Wilton CT 06897. (203)762-9002. Fax: (203)762-2629. E-mail: information@maceynoyes.com. Website: www.maceynoyes.com. **Designer:** Jason Arena. Structural Design Director: Tod Dawson. Estab. 1979. Specializes in corporate and brand identity systems, graphic and structural packaging design, retail merchandising systems, naming and nomenclature systems, Internet and digital media design. Clients: corporations (marketing managers, product managers). Current clients include Duracell, Norelco, Motorola, Remington, Pitney Bowes, Altec Lansing, Philips, Iomega Corp. Majority of clients are retail suppliers of consumer goods.

Needs Approached by 25 artists/year. Works with 2-3 illustrators and 5 designers/year. Prefers local and international artists with experience in package comps, Macintosh and type design. Uses technical and product illustrators mainly for ad slick, in-use technical and front panel product. Uses designers for conceptual layouts and product design. Also uses freelancers for mechanicals, retouching, airbrushing, lettering, logos and industrial/structural design. Needs computer-literate freelancers for design, illustration and production. 40% of freelance work demands knowledge of QuarkXPress, Illustrator, Photoshop, Director, Flash and Shockwave.

First Contact & Terms Send query letter with résumé. Samples are filed or are returned by SASE if requested by artist. Responds only if interested. Will contact artist for portfolio review if interested. Portfolio should include thumbnails, roughs and transparencies. Pays for design by the hour, $25-50. Pays for illustration by the project, $100-2,500. Rights purchased vary according to project. Finds new artists through sourcebooks and agents.

▣ MCKENZIE HUBBELL CREATIVE SERVICES

5 Iris Lane, Westport CT 06880. (203)454-2443. Fax: (203)222-8462. E-mail: dmckenzie@mckenziehubbell.com or nhubbell@mckenziehubbell.com. Website: www.mckenziehubbell.com. **Principal:** Dona McKenzie. Specializes in business to business communications, annual reports, corporate identity, direct mail and publication design. Expanded services include: copywriting and editing, advertising and direct mail, marketing and public relations, website design and development, and multimedia and CD-ROM.

Needs Approached by 100 freelance artists/year. Works with 5 freelance designers/year. Uses freelance designers mainly for computer design. Also uses freelance artists for brochure and catalog design. 100% of design and 50% of illustration demand knowledge of QuarkXPress 4.0, Illustrator 8.0 and Photoshop 5.5.

First Contact & Terms Send query letter with brochure, résumé, photographs and photocopies. Samples are filed or are returned by SASE if requested by artist. Write to schedule an appointment to show a portfolio. Pays for design by the hour, $25-75. Pays for illustration by the project, $150-3,000. Rights purchased vary according to project.

◼ ULTITECH, INC.

Foot of Broad St., Stratford CT 06615. (203)375-7300. Fax: (203)375-6699. E-mail: comcowic@meds.com. Website: www.meds.com. **President:** W.J. Comcowich. Estab. 1993. Number of employees: 3. Approximate annual billing: $1 million. Integrated marketing communications agency. Specializes in interactive multimedia, software, online services. Product specialties are medicine, science, technology. Current clients include GlaxoSmith-Kline, Pharmacia, Baxter.

Needs Approached by 10-20 freelance illustrators and 10-20 designers/year. Works with 2-3 freelance illustrators and 6-10 designers/year. Prefers freelancers with experience in interactive media design and online design. Uses freelancers mainly for interactive media—online design (WWW). Also for animation, brochure and web page design, medical illustration, multimedia projects, TV/film graphics. 10% of work is with print ads. 100% of freelance design demands skills in Photoshop, QuarkXPress, Illustrator, 3D packages.

First Contact & Terms Designers send query letter with résumé. Illustrators send postcard sample and/or query letter with photocopies, résumé, tearsheets. Prefers e-mail submission. Samples are filed. Responds only if interested. Request portfolio review in original query. Pays for design by the project or by the day. Pays for illustration by the project. Buys all rights. Finds artists through sourcebooks, word of mouth.

Tips "Learn design principles for interactive media."

DELAWARE

ALOYSIUS BUTLER & CLARK (AB&C)

819 N. Washington St., Wilmington DE 19801. (302)655-1552. Fax: (302)655-3105. Website: www.a-b-c.com. **Contact:** Tom Desanto. Ad agency. Clients: healthcare, banks, industry, restaurants, hotels, businesses, government offices.

Needs Works with 12 or more illustrators and 3-4 designers/year. Uses artists for trade magazines, billboards, direct mail packages, brochures, newspapers, stationery, signage and posters. 95% of design and 15% of illustration demand skills in QuarkXPress, Illustrator or Photoshop.

First Contact & Terms Designers send query letter with résumé and photocopies. Illustrators send postcard samples. Samples are filed; except work that is returned only if requested. Responds only if interested. Works on assignment only. Pays for design by the hour, $20-50. Pays for illustration by the hour; or by the project, $250-1,000.

CUSTOM CRAFT STUDIO

310 Edgewood St., Bridgeville DE 19933. (302)337-3347. Fax: (302)337-3444. **Vice President:** Eleanor H. Bennett. AV producer.

Needs Works with 12 freelance illustrators and 12 designers/year. Works on assignment only. Uses freelancers mainly for work on filmstrips, slide sets, trade magazines and newspapers. Also for print finishing, color negative retouching and airbrush work. Prefers pen & ink, airbrush, watercolor and calligraphy. 10% of freelance work demands knowledge of Illustrator. Needs editorial and technical illustration.

First Contact & Terms Send query letter with résumé, slides or photographs, brochure/flyer and tearsheets to be kept on file. Samples returned by SASE. Responds in 2 weeks. Originals not returned. Pays by the project, $25 minimum.

▣ GLYPHIX ADVERTISING

105 Second St., Lewes DE 19958. (302)645-0706. Fax: (302)645-2726. E-mail: rjundt@shore.intercom.net. Website: www.glyphixadv.com. **Creative Director:** Richard Jundt. Estab. 1981. Number of employees: 2. Approximate annual billing: $200,000. Ad agency. Specializes in collateral and advertising. Current clients include local colleges, ATR Galleries locally and New York City and Cytec Industries. Client list available upon request.

Needs Approached by 10-20 freelancers/year. Works with 2-3 freelance illustrators and 2-3 designers/year. Prefers local artists only. Uses freelancers mainly for "work I can't do." Also for brochure and catalog design and illustration and logos. 20% of work is with print ads. 100% of freelance work demands knowledge of Photoshop, QuarkXPress, Illustrator and Delta Graph.

First Contact & Terms Send query letter with samples. Responds in 10 days if interested. Artist should follow-up with call. Portfolio should include b&w and color final art, photographs and roughs. Buys all rights. Finds artists through word of mouth and submissions.

WASHINGTON DC

▣ ▣ ARNOLD & ASSOCIATES

1834 Jefferson Pl. N.W., Washington DC 20036. (703)837-8850. Fax: (703)838-3626. Website: www.arnold.tv. **President:** John Arnold. AV/video firm. Clients include United Airlines, Colt 45, Amtrak, US Postal Service, Edison Electric Institute, Nescafé.

Needs Works with 30 artists/year. Prefers local artists, award-winning and experienced. "We're an established, national firm." Works on assignment only. Uses freelancers for multimedia, slide show and staging production.
First Contact & Terms Send query letter with brochure, tearsheets, slides and photographs to be kept on file. Call for appointment to show portfolio, which should include final reproduction/product and color photographs. Pays for design by the hour, $50-100 or by the project, $500-3,500. Pays for illustration by the project, $500-4,000. Considers complexity of the project, client's budget and skill and experience of artist when establishing payment.

▣ LOMANGINO STUDIO INC.

1042 Wisconsin Ave., Washington DC 20007. (202)338-4110. Fax: (202)338-4111. Website: www.lomangino.c om. **President:** Donna Lomangino. Estab. 1987. Number of employees: 6. Specializes in annual reports, corporate identity, website and publication design. Clients: corporations, nonprofit organizations. Client list available upon request. Professional affiliations: AIGA Washington DC.
Needs Approached by 25-50 freelancers/year. Works with 1 freelance illustrator/year. Uses illustrators and production designers occasionally for publication. Also for multimedia projects. Accepts disk submissions, but not preferable. 99% of design work demands skills in Illustrator, Photoshop and QuarkXPress.
First Contact & Terms Send postcard sample of work or URL. Samples are filed. Will contact artist for portfolio review if interested. Pays for design and illustration by the project. Finds artists through sourcebooks, word of mouth and studio files.
Tips "Please don't call. Send samples or URL for consideration."

DON SCHAAF & FRIENDS, INC.

1640 Wisconsin Ave., NW, Washington DC 20007. (202)965-2600. Fax: (202)965-2669. E-mail: donschaaf@aol. com. **Senior Designer:** Heide Paddock. Estab. 1990. Number of employees: 10. Approximate annual billing: $4.2 million. Design firm. Specializes in ads, brochures and print campaigns. Product specialty is high tech communication. Current clients include AOL; MCI; Polycom; Legi-Slate. Client list available upon request. Professional affiliations: AIGA; Art Directors Club of Metropolitan Washington DC. Listed #265 on Inc. 500 list of fastest growing private companies.
Needs Approached by 50 illustrators and 25 designers/year. Works with 20 illustrators/year. Also for brochure illustration, multimedia projects, TV/film graphics and web page design. 37% of work is with print ads. 90% of illustration demands skills in Photoshop, Illustrator and QuarkXPress.
First Contact & Terms Send postcard sample or query letter with follow-up postcard every 3 months. Samples are filed. Responds only if interested. Portfolios of photographs may be dropped every Thursday and Friday. Pays for illustration by the project, $250-5,000. Rights purchased vary according to project. Finds artists through sourcebooks and word of mouth.

FLORIDA

Ⓝ AURELIO & FRIENDS, INC.

14971 SW 43 Terrace, Miami FL 33185. (305)225-2434. Fax: (305)225-2121. E-mail: aurelio97@aol.com. **President:** Aurelio Sica. Vice President: Nancy Sica. Estab. 1973. Number of employees: 3. Specializes in corporate advertising and graphic design. Clients: corporations, retailers, large companies, hotels and resorts.
Needs Approached by 4-5 freelancers/year. Works with 1-2 freelance illustrators and 3-5 designers/year. Also uses freelancers for ad design and illustration, brochure, catalog and direct mail design, and mechanicals. 50% of freelance work demands knowledge of Adobe Ilustrator, Photoshop and QuarkXPress.
First Contact & Terms Send brochure and tearsheets. Samples are filed. Will contact artist for portfolio review if interested. Portfolio should include b&w and color final art, photographs, roughs and transparencies. Pays for design and illustration by the project. Buys all rights.

Ⓝ ▣ BROMLEY COMMUNICATIONS

1799 Coral Way, Suite 510, Miami FL 33145. (305)442-1586. Fax: (305)442-2598. E-mail: orlando.sosa@publi cis-sanlev.com. **Creative Director:** Orlando Sosa. Number of employees: 80. Approximate annual billing: $80 million. Estab. 1986. Full-service, multimedia ad agency and PR firm. Specializes in TV, radio and magazine ads, etc. Specializes in consumer service firms and Hispanic markets. Current clients include BellSouth Telecommunications, Metro-Dade, Coca-Cola, The House of Seagram, Procter & Gamble, BMW, Nestle.
 ● In February 2004 the Miami agency Publicis Sanchez & Levitan merged with Texas' Bromley Communications, becoming the top Hispanic advertising agency in the U.S.
Needs Approached by 1 artist/month. Prefers local artists only. Works on assignment only. Uses freelancers for storyboards, slide illustration, new business presentations and TV/film graphics and logos. 35% of work is

with print ads. 25% of freelance work demands knowledge of PageMaker, QuarkXPress and Illustrator.
First Contact & Terms Send query letter with brochure and résumé. Samples are not filed and are returned by SASE only if requested by artist. Responds only if interested. Write for appointment to show portfolio.

🔲 GOLD & ASSOCIATES INC.
6000-C Sawgrass Village Circle, Ponte Vedra Beach FL 32082. (904)285-5669. Fax: (904)285-1579. **Creative Director/President:** Keith Gold. Incorporated in 1988. Full-service multimedia, marketing and communications firm. Specializes in graphic design and advertising. Product specialties are entertainment, medical, publishing, tourism and sports. Four locations.
Needs Approached by over 100 freelancers/year. Works with approximately 25 freelance illustrators/year. Works primarily with artist reps. On basis assignment only. Uses freelancers for annual reports, books, brochures, editorial, technical, print ad illustration; storyboards, animatics, animation, music videos. 65% of work is in print. 50% of freelance work demands knowledge of Illustrator, QuarkXPress and Photoshop.
First Contact & Terms Contact through artist rep or send query letter with photocopies, tearsheets and capabilities brochure. Samples are filed. Responds only if interested. Request portfolio review in original query. Will contact artists for portfolio review if interested. Follow up with letter after initial query. Portfolio should include tearsheets. "Maximum number of hours is negotiated up front." Pays for illustration by the project, $200-7,500. Buys all rights. Finds artists primarily through sourcebooks and reps.

TOM GRABOSKI ASSOCIATES, INC.
4649 Ponce de Leon Blvd., #401, Coral Gables FL 33146. (305)669-2550. Fax: (305)669-2539. E-mail: mail@tgade sign.com. **President:** Tom Graboski. Estab. 1980. Specializes in exterior/interior signage, environmental graphics, corporate identity, urban design and print graphics. Clients: corporations, cities, museums, a few ad agencies. Current clients include Universal Studios, Florida; Royal Caribbean Cruise Line; The Equity Group; Disney Development; Celebrity Cruises; Baptist Health So. Florida; City of Miami; City of Coral Gables.
Needs Approached by 20-30 freelance artists/year. Works with approximately 4-8 designers/draftspersons/year. Prefers artists with a background in signage and knowledge of architecture and industrial design. Freelance artists used in conjunction with signage projects, occasionally miscellaneous print graphics. 100% of design and 10% of illustration demand knowledge of Illustrator, Photoshop and QuarkXPress.
First Contact & Terms Send query letter with brochure and résumé. "We will contact designer/artist to arrange appointment for portfolio review. Portfolio should be representative of artist's work and skills; presentation should be in a standard portfolio format." Pays by the project. Payment varies by experience and project. Rights purchased vary by project.
Tips "Look at what type of work the firm does. Tailor presentation to that type of work." For this firm "knowledge of environmental graphics, detailing, a plus."

🔲 🔲 KELLY & CO., GRAPHIC DESIGN, INC.
7490 30th Ave. N., St. Petersburg FL 33710. (813)341-1009. **Art Director:** Ken Kelly. Estab. 1971. Specializes in print media design, logo design, corporate identity, ad campaigns, direct mail, brochures, publications, signage, architectural and technical illustrations. Clients: industrial, banking, auto, boating, real estate, accounting, furniture, travel and ad agencies. Majority of clients are industrial.
Needs Works with 2 illustrators and 1 designer/year. Prefers artists with a minimum of 5 years of experience. "Local artists preferred. Must have a good working attitude." Uses artists for design, technical illustration, brochures, catalogs, magazines, newspapers, P-O-P displays, retouching, airbrushing, posters, model making, direct mail packages, charts/graphs, lettering and logos. 90% of design and 75% of illustration demands skills in PageMaker, QuarkXPress, FreeHand, Illustrator, Photoshop or "other programs."
First Contact & Terms Send query letter with résumé, brochure and photocopies, or "copies of work showing versatility." Accepts submissions on Mac floppy or CD. Samples are filed. Responds only if interested. Pays for design by the hour, $35-55. Pays for illustration by the hour, $65-95; by the day, $90-110. Buys all rights.
Tips "Be highly talented in all areas with reasonable rates. Don't oversell yourself. Must be honest with a high degree of integrity and appreciation. Send clean, quality samples and résumé. I prefer to make the contact. Our need for freelancers has been reduced."

✅ 🔲 MYERS, MYERS & ADAMS ADVERTISING, INC.
938 N. Victoria Park Rd., Fort Lauderdale FL 33304. (954)523-6262. Fax: (954)523-3517. E-mail: peter@mmanda .com. Website: www.mmanda.com. **Creative Director:** Virginia Myers. Estab. 1986. Number of employees: 6. Approximate annual billing: $2 million. Ad agency. Full-service, multimedia firm. Specializes in magazines and newspaper ads; radio and TV; brochures; and various collateral. Product specialties are consumer and business-to-business. Current clients include Harley-Davidson, Wendy's and Embassy Suites. Professional affiliation: Advertising Federation.

Needs Approached by 10-15 freelancers/year. Works with 3-5 freelance illustrators and 3-5 designers/year. Uses freelancers mainly for overflow. Also for animation, brochure and catalog illustration, model-making, posters, retouching and TV/film graphics. 55% of work is with print ads. Needs computer-literate freelancers for illustration and production. 20% of freelance work demands knowledge of PageMaker, Photoshop, QuarkX-Press and Illustrator.

First Contact & Terms Send postcard-size sample of work or send query letter with tearsheets. Samples are filed and are returned by SASE if requested by artist. Will contact artist for portfolio review if interested. Portfolio should include b&w and color final art, roughs, tearsheets and thumbnails. Pays for design and illustration by the project, $50-1,500. Buys all rights. Finds artists through *Creative Black Book*, *Workbook* and artists' submissions.

ⓝ PRO INK

2826 NE 19th Dr., Gainesville FL 32609-3391. (352)377-8973. Fax: (352)373-1175. E-mail: terry@proink.com. Website: www.proink.com. **President:** Terry Van Nortwick. Estab. 1979. Number of employees: 5. Specializes in publications, marketing, healthcare, engineering, development and ads. Professional affiliations: Public Relations Society of America, Society of Professional Journalists, International Association of Business Communicators, Gainesville Advertising Federation, Florida Public Relations Association.

Needs Works with 6-10 freelancers/year. Works on assignment only. Uses freelancers for brochure illustration, airbrushing and lettering. 80% of freelance work demands knowledge of PageMaker, Illustrator, QuarkXPress, Photoshop or FreeHand. Needs editorial, medical and technical illustration.

First Contact & Terms Send résumé, samples, tearsheets, photostats, photocopies, slides and photography. Samples are filed or are returned if accompanied by SASE. Responds only if interested. Call or write for appointment to show portfolio of original/final art. Pays for design and illustration by the project, $50-500. Rights purchased vary according to project.

⬛ ⓘ ROBERTS COMMUNICATIONS & MARKETING, INC.

5405 Cypress Center Dr., Suite 250, Tampa FL 33609-1025. (813)281-0088. Fax: (813)281-0271. Website: www.r obertscommunications.com. **Creative Director:** Amy Phillips. Art Director: Eugene Newcomb. Production Artist: Joel Barbosa. Estab. 1986. Number of employees: 15. Ad agency, PR firm. Full-service multimedia firm. Specializes in integrated communications campaigns using multiple media and promotion. Professional affiliations: AIGA, PRSA, AAF, TBAF and AAAAS.

Needs Approached by 50 freelancers/year. Works with 15 freelance illustrators and designers/year. Prefers local artists with experience in conceptualization and production knowledge. Uses freelancers for billboards, brochure design and illustration, lettering, logos, mechanicals, posters, retouching and website production. 60% of work is with print ads. 80% of freelance work demands knowledge of Photoshop 6.5, QuarkXPress 6.0 and Illustrator 8.5.

First Contact & Terms Send postcard sample or query letter with photocopies, résumé and SASE. Samples are filed or are returned by SASE if requested by artist. Portfolios may be dropped off every Monday. Will contact artist for portfolio review if interested. Portfolio should include b&w and color final art, roughs and thumbnails. Pays for design by the hour, $40-80; by the project, $200 minimum; by the day, $200-600. Pays for illustration by the project, negotiable. Refers to Graphic Arts Guild Handbook for fee structure. Rights purchased vary according to project. Finds artists through agents, sourcebooks, seeing actual work done for others, annuals (*Communication Arts, Print, One Show*, etc.).

Tips Impressed by ''work that demonstrates knowledge of product, willingness to work within budget, contributing to creative process, delivering on-time.''

ⓝ THE T-SHIRT GALLERY LTD.

P.O. Box 1004, Lake Worth FL 33460-1004. (212)838-1212. **Vice President:** Flora Azaria. Specializes in T-shirts. Current clients include: *Seventeen Magazine* and Peter Max Studio. Client list not available.

Needs Approached by 10 artists/year. Works with 8 illustrators and 9 designers/year. Uses artists for design and illustrations.

First Contact & Terms Send query letter with résumé and samples. Samples not filed are returned only if requested. Responds in weeks. To show a portfolio, mail appropriate materials. Pays for design by the project, $50-500. Pays for illustration by the project, $50-500. Considers how work will be used when establishing payment.

ⓝ URBAN TAYLOR & ASSOCIATES

12250 SW 131 Ave., Miami FL 33186. (305)255-7888. Fax: (305)256-7080. E-mail: urbantay@aol.com. Website: www.gate.net/ ~ urbantay. **President:** Alan Urban. Estab. 1976. Specializes in annual reports, corporate identity

and communications and publication design. Current clients include University of Miami, Polaroid and Hughes Supply, Inc. Professional affiliation: AIGA.

Needs Approached by 10 freelancers/year. Works with 1-2 freelance illustrators and 1-2 designers/year. Works with artist reps and local freelancers. Looking for a variety of editorial, technical and corporate communications illustration styles and freelancers with Mac experience. Works on assignment only. Uses illustrators mainly for brochures and publications. Also uses freelancers for lettering and charts/graphs. 100% of freelance work demands knowledge of QuarkXPress, FreeHand, Illustrator, Photoshop or Microsoft Word.

First Contact & Terms Send query letter with SASE and appropriate samples. Samples are filed. Will contact artist for portfolio review if interested. Pays for design by the project. "Payment depends on project and quantity printed." Rights purchased vary according to project. Finds artists through sourcebooks, direct mail pieces, referral from collegues, clients and reps.

Tips "The field is completely technical—provide all illustrations on Mac compatible disk or CD-ROM.'"

Ⓝ ⓥ Ⓘ MICHAEL WOLK DESIGN ASSOCIATES

3841 NE Second Ave., Suite #303, Miami FL 33137-3639. (305)576-2898. Fax: (305)576-2899. E-mail: mwolk@wolkdesign.com. Website: www.wolkdesign.com. **Creative Director:** Michael Wolk. Estab. 1985. Specializes in corporate identity, displays, interior design and signage. Clients: corporate and private. Client list available on website.

Needs Approached by 10 freelancers/year. Works with 5 illustrators and 5 freelance designers/year. Prefers local artists only. Works on assignment only. Needs editorial and technical illustration mainly for brochures. Uses designers mainly for interiors and graphics. Also for brochure design, mechanicals, logos and catalog illustration. Needs "progressive" illustration. Needs computer-literate freelancers for design, production and presentation. 75% of freelance work demands knowledge of PageMaker, QuarkXPress, FreeHand, Illustrator or other software.

First Contact & Terms Send query letter with slides. Samples are not filed and are returned by SASE. Responds only if interested. To show a portfolio, mail slides. Pays for design by the hour, $10-20. Rights purchased vary according to project.

GEORGIA

CRITT GRAHAM & ASSOCIATES

2970 Clairmont Rd., Suite 850, Atlanta GA 30329. (404)320-1737. Fax: (404)320-1920. E-mail: cgaoffice@aol.com. Website: www.crittgraham.com. **Creative Director:** Deborah Pinals. Estab. 1979. Specializes in design and production of annual reports, corporate magazines, capabilities brochures, identification systems and packaging, product literature, multi-media/interactive presentations and websites. Clients: primarily major corporations; "15 are members of the Fortune 1000." Current clients include Compaq Computer, Home Depot, IBM, Proctor & Gamble, Eastman Chemical, Harris, Royal Caribbean Cruises.

Needs Works with 5-10 freelance illustrators/year. Also needs photographers, illustrators, typesetters and computer production designers. Also for multimedia projects. 100% of design and 75% of illustration requires computer skills. All design work is done internally.

First Contact & Terms Designers send query letter with résumé and photocopies. Illustrators send postcard samples and tearsheets. Accepts submissions on disk compatible with FreeHand 5.5. Send EPS files. Samples are filed. Will contact artist for portfolio review if interested. Pays for illustration by the project, depending on style. Considers buying second rights (reprint rights) to previously published work. Finds artists through word of mouth, magazines, artists' submissions/self-promotions, sourcebooks and agents.

Tips "Price is always a consideration, also usage and sometimes buy-out. Try not to price yourself out of a job."

▣ Ⓘ EJW ASSOCIATES, INC.

Crabapple Village Office Park, 1602 Abbey Court, Alpharetta GA 30004. (770)664-9322. Fax: (770)664-9324. E-mail: advertise@ejwassoc.com. Website: www.ejwassoc.com. **President:** Emil Walcek. Estab. 1982. Ad agency. Specializes in space ads, corporate ID, brochures, show graphics. Product specialty is business-to-business.

Needs Works with 24 freelance illustrators and 12 designers/year. Prefers local freelancers with experience in Mac computer design and illustration and Photoshop expertise. Works on assignment only. Uses freelancers for brochure, website development, catalog and print ad design and illustration, editorial, technical illustration and logos. 50% of work is with print ads. Needs computer-literate freelancers for design, illustration, production and presentation. 75% of freelance work demands skills in FreeHand, Photoshop, web coding, FLASH.

First Contact & Terms Send query letter with résumé, photostats, slides and website. Samples are filed or are returned by SASE if requested by artist. Responds only if interested. Write for appointment to show portfolio

of thumbnails, roughs, final art, tearsheets. Pays for design by the hour, $40-80; by the day, $300-600; or by the project. Pays for illustration by the project. Buys all rights.

Tips Looks for "experience in non-consumer, industrial or technology account work. Visit our website first— then e-mail or call. Do not send e-mail attachments."

LORENC & YOO DESIGN, INC.

109 Vickery St., Roswell GA 30075. (770)645-2828. Fax: (770)998-2452. E-mail: jan@lorencyoodesign.com. Website: www.lorencyoodesign.com. **President:** Mr. Jan Lorenc. Specializes in architectural signage design; environmental, exhibit, furniture and industrial design. Clients: corporate, developers, product manufacturers, architects, real estate and institutions. Current clients include Gerald D. Hines Interests, MCI, Georgia-Pacific, IBM, Urban Retail, Mayo Clinic. Client list available upon request.

Needs Approached by 25 freelancers/year. Works with 5 illustrators and 10 designers/year. Local senior designers only. Uses freelancers for design, illustration, brochures, catalogs, books, P-O-P displays, mechanicals, retouching, airbrushing, posters, direct mail packages, model-making, charts/graphs, AV materials, lettering and logos. Needs editorial and technical illustration. Especially needs architectural signage and exhibit designers. 95% of freelance work demands knowledge of QuarkXPress, Illustrator or FreeHand.

First Contact & Terms Send brochure, weblink, or CD, résumé and samples to be kept on file. Prefers digital files as samples. Samples are filed or are returned. Call or write for appointment to show portfolio of thumbnails, roughs, original/final art, final reproduction/product and color photostats and photographs. Pays for design by the hour, $40-100; by the project, $250-20,000; by the day, $80-400. Pays for illustration by the hour, $40-100; by the project, $100-2,000; by the day, $80-400. Considers complexity of project, client's budget, and skill and experience of artist when establishing payment.

Tips "Sometimes it's more cost-effective to use freelancers in this economy, so we have scaled down permanent staff."

🅽 J. WALTER THOMPSON COMPANY

400 Colony Square, 1201 Peachtree St. NE, Suite 980, Atlanta GA 30361. (404)365-7300. Fax: (404)365-7333. Website: www.jwtworld.com. **Executive Creative Director:** Scott Nelson. Ad agency. Clients: mainly financial, industrial and consumer. "This office does creative work for Atlanta and the southeastern U.S."

Needs Works on assignment only. Uses freelancers for billboards, consumer and trade magazines and newspapers. Needs computer-literate freelancers for design, production and presentation. 60% of freelance work demands skills in Illustrator, Photoshop or QuarkXPress.

First Contact & Terms *Deals with artist reps only.* Send slides, original work, stats. Samples returned by SASE. Responds only if interested. Originals not returned. Call for appointment to show portfolio. Pays by the hour, $20-80; by the project, $100-6,000; by the day, $140-500.

Tips Wants to see samples of work done for different clients. Likes to see work done in different mediums, variety and versatility. Freelancers interested in working here should "be *professional* and do top-grade work."

HAWAII

🅽 LEIMER CROSS DESIGN

12 Aulii Dr., Makawao HI 96768-8206. (808)572-2382. Fax: (802)572-2632. E-mail: kerry@leimercross.com. Website: www.leimercross.com. **Partner:** Dorothy Cross. Creative Director: Kerry Leimer. Estab. 1983. Specializes in annual reports, publication design, marketing brochures. Clients: corporations and service companies. Client list not available.

Needs Approached by 75 freelance artists/year. Works with 4-5 illustrators and 6-8 designers/year. Prefers artists with experience in working for corporations. Uses freelance illustrators mainly for annual reports, lettering and marketing materials. Uses freelance designers mainly for "layout per instructions," production. Also for brochure illustration, mechanicals, charts/graphs.

First Contact & Terms Send query letter with résumé, tearsheets and photographs. Samples are filed. Responds only if interested. To show a portfolio, mail thumbnails, roughs, tearsheets and photographs. Pays for design by the hour or by the project. Pays for illustration by the project. Rights purchased vary according to project.

🄼 MILICI VALENTI NG PACK

999 Bishop St., 24th Floor, Honolulu HI 96813. (808)536-0881. Fax: (808)529-6208. Website: www.milici.com. **Creative Director:** George Chalekian. Ad agency. Number of employees: 74. Approximate annual billing: $40,000,000. Serves clients in travel and tourism, food, finance, utilities, entertainment and public service. Clients include First Hawaiian Bank, Aloha Airlines, Sheraton Hotels.

Needs Works with 2-3 freelance illustrators/month. Artists must be familiar with advertising demands; used

to working long distance through the mail and over the Internet; and be familiar with Hawaii. Uses freelance artists mainly for illustration, retouching and lettering for newspapers, multimedia kits, magazines, radio, TV and direct mail.

First Contact & Terms Send brochure, flier and tearsheets or PDFs to be kept on file for future assignments. Pays $200-2,000.

▣ ERIC WOO DESIGN, INC.

733 Bishop St., Suite 1280, Honolulu HI 96813. (808)545-7442. Fax: (808)545-7445. E-mail: ericwoodesign@haw aii.rr.com. Website: www.ericwoodesign.com. **Principal:** Eric Woo. Estab. 1985. Number of employees: 3.5. Approximate annual billing: 500,000. Design firm. Specializes in image development, packaging, web and CD-ROM design, print. Specializes in state/corporate. Current clients include State of Hawaii and University of Hawaii. Client list available upon request.

Needs Approached by 5-10 illustrators and 10 designers/year. Works with 1-2 illustrators/year. Prefers freelancers with experience in multimedia. Uses freelancers mainly for multimedia projects and lettering. 5% of work is with print ads. 90% of design demands skills in Photoshop, Illustrator, Quark, Flash, Go Live, Dreamweaver and Metropolis.

First Contact & Terms Designers send query letter with brochure, photocopies, photographs, résumé and tearsheets. Illustrators send postcard sample of work or query letter with brochure, photocopies, photographs, résumé, tearsheets. Send follow-up postcard samples every 1-2 months. Accepts submissions on disk in above software. Samples are filed. Will call if interested. Will contact for portfolio review of final art, photographs, photostats, roughs, slides, tearsheets, thumbnails and transparencies. Pays for design by the hour, $15-50. Pays for illustration by the project. Rights purchased vary according to project.

Tips "Design and draw constantly. Have a good sense of humor and enjoy life."

IDAHO

▣ ▣ HNA IMPRESSION MANAGEMENT

1524 W. Hays St., Boise ID 83702. (208)344-4631. Fax: (208)344-2458. E-mail: tony@hedden-nicely.com. Website: www.hedden-nicely.com. **Production Coordinator:** Tony Uria. Estab. 1986. Number of employees: 7. Approximate annual billing: $600,000. Ad agency. Specializes in print materials—collateral, display, direct mail. Product specialties are industrial, manufacturing.

Needs Approached by 5 illustrators and 10 designers/year. Works with 1 illustrator and 6 designers/year. Prefers local freelancers. Prefers that designers work electronically with own equipment. Uses freelancers mainly for logos, brochures. Also for airbrushing, animation, billboards, brochure, brochure illustration, lettering, model-making, posters, retouching, storyboards. 10% of work is with print ads. 90% of design demands knowledge of PageMaker, Photoshop, Illustrator 8.0. 40% of illustration demands knowledge of Photoshop 4.0, Illustrator 8.0.

First Contact & Terms Designers send query letter with brochure and résumé. Illustrators send postcard sample of work. Accepts any Mac-compatible Photoshop or Adobe file on CD or e-mail. Samples are filed. Responds only if interested when an appropriate project arises. Art director will contact artists for portfolio review of color, final art, tearsheets if interested. Pays by the project. Rights purchased vary according to project, all rights preferred. "All of our freelancers have approached us through query letters or cold calls."

ILLINOIS

▣ ▣ BEDA DESIGN

38663 Thorndale Place, Lake Villa IL 60046. Phone/fax: (847)245-8939. **President:** Lynn Beda. Estab. 1971. Number of employees: 2-3. Approximate annual billing: $250,000. Design firm. Specializes in packaging, publishing, film and video documentaries. Current clients include business-to-business accounts, producers to writers, directors and artists.

Needs Approached by 6-12 illustrators and 6-12 designers/year. Works with 6 illustrators and 6 designers/year. Prefers local freelancers. Also for retouching, technical illustration and production. 50% of work is with print ads. 75% of design demands skills in Photoshop, QuarkXPress, Illustrator, Premiere, Go Live.

First Contact & Terms Designers send query letter with brochure, photocopies and résumé. Illustrators send postcard samples and/or photocopies. Samples are filed and are not returned. Will contact for portfolio review if interested. Payments are negotiable. Buys all rights. Finds artists through word of mouth.

⊡ BENTKOVER'S DESIGN & MORE

1222 Cavell, Suite 3C, Highland Park IL 60035. (847)831-4437. Fax: (847)831-4462. **Creative Director:** Burt Bentkover. Estab. 1989. Number of employees: 2. Approximate annual billing: $200,000. Specializes in annual reports, ads, package and brochure design. Clients: business-to-business, foodservice.

Needs Works with 3 freelance illustrators/year. Works with artist reps. Prefers freelancers with experience in computer graphics, multimedia, Macintosh. Uses freelancers for direct mail and brochure illustration. 80% of freelance work demands computer skills.

First Contact & Terms Send brochure, photocopies and tearsheets. No original art—only disposable copies. Samples are filed. Responds in 1 week if interested. Request portfolio review in original query. Will contact artist for portfolio review if interested. Portfolio should include b&w and color photocopies. ''No final art or photographs.'' Pays for design and illustration by the project. Rights purchased vary according to project. Finds artists through sourcebooks and agents.

⊡ ▣ BRAGAW PUBLIC RELATIONS SERVICES

800 E. Northwest Hwy., Palatine IL 60074. (847)934-5580. Fax: (847)934-5596. **President:** Richard S. Bragaw. Number of employees: 3. PR firm. Specializes in newsletters and brochures. Clients: professional service firms, associations and industry. Current clients include Kaiser Precision Tooling, Inc. and Nykiel-Carlin and Co., Ltd.

Needs Approached by 12 freelancers/year. Works with 2 freelance illustrators and 2 designers/year. Prefers local freelancers only. Works on assignment only. Uses freelancers for direct mail packages, brochures, signage, AV presentations and press releases. 90% of freelance work demands knowledge of PageMaker. Needs editorial and medical illustration.

First Contact & Terms Send query letter with brochure to be kept on file. Responds only if interested. Pays by the hour, $25-75 average. Considers complexity of project, skill and experience of artist and turnaround time when establishing payment. Buys all rights.

Tips ''We do not spend much time with portfolios.''

THE CHESTNUT HOUSE GROUP INC.

2121 St. Johns Ave., Highland Park IL 60035. (847)432-3273. Fax: (847)432-3229. E-mail: chestnut@comcast.n et. Website: www.chestnuthousegroup.com. **Contact:** Miles Zimmerman. Clients: major educational publishers.

Needs Illustration, layout and electronic page production. Needs computer-literate freelancers with educational publishing experience. Uses experienced freelancers only. Freelancers should be familiar with QuarkXPress and various drawing and painting programs for illustrators. Pays for production by the hour. Pays for illustration by the project.

First Contact & Terms Illustrators, submit samples.

☑ ▣ DESIGN ASSOCIATES

1828 Asbury Ave., Evanston IL 60201-3504. (847)425-4800. E-mail: info@designassociatesinc.com. Website: www.designassociatesinc.com. **Contact:** Paul Uhl. Estab. 1986. Number of employees: 3. Specializes in text and trade book design, annual reports, corporate identity, website development. Clients: corporations, publishers and museums. Client list available upon request.

Needs Approached by 10-20 freelancers/year. Works with 100 freelance illustrators and 5 designers/year. Uses freelancers for design and production, illustration and photography, lettering. 100% of freelance work demands knowledge of Illustrator, Photoshop and QuarkXPress.

First Contact & Terms Send query letter with samples that best represent work. Accepts disk submissions. Samples are filed. Will contact artist for portfolio review if interested. Portfolio should include b&w and color samples. Pays for design by the hour and by the project. Pays for illustration by the project. Buys all rights. Finds artists through sourcebooks, reps and word of mouth.

⊡ DESIGN RESOURCE CENTER

1548 Bond St., Suite 114, Naperville IL 60563. (630)357-6008. Fax: (630)357-6040. E-mail: info@drcchicago.c om. Website: www.designresourcecenter.com. **President:** John Norman. Estab. 1990. Number of employees: 12. Approximate annual billing: $850,000. Specializes in package design and display, brand and corporate identity. Clients: corporations, manufacturers, private label.

Needs Approached by 5-10 freelancers/year. Works with 3-5 freelance designers and production artists and 3-5 designers/year. Uses designers mainly for Macintosh or concepts. Also uses freelancers for brochure, poster and P-O-P design and illustration, lettering, logos and package design. Needs computer-literate freelancers for design, illustration and production. 100% of freelance work demands knowledge of Illustrator 10, FreeHand, QuarkXPress, Photoshop.

First Contact & Terms Send query letter with brochure, photocopies, photographs and résumé. Samples are filed. Does not reply. Artist should follow up. Portfolio review sometimes required. Portfolio should include

b&w and color final art, photocopies, photographs, photostats, roughs and thumbnails. Pays for design by the hour, $15-40. Pays for illustration by the project. Buys all rights. Finds artists through word of mouth, referrals.

☑ QUALLY & COMPANY, INC.
2 East Oak, Suite 2903, Chicago IL 60611. (847)864-4154. **Creative Director:** Robert Qually. Specializes in integrated marketing/communication and new product launches. Clients: major corporations, high net worth individuals and think tanks.

Needs Works with 10-12 freelancers/year. "Freelancers must have talent and the right attitude." Works on assignment only. Uses freelancers for design, copywriting, illustration, retouching, and computer production.

First Contact & Terms Send query letter with résumé, business card and samples that we can keep on file. Call or write for appointment to show portfolio.

Tips Looking for "people with ideas, talent, point of view, style, craftsmanship, depth and innovation" in portfolio or samples. Sees "too many look-alikes, very little innovation."

🅽 CHUCK THOMAS CREATIVE, INC.
210 S. 5th Ave., St. Charles IL 60174. (630)587-6000. Fax: (630)587-6430. E-mail: branding@ctcreative.com. Website: www.ctcreative.com. Estab. 1989. Integrated marketing communications agency. Specializes in consulting, creative branding, collateral. Product specialties healthcare, family. Current clients include Kidspeace, Cook Communications, Opportunity International.

Needs Works with 1-2 freelance illustrators and 2-3 designers/year. Needs freelancers for brochure design and illustration, logos, multimedia projects, posters, signage, storyboards, TV/film graphics. 20% of work is with print ads. 100% of freelance design demands skills in PageMaker, FreeHand.

First Contact & Terms Designers send query letter with brochure and photocopies. Illustrators send postcard sample of work. Samples are filed. Responds only if interested. Portfolio review not required. Pays by the project. Buys all rights.

🅽 WATERS & WOLFE
1603 Orrington, Suite 990, Evanston IL 60201. (847)475-4500. Fax: (847)475-3947. E-mail: jbeuving@wnwolfe.com. Website: www.wnwolfe.com. **Senior Art Director:** Jeff Beuving. President: Paul Frankel. Estab. 1984. Number of employees: 15. Approximate annual billing: $2 million. Ad agency, AV firm, PR firm. Full-service, multimedia firm. Specializes in collateral, annual reports, magazine ads, trade show booth design, videos, PR. "We are full service from logo design to implementation of design." Product specialty is business-to-business. Client list not available.

Needs Approached by 50 freelancers/year. Works with 5 freelance illustrators and 5 designers/year. Uses freelancers mainly for layout and illustrations. Also for animation, lettering, logos, mechanicals, retouching, signage and TV/film graphics. 25% of work is with print ads. Needs computer-literate freelancers for design, web programming, illustration, production and presentation. 90% of freelance work demands knowledge of Photoshop 5.0, QuarkXPress 4.0, Illustrator 8.0.

First Contact & Terms Send query letter with brochure, photocopies, photographs, résumé and tearsheets. Will also accept printouts of artist's samples. Samples are filed. Will contact artist for portfolio review if interested. Portfolio should include color final art, roughs, tearsheets and thumbnails. Pays for design by the hour or by the project. Pays for illustration by the project. Rights purchased vary according to project. Finds artists through sourcebooks, word of mouth, artists' submissions and agents.

Tips "I am impressed by professionalism. Complete projects on timely basis, have thorough knowledge of task at hand."

CHICAGO

🅽 ▣ GETER ADVERTISING INC.
75 E. Wacker Dr., Chicago IL 60601. (312)782-7300. **Account Executive:** Jill Rubin. Estab. 1978. Ad agency. Full-service, multimedia firm. Product specialty is professional services. Client list not available.

Needs Approached by 20-50 freelancers/year. Permanent part-time positions in design available. Prefers artists with experience in computer layout—work done at our office. Uses freelancers mainly for print ads, brochures and outdoor design. Also uses freelancers for billboards, brochure design, logos, posters, signage and TV/film graphics. 50% of work is with print ads. Needs computer-literate freelancers for design, illustration, production and presentation. 100% of freelance work demands skills in PageMaker, FreeHand, Photoshop, QuarkXPress, Illustrator and Corel Draw (latest versions).

First Contact & Terms Send query letter with photocopies and résumé. Samples are reviewed immediately and filed or returned. Agency will contact artist for portfolio review if interested. Portfolio should include b&w and

(sidebar) Advertising & Design

color final art and tearsheets. Pays for design by the hour, $15-25; by the project, $50-2,000; by the day, $100-200. Buys all rights.

Tips Impressed with freelancers who possess "skill on computer, good artistic judgment, speed, and who can work with our team."

N ▣ PUBLICIS/DIALOG
111 E. Wacker Dr., Chicago IL 60601. (312)552-4600. Fax: (312)552-4650. E-mail: charles.hutchinson@publicis-usa.com. **Graphics Coordinator:** Charles Hutchinson. Estab. 1928. Number of employees: 46. Approximate annual billing: $5.5 million. PR firm. Full-service, multimedia firm. Specializes in newspaper, magazine, collaterals, video. Product specialties are consumer and business to business. Current clients include Bombardier, Sargento, Square D, McCain Foods.

Needs Approached by 2 freelance artists/month. Works with 2 illustrators and 3 designers/month. Prefers artists with experience in desktop publishing (Macintosh). Works on assignment only. Uses freelancers mainly for newsletters. Also for brochure and catalog design, lettering and logos. 70% of work is with print ads. Needs computer-literate freelancers for design, illustration, production and presentation. 80% of freelance work demands skills in Aldus Pagemaker, Illustrator, QuarkXPress, Photoshop or FreeHand.

First Contact & Terms Send query letter with brochure, photocopies and résumé. Samples are not returned. To show portfolio, mail appropriate materials: thumbnails, rough, printed piece. Pays for design by the hour, $20-65. Pays for illustration by the project, $150-500. Rights purchased vary according to project.

N THE QUARASAN GROUP, INC.
405 W. Superior St., Chicago IL 60610-3613. (312)981-2500. Fax: (312)981-2507. E-mail: info@quarasan.com. Website: www.quarasan.com. **President:** Randi S. Brill. Specializes in educational products. Clients: educational publishers. Client list not available. Submission guidelines on website.

Needs Approached by 400 freelancers/year. Works with 700-900 illustrators/year. Freelancers with publishing experience preferred. Uses freelancers for illustration, books, mechanicals, charts/graphs, lettering and production. Needs computer-literate freelancers for illustration. 50% of freelance illustration work demands skills in Illustrator, QuarkXPress, Photoshop or FreeHand. Needs editorial, technical, medical and scientific illustration.

First Contact & Terms Send query letter with brochure or résumé and samples to be circulated and kept on file. Prefers "anything that we can retain for our files: photocopies, color tearsheets, e-mail submissions, disks or dupe slides that do not have to be returned" as samples. Responds only if interested. Pays for illustration by the piece/project, $40-750 average. Considers complexity of project, client's budget, how work will be used and turnaround time when establishing payment. "For illustration, size and complexity are the key factors."

Tips "Our publishers continue to require us to use only those artists willing to work on a work-for-hire basis. This is slowly changing, but at present, this is still often a requirement. Our other markets are more receptive to alternate arrangements. Let us know your requirements early in the game!"

▣ L.C. WILLIAMS & ASSOCIATES
150 N. Michigan Ave., Suite 3800, Chicago IL 60601. (312)565-3900. Fax: (312)565-1770. E-mail: ccalvert@lcwa.com. **Creative Director:** Cindy Calvert. Estab. 2000. Number of employees: 28. Approximate annual billing: $3.5 million. PR firm. Specializes in marketing, communication, publicity, direct mail, brochures, newsletters, trade magazine ads, AV presentations. Product specialty is consumer home products. Current clients include Pergo, Ace Hardware, La-Z-Boy Inc. and Glidden. Promotional Products Association International. Professional affiliations: Chicago Direct Marketing Association, Sales & Marketing Executives of Chicago, Public Relations Society of America, Publicity Club of Chicago.

- ● LCWA is among the top 15 public relations agencies in Chicago. It maintains a satellite office in New York.

Needs Approached by 50-100 freelancers/year. Works with 1-2 freelance illustrators and 2-5 designers/year. Works on assignment only. Uses freelancers mainly for brochures, ads, newsletters. Also for print ad design and illustration, editorial and technical illustration, mechanicals, retouching and logos. 90% of freelance work demands computer skills.

First Contact & Terms Send query letter with brochure and résumé. Samples are filed. Does not reply. Request portfolio review in original query. Artist should call within 1 week. Portfolio should include printed pieces. Pays for design and illustration by the project, fee varies. Rights purchased vary according to project. Finds artists through word of mouth and queries.

Tips "Many new people are opening shop and you need to keep your name in front of your prospects."

INDIANA

▣ ADVANCED DESIGNS CORPORATION

1169 W. Second St., Bloomington IN 47403. (812)333-1922. Fax: (812)333-2030. **President:** Martin Riess. Graphics Dept.: Doug Arnold. Estab. 1982. AV firm. Weather radar systems and associated graphics. Specializes in TV news broadcasts. Product specialties are the Doppler Radar and Display Systems.

Needs Prefers freelancers with experience. Works on assignment only. Uses freelancers mainly for TV/film (weather) and cartographic graphics. Needs computer-literate freelancers for production. 100% of freelance work demands skills in ADC Graphics.

First Contact & Terms Send query letter with résumé and SASE. Samples are not filed and are returned by SASE. Pays for design and illustration by the hour, $7 minimum. Will contact artist for portfolio review if interested. Rights purchased vary according to project. Finds artists through classifieds.

▣ ASHER AGENCY

535 W. Wayne, Fort Wayne IN 46802. (260)424-3373. Fax: (260)424-0848. E-mail: asherideas@centralnet.net.com. **Senior Art Director:** Jaqui Russett. Estab. 1974. Number of employees: 21. Approximate annual billing: $12 million. Full service ad agency and PR firm. Clients: automotive firms, financial/investment firms, area economic development agencies, health care providers, fast food companies, gaming companies and industrial.

Needs Works with 5-10 freelance artists/year. Assigns 25-50 freelance jobs/year. Prefers local artists. Works on assignment only. Uses freelance artists mainly for illustration. Also uses freelance artists for design, brochures, catalogs, consumer and trade magazines, retouching, billboards, posters, direct mail packages, logos and advertisements.

First Contact & Terms Send query letter with brochure showing art style or tearsheets and photocopies. Samples are filed or are returned by SASE. Responds only if interested. Will contact artist for portfolio review if interested. Portfolio should include roughs, original/final art, tearsheets and final reproduction/product. Pays for design by the hour, $40 minimum. Pays for illustration by the project, $40 minimum. Finds artists usually through word of mouth.

BOXFIRE

400 Victoria Centre, 22 E. Washington St., Indianapolis IN 46204. (317)631-0260. E-mail: mark_gause@burnthatbox.com. Website: www.burnthatbox.com. **CEO/Creative Director:** Mark Gause. Creative Directors: Mary Hayes and Sean Cunat. Art Directors: Jim Collins, Kevin Nelson and Jason Cummings. Production Coordinator: Terry Tyler. Number of employees: 31. Approximate annual billing: $26 million. Marketing firm. Specializes in business-to-business, food service, transportation products and services, computer equipment, medical, life sciences and electronics.

Needs Approached by 50 freelancers/year. Works with 15 freelance photographers, illustrators and 5 designers/year. Works on assignment only. Uses freelancers for technical line art, color illustrations and airbrushing. 100% of freelance design and 25% of illustration demand computer skills.

First Contact & Terms Send query letter with résumé and photocopies. Accepts disk submissions. Samples not filed are returned. Responds only if interested. Call or write for appointment to show portfolio, or mail final reproduction/product and tearsheets. Pays by the project, $100 minimum. Buys all rights.

Tips "Show samples of good creative talent."

▣ BOYDEN & YOUNGBLUTT ADVERTISING & MARKETING.

120 W. Superior St., Fort Wayne IN 46802. (260)422-4499. Fax: (260)422-4044. E-mail: info@b-y.net. Website: www.b-y.net. **Vice President:** Jerry Youngblutt. Estab. 1990. Number of employees: 16. Ad agency. Full-service, multimedia firm. Specializes in magazine ads and collateral.

Needs Approached by 10 freelancers/year. Works with 3-4 freelance illustrators and 5-6 designers/year. Uses freelancers mainly for collateral layout and web. Also for annual reports, billboards, brochure design and illustration, logos and model-making. 50% of work is with print ads and 50% web. Needs computer-literate freelancers for design. 100% of freelance work demands knowledge of FreeHand, Photoshop, Adobe Ilustrator and Web Weaver.

First Contact & Terms Send query letter with photostats and résumé. Samples are filed. Will contact artist for portfolio review if interested. Portfolio should include b&w and color final art. Pays for design and illustration by the project. Buys all rights.

Tips Finds artists through sourcebooks, word of mouth and artists' submissions. "Send a precise résumé with what you feel are your 'best' samples—less is more."

▣ JMH CORPORATION

921 E. 66th St., Indianapolis IN 46220. (317)255-3400. E-mail: jmh@jmhdesign.com. Website: jmhdesign.com. **President:** J. Michael Hayes. Number of employees: 3. Specializes in annual reports, corporate identity, advertis-

ing, collateral, packaging, publications and website development. Clients: publishers, consumer product manufacturers, corporations and institutions. Professional affiliations: AIGA.

Needs Approached by 30-40 freelancers/year. Works with 5 freelance illustrators and 2 designers/year. Prefers experienced, talented and responsible freelancers only. Works on assignment only. Uses freelancers for advertising, brochure and catalog design and illustration, P-O-P displays, retouching, charts/graphs and lettering. Needs editorial and medical illustration. 100% of design and 30% of illustration demand skills in QuarkXPress, Illustrator or Photoshop (latest versions).

First Contact & Terms Send query letter with brochure/flyer, résumé, photocopies, photographs, tearsheets and slides. Accepts disk submissions compatible with QuarkXPress 4.0 and Illustrator 8.0. Send EPS files. Samples returned by SASE, "but we prefer to keep them." Response time "depends entirely on our needs." Write for appointment to show portfolio. Pays for design by the hour, $20-50, or by the project, $100-1,000. Pays for illustration by the project, $300-5,000.

Tips "Prepare an outstanding mailing piece and 'leave-behind' that allows work to remain on file. Keep doing great work and stay in touch." Advises freelancers entering the field to "send samples regularly. Call to set a portfolio presentation. Do great work. Be persistent. Love what you do. Have a balanced life."

▣ OMNI PRODUCTIONS

12316 Brookshire Pkwy., Carmel IN 46082-0302. (317)848-3456. E-mail: winston@omniproductions.com. Website: omniproductions.com. **President:** Winston Long. Estab. 1984. AV firm. Full-service, multimedia firm. Specializes in video, Intranet, CD-ROM and Internet. Current clients include "a variety of industrial clients, international."

Needs Works on assignment only. Uses freelancers for brochure design and illustration, storyboards, slide illustration, animation, and TV/film graphics. Needs computer-literate freelancers for design, illustration and production. Most of freelance work demands computer skills.

First Contact & Terms Send résumé. Samples are filed and are not returned. Artist should followup with call and/or letter after initial query. Pays by the project. Finds artists through agents, word of mouth and submissions.

IOWA

▣ F.A.C. MARKETING

P.O. Box 782, Burlington IA 52601. (319)752-9422. Fax: (319)752-7091. Website: www.facmarketing.com. **President:** Roger Sheagren. Estab. 1952. Number of employees: 5. Approximate annual billing: $500,000. Ad agency. Full-service, multimedia firm. Specializes in newspaper, television, direct mail. Product specialty is funeral home to consumer.

Needs Approached by 30 freelancers/year. Works with 1-2 freelance illustrators and 4-6 designers/year. Prefers freelancers with experience in newspaper and direct mail. Uses freelancers mainly for newspaper design. Also for brochure design and illustration, logos, signage and TV/film graphics. Freelance work demands knowledge of PageMaker, Photoshop, CorelDraw and QuarkXPress.

First Contact & Terms Send query letter with brochure, photostats, SASE, tearsheets and photocopies. Samples are filed or returned by SASE if requested by artist. Request portfolio review in original query. Portfolio should include b&w photostats, tearsheets and thumbnails. Pays by the project, $100-500. Rights purchased vary according to project.

Ⓝ FLEXSTEEL INDUSTRIES INC.

3200 Jackson, Dubuque IA 52004-0877. (563)556-7730. Fax: (563)556-8345. Website: www.flexsteel.com. **Advertising Manager:** Tom R. Baldwin or Lance Rygh. Estab. 1893. Full-service, multimedia firm, manufacturer with full-service in-house agency. Specializes in furniture advertising layouts, price lists, etc. Product specialty is consumer-upholstered furniture.

Needs Approached by 1 freelance artist/month. Works with 2-4 illustrators/month. Prefers artists who can do both wash and line illustration of upholstered furniture. Uses freelance artists for catalog and print ad illustration, retouching, billboards and posters. Works on assignment only. 25% of work is with print ads.

First Contact & Terms Send query letter with résumé, tearsheets and samples. Samples are filed or are returned by SASE if requested by artist. Responds only if interested. To show a portfolio, mail thumbnails, roughs and b&w tearsheets. Pays for design and illustration by the project. Buys all rights.

☑ 🏃 BRYANT, LAHEY & BARNES, INC.

5300 Foxridge Dr., Shawnee Mission KS 66202. (913)262-7075. **Contact:** Art Director. Ad agency. Clients: agriculture and veterinary firms.

Needs Local freelancers only. Uses freelancers for illustration and production, via Mac format only; keyline and paste-up; consumer and trade magazines and brochures/flyers.

First Contact & Terms Query by phone. Send business card and résumé to be kept on file for future assignments. Originals not returned. Negotiates payment.

Ⓝ ▣ GRETEMAN GROUP

1425 E. Douglas Ave., Wichita KS 67211. (316)263-1004. Fax: (316)263-1060. E-mail: info@gretemangroup.com. Website: www.gretemangroup.com. **Owner:** Sonia Greteman. Estab. 1989. Number of employees: 19. Capitalized billing: $20 million. Creative agency. Specializes in corporate identity, advertising, annual reports, signage, website design, interactive media, brochures, collateral. Professional affiliations: AIGA.

Needs Approached by 2 illustrators and 10-20 designers/year. Works with 2 illustrators and 2 designers/year. Also for brochure illustration. 10% of work is with print ads. 100% of design demands skills in PageMaker, FreeHand, Photoshop, QuarkXPress, Illustrator. 30% of illustration demands computer skills.

First Contact & Terms Send query letter with brochure and résumé. Accepts disk submissions. Send EPS files. Samples are filed. Will contact for portfolio review of b&w and color final art and photostats if interested. Pays for design by the hour. Pays for illustration by the project. Rights purchased vary according to project.

▣ MARKETAIDE SERVICES, INC.

Box 500, Salina KS 67402-0500. (785)825-7161. Fax: (785)825-4697. E-mail: stackett@marketaide.com. Website: www.marketaide.com. **Production Manager:** Shiela Tackett. Graphic Designers: Marla Kuiper and Dee Warren. Web Designer: Scott Rosebrook. Full-service ad/marketing/direct mail firm. Clients: financial, industrial and educational.

Needs Prefers artists within one-state distance who possess professional expertise. Works on assignment only. Needs computer-literate freelancers for design, illustration and web design. 90% of freelance work demands knowledge of QuarkXPress, Illustrator and Photoshop.

First Contact & Terms Send query letter with résumé, business card and samples to be kept on file. Samples not filed are returned by SASE only if requested. Responds only if interested. Write for appointment to show portfolio. Pays for design by the hour, $15-75 average; "since projects vary in size, we are forced to estimate according to each job's parameters." Pays for illustration by the project.

Tips "Artists interested in working here should be highly polished in technical ability, have a good eye for design and be able to meet all deadline commitments."

🏃 TASTEFUL IDEAS, INC.

5822 Nall Ave., Mission KS 66205. (913)722-3769. Fax: (913)722-3967. E-mail: one4ideas@aol.com. Website: www.tastefulideas.com. **President:** John Thomsen. Estab. 1986. Number of employees: 4. Approximate annual billing: $500,000. Design firm. Specializes in consumer packaging. Product specialties are largely, but not limited to, food and foodservice.

Needs Approached by 15 illustrators and 15 designers/year. Works with 3 illustrators and 3 designers/year. Prefers local freelancers. Uses freelancers mainly for specialized graphics. Also for airbrushing, animation, humorous and technical illustration. 10% of work is with print ads. 75% of design and illustration demand skills in Photoshop and Illustrator.

First Conact & Terms Designers send query letter with photocopies. Illustrators send query letter with photostats. Accepts disk submissions from designers and illustrators compatible with Illustrator, Photoshop—Mac based. Samples are filed. Responds only if interested. Art director will contact artist for portfolio review of final art of photostats if interested. Pays by the project. Finds artists through submissions.

▣ WEST CREATIVE, INC.

9552 W. 116th Terrace, Overland Park KS 66210. (913)661-0561. Fax: (816)561-2688. E-mail: stan@westcreative.com. Website: www.westcreative.com. **Creative Director:** Stan Chrzanowski. Estab. 1974. Number of employees: 8. Approximate annual billing: $600,000. Design firm and agency. Full-service, multimedia firm. Client list available upon request. Professional affiliation: AIGA.

Needs Approached by 50 freelancers/year. Works with 4-6 freelance illustrators and 1-2 designers/year. Uses freelancers mainly for illustration. Also for animation, lettering, mechanicals, model-making, retouching and TV/film graphics. 20% of work is with print ads. Needs computer-literate freelancers for design, illustration

and production. 95% of freelance work demands knowledge of FreeHand, Photoshop, QuarkXPress and Illustrator. Full service web design capabilities.

First Contact & Terms Send postcard-size sample of work or send query letter with brochure, photocopies, résumé, SASE, slides, tearsheets and transparencies. Samples are filed or returned by SASE if requested by artist. Responds only if interested. Portfolios may be dropped off every Monday-Thursday. Portfolios should include color photographs, roughs, slides and tearsheets. Pays for illustration by the project; pays for design by the hour, $25-60. "Each project is bid." Rights purchased vary according to project. Finds artists through *Creative Black Book* and *Workbook*.

▣ 🍸 WP POST & GRAPHICS

228 Pennsylvania, Wichita KS 67214-4149. (316)263-7212. Fax: (316)263-7539. E-mail: wppost@aol.com. Website: www.wponline.com. **Art Director:** Kelly Flack. Estab. 1968. Number of employees: 4. Ad agency, design firm, video production/animation. Specializes in TV commercials, print advertising, animation, web design, packaging. Product specialties are automative, broadcast, furniture, restaurants. Current clients include Adventure RV and Truck Center, The Wichita Eagle, Dick Edwards Auto Plaza, Turner Tax Wise. Client list available upon request. Professional affiliations: Advertising Federation of Wichita.

 • Recognized by the American Advertising Federation of Wichita for excellence in advertising.

Needs Approached by 2 illustrators and 10 designers/year. Works with 1 illustrator and 2 designers/year. Prefers local designers with experience in Macintosh production, video and print. Uses freelancers mainly for overflow work. Also for animation, brochure design and illustration, catalog design and illustration, logos, TV/film graphics, web page design and desktop production. 10% of work is with print ads. 100% of freelance work demands knowledge of Photoshop, FreeHand and QuarkXPress.

First Contact & Terms Designers send query letter with résumé and self-promotional sheet. Illustrators send postcard sample of work or query letter with résumé. Send follow-up postcard samples every 3 months. Accepts disk submissions if compatible with Macintosh-formatted, Photoshop 4.0, FreeHand 7.0, or an EPS file. Samples are filed and are not returned. Responds only if interested. Art director will contact artist for portfolio review of b&w, color, final art, illustration if interested. Pays by the project. Rights purchased vary according to project and are negotiable. Finds artists through local friends and coworkers.

Tips "Be creative, be original, and be able to work with different kinds of people."

KENTUCKY

Ⓝ HAMMOND DESIGN ASSOCIATES, INC.

206 W. Main, Lexington KY 40507. (859)259-3639. Fax: (859)259-3697. Website: www.hammonddesign.com. **Vice-President:** Grady Walter. Estab. 1986. Specializes in direct mail, package and publication design and annual reports, brand and corporate identity, display and signage. Clients: corporations, universities and medical facilities.

Needs Approached by 35-50 freelance/year. Works with 5-7 illustrators and 5-7 designers/year. Works on assignment only. Uses freelancers mainly for brochures and ads. Also for editorial, technical and medical illustration, airbrushing, lettering, P-O-P and poster illustration; and charts/graphs. 100% of design and 50% of illustration require computer skills.

First Contact & Terms Send postcard sample or query letter with brochure or résumé. "Sample in query letter a must." Samples are filed or returned by SASE if requested by artist. Responds only if interested. Will contact artist for portfolio review if interested. Pays by the project.

MERIDIAN COMMUNICATIONS

325 W. Main St., Suite 300, Lexington KY 40507. (859)252-3350. Fax: (859)281-5729. E-mail: mes@meridiancomm.com. Website: www.meridiancomm.com. **CEO:** Mary Ellen Slone. Estab. 1975. Number of employees: 58. Ad agency. Full-service, multimedia firm. Specializes in ads (magazine and newspaper), TV and radio spots, packaging, newsletters, etc. Current clients include Three Chimneys Farm, IncrediPet, Banfield Pet Hospitals, Slone's Signature Markets, Georgetown College, University of KY.

Needs Approached by 6 artists/month. Works with 2 illustrators and 6 designers/month. Prefers regional/national artists. Works on assignment only. Uses freelancers for brochure and catalog design and illustration, print ad illustration, storyboards, animatics, animation, posters, TV/film graphics, logos.

First Contact & Terms Send query letter with résumé, photocopies, photographs and tearsheets. Samples are filed. Pays negotiable rates for design and illustration. Rights purchased vary according to project.

THE WILLIAMS McBRIDE GROUP

344 E. Main St., Lexington KY 40507. (859)253-9319. Fax: (859)233-0180. Second location, 709 E. Market St., Louisville KY 40202. (502)583-9972. Fax: (502)583-7009. E-mail: mail@williamsmcbride.com. Website:

www.williamsmcbride.com. **Partners:** Robin Williams Brohm and Kimberly McBride. Estab. 1988. Number of employees: 7. Design firm specializing in brand management, corporate identity and business-to-business marketing.

Needs Approached by 10-20 freelance artists/year. Works with 4 illustrators and 3 designers/year. Prefers freelancers with experience in corporate design, branding. Works on assignment only. 100% of freelance design work demands knowledge of QuarkXPress, Photoshop and Illustrator. Will review résumés of web designers with knowledge of Director and Flash.

First Contact & Terms Designers send query letter with résumé. Will review portfolios electronically or hard-copy samples. Illustrators send website or postcard sample of work. Samples are filed. Responds only if interested. Pays for design by the hour, $50-65. Pays for illustration by the project. Rights purchased vary according to project. Finds artists through submissions, word of mouth, *Creative Black Book*, *Workbook* and *American Showcase*, artist's representatives.

Tips "Keep our company on your mailing list; remind us that you are out there."

LOUISIANA

ANTHONY DI MARCO

301 Aris Ave., Metairie LA 70005. (504)833-3122. **Creative Director:** Anthony Di Marco. Estab. 1972. Number of employees: 1. Specializes in illustration, sculpture, costume design, and art and photo restoration and retouching. Current clients include Audubon Institute, Louisiana Nature and Science Center, Fair Grounds Race Course. Client list available upon request. Professional affiliations: Art Directors Designers Association, Entergy Arts Council, Louisiana Crafts Council, Louisiana Alliance for Conservation of Arts.

- Anthony DiMarco recently completed the re-creation of a 19th-century painting, *Life on the Metairie*, for the Fair Grounds racetrack. The original painting was destroyed by fire in 1993.

Needs Approached by 50 or more freelancers/year. Works with 5-10 freelance illustrators and 5-10 designers/year. Seeks "local freelancers with ambition. Freelancers should have substantial portfolios and an understanding of business requirements." Uses freelancers mainly for fill-in and finish: design, illustration, mechanicals, retouching, airbrushing, posters, model-making, charts/graphs. Prefers highly polished, finished art in pen & ink, airbrush, charcoal/pencil, colored pencil, watercolor, acrylic, oil, pastel, collage and marker. 25% of freelance work demands computer skills.

First Contact & Terms Send query letter with résumé, business card, slides, brochure, photocopies, photographs, transparencies and tearsheets to be kept on file. Samples not filed are returned by SASE. Responds in 1 week if interested. Call or write for appointment to show portfolio. Pays for illustration by the hour or by the project, $100 minimum.

Tips "Keep professionalism in mind at all times. Put forth your best effort. Apologizing for imperfect work is a common mistake freelancers make when presenting a portfolio. Include prices for completed works (avoid overpricing). Three-dimensional works comprise more of our total commissions than before."

FOCUS COMMUNICATIONS, INC.

5739 Lovers Ln., Shreveport LA 71105. (318)219-7688. **President:** Jim Huckaby. Estab. 1976. Number of employees: 3. Approximate annual billing: $1 million. Specializes in corporate identity, direct mail design and full service advertising. Clients: medical, financial and retail. Professional affiliations: AAF.

Needs Approached by 5 freelancers/year. Works with 2 freelance illustrators and designers/year. Prefers local artists with experience in illustration, computer (Mac) design and composition. Uses illustrators mainly for custom projects; print ads. Uses designers mainly for custom projects; direct mail, logos. Also uses freelancers for ad and brochure design and illustration, audiovisual materials, charts/graphs, logos, mechanicals and retouching. Needs computer-literate freelancers for design, illustration and production. 85% of freelance work demands skills in Photoshop, FreeHand and QuarkXPress.

First Contact & Terms Send postcard sample of work or send query letter with brochure, photocopies, photostats, slides, tearsheets and transparencies. Samples are filed. Will contact artist for portfolio review if interested. Portfolio should include b&w and color final art and slides. Pays for design by the hour, $40-75; by the project. Pays for illustration by the project, $100-1,000. Negotiates rights purchased.

Tips Impressed by "turnkey capabilities in Macintosh design and finished film/proof composition."

THE O'CARROLL GROUP

710 W. Prien Lake Rd., Suite 110, Lake Charles LA 70601. (337)478-7396. Fax: (337)478-0503. E-mail: pocarroll @ocarroll.com. Website: www.ocarroll.com. **President:** Peter O'Carroll. Estab. 1978. Ad agency/Public Relations. Specializes in newspaper, magazine, outdoor, radio and TV ads. Product specialty is consumer. Client list available upon request.

Needs Approached by 1 freelancer/month. Works with 1 illustrator every 3 months. Prefers freelancers with experience in computer graphics. Works on assignment only. Uses freelancers mainly for time-consuming computer graphics. Also for brochure and print ad illustration and storyboards. Needs website developers. 65% of work is with print ads. 50% of freelance work demands skills in Illustrator and Photoshop.

First Contact & Terms Send query letter with résumé and paper or electronic samples. Samples are filed or returned by SASE if requested. Responds only if interested. Will contact artist for portfolio review if interested. Pays for design by the project. Pays for illustration by the project. Rights purchased vary according to project. Find artists through viewing portfolios, submissions, word of mouth, American Advertising Federation district conferences and conventions.

MAINE

ⓝ ▣ DW GROUP

50 Monument Square, Portland ME 04101. (207)775-5100. Fax: (207)775-5147. E-mail: dw@dwgroup.com. Website: www.dwgroup.com. **Creative Director:** Roberta Greany. Production Manager: Cheryl Paiva. Estab. 1985. Number of employees: 10. Approximate annual billing: $2 million. Integrated marketing communications agency. Current clients include Outward Bound, Generation Fifth Application, Eastern Maine Healthcare, Bangor Gas Co. and Harvard. Professional affiliations: Get A Clue! Lambert Coffin Infutech, Boston Ad Club, One Club and Ad Club of Maine.

Needs Approached by 10 illustrators and 10 designers/year. Works with 5 illustrators and 2 designers/year. Uses freelancers mainly for illustration. Also for airbrushing, catalog, humorous, medical and technical illustration, model-making, multimedia projects, signage, storyboards, signage and TV/film graphics. 25% of work is with print ads. 100% of design demands skills in Photoshop, Illustrator and QuarkXPress.

First Contact & Terms Designers send query letter with brochure, photographs, résumé, slides, tearsheets and transparencies. Illustrators send postcard sample and query letter with brochure, photographs, résumé, slides, tearsheets and transparencies. Send follow-up postcard every 6 months. Accepts disk submissions compatible with Mac formats. Samples are filed. Responds only if interested. Art director will contact artist for portfolio review of b&w and color photographs, roughs, slides, tearsheets and transparencies if interested. Pays for design by the hour, $35-55; pays for illustration by the project, $50-2,500. Rights purchased vary according to project. Finds artists through word of mouth.

ⓝ ▣ MICHAEL MAHAN GRAPHICS

48 Front, P.O. Box 642, Bath ME 04530-0642. (207)443-6110. Fax: (207)443-6085. E-mail: m2design@ime.net. **Contact:** Linda Delorme. Estab. 1986. Number of employees: 5. Approximate annual billing: $500,000. Design firm. Specializes in publication design—catalogs and direct mail. Product specialties are furniture, fine art and high tech. Current clients include Bowdoin College, Bath Iron Works and Bradco Chair. Client list available upon request. Professional affiliations: G.A.G., AIGA and Art Director's Club-Portland, ME.

Needs Approached by 5-10 illustrators and 10-20 designers/year. Works with 2 illustrators and 2 designers/year. Uses freelancers mainly for production. Also for brochure, catalog and humorous illustration and lettering. 5% of work is with print ads. 100% of design demands skills in Photoshop and QuarkXPress.

First Contact & Terms Designers send query letter with photocopies and résumé. Illustrators send query letter with photocopies. Accepts disk submissions. Samples are filed and are not returned. Responds only if interested. Art director will contact artist for portfolio review of final art roughs and thumbnails if interested. Pays for design by the hour, $15-40. Pays for illustration by the hour, $18-60. Rights purchased vary according to project. Finds artists through word of mouth and submissions.

MARYLAND

⚎ SAM BLATE ASSOCIATES LLC

10331 Watkins Mill Dr., Montgomery Village MD 20886-3950. (301)840-2248. Fax: (301)990-0707. Toll-Free: (877)821-6824. E-mail: info@writephotopro.com. Website: www.writephotopro.com. **President:** Sam Blate. Number of employees: 2. Approximate annual billing: $120,000. AV and editorial services firm. Clients: business/professional, US government, private.

Needs Approached by 6-10 freelancers/year. Works with 1-5 freelance illustrators and 1-2 designers/year. Only works with freelancers in the Washington DC metropolitan area. Works on assignment only. Uses freelancers for cartoons (especially for certain types of audiovisual presentations), editorial and technical illustrations (graphs, etc.) for 35mm and digital slides, pamphlet and book design. Especially important are "technical and

aesthetic excellence and ability to meet deadlines.'' 80% of freelance work demands knowledge of PageMaker, Photoshop, and/or Powerpoint for Windows.

First Contact & Terms Send query letter with résumé and website, tearsheets, brochure, photocopies, slides, transparencies or photographs to be kept on file. Accepts disk submissions compatible with Photoshop and PageMaker. IBM format only. ''No original art.'' Samples are returned only by SASE. Responds only if interested. Pays by the hour, $20-50. Rights purchased vary according to project, ''but we prefer to purchase first rights only. This is sometimes not possible due to client demand, in which case we attempt to negotiate a financial adjustment for the artist.''

Tips ''The demand for technically-oriented artwork has increased.''

DEVER DESIGNS

1056 West St., Laurel MD 20707. (301)776-2812. Fax: (301)953-1196. E-mail: info@deverdesigns.com. Website: www.deverdesigns.com. **President:** Jeffrey Dever. Marketing Director: Holly Hagen. Estab. 1985. Number of employees: 8. Specializes in annual reports, corporate identity and publication design. Clients: corporations, museums, government agencies, associations, nonprofit organizations.

Needs Approached by 100 freelance illustrators/year. Works with 30-50 freelance illustrators/year. Prefers artists with experience in editorial illustration. Uses illustrators mainly for publications.

First Contact & Terms Send postcard, samples or query letter with photocopies, résumé and tearsheets. Accepts PDFs and disk submissions compatible with Photoshop, Illustrator or QuarkXPress, but prefers hard copy samples which are filed. Will contact artist for portfolio review if interested. Portfolio should include b&w and/or color photocopies for files. Pays for illustration by the project. Rights purchased vary according to project. Finds artists through referrals.

Tips Impressed by ''uniqueness and consistent quality.''

▣ PICCIRILLI GROUP

502 Rock Spring Rd., Bel Air MD 21014. (410)879-6780. Fax: (410)879-6602. E-mail: info@picgroup.com. Website: www.picgroup.com. **President:** Charles Piccirilli. Executive Vice President: Micah Piccirilli. Estab. 1974. Specializes in design and advertising; also annual reports, advertising campaigns, direct mail, brand and corporate identity, displays, packaging, publications and signage. Clients: recreational sport industries, fleet leasing companies, technical product manufacturers, commercial packaging corporations, direct mail advertising firms, realty companies, banks, publishers and software companies.

Needs Works with 4 freelance designers/year. Works on assignment only. Mainly uses freelancers for layout or production. Prefers local freelancers. 75% of design demands skills in Illustrator 5.5 and QuarkXPress 3.3.

First Contact & Terms Send query letter with brochure, résumé and tearsheets; prefers originals as samples. Samples returned by SASE. Responds on whether to expect possible future assignments. To show a portfolio, mail roughs and finished art samples or call for an appointment. Pays for design and illustration by the hour, $20-45. Considers complexity of project, client's budget, and skill and experience of artist when establishing payment. Buys one-time or reprint rights; rights purchased vary according to project.

Tips ''Portfolios should include work from previous assignments. The most common mistake freelancers make is not being professional with their presentations. Send a cover letter with photocopies of work.''

▣ ▣ SPIRIT CREATIVE SERVICES INC.

3157 Rolling Rd., Edgewater MD 21037. (410)956-1117. Fax: (410)956-1118. E-mail: alice@spiritcreativeservices .com. Website: www.spiritcreativeservices.com. **President:** Alice Yeager. Estab. 1992. Number of employees: 2. Approximate annual billing: $90,000. Specializes in catalogs, signage, books, annual reports, brand and corporate identity, display, direct mail, package and publication design, web page design, technical and general illustration, copywriting, photography and marketing. Clients: associations, corporations, government. Client list available upon request.

Needs Approached by 30 freelancers/year. Works with local designers only. Uses freelancers for ad, brochure, catalog, poster and P-O-P design and illustration, books, direct mail and magazine design, audiovisual materials, crafts/graphs, lettering, logos and mechanicals. Also for multimedia and Internet projects. 100% of design and 10% of illustration demands knowledge of Illustrator, Photoshop and PageMaker, A Type Manager and QuarkXPress. Also HTML coding and knowledge of web design.

First Contact & Terms Send 2-3 samples of work with résumé. Accepts hardcopy submissions. Samples are filed. Responds in 1-2 weeks if interested. Request portfolio review in original query. Artist should follow up with call and/or letter after initial query. Portfolio should include b&w and color final art, tearsheets, sample of comping ability. Pays for design by the project, $50-6,000.

Tips ''Paying attention to due dates, details, creativity, communication and intuition is vital.''

MASSACHUSETTS

◆ RICHARD BERTUCCI/GRAPHIC COMMUNICATIONS
3 Juniper Lane, Dover MA 02030-2146. (508)785-1301. Fax: (508)785-2072. E-mail: rich.bert@netzero.net. **Owner:** Richard Bertucci. Estab. 1970. Number of employees: 1. Approximate annual billing: $500,000. Specializes in annual reports, corporate identity, display, direct mail, package design, print advertising, collateral material. Clients: companies and corporations. Professional affiliations: AIGA.

Needs Approached by 12-24 freelancers/year. Works with 6 freelance illustrators and 3 designers/year. Prefers local artists with experience in business-to-business advertising. Uses illustrators mainly for feature products. Uses designers mainly for fill-in projects, new promotions. Also uses freelancers for ad, brochure and catalog design and illustration, direct mail, magazine and newspaper design and logos. 50% of design and 25% of illustration demand knowledge of Illustrator, Photoshop and QuarkXPress.

First Contact & Terms Send postcard sample of work or send query letter with brochure and résumé. Samples are filed. Will contact artist for portfolio review if interested. Portfolio should include b&w and color roughs. Pays for design by the project, $500-5,000. Pays for illustration by the project, $250-2,500. Rights purchased vary according to project.

Tips "Send more information, not just a postcard with no written information." Chooses freelancers based on "quality of samples, turn-around time, flexibility, price, location."

FLAGLER ADVERTISING/GRAPHIC DESIGN
Box 280, Brookline MA 02446. (617)566-6971. Fax: (617)566-0073. **President/Creative Director:** Sheri Flagler. Specializes in corporate identity, brochure design, ad campaigns and package design. Clients: finance, real estate, high-tech and direct mail agencies, infant/toddler manufacturers.

Needs Works with 10-20 freelancers/year. Works on assignment only. Uses freelancers for illustration, photography, retouching, airbrushing, charts/graphs and lettering.

First Contact & Terms Send résumé, business card, brochures, photocopies or tearsheets to be kept on file. Call or write for appointment to show portfolio. Samples filed and are not returned. Responds only if interested. Pays for design and illustration by the project, $150-2,500. Considers complexity of project, client's budget and turnaround time when establishing payment.

Tips "Send a range and variety of styles showing clean, crisp and professional work."

◆ G2 PARTNERS
209 W. Central St., Natick MA 01760. (508)651-8158. Fax: (508)655-1637. Website: www.g2partners.com. Estab. 1975. Number of employees: 2. Ad Agency. Specializes in advertising, direct mail, branding programs, literature, annual reports, corporate identity. Product specialty is business-to-business.

Needs Uses freelancers mainly for advertising, direct mail and literature. Also for brochure and print ad illustration.

First Contact & Terms Samples are filed or are returned by SASE if requested by artist. Does not reply. Portfolio review not required. Pays for illustration by the project, $500-3,500. Finds artists through annuals and sourcebooks.

◆ ▣ MATZELL RICHARD & WATTS
195 State St., Suite 4, Boston MA 02109-2602. (617)742-4411. Fax: (617)742-4484. E-mail: kcmrw@wing.net. Website: www.mrwinc.com. **Executive Vice President, Creative Director:** Jim Richard. Estab. 1983. Number of employees: 13. Approximate annual billing: $10 million. Ad agency. Specializes in ads, collateral, DM. Product specialties are high tech, healthcare. Client list available upon request.

Needs Approached by 40-50 freelance illustrators and 40-50 designers/year. Works with 5-10 freelance illustrators and 2-5 designers/year. Prefers freelancers with experience in a variety of techniques: brochure, medical and technical illustration, multimedia projects, retouching, storyboards, TV/film graphics and web page design. 75% of work is with print ads. 90% of design and 90% of illustration demands skills in FreeHand, Photoshop, QuarkXPress, Illustrator.

First Contact & Terms Designers send query letter with photocopies, photographs, résumé. Illustrators send postcard sample and résumé, follow-up postcard every 6 months. Accepts disk submissions compatible with QuarkXPress 7.5/version 3.3. Send EPS files. Samples are filed. Will contact for portfolio review of b&w, color final art if interested. Pays by the hour, by the project or by the day depending on experience and ability. Rights purchased vary according to project. Finds artist through sourcebooks and word of mouth.

DONYA MELANSON ASSOCIATES
5 Bisson Lane, Merrimac MA 01860. (978)346-9240. Fax: (978)346-8345. E-mail: dmelanson@dmelanson.com. Website: www.dmelanson.com. **Contact:** Donya Melanson. Advertising agency. Number of employees: 6. Cli-

ents: industries, institutions, education, associations, publishers, financial services and government. Current clients include: US Geological Survey, Mannesmann, Cambridge College, American Psychological Association, Brookings Institution Press and US Dept. of Agriculture. Client list available upon request.

Needs Approached by 30 artists/year. Works with 3-4 illustrators/year. Most work is handled by staff, but may occasionally use illustrators and designers. Uses artists for stationery design, direct mail, brochures/flyers, annual reports, charts/graphs and book illustration. Needs editorial and promotional illustration. 50% of freelance work demands skills in Illustrator, QuarkXPress or Photoshop.

First Contact & Terms Query with brochure, résumé, photostats and photocopies. Provide materials (no originals) to be kept on file for future assignments. Originals returned to artist after use only when specified in advance. Call or write for appointment to show portfolio or mail thumbnails, roughs, final art, final reproduction/product and color and b&w tearsheets, photostats and photographs. Pays for design and illustration by the project, $100 minimum. Considers complexity of project, client's budget, skill and experience of artist and how work will be used when establishing payment.

Tips "Be sure your work reflects concept development. We would like to see more electronic design and illustration capabilities."

☒ ☑ MONDERER DESIGN, INC.

2067 Massachusetts Ave., 3rd Floor, Cambridge MA 02140. (617)661-6125. Fax: (617)661-6152. E-mail: info@monderer.com. Website: www.monderer.com. **Creative Director:** Jeffrey Gobin. Estab. 1982. Specializes in annual reports, corporate identity, package and publication design, employee benefit programs, corporate capability brochures. Clients: corporations (hi-tech, industry, institutions, healthcare, utility, consulting, service) and nonprofit organizations. Current clients include Aspen Technology, Spotfire, eCredit.com, Dynisco, Harvard AIDS Project and Project Hope. League School, Pegasystems and Millipore. Client list on website.

Needs Approached by 40 freelancers/year. Works with 5-10 freelance illustrators and 1-5 designers/year. Works on assignment only. Uses illustrators mainly for corporate communications. Uses designers for design and production assistance. Also uses freelancers for mechanicals and illustration. Needs computer-literate freelancers for design, illustration and production. 50% of freelance work demands knowledge of Illustrator, QuarkXPress, Photoshop or FreeHand. Needs editorial and corporate illustration.

First Contact & Terms Send query letter with brochure, tearsheets, photographs, photocopies or nonreturnable postcards. Will look at links and PRF files. Samples are filed. Will contact artist for portfolio review if interested. Portfolio should include b&w and color-finished art samples. Sometimes requests work on spec before assigning a job. Pays for design by the hour, $15-25; by the project. Pays for illustration by the project, $250 minimum. Negotiates rights purchased. Finds artists through submissions/self-promotions and sourcebooks.

☒ ☒ PRECISION ARTS ADVERTISING INC.

57 Fitchburg Rd., Ashburnham MA 01430. (978)827-4927. Fax: (978)827-4928. E-mail: artistmarket@precisionarts.com. Website: www.precisionarts.com. **President:** Terri Adams. Estab. 1985. Number of employees: 2. Full-service web/print ad agency. Specializes in internet marketing strategy, website/print design, graphic design. Product specialty is manufacturing, including plastics, surgical and medical instruments, electronic equipment and instrumentation. Client list available upon request. Clients include: Northern Products, Safety Source Northeast, Ranor.

Needs Approached by 5 freelance illustrators and 5 designers/year. Works with 1 freelance illustrator and 1 designer/year. Prefers local freelancers. 49% of work is with printing/marketing. 36% of work is web design. Freelance web skills required in Macintosh DreamWeaver and Photoshop; freelance print skills required in QuarkXPress, Photoshop, Illlustrator and Pre-Press.

First Contract & Terms Send résumé with links to artwork and suggested hourly rate.

☒ ☒ RICHLAND DESIGN ASSOCIATES

47 Studio Rd., Newton MA 02166. (617)965-8900. Fax: (617)796-9223. E-mail: richland@richland.com. Website: www.richland.com. **President:** Judy Richland. Estab. 1981. Number of employees: 3. Approximate annual billing: $500,000. Specializes in annual reports, corporate identity, direct mail and package design. Clients: corporations, museums, schools, state agencies. Current clients include Nynex Properties, Apple Computer, Integrate Computer Solutions. Client list available upon request. Professional affiliations: AIGA.

Needs Approached by 10 freelancers/year. Works with 5 freelance illustrators and 10 designers/year. Prefers local artists only. Uses illustrators mainly for annual reports. Also uses freelancers for ad, catalog and direct mail design. Freelancers should be familiar with QuarkXPress, Photoshop, Illustrator and Aldus Freehand.

First Contact & Terms Send query letter with brochure, photographs, résumé and tearsheets. Samples are filed. Will contact artist for portfolio review if interested. Portfolio should include b&w and color photographs, slides and thumbnails. Pays for design and illustration by the project. Rights purchased vary according to project.

ⓃⒺ RUBY SHOES STUDIO, INC.

6 Marion Rd., Middleboro MA 02364. (508)946-9909. Fax: (508)946-9969. Website: www.rubyshoes.com. **Creative Director:** Susan Tyrrell Donelan. Estab. 1984. Number of employees: 12. Specializes in corporate identity, direct mail, website design, package and publication design. Client list available upon request.

Needs Approached by 150-300 freelancers/year. Works with 10-20 freelance illustrators and 10-20 designers/year. Uses freelance illustrators mainly for brochure illustration. Uses freelance designers mainly for ad design and mechanicals. Also uses freelancers for brochure and P-O-P design and illustration, 3-D design, mechanicals, airbrushing, lettering, logos, poster and direct mail design and graphs. Freelancers should be familiar with Illustrator, Photoshop, QuarkXPress, and/or 3-D Design.

First Contact & Terms Send query letter with nonreturnable samples, such as tearsheets and résumé. Samples are filed or are returned by SASE. Responds only if interested. To show a portfolio, mail roughs, original/final art, b&w and color tearsheets and slides. Pays for design by the hour, $20-30; by the project, $150-1,500. Pays for illustration by the project. Buys first or one-time rights.

Ⓝ🔲 SELBERT-PERKINS DESIGN COLLABORATIVE

11 Water St., Arlington MA 02476. (781)574-6605. Fax: (781)574-6606. E-mail: ereed@spdeast.com. Website: www.selbertperkins.com. Estab. 1980. Number of employees: 25. Specializes in annual reports, brand identity design, displays, landscape architecture and urban design, direct mail, product and package design, exhibits, interactive media and CD-ROM design and print and environmental graphic design. Clients: airports, colleges, theme parks, corporations, hospitals, computer companies, retailers, financial institutions, architects. Professional affiliations: AIGA, SEGD.

- This firm has an office at 200 Culver Blvd., Playa del Rey CA 90293. (310)882-5223. Fax: (310)822-5203. E-mail: nmartinez@spdwest.com.

Needs Approached by "hundreds" of freelancers/year. Works with 10 freelance illustrators and 20 designers/year. Prefers artists with "experience in all types of design and computer experience." Uses freelance artists for brochures, mechanicals, logos, P-O-P, poster and direct mail. Also for multimedia projects. 100% of freelance work demands knowledge of QuarkXPress, FreeHand, Photoshop, PageMaker, Canvas and Persuasion.

First Contact & Terms Send query letter with brochure, résumé, tearsheets, photographs, photocopies, slides and transparencies. Samples are filed. Responds only if interested. Portfolios may be dropped off every Monday-Friday. Artist should follow up with call and/or letter after initial query. Will contact artist for portfolio review if interested. Pays for design by the hour, $15-35 or by the project. Pays for illustration by the project. Rights purchased vary according to project. Finds artists through word of mouth, magazines, submissions/self-promotions, sourcebooks and agents.

Ⓝ SPECTRUM BOSTON CONSULTING, INC.

9 Park St., Boston MA 02108. (617)367-1008. Fax: (617)367-5824. E-mail: gboesel@spectrumboston.com. **President:** George Boesel. Estab. 1985. Specializes in brand and corporate identity, display and package design and signage. Clients: consumer, durable manufacturers.

Needs Approached by 50 freelance artists/year. Works with 15 illustrators and 3 designers/year. All artists employed on work-for-hire basis. Works on assignment only. Uses illustrators mainly for package and brochure work. Also for brochure design and illustration, mechanicals, logos, P-O-P design and illustration and model-making. 100% of design and 85% of illustration demand knowledge of Illustrator, QuarkXPress, Photoshop or FreeHand. Needs technical and instructional illustration.

First Contact & Terms Designers send query letter with résumé and photocopies. Illustrators send query letter with tearsheets, photographs and photocopies. Accepts any Mac-formatted disk submissions except for PageMaker. Samples are filed. Responds only if interested. Call or write for appointment to show portfolio of roughs, original/final art and color slides.

✅ⒺⒽ TR PRODUCTIONS

209 W. Central Street, Suite 108, Natick MA 01760. (508)650-3400. Fax: (508)650-3455. Website: trprod.com. **Creative Director:** Cary M. Benjamin. Estab. 1947. Number of employees: 12. AV firm. Full-service multimedia firm. Specializes in FLASH, collateral, multimedia, web graphics and video.

Needs Approached by 15 freelancers/year. Works with 5 freelance illustrators and 5 designers/year. Prefers local freelancers with experience in slides, web, multimedia, collateral and video graphics. Works on assignment only. Uses freelancers mainly for slides, web, multimedia, collateral and video graphics. Also for brochure and print ad design and illustration, slide illustration, animation and mechanicals. 25% of work is with print ads. Needs computer-literate freelancers for design, production and presentation. 95% of work demands skills in FreeHand, Photoshop, Premier, After Effects, Powerpoint, QuarkXPress, Illustrator, Flash and Front Page.

First Contact & Terms Send query letter. Samples are filed. Does not reply. Artist should follow up with call. Will contact artist for portfolio review if interested. Rights purchased vary according to project.

Advertising & Design

N TVN-THE VIDEO NETWORK

31 Cutler Dr., Ashland MA 01721-1210. (508)881-1800. E-mail: tvnvideo@aol.com. Website: www.tvnvideo.com. **Producer:** Gregg McAllister. Estab. 1986. AV firm. Full-service multimedia firm. Specializes in video production for business, broadcast and special events. Product specialties "cover a broad range of categories." Current clients include Marriott, Digital, IBM, Waters Corp., National Park Service.

Needs Approached by 1 freelancer/month. Works with 1 illustrator/month. Prefers freelancers with experience in Mac/NT, Amiga PC, The Video Toaster, 2D and 3D programs. Works on assignment only. Uses freelancers mainly for video production, technical illustration, flying logos and 3-D work. Also for storyboards, animation, TV/film graphics and logos.

First Contact & Terms Send query letter with videotape or computer disk. Samples are filed or are returned. Responds in 2 weeks. Will contact artist for portfolio review if interested. Portfolio should include videotape and computer disk. Pays for design by the hour, $50; by the project, $1,000-5,000; by the day, $250-500. Buys all rights. Finds artists through word of mouth, magazines and submissions.

Tips Advises freelancers starting out in the field to find a company internship or mentor program.

N WAVE DESIGN WORKS

P.O. Box 995, Norfolk MA 02056. Phone/fax: (508)541-9171. E-mail: ideas@wavedesignworks.com. **Principal:** John Buchholz. Estab. 1986. Specializes in corporate identity and display, package and publication design. Clients: corporations—primarily biotech and software. Current clients include Genzyme, New England Biolabs, Siemens Medical, Neurometrix.

Needs Approached by 24 freelance graphic artists/year. Works with 1-5 freelance illustrators and 1-5 freelance designers/year. Works on assignment only. Uses illustrators mainly for ad illustration. Also uses freelance artists for brochure, catalog, poster and ad illustration; lettering; and charts/graphs. 100% of design and 50% of illustration demand knowledge of QuarkXPress, Illustrator or Photoshop, Indesign.

First Contact & Terms Send query letter with brochure, résumé, photocopies, photographs, SASE, slides, transparencies and tearsheets. Accepts disk submissions compatible with above programs. Samples are filed. Responds only if interested. Artist should follow up with call and/or letter after initial query. Portfolio should include b&w and color thumbnails and final art. Pays for design by the hour, $12.50-25. Pays for illustration by the project. Rights purchased vary according to project. Finds artists through submissions and sourcebooks.

N ▣ WEYMOUTH DESIGN, INC.

332 Congress St., Boston MA 02210-1217. (617)542-2647. Fax: (617)451-6233. E-mail: jlizardo@weymouthdesign.com. **Office Manager:** Judith Benfari. Estab. 1973. Number of employees: 16. Specializes in annual reports, corporate collateral, designing websites and laptop presentations, CD-ROMs and miscellaneous multimedia. Clients: corporations and small businesses. Client list not available. Professional affiliation: AIGA.

Needs Works with 3-5 freelance illustrators and/or photographers. Needs editorial, medical and technical illustration mainly for annual reports. Also uses freelancers for multimedia projects.

First Contact & Terms Send query letter with résumé or illustration samples and/or tearsheets. Samples are filed or are returned by SASE if requested by artist. Will contact artist for portfolio review if interested.

MICHIGAN

▣ BIGGS GILMORE COMMUNICATIONS

261 E. Kalamazoo Ave., Suite 300, Kalamazoo MI 49007-3990. (269)349-7711. Fax: (269)349-3051. Website: www.biggs-gilmore.com. Estab. 1973. Ad agency. Full-service, multimedia firm. Specializes in traditional advertising (print, collateral, TV, radio, outdoor), branding, strategic planning, e-business development, and media planning and buying. Product specialties are consumer, business-to-business, marine and healthcare.

• This is one of the largest agencies in southwestern Michigan. Clients include DuPont, Kellogg Company, Zimmer Inc., Armstrong Machine Works, American Greetings, Forest Laboratories, Pfizer Animal Health and Wilmington Trust.

Needs Approached by 10 artists/month. Works with 1-3 illustrators and designers/month. Works both with artist reps and directly with artist. Prefers artists with experience with client needs. Works on assignment only. Uses freelancers mainly for completion of projects needing specialties. Also for brochure, catalog and print ad design and illustration, storyboards, mechanicals, retouching, billboards, posters, TV/film graphics, lettering and logos.

First Contact & Terms Send query letter with brochure, photocopies and résumé. Samples are filed. Responds only if interested. Call for appointment to show portfolio. Portfolio should include all samples the artist considers appropriate. Pays for design and illustration by the hour and by the project. Rights purchased vary according to project.

N ▣ LEO J. BRENNAN, INC. Marketing Communications

2359 Livernois, Troy MI 48083-1692. (248)524-3222. Fax: (248)362-2355. E-mail: lbrennan@ljbrennan.com. Website: www.ljbrennan.com. **Vice President:** Virginia Janusis. Estab. 1969. Number of employees: 11. Ad agency, PR and marketing firm. Clients: industrial, electronics, robotics, automotive, banks and CPAs.

Needs Works with 2 illustrators and 2 designers/year. Prefers experienced artists. Uses freelancers for design, technical illustration, brochures, catalogs, retouching, lettering, keylining and typesetting. Also for multimedia projects. 50% of work is with print ads. 100% of freelance work demands knowledge of IBM software graphics programs.

First Contact & Terms Send query letter with résumé and samples. Samples not filed are returned only if requested. Responds only if interested. Call for appointment to show portfolio of thumbnails, roughs, original/final art, final reproduction/product, color and b&w tearsheets, photostats and photographs. Payment for design and illustration varies. Buys all rights.

N ▣ CREATIVE HOUSE MARKETING

222 Main St., Suite 111, Rochester MI 48307. (248)601-5223. Fax: (248)928-0473. E-mail: results@creative-house.com. **Executive Vice President/Creative Director:** Don Anderson. Estab. 1964. Full service advertising/marketing firm. Clients: home building products, sporting goods, automotive OEM, industrial manufacturing OEM, residential and commercial construction, land development, consumer, retail, finance, manufacturing, b to b and healthcare.

Needs Assigns 20-30 jobs; buys 10-20 illustrations/year. Works with 6 illustrators and 4 designers/year. Prefers local artists. Uses freelancers for work on filmstrips, consumer and trade magazines, multimedia kits, direct mail, television, brochures/flyers and newspapers. Most of work involves illustration, design and comp layouts of ads, brochures, catalogs, annual reports and displays. 25% of work is with print ads.

First Contact & Terms Query with résumé, business card and brochure/flier or postcard sample to be kept on file. Artist should follow up with call. Samples returned by SASE. Responds in 2 weeks. Originals not returned. Prefers to see online portfolios. Pays for design by the hour, $25-45; by the day, $240-400; or by the project. Pays for illustration by the project, $200-2,000. Considers complexity of project, client's budget and rights purchased when establishing payment. Reproduction rights are purchased as a buy-out.

N ▣ WILLIAM M. SCHMIDT ASSOCIATES

1991 Severn Rd., Gross Pointe MI 48236. (313)881-8075. Fax: (313)881-1930. Website: www.wmsa.com. **President:** John M. Schmidt. Estab. 1942. Primarily specializes in product and transportation design, as well as corporate identity, displays, interior and package design, signage and technical illustration. Clients: companies and agencies. Majority of clients are in Fortune 500. Client list available upon request.

Needs Approached by 30-40 freelance artists/year. Works with 2-3 freelance illustrators and designers/year. Prefers local artists with experience in automotive and product design. Works on assignment only. Also uses freelance artists for brochure design and illustration, mechanicals, airbrushing, logos and model-making. Needs technical illustrations. Needs computer-literate freelancers for design and production. 40% of freelance work demands computer literacy in PageMaker, FreeHand, Photoshop, Illustrator, Alias/Wavefront.

First Contact & Terms Send query letter with résumé, SASE and slides. Samples are not filed and are returned by SASE. Responds in 2 weeks. To show a portfolio, mail slides, roughs and preliminary sketches. Pays for design and illustration by the hour, $15-30 or by the project. Buys all rights.

N ▣ J. WALTER THOMPSON USA

500 Woodward Ave., Detroit MI 48226-3428. (313)964-3800. Website: www.jwtworld.com. **Art Administrator:** Steve Brouwer. Number of employees: 450. Approximate annual billing: $50 million. Ad agency. Clients: automotive, consumer, industry, media and retail-related accounts.

Needs Approached by 50 freelancers/year. Works with 15 freelance illustrators and 5 designers/year. "Prefer using local talent. Will use out-of-town talent based on unique style." 75% of design and 50% of illustration demand knowledge of Photoshop. Deals primarily with established artists' representatives and art/design studios. Uses in-house computer/graphic studio.

First Contact & Terms Send postcard sample. Assignments awarded on lowest bid. Call for appointment to show portfolio of thumbnails, roughs, original/final art, final reproduction/product, color tearsheets, photostats and photographs. Pays for design and illustration by the project.

Tips "Portfolio should be comprehensive but not too large. Organization of the portfolio is as important as the sample. Mainly, consult professional rep."

N ▣ VARON & ASSOCIATES, INC.

989 Chicago Rd., Troy MI 48083. (248)307-0587. **President:** Sharron Varon. Estab. 1963. Specializes in annual reports; brand and corporate identity; display, direct mail and package design and technical illustration. Clients:

corporations (industrial and consumer). Current clients include Dallas Industries Corp., Enprotech Corp., FEC Corp., Johnstone Pump Corp., Microphoto Corp., PW & Associates. Client list available upon request.

Needs Approached by 20 freelancers/year. Works with 7 illustrators and 7 designers/year. Prefers local freelancers only. Works on assignment only. Uses freelancers mainly for brochure, catalog, P-O-P and ad design and illustration, direct mail design, mechanicals, retouching, airbrushing, audiovisual materials and charts/graphs. Needs computer-literate freelancers for design, illustration and presentation. 70% of freelance work demands knowledge of PageMaker, QuarkXPress, FreeHand or Illustrator.

First Contact & Terms Send brochure, samples, slides and transparencies. Samples are filed. Reports back to the artist only if interested. Portfolios may be dropped off every Monday-Friday. Call for appointment. Portfolio should include color thumbnails, roughs, final art and tearsheets. Buys all rights. Finds artists through submissions.

MINNESOTA

◻ PATRICK REDMOND DESIGN

P.O. Box 75430-AGDM, St. Paul MN 55175-0430. (651)503-4480. E-mail PatrickRedmond@apexmail.com and redmond@patrickredmonddesign.com. Website (for business) www.PatrickRedmondDesign.com. **Designer/Owner/President:** Patrick M. Redmond, M.A. Estab. 1966. Number of employees: 1. Specializes in book cover design, logo and trademark design, brand and corporate identity, package, publication and direct mail design, website design, design consulting and education and posters. Has provided design services for many clients in the following categories: publishing, advertising, marketing, retail, financial, food, arts, education, computer, manufacturing, small business, healthcare, government and professions. Recent clients include: independent publishers, performing artists, etc.

Needs Clients use freelancers mainly for editorial and technical illustration, publications, books, brochures and newsletters. Also for website and multimedia projects. 80% of freelance work demands knowledge of Macintosh, QuarkXPress, Photoshop, Illustrator, InDesign (latest versions).

First Contact & Terms Send postcard sample and/or photocopies. Samples not filed are thrown away. No samples returned. Responds only if interested. "Artist will be contacted for portfolio review if work seems appropriate for client needs. Patrick Redmond Design will not be responsible for acceptance of delivery or return of portfolios not specifically requested from artist or rep. Samples must be presented in person unless other arrangements are made. Unless specifically agreed to in writing in advance, portfolios should not be sent unsolicited." Client pays for design and illustration by the project. Rights purchased vary according to project. Considers buying second rights (reprint rights) to previously published work. Finds artists through word of mouth, magazines, submissions/self-promotions, exhibitions, competitions, CD-ROM, sourcebooks, agents and WWW.

Tips "Provide website address so samples of your work may be viewed on the WWW. I see trends toward extensive use of the WWW and a broader spectrum of approaches to images, subject matter and techniques. Clients also seem to have increasing interest in digitized, copyright-free stock images of all kinds." Advises freelancers starting out in the field to "create as much positive exposure for your images or design examples as possible. Make certain your name and location appear with image or design credits. Photos, illustrations and design are often noticed with serendipity. For example, your work may be just what a client needs—so make sure you have name and UFL in credit. If possible, include your e-mail address and www URL with or on your work. Do not send samples via e-mail unless specifically requested. At times, client and project demands require working in teams online, via internet, sending/receiving digital files to and from a variety of locations. *Do not* send digital files/images as attachments to e-mails unless specifically requested. Provide names of categories you specialize in, website addresses/url's where your work/images may be viewed."

TAKE 1 PRODUCTIONS

9969 Valley View Rd., Minneapolis MN 55344. (952)831-7757. Fax: (952)831-2193. Website: www.take1productions.com. **Producer:** Rob Hewitt. Estab. 1985. Number of employees: 10. Approximate annual billing: $800,000. AV firm. Full-service multimedia firm. Specializes in video and multimedia production. Specialty is industrial. Current clients include 3M, NordicTrack and Kraft. Client list available upon request. Professional affiliations: MCAI, SME, IICS.

Needs Approached by 100 freelancers/year. Works with 10 freelance illustrators/year. Prefers freelancers with experience in video production. Uses freelancers for graphics, sets. Also for animation, brochure design, logos, model making, signage and TV/film graphics. 2% of work is with print ads. 90% of freelance work demands knowledge of Photoshop and Lightwave.

First Contact & Terms Send query letter with video. Samples are filed. Will contact artist for portfolio review

if interested. Pays for design and illustration by the hour or by the project. Rights purchased vary according to project. Finds artists through sourcebooks, word of mouth.

Tips "Tell me about work you have done with videos."

▣ ▤ UNO HISPANIC ADVERTISING AND DESIGN

2836 Lindale S., Suite 002, Minneapolis MN 55408. (612)874-1920. E-mail: unoonline.com. Website: www.unoo nline.com. **Creative Director:** Luis Fitch. Marketing Director: Carolina Ornelas. Estab. 1990. Number of employees: 6. Approximate annual billing: $950,000. Specializes in brand and corporate identity, display, package and retail design and signage for the US Hispanic markets. Clients: Latin American corporations, retail. Current clients include MTV Latino, Target, Mervyn's, 3M, Dayton's, SamGoody, Univision, Wilson's. Client list available upon request. Professional affiliations: AIGA, GAG.

Needs Approached by 33 freelancers/year. Works with 40 freelance illustrators and 20 designers/year. Works only with artists' reps. Prefers local artists with experience in retail design, graphics. Uses illustrators mainly for packaging. Uses designers mainly for retail graphics. Also uses freelancers for ad and book design, brochure, catalog and P-O-P design and illustration, audiovisual materials, logos and model making. Also for multimedia projects (Interactive Kiosk, CD-Educational for Hispanic Market). 60% of design demands computer skills in Illustrator, Photoshop, FreeHand and QuarkXPress.

First Contact & Terms Designers send postcard sample, brochure, résumé, photographs, slides, tearsheets and transparencies. Illustrators send postcard sample, brochure, photographs, slides and tearsheets. Accepts disk submissions compatible with Illustrator, Photoshop, FreeHand. Send EPS files. Samples are filed. Will contact artist for portfolio review if interested. Portfolio should include color final art, photographs and slides. Pays for design by the project, $500-6,000. Pays for illustration by the project, $200-20,000. Rights purchased vary according to project. Finds artists through artist reps, *Creative Black Book* and *Workbook*.

Tips "It helps to be bilingual and to have an understanding of Hispanic cultures."

MISSOURI

▣ ▤ PHOENIX LEARNING GROUP, INC.

2349 Chaffee Dr., St. Louis MO 63146. (314)569-0211. Website: phoenixlearninggroup.com. **President:** Heinz Gelles. Executive Vice President: Barbara Bryant. Vice President, Market Development: Kathy Longsworth. Number of employees: 50. Clients: libraries, museums, religious institutions, US government, schools, universities, film societies and businesses. Produces and distributes educational films.

Needs Works with 1-2 freelance illustrators and 2-3 designers/year. Prefers local freelancers only. Uses artists for motion picture catalog sheets, direct mail brochures, posters and study guides. Also for multimedia projects. 85% of freelance work demands knowledge of PageMaker, QuarkXPress and Illustrator.

First Contact & Terms Send postcard sample and query letter with brochure (if applicable). Send recent samples of artwork and rates to director of promotions. "No telephone calls please." Responds if need arises. Buys all rights. Keeps all original art "but will loan to artist for use as a sample." Pays for design and illustration by the hour or by the project. Rates negotiable. Free catalog upon written request.

▤ ▣ RHYCOM STRATEGIC ADVERTISING

(formerly Bryan/Donald, Inc. Advertising), 2345 Grand Blvd., Suite 250, Kansas City MO 64108. (816)471-4866. Website: www.rhycom.com. **President:** Rick Rhyner. Multimedia, full-service ad agency. Clients: food, pharmaceutical, insurance, franchises.

Needs Works on assignment only. Uses freelancers for design, illustration, brochures, catalogs, books, newspapers, consumer and trade magazines, P-O-P display, mechanicals, retouching, animation, billboards, posters, direct mail packages, lettering, logos, charts/graphs and ads.

First Contact & Terms Send samples showing your style. Samples are not filed and are not returned. Responds only if interested. Call for appointment to show portfolio. Considers complexity of project and skill and experience of artist when establishing payment. Buys all rights.

▣ ▤ SIGNATURE DESIGN

2101 Locust, St. Louis MO 63103. (314)621-6333. Fax: (314)621-0179. E-mail: info@theresemckee.com. Website: www.theresemckee.com. **Owner:** Therese McKee. Estab. 1993. Interpretive graphic and exhibit design firm producing conceptual design, design development and project management for exhibits in museums, visitor centers and parks; interpretive signage for parks and gardens; and computer interactives and graphics for websites. Current clients include Bureau of Land Management, Missouri Botanical Garden, United States Post Office. Client list available upon request.

Needs Approached by 15 freelancers/year. Works with 1-2 illustrators and 1-2 designers/year. Prefers local

freelancers only. Works on assignment only. 50% of freelance work demands knowledge of QuarkXPress, FLASH animation, Illustrator or Photoshop.

First Contact & Terms Send query letter with résumé, tearsheets and photocopies. Samples are filed. Responds only if interested. Artist should follow up with letter after initial query. Portfolio should include "whatever best represents your work." Pays for design by the hour. Pays for illustration by the project.

▣ STOBIE GROUP, LLC

240 Sovereign Court, St. Louis MO 63011. (636)256-9400. Fax: (636)256-0943. E-mail: mtuttle@stobiegroup.c om. Website: www.stobiegroup.com. **Creative Director:** Mary Tuttle. Estab. 1935. Number of employees: 10. Approximate annual billing: $8 million. Ad agency. Full-service, multimedia firm. Product specialties are business-to-business, industrial, healthcare and consumer services. Current clients include Star Manufacturing, RehabCare Group, Mallinckrodt.

Needs Approached by 100-150 freelancers/year. Works with 12 freelance illustrators and 6 designers/year. Uses freelancers for art direction, design, illustration, photography, production. Also for brochure, catalog, print ad and slide illustration. 80% of work is with print. 75% of freelance work demands knowledge of QuarkXPress, Illustrator and Photoshop. Needs technical, medical and creative illustration.

First Contact & Terms Send query letter with résumé, photostats, photocopies, and slides. Samples are filed or are returned by SASE if requested by artist. Will contact artist for portfolio review if interested. Portfolios should be e-mailed and should include thumbnails, roughs, original/final art and tearsheets. Sometimes requests work on spec before assigning a job. Pays for design by the project. Pays for illustration by the project. Negotiates rights purchased. Finds artists through word of mouth, reps and work samples.

Tips Freelancers "must be well organized, meet deadlines, listen well and have a concise portfolio of abilities."

THE ZIPATONI CO.

555 Washington Ave., St. Louis MO 63101-2019. (314)231-2400. Fax: (314)231-6622. E-mail: administrator@zip atoni.com. Website: www.zipatoni.com. **Art Buyer:** Christine Molitor. Estab. 1984. Number of employees: 235. Approximate annual billing: $30 million. Sales promotion agency, creative/design service, event marketing agency. Specializes in new product development, brand extensions, promotional packaging and brand and corporate identity. Also maintains electronic design division which designs, develops and manages client websites, develops client intranets, extranets and CD-ROMs, and consults on web marketing strategies, competitive analysis, and domain name research. Product specialties are food and beverage. Current clients include Miller Brewing Co., Energizer Battery, Chicken of the Sea, Bacardi, Ralston Purina, Campbell's Soup, Edy's/Dreyer's and the Coca-Cola Company. Client list available on website.

Needs Approached by 200 illustrators and 50 designers/year. Works with 35 illustrators/year. Uses freelancers mainly for point-of-purchase displays, brochures. Also for brochure design and illustration, model-making, posters and web graphics.

First Contact & Terms Send query letter with brochure or photocopies and résumé. Send postcard sample of work with follow-up postcard samples every 3 months. Accepts disk submissions. Samples are filed. Pays by the project, $300-8,000. Negotiates rights purchased. Finds illustrators through *American Showcase*, *Black Book*, *Directory of Illustration* and submissions.

MONTANA

▣ WALKER DESIGN GROUP

47 Dune Dr., Great Falls MT 59404. (406)727-8115. Fax: (406)791-9655. **President:** Duane Walker. Number of employees: 6. Design firm. Specializes in annual reports and corporate identity. Professional affiliations: AIGA and Ad Federation.

Needs Uses freelancers for animation, annual reports, brochure, medical and technical illustration, catalog design, lettering, logos and TV/film graphics. 80% of design and 90% of illustration demand skills in PageMaker, Photoshop and Adobe Illustration.

First Contact & Terms Send query letter with brochure, photocopies, photographs, résumé, slides and/or tearsheets. Accepts disk submissions. Samples are filed and are not returned. Responds only if interested. To arrange portfolio review, artist should follow up with call or letter after initial query. Portfolio should include color photographs, photostats and tearsheets. Pays by the project; negotiable. Finds artists through *Workbook*.

Tips "Stress customer service and be very aware of time lines."

NEBRASKA

BRIARDY DESIGN

5414 NW Radial Hwy., Suite 200, Omaha NE 68104. (402)561-1000. E-mail: mbriardy@briardydesign.com. Website: www.briardydesign.com. **Creative Director/Owner:** Michael P. Briardy. Estab. 1995. Number of employees: 1. Design firm. Specializes in packaging, P.O.P., corporate identity, environmental graphic design. Product specialties are food, financial, construction. Professional affiliations: AIGA, Nebraska.

• Briardi Design also has an office in Denver.

Needs Approached by 5 illustrators and 5 designers/year. Uses freelancers for humorous, medical and technical illustration, model making and signage. 20% of work is with print ads. 90% of design demands knowledge of Photoshop 3.0, FreeHand 5.0, QuarkXPress 3.0. 50% of illustration demands knowledge of Photoshop 3.0, Illustrator 5.0, FreeHand 5.0, QuarkXPress 3.0.

First Contact & Terms Designers send query letter with brochure, photocopies and résumé. Illustrators send postcard sample of work. Illustrators send query letter with brochure, photocopies, résumé. Send follow-up postcard samples every 6 months. Accepts disk submissions. Send EPS, FreeHand, Illustrator, TIFF, BMP or Quark 3.0 files. Samples are not filed and are not returned. Does not report back. Artist should call. Will contact artist for portfolio review of color, final art and photographs if interested. Payment negotiable. Finds artists through both word of mouth and creative sourcebooks and trade journals.

Tips ''Meet the objective on time.''

MICHAEL EDHOLM DESIGN

4201 Teri Lane, Lincoln NE 68502. (402)489-4314. **President:** Michael Edholm. Estab. 1989. Number of employees: 1. Approximate annual billing: $70,000. Specializes in annual reports; corporate identity; direct mail; package and publication design. Clients: ad agencies, insurance companies, universities and colleges, publishers, broadcasting. Professional affiliations: AIGA.

Needs Approached by 20 freelancers/year. Also uses freelancers for ad, catalog and poster illustration; brochure design and illustration; direct mail design; logos; web design; and model-making. 20% of freelance work demands knowledge of Illustrator, Photoshop, FreeHand, PageMaker and QuarkXPress.

First Contact & Terms Contact through telephone or mail. Send postcard sample of work or send brochure, photocopies, SASE and tearsheets. Samples are filed. Will contact artist for portfolio review if interested. Portfolio should include b&w and color final art, photographs and slides. Pays for design and illustration by the project. Rights purchased vary according to project. Finds artists through *Workbook*, *Showcase*, direct mail pieces.

IDEA BANK MARKETING

701 W. Second St., Hastings NE 68902-2117. (402)463-0588. Fax: (402)463-2187. E-mail: mail@ideabankmarketing.com. Website: www.ideabankmarketing.com. **Creative Director:** Sherma Jones. Estab. 1982. Number of employees: 7. Approximate annual billing: $1,000,000. Ad agency. Specializes in print materials, direct mail. Product specialty is manufacturers. Client list available upon request. Professional affiliations: Advertising Federation of Lincoln.

Needs Approached by 2 illustrators/year. Works with 2 illustrators and 2 designers/year. Prefers local designers only. Uses freelancers mainly for illustration. Also for airbrushing, catalog and humorous illustration, lettering. 30% of work is with print ads. 75% of design demands knowledge of Photoshop, Illustrator, FreeHand. 60% of illustration demands knowledge of FreeHand, Photoshop, Illustrator.

First Contact & Terms Designers and illustrators send query letter with brochure. Send follow-up postcard samples every 6 months. Accepts disk submissions compatible with original illustration files or Photoshop files. Samples are filed or returned by SASE. Responds only if interested. Will contact artist for portfolio review of b&w, color, final art, tearsheets if interested. Pays by the project. Rights purchased vary according to project and are negotiable. Finds artists through word of mouth.

SWANSON RUSSELL ASSOCIATES

9140 W. Dodge Rd., #402, Omaha NE 68114. (402)393-4940. Fax: (402)393-6926. E-mail: paul_b@oma.sramarketing.com. Website: www.sramarketing.com. **Associate Creative Director:** Paul Berger. Estab. 1963. Number of employees: 70. Approximate annual billing: $40 million. Integrated marketing communications agency. Specializes in collateral, catalogs, magazine and newspaper ads, direct mail. Product specialties are healthcare, pharmaceuticals, agriculture. Current clients include Schering-Plough Animal Health, Alegent Health, AGP Inc. Professional affiliations: 4A's, PRSA, AIGA, Ad Club.

Needs Approached by 12 illustrators and 3-4 designers/year. Works with 5 illustrators and 2 designers/year. Prefers freelancers with experience in agriculture, pharmaceuticals, human and animal health. Uses freelancers mainly for collateral, ads, direct mail, storyboards. Also for brochure design and illustration, humorous and

technical illustration, lettering, logos, mechanicals, posters, storyboards. 10% of work is with print ads. 90% of design demands knowledge of Photoshop 7.0, FreeHand 5.0, QuarkXPress 3.3. 30% of illustration demands knowledge of Photoshop, Illustrator, FreeHand.

First Contact & Terms Designers send query letter with photocopies, photographs, photostats, SASE, slides, tearsheets, transparencies. Illustrators send query letter with SASE. Send follow-up postcard samples every 3 months. Accepts Mac compatible disk submissions. Send self expanding archives and player for multimedia, or JPEG, EPS and TIFFs. Software: Quark, FreeHand or Adobe. Samples are filed or returned by SASE. Responds only if interested within 2 weeks. Art director will contact artist for portfolio review of final art, photographs, photostats, transparencies if interested. Pays for design by the hour, $50-65; pays for illustration by the project, $250-3,000. Rights purchased vary according to project. Finds artists through agents, submissions, word of mouth, *Laughing Stock*, *American Showcase*.

ℕ WEBSTER DESIGN ASSOCIATES, INC.

5060 Dodge St., Omaha NE 68132. (402)551-0503. (402)551-1410. **Contact:** Tammy Williams. Estab. 1982. Number of employees: 12. Approximate annual billing: $16.3 million. Design firm specializing in 3 dimensional direct mail, corporate identity, human resources, print communications, web-interactive brochure/annual report design. Product specialites are telecommunications, corporate communications and human resources. Client list available upon request. Member of AIGA, Chamber of Commerce and Metro Advisory Council.

- Webster Design has chalked up a long list of awards for their exciting 3-D direct mail campaigns for clients. Work has been featured in *American Corporate Identity* and *Print's Regional Design Annual 1996*.

Needs Approached by 50 freelance illustrators and 50-75 freelance designers/year. Works with 12 freelance illustrators and 6 freelance designers/year. Prefers national and international artists with experience in QuarkXPress, Illustrator and Photoshop. Uses freelancers mainly for illustration, photography and annual reports. 15% of work is with print ads. 100% of freelance design and 70% of freelance illustration require knowledge of Aldus Freehand, Photoshop, Illustrator and QuarkXPress.

First Contact & Terms Designers send brochure, photographs and résumé. Illustrators send postcard sample of work or query letter with brochure and photographs. Send follow-up postcard every 3 months. Accepts submissions on disk, Photoshop and Illustrator. EPS preferred in most cases. Sample are filed or returned. Responds only if interested. To show portfolio, artist should follow-up with a call and/or letter after initial query. Portfolio should include b&w and color tearsheets, thumbnails and transparencies. Pays by the project. Rights purchased vary according to project. Finds artists through *Creative Black Book*, magazines and submissions.

NEVADA

ℤ VISUAL IDENTITY

6250 Mountain Vista, L-5, Henderson NV 89014. (702)454-7773. Fax: (702)454-6293. Website: www.visualid.net. **Creative Designer:** William Garbacz. Estab. 1987. Number of employees: 5. Approximate annual billing: $500,000. Specializes in annual reports; brand and corporate identity; display, direct mail, package and publication design; signage and gaming brochures. Clients: ad agencies and corporations. Current clients include Sam's Town, Sports Club L.V. and Westward-Ho.

Needs Approached by 50 freelancers/year. Works with 3 freelancers and 3 designers/year. Prefers local artists with experience in gaming. Uses illustrators and designers mainly for brochures and billboards. Also uses freelancers for ad, P-O-P and poster design and illustration; direct mail, magazine and newspaper design; lettering; and logos. Needs computer-literate freelancers for design, illustration, production, presentation and 3D. 99% of freelance work demands knowledge of Illustrator, Photoshop, FreeHand, QuarkXPress, Painter, Ray Dream.

First Contact & Terms Send résumé and tearsheets. Samples are filed. Will contact artist for portfolio review if interested. Portfolio should include photocopies and roughs. Pays for design and illustration by the project, $100-1,000. Rights purchased varied according to project.

Tips Finds artists through "any and every source available."

NEW HAMPSHIRE

YASVIN DESIGNERS

45 Peterborough Rd., Box 116, Hancock NH 03449. (603)525-3000. Fax: (603)525-3300. **Contact:** Creative Director. Estab. 1990. Number of employees: 3. Specializes in annual reports, brand and corporate identity, package design and advertising. Clients: corporations, colleges and institutions.

Needs Approached by 10-15 freelancers/year. Works with 6 freelance illustrators and 2 designers/year. Uses freelancers for book production, brochure illustration, logos. 50% of freelance work demands knowledge of Illustrator, Photoshop, FreeHand and/or QuarkXPress.

First Contact & Terms Send postcard sample of work or send query letter with photocopies, SASE and tearsheets. Samples are filed. Responds only if interested. Request portfolio review in original query. Portfolio should include b&w and color photocopies, roughs and tearsheets. Pays for design by the project and by the day. Pays for illustration by the project. Rights purchased vary according to project. Finds artists through sourcebooks and artists' submissions.

NEW JERSEY

✦ ▣ AM/PM ADVERTISING, INC.

345 Claremont Ave., Suite 26, Montclair NJ 07402. (973)824-8600. Fax: (973)824-6631. E-mail: mpt4220@aol.com. **President:** Bob Saks. Estab. 1962. Number of employees: 130. Approximate annual billing: $24 million. Ad agency. Full-service multimedia firm. Specializes in national TV commercials and print ads. Product specialties are health and beauty aids. Current clients include J&J, Bristol Myers, Colgate Palmolive. Client list available upon request. Professional affiliations: AIGA, Art Directors Club, Illustration Club.

Needs Approached by 35 freelancers/year. Works with 3 freelance illustrators and designers/month. Agency prefers to work with local freelancers only with experience in animation, computer graphics, film/video production, multimedia, Macintosh. Works only with artist reps. Works on assignment only. Uses freelancers mainly for illustration and design. Also for brochure design and illustration, storyboards, slide illustration, animation, technical illustration, TV/film graphics, lettering and logos. 30% of work is with print ads. 50% of work demands knowledge of PageMaker, QuarkXPress, FreeHand, Illustrator or Photoshop.

First Contact & Terms Send postcard sample and/or query letter with brochure, résumé and photocopies. Samples are filed or returned. Responds in 10 days. Portfolios may be dropped off every Friday. Artist should follow up after initial query. Portfolio should include b&w and color thumbnails, roughs, final art, tearsheets, photographs and transparencies. Pays by the hour, $35-100; by the project, $300-5,000; or with royalties (25%). Rights purchased vary according to project.

Tips "When showing work, give time it took to do job and costs."

▣ BLOCK ADVERTISING & MARKETING, INC.

3 Clairidge Dr., Verona NJ 07044. (973)857-3900. Fax: (973)857-4041. E-mail: blockmark@aol.com. **Senior VP/Creative Director:** Karen DeLuca. Senior Art Director: Jay Baumann. Studio Manager: John Murray. Art Director: Evan Daly. Estab. 1939. Number of employees: 25. Approximate annual billing: $12 million. Product specialties are food and beverage, education, finance, home fashion, giftware, healthcare and industrial manufacturing. Professional affiliations: Ad Club of North Jersey.

Needs Approached by 100 freelancers/year. Works with 25 freelance illustrators and 25 designers/year. Prefers to work with "freelancers with at least 3-5 years experience as Mac-compatible artists and 'on premises' work as Mac artists." Uses freelancers for "consumer friendly" technical illustration, layout, lettering, mechanicals and retouching for ads, annual reports, billboards, catalogs, letterhead, brochures and corporate identity. Needs computer-literate freelancers for design and presentation. 90% of freelance work demands knowledge of QuarkXPress, Illustrator, Type-Styler and Photoshop.

First Contact & Terms To show portfolio, mail appropriate samples and follow up with a phone call. E-mail résumé and samples of work or mail the same. Responds in 2 weeks. Pays for design by the hour, $20-60. Pays for illustration by the project, $250-5,000 or more.

Tips "We are fortunately busy—we use four to six freelancers daily. Be familiar with the latest versions of QuarkXpress, Illustrator and Photoshop. We like to see sketches of the first round of ideas. Make yourself available occasionally to work on premises. Be flexible in usage rights!"

▣ NORMAN DIEGNAN & ASSOCIATES

3 Martens Rd., Lebanon NJ 08833. (908)832-7951. **President:** N. Diegnan. Estab. 1977. Number of employees: 5. Approximate annual billing: $1 million. PR firm. Specializes in magazine ads. Product specialty is industrial.

Needs Approached by 10 freelancers/year. Works with 20 freelancers illustrators/year. Works on assignment only. Uses freelancers for brochure, catalog and print ad design and illustration, storyboards, slide illustration, animatics, animation, mechanicals, retouching and posters. 50% of work is with print ads. Needs editorial and technical illustration.

First Contact & Terms Send query letter with brochure and tearsheets. Samples are filed and not returned. Responds in 1 week. To show portfolio, mail roughs. Pays for design and illustration by the project. Rights purchased vary according to project.

IRVING FREEMAN DESIGN CO.

10 Jay St., #2, Tenafly NJ 07670. (201)569-4949. Fax: (201)569-4979. E-mail: irv@freemanwolff.com. Website: www.freemanwolff.com. **CEO/CCO:** Irving Freeman. Estab. 1972. Approximate annual billing: $100,000. Specializes in Web design, corporate identity and collateral. Clients: corporations and publishers. Current clients include HarperCollins, Simon & Schuster and Warner Books. Client list available upon request. Professional affiliations: GAG.

Needs Approached by 10 freelancers/year. Prefers local artists only. Uses designers mainly for book interiors. Needs computer-literate freelancers for design, production and presentation. 100% of freelance work demands knowlege of Illustrator, Photoshop, QuarkXPress and Flash/Dreamweaver.

First Contact & Terms Send postcard sample of work or send brochure, photocopies, photographs and tearsheets. Samples are filed. Responds in 1 month. Will contact artist for portfolio review if interested. Portfolio should include final art. Pays for design by the hour, by the project and by the day. Rights purchased vary according to project. Finds artists through sourcebooks.

HOWARD DESIGN GROUP, INC.

20 Nassau St., Suite 115, Princeton NJ 08542. (609)924-1106. Fax: (609)924-1165. E-mail: diane@howarddesign.com. **Partner:** Diane Savoy. Estab. 1980. Number of employees: 9. Specializes in websites, corporate identity, college recruitment materials and publication design. Clients: corporations, schools and colleges.

Needs Approached by 20 freelancers/year. Works with 10 freelance illustrators and 5 designers/year. Uses illustrators mainly for publication design. Also uses freelancers for brochure design and illustration; catalog, direct mail, magazine and poster design; logos. Needs computer-literate freelancers for design and production. 100% of freelance work demands knowlege of Illustrator, Photoshop, FreeHand and QuarkXPress.

First Contact & Terms Send résumé. Samples are filed. Will contact artist for portfolio review if interested. Portfolio should include color final art, roughs and thumbnails. Pays for design and illustration by the project. Buys one-time rights. Finds artists through *Showcase*.

Tips Looks for "innovative design in portfolio."

LARRY KERBS STUDIOS

581 Mountain Ave., Gillette NJ 07433. (908)604-6137. Fax: (908)647-0543. E-mail: kerbscreative@earthlink.net. **Contact:** Larry Kerbs. Specializes in sales promotion design, ad work and placement, annual reports, corporate identity, publications and technical illustration. Clients: industrial, chemical, medical devices, insurance, travel, PR, over-the-counter specialties.

 • Also has a western branch. See this company's listing in New Mexico for complete submission information.

OXFORD COMMUNICATIONS, INC.

11 Music Mountain Blvd., Lambertville NJ 08530. (609)397-4242. Fax: (609)397-8863. Website: www.oxfordcommunications.com. **Creative Director:** Chuck Whitmore. Estab. 1986. Ad agency. Full-service, multimedia firm. Specializes in print advertising and collateral. Product specialties are health care, real estate and hightech.

Needs Approached by 6 freelancers/month. Works with 1 illustrator and 3 designers every 6 months. Prefers local freelancers with experience in comping and desktop publishing. Uses freelancers mainly for mechanicals. Also for brochure design and illustration, technical and fashion illustration, print ad illustration, mechanicals, retouching and logos. 75% of work is with print ads.

First Contact & Terms Send query letter with photocopies and résumé. Samples are filed. Responds only if interested. Will contact artist for portfolio review if interested. Portfolio should include b&w and/or color photostats, tearsheets, photographs and slides. Pays for design and illustration by the project, negotiable. Rights purchased vary according to project.

PRINCETON MARKETECH

196 Rt. 571, Building 2, Suite 15, Princeton Junction NJ 08550. (609)936-0021. Fax: (609)936-0015. E-mail: renee@princetonmarketech.com. Website: www.princetonmarketech.com. **Creative Director:** Reneé Hobbs. Estab. 1987. Number of employees: 3. Approximate annual billing: $3 million. Ad agency. Specializes in direct mail, multimedia, web sites. Product specialties are financial, computer, senior markets. Current clients include J.P. Morgan Chase, Citizen's Bank, Diamond Tours, Simmons Associates. Client list available upon request.

Needs Approached by 12 freelance illustrators and 25 designers/year. Works with 2 freelance illustrators and 5 designers/year. Prefers local designers with experience in Macintosh. Uses freelancers for airbrushing, animation, brochure design and illustration, multimedia projects, retouching, technical illustration, TV/film graphics. 10% of work is with print ads. 90% of design demands skills in Photoshop, QuarkXPress, Illustrator, Macromedia Director. 50% of illustration demands skills in Photoshop, Illustrator.

First Contact & Terms Send query letter with résumé, tearsheets, video or sample disk. Send follow-up postcard

every 6 months. Accepts disk submissions compatible with QuarkXPress, Photoshop. Send EPS, PICT files. Samples are filed. Responds only if interested. Pay negotiable. Rights purchased vary according to project.

SMITH DESIGN ASSSOCIATES

205 Thomas St., Box 8278, Glen Ridge NJ 07028. (973)429-2177. Fax: (973)429-7119. E-mail: laraine@smithdesign.com. Website: www.smithdesign.com. **Vice President:** Laraine Blauvelt. Clients: cosmetics firms, toy manufacturers, life insurance companies, office consultants. Current clients: Popsicle, Good Humor, Motts. Client list available upon request.

Needs Approached by more than 100 freelancers/year. Works with 10-20 freelance illustrators and 3-4 designers/year. Requires high level, experienced, talent, quality work and reliability. Uses freelancers for package design, concept boards, brochure design, print ads, newsletters illustration, POP display design, retail environments, web programming. 90% of freelance work demands knowledge of Illustrator, QuarkXPress, 3-D rendering programs. Design style must be current to trends. Our work ranges from "classic brands" to "of the moment/cutting edge." Particularly when designing for KIDS and TEENS.

First Contact & Terms Send query letter with brochure/samples showing work, style and experience. Include contact information. Samples are filed or are returned only if requested by artist. Responds in 1 week. Call for appointment to show portfolio. Pays for design by the hour, $25-100; or by the project, $175-5,000. Pays for illustration by the project, $175-5,000. Considers complexity of project and client's budget when establishing payment. Buys all rights. (For illustration work, rights may be limited to a particular use TBD). Also buys rights for use of existing non-commissioned art. Finds artists through word of mouth, self-promotions/sourcebooks and agents.

Tips "Know who you're presenting to (visit our website to see our needs). Show work which is relevant to our business at the level and quality we require. We use more freelance designers and illustrators for diversity of style and talent."

NEW MEXICO

BOOKMAKERS LTD.

P.O. Box 1086, Taos NM 87571. (505)776-5435. Fax: (505)776-2762. E-mail: bookmakers@newmex.com. Website: www.bookmakersltd.com. **President:** Gayle Crump McNeil. "We are agents for children's book illustrators and provide design and product in services to the publishing industry."

First Contact & Terms Send query letter with samples showing style and SASE if samples need returning. Responds in 1 month.

Tips The most common mistake freelancers make in presenting samples or portfolios is "too much variety—not enough focus."

☑ LARRY KERBS STUDIOS

207 W. Cordova Rd., Santa Fe NM 87505. (505)988-5904, Fax: (505)988-9107. E-mail: kerbscreative@earthlink.net. **Contact:** Larry Kerbs. Specializes in sales promotion design, ad work and placement, annual reports, corporate identity, publications and technical illustration. Clients: industrial, chemical, insurance, travel, PR.
- Eastern US **Contact:** Jim Lincoln, 581 Mountain Ave., Gillette NJ 07433. (908)604-6137. Fax: (908)647-0543. E-mail: chlincoln@earthlink.net.

Needs Works with computer production people, 1 illustrator and 1 designer/month. Uses artists for direct mail, layout, illustration, technical art, annual reports, trade magazine ads, product brochures and direct mail. Needs computer-literate freelancers, prefers those with strong design training. Needs editorial and technical illustration. Looks for realistic editorial illustration, montages, 2-color and 4-color.

First Contact & Terms Mail samples or call for interview. Prefers b&w or color line drawings, renderings, layout roughs and previously published work as samples. Provide business card and résumé to be kept on file for future assignments. Negotiates payment by the project.

Tips "Strengthen typographic knowledge and application; know computers, production and printing in depth to be of better service to yourself and to your clients."

▣ R H POWER AND ASSOCIATES, INC.

320 Osuna NE, Bldg. B, Albuquerque NM 87107. (505)761-3150. Fax: (503)761-3153. E-mail: rhpower@qwest.net. Website: www.rhpower.com. **Art Director:** Bruce Yager. Creative Director: Roger L. Vergara. Estab. 1989. Number of employees: 12. Ad agency. Full-service, multimedia firm. Specializes in TV, magazine, billboard, direct mail, newspaper, radio. Product specialties are recreational vehicles and automotive. Current clients include Kem Lite Corporation, RV Sales & Rentals of Albany, Ultra-Fab Products, Collier RV, Nichols RV, American RV and Marine. Client list available upon request.

Needs Approached by 10-50 freelancers/year. Works with 5-10 freelance illustrators and 5-10 designers/year. Prefers freelancers with experience in retail automotive layout and design. Uses freelancers mainly for work overload, special projects and illustrations. Also for annual reports, billboards, brochure and catalog design and illustration, logos, mechanicals, posters and TV/film graphics. 50% of work is with print ads. 100% of design demands knowledge of Photoshop 6.0, QuarkXPress and Illustrator 8.0.

First Contact & Terms Send query letter with photocopies or photographs and résumé. Accepts disk submissions in PC format compatible with CorelDraw, QuarkXPress or Illustrator 8.0. Send PC EPS files. Samples are filed and are not returned. Will contact artist for portfolio review if interested. Portfolio should include b&w and color final art, roughs and thumbnails. Pays for design and illustration by the hour, $12 minimum; by the project, $100 minimum. Buys all rights.

Tips Impressed by work ethic and quality of finished product. "Deliver on time and within budget. Do it until it's right without charging for your own corrections."

NEW YORK

CARNASE, INC.
21 Dorset Rd., Scarsdale NY 10583. (212)777-1500. Fax: (914)725-9539. **President:** Tom Carnase. Estab. 1978. Specializes in annual reports, brand and corporate identity, display, landscape, interior, direct mail, package and publication design, signage and technical illustration. Clients: agencies, corporations, consultants. Current clients include: Clairol, Shiseido Cosmetics, Times Mirror, Lintas: New York. Client list not available.
• President Tom Carnase predicts "very active" years ahead for the design field.
Needs Approached by 60 freelance artists/year. Works with 2 illustrators and 1 designer/year. Prefers artists with 5 years experience. Works on assignment only. Uses artists for brochure, catalog, book, magazine and direct mail design and brochure and collateral illustration. Needs computer-literate freelancers. 50% of freelance work demands skills in QuarkXPress or Illustrator.
First Contact & Terms Send query letter with brochure, résumé and tearsheets. Samples are filed. Responds in 10 days. Will contact artist for portfolio review if interested. Portfolio should include photostats, slides and color tearsheets. Negotiates payment. Rights purchased vary according to project. Finds artists through word of mouth, magazines, artists' submissions/self-promotions, sourcebooks and agents.

DESIGN CONCEPTS
137 Main St., Unadilla NY 13849. (607)369-4709. **Owner:** Carla Schroeder Burchett. Estab. 1972. Specializes in annual reports, brand identity, design and package design. Clients: corporations, individuals. Current clients include American White Cross and Private & Natural.
Needs Approached by 6 freelance graphic artists/year. Works with 2 freelance illustrators and designers/year. Prefers artists with experience in packaging, photography, interiors. Uses freelance artists for mechanicals, poster illustration, P-O-P design, lettering and logos.
First Contact & Terms Send query letter with tearsheets, brochure, photographs, résumé and slides. Samples are filed or are returned by SASE if requested by artist. Responds. Artists should follow up with letter after initial query. Portfolio should include thumbnails and b&w and color slides. Pays for design by the hour, $30 minimum. Negotiates rights purchased.
Tips "Artists and designers are used according to talent; team cooperation is very important. If a person is interested and has the professional qualification, he or she should never be afraid to approach us—small or large jobs."

N GARRITY COMMUNICATIONS, INC.
217 N. Aurora St., Ithaca NY 14850. (607)272-1323. Website: www.garrity.com. **Art Directors:** Steve Carver and Debra Martens. Estab. 1978. Ad agency, AV firm. Specializes in trade ads, newspaper ads, annual reports, video, etc. Product specialties are financial services, food, higher ed.
Needs Approached by 8 freelance artists/month. Works with 2 freelance illustrators and 1 freelance designer/month. Works on assignment only. Uses freelance artists mainly for work overflow situations; some logo specialization. Also uses freelance artists for brochure design and illustration, print ad illustration, TV/film graphics and logos. 40% of work is with print ads. 90% of freelance work demands knowledge of Photoshop, Illustrator, InDesign.
First Contact & Terms Send query letter with brochure and photocopies. Samples are filed and are not returned. Responds only if interested. Will contact artist for portfolio review if interested. Pays for design by the hour, $25-75. Pays for illustration by the project, $150-1,500. Rights purchased vary according to project. Finds artists through sourcebooks, submissions.

print

America's Graphic Design Magazine

Subscribe and save 65%

Every issue of _PRINT_

- explores the art, influence, power and passion of visual communication

- takes you beyond the beauty and style to the ideas and points of view that drive today's designers

- connects you to the past, present and future of graphic design

Every issue of _PRINT_ makes you a better designer

Use the post-paid card below to get a year of _PRINT_ for only $37, the <u>lowest rate available</u>.

Subscribe now and save 65% off the newsstand price.

You'll get...

PRINT's Regional Design Annual
The most comprehensive yearly profile of graphic design in America, packed with the best, most current work in the country.

PRINT's European Design Annual
A portfolio of the finest work being created across the Continent, with commentary on national styles and international trends.

PRINT's Digital Design Annual
An annual showcase of the most cutting-edge digital art being created in the areas of animation, Web sites, television ads, kiosks and more.

Plus 3 regular issues — a full year of *PRINT* at the introductory rate of just $37. (Annual newsstand rate $106.)

NO POSTAGE
NECESSARY
IF MAILED
IN THE
UNITED STATES

BUSINESS REPLY MAIL
FIRST-CLASS MAIL PERMIT NO. 338 FLAGLER BCH FL

POSTAGE WILL BE PAID BY ADDRESSEE

print

PO BOX 421352
PALM COAST FL 32142-9115

⦿ LEONE DESIGN GROUP INC.

7 Woodland Ave., Larchmont NY 10538. (914)834-5700. Fax: (914)834-6190. E-mail: leonegroup@earthlink.n et. Website: www.leonedesign.com. **President:** Lucian J. Leone. Specializes in corporate identity, publications, signage and exhibition design. Clients: nonprofit organizations, museums, corporations, government agencies. Client list not available. Professional affiliations: AAM, SEGD, MAAM, AASLH, NAME.

Needs Approached by 30-40 freelancers/year. Works with 10-15 freelance designers/year. Uses freelancers for exhibition design, brochures, catalogs, mechanicals, model making, charts/graphs and AV materials. Needs computer-literate freelancers for design and presentation. 100% of freelance work demands knowledge of QuarkXPress, Photoshop, Illustrator.

First Contact & Terms Send query letter with résumé, samples and photographs. Samples are filed unless otherwise stated. Samples not filed are returned only if requested. Responds in 2 weeks. Write for appointment to show portfolio of thumbnails, b&w and color original/final art, final reproduction/product and photographs. Pays for design by the hour, $20-45 or on a project basis. Considers client's budget and skill and experience of artist when establishing payment.

⦿ McANDREW ADVERTISING

210 Shields Rd., Red Hook NY 12571. Phone/fax: (845)756-2276. E-mail: robertrmca@aol.com. **Art/Creative Director:** Robert McAndrew. Estab. 1961. Number of employees: 3. Approximate annual billing: $200,000. Ad agency. Clients: industrial and technical firms. Current clients include chemical processing equipment, electrical components.

Needs Approached by 10 freelancers/year. Works with 2 freelance illustrators and 2 designers/year. Uses mostly local freelancers. Uses freelancers mainly for design, direct mail, brochures/flyers and trade magazine ads. Needs technical illustration. Prefers realistic, precise style. Prefers pen & ink, airbrush and occasionally markers. 30% of work is with print ads. Freelance work demands computer skills.

First Contact & Terms Query with business card and brochure/flier to be kept on file. Samples not returned. Responds in 1 month. Originals not returned. Will contact artist for portfolio review if interested. Portfolio should include roughs and final reproduction. Pays for illustration by the project, $35-300. Pays for design by the project. Considers complexity of project, client's budget and skill and experience of artist when establishing payment. Finds artists through sourcebooks, word of mouth and business cards in local commercial art supply stores.

Tips Artist needs "an understanding of the product and the importance of selling it."

⦿ MEDIA LOGIC, INC.

One Park Place, Albany NY 12205. (518)456-3015. Fax: (518)456-4279. E-mail: postmaster@mlinc.com. Website: www.mlinc.com. **Production Manager:** Jen Hoehn. Recruiter: Susan Wolff. Estab. 1984. Number of employees: 83. Approximate annual billing: $20 million. Integrated marketing communications agency. Specializes in advertising, marketing communications, design. Product specialties are retail, entertainment. Current clients include education, business-to-business, industrial. Professional affiliations: American Marketing Associates, Ad Club of Northeast NY.

- For the second consecutive year, Media Logic has been ranked as one of th industry's top 100 integrated marketing agencies by *PROMO* magazine.

Needs Approached by 20-30 freelance illustrators and 20-30 designers/year. Works with 2 freelance illustrators and 2 designers/year. Prefers freelancers with experience in Mac/Photoshop. Also for annual reports, brochure design, mechanicals, multimedia projects, retouching, web page design. 30% of work is with print ads. 100% of design and 60% of illustration demand skills in Photoshop, QuarkXPress, Illustrator, Director.

First Contact & Terms Designers send query letter with photocopies, résumé. Illustrators send postcard and/or query letter with résumé to Susan Wolff. Accepts disk submissions compatible with QuarkXPress 7.5/version 3.3. Send EPS files. Samples are not filed and are returned. Responds only if interested. Portfolios may be dropped off Monday-Friday. Pays by the project; negotiable. Buys all rights.

Tips "Be fast, flexible, talented and able to work with demanding creative director."

MITCHELL STUDIOS DESIGN CONSULTANTS

1810-7 Front St., East Meadow NY 11554. (516)832-6230. Fax: (516)832-6232. E-mail: msdcdesign@aol.com. **Principals:** Steven E. Mitchell and E.M. Mitchell. Estab. 1922. Specializes in brand and corporate identity, displays, direct mail and packaging. Clients: major corporations.

Needs Works with 5-10 freelance designers and 20 illustrators/year. "Most work is started in our studio." Uses freelancers for design, illustration, mechanicals, retouching, airbrushing, model-making, lettering and logos. 100% of design and 50% of illustration demands skills in Illustrator 5, Photoshop 5 and QuarkXPress 3.3. Needs technical illustration and illustration of food, people.

First Contact & Terms Send query letter with brochure, résumé, business card, photographs and photocopies

to be kept on file. Accepts nonreturnable disk submissions compatible with Illustrator, QuarkXPress, FreeHand and Photoshop. Responds only if interested. Call or write for appointment to show portfolio of roughs, original/final art, final reproduction/product and color photostats and photographs. Pays for design by the hour, $25 minimum; by the project, $250 minimum. Pays for illustration by the project, $250 minimum.

Tips "Call first. Show actual samples, not only printed samples. Don't show student work. Our need has increased—we are very busy."

JACK SCHECTERSON ASSOCIATES

5316 251 Place, Little Neck NY 11362. (718)225-3536. Fax: (718)423-3478. **Principal:** Jack Schecterson. Estab. 1967. Ad agency. Specializes in 2D and 3D visual marketing; new product introduction; product; package; graphic and corporate design.

Needs Works direct and with artist reps. Prefers local freelancers. Works on assignment only. Uses freelancers for package, product, and corporate design; illustration, brochures, catalogs, logos. 100% of design and 90% of graphic illustration demands skills in Illustrator, Photoshop and QuarkXPress.

First Contact & Terms Send query letter with brochure, photocopies, tearsheets, résumé, photographs, slides, transparencies and SASE; "whatever best illustrates work." Samples not filed are returned by SASE only if requested by artist. Request portfolio review in original query. Will contact artist for portfolio review if interested. Portfolio should include roughs, b&w and color—"whatever best illustrates creative abilities/work." Pays for design and illustration by the project; depends on budget. Buys all rights.

SIOGEN

PO Box 20976, Brooklyn NY 11202-0976. (201)659-7663. Fax: (201)418-8967. E-mail: siogen@email.com. **Art Director:** Henry Suazo. Number of employees: 4. Design firm, visual communications. Specializes in graphic designs for print. Current clients include general public and small businesses. Client list not available. Professional affiliations: FDNY.

Needs Approached by 10 illustrators and 15 designers/year. Works with 5 illustrators and 8 designers/year. Prefers to work with local freelance designers and illustrators with experience in computer graphics and Macintosh. Uses freelancers for wedding invitations, also for brochure design, catalog design, logos, print ads and retouching. 10% of work is with print ads. 90% of design demands skills in InDesign, Illustrator, QuarkXPress and Photoshop. 60% of illustration work demands skills in Illustrator.

First Contact & Terms Designers: Send query letter with tearsheets. Illustrators: Send photocopies. Accepts e-mail submissions. Designers and illustrators should use 300 dpi TIFF/JPEG. Samples are not filed and returned by SASE. Responds only if interested. Company will contact artist for portfolio review if interested. Portfolios should include b&w and color finished art and original art. Pays for design by the hour, $20 maximum; pays for illustration by the hour, $15 maximum. Buys all rights. Finds artists through sourcebooks and word of mouth.

Tips "Illustrators and graphic designers should be as creative as possible. Portfolios should reflect creativity without limitations. Images should be crisp, sharp and more importantly, unique."

TOBOL GROUP, INC.

14 Vandeventer Ave., #L-2, Port Washington NY 11080. (516)767-8182. Fax: (516)767-8185. Estab. 1981. Ad agency. Product specialties are "50/50, business to business and business to consumer." Current clients include: Weight Watchers, Mainco, Lightalarms and Fiberall.

Needs Approached by 2 freelance artists/month. Works with 1 freelance illustrator and 1 designer/month. Works on assignment only. Uses freelancers for brochure, catalog and print ad design and technical illustration, mechanicals, retouching, billboards, posters, TV/film graphics, lettering and logos. 45% of work is with print ads. 75% of freelance work demands knowledge of QuarkXPress or Illustrator.

First Contact & Terms Send query letter with SASE and tearsheets. Samples are filed or are returned by SASE. Responds in 1 month. Call for appointment to show portfolio or mail thumbnails, roughs, b&w and color tearsheets and transparencies. Pays for design by the hour, $25 minimum; by the project, $100-800; by the day, $200 minimum. Pays for illustration by the project, $300-1,500 ($50 for spot illustrations). Negotiates rights purchased.

NEW YORK CITY

AVANCÉ DESIGNS, INC.

1775 Broadway, Suite 419, New York NY 10019-1903. (212)876-4265. Fax: (212)876-3078. E-mail: info@avance-designs.com. Website: www.avance-designs.com. Estab. 1986. "Avancé Designs are specialists in visual communication. We maintain our role by managing multiple design disciplines from print and information design,

to website design and interactive media." Clients include Fairchild Publications, Fashion Group International.
Needs Designers, web designers, strong in Photoshop, Illustrator programmers in PHC, ASP, DHTML, Java-Script and Java.
First Contact & Terms Send query letter. Samples of interest are filed and are not returned. Responds only if interested.

ⓃⓂ BBDO NEW YORK

1285 Avenue of the Americas, New York NY 10019-6028. (212)459-5000. Fax: (212)459-6645. Website: www.bb do.com. **Illustration Manager/Creative Project Coordinator:** Ron Williams. Estab. 1891. Number of employees: 850. Annual billing: $50,000,000. Specializes in business, consumer advertising, sports marketing and brand development. Clients include Texaco, Frito Lay, Bayer, Campbell Soup, FedEx, Pepsi, Visa and Pizza Hut. Ad agency. Full-service multimedia firm.
 • BBDO Art Director told our editors he is always open to new ideas and maintains an open drop-off policy. If you call and arrange to drop off your portfolio, he'll review it, and you can pick it up in a couple days.

ⓃⓋⒺ COUSINS DESIGN

330 E. 33rd St., New York NY 10016. (212)685-7190. Fax: (212)689-3369. E-mail: cousinsdesign@aol.com. Website: www.cousinsdesigning.com. **President:** Michael Cousins. Number of employees: 4. Specializes in packaging and product design. Clients: marketing and manufacturing companies. Professional affiliation: IDSA.
Needs Works with freelance designers. Prefers local designers. Works on assignment only. Uses artists for design, illustration, mechanicals, retouching, airbrushing, model making, lettering and logos.
First Contact & Terms Send nonreturnable postcard sample or e-mail your link. Samples are filed. Responds in 2 weeks only if interested. Write for appointment to show portfolio of roughs, final reproduction/product and photostats. Pays for design by the hour or flat fee. Considers skill and experience of artist when establishing payment. Buys all rights.
Tips "Send great work that fits our direction."

DLS DESIGN

156 Fifth Ave., New York NY 10010. (212)255-3464. E-mail: info@dlsdesign.com. Website: www.dlsdesign.c om. **President:** David Schiffer. Estab. 1986. Number of employees: 3. Web and graphic design firm. Specializes in implementation of graphically rich websites and other on-screen interfaces, especially software icons and high-end print work and logo design. Client sectors are corporate, law, publishing, nonprofit, enertainment, fashion, media and industrial companies. Current clients include Horizon Media, Telcordia Technologies, New-castle/Acoustone Fabrics and many others. Professional affiliation: BNI (Business Network International).
 • Awards include: 2004—Two Communicator Awards for Best Websites and Graphics and over a dozen others dating back 10 years.
Needs "About 75% of our work is high-end corporate websites. Work is clean, but can also be high in the 'delight factor.' " Requires designers and illustrators fluent in Photoshop, Image Ready, Dreamweaver and Flash.
First Contact & Terms E-mail is acceptable, but unsolicited attached files will be rejected. "Please wait until we say we are interested, or direct us to your URL to show samples." Uses some hourly freelance help in website production; occasionally needs editorial illustrations in traditional media.

ERICKSEN ADVERTISING & DESIGN, INC.

12 W. 37th St., New York NY 10018. Fax: (212)239-3321. **Director:** Robert Ericksen. Full-service ad agency providing all promotional materials and commercial services for clients. Product specialties are promotional, commercial and advertising material for the entertainment industry. Current clients include BBC, National Geographic, Scripps Network.
Needs Works with several freelancers/year. Assigns several jobs/year. Works on assignment only. Uses free-lancers mainly for advertising, packaging, brochures, catalogs, trade, P-O-P displays, posters, lettering and logos. Prefers composited and computer-generated artwork.
First Contact & Terms Contact through artist's agent or send query letter with brochure or tearsheets and slides. Samples are filed and are not returned unless requested with SASE; unsolicited samples are not returned. Responds in 1 week if interested or when artist is needed for a project. Does not respond to all unsolicited samples. "Only on request should a portfolio be sent." Pays for illustration by the project, $500-5,000. Buys all rights, and retains ownership of original in some situations. Finds artists through word of mouth, magazines, submissions and sourcebooks.
Tips "Advertising artwork is becoming increasingly 'commercial' in response to very tightly targeted marketing (i.e., the artist has to respond to increased creative team input versus the fine art approach."

N GREY WORLDWIDE INC.

777 Third Ave., New York NY 10017. Fax: (212)546-2255. **Vice President/Art Buying Manager:** Jayne Horowitz. Number of employees: 1,800. Specializes in cosmetics, food and toys. Professional affiliations: 4A's Art Services Committee.

• This company has six art buyers, each of whom makes about 50 assignments per year. Freelancers are needed mostly for illustration and photography, but also for model-making, fashion styling and lettering.

Needs Approached by hundreds of freelancers/year. Works with some freelance illustrators and few designers/year.

First Contact & Terms Works on assignment only. Call at beginning of the month for appointment to show portfolio of original/final art. Pays by the project. Considers client's budget and rights purchased when establishing fees.

Tips "Be prepared and very professional when showing a portfolio. Show your work in a neat and organized manner. Have sample leave-behinds and do not expect to leave with a job. It takes time to plant your ideas and have them accepted."

N HILL AND KNOWLTON, INC.

466 Lexington Ave., New York NY 10017. (212)885-0300. Fax: (212)885-0570. E-mail: maldinge@hillandknowlton.com. Website: www.hillandknowlton.com. **Corporate Design Group:** Michael Aldinger. Estab. 1927. Number of employees: 1,200 (worldwide). PR firm. Full-service multimedia firm. Specializes in annual reports, collateral, corporate identity, advertisements and sports marketing.

Needs Works with 0-10 freelancers/illustrators/month. Works on assignment only. Uses freelancers for editorial, technical and medical illustration. Also for storyboards, slide illustration, animatics, mechanicals, retouching and lettering. 10% of work is with print ads. Needs computer-literate freelancers for illustration. Freelancers should be familiar with QuarkXPress, FreeHand, Illustrator, Photoshop or Delta Graph.

First Contact & Terms Send query letter with promo and samples. Samples are filed. Does not reply, in which case the artist should "keep in touch by mail—do not call." Call and drop-off only for a portfolio review. Portfolio should include dupe photographs. Pays for illustration by the project, $250-5,000. Negotiates rights purchased.

Tips Looks for "variety; unique but marketable styles are always appreciated."

N ▣ LIEBER BREWSTER DESIGN, INC.

19 W. 34th St., Suite 618, New York NY 10001. (212)279-9029. E-mail: office@lieberbrewster.com. **Principal:** Anna Lieber. Estab. 1988. Specializes in annual reports, corporate identity, direct mail and package design, publications, exhibits, environments, advertising, web development, interactive presentation, branding and signage. Clients: publishing, nonprofits, corporate, financial services, foodservice, retail. Client list available upon request. Professional affiliations: NAWBO, AIGA.

Needs Approached by more than 100 freelancers/year. Works with 10 freelance illustrators, photographers and 10 designers/year. Works on assignment only. Uses freelancers for HTML programming, multimedia presentations, web development, logos, direct mail design, charts/graphs, audiovisual materials. Needs computer-literate freelancers for design, illustration, production and presentation. 90% of freelance work demands skills in Illustrator, QuarkXPress or Photoshop. Needs editorial, technical, medical and creative color illustration, photography, photo montage, icons.

First Contact & Terms Send query letter with résumé, tearsheets and photocopies. Samples are filed. Will contact artist for portfolio review if interested. Portfolio should include b&w and color work. Pays for design by the hour. Pays for illustration and photography by the project. Rights purchased vary according to project. Finds artists through promotional mailings.

☑ ▣ LUBELL BRODSKY INC.

350 W. 43rd St., Suite 21B, New York NY 10036-6472. (212)684-2600. **Art Directors:** Ed Brodsky and Ruth Lubell. Number of employees: 5. Specializes in corporate identity, direct mail, promotion, consumer education and packaging. Clients: ad agencies and corporations. Professional affiliations: ADC, TDC.

Needs Approached by 100 freelancers/year. Works with 10 freelance illustrators and photographers and 1-2 designers/year. Works on assignment only. Uses freelancers for illustration, retouching, charts/graphs, AV materials and lettering. 100% of design and 30% of illustration demands skills in Photoshop.

First Contact & Terms Send postcard sample, brochure or tearsheets to be kept on file. Responds only if interested.

Tips Looks for unique talent.

N MCCAFFERY RATNER GOTTLIEB & LANE, LLC.

370 Lexington Ave., New York NY 10017. (212)706-8425. E-mail: hjones@mrgl.net. Website: www.mrgl.net. **VP Senior Art Director:** Howard Jones. Estab. 1983. Ad agency specializing in advertising and collateral ma-

terial. Current clients include Olympus Corporation and General Cigar (Macanudo, Partagas, Bolivar, Punch, Excalibur).

Needs Works with 6 freelance photographers/illustrators/year. Works on assignment only. Also uses artists for brochure and print ad illustration, mechanicals, retouching, billboards, posters, lettering and logos. 80% of work is with print ads.

First Contact & Terms Send query letter with brochure, tearsheets, photostats, photocopies and photographs. Responds only if interested. To show a portfolio, mail appropriate materials or drop off samples. Portfolio should include original/final art, tearsheets and photographs; include color and b&w samples. Pays for illustration by the project, $75-5,000. Rights purchased vary according to project.

Tips ''Send mailers and drop off portfolio.''

☑ MIZEREK DESIGN INC.

333 E. 14th St., New York NY 10003. (212)777-3344. Fax: (212)777-8181. E-mail: leonard@mizerek.net. Website: www.mizerek.net. **President:** Leonard Mizerek. Estab. 1975. Specializes in catalogs, direct mail, jewelry, fashion and technical illustration. Clients: corporations—various product and service-oriented clientele. Current clients include: Rolex, Leslie's Jewelry, World Wildlife, The Baby Catalog, Time Life and Random House.

Needs Approached by 20-30 freelancers/year. Works with 10 freelance designers/year. Works on assignment only. Uses freelancers for design, technical illustration, brochures, retouching and logos. 85% of freelance work demands skills in Illustrator, Photoshop and QuarkXPress.

First Contact & Terms Send postcard sample or query letter with résumé, tearsheets and transparencies. Accepts disk submissions compatible with Illustrator and Photoshop 3.0. Will contact artist for portfolio review if interested. Portfolio should include original/final art and tearsheets. Pays for design by the project, $500-5,000. Pays for illustration by the project, $500-3,500. Considers client's budget and turnaround time when establishing payment. Finds artists through sourcebooks and self-promotions.

Tips ''Let the work speak for itself. Be creative. Show commercial product work, not only magazine editorial. Keep me on your mailing list!''

⬛ 🖥 NAPOLEON ART STUDIO

420 Lexington Ave., Suite 3020, New York NY 10170. (212)692-9200. Fax: (212)692-0309. E-mail: scott@napny. com. Website: www.napny.com. **Studio Manager:** Scott Stein. Estab. 1985. Number of employees: 40. AV firm. Full-service, multimedia firm. Specializes in storyboards, magazine ads, computer graphic art animatics. Product specialty is consumer. Current clients include ''all major New York City ad agencies.'' Client list not available.

Needs Approached by 20 freelancers/year. Works with 15 freelance illustrators and 5 designers/year. Prefers local freelancers with experience in animation, computer graphics, film/video production, multimedia, Macintosh. Works on assignment only. Uses freelancers for airbrushing, animation, direct mail, logos and retouching. 10% of work is with print ads. Needs computer-literate freelancers for design, illustration, production and presentation. 80% of freelance work demands skills in Illustrator or Photoshop.

First Contact & Terms Send query letter with photocopies, tearsheets and ³/₄″ or VHS tape. Samples are filed. Responds only if interested. Will contact artist for portfolio review if interested. Portfolio should include b&w and color thumbnails. Pays for design and illustration by the project. Rights purchased vary acording to project. Finds artists through word of mouth and submissions.

🌐 🖥 NICOSIA CREATIVE EXPRESSO, LTD.

355 W. 52nd St., 8th Floor, New York NY 10019. (212)515-6600. Fax: (212)265-5422. E-mail: info@niceltd.com. Website: www.niceltd.com. **President/Creative Director:** Davide Nicosia. Estab. 1993. Number of employees: 20. Specializes in graphic design, corporate/brand identity, brochures, promotional material, packaging, fragrance bottles and 3-D animations. Current clients include Cosmopolitan Cosmetics, Estee Lauder Companies, Procter & Gamble and Wella.

• NICE is an innovative graphic design firm. Their team of multicultural designers deliver design solutions for the global marketplace.

Needs Approached by 70 freelancers/year. Works with 6 freelance illustrators and 8 designers/year. Works by assignment only. Uses illustrators, designers, 3-D computer artists and computer artists familiar with Illustrator, Photoshop, After Effects, Premiere, QuarkXPress, Macromedia Director, Flash and Alias Wavefront.

First Contact & Terms Send query letter and résumé. Responds for portfolio review only if interested. Pays for design by the hour. Pays for illustration by the project. Rights purchased vary according to project.

Tips Looks for ''promising talent and the right attitude.''

Ⓝ NOTOVITZ COMMUNICATIONS

47 E. 19th St., New York NY 10003. (212)677-9700. Fax: (212)677-9704. E-mail: joseph@notovitz.com. Website: www.notovitz.com. **President:** Joseph Notovitz. Number of employees: 4. Approximate annual billing: $1.2

million. Specializes in corporate design (annual reports, literature, publications, websites), corporate identity and signage. Clients: finance, medicine and industry. Professional affiliation: APDF.

Needs Approached by 100 freelancers/year. Works with 10 freelance illustrators and 10 designers/year. Uses freelancers for brochure, poster, direct mail and booklet illustration; mechanicals; charts/graphs; and logo design. Needs computer-literate freelancers for design, illustration and production. 90% of freelance work demands knowledge of PageMaker, QuarkXPress, Illustrator or Photoshop. Needs pool of freelance web developers.

First Contact & Terms Send résumé, printed pieces and tearsheets to be kept on file. Samples not filed are returned by SASE. Responds in 1 week. Call for appointment to show portfolio of roughs, original/final art and final reproduction/product. Pays for design by the hour, $15-50 or by the project, $200-1,500. Pays for illustration by the project, $200-5,000; also negotiates.

Tips "Do a bit of research on the firm you are contacting. Send pieces which reflect our firm's style and needs. If we never produce book covers, book cover art does not interest us. Know the computer software used by the industry and know it thoroughly."

🄽 ▣ 🄸 🆅 NOVUS VISUAL COMMUNICATIONS, INC.

121 E. 24th St., 12th Floor, New York NY 10010-2950. (212)473-1377. Fax: (212)505-3300. E-mail: novus@novus communications.com. Website: www.novuscommunications.com. **President:** Robert Antonik. Vice President/ Creative Director: Denis Payne. Estab. 1984. Creative marketing and communications firm. Specializes in advertising, annual reports, brand and corporate identity, display, direct mail, fashion, package and publication design, technical illustration and signage. Clients: healthcare, telecommunications, consumer products companies. Client list available upon request.

Needs Approached by 12 freelancers/year. Works with 2-4 freelance illustrators and 2-6 designers/year. Works with artist reps. Prefers local artists only. Uses freelancers for ad, brochure, catalog, poster and P-O-P design and illustration, airbrushing, audiovisual materials, book, direct mail, magazine and newpaper design, charts/ graphs, lettering, logos, mechanicals and retouching. 75% of freelance work demands skills in Illustrator, Photoshop, FreeHand, PageMaker and QuarkXPress.

First Contact & Terms Contact only through artist rep. Send postcard sample of work. Samples are filed. Responds ASAP. Follow up with call. Pays for design by the hour, $15-75; by the day, $200-300; by the project, $200-1,500. Pays for illustration by the project, $150-1,750. Rights purchased vary according to project. Finds artists through *Creative Illustration, Workbook*, agents and submissions.

Tips "First impressions are important, a portfolio should represent the best, whether it's 4 samples or 12." Advises freelancers entering the field to "always show your best creation. You don't need to overwhelm your interviewer, and it's always a good idea to send a thank you or follow-up phone call."

☑ ▣ OUTSIDE THE BOX INTERACTIVE

130 W. 25th St., New York NY 10001. (212)463-7160. Fax: (212)463-9179. E-mail: theoffice@outboxin.com. Website: www.outboxin.com. **Vice President and Director of Multimedia:** Lauren Schwartz. Estab. 1995. Number of employees: 10. OTBI, a full service firm combining graphics, video, animation, text, music and sounds into effective interactive programs, with other media. Our product mix includes internet/intranet/ extranet development and hosting, corporate presentations, disk-based direct mail, customer/product kiosks, games, interactive press kits, advertising, marketing and sales tools. We also offer web hosting for product launches, questionnaires and polls. Our talented staff consists of writers, designers and programmers.

Needs Approached by 5-10 freelance illustrators and 5-10 designers/year. Works with 8-10 freelance illustrators and 8-10 designers/year. Prefers freelancers with experience in computer arts. Also for airbrushing, animation, brochure and humorous illustration, logos, model-making, multimedia projects, posters, retouching, storyboards, TV/film graphics, web page design. 90% of design demands skills in Photoshop, QuarkXPress, Illustrator, Director HTML, Java Script and any 3D program. 60% of illustration demands skills in Photoshop, QuarkXPress, Illustrator, any animation and 3D program.

First Contact & Terms Send query letter with brochure, photocopies, photographs, photostats, résumé, SASE, slides, tearsheets, transparencies. Send follow-up postcard every 3 months. Accepts disk submissions compatible with Power PC. Samples are filed and are returned by SASE. Will contact if interested. Pays by project. Rights purchased vary according to project.

Tips "Be able to think on your feet and to test your limits."

PRO/CREATIVES COMPANY

25 W. Burda Place, New York NY 10956-7116. **President:** D. Rapp. Estab. 1986. Ad agency and marketing/ promotion PR firm. Specializes in direct mail, ads, collateral. Product specialties are consumer/trade, goods/ services.

Needs Works on assignment only. Uses freelancers for brochure and print ad design and illustration. 30% of work is with print ads.

First Contact & Terms Samples are filed or are returned by SASE. Portfolio review not required. Pays for design and illustration by the project.

N GERALD & CULLEN RAPP, INC.

420 Lexington Ave., Suite 3100, New York NY 10170. (212)889-3337. Fax: (212)889-3341. E-mail: sam@rappart. com. Website: www.theispot.com/rep/rapp. Number of employees: 10. Approximate annual billing: $5 million. **Associate:** John Knepper. Estab. 1944. Clients: ad agencies, coporations and magazines. Client list not available. Professional affiliations: GAG, SPAR, S.I.

Needs Approached by 500 freelance artists/year. Works with 45 exclusive freelance illustrators. Works on assignment only. Uses freelance illustrators for editorial advertising and corporate illustration.

First Contact & Terms Send query letter with tearsheets and SASE. Samples are filed or returned by SASE if requested by artist. Responds in 2 weeks. Call or write for appointment to show portfolio or mail appropriate materials. Pays for illustration by the project, $500-40,000. Negotiates rights purchased.

N RED ROOSTER GROUP

(formerly Howard Levy Design), 150 Varick St., 8th Floor, New York NY 10013. (212)929-2657. E-mail: howard @redroostergroup.com; john@redroostergroup.com. Website: www.redroostergroup.com. **Creative Director:** Howard Levy. Creative Captain: John Napolitano. Estab. 1991. Number of employees: 3. Specializes in corporate marketing and communication design: identities, brochures, annual reports, magazines, books, website design and promotion. Professional affiliation: AIGA.

Needs Approached by 50 freelancers/year. Works with 5 freelance illustrators and 3 designers/year. Prefers artists with experience in QuarkXPress, Illustrator and Photoshop. Uses designers and illustrators mainly for magazines, annual reports, brochures and illustration, lettering, logos, mechanicals, posters and retouching. 80% of freelance work demands knowledge of Photoshop, QuarkXPress and Illustrator.

First Contact & Terms Send query letter with brochure, photocopies, photographs, résumé, SASE and tearsheets and transparencies. Responds only if interested. Pays for design by the hour, $25-35; or by the project, $500-5,000. Pays for illustration, $100-1,000 for color inside; or by the project, $500-2,000 for 2-page spreads. Finds artists through creative sourcebooks and submissions.

Tips "We are seeking illustrators with strong conceptual skills for environmental and non-profit socially responsible clients. Also seeking local designers with strong financial and corporate experience."

N SAATCHI & SAATCHI ADVERTISING WORLDWIDE

375 Hudson St., New York NY 10014-3620. (212)463-2000. Fax: (212)463-9855. Website: www.saatchi-saatchi.c om. **Contact:** Senior Art Buyer. Full-service advertising agency. Clients include: Delta Airlines, Eastman Kodak, General Mills and Procter & Gamble.

Needs Approached by 50-100 freelancers/year. Works with 1-5 designers and 15-35 illustrators/year. Uses freelancers mainly for illustration and advertising graphics. Prefers freelancers with knowledge of electronic/ digital delivery of images.

First Contact & Terms Send query letter and nonreturnable samples or postcard sample. Prefers illustrators' sample postcards or promotional pieces to show "around a half a dozen illustrations," enough to help art buyer determine illustrator's style and visual vocabulary. Files interesting promo samples for possible future assignments. Pays for design and illustration by the project.

ARNOLD SAKS ASSOCIATES

350 E. 81st St., New York NY 10028. (212)861-4300. Fax: (212)535-2590. E-mail: afiorillo@saksdesign.com. **Vice President:** Anita Fiorillo. Estab. 1967. Specializes in annual reports and corporate communications. Clients: Fortune 500 corporations. Current clients include Alcoa, Wyeth, Xerox and Hospital for Special Surgery. Client list available upon request.

Needs Works with 1 or 2 computer technicians and 1 designer/year. "Computer technicians: accuracy and speed are important, as is a willingness to work late nights and some weekends." Uses illustrators for technical illustration and occasionally for annual reports. Uses designers mainly for in-season annual reports. Also uses artists for brochure design and illustration, mechanicals and charts/graphics. Needs computer-literate freelancers for production and presentation. All freelance work demands knowledge of QuarkXPress, Illustrator or Photoshop.

First Contact & Terms Send query letter with brochure and résumé. Samples are filed. Responds only if interested. Write for appointment to show portfolio. Portfolio should include finished pieces. Pays for design by the hour, $25-60. Pays for illustration by the project, $200 minimum. Payment depends on experience and terms and varies depending upon scope and complication of project. Rights purchased vary according to project.

Advertising & Design

TRITON ADVERTISING, INC.

15 W. 44th St., New York NY 10036. (212)840-3040. Fax: (212)575-9391. E-mail: tritonco@aol.com. Website: www.tritonadv.com. **Creative Director:** Eric Friedmann. Number of employees: 20. Ad agency. Estab. 1950. Clients: fashion industry, entertainment, retail, direct, health care and Broadway shows.

Needs Works with 6 illustrators and 6 designers/year. Uses freelancers for consumer magazines, brochures/flyers and newspapers; occasionally buys cartoon-style illustrations. Prefers pen & ink and collage. 90% of work is with print ads. 100% of design and 70% of illustration demand knowledge of QuarkXPress, FreeHand and Photoshop.

First Contact & Terms Send postcard sample with brochure and résumé to Eric Friedmann. Accepts submissions on disk compatible with Mac. Originals not returned. Pays for illustration and design by the project, $100-3,500.

Tips "Don't get too complex—make it really simple. Don't send originals."

NORTH CAROLINA

BOB BOEBERITZ DESIGN

247 Charlotte St., Asheville NC 28801. (828)258-0316. E-mail: bobb@main.nc.us. Website: www.bobboeberitzd esign.com. **Owner:** Bob Boeberitz. Estab. 1984. Number of employees: 1. Approximate annual billing: $80,000. Specializes in graphic design, corporate identity and package design. Clients: retail outlets, hotels and restaurants, textile manufacturers, record companies, publishers, professional services. Majority of clients are business-to-business. Current clients include Para Research Software, Blue Duck Music, Quality America, Owen Manufacturing Co., Cross Canvas Co. and High Windy Audio. Professional affiliations: AAF, Asheville Chamber, NARAS, Asheville Freelance Network, Asheville Creative Services Group.

 • Owner Bob Boeberitz predicts "everything in art design will be done on computer; more electronic; more stock images; photo image editing and conversions will be used; there will be less commissioned artwork."

Needs Approached by 50 freelancers/year. Works with 5 freelance illustrators/year. Works on assignment only. Uses freelancers primarily for technical illustration and comps. Prefers pen & ink, airbrush and acrylic. 50% of freelance work demands knowledge of PageMaker, Illustrator, Photoshop or CorelDraw.

First Contact & Terms Send query letter with résumé, brochure, SASE, photographs, slides and tearsheets. "Anything too large to fit in file" is discarded. Accepts disk submissions compatible with IBM PCs. Send AI-EPS, PDF, JPG, GIF, HTML and TIFF files. Samples are returned by SASE if requested. Responds only if interested. Will contact artist for portfolio review if interested. Portfolio should include thumbnails, roughs, final art, b&w and color slides and photographs. Sometimes requests work on spec before assigning a job. Pays for design and illustration, by the project, $50 minimum. Rights purchased vary according to project. Will consider buying second rights to previously published artwork. Finds artists through word of mouth, submissions/self-promotions, sourcebooks, agents.

Tips "Show sketches—sketches help indicate how an artist thinks. The most common mistake freelancers make in presenting samples or portfolios is not showing how the concept was developed, what their role was in it. I always see the final solution, but never what went into it. In illustration, show both the art and how it was used. Portfolios should be neat, clean and flattering to your work. Show only the most memorable work, what you do best. Always have other stuff, but don't show everything. Be brief. Don't just toss a portfolio on my desk; guide me through it. A 'leave-behind' is helpful, along with a distinctive-looking résumé. Be persistent but polite. Call frequently. I don't recommend cold calls (you rarely ever get to see anyone) but it is an opportunity for a 'leave behind.' I recommend using the mail. E-mail is okay, but it isn't saved. Asking people to print out your samples to save in a file asking too much. I like postcards. They get noticed, maybe even kept. They're economical. And they show off your work. And you can do them more frequently. Plus you'll have a better chance to get an appointment. After you've had an appointment, send a thank you note. Say you'll keep in touch and do it!"

IMAGE ASSOCIATES INC.

4909 Windy Hill Dr., Raleigh NC 27609. (919)876-6400. Fax: (919)876-7064. E-mail: carla@imageassociates.c om. Website: www.imageassociates.com. **President:** Carla Davenport. Estab. 1984. Number of employees: 35. Marketing communications group offering advanced Web-based solutions, multimedia and print. Visual communications firm specializing in computer graphics and AV, multi-image, interactive multimedia, Internet development, print and photographic applications.

Needs Approached by 10 freelancers/year. Works with 4 freelance illustrators and 4 designers/year. Prefers freelancers with experience in Web, CD-ROM and print. Works on assignment only. Uses freelancers mainly for Web design and programming. Also for print ad design and illustration and animation. 90% of freelance work demands skills in Flash, HTML, DHTML, ASP, Photoshop and Macromind Director.

First Contact & Terms Send query letter with brochure, résumé and tearsheets. Samples are filed or are returned

by SASE if requested by artist. Responds only if interested. To show portfolio, mail roughs, finished art samples, tearsheets, final reproduction/product and slides. Pays for assignments by the project, $100 minimum. Considers complexity of project, client's budget and how work will be used when establishing payment. Rights purchased vary according to project.

Ⓝ SMITH ADVERTISING & ASSOCIATES

321 Arch St., Fayetteville NC 28301. (910)323-0920. Fax: (910)486-8075. E-mail: kcastle@smithadv.com. Website: www.smithadv.com. **Production Manager:** Kelley Castle. Estab. 1974. Ad agency. Full-service, multimedia firm. Specializes in newspaper, magazine, broadcast, collateral, PR, custom presentations and web design. Product specialties are financial, healthcare, manufacturing, business-to-business, real estate, tourism. Current clients include Sarasota CVB, NC Ports, Southeastern Regional Medical Center, Standard Tobacco Corp. Client list available upon request.

Needs Approached by 0-5 freelance artists/month. Works with 5-10 freelance illustrators and designers/month. Prefers artists with experience in Macintosh. Works on assignment only. Uses freelance artists mainly for mechanicals and creative. Also uses freelance artists for brochure, catalog and print ad illustration and animation, mechanicals, retouching, model-making, TV/film graphics and lettering. 50% of work is with print ads. Needs computer-literate freelancers for design, illustration, production and presentation. 95% of freelance work demands knowledge of QuarkXPress, Illustrator or Photoshop.

First Contact & Terms Send query letter with résumé and copies of work. Samples are returned by SASE if requested by artist. Responds in 3 weeks. Artist should call. Will contact artist for portfolio review if interested. Portfolio should include b&w and color thumbnails, final art and tearsheets. Pays for design and illustration by the project, $100. Buys all rights.

NORTH DAKOTA

▣ FLINT COMMUNICATIONS

101 Tenth St. N., Fargo ND 58102. (701)237-4850. Fax: (701)234-9680. Website: www.flintcom.com. **Art Directors:** Gerri Lien, Dawn Koranda and Jeff Reed. Estab. 1947. Number of employees: 40. Approximate annual billing: $9 million. Ad agency. Full-service, multimedia firm. Product specialties are agriculture, manufacturing, healthcare, insurance and banking. Professional affiliations: AIGA.

Needs Approached by 50 freelancers/year. Works with 6-10 freelance illustrators and 3-4 designers/year. Uses freelancers for annual reports, brochure design and illustration, lettering, logos and TV/film graphics. 40% of work is with print ads. 20% of freelance work demands knowledge of PageMaker, Photoshop, QuarkXPress and Illustrator.

First Contact & Terms Send postcard-size or larger sample of work and query letter. Samples are filed. Will contact artist for portfolio review if interested. Pays for illustration by the project, $100-2,000. Rights purchased vary according to project.

SIMMONS/FLINT ADVERTISING

P.O. Box 5700, Grand Forks ND 58206-5700. (701)746-4573. Fax: (701)746-8067. E-mail: YvonneRW@simmons adv.com. Website: www.simmonsflint.com. **Contact:** Yvonne Westrum. Estab. 1947. Number of employees: 8. Approximate annual billing: $5.5 million. Ad agency. Specializes in magazine ads, collateral, documentaries, web design etc. Product specialties are agriculture, gardening, fast food/restaurants, electric utilities. Client list available upon request.

● A division of Flint Communications, Fargo ND. See listing in this section.

Needs Approached by 3-6 freelancers/year. Works with 3 freelance illustrators and 2 designer/year. Works on assignment only. Uses freelancers mainly for illustration. Also for brochure, catalog and print ad design and illustration; storyboards; billboards; and logos. 10% of work is with print ads. 10% of freelance work demands knowledge of QuarkXPress, Photoshop, Illustrator.

First Contact & Terms Send postcard sample or tearsheets. Samples are filed or are returned. Will contact artist for portfolio review if interested. Portfolio should include color thumbnails, roughs, tearsheets, photostats and photographs. Pays for design and illustration by the hour, by the project, or by the day. Rights purchased vary according to project.

OHIO

Ⓝ BRIGHT LIGHT PRODUCTIONS, INC.

602 Main St., Suite 810, Cincinnati OH 45202. (513)721-2574. Fax: (513)721-3329. **President:** Linda Spalazzi. Estab. 1976. AV firm. "We are a full-service film/video communications firm producing TV commercials and corporate communications."

Needs Works on assignment only. Uses artists for editorial, technical and medical illustration and brochure and print ad design, storyboards, slide illustration, animatics, animation, TV/film graphics and logos. Needs computer-literate freelancers for design and production. 50% of freelance work demands knowledge of Photoshop, Illustrator and After Effects.

First Contact & Terms Send query letter with brochure and résumé. Samples not filed are returned by SASE only if requested by artist. Request portfolio review in original query. Portfolio should include roughs and photographs. Pays for design and illustration by the project. Negotiates rights purchased. Finds artists through recommendations.

Tips "Our need for freelance artists is growing."

▣ HOLLAND COMMUNICATIONS

700 Walnut St., Suite 300, Cincinnati OH 45202-2011. (513)721-1310. Fax: (513)721-1269. E-mail: Mholland@ho llandroi.com. Website: www.hollandROI.com. **Partner:** Mark Holland. Estab. 1937. Number of employees: 17. Approximate annual billing: $12 million. Ad agency. Full-service, multimedia firm. Professional affiliation: AAAA.

Needs Approached by 6-12 freelancers/year. Works with 5-10 freelance illustrators and 2-3 designers/year. Prefers artists with experience in Macintosh. Uses freelancers for brochure illustration, logos and TV/film graphics. 100% of freelance work demands knowledge of Photoshop, QuarkXPress and Illustrator.

First Contact & Terms Send query letter with photocopies and résumé. Accepts submissions on disk. Samples are filed and are not returned. Will contact artist for portfolio review if interested. Portfolio should include b&w and color final art, photographs, roughs, tearsheets and thumbnails. Pays for design by the hour, by the project and by the day. Pays for illustration by the project. Rights purchased vary according to project.

▣ INNOVATIVE MULTIMEDIA (formerly Instant Replay)

2515 Essex, Suite 164, Cincinnati OH 45206. (513)569-8600. Fax: (513)569-8608. **President:** Terry Hamad. Estab. 1977. AV/Post Production/Graphic Design firm. "We are a full-service film/video production and video post production house with our own sound stage. We also do traditional animation and 3-D computer animation for broadcast groups, corporate entities and ad agencies. We do many corporate identity pieces as well as network affiliate packages, car dealership spots and general regional and national advertising for TV market." Current clients include Procter and Gamble, General Electric and Western Southern.

Needs Works with 1 designer/month. Prefers freelancers with experience in video production. Works on assignment only. Uses freelancers mainly for production. Also uses freelancers for storyboards, animatics, animation and TV/film graphics.

First Contact & Terms Send query letter with résumé, photocopies, slides and videotape. "Interesting samples are filed." Samples not filed are returned by SASE only if requested. Responds only if interested. Call for appointment to show slide portfolio. Pays by the hour, $25-50 or by the project and by the day (negotiated by number of days.) Pays for production by the day, $75-300. Considers complexity of project, client's budget and turnaround time when establishing payment. Buys all rights.

▣ ▣ ▣ LIGGETT-STASHOWER

1228 Euclid Ave., Cleveland OH 44115. (216)348-8500. Fax: (216)736-8113. E-mail: artbuyer@liggett.com. Website: www.liggett.com. **Art Buyer:** Rachel Williams. Estab. 1932. Ad agency. Full-service multimedia firm. Works in all formats. Handles all product categories. Current clients include Sears Optical, Forest City Management, Cedar Point, Crane Performance Siding, Geauga Lake, Henkel Consumer Adhesives, Ohio Lottery and Timber Tech.

Needs Approached by 120 freelancers/year. Works with freelance illustrators and designers. Prefers local freelancers. Works on assignment only. Uses freelancers mainly for brochure, catalog and print ad design and illustration, storyboards, slide illustration, animatics, animation, retouching, billboards, posters, TV/film graphics, lettering and logos. Needs computer-literate freelancers for illustration and production. 90% of freelance work demands skills in QuarkXPress, FreeHand, Photoshop or Illustrator.

First Contact & Terms Send query letter. Samples are filed and are not returned. Responds only if interested. To show portfolio, mail tearsheets and transparencies. Pays for design and illustration by the project. Negotiates rights purchased.

Tips Please consider that art buyers and art directors are very busy and receive at least 25 mailings per day from freelancers looking for work opportunities. We might have loved your promo piece, but chances of us remembering it by your name alone when you call are slim. Give us a hint—"it was red and black" or whatever. We'd love to discuss your piece, but it's uncomfortable if we don't know what you're talking about.

⃞ LOHRE & ASSOCIATES
2330 Victory Parkway, Suite 701, Cincinnati OH 45206. (513)961-1174. E-mail: sales@lohre.com. Website: www.lohre.com. **President:** Chuck Lohre. Number of employees: 8. Approximate annual billing: $1 million. Ad agency. Specializes in industrial firms. Professional affiliation: BMA.

Needs Approached by 24 freelancers/year. Works with 10 freelance illustrators and 10 designers/year. Works on assignment only. Uses freelance artists for trade magazines, direct mail, P-O-P displays, multimedia, brochures and catalogs. 100% of freelance work demands knowledge of PageMaker, FreeHand, Photoshop and Illustrator.

First Contact & Terms Send postcard sample or e-mail. Accepts submissions on disk, any Mac application. Pays for design and illustration by the hour, $10 minimum.

Tips Looks for artists who ''have experience in chemical and mining industry, can read blueprints and have worked with metal fabrication. Also needs Macintosh-literate artists who are willing to work at office, during day or evenings.''

⃞ ⃞ CHARLES MAYER STUDIOS INC.
168 E. Market St., Akron OH 44308. (330)535-6121. **President:** C.W. Mayer, Jr. AV producer. Estab. 1934. Number of employees: 65. Approximate annual billing: $2 million. Clients: mostly industrial. Produces film and manufactures visual aids for trade show exhibits.

Needs Uses illustrators for catalogs, filmstrips, brochures and slides. Also for brochures/layout, photo retouching and cartooning for charts/visuals. In addition, has a large gallery and accepts paintings, watercolors, etc. on a consignment basis, 33%-40% commissions.

First Contact & Terms Send slides, photographs, photostats or b&w line drawings or arrange interview to show portfolio. Samples not filed are returned by SASE. Responds in 1 week. Provide résumé and a sample or tearsheet to be kept on file. Originals returned to artist at job's completion. Negotiates payment.

STEVENS BARON COMMUNICATIONS
Hanna Bldg., Suite 645, 1422 Euclid Ave., Cleveland OH 44115-1900. (216)621-6800. Fax: (216)621-6806. Website: www.stevensbaron.com. **President:** Edward M. Stevens, Sr. Estab. 1956. Ad agency. Specializes in public relations, advertising, corporate communications, magazine ads and collateral. Product specialties are business-to-business, food, building products, technical products, industrial food service, healthcare, safety.

Needs Approached by 30-40 freelance artists/month. Prefers artists with experience in food and technical equipment. Works on assignment only. Uses freelance artists mainly for specialized projects. Also uses freelance artists for brochure, catalog and print ad illustration and retouching. Freelancers should be familiar with PageMaker, QuarkXPress, FreeHand, Illustrator and Photoshop.

First Contact & Terms Send query letter with résumé and photocopies. Samples are filed and are not returned. Does not reply back. ''Artist should send only samples or copies that do not need to be returned.'' Will contact artist for portfolio review if interested. Portfolio should include final art and tearsheets. Pay for design depends on style. Pay for illustration depends on technique. Buys all rights. Finds artists through agents, sourcebooks, word of mouth and submissions.

OKLAHOMA

KIZER INC. ADVERTISING & COMMUNICATIONS
4513 Classen Blvd., Oklahoma City OK 73118. (405)858-4906. Fax: (405)840-4842. E-mail: bill@kizerincorporated.com. Website: www.kizerincorporated.com. **Principal:** William Kizer. Estab. 1998. Number of employees: 3. Ad agency. Specializing in magazine ads, annual reports, collateral material. Professional affiliations: OKC Ad Club, AMA, AIGA.

Needs Approached by 20 illustrators/year. Works with 3 illustrators and 3 designers/year. 50% of work is with print ads. 100% of design demands knowledge of InDesign, FreeHand, Photoshop. 50% of illustration demands knowledge of FreeHand, Photoshop.

First Contact & Terms Designers send query letter with samples. Illustrators send query letter with samples. Accepts disk submissions compatible with FreeHand or Photoshop file. Samples are filed and are not returned. Responds only if interested. To show portfolio, artist should follow up with call. Portfolio should include ''your best work.'' Pays by the project. Rights purchased vary according to project. Finds artists through agents, sourcebooks, online services, magazines, word of mouth, artist's submissions.

⃞ PLANT & ASSOCIATES
1831 E. 71st St., Tulsa OK 74136. (918)877-2792. **Vice President:** Jennifer Payne. Estab. 1990. Number of employees: 4. Specializes in collateral pieces, packaging, P.O.P., promotional products and annual reports. Current clients include Hilti and Vintage Petroleum. Client list available upon request.

Needs Approached by 6-8 illustrators and 6-8 designers/year. Works with 3-4 illustrators and 4-5 designers/year. Prefers local designers only. Uses freelancers mainly for concepts for packaging, print collateral and audiovisual work. Also for billboards, brochure design and illustration, catalog design, logos. 10-15% of work is with print ads. 100% of design demands knowledge of PageMaker, FreeHand, Photoshop, QuarkXPress, Illustrator. 50% of illustration demands computer knowledge.

First Contact & Terms Send query letter with résumé. Accepts disk submissions compatible with QuarkXPress 7.5/version 3.32. Samples are filed, but can be returned. Responds only if interested. Will contact for portfolio review of photographs, roughs, thumbnails, transparencies. Pays by the hour. Finds artists through word of mouth, artists or agency contact.

Tips "Have great attitude. Have great work ethic. You must love working with professional happy women."

OREGON

N ADFILIATION ADVERTISING

P.O. Box 5855, Eugene OR 97405. (541)687-8262. Fax: (541)687-8576. E-mail: vip@adfiliation.com. Website: www.adfiliation.com. **President/Creative Director:** Gary Schubert. Media Director/VP: Gwen Schubert. Estab. 1976. Ad agency. "We provide full-service advertising to a wide variety of regional and national accounts. Our specialty is print media, serving predominantly industrial and business-to-business advertisers." Product specialties are forest products, heavy equipment, software, sporting equipment, food and medical.

Needs Works with approximately 4 freelance illustrators and 2 designers/year. Works on assignment only. Uses freelancers mainly for specialty styles. Also for brochure and magazine ad illustration (editorial, technical and medical), retouching, animation, films and lettering. 80% of work is with print ads. 80% of freelance work demands knowledge of Illustrator, QuarkXPress, FreeHand, Director, Photoshop, multimedia program/design.

First Contact & Terms Send query letter, brochure, résumé, slides and photographs. Samples are filed or are returned by SASE only if requested. Responds only if interested. Write for appointment to show portfolio. Pays for design and illustration and by the hour, $25-100. Rights purchased vary according to project.

Tips "We're busy. So follow up with reminders of your specialty, current samples of your work and the convenience of dealing with you. We are looking at more electronic illustration. Find out what the agency does most often and produce a relative example for indication that you are up for doing the real thing! Follow up after initial interview of samples. Do not send fine art, abstract subjects."

CREATIVE COMPANY, INC.

726 NE Fourth St., McMinnville OR 97128. (866)363-4433. Fax: (866)363-6817. E-mail: jlmorrow@creativeco.com. Website: www.creativeco.com. **President/Owner:** Jennifer Larsen Morrow. Specializes in marketing-driven corporate identity, collateral, direct mail, packaging and P-O-P displays. Product specialties are food, garden products, financial services, colleges, manufacturing, pharmaceutical, medical, transportation programs.

Needs Works with 6-10 freelance designers and 3-7 illustrators/year. Prefers local artists. Works on assignment only. Uses freelancers for design, illustration, computer production (Mac), retouching and lettering. "Looking for clean, fresh designs!" 100% of design and 60% of illustration demand skills in QuarkXPress, Pagemaker, FreeHand, Illustrator and Photoshop.

First Contact & Terms Send query letter with brochure, résumé, business card, photocopies and tearsheets to be kept on file. Samples returned by SASE only if requested. Will contact for portfolio review if interested. "We require a portfolio review. Years of experience not important if portfolio is good. We prefer one-on-one review to discuss individual projects/time/approach." Pays for design by the hour or project, $50-90. Pays for illustration by the project. Considers complexity of project and skill and experience of artist when establishing payment.

Tips Common mistakes freelancers make in presenting samples or portfolios are: "1) poor presentation, samples not mounted or organized; 2) not knowing how long it took them to do a job to provide a budget figure; 3) not demonstrating an understanding of the audience, the problem or printing process and how their work will translate into a printed copy; 4) just dropping in without an appointment; 5) not following up periodically to update information or a résumé that might be on file."

WISNER ASSOCIATES, Advertising, Marketing & Design

18200 NW Sauvie Island Rd., Portland OR 97231-1338. (503)282-3929. Fax: (503)282-0325. E-mail: wizbiz@pacifer.com. **Creative Director:** Linda Wisner. Estab. 1979. Number of employees: 1. Specializes in brand and corporate identity, book design, direct mail, packaging, publications and exhibit design. Clients: small businesses, manufacturers, restaurants, service businesses and book publishers.

Needs Works with 3-5 freelance illustrators/year. Prefers experienced freelancers and "fast, accurate work." Works on assignment only. Uses freelancers for technical and fashion illustration and graphic production. Knowledge of QuarkXPress, Photoshop, Illustrator and other software required.

First Contact & Terms Send query letter with résumé and samples. Prefers "examples of completed pieces which show the fullest abilities of the artist." Samples not kept on file are returned by SASE only if requested. Will contact artist for portfolio review if interested. Pays for illustration by the hour, $20-45 average or by the project, by bid. Pays for computer work by the hour, $15-25.

PENNSYLVANIA

Ⓝ DICCICCO BATTISTA COMMUNICATIONS

Dept. AM, 655 Business Center Dr., Horsham PA 19044. (215)957-0300. Website: www.dbcommunications.net. **Creative Director:** Carol Corbett. Estab. 1967. Full-service, multimedia, business-to-business ad agency. "High Creative." Specializes in food and business-to-business. Current clients include Hatfield Meats, Primavera, Hallowell and Caulk Dental Supplies.

Needs Works with 10 freelance illustrators and 25 freelance designers/month. Uses freelance artists mainly for paste-up and mechanicals, illustration, photography and copywriting. Also uses artists for brochure design, slides, print ads, animatics, animation, retouching, TV/film grapics, lettering and logos. 60% of work is with print ads.

First Contact & Terms Send query letter with brochure, résumé, tearsheets, photostats, photocopies, photographs, slides and SASE. Samples are filed or are returned by SASE only if requested by artist. Responds only if interested. Write to schedule an appointment to show a portfolio, which should include roughs, original/final art, tearsheets, final reproduction/product, photographs, slides; include color and b&w samples. Pays for design by the hour, $15-50. Pays for illustration by the project. Rights purchased vary according to project.

Tips "Not everything they've had printed is worth showing—good ideas and good executions are worth more than mediocre work that got printed. Check on agency's client roster in the Red Book—that should tell you what style or look they'll be interested in."

Ⓝ ▣ DLD CREATIVE

620 E. Oregon Rd., Lititz PA 17543. (717)569-6568. Fax: (717)569-7410. E-mail: info@dldcreative.com. Website: www.dldcreative.com. **President/Creative Director:** Dave Loose. Estab. 1986. Number of employees 12. Full-service design firm. Specializes in branding and corporate communications. Client list available upon request.

Needs Approached by 4 illustrators and 12 designers/year. Works with 4 illustrators/year. Uses freelancers mainly for illustration. Also for animation, catalog, humorous and technical illustration and TV/film graphics. 10% of work is with print ads. 50% of design demands skills in Photoshop, QuarkXPress, Illustrator.

First Contact & Terms Designers send query letter with photocopies, résumé and tearsheets. Illustrators send postcard sample of work. Accepts e-mail submissions. Samples are filed. Responds only if interested. No calls, please. Portfolio should include color final art and concept roughs. Pays for design and illustration by the project. Buys all rights. Finds artists through *American Showcase*, postcard mailings, word of mouth.

Tips "Be conscientious of deadlines, willing to work with hectic schedules. Must be top talent and produce highest quality work."

Ⓝ THE NEIMAN GROUP

Harrisburg Transportation Center, 614 N. Front St., Harrisburg PA 17101. (717)232-5554. Fax: (717)232-7998. E-mail: neimangrp@aol.com. Website: www.neimangroup.com. **Senior Art Director:** Frank Arendt. Estab. 1978. Full-service ad agency specializing in print collateral and ad campaigns. Product specialties are healthcare, banks, retail and industry.

Needs Works with 5 illustrators and 4 designers/month. Prefers local artists with experience in comps and roughs. Works on assignment only. Uses freelancers mainly for advertising illustration and comps. Also uses freelancers for brochure design, mechanicals, retouching, lettering and logos. 50% of work is with print ads. 3% of design and 1% of illustration demand knowledge of Illustrator and Photoshop.

First Contact & Terms Designers send query letter with résume. Illustrators send postcard sample, query letter or tearsheets. Samples are filed. Will contact artist for portfolio review if interested. Portfolio should include color thumbnails, roughs, original/final art, photographs. Pays for design and illustration by the project, $300 minimum. Finds artists through sourcebooks and workbooks.

Tips "Try to get a potential client's attention with a novel concept. Never, ever, miss a deadline. Enjoy what you do."

Ⓝ WILLIAM SKLAROFF DESIGN ASSOCIATES

Berwyn PA. (610)647-4470. Fax: (610)647-4655. E-mail: wsklaroff@aol.com. **Design Director:** William Sklaroff. Estab. 1956. Specializes in display, interior, package and publication design and corporate identity and signage. Clients: contract furniture, manufacturers, healthcare corporations. Current clients include: Kaufman, Halcon

Corporation, L.U.I. Corporation, McDonald Products, Shoup Electronic Voting Solutions, BK/Barrit, Herman Miller, Smith Metal Arts, Baker Furniture, Novikoff, Harden Furniture and Metrologic Instruments. Client list available upon request.

Needs Approached by 2-3 freelancers/year. Works with 2-3 freelance illustrators and 2-3 designers/year. Works on assignment only. Uses freelancers mainly for assistance on graphic projects. Also for brochure design and illustration, catalog and ad design, mechanicals and logos.

First Contact & Terms Send query letter with brochure, résumé and slides to William Sklaroff. Samples are returned. Responds in 3 weeks. Pays for design by the hour. Rights purchased vary according to project. Finds artists through word of mouth and submissions.

WARKULWIZ DESIGN ASSOCIATES INC.

2218 Race St., Philadelphia PA 19103. (215)988-1777. Fax: (215)988-1780. E-mail: wda@warkulwiz.com. Website: www.warkulwiz.com. **President:** Bob Warkulwiz. Estab. 1985. Number of employees: 6. Approximate annual billing: $1 million. Specializes in annual reports, publication design and corporate communications. Clients: corporations and universities. Current clients include Firstrust Bank, Penn Law and Wharton School. Client list available upon request. Professional affiliations: AIGA, 1ABC.

Needs Approached by 100 freelancers/year. Works with 10 freelance illustrators and 5-10 photographers/year. Works on assignment only. Uses freelance illustrators mainly for editorial and corporate work. Also uses freelance artists for brochure and poster illustration and mechanicals. Freelancers should be familiar with most recent versions of QuarkXPress, Illustrator, Photoshop, FreeHand and Director.

First Contact & Terms Send query letter with tearsheets and photostats. Samples are filed. Responds only if interested. Call for appointment to show portfolio of "best edited work—published or unpublished." Pays for illustration by the project, "depends upon usage and complexity." Rights purchased vary according to project.

Tips "Be creative and professional."

RHODE ISLAND

☑ MARTIN THOMAS, INC.

334 County Rd., Barrington RI 02806-2410. (401)245-8500. Fax: (401)245-1242. E-mail: jshansky@cox.net. Website: www.martinthomas.com. **Contact:** Martin K. Pottle. Estab. 1987. Number of employees: 12. Approximate annual billing: $7 million. Ad agency, PR firm. Specializes in industrial, business-to-business. Product specialties are plastics, medical and automotive. Professional affiliations: American Association of Advertising Agencies, Boston Ad Club.

Needs Approached by 10-15 freelancers/year. Works with 6 freelance illustrators and 10-15 designers/year. Prefers freelancers with experience in business-to-business/industrial. Uses freelancers mainly for design of ads, literature and direct mail. Also for brochure and catalog design and illustration. 85% of work is print ads. 70% of design and 40% of illustration demands skills in QuarkXPress.

First Contact & Terms Send query letter with brochure and résumé. Samples are filed and are returned. Responds in 3 weeks. Will contact artist for portfolio review if interested. Portfolio should include b&w and color final art. Pays for design and illustration by the hour and by the project. Buys all rights. Finds artists through *Creative Black Book*.

Tips Impress agency by "knowing industries we serve."

▣ SILVER FOX ADVERTISING

11 George St., Pawtucket RI 02860. (401)725-2161. Fax: (401)726-8270. E-mail: sfoxstudios@earthlink.net. Website: www.silverfoxstudios.com. **President:** Fred Marzocchi, Jr. Estab. 1979. Number of employees: 8. Approximate annual billing: $1 million. Specializes in annual reports; brand and corporate identity; display, package and publication design; and technical illustration. Clients: corporations, retail. Client list available upon request.

Needs Approached by 16 freelancers/year. Works with 6 freelance illustrators and 12 designers/year. Works only with artist reps. Prefers local artists only. Uses illustrators mainly for cover designs. Also for multimedia projects. 50% of freelance work demands knowledge of Illustrator, Photoshop, PageMaker and QuarkXPress.

First Contact & Terms Send query letter with résumé and photocopies. Accepts disk submissions compatible with Photoshop 5.0 or Illustrator 8.0. Samples are filed. Does not reply. Artist should follow up with call and/or letter after initial query. Portfolio should include final art, photographs, roughs and slides.

TENNESSEE

N ANDERSON STUDIO, INC.

2609 Grissom Dr., Nashville TN 37204. (615)255-4807. Fax: (615)255-4812. **Contact:** Andy Anderson. Estab. 1976. Specializes in T-shirts (designing and printing of art on T-shirts for retail/wholesale promotional market). Clients: business, corporate retail, gift and specialty stores.

Needs Approached by 20 freelancers/year. Works with 1-2 freelance illustrators and 1-2 designers/year. ''We use freelancers with realistic (photorealistic) style. Works on assignment only. We need artists for automotive-themed art. Also motorcycle designs as seen in the current line of shirts produced for Orange County Choppers of the Discovery Channel. We're also in need of Hot Rod art and designs for T-shirts along with graphic work and logo designs of the same.''

First Contact & Terms Send postcard sample or query letter with color copies, brochure, photocopies, photographs, SASE, slides, tearsheets and transparencies. Samples are filed and are returned by SASE if requested by artist. Portfolio should include slides, color tearsheets, transparencies and color copies. Sometimes requests work on spec before assigning a job. Pays for design and illustration by the project, $300-1,000 or in royalties per piece of printed art. Negotiates rights purchased. Considers buying second rights (reprint rights) to previously published work.

Tips ''Be flexible in financial/working arrangements. Most work is on a commission or flat buyout. We work on a tight budget until product is sold. Art-wise, the more professional the better.'' Advises freelancers entering the field to ''show as much work as you can. Even comps or ideas for problem solving. Let art directors see how you think. Don't send disks. Takes too long to review. Most art directors like hard copy art.''

N HARMON GROUP

807 Third Ave. S., Nashville TN 37210. (615)256-3393. Fax: (615)256-3464. E-mail: abinfo@abstudios.com. Website: www.harmongrp.com. **President:** Rick Arnemann. Estab. 1988. Number of employees: 20. Approximate annual billing: $3.7 million. Specializes in brand identity, display and direct mail design and signage. Clients: ad agencies, corporations, mid-size businesses. Current clients include Best Products, Service Merchandise, WalMart, Hartmann Luggage. Client list available upon request. Professional affiliations: Creative Forum.

Needs Approached by 20 freelancers/year. Works with 4-5 freelance illustrators and 5-6 designers/year. Uses illustrators mainly for P-O-P. Uses designers mainly for fliers and catalogs. Also uses freelancers for ad, brochure, catalog, poster and P-O-P design and illustration, logos, magazine design, mechanicals and retouching. 85% of freelance work demands skills in Illustrator 5.5, Photoshop 3.0 and QuarkXPress 3.31.

First Contact & Terms Send photographs, résumé, slides and transparencies. Samples are filed. Will contact artist for portfolio review if interested. Portfolio should include color final art, roughs, slides and thumbnails. Pays for design and illustration by the project. Rights purchased vary according to project. Finds artists through sourcebooks and portfolio reviews.

N ◼ THE TOMBRAS GROUP

630 Concord St., Knoxville TN 37919. (865)524-5376. Fax: (865)524-5667. E-mail: mmccampbell@tombras.com. Website: www.tombras.com. **Executive Creative Director:** Mitch McCampbell. Estab. 1946. Number of employees: 60. Approximate annual billing: $35 million. Ad agency. Full-service multimedia firm. Specializes in full media advertising, collateral, PR. Current clients include The State of Tennessee and Eastman Chemical. Client list available upon request. Professional affiliations: AAAA, Worldwide Partners, PRSA.

Needs Approached by 20-25 freelancers/year. Works with 20-30 freelance illustrators and 10-15 designers/year. Uses freelancers mainly for illustration and photography. Also for brochure design and illustration, modelmaking and retouching. 60% of work is with print ads. Needs computer-literate freelancers for design and presentation. 25% of freelance work demands skills in FreeHand, Photoshop and QuarkXPress.

First Contact & Terms Send query letter with photocopies and résumé. Samples are filed. Will contact artist for portfolio review if interested. Portfolio should include b&w and color samples. Pays for design by the hour, $25-75; by the project, $250-2,500. Pays for illustration by the project, $100-10,000. Rights purchased vary according to project.

Tips ''Stay in touch with quality promotion. 'Service me to death' when you get a job.''

TEXAS

✠ DYKEMAN ASSOCIATES INC.

4115 Rawlins, Dallas TX 75219. (214)528-2991. Fax: (214)528-0241. E-mail: adykeman@airmail.net. Website: dykemanassoc.com. **Contact:** Alice Dykeman. PR/marketing firm. Specializes in business, industry, hospitality, sports, environmental, energy, health.

Needs Works with 5 illustrators and designers/year. Local freelancers only. Uses freelancers for editorial and technical illustration, brochure design, exhibits, corporate identification, POS, signs, posters, ads and all design and finished artwork for graphics and printed materials. PC or Mac.

First Contact & Terms Request portfolio review in original query. Pays by the project, $250-3,000. "Artist makes an estimate; we approve or negotiate."

Tips "Be enthusiastic. Present an organized portfolio with a variety of work. Portfolio should reflect all that an artist can do. Don't include examples of projects for which you only did a small part of the creative work. Have a price structure but be willing to negotiate per project. We prefer to use artists/designers/illustrators who will work with barter (trade) dollars and join one of our trade exchanges. We see steady growth ahead."

Ⓝ Ⓣ JUDE STUDIOS

(formerly Penn-Jude Partners), 8000 Research Forest, Suite 115-266, The Woodlands TX 77382. (281)364-9366. Fax: (281)364-9529. **Creative Director:** Judith Dollar. Estab. 1994. Number of employees: 2. Design firm. Specializes in printed material, brochure, trade show, collateral. Product specialties are industrial, restaurant, homebuilder, financial, high-tech business to business event marketing materials. Professional affiliations: Art Directors of Houston, AAF.

Needs Approached by 20 illustrators and 6 designers/year. Works with 10 illustrators and 2 designers/year. Prefers local designers only. Uses freelancers mainly for newsletter, logo and brochures. Also for airbrushing; brochure design and illustration; humorous, medical, technical illustration; lettering, logos, mechanicals and retouching. 90% of design demands skills in FreeHand, Photoshop, QuarkXPress. 30% of illustration demands skills in FreeHand, Photoshop, QuarkXPress.

First Contact & Terms Designers send brochure, photocopies, photographs, photostats, résumé, tearsheets. Illustrators send query letter with brochure, photocopies, photographs or tearsheets. Accepts disk submissions. Send TIFF, EPS, PDF or JPEG files. Samples are filed and are not returned. Art director will contact artist for portfolio review if interested. Pays by the project; varies. Negotiates rights purchased. Finds artists through *American Show Case, Workbook, RSVP* and artist's reps.

Tips Wants freelancers with good type usage who contribute to concept ideas. We are open to designers and illustrators who are just starting out their careers.

STEVEN SESSIONS INC.

5177 Richmond, Suite 500, Houston TX 77056. (713)850-8450. Fax: (713)850-9324. E-mail: Steven@Sessionsgroup.com. Website: www.sessionsgroup.com. **President, Creative Director:** Steven Sessions. Estab. 1981. Number of employees: 8. Approximate annual billing: $2.5 million. Specializes in annual reports; brand and corporate identity; fashion, package and publication design. Clients: corporations and ad agencies. Current clients include Compaq Computer, Kellogg Foods, Texas Instruments. Client list available upon request. Professional affiliations: AIGA, Art Directors Club, American Ad Federation.

Needs Approached by 50 freelancers/year. Works with 10 illustrators and 2 designers/year. Uses freelancers for brochure, catalog and ad design and illustration; poster illustration; lettering; and logos. 100% of freelance work demands knowledge of Illustrator, QuarkXPress, Photoshop or FreeHand. Needs editorial, technical and medical illustration.

First Contact & Terms Designers send query letter with brochure, tearsheets, slides and SASE. Illustrators send postcard sample or other nonreturnable samples. Samples are filed. Responds only if interested. To show portfolio, mail slides. Payment depends on project, ranging from $1,000-30,000/illustration. Rights purchased vary according to project.

UTAH

Ⓝ BROWNING ADVERTISING

1 Browning Place, Morgan UT 84050. (801)876-2711. Fax: (801)876-3331. **Contact:** Senior Art Director. Estab. 1878. Distributor and marketer of outdoor sports products, particularly firearms. Inhouse agency for 3 main clients. Inhouse divisions include non-gun hunting products, firearms and accessories.

Needs Approached by 50 freelancers/year. Works with 20 freelance illustrators and 20 designers/year. Prefers freelancers with experience in outdoor sports—hunting, shooting, fishing. Works on assignment only. Uses freelancers mainly for design, illustration and production. Also for advertising and brochure layout, catalogs, product rendering and design, signage, P-O-P displays, and posters.

First Contact & Terms Send query letter with résumé and tearsheets, slides, photographs and transparencies. Samples are not filed and are not returned. Responds only if interested. To show portfolio, mail photostats, slides, tearsheets, transparencies and photographs. Pays for design by the hour, $50-75. Pays for illustration by the project. Buys all rights or reprint rights.

☑ ALAN FRANK & ASSOCIATES INC.

Dept. AM, 1524 S. 1100 E., Salt Lake City UT 84105. (801)486-7455. Fax: (801)486-7454. **Art Director:** Scott Taylor. Serves clients in travel, fast food chains and retailing. Clients include KFC, ProGolf.
Needs Uses freelancers for illustrations, animation and retouching for annual reports, billboards, ads, letterheads, TV and packaging.
First Contract & Terms Mail art with SASE. Responds in 2 weeks. Minimum payment: $500, animation; $100, illustrations; $200, brochure layout.

VERMONT

HARRY SPRUYT DESIGN

P.O. Box 706, Putney VT 05346-0706. Specializes in design/invention of product, package and device, design counseling service shows "in-depth concern for environments and human factors with the use of materials, energy and time; product design evaluation and layout." Clients: product manufacturers, design firms, consultants, ad agencies, other professionals and individuals. Client list available.
Needs Works on assignment only.

VIRGINIA

ⓝ BERMAN/KAPLER PROPERTIES L.L.C.

1600 Tysons Blvd., 8th Floor, McLean VA 22102. (703)556-3242. **Art Director:** Jeff Berman. Estab. 1974. Specializes in annual reports, corporate identity, signage, advertising and PR programs. Clients: real estate developers, architects, high-technology corporations, financially-oriented firms (banks, investment firms, etc.) and associations.
Needs Works with 10 freelance artists/year. Mainly uses artists for architectural rendering and mechanical/production. Also uses artists for design and illustration of brochures, magazines, books, P-O-P displays, retouching, airbrushing, posters, model making, AV materials, lettering and advertisements. Needs computer-literate freelancers for design and production. 75% of freelance work demands computer literacy in Quark XPress.
First Contact & Terms "Artists should be highly professional, with at least 5 years of experience. Restricted to local artists for mechanicals only." Send query letter with brochure, résumé, business card and samples to be kept on file. Call or write for appointment to show portfolio or contact through agent. "Samples should be as compact as possible; slides not suggested." Samples not kept on file are returned by SASE. Responds only if interested. Pays for design by the hour, $20-50. Pays for illustration by the project, $200 minimum.
Tips Artists should have a "totally professional approach." The best way for illustrators or designers to break into our field is a "phone call followed by a strong portfolio presentation" which should include "original completed pieces."

EDDINS MADISON CREATIVE

6121 Lincolnia Rd., #410 Alexandria VA 22312. (703)750-0030. Fax: (703)750-0990. E-mail: denise@emcreative. com. Website: www.em-creative.com. **Creative Director:** Marcia Eddins. Estab. 1983. Number of employees: 9. Specializes in brand and corporate identity and publication design. Clients: corporations, associations and nonprofit organizations. Current clients include Reuters, ABC, National Fire Protection Assoc., Nextel. Client list available upon request.
Needs Approached by 20-25 freelancers/year. Works with 4-6 freelance illustrators and 2-4 designers/year. Uses only artists with experience in Macintosh. Uses illustrators mainly for publications and brochures. Uses designers mainly for simple design and Mac production. Also uses freelancers for airbrushing, brochure and poster design and illustration, catalog design, charts/graphs. Needs computer-literate freelancers for design, production and presentation. 100% of freelance work demands knowledge of Illustrator, Photoshop, FreeHand and QuarkXPress.
First Contact & Terms Send postcard sample of work or send query letter with photocopies and résumé. Samples are filed. Will contact artist for portfolio review if interested. Rights purchased vary according to project. Finds artists through sourcebooks, design/illustration annuals and referrals.
Tips Impressed by "great technical skills, nice cover letter, good/clean résumé and good work samples."

▣ WORK, INC.

111 Virginia St., Suite 500, Richmond VA 23219. (804)225-0100. Fax: (804)225-0369. E-mail: dbrooks@workadvertising.com. Website: www.workadvertising.com. **Contact:** Cabell Harris, president, chief creative director. Estab. 1994. Number of employees: 38. Approximate annual billing: $44 million. Ad agency. Specializes in

strategic council, account management, creative and production services. Current clients include Virginia Tobacco Settlement Foundation, Virginia Tourism Corporation, Ogilvy and Mather, Great Valu, Super 8, Saxon Capital, Inc. Client list available upon request. Professional affiliations: Advertising Club of Richmond, AIGA.

Needs Approached by 25 illustrators and 35-40 designers/year. Works with 2-3 illustrators and 6-7 designers/year. Works on assignment only. Prefers freelancers with experience in animation, computer graphics, Macintosh. Uses freelancers mainly for new business pitches and specialty projects. Also for logos, mechanicals, TV/film graphics, posters, print ads and storyboards. 40% of work is with print ads. 95% of design work demands knowledge of FreeHand, Illustrator, Photoshop and QuarkXPress. 20% of illustration work demands knowledge of FreeHand, Illustrator, Photoshop and QuarkXPress.

First Contact & Terms Send query letter with photocopies, photographs, résumé, tearsheets, URL. Accepts e-mail submissions. Check website for formats. Samples are filed or returned. Responds only if interested. Request portfolio review in original query. Company will contact artist for portfolio review if interested. Portfolio should include b&w and color finished art, photographs, slides, tearsheets and transparencies. Pays freelancers usually a set budget with a buyout. Negotiates rights purchased. Finds freelancers through artists' submissions, sourcebooks and word of mouth.

Tips "Send nonreturnable samples (lasers) of work with résumé. Follow up by e-mail."

WASHINGTON

▣ AUGUSTUS BARNETT ADVERTISING/DESIGN

P.O. Box 197, Fox Island WA 98333. (253)549-2396. Fax: (253)549-4707. E-mail: charlieb@augustusbarnett.com. **President/Creative Director:** Charlie Barnett. Estab. 1981. Approximate annual billing: $1.2 million. Specializes in food, beverages, mass merchandise, retail products, corporate identity, package design, business-to-business advertising, marketing, financial. Clients: corporations, manufacturers. Current clients include Tree Top, Inc., Gilbert Global, Russell Investment Group, Robinson, Noble & Saltbush, Olympia Federal Savings, VOLTA, City of Tacoma. Client list available upon request. Professional affiliations: AAF and AIGA.

Needs Approached by more than 50 freelancers/year. Works with 2-4 freelance illustrators and 2-3 designers/year. Prefers freelancers with experience in food/retail and Mac usage. Works on assignment only. Uses illustrators for product, theme and food illustration, some identity and business-to-business. Also uses freelancers for illustration, multimedia projects and lettering. 90% of freelance work demands skills in FreeHand 10.1 and Photoshop 6.0+. Send query letter with samples, résumé and photocopies. Samples are filed. Responds in 1 month. Pays for design by the hour, negotiable. Pays for illustration by project/use and buyouts. Rights purchased vary according to project.

Tips "Freelancers must understand design is a business, deadlines and budgets. Design for the sake of design alone is worthless if it doesn't meet or exceed clients' objectives. Communicate clearly. Be flexible."

▣ CREATIVE CONSULTANTS

2608 W. Dell Dr., Spokane WA 99208-4428. (509)326-3604. Fax: (509)327-3974. E-mail: ebruneau@creativeconsultants.com. Website: www.creativeconsultants.com. **President:** Edmond A. Bruneau. Estab. 1980. Approximate annual billing: $300,000. Ad agency and design firm. Specializes in collateral, logos, ads, annual reports, radio and TV spots. Product specialties are business and consumer. Client list available upon request.

Needs Approached by 20 illustrators and 25 designers/year. Works with 10 illustrators and 15 designers/year. Uses freelancers mainly for animation, brochure, catalog and technical illustration, model-making and TV/film graphics. 36% of work is with print ads. Designs and illustration demands skills in Photoshop and QuarkXPress.

First Contact & Terms Designers send query letter. Illustrators send postcard sample of work and e-mail. Accepts disk submissions if compatible with Photoshop, QuarkXPress, PageMaker and FreeHand. Samples are filed. Responds only if interested. Pays by the project. Buys all rights. Finds artists through Internet, word of mouth, reference books and agents.

▣ GIRVIN STRATEGIC BRANDING AND DESIGN

1601 Second Ave., 5th Floor, Seattle WA 98101-1575. (206)674-7808. Fax: (206)674-7909. Website: www.girvin.com. Design Firm. Estab. 1977. Number of employees: 34. Specializes in corporate identity and brand strategy, naming, Internet strategy, graphic design, signage, and packaging. Current clients include Warner Bros., Procter & Gamble, Paramount, Wells Fargo, Johnson & Johnson, and Kraft/Nabisco.

Needs Works with several freelance illustrators, production artists and designers/year.

First Contact & Terms Designers send query letter with appropriate samples. Illustrators send postcard sample or other nonreturnable samples. Will contact for portfolio review if interested. Payment negotiable.

◪ HORNALL ANDERSON DESIGN WORKS, INC.

1008 Western Ave., Suite 600, Seattle WA 98104. (206)467-5800. Fax: (206)467-6411. E-mail: info@hadw.com. Website: www.hadw.com. Estab. 1982. Number of employees: 70. Design firm. Specializes in full range brand and marketing strategy consultation; corporate, integrated brand and product identity systems; new media; interactive media websites; packaging; collateral; signage; trade show exhibits; environmental graphics and annual reports. Product specialties are large corporations to smaller businesses. Current clients include Microsoft, K2 Corporation, Weyerhaeuser, Seattle Sonics, Quantum, Leatherman Tools, Oneworld Challenge, Jack In The Box, Mahlum Architects, AT&T Wireless. Professional affiliations: AIGA, Society for Typographic Arts, Seattle Design Association, Art Directors Club.

• This firm has received numerous awards and honors, including the International Mobius Awards, National Calendar Awards, London International Advertising Awards, Northwest and National ADDY Awards, Industrial Designers Society of America IDEA Awards, Communication Arts, Los Angeles Advertising Women LULU Awards, Brand Design Association Gold Awards, AIGA, Clio Awards, Communicator Awards, Web Awards.

Needs "Interested in all levels, from senior design personnel to interns with design experience. Additional illustrators and freelancers are used on an as needed basis in design and online media projects."

First Contact & Terms Designers send query letter with photocopies and résumé. Illustrators send query letter with brochure and follow-up postcard. Accepts disk submissions compatible with QuarkXPress, FreeHand or Photoshop, "but the best is something that is platform/software independent (i.e., Director)." Samples are filed. Responds only if interested. Portfolios may be dropped off. Rights purchased vary according to project. Finds designers through word of mouth and submissions; illustrators through sourcebooks, reps and submissions.

N ◪ TMA TED MADER ASSOCIATES, INC.

2562 Dexter Ave. N., Seattle WA 98109. (206)270-9360. Also 280 Euclid Ave., Oakland, CA. E-mail: info@tmade sign.com. Website: www.tmadesign.com. **Principal:** Ted Mader. General Manager: Cindy Dieter. Design firm. Number of employees: 16. Specializes in corporate and brand identity, displays, direct mail, fashion, packaging, publications, signage, book covers, interactive media and CD-ROM. Client list available upon request.

Needs Approached by 150 freelancers/year. Works with 25 freelance illustrators and 10-20 designers/year. Uses freelancers for illustration, retouching, electronic media, production and lettering. Freelance work demands knowledge of QuarkXPress, FreeHand, Illustrator, Photoshop, Director or HTML programming.

First Contact & Terms Send postcard sample or query letter with résumé and samples. Accepts disk submissions compatible with Mac. Samples are filed. Write or call for an appointment to show portfolio. Pays by the project. Considers skill and experience of freelancer and project budget when establishing payment. Rights purchased vary according to project.

WISCONSIN

◪ AGA CREATIVE COMMUNICATIONS

2400 E. Bradford Ave., Suite 206, Milwaukee WI 53211-4165. (414)962-9810. E-mail: greink@juno.com. **CEO:** Art Greinke. Estab. 1984. Number of employees: 4. Marketing communications agency (includes advertising and public relations). Full-service multimedia firm. Specializes in special events (large display and photo work), print ads, TV ads, radio, all types of printed material (T-shirts, newsletters, etc.). Clients include The Great Circus Parade, Clear Channel Radio, Circus World Museum, GGS, Inc., IBM, Universal Savings Bank and Landmark Theatre Chain. Also sports, music and entertainment personalities. Professional affiliations: PRSA, IABC, NARAS.

Needs Approached by 125 freelancers/year. Works with 25 freelance illustrators and 25 designers/year. Uses freelancers for "everything and anything"—brochure and print ad design and illustration, storyboards, slide illustration, retouching, model making, billboards, posters, TV/film graphics, lettering and logos. Also for multimedia projects. 40% of work is with print ads. 75% of freelance work demands skills in PageMaker, Illustrator, Quark, Photoshop, FreeHand or Powerpoint.

First Contact & Terms Send postcard sample and/or query letter with brochure, résumé, photocopies, photographs, SASE, slides, tearsheets, transparencies. Samples are filed and are not returned. Responds only if interested. Will contact artists for portfolio review if interested. Portfolio should include b&w and color thumbnails, roughs, final art, tearsheets, photographs, transparencies, etc. Pays by personal contract. Rights purchased vary according to project. Finds artists through submissions and word of mouth.

Tips "We look for stunning, eye-catching work—surprise us! Fun and exotic illustrations are key!"

⃞ HANSON/DODGE DESIGN

220 E. Buffalo St., Milwaukee WI 53202-5704. (414)347-1266. Fax: (414)347-0493. Website: www.hanson-dodge.com. **CEO:** Ken Hanson. Estab. 1980. Number of employees: 40. Approximate annual billing: $4.6 million. Specializes in integrated design, brand and corporate identity; catalog, display, direct mail and package design; signage; websites and digital publishing systems. Clients: corporations, agencies. Current clients include Trek Bicycle, Timex, T-Fal, Hushpuppies. Client list available upon request. Professional affiliations: AIGA, APDF, ACD.

Needs Approached by 30 freelancers/year. Works with 2-3 freelance illustrators, 2-3 designers and 5-8 production artists/year. Needs computer-literate freelancers for design, illustration and production. 90% of freelance work demands knowledge of Illustrator, Photoshop and QuarkXPress.

First Contact & Terms Send letter of introduction and position sought with résumé and nonreturnable samples to Hanson/Dodge Design, Attn: Claire Chin or e-mail postmaster@hanson-dodge.com. Résumés and samples are kept on file for 6 months. Responds in 2 weeks. Artist should follow-up with call. Pays for design and illustration by the hour. Finds artists through word of mouth, submissions.

UNICOM

9470 N. Broadmoor Rd., Bayside WI 53217. (414)352-5070. Fax: (414)352-4755. **Senior Partner:** Ken Eichenbaum. Estab. 1974. Specializes in annual reports, brand and corporate identity, display, direct, package and publication design and signage. Clients: corporations, business-to-business communications, and consumer goods. Client list available upon request.

Needs Approached by 5-10 freelancers/year. Works with 1-2 freelance illustrators/year. Works on assignment only. Uses freelancers for brochure, book and poster illustration, pre-press composition.

First Contact & Terms Send query letter with brochure. Samples not filed or returned. Does not reply; send nonreturnable samples. Write for appointment to show portfolio of thumbnails, photostats, slides and tearsheets. Pays by the project, $200-3,000. Rights purchased vary according to project.

WYOMING

BRIDGER PRODUCTIONS, INC.

P.O. Box 8131, Jackson WY 83001. (307)733-7871. Fax: (307)734-1947. E-mail: info@bridgerproductions.com. Website: www.bridgerproductions.com. **Director/Cameraman:** Michael J. Emmer. Estab. 1990. AV firm. Full-service, multimedia firm. Specializes in national TV sports programming, national commercials, marketing videos, documentaries. Product specialties are skiing, mountain biking, mountain scenery. Current clients include Life Link International, Crombies, JH Ski Corp., State of Wyoming. Client list available upon request.

Needs Approached by 2 freelance artists/month. Works with 0-1 freelance illustrator and designer/month. Works on assignment only. Uses freelance artists for everything. Also uses freelance artists for storyboards, animation, model-making, billboards, TV/film graphics, lettering and logos. Needs computer-literate freelancers for design, illustration and production. 80% of freelance work demands knowledge of Amiga/Lightwave and other 3-D and paint programs.

First Contact & Terms Send query letter with film and video work—animations, etc. Samples are filed and are not returned. Responds only if interested. Will contact artist for portfolio review if interested. Portfolio should include 16mm, 35mm, motion picture and video work. Pays for design by the project, $150-20,000. Pays for illustration by the project, $150-1,500. Rights purchased vary according to project. Finds artists through word of mouth and submissions.

CANADA

⃞ ⃞ PULLIN PRODUCTIONS, LTD.

927 Lake Emerald Pl. SE, Calgary AB T2J 2K2 Canada. (403)278-8822. Fax: (403)278-6901. E-mail: info@pullinproductions.com. Website: www.pullinproductions.com. **Creative Director:** Chris Pullin. Film, video and AV production firm.

Needs Works with 4 artists/year. Works on assignment only. Uses freelancers for design; technical, poster and print ad illustration; brochures; P-O-P displays; animation and motion pictures (including posters for feature films). Needs computer-literate freelancers for production and presentation. 15% of freelance work demands computer skills.

First Contact & Terms Send query letter with résumé and samples. Samples not filed are not returned. Responds only if interested. To show portfolio, mail appropriate materials. Pays for design by the hour, $10-50. Buys all rights.

Tips Need for freelance artists has decreased slightly.

☒ WARNE MARKETING & COMMUNICATIONS

1300 Yonge St., Suite 502, Toronto ON M4T 1X3 Canada. (416)927-0881. Fax: (416)927-1676. E-mail: john@war ne.com. Website: www.warne.com. **Graphics Studio Manager:** John Coljee. Number of employees: 11. Approximate annual billing: $4.5 million. Specializes in business-to-business promotion. Current clients: Johnston Equipment, Vitek Viscon, Butler Buildings. Professional affiliations: INBA, MIC, BMA, CCAB.

Needs Approached by 5-6 freelancers/year. Works with 4-5 freelance illustrators and 1-2 designers/year. Works on assignment only. Uses freelancers for design and technical illustrations, brochures, catalogs, P-O-P displays, retouching, billboards, posters, direct mail packages, logos. Artists should have "creative concept thinking."

First Contact & Terms Send query letter with résumé and photocopies. Samples are not returned. Responds only if interested. Pays for design by the hour, or by the project. Considers complexity of project, client's budget and skill and experience of artist when establishing payment. Buys all rights.

Record Labels

Record labels hire freelance artists to create packaging, merchandising material, store displays, posters and even T-shirts. But for the most part, you'll be creating work for CD booklets and covers. Your greatest challenge in this market will be working within the size constraints. The dimensions of a CD cover are 4³/₄×4³/₄ inches, packaged in a 5×5 inch jewel box. Inside each CD package is a 4-5 panel fold-out booklet, inlay card and CD. Photographs of the recording artist, illustrations, liner notes, titles, credit lines and lyrics all must be placed into that relatively small format.

It's not unusual for an art director to work with several freelancers on one project. For example, one freelancer might handle typography, another illustration; a photographer is sometimes used and a designer can be hired for layout. Labels also turn to outside creatives for display design, promotional materials, collateral pieces or video production.

LANDING THE ASSIGNMENT

Check the listings in the following section to see how each label prefers to be approached and what type of samples to send. Disk and e-mail submissions are encouraged by many of these listings. Check also to see what type of music they produce. Assemble a portfolio of your best art and design in case an art director wants to see more of your work.

Be sure your portfolio includes quality samples. It doesn't matter if the work is of a different genre—quality is key. If you don't have any experience in the industry, create your own CD package, featuring one of your favorite recording artists or groups.

Get the name of the art director or creative director from the listings in this section and send a cover letter with samples, asking for a portfolio review. If you are not contacted within a couple of months, send a follow-up postcard or sample to the art director or other contact person.

Once you nail down an assignment, get an advance and a contract. Independent labels usually provide an advance and payment in full when a project is done. When negotiating a contract, ask for a credit line on the finished piece and samples for your portfolio.

You don't have to live in one of the recording capitals to land an assignment, but it does help to familiarize yourself with the business. Visit record stores and study the releases of various labels. For further information about CD design read *Rock Art*, by Spencer Drate (PBC International), and *The Best Music CD Art & Design* (Rockport).

Helpful resources

For More Info Learn more about major labels and "indies" by reading industry trade magazines like *Spin, Rolling Stone, Vibe, Revolver, Hit Parader* and *Billboard*. Each year around March, the Recording Industry Association of America (RIAA) releases sales figures for the industry. The RIAA's report also gives the latest trends on packaging and format as well as music sales by genre. To request the most recent report, call the RIAA at (202)775-0101 or visit www.riaa.com.

ACTIVATE ENTERTAINMENT

11328 Magnolia Blvd., Suite 3, North Hollywood CA 91601. (818)505-6573. Fax: (818)508-1101. **President:** James Warsinske. Estab. 2000. Produces CDs and tapes: rock & roll, R&B, soul, dance, rap and pop by solo artists and groups.

Needs Produces 2-6 soloists and 2-6 groups/year. Uses 4-10 visual artists for CD and album/tape cover design and illustration; brochure design and illustration; catalog design, layout and illustration; direct mail packages; advertising design and illustration. 50% of freelance work demands knowledge of PageMaker, Illustrator, QuarkXPress, Photoshop.

First Contact & Terms Send query letter with SASE, tearsheets, photographs, photocopies, photostats, slides and transparencies. Samples are filed. Responds in 1 month. To show portfolio, mail roughs, printed samples, b&w and color photostats, tearsheets, photographs, slides and transparencies. Pays by the project, $100-1,000. Buys all rights.

Tips "Get your art used commercially, regardless of compensation. It shows what applications your work has."

ARK 21

The Copeland Group, 14724 Ventura Blvd., Penthouse Suite, Sherman Oaks CA 91403. (818)461-1700. Fax: (818)461-1745. E-mail: jbevilaqua@ark21.com. Website: www.ark21.com. **Production Manager:** John Bevilacqua. President: Miles Copeland. Estab. 1996. Produces CDs and cassettes for a variety of niche markets: swing, hillbilly by solo artists and groups. Recent releases: *The Red Planet* soundtrack; *Secrets*, by The Human League.

Needs Produces 20-30 releases/year. Works with 5-10 freelancers/year. Prefers local designers and illustrators who own Macs. Uses freelancers for album and CD cover and CD booklet design and illustration; poster design; point of purchase and production work. 100% of design demands knowledge of Illustrator, QuarkXPress, Photoshop.

First Contact & Terms Send postcard sample of work. Accepts disk submissions compatible with Mac. Samples are filed or returned by SASE if requested. Does not reply. Artist should send a different promo in a few months. Portfolios may be dropped off Monday through Friday. Will contact for portfolio review if interested. Portfolio should include b&w and color final art, photocopies, photographs, photostats, roughs, slides, tearsheets, thumbnails or transparencies. Pays by the project. Buys all rights. Finds artists through interesting promos, *The Alternative Pick*.

ART ATTACK RECORDINGS/MIGHTY FINE RECORDS

3305 N. Dodge Blvd., Tucson AZ 85716. (602)881-1212. **President:** William Cashman. Produces rock, country/western, jazz, pop, R&B; solo artists.

Needs Produces 12 albums/year. Works with 1-2 freelance designers and 1-2 illustrators/year. Uses freelancers for CD/album/tape cover design and illustration; catalog design and layout; advertising design, illustration and layout; posters; multimedia projects.

First Contact & Terms Works on assignment only. Send postcard sample or brochure to be kept on file. Samples not filed are returned by SASE only if requested. Responds only if interested. Write for appointment to show portfolio. Original artwork is not returned. Pays for design by the hour, $15-25, or by the project, $100-500. Pays for illustration by the project, $100-500. Considers complexity of project and available budget when establishing payment. Buys all rights. Sometimes interested in buying second rights (reprint rights) to previously published artwork.

ATLAN-DEC/GROOVELINE RECORDS

2529 Green Forest Ct., Snellville GA 30078-4183. (770)985-1686. E-mail: atlandec@prodigy.net. Website: www. atlan-dec.com. **Art Director:** Wileta J. Hatcher. Estab. 1994. Produces CDs and cassettes: gospel, jazz, pop, R&B, rap artists and groups. Recent releases: *Stepping Into the Light*, by Mark Cocker.

Needs Produces 2-4 releases/year. Works with 1-2 freelancers/year. Prefers freelancers with experience in CD and cassette cover design. Uses freelancers for album cover, cassette cover, CD booklet and poster design. 80% of freelance work demands knowledge of Photoshop.

First Contact & Terms Send postcard sample of work or query letter with brochure, photocopies, photographs and tearsheets. Samples are filed. Will contact for portfolio review of b&w, color, final art if interested. Pays for design by the project, negotiable. Negotiates rights purchased. Finds artists through submissions.

BAL RECORDS

Box 369, LaCanada CA 91012. (818)548-1116. E-mail: balmusic@pacbell.net. **President:** Adrian P. Bal. Secretary-Treasurer: Berdella Bal. Estab. 1965. Produces 1-2 CDs: rock & roll, jazz, R&B, pop, country/western and church/religious. Recent releases: *Travel With Me*, by Adrian Bal.

First Contact & Terms Samples are not filed and are returned by SASE. Responds ASAP. Portfolio review requested if interested in artist's work. Sometimes requests work on spec before assigning a job. Finds new artists through submissions.

Tips "I don't like the abstract designs."

BATOR & ASSOCIATES

31 State St., Suite 44D, Monson MA 01057. **Art Director:** Robert S. Bator. Estab. 1969. Handles rock and country.

Needs Buys 5,000 line drawings and logo designs/year. Illustrations, full-color and line for various advertising and books—adult and children; callligraphy designs.

First Contact & Terms Slides and photostats welcome. Also have special need for top-notch calligraphy. Samples welcome. Works with freelancers on assignment only. Responds in 5 days with SASE. Pays by the project. Buys one-time rights; other rights negotiable. Send no originals, only your copies.

⦿ BELUGA BLUE

836 Columbus Blvd., Coral Gables Fl 33134. (305)531-2830. Fax: (305)567-1367. E-mail: uslara@mac.com. **Art Director:** nil lara. Estab. 1986. Produces CDs: Afro-Cuban. Recent releases: *nil lara*, *My First Child* and *The Monkey*, all by nil lara.

First Contact & Terms Send postcard sample of work. Accepts disk submissions compatible with Mac. Samples are filed. Responds only if interested. Pay negotiable. Negotiates rights purchased. Finds artists through word of mouth, or "seeing work in an art show."

Tips Sees a trend toward "organic and raw, environment-friendly packaging."

BLACK DIAMOND RECORDS INCORPORATED

P.O. Box 222, Pittsburg CA 94565. (510)980-0893. Fax: (925)432-4342. E-mail: blkdiamondrec@aol.com. Website: www.blackdiamondrecord.com. **Contact:** Jerry J. Bobelli, President. Estab. 1988. Produces tapes, CDs and vinyl 12-inch and 7-inch records: jazz, pop, R&B, soul, urban hib hop by solo artists and groups. Recent releases: "X-Boyfriend," by Héye featuring Dashawn; "Simple and Easy," by Dean Gladney.

Needs Produces 2 solo artists and 3 groups/year. Works with 2 freelancers/year. Prefers freelancers with experience in album cover and insert design. Uses freelancers for CD/tape cover and advertising design and illustration; direct mail packages; and posters. Needs computer-literate freelancers for production. 85% of freelance work demands knowledge of PageMaker, FreeHand.

First Contact & Terms Send query letter with résumé. Samples are filed or returned. Responds in 3 months. Write for appointment to show portfolio of b&w roughs and photographs. Pays for design by the hour, $100; by the project, varies. Rights purchased vary according to project.

Tips "Be unique, simple and patient. Most of the time success comes to those whose artistic design is unique and has endured rejection after rejection."

⦿ BLUE NOTE, ANGEL AND MANHATTAN RECORDS

150 5th Aveune, 6th Floor, New York NY 10010. (212)786-8600. Website: www.bluenote.com and www.angelre cords.com. **Creative Director:** Gordon H. Jee. Creative Assistant: Jen Ditsler. Estab. 1939. Produces albums, CDs, cassettes, advertising and point-of-purchase materials. Produces classical, jazz, pop and world music by solo artists and groups. Recent releases by Norah Jones, Al Green and Chick Corea.

Needs Produces approximately 200 releases in US/year. Works with about 10 freelancers/year. Prefers designers with experience in QuarkXPress, Illustrator, Photoshop who own Macs. Uses freelancers for album cover design and illustration; cassette cover design and illustration; CD booklet and cover design and illustration; poster

design. Also for advertising. 100% of design demands knowledge of Illustrator, QuarkXPress, Photoshop (most recent versions on all).

First Contact & Terms Send postcard sample of work. Samples are filed. Responds only if interested. Portfolios may be dropped off every Thursday and should include b&w and color final art, photographs and tearsheets. Pays for design by the hour, $12-20; by the project, $1,000-5,000. Pays for illustration by the project, $750-2,500. Rights purchased vary according to project. Finds artists and designers through submissions, portfolio reviews, networking with peers.

CHATTAHOOCHEE RECORDS

P.O. 5754, Sherman Oaks CA 91413. (818)788-6863. Fax: (818)788-4229. **A&R:** Chris Yardum. Estab. 1958. Produces CDs and tapes: rock & roll, pop by groups. Recent releases: *Thanks for Nothing*, by DNA.

Needs Produces 1-2 groups/year. Works with 1 visual artist/year. Prefers local artists only. Works on assignment only. Uses artists for CD cover design and illustration; tape cover design and illustration; advertising design and illustration; posters. 50% of freelance work demands knowledge of Illustrator.

First Contact & Terms Send query letter with brochure, résumé and photographs. Samples are filed and are not returned. Responds only if interested. To show portfolio, mail final art and photographs. Pays for design by the project. Rights purchased vary according to project.

CHERRY STREET RECORDS, INC.

P.O. Box 52626, Tulsa OK 74152. (918)742-8087. Fax: (918)742-8000. E-mail: ryoung@cherrystreetrecords.com. Website: www.cherrystreetrecords.com. **President:** Rodney Young. Estab. 1991. Produces CDs and tapes: rock, R&B, country/western, soul, folk by solo and group artists. Recent releases: *Land of the Living*, by Richard Elkerton; *Find You Tonight*, by Brad Absher; *Rhythm Gypsy*, by Steve Hardin.

Needs Produces 2 solo artists/year. Approached by 10 designers and 25 illustrators/year. Works with 2 designers and 2 illustrators/year. Prefers freelancers with experience in CD and cassette design. Works on assignment only. Uses freelancers for CD/album/tape cover design and illustration; catalog design; multimedia projects and advertising illustration. 100% of design and 50% of illustration demand knowledge of Illustrator and CorelDraw for Windows.

First Contact & Terms Send postcard sample or query letter with photocopies and SASE. Accepts disk submissions compatible with Windows '95 in above programs. Samples are filed or are returned by SASE. Responds only if interested. Write for appointment to show portfolio of printed samples, b&w and color photographs. Pays by the project, up to $1,250. Buys all rights.

Tips "Compact disc covers and cassettes are small; your art must get consumer attention. Be familiar with CD and cassette music layout on computer in either Adobe or Corel. Be familiar with UPC bar code portion of each program. Be under $500 for layout to include buyout of original artwork and photographs. Copyright to remain with Cherry Street; no reprint rights or negatives retained by illustrator, photographer or artist."

CREEK RECORDS/CREEKER MUSIC PUB.

Box 1946, Cave Creek AZ 85327. (602)488-8132. **Junior Vice President:** Jeff Lober. Estab. 1996. Produces albums, CDs, CD-ROMs, cassettes: classical, country, folk, jazz, pop, progressive, R&B, rock, soul, Latin-Spanish and Middle Eastern by solo artists and groups. Recent releases: *Rescue Me*, by Chrissy Williams; *30 Second Dream*, by Richard Towers; *Camelon Soul (Going Through the Changes)*, by Will; *Venna Fournier*, by Jade.

Needs Produces 30-35 releases/year. Works with 5-6 freelancers/year. Uses freelancers for album cover design and illustration; cassette cover design and illustration; CD booklet design and illustration; CD cover design and illustration; CD-ROM design and packaging. 50% of freelance work demands knowledge of QuarkXPress, Photoshop, FreeHand.

First Contact & Terms Send query letter with brochure and photostats. Accepts Mac-compatible disk submissions. Samples are filed or returned by SASE. Will contact artist for portfolio review of b&w, color art if interested. Pays by the project, $200-1,000. Buys all rights.

Tips Look at CD covers in stores and use your own ideas from there. Looks for "something that will sell the CD besides the music."

EARACHE RECORDS

43 W. 38th St., New York NY 10018. (212)840-9090. Fax: (212)840-4033. E-mail: usaproduction@earache.com. Website: www.earache.com. **Product Manager:** Tim McVicker. UK estab. 1986; US estab. 1993. Produces albums, CDs, CD-ROMs, cassettes, 7″, 10″ and 12″ vinyl: rock, industrial, heavy metal techno, death metal, grind core. Recent releases: *The Haunted Made Me Do It*, by The Haunted; *Gateways to Annihilation*, by Morbid Angel.

Needs Produces 18 releases/year. Works with 4-6 freelancers/year. Prefers designers with experience in music field who own Macs. Uses freelancers for album cover design; cassette cover illustration; CD booklet and cover

design and illustration; CD-ROM design. Also for advertising and catalog design. 90% of freelance work demands knowledge of Illustrator 7.0, QuarkXPress 4.0, Photoshop 5.0, FreeHand 7.

First Contact & Terms Send postcard sample of work. Samples are filed and not returned. Does not reply. Artist should follow up with call and/or letter after initial query. Will contact artist for portfolio review of color, final art, photocopies, photographs if interested. Pays by the project. Buys all rights.

Tips "Know the different packaging configurations and what they are called. You must have a background in music production/manufacturing."

ℕ GEFFEN A&M RECORDS

2220 Colorado Ave., Santa Monica CA 90404. (310)865-7606. Website: www.geffen.com. **Contact:** Nicole Frantz or Stephanie Hsu. Produces progressive, R&B and rock music. Recent releases: *Dilated Peoples*, by The Tipping Point; *The Printz*, by Bumblebeez 81.

 • Geffen has a drop-off policy for portfolios. You can drop off your book Monday-Friday from 7am to 7pm and arange for pick-up in 24 hours. They "rarely" use freelance illustrators because most of the covers feature photography.

Tips "The art department and creative services love to see truly original work. Don't be too conservative, but do create a portfolio that's consistent. Don't be afraid to push the limits."

HULA RECORDS

99-139 Waiua Way, Unit #56, Aiea HI 96701. (808)485-2294. Fax: (808)485-2296. E-mail: hularecords@hawaii.r r.com. Website: www.hawaiian-music.com. **President:** Donald P. McDiarmid III. Produces educational and Hawaiian records; group and solo artists.

Needs Produces 1-2 soloists and 3-4 groups/year. Works on assignment only. Uses artists for album cover design and illustration, brochure and catalog design, catalog layout, advertising design and posters.

First Contact & Terms Send query letter with tearsheets and photocopies. Samples are filed or are returned only if requested. Responds in 2 weeks. Write for appointment to show portfolio. Pays by the project, $50-350. Considers available budget and rights purchased when establishing payment. Negotiates rights purchased.

IMAGINARY ENTERTAINMENT CORP.

P.O. Box 66, Whites Creek TN 37189. (615)299-9237. E-mail: jazz@imaginaryrecords.com. Website: www.imag inaryrecords.com. **Proprietor:** Lloyd Townsend. Estab. 1982. Produces CDs, tapes and LP's: rock, jazz, classical, folk and spoken word. Releases include: *Kaki*, by S.P. Somtow; *Triologue*, by Stevens, Siegel and Ferguson; and *Fifth House*, by the New York Trio Project.

Needs Produces 1-2 solo artists and 1-2 groups/year. Works with 1-2 freelancers/year. Works on assignment only. Uses artists for CD/LP/tape cover design and illustration.

First Contact & Terms Prefers first contact through e-mail with link to online portfolio, otherwise send query letter with brochure, tearsheets, photographs and SASE if sample return desired. Samples are filed or returned by SASE if requested by artist. Responds in 3 months. To show portfolio, mail thumbnails, roughs and photographs. Pays by the project, $25-500. Negotiates rights purchased.

Tips "I always need one or two dependable artists who can deliver appropriate artwork within a reasonable time frame."

JAY JAY RECORD, TAPE & VIDEO CO.

P.O. Box 41-4156, Miami Beach FL 33141. Phone/fax: (305)758-0000. **President:** Walter Jagiello. Produces CDs and tapes: country/western, jazz and polkas. Recent releases: *Super Hits*, by Li'l Wally Jagiello; *A Salute to Li'l Wally*, by Florida's Harmony Band with Joe Oberaitis (super polka man).

Needs Produces 7 CDs, tapes and albums/year. Works with 3 freelance designers and 2 illustrators/year. Works on assignment only. Uses freelancers for album cover design and illustration; brochure design; catalog layout; advertising design, illustration and layout; and posters. Sometimes uses freelancers for newspaper ads. Knowledge of MIDI-music lead sheets helpful for freelancers.

First Contact & Terms Send brochure and tearsheets to be kept on file. Call or write for appointment to show portfolio. Samples not filed are returned by SASE. Responds in 2 months. Requests work on spec before assigning a job. Pays for design by the project, $20-50. Considers skill and experience of artist when establishing payment. Buys all rights.

ℕ KIMBO EDUCATIONAL

10 N. Third Ave., Long Branch NJ 07740. E-mail: kimboed@aol.com. Website: www.kimboed.com. **Production Manager:** Amy Laufer. Educational CD/cassette company. Produces 8 cassettes and compact discs/year for schools, teacher-supply stores and parents. Primarily early childhood/physical fitness.

Needs Works with 3 freelancers/year. Prefers local artists on assignment only. Uses artists for CD/cassette/

covers; catalog and flier design; and ads. Helpful if artist has experience in the preparation of CD cover jackets or cassette inserts.

First Contact & Terms "It is very hard to do this type of material via mail." Send letter with photographs or actual samples of past work. Responds only if interested. Pays for design and illustration by the project, $200-500. Considers complexity of project and budget when establishing payment. Buys all rights.

Tips "The jobs at Kimbo vary tremendously. We produce material for various levels—infant to senior citizen. Sometimes we need cute 'kid-like' illustrations, and sometimes graphic design will suffice. We are an educational firm, so we cannot pay commercial record/cassette/CD art prices."

PATTY LEE RECORDS

6034½ Graciosa Dr., Hollywood CA 90068. (323)469-5431. Website: www.PattyLeeRecords.com. **Contact:** Patty Lee. Estab. 1986. Produces CDs and tapes: New Orleans rock and roll, jazz and eclectic by solo artists. Recent releases: *Sizzlin'*, by Armand St. Martin; *Magnetic Boots*, by Angelyne; *Return to Be Bop*, by Jim Sharpe; remastered *Alligator Ball*, by Armand St. Martin.

Needs Produces 2 soloists/year. Works with several designers and illustrators/year. Works on assignment only. Uses freelancers for CD/tape cover; sign and brochure design; and posters.

First Contact & Terms Send postcard sample. Samples are filed or are returned by SASE. Responds only if interested. "Please do not send anything other than an introductory letter or card." Pays by the project; $100 minimum. Rights purchased vary according to project. Finds new artists through word of mouth, magazines, submissions/self-promotional material, sourcebooks, agents and reps and design studios.

Tips "The postcard of their style and genre is the best indication to us as to what the artists have and what might fit into our needs. If the artist does not hear from us, it is not due to a negative reflection on their art."

🌐 LEMATT MUSIC

(Pogo Records Ltd., Swoop Records, Grenouille Records, Zarg Records, Lee Sound Productions, R.T.F.M., Lee Music Ltd., Check Records, Value For Money Productions and X.R.L. Records), White House Farm, Shropshire TF9 4HA England. (01630) 647374. Fax: (01630)647612. **Producer:** Xavier Lee. Lawyer: Keith Phillips. Produces CDs, tapes and albums: rock, dance, country/western, pop and R&B by group and solo artists. Recent releases: *Nightmare*, by Nightmare; *Fire*, by Nightmare; "Beautiful Sunday" and *Then and Now*, by Daniel Boone.

Needs Produces 25 CDs, tapes/year. Works with 3-4 freelance designers and 3-4 illustrators/year. Works on assignment only. Uses a few cartoons and humorous and cartoon-style illustrations where applicable. Uses freelancers for album cover design and illustration; advertising design, illustration and layout; and posters. Needs computer-literate freelancers for design, illustration and presentation. 30% of freelance work demands computer skills.

First Contact & Terms Send query letter with brochure, résumé, business card, slides, photographs, DVDs and videos to be kept on file. Samples not filed are returned by SASE. (Nonresidents send IRCs.) Responds in 3 weeks. To show portfolio, mail final reproduction/product and photographs. Original artwork sometimes returned to artist. Payment negotiated. Finds new artists through submissions and design studios.

LUCIFER RECORDS, INC.

Box 263, Brigantine NJ 08203. (609)266-2623. **President:** Ron Luciano. Produces pop, dance and rock.

Needs Produces 2-12 records/year. Prefers experienced freelancers. Works on assignment only. Uses freelancers for album cover and catalog design; brochure and advertising design, illustration and layout; direct mail packages; and posters.

First Contact & Terms Send query letter with résumé, business card, tearsheets, photostats or photocopies. Responds only if interested. Original art sometimes returned to artist. Write for appointment to show portfolio, or mail tearsheets and photostats. Pays by the project. Negotiates pay and rights purchased.

MAGGIE'S MUSIC, INC.

Box 490, Shady Side MD 20764. E-mail: mail@maggiesmusic.com. Website: www.maggiesmusic.com. **President:** Maggie Sansone. Estab. 1984. Produces CDs and tapes: contemporary acoustic, Christmas and Celtic. Recent releases: *Acoustic Journey*, by Al Petteway and Amy White; *Mystic Dance*, by Maggie Sansone; *Early American Roots*, by Hesperus; *Scottish Fire*, by Bonnie Rideout.

Needs Produces 3-4 albums/year. Works with freelance graphic designers. Prefers freelancers with experience in CD covers and Celtic designs. Works on assignment only.

First Contact & Terms Send e-mail query only. Company will contact artist if interested.

Tips This company asks that the artist request a catalog first "to see if their product is appropriate for our company."

MIGHTY RECORDS

BMI Music Publishing Co.—Corporate Music Publishing Co.—ASCAP, Stateside Music Publishing Co.—BMI, 150 West End Ave., Suite 6-D, New York NY 10023. (212)873-5968. **Manager:** Danny Darrow. Estab. 1958. Produces CDs and tapes: jazz, pop, country/western; by solo artists. Releases: New trend jazz release *Impulse*, by Danny Darrow.

Needs Produces 1-2 solo artists/year. Works on assignment only. Uses freelancers for CD/tape cover, brochure and advertising design and illustration; catalog design and layout; and posters.

First Contact & Terms Samples are not filed and are not returned. Rights purchased vary according to project.

NEURODISC RECORDS, INC.

3801 N. University Dr., Suite #403, Ft. Lauderdale FL 33351. (954)572-0289. Fax: (954)572-2874. E-mail: info@neurodisc.com. Website: www.neurodisc.com. **Contact:** John Wai and Tom O'Keefe. Estab. 1990. Produces albums, CDs: chillout, dance, electrobass, electronic lounge, New Age, progressive, rap, urban. Recent releases: *Drive*, by Peplab; *Beyond the Horizon*, by Tastexperience; *See the Sound*, by Etro Anime; *Bass Crunk*, by Bass Crunk.

Needs Produces 10 releases/year. Works with 5 freelancers/year. Prefers designers with experience in designing covers. Uses freelancers for album cover design and illustration; animation; cassette cover design and illustration; CD booklet design and illustration; CD cover design and illustration; poster design; Web page design. Also for print ads. 100% of freelance work demands computer skills.

First Contact & Terms Send postcard sample or query letter with brochure, photocopies and tearsheets. Samples are not filed and are returned by SASE if requested by artist. Will contact artist for portfolio review if interested. Pays by the project. Buys all rights.

N NORTH STAR MUSIC INC.

22 London St., East Greenwich RI 02818. (401)886-8888. Fax: (401)886-8886. E-mail: info@northstarmusic.com. Website: www.northstarmusic.com. **President:** Richard Waterman. Estab. 1985. Produces CDs and tapes: jazz, classical, folk, traditional, contemporary, world beat, New Age by solo artists and groups. Recent releases: *Love is a Rose*, by Otis Read & Friends.

Needs Produces 4 solo artists and 4 groups/year. Works with 2 freelancers/year. Prefers freelancers with experience in CD and cassette cover design. Works on assignment only. Uses artists for CD/tape cover and brochure design and illustration; catalog design, illustration and layout; direct mail packages. 80% of design and 20% of illustration demand knowledge of QuarkXPress 4.0.

First Contact & Terms Send postcard sample or query letter with brochure, photocopies and SASE. Accepts disk submissions compatible with QuarkXPress 4.0. Send EPS or TIFF files. Samples are filed. Responds only if interested. To show portfolio, mail color roughs and final art. Pays for design by the project, $500-1,000. Buys first rights, one-time rights or all rights.

Tips "Learn about our label style of music/art. Send appropriate samples."

ONE STEP TO HAPPINESS MUSIC

Jacobson & Colfin, P.C., 19 W, 21st, #603A, New York NY 10010. (212)691-5630. Fax: (212)645-5038. E-mail: Bruce@thefirm.com. **Attorney:** Bruce E. Colfin. Produces CDs, tapes and albums: reggae group and solo artists. Release: *Make Place for the Youth*, by Andrew Tosh.

Needs Produces 1-2 soloists and 1-2 groups/year. Works with 1-2 freelancers/year on assignment only. Uses artists for CD/album/tape cover design and illustration.

First Contact & Terms Send query letter with brochure, résumé and SASE. Samples are filed or returned by SASE if requested by artist. Responds in 2 months. Call or write for appointment to show portfolio of tearsheets. Pays by the project. Rights purchased vary according to project.

OPUS ONE

Box 604, Greenville ME 04441. (207)997-3581. **President:** Max Schubel. Estab. 1966. Produces CDs, LPs, 78s, contemporary American concert and electronic music.

Needs Produces 6 releases/year. Works with 1-2 freelancers/year. Prefers freelancers with experience in commercial graphics for compact discs. Uses freelancers for CD cover design.

First Contact & Terms Send postcard sample or query letter with rates and example of previous artwork. Samples are filed. Pays for design by the project. Buys all rights. Finds artists through meeting them in arts colonies, galleries or by chance.

Tips "Contact record producer directly. Send samples of work that relate in size and subject matter to what Opus One produces. We want witty and dynamic work."

R.E.F. RECORDING COMPANY/FRICK MUSIC PUBLISHING COMPANY

404 Bluegrass Ave., Madison TN 37115. (615)865-6380. E-mail: bob-scott-frick@juno.com. **Contact:** Bob Frick. Produces CDs and tapes: southern gospel, country gospel and contemporary Christian. Recent releases: *Seasonal Pickin*, by Bob Scott Frick; *Righteous Pair*; *Pray When I Want To*.

Needs Produces 30 records/year. Works with 10 freelancers/year on assignment only.

First Contact & Terms Send résumé and photocopies to be kept on file. Write for appointment to show portfolio. Samples not filed are returned by SASE. Responds in 10 days only if interested.

☑ REDEMPTION RECORDING CO.

P.O. Box 10238, Beverly Hills CA 90213. (323)666-0221. E-mail: info@redemption.net. Website: www.redempti on.net. **Contact:** Ryan Kuper. Estab. 1990. Produces CD ROMs and cassettes: indie rock/punk and rock by groups. Recent releases: *s/t*, by Race For Titles; *Everyone Here is Wrong*, by The Working Title.

Needs Produces 5-10 releases/year. Works with 5 freelancers/year. Prefers artists with experience in CD designin and associated layouts. Uses freelancers for cassette cover, CD cover, poster and web design. 75% of design work demands knowledge of Illustrator and Photoshop.

First Contact & Terms Send URL. Samples are filed and not returned. Responds only if interested. Portfolio not required. Rights purchased vary according to project. Finds freelancers through websites and examples currently in the market.

▣ RHYTHMS PRODUCTIONS/TOM THUMB MUSIC

Box 34485, Los Angeles CA 90034-0485. **President:** R.S. White. Estab. 1955. Produces CDs, cassettes of children's music.

Needs Works on assignment only. Works with 3-4 freelance artists/year. Prefers Los Angeles artists who have experience in advertising, catalog development and cover illustration/design. Uses freelance artists for album, cassette and CD cover design and illustration; animation; CD booklet design and illustration; CD-ROM packaging. Also for catalog development. 95% of design and 50% of illustration demand knowledge of QuarkXPress and Photoshop.

First Contact & Terms Send query letter photocopies and SASE. Samples are filed or are returned by SASE if requested. Responds in 6 weeks. "We do not review portfolios unless we have seen photocopies we like." Pays by the project. Buys all rights. Finds artists through submissions and recommendations.

Tips "We like illustration that is suitable for children. We find that cartoonists have the look we prefer. However, we also like art that is finer and that reflects a 'quality look' for some of our more classical publications. Our albums are for children and are usually educational. We don't use any violent or extreme art which is complex and distorted."

☑ ▣ ROCK DOG RECORDS

P.O. Box 3687, Hollywood CA 90078. (800)339-0567. E-mail: gerry.cannizzaro@att.net. Website: www.rockdog records.com. **Vice President of Production:** Gerry North Cannizzaro. CFO: Patt Connolly. Estab. 1987. Produces CDs and tapes: rock, R&B, dance, New Age, contemporary instrumental, ambient and music for film, TV and video productions. Recent releases: *This Brave New World*, by Brainstorm; *Fallen Angel*, by Iain Hersey; *The Best of Brainstorm*, by Brainstorm.

- This company has a second location at P.O. Box 884, Syosset, NY 11791-0899. (516)544-9596. Fax: (516)364-1998. A&R, Promotion and Distribution: Maria Cuccia.

Needs Produces 2-3 solo artists and 2-3 groups/year. Approached by 50 designers and 200 illustrators/year. Works with 5-6 designers and 25 illustrators/year. Prefers freelancers with experience in album art. Uses artists for CD album/tape cover design and illustration, direct mail packages, multimedia projects, ad design and posters. 95% of design and 75% of illustration demand knowledge of Print Shop or Photoshop.

First Contact & Terms Send postcard sample or query letter with photographs, SASE and photocopies. Accepts disk submissions compatible with Windows '95. Send Bitmap, TIFF, GIF or JPG files. Samples are filed or are returned by SASE. Responds in 2 weeks. To show portfolio, mail photocopies. Sometimes requests work on spec before assigning a job. Pays for design by the project, $50-500. Pays for illustration by the project, $50-500. Interested in buying second rights (reprint rights) to previously published work. Finds new artists through submissions from artists who use *Artist's & Graphic Designer's Market*.

Tips "Be open to suggestions; follow directions. Don't send us pictures, drawings (etc.) of people playing an instrument. Usually we are looking for something abstract or conceptual. We look for prints that we can license for limited use."

SAHARA RECORDS AND FILMWORKS ENTERTAINMENT

28 E. Jackson Bldg., 10th Floor, #S627, Chicago IL 60604-2263. (773)509-6381. Fax: (312)922-6964. E-mail: info@edmsahara.com. Website: www.edmsahara.com. **Contact:** Dwayne Woolridge, marketing director. Estab.

1981. Produces CDs, cassettes: jazz, pop, R&B, rap, rock, soul, TV-film music by solo artists and groups. Recent releases: *Pay the Price* and *Rice Girl* film soundtracks; *Dance Wit Me*, by Steve Lynn.

Needs Produces 25 releases/year. Works with 2 freelancers/year. Uses freelancers for CD booklet design and illustration; CD cover design and illustration; poster design and animation.

First Contact & Terms Contact only through artist rep. Samples are filed. Responds only if interested. Payment negotiable. Buys all rights. Finds artists through agents, artist's submissions, *The Black Book* and *Directory of Illustration*.

N ⊞ SCOTDISC B.G.S. PRODUCTIONS LTD.

Newtown St., Kilsyth, Glasgow G65 0JX Scotland. 44(0)1236-821081. Fax: 44(0)1236-826900. E-mail: nscott@scotdisc.co.uk. Website: www.scotdisc.co.uk. **Director:** Dougie Stevenson. Produces country and folk; solo artists. Recent releases: *Black Watch Pipe Band*; *In the Garden*.

Needs Produces 15-20 records/videos per year. Approached by 3 designers and 2 illustrators/year. Works with 1 designer and 2 illustrators/year for album cover design and illustration; brochure design, illustration and layout; catalog design, illustration and layout; advertising design, illustration and layout; posters.

First Contact & Terms Send postcard sample or brochure, résumé, photocopies and photographs to be kept on file. Call or write for appointment to show portfolio. Accepts disk submissions compatible with Illustrator 3.2 or FreeHand 3.0. Send Mac-formatted EPS files. Samples not filed are returned only if requested. Responds only if interested. Pays by the hour, $30 average. Considers available budget when establishing payment. Buys all rights.

SILVER WAVE RECORDS

2475 Broadway, Suite 300, Boulder CO 80304. (303)443-5617. Fax: (303)443-0877. E-mail: valerie@silverwave.com. Website: www.silverwave.com. **Art Director:** Valerie Sanford. Estab. 1986. Produces CDs, cassettes: Native American and world music. Recent releases: *Feed the Fire*, by Mary Youngblood; *Covenant*, by Joanne Shenandoah; *Indians Indians*, by Robert Mirabal; *Red Moon*, by Peter Kater and R. Carlos Nakai and others.

Needs Produces 4 releases/year. Works with 4-6 illustrators, artists, photographers a year. Uses illustrators for CD cover illustration.

First Contact & Terms Send postcard sample or query letter with 2 or 3 samples. Samples are filed. Will contact for portfolio review if interested. Pays by the project. Rights purchased vary according to project.

Tips "Develop some good samples and experience. I look in galleries, art magazines, *Workbook*, *The Black Book* and other trade publications. I visit artist's booths at Native American 'trade shows.' Word of mouth is effective. We will call if we like work or need someone." When hiring freelance illustrators, looks for a specific style for a particular project. "Currently we are producing contemporary Native American music and will look for art that expresses that."

N SOMNIMAGE CORPORATION

P.O. Box 24, Bradley IL 60915. E-mail: somnimage@aol.com. Website: www.somnimage.com. **Contact:** Mykel Boyd. Estab. 1998. Produces albums, CDs, CD-ROMs, cassettes and vinyl: classical, folk, jazz, pop, progressive, rap, rock, experimental and electronic music by solo artists and groups. Recent releases: *Wolf Sheep Cabbage*, by The Hafler Trio; Kafka tribute CD compilation.

Needs Produces 10 releases/year. Works with 10 freelancers/year. Looking for creative art. Uses freelancers for cover design and illustration; cassette cover design and illustration; CD booklet design and illustration; CD cover design and illustration; CD-ROM design and packaging and poster design. Freelancers should be familiar with PageMaker, Illustrator, QuarkXPress, Photoshop, FreeHand.

First Contact & Terms Send query letter with brochure, résumé, photostats, transparencies, photocopies, photographs, slides, SASE, tearsheets. Accepts disk submissions. Samples are filed or returned by SASE if requested by artist. Responds in 3 months. Will contact artist for portfolio review of b&w and color final art, photocopies, photographs, photostats, roughs, slides, tearsheets, thumbnails and transparencies, if interested. Pays by the project. Negotiates rights purchased. Finds artists through word of mouth.

Tips "We are interested in surreal art, dada art, dark themed photography too."

N STARDUST RECORDS/WIZARD RECORDS/THUNDERHAWK RECORDS

341 Billy Goat Hill Rd., Winchester TN 37398. (931)649-2577. Fax: (931)649-2732. E-mail: cbd@vallnet.com. Website: http://stardustcountrymusic.com. **Contact:** Col. Buster Doss. Produces CDs, tapes and albums: rock, folk, country/western. Recent releases: *13 Red Roses Plus One*, by Jerri Arnold; *It's the Heart*, by Brant Miller.

Needs Produces 12-20 CDs and tapes/year. Works with 2-3 freelance designers and 1-2 illustrators/year on assignment only. Uses freelancers for CD/album/tape cover design and illustration; brochure design; and posters.

First Contact & Terms Send query letter with brochure, tearsheets, résumé and SASE. Samples are filed.

Responds in 1 week. Call for appointment to show portfolio of thumbnails, b&w photostats. Pays by the project. Finds new artists through *Artist's & Graphic Designer's Market*.

⊕ SWOOP RECORDS

White House Farm, Shropshire, TF9 4HA United Kingdom. Phone: 01630-647374. Fax: 01630-647612. **A&R International Manager:** Xavier Lee. International A&R: Tanya Woof. Estab. 1971. Produces albums, CDs, cassettes and video: classical, country, folk, gospel, jazz, pop, progressive, R&B, rap, rock, soul by solo artists and groups. Recent releases: *It's a Very Nice*, by Groucho; *New Orleans*, by Nightmare.

Needs Produces 40 releases/year. Works with 6 freelancers/year. Prefers album, cassette, CD, and DVD cover design and illustration; CD and DVD booklet design and illustration; poster design.

First Contact & Terms Send sample of work with SASE (nonresidents send IRCs). Samples are filed for future reference. Responds in 6 weeks. Payment negotiated. Buys all rights. Finds artists through submissions.

ℕ TOM THUMB MUSIC

(division of Rhythms Productions), Box 34485, Los Angeles CA 90034. **President:** Ruth White. Music and book publisher for children's market.

Needs Works on assignment only. Prefers Los Angeles freelancers with cartooning talents and animation background. Uses freelancers for catalog cover and book illustration, direct mail brochures, layout, magazine ads, multimedia kits, paste-up and album design. Needs computer-literate freelancers for animation. Artists must have a style that appeals to children.

First Contact & Terms Buys 3-4 designs/year. Send query letter with brochure showing art style or résumé, tearsheets and photocopies. Samples are filed or are returned by SASE. Responds in 3 weeks. Pays by the project. Considers complexity of project, available budget and rights purchased when establishing payment. Buys all rights on a work-for-hire basis.

Tips ''You need to be up to date with technology and have a good understanding of how to prepare art projects that are compatible with printers' requirements.''

ℕ TOPNOTCH® ENTERTAINMENT CORP.

Box 1515, Sanibel Island FL 33957-1515. (239)982-1515. E-mail: topnotch@wolanin.com. Website: www.wolan in.com. **Chairman/CEO:** Vincent M. Wolanin. Estab. 1973. Produces aviation art, advertising layouts, logos, albums, CDs, DVDs, CD-ROMs, tour merchandise, cassettes: pop, progressive, R&B, rock, soul by solo artists and groups.

Needs Produces 6-8 unique designs/year. Works with 3-6 freelancers/year on work-for-hire basis. Prefers designers who use PC-based programs. Uses freelancers for design and illustration; animation; creative design and illustration; CD booklet design and illustration; CD cover design and illustration; CD-ROM design and packaging; poster design; web page design. Also for outside entertainment projects like Superbowl-related events and aviation-related marketing promotions and advertising. 90% of design and illustration demands knowledge of PageMaker, Illustrator, QuarkXPress, Photoshop, FreeHand, Corel, FrontPage, Astound.

First Contact & Terms Send query e-mail or letter with brochure, résumé, photostats, transparencies, photocopies, photographs, slides, SASE, tearsheets. Accepts disk or e-mail submissions compatible with IBM. Samples are filed. Does not report back. Artist should contact again in 1 year. Request portfolio review in original query. Artist should follow up with letter after initial query. Portfolio should include color, final art, photographs, slides, tearsheets. Pays for design and illustration by the project. Buys all rights. Also accepts link submissions to artists' websites.

Tips ''We look for new ways, new ideas, eye catchers; let me taste the great wine right away. Create great work and be bold. Don't get discouraged.''

ℕ TOUCHE RECORDS CO.

P.O. Box 96, El Cerrito CA 94530. (510)524-4937. Fax: (510)524-9577. **Executive Vice President:** James Bronson, Jr. Estab. 1955. Produces CDs, tapes and LPs: jazz, soul, R&B and rap. Recent releases: *Happiness Is Takin Care Of Natural Business*, by 'Al' Tanner.

Needs Produces 1-10 solo artists/year. Approached by 10 designers and 6 illustrators/year. Works with 3 designers and 1 illustrator/year. Works on assignment only. Uses artists for CD cover design and illustration; tape cover illustration; brochure design and illustration; catalog design, illustration and layout; direct mail packages; advertising design and illustration; and posters.

First Contact & Terms Send query letter with brochure, résumé, photocopies and tearsheets. Samples are filed. Responds in 10 days. To show portfolio, mail portfolio of roughs. Pays for design by the project. Buys all rights.

Tips ''All artwork gets my attention.''

TROPIKAL PRODUCTIONS/WORLD BEATNIK RECORDS

20 Amity Lane, Rockwall TX 75087. Phone/fax: (972)771-3797. E-mail: tropikal@juno.com. Website: www.trop ikalproductions.com. **Contact:** Jim Towry. Estab. 1981. Produces albums, CDs, cassettes: world beat, soca, jazz, reggae, hip-hop, latin, Hawaiian, gospel. Recent releases: *Cool Runner*; *Alive Montage*; *The Island*, by Watusi; *Inna Dancehall*, by Ragga D.

Needs Produces 5-10 releases/year. Works with 5-10 freelancers/year. Prefers freelancers with experience in CD/album covers, animation and photography. Uses freelancers for CD cover design and illustration; animation; cassette cover design and illustration; CD booklet design and illustration; CD cover design and illustration; poster design. 50% of freelance work demands knowledge of Illustrator, Photoshop.

First Contact & Terms Send brochure, résumé, photostats, photocopies, photographs, tearsheets. Accepts Mac or IBM-compatible disk submissions. Send EPS files. "No X-rated material please." Samples are filed or returned by SASE if requested by artist. Responds in 15 days. Will contact for portfolio review of b&w, color, final art, photocopies, photographs, roughs if interested. Pays by the project; negotiable. Rights purchased vary according to project; negotiable. Finds artists through referrals, submissions.

Tips "Show versatility; create theme connection to music."

☑ ⛖ TRUE NORTH RECORDS/FINKELSTEIN MANAGEMENT CO. LTD.

260 Richmond St. W., Suite 501, Toronto ON M5V 1W5 Canada. (416)596-8696. Fax: (416)596-6861. E-mail: general_inquiries@truenorthrecords.com. **Contact:** Dan Broome. Estab. 1969. Produces CDs, tapes and albums: rock and roll, folk and pop; solo and group artists. Recent releases: *The Charity of Night*, by Bruce Cockburn; *Industrial Lullaby*, by Stephen Fearing; *Bark*, by Blackie and the Rodeo Kings; *Howie Beck*, by Howie Beck.

Needs Produces 2 soloist and 2 groups/year. Works with 4 designers and 1 illustrator/year. Prefers artists with experience in album cover design. Uses artists for CD cover design and illustration, album/tape cover design and illustration, posters and photography. 50% of freelance work demands computer skills.

First Contact & Terms Send postcard sample, brochure, résumé, photocopies, photographs, slides, transparencies with SASE. Samples are filed or are returned by SASE if requested by artist. Responds only if interested. Pays by the project. Buys all rights.

VARESE SARABANDE RECORDS

11846 Ventura Blvd., Suite 130, Studio City CA 91604. (818)753-4143. Fax: (818)753-7596. Website: www.vares esarabande.com. **Vice President:** Robert Townson. Estab. 1978. Produces CDs: film music soundtracks. Recent releases: *The Day the Earth Stood Still*, by Bernard Herrmann; *Varese Sarabande: A 25th Anniversary Celebration* (4 CD set); *House of Sand and Fog*, by James Horner; *Alias*, by Michael Giacchino.

Needs Works on assignment only. Uses artists for CD cover illustration and promotional material.

First Contact & Terms Send query letter with photostats, slides and transparencies. Samples are filed. Responds only if interested. Pays by the project.

Tips "Be familiar with the label's output before approaching them."

VERVE MUSIC GROUP

1755 Broadway, 3rd Floor, New York NY 10019. (212)331-2000. Fax: (212)331-2065. Website: www.vervemusic group.com. Vice President Creative Services: Hollis King. **Associate Director:** Sherniece Johnson-Smith. Produces albums, CDs: jazz, progressive by solo artists and groups. Recent releases: *The Girl in the Other Room*, by Diana Krall.

• Verve Music Group houses the Verve, GRP, Impulse! and Verve Forecast record labels.

Needs Produces 120 releases/year. Works with 20 freelancers/year. Prefers designers with experience in CD cover design who own Macs. Uses freelancers for album cover design and illustration; CD booklet design and illustration; CD cover design and illustration. 100% of freelance design demands computer skills.

First Contact & Terms Send nonreturnable postcard sample of work. Samples are filed. Does not reply. Portfolios may be dropped off Monday through Friday. Will contact artist for portfolio review if interested. Pays for design by the project, $1,500 minimum; pays for illustation by the project, $2,000 minimum.

ⓝ VIRGIN RECORDS

150 Fifth Ave., New York NY 10010. (212)786-8300. Website: www.virginrecords.com. **Contact:** Creative Dept. Recent releases: *Damita Jo*, by Janet Jackson; *Feels Like Home*, by Norah Jones. Uses freelancers for CD and album cover design and illustration. Send query letter with samples. Portfolios may be dropped off on Wednesdays between 10 a.m. and 5 p.m. Samples are filed. Responds only if interested.

▣ WATCHESGRO MUSIC, BMI—INTERSTATE 40 RECORDS

9208 Spruce Mountain Way, Las Vegas NV 89134. (702)363-8506. **President:** Eddie Lee Carr. Estab. 1975. Produces CDs, tapes and albums: rock, country/western and country rock. Releases include: *The Baby*, by

Blake Shelton; *Three Wooden Crosses*, by Randy Travis; *I Will*, by Chad Simmons; *Jude*, by Judy Willis; *Sonny*, by Sonny Marshall; *Deep in the South*, by Sean O'Brien.

• Watchesgro Music has placed songs in feature films: *Waitin' to Live, 8 Mile, Die Another Day, DareDevil 2003*.

Needs Produces 8 solo artists/year. Works with 3 freelancers/year for CD/album/tape cover design and illustration and videos.

First Contact & Terms Send query letter with photographs. Samples are filed or are returned by SASE. Responds in 1 week only if interested. To show portfolio, mail b&w samples. Pays by the project. Negotiates rights purchased.

Artists' Reps

Many artists find leaving promotion to a rep allows them more time for the creative process. In exchange for actively promoting an artist's career, the representative receives a percentage of sales (usually 25-30%). Reps focus either on the fine art or commercial markets, rarely both. Very few reps handle designers.

Fine art reps promote the work of fine artists, sculptors, craftspeople and fine art photographers to galleries, museums, corporate art collectors, interior designers and art publishers. Commercial reps help illustrators obtain assignments from advertising agencies, publishers, magazines and other art buyers. Some reps also act as licensing agents.

What reps do

Reps work with you to bring your portfolio up to speed and actively promote your work to clients. Usually a rep will recommend advertising in one of the many creative directories such as *American Showcase* or *Creative Illustration* so that your work will be seen by hundreds of art directors. (Expect to make an initial investment in costs for duplicate portfolios and mailings.) Reps also negotiate contracts, handle billing and collect payments.

Getting representation isn't as easy as you might think. Reps are choosy about who they represent, not just in terms of talent but also in terms of marketability and professionalism. Reps will only take on talent they know will sell.

What to send

Once you've gone through the listings here and compiled a list of art reps who handle your type and style of work, contact them with a brief query letter and nonreturnable copies of your work. Check each listing for specific information.

Learn about reps

For More Info

The Society of Photographers and Artists Representatives (SPAR) is an organization for professional representatives. SPAR members are required to maintain certain standards and follow a code of ethics. For more information, write to SPAR, 60 E. 42nd St., Suite 1166, New York NY 10165, or visit their website www.spar.org.

☑ **FRANCE ALINE INC.**

1460 N. Mansfield Ave., Suite 319, Hollywood CA 90028. (323)467-2840. Fax: (323)467-0210. E-mail: france@francealine.com. **Owner:** France Aline. Commercial illustration, photography and digital artists representative. Specializes in logo design, advertising. Markets include: advertising, corporations, design firms, movie studios, record companies. Artists include: Jill Sabella, Craig Mullins, Ezra Tucker, Elisa Cohen, Justin Brandstater, Nora Feller, Peter Greco, Erica Lennand and Thomas Blacksedir.

Handles Illustration, photography.

Terms Rep receives 25% commission. Exclusive area representation is required. Advertises in *American Showcase*, *The Workbook* and *Blackbook*.

How to Contact For first contact, send tearsheets or e-mail france@francealine.com. Responds in a few days. Portfolio should include tearsheets, photographs.

Tips "Send promotions."

Ⓝ **aREP**

P.O. Box 16576, Golden CO 80402. (720)320-4514. Fax: (720)489-3786. E-mail: Christelle@aRep.biz. Website: www.aRep.biz. **Owner:** Christelle Newkirk. Commercial artists representative. Estab. 2000. Represents 1 illustrator, 1 photographer, 1 digital composite artist. aRep is a one-stop small boutique specializing in commerical work. Markets include advertising agencies, corporations/client direct, design firms, editorial/magazines. Artists include Rick Souders. For more names, please see website.

Handles Illustration. "I would be particularly interested in reviewing portfolios of illustrators located in Colorado."

Terms Rep receives 20% commission. Exclusive regional representation is required. Advertising costs are paid by artist. "Must leave a portfolio with me and leave behinds (required for direct mail pieces)."

How to Contact For first contact, send direct query letter with bio, direct mail flier/brochure, tearsheets. Responds in 1 week. After initial contact, call to schedule an appointment or e-mail. Portfolio should include b&w and color finished art, photographs, tearsheets.

☑ **ART LICENSING INTERNATIONAL**

7350 So. Tamiami Trail #227, Sarasota FL 34231. (941)966-8912. Fax: (941)966-8914. E-mail: artlicensing@comcast.net. Website: www.artlicensinginc.com. **President:** Michael Woodward, author of *Art Licensing 101*. Licensing agent. Estab. 1986. Licensing agents for artists, illustrators, photographers, concept designers and TV cartoon concepts. Handles collections of work submitted by artists for licensing across a range of product categories, such as greeting cards, calendars, stationery and gift products, jigsaw puzzles, partyware, textiles, housewares, etc.

Needs Prefers collections of art, illustrations or photography which have wide consumer appeal.

First Contact & Terms Send examples on CD (TIFF or JPEG files), color photocopies or slides/transparencies with SASE. Fine artists should send short bio. Terms are 50/50 with no expenses to artists "as long as artist can provide high resolution scans if we agree on representation. Our agency specializes in aiming to create a full licensing program so we can license art across a varied product range. We are therefore only interested in collections, or groups of artworks or concepts which have commercial appeal. Artists need to consider actual products when creating new art.

Tips "Look at actual products in retail outlets and get a feel for what is selling well. Ask store owners or sales assistants what's 'hot.' Get to know the markets you are actually trying to sell your work to."

Ⓝ 🌐 **ARTIST PARTNERS LTD.**

14-18 Hamyard, London England WID 7DE. 0044 207 734 7991. Fax: 0044 207 287 0371. E-mail: chris@artistpartners.com. Website: www.artistpartners.com. **Owner:** Christine Isteed. Commercial illustration representative. Estab. 1951. Represents 10 fine artists, 20 illustrators, 1 photographer. Specializes in realistic illustration. Markets include advertising agencies, design firms, editorial/magazines, publishing/books, record companies, sales/promotion firms.

Handles Illustration.

Terms Exclusive representation is required. Advertising costs are split.

How to Contact For first contact, send query letter with bio, tearsheets. Responds in 1 week. After initial contact, call to schedule an appointment. Portfolio should include color photographs, tearsheets.

Ⓝ **ARTREPS**

23035 Ventura Blvd., Suite 102, Woodland Hills CA 91364. (818)222-8265 or (800)959-6040. E-mail: info@artrepsart.com or artrepsart@aol.com. Website: www.artrepsart.com. Art Director: Phoebe Batoni. Fine art representative, art consultant, publisher. Estab. 1993. Represents fine artists. Specializes in working with royalty publish-

ers for posters; open editions; limited edition giclees; and galleries, interior designers and licensing agents. Markets include: art publishers; corporate collections; galleries; interior decorators. Represents: Barbara Cleary, Lili Maglione, Peter Colvine, Ann Christensen, Peter Wilkinson and Ron Peters.

● This agency attends Art Expo and Décor Expo to promote its clients.

Handles Fine art. Works on paper, canvas and mixed media; no sculpture.

Terms Handled on a individual basis. For promotional purposes, talent must provide adequte materials.

How to Contact For first contact, send query letter with résumé, bio, either direct mail flier/brochure, tearsheets, slides, photographs, photocopies or photostats and SASE (for return of materials). Will look at CD or website but prefers to review artwork in a tangible form. Responds in 2 weeks.

Tips ''We're interested in fine art with universal mainstream appeal. Check out the kind of art that's selling at your local frame shop and fine art galleries or at retailers like Pier One Imports and Bed Bath & Beyond. Presentation counts, so make sure your submission looks professional.''

ARTVISIONS

12117 SE 26th St., Bellevue WA 98005-4118. E-mail: art@artvisions.com. Website: www.artvisions.com. **President:** Neil Miller. Estab. 1993. ArtVisions is a service of avidre, inc. Markets include publishers of limited edition prints, calendars, home decor, stationery, note cards, greeting cards, posters, manufacterers of giftware, home furnishings, textiles, puzzles and games.

Handles Fine art licensing only.

Terms Agent's commission varies. ''We produce highly targeted direct marketing programs focused on opportunities to license art. We develop materials, including web and e-mail, especially for and partially funded by you. Requires exclusive worldwide representation for licensing (the artist is free to market original art—written contract provided).

How to Contact Send slides/photos/tearsheets or brochures via mail, with SASE for return. Always label your materials. ''We cannot respond to inquiries that do not include examples of your art.''

Tips ''We do not buy art, we are a licensing agent for artists. Our income is derived from commissions from licensing fees we generate for you, so, we are very careful about selecting artists for our service. To gain an idea of the type of art we seek, please view our website: www.artvisions.com before submitting. Our way of doing business is very labor intensive and each artist's market plan is unique. Be prepared to invest in yourself including a share of your promotional costs.''

ARTWORKS ILLUSTRATION

325 W. 38th St., New York NY 10018. (212)239-4946. Fax: (212)239-6106. E-mail: artworksillustration@earthlink.net. Website: www.artworksillustration.com. **Contact:** Betty Krichman, partner. Commercial illustration representative. Estab. 1990. Member of Society of Illustrators. Represents 30 illustrators. Specializes in publishing. Markets include advertising agencies, design firms, paper products/greeting cards, movie studios, publishing/books, sales/promotion firms, corporations/client direct, editorial/magazines. Artists include Dan Brown, Dennis Lyall, Jerry Vanderstelt.

Handles Illustration. Looking for interesting juvenile.

Terms Rep receives 25% commission; 30% for out of town artists (outside tri-state area). Exclusive area representation required. Advertising costs are split: 75% paid by artist; 25% paid by rep. Advertises in *American Showcase* and *ISPOT*.

How to Contact For first contact, send e-mail samples. Responds only if interested. After initial contact, drop off or mail portfolio. Portfolio should include slides, tearsheets, transparencies.

CAROL BANCROFT & FRIENDS

121 Dodgingtown Rd., P.O. Box 266, Bethel CT 06801. (203)748-4823. Fax: (203)748-4581. E-mail: artists@carolbancroft.com. Website: www.carolbancroft.com. **Owner:** Carol Bancroft. Illustration representative for children's publishing. Estab. 1972. Member of SPAR, Society of Illustrators, Graphic Artists Guild, SCBWI. Represents over 40 illustrators. Specializes in representing artists who illustrate for children's publishing—text, trade and any children's-related material. Clients include Scholastic, Holt, HarperCollins, Penguin USA. Artist list available upon request.

Handles Illustration for children of all ages.

Terms Rep receives 30% commission. Advertising costs are split: 75% paid by talent; 25% paid by representative. For promotional purposes, artist should provide ''Web address on an e-mail or samples via mail: laser copies (not slides), tearsheets, promo pieces, books, good color photocopies, etc.; 6 pieces or more; narrative scenes with children and/or animals interacting.'' Advertises in *RSVP*, *Picture Book*, *Directory of Illustration*.

How to Contact Send samples and SASE. ''Artists must call no sooner than one month after sending samples.''

Tips ''We look for artists who can draw animals and people with imagination and energy, depicting engaging characters with action in situational settings.''

BERENDSEN & ASSOCIATES, INC.

2233 Kemper Lane, Cincinnati OH 45206. (513)861-1400. Fax: (513)861-6420. E-mail: bob@illustratorsrep.com. Website: www.illustratorsrep.com and www.StockArtRep.com. President: Bob Berendsen. Commercial illustration, photography, artists' representative. Incorporated 1986. Represents 50 illustrators, 15 photographers. Specializes in "high-visibility consumer accounts." Markets include: advertising agencies; corporations/client direct; design firms; editorial/magazines; paper products/greeting cards; publishing/books; sales/promotion firms. Clients include Disney, CNN, Pentagram, F+W Publications. Additional client list available upon request. Represents: Jake Ellison, Bill Fox, Frank Ordaz, Wendy Ackison, Marcia Hartsock, Duff Orlemann, Jack Pennington, Dave Reed, Garry Richardson, Ursula Roma, Robert Schuster.

• This rep has four websites: illustratorsrep.com, photographersrep.com, designersrep.com and stockartrep.com. The fast-loading pages are easy for art directors to access—a great promotional tool for their talent.

Handles Illustration, photography. "We are always looking for illustrators who can draw people, product and action well. Also, we look for styles that are metaphoric in content, and it's a plus if the stock rights are available."

Terms Rep receives 30% commission. Charges "mostly for postage but figures not available." No geographic restrictions. Advertising costs are split: 70% paid by talent; 30% paid by representative. For promotional purposes, "artist must co-op in our direct mail promotions, and sourcebooks are recommended. Portfolios are updated regularly." Advertises in *RSVP*, *Creative Illustration Book*, *Directory of Illustration* and *American Showcase*.

How to Contact For first contact, send an e-mail with no more than 6 JPEGs attached or send query letter, résumé, and any nonreturnable tearsheets, slides, photographs or photocopies.

Tips Artists should have a "proven style with at least ten samples of that style."

N BERNSTEIN & ANDRIULLI INC.

58 W. 40th St., New York NY 10018. (212)682-1490. Fax: (212)286-1890. E-mail: artinfo@ba-reps.com or photoinfo@ba-reps.com. Website: www.ba-reps.com. **Contact:** Tony Andriulli. Commercial illustration and photography representative. Estab. 1975. Member of SPAR. Represents 54 illustrators, 16 photographers. Staff includes Anthony Andriulli; Howard Bernstein; Gregg Lhotsky; Molly Birenbaum; Francine Rosenfeld. Markets include: advertising agencies; corporations/client direct; design firms; editorial/magazines; paper products/greeting cards; publishing/books; sales/promotion firms.

Handles Illustration and photography.

Terms Rep receives a commission. Exclusive career representation is required. No geographic restrictions. Advertises in *American Showcase*, *Black Book*, *The Workbook*, *New York Gold*, *Bernstein & Andriulli International Illustration*, *CA Magazine*, *Archive*.

How to Contact For first contact, send query letter, direct mail flier/brochure, tearsheets, slides, photographs, photocopies. Responds in 1 week. After initial contact, drop off or mail appropriate materials for review. Portfolio should include tearsheets, slides, photographs.

SAM BRODY, ARTISTS & PHOTOGRAPHERS REPRESENTATIVE & CONSULTANT

77 Winfield St., Apt. 4, E. Norwalk CT 06855-2138. Phone/fax: (203)854-0805 (for fax, add 999). E-mail: sambrody@bigplanet.com. **Contact:** Sam Brody. Commercial illustration and photography representative and broker. Estab. 1948. Member of SPAR. Consultant to illustrators, photographers, designers. Markets include: advertising agencies; corporations/client direct; design firms; editorial/magazines; publishing/books; sales/promotion firms.

Handles Illustration, photography, design, "great writer and director talents."

Terms Agent receives 30% commission. Exclusive area representation is required. For promotional purposes, talent must provide back-up advertising material, i.e., cards (reprints—*Workbook*, etc.), websites and self-promos.

How to Contact For first contact, send bio, direct mail flier/brochure, tearsheets. Responds in 3 days or within 1 day if interested. After initial contact, call for appointment or drop off or mail in appropriate materials for review. Portfolio should include tearsheets, slides, photographs. Obtains new talent through recommendations from others, solicitation.

Tips Considers "past performance for clients that I check with and whether I like the work performed."

N BROWN INK ASSOCIATES

62 W. 39th St., New York NY 10018. (212)730-4898. Fax: (212)768-3977. E-mail: illobob@juno.com. Website: www.browninkonline.com. **President/Owner:** Bob Brown. Commercial illustration representative. Digital fine art publisher and distributor. Estab. 1979. Represents 8 fine artists, 8 illustrators. Specializes in advertising, magazine editorials and book publishing, fine art—all categories. Licenses fine artists and illustrators. Markets include advertising agencies, corporations/client direct, design firms, editorial/magazines, galleries, movie

studios, paper products/greeting cards, publishing/books, record companies, sales/promotion firms. Artists include Bob Brown, Ester Deen, Gary Drake.

Handles Fine art, illustration, digital fine art, digital fine art printing, licensing material. Looking for professional artists—those who are interested in making a living with their art. Art samples and portfolio required.

Terms Rep receives 25% commission on illustration assignment; 50% on publishing (digital publishing) after expenses. "The only fee we charge is for services rendered (scanning, proofing, printing, etc.). We pay postage, labels and envelopes. Exclusive area representation required (only in the NY, NJ, CT region of the country). Advertising costs are paid by artist or split: 75% paid by artist; 25% paid by rep. Artists must pay for their own promotional material. For promotional purposes, talent must provide a full color direct mail piece, an 11×14 flexible portfolio, digital files and CD. Advertises in *Workbook*.

How to Contact For first contact, send bio, direct mail flier/brochure, photocopies, photographs, résumé, SASE, tearsheets, slides, digital images/CD, query letter (optional). Responds only if interested. Visuals must be sent—otherwise we will not respond. After initial contact, call to schedule an appointment, drop off or mail portfolio, or e-mail. Portfolio should include b&w and color finished art, original art, photographs, slides, tearsheets, transparencies (35mm, 4×5 and 8×10).

Tips "Be as professional as possible! Your presentation is paramount. The competition is fierce, therefore your presentation (portfolio) and art samples need to match or exceed that of the competition."

⚏ BRUCK AND MOSS ASSOCIATES

(212)980-8061. Website: www.bruckandmoss.com. **Contact:** Eileen Moss or Nancy Bruck. Commercial illustration representative. Estab. 1978. Represents 12 illustrators. Markets include: advertising agencies; corporations/client direct; design firms; editorial/magazines; publishing/books; sales/promotion firms; direct marketing.

Handles Illustration.

Terms Rep receives 30% commission. Exclusive representation is required. No geographic restrictions. Advertising costs are split: 70% paid by talent; 30% paid by representative. For promotional purposes, talent must provide "4×5 transparencies mounted on 7×9 black board. Talent pays for promotional card for the first year and for trade ad."

How to Contact Check website for e-mail and additional contact information. For first contact, send tearsheets, "if sending slides, include SASE." After initial contact, drop off or mail in appropriate materials for review. Portfolios should include tearsheets. If mailing portfolio include SASE or Federal Express form.

Tips "Make sure you have had experience repping yourself. Don't approach a rep on the phone, they are too busy for this. Put them on a mailing list and mail samples. Don't approach a rep who is already repping someone with the same style."

⚏ BUZZ LICENSING

(800)975-2899. Fax: (773)883-0375. E-mail: rita.marie@mindspring.com. Website: www.buzzlicensing.com. **President:** Rita Marie. Licensing artists and brands. Estab. 2000. Member of LIMA. Represents 1 fine artist, 5 illustrators. Specializes in artists and brands. Licenses illustrators. Markets include paper products/greeting cards, puzzles, home decor. Artists include Susan Martinelli, Joe Cepeda, David Willardson.

Handles Fine art, illustration, photography.

Terms Exclusive representation required.

How to Contact For first contact, send query letter with photocopies, photographs, SASE, tearsheets. Responds only if interested. After initial contact, call to schedule an appointment. Portfolio should include b&w and color finished art, tearsheets.

WOODY COLEMAN PRESENTS, INC.

dba Portsort.com (artist-controlled cooperative). 490 Rockside Rd., Cleveland OH 44131. (216)661-4222. Fax: (216)661-2879. E-mail: woody@portsort.com. Website: www.portsort.com. **Contact:** Laura Ray, CEO. Estab. 1978. Member of Graphic Artists Guild. Specializes in illustration. Markets include: advertising agencies; corporations/client direct; design firms; editorial/magazines; paper products/greeting cards; publishing/books; sales/promotion firms; public relations firms.

Handles Illustration.

Terms Organization negotiates and invoices all projects and receives 25% commission. Selected professional illustrators will receive free placement of 12-image portfolio on Internet Database (see www.portsort.com). For promotional purposes, talent must provide "all 12 or more image portfolios in 4×5 transparencies or high-quality prints, as well as 12-72 dpi scans." Advertises in *American Showcase*, *Black Book*, *The Workbook*, other publications.

How to Contact For first contact, send query letter, tearsheets, slides, SASE, or e-mail under 100K images. Responds in 1 month, only if interested. Portfolio should include tearsheets, 4×5 transparencies.

Tips "Solicitations are made directly to our Cooperative. Concentrate on developing 12 specific examples of a

single style exhibiting work aimed at a particular specialty (multiple 12-image portfolios allowed), such as fantasy, realism, Americana or a particular industry such as food, medical, architecture, transportation, film, etc.''

DANIELE COLLIGNON

200 W. 15th St., New York NY 10011. (212)243-4209. **Contact:** Daniele Collignon. Commercial illustration representative. Estab. 1981. Member of SPAR, Graphic Artists Guild, Art Director's Club. Represents 12 illustrators. Markets include: advertising agencies; corporations/client direct; design firms; editorial/magazines; publishing/books.

Handles Illustration.

Terms Rep receives 30% commission. Exclusive area representation is required. No geographic restrictions. Advertising costs are split: 75% paid by talent; 25% paid by representative. For promotional purposes, talent must provide 8×10 transparencies (for portfolio) to be mounted, printed samples, professional pieces. Advertises in *American Showcase*, *Black Book*, *The Workbook*.

How to Contact For first contact, send direct mail flier/brochure, tearsheets. Responds in 5 days, only if interested. After initial contact, drop off or mail in appropriate materials for review. Portfolio should include tearsheets, transparencies.

CREATIVE FREELANCERS INC.

99 Park Ave., #210A, New York NY 10016. (800)398-9544. Fax: (203)532-2927. E-mail: cfonline@freelancers.com. Website: www.freelancers.com. **Contact:** Marilyn Howard. Commercial illustration and designers representative. Estab. 1988. Represents over 30 illustrators and designers. ''Our staff members have art direction, art buying or illustration backgrounds.'' Specializes in children's books, advertising, architectural, conceptual. Markets include: advertising agencies; corporations/client direct; design firms; editorial/magazines; paper products/greeting cards; publishing/books; sales/promotion firms.

Handles Illustration and design. Artists must have published work.

Terms Rep receives 30% commission. Exclusive area representation is preferred. Advertising costs are split: 75% paid by talent; 25% paid by representative. For promotional purposes, talent should provide ''JPEG or GIF images and be listed at our website. Transparency portfolio preferred if we take you on, but we are flexible.'' Advertises in *American Showcase*, *Workbook*.

How to Contact For first contact, send tearsheets or file copies. Responds only if interested.

Tips Looks for experience, professionalism and consistency of style. Obtains new talent through ''word of mouth and website.''

☑ CWC INTERNATIONAL, INC.

296 Elizabeth St., #1F, New York NY 10012. (646)486-6586. Fax: (646)486-7622. E-mail: agent@cwc-i.com. Website: www.cwc-i.com. **Contact:** Koko Nakano, senior creative agent. Commercial ilustration representative. Member of Graphic Artists Guild. Represents 21 illustrators. Specializes in advertising, fashion. Markets include advertising agencies, corporations/client direct, design firms, editorial/magazines, galleries, paper products/greeting cards, publishing/books, record companies. Artists include Tobie Giddio, Stina Persson, Chris Long, Kenzo Minami.

Handles Fine art, illustration.

Terms Exclusive area representation required.

How to Contact For first contact, send query letter with direct mail flier/brochure, photocopies (3-4 images) and résumé via snail mail or e-mail. Responds only if interested.

Tips ''Please do not call. When sending any image samples by e-mail, be sure the entire file will not exceed 300K.''

☑ LINDA DE MORETA REPRESENTS

1839 Ninth St., Alameda CA 94501. (510)769-1421. Fax: (510)521-1674. E-mail: linda@lindareps.com. Website: www.lindareps.com. **Contact:** Linda de Moreta. Commercial illustration and photography representative; also portfolio and career consultant. Estab. 1988. Represents 8 illustrators, 2 photographers. Markets include: advertising agencies; design firms; corporations/client direct; editorial/magazines; paper products/greeting cards; publishing/books. Represents: Chuck Pyle, Pete McDonnell, Tina Healey, Barbara Callow, Craig Hannah, Monica Dengo, Tina Rachelle, James Chiang, John Howell and Kermit Hayes.

Handles Photography, illustration, lettering/title design.

Terms Commission, exclusive representation requirements and advertising costs are according to individual agreements. Materials for promotional purposes vary with each artist. Advertises in *The Workbook*, *Directory of Illustration*, *Alternative Pick*.

How to Contact For first contact, send direct mail flier/brochure, slides or photocopies and SASE. ''Please do

not send original art. SASE for any items you wish returned." Responds to any inquiry in which there is an interest. Portfolios are individually developed for each artist and may include transparencies, prints or tearsheets.

Tips Obtains new talent through client and artist referrals primarily, some solicitation. "I look for great creativity, a personal vision and style of photography or illustration combined with professionalism, maturity and passion."

THE DESKTOP GROUP

(formerly Freelance Advancers,Inc.), 420 Lexington Ave., Suite 2100, New York NY 10170. (212)916-0824. Fax: (212)867-1759. E-mail: jobs@thedesktopgroup.com. Website: www.thedesktopgroup.com. Estab. 1991. Specializes in recruiting and placing creative talent on a freelance basis. Markets include: advertising agencies, design firms, publishers (book and magazine), corporations, and banking/financial firms.

Handles Artists with Macintosh (and Windows) software and multimedia expertise: graphic designers, production artists, pre-press technicians, presentation specialists, traffickers, art directors, Web designers, content developers, project managers, copywriters, and proofreaders.

How to Contact For first contact, e-mail résumé, cover letter and work samples.

Tips "Our clients prefer working with talented artists who have flexible, easy-going personalities and who are very professional."

FORTUNI

2508 E. Belleview Place, Milwaukee WI 53211. (414)964-8088. Fax: (414)332-9629. E-mail: e-mail@fortuni.com. **Contact:** Marian F. Deegan. Commercial illustration, photography representative. Estab. 1989. Member of Graphic Artists Guild. Represents 6 illustrators, 4 photographers. Markets include: advertising agencies; corporations/client direct; design firms; editorial/magazines; publishing/books. Artists include Peter Carter, Samantha Burton, Janet Drew, Dick Baker, Zelda Bean, Rijalynne Saari, Jody Winger and Kendra Shaw.

Handles Illustration, photography. "I am interested in artists who have developed a consistent, distinctive style of illustration, and target the national advertising market."

Terms Rep receives 30% commission. Advertising costs are split: 70% paid by talent; 30% paid by representative. For promotional purposes, talent must provide direct mail support, advertising, and a minimum of 4 duplicate transparency portfolios. "All promotional materials are developed and produced within my advertising specifications." Advertises in *The Workbook*.

How to Contact For first contact, send direct mail flier/brochure, slides, photographs, photocopies, SASE. Responds in 2 weeks if SASE is enclosed.

ROBERT GALITZ FINE ART/ACCENT ART

166 Hilltop Court, Sleepy Hollow IL 60118. (847)426-8842. Fax: (847)426-8846. **Contact:** Robert Galitz. Fine art representative. Estab. 1985. Represents 100 fine artists (includes 2 sculptors). Specializes in contemporary/abstract corporate art. Markets include: architects, corporate collections, galleries, interior decorators, private collections. Represents: Roland Poska, Jan Pozzi, Diane Bartz and Louis De Mayo.

Handles Fine art.

Terms Agent receives 25-40% commission. No geographic restrictions; sells mainly in Chicago, Illinois, Wisconsin, Indiana and Kentucky. For promotional purposes talent must provide "good photos and slides." Advertises in monthly art publications and guides.

How to Contact For first contact, send query letter, slides, photographs. Responds in 2 weeks. After initial contact, call for appointment to show portfolio of original art. Obtains new talent through recommendations from others, solicitation, conferences.

Tips "Be confident, persistent. Never give up or quit."

RITA GATLIN REPRESENTS INC.

83 Walnut Ave., Corte Madera CA 94925. (415)924-7881. Fax: (415)924-7891. E-mail: gatlin@ritareps.com. Website: www.ritareps.com. Agent: Rita Gatlin. Commercial illustration. Estab. 1991. Member of Society of Illustrators. Represents 12 illustrators. Markets include: advertising agencies; corporations/client direct; design firms; editorial/magazines; paper products/greeting cards; publishing/books. Artists include Sudi McCollum, Mary Ross and more. See our website.

Handles Commercial illustrators only.

Terms Rep receives 25% commission. Charges fees for portfolio materials (mounting and matting); postage for yearly direct mail divided among artists. Advertising costs are split: 75% paid by talent; 25% paid by representative. For promotional purposes, talent must provide at least one 8½×11 printed page. Portfolios can be in transparency form or reflective art. Advertises in *American Showcase*, *The Workbook*, *Directory of Illustration*, *Blackbook*.

How to Contact For first contact, send query letter and tearsheets. Responds in 5 days. After initial contact, call to schedule an appointment for portfolio review.

Tips "Artists must have a minimum of five years experience as commercial illustrators." When asked what their illustration style is, it's best not to say they can do all styles—it's "a sign of a beginner. Choose a medium and excel."

BARBARA GORDON ASSOCIATES, LTD.

165 E. 32nd St., New York NY 10016. (212)686-3514. Fax: (212)532-4302. **Contact:** Barbara Gordon. Commercial illustration and photography representative. Estab. 1969. Member of SPAR, Society of Illustrators, Graphic Artists Guild. Represents 9 illustrators, 1 photographer. "I represent only a small, select group of people and therefore give a great deal of personal time and attention to the people I represent."

Terms No information provided. No geographic restrictions in continental US.

How to Contact For first contact, send direct mail flier/brochure. Responds in 2 weeks. After initial contact, drop off or mail appropriate materials for review. Portfolio should include tearsheets, slides, photographs; "if the talent wants materials or promotion piece returned, include SASE." Obtains new talent through recommendations from others, solicitation, conferences, etc.

Tips "I do not care if an artist or photographer has been published or is experienced. I am essentially interested in people with a good, commercial style. Don't send résumés and don't call to give me a verbal description of your work. Send promotion pieces. *Never* send original art. If you want something back, include a SASE. Always label your slides in case they get separated from your cover letter. And always include a phone number where you can be reached."

⊠ ANITA GRIEN—REPRESENTING ARTISTS

155 E. 38th St., New York NY 10016. E-mail: agrien@aol.com. Representative not currently seeking new talent.

☑ CAROL GUENZI AGENTS, INC.

865 Delaware St., Denver CO 80204. (303)820-2599. E-mail: art@artagent.com. Website: www.artagent.com. **Contact:** Carol Guenzi. Commercial illustration, photography, new media, and film representative. Estab. 1984. Member of Denver Advertising Federation and Art Directors Club of Denver. Represents 29 illustrators, 6 photographers and 3 multimedia developers. Specializes in a "wide selection of talent in all areas of visual communications." Markets include: advertising agencies; corporations/client direct; design firms; editorial/magazine, paper products/greeting cards, sales/promotions firms. Clients include Integer, BBDO, DDB Needham, Dugan Valva Contess. Partial client list available upon request. Represents Christer Eriksson, Juan Alvarez, Shelly Bartek, Dick Alweis, Dan Bulleit, Jim Chow and Kelly Hume.

Handles Illustration, photography. Looking for "unique style application."

Terms Rep receives 25% commission. Exclusive area representative is required. Advertising costs are split: 75% paid by talent; 25% paid by the representation. For promotional purposes, talent must provide "promotional material after six months, some restrictions on portfolios." Advertises in *American Showcase*, *Black Book*, *Directory of Illustration*, *The Workbook*.

How to Contact For first contact, send PDF's or JPEGs or direct mail flier/brochure. Responds in 3 weeks, only if interested. Call or write for appointment to drop off or mail in appropriate materials for review, depending on artist's location. Portfolio should include tearsheets, slides, photographs. Obtains new talent through solicitation, art directors' referrals, an active pursuit by individual artist.

Tips "Show your strongest style and have at least 12 samples of that style before introducing all your capabilities. Be prepared to add additional work to your portfolio to help round out your style. Have a digital background."

GUIDED IMAGERY DESIGN & PRODUCTIONS

(formerly Guided Imagery Productions), 2995 Woodside Rd., #400, Woodside CA 94062. (650)324-0323. Fax: (650)324-9962. **Owner/Director:** Linda Hoffman. Fine art representative. Estab. 1978. Member of Hospitality Industry Association. Represents 3 illustrators, 12 fine artists. Specializes in large art production—perspective murals (trompe l'oeil); unusual painted furniture/screens. Markets include: design firms; interior decorators; hospitality industry.

Handles Looking for "mural artists (realistic or trompe l'oeil) with good understanding of perspectives."

Terms Rep receives 33-50% commission. 100% of advertising costs paid by representative. For promotional purposes, talent must provide a direct mail piece to preview work, along with color copies of work (SASE too). Advertises in *Hospitality Design*, *Traditional Building Magazine* and *Design Journal*.

How to Contact For first contact, send query letter, résumé, photographs, photocopies and SASE. Responds in 1 month. After initial contact, mail appropriate materials. Portfolio should include photographs.

Tips Wants artists with talent, references and follow-through. "Send color copies of original work that show

your artistic style. Never send one-of-a-kind artwork. My focus is 3-D murals. References from previous clients very helpful.'' Please—no cold calls.

PAT HACKETT/ARTIST REPRESENTATIVE

7014 N. Mercer Way, Mercer Island WA 98040. (206)447-1600. Fax: (206)447-0739. E-mail: pathackett@aol.com. Website: www.pathackett.com. **Contact:** Pat Hackett. Commercial illustration and photography representative. Estab. 1979. Represents 12 illustrators, 1 photographer. Markets include: advertising agencies; corporations/client direct; design firms; editorial/magazines.

Handles Illustration.

Terms Rep receives 25-33% commission. Exclusive representation is required. Advertising costs are split: 75% paid by talent; 25% paid by representative. For promotional purposes, talent must provide ''standardized portfolio, i.e., all pieces within the book are the same format. Reprints are nice, but not absolutely required.'' Advertises in *Showcase, The Workbook*.

How to Contact For first contact, send direct mail flier/brochure. Responds in 1 week, only if interested. After initial contact, drop off or mail in appropriate materials: tearsheets, slides, photographs, photostats, photocopies. Obtains new talent through ''recommendations and calls/letters.''

Tips Looks for ''experience in the *commercial* art world, professional presentation in both portfolio and person, cooperative attitude and enthusiasm.''

BARB HAUSER, ANOTHER GIRL REP

P.O. Box 421443, San Francisco CA 94142-1443. (415)647-5660. Fax: (415)546-4180. E-mail: barb@girlrep.com. Website: www.girlrep.com. Estab. 1980. Represents 8 illustrators. Markets include: primarily advertising agencies and design firms; corporations/client direct.

Handles Illustration.

Terms Rep receives 25-30% commission. Exclusive representation in the San Francisco area is required.

How to Contact For first contact, send direct mail flier/brochure, tearsheets, slides, photographs, photocopies and SASE or e-mail without attachments. Responds in 1 month.

JOANNE HEDGE/ARTIST REPRESENTATIVE

1415 Garden St., Glendale CA 91201. (818)244-0110. Fax: (818)244-0136. E-mail: hedgegraphics@earthlink.com. Website: www.hedgereps.com. **Contact:** J. Hedge. Commercial illustration representative. Estab. 1975. Represents 10 illustrators. Specializes in ''high-quality, painterly and realistic illustration, digital art and lettering, also vintage and period styles.'' Markets include advertising agencies, design firms, movie studios, package design firms and Web/interactive clients.

Handles Illustration. Seeks established realists in airbrush, painting and digital art.

Terms Rep receives 30% commission. Artist pays quarterly portfolio maintenance expenses. Advertising costs are split: 75% paid by talent; 25% paid by representative. For promotional purposes, talent should provide ''ad reprint flyer, 4×5 or 8×10 copy transparencies, matted on 11×14 laminate mattes.'' Advertises in *The Workbook*, *Directory of Illustration* and website.

How to Contact Send query letter with direct mail flier/brochure or e-mail with samples attached or website address to view your work. Responds if interested.

Tips Obtains new talent after talent sees *Workbook* directory ad, or through referrals from art directors or other talent. ''Have as much experience as possible and zero or one other rep. That, and a good looking 8½×11 flier!''

Ⓝ HERMAN AGENCY

350 Central Park West, New York NY 10025. (212)749-4907. Fax: (212)663-5151. E-mail: hermanagen@aol.com. Website: www.HermanAgencyInc.com. **Owner/President:** Ronnie Ann Herman. Commercial illustration representative. Estab. 1999. Member of SCBWI. Represents 33 illustrators, 3 photographers. Specializes in children's market. Artists include Seymour Chwast, Alexi Natchev, Joy Allen.

Handles Illustration. Looking for artists with strong history of publishing in the children's market.

Terms Rep receives 25% commission. Exclusive representation required. Advertising costs are split: 75% paid by the artist; 25% paid by rep. Advertises in direct mailing.

How to Contact For first contact, send bio, photocopies, SASE, tearsheets, list of published books. Responds in 4 weeks. After initial contact, contact will be made by agency. Portfolio should include b&w and color tearsheets, copies of published books.

Tips ''Check our website to see if you belong with our agency.''

☑ HK PORTFOLIO

10 E. 29th St., Suite 40G, New York NY 10016. (212)689-7830. Fax: (212)689-7829. E-mail: mela@hkportfolio.com. Website: www.hkportfolio.com. **Contact:** Mela Bolinao. Commercial illustration representative. Estab.

1986. Member of SPAR, Society of Illustrators and Graphic Artists Guild. Represents 50 illustrators. Specializes in illustration for juvenile markets. Markets include: advertising agencies; editorial/magazines; publishing/books.

Handles Illustration.

Terms Rep receives 25% commission. No geographic restrictions. Advertising costs are split: 75% paid by talent; 25% paid by representative. Advertises in *Picture Book* and *Workbook*.

How to Contact No geographic restrictions. For first contact, send query letter, direct mail flier/brochure, tearsheets, slides, photographs, photostats and SASE. Responds in 1 week. After initial contact, drop off or mail in appropriate materials for review. Portfolio should include tearsheets, slides, photographs, photostats, photocopies.

Tips Leans toward "highly individual personal styles."

ℕ IRMEL HOLMBERG

280 Madison Ave., New York NY 10016. (212)545-9155. Fax: (212)545-9462. Rep: I. Holmberg. Commercial illustration representative. Estab. 1980. Member of SPAR. Represents 30 illustrators. Markets include: advertising agencies; corporations/client direct; design firms; editorial/magazines; publishing/books.

Terms Rep receives 30% commission. Exclusive area representation is required. Advertising costs are split: 70% paid by talent; 30% paid by representative. For promotional purposes, talent must provide versatile portfolio with new fresh work. Advertises in *American Showcase*, *The Workbook*.

How to Contact For first contact, send direct mail flier/brochure. Responds in 2 weeks only if interested. After initial contact, call to schedule an appointment. Portfolio should include original art, tearsheets, slides, photocopies.

SCOTT HULL ASSOCIATES

303 E. Social Row Rd., Dayton OH 45458. (937)433-8383. Fax: (937)433-0434. E-mail: scott@scotthull.com. Website: www.scotthull.com. **Contact:** Scott Hull. Commercial illustration representative. Estab. 1981. Represents 30 plus illustrators.

How to Contact Contact by sending e-mail samples, tearsheets or appropriate materials for review. Follow up with phone call. Responds in 2 weeks.

Tips Looks for "an interesting style and a desire to grow, as well as a marketable portfolio."

ℕ THE INTERMARKETING GROUP

29 Holt Road, Amherst NH 03031. (603)672-0499. **President:** Linda Gerson. Art licensing agency. Estab. 1985. Represents 8 illustrators. Specializes in art licensing. Licenses fine artists, illustrators. Markets include paper products/greeting cards, publishing/books, all consumer product applications of art. Artists include Tracy Flickinger, Manlee Carroll, Kate Beetle, Janet Amendola, Cheryl Welch, Rebecca Beuker, Loren Guttormson, Natalie Samolb.

Handles Fine art, illustration.

Terms Will discuss terms of representation directly with the artists of interest. Advertising costs are paid by the artist. For promotional purposes, talent must provide color copies, biography.

How to Contact For first contact, send query letter with bio, direct mail flier/brochure, photocopies, SASE, tearsheets, a good representation of your work in color. Responds in 3 weeks. After initial contact, we will be in contact with you if interested. Portfolio should include color tearsheets.

Tips "Present your work in an organized way. Send the kind of work you enjoy doing and is the most representative of your style."

ℕ VINCENT KAMIN & ASSOCIATES

400 W. Erie St., Chicago IL 60610. (312)787-8834. Fax: (312)787-8172. Website: http://vincekamin.com. Commercial photography, graphic design representative. Estab. 1971. Member of SPAR. Represents 6 illustrators, 6 photographers, 1 designer, 1 fine artist (includes 1 sculptor). Markets include: advertising agencies. Represents Steve Bjorkman, Lee Duggan, Andrzej Dudzinski and Gail Randall.

Handles Illustration, photography.

Terms Rep receives 30% commission. Advertising costs are split: 90% paid by talent; 10% paid by representative. Advertises in *The Workbook* and *Chicago Directory*.

How to Contact For first contact, send tearsheets. Responds in 10 days. After initial contact, call to schedule an appointment. Portfolio should include tearsheets.

ℕ TANIA KIMCHE

111 Barrow St., Suite 8D, New York NY 10014. (212)255-1144. Fax: (212)242-6367. E-mail: tanikim@aol.com. **Contact:** Tania. Commercial illustration representative. Estab. 1981. Member of SPAR. Represents 9 illustrators.

"We do everything, a lot of design firm, corporate/conceptual work." Markets include: advertising agencies; corporations/client direct; design firms; editorial/magazines; publishing books; sales/promotion firms.
Handles Illustration. Looking for "conceptual/corporate work."
Terms Rep receives 25% commission if the artist is in town; 30% if the artist is out of town. Splits postage and envelope expense for mailings with artists. Advertising costs are split: 75% paid by the talent; 25% paid by the representative. For promotional purposes, talent advertists both online and off.
How to Contact For first contact, send bio, tearsheets, slides. Responds in months, only if interested. After initial contact, drop off or mail in appropriate materials for review. Portfolio should include tearsheets, slides, photostats.
Tips Obtains new talent through recommendations from others or "they contact me. Do not call. Send promo material in the mail. Don't waste time with a résumé—let me see the work."

KIRCHOFF/WOHLBERG, ARTISTS REPRESENTATION DIVISION

866 United Nations Plaza, #525, New York NY 10017. (212)644-2020. Fax: (212)223-4387. Website: www.kircho ffwohlberg.com. **President:** Morris A. Kirchoff. Director of Operations: John R. Whitman. Artist's Representative: Elizabeth Ford. Estab. 1930. Member of SPAR, Society of Illustrators, AIGA, Associaton of American Publishers, Bookbuilders of Boston, New York Bookbinders' Guild. Represents over 50 illustrators. Specializes in juvenile and young adult trade books and textbooks. Markets include: publishing/books.
Handles Illustration and photography (juvenile and young adult).
Terms Rep receives 25% commission. Exclusive representation to book publishers is usually required. Advertising costs paid by representative ("for all Kirchoff/Wohlberg advertisements only"). "We will make transparencies from portfolio samples; keep some original work on file." Advertises in *American Showcase, Art Directors' Index, Society of Illustrators Annual, The Black Book*, children's book issues of *Publishers Weekly*.
How to Contact Please send all correspondence to the attention of Elizabeth Ford. For first contact, send query letter, "any materials artists feel are appropriate." Responds in 6 weeks. "We will contact you for additional materials." Portfolios should include "whatever artists feel best represents their work. We like to see children's illustration in any style."

KLIMT REPRESENTS

15 W. 72nd St., 7-U, New York NY 10023. (212)799-2231. E-mail: klimt@prodigy.net. Website: www.klimtreps. com. **Contact:** Bill or Maurine. Commercial illustration representative. Estab. 1978. Member of Society of Illustrators, Graphic Artists Guild. Represents 8 illustrators. Specializes in paperback covers, young adult, romance, science fiction, mystery, etc. Markets include: advertising agencies; corporations/client direct; design firms; editorial/magazines; paper products/greeting cards; publishing/books; sales/promotion firms. Represents: Blattel, Juan Moreno, Ron Spears, Tom Patrick, Fred Smith, Ben Stahl, Shannon Maer, Tery Herman and David Blattel.
Handles Illustration.
Terms Rep receives 25% commission, 30% commission for "out of town if we do shoots." The artist is responsible for only his own portfolio. Exclusive area representation is required. Advertising costs are split: 75% paid by talent; 25% paid by representative. For promotional purposes, talent must provide 4×5 or 8×10 mounted transparencies. Advertises through direct mail.
How to Contact For first contact, send direct mail flier/brochure, and "any image that doesn't have to be returned unless supplied with SASE." Responds in 5 days. After initial contact, call for appointment to show portfolio of professional, mounted transparencies.

ANN KOEFFLER ARTIST REPRESENTATION

1020 W. Riverside Dr., #45, Burbank CA 91506. (818)260-8980. Fax: (818)260-8990. E-mail: annartrep@aol.c om. Website: www.annkoeffler.com. **Owner/Operator:** Ann Koeffler. Commercial illustration representative. Estab. 1984. Member of Society of Illustrators. Represents 20 illustrators. Markets include: advertising agencies, corporations/client direct, design firms, editorial/magazines, paper products/greeting cards, publishing/books, individual small business owners.
Will Handle Interested in reviewing illustration. Looking for artists who are digitally adept.
Terms Rep receives 25-30% commission. Advertising costs 100% paid by talent. For promotional purposes, talent must provide an initial supply of promotional pieces and a committtment to advertise regularly. Advertises in *The Workbook* and *Black Book*.
How to Contact For first contact, send tearsheets or send images digitally. Responds in 1 week. Portfolio should include photocopies, 4×5 chromes.
Tips "I only carry artists who are able to communicate clearly and in an upbeat and professional manner."

SHARON KURLANSKY ASSOCIATES

192 Southville Rd., Southborough MA 01772. (508)460-0037. Fax: (508)480-9221. E-mail: lstock@charter.net. Website: www.laughing-stock.com. **Contact:** Sharon Kurlansky. Commercial illustration representative. Estab. 1978. Represents 9 illustrators. Markets include: advertising agencies; corporations/client direct; design firms; editorial/magazines; paper products/greeting cards; publishing/books; sales/promotion firms. Client list available upon request. Represents: Tim Lewis, Bruce Hutchison and Blair Thornley. Licenses stock illustration for all markets.

Handles Illustration.

Terms Rep receives 25% commission. Exclusive area representation is required. Advertising costs are split: 75% paid by talent; 25% paid by representative. "Will develop promotional materials with talent. Portfolio presentation formated and developed with talent also." Advertises in *American Showcase*, *The Creative Illustration Book*, under artist's name.

How to Contact For first contact, send direct mail flier/brochure, tearsheets, slides and SASE. Responds in 1 month if interested. After initial contact, call for appointment to show portfolio of tearsheets, photocopies. Obtains new talent through various means.

LANGLEY CREATIVE

333 N. Michigan Ave., Suite 1322, Chicago IL 60601. (312)782-0244. Fax: (312)782-1535. E-mail: artrepsjl@aol.com. Website: www.sharonlangley.com. **Contact:** Sharon Langley. Commercial illustration representative. Estab. 1988. Member of CAR (Chicago Artists Representatives). Represents 29 illustrators. Markets include: advertising agencies; corporations; design firms; editorial/magazines; publishing/books; promotion. Clients include Leo Burnett Launch Communications, Scott Foresman, BBDO.

Handles Illustration. Although representative prefers to work with established talent, "I am receptive to reviewing samples by enthusiastic up-and-coming artists."

Terms Rep receives 25% commission. Exclusive area representation is preferred. Advertising costs are split: 75% paid by talent; 25% paid by representative. For promotional purposes, talent must provide printed promotional pieces, well organized, creative portfolio. Advertises in *The Workbook*. "If your book is not ready to show, be willing to invest in a 'zippy' new one."

How to Contact For first contact, send "samples via e-mail or printed materials that do not have to be returned." Responds only if interested. Obtains new talent through recommendations from art directors, referrals and submissions.

Tips "You need to be focused in your direction and style. Be willing to create new samples. Be a 'team player.' The agent and artist form a bond and the goal is success. Don't let your ego get in the way. Be open to constructive criticism and if one agent turns you down, quickly move to the next name on your list."

N: LOTT REPRESENTATIVES

11 E. 47th St., Floor 6, New York NY 10017. (212)755-5737. **Vice President:** Peter Lott. Commercial illustration representative. Estab. 1958. Member of Society of Illustrators. Markets include advertising agencies, corporations/client direct, design firms, editorial/magazines, movie studios, paper products/greeting cards, public art, publishing/books, record companies, sales/promotion firms. Artists include Tim O'Brien, Tsukushi, Craig White.

Handles Illustration.

Terms Advertises in *American Showcase*, *Creative Black Book*, *RSVP*.

How to Contact For first contact, send query letter with tearsheets. Responds only if interested. After initial contact, call to schedule an appointment.

MAGNET REPS

3450 Vinton Ave., Los Angeles CA 90034. (310)876-7111. Fax: (310)876-7199. E-mail: art@magnetreps.com. Website: http://magnetreps.com. **Contact:** Paolo Rizzi, director. Commercial illustration representative. Estab. 1998. Member of Graphic Artists Guild. Represents 12 illustrators. Markets include advertising agencies, corporations/client direct, design firms, editorial/magazines, movie studios, paper products/greeting cards, publishing/books, record companies, character development. Artists include Ben Shannon, Red Nose Studio, Shawn Barber.

Handles Illustration. Looking for artists with the passion to illustrate every day, an awareness of cultural trends in the world we live in, and a basic understanding of the business of illustration.

Terms Exclusive representation required. Advertising costs are split. For promotional purposes, talent must provide a well-developed, consistent portfolio. Advertises in *Workbook* and *Alternative Pick*.

How to Contact For first contact, submit a Web link to portfolio, or 2 sample JPEGs for review via e-mail only. Responds in 1 month. We will contact artist via e-mail if we are interested. Portfolio should include color print outs, good quality.

Tips "Be realistic about how your style matches our agency. We do not represent scientific, technical, medical, sci-fi, hyper-realistic, story boarding, landscape, pin-up, cartoon or cutesy styles. We will not represent artists that imitate the style of one of our existing artists."

☑ MARLENA AGENCY

145 Witherspoon St., Princeton NJ 08542. (609)252-9405. Fax: (609)252-1949. E-mail: marzena@verizon.net. Website: marlenaagency.com. **Artist Reps:** Marlena Torzecka, Ella Lupo, Greta T'Jonck. Commercial illustration representative. Estab. 1990. Member of Art Directors Club of New York, Society of Illustrators. Represents 28 illustrators from France, Poland, Germany, Hungary, Italy, Spain, Canada and US. Specializes in conceptual illustration. Markets include: advertising agencies; corporations/client direct; design firms; editorial/magazines; publishing/books; theaters. Represents: Cyril Cabry, Linda Helton and Gerard DuBois.
* This agency produces promotional materials for artists such as wrapping paper, calendars, brochures.
Handles Illustration, fine art and prints.
Terms Rep receives 30% commission; 35% if translation needed. Costs are shared by all artists. Exclusive area representation is required. Advertising costs are split: 70% paid by talent; 30% paid by representative. For promotional purposes, talent must provide slides (preferably 8×10 framed); direct mail pieces, 3-4 portfolios. Advertises in *American Showcase, Black Book, Illustrators 35* (New York City), *Workbook, Alternative Pick.* Many of the artists are regularly featured in CA Annuals, The Society of Illustrators Annuals, American Illustration Annuals.
How to Contact For first contact send tearsheets or e-mail low resolution images. Responds in 1 week only if interested. After initial contact, drop off or mail appropriate materials. Portfolio should include tearsheets.
Tips Wants artists with "talent, good concepts—intelligent illustration, promptness in keeping up with projects, deadlines, etc."

Ⓝ MASLOV-WEINBERG

608 York St., San Francisco CA 94110. (415)641-1285. Fax: (415)641-5500. E-mail: larryuu@aol.com. Website: www.maslov.com. **Partner:** Larry Weinberg. Commercial illustration representative. Estab. 1988. Represents 2 fine artists, 15 illustrators. Markets include advertising agencies, corporations/client direct, design firms, editorial/magazines, movie studios, paper products/greeting cards, publishing/books, record companies, sales/promotion firms. Artists include Mark Matcho, Mark Ulriksen, Pamela Hobbs.
Handles Illustration.
Terms Rep receives 25% commission. Exclusive representation required. Advertising costs are split: 75% paid by artist; 25% paid by rep. Advertises in *American Showcase, Workbook.*
How to Contact For first contact, send query letter with direct mail flier/brochure. Responds only if interested. After initial contact, write to schedule an appointment.

MENDOLA ARTISTS

420 Lexington Ave., New York NY 10170. (212)986-5680. Fax: (212)818-1246. E-mail: mendolaart@aol.com. **Contact:** Tom Mendola. Commercial illustration representative. Estab. 1961. Member of Society of Illustrators, Graphic Artists Guild. Represents 60 or more illustrators. Markets include: advertising agencies; corporations/client direct; design firms; editorial/magazines; sales/promotion firms.
Handles Illustration. "We work with the top agencies and publishers. The calibre of talent must be in the top 5%."
Terms Rep receives 25% commission. Artist pays for all shipping not covered by client and 75% of promotion costs. Exclusive area representation is sometimes required. Advertising costs are split: 75% paid by talent; 25% paid by representative.
How to Contact "Send e-mail with link to website or JPEGs. Alternatively, send printed samples with SASE or items that you do not need returned. We will contact you if interested in seeing additional work."

Ⓝ MHS LICENSING

11100 Wayzata Blvd., Suite 550, Minneapolis MN 55305-5517. (952)544-1377. Fax: (952)544-8663. E-mail: artreviewcommittee@mhslicensing.com. Website: www.mhslicensing.com. **President:** Marty H. Segelbaum. Licensing agency. Estab. 1995. Member of LIMA. Represents 18 fine artists, 1 photographer, and 4 illustrators or other artists and brands. Markets include paper products/greeting cards, publishing/books, sales promotion firms and other consumer products including giftware, stationery/paper, tabletop, apparel home fashions, textiles, etc. Artists include Hautman Brothers, Judy Buswell, Erika Oller, Kathy Hatch, Constance Coleman and many others.
* See Insider Report with pet portraitist Constance Coleman in the Gallery section of this book.
Handles Fine art, illustration, photography and brand concepts.
Terms Negotiable with firm.

How to Contact Send query letter with bio, tearsheets, approximately 10 low res jpegs via email to artreviewcommitt ee@mhslicensing.com is also acceptable. "See submission guidelines on website. Keep your submission simple and affordable by leaving all the fancy packaging, wrapping and enclosures in your studio. 8½"×11" tearsheets (inkjet is fine), biography, and SASE are all that we need for review." Responds in 6 weeks. No appointments scheduled, please no calls. Portfolio should include color tearsheets. Send SASE for return of material.

Tips "Our mutual success is based on providing manufacturers with trend forward artwork. Please don't duplicate what is already on the market but think instead, 'What are consumers going to want to buy in nine months, one year, or two years?' We want to learn how you envision your artwork being applied to a variety of product types. Artists are encouraged to submit their artwork mocked-up into potential product collections ranging from stationery to tabletop to home fashion (kitchen, bed, and bath). Visit your local department store or mass retailer to learn more about the key items in these categories. And, if you have multiple artwork styles, include them with your submission."

DAVID MONTAGANO

211 E. Ohio, #2006, Chicago IL 60611. (312)527-3283. Fax: (312)527-2108. E-mail: dm@davidmontagano.com. Website: davidmontagano.com. **Contact:** David Montagano. Commercial illustration, photography and television production representative and broker. Estab. 1983. Represents 8 illustrators, 3 photographers. Markets include: advertising agencies; corporations/client direct; design firms; editorial/magazines; paper products.
Handles Illustration, photography, design, marker and storyboard illustration.
Terms Rep receives 30% commission. No geographic restrictions. Advertises in *American Showcase, The Workbook, CIB.*
How to Contact For first contact, send direct mail flier/brochure, tearsheets, photographs. Portfolio should include original art, tearsheets, photographs.

MORGAN GAYNIN INC.

194 Third Ave., New York NY 10003. (212)475-0440. Fax: (212)353-8538. E-mail: info@morgangaynin.com. Website: www.morgangaynin.com. **Partners:** Vicki Morgan and Gail Gaynin. Commercial illustration representative. Estab. 1974. Markets include: advertising agencies; corporations/client direct; design firms; magazines; books; sales/promotion firms.
Handles Illustration.
Terms Rep receives 30% commission. Exclusive area representation is required. No geographic restrictions. Advertising costs are split: 70% paid by talent; 30% paid by representative. Advertises in directories, on the Web, direct mail.
How to Contact For first contact, send "an e-mail with a URL. No drop-off policy."

MUNRO CAMPAGNA

630 N. State St., Chicago IL 60610. (312)321-1336. Fax: (312)321-1350. E-mail: steve@munrocampagna.com. Website: www.munrocampagna.com. **President:** Steve Munro. Commercial illustration, photography representative. Estab. 1987. Member of SPAR, CAR (Chicago Artists Representatives). Represents 22 illustrators, 2 photographers. Markets include advertising agencies; corporations/client direct; design firms; publishing/books. Represents: Pat Dypold and Douglas Klauba.
Handles Illustration.
Terms Rep receives 25-30% commission. Exclusive area representation is required. Advertising costs are split: 75% paid by talent; 25% paid by representative. For promotional purposes, talent must provide 2 portfolios. Advertises in *American Showcase, Black Book, The Workbook.*
How to Contact For first contact, send query letter, bio, tearsheets and SASE. Responds in 2 weeks. After initial contact, write to schedule an appointment. Portfolio should include 4×5 or 8×10 transparencies.

THE NEWBORN GROUP, INC.

115 W. 23rd St., Suite 43A, New York NY 10011. (212)989-4600. Fax: (212)989-8998. Website: www.newborngr oup.com. **Owner:** Joan Sigman. Commercial illustration representative. Estab. 1964. Member of SPAR, Society of Illustrators, Graphic Artists Guild. Represents 12 illustrators. Markets include: advertising agencies; design firms; editorial/magazines; publishing/books. Clients include Leo Burnett, Penguin Putnam, Time Inc., Weschler Inc.
Handles Illustration.
Terms Rep receives 30% commission. Exclusive area representation is required. Advertising costs are split: 70% paid by talent; 30% paid by representative. Advertises in *American Showcase, The Workbook, Directory of Illustration.*
How to Contact "Not reviewing new talent."
Tips Obtains new talent through recommendations from other talent or art directors.

LORI NOWICKI AND ASSOCIATES

310 W. 97th St., #24, New York NY 10025. E-mail: lori@lorinowicki.com. Website: www.lorinowicki.com. Estab. 1993. Represents 20 illustrators. Markets include: advertising agencies; design firms; editorial/magazines; publishing/books; children's publishing.

Handles Illustration and author/illustrators.

Terms Rep receives 25-30% commission. Cost for direct mail promotional pieces is paid by illustrator. Exclusive area representation is required. Advertising costs are split: 75% paid by talent; 25% paid by representative. Advertises in *The Workbook*, *Black Book*, *Showcase*, *Directory of Illustration*.

How to Contact For first contact, send query letter, résumé, non-returnable tearsheets, or e-mail a link to your website. Samples are not returned. "Do not phone, do not e-mail attachments, will contact if interested." Wants artists with consistent style. "We are aspiring to build a larger children's publishing division and specifically looking for author/illustrators."

CAROLYN POTTS & ASSOC. INC.

848 Dodge Ave., #236, Evanston IL 60202. (847)864-7644. E-mail: carolyn@cpotts.com. **President:** Carolyn Potts. Commercial photography, illustration representative and marketing consultant for creative professionals. Estab. 1976. Member of SPAR, CAR (Chicago Artists Reps). Represents photographers and illustrators. Specializes in contemporary advertising and design. Markets include: advertising agencies; corporations/client direct; design firms; publishing/books. Artists include Julia La Pine, John Craig, Rhonda Voo and Karen Bell.

Handles Illustration, photography. Looking for "artists able to work with new technologies (interactive, computer, etc.)."

Terms Rep receives 30-35% commission. Artists share cost of their direct mail postage and preparation. Exclusive area representation is required. Advertising costs are split: 70% paid by the talent; 30% paid by the representative after initial trial period wherein artist pays 100%. For promotional purposes, talent must provide direct mail piece and multiple portfolios. Advertises in *American Showcase*, *Black Book*, *The Workbook*, *Single Image*.

How to Contact For first contact, send direct mail flier/brochure and SASE. Responds in 3 days. After initial contact, write to schedule an appointment. Portfolio should include tearsheets, slides, photographs.

Tips Looking for artists with high level of professionalism, awareness of current advertising market, professional presentation materials (that includes a digital portfolio) and positive attitude.

Ⓝ PUBLISHERS' GRAPHICS

231 Judd Rd., Easton CT 06612. (203)445-1511. Fax: (203)445-1411. E-mail: paigeg@publishersgraphics.com. Website: www.publishersgraphics.com. **Sales & Contract Manager:** Martha Boil. Commercial illustration representative for juvenile markets. Estab. 1970. Member of Society of Children's Book Writers and Illustrators, Author's Guild Inc. Staff includes Paige C. Gillies (President, selects illustrators, develops talent). Specializes in children's book illustration. Markets include: publishing/books. Represents: G. Brian Karas, Lisa McCue, Dan Andreasen, Pam Paparone, Lynne Cravath, SD Schindler, R.W. Alley, JoAnn Adinolfi, Benrei Huang and Teri Weidner.

Handles Illustration.

Terms Rep receives 25% commission. Exclusive area representation is required. For promotional purposes, talent must provide original art, proofs, photocopies "to start. The assignments generate most sample/promotional material thereafter unless there is a stylistic change in the work."

How to Contact Portfolio is closed.

Tips "Show samples that relate to the market in which you wish to find representation."

GERALD & CULLEN RAPP, INC.

420 Lexington Ave., Penthouse, New York NY 10170. (212)889-3337. Fax: (212)889-3341. E-mail: lara@rappart.com. Website: www.theispot.com/rep/rapp. **Contact:** Lara Tomlin. Commercial illustration representative. Estab. 1944. Member of SPAR, Society of Illustrators, Graphic Artists Guild. Represents 50 illustrators. Markets include: advertising agencies; corporations/client direct; design firms; editorial/magazines; paper products/greeting cards; publishing/books; sales/promotion firms. Represents: Jonathan Carlson, Mark Rosenthal, Seth and James Steinberg.

Handles Illustration.

Terms Rep receives 25-30% commission. Exclusive area representation is required. No geographic restrictions. Split of advertising costs is negotiated. Advertises in *American Showcase*, *The Workbook*, *Graphic Artists Guild Directory* and *CA*, *Print* magazines. "Conducts active direct mail program and advertises on the Internet."

How to Contact For first contact, send query letter, direct mail flier/brochure or e-mail with no more than 1 image attached. Responds in 1 week. Obtains new talent through recommendations from others, solicitations.

The Magazine *for Pastel Artists!*

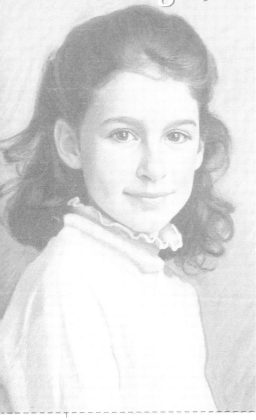

The Pastel Journal is the leading magazine for pastel artists of all skill levels. Thousands enjoy this unique publication packed with beautiful artwork and addressing the real challenges and experiences of pastel artists today.

Each bi-monthly issue of **The Pastel Journal** brings you:

- *in-depth articles featuring expert tips and techniques that inspire your own art style*
- *up-to-the-minute interviews with pastel artists*
- *a gallery of gorgeous artwork from leading artists*
- *comprehensive listings of workshops and contests*
- *expert advice on how to market your artwork*
- *product reviews to help you choose the best art materials*
- *and much, much more!*

So treat yourself to a subscription to **The Pastel Journal**, and take your art to the next exciting level.

**Return the card below
and save 25% today!**

Why *The Pastel Journal?*

Beyond the artists' different technical approaches, ***The Pastel Journal*** also focuses on the compelling philosophies and thoughts behind their work. You'll find invaluable information as well as priceless creative inspiration in the breadth and scope of this magazine.

• *Learn how an exciting variety of artists use pastel in creating breathtaking landscapes, still lifes, portraits, wildlife art, and more.*

• *Discover concrete, useful information about methods and materials, such as how to frame your artwork; how to shoot professional slides; and how to build your own Web site.*

• *Explore opportunities and resources through a regular column on marketing, comprehensive workshop and exhibition listings, sources for supplies and services, and much more.*

If you've ever given a thought to working in pastel, or if you're an artist working in another medium looking for more substance and inspiration in an art magazine, here's a chance to give ***The Pastel Journal*** a try.

Send in the card below and subscribe today!

PROCESS IMMEDIATELY!

BUSINESS REPLY MAIL
FIRST-CLASS MAIL PERMIT NO. 349 FLAGLER BEACH FL

POSTAGE WILL BE PAID BY ADDRESSEE

PO BOX 421411
PALM COAST FL 32142-9813

⟨N⟩ KERRY REILLY: REPS

1826 Asheville Place, Charlotte NC 28203. Phone/fax: (704)372-6007. **Contact:** Kerry Reilly. Commercial illustration and photography representative. Estab. 1990. Represents 16 illustrators, 2 photographers and animatics. Markets include: advertising agencies; corporations/client direct; design firms; editorial/magazines. Clients include GM, VW, Disney World, USPO.

• Kerry Reilly: Reps is partnering with Steven Edsey & Sons.

Handles Illustration, photography. Looking for computer graphics: Photoshop, Illustrator, FreeHand, etc.

Terms Rep receives 25% commission. Exclusive area representation is required. No geographic restrictions. Advertising costs are split: 75% paid by talent; 25% paid by representative. For promotional purposes, talent must provide at least 2 pages printed leave-behind samples. Preferred format is 9×12 pages, portfolio work on 4×5 transparencies. Advertises in iSpot.

How to Contact For first contact, send direct mail flier/brochure or samples of work. Responds in 2 weeks. After initial contact, call for appointment to show portfolio or drop off or mail tearsheets, slides, 4×5 transparencies.

Tips "Have printed samples and electronic samples (in JPEG format)."

⟨N⟩ REMEN-WILLIS DESIGN GROUP

2964 Colton Road, Pebble Beach CA 93953. (831)655-1407. Fax: (831)655-1408. E-mail: annrwillis@aol.com. Website: www.picture-book.com. **Art Rep:** Ann Remen-Willis. Children's books only/no advertising. Estab. 1984. Member of SCBWI. Represents 2 fine artists, 15 illustrators. Specializes in children's books trade and text. Markets include design firms, editorial/magazines, paper products/greeting cards, publishing/books. Artists include Dominic Catalano, Dennis Hockerman, Christine Benjamin.

Handles Illustration.

Terms Rep receives 25% commission. Advertising costs are split: 50% paid by artist; 50% paid by rep. Advertises in *Picturebook*.

How to Contact For first contact, send query letter with tearsheets. Responds in one week. After initial contact, call to schedule an appointment. Portfolio should include b&w and color tearsheets.

Tips "Fill portfolio with samples of art you want to continue receiving as commissions. Do not include that which is not a true representation of your style and capability."

⟨N⟩ LILLA ROGERS STUDIO

E-mail: info@lillarogers.com. Website: www.lillarogers.com. **Agent:** Ashley Lorenz. Commercial illustration representative. Estab. 1984. Represents 19 illustrators. Markets include advertising agencies, corporations/client direct, design firms, editorial/magazines, paper products/greeting cards, publishing/books, record companies, sales/promotion firms, children's books, surface design. Artists include Maria Carluccio, Diane Bigda, Jon Cannell.

Handles Illustration.

Terms Rep receives 30% commission. Exclusive representation required. Advertising costs are split: 70% paid by artist; 30% paid by rep. Advertises in *Print Magazine*.

How to Contact For first contact, e-mail a link to your site, or 3-5 JPEGs. Responds only if interested.

Tips "It's good to check out the agency's website and see if you feel like it's a good fit. Explain why you want an agent and think we are a good match."

THE ROLAND GROUP

4948 St. Elmo Ave., Suite #201, Bethesda MD 20814. (301)718-7955. Fax: (301)718-7958. E-mail: info@therolandgroup.com. Website: www.therolandgroup.com. Commercial illustration and photography representative. Estab. 1988. Member of SPAR, Society of Illustrators, Ad Club, Production Club. Represents 20 illustrators and over 300 photographers. Markets include: advertising agencies; corporations/client direct; design firms; editorial/magazines; paper products/greeting cards; publishing books.

Handles Illustration and photography.

Terms Rep receives 35% commission. Exclusive and non-exclusive representation available. Also work with artists on a project-by-project basis. For promotional purposes, talent must provide 8½×11 promo sheet. Advertises in *American Showcase*, *The Workbook*, *International Creative Handbook*, *Black Book* and *KLIK*.

How to Contact For first contact, send query letter, tearsheets and photocopies. Responds only if interested. Portfolio should include nonreturnable tearsheets, photocopies.

LIZ SANDERS AGENCY

2415 E. Hangman Creek Lane, Spokane WA 99224. (509)993-6400. Fax: (509)466-5400. E-mail: liz@lizsanders.com. Website: www.lizsanders.com. **Contact:** Liz Sanders, owner. Commercial illustration representative. Estab. 1985. Represents 10 illustrators. Specializes in marketing of individual artists within an ever-evolving illustration world. Markets include advertising agencies, corporations/client direct, design firms, editorial/magazines, juve-

nile markets, paper products/greeting cards, publishing/books, record companies, sales/promotion firms.

Handles Interested in illustration. Looking for fresh, unique talent committed to long-term careers whereby the agent/talent relationship is mutually respectful, responsive and measurably successful.

Terms Rep receives 25-30% commission. Exclusive representation required. Advertises in *Picturebook*, *American Showcase*, *Workbook*, *Directory of Illustration*, direct mail material, traditional/electronic portfolio for agent's personal presentations, means to advertise if not substantially, then consistently.

How to Contact For first contact, send nonreturnable printed pieces or e-mailed Web address. Responds only if interested. After initial contact, call to schedule an appointment, depending on geographic criteria. Portfolio should include tearsheets, photocopies and digital output.

Tips ''Concisely present a single, focused style supported by 8-12 strong samples. Only send a true portfolio upon request.''

JOAN SAPIRO ART CONSULTANTS

4750 E. Belleview Ave., Greenwood Village CO 80121. (303)793-0792. Fax: (303)290-9204. E-mail: jsac@qwest. net. **Contact:** Laura Hohlfield or Joan Sapiro. Estab. 1980. Specializes in ''corporate art with other emphasis on hospitality, health care and art consulting/advising to private collectors.''

Handles All mediums of artwork and all prices if applicable for clientele.

Terms Artist must be flexible and willing to ship work on consignment. Also must be able to provide sketches, etc. if commission piece involved. No geographic restrictions.

How to Contact For first contact, send résumé, bio, direct mail flier/brochure, tearsheets, slides, photographs, price list—net (wholesale) and SASE. After initial contact, drop off or mail in appropriate materials for review.

Tips Obtains new talent through recommendations, publications, travel, research, university faculty.

N SMART LICENSING, INC.

19804 Falling Spring Ct., Laytonsville MD 20882. (240)632-0797. E-mail: spaskow@verizon.net. Website: www. smartlicensing.net. **President:** Steffi Paskow. Art licensor, art publisher. Estab. 2001. Represents 11 fine artists. Specializes in realism. Licenses fine artists, illustrators. Markets include corporations/client direct, galleries, paper products/greeting cards, public art, sales/promotion firms. Artists include Edward Gordon, Linda Koast, Kim Kessler.

Handles Fine art, Illustration.

Terms Rep receives 50% commission. Exclusive representation required. Advertising costs are split.

How to Contact For first contact, send query letter with bio, direct mail flier/brochure, photographs, résumé, tearsheets. Responds in 3 weeks. After initial contact, call to schedule an appointment. Portfolio should include b&w and color finished art, original art, photographs, tearsheets, digital file.

Tips ''It's important to align yourself with a firm that has a track record and solid business reputation.''

SUSAN AND CO.

5002 92nd Ave. SE, Mercer Island WA 98040. (206)232-7873. Fax: (206)232-7908. E-mail: susan@susanandco.c om. Website: www.susanandco.com. **Owner:** Susan Trimpe. Commercial illustration, photography representative. Estab. 1979. Member of SPGA. Represents 19 illustrators, 2 photographers. Specializes in commercial illustrators. Markets include advertising agencies; corporations/client direct; design firms; publishing/books. Artists include: Bryn Barnard, Linda Ayriss and Larry Jost.

Handles Looks for ''current illustration styles.''

Terms Rep receives 30% commission. National representation is required. Advertising costs are split: 70% paid by talent; 30% paid by representative.

How to Contact For first contact, send query letter and direct mail flier/brochure. Responds in 2 weeks only if interested. After initial contact, call to schedule an appointment. Portfolio should ''be representative of unique style.''

THOSE 3 REPS

2909 Cole, Suite #333, Dallas TX 75204. (214)871-1316. Fax: (214)880-0337. E-mail: moreinfo@those3reps.com. Website: www.those3reps.com. **Contact:** Debbie Bozeman, Carol Considine. Artist representative. Estab. 1989. Member of Dallas Society of Visual Community, ASMP, SPAR and Dallas Society of Illustrators. Represents 15 illustrators, 8 photographers. Specializes in commercial art. Markets include: advertising agencies; corporations/client direct; design firms; editorial/magazines.

Handles Illustration, photography (including digital).

Terms Rep receives 30% commission; 30% for out-of-town jobs. Exclusive area representation is required. Advertising costs are split: 70% paid by talent; 30% paid by representative. For promotional purposes, talent must provide 2 new pieces every 2 months, national advertising in sourcebooks and at least 1 mailer. Advertises in *Workbook*, own book.

How to Contact For first contact, send query letter and tearsheets. Responds in days or weeks only if interested. After initial contact, call to schedule an appointment, drop off or mail in appropriate materials. Portfolio should include tearsheets, photostats, transparencies, digital prints.
Tips Wants artists with "strong unique consistent style."

☑ ⚄ THREE IN A BOX INC.

862 Richmond St. E, Suite 201, Toronto ON M6J 1C9 Canada. (416)367-2446. Fax: (416)367-3362. E-mail: info@threeinabox.com. Website: www.threeinabox.com. **Contact:** Holly Venable, managing director. Commercial illustration representative. Estab. 1990. Member of Graphic Artists Guild. Represents 53 illustrators, 2 photographers. Specializes in illustration. Licenses illustrators and photographers. Markets include advertising agencies, corporations/client direct, design firms, editorial/magazines, paper products/greeting cards, publishing/books, record companies, sales/promotion firms. Artists include Otto Steininger, Martin O'Neill and Peter Ferguson.
Handles Illustration. Looking for advertising, infographic specialists and illustrators with a solid portfolio of editorial work in one style.
Terms Rep receives 30% commission. Exclusive representation required. Advertising costs are split: 70% paid by artist; 30% paid by rep.
How to Contact For first contact, send query letter and URL to info@threeinabox.com. Responds in 1 week. After initial contact, we'll call if interested. Portfolio should include digital.
Tips "Try to specialize; you can't do everything well."

☑ CHRISTINA A. TUGEAU: ARTIST AGENT

3009 Margaret Jones Lane, Williamsburg VA 23185. E-mail: chris@catugeau.com. Website: www.catugeau.com. **Owner:** Chris Tugeau. Children's publishing market illustration representative (K-12). Estab. 1994. Member of Graphic Artists Guild, SPAR, SCBWI. Represents 40 illustrators. Specializes in children's book publishing and educational market and related areas. Represents: Stacey Schuett, Larry Day, Bill Farnsworth, Melissa Iwai, Keiko Motoyama, Jason Wolff, Jeremy Tugeau, Priscilla Burris, John Kanzler, Ann Barrow, Heather Maione, Chris Demarest, Daniel J. Mahoney and others.
Handles Illustration. Must be proficient at illustrating children and animals in a variety of interactive situations, backgrounds, full color/b&w, and with a strong narrative sense.
Terms Rep receives 25% commission. Exclusive USA representation is required. For promotional purposes, talent must provide a direct mail promo piece, 8-10 good "back up" samples (multiples), 3 strong portfolio pieces. Advertises in *RSVP*, *GAG Directory of Illustration* and *Picturebook*.
How to Contact For first contact, e-mail a few JPEG samples or send direct mail flier/brochure, tearsheets, photocopies, books, SASE, "No slides! No originals." Responds by 2 weeks.
Tips "You should have a style uniquely and comfortably your own and be great with deadlines. Will consider young, new artists to the market with great potential and desire, as well as published, more experienced illustrators. Best to study and learn the market standards and expectations by representing yourself for a while when new to the market."

GWEN WALTERS

1801 S. Flagler Dr. #1202, West Palm Beach FL 33401. (561)805-7739. Fax: (561)805-5751. E-mail: Artincgw@aol.com. Website: www.GwenWaltersartrep.com. Commercial illustration representative. Estab. 1976. Member of Graphic Artists Guild. Represents 17 illustrators. "I lean more toward book publishing." Markets include: advertising agencies; corporations/client direct; editorial/magazines; paper products/greeting cards; publishing/books; sales/promotion firms. Represents: Gerardo Suzan, Fabricio Vanden Broeck, Resario Valderrama, Lave Gregory, Susan Spellman, Sally Schaedler, Judith Pfeiffer, Yvonne Gilbert, Gary Torrisi, Larry Johnson, Pat Davis and Linda Pierce.
Handles Illustration.
Terms Rep receives 30% commission. Charges for color photocopies. Advertising costs are split; 50% paid by talent; 50% paid by representative. For promotional purposes, talent must provide direct mail pieces. Advertises in *RSVP*, *Directory of Illustration* and *Picture Book*.
How to Contact For first contact, send résumé, bio, direct mail flier/brochure. After initial contact, representative will call. Portfolio should include "as much as possible."
Tips "You need to pound the pavement for a couple of years to get some experience under your belt. Don't forget to sign all artwork. So many artists forget to stamp their samples."

⚇ WASHINGTON-ARTISTS' REPRESENTATIVE INC. (II)

22727 Cielo Vista #2, San Antonio TX 78255-9501. (210)698-1409. E-mail: artrep@sbcglobal.net. Website: www.theispot.com. **Contact:** Dick Washington. Commercial illustration representative. Estab. 1983. Represents 12 illustrators.

Terms No information provided.

How to Contact For first contact, send tearsheets. Responds in 2 weeks, only if interested. After initial contact, call for appointment to show portfolio of original art, tearsheets, slides. Usually obtains new talent through recommendations and solicitation.

Tips "Make sure that you are ready for a real commitment and relationship. It's an important step for an artist, and it should be taken seriously."

WATSON & SPIERMAN PRODUCTIONS

636 Broadway, Suite 708, New York NY 10012. (212)431-4480. Fax: (212)253-9996. E-mail: email@watsonspier man.com. Website: www.watsonspierman.com. Commercial illustration/photography representative. Estab. 1992. Member of SPAR. Represents 9 fine artists, 8 illustrators, 10 photographers. Specializes in general illustration, photography. Markets include advertising agencies, design firms, galleries, paper products/greeting cards, record companies, publishing/books, sales/promotion firms, corporations/client direct, editorial/magazines. Artists include Kan, Monica Lind, Daniel Arsenault, Adam Brown, Bryan Helm, Joseph Ilan, Frank Siteman, North Sullivan, Kim Harlow, Annabelle Verhoye, Pierre Chanteau, Kristofer Dan-Bergman, Lou Wallach, Dan Cotton, Glenn Hilario, Dannielle Siegelbaum, Ty Wilson, Fulvia Zambon.

Handles Fine art, illustration, photography.

Terms Rep receives 30% commission. Exclusive representation required. Advertising costs are paid by artist. Artist must publish every year in a sourcebook with all Watson & Spierman talent. Advertises in *American Showcase* and *Workbook*.

How to Contact For first contact, send link to website. Responds only if interested. After initial contact, drop off or mail portfolio. Portfolio should include b&w, color, finished art, original art, photographs, tearsheets.

Tips "We love to hear if an artist has an ad out or recently booked a job. Those are the updates that are most important to us."

DEBORAH WOLFE LTD.

731 N. 24th St., Philadelphia PA 19130. (215)232-6666. Fax: (215)232-6585. E-mail: inquiry@illustrationOnLine. com. Website: www.illustrationOnLine.com. **Contact:** Deborah Wolfe. Commercial illustration representative. Estab. 1978. Represents 25 illustrators. Markets include: advertising agencies; corporations/client direct; design firms; editorial/magazines; publishing/books.

Handles Illustration.

Terms Rep receives 25% commission. Advertises in *American Showcase*, *Black Book*, *The Workbook*, *Directory of Illustration* and *Picturebook*.

How to Contact For first contact, send direct mail flier/brochure, tearsheets, slides or e-mail. Responds in 3 weeks.

Organizations, Publications & Websites

There are literally millions of artist- and designer-related websites out there. Here are just a few that we at *Artist's & Graphic Designer's Market* think are particularly useful.

BUSINESS

Arts Business Exchange: www.artsbusiness.com.
Sign up for the free e-mail newsletter and get updates on trends, Canadian art news, sales data and art law and policy.

Starving Artists Law: www.starvingartistslaw.com.
Start here for answers to your legal questions.

Tera's Wish: www.teras-wish.com/marketing.htm.
Tera Leigh, author of *How to Be Creative If You Never Thought You Could* (North Light Books), shares tips and ideas for marketing, promotion, P.R. and more.

ILLUSTRATORS

Altpick.com: The Source for Creative Talent & Imagination: www.altpick.com.
News, competition deadlines, artist listings and much more. Check out the wealth of information listed.

Association of Medical Illustrators: www.ami.org.
A must-visit for anyone interested in the highly specialized niche of medical illustration.

The Association of Science Fiction and Fantasy Artists: www.asfa-art.org.
Home of the Chesley Awards, this site is essential for anyone connected to the visual arts of science fiction, fantasy, mythology and related topics.

Canadian Association of Photographers and Illustrators in Communications (CAPIC): www.capic.org.
There's a ton of copyright and industry news and articles on this site, also help with insurance, lawyers, etc.

Canadian Society of Children's Authors, Illustrators and Performers: www.canscaip.org.
This organization promotes all aspects of Children's writing, illustration and performance.

THE DRAWING BOARD: members.aol.com/thedrawing.
Get everything here—from pricing guidelines to events, tips to technique.

Greeting Card Association: www.greetingcard.org.
A great place for learning about and networking in the greeting card industry.

Magatopia: www.magatopia.com.
Online magazine articles, Web searches for art jobs, weekly columns on freelancing. . . . there's a lot to explore at this site.

Magazines A-Z: www.magazinesatoz.com.
This is a straightforward listing of a bunch of magazines.

The Medical Illustrators' Home Page: www.medartist.com.
A site for medical illustrators who want to post their work for stock imagery or view others' work.

Society of Children's Book Writers and Illustrators: www.scbwi.org.
With chapters all over the world, SCBWI is the premier organization for professionals in children's publishing.

The Society of Illustrators: www.societyillustrators.org.
Since 1901, this organization has been working to promote the interest of professional illustrators. Information on exhibitions, career advice and many other links provided.

Theispot.com: www.theispot.com.
An online "home for illustrators" developed by Gerald Rapp, which showcases illustrators' work and serves as a meeting place where illustrators can discuss their profession and share ideas.

Writers Write: Greeting Cards: www.writerswrite.com/greetingcards.
This site has links to greeting card companies and their submission information.

FINE ART

American Artist Registry: www.artistregistry.com.
A registry where you can post art, get updates on calls for entries throughout the United States and much more.

Art Deadlines List: www.artdeadlineslist.com.
The e-mail version of this list is free. It's a great source for deadlines for calls for entries, competitions, scholarships, festivals and more.

Art Dealers Association of America: www.artdealers.org.
Opportunities and information on marketing your work, galleries and dealers.

Artdeadline.com: artdeadline.com.
Called the "Art Professional's Resource," this site lists information for funding, grants, commissions for art in public places, representation. . . . the list goes on and on.

Artist Help Network: www.artisthelpnetwork.com.
Find career, legal and financial advice along with multiple regional, national and international resources.

Artist Resource: www.artistresource.org.
Growing online art organization offering career development information for artists from Northern California and beyond.

The Artist's Network: www.artistsnetwork.com.
Get articles, excerpts and tips from *The Artist Magazine*, *Watercolor Magic*, and *Decorative Artist's Workbook*.

Artline: www.artline.com.

Artline is comprised of 7 dealer associations: Art Dealers Association of America, Art Dealers Association of Greater Washington, Association of International Photography Art Dealers, Chicago Art Dealers Association, International Fine Print Dealers Association, San Francisco Art Dealers Association, and Society of London Art Dealers. The website has information about exhibits and artists worldwide.

New York Foundation for the Arts: www.nyfa.org.

With news, a searchable database of opportunities for artists, links to other useful sites such as databases of galleries and the Artist's Community Federal Credit Union, this site is loaded!

CARTOONS & COMIC BOOK ART

The Comic Book Legal Defense Fund: www.cbldf.org.

"Defending the comic industry's first amendment rights since 1986."

Friends of Lulu: www.friends-lulu.org.

This national nonprofit organization's purpose is to "promote and encourage female readership and participation in the comic book industry."

National Cartoonists Society: www.reuben.org.

Home and birthplace of the famed Reuben Awards, this organization holds something for cartoonists interested in everything from caricature to animation.

TalkAboutComics.com: www.talkaboutcomics.com.

"Free community resource for small press and Web comics creators and fans."

The Nose: www.the-nose.com.

"Online caricature artist index."

ADVERTISING, DESIGN & GRAPHIC ART

Advertising Age: www.adage.com.

This site is a database of advertising agencies.

American Institute of Graphic Arts: www.aiga.org.

Whether or not you join the organization, this site is a must for designers! From inspiration to insurance the AIGA is the designer's spot.

The Art Directors Club: www.adcny.org.

Founded in 1920, this international not-for-profit organization features job listings, educational opportunities and annual awards in advertising, graphic design, new media and illustration.

Association Typographique Internationale (ATYPI): www.atypi.org.

Dedicated entirely to typography and type, if fonts are your specialty, make sure this site is on your favorites list.

Graphic Artists Guild: www.gag.org.

The art and design industry standard.

HOW **Magazine:** www.howdesign.com.

One of the premier publications dedicated to design, the website features jobs, business resources, inspiration and news, as well as conference information.

Society of Graphic Designers of Canada: www.gdc.net.
Great site for Canadian designers that offers industry news, job postings and forums.

Type Directors Club: www.tdc.org.
Events, news, awards and scholarships are all here for "those interested in excellence in typography."

OTHER USEFUL SITES

Animation World Network: www.awn.com.
Animation industry database, job postings, resume database, education resources, discussion forums, links, newsletters and a host of other resources cover everything animation.

Art Schools: www.artschools.com.
A free online directory with a searchable database of art schools all over the world. They also have information on financial aid, majors and lots more.

Artbusiness.com: www.artbusiness.com.
Contains art-business-related articles, reviews business-of-art books and sells classes on marketing for artists.

The Artist's Magazine: www.artistsmagazine.com.
Archives of articles covering everything from the newest type of colored pencil to techniques in waterolors.

Artlex Art Dictionary: www.artlex.com.
Art dictionary with more than 3,200 terms.

Communication Arts Magazine: www.commarts.com.
Publication and website covering all aspects of design from print to digital.

Imagesite: www.imagesite.com.
Lists searchable databases of advertising agencies, art reps, competitions, galleries and printers.

International Animation Association: asifa.net.
ASIFA or Association Internationale du Film d'Animation is an international group dedicated to the art of animation. They list worldwide news and information on chapters of the group, as well as conferences, contests and workshops.

Music Connection: www.musicconnection.com.
If you're working hard to get your art on CD covers, you'll want to keep up with the ever-changing world of the music industry.

Portfolios.com: www.portfolios.com.
Serving both artists and clients looking for artists, portfolios.com offers a variety of services for everyone. This is a really nice site; you can post up to a five-image portfolio for free.

Glossary

Acceptance (payment on). An artist is paid for his work as soon as a buyer decides to use it.

Adobe Illustrator®. Drawing and painting computer software.

Adobe PageMaker®. Page-layout design software (formerly Aldus PageMaker). Product relaunched as InDesign.

Adobe Photoshop®. Photo manipulation computer program.

Advance. Amount paid to an artist before beginning work on an assigned project. Often paid to cover preliminary expenses.

Airbrush. Small pencil-shaped pressure gun used to spray ink, paint or dye to obtain gradated tonal effects.

Aldus FreeHand. Illustration software (see Macromedia FreeHand).

Aldus PageMaker. Page layout software (see Adobe PageMaker).

Anime. Japanese word for animation.

Art director. In commercial markets, the person responsible for choosing and purchasing artwork and supervising the design process.

Biannually. Occurring twice a year.

Biennially. Occurring once every two years.

Bimonthly. Occurring once every two months.

Biweekly. Occurring once every two weeks.

Book. Another term for a portfolio.

Buy-out. The sale of all reproduction rights (and sometimes the original work) by the artist; also subcontracted portions of a job resold at a cost or profit to the end client by the artist.

Calligraphy. The art of fine handwriting.

Camera-ready. Art that is completely prepared for copy camera platemaking.

Capabilities brochure. A brochure, similar to an annual report, outlining for prospective clients the nature of a company's business and the range of products or services it provides.

Caption. See gagline.

Carriage trade. Wealthy clients or customers of a business.

CD-ROM. Compact disc read-only memory; non-erasable electronic medium used for digitized image and document storage and retrieval on computers.

Collateral. Accompanying or auxiliary pieces, such as brochures, especially used in advertising.

Color separation. Photographic process of separating any multi-color image into its primary component parts (cyan, magenta, yellow and black) for printing.

Commission. 1) Percentage of retail price taken by a sponsor/salesman on artwork sold. 2) Assignment given to an artist.

Comprehensive. Complete sketch of layout showing how a finished illustration will look when printed; also called a comp.

Copyright. The exclusive legal right to reproduce, publish and sell the matter and form of a literary or artistic work.

Consignment. Arrangement by which items are sent by an artist to a sales agent (gallery, shop, sales rep, etc.) for sale with the understanding the artist will not receive payment until work is sold. A commission is almost always charged for this service.

Direct-mail package. Sales or promotional material that is distributed by mail. Usually consists of an outer envelope, a cover letter, brochure or flier, SASE, and postpaid reply card, or order form with business reply envelope.

Dummy. A rough model of a book or multi-page piece, created as a preliminary step in determining page layout and length. Also, a rough model of a card with an unusual fold or die cut.

Edition. The total number of prints published of one piece of art.

Elhi. Abbreviation for elementary/high school used by publishers to describe young audiences.

Environmental graphic design (EGD). The planning, designing and specifying of graphic elements in the built and natural environment; signage.

EPS files. Encapsulated PostScript—a computer format used for saving or creating graphics.

Estimate. A ballpark figure given to a client by a designer anticipating the final cost of a project.

Etching. A print made by the intaglio process, creating a design in the surface of a metal or other plate with a needle and using a mordant to bité out the design.

Exclusive area representation. Requirement that an artist's work appear in only one outlet within a defined geographical area.

Finished art. A completed illustration, mechanical, photo or combination of the three that is ready to go to the printer. Also called camera-ready art.

Gagline. The words printed with a cartoon (usually directly beneath); also called a caption.

Giclée Method of creating limited and unlimited edition prints using computer technology in place of traditional methods of reproducing artwork. Original artwork or transparency is digitally scanned and the stored information is manipulated on screen using computer software (usually Photoshop). Once the image is refined on screen, it is printed on an Iris printer, a specialized ink-jet printer designed for making giclée prints.

Gouache. Opaque watercolor with definite, appreciable film thickness and an actual paint layer.

Halftone. Reproduction of a continuous tone illustration with the image formed by dots produced by a camera lens screen.

Informational graphics. Information, especially numerical data, visually represented with illustration and text; charts/graphs.

IRC. International Reply Coupon; purchased at the post office to enclose with artwork sent to a foreign buyer to cover his postage cost when replying.

Iris print. Limited and unlimited edition print or giclée output on an Iris or ink-jet printer (named after Iris Graphics of Bedford, Massachusetts, a leading supplier of ink-jet printers).

JPEG files. Joint Photographic Experts Group—a computer format used for saving or creating graphics.

Keyline. Identification of the positions of illustrations and copy for the printer.

Kill fee. Portion of an agreed-upon payment an artist receives for a job that was assigned, started, but then canceled.

Layout. Arrangement of photographs, illustrations, text and headlines for printed material.

Licensing. The process whereby an artist who owns the rights to his or her artwork permits (through a written contract) another party to use the artwork for a specific purpose for a specified time in return for a fee and/or royalty.

Lithography. Printing process based on a design made with a greasy substance on a limestone slab or metal plate and chemically treated so image areas take ink and non-image areas repel ink.

Logo. Name or design of a company or product used as a trademark on letterhead, direct mail packages, in advertising, etc., to establish visual identity.

Mechanicals. Preparation of work for printing.

Multimedia. A generic term used by advertising, public relations and audiovisual firms to describe productions involving animation, video, Web graphics or other visual effects. Also, a term used to reflect the varied in-house capabilities of an agency.

Naif. Native art of such cultures as African, Eskimo, Native American, etc., usually associated with daily life.

Offset. Printing process in which a flat printing plate is treated to be ink-receptive in image areas and ink-repellent in non-image areas. Ink is transferred from the printing plate to a rubber plate, and then to the paper.

Overlay. Transparent cover over copy, on which instruction, corrections or color location directions are given.

Panel. In cartooning, the boxed-in illustration; can be single panel, double panel or multiple panel.

PMT. Photomechanical transfer; photostat produced without a negative.

P-O-P. Point-of-purchase; in-store marketing display that promotes a product.

Prima facie. Evidence based on the first impression.

Print. An impression pulled from an original plate, stone, block screen or negative; also a positive made from a photographic negative.

Production artist. In the final phases of the design process, the artist responsible for mechanicals and sometimes the overseeing of printing.

QuarkXPress. Page layout computer program.

Query. Letter to an art director or buyer eliciting interest in a work an artist wants to illustrate or sell.

Quotation. Set fee proposed to a client prior to commencing work on a project.

Rendering. A drawn representation of a building, interior, etc., in perspective.

Retail. The sale of goods in small quantities directly to the consumer.

Roughs. Preliminary sketches or drawings.

Royalty. An agreed percentage paid by a publisher to an artist for each copy of a work sold.

SASE. Self-addressed, stamped envelope.

Self-publishing. In this arrangement, an artist coordinates and pays for printing, distribution and marketing of his/her own artwork and in turn keeps all ensuing profits.

Semiannual. Occurring twice a year.

Semimonthly. Occurring twice a month.

Semiweekly. Occurring twice a week.

Serigraph. Silkscreen; method of printing in which a stencil is adhered to a fine mesh cloth stretched over a wooden frame. Paint is forced through the area not blocked by the stencil.

Speculation. Creating artwork with no assurance that a potential buyer will purchase it or reimburse expenses in any way; referred to as work "on spec."

Resources

Spot illustration. Small illustration used to decorate a page of type or to serve as a column ending.

Storyboard. Series of panels that illustrate a progressive sequence or graphics and story copy of a TV commercial, film or filmstrip. Serves as a guide for the eventual finished product.

Tabloid. Publication whose format is an ordinary newspaper page turned sideways.

Tearsheet. Page containing an artist's published illustration, cartoon, design or photograph.

Thumbnail. A rough layout in miniature.

TIFF files. Tagged Image File Format—a computer format used for saving or creating graphics.

Transparency. A photographic positive film such as a color slide.

Type spec. Type specification; determination of the size and style of type to be used in a layout.

Velox. Photoprint of a continuous tone subject that has been transformed into line art by means of a halftone screen.

VHS. Video Home System; a standard videotape format for recording consumer-quality videotape, most commonly used in home videocassette recording and portable camcorders.

Video. General category comprised of videocassettes and videotapes.

Wash. Thin application of transparent color or watercolor black for a pastel or gray tonal effect.

Wholesale. The sale of commodities in large quantities usually for resale (as by a retail merchant).

Enter our drawing for a
free copy of the next edition

Reader Survey:
Tell us about yourself!

1. How often do you purchase *Artist's & Graphic Designer's Market*?

◯ every year
◯ every other year
◯ This is my first edition

2. Describe yourself and your artwork—and how you use *AGDM*.

3. What do you like best about *AGDM*?

4. Would you like to see an online version of *AGDM*?

◯ Yes
◯ No

Name: _____
Address: _____
City: _____ State: _____ Zip: _____
Phone: _____ e-mail _____
Website: _____

Fax to Mary Cox, (513) 531-2686 or mail to Artist's & Graphic Designer's Market, 4700 East Galbraith Road, Cincinnati, OH 45236, or e-mail artdesign@fwpubs.com. Respond by March 30, 2005. **Twenty names will be drawn from respondents to receive free copies of the next edition.**

Niche Marketing Index

The following indexes can help you find the most apropriate listings for the kind of artwork you create. Check the individual listings for specific information about submission requirements.

Children's Publications/Products

Niche Marketing Index

Informational Graphics

Licensing

Medical Illustration

Mugs

Multicultural

Multimedia

Religious/Spiritual

General Index